AN AMERICAN ODYSSEY

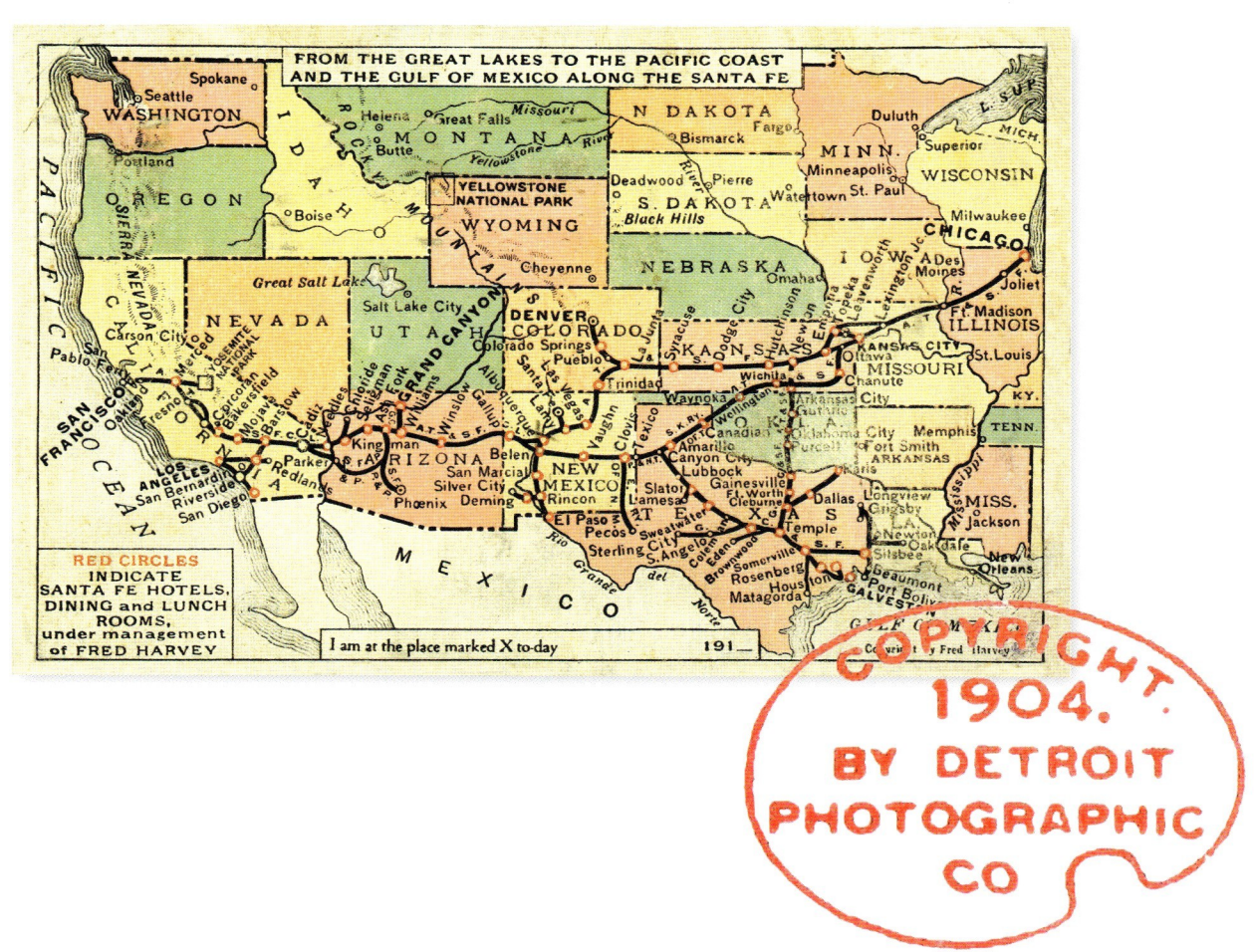

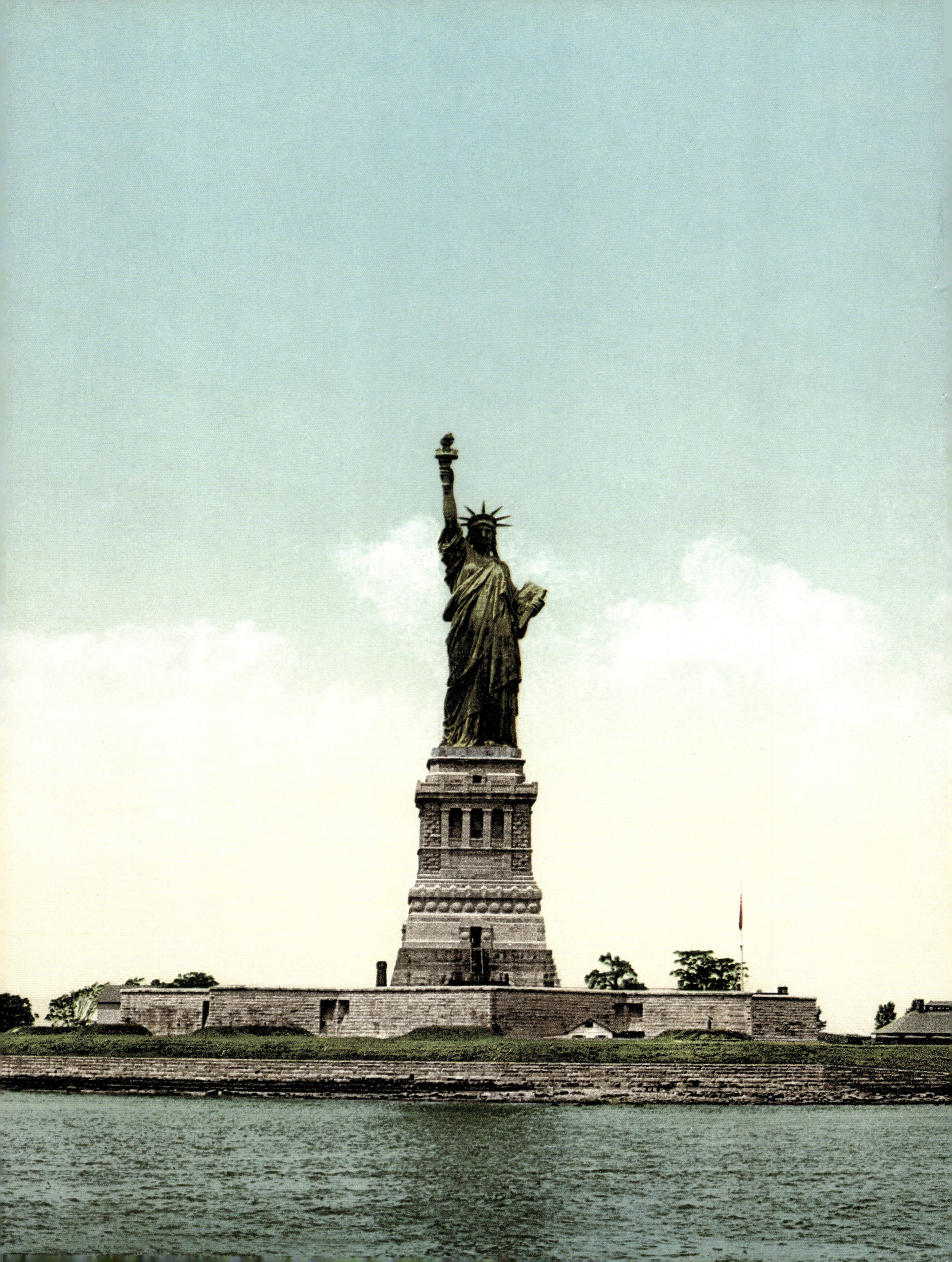

MARC WALTER & SABINE ARQUÉ

AN AMERICAN ODYSSEY

PHOTOS FROM THE
DETROIT PHOTOGRAPHIC COMPANY
1888–1924

TASCHEN

CONTENTS / INHALT / SOMMAIRE

INTRODUCTION / EINLEITUNG / INTRODUCTION

6 / 14 / 22

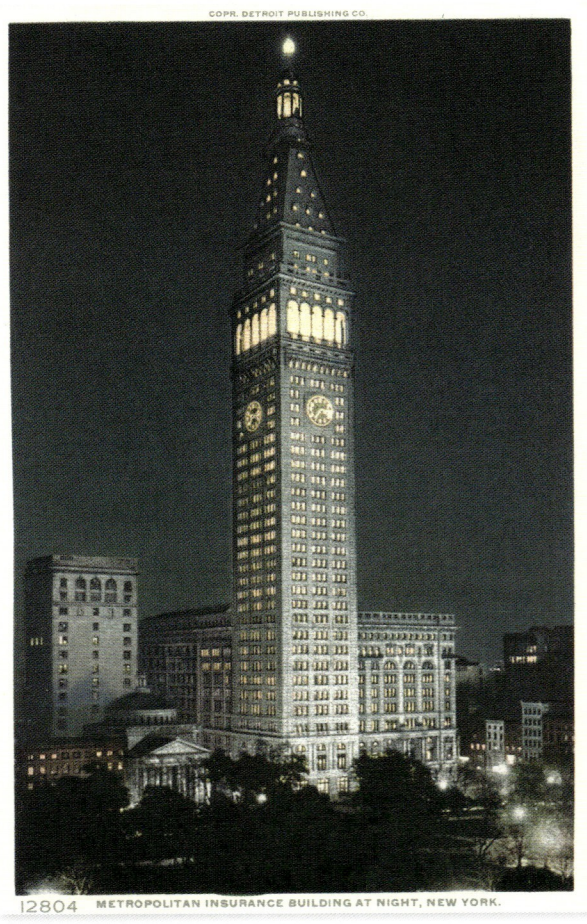

I
NEW YORK CITY

30

II
THE EAST COAST AND QUEBEC

DIE OSTKÜSTE UND QUEBEC
LA CÔTE EST ET LE QUÉBEC

86

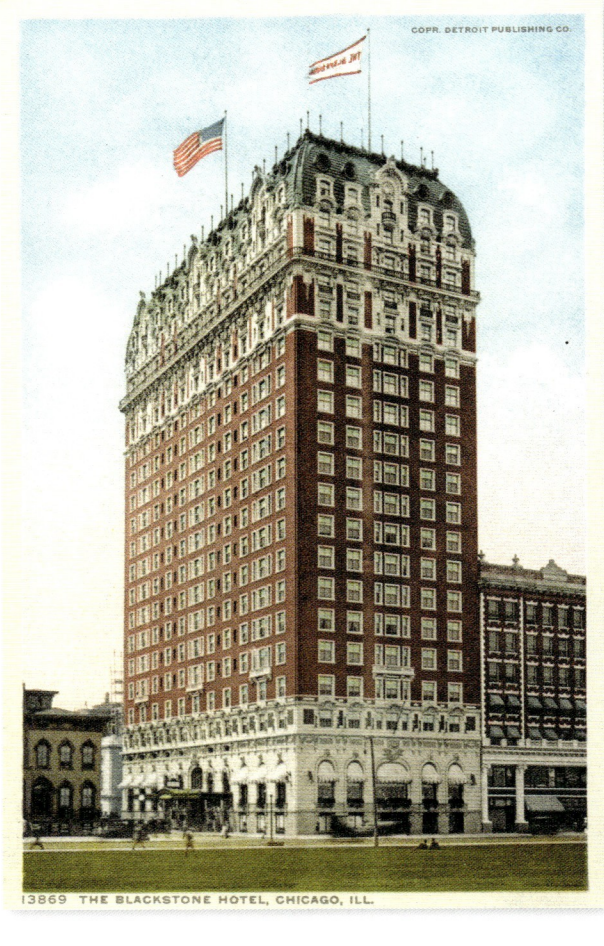

III
THE GREAT LAKES AND THE MIDWEST

DIE GROSSEN SEEN UND DER MITTLERE WESTEN
LES GRANDS LACS ET LE MIDDLE WEST

208

Note
Although the photochroms reproduced in this book were all made between 1895 and 1910, the black-and-white negatives used to print them often date from much earlier. For this reason we have decided not to date the photochroms. The same is true of the Phostint postcards printed between 1898 and 1912; the photos on which they were based were also frequently dated much earlier.
By contrast, the original glass plates from the Library of Congress are dated (at times rather approximately), and these dates have been reproduced here.

Hinweis
Die in diesem Buch abgebildeten Photochrome wurden alle zwischen 1895 und 1910 hergestellt. Da die für den Druck der Photochrome verwendeten Schwarzweißnegative jedoch in den meisten Fällen zu einem früheren Zeitpunkt entstanden, haben wir es vorgezogen, die Photochrome nicht zu datieren. Dasselbe gilt für die Phostint-Postkarten, die zwischen 1898 und 1912 gedruckt wurden, deren Klischees jedoch meist ebenfalls älter sind. Die originalen Glasplatten aus dem Bestand der Library of Congress hingegen sind (bisweilen annäherungsweise) datiert; diese Daten haben wir entsprechend angegeben.

Avertissement
Tous les photochromes reproduits dans cet ouvrage ont été produits entre 1895 et 1910. Les négatifs en noir et blanc ayant servi à imprimer ces photochromes étant le plus souvent bien antérieurs à leur production, nous avons cependant jugé préférable de ne pas dater ces photochromes. Il en va de même pour les cartes postales Phostint, imprimées entre 1898 et 1912 mais dont les clichés sont, eux aussi, souvent antérieurs. Les plaques de verre originales provenant du fonds de la Bibliothèque du Congrès sont, elles, datées (parfois approximativement), et nous avons donc indiqué ces dates.

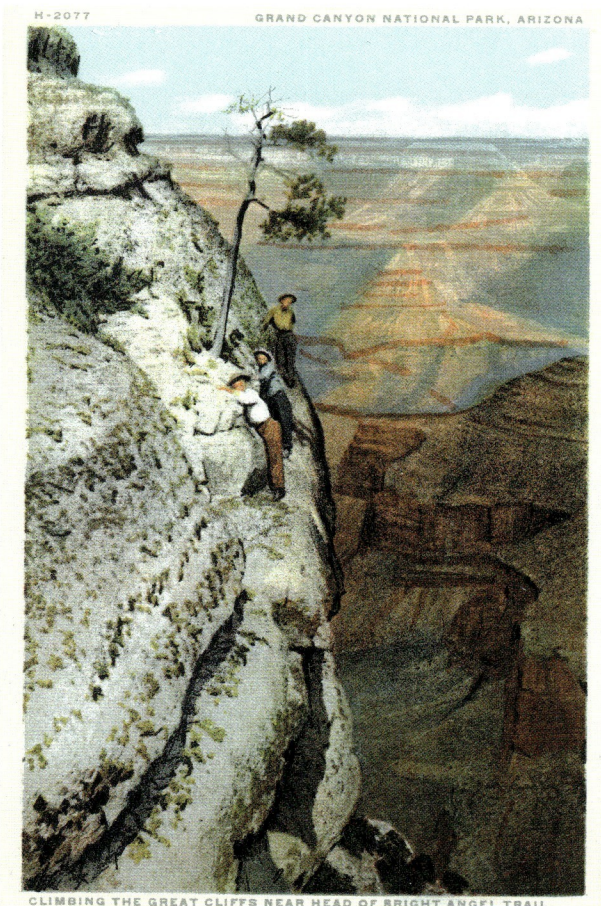

IV
THE OLD SOUTH AND THE CARIBBEAN

DER ALTE SÜDEN UND DIE KARIBIK
LE VIEUX SUD ET LES CARAÏBES

276

V
THE WILD WEST

DER WILDE WESTEN
LE FAR WEST

390

VI
THE PACIFIC COAST

DIE PAZIFIKKÜSTE
LA CÔTE PACIFIQUE

518

APPENDIX 606

INDEX 608

BIBLIOGRAPHY / BIBLIOGRAFIE / BIBLIOGRAPHIE 611

ACKNOWLEDGEMENTS / DANK / REMERCIEMENTS 612

Page 10, left: William Henry Jackson's assistant and the mule carrying his equipment, Colorado, ca. 1873
Page 10, right: *The Studio of the Photographic Pioneer on the West Plateau of the Trois Tetons*, original photo of 1872
Right: *How to Photograph Mountains* or *The Studio of the Photographic Pioneer on the West Plateau of the Trois Tetons*, watercolor by William Henry Jackson, 1936; adapted by Jackson from his original photo of 1872

Seite 10, links: William Henry Jacksons Assistent mit einem Maultier, das sein Material trägt, Colorado, um 1873
Seite 10, rechts: *Das Studio des Fotopioniers auf dem Westplateau der Teton-Bergkette*, Originalfotografie von 1872
Rechts: *Wie man im Gebirge fotografiert* oder *Das Studio des Fotopioniers auf dem Westplateau der Teton-Bergkette*, Aquarell von William Henry Jackson, 1936: Bearbeitung einer Originalfotografie von 1872 durch den Fotografen Jackson selbst.

Page 10, à gauche: l'assistant de William Henry Jackson et la mule portant son matériel, Colorado, vers 1873
Page 10, à droite: *Le studio du photographe pionnier sur le plateau ouest des Trois Tétons*, photographie originale de 1872
À droite: *Comment on photographie dans les montagnes*, ou *Le studio du photographe pionnier sur le plateau ouest des Trois Tétons*, aquarelle par William Henry Jackson, 1936: adaptation par Jackson lui-même de sa photographie originale de 1872

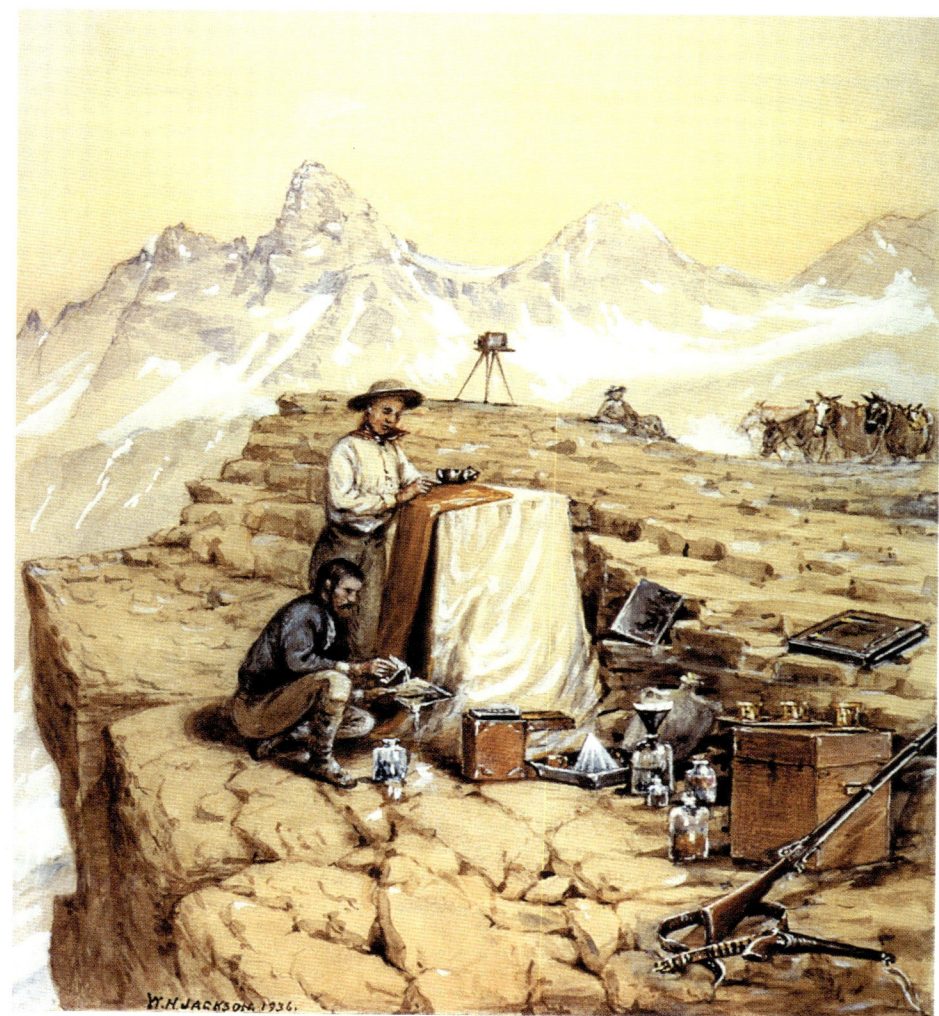

situation was critical. Husher had no trouble convincing him to join the Detroit Photochrom Co.
The contract offered to Jackson by Husher and William Livingstone included the purchase of his Denver studio and his entire stock of negatives—some 10,000 works covering not only the American West but more "exotic" destinations, such as India, Sri Lanka, China, and Indonesia. These came to constitute the most substantial archive of the DPC. Appointed director of production, Jackson learned the Photochrom process and helped tint his own pictures with the assistance of the watercolor sketches with which his notebooks were crammed.
Jackson continued to undertake reportages throughout the United States until 1903, when he succeeded Edwin Husher as the head of the Detroit Photochrom Co. In 1902, he went to Florida on board a specially equipped train—the California Limited, sponsored by the Santa Fe Railroad Co.—to promote the photochroms of the DPC. From there, he traveled on to Cuba and the Bahamas, continuing to accumulate negatives on behalf of the company.

THE CONQUEST OF THE AMERICAN MARKET
At the same time, the brothers Livingstone and Husher implemented a commercial strategy on a very large scale. Husher bought negatives from various North American photographers and salaried a number of photographers such as Lycurgus Solon Glover and Henry Greenwood Peabody, the latter renowned for his sea views and his photographs of the America's Cup. In fact, over and above the production of photochroms, the directors of the DPC were set on realizing a major ambition: using the Photochrom process to print postcards and conquer the market opened up by the American government in 1898 to private companies through the reduced cost of postal stamps. That same year, under the trade name Photochrom Co., they issued an experimental first series comprising some 40 views (California; Colorado; Washington, D.C.; Florida; Boston; Detroit; Niagara; Salt Lake City; etc.), followed in 1899 by a second set principally composed of shots of Yellowstone and Michigan. In late 1903, their first catalogue, titled *Color Souvenir Post Cards*, listed four series (1,000, 5,000, 6,000, and 7,000), including nearly 2,000 titles.[9] In 1905, in the cards of the 9,000 series, the name Detroit Photochrom Co. was replaced by that of the Detroit Publishing Co. (also DPC).
That year, the DPC was at the height of its prosperity. It employed 40 salaried employees and some dozen sales reps. It had opened its own shops in Detroit, New York, and Los Angeles and had branches in many other cities, including some in Europe. William Livingstone and his board of management crisscrossed the United States in their private publicity train, notably exhibiting panoramic photochroms and "Mammoths" (giant photochroms), among which figured views of the major American tourist sites, such as Yellowstone, Niagara Falls, the Grand Canyon, the Great Salt Lake, and Yosemite. For tourism was the stock in trade of the DPC; its directors understood this and sold their products from sales points located close to the most frequented sites. Because it had remained unique, the photochrom was the leading product of the company: more than 1,600 "strictly American" subjects (landscapes, types, urban views, and so on) came into being between 1899 and 1905, ranging from the small (3½ × 7 in. / 9 × 18 cm) and standard formats (6½ × 8¾ in. / 16.5 × 22.5 cm) to several panoramic formats and the "Mammoth" (approximately 16½ × 20½ in. / 42 × 52 cm). To this should be added some 40 reproductions of works of art, all of which were also American. These photochroms were available individually or in thematic souvenir albums, depending where they were distributed. Clients were even able to obtain "made to order" items. However, photochroms remained rather expensive and the DPC sold still more black-and-white images ("silver prints") and postcards. The printing of Phostint postcards—a trade name registered in 1907 to identify the superior quality obtained thanks to the Photochrom process—reached a peak around 1910.
At this point, the DPC decided to give priority to the most popular touristic subjects and signed a contract with the Fred Harvey hotel and restaurant chain. Harvey owned establishments the length of the Santa Fe Railroad and thought postcards "the best way to promote your Hotel or Restaurant";[10] he therefore ordered hundreds of thousands from the DPC. Finally, in 1912, there appeared little thematic packs of 40 cards called "Little Phostint Journeys." "These cards could be projected onto a screen as 'big striking images' in order to make the journey 'more vivid,'" notes John Jezierski, citing the words used by the DPC in its publicity. By 1932, more than 30,000 postcards of different subjects had been published in millions of copies; the use of the Photochrom process made it possible to publish variants at each successive reprinting.

THE END OF AN ERA
According to a report by William Henry Jackson,[11] the DPC's total production during its prosperous times frequently attained seven million images a year. However, the DPC's production began to decline in the 1910s. Competition

INTRODUCTION

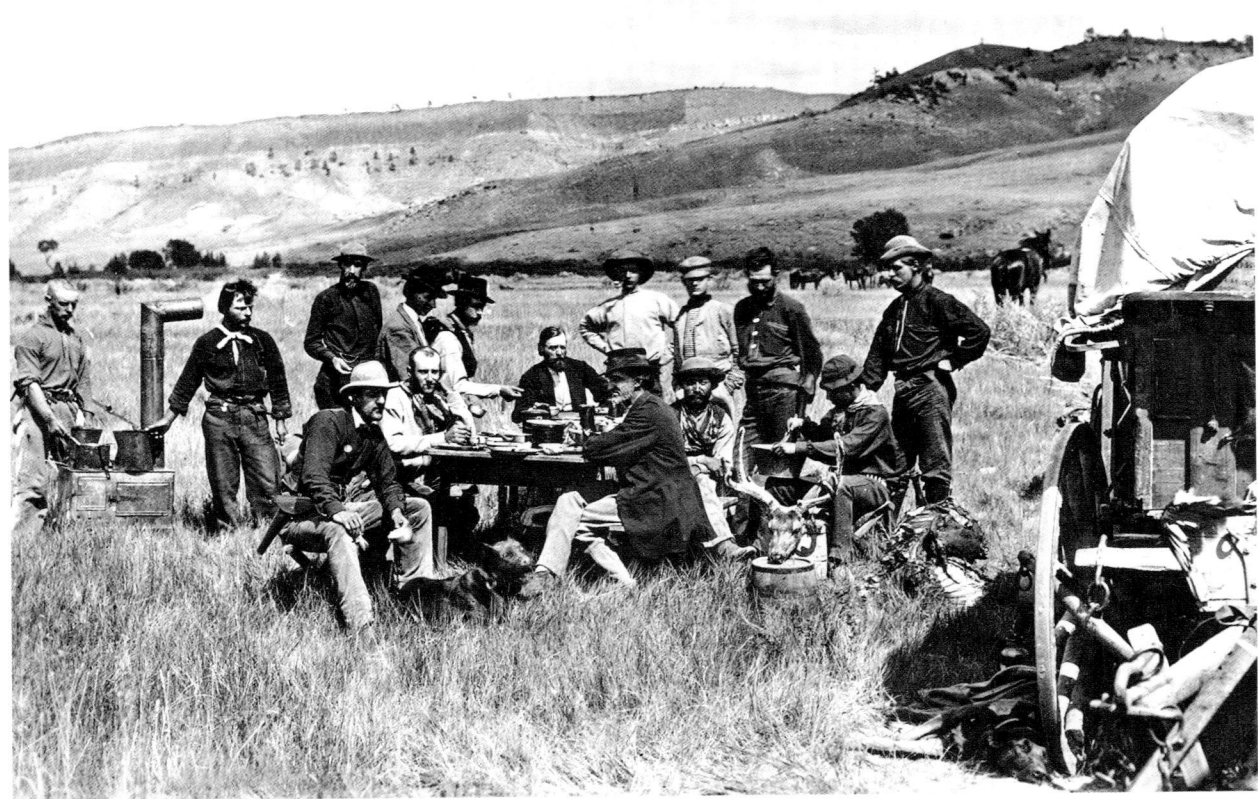

was increasingly stiff and photochrom and Phostint production costs were too high. World War I and the recession of 1920–22 were fatal for the company. In 1924, it went into receivership; Jackson was dismissed and the company's 40,000 negatives were sold off. However, the DPC continued to sell off its stocks and produce orders for clients attached to the quality of Phostint productions until 1932, when the company was liquidated.

In 1936, William Henry Jackson returned to Detroit to inquire after his negatives. They and those of other photographers, along with the relevant prints, had initially been acquired by the Henry Ford Museum and Greenfield Village of Dearborn, Michigan, to form part of the collection of the Edison Institute[12] and subsequently, in 1949, donated to the State Historical Society of Colorado. The Society kept exclusively those parts of the archives that related to territories on the west bank of the Mississippi and handed over the rest—some 25,000 glass negatives and 300 photochroms in addition to 900 glass plates by Jackson—to the Library of Congress in Washington, D.C., where they remain today. In relation to this donation, however, one mystery remains. The writer and editor of the magazine *Camera Arts*, Jim Hughes,[13] reports that, in the 1980s, the head of a Missouri publishing house specializing in the history of the Wild West was alerted by one of its authors to the fact that a collection of glass plates and "color prints" stored in a warehouse in Bozeman, Montana, was about to be destroyed. Hughes had this entire collection brought to St. Louis to be inventoried; there, he discovered thousands of photochroms bearing the DPC copyright mark that were in perfect condition, having never been distributed. This extraordinary horde was discovered in the home of the widow of the son of one of Jackson's old friends, the photographer Frank Jay Haynes, so we are left to surmise that Jackson himself had entrusted it to him. But this is mere supposition. Of those photochrom "survivors," 1,300 have since been bought by a Minnesota gallery, the American Photochrom Archive.

In Europe as in the United States, photochroms were long forgotten. Specialists of photography could not help but feel reservations about "these images, whose colors seemed to them so artificial" (thus wrote the historian of photography Nathalie Boulouch). It was only in 1974 that the curator of the Zurich Central Library, Bruno Weber, discovered the photochroms left to the Municipal Library by Photoglob in 1914. They were in the basement of his library, carefully stored in a cupboard that had not been opened since then. Smitten by the fresh colors and impressed by the technical quality of the Photochrom process, he organized an exhibition (1974–75), set about publicizing the procedure (1979), and published a number of articles and a first work on Germany in 1900, *Deutschland um die Jahrhundertwende* (1990). At the same time, another great collector of photochroms, Marc Walter, was continuing to expand his own collection, which had been gradually forming over more than 20 years. In 2006, he published a book titled *Portrait d'un monde en couleurs* (Portrait of a World in Color),[14] which was widely copublished in Europe. There followed four titles in the collection "Magie du photochrome" (The Magic of the Photochrom)[15] and two illustrated volumes in four languages on the "giant" photochroms of the Alps.[16] Finally, he copublished the catalogue of his exhibition "Voyage en couleur" (Color Voyage), held at the Bibliothèque Forney, Paris, from January to April 2009.

And so the photochrom adventure continues…

1. Andrew Sinclair, *A Concise History of the United States* (London: Thames & Hudson, 1967).
2. Ibid.
3. Ibid.
4. Nathalie Boulouch, "Fécondité de la couleur," in *Voyage en couleur, photochromie (1876–1914)*, exh. cat., Bibliothèque Forney, Paris, January 27–April 16, 2009 (Paris: Paris bibliothèques/Eyrolles, 2009).
5. John Vincent Jezierski, "Le photochrome, Photoglob et la Detroit Publishing Company," in *Voyage en couleur*, op. cit.
6. Ibid.
7. Ibid.
8. James L. Lowe and Ben Papell, *Detroit Publishing Company Collector's Guide*, First Edition, Deltiologists of America, *An International Society of Picture Postcard Collectors*, © James Lowe, 1975.
9. Lowe and Papell, ibid.
10. Nancy Stickels Stechschulte, *The Detroit Company Postcards*, First Edition © 1994 by Nancy Stickels Stechschulte.
11. William Henry Jackson, *Time Exposure* (New York: G. P. Putnam's Son, 1940), quoted in Stickels Stechschulte, op. cit.
12. Ibid.
13. Jim Hughes, *The Birth of a Century* (London and New York: Tauris Parke Books, 1994).
14. Marc Walter and Sabine Arqué, *Portrait d'un monde en couleurs* (Paris: Éditions Solar, 2006).
15. Collection "Magie du photochrome" (Paris: Éditions De Monza, 2007–2008).
16. *Alpen-Alpes-Alpi-Alps*, copublication (Paris and Zurich: De Monza/Photoglob, 2009) and *Schweiz-Suisse-Svizzera-Switzerland* (Zurich: Photoglob, 2009).

Page 12: The team of the United States Geographical and Geological Survey of the Territories, gathered around Hayden (seated, center) in their Red Buttes camp, Wyoming, 1870; William Henry Jackson (standing, right), then aged 28
Right: **Mount of the Holy Cross**, watercolored print by William Henry Jackson after one of his negatives of 1873
Below: **Mount of the Holy Cross, Colorado**, photochrom

William Henry Jackson inherited from his mother, a watercolorist, a taste for drawing and color. Before the American Civil War, at 18 years of age, he was coloring daguerreotypes for a Vermont photographer. In 1868, he opened his first photographic studio, Jackson Brothers, Photographers in Omaha, Nebraska. He made many portraits of Native Americans in the neighboring Indian reserves and took part in a numerous survey expeditions in the Rockies and Yellowstone. Production director at the Detroit Photographic Co., he learned the Photochrom procedure and began coloring his own photos with the help of the watercolor sketches that filled his notebooks.

Page 12 : l'équipe de l'United States Geographical and Geological Survey of the Territories, rassemblée autour de Hayden (assis au centre), au camp de Red Buttes, Wyoming, en 1870 ; debout, à droite, William Henry Jackson alors âgé de 28 ans
À droite : **le mont Holy Cross**, tirage aquarellé par William Henry Jackson d'après l'un de ses négatifs de 1873
En bas : **le mont Holy Cross, Colorado**, photochrome

William Henry Jackson a hérité de sa mère aquarelliste, le goût du dessin et de la couleur. Avant la guerre de Sécession, à l'âge de 18 ans, il colorie des daguerréotypes chez un photographe du Vermont. En 1868, il ouvre son premier studio photographique, Jackson Brothers, Photographers, à Omaha (Nebraska), réalise de nombreux portraits d'Indiens dans les réserves avoisinantes et effectue des missions d'exploration dans les Rocheuses et à Yellowstone. Directeur de production de la Detroit Photographic Co., il apprend le procédé *Photochrom* et participe à la mise en couleurs de ses propres clichés.

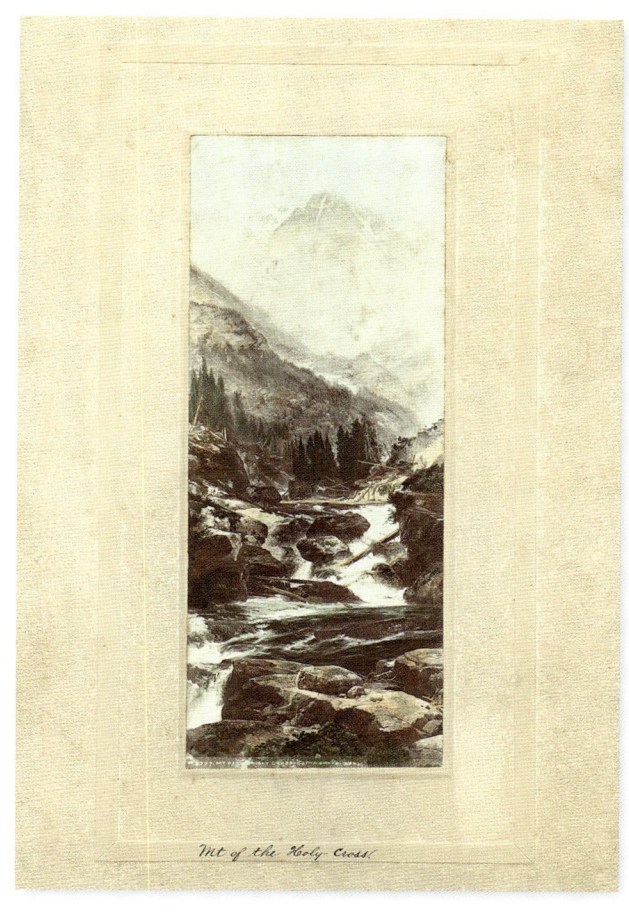

Seite 12: Das Team des United States Geographical and Geological Survey of the Territories um Hayden (Mitte, sitzend) im Lager von Red Buttes, Wyoming, 1870; rechts, stehend, William Henry Jackson im Alter von 28 Jahren
Rechts: **Der Berg Holy Cross**, aquarellierter Abzug von William Henry Jackson nach einem seiner Negative von 1873
Unten: **Der Berg Holy Cross, Colorado**, Photochrom

William Henry Jackson hatte von seiner Mutter, einer Aquarellmalerin, den Sinn für das Zeichnen und für Farbe geerbt. Vor dem Sezessionskrieg kolorierte er, im Alter von 18 Jahren, bei einem Fotografen in Vermont Daguerreotypien. Im Jahr 1868 eröffnete er mit Jackson Brothers, Photographers sein erstes Fotoatelier in Omaha (Nebraska), fertigte in den angrenzenden Reservaten zahlreiche Indianerporträts an und führte Forschungsaufträge in den Rocky Mountains und am Yellowstone durch. Als Produktionsleiter der Detroit Photographic Co. erlernte er das Photochrom-Verfahren und beteiligte sich an der Kolorierung seiner eigenen Klischees, indem er auf die zahlreichen Aquarelle aus seinem Skizzenbuch zurückgriff.

INTRODUCTION

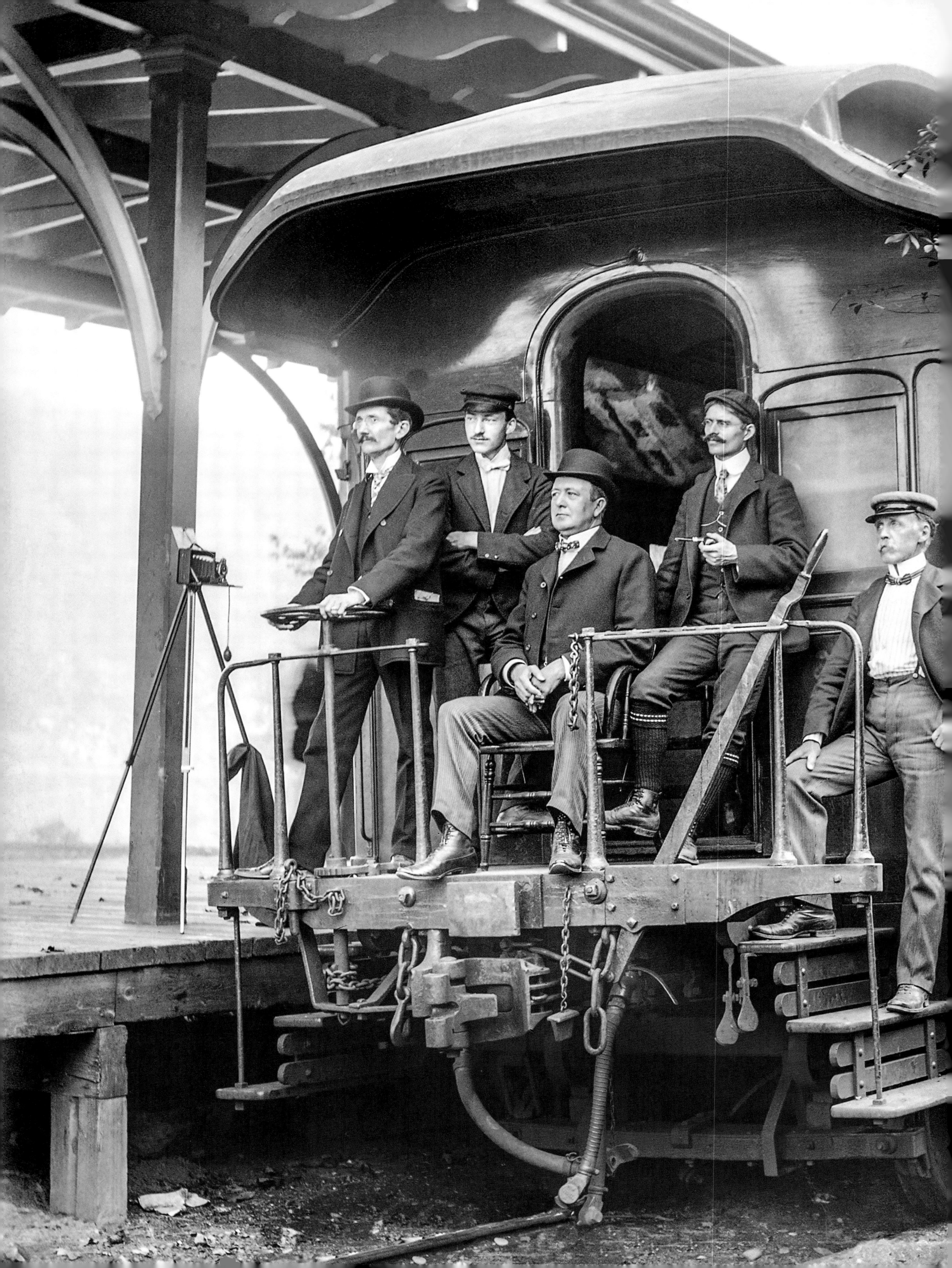

KLEINE GESCHICHTE DER DETROIT PHOTOGRAPHIC COMPANY

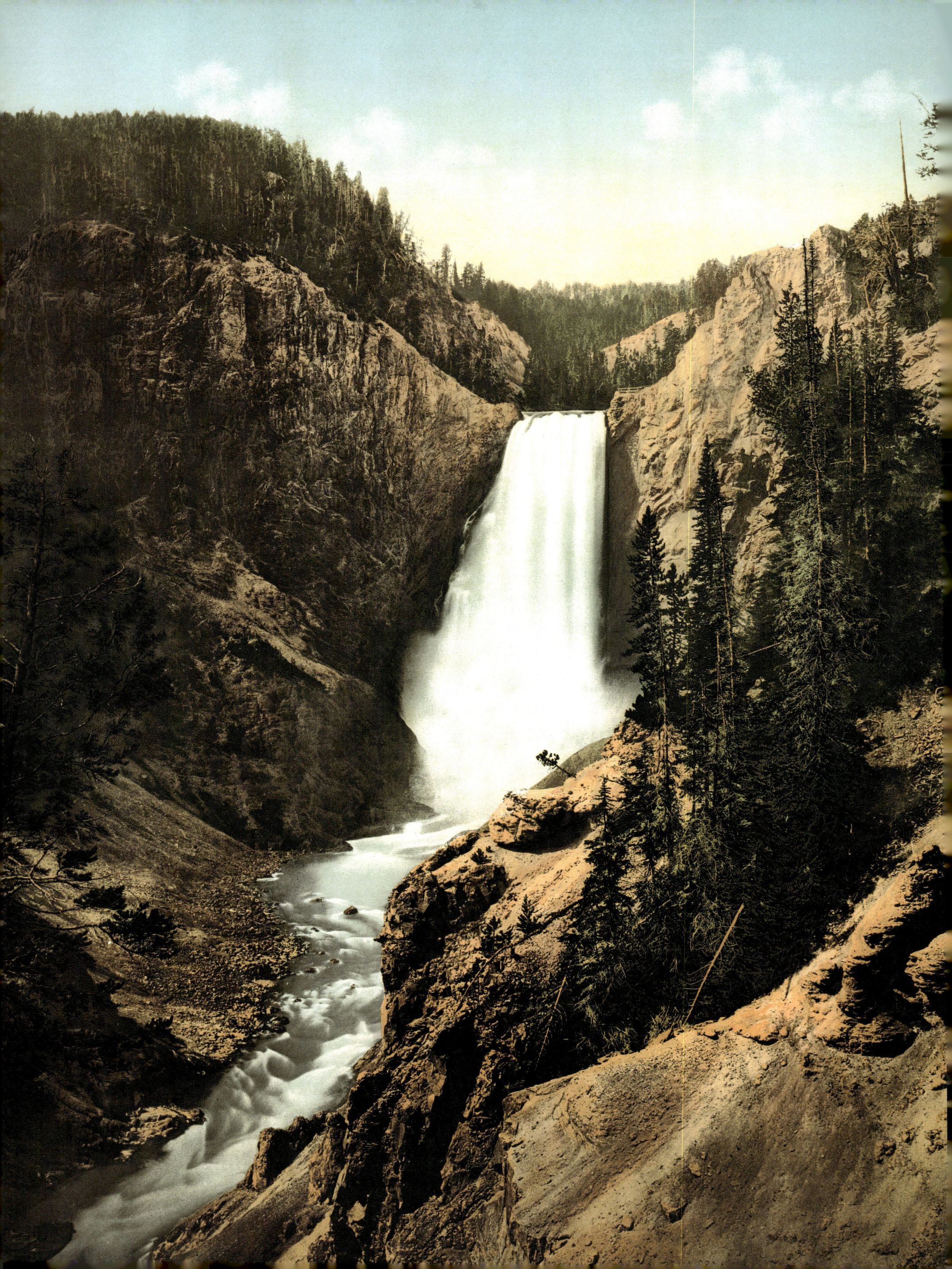

Page 14/15: Photographic car and members of the Detroit Photographic Co., Lackawanna & Western Railroad, Delaware, ca. 1900
Page 16: Lower Falls of the Yellowstone, Yellowstone National Park, Wyoming, photochrom
Right: "Street Scene at Night in Los Angeles," darkroom trickery on a postcard: the Detroit Publishing Co. wording was added by the DPC photochromists.

Seite 14/15: Foto-Waggon und Angehörige der Detroit Photographic Co., Lackawanna & Western Railroad, Delaware, um 1900
Seite 16: Die Lower Falls (untere Wasserfälle) des Yellowstone River, Yellowstone-Nationalpark, Wyoming, Photochrom
Rechts: „Nächtliche Straßenszene in Los Angeles", Fotomontage auf einer Postkarte: Das Reklameschild „Detroit Publishing Co." wurde von den Photochromisten der Detroit Co. hinzugefügt.

Pages 14/15 : membres de la Detroit Photographic Co. devant leur wagon, Lackawanna & Western Railroad, Delaware, vers 1900
Page 16 : chutes inférieures de la Yellowstone River, Yellowstone National Park, Wyoming, photochrome
À droite : « Scène de rue la nuit à Los Angeles », trucage sur une carte postale : le panneau publicitaire « Detroit Publishing Co. » a été rajouté par les chromistes de la Detroit Co.

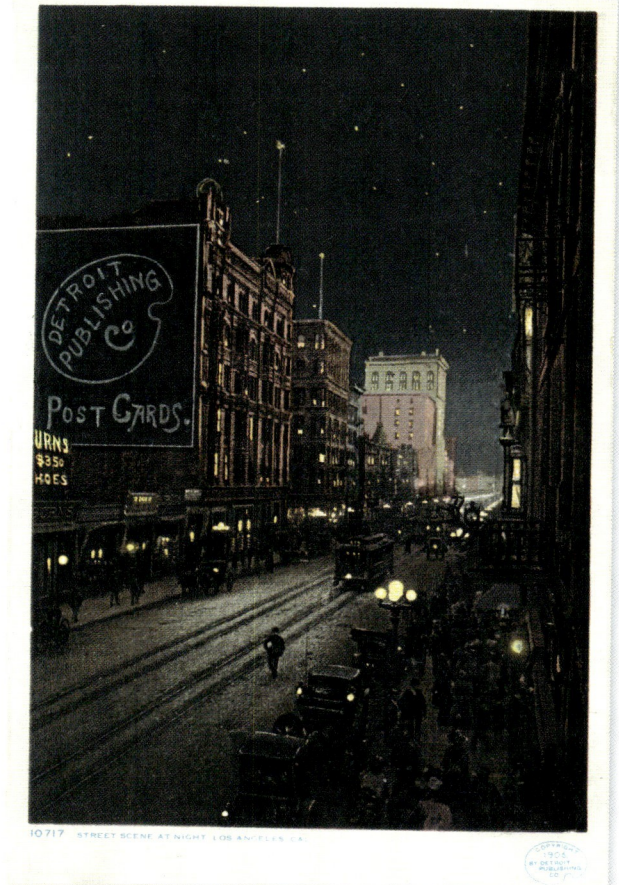

Die Fotoarchiv der Detroit Photographic Company (DPC) ist vermutlich die bedeutendste fotografische Sammlung zu Nordamerika in den Jahren 1888–1924, die jemals zusammengetragen worden ist: 100 000 Sujets – Landschaften, städtische und ländliche Szenen, ethnische Typen, Architektur und viele andere – auf Glasplatten und Schwarzweißnegativen. Mehrere Tausend davon wurden in Farbe reproduziert mithilfe einer neuen fotolithografischen Technik aus der Schweiz, die ab 1895 Anwendung fand: dem Photochrom-Verfahren. Diese Photochrome sind daher die ersten fotografischen Farbansichten des nordamerikanischen Kontinents. Der Grand Canyon in Farbe, beinahe zehn Jahre vor der Erfindung des Autochroms durch die Brüder Lumière! Um den Schock, den eine solche Neuheit beim damaligen Publikum auslöste, überhaupt nachvollziehen zu können, müssen wir hundert Jahre zurückspringen.

1895 war der – zu Beginn der 1850er-Jahre entdeckte – Grand Canyon natürlich bereits bei wissenschaftlichen Expeditionen, die die Regierung in den Jahren 1860–1870 organisierte, fotografiert worden: Timothy O'Sullivan, J.J. Fennemore, William Bell, William Henry Jackson und John K. Hillers brachten Schwarzweißbilder davon mit nach Hause. Doch die Farben des Grand Canyon, die Rot-, Braun- und Ockertöne, das Weiß seiner von der Sonne verbrannten Gesteinsschichten kannten nur wenige Auserwählte. Die Farben der „indianischen Erde", wie Henry Miller sie nannte, die uns heute so vertraut sind, da sie so oft gefilmt, fotografiert und in millionenfacher Auflage auf Postkarten reproduziert worden sind, hat die Welt durch die nach den Negativen von W.H. Jackson hergestellten Photochrome kennengelernt. Doch bevor wir auf die technischen Aspekte des Photochrom-Verfahrens eingehen und die Geschichte der Detroit Photographic Company vorstellen, sollten wir einen Blick auf die Vereinigten Staaten jener Zeit werfen, in der sich dieses großartige kommerzielle Abenteuer ereignete. Der Erfolg der Detroit Photographic Company wurde durch den politischen Kontext des Landes sehr begünstigt, das zu dieser Zeit eine nie da gewesene wirtschaftliche Entwicklung vollzog.

DIE VEREINIGTEN STAATEN AN DER SCHWELLE ZUM 20. JAHRHUNDERT

Mit dem ausgehenden 19. Jahrhundert kam der nach dem Sezessionskrieg (April 1865) in Angriff genommene Wiederaufbau zu seinem Ende. Die Grenze, „the frontier" – die zwischen den Siedlungen der Pioniere und den großen, noch unbesiedelten Gebieten verlief – verschwand 1890 offiziell, und die Indianer wurden in Reservaten westlich des Mississippi zusammengepfercht. Am Ende des Spanisch-Amerikanischen Krieges (1898) dehnten die USA ihren Einfluss auf Kuba (wurde unter Protektorat gestellt), die Karibik und das Gebiet von Panama aus und unterhielten sehr „enge" Beziehungen zu Mexiko. Zur gleichen Zeit erholten sich die Farmer der Great Plains nur schleppend von der wirtschaftlichen Depression in den Jahren 1870–1890, und es herrschten erhebliche Differenzen zwischen den Staaten. Die neuen Immigranten machten 1890 mehr als die Hälfte der vor Ort geborenen weißen Bevölkerung aus: Zwischen 1850 und 1900 waren 15 Millionen angekommen (1920 waren es bereits 12 Millionen mehr).[1] Die industrialisierten Regionen, die großen Metropolen der Ostküste, New York, Washington, Boston, Philadelphia und Baltimore, und die industriellen Hauptstädte der Region der Großen Seen, Chicago, Cleveland und Detroit, rivalisierten nach Kräften miteinander und verschrieben sich ganz und gar dem Gewerbe oder dem Handel. Die Eisenbahn- und Erdölmagnaten beherrschten den gesamten Kontinent, und zugleich verschärfte sich die soziale Ungleichheit. Die aus der Immigration hervorgegangenen Minderheiten und die Schwarzen waren in Ghettos zusammengedrängt. Die ehemaligen Staaten der Konföderation fielen in die Hände der Demokraten und rassistischer Organisationen wie des Ku-Klux-Klan: Der Süden vegetierte vor sich hin und war den Geschäftsleuten aus dem Osten ausgeliefert, die nach billigen Arbeitskräften Ausschau hielten. Auf seiner großen Reise durch Amerika in den Jahren 1904 und 1905 schreibt der französische Journalist Jules Huret von „der schmerzhaften Empfindung, die einen angesichts des durch das Elend dargebotenen Schauspiels überkommt". – „Die Unglückseligen", so notiert er weiter, „dürfen sich nicht dem reißenden Strom der Geschäftsstädte aussetzen, denn dort würde ihre Schwäche zerrieben und ihre Klagen würden ungehört verhallen."

Zu diesen Unglückseligen zählten viele Immigranten, die im Osten keine Arbeit fanden und daher immer weiter ins Landesinnere vordrangen, um sich im Westen niederzulassen, wo die Bevölkerung zwischen 1870 und 1890 von 7 Millionen auf 17 Millionen Einwohner anstieg.[2] Und obgleich die Eisenbahn den gesamten Kontinent erobert hatte – 1893 gab es in den USA ungefähr 273 000 Kilometer Bahntrasse und vier Transkontinentalstrecken[3] –, waren die von den Gesellschaften vorgegebenen Tarife derart hoch, dass viele sich noch mit Karren fortbewegten, und zwar entlang der neuen Bahntrassen.

EINLEITUNG

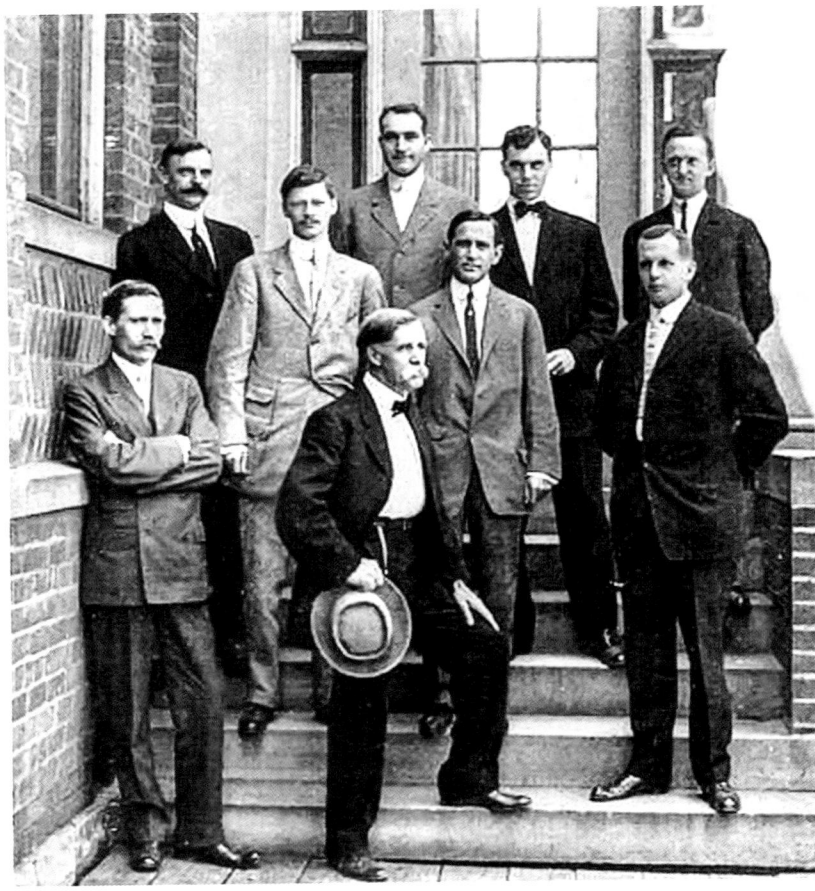

Left: The directors of the Detroit Publishing Company on the steps of their factory, on the corner of Vermont and Alexandrine Avenues, Detroit, ca. 1910–20; William A. Livingstone (rear, left), Robert B. Livingstone (third from left), and William Henry Jackson (standing, center, hat in hand)
Page 19: Photochrom Company building, side view, Detroit, Michigan, ca. 1900

Links: Die Direktoren der Detroit Publishing Company auf den Stufen ihrer Firma an der Ecke Vermont und Alexandrine Avenue in Detroit, um 1910–1920: darunter William A. Livingstone (hinten links), Robert B. Livingstone (Dritter von links) und William Henry Jackson (Mitte, stehend, mit Hut in der Hand)
Seite 19: Fabrikgebäude der Photochrom Company, Seitenansicht, Detroit, Michigan, um 1900

À gauche: les directeurs de la Detroit Publishing Company sur les marches de leur usine, à l'angle des avenues Vermont et Alexandrine à Detroit, vers 1910–1920: parmi eux, William A. Livingstone (au fond, à gauche), Robert B. Livingstone (le 3e à partir de la gauche) et William Henry Jackson (debout, au centre, chapeau à la main)
Page 19: fabrique de la Photochrom Company, vue latérale, Detroit, Michigan, vers 1900

Dies bildete den Kontext zum kommerziellen Abenteuer der Detroit Photographic Company (DPC), die 1888 im Handelsregister der Stadt Detroit (Michigan) erscheint und deren Geschichte eng verknüpft ist mit der einer europäischen, genauer gesagt Schweizer Gesellschaft: der Photochrom Co. Zürich (PZ).

DIE GEBURTSSTUNDE DER DETROIT PHOTOCHROM COMPANY
In der Absicht, ein fotolithografisches Verfahren eigener Erfindung, den Photochromdruck, zu vermarkten, gründete die hundert Jahre alte Züricher Druckerei Orell Füssli 1889 die Firma Photochrom Co. Das von dem Lithografen und leitenden Maschinenmeister bei Orell Füssli Hans Jakob Schmid perfektionierte Verfahren, das am 4. Januar 1888 zum Patent angemeldet wurde, erlaubte es, von einem Schwarzweißnegativ serielle Farbabzüge zu machen. Diese perfekte Verbindung von Fotografie und Lithografie stellte seinerzeit eine wahre Revolution dar, denn während „photochrome Reproduktionen" bereits seit 1878 existierten,[4] war der Photochromdruck das einzige Verfahren, mit dessen Hilfe eine serielle Produktion möglich war und das eine kommerzielle Nutzung erlaubte. Und auf welchem Niveau! Die besondere Fähigkeit der Direktoren der Photochrom Co. Zürich, der Brüder Wild, bestand darin, dass sie den unbedingten Willen hatten, „der ganzen Welt die Kunst des Photochromdrucks nahezubringen", schreibt der Fotografiehistoriker Professor John V. Jezierski in einem Text über das Photochrom.[5]
Um es soweit zu bringen, eröffneten sie „in allen europäischen Großstädten", allen voran in London im Jahr 1893, eigenständige Filialen. Der Erfolg der Photochrom Co. Ltd. London war der erste Schritt hin zur Gründung der Detroit Photochrom Company im Jahr 1895. Im selben Jahr 1895 fusionierte die Photochrom Co. Zürich mit der Druckerei und mit dem Fotostudio Schroeder & Cie und nannte sich fortan Photoglob Co. Zürich.
Die erste Begegnung zwischen Heinrich Wild und einem Mitglied der Detroit Company fand im Sommer 1894 in der Schweiz statt, als Rodolph Demme, ein junger Berner, der unlängst in die USA emigriert war und soeben die Tochter einer der reichsten Familien Detroits (Michigan) geheiratet hatte, auf seiner Hochzeitsreise in sein Heimatland zurückkehrte, um seiner Familie seine Gemahlin vorzustellen. Bei dem Treffen kamen die beiden Männer auf Geschäftliches zu sprechen. Rodolph Demme, der sich für Fotografie begeisterte und mit der Finanzwelt von Detroit vertraut war, war genau der Mann, den Heinrich Wild brauchte, um jenseits des Atlantiks Fuß zu fassen. Am 3. Oktober 1895 genehmigte der Verwaltungsrat von Photoglob die zwischen Heinrich Wild und Demme getroffene Vereinbarung, und am 12. Dezember 1895 wurde die Gesellschaft mit beschränkter Haftung Photochrom Company of Detroit ins Leben gerufen. „Bis die Fabrik gebaut und die Techniker ausgebildet sind, was vermutlich nächstes Jahr der Fall sein wird, agiert die Photochrom Company in Detroit im Wesentlichen als Vertriebsagentur der Photoglob Zürich." Und „in der Zwischenzeit [...] wird der renommierte Fotograf und das Aufsichtsratsmitglied der neuen Gesellschaft Edwin H. Husher nach Zürich gesandt, um dort in die Feinheiten des Photochrom-Verfahrens eingearbeitet zu werden".[6]
Doch bei Hushers Rückkehr nach Detroit Ende März 1896 steht die Photochrom Company kurz vor dem Konkurs. „Auch ohne die genaue Ursache der Krise zu kennen, kann man wohl sagen, dass Demme seine Fähigkeiten, den Wortlaut der Vereinbarung zu respektieren, stark überschätzt und einen Großteil der 20 000 Dollar des Kapitals, das Photoglob nach Detroit geschickt hatte, um die neue Filiale aufzubauen, veruntreut hatte."[7] Wie dem auch sei, im März 1897 wurde zwischen Zürich und Detroit eine neue Vereinbarung verabschiedet, Demme wurde seiner Aufgaben entbunden und eine neue Aktionärsgruppe übernahm unter Leitung der Familie Livingstone die Kontrolle über die Detroit Photochrom Company. Ende 1897 schickte die Photoglob ein Team von Photochromdruck-Technikern nach Detroit, eine moderne Fabrik wurde an der Ecke Vermont Avenue und Linden Avenue errichtet, und auf der Woodward Avenue eröffnete ein Laden mit Ausstellungsraum, in dem der Öffentlichkeit die Leistungen der Firma präsentiert wurden. Vor allem aber engagierte Husher mit William Henry Jackson 1897 einen der Pioniere der amerikanischen Fotografie.

DAS ABENTEUERLICHE LEBEN WILLIAM HENRY JACKSONS
1897 war Jackson 54 Jahre alt. Von seiner Mutter, einer Aquarellmalerin, hatte er den guten Geschmack und das Gespür für Farbe geerbt, und so malte er seit frühester Kindheit auf Glas. Als der Sezessionskrieg ausbrach, war er 18 Jahre alt, arbeitete für den Fotografen Mowry in Vermont und beschäftigte sich hauptsächlich mit der Kolorierung von Daguerreotypien. Als er in das 12. Infanterieregiment von Vermont eingezogen wurde, wurde er von seinen Offizieren an die Front geschickt, um von dort Skizzen von den feindlichen Stellungen mitzubringen. Am 1. Juli 1863 war er auf dem Schlachtfeld von Gettysburg (Pennsylvania), wo Tausende von Soldaten bei-

EINLEITUNG

der Lager ums Leben kamen. Nach seiner Entlassung verdiente Jackson seinen Lebensunterhalt durch Reisen, auf denen er sein Skizzenbuch stets bei sich führte. Er begleitete den Vorstoß der Eisenbahn von Chicago bis Saint Joseph (Missouri), folgte dann dem Fluss stromaufwärts bis nach Nebraska, begleitet von Rinderherden und Warenkonvois auf ihrem Weg nach Westen. Auf diese Weise gelangte er bis nach Kalifornien und kam dann nach Omaha (Nebraska) zurück, wo er sich niederließ und 1868 mit seinem Bruder zusammen als „Jackson Brothers, Photographers" ein erstes Fotostudio eröffnete.[8] Dort begann er Porträts von den Indianern aus den umliegenden Reservaten, von Pawnees, Omahas, Otoes, Osages etc., anzufertigen. Einige Porträts entstanden im Studio, doch er begab sich auch mit seiner von einem Pferd gezogenen Dunkelkammer in die Reservate. Schon bald ersetzte er diese schwere Ausrüstung durch eine tragbare Dunkelkammer eigener Herstellung, mit der er auch größere Expeditionen unternehmen konnte.

Dreißig Jahre lang führte Jackson im Auftrag des United States Geological and Geographical Survey of the Territories unter Leitung des Geologen Ferdinand V. Hayden Forschungsaufträge in den Rocky Mountains und am Yellowstone durch. Für die World's Transportation Commission bestritt er auch andere Einsätze auf der Welt und fertigte Reportagen für die Wochenzeitung *Harper's Weekly* an. Dennoch traf die wirtschaftliche Depression 1893 sein in Denver (Colorado) eröffnetes Studio, und als er 1896 in New York Husher begegnete, befand er sich in einer kritischen Situation. Husher fiel es nicht schwer, ihn davon zu überzeugen, bei der Detroit Photochrom Company einzusteigen.

Der Vertrag, den Husher und William Livingstone Jackson unterbreiteten, sah vor, dessen Studio in Denver und dessen Bestand an Negativen aufzukaufen – die ca. 10 000 Stück umspannten nicht nur den amerikanischen Westen, sondern auch „exotischere" Ziele wie Indien, Sri Lanka, China oder Indonesien, die den bedeutendsten Fundus der Detroit Company ausmachen sollten. Nach seiner Ernennung zum Produktionsleiter erlernte Jackson das Photochromdruck-Verfahren und beteiligte sich unter Zuhilfenahme der aquarellierten Skizzen aus seinen Skizzenbüchern an der Kolorierung seiner eigenen Klischees.

Jackson setzte seine Reportagen überall in den USA so lange fort, bis er 1903 Edwin Husher an der Spitze der Detroit Company ablöste. 1902 reiste er in einem eigens für die Vermarktung der Photochrome der Detroit Company ausgestatteten, von der Eisenbahngesellschaft Santa Fe Railroad gesponserten Zug, dem California Limited, nach Florida. Anschließend fuhr er nach Kuba und auf die Bahamas, wobei er für die Gesellschaft weitere Negative zusammentrug.

DIE EROBERUNG DES AMERIKANISCHEN MARKTES
Gleichzeitig entwickelten die Brüder Livingstone und Husher eine groß angelegte Verkaufsstrategie. Husher kaufte Negative von verschiedenen nordamerikanischen Fotografen und bezahlte festangestellte Fotografen wie Lycurgus Solon Glover oder Henry Greenwood Peabody, der für seine Meeresansichten und seine Klischees vom America's Cup bekannt war. Im Grunde aber hatten die Führungskräfte der Detroit Company über die Produktion von Photochromen hinaus ein großes Ziel: das Photochromdruck-Verfahren zu verwenden, um Postkarten zu drucken und den Markt zu erobern, den die Regierung 1898 dank der Senkung der Portokosten für Privatunternehmen geöffnet hatte. 1898 lancierten sie unter der Marke Photochrom Co. eine erste Versuchsserie mit vierzig Ansichten (Kalifornien, Colorado, Washington, D.C., Florida, Boston, Detroit, Niagara, Salt Lake City), 1899 folgte eine zweite, die insbesondere Ansichten von Yellowstone und Michigan umfasste. Ende 1903 verzeichnete ihr erster Katalog unter dem Namen „Color Souvenir Post Cards" vier Serien – 1 000, 5 000, 6 000 und 7 000 –, die insgesamt an die 2 000 Titel zählten.[9] 1905 stand auf den Karten der Serie 9 000 nicht mehr der Name Detroit Photochrom Company, sondern stattdessen Detroit Publishing Company.

Im selben Jahr befand sich die DPC auf dem Höhepunkt ihres Erfolgs. Sie beschäftigte vierzig Angestellte und ein Dutzend Vertreter. Sie hatte Geschäfte in Detroit, New York und Los Angeles eröffnet und besaß Filialen in zahlreichen anderen Städten, auch in Europa. William Livingstone und sein Vorstand durchquerten die Vereinigten Staaten in ihrem privaten Werbezug und stellten vor allem Panorama-Photochrome und „Mammoths" (riesige Photochrome) aus, zu denen die Ansichten der großen amerikanischen Touristenattraktionen wie Yellowstone, die Niagarafälle, der Grand Canyon, der Great Salt Lake, Yosemite etc. zählten. Denn der Tourismus war das „Hauptgeschäft" der Detroit Company; ihre Direktoren hatten das begriffen und vertrieben ihre Produkte an Verkaufsstellen in unmittelbarer Nähe zu den meistbesuchten Orten. Das Photochrom war wegen seiner Einzigartigkeit das Aushängeschild der Detroit, und zwischen 1899 und 1905 entstanden über 1 600 „durch und durch amerikanische" Motive (Landschaften, Typen, Stadtansichten

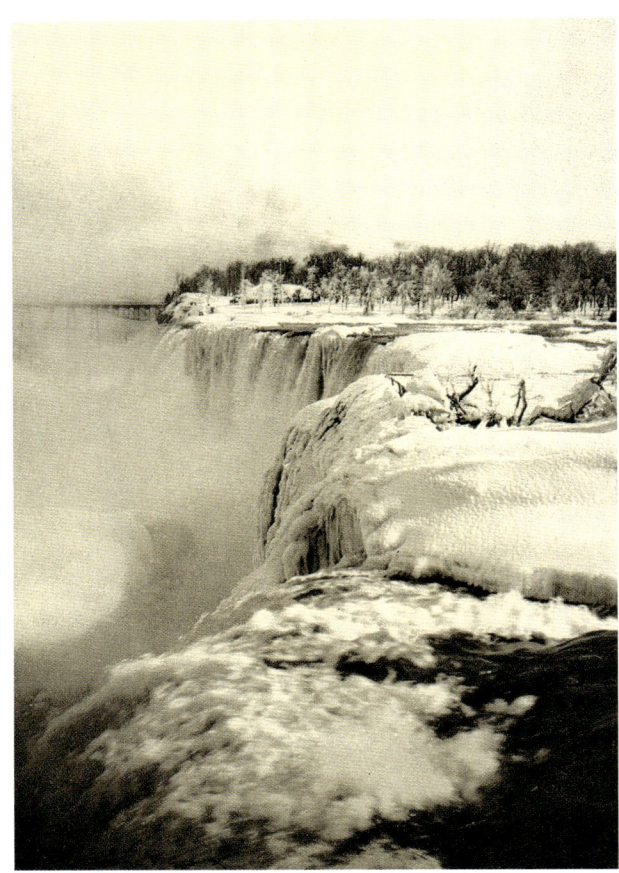
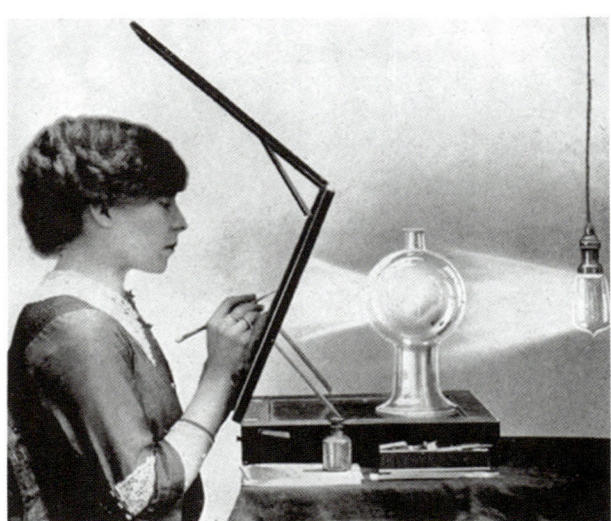

Left: **Niagara Falls, American Falls in winter, silver print**
Right: **Retoucher at work in the studio of Detroit Publishing Co., 1913**
Page 21: **Niagara Falls, American Falls in winter, photochrom**
Although photochroms were its hallmark product, the Detroit Photographic Co. annually sold many more black-and-white images from its catalogue of "Silver Prints," where it listed more than 16,000 photographs in a variety of sizes and price ranges from all states and territories of the American market.

Links: **Die Niagarafälle auf der amerikanischen Seite im Winter, Silver Print**
Rechts: **Retuschiererin bei der Arbeit im Atelier der Detroit Publishing Co., 1913**
Seite 21: **Die Niagarafälle auf der amerikanischen Seite im Winter, Photochrom**
Obgleich die Photochrom-Ansichten das Aushängeschild der Detroit Photographic Co. waren, wurden von den Schwarzweißbildern aus dem Katalog „Silver Prints", in dem über 16 000 Fotografien aus allen geografischen Regionen des nordamerikanischen Marktes in unterschiedlichen Formaten und Preiskategorien aufgelistet waren, jedes Jahr doch weit mehr Exemplare verkauft.

À gauche : **les chutes du Niagara, côté américain en hiver, silver print**
À droite : **retoucheuse au travail dans l'atelier de la Detroit Publishing Co., 1913**
Page 21 : **les chutes du Niagara, côté américain en hiver, photochrome**
Si les photochromes étaient le produit phare de la Detroit Photographic Co., la compagnie produisait encore davantage d'images en noir et blanc, les « silver prints ». Plus de 16 000 photographies des différents États, territoires et provinces du marché nord-américain figuraient à son catalogue, disponibles dans plusieurs formats et à des prix variés.

etc.), angefangen beim kleinen Format (9 x 18 cm) über das Standardformat (16,5 x 22,5 cm) und mehrere Panoramaformate bis hin zum „Mammoth" (ca. 42 x 52 cm); zu diesen muss man noch um die vierzig Reproduktionen von – ebenfalls amerikanischen – Kunstwerken hinzuzählen. Alle Photochrome wurden, je nach Ort, an dem sie verkauft wurden, einzeln oder als thematische Souveniralben angeboten. Kunden, die dies wünschten, konnten gewissermaßen maßgeschneiderte Sonderbestellungen in Auftrag geben. Die Photochrome waren allerdings ziemlich teuer und die DPC verkaufte noch mehr Schwarzweißbilder (Silbergelatineabzüge) und Postkarten.

Der Druck von Postkarten der 1907 eingeführten Schutzmarke Phostint, durch die die im Photochrom-Verfahren erzielte hochwertige Qualität anerkannt wurde, erreichte um 1910 seinen Höhepunkt. Zu dieser Zeit entschied die DPC, beliebteren touristischen Motiven den Vorrang zu geben, und schloss eine Vereinbarung mit der Hotel- und Restaurantkette Fred Harvey. Der Unternehmer, der Einrichtungen entlang der gesamten Bahnstrecke der Santa Fe Railroad besaß, fand, dass Postkarten „die beste Art" seien, „um für Ihr Hotel oder Restaurant zu werben"[10] und bestellte mehrere Hunderttausend davon bei der DPC. 1912 erschienen schließlich Themenhefte zu je vierzig Karten, die „Little Phostint Journeys". „Diese Karten ließen sich ‚in großen prachtvollen Bildern' auf eine Leinwand projizieren, um die Reise ‚noch lebendiger' zu gestalten", notierte John Jezierski und zitierte dabei die Werbung der DPC. Bis 1932 wurden über 30 000 Postkarten mit unterschiedlichen Motiven in einer Auflage von mehreren Millionen Exemplaren publiziert; das Photochromdruck-Verfahren erlaubte dabei mit jedem neuen Druck vielfältige Varianten.

DAS ENDE EINER ÄRA

Laut einem Bericht von William Henry Jackson[11] erreichte die Gesamtproduktion der DPC in ihren besten Zeiten sieben Millionen Bilder pro Jahr. Ab den 1910er-Jahren nahm die Aktivität der DPC jedoch ab. Die Konkurrenz verschärfte sich, und die Produktionskosten für Photochrome und Phostints waren zu hoch. Der Erste Weltkrieg und die anschließende wirtschaftliche Rezession der Jahre 1920–1922 setzten dem Unternehmen in Detroit zu. 1924 wurde es zum Gegenstand eines Vergleichsverfahrens, Jackson wurde verabschiedet, und seine 40 000 Negative wurden eingelagert. Die DPC fuhr jedoch bis zu ihrer vollständigen Auflösung im Jahr 1932 fort, ihre Lagerbestände zu verkaufen und für Kunden, denen besonders an der Phostint-Qualität gelegen war, einige Aufträge auszuführen. 1936 kam William Henry Jackson nach Detroit zurück, um sich nach seinen Negativen zu erkundigen. Sie wurden zusammen mit denen anderer Fotografen und den dazugehörigen Abzügen zuerst vom Henry Ford Museum und Greenfield Village in Dearborn (Michigan) für die Sammlung des Edison Institute angekauft[12] und 1949 der State Historical Society of Colorado übergeben. Letztere bewahrte nur den Teil der Sammlung auf, der die Gebiete westlich des Mississippi betraf, und übergab die verbleibenden ungefähr 25 000 Negative auf Glas und 300 Photochrome sowie 900 große, von Jackson signierte Glasplatten an die Library of Congress in Washington, wo sie sich noch heute befinden.

Eine Frage hinsichtlich dieser Übergabe bleibt jedoch ungeklärt: Der Schriftsteller und Herausgeber der Zeitschrift *Camera Arts* Jim Hughes weiß zu berichten, dass in den 1980er-Jahren der Präsident eines auf die Geschichte des Wilden Westens spezialisierten Verlages in Missouri von einem seiner Autoren darüber informiert wurde, dass man sich anschickte, eine Sammlung von Glasplatten und „Farbabzügen" zu zerschlagen, die in einem Depot in Bozeman (Montana) gelagert war.[13] Er ließ die vollständige Sammlung nach St. Louis transportieren, um sie zu inventarisieren, und entdeckte dabei Tausende perfekt erhaltene Photochrome mit dem Copyright der DPC, die noch nicht vermarktet worden waren! Der verborgene Schatz war bei der Witwe des Sohnes eines alten Freundes von Jackson, des Fotografen Frank Jay Haynes, aufgefunden worden; es ist anzunehmen, dass Jackson selbst ihm diesen anvertraut hatte – doch das bleibt Spekulation. 1 300 dieser „geretteten" Photochrome wurden seither von The American Photochrom Archive, einer Galerie in Minnesota, aufgekauft.

In Europa wie auch in den USA waren Photochrome lange Zeit in Vergessenheit geraten. Spezialisten für Fotografie konnten nur „mit Zurückhaltung auf diese Bilder mit ihrer Ansicht nach künstlichen Farben reagieren", schreibt die Fotografiehistorikerin Nathalie Boulouch. Erst 1974 entdeckte der Kurator der Zentralbibliothek Zürich, Bruno Weber, die Photochrome, die der Stadtbibliothek vor 1914 von Photoglob vermacht worden waren und die im Untergeschoss seiner eigenen Bibliothek eingelagert und sorgfältig in einen Schrank einsortiert waren, der noch nie geöffnet worden war. Er war derart hingerissen von der Frische der Farben und so beeindruckt von der technischen Qualität des Wiedergabeverfahrens, dass er eine Ausstellung organisierte (1974–1975), sich dafür einsetzte, das Verfahren zu erläutern

The Photochrom process—from the Greek *photos* (signifying "light") and *khroma* (meaning "color")—allowed a color photo to be obtained from a black-and-white negative. It is a planographic method of reproduction intended to replicate the halftones of photography throughout the grayscale from black to white or from shadow to light.

The procedure requires successive printings, since, without screens, each color required the use of a different lithographic stone. The technique exploits the photosensitivity of bitumen. Invented in 1889 by Hans Jakob Schmid, chief lithographer at the Orell Füssli printworks in Zurich, the Photochrom process was transmitted to the Detroit Photographic Co. by a technician who had worked for the Swiss company, Albert Schuler, in 1895–96. In the United States, it was marketed under the name of the "Aäc color photography process."

It required a stone for each color and therefore a minimum of four: red, blue, yellow, and black. The stone was coated with transparent ink, which was then transferred to photographic printing paper. The inks were mixed one by one and applied by presses finely adjusted to gauge the intensity of color. A hand-inked stone could produce 200 prints an hour and was "remade" after 5,000 passes. The work of the colorists and engravers is phenomenal: if you examine a photochrom through a magnifying glass, you realize that it often consists of more than 10 ink colors. In some cases, as many as 14 different tint stones were used.

Der Photochromdruck – von griechisch *phôtos* (Licht) und *khrôma* (Farbe) – ermöglicht es, ausgehend von einem Schwarzweißnegativ ein Farbbild herzustellen. Diese Reproduktionsmethode im Flachdruckverfahren dient dazu, die Halbtöne der Fotografien auf der gesamten Grautonskala von Weiß bis Schwarz – also von Licht bis Schatten – zu rekonstruieren.

Für dieses Verfahren werden aufeinanderfolgende rasterlose Drucke benötigt, wobei für jede Farbe ein anderer Lithostein erforderlich ist; die Technik nutzt die Lichtempfindlichkeit von Bitumen.

Der 1889 von Hans Jakob Schmid, dem Cheflithografen der Druckerei Orell Füssli in Zürich, entwickelte Photochromdruck wurde 1895–1896 von Albert Schuler, einem ehemaligen Techniker der Schweizer Firma, an die Detroit Photographic Co. weitergegeben. In den Vereinigten Staaten wurde er unter dem Namen „Aäc-Verfahren für Farbfotografien" vermarktet. Man benötigte einen Stein pro Farbe, insgesamt also mindestens vier – je einen für Rot, Blau, Gelb und Schwarz. Zuerst trug man transparente Tinte auf den Stein auf und übertrug diese dann auf ein Fotopapier. Jede Tinte wurde einzeln gemischt und unter Berücksichtigung der gewünschten Farbintensität mit Presseuren aufgetragen. Mit solch einem per Hand mit Tinte eingefärbten Stein ließen sich zweihundert Drucke pro Stunde herstellen; nach jeweils fünftausend Durchgängen wurde er „erneuert". Die Koloristen und Graveure leisteten Unglaubliches: Wenn man sich ein Photochrom unter der Lupe ansieht, stellt man fest, dass häufig Tinte in mehr als zehn verschiedenen Farben verwendet wurde: Man hat bis zu 14 verschiedene Steine eingefärbt!

Le procédé *Photochrom* – du grec *phôtos*, lumière, et *khrôma*, couleur – permet d'obtenir une image en couleur à partir d'un négatif en noir et blanc. C'est une méthode de reproduction par impression à plat destinée à restituer les demi-teintes des photographies sur toute l'échelle des gris allant du blanc au noir – autrement dit de la lumière à l'ombre. Le procédé suppose des impressions successives sans trame, chaque couleur nécessitant l'utilisation d'une pierre lithographique différente; la technique exploite la photosensibilité du bitume de Judée.

Inventé en 1889 par Hans Jakob Schmid, chef lithographe de l'imprimerie Orell Füssli à Zurich, le procédé *Photochrom* fut transmis à la Detroit Photographic Co. par un ancien technicien de la firme suisse, Albert Schuler, en 1895–1896. Aux États-Unis, il fut commercialisé sous le nom de « procédé Aäc de photographie en couleurs ».

Il fallait une pierre par couleur, soit au moins quatre – pour le rouge, le bleu, le jaune et le noir. On appliquait une encre transparente sur la pierre puis on la transférait sur un papier d'épreuve photographique. Les encres étaient mélangées une par une et appliquées par des presseurs en tenant compte de l'intensité de couleur que l'on voulait obtenir. Une pierre ainsi encrée à la main pouvait produire deux cents impressions par heure; elle était « refaite » tous les cinq mille passages. Le travail des coloristes et des graveurs est phénoménal, car si l'on observe un photochrome à la loupe, on se rend compte qu'il y a souvent plus de dix encres de couleurs différentes: on aurait encré jusqu'à quatorze pierres différentes !

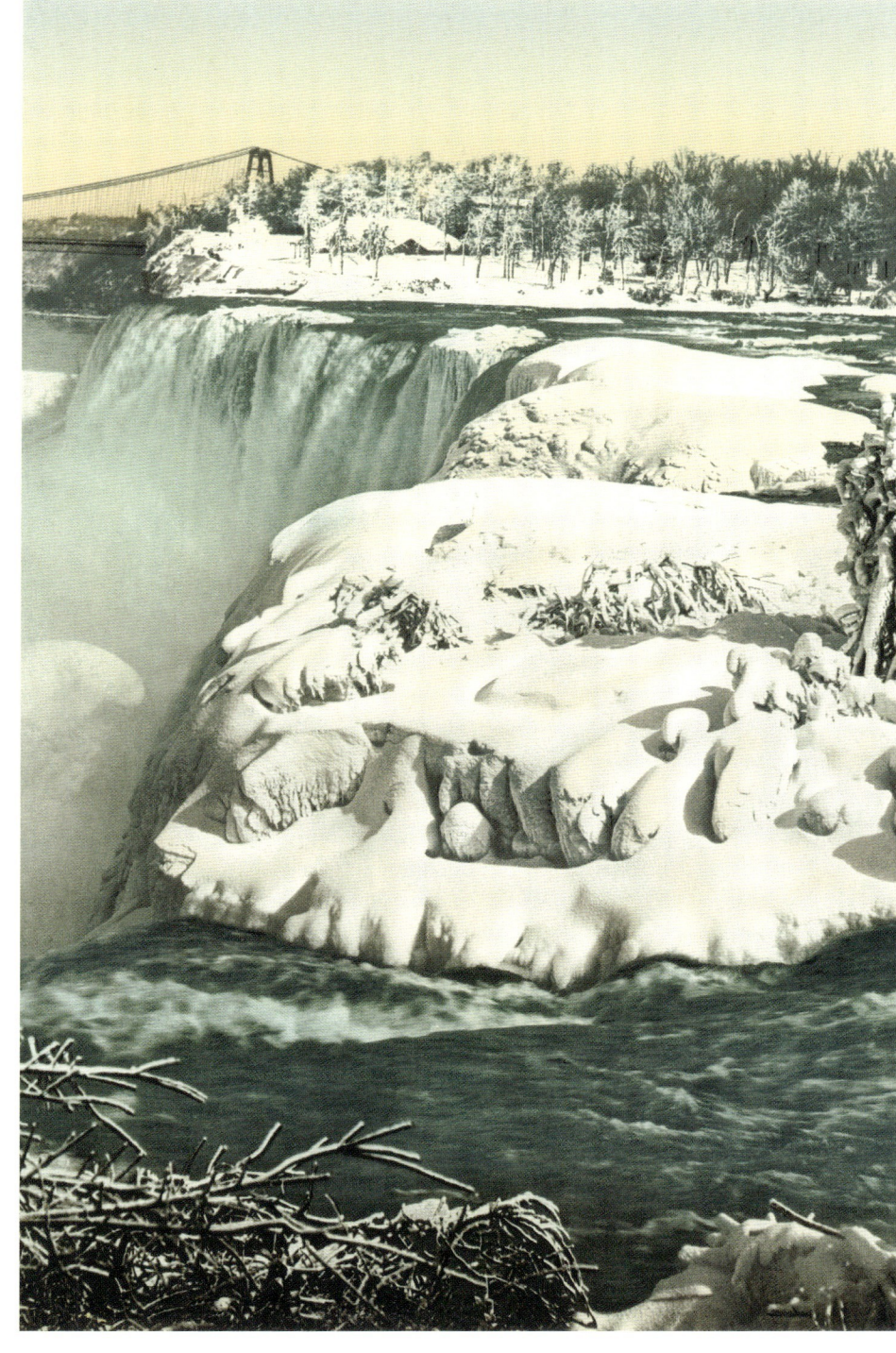

(1979), und Artikel und ein erstes Werk mit dem Titel *Deutschland um die Jahrhundertwende* (1990) veröffentlichte. Gleichzeitig fuhr ein anderer großer Liebhaber der Photochrome, Marc Walter, fort, seine eigene Sammlung zu erweitern, die er über zwanzig Jahre hinweg allmählich aufgebaut hatte. 2006 veröffentlichte er ein erstes Buch, *Portrait d'un monde en couleurs*,[14] das von mehreren europäischen Verlagen publiziert wurde; es folgten vier Titel der Sammlung „Magie du photochrome"[15] und zwei viersprachige Alben über die großformatigen Photochrome der Alpen.[16] Schließlich war er noch Mitherausgeber des Katalogs zu seiner Ausstellung *Voyage en couleur*, die von Januar bis April 2009 in der Bibliothèque Forney, Paris, gezeigt wurde. Und das Abenteuer des Photochroms geht weiter…

[1] Andrew Sinclair: *A concise history of the United States*, Thames and Hudson, London 1967.
[2] Ebd.
[3] Ebd.
[4] Nathalie Boulouch: „Fécondité de la couleur", in: Katalog zur Ausstellung *Voyage en couleur, photochromie (1876–1914)*, Bibliothèque Forney, Paris, 27. Januar bis 16. April 2009, © Paris bibliothèques / Eyrolles, 2009.
[5] John Vincent Jezierski: „Le photochrome, Photoglob et la Detroit Publishing Company", in: Katalog zur Ausstellung *Voyage en couleur, photochromie (1876–1914)*, Bibliothèque Forney, Paris, vom 27. Januar bis 16. April 2009, © Paris bibliothèques / Eyrolles, 2009.
[6] Ebd.
[7] Ebd.
[8] James L. Lowe und Ben Papell: *Detroit Publishing Company Collector's Guide*, Erstausgabe, Deltiologists of America, *An International Society of Picture Postcard Collectors*, © James Lowe, 1975.
[9] Lowe und Papell, ebd.
[10] Nancy Stickels Stechschulte: *The Detroit Company Postcards*, Erstausgabe © 1994 Nancy Stickels Stechschulte.
[11] William Henry Jackson: *Time Exposure*, G. P. Putnam's Son, New York 1940, zitiert nach: Nancy Stickels Stechschulte, Anm. 10.
[12] Ebd.
[13] Jim Hughes: *The Birth of a Century*, Tauris Parke Books, London und New York, 1994.
[14] Marc Walter und Sabine Arqué: *Portrait d'un monde en couleurs*, Solar, Paris, 2006.
[15] Reihe „Magie du photochrome", De Monza, Paris, 2007–2008.
[16] *Alpen-Alpes-Alpi-Alps*, Gemeinschaftsedition De Monza / Photoglob, 2009, und *Schweiz-Suisse-Svizzera-Switzerland*, Photoglob, Zürich 2009.

EINLEITUNG

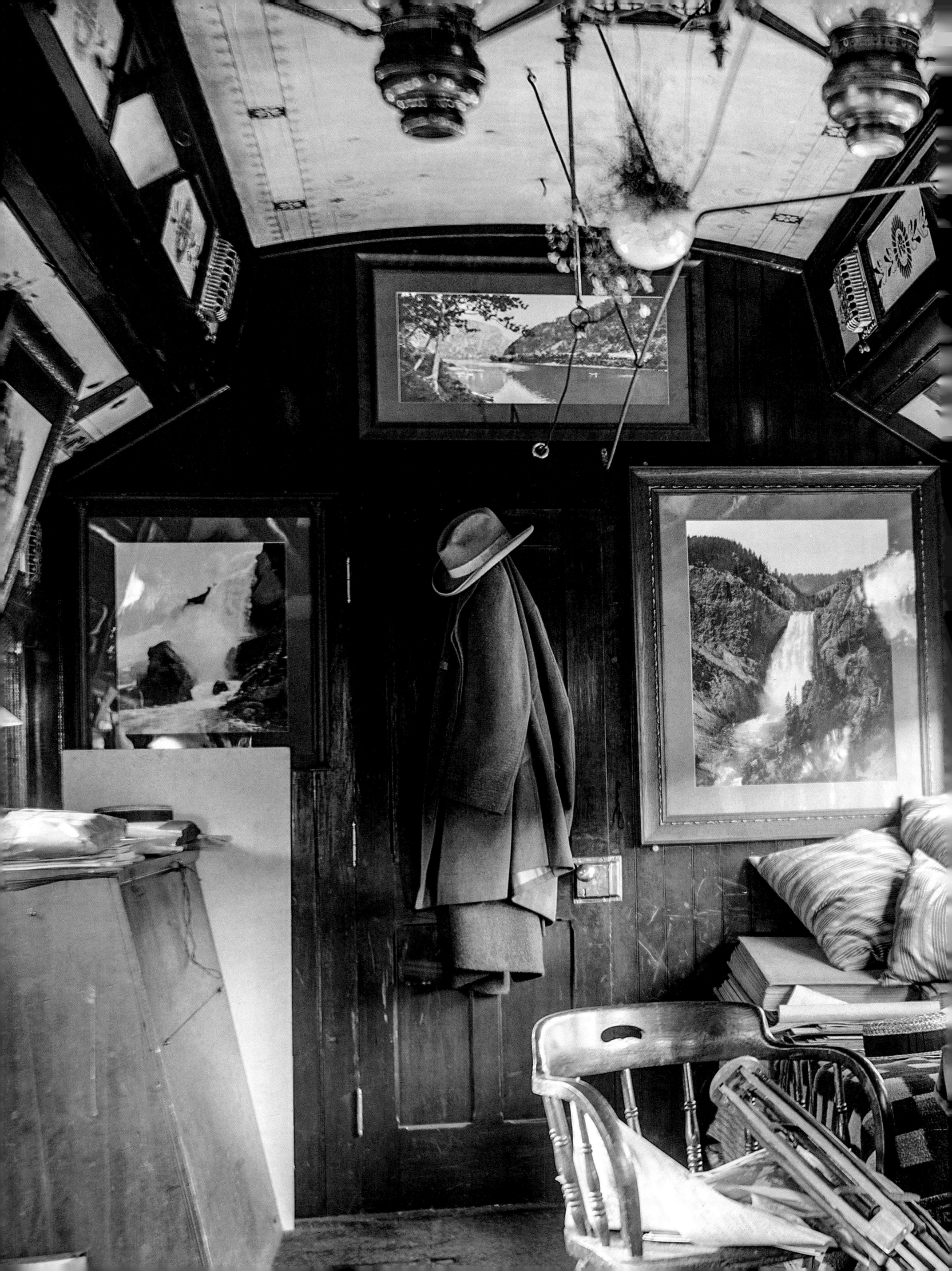

BRÈVE HISTOIRE DE LA DETROIT PHOTOGRAPHIC COMPANY

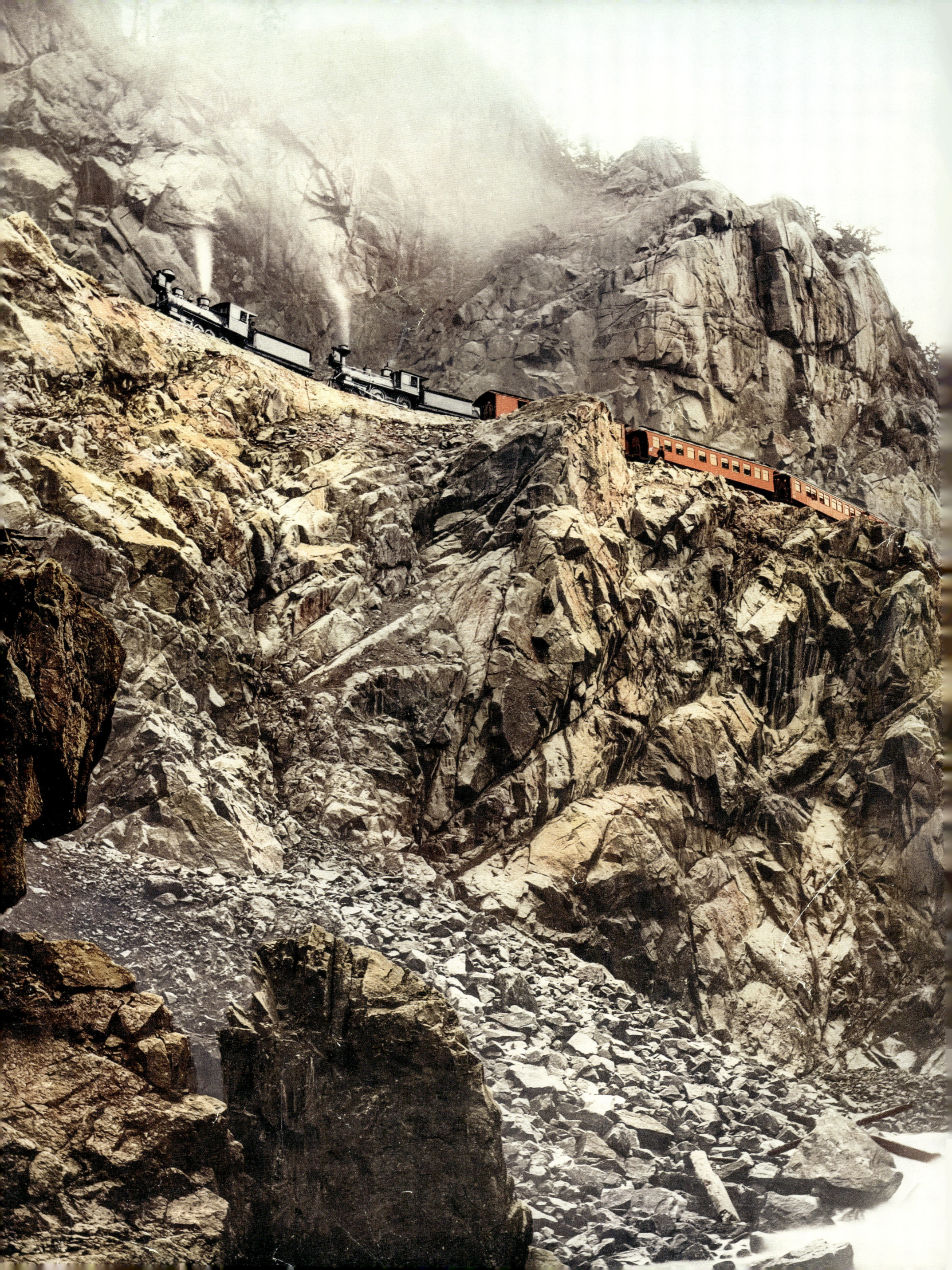

Page 22/23: On board the Detroit Photographic Co.'s special car, Lackawanna & Western Railroad, 1902
Page 24: Animas Canyon, Colorado, photochrom
Right: Last edition of the photochrom catalogue common to the Photoglob, Zurich; Photochrom Co. Ltd., London; and Detroit Photographic Co., 1911

Seite 22/23: An Bord des Sonderwaggons der Detroit Photographic Co., Lackawanna & Western Railroad, 1902
Seite 24: Animas Canyon, Colorado, Photochrom
Rechts: Letzte Ausgabe des gemeinsamen Photochrom-Katalogs der Gesellschaften Photoglob Zürich, Photochrom Co. Ltd., London, und Detroit Photographic Co., 1911

Pages 22/23 : à bord du wagon spécial de la Detroit Photographic Co., Lackawanna & Western Railroad, 1902
Page 24 : Animas Canyon, Colorado, photochrome
À droite : dernière édition du catalogue de photochromes commun aux compagnies Photoglob Zurich, Photochrom Co. Ltd., London, et Detroit Photographic Co., 1911

Le fonds photographique de la Detroit Photographic Company (DPC) est probablement le plus important jamais constitué sur l'Amérique du Nord entre 1888 et 1924 : 100 000 sujets – paysages, scènes urbaines et rurales, types ethniques, architecture… –, sous forme de plaques de verre et de négatifs en noir et blanc, dont plus d'un millier ont été reproduits en couleurs grâce à une nouvelle technique photolithographique d'origine suisse, utilisée à partir de 1895, le procédé *Photochrom*. Ces photochromes sont donc les premières vues photographiques en couleurs du continent nord-américain.
Le Grand Canyon en couleurs, près de dix ans avant l'invention de l'autochrome par les frères Lumière ! Il nous faut, pour bien comprendre le choc d'une telle nouveauté sur le public de l'époque, faire un bond en arrière d'une centaine d'années.
En 1895, le Grand Canyon – découvert au début des années 1850 – a certes déjà été photographié lors d'expéditions scientifiques organisées par le Gouvernement dans les années 1860–1870 : Timothy O'Sullivan, J.J. Fennemore, William Bell, William Henry Jackson ou encore John K. Hillers en ont rapporté des clichés en noir et blanc. Mais les *couleurs* du Grand Canyon, les rouges, les bruns, les ocres, le blanc de ses strates brûlées par le soleil, seuls quelques rares élus les connaissent. Les couleurs de la « terre indienne » – ainsi nommée par Henry Miller –, qui nous sont aujourd'hui familières tant celle-ci a été filmée, photographiée, reproduite en cartes postales à des millions d'exemplaires, ce sont les photochromes issus des négatifs de W. H. Jackson qui les ont révélées au monde.
Mais avant d'aborder l'aspect technique de la mise en couleurs de ces négatifs par le procédé *Photochrom* et de résumer l'odyssée de la Detroit Photographic Co., il faut faire un rapide « tour des États-Unis » au moment où se déroule cette grande aventure commerciale, largement favorisée par le contexte politique d'un pays qui connaît un développement économique sans précédent.

LES ÉTATS-UNIS À L'ORÉE DU XXᵉ SIÈCLE
Au tournant du XIXᵉ siècle, la reconstruction entreprise depuis la fin de la guerre de Sécession (avril 1865) vient de s'achever. La Frontière – la ligne qui séparait les établissements de pionniers des grands espaces encore sauvages était connue sous le nom de « Frontière » – a officiellement disparu (1890), les Indiens sont parqués dans des réserves à l'ouest du Mississippi. À l'issue de la guerre hispano-américaine (1898), les États-Unis étendent leur influence sur Cuba (mise sous protectorat), sur les Caraïbes, sur la zone de Panama et entretiennent des relations très « serrées » avec le Mexique. Dans le même temps, les fermiers des Grandes Plaines se remettent difficilement de la dépression économique des années 1870–1890 et les différences entre les États sont considérables. Les nouveaux immigrants comptent, en 1890, pour plus de la moitié de la population blanche née sur place : 15 millions d'entre eux sont arrivés entre 1850 et 1900 (ils seront 12 millions de plus en 1920[1]). Les régions industrialisées, les grandes métropoles de la côte Est, New York, Washington, Boston, Philadelphie, Baltimore, les capitales industrielles de la région des Grands Lacs, Chicago, Cleveland, Detroit, rivalisent de puissance, tout entières vouées aux affaires ou au commerce. Les magnats du chemin de fer et du pétrole règnent sur la totalité du continent où les inégalités sociales se creusent. Les minorités issues de l'immigration et les Noirs s'entassent dans des ghettos. Les anciens États confédérés ont été abandonnés aux mains des démocrates et aux organisations racistes, tel le Ku Klux Klan : le Sud souffre, livré aux hommes d'affaires de l'Est en quête d'une main-d'œuvre bon marché. Lors du grand voyage qu'il fit en Amérique en 1904–1905, le journaliste français Jules Huret note « la sensation douloureuse que l'on ressent au spectacle de la misère ». « Les malheureux, écrit-il, ne doivent pas s'aventurer dans ce torrent d'énergie qu'est la ville d'affaires, où leur faiblesse serait broyée, où leurs plaintes ne seraient pas entendues. »
Parmi ces malheureux, il y a beaucoup d'immigrants qui, ne trouvant pas de travail à l'Est, s'enfoncent toujours plus avant à l'intérieur du continent pour gagner l'Ouest, dont la population est passée, entre 1870 et 1890, de 7 millions à 17 millions d'habitants[2]. Et, bien que le chemin de fer ait conquis l'ensemble du continent – en 1893, les États-Unis comptent environ 273 000 kilomètres de voies ferrées et 4 lignes transcontinentales[3] –, les tarifs imposés par les compagnies sont si élevés que beaucoup cheminent encore dans des chariots, en suivant les nouvelles lignes ferroviaires…
Tel est le contexte dans lequel s'inscrit l'aventure commerciale de la Detroit Photographic Company (DPC), qui apparaît en 1888 dans les registres de la ville de Detroit (Michigan) et dont l'histoire est intimement liée à celle d'une société européenne, plus précisément suisse : la Photochrom Co. de Zurich (PZ).

NAISSANCE DE LA DETROIT PHOTOCHROM CO.
En 1889, dans le but de commercialiser un procédé photolithographique de son invention, le *Photochrom*, la séculaire imprimerie Orell Füssli de Zurich crée la Photochrom Co. Ce procédé mis au point par le lithographe Hans Jakob Schmid

INTRODUCTION

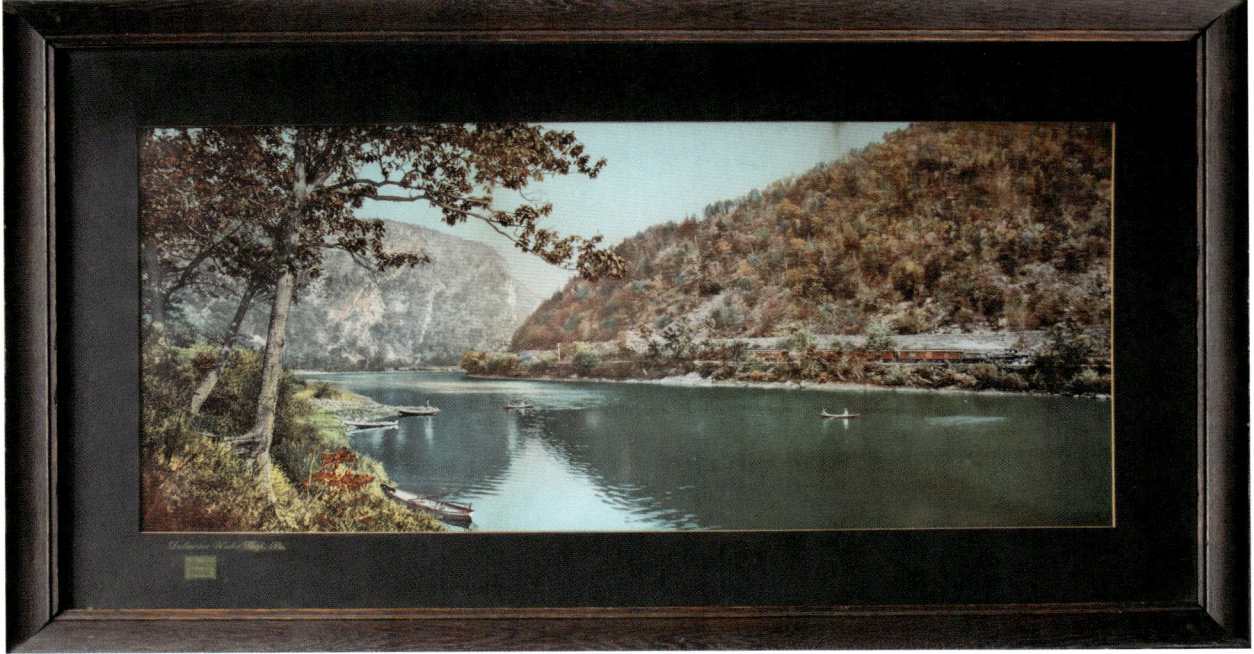

Left: Photochrom of the Delaware Water Gap (Pennsylvania) in its original frame, visible on the wall of the DPC gallery-car (in the background, upper left)
Page 27:
Left: Jas. K. Stewart's postcard shop, Cincinnati, Ohio, ca. 1910
Right: Art rooms of Detroit Photographic Co., general view, 231 Woodward Avenue, Detroit

Links: Photochrom des Delaware Water Gap (Pennsylvania) im Originalrahmen, den man an der Wand des Galerie-Waggons der DPC erkennen kann (im Hintergrund des Bildes, oben)
Seite 27:
Links: Der Postkartenladen von Jas. K. Stewart in Cincinnati, Ohio, um 1910
Rechts: Der Ausstellungsraum der Detroit Photographic Co. in der Woodward Avenue 231, Detroit, um 1900

À gauche : photochrome du Delaware Water Gap (Pennsylvanie) dans son cadre d'origine, que l'on reconnaît sur la paroi du wagon-galerie de la DPC (au fond de l'image, en haut)
Page 27 :
À gauche : la boutique de cartes postales de Jas. K. Stewart à Cincinnati, Ohio, vers 1910
À droite : la salle des reproductions d'art de la Detroit Photographic Co., 231 Woodward Avenue, Detroit, vers 1900

– machiniste en chef d'Orell Füssli –, dont le brevet a été déposé le 4 janvier 1888, permet de tirer en série des épreuves en couleurs à partir d'un négatif en noir et blanc. Mariage parfait entre photographie et lithographie, c'est à l'époque une vraie révolution car, si les « reproductions photochromiques » existaient depuis 1878[4], le procédé *Photochrom* est le seul à autoriser la production en série et le seul à pouvoir être exploité commercialement. Et à quelle échelle ! Tout le talent des frères Wild, directeurs de Photochrom Co. Zurich, a été d'avoir eu l'ambition de « mettre l'art du photochrome à la portée du monde entier », écrit le professeur et historien de la photographie John V. Jezierski dans un texte consacré au photochrome[5]. Pour y parvenir, ils ouvrent des filiales indépendantes « dans toutes les grandes villes européennes », et d'abord à Londres, en 1893. Le succès de la Photochrom Co. Ltd. est à l'origine de la création, en 1895, de la Detroit Photochrom Company. (La même année 1895, Photochrom Co. Zurich fusionne avec l'imprimerie et studio photographique Schroeder & Cie et prend le nom de Photoglob Co. Zurich.)

La première rencontre entre Heinrich Wild et un membre de la Detroit Company a lieu à l'été 1894 en Suisse, lorsque Rodolph Demme, un jeune Bernois récemment émigré aux États-Unis qui vient d'épouser la fille d'une des plus riches familles de Detroit (Michigan), se rend en voyage de noces dans son pays d'origine afin de présenter son épouse à sa famille. Il rencontre Heinrich Wild, et les deux hommes en viennent à parler affaires. Passionné de photographie et familier du monde de la finance de Detroit, Rodolph Demme est l'homme que cherchait Wild pour s'implanter outre-Atlantique. Le 3 octobre 1895, le conseil d'administration de Photoglob approuve un accord entre Heinrich Wild et Demme et, le 12 décembre 1895, la société à responsabilité limitée Photochrom Company of Detroit voit le jour : « En attendant qu'une usine soit construite et que des techniciens soient formés, vraisemblablement dans l'année à venir, la Photochrom Company de Detroit fonctionnerait en priorité comme une agence de distribution de Photoglob Zurich. » Et, « dans l'intérim [...], Edwin H. Husher, photographe réputé et membre du conseil d'administration de la nouvelle société, est envoyé à Zurich afin d'y apprendre les subtilités du procédé *Photochrom*[6]. » Mais, de retour à Detroit à la fin du mois de mars 1896, Husher trouve la Photochrom Company au bord du dépôt de bilan... « À défaut de connaître exactement la nature de la crise, il semblerait que Demme avait quelque peu surévalué ses capacités à respecter les termes de l'accord et qu'il aurait détourné une bonne partie des 20 000 dollars du capital que Photoglob avait envoyé à Detroit pour mettre sur pied sa nouvelle succursale...[7] » Quoi qu'il en soit, en mars 1897 un nouvel accord entre Zurich et Detroit est passé, Demme est démis de ses fonctions et un nouveau groupe d'actionnaires prend le contrôle de la Detroit Photochrom Company sous la houlette de la famille Livingstone. Fin 1897, Photoglob envoie à Detroit une équipe de techniciens en photochromie, une usine moderne est édifiée à l'angle des avenues Vermont et Linden et un magasin d'exposition ouvert sur la Woodward Avenue présente au public les productions de la société. Et, surtout, en 1897, Husher engage l'un des pionniers de la photographie américaine, William Henry Jackson.

LA VIE AVENTUREUSE DE WILLIAM HENRY JACKSON

En 1897, Jackson a 54 ans. De sa mère, aquarelliste, il a hérité le goût du dessin et de la couleur : il peint sur verre depuis son plus jeune âge. Lorsque la guerre de Sécession éclate, il a 18 ans et travaille pour un photographe du Vermont, Mowry, se consacrant notamment au coloriage de daguerréotypes. Enrôlé dans le 12e régiment d'infanterie du Vermont, il est envoyé sur les lignes de front par ses officiers afin d'en rapporter des croquis des positions ennemies ; le 1er juillet 1863, il est sur le champ de bataille de Gettysburg (Pennsylvanie), où des milliers de soldats des deux camps ont trouvé la mort. Une fois démobilisé, Jackson gagne sa vie en voyageant, ne se séparant jamais de son carnet de croquis. De Chicago à Saint-Joseph (Missouri), il suit l'avancée du chemin de fer puis remonte le cours du fleuve jusqu'au Nebraska, escortant des troupeaux de bœufs et des convois de marchandises en route vers l'ouest. Il ira ainsi jusqu'en Californie, avant de se fixer à Omaha (Nebraska) où, en 1868, il ouvre, avec son frère, un premier studio photographique, « Jackson Brothers, Photographers »[8]. Là, il commence à faire des portraits des Indiens des réserves avoisinantes, Pawnees, Omahas, Otoes, Osages, etc. Il réalise certains portraits dans son studio, mais il se rend aussi dans les réserves avec sa chambre noire tirée par un cheval. Très vite, afin de pouvoir mener des expéditions lointaines, il remplace cet équipement trop lourd par une chambre noire portative de sa fabrication.

Pendant une trentaine d'années, Jackson remplit des missions d'exploration dans les Rocheuses et à Yellowstone pour le compte de la United States Geological and Geographical Survey of the Territories, placée sous le contrôle du géologue Ferdinand V. Hayden. Il effectue aussi d'autres missions à travers le monde pour la World's Transportation Commission, ainsi que des reportages

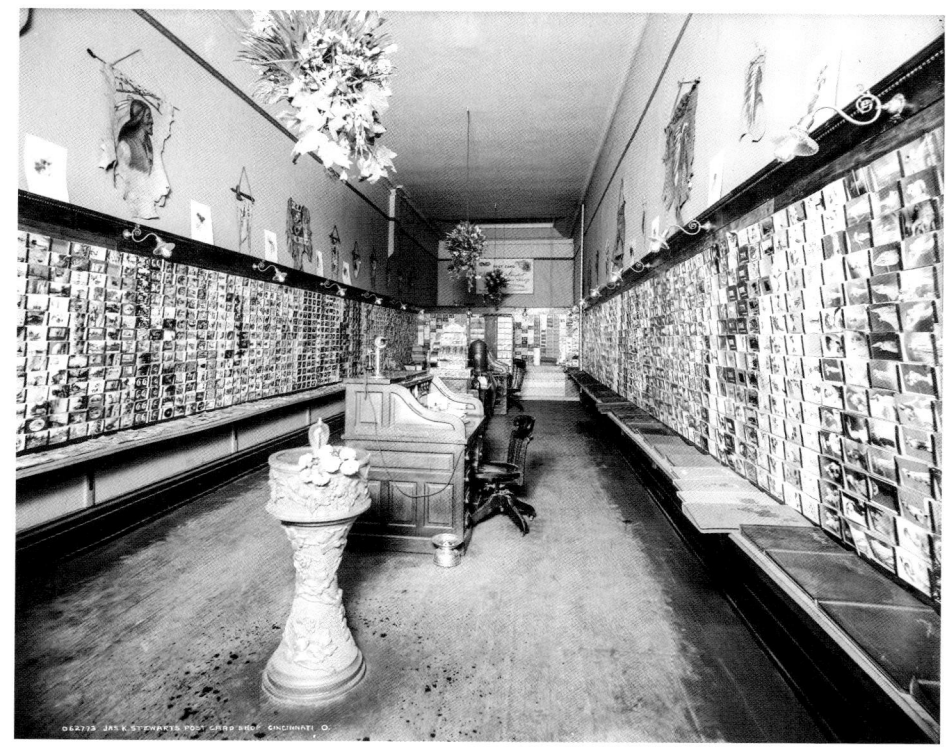
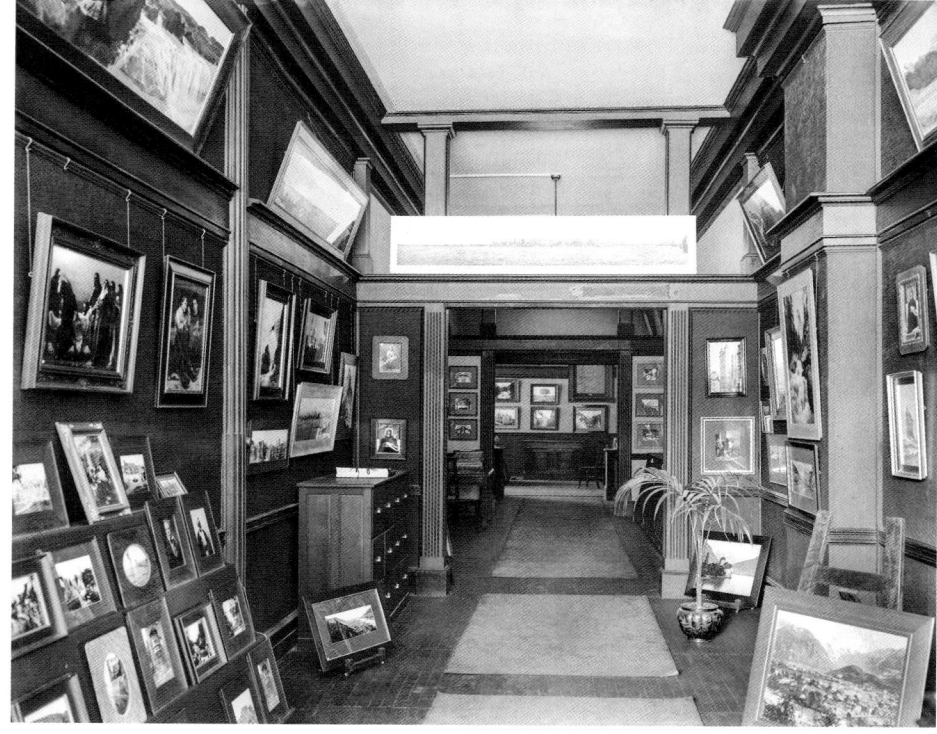

pour l'hebdomadaire *Harper's Weekly*. Cependant, en 1893, la crise économique frappe le studio qu'il a ouvert à Denver (Colorado) et, lorsqu'il rencontre Husher à New York en 1896, il est dans une situation critique. Husher n'aura aucun mal à le convaincre de rejoindre la Detroit Co. Le contrat que Husher et William Livingstone proposent à Jackson comprend le rachat de son studio de Denver et de son stock de négatifs – quelque 10 000 pièces couvrant non seulement l'Ouest américain, mais aussi des destinations plus « exotiques » telles que les Caraïbes, l'Inde, le Sri Lanka (Ceylan), la Chine ou l'Indonésie, qui vont constituer le fonds le plus important de la Detroit Co. Nommé directeur de production, Jackson apprend le procédé *Photochrom* et participe à la mise en couleurs de ses propres clichés en s'aidant des croquis aquarellés dont ses carnets sont remplis.

Jusqu'en 1903, année où il va succéder à Edwin Husher à la tête de la Detroit, Jackson poursuit ses reportages à travers les États-Unis. En 1902, il se rend en Floride à bord d'un train spécialement équipé pour promouvoir les photochromes de la Detroit Co., le California Limited, sponsorisé par la compagnie du Santa Fe Railroad. Il gagne ensuite Cuba et les Bahamas, continuant à accumuler des négatifs pour le compte de la compagnie.

LA CONQUÊTE DU MARCHÉ AMÉRICAIN

Parallèlement, les frères Livingstone et Husher mettent en place une stratégie commerciale de grande envergure. Husher achète des négatifs à divers photographes d'Amérique du Nord et salarie des photographes permanents, comme Lycurgus Solon Glover ou Henry Greenwood Peabody, réputé pour ses vues maritimes et ses clichés de la Coupe de l'America. En réalité, au-delà de la production de photochromes, les dirigeants de la Detroit Co. ont une grande ambition : utiliser le procédé *Photochrom* pour imprimer des cartes postales et conquérir le marché que le Gouvernement a ouvert en 1898 aux compagnies privées grâce à la baisse du coût du timbrage. En 1898 ils lancent, sous la marque Photochrom Co., une première série expérimentale d'une quarantaine de vues (Californie, Colorado, Washington, D.C., Floride, Boston, Detroit, Niagara, Salt Lake City), suivie en 1899 d'une deuxième qui comprend notamment des vues de Yellowstone et du Michigan. À la fin de l'année 1903, leur premier catalogue, intitulé *Color Souvenir Post Cards*, répertorie quatre séries, 1 000, 5 000, 6 000, 7 000, totalisant près de 2 000 références[9]. En 1905, sur les cartes de la série 9 000, le nom de Detroit Photochrom Company cesse d'apparaître, au profit de celui de Detroit Publishing Company.

En cette année 1905, la DPC est au sommet de sa prospérité. Elle emploie quarante salariés et une douzaine de représentants. Elle a ouvert des magasins de vente à Detroit, à New York et Los Angeles, et possède des succursales dans de nombreuses autres villes, y compris en Europe. William Livingstone et son comité directorial sillonnent les États-Unis dans leur train privé publicitaire, exposant notamment les photochromes panoramiques et les « Mammoths » (les photochromes géants), parmi lesquels figurent des vues des grands sites touristiques américains : Yellowstone, les chutes du Niagara, le Grand Canyon, le Grand Lac salé, Yosemite, etc. Car le tourisme est le « fonds de commerce » de la Detroit Co. ; ses dirigeants l'ont compris qui diffusent leurs produits dans des points de vente situés aux abords des sites les plus fréquentés. Parce qu'il est unique, le photochrome est le produit phare de la Detroit : plus de 1 600 sujets (paysages, types, vues urbaines, etc.) « purement américains » ont vu le jour entre 1899 et 1905, depuis le petit format (9 x 18 cm), le format standard (16,5 x 22,5 cm), plusieurs formats panoramiques, jusqu'au « Mammoth » (42 x 52 cm environ) ; il faut y ajouter une quarantaine de reproductions d'œuvres d'art, américaines également. Tous les photochromes sont proposés à la pièce, ou en albums souvenirs thématiques, selon les lieux où ils sont distribués. Les clients qui le désirent peuvent même passer des commandes spéciales, du « sur mesure » en quelque sorte. Cependant, les photochromes sont assez chers et la DPC vend encore plus d'images en noir et blanc (les « silver prints ») et de cartes postales.

L'impression de cartes postales Phostint – marque déposée en 1907, homologuant la qualité supérieure obtenue grâce au procédé *Photochrom* – connaît son apogée autour de 1910. À cette époque, la DPC décide de privilégier des sujets touristiques plus populaires et passe un accord avec la chaîne d'hôtels et de restauration Fred Harvey. L'entrepreneur, qui possède des établissements tout le long de la ligne du Santa Fe Railroad, considère que les cartes postales sont « *the best way to promote your Hotel or Restaurant*[10] » (« le meilleur moyen de promouvoir votre hôtel ou votre restaurant ») et il en commande des centaines de milliers à la DPC. Enfin, en 1912 paraissent des carnets thématiques de quarante cartes, les « Little Phostint Journeys » (« Petits voyages en Phostint »). « Ces cartes pouvaient être projetées sur un écran, "en grandes images éclatantes" pour rendre le voyage "plus animé" », note John Jezierski, reprenant les termes employés par la DPC dans sa publicité. Jusqu'en 1932, plus de 30 000 cartes postales de sujets différents

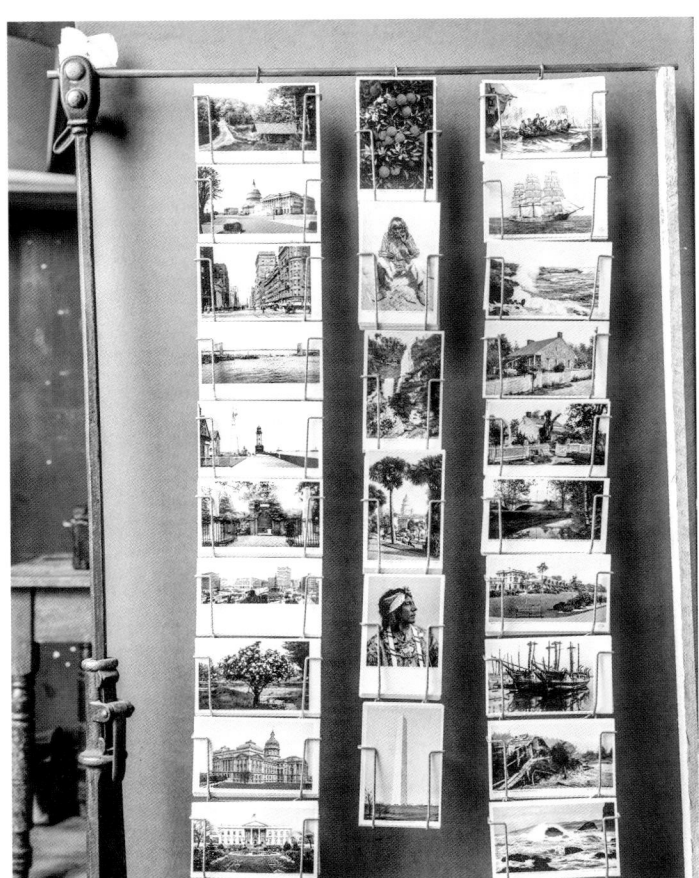

Left: Detroit Publishing Co. postcard display rack, ca. 1910
Links: Postkartenständer der Detroit Publishing Co., um 1910
À gauche: présentoir de cartes postales de la Detroit Publishing Co., vers 1910

ont été publiées à plusieurs millions d'exemplaires ; l'emploi du procédé *Photochrom* en a autorisé de multiples variantes, au fur et à mesure des réimpressions.

LA FIN D'UNE ÉPOQUE

Selon un rapport de William Henry Jackson[11], la production totale de la DPC au temps de sa prospérité atteignait couramment sept millions d'images par an. Cependant, à partir des années 1910, l'activité de la DPC décline. La concurrence se fait rude, les coûts de production des photochromes et des Phostint sont trop élevés. La Première Guerre mondiale, puis la récession économique des années 1920-1922 frappent la compagnie de Detroit. En 1924, elle est placée en règlement judiciaire, Jackson est remercié et ses 40 000 négatifs sont remisés. La DPC continuera cependant d'écouler ses stocks et d'honorer quelques commandes pour des clients attachés à la qualité Phostint jusqu'en 1932, date de sa liquidation totale.

En 1936, William Henry Jackson revint à Detroit s'enquérir de ses négatifs. Ces derniers et les tirages correspondants furent d'abord acquis par le Henry Ford Museum and Greenfield Village de Dearborn (Michigan) au sein de la collection de l'Edison Institute[12] puis, en 1949, cédés à la State Historical Society of Colorado. Cette dernière ne conserva que la partie du fonds concernant les territoires situé à l'ouest du Mississippi et remit le reste – soit quelque 25 000 négatifs sur verre et 300 photochromes, plus 900 grandes plaques de verre signées Jackson – à la Bibliothèque du Congrès à Washington, où ils se trouvent toujours.

Un mystère demeure pourtant concernant cette cession : écrivain et éditeur du magazine *Camera Arts*, Jim Hughes[13] rapporte que, dans les années 1980, le président d'une maison d'édition du Missouri spécialisée dans l'histoire du Far West fut averti par l'un de ses auteurs que l'on s'apprêtait à détruire une collection de plaques de verre et de « tirages en couleurs » stockée dans un entrepôt de Bozeman (Montana). Il fit transporter la totalité de cette collection à Saint-Louis pour en faire l'inventaire et découvrit des milliers de photochromes portant le copyright de la DPC, en parfait état, qui n'avaient jamais été distribués ! Le « magot » ayant été retrouvé chez la veuve du fils d'un des vieux amis de Jackson, le photographe Frank Jay Haynes, on peut supposer que Jackson lui-même le lui avait confié… On ne peut que supposer. 1 300 de ces photochromes « rescapés » ont été rachetés depuis par une galerie du Minnesota, The American Photochrom Archive.

En Europe comme aux États-Unis, les photochromes ont été longtemps oubliés. Les spécialistes de la photographie ne pouvaient que « rester réservés devant ces images aux couleurs artificielles à leurs yeux », écrit l'historienne de la photographie Nathalie Boulouch… Ce n'est qu'en 1974 que le conservateur de la Bibliothèque centrale de Zurich, Bruno Weber, découvrit les photochromes légués jusqu'en 1914 à la Bibliothèque municipale par Photoglob, entreposés au sous-sol de sa propre bibliothèque, soigneusement rangés dans une armoire qui n'avait jamais été ouverte. Totalement séduit par la fraîcheur des couleurs et impressionné par la qualité technique du procédé de restitution, il organisa une exposition (1974-1975), s'employa à faire expliciter le procédé (1979), publia des articles et un premier ouvrage sur l'« Allemagne en 1900 » (*Deutschland um die Jahrhundertwende*, 1990). Parallèlement, un autre grand amateur de photochromes, Marc Walter, continuait d'agrandir sa propre collection, constituée lentement depuis plus de vingt ans. En 2006, il fit paraître un premier livre, *Portrait d'un monde en couleurs*[14], largement coédité en Europe ; suivirent quatre titres de la collection « Magie du photochrome »[15] et deux albums en quatre langues sur les photochromes « géants » des Alpes[16]. Enfin, il coédita le catalogue de son exposition *Voyage en couleur* qui se tint à la bibliothèque Forney à Paris de janvier à avril 2009.

Et l'aventure du photochrome continue…

[1] Andrew Sinclair, *A concise history of the United States*, Thames and Hudson, Londres, 1967.
[2] *Ibid.*
[3] *Ibid.*
[4] Nathalie Boulouch, « Fécondité de la couleur », catalogue de l'exposition *Voyage en couleur, photochromie (1876–1914)*, bibliothèque Forney, Paris, 27 janvier–16 avril 2009, © Paris bibliothèques / Eyrolles, 2009.
[5] John Vincent Jezierski, « Le photochrome, Photoglob et la Detroit Publishing Company », in catalogue de l'exposition *Voyage en couleur, photochromie (1876–1914)*, bibliothèque Forney, Paris, 27 janvier–16 avril 2009, © Paris bibliothèques / Eyrolles, 2009.
[6] *Ibid.*
[7] *Ibid.*
[8] James L. Lowe et Ben Papell, *Detroit Publishing Company Collector's Guide*, First Edition, Deltiologists of America, An International Society of Picture Postcard Collectors, © James Lowe, 1975.
[9] *Ibid.*
[10] Nancy Stickels Stechschulte, *The Detroit Company Postcards*, First Edition, © Nancy Stickels Stechschulte, 1994.
[11] William Henry Jackson, *Time Exposure*, G. P. Putnam's Son, New York, 1940, cité in Nancy Stickels Stechschulte, *The Detroit Company Postcards*, First Edition © Nancy Stickels Stechschulte, 1994.
[12] *Ibid.*
[13] Jim Hughes, *The Birth of a Century*, Tauris Parke Books, Londres et New York, 1994.
[14] Marc Walter et Sabine Arqué, *Portrait d'un monde en couleurs*, Paris, Solar, 2006.
[15] Collection « Magie du photochrome », Paris, De Monza, 2007–2008.
[16] *Alpen-Alpes-Alpi-Alps*, coédition De Monza / Photoglob, 2009 et *Schweiz-Suisse-Svizzera-Switzerland*, Photoglob, Zurich, 2009.

Right: "Little Phostint Journeys", postcard sets, ca. 1915
Bottom: "Mammoths," special format and large panoramic American photochroms, from the Marc Walter collection

Rechts: „Little Phostint Journeys", Postkartensets, um 1915
Unten: Einige amerikanische Photochrome: „Mammoths", Sonderformate und große Panoramabilder aus der Sammlung von Marc Walter

À droite : « Little Phostint Journeys », carnets de cartes postales, vers 1915
En bas : quelques photochromes américains : « Mammoths », formats spéciaux et grand panoramique, de la collection de Marc Walter

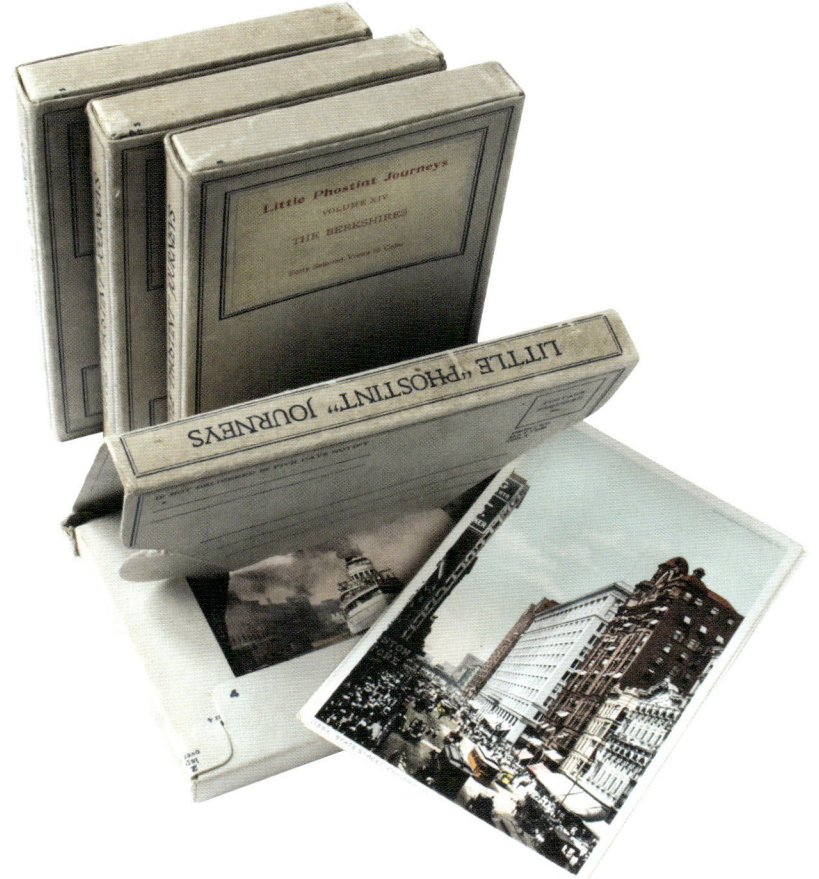

INTRODUCTION

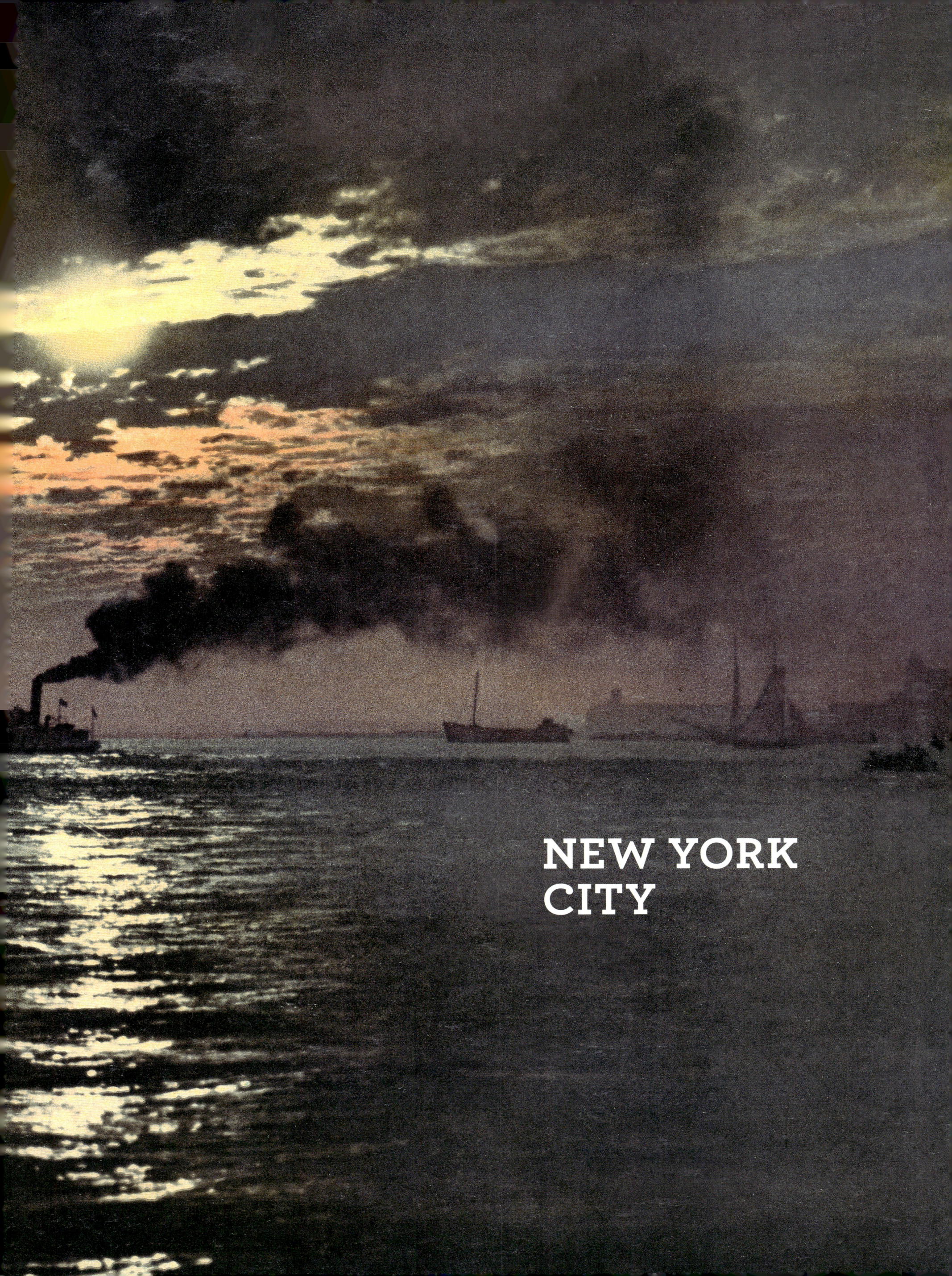

NEW YORK CITY

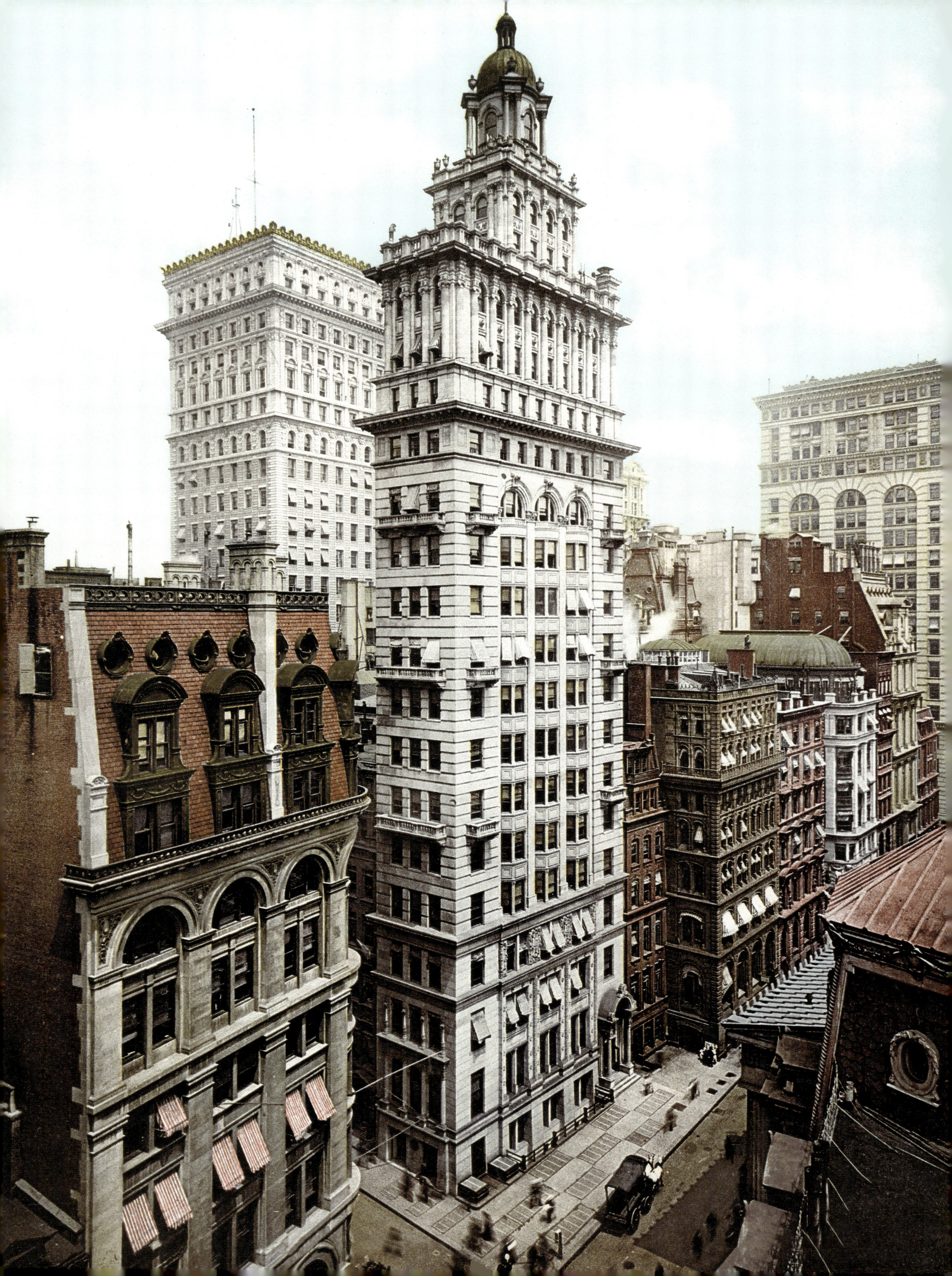

Page 30/31: Sunset from the Battery, photochrom
Page 32: Gillender Building, photochrom
Near right: East River and Brooklyn Bridge
Far right: Cortlandt Street showing the Singer Building

Seite 30/31: Sonnenuntergang von Battery aus, Photochrom
Seite 32: Gillender Building, Photochrom
Rechts: East River und Brooklyn Bridge
Rechts außen: Cortlandt Street mit Singer Building

Pages 30/31 : coucher de soleil depuis la Battery, photochrome
Page 32 : Gillender Building, photochrome
Ci-contre : l'East River et le pont de Brooklyn
À droite : Cortlandt Street avec l'immeuble Singer

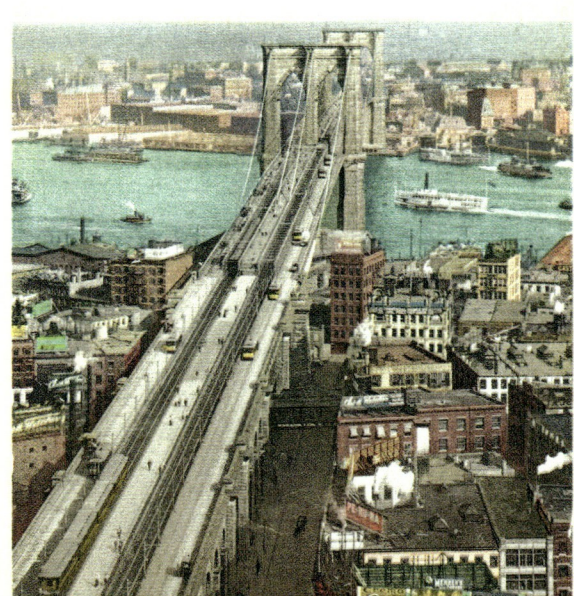
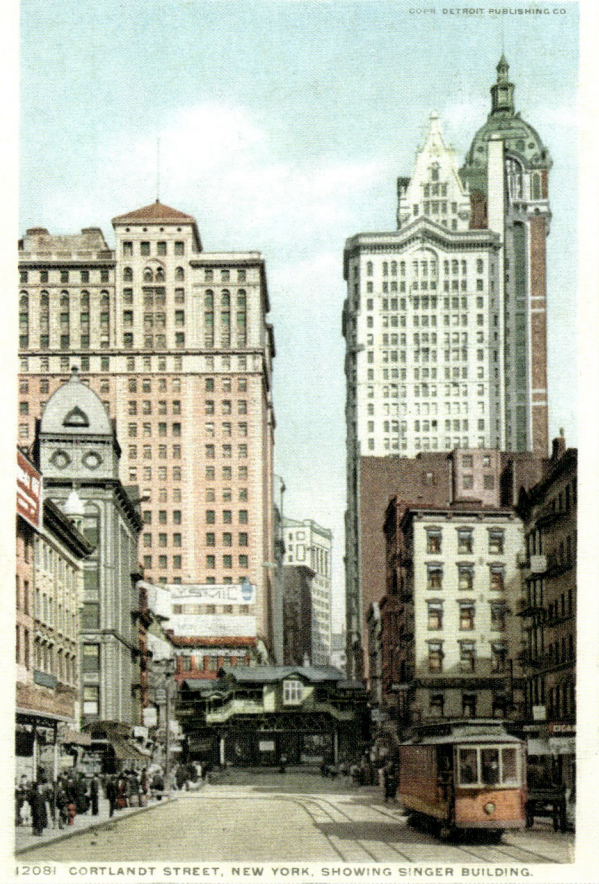

NEW YORK CITY

By 1890, New York was the most populous city in the United States. More than 1,500,000 inhabitants lived on Manhattan Island (300,000 more than in 1880). That was the year in which the Danish-born journalist and photographer Jacob A. Riis, determined to alert the municipal authorities to the crucial issue of housing, published his milestone book *How the Other Half Lives: Studies among the Tenements of New York.* In it, he depicted the abominable living conditions inflicted on the poor immigrants who represented two-thirds of New York's population: the Irish, Germans, Italians, Russian and Polish Jews, Chinese, and others crowded into the insalubrious housing of the Lower East Side and Harlem (Little Italy), in particular in the Mulberry Street area, known as the "Bend." Riis denounced infant mortality, epidemics caused by the absence of the most elementary hygiene, the saloons where alcoholism proliferated, the shameful profits made by those who rented out hovels, and the negligence of the municipal police. When, in 1895, Theodore Roosevelt was named president of the Board of Commissioners of the New York City Police Department, he accompanied Riis through the slums and continued to support him after his election to the presidency in 1901, ensuring the passage of the new law on tenement houses that obliged proprietors to rent decent housing fitted with windows and ventilation.

At the same time, the business and residential quarters of Manhattan were prospering. Travelers visiting the city in the first five years of the century were astonished by the frenetic activity, the agitation of Wall Street, the vertiginous height of the apartment buildings—constructed by sure-footed Mohawk workmen—and their electric elevators, the racket made by the streetcars, and the press of people crowding into the new subway and elevated railway. They marveled at the abundance of advertising billboards, the scintillating lights of Broadway ("The Great White Way"), and the opulence of Fifth Avenue or Park Avenue. At the opening evening of the Metropolitan Opera on November 24, 1902, the Astors, the Vanderbilts, the Whitneys, the Goulds, and the Belmonts attended a performance of *Otello* with the great Emma Eames. In 1904, it was the turn of Wagner's *Parsifal*, directed by Alfred Hertz, for which a new stage was constructed. And on January 1, 1908, Gustav Mahler himself was the conductor of *Tristan und Isolde*; he conducted the orchestra of the "Met" for a year. While the slums were sordid, the great Manhattan hotels—the Waldorf Astoria, the Commodore, the Plaza, and the Belmont—competed for ever greater luxury. The 1,500 rooms of the Waldorf were hung with silk or velvet brocade, their furniture was mahogany, and the beds were garnished with ivory. The walls of the ballroom were marble and the floors were covered in oriental carpets. And everywhere "stucco, decorated, gilded stucco, like in a Byzantium cathedral," as the traveler Jules Huret observed, that same Huret who had warned that the "wretched must never entrust themselves to that torrent of energy, the business city". This was New York, paradise or inferno, gate of the New World, and a symbol of liberty and hope.

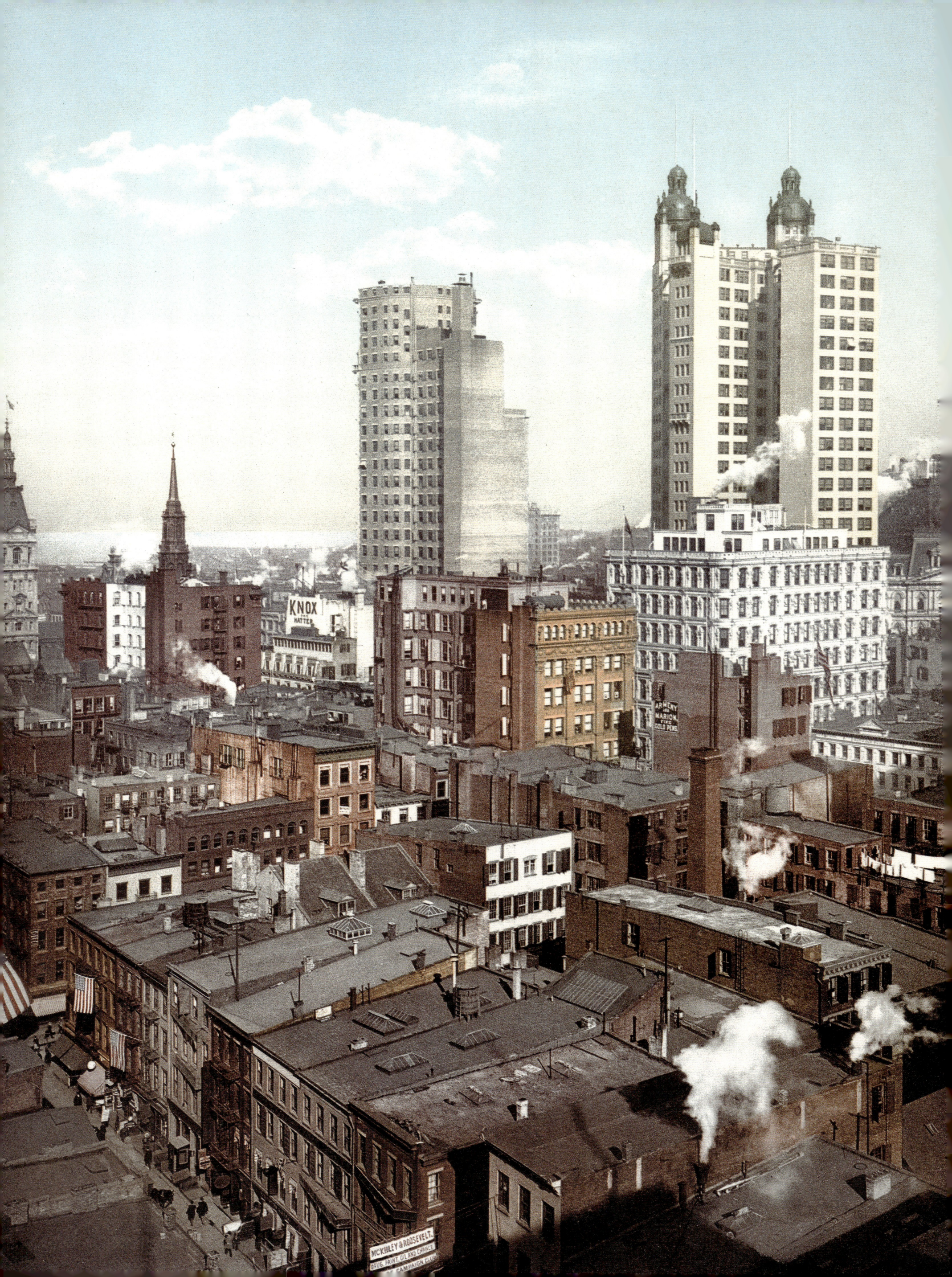

Page 34: The tallest building in the world,
Park Row Building, photochrom
Near right: Bankers Trust and Equitable buildings
Far right: The Vanderbilt Hotel

Seite 34: Das Park Row Building, das höchste Gebäude
der Welt, Photochrom
Rechts: Bankers Trust Building und Equitable Building
Rechts außen: Das Hotel Vanderbilt

Page 34 : l'immeuble le plus haut du monde,
Park Row Building, photochrome
Ci-contre : l'immeuble du Bankers Trust et celui
de l'Equitable
À droite : l'hôtel Vanderbilt

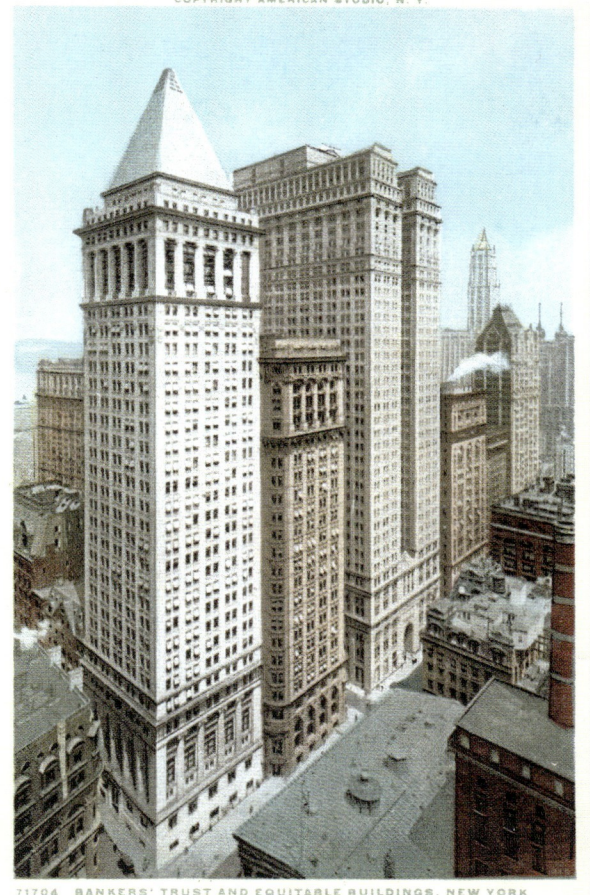
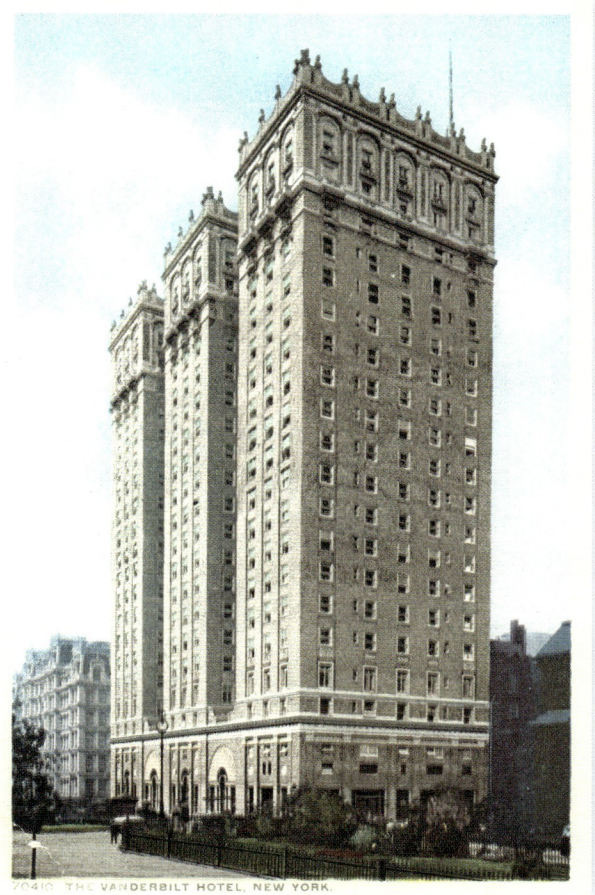

NEW YORK CITY

1890 war New York die bevölkerungsreichste Stadt der Vereinigten Staaten: Über 1 500 000 Einwohner lebten auf der Insel Manhattan (300 000 mehr als 1880). Im selben Jahr veröffentlichte der dänische Journalist und Fotograf Jacob A. Riis, fest entschlossen, die Stadtverwaltung auf das fundamentale Wohnungsproblem aufmerksam zu machen, ein Buch, das Geschichte machen sollte: *How the Other Half Lives. Studies among the Tenements of New York* (Wie die andere Hälfte [der New Yorker] lebt. Studien über Mietwohnungen in New York City). Er beschrieb darin die schrecklichen Lebensbedingungen der armen Einwanderer, die zwei Drittel der New Yorker Bevölkerung ausmachten: Iren, Deutsche, Italiener, russische und polnische Juden, Chinesen und viele andere, die in den gesundheitsschädigenden Unterkünften der Lower East Side und in Harlem (Little Italy), insbesondere in der Gegend um Mulberry Street, „the Bend" genannt, zusammengedrängt waren. Riis prangerte die Kindersterblichkeit an, die Epidemien wegen eines grundlegenden Mangels an Hygiene, die Saloons, in denen die Trunksucht herrschte, die schandhaften Profite, die die Vermieter dieser Bruchbuden erzielten, und die Fahrlässigkeit der städtischen Polizei. Nach seiner Ernennung zum Polizeipräfekten von New York 1895 begleitete Theodore Roosevelt Riis an Ort und Stelle und unterstützte ihn auch noch nach seinem Aufstieg zum Präsidenten im Jahr 1901; er ließ über das neue Gesetz zu den *Tenement Houses* abstimmen, das die Eigentümer verpflichtete, menschenwürdige Wohnungen mit Fenstern und Belüftungsschächten zu vermieten.

Zur gleichen Zeit prosperierten die Geschäfts- und Wohnviertel von Manhattan. Reisende in den Jahren 1900–1915 staunten über das hektische Treiben in der Stadt, über die Ruhelosigkeit der Wall Street, die schwindelerregende Höhe der – von Mohawk errichteten – Gebäude, über deren elektrische Aufzüge, den Lärm der Straßenbahnen und die Menschenmenge, die sich in die Waggons der neuen U-Bahn oder der Hochbahn zwängte. Sie wunderten sich über die unzähligen Werbeschilder, die glitzernden Nächte am Broadway – dem „Great White Way" – und über die Pracht der Fifth Avenue oder der Park Avenue. Bei der Eröffnung der Metropolitan Opera am Abend des 24. November 1902 wohnten die Astors, die Vanderbilts, die Whitneys, die Goulds und die Belmonts einer *Otello*-Aufführung mit der großen Emma Eames bei. 1904 dirigierte Alfred Hertz Wagners *Parsifal*, für den eigens eine neue Bühne gebaut worden war. Und am 1. Januar 1908 leitete Gustav Mahler höchstpersönlich die Aufführung von *Tristan und Isolde*; ein Jahr lang dirigierte er das Orchester der „Met". So schäbig die einfachen Bezirke waren, so luxuriös waren die Grand Hotels von Manhattan, das Waldorf Astoria, das Commodore, das Plaza oder das Belmont. Die 1 500 Zimmer des Waldorf Astoria waren mit Seide oder durchwirktem Samt ausgekleidet, die Möbel waren aus Mahagoni und die Betten mit Elfenbeinintarsien verziert. Die Wände der Ballsäle waren aus Marmor, Orientteppiche bedeckten die Böden. Und überall „Stuck, verzierter, vergoldeter Stuck wie in einer byzantinischen Kathedrale", schwärmte Jules Huret – derselbe, der auch warnte, dass „die Unglückseligen sich" nicht „dem reißenden Strom der Geschäftsstädte aussetzen" dürften. New York war das Paradies und die Hölle, das Tor zur Neuen Welt, ein Symbol für Freiheit und Hoffnung.

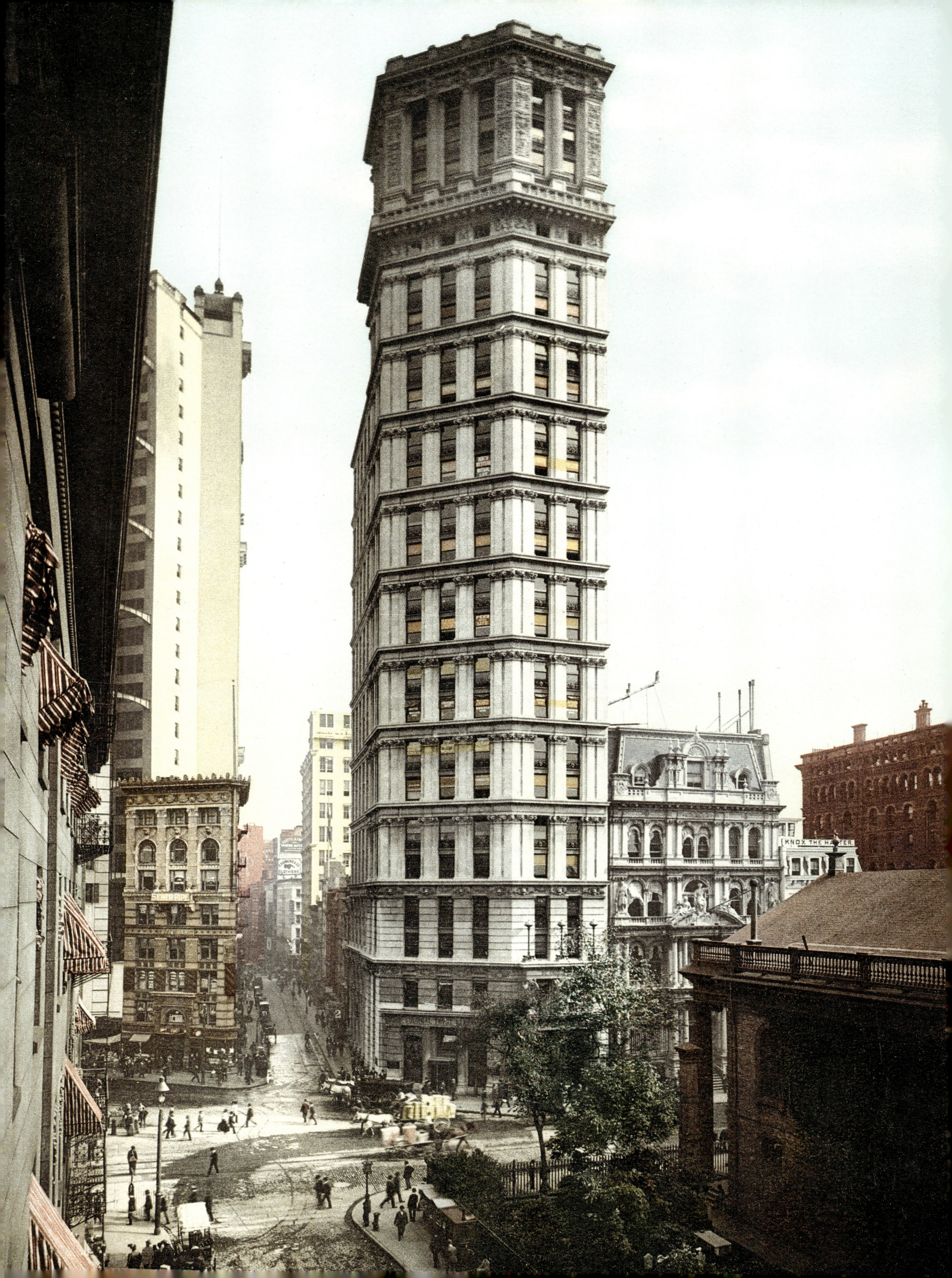

Page 36: St. Paul Building, photochrom
Near right: Times Building
Far right: Metropolitan Insurance Building at night

Seite 36: St. Paul Building, Photochrom
Rechts: Times Building
Rechts außen: Das Metropolitan Insurance Building bei Nacht

Page 36: St. Paul Building, photochrome
Ci-contre: l'immeuble du Times
À droite: l'immeuble de la Metropolitan Insurance la nuit

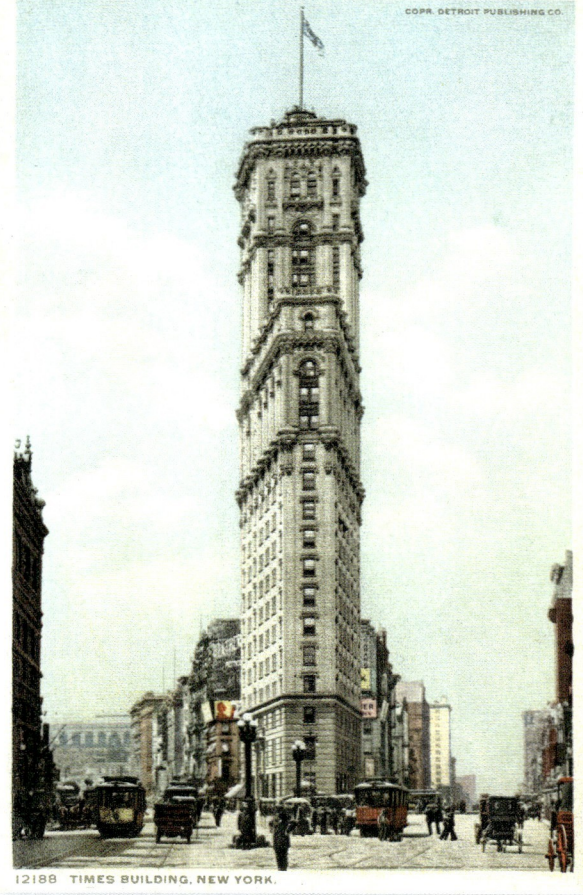
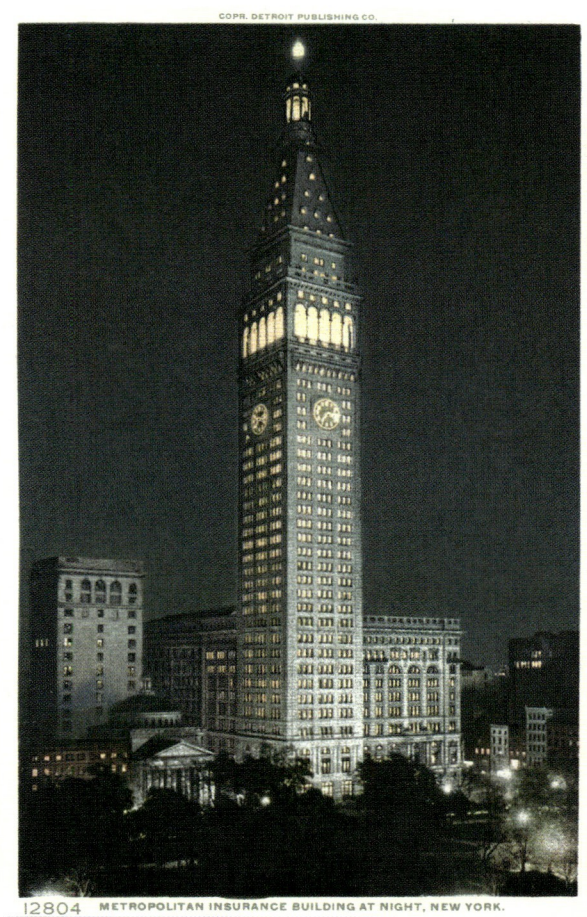

NEW YORK CITY

En 1890, New York est la ville la plus peuplée des États-Unis : plus d'un million et demi d'habitants vivent sur l'île de Manhattan (300 000 de plus qu'en 1880). Cette même année, décidé à sensibiliser les autorités municipales au problème crucial du logement, le journaliste et photographe d'origine danoise Jacob A. Riis publie un livre qui fera date : *How the Other Half Lives, Studies among the Tenements of New York (Comment vit l'autre moitié [des New-Yorkais], études réalisées dans les immeubles d'habitation de la ville de New York)*. Il y dépeint les conditions de vie abominables des immigrés pauvres, qui représentent les deux tiers de la population new-yorkaise – Irlandais, Allemands, Italiens, Juifs russes et polonais, Chinois... –, entassés dans les logements insalubres du Lower East Side et de Harlem (Little Italy), notamment dans le quartier de Mulberry Street, le « Bend ». Riis dénonce la mortalité infantile, les épidémies dues à l'absence de l'hygiène la plus élémentaire, les *saloons* où sévit l'alcoolisme, les profits honteux encaissés par les loueurs de ces taudis et l'incurie de la police municipale. Nommé préfet de police de New York en 1895, Theodore Roosevelt accompagnera Riis sur le terrain et continuera de le soutenir, après son accession à la présidence en 1901, en faisant voter la nouvelle loi sur les *tenement houses*, qui oblige les propriétaires à louer des logements décents, munis de fenêtres et de bouches d'aération.

Dans le même temps, les quartiers d'affaires et résidentiels de Manhattan prospèrent. Dans les années 1900–1915, les voyageurs de passage s'étonnent de l'activité frénétique de la ville, de l'agitation de Wall Street, de la hauteur vertigineuse des immeubles – construits par des Indiens Mohawks – et de leurs ascenseurs électriques, du fracas des tramways, de la foule qui se presse dans les rames du nouveau métro ou de l'Elevated Railway. Ils s'émerveillent devant l'abondance des panneaux publicitaires et les nuits scintillantes de Broadway – « the Great White Way » (la « Grande Avenue blanche ») –, devant l'opulence de la 5e Avenue ou de Park Avenue. À la soirée d'ouverture du Metropolitan Opera, le 24 novembre 1902, les Astor, les Vanderbilt, les Whitney, les Gould et les Belmont assistent à une représentation d'*Otello* avec la grande Emma Eames. En 1904, c'est le *Parsifal* de Wagner, dirigé par Alfred Hertz, pour lequel on a construit une nouvelle scène. Et le 1er janvier 1908, Gustav Mahler en personne est au pupitre pour *Tristan et Yseult* ; il dirigera l'orchestre du « Met » pendant un an. Autant les bas quartiers sont sordides, autant les grands hôtels de Manhattan, le Waldorf Astoria, le Commodore, le Plaza et le Belmont sont luxueux. Les mille cinq cents chambres du Waldorf sont tendues de soie ou de velours broché, le mobilier est en acajou, les lits incrustés d'ivoire. Les murs des salles de bal sont en marbre, les sols recouverts de tapis d'Orient. Et, partout, « du stuc, du stuc orné, doré, comme dans une cathédrale byzantine », s'enthousiasme Jules Huret, celui-là même qui observait que « les malheureux ne doivent pas s'aventurer dans ce torrent d'énergie... ». Un paradis ou un enfer, telle était New York, porte du Nouveau Monde, symbole de liberté et d'espérance.

Top: Statue of Liberty, photochrom
Bottom left: Ellis Island, New York Harbor, bird's-eye view
Bottom right: Ellis Island, inspection room

The statue was intended to embody Franco-American friendship and commemorate the centenary of the Declaration of Independence but it proved no easy matter to raise the necessary funds. Commissioned in 1876, the sculptor Frédéric Auguste Bartholdi called in the engineer Gustave Eiffel to construct a copper framework for his colossal work. When *Liberty Illuminating the World* arrived in New York in June 1885, her pedestal was still not ready; it required a press campaign and the financial support of Joseph Pulitzer's newspaper to raise the sum required. It was finally dedicated on October 28, 1886, ten years later.

Oben: Die Freiheitsstatue, Photochrom
Unten links: Ellis Island, Blick von oben auf den New Yorker Hafen
Unten rechts: Ellis Island, Raum zur Einwanderungskontrolle

Die Statue sollte zum hundertsten Jahrestag der Unabhängigkeitserklärung errichtet werden und die franko-amerikanische Freundschaft symbolisieren, doch es war keine leichte Aufgabe, die dafür notwendigen Mittel zusammenzubekommen. 1876 wurde der Bildhauer Frédéric Auguste Bartholdi beauftragt und zog für das Metallgerüst seines kolossalen Werkes aus Kupfer den Ingenieur Gustave Eiffel hinzu. Als *Die Freiheit, die die Welt erhellt* im Juni 1885 endlich in New York ankam, war ihr Sockel noch nicht fertig; eine Pressekampagne und die finanzielle Unterstützung durch die Zeitung Joseph Pulitzers waren nötig, um die Finanzierung sicherzustellen. Am 28. Oktober 1886 wurde die Freiheitsstatue schließlich mit zehnjähriger Verspätung eingeweiht.

Ci-dessus : la statue de la Liberté, photochrome
En bas à gauche : Ellis Island, panorama du port de New York
En bas à droite : Ellis Island, la salle d'inspection

Réunir, de part et d'autre de l'Atlantique, les fonds nécessaires à la réalisation de la statue qui devait commémorer le centenaire de la Déclaration d'Indépendance et symboliser l'amitié franco-américaine, ne fut pas chose facile. Commissionné en 1876, le sculpteur Frédéric Auguste Bartholdi dut faire appel à l'ingénieur Gustave Eiffel pour construire la charpente métallique de son œuvre colossale en cuivre. Lorsque *La Liberté éclairant le monde* arriva enfin à New York, en juin 1885, son piédestal n'était pas prêt ; il fallut une campagne de presse et le soutien financier du journal de Joseph Pulitzer pour trouver son financement. C'est le 28 octobre 1886, avec dix ans de retard sur la date anniversaire, que la statue fut inaugurée !

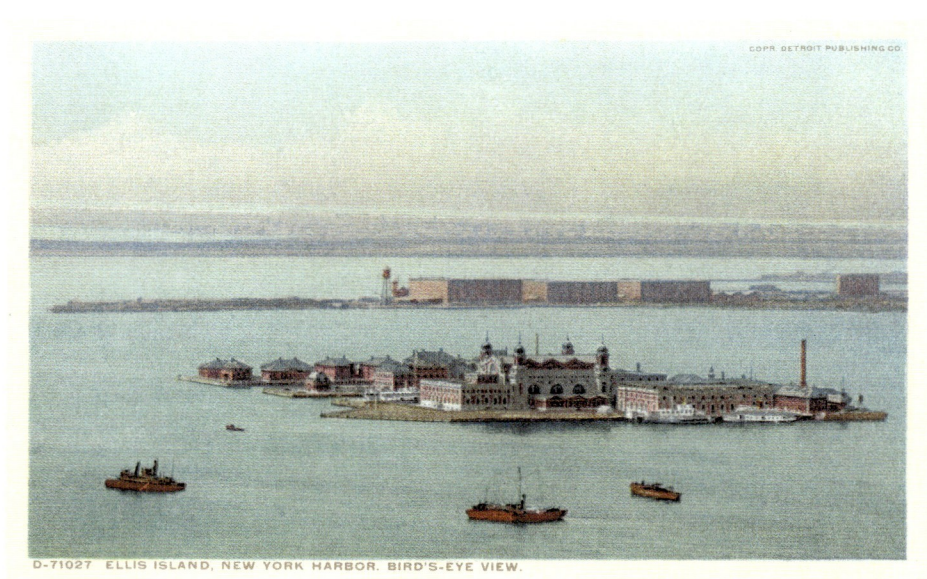
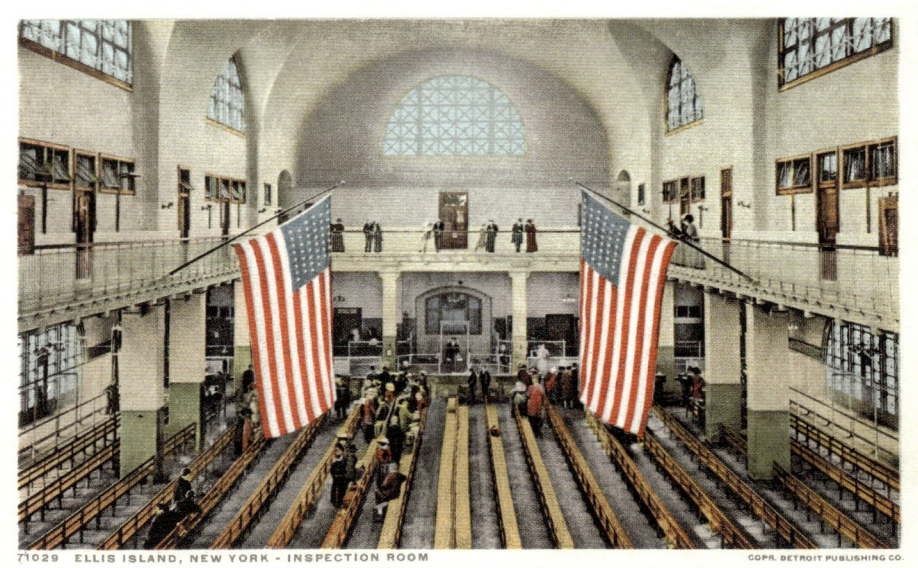

Top: **Battery Park showing New York Aquarium, photochrom**
Bottom left: **Municipal ferry** *City of New York*
Bottom right: **Main-floor view of the New York Aquarium**

For more than 100 years, New York Harbor symbolized access to the freedoms of the New World. The Battery and subsequently the new immigration center on Ellis Island were the first glimpse of those freedoms for those driven from their native lands by hunger or anti-Semitism and whose only hope was to seek a better standard of living on the far shore of the Atlantic. On January 2, 1892, Annie Moore, a 15-year-old Irish girl accompanied by her two brothers, was the first immigrant naturalized on Ellis Island.

Oben: **Battery Park und das New Yorker Aquarium, Photochrom**
Unten links: **Die städtische Fähre** *City of New York*
Unten rechts: **Der große Saal im Erdgeschoss des Aquariums**

Der New Yorker Hafen galt über hundert Jahre lang als das Tor zur Neuen Welt und zur Freiheit. Tag für Tag landeten zuerst in Battery und später im neuen Einwanderungszentrum von Ellis Island all jene, die vor dem Hunger oder dem Antisemitismus aus ihren Heimatländern geflohen waren und deren einzige Hoffnung es war, auf der anderen Seite des Atlantiks bessere Lebensbedingungen vorzufinden. Am 2. Januar 1892 wurde die 15-jährige Irin Annie Moore in Begleitung ihrer beiden Brüder als erste Immigrantin auf Ellis Island eingebürgert.

Ci-dessus : **Battery Park et l'Aquarium de New York, photochrome**
En bas à gauche : **le ferry municipal** *City of New York*
En bas à droite : **la grande salle du rez-de-chaussée de l'Aquarium**

Le port de New York symbolisa pendant plus de cent ans l'accès au Nouveau Monde et à la liberté. À la Batterie, puis au nouveau centre d'immigration d'Ellis Island, débarquèrent jour après jour ceux qui avaient été chassés de leur pays d'origine par la faim ou par l'antisémitisme, dont le seul espoir était de trouver outre-Atlantique des conditions de vie meilleures. Le 2 janvier 1892, Annie Moore, une jeune Irlandaise de 15 ans, accompagnée de ses deux frères, fut la première émigrante naturalisée à Ellis Island.

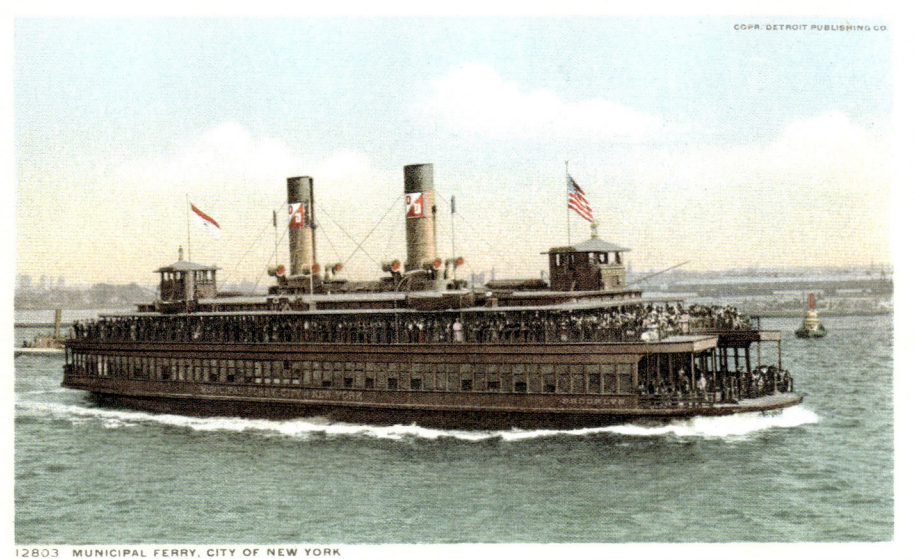

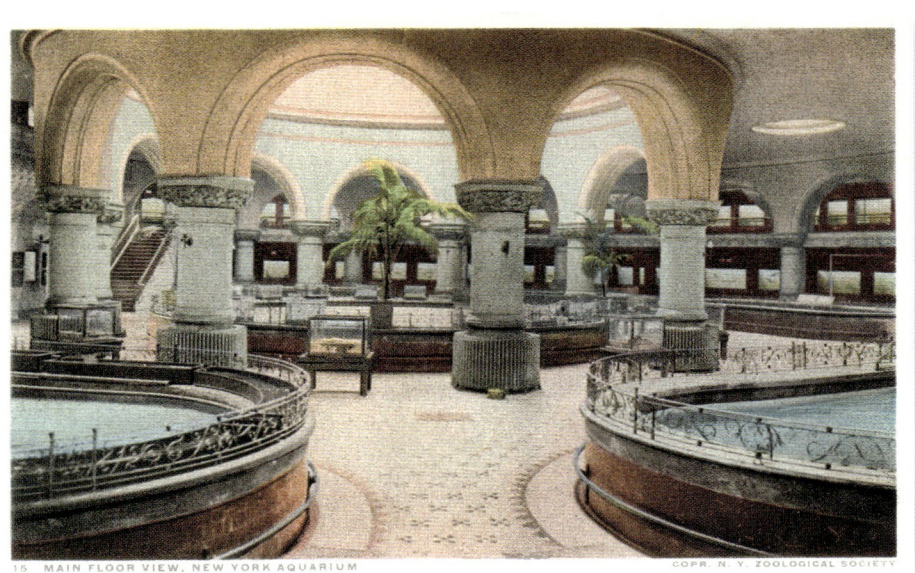

NEW YORK CITY | BATTERY PARK

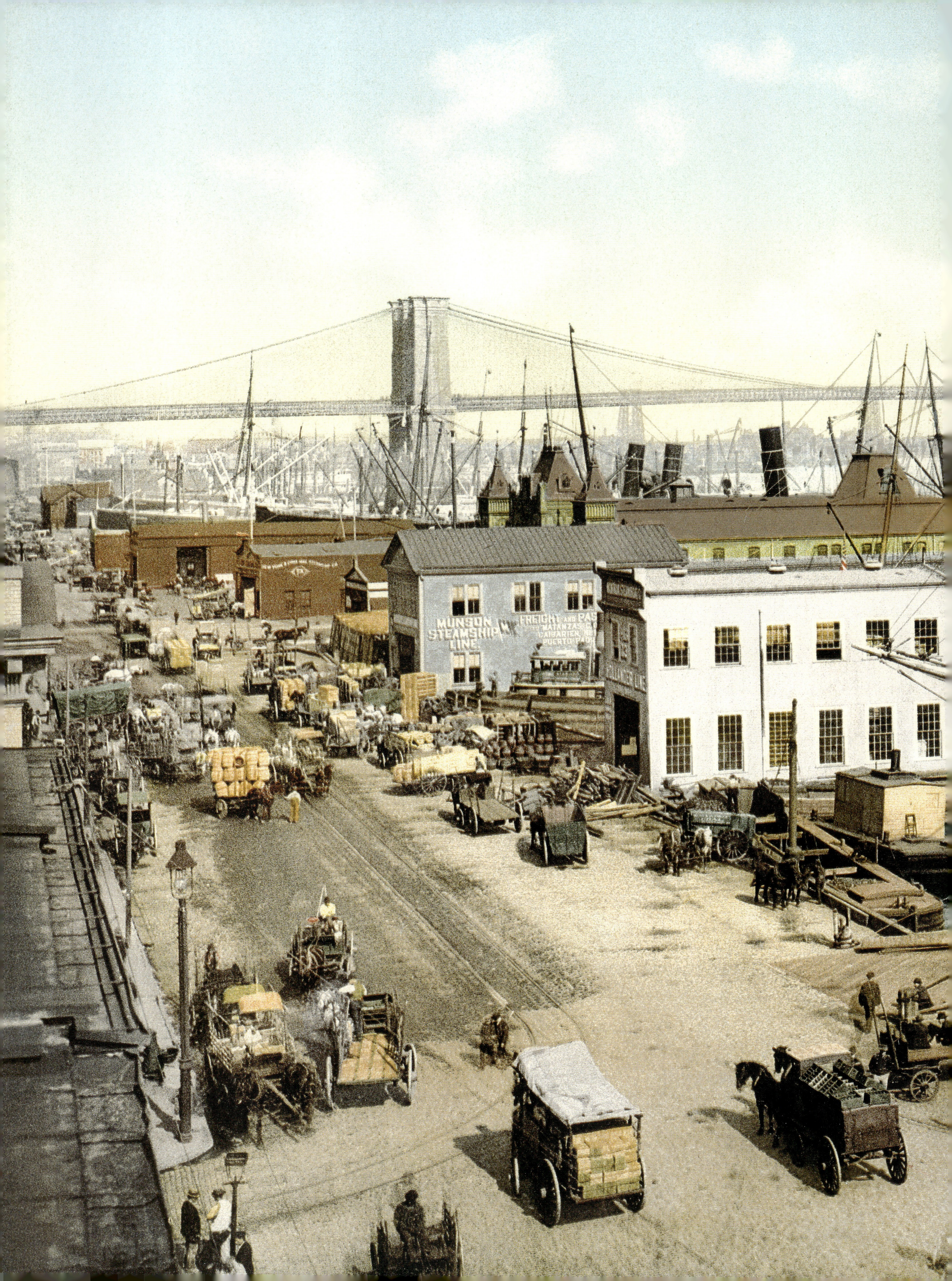

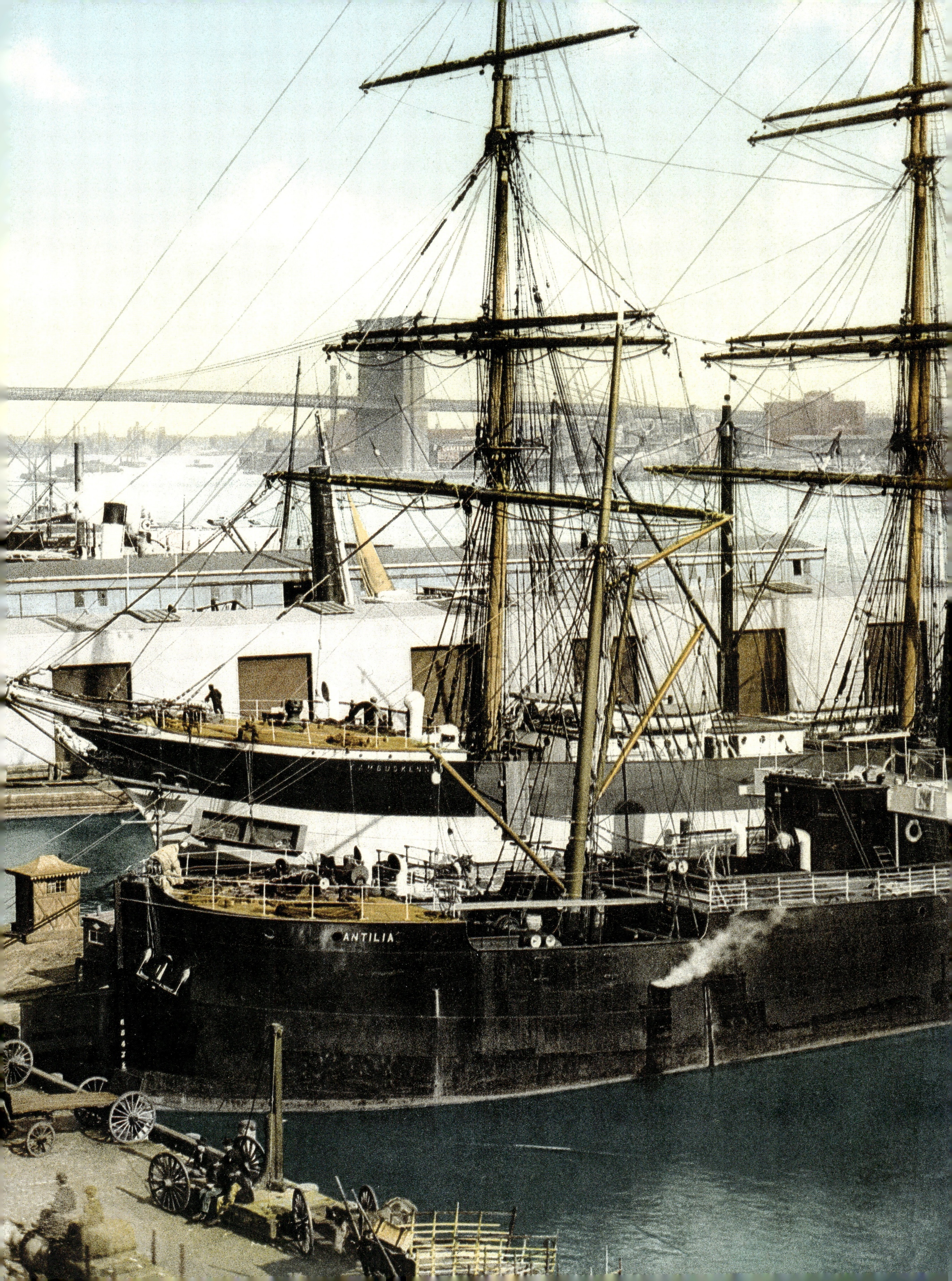

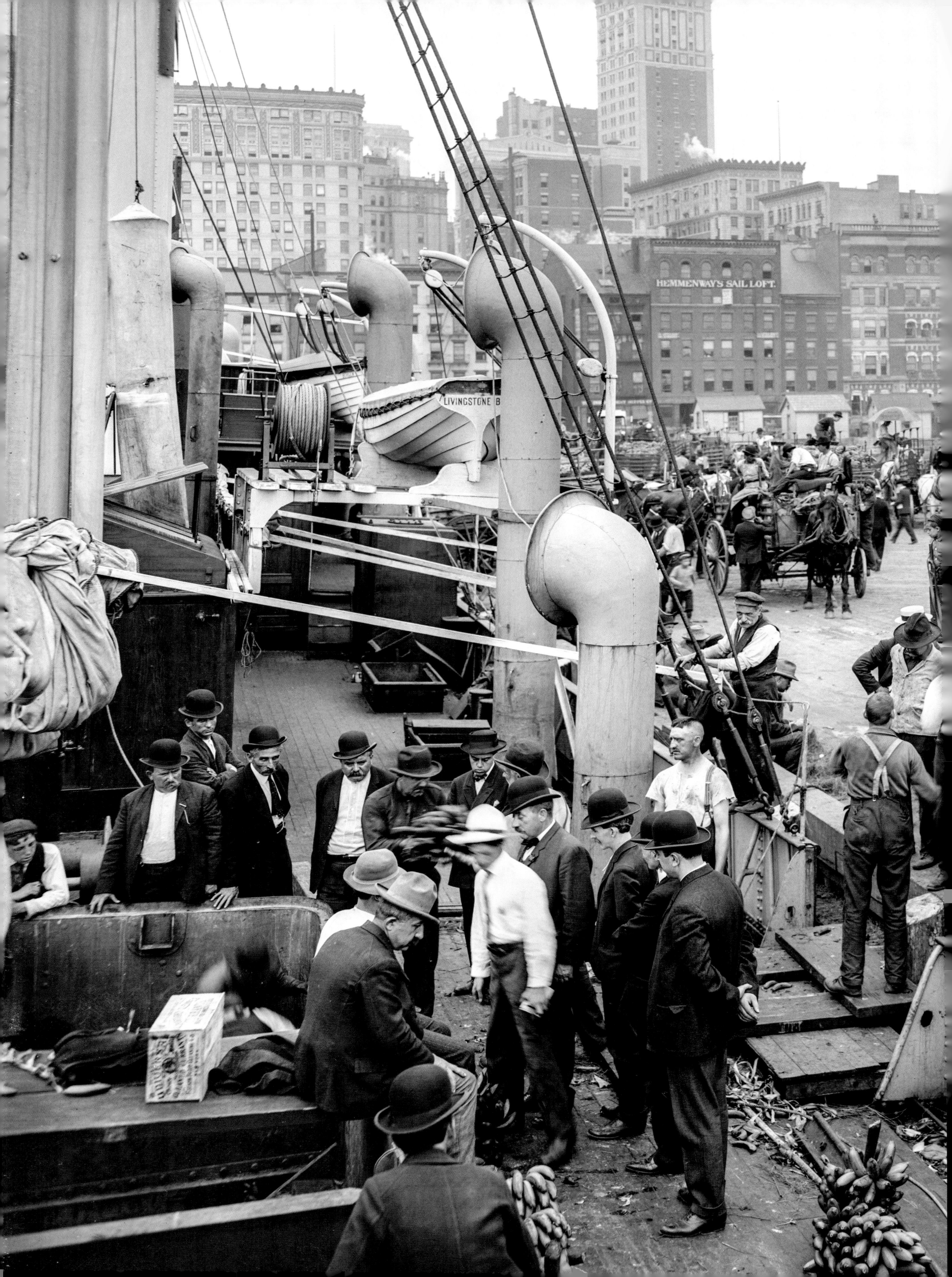

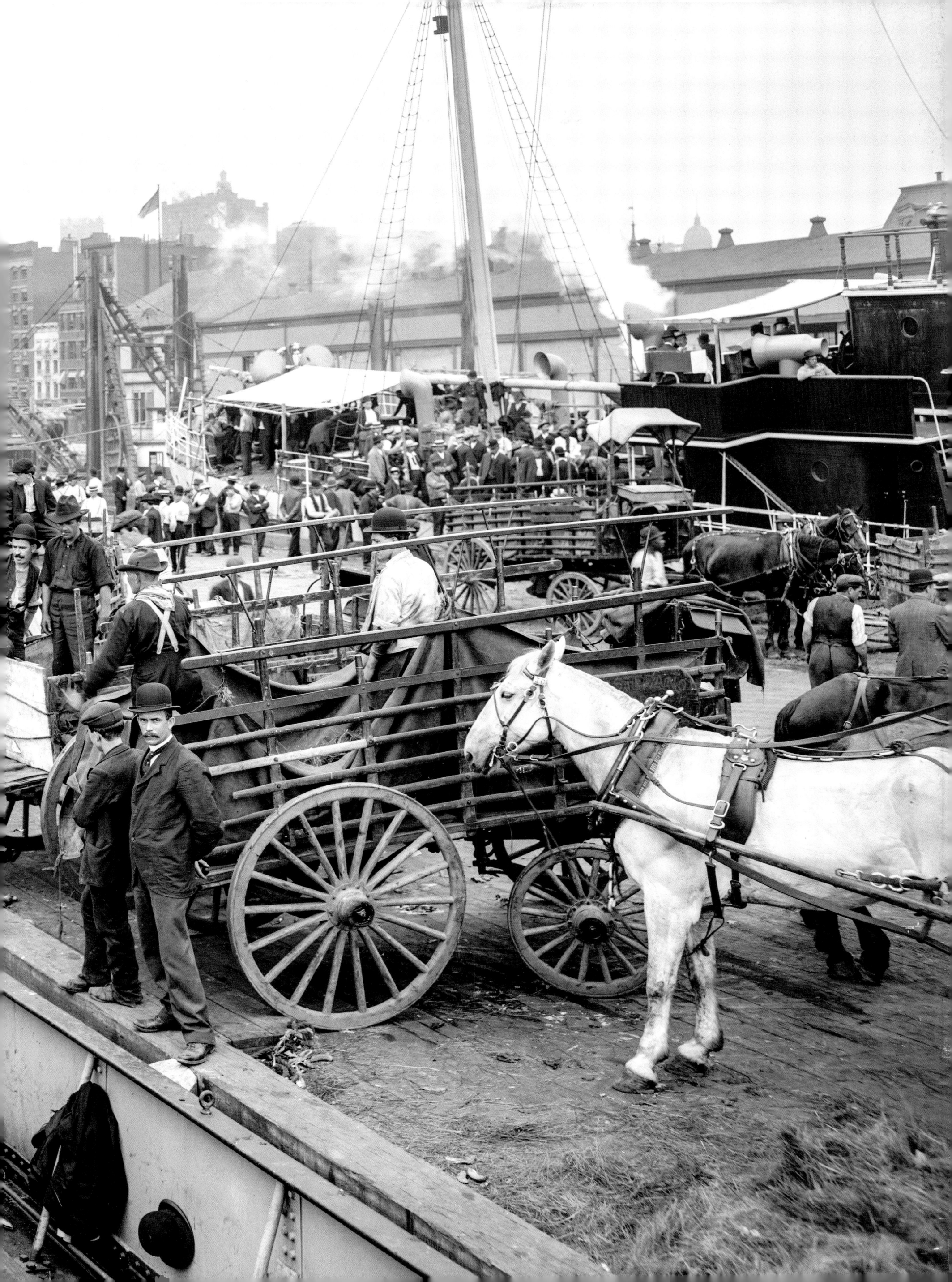

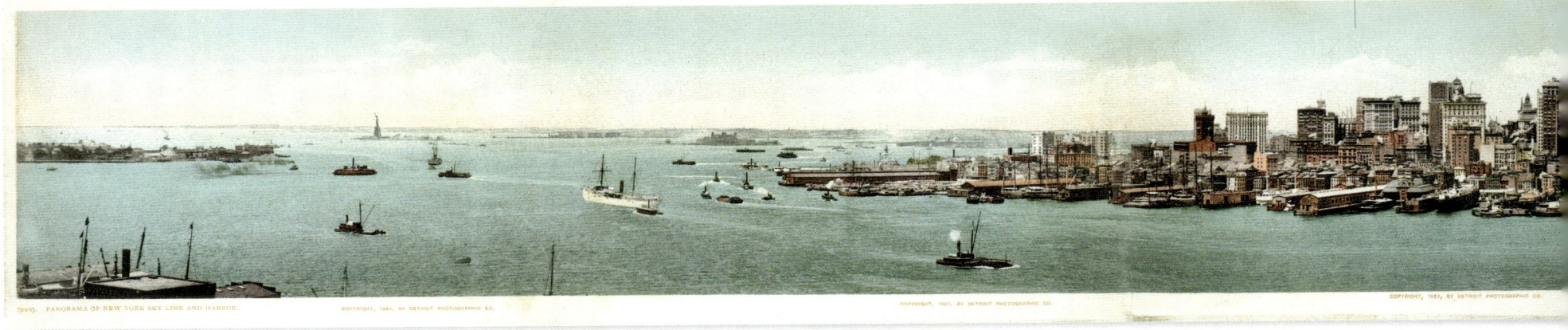

Page 40/41: South Street and Brooklyn Bridge, photochrom
Page 42/43: New York, banana docks, glass negative, 1900
Top: Panorama of New York harbor
Bottom: Approach to Brooklyn Bridge, Brooklyn

To speak of the Port of New York as it was when the oldest of these photographs were taken is to evoke the name of Walt Whitman. "Crossing Brooklyn Ferry" was written in 1856 and revised in 1881:
"I too many and many a time cross'd the river …/I watched the Twelfth-month sea-gulls …/Look'd toward the lower bay to notice the arriving ships …/Saw the white sails of schooners and sloops—saw the ships at anchor,/The sailors at work … / The round masts, the swinging motion of the hulls …/The large and small steamers in motion, the pilots in their pilot-houses …"
Brooklyn Bridge was close to completion at the date of Whitman's revision and opened in 1883; its construction had taken 14 years.

Seite 40/41: South Street und Brooklyn Bridge, Photochrom
Seite 42/43: New York, Dock für Bananendampfer, Glasnegativ, 1900
Oben: Panorama des New Yorker Hafens
Unten: Anfahrt auf die Brooklyn Bridge, Brooklyn

Wenn man einen Eindruck davon bekommen will, wie der New Yorker Hafen zu der Zeit war, als die ältesten dieser Ansichten entstanden, so kommt man um den Namen Walt Whitman nicht herum. Hier sind einige kurze Ausschnitte aus dem Gedicht „Crossing Brooklyn Ferry", das 1856 verfasst und 1881 überarbeitet wurde:
„Auch ich überquerte zahlreiche Male den Fluss … / folgte mit dem Blick den Dezembermöwen … / Schaute zur Bucht hin, um die Schiffe ankommen zu sehen … / Sah die weißen Segel der Schoner – sah die Schiffe vor Anker liegen / … die Seeleute bei der Arbeit … / Die runden Masten, die schaukelnden Schiffskörper … / Die großen und kleinen Dampfschiffe in Bewegung, die Seelotsen in ihrer Kabine …"
Als Whitman das Gedicht überarbeitete, war die Brooklyn Bridge so gut wie fertiggestellt; sie wurde 1883 nach 14-jähriger Bauzeit eröffnet.

Pages 40/41 : South Street et le pont de Brooklyn Bridge, photochrome
Pages 42/43 : New York, docks aux bananes, plaque de verre, 1900
Ci-dessus : panorama du port de New York
En bas : en arrivant au pont de Brooklyn, Brooklyn

Pour évoquer le port de New York tel qu'il était lorsque les plus anciennes de ces vues furent prises, un nom s'impose, celui de Walt Whitman. Voici de courts extraits de « Crossing Brooklyn Ferry », un poème écrit en 1856 et révisé en 1881 :
« Moi aussi, nombre et nombre de fois je passai la rivière…/ suivis des yeux les mouettes de décembre…/ regardai du côté de la baie pour voir arriver les bateaux…/ vis les voiles blanches des goélettes – vis les navires à l'ancre…/ les marins au travail…/ les mâts arrondis, le balancement des coques…/ les grands et les petits vapeurs en mouvement, les pilotes dans leurs cabines… »
Le pont de Brooklyn était en voie d'achèvement lorsque Whitman retoucha ce poème ; il fut mis en service en 1883, après quatorze ans de travaux.

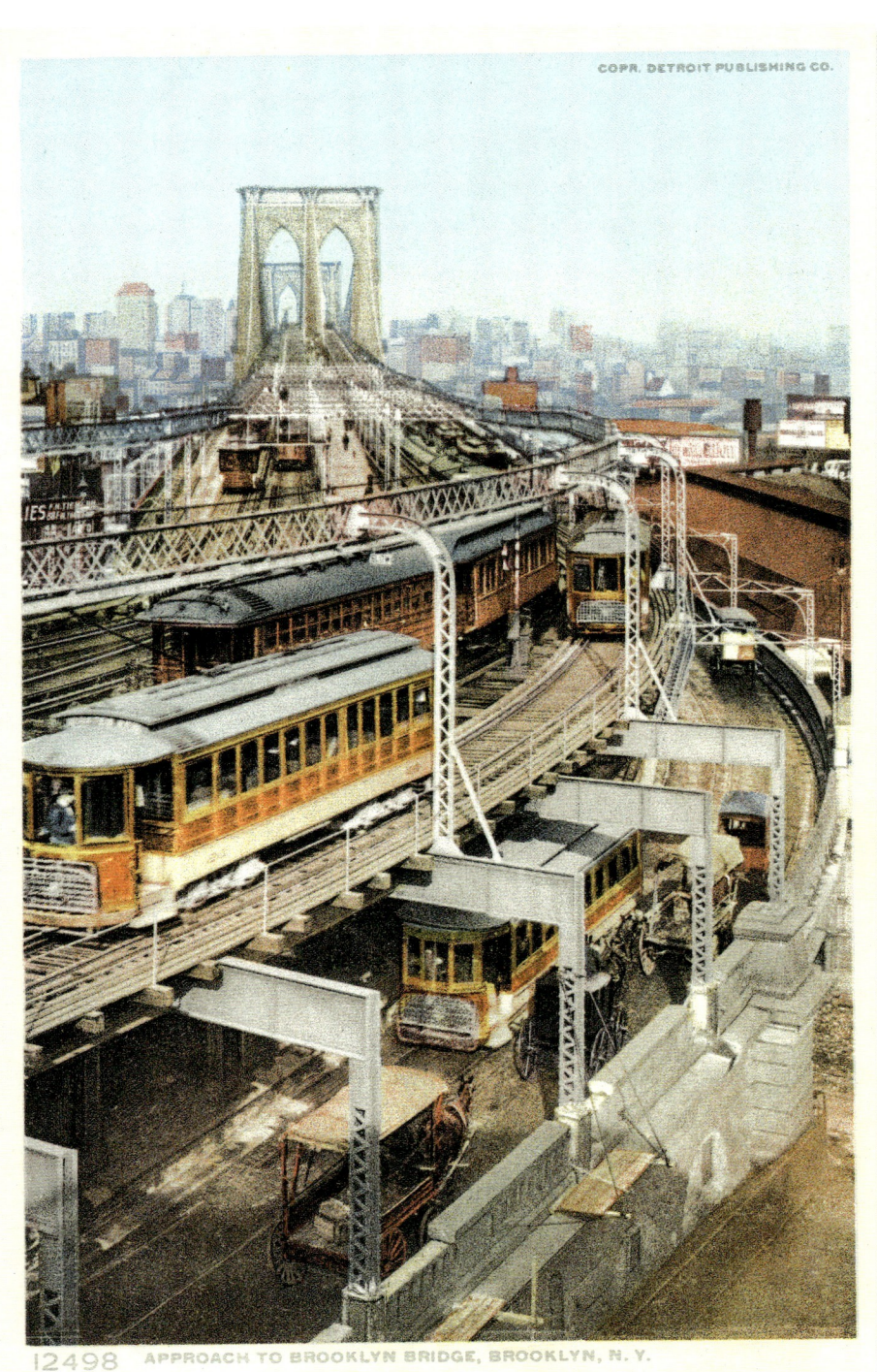

Page 45, from left to right and top to bottom:
The wharves from Brooklyn Bridge
The Manhattan Bridge, New York and Brooklyn
The docks along West Street
Manhattan entrance to Brooklyn Bridge
Recreation pier
Banana docks

Seite 45, von links nach rechts und von oben nach unten:
Die Quais von der Brooklyn Bridge aus
Manhattan Bridge, New York und Brooklyn
Die Docks entlang der West Street
Zugang zur Brooklyn Bridge von Manhattan aus
Vergnügungspier
Docks mit Bananendampfern

Page 45, de gauche à droite et de haut en bas :
Les quais depuis le pont de Brooklyn
Le pont de Manhattan Bridge, New York et Brooklyn
Les docks le long de West Street
L'entrée du pont de Brooklyn du côté de Manhattan
La jetée de loisirs
Docks aux bananes

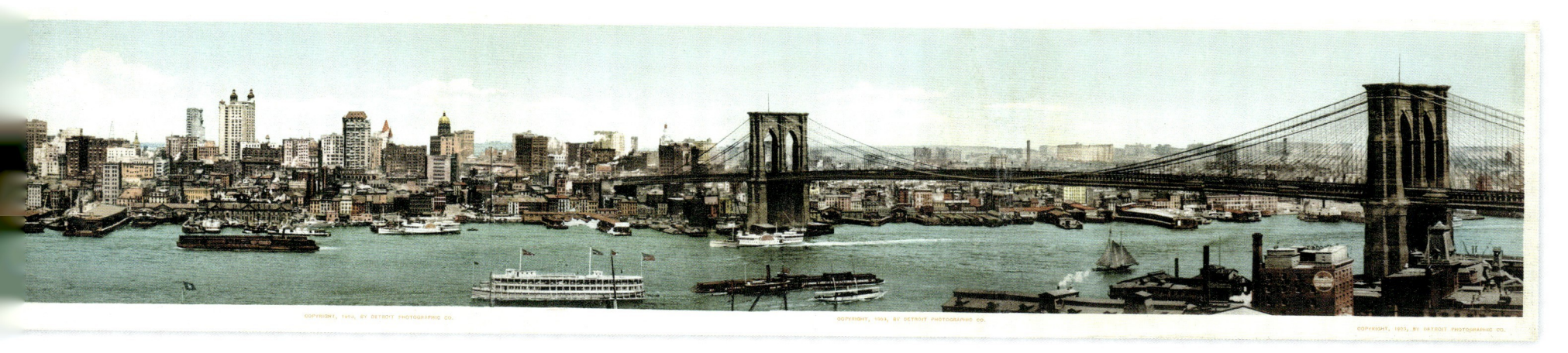

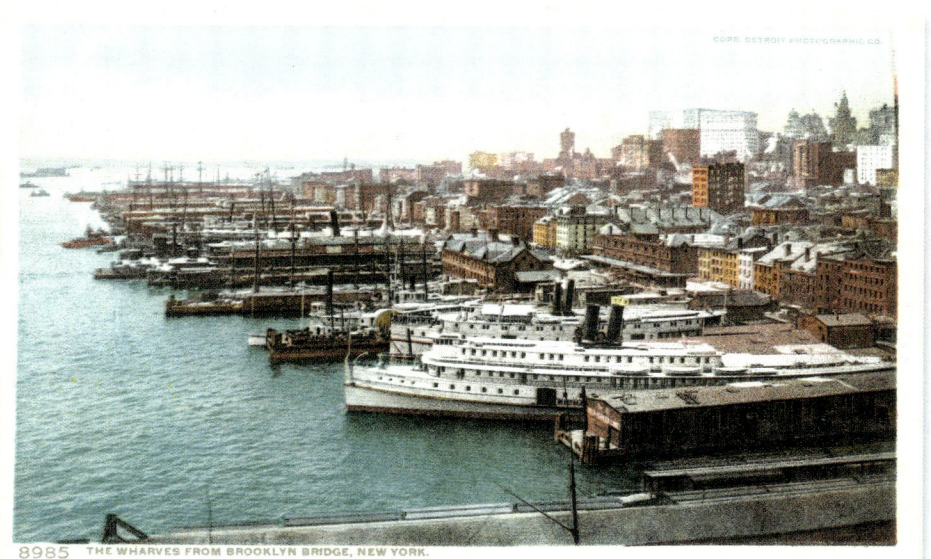
8985 THE WHARVES FROM BROOKLYN BRIDGE, NEW YORK.

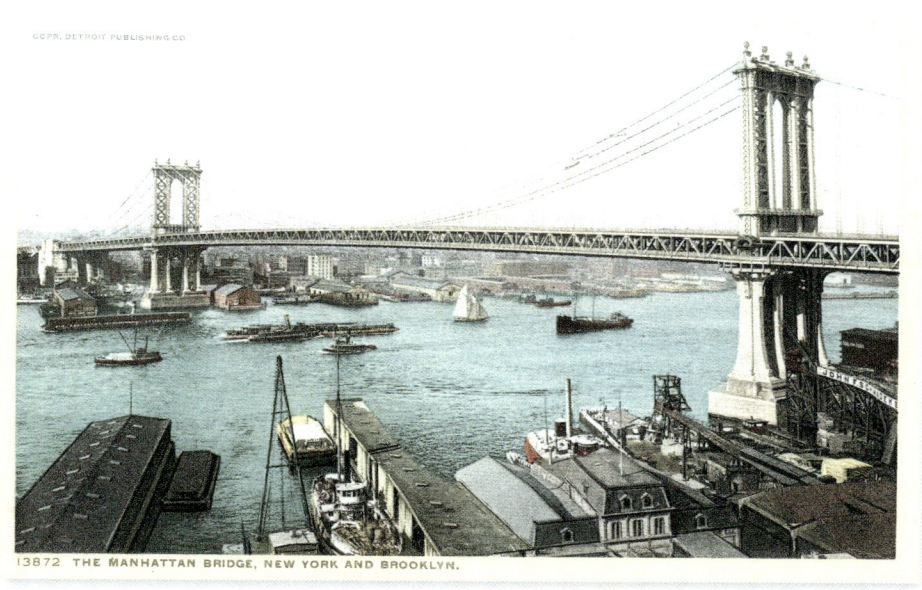
13872 THE MANHATTAN BRIDGE, NEW YORK AND BROOKLYN.

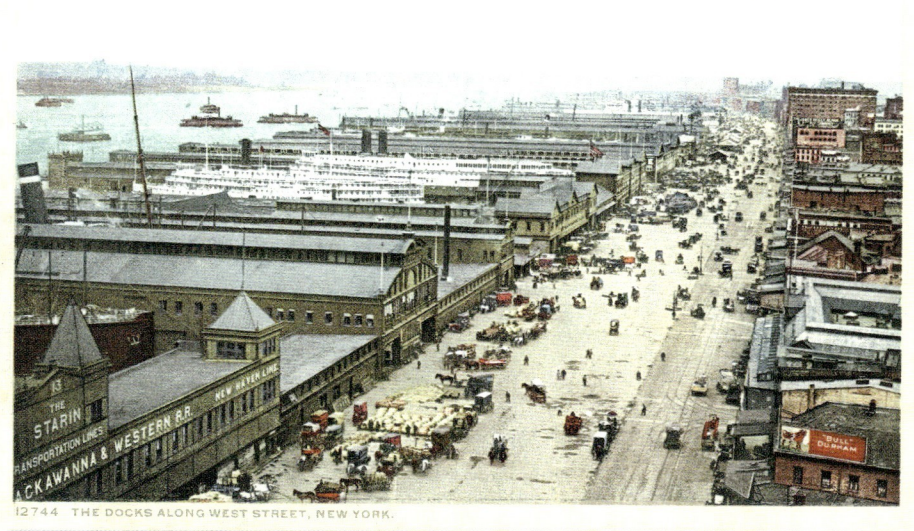
12744 THE DOCKS ALONG WEST STREET, NEW YORK.

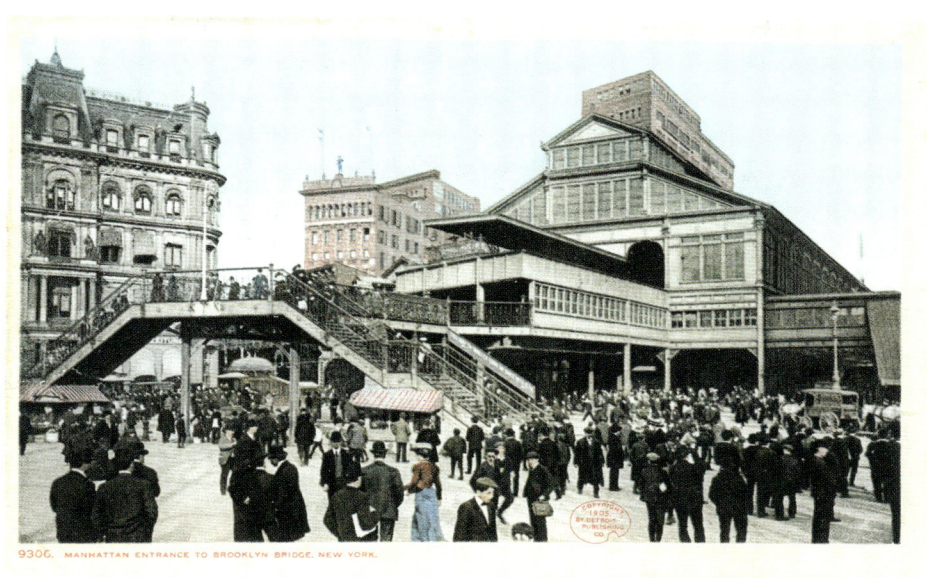
9306. MANHATTAN ENTRANCE TO BROOKLYN BRIDGE, NEW YORK.

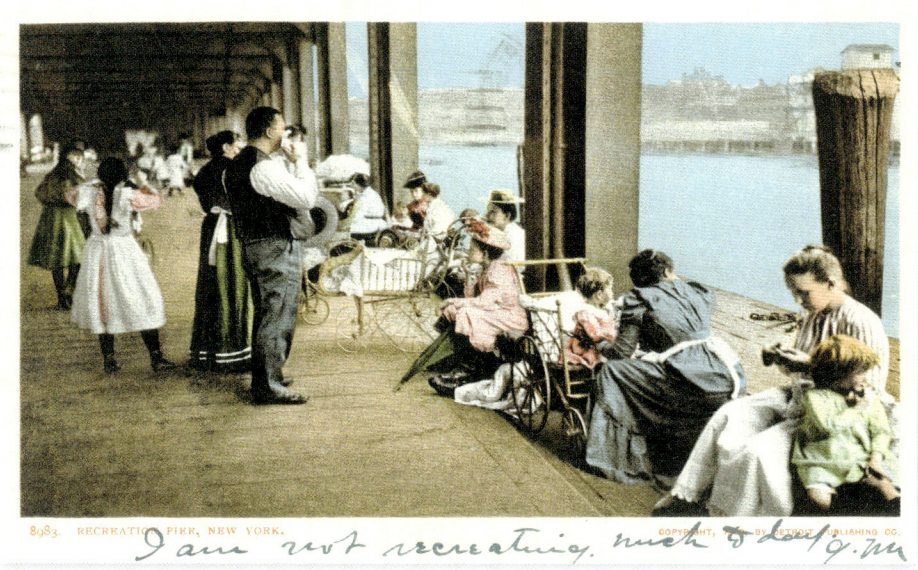

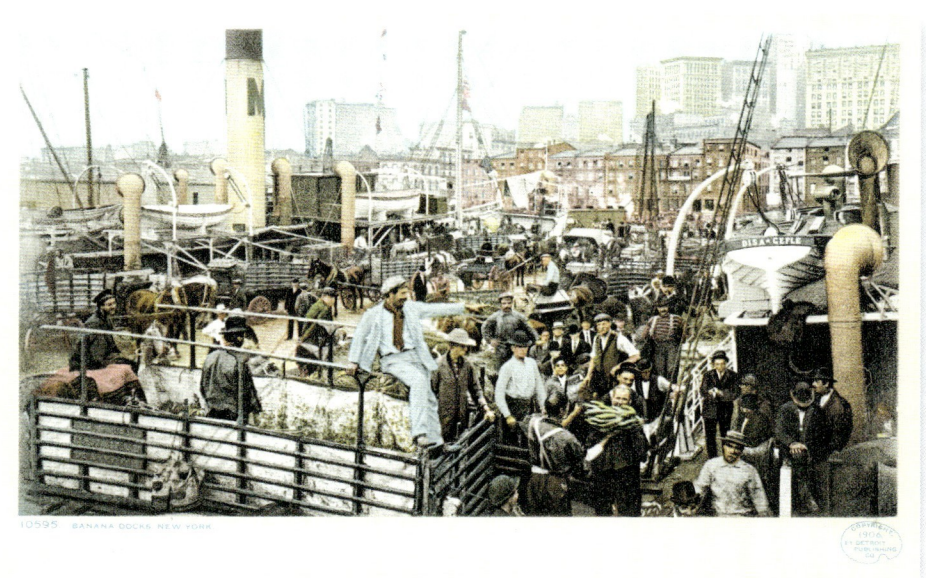

NEW YORK CITY | HARBOR | BROOKLYN BRIDGE

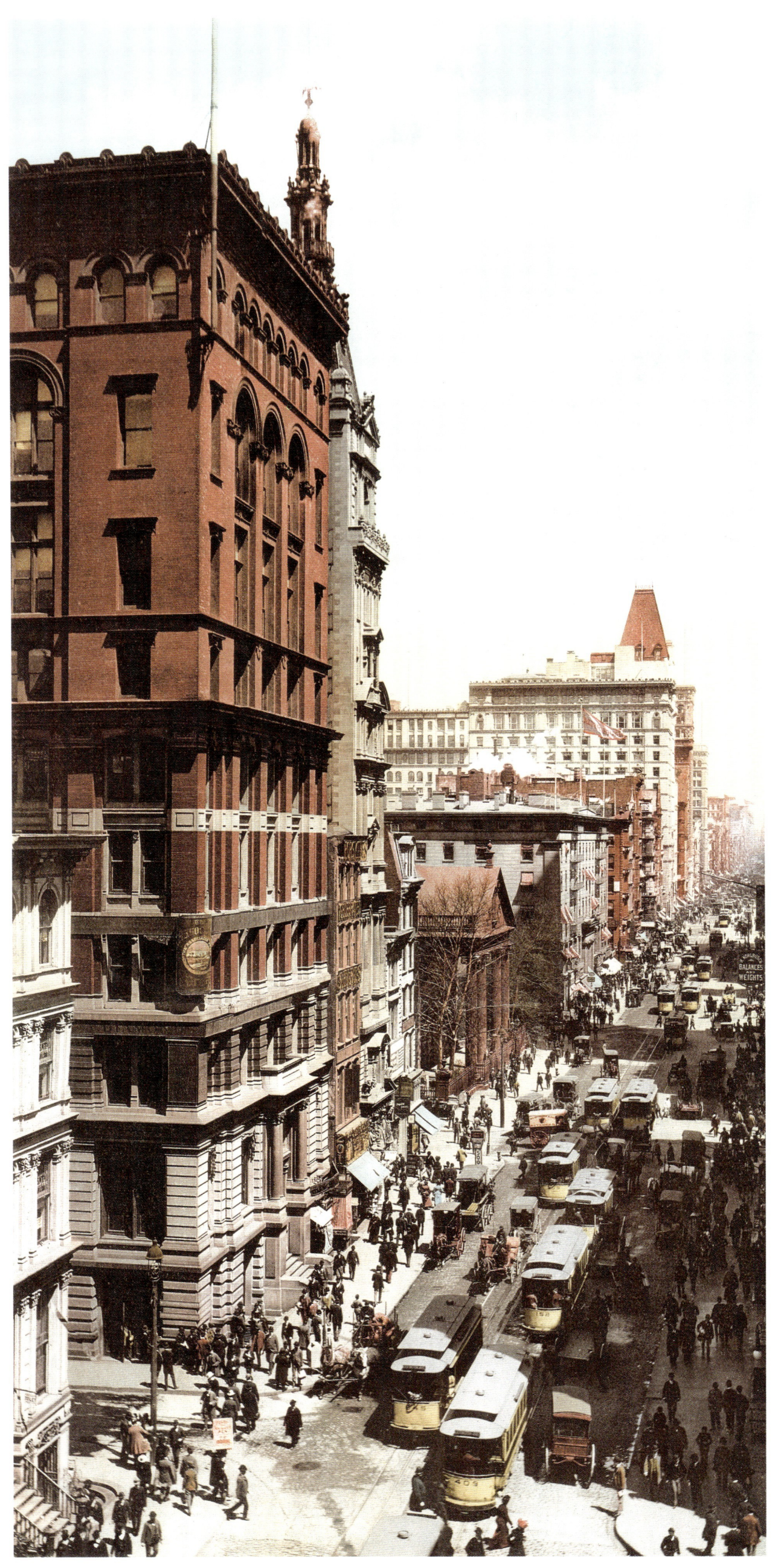

Left: Broadway up from Dey Street, photochrom
Page 47: Trinity Church, photochrom
Page 48/49: Broadway at Fulton Street, New York, glass negative, 1910–1920

Recognized by the Church of England in 1698, the first Episcopal Trinity Church was burned down during the American Revolutionary War of 1776. It was renovated in 1790 but so gravely damaged by the heavy snows of 1838–39 that it had to be torn down. Located on Broadway opposite Wall Street, the current Neo-Gothic church, built of red sandstone, was designed by Richard Upjohn, the founder of the American Institute of Architecture. Trinity Church was consecrated in 1846. The Gothic-Revival style of the building and its large stained-glass windows with their biblical scenes scandalized Upjohn's Puritan contemporaries and he prudently concluded that the decoration of the nave walls should remain sober.

Links: Der Broadway oberhalb der Dey Street, Photochrom
Seite 47: Trinity Church, Photochrom
Seite 48/49: Der Broadway auf Höhe der Fulton Street, New York, Glasnegativ, 1910–1920

Trinity Church, die von der Anglikanischen Kirche 1698 anerkannte erste Episkopalkirche, wurde während des Unabhängigkeitskrieges von 1776 in Brand gesetzt; sie wurde zwar 1790 renoviert, doch in den Winterstürmen der Jahre 1838–1839 schwer beschädigt und schließlich ganz abgerissen. Die heutige, am Broadway gegenüber der Wall Street gelegene neugotische Kirche aus rotem Sandstein wurde vom Gründer des Amerikanischen Architekturinstituts, Richard Upjohn, entworfen. Die Trinity Church wurde 1846 eingeweiht. Der spätgotische Baustil sowie die großen Kirchenfenster und die Vielzahl effekthascherischer Darstellungen von biblischen Szenen brachten Upjohn bei seinen puritanischen Zeitgenossen heftige Kritik ein. Der Architekt bemühte sich daher, den Dekor der Seitenwände so schlicht wie möglich zu halten.

À gauche : Broadway en amont de Dey Street, photochrome
Page 47 : l'église de la Trinité (Trinity Church), photochrome
Pages 48/49 : Broadway à Fulton Street, New York, plaque de verre, 1910–1920

Reconnue par l'Église d'Angleterre en 1698, la première église épiscopale de Trinity Church fut incendiée pendant la révolution de 1776 ; rénovée en 1790 mais gravement endommagée par les intempéries de l'hiver 1838–1839, elle fut complètement démolie. Sur Broadway, en face de Wall Street, l'église néogothique actuelle en grès rouge a été conçue par Richard Upjohn, le fondateur de l'Institut américain d'architecture. Trinity Church fut consacrée en 1846. Le style flamboyant du bâtiment, la présence de grands vitraux et les nombreuses représentations de scènes saintes « tape-à-l'œil » valurent à Upjohn de virulentes critiques de la part de ses contemporains puritains. L'architecte veilla donc à ce que le décor des murs latéraux restât sobre.

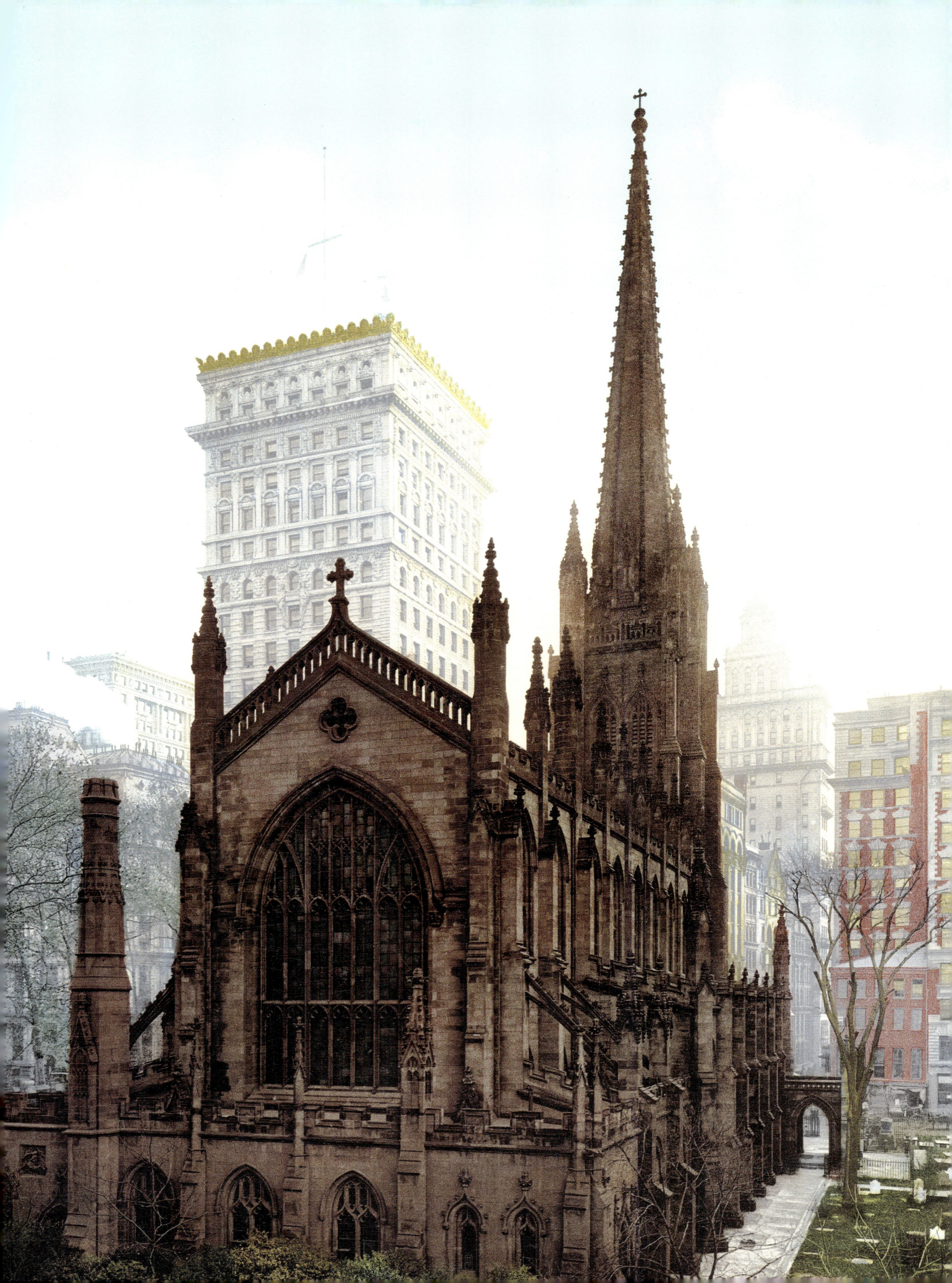

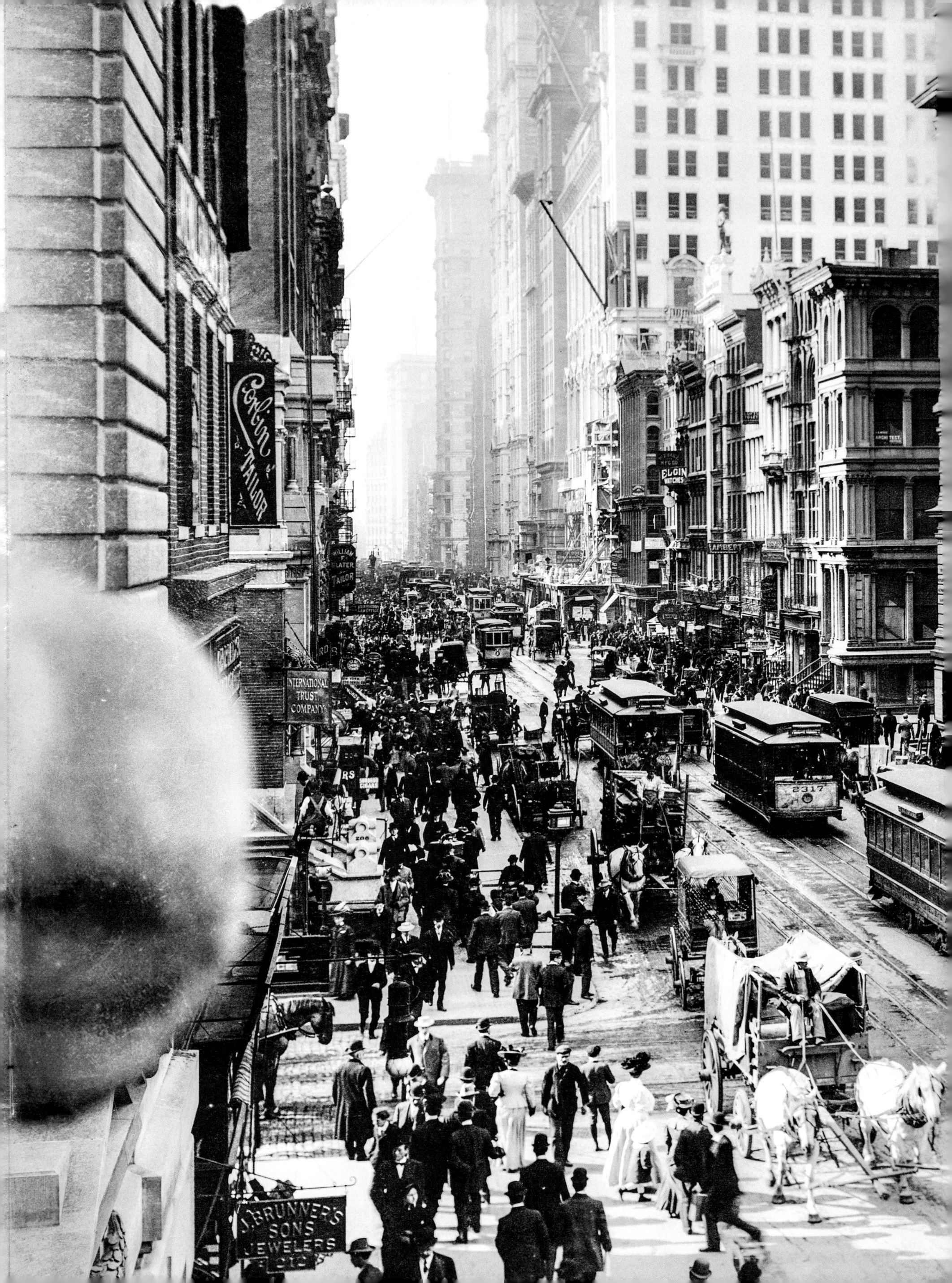

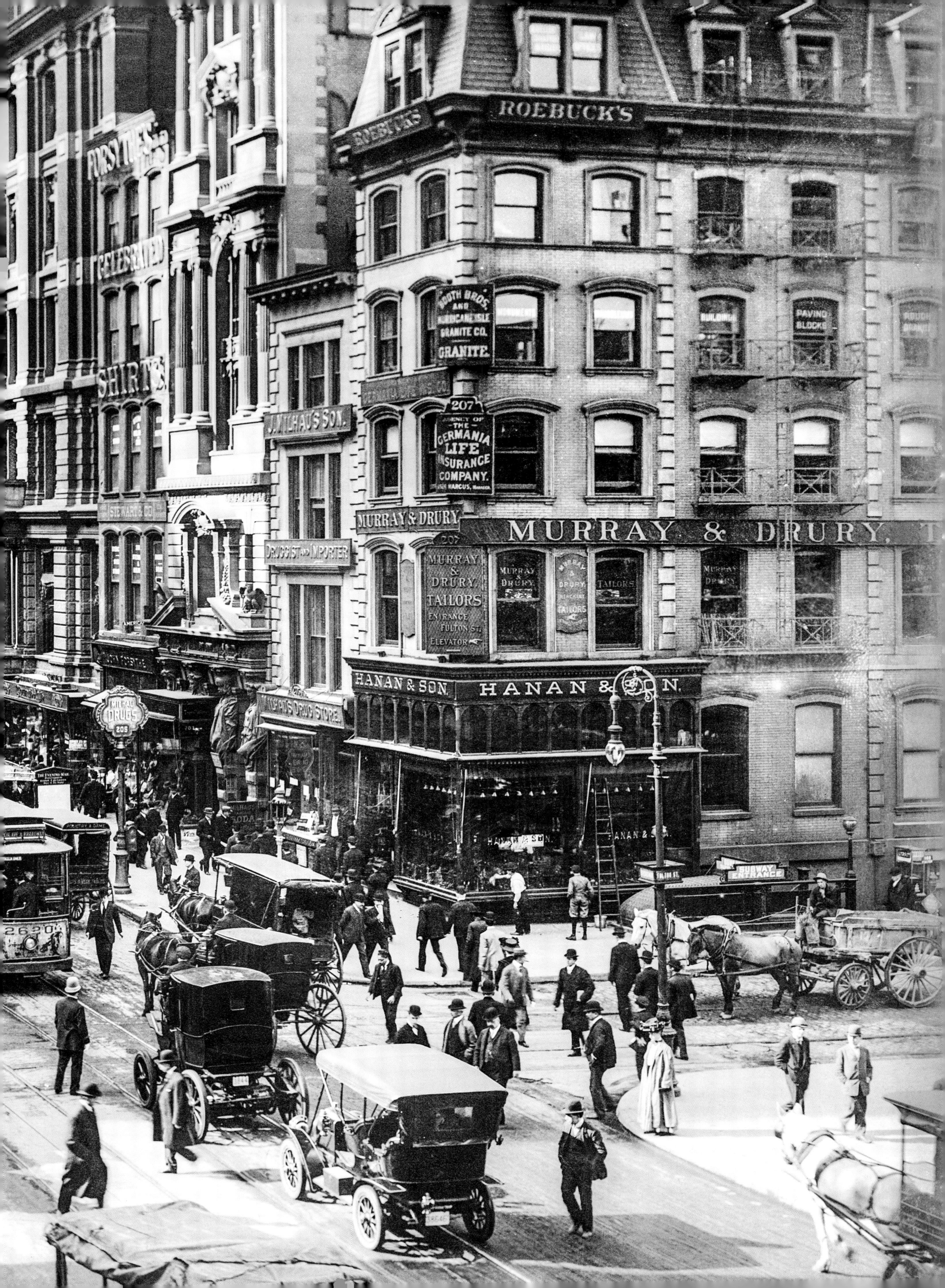

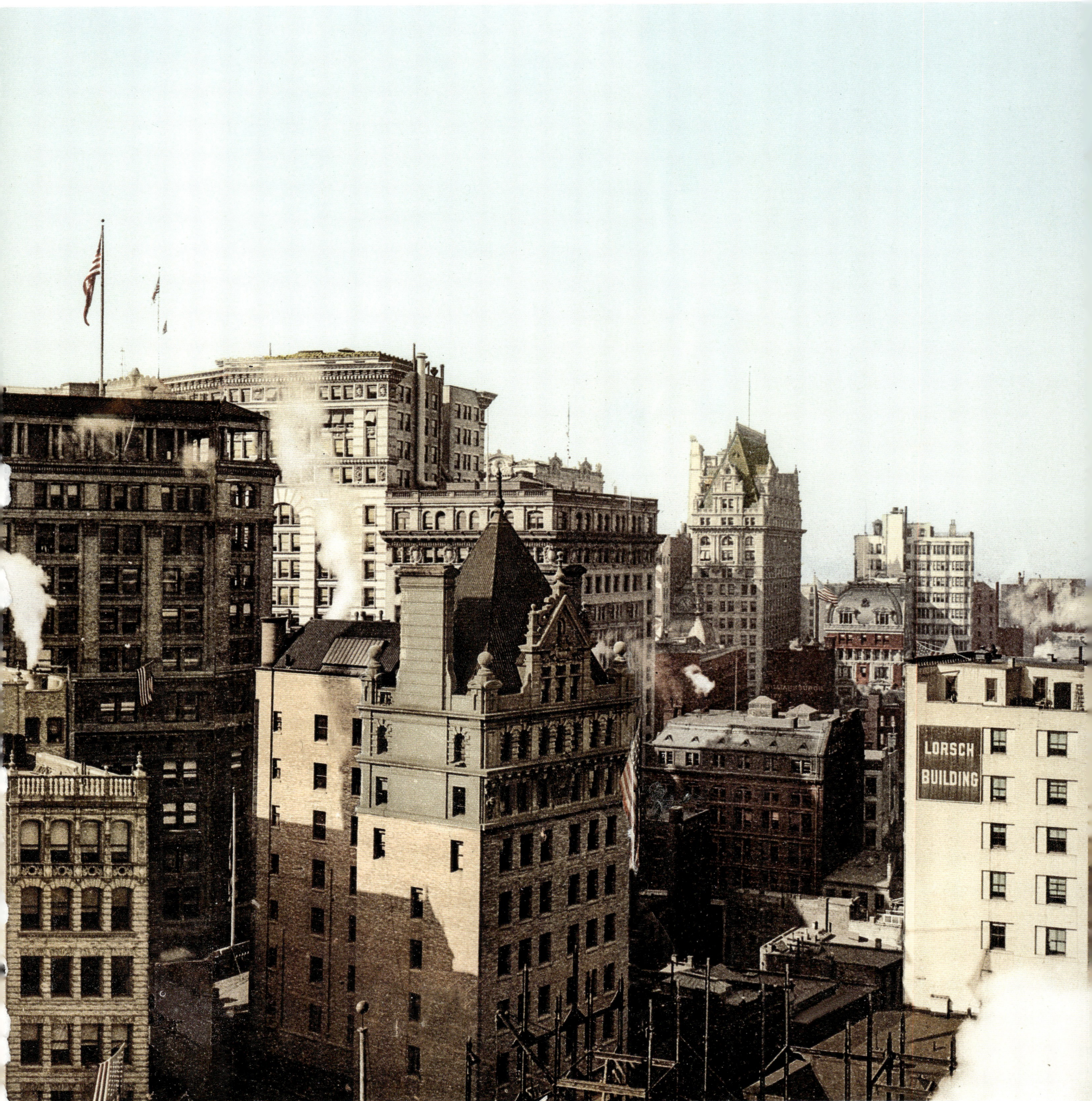

New York City, business district seen from a tall building, photochrom

New York City, das Geschäftsviertel von einem Wolkenkratzer aus betrachtet, Photochrom

New York City, le quartier des affaires vu du haut d'un gratte-ciel, photochrome

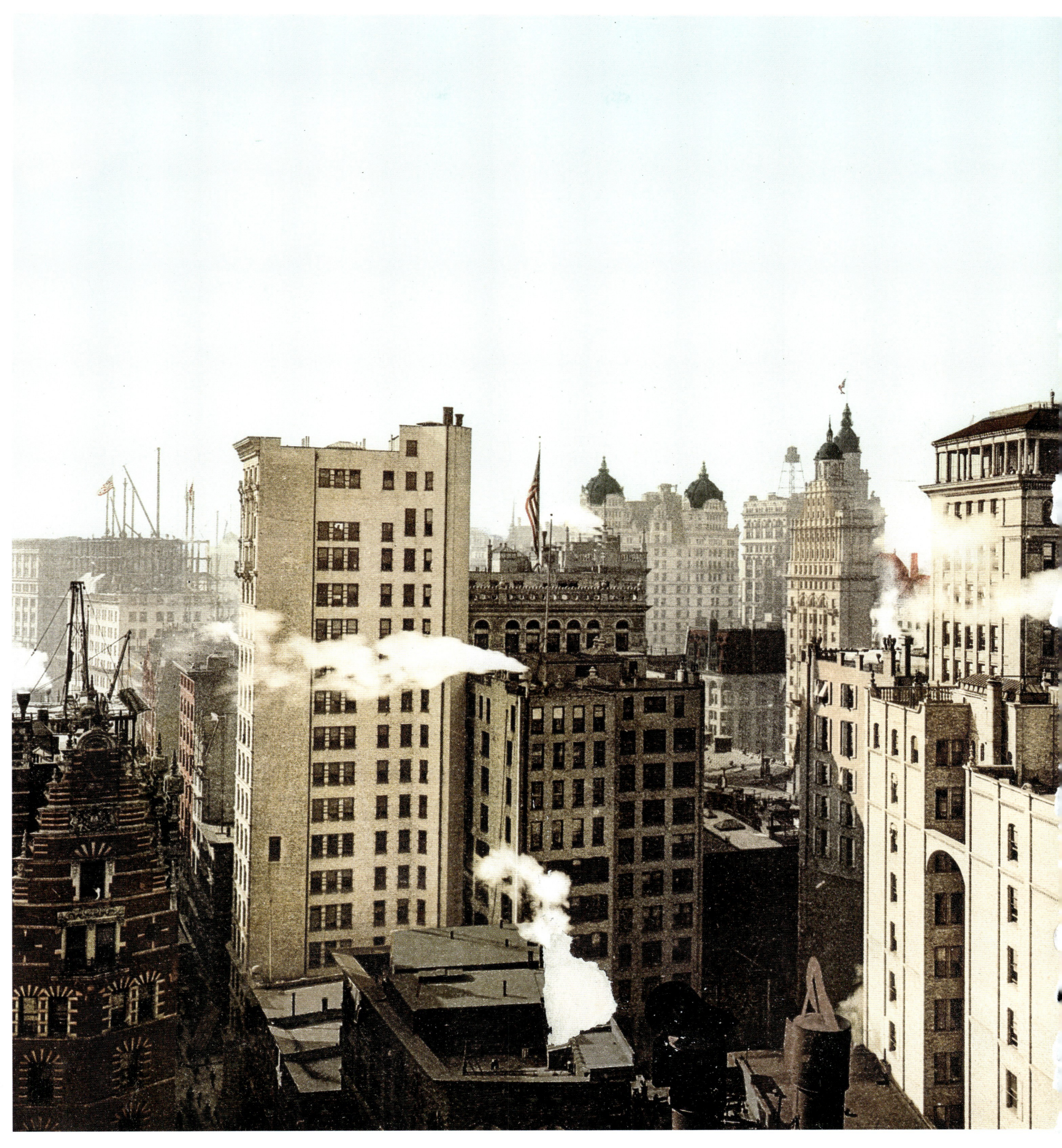

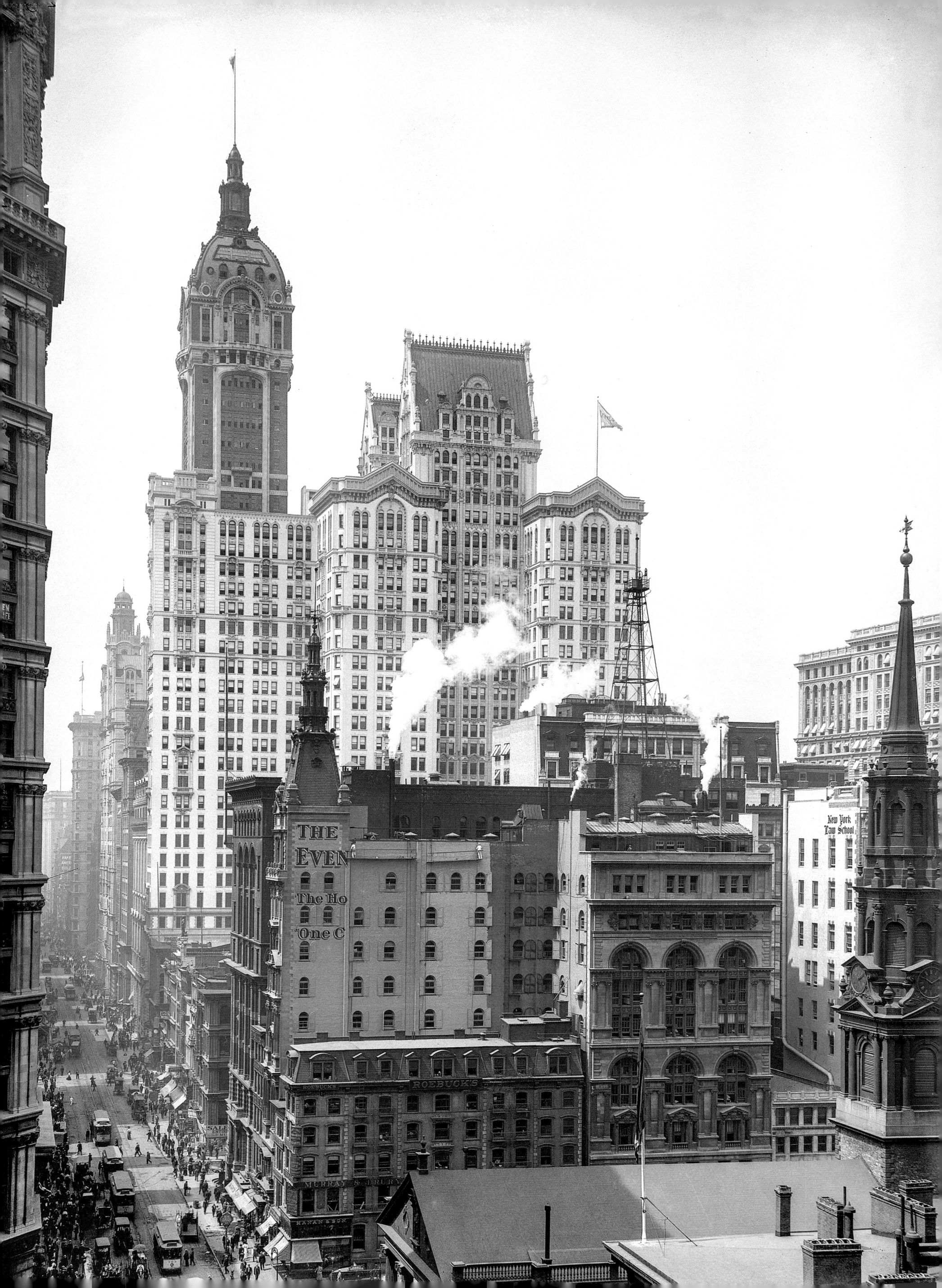

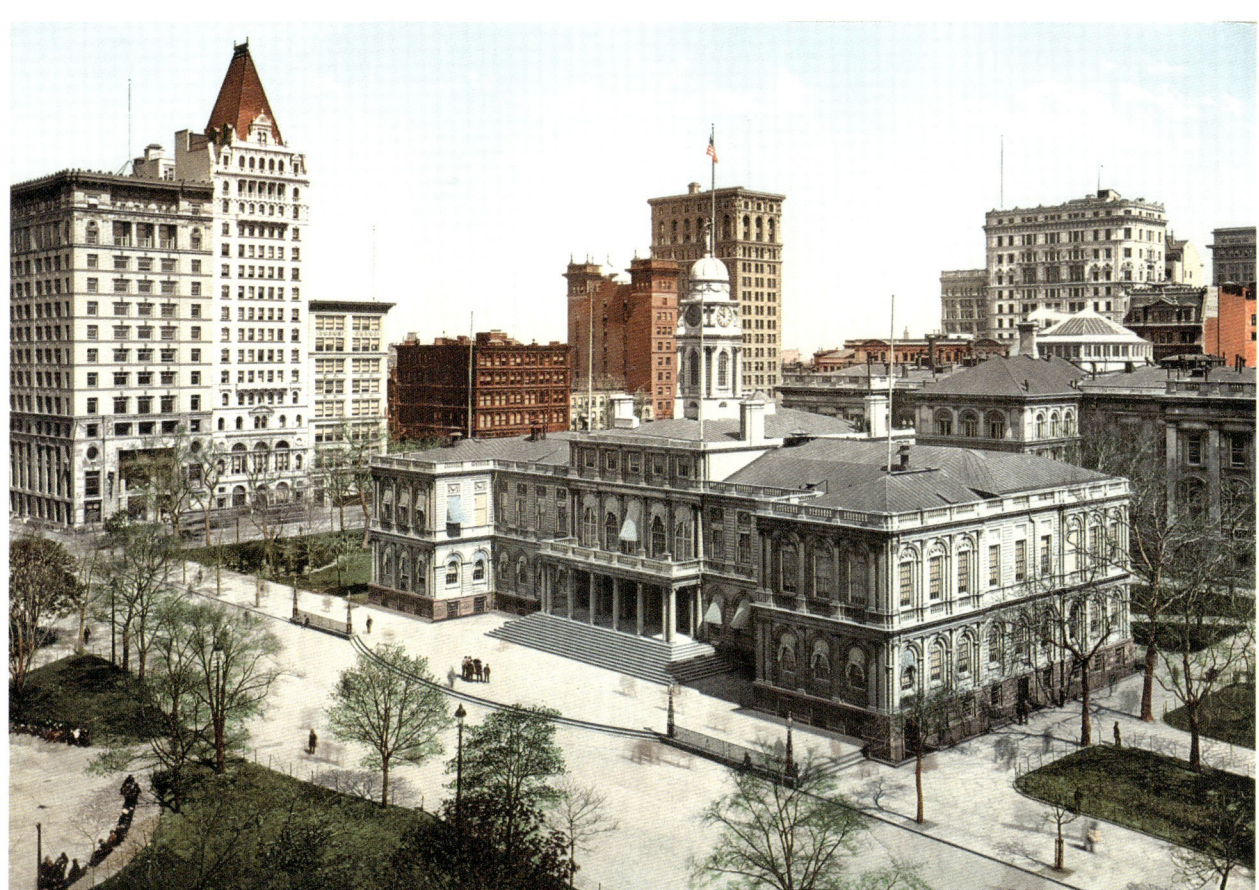

Page 50: **Singer Building (left), City Investing & Hudson Terminal buildings, glass negative, 1909**
Top: **J. P. Morgan & Co.'s offices**
Left: **City Hall, photochrom**
Bottom: **Newspaper Row, photochrom**

Park Row was in its day (1899) the tallest skyscraper in New York and dominated the Financial District at a height of 390 feet (119 m). Bearing in mind that the oldest skyscraper, the Equitable Life Building, erected in 1870, was only 142 feet (43 m) tall (and considered prodigious in *its* time), we can see that the challenges facing engineers of the period were considerable—and understand the astonishment of Europeans facing these monsters of modernity. The skyscrapers just went on growing: the Singer Building (1908) reached 612 feet (187 m), the 1909 Metropolitan Life Tower 700 feet (213 m), and the 1913 Woolworth Building 792 feet (241 m). The latter was not dethroned until 1930, by the Bank of Manhattan Trust Building (927 feet / 283 m) and, in the same year, the Chrysler Building (1,046 feet / 319 m), followed in 1931 by the Empire State Building (1,250 feet / 381 m).

Seite 50: **Singer Building (links), City Investing Building und Hudson Terminal, Glasnegativ, 1909**
Oben: **Die Büros von J. P. Morgan & Co.**
Mitte: **Das Rathaus (City Hall), Photochrom**
Unten: **Die Newspaper Row, Photochrom**

Das Park Row Building, das das Geschäftsviertel beherrscht, war mit 119 Metern zu jener Zeit (1899) der höchste Wolkenkratzer von New York. Wenn man weiß, dass das älteste Hochhaus, das 1870 errichtete Equitable Life Building, nur 43 Meter hoch war (und das war bereits eine große Leistung), dann sieht man, welche Herausforderungen die Ingenieure jener Zeit auf sich nahmen, und man versteht das Erstaunen der Europäer angesichts dieser neuzeitlichen Ungetüme. Und der Wettlauf beschleunigte sich: Das Singer Building (1908) erreichte 187 Meter, der Metropolitan Life Tower (1909) 213 Meter und das Woolworth Building (1913) 241 Meter – das Woolworth-Gebäude wurde erst 1930 vom Manhattan Trust Building (283 Meter), dem Chrysler Building (319 Meter) und 1931 vom Empire State Building (381 Meter) übertroffen.

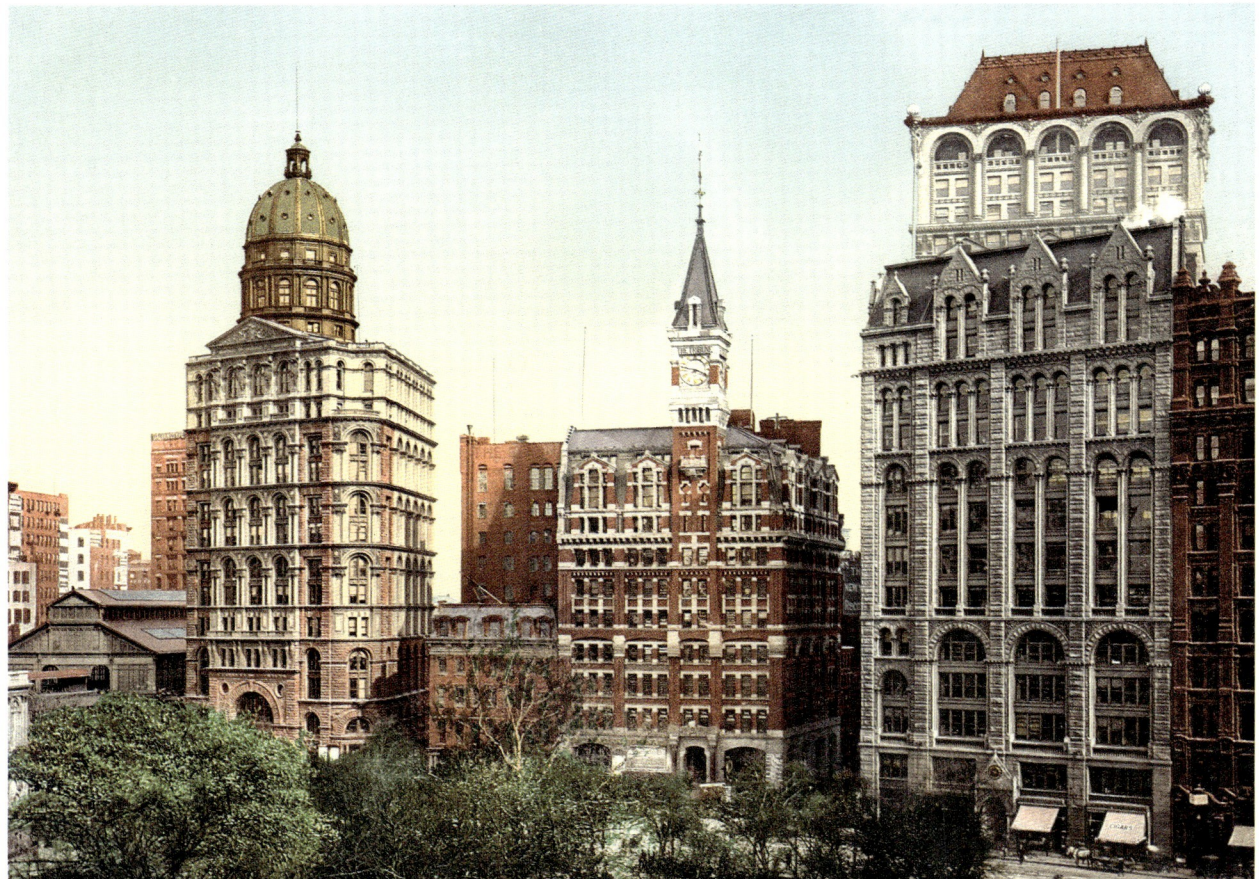

Page 50 : **les immeubles Singer (à gauche) et City Investing & Hudson Terminal, plaque de verre, 1909**
En haut : **les bureaux de J. P. Morgan & Co.**
Ci-contre en haut : **l'hôtel de ville (City Hall), photochrome**
Ci-contre : **Newspaper Row, photochrome**

Dominant le quartier des affaires, l'immeuble de Park Row fut en son temps (1899) le plus haut gratte-ciel de New York : 119 mètres. Si l'on sait que le plus ancien, l'Equitable Life Building, édifié en 1870, ne mesurait que 43 mètres (ce qui était déjà une performance), on réalise quels défis relevèrent les ingénieurs de l'époque et on comprend l'étonnement des Européens face à ces monstres des temps modernes. Et la course continua : le Singer Building (1908) atteignit 187 mètres, le Metropolitan Life Tower (1909) 213 mètres et le Woolworth (1913) 241 mètres – ce dernier ne sera détrôné qu'en 1930 par le Manhattan Trust (283 mètres), le Chrysler (319 mètres) et l'Empire State (381 mètres, 1931).

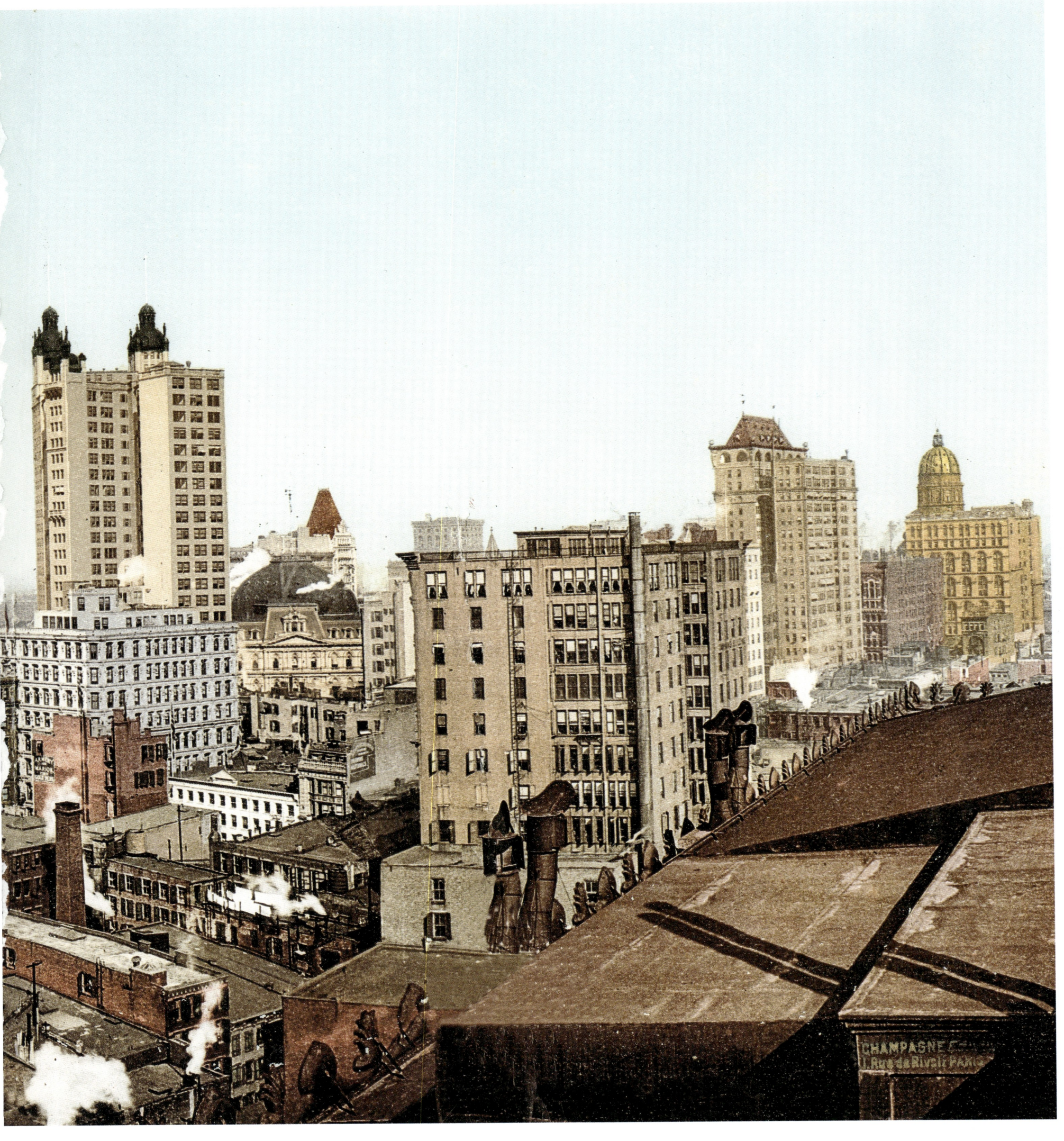

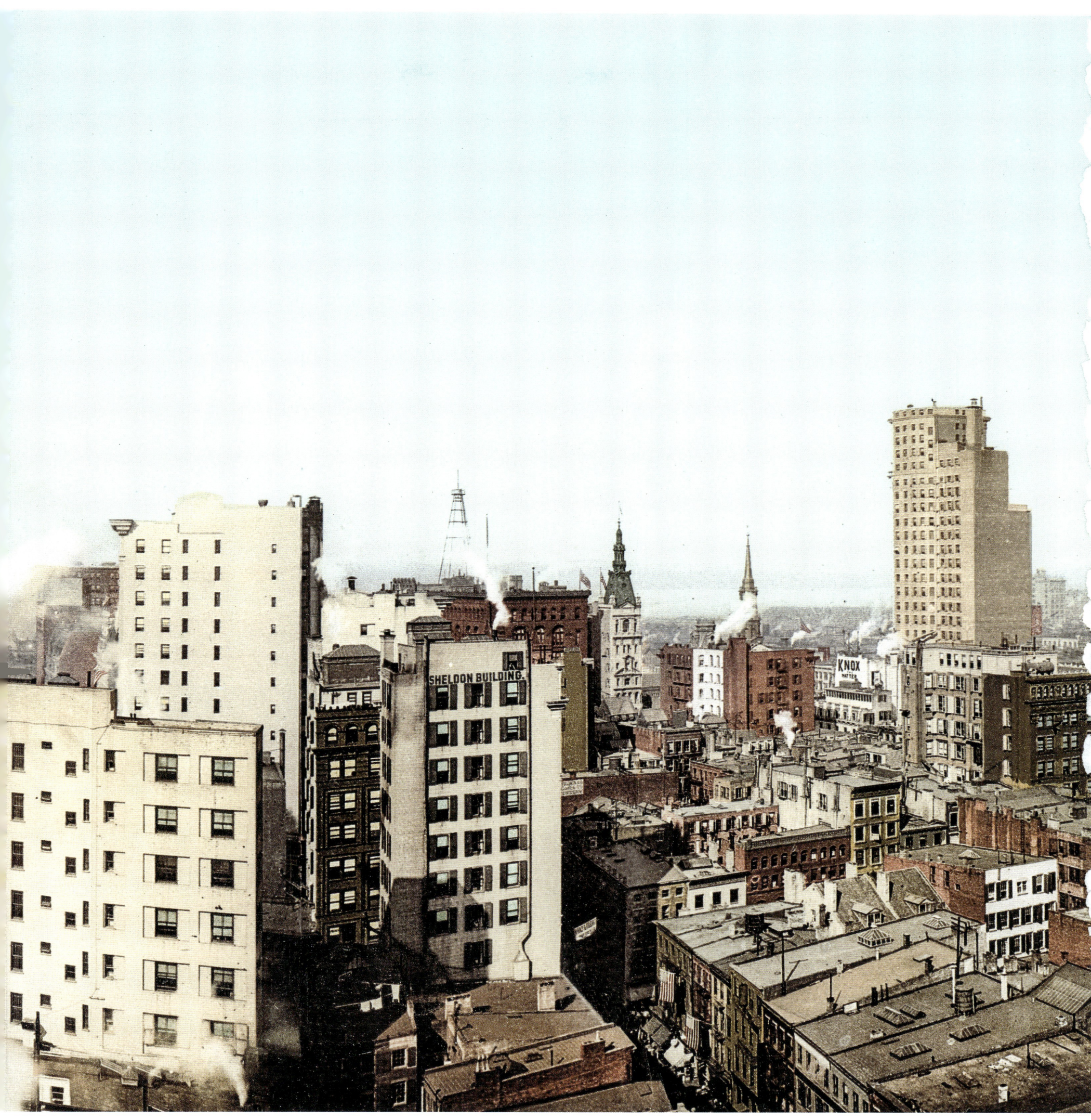

NEW YORK CITY | WALL STREET

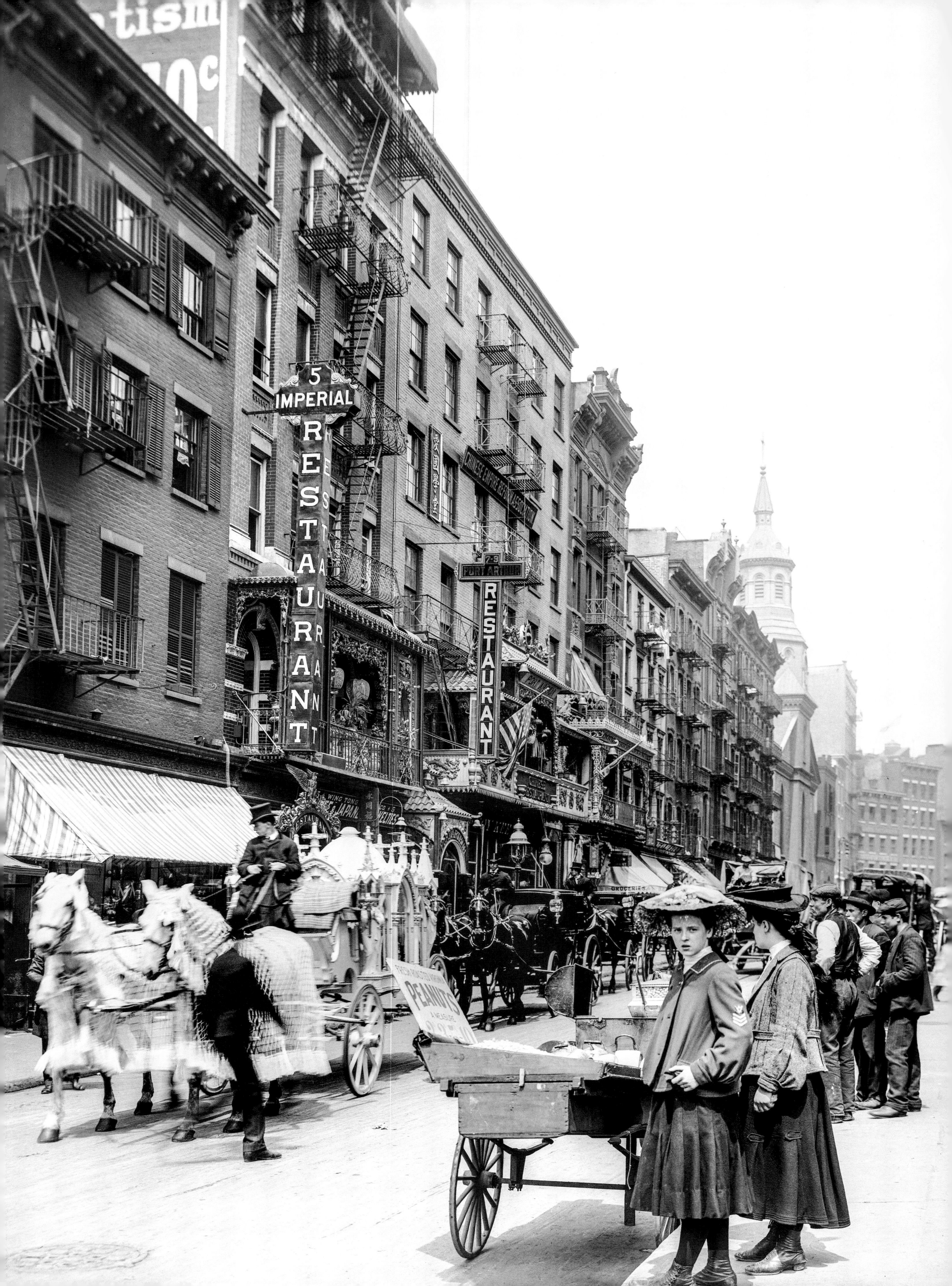

Page 56: **Mott Street, glass negative, 1900–1910**
Right: **Mott Street**
Below: **A Chinese green grocer's**
Bottom: **In Chinatown**

The colors of Mott Street, the main thoroughfare through New York's Chinatown, are red and yellow; that is what Jacob A. Riis said in his 1890 investigation of Lower Manhattan's slum tenements, the first resort of the impoverished immigrant. He found Chinatown less colorful and exuberant than Mulberry Street, where the Italians lived. Life in Chinatown was hidden away behind its facades—perhaps because of Americans' suspicion of the Chinese, he added. Riis blamed the Chinese passion for gambling on the game of "fan-tan," and remarked on the pervasive scent of opium and the almost total absence of women.

Seite 56: **Mott Street, Glasnegativ, 1900–1910**
Rechts: **Mott Street**
Unten: **Ein chinesischer Obst- und Gemüsehändler**
Darunter: **Chinatown**

Rot und Gelb sind die Farben der Mott Street, der wichtigsten Straße des chinesischen Viertels von New York, konstatierte Jacob A. Riis, als er 1890 die Elendsquartiere in den Einwanderungsvierteln von Lower Manhattan erkundete. Seiner Ansicht nach war Chinatown jedoch weniger farbenreich und weniger fröhlich als Mulberry Street, die Straße der Italiener. In Chinatown verberge sich das Leben hinter den Fassaden der Geschäfte, möglicherweise wegen der misstrauischen Haltung der Amerikaner gegenüber den Chinesen, fügte er hinzu. Riis beschrieb die Spielleidenschaft der Chinesen (für das Fan Tan), erwähnte den durchdringenden Geruch von Opium und die fast gänzliche Abwesenheit von Frauen.

Page 56 : **Mott Street, plaque de verre, 1900–1910**
À droite : **Mott Street**
Ci-dessous : **un marchand chinois de fruits et légumes**
En bas : **dans le quartier de Chinatown**

Le rouge et le jaune sont les couleurs de Mott Street, la principale rue du quartier chinois de New York : c'est le constat que fait Jacob A. Riis qui enquête en 1890 sur les taudis des quartiers d'immigration du bas Manhattan. Selon lui, cependant, Chinatown est moins coloré, moins gai que Mulberry Street, la rue des Italiens. La vie à Chinatown se cache derrière les façades des boutiques, peut-être à cause de l'attitude méfiante des Américains vis-à-vis des Chinois, ajoute-t-il. Riis décrit la passion des Chinois pour le jeu (le *fan tan*), évoque l'odeur persistante de l'opium et l'absence quasi totale de femmes.

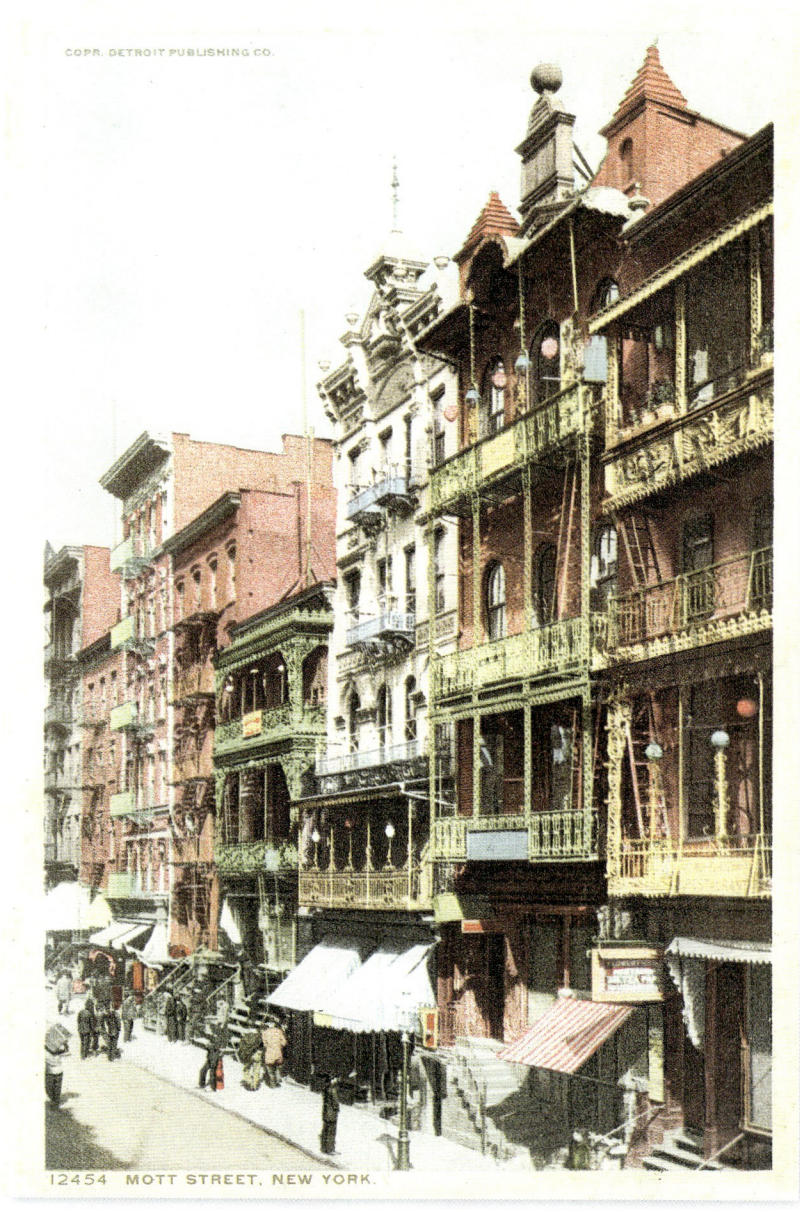

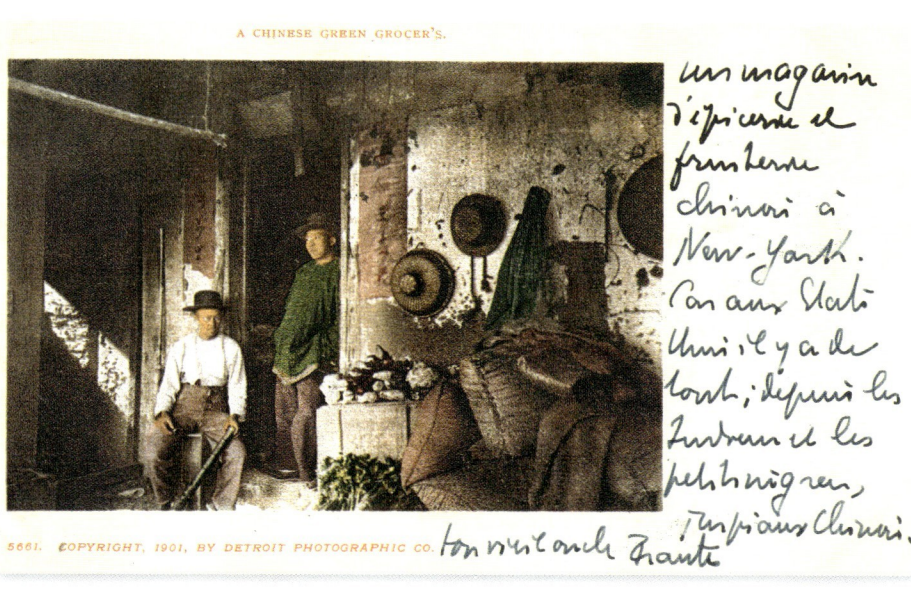

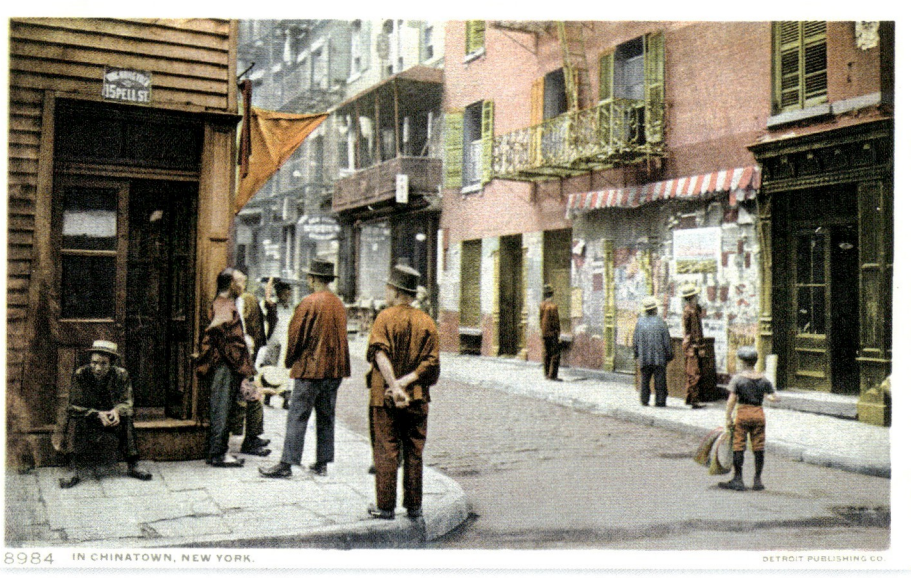

NEW YORK CITY | CHINATOWN

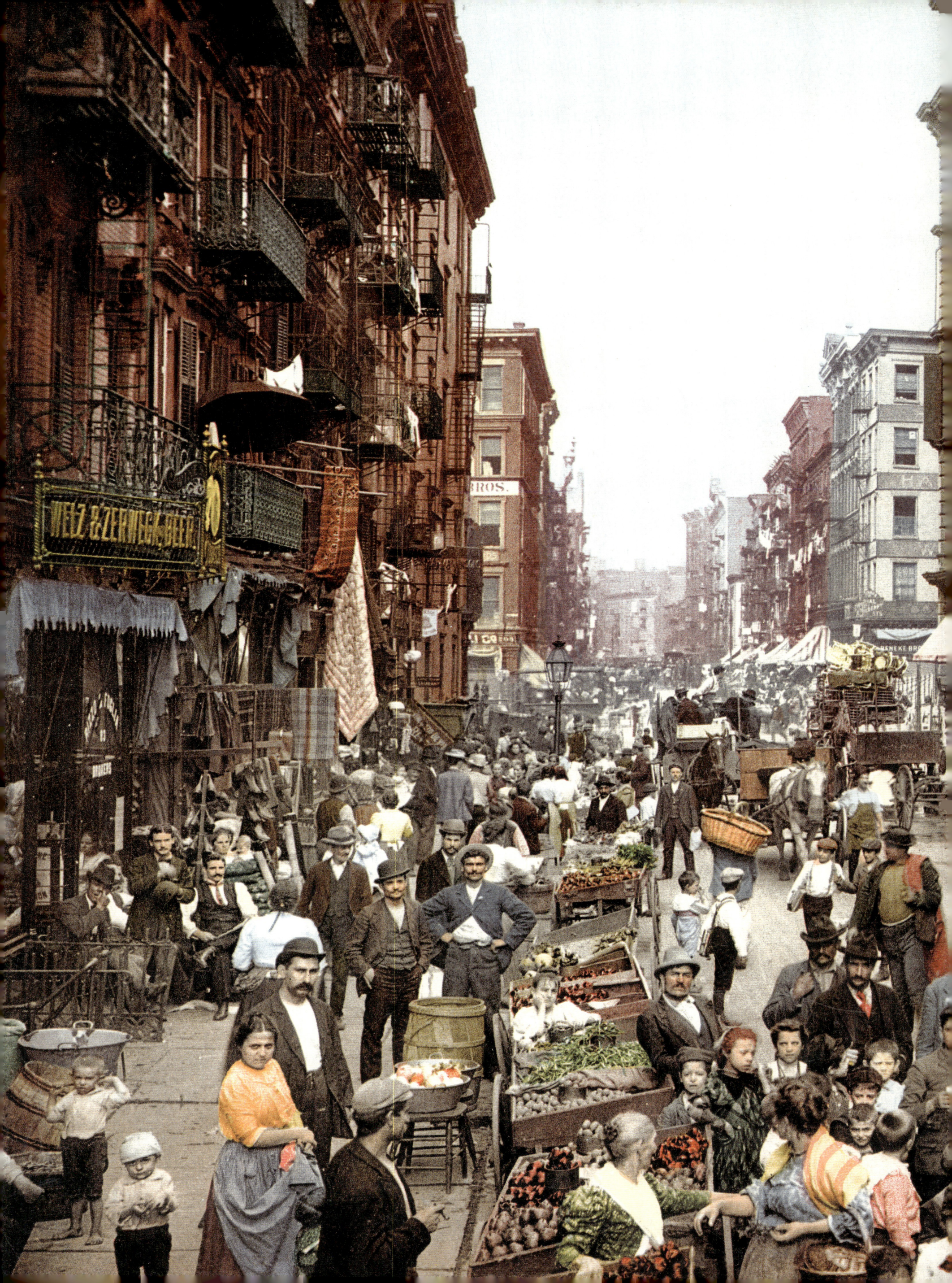

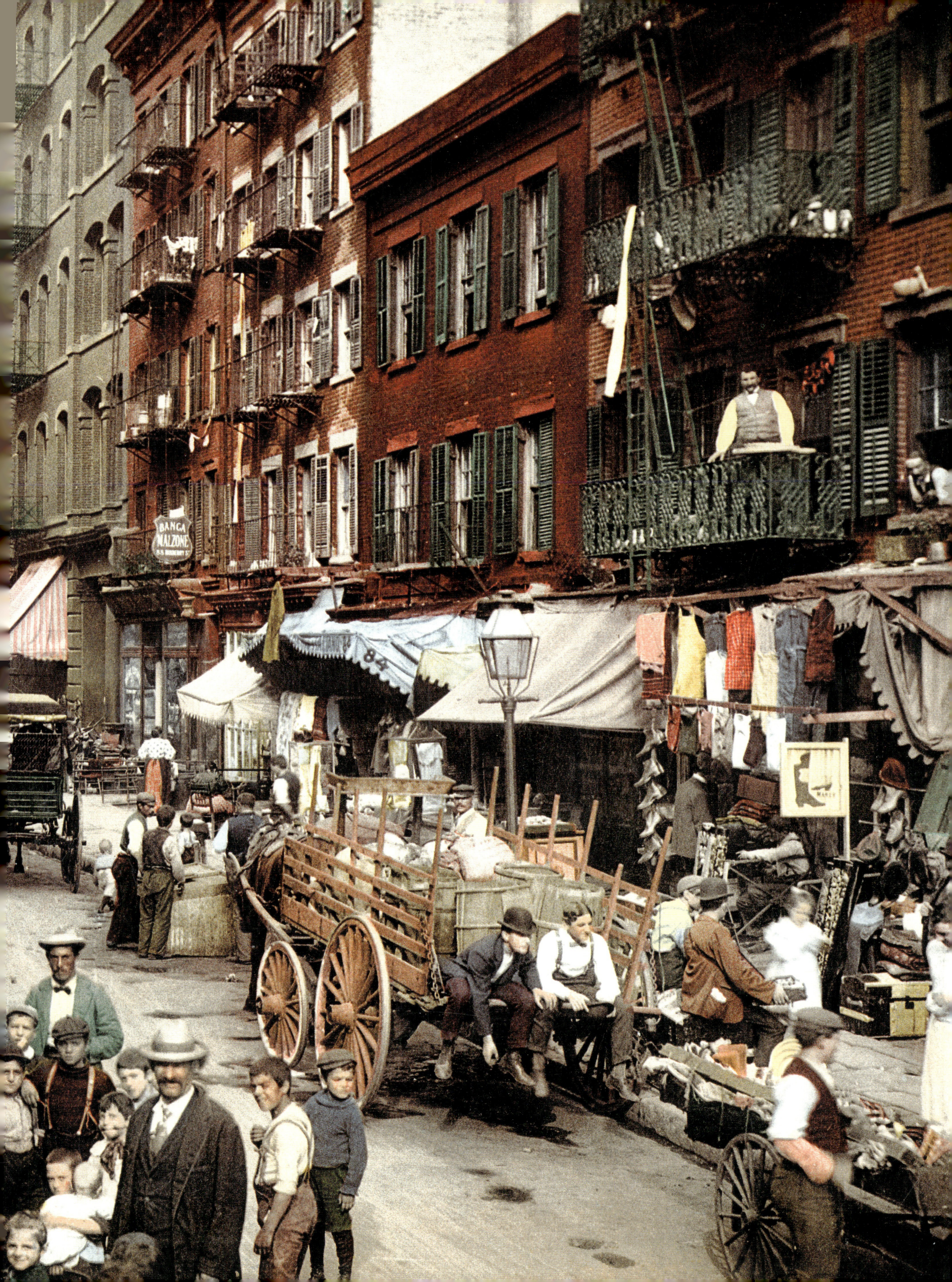

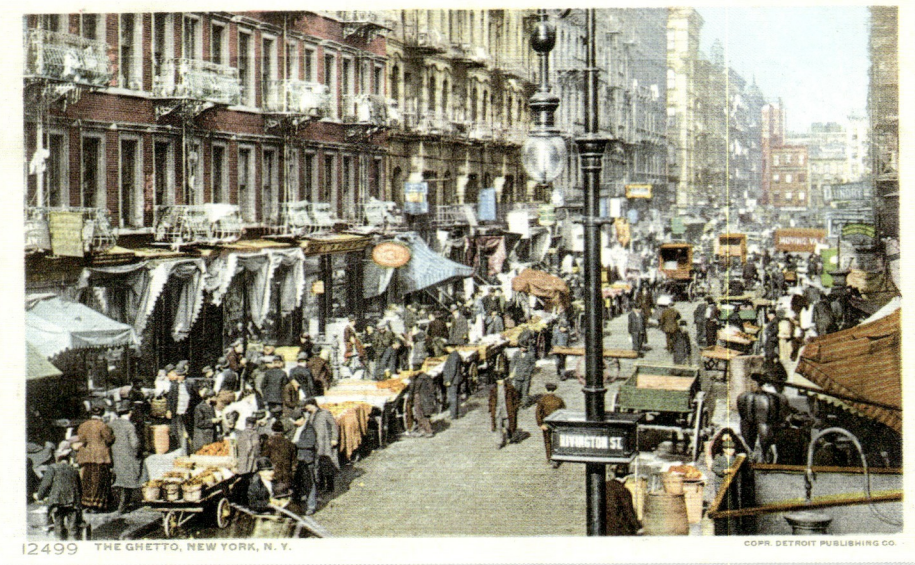

Page 58/59: Mulberry Street, photochrom
Top: The ghetto
Right: Sidewalk haberdashery, photochrom
Bottom: The close of a career in New York, glass negative, ca. 1906
Page 61:
Top left: A telescope man
Top right: Italian bread peddler
Bottom: Italian bread peddler, Mulberry Street, glass negative, ca. 1900

Seite 58/59: Mulberry Street, Photochrom
Oben: Das Ghetto
Rechts: Fliegender Händler, Photochrom
Unten: Das Ende eines Lebenswegs in New York, Glasnegativ, um 1906
Seite 61:
Oben links: Der Mann mit dem Teleskop
Oben rechts: Italienischer Brotverkäufer
Unten: Italienischer Brotverkäufer, Mulberry Street, Glasnegativ, um 1900

Pages 58/59: Mulberry Street, photochrome
Ci-dessus: le Ghetto
À droite: vendeur ambulant, photochrome
Ci-dessous: la fin d'une vie de labeur à New York, plaque de verre, vers 1906
Page 61:
En haut à gauche: l'« homme au téléscope »
En haut à droite: vendeur de pains italiens
En bas: vendeur de pains italiens, Mulberry Street, plaque de verre, vers 1900

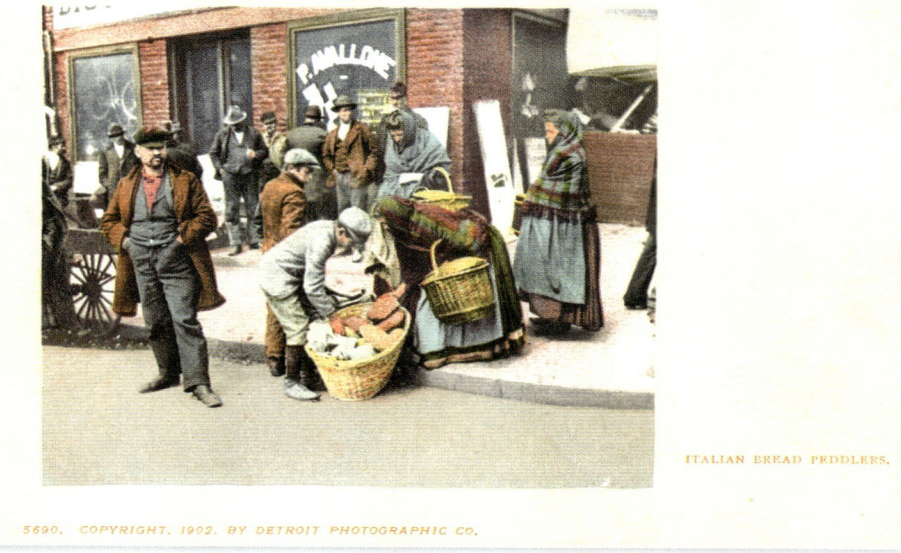

Page 62/63: **A Monday washing**, photochrom
Page 64/65: **The Bowery**, photochrom

Until the beginning of the last century, Little Italy lay north of Canal Street, between Mott, Elizabeth, and Mulberry Streets. Chinatown gradually nibbled away at this Mediterranean enclave and, today, only Mulberry Street remains representative of the Italian community. Jacob A. Riis described the good-natured penury of this slum, whose inhabitants tried to spend as much of the day as they could out of doors; he details the exploitation of the poorest by the padroni and the way in which the new arrivals fell into the hands of the mafiosi.
On the other side of Bowery, on the East Side, Baxter Street was the main artery running through the Jewish quarter. Most of the immigrants in the ghetto arrived from Eastern Europe in the 1850s and afterwards: Russian, Polish, and German Jews fleeing the pogroms and persecution that intensified through the 19th century to reach a peak of horror in the Holocaust.

Seite 62/63: **Die Montagswäsche**, Photochrom
Seite 64/65: **Die Bowery**, Photochrom

Bis Mitte des vergangenen Jahrhunderts erstreckte sich „Little Italy" (Klein-Italien), das Viertel der italienischen Immigranten, nördlich der Canal Street zwischen Mott Street, Elizabeth Street und Mulberry Street. Chinatown höhlte Stück für Stück diese Mittelmeerenklave aus – wobei Mulberry Street bis heute die typischste Straße geblieben ist. Jacob A. Riis beschrieb die immerhin nicht bedrohliche Armut dieses Viertels, dessen Bewohner, soweit es ihnen möglich war, im Freien lebten, und die Ausbeutung der Ärmsten durch die „padrone", die Kontrolle, die einige Mafiosi über die Neuankömmlinge ausübten.
Baxter Street auf der anderen Seite der in der East Side gelegenen Bowery Street war die Hauptstraße des Ghettos, des jüdischen Viertels. Die meisten Immigranten des Ghettos waren Juden, die ab den 1850er-Jahren aus Osteuropa gekommen waren – Russen, Polen oder Deutsche – und vor der Judenverfolgung flohen, die bekanntlich im 20. Jahrhundert mit dem Holocaust ihren schrecklichen Höhepunkt fand.

Pages 62/63 : **la lessive du lundi**, photochrome
Pages 64/65 : **la Bowery**, photochrome

Jusqu'au milieu du siècle dernier, le quartier des immigrants italiens, « Little Italy » (la Petite Italie), s'étendait au nord de Canal Street, entre Mott Street, Elizabeth Street et Mulberry Street. Chinatown grignota petit à petit cette enclave méditerranéenne ; Mulberry Street reste aujourd'hui la rue la plus typique. Jacob A. Riis décrit la misère bon enfant de ce quartier dont les habitants vivaient dehors autant qu'ils le pouvaient, l'exploitation des plus pauvres par les *padroni*, le contrôle exercé par quelques *mafiosi* sur les nouveaux arrivants.
De l'autre côté de la Bowery, dans l'East Side, Baxter Street était la rue principale du Ghetto, le quartier juif. La plupart des immigrants du Ghetto étaient des Juifs arrivés d'Europe de l'Est à partir des années 1850 – des Russes, des Polonais, des Allemands… –, fuyant les persécutions antisémites qui, comme on le sait, allèrent en s'amplifiant jusqu'au milieu du xxe siècle.

NEW YORK CITY | LITTLE ITALY

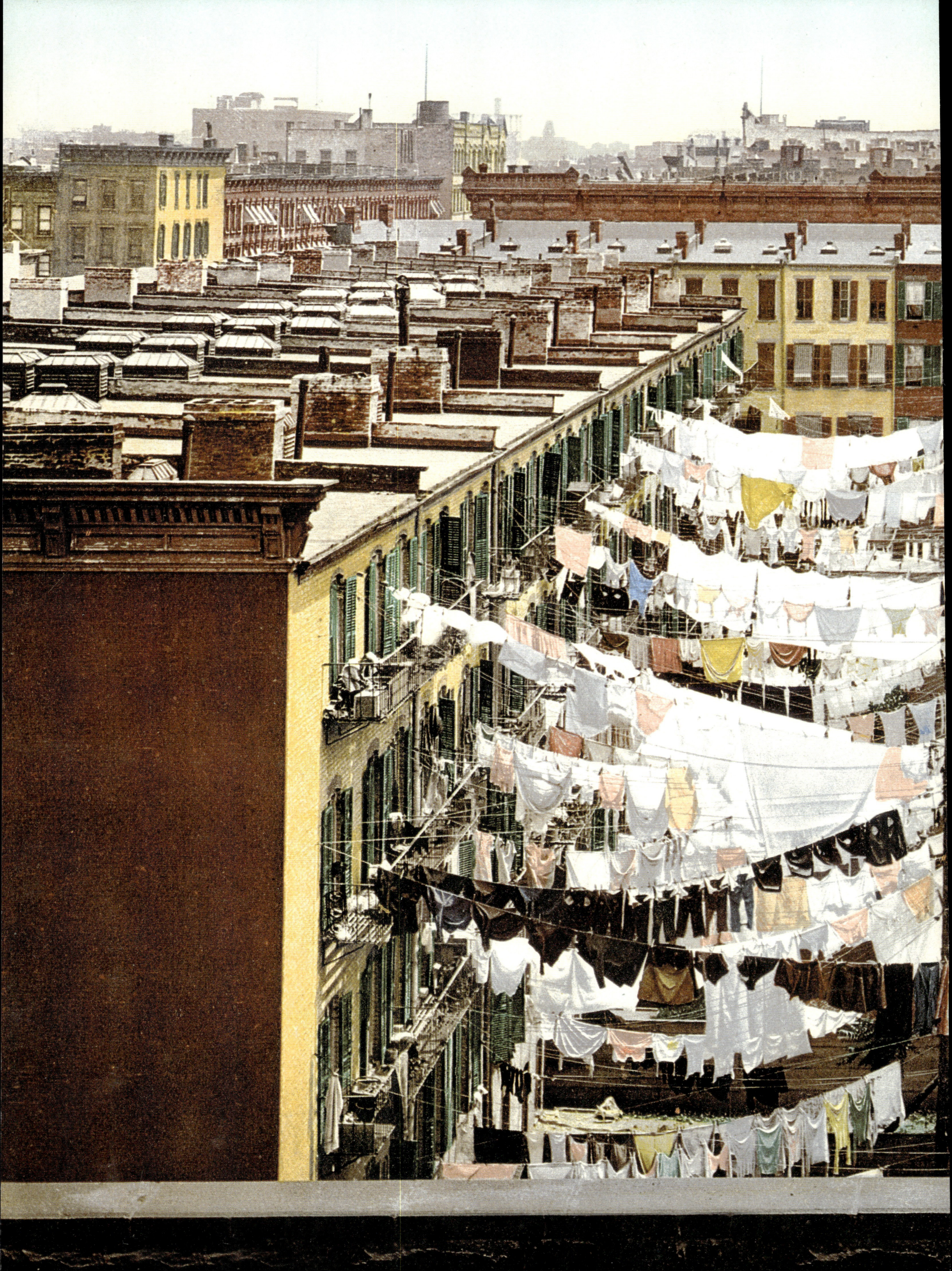

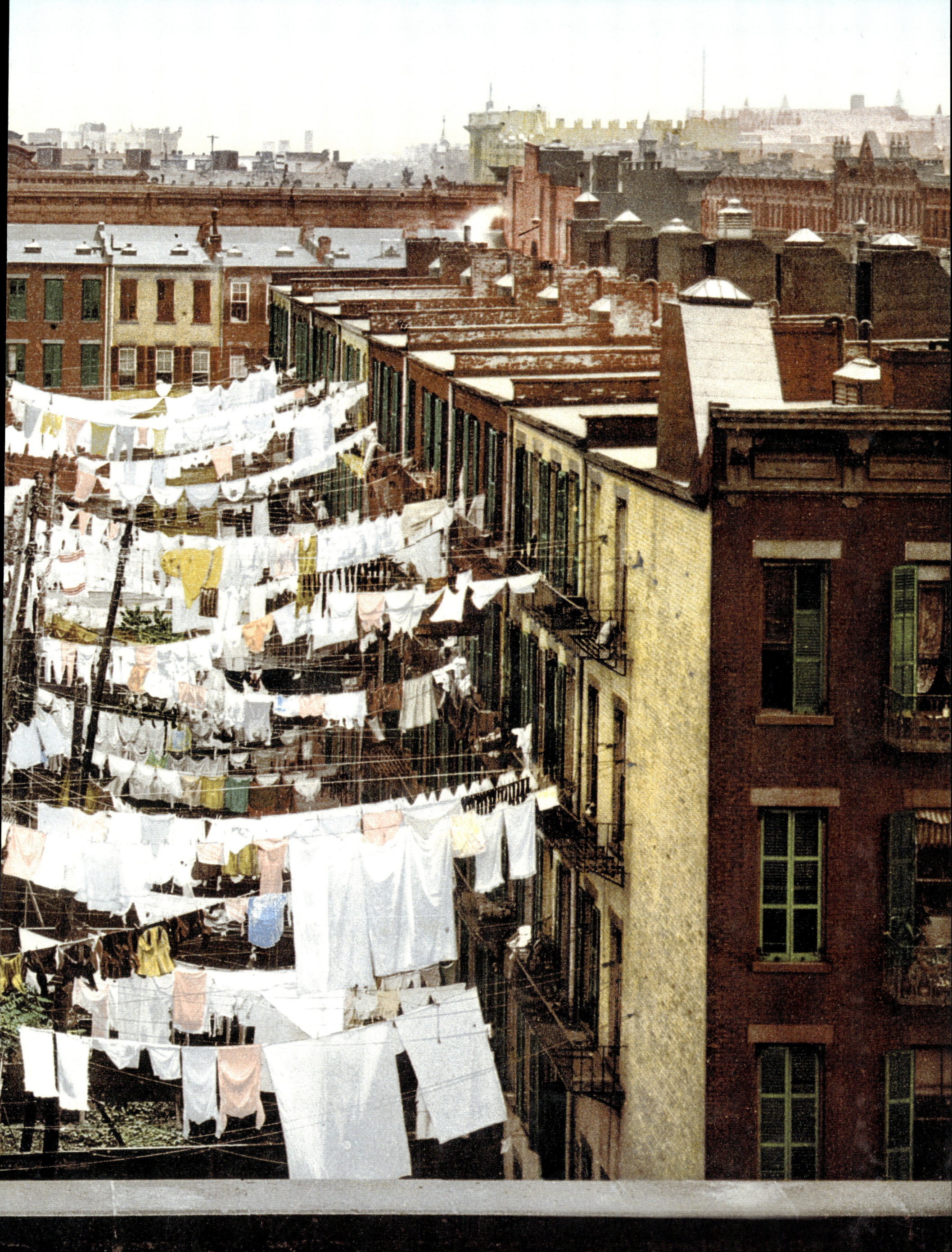

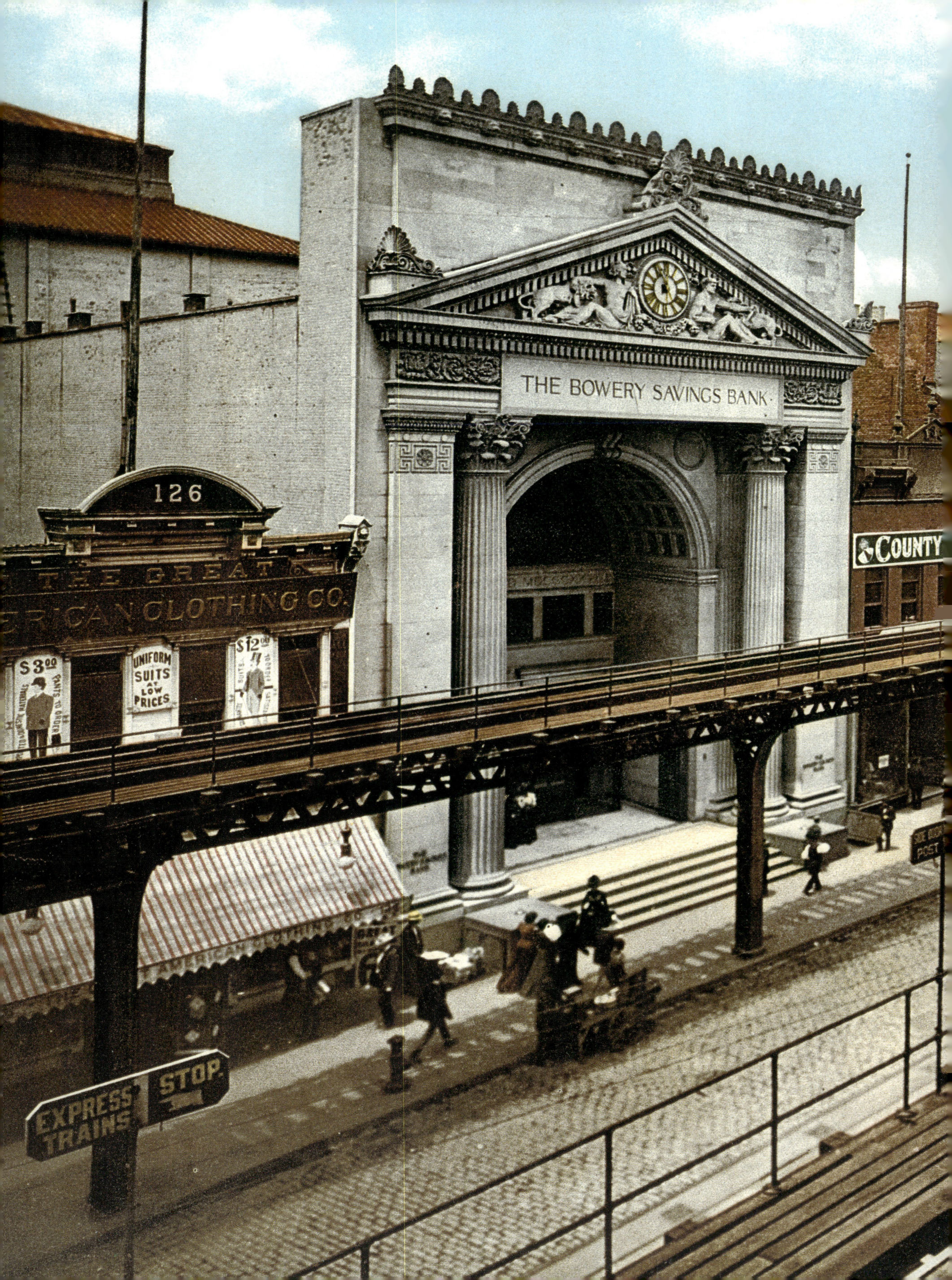

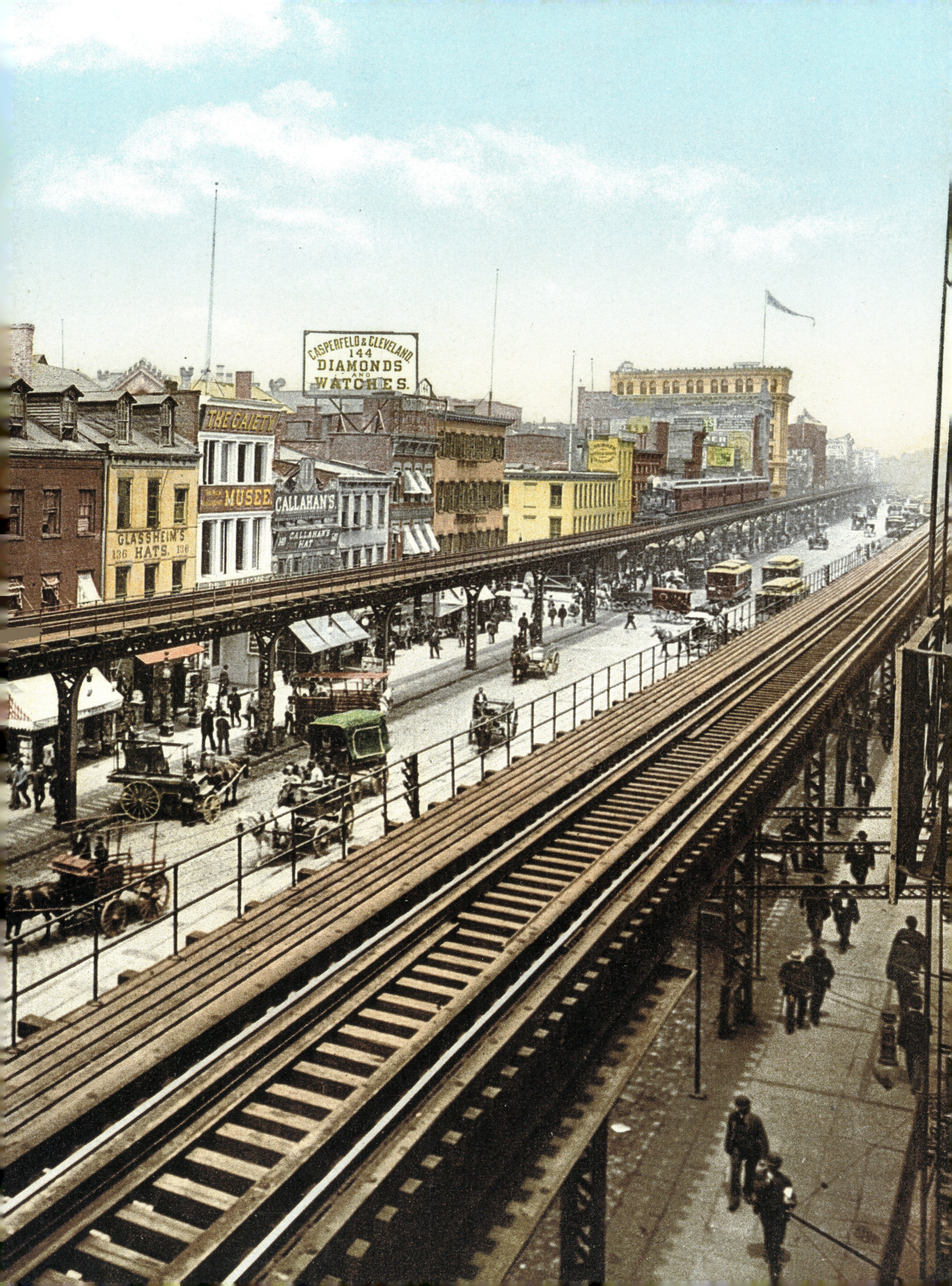

NEW YORK UNDER SNOW / NEW YORK IM SCHNEE / NEIGE À NEW YORK

When the cold air from the Arctic reaches the warm waters of the Carolina coast, the thermic shock creates violent blizzards and spectacular snowstorms. From March 11–14, 1888, the "Great White Hurricane" paralyzed the coast from New Jersey to Maine; the snow that fell on New York blockaded people into their houses for more than a week. People tried to dispose of the snowdrifts by throwing them into the Hudson. When the snow melted, major floods followed, notably in Brooklyn, where more than 200 people died. Blizzards again assailed the city in February 1899 and January 1905. *The New York Times* of January 26, 1905, described the "ghostly appearance" of buildings on Broadway left shapeless by the snow; there were piles of snow 8 feet (2.5 m) tall on Madison Square and the sight of an automobile being towed by two horses. The blizzard is even said to have disrupted the amateur world billiards championship: the ivory balls, reacting to the cold, were said to have lost their elasticity and caused the defeat of the favorite.

Wenn an der Ostküste die kalte Luft der Arktis auf das warme Wasser der Küste Carolinas trifft, löst die plötzliche Erwärmung heftige Blizzards und spektakuläre Schneestürme aus. Vom 11. bis zum 14. März 1888 legte der „Große weiße Hurrikan" die Küste von New Jersey bis nach Maine lahm; durch die Schneefälle in New York steckten die Menschen fast eine Woche zu Hause fest. Man versuchte, die Schneemassen zu beseitigen, indem man sie in den Hudson kippte. Als der Schnee schmolz, kam es insbesondere in Brooklyn zu starken Überschwemmungen. Man zählte dort 200 Todesopfer. Zwei weitere Blizzards entluden sich über der Stadt, der eine im Februar 1899 und der andere im Januar 1905. Die *New York Times* vom 26. Januar 1905 beschreibt den Anblick der Gebäude am Broadway als „gespenstisch", ihre Form sei nicht mehr zu erkennen gewesen, 2,5 Meter hohe Schneehaufen auf dem Madison Square, ein Automobil sei von zwei Pferden abgeschleppt worden, und der Blizzard habe sogar die Amateurmeisterschaften im Billard durcheinandergebracht: Die kälteempfindlichen Elfenbeinkugeln hätten ihre Elastizität verloren und damit die Niederlage des Favoriten in diesem Wettkampf herbeigeführt!

Sur la côte Est, lorsque l'air froid venu de l'Arctique atteint les eaux chaudes des côtes de la Caroline, le choc thermique crée de violents blizzards et des tempêtes de neige spectaculaires. Du 11 au 14 mars 1888, le « Grand Ouragan blanc » paralysa la côte, du New Jersey au Maine ; la neige qui tomba sur New York bloqua les habitants chez eux pendant près d'une semaine. On tenta de se débarrasser des congères en les jetant dans l'Hudson. Lorsque la neige fondit, de graves inondations se produisirent, notamment à Brooklyn où l'on dénombra deux cents morts. Deux autres blizzards s'abattirent sur la ville, en février 1899 et en janvier 1905. Le *New York Times* du 26 janvier 1905 décrit l'« aspect fantomatique » des buildings de Broadway dont on ne distingue plus la forme, les tas de neige de 2,50 mètres de haut sur Madison Square, le remorquage d'une automobile par deux chevaux. Le blizzard aurait même perturbé le championnat de billard amateur : sensibles au froid, les billes d'ivoire auraient perdu leur élasticité, causant la défaite du favori de la compétition !

Below: In a New York blizzard, glass negative, 1899
Page 67:
Top left: A wintry day on Broadway
Top right: Winter blockade in New York
Middle: Curling in Central Park
Bottom: Fifth Avenue after a snow storm, glass negative, 1905

Unten: Blizzard über New York, Glasnegativ, 1899
Seite 67:
Oben links: Ein Wintertag auf dem Broadway
Oben rechts: Eine vom Schnee blockierte Straße in New York
Mitte: Eisstockschießen im Central Park
Unten: Die Fifth Avenue nach einem Schneesturm, Glasnegativ, 1905

Ci-dessous : blizzard sur New York, plaque de verre, 1899
Page 67 :
En haut à gauche : jour d'hiver à Broadway
En haut à droite : rue de New York bloquée par la neige
En dessous : curling à Central Park
En bas : la 5e Avenue après une tempête de neige, plaque de verre, 1905

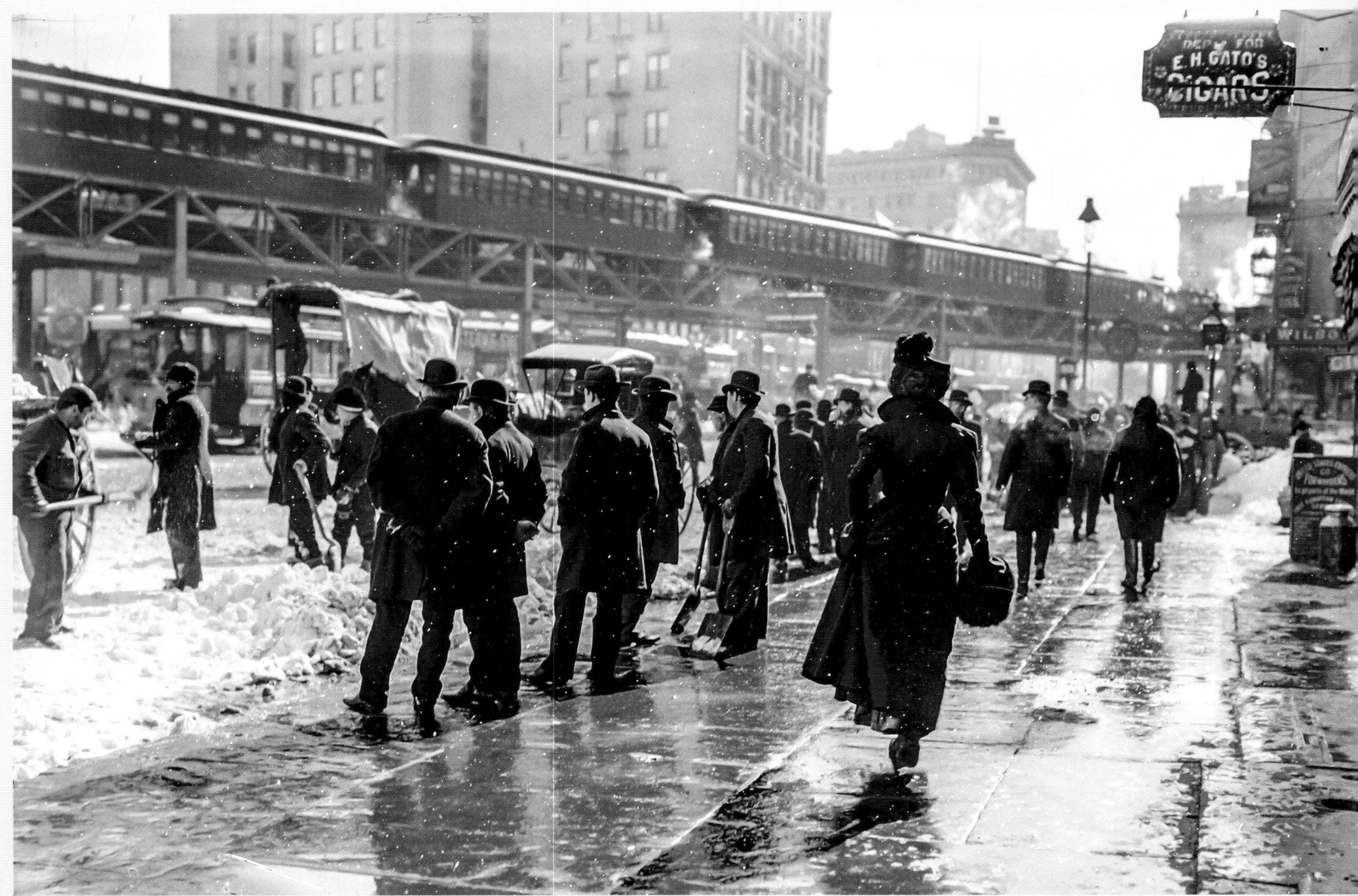

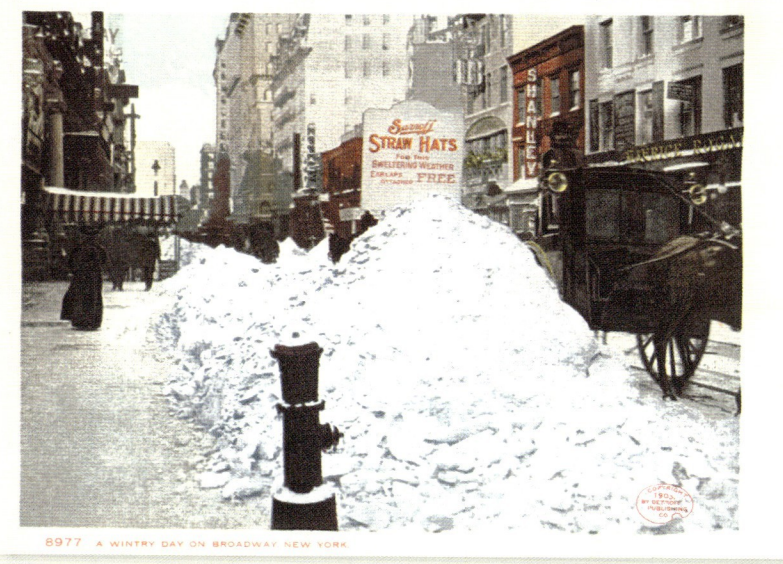

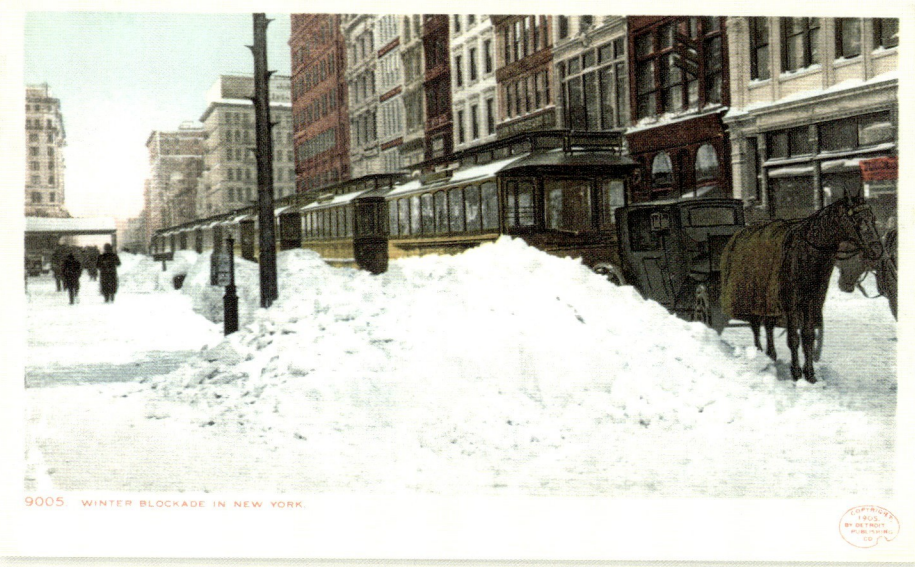

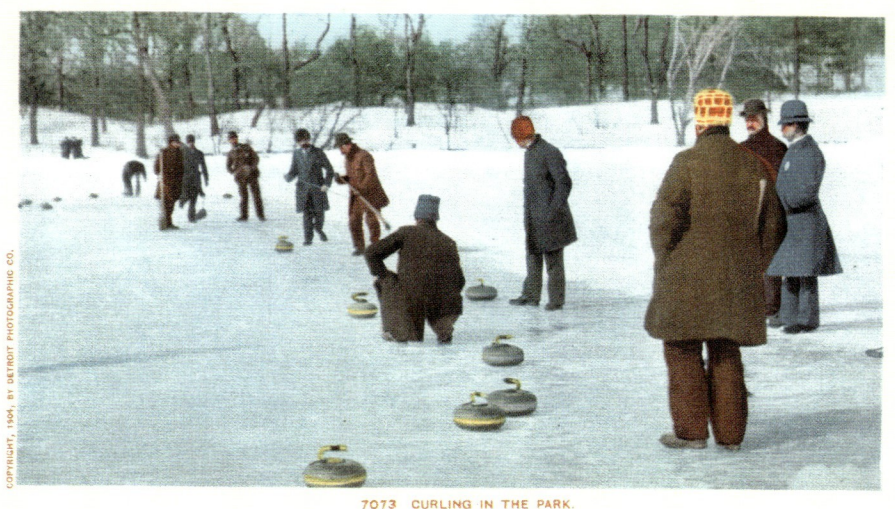

The New York Times of January 26, 1905, described the "ghostly appearance" of buildings on Broadway left shapeless by the snow; there were piles of snow 8 feet (2.5 meters) tall on Madison Square.

Die New York Times vom 26. Januar 1905 beschreibt den Anblick der Gebäude am Broadway als „gespenstisch", ihre Form sei nicht mehr zu erkennen gewesen, 2,5 Meter hohe Schneeberge türmten sich auf dem Madison Square.

Le New York Times du 26 janvier 1905 décrit l'«aspect fantomatique» des buildings de Broadway dont on ne distingue plus la forme, les tas de neige de 2,50 mètres de haut sur Madison Square.

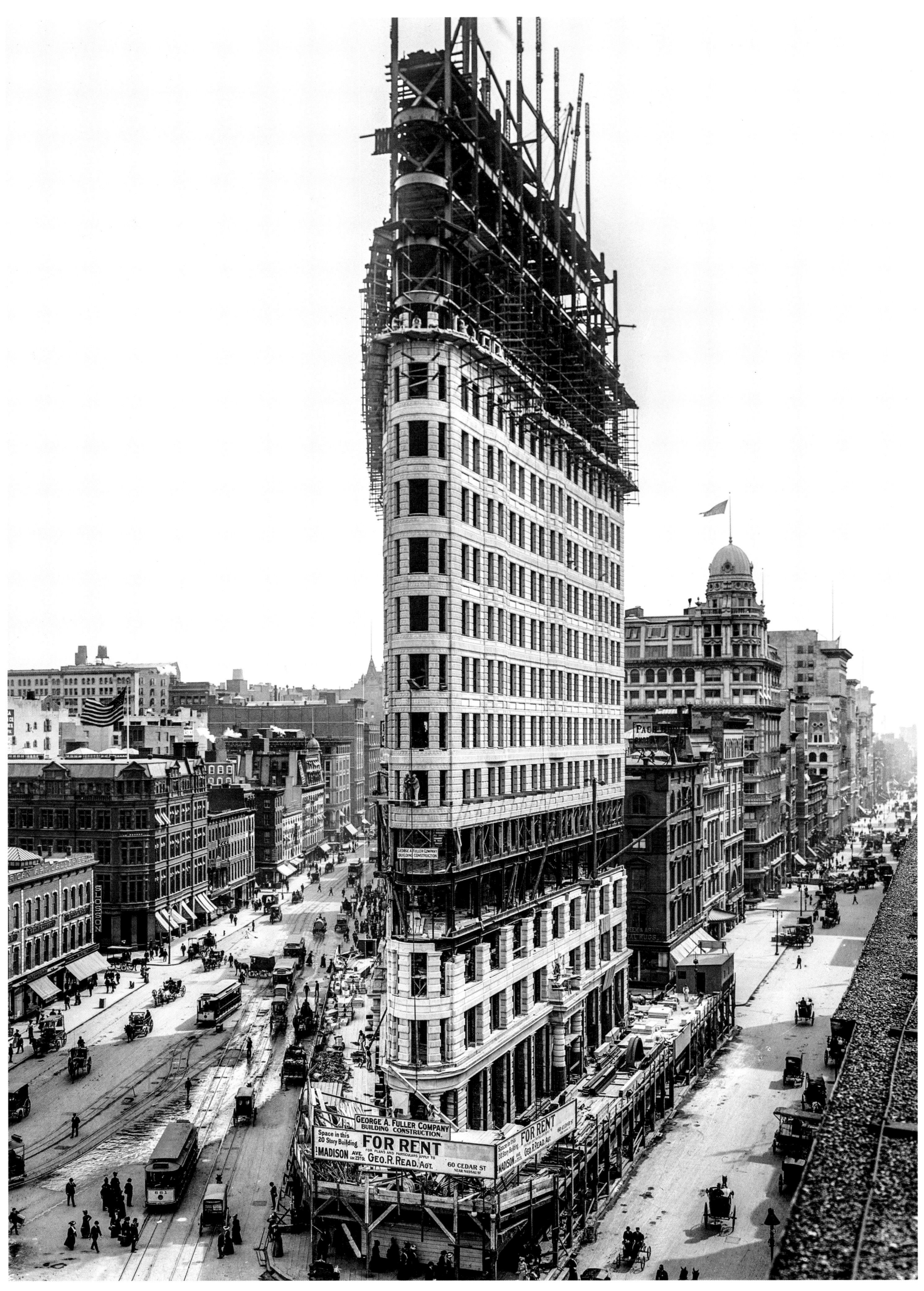

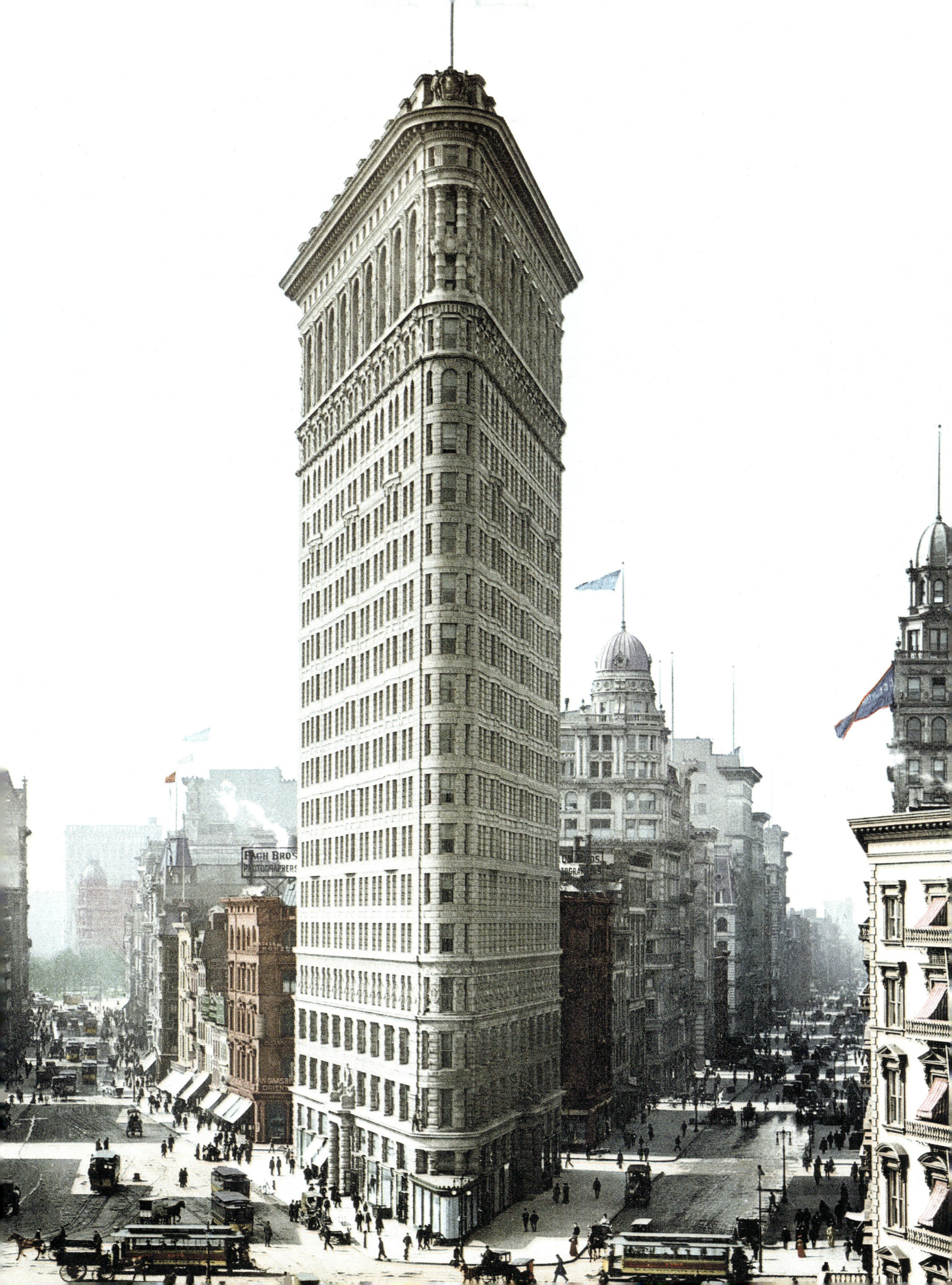

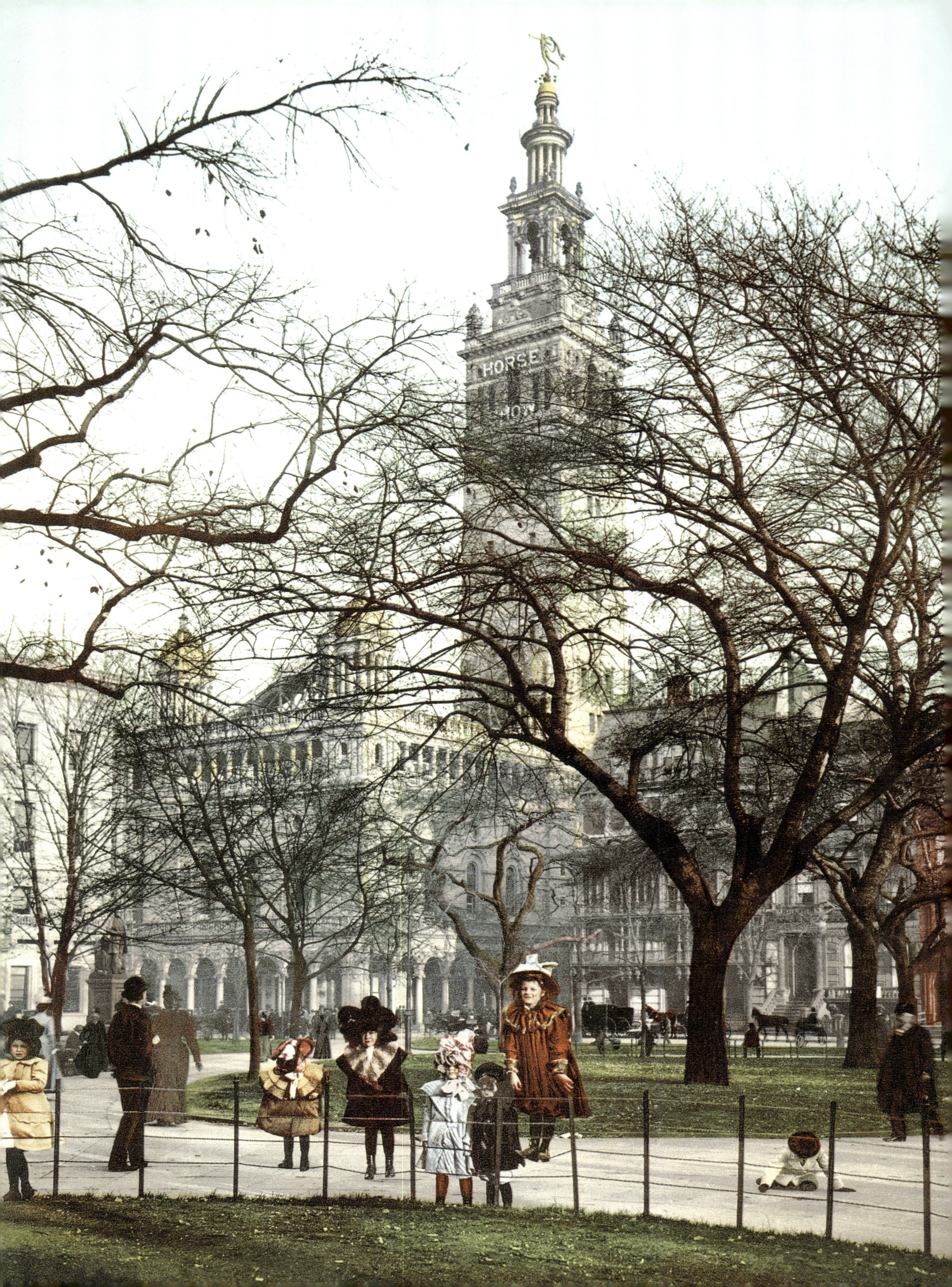

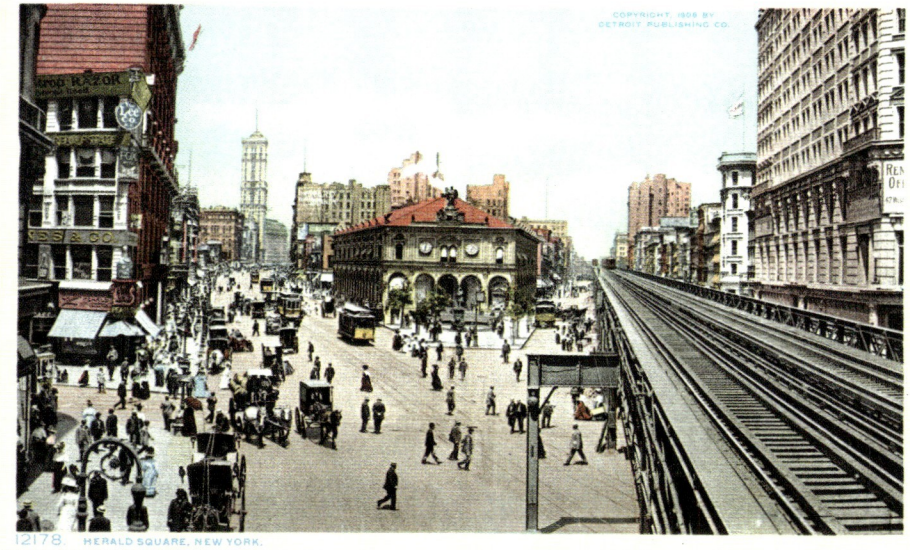
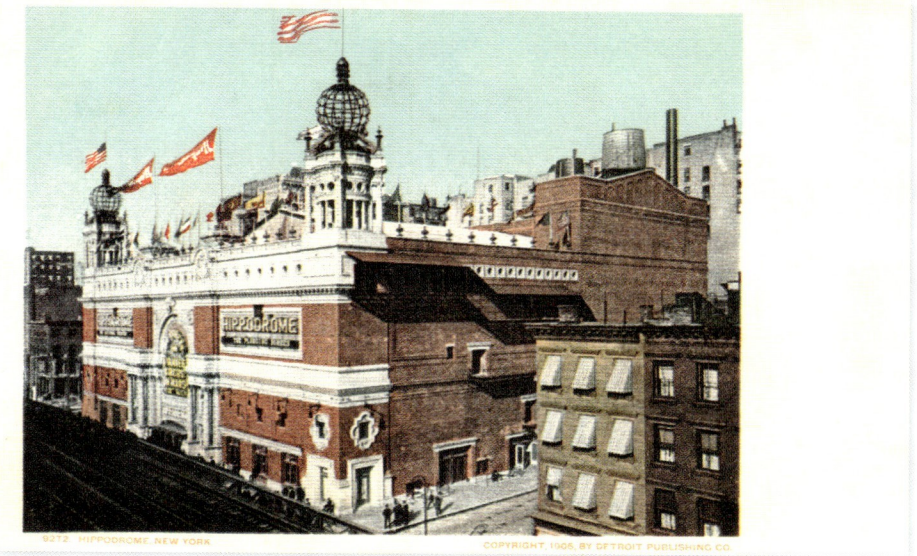

Page 68: **Flatiron Building**, glass negative, 1901–1902
Page 69: **Flatiron Building**, photochrom
Page 70: **Madison Square Garden**, photochrom
Top left: **Herald Square**
Top right: **Hippodrome**
Bottom: **Cab stand at Madison Square**, glass negative, 1900

On the corner of 23rd Street, at the junction of Broadway and Fifth Avenue, the Flatiron Building arose in 1902 to the design of the architect Daniel Burnham; the wind swirls around its 22 floors like water around the bow of a ship. These photographs of the Flatiron Building were taken from Madison Square, one of the first in New York to be lit by electricity; its streetlights were installed in December 1880. The Beaux-Arts-style edifice on the opposite page is "Madison Square Garden II," built by Stanford White in 1890 and demolished in 1925.

Seite 68: **Flatiron Building**, Glasnegativ, 1901–1902
Seite 69: **Flatiron Building**, Photochrom
Seite 70: **Madison Square Garden**, Photochrom
Oben links: **Herald Square**
Oben rechts: **Die Pferderennbahn**
Unten: **Haltestelle für Pferdedroschken am Madison Square**, Glasnegativ, 1900

An der Ecke der 23rd Street, wo sich Broadway und Fifth Avenue kreuzen, ragt seit 1902 das Flatiron (Bügeleisen) Building auf, dieses seltsame flache Gebäude mit abgerundeter Kante des Architekten Daniel Burnham, um dessen 22 Stockwerke unablässig der Wind wirbelt wie das Wasser um einen Schiffsbug. Der Madison Square – von dem aus diese Aufnahmen des Flatiron Building entstanden – war einer der ersten Plätze New Yorks, die mit elektrischem Licht erleuchtet wurden, und zwar seit Dezember 1880. Das Gebäude im Beaux-Arts-Stil ist das „Madison Square Garden II", das 1890 von Stanford White errichtet und 1925 abgerissen wurde.

Page 68 : **Flatiron Building**, plaque de verre, 1901–1902
Page 69 : **Flatiron Building**, photochrome
Page 70 : **Madison Square Garden**, photochrome
En haut à gauche : **Herald Square**
En haut à droite : **l'hippodrome**
Ci-dessous : **station de fiacres à Madison Square**, plaque de verre, 1900

À l'angle de la 23ᵉ Rue, au carrefour de Broadway et de la 5ᵉ Avenue, le Flatiron (le « Fer à repasser »), étrange bâtiment plat à l'arête arrondie dû à l'architecte Daniel Burnham, dresse depuis 1902 ses vingt-deux étages autour desquels le vent tournoie en permanence comme l'eau sur l'étrave d'un navire. Madison Square – d'où furent prises nos vues du Flatiron –, fut l'un des premiers sites new-yorkais éclairés à l'électricité ; c'était en décembre 1880. Le bâtiment de style Beaux-Arts que nous voyons sur l'image de la page de gauche est le « Madison Square Garden II », conçu par Stanford White en 1890 et démoli en 1925.

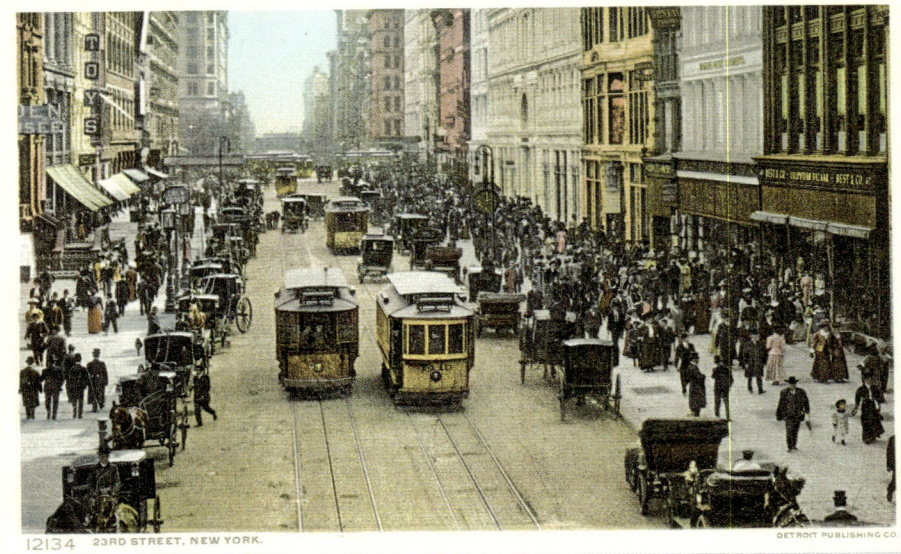
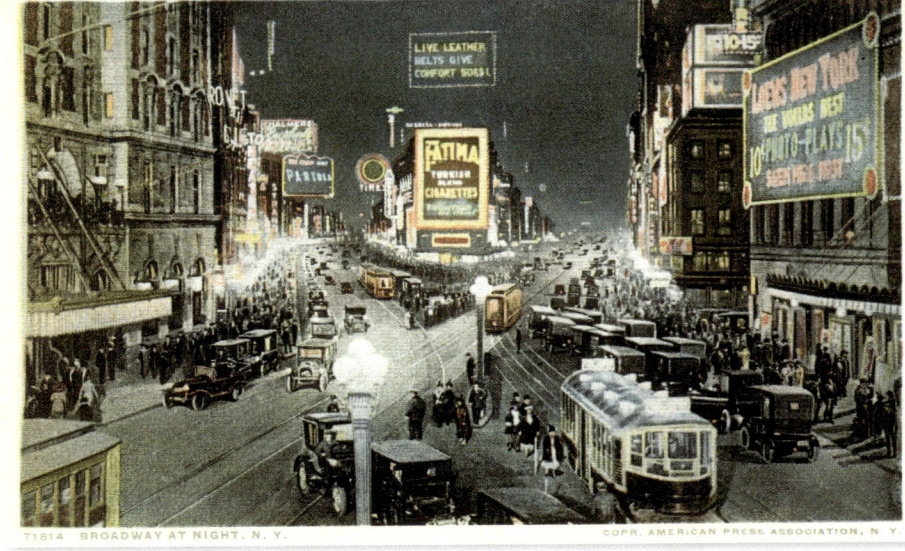

Top left: 23rd Street, Broadway
Top right: Broadway at night
Bottom: Bowling Green and Lower Broadway, photochrom
Page 73:
Top left: Grand Central Station
Top right: Interior of Grand Central Station
Middle: Track level, main exit concourses at Pennsylvania Station
Bottom: Dewey Arch on Madison Square, photochrom

In 1900, Broadway by night was "the Great White Way," Times Square, the Theatre District with its brilliantly illuminated facades; Broadway by day was one of New York's most important arteries, bustling with life and linking Central Park to South Manhattan's Bowling Green, the oldest square in New York and the site of the Washington Building.

Oben links: 23rd Street, Broadway
Oben rechts: Der Broadway bei Nacht
Unten: Bowling Green und Lower Broadway, Photochrom
Seite 73:
Oben links: Der Bahnhof Grand Central Station
Oben rechts: Die Grand Central Station von innen
Mitte: Blick auf die Bahnsteige und Übergänge in der Pennsylvania Station
Unten: Der Dewey Arch am Madison Square, Photochrom

Der Broadway bei Nacht, das war im Jahr 1900 der „Great White Way" (Große Weiße Boulevard), der Times Square, das hell erleuchtete Theaterviertel; der Broadway am Tag, das war von Bowling Green – dem ältesten Platz New Yorks mit dem Washington Building südlich von Manhattan – bis zum Central Park eine fünf Meilen lange Hauptverkehrsader, in der das Leben nur so brummte, die belebteste Straße New Yorks.

En haut à gauche : 23ᵉ Rue, Broadway
En haut à droite : Broadway la nuit
En bas : Bowling Green et le bas Broadway, photochrome
Page 73 :
En haut à gauche : la gare de Grand Central Station
En haut à droite : l'intérieur de Grand Central Station
En dessous : vue surplombante des quais et des passerelles de Pennsylvania Station
En bas : l'arc de triomphe de Madison Square (Dewey Arch), photochrome

Broadway la nuit, en 1900, c'était le « Great White Way » (la grande avenue blanche), Times Square, le quartier des théâtres qui brillait de toutes ses lumières ; Broadway le jour, c'était, sur cinq *miles*, de Bowling Green – la plus ancienne place de New York, avec le Washington Building au sud de Manhattan – jusqu'à Central Park, une grande artère bourdonnante de vie, la plus animée de New York.

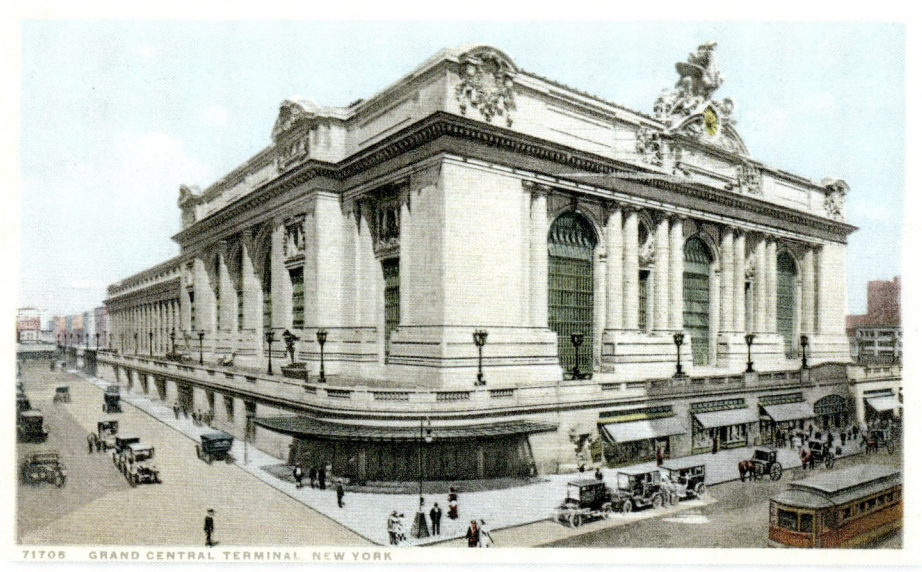
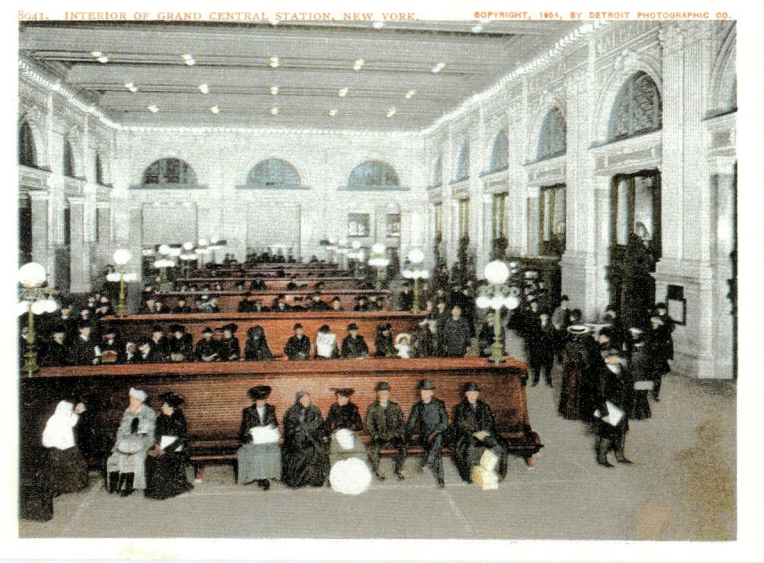
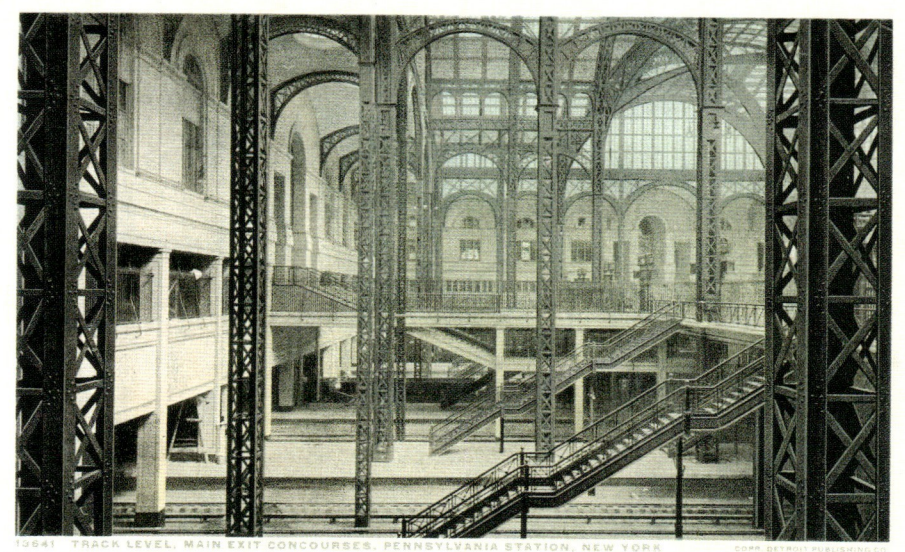

NEW YORK CITY | BROADWAY | MADISON SQUARE

SUBWAY / U-BAHN / MÉTRO

For a variety of reasons political and financial, the first attempt at underground transport in New York, a section of less than 330 feet (100 m) excavated in 1869 beneath Broadway and Lower Manhattan—the Beach Pneumatic Transit—was not followed up. The municipality preferred to invest in the Elevated Railway. But the terrible blizzard of 1888, which paralyzed traffic throughout the city and caused accidents on the "El," encouraged the municipality to make other arrangements. Plans for an underground railway were presented in 1894 and construction began in 1900. The first line, from City Hall to 135th Street, was opened on October 27, 1904. George McClellan, the mayor of New York, drove the first train himself; it left City Hall at 2:35 in the afternoon. On October 28, *The New York Times* reported that 127,381 passengers took the regular trains that followed between 7:00 pm and midnight. With its walls and ceilings lined with polychrome tiles and its amethyst glass skylights, City Hall Station, which has been closed since 1945, is one of the most beautiful in the world.

Aus verschiedenen Gründen, sowohl politischen wie auch finanziellen, fand der erste Versuch, in New York eine U-Bahn zu bauen – der Beach Pneumatic Transit, ein 1869 unter dem Broadway und Lower Manhattan gegrabener, weniger als 100 Meter langer Streckenabschnitt –, keine Fortsetzung. Die Stadtverwaltung investierte lieber in die schnelle Hochbahn Elevated Railway. Doch der schreckliche Blizzard von 1888, der den gesamten Verkehr lahmlegte und Unfälle bei der Hochbahn verursachte, veranlasste die Abgeordneten dazu, andere Vorkehrungen zu treffen. 1894 wurde ein U-Bahn-Projekt präsentiert, mit dessen Bau man 1900 begann. Die erste Linie – von City Hall bis zur 135th Street – wurde am 27. Oktober 1904 eingeweiht. Der Bürgermeister von New York, George McClellan, fuhr höchstpersönlich den ersten Zug, der City Hall um 14.35 Uhr verließ. 127 381 Fahrgäste benutzten die folgenden Züge zwischen 19 und 24 Uhr, berichtete die New York Times am 28. Oktober. Die mit polychromer Keramik gefliesten Wände und Gewölbe und die amethystfarbenen facettierten Dachfenster, die die Bahnsteige erhellen, machen die seit 1945 geschlossene Station City Hall zu einer der schönsten der Welt.

Pour diverses raisons, politiques autant que financières, le premier essai de transport souterrain à New York – le Beach Pneumatic Transit, un tronçon de moins de 100 mètres creusé en 1869 sous Broadway et Lower Manhattan – resta sans suite. La municipalité préféra investir dans l'Elevated Railway, le « chemin de fer rapide surélevé ». Mais le terrible blizzard de 1888, qui paralysa l'ensemble du trafic et causa des accidents sur l'Elevated, incita les élus à prendre d'autres dispositions. Un projet de métro fut présenté en 1894 dont la construction commença en 1900. La première ligne, de City Hall à la 135e Rue, fut inaugurée le 27 octobre 1904. Le maire de New York en personne, George McClellan, conduisait le premier train qui quitta City Hall à 14 h 35. Le *New York Times* du 28 octobre rapporte que 127 381 passagers empruntèrent les trains suivants, entre 19 h et minuit. Avec ses voûtes et ses murs carrelés de céramiques polychromes et ses verrières taillées en améthyste éclairant les quais, la station de City Hall, fermée depuis 1945, est l'une des plus belles du monde.

Below: **Ticket office, City Hall station, glass negative, 1904**
Page 75:
Top left: **Subway entrance and exit kiosks**
Middle left: **Electric locomotive in Pennsylvania subway station**
Middle right: **Express trains in the subway station at Spring Street**
Bottom: **City Hall subway station, glass negative, 1904**

Unten: **Fahrkartenschalter an der Haltestelle City Hall, Glasnegativ, 1904**
Seite 75:
Oben links: **U-Bahn-Eingang und -Ausgang mit Kiosk**
Mitte links: **Elektrolokomotive im U-Bahnhof Pennsylvania**
Mitte rechts: **Eilzüge in der U-Bahn-Station Spring Street**
Unten: **U-Bahnhof City Hall, Glasnegativ, 1904**

Ci-dessous : **guichet à la station City Hall, plaque de verre, 1904**
Page 75 :
En haut : **entrée et kiosques de sortie de métro**
En dessous à gauche : **locomotive électrique à la station de métro de Pennsylvania**
En dessous à droite : **trains express à la station Spring Street**
En bas : **la station de métro City Hall, plaque de verre, 1904**

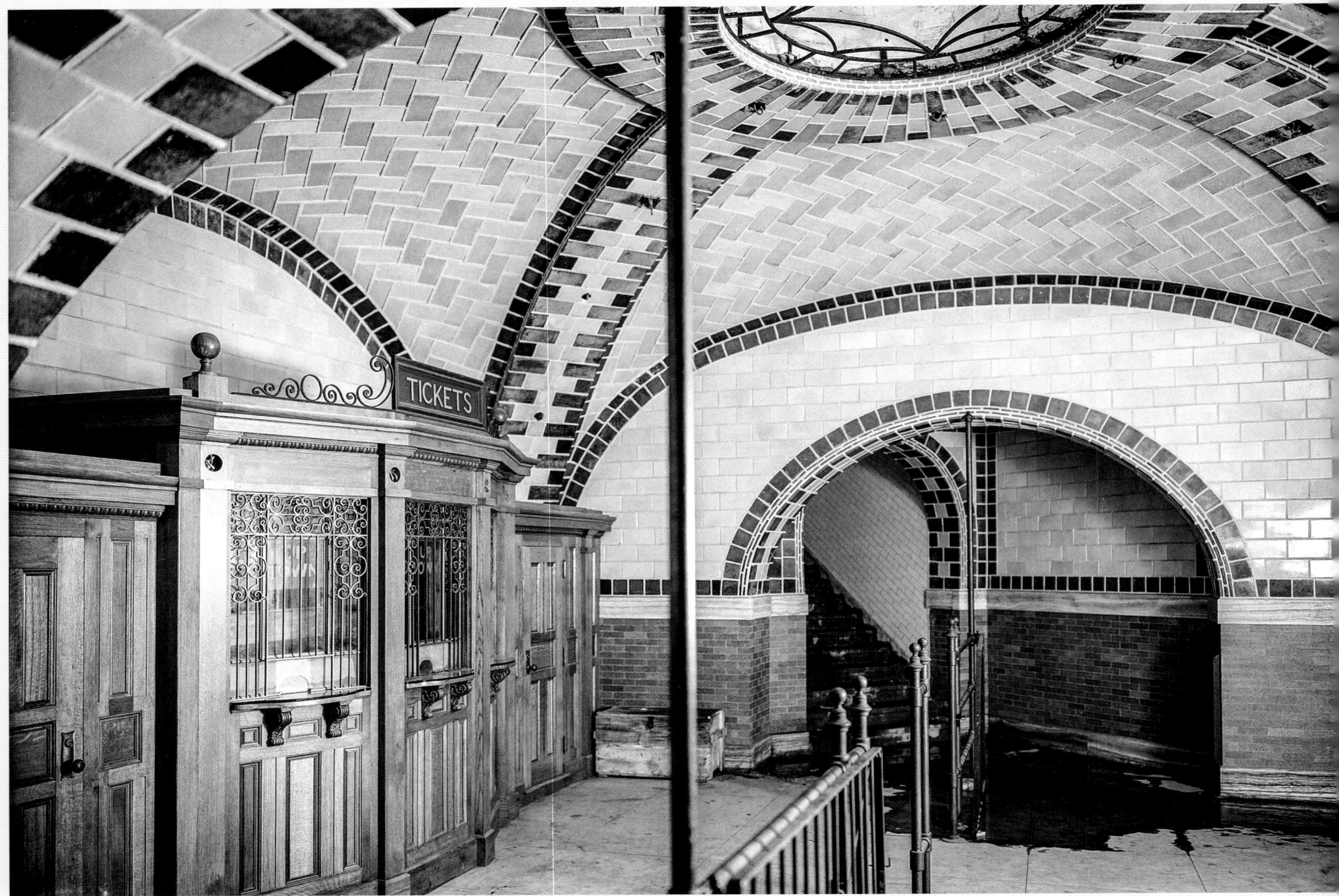

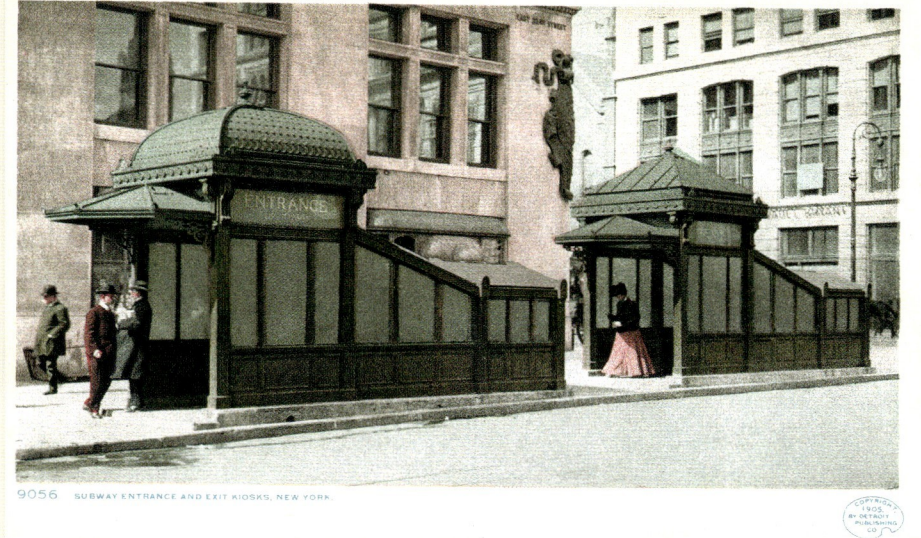

With its walls and ceilings lined with polychrome tiles and its amethyst glass skylights, City Hall Station, which has been closed since 1945, is one of the most beautiful in the world.

Die mit polychromer Keramik gefliesten Wände und Gewölbe und die amethystfarbenen facettierten Dachfenster, die die Bahnsteige erhellen, machen die seit 1945 geschlossene Station City Hall zu einer der schönsten U-Bahn-Stationen der Welt.

Avec ses voûtes et ses murs carrelés de céramiques polychromes et ses verrières taillées en améthyste éclairant les quais, la station de City Hall, fermée depuis 1945, est l'une des plus belles du monde.

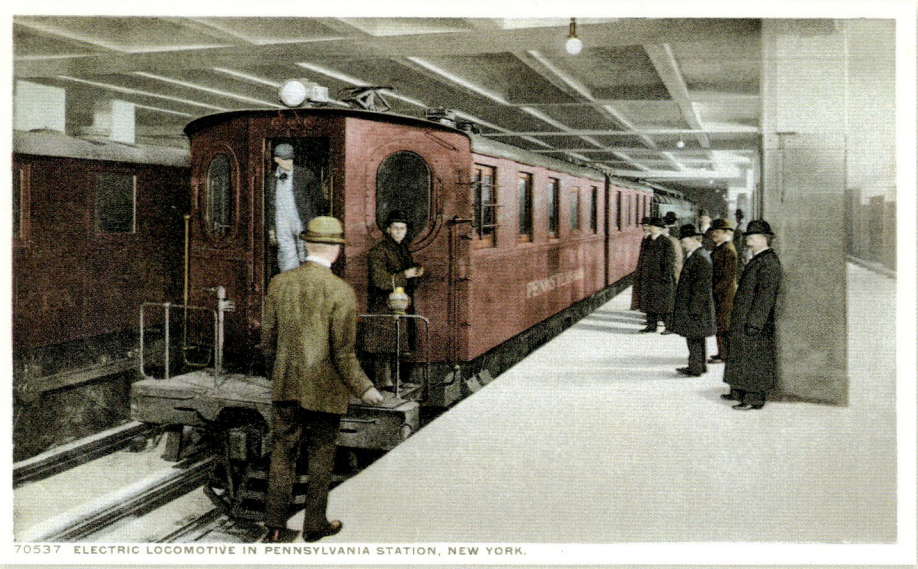

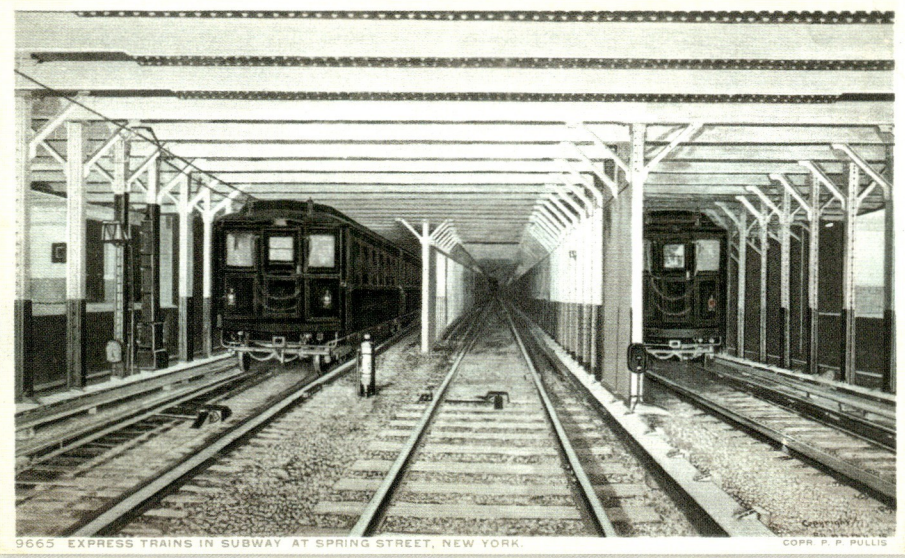

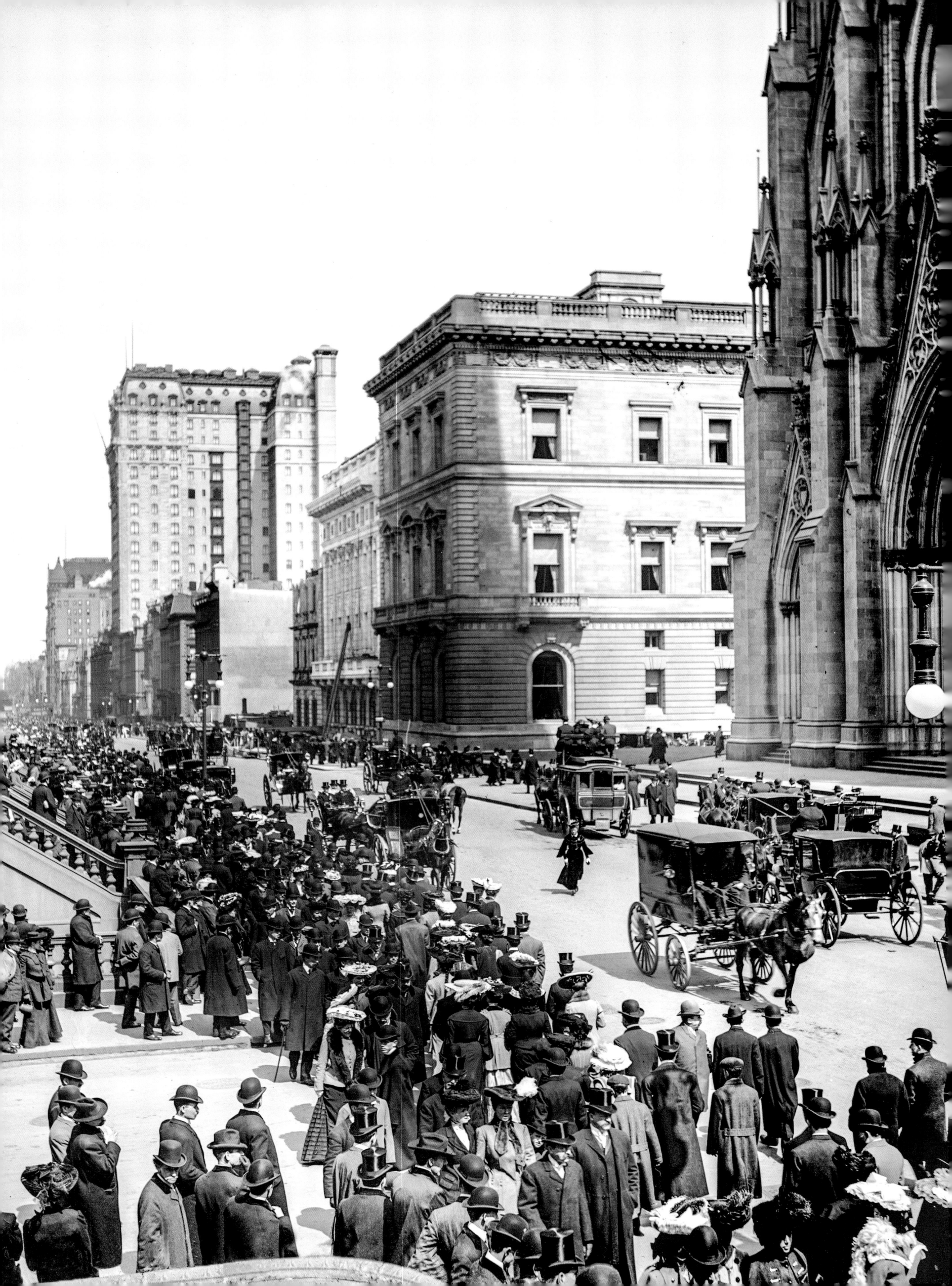

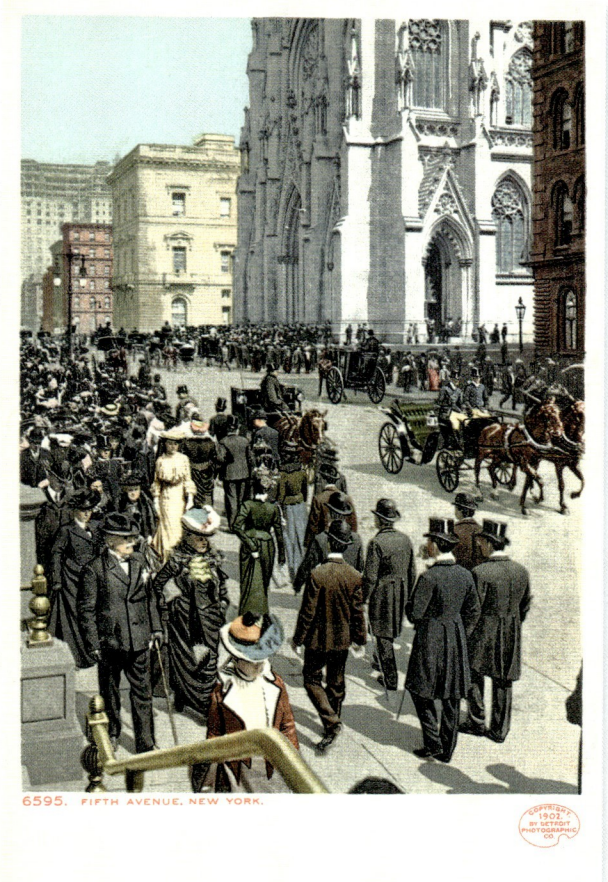

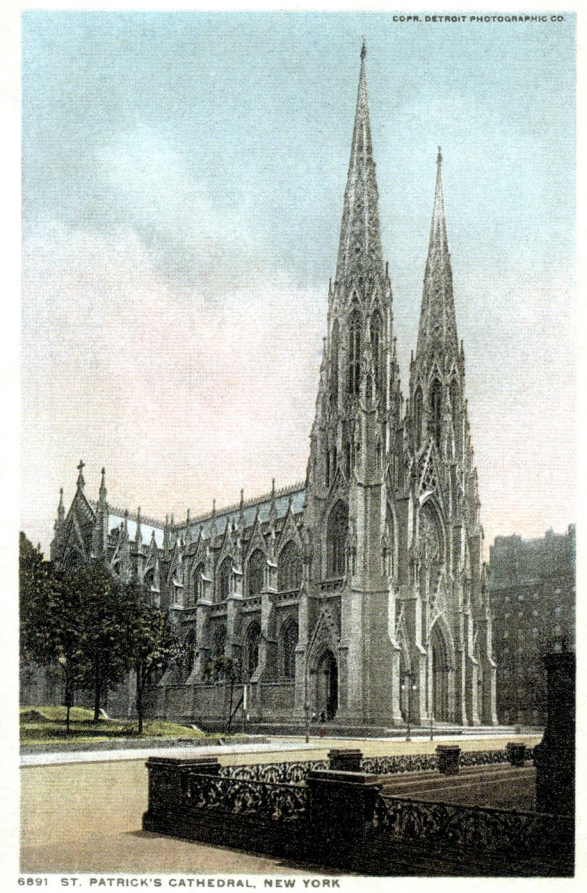

Page 76 : le matin de Pâques sur la 5ᵉ Avenue, plaque de verre, vers 1900
À gauche : la 5ᵉ Avenue (Fifth Avenue)
Ci-contre : la cathédrale St. Patrick
Ci-dessous : l'immeuble du Knickerbocker Trust et l'hôtel Waldorf Astoria

La cathédrale St. Patrick est née du rêve du combatif archevêque de New York, John Hughes, fervent catholique d'origine irlandaise. La première pierre fut posée en 1858 devant un rassemblement de 60 000 personnes, « le plus grand jamais vu à New York » rapporta le journaliste du *New York Herald Tribune* envoyé pour couvrir l'événement. La construction de cette « folie » (*Hughes' folly*), interrompue durant la guerre de Sécession, ne put être achevée qu'en 1878, grâce à une fête de charité qui permit de réunir les fonds nécessaires à son achèvement. St. Patrick, « le plus noble sanctuaire jamais élevé en Amérique à la mémoire de saint Patrick et à la gloire de l'Église catholique américaine », fut consacrée le 25 mai 1879.

Page 76: Easter morning on Fifth Avenue, glass negative, ca. 1900
Top left: Fifth Avenue
Top right: St. Patrick's Cathedral
Right: Knickerbocker Trust Building and Waldorf Astoria

St. Patrick's Cathedral was the dream of the combative first Archbishop of New York, John Hughes, a fervent Catholic of Irish origin. The cornerstone was laid in 1858 before an assembly of 60,000 people, the largest ever seen in New York, according to the reporter from the *New York Herald Tribune* assigned to cover the event. The construction of "Hughes's folly" was interrupted by the American Civil War and completed only in 1878, when sufficient contributions to furnish the cathedral were garnered by a fund-raising fair. The "noblest temple ever raised in any land to the memory of Saint Patrick, and the glory of Catholic America" was consecrated on May 25, 1879.

Seite 76: Ostervormittag auf der Fifth Avenue, Glasnegativ, um 1900
Oben links: Fifth Avenue
Oben rechts: St. Patrick's Cathedral
Rechts: Das Knickerbocker Trust Building und das Hotel Waldorf Astoria

Die St. Patrick's Cathedral war ein Wunschtraum des streitbaren New Yorker Erzbischofs John Hughes, eines tiefgläubigen Katholiken irischer Herkunft. Der Grundstein wurde 1858 vor einer Ansammlung von 60 000 Menschen gelegt, „der größten, die New York jemals gesehen hatte", schrieb der Journalist der *New York Herald Tribune*, der mit dem Bericht über das Ereignis beauftragt war. Die Arbeiten an „Hughes' Prachtbau" wurden während des Sezessionskrieges unterbrochen und konnten erst 1878 mithilfe einer Wohltätigkeitsveranstaltung, auf der man die zu seiner Vollendung notwendigen Mittel zusammentrug, beendet werden. St. Patrick's Cathedral, „der erhabenste Tempel, der jemals in einem Land zum Gedenken an den heiligen Patrick und zum Ruhme der katholischen Kirche in Amerika errichtet wurde", wurde am 25. Mai 1879 eingeweiht.

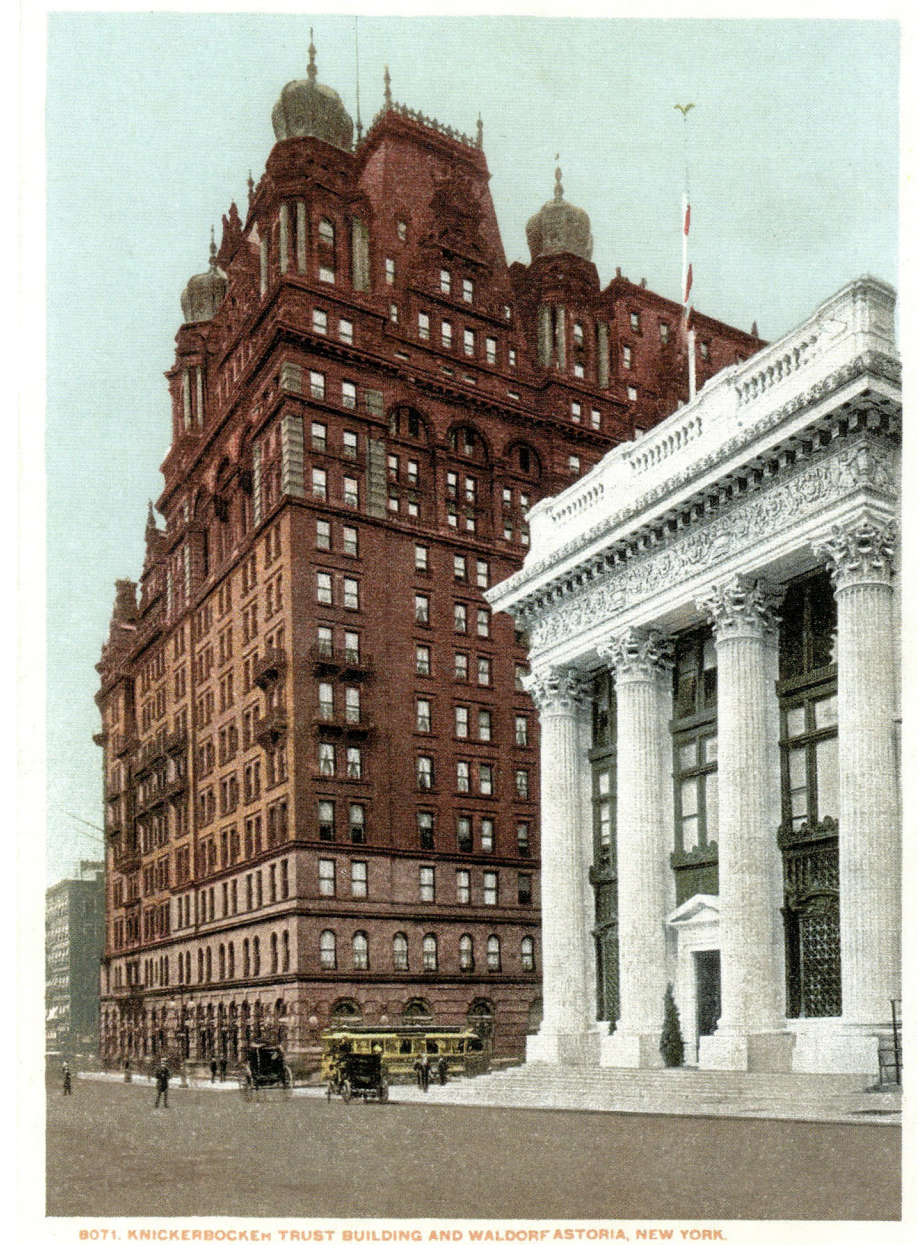

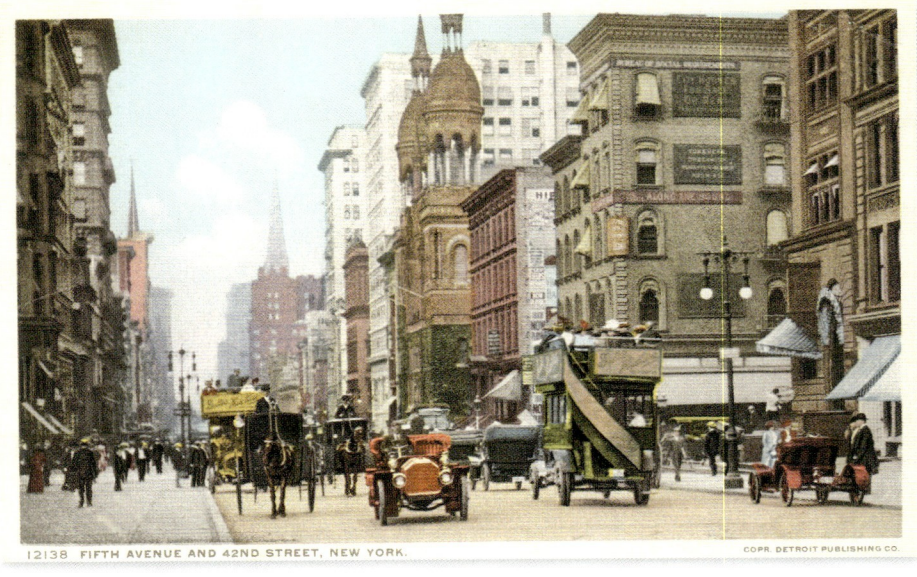
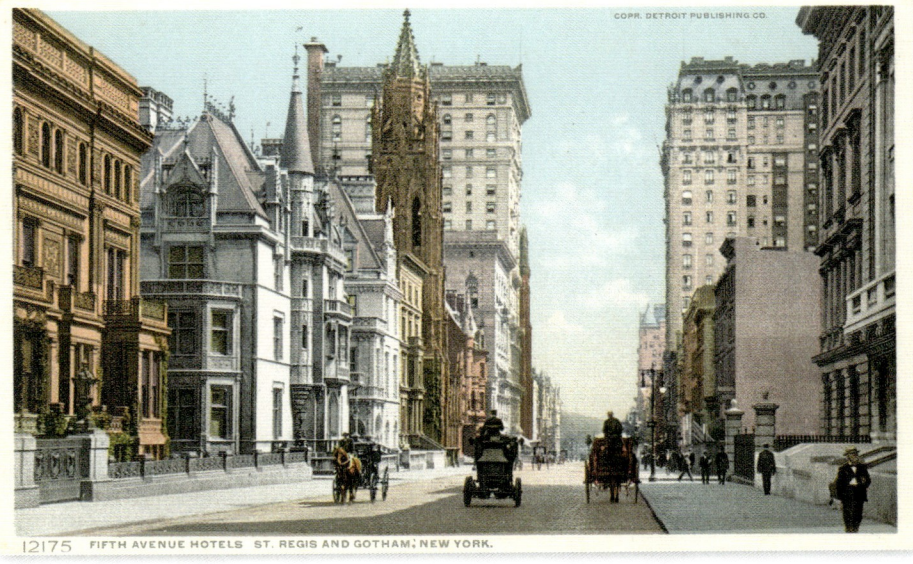

Top left: **Fifth Avenue and 42nd Street**
Top right: **Fifth Avenue hotels St. Regis and Gotham**
Right: **Staging on Fifth Avenue**
Bottom: **Fifth Avenue at 51st Street, photochrom**

Oben links: **Die Fifth Avenue an der Ecke 42nd Street**
Oben rechts: **Die Hotels St. Regis und Gotham an der Fifth Avenue**
Rechts: **Pferdekutsche auf der Fifth Avenue**
Unten: **Die Fifth Avenue auf Höhe der 51st Street, Photochrom**

En haut à gauche : la 5ᵉ Avenue au croisement de la 42ᵉ Rue
En haut à droite : les hôtels St. Regis and Gotham sur la 5ᵉ Avenue
À droite : attelage sur la 5ᵉ Avenue
En bas : la 5ᵉ Avenue à la hauteur de la 51ᵉ Rue, photochrome

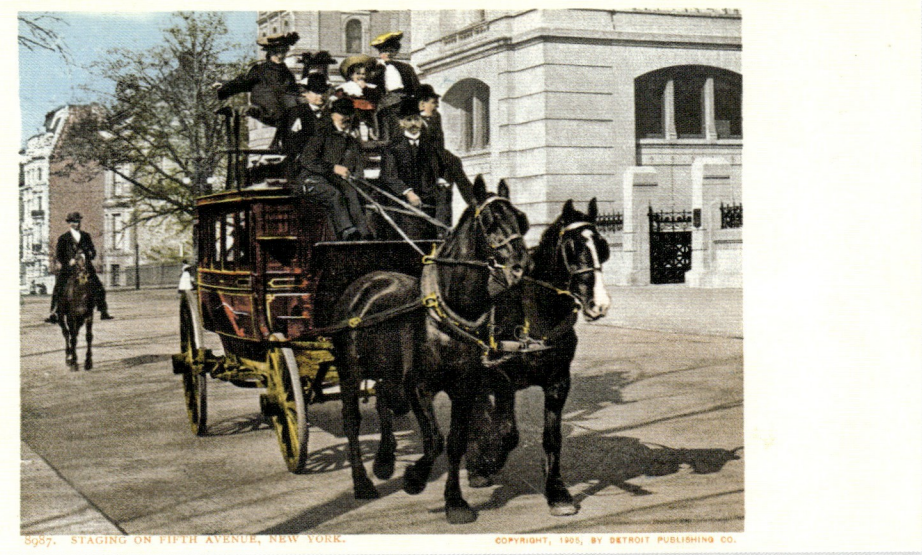

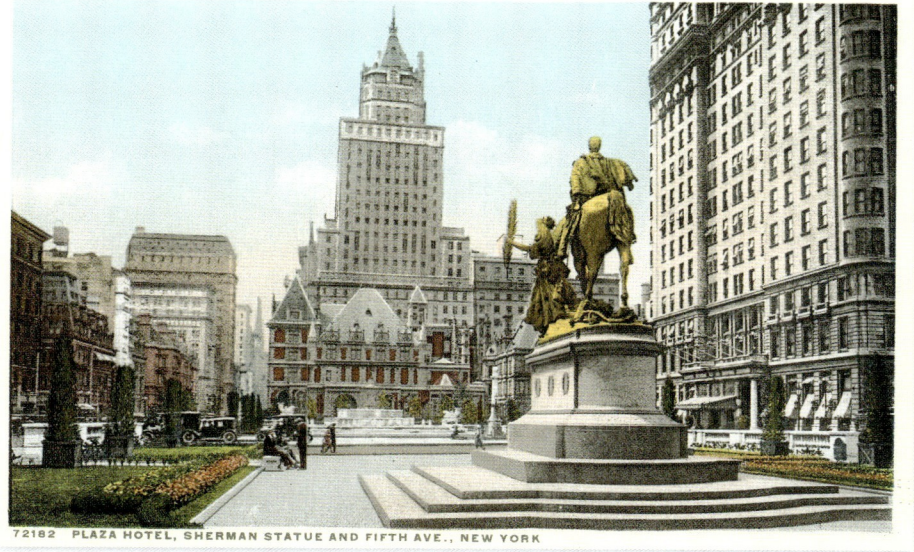
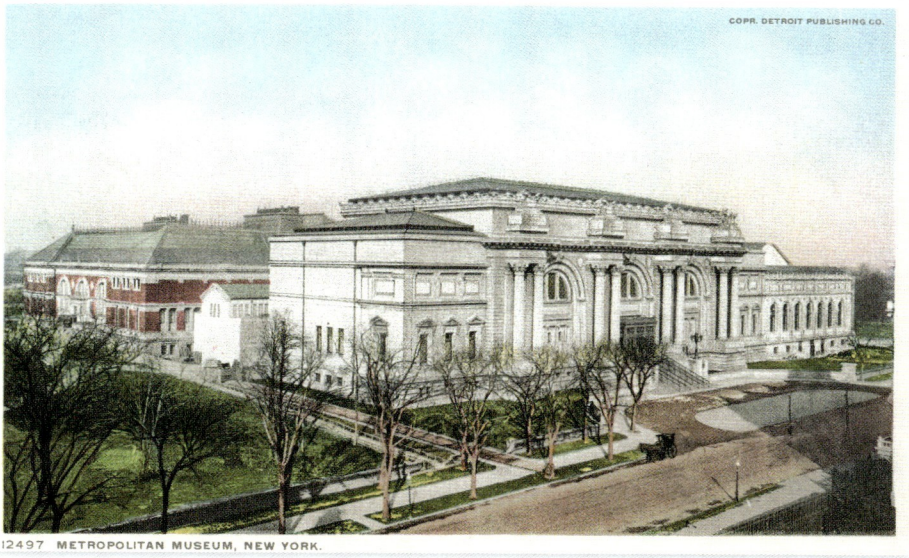

Top left: Plaza Hotel, Sherman Statue and Fifth Avenue
Top right: Metropolitan Museum of Art
Bottom: Fifth Avenue at 65th Street, photochrom

Location of choice for the great New York families—the Astors, Vanderbilts, Goulds, Carnegies, Fricks, and others—Fifth Avenue came to symbolize the Gilded Age (ca. 1870–1910), a period of legendary opulence for the U.S. elite. Competing to outspend each other, the magnates of the time commissioned the fashionable architects Stanford White and Richard Morris Hunt to design grand mansions in the style of Renaissance palaces or Florentine palazzi. On Millionaire's Row, a few steps led from their residences to "their" hotels—the Fifth Avenue, the Plaza, the Waldorf Astoria, the St. Regis—"their" clubs, "their" restaurants, and even "their" opera, since the Metropolitan Opera House, which opened in 1883, was financed by Alva Vanderbilt.

Oben links: Das Hotel Plaza, Sherman-Statue und Fifth Avenue
Oben rechts: Metropolitan Museum of Art
Unten: Fifth Avenue auf Höhe der 65th Street, Photochrom

Die Fifth Avenue, der von den großen Familien New Yorks – den Astors, Vanderbilts, Goulds, Carnegies und Fricks – bevorzugte Wohnort, steht symbolisch für jene Epoche extremer Pracht unter den Eliten, die zu Recht als „Gilded Age" (Vergoldetes Zeitalter) bezeichnet wird und die etwa von 1870 bis 1910 dauerte. Die Wohlhabenden jener Zeit wetteiferten mit ihrem Reichtum und betrauten die damals führenden Architekten Stanford White und Richard Morris Hunt mit der Aufgabe, ihnen dort als Wohnsitz die Replik eines Renaissance-Schlosses oder eines florentinischen Palazzos zu errichten. Ihre Anwesen auf der „Millionaire's Row" (Allee der Millionäre) lagen in unmittelbarer Nachbarschaft zu „ihren" Grand Hotels (Fifth Avenue, Plaza, Waldorf Astoria, St. Regis), „ihren" Clubs, „ihren" Restaurants oder gar „ihrer" Oper, denn die 1883 eröffnete Metropolitan Opera wurde von Alva Vanderbilt finanziert.

En haut à gauche : l'hôtel Plaza, la statue de Sherman et la 5e Avenue
En haut à droite : le Metropolitan Museum of Art
En bas : la 5e Avenue à la hauteur de la 65e Rue, photochrome

Lieu d'élection des grandes familles new-yorkaises – les Astor, Vanderbilt, Gould, Carnegie, Frick… –, la 5e Avenue symbolise cette période d'extrême opulence des élites, très justement nommée l'« Âge d'or » (the Gilded Age), qui dura des années 1870 à 1910 environ. Rivalisant de richesse, les nantis de l'époque confièrent aux architectes en vue, Stanford White et Richard Morris Hunt, le soin d'élever là leurs résidences, répliques de châteaux Renaissance ou de palais florentins. Sur cette « allée des millionnaires » (Millionaire's Row), leurs demeures côtoyaient « leurs » grands hôtels (Fifth Avenue, Plaza, Waldorf Astoria, St. Regis), « leurs » clubs, « leurs » restaurants et même « leur » opéra, puisque le Metropolitan, inauguré en 1883, fut financé par Alva Vanderbilt.

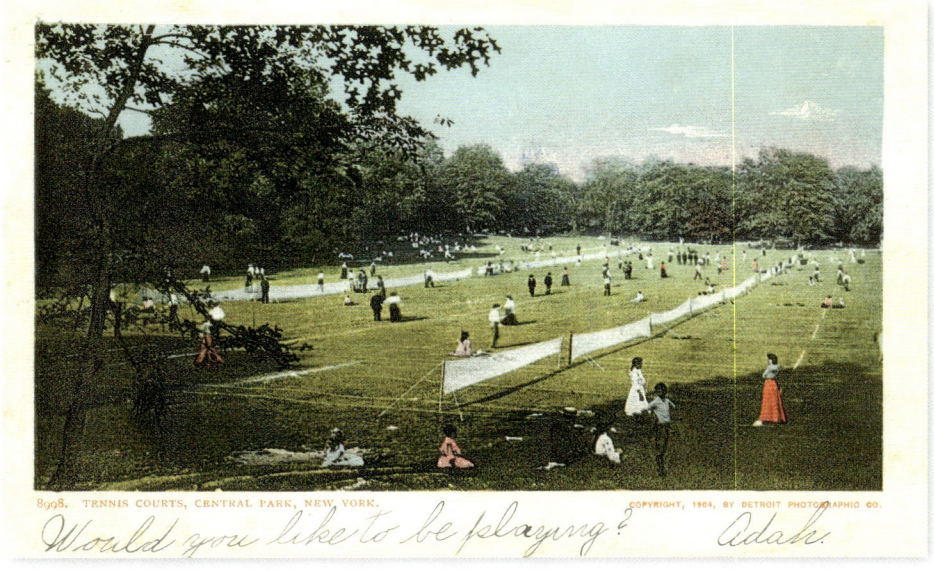

Above: **Tennis courts in Central Park**
Below: **Lower end of the Mall, Central Park, photochrom**

The landscaping of Central Park, designed by Frederick Law Olmsted and Calvert Vaux, lasted ten years and cost New York City a cool $10 million. An idea was circulating in the salons of Fifth Avenue that the elite should demonstrate its altruism by offering the poor a place of relaxation in the open air. By happy chance, this would also enable the elite to parade through the avenues of the new park in their barouches. The marshy, rocky area chosen was, in any case, not suitable for development. Central Park opened in winter 1858 and, in December, the first skaters took to the frozen lake south of the Ramble.

Oben: **Tennisplätze im Central Park**
Unten: **Das untere Ende der Mall, Central Park, Photochrom**

Die Umsetzung der von Frederick Law Olmsted und Calvert Vaux stammenden Entwürfe für den Central Park dauerte zehn Jahre und kostete die Stadt New York die Kleinigkeit von zehn Millionen Dollar. Die in den Salons der Fifth Avenue geborene Idee bestand darin, den Altruismus der Elite unter Beweis zu stellen, indem sie den Armen einen Ort schenkte, an dem sie sich im Freien vergnügen konnten – dieselbe Elite, die sich zugleich voller Stolz mit ihren Kaleschen im neuen Park würde präsentieren können. Das ausgewählte Terrain war sumpfig und felsig und konnte ohnehin nicht bebaut werden. Der Central Park wurde im Winter 1858 eröffnet; im Dezember begaben sich die ersten Schlittschuhläufer auf den zugefrorenen See südlich des „Ramble" (wörtlich „Spaziergang").

En haut : **courts de tennis à Central Park**
En bas : **le bas de l'avenue principale (le Mall), Central Park, photochrome**

L'aménagement de Central Park, conçu par Frederick Law Olmsted et Calvert Vaux, dura dix ans et coûta à la Ville de New York la bagatelle de dix millions de dollars. L'idée, née dans les salons de la 5ᵉ Avenue, était de démontrer que l'élite pouvait faire montre d'altruisme en offrant aux plus pauvres un lieu où profiter du grand air…– tout en paradant elle-même, en calèche, dans le nouveau parc. Le terrain choisi, marécageux et rocheux, était de toute façon inconstructible. Central Park ouvrit en hiver 1858 ; en décembre, les premiers patineurs se lançaient sur le lac gelé, au sud du « Ramble » (littéralement « la promenade »).

From top to bottom:
The lake and terrace, Central Park
An afternoon procession on Driveway
Goat carriages in Central Park

Von oben nach unten:
See und Terrasse im Central Park
Kaleschen auf dem Driveway am Nachmittag
Ziegengespanne im Central Park

De haut en bas :
Le lac et la terrasse de Central Park
Calèches sur la Driveway l'après-midi
Voitures à chèvres à Central Park

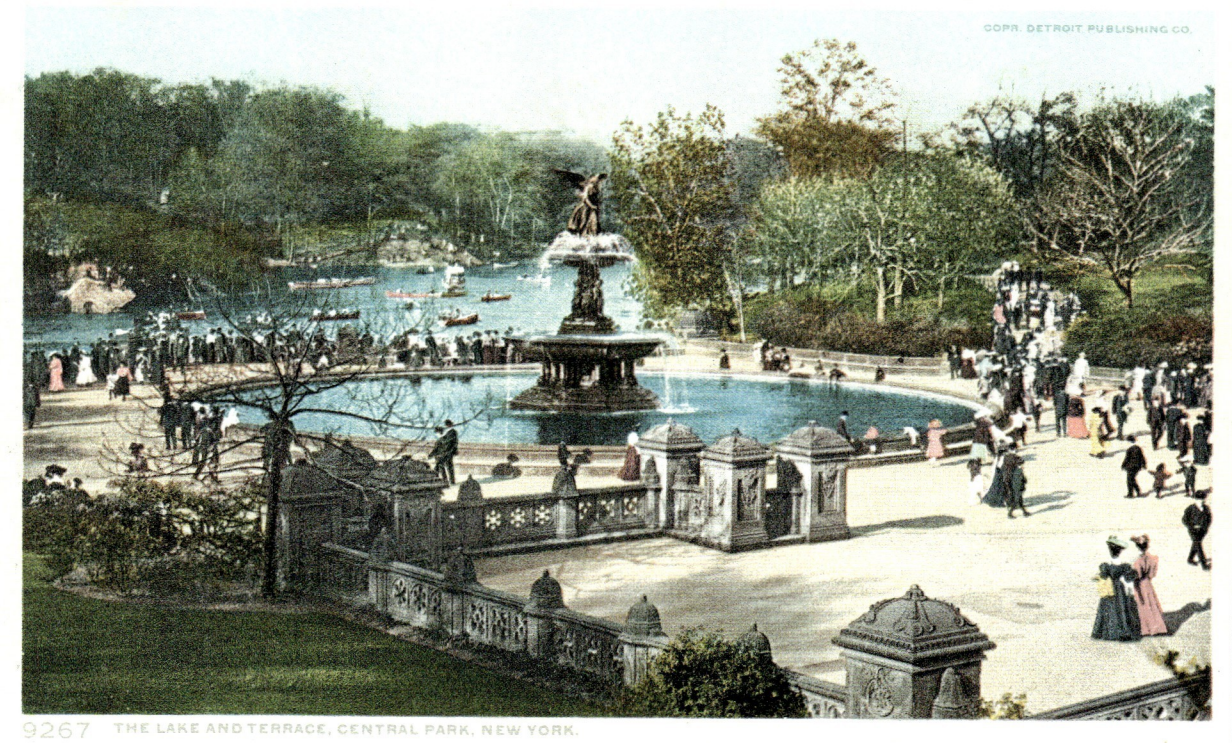

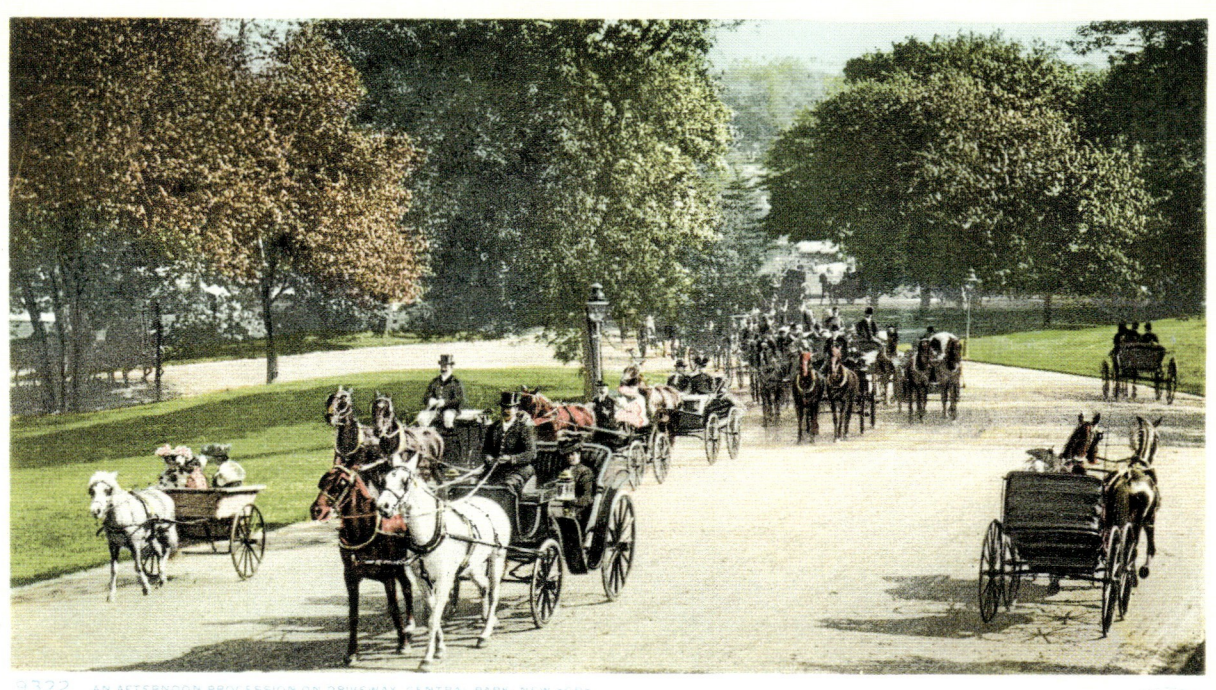

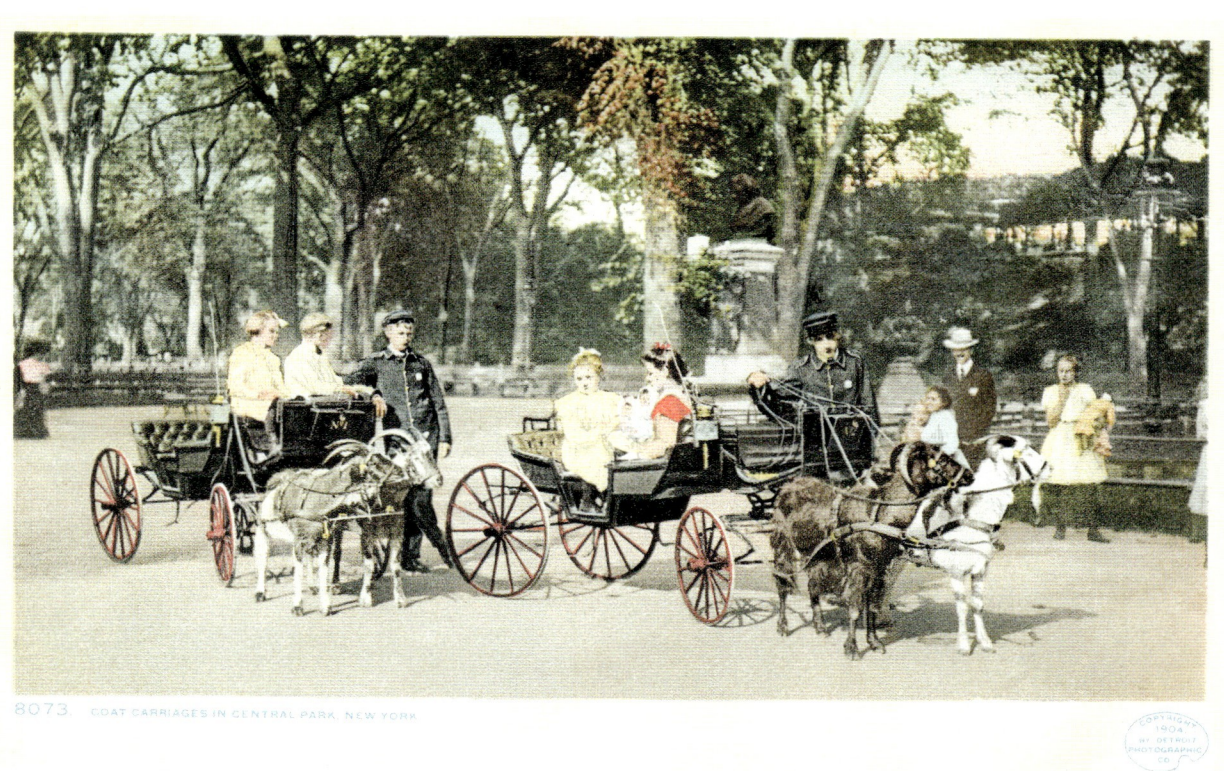

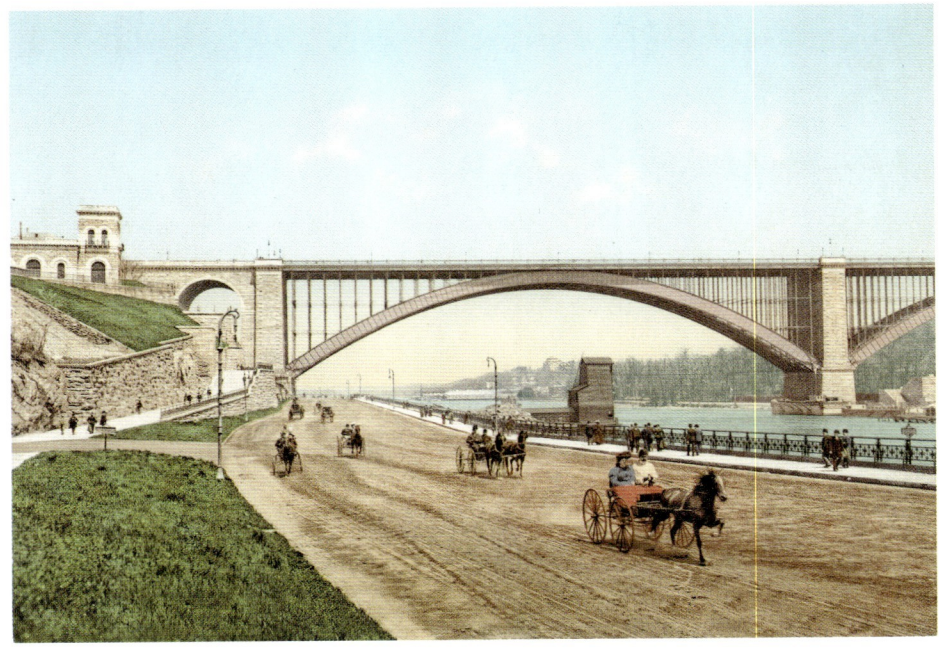
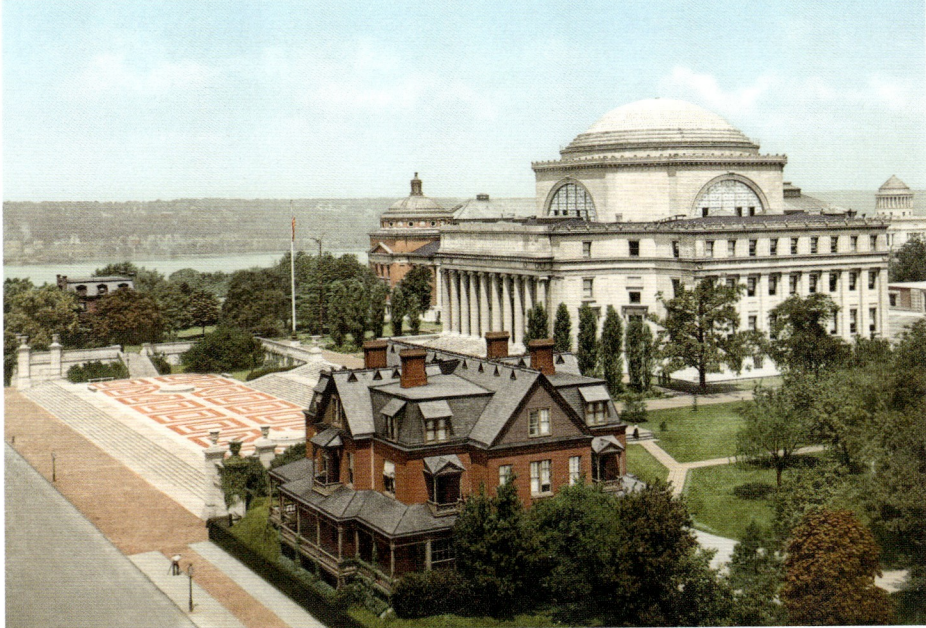

Top left: **Washington Bridge and Speedway**, photochrom
Top right: **Morningside Heights, Columbia University, the Library**, photochrom
Bottom: **Brooklyn, the Circle, Prospect Park**, photochrom

Oben links: **Washington Bridge und Schnellstraße**, Photochrom
Oben rechts: **Columbia University, Bibliothek**, Photochrom
Unten: **Brooklyn, the Circle, Prospect Park**, Photochrom

En haut à gauche : **le pont de Washington Bridge et la voie rapide**, photochrome
En haut à droite : **université de Columbia, la bibliothèque**, photochrome
En bas : **Brooklyn, the Circle (la Courbe), Prospect Park**, photochrome

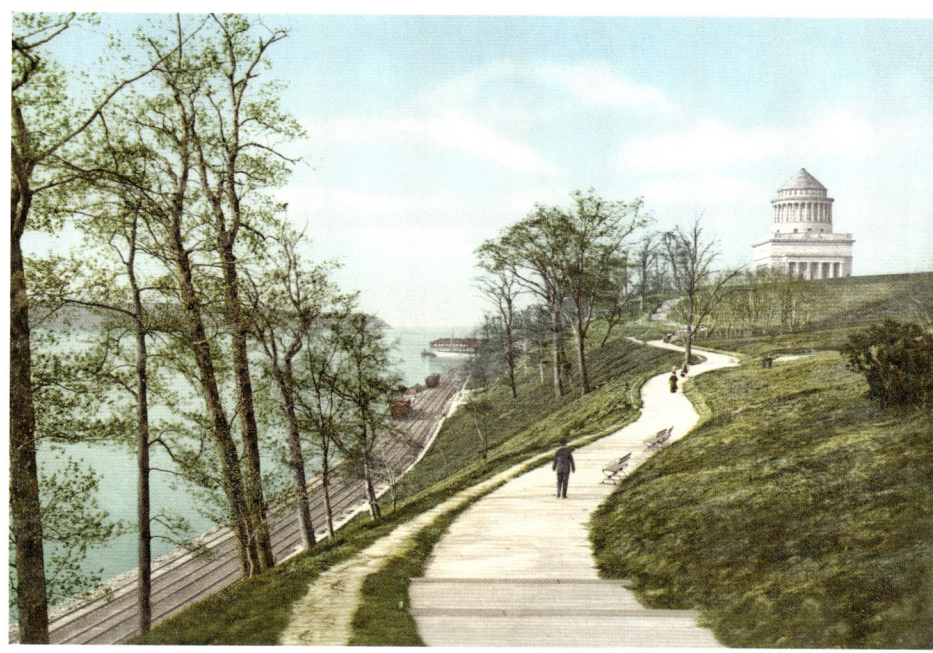

Above: **Grant's Tomb and Riverside Park**, photochrom
Below: **Rubber-neck auto, Riverside Drive, New York**, glass negative, 1900–1915

Beyond the Upper West Side, Riverside Drive runs through the hills that overlook the Hudson and offers one of the most beautiful views of Manhattan. The avenue was part of Frederick Law Olmsted's plan for Riverside Park, the construction of which began in the early 1870s. To the north, in Washington Heights, the Washington Bridge, built in 1890, bestrides Harlem River, connecting 181st Street with the Bronx. And to the south, the University of Columbia, formerly Columbia College on Madison Avenue, took up residence in Morningside Heights in 1897.

Oben: **Grant's Tomb und Riverside Park**, Photochrom
Unten: **Doppeldeckerbus, Riverside Drive**, Glasnegativ, 1900–1915

Jenseits der Upper West Side liegt der Riverside Drive. Er verläuft entlang der Hügel, die den Hudson River überragen, und bietet dem Fußgänger einige der schönsten Rundblicke über Manhattan. Die Allee gehörte zum Bebauungsplan des Riverside Park, den Frederick Law Olmsted, der Architekt des Central Park, entworfen hatte und mit dessen Bau man Anfang der 1870er-Jahre begann. Im nördlich gelegenen Stadtteil Washington Heights überspannt auf Höhe der 181st Street die 1890 errichtete Washington Bridge den Harlem River. Im Süden hat die Columbia University – das ehemalige Columbia College der Madison Avenue – 1897 die Anhöhe von Morningside als Standort gewählt.

Ci-dessus : **le tombeau de Grant et Riverside Park**, photochrome
En bas : **voiture de tourisme à impériale, Riverside Drive**, plaque de verre, 1900–1915

Par-delà l'Upper West Side, longeant les collines qui dominent l'Hudson, Riverside Drive offre au promeneur quelques-uns des plus beaux panoramas de Manhattan. L'avenue faisait partie du plan d'aménagement du parc de Riverside conçu par l'architecte de Central Park, Frederick Law Olmsted ; sa construction commença au début des années 1870. Au nord, dans le quartier de Washington Heights, à la hauteur de la 181e Rue, le pont de Washington, édifié en 1890, enjambe la Harlem River. Et au sud, l'université de Columbia – l'ancien Columbia College de Madison Avenue – a élu domicile sur les hauteurs de Morningside en 1897.

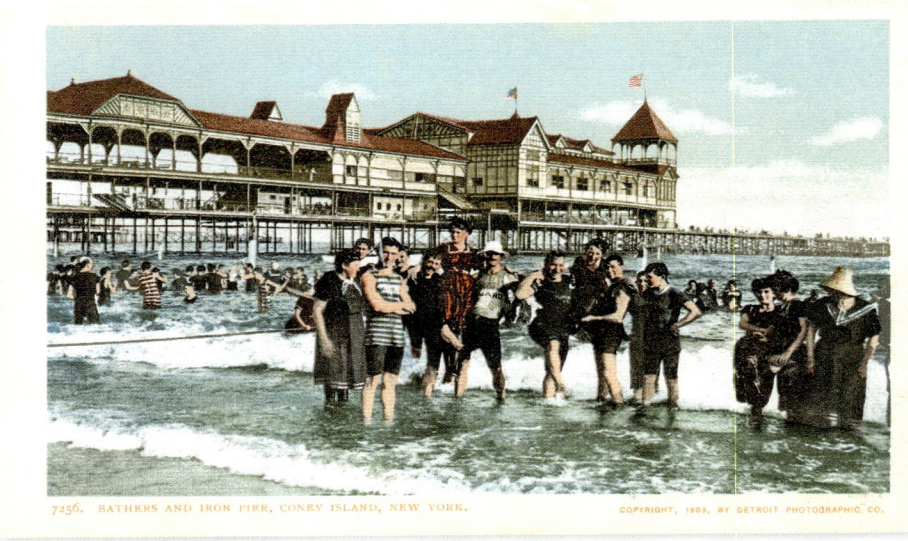 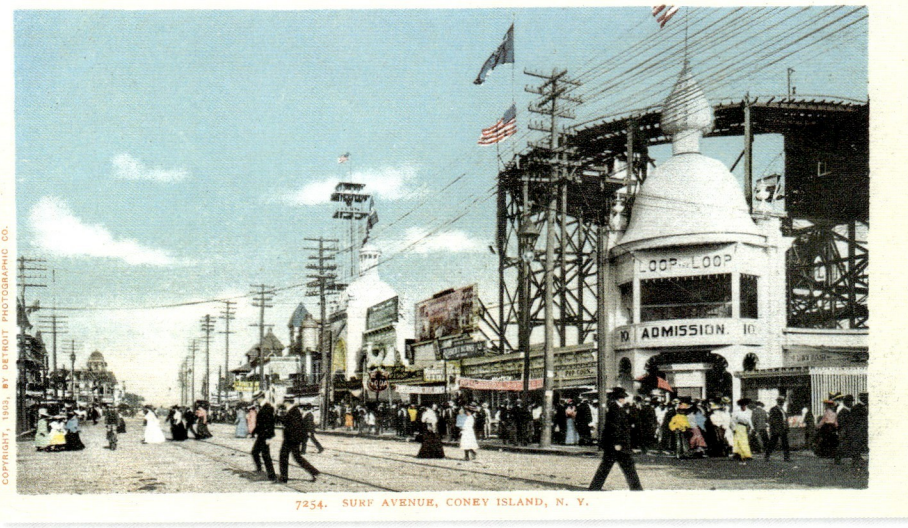

Top left: Bathers and iron pier, Coney Island
Top right: Surf Avenue
Bottom: The miniature railway, glass negative, ca. 1905

At the southern tip of Brooklyn, the peninsula of Coney Island was at the height of its glory in the 1880s. The first carousel opened on Surf Avenue in 1876 and the little seaside resort of New York was transformed into the "playground of the world" with its Luna Park, Dreamland, Steeplechase Park, and the chic beaches of the grand hotels: Brighton Beach, West Brighton Beach, Manhattan Beach, and Rockaway Beach.
In the 1890s, ten million visitors came to Coney Island every summer.

Oben links: Badende und Blick auf die Mole von Coney Island
Oben rechts: Surf Avenue
Unten: Miniaturzug, Glasnegativ, um 1905

Die Halbinsel Coney Island an der Südspitze von Brooklyn erlebte ihre Hochzeit ab den 1880er-Jahren. Das erste Karussell eröffnete 1876 auf der Surf Avenue, und fortan verwandelte sich der kleine Badeort der New Yorker mit dem Luna Park, dem „Dreamland", dem Park für Steeplechase-Pferderennen, den „englischen" Stränden und seinen Grand Hotels Brighton Beach, West Brighton Beach, Manhattan Beach und Rockaway Beach zum „playground of the world" (Spielplatz der Welt). In den 1890er-Jahren kamen jeden Sommer zehn Millionen Besucher nach Coney Island.

En haut à gauche : baigneurs et vue de la jetée de Coney Island
En haut à droite : Surf Avenue
En bas : le train miniature, plaque de verre, vers 1905

À la pointe sud de Brooklyn, la péninsule de Coney Island connut son heure de gloire à partir des années 1880. Le premier carrousel ouvrit sur Surf Avenue en 1876 et la petite station balnéaire des New-Yorkais se transforma en *playground of the world* («cour de récréation du monde»), avec son Luna Park, son «Dreamland», son parc de steeple-chase, ses plages «à l'anglaise» et leurs grands hôtels : Brighton Beach, West Brighton Beach, Manhattan Beach, Rockaway Beach. Dans les années 1890, dix millions de visiteurs fréquentaient chaque été Coney Island.

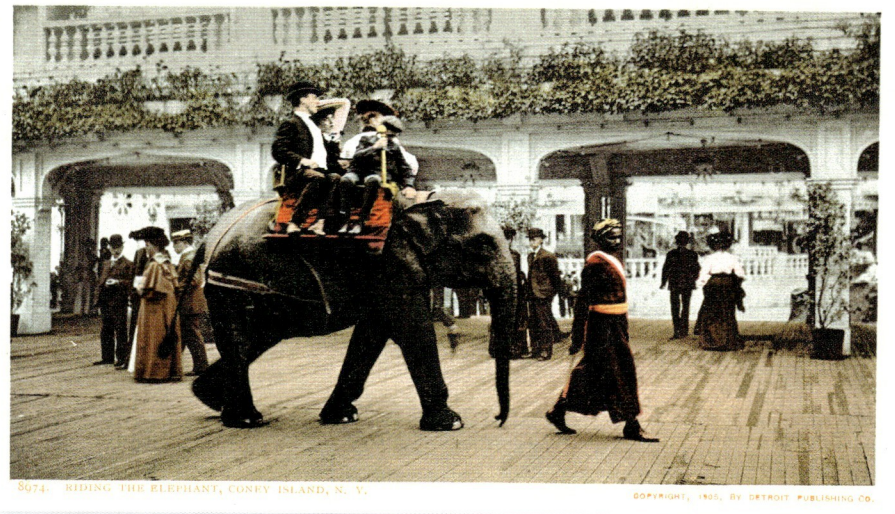

Above: Riding an elephant
Right: "The great coal mine"
Below: Luna Park, the promenade, Coney Island,
glass negative, 1903–1910

Oben: Auf dem Rücken eines Elefanten
Rechts: „Das große Kohlebergwerk"
Unten: Luna Park, die Promenade, Coney Island,
Glasnegativ, 1903–1910

En haut : à dos d'éléphant
À droite : une attraction, la « grande mine de charbon »
En bas : Luna Park, la promenade, Coney Island,
plaque de verre, 1903–1910

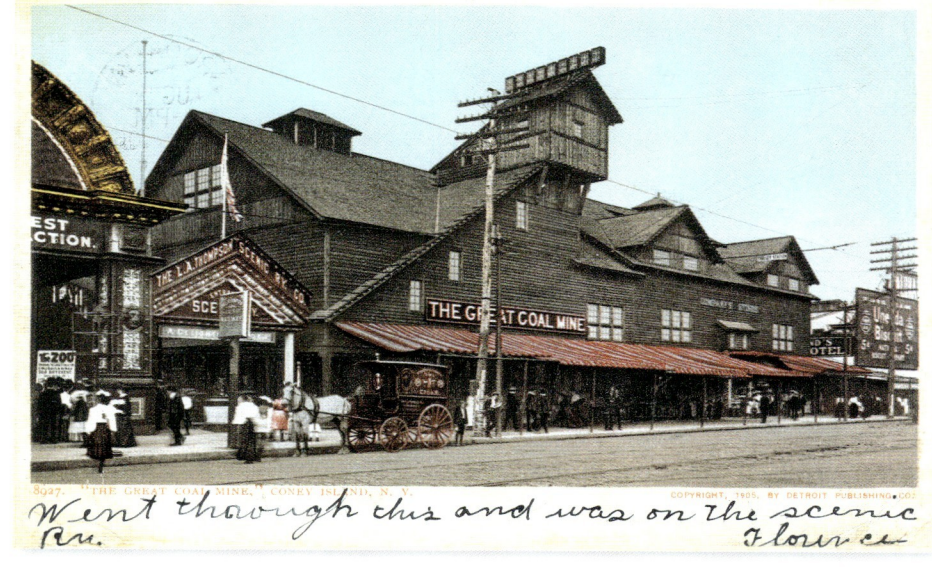

NEW YORK CITY | CONEY ISLAND

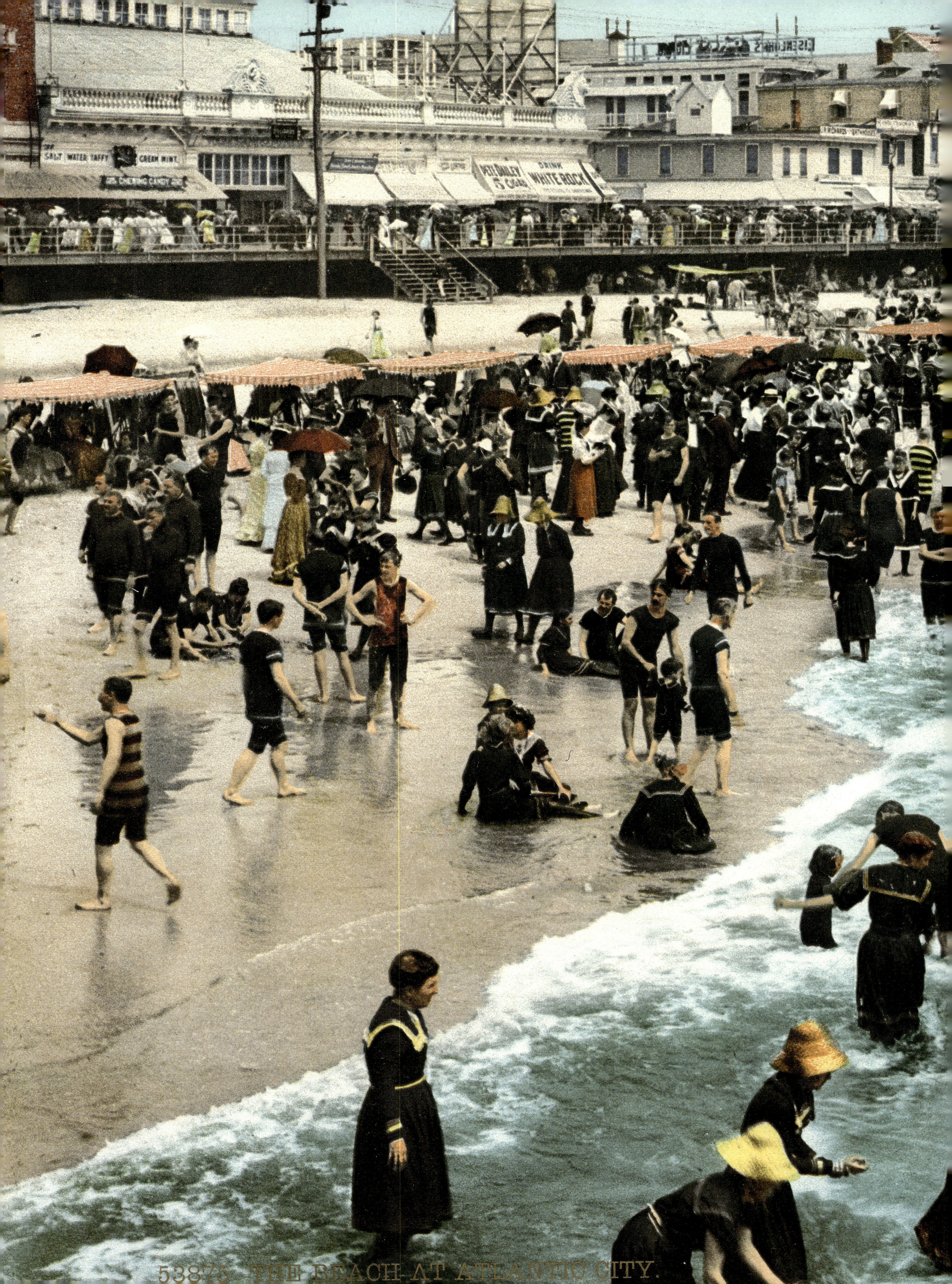

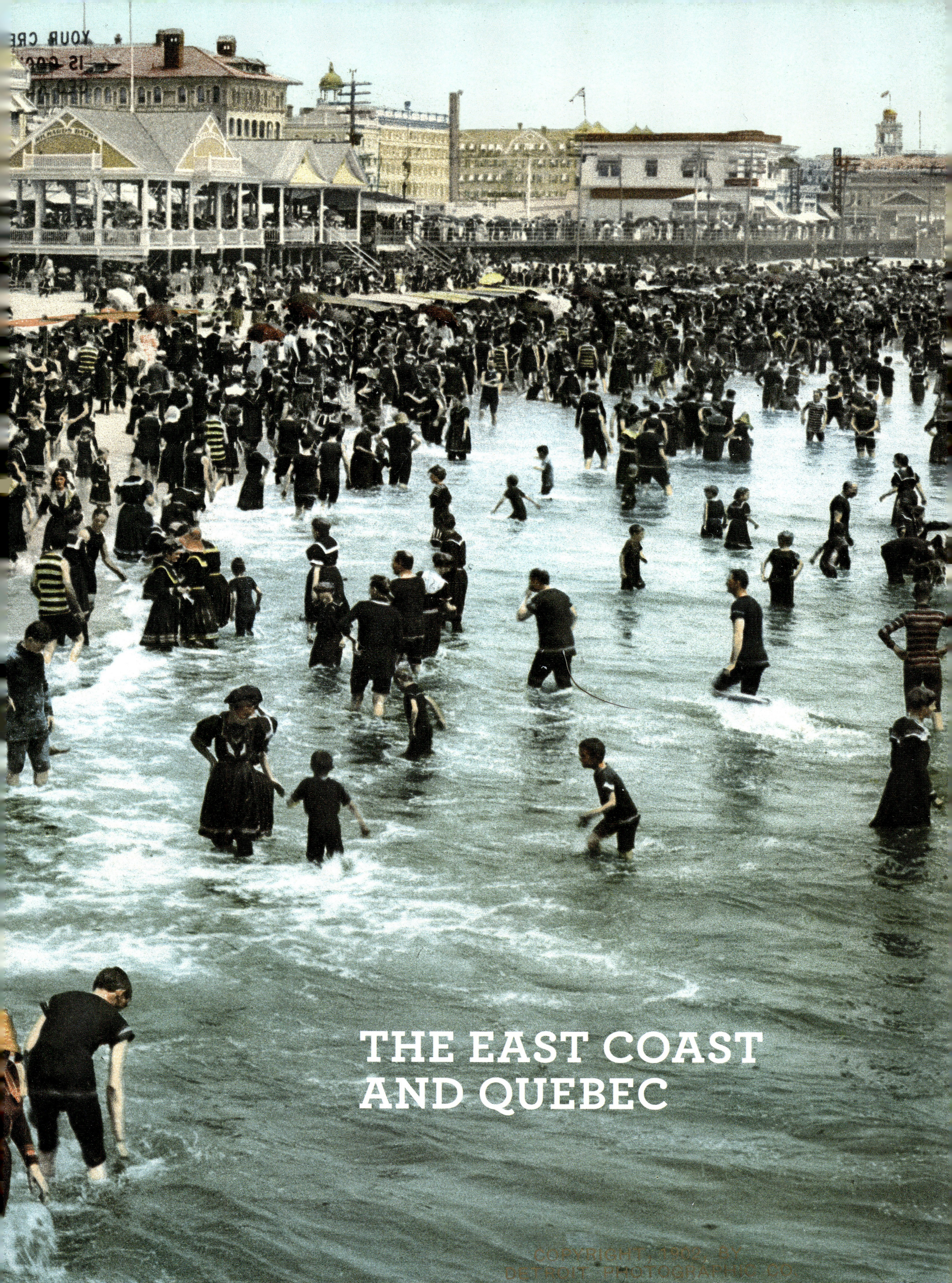

THE EAST COAST AND QUEBEC

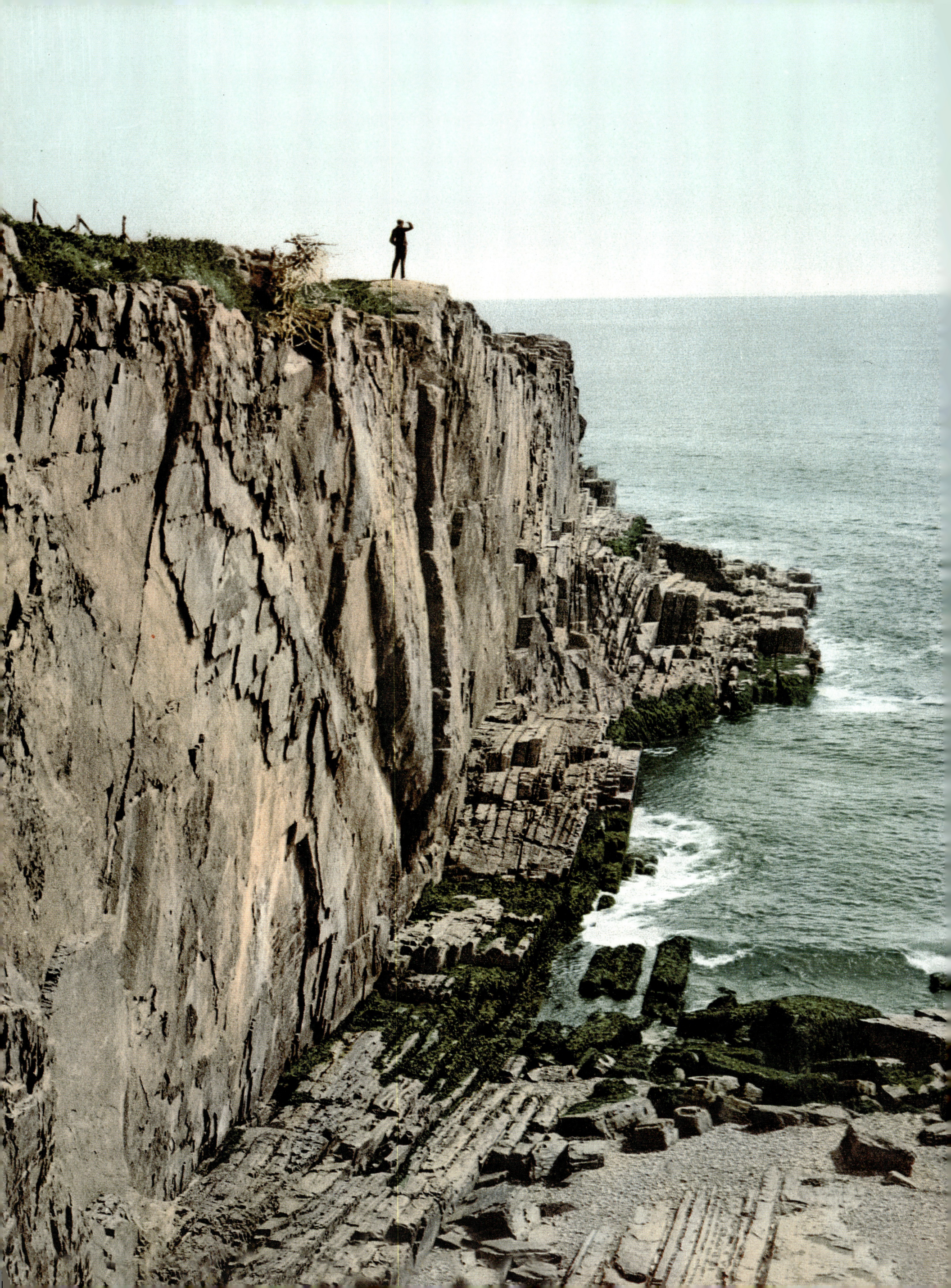

Page 86/87: **The beach of Atlantic City, New Jersey,** photochrom
Page 88: **Sea Wall at Bald Head Cliff, Maine,** photochrom
Near right: **Old South Church (former Old South Meeting House), Boston, Massachusetts**
Far right: **Parker House Hotel, Boston, Massachusetts**

Seite 86/87: **Der Strand von Atlantic City, New Jersey,** Photochrom
Seite 88: **Felswand am Bald Head Cliff, Maine,** Photochrom
Rechts: **Die Kirche Old South Church (ehemals Old South Meeting House), Boston, Massachusetts**
Rechts außen: **Das Hotel Parker House, Boston, Massachusetts**

Pages 86/87 : **la plage d'Atlantic City, New Jersey,** photochrome
Page 88 : **la falaise de Bald Head Cliff, Maine,** photochrome
Ci-contre : **l'église d'Old South (ancienne Old South Meeting House), Boston, Massachusetts**
À droite : **l'hôtel Parker House, Boston, Massachusetts**

THE EAST COAST AND QUEBEC

The first American Baedeker, which appeared in 1893, tells us that it took between ten and twelve hours on the Grand Trunk Railway to cover the 250 or so miles (400 km) separating Portland, Maine, from Montreal; a further five hours was required to reach Quebec. The journey was comfortable enough but excessively long. Things were more complicated for Samuel de Champlain, who laid the foundations of Quebec in 1608; he descended the Atlantic coast as far as Cape Cod, Massachusetts, and explored Canada on horseback, on foot, and by canoe from Acadia, Nova Scotia, to the lake that bears his name on the frontier of New York State. To accomplish this, he had to negotiate with the Algonquins and Hurons, who were themselves at war with the Iroquois. By comparison, the train journey of 1893 was child's play. If we further consider that, abandoned by the French and chased by the English, the Acadians left their colony in the middle of the 18th century by wagon, some of them traveling as far as New Orleans, we can but be confirmed in our idea that the late 19th century belonged to modernity. The photographs of the northeastern coast of America published here offer further testimony to this effect. Steamboats, towns lit by electricity, hydroelectric installations at Niagara Falls, streetcars, skyscrapers, huge metal bridges over the Hudson and Niagara Rivers, the blast furnaces of Pittsburgh, the industrial port equipment of Buffalo on Lake Erie, the shipbuilding yards of Kittery, Maine, or Philadelphia: here is evidence that the former English colonies of the East Coast had their eyes firmly fixed on the future.

During the summer, from Maine to Baltimore, "luxury" hotels opened their doors to ever greater numbers of "bathers" along the entire Atlantic seaboard. Atlantic City in New Jersey was *the* fashionable resort of the time. York and Old Orchard in Maine and the beaches of Nantucket and Nantasket in Massachusetts filled up every weekend and throughout the summer holidays; Newport, Rhode Island's capital of yachting, saw the America's Cup races and the regattas of the Yacht Club of New York. Inland, in the Hudson Valley and the Appalachians, tourism benefited from improved transport and the new amenities on the ground: cog railways in the White Mountains, hotels, steam excursions on the Hudson and on Lakes George, Champlain, Winnipesaukee, and so on.

Finally, the East Coast was by far the most densely populated part of the United States. New York, as we have seen, but Boston, Philadelphia, and Baltimore, too, all saw their populations grow year by year as the succession of political problems in Europe or Asia (and China, in particular) dictated. According to an article by Professor Maurice Zimmermann (in the *Annales de Géographie*, 1909), "the years 1905, 1906, 1907, 1910 and 1913 saw more than one million migrants disembark, with an absolute record in 1907 during which more than 1.28 million people came to the United States."

Page 90: Lake George, photochrom
Top right: The Capitol from Union Station, Washington, D.C.
Below right: Mohonk House from Pine Bluff, Lake Mohonk, New York

Seite 90: Lake George, Photochrom
Oben rechts: Das Kapitol vom Bahnhof Union Station aus, Washington, D.C.
Unten rechts: Das Hotel Mohonk House von Pine Bluff aus, Mohonk-See, New York

Page 90 : lac George, photochrome
En haut à droite : le Capitole depuis la gare d'Union Station, Washington, D.C.
En bas à droite : l'hôtel Mohonk House vu depuis Pine Bluff, lac Mohonk, New York

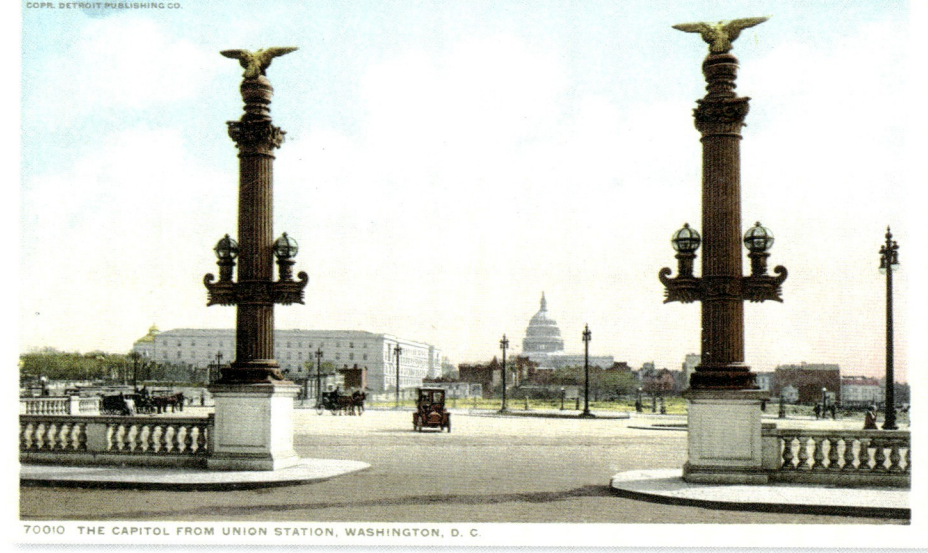

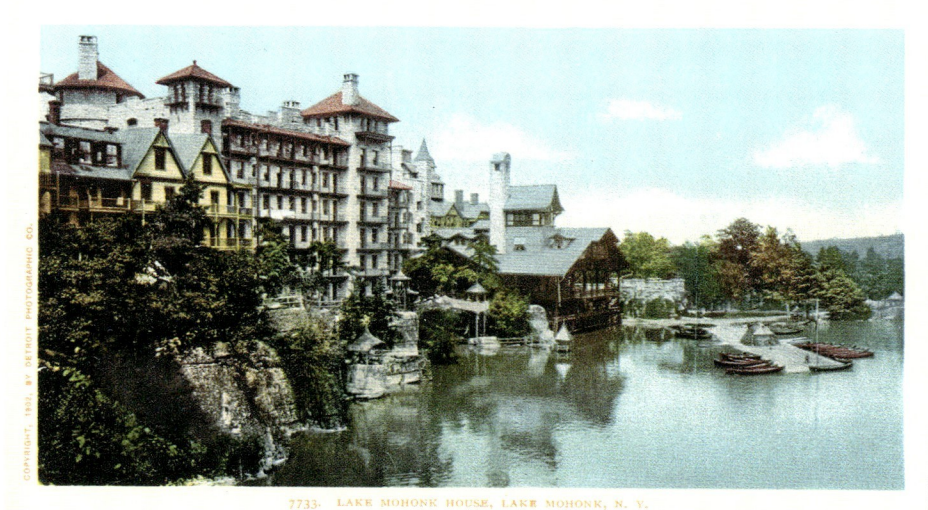

DIE OSTKÜSTE UND QUEBEC

Im ersten, 1893 erschienenen Nordamerika-Führer von Baedeker war zu lesen, dass die Zugfahrt mit der Eisenbahngesellschaft Grand Trunk Railway für die rund 400 Kilometer von Portland (Maine) bis Montreal zehn bis zwölf Stunden dauert. In weiteren fünf Stunden erreichte der Reisende, nach einer bequemen, aber für unsere Begriffe doch reichlich langen Fahrt, das weiter nördlich gelegene Quebec. Samuel de Champlain, der 1608 den Grundstein Quebecs legte, erkundete die Atlantikküste bis hinunter nach Cape Cod (Massachusetts) und Kanada zu Pferde, zu Fuß und mit dem Kanu, von Akadien (Neuschottland) bis zum gleichnamigen See an der Grenze zum Bundesstaat New York – und musste dabei noch mit den indianischen Stämmen der Algonkin und der Huronen verhandeln, die wiederum die Irokesen bekämpften. Dagegen war das Reisen im Jahr 1893 ein Kinderspiel geworden! Wenn man außerdem bedenkt, dass die von den Engländern vertriebenen und von den Franzosen im Stich gelassenen Akadier in der Mitte des 18. Jahrhunderts ihre Kolonie mit dem Karren verließen und dass einige auf diese Weise bis nach New Orleans gelangten, dann wirkt die Vorstellung umso tröstlicher, dass das Ende des 19. Jahrhunderts bereits eine moderne Epoche war. Die fotografischen Aufnahmen der nordamerikanischen Ostküste, die wir hier veröffentlichen, liefern im Übrigen den Beweis dafür.

Dampfschifffahrt, Städte mit elektrischer Beleuchtung, die Errichtung eines Wasserkraftwerks an den Niagarafällen, Straßenbahnen, Wolkenkratzer, große Stahlbrücken über den Hudson und den Niagara River, Hochöfen in Pittsburgh, Industriehafenanlagen in Buffalo am Eriesee, Schiffswerften in Kittery (Maine) oder Philadelphia – die ehemaligen englischen Kolonien an der Ostküste wandten sich entschieden der Zukunft zu.

Von Maine bis Baltimore öffneten zur schönsten Jahreszeit Hotels mit allem Komfort den entlang der Atlantikküste immer zahlreicher werdenden Badegästen ihre Pforten. Atlantic City im Staate New Jersey war zu dieser Zeit der beliebteste Badeort schlechthin. In Old Orchard und York (Maine) und an den Stränden von Nantucket und Nantasket in Massachusetts herrschte an jedem Wochenende und in den Sommerferien reges Treiben; in Newport, der Hochburg des Segelsports in Rhode Island, wurden der America's Cup und die Regatten des Yacht Clubs von New York abgehalten. Im Landesinnern, im Hudsontal in den Appalachen, profitierte der Tourismus vom Fortschritt in der Transportindustrie und der Bewirtschaftung der Naturschauplätze: Zahnradbahnen in den White Mountains, neu errichtete Hotelbetriebe, Dampferfahrten auf dem Hudson River sowie auf dem Lake George, dem Lake Champlain, dem Lake Winnipesaukee und anderen.

Die Ostküste war also die bei Weitem bevölkerungsreichste Region der Vereinigten Staaten: Dies galt – wie wir gesehen haben – für New York, doch auch die Einwohnerzahlen von Boston, Philadelphia und Baltimore nahmen aufgrund der Immigration, die mit den politischen Unruhen in Europa und Asien, vor allem in China, in Zusammenhang stand, von Jahr zu Jahr zu. Laut einem Artikel von Professor Maurice Zimmermann (erschienen in den *Annales de Géographie*, 1909) „kamen in den Jahren 1905, 1906 und 1907 über eine Million Migranten ins Land, wobei der absolute Rekord in das Jahr 1907 fiel, in dem über 1,28 Millionen Menschen in die Vereinigten Staaten einreisten".

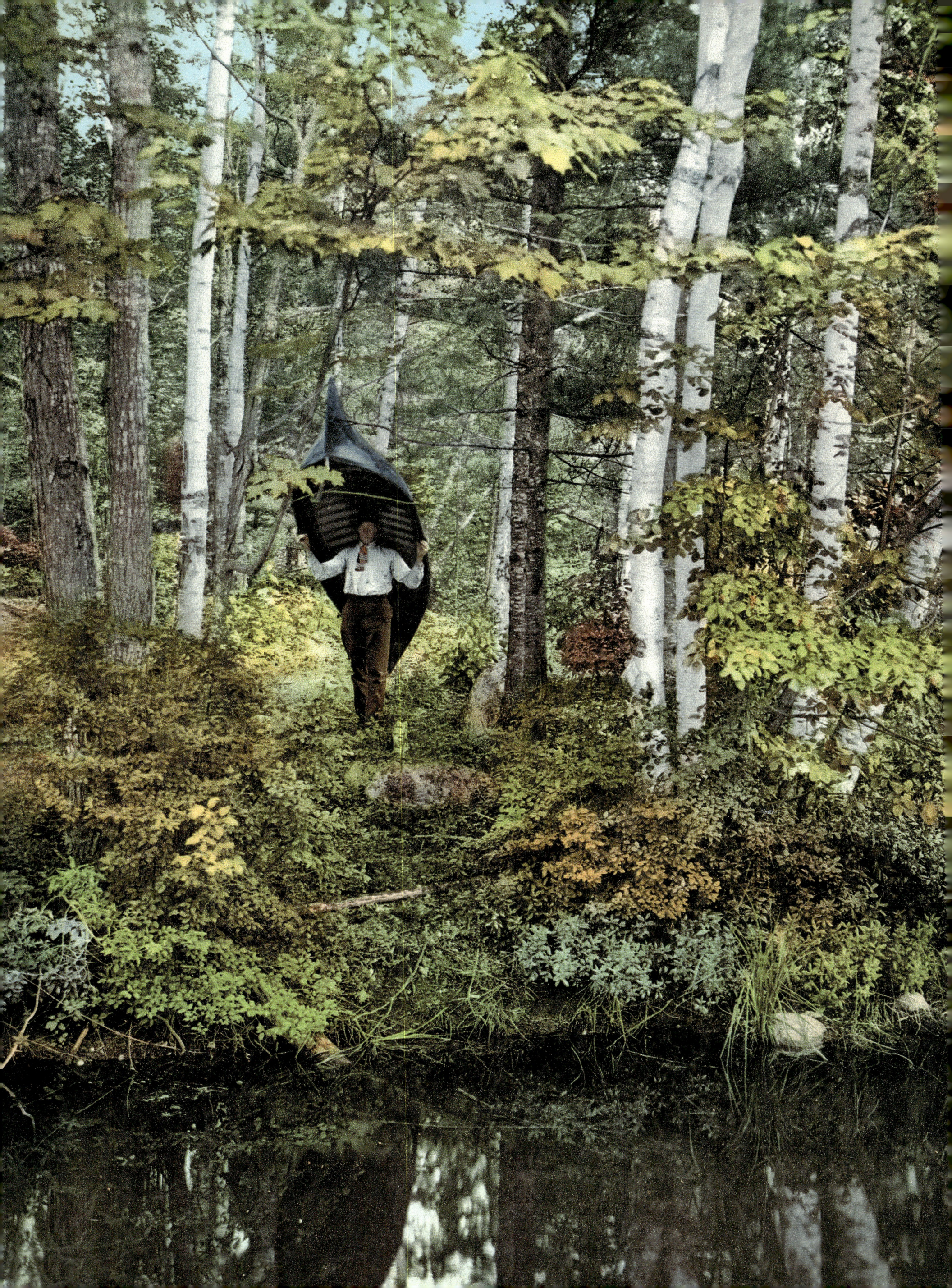

Page 92: An Adirondack carry, photochrom
Near right: Frankenstein Trestle, Crawford Notch, White Mountains, New Hampshire
Far right: Undercliff, Lake Minnewaska, New York

Seite 92: Ein Kanuträger in den Adirondacks, Photochrom
Rechts: Die Eisenbahnbrücke Frankenstein Trestle, Crawford Notch, White Mountains, New Hampshire
Rechts außen: Unter dem Felsen, Lake Minnewaska, New York

Page 92 : porteur de canoë dans les Adirondacks, photochrome
Ci-contre : le pont ferroviaire de Frankenstein, Crawford Notch, White Mountains, New Hampshire
À droite : sous la falaise, lac Minnewaska, New York

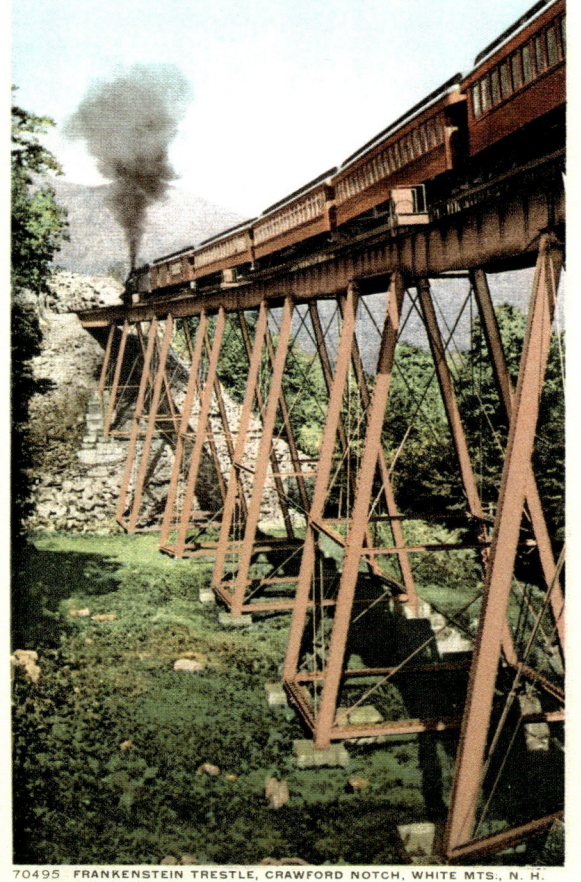
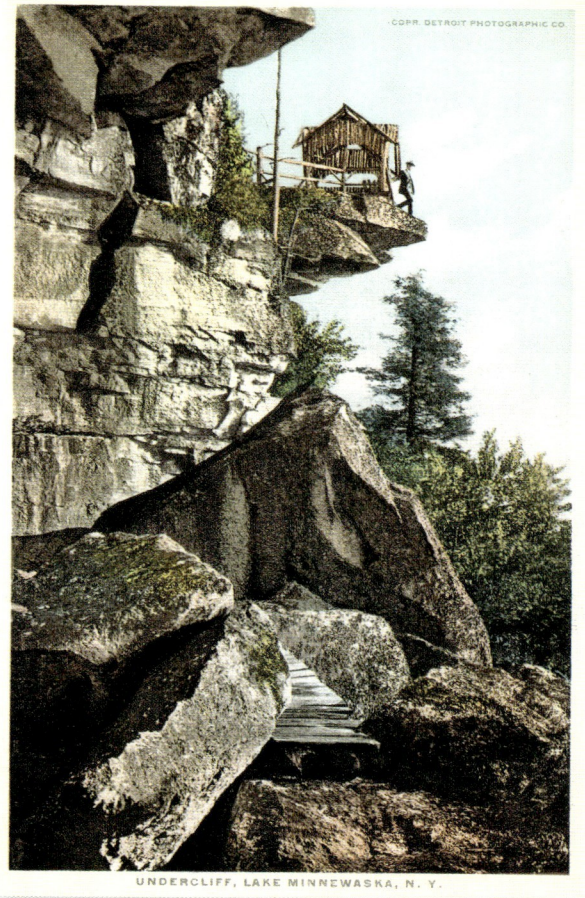

LA CÔTE EST ET LE QUÉBEC

Le premier guide Baedeker américain, paru en 1893, nous apprend qu'il fallait dix à douze heures de train pour parcourir, grâce au chemin de fer du Grand Trunk Railway, les quelque 400 kilomètres qui séparent Portland (Maine) de Montréal ; cinq heures supplémentaires menaient le voyageur plus au nord, à Québec, à l'issue d'un voyage confortable mais qui nous semble tout de même assez long. Quand on aura dit que Samuel de Champlain, qui jeta les fondations de Québec en 1608, descendit la côte atlantique jusqu'à Cape Cod (Massachusetts) et explora le Canada, à cheval, à pied ou en canoë, d'Acadie (Nouvelle-Écosse) jusqu'au lac qui porte son nom à la frontière de l'État de New York – et cela en devant négocier avec les Indiens Algonquins et Hurons, qui eux-mêmes combattaient les Iroquois –, on trouvera que voyager en 1893 était devenu un jeu d'enfant ! Si l'on ajoute que, chassés par les Anglais et abandonnés par les Français, les Acadiens quittèrent leur colonie au milieu du XVIIIe siècle en charrette, et que certains allèrent ainsi jusqu'à La Nouvelle-Orléans, on ne pourra qu'être conforté dans l'idée que la fin du XIXe siècle était une époque moderne. Les vues photographiques de la côte Est de l'Amérique du Nord publiées ici en apportent d'ailleurs la preuve.

Bateaux à vapeur, villes éclairées à l'électricité, aménagements hydro-électriques des chutes du Niagara, tramways, gratte-ciel, grands ponts métalliques au-dessus de l'Hudson et de la Niagara River, hauts-fourneaux de Pittsburgh, équipements portuaires industriels de Buffalo sur le lac Érié, chantiers navals de Kittery (Maine) ou de Philadelphie : les anciennes colonies anglaises de la côte Est se tournent résolument vers l'avenir.

Du Maine à Baltimore, à la belle saison, des hôtels « tout confort » ouvrent leurs portes aux « baigneurs » toujours plus nombreux le long du littoral atlantique. Atlantic City, dans le New Jersey, est *la* station en vogue du moment. York, Old Orchard dans le Maine, les plages de Nantucket et de Nantasket dans le Massachusetts s'animent chaque week-end et pendant les vacances d'été ; Newport, haut lieu du yachting dans le Rhode Island, accueille la Coupe de l'America et les régates du Yacht Club de New York. À l'intérieur des terres, dans la vallée de l'Hudson, dans les Appalaches, le tourisme bénéficie du progrès des transports et de l'aménagement des sites naturels : trains à crémaillère dans les White Mountains, création d'établissements hôteliers, organisation d'excursions en steamer sur l'Hudson, sur les lacs George, Champlain, Winnipesaukee, etc.

Enfin, la côte Est est, de loin, la plus peuplée des États-Unis : New York mais aussi Boston, Philadelphie et Baltimore voient leur population augmenter d'année en année du fait de l'immigration qui suit le rythme des troubles politiques européens et asiatiques, notamment chinois. Selon un article du professeur Maurice Zimmermann, paru dans les *Annales de Géographie* en 1909, « les années 1905, 1906 et 1907 voient débarquer plus d'un million de migrants, avec un record absolu pour l'année 1907 durant laquelle plus de 1,28 million de personnes rejoignent les États-Unis. »

NEW YORK

Page 94/95: Poughkeepsie Bridge (over the Hudson), photochrom
Right: West Point from the Hudson River
Middle: The casino on the summit of Mount Beacon
Bottom: Mount Beacon Incline Railway, photochrom

Seite 94/95: Poughkeepsie Bridge (über den Hudson), Photochrom
Rechts: West Point vom Hudson River aus
Mitte: Das Casino auf dem Gipfel des Mount Beacon
Unten: Die Zahnradbahn am Mount Beacon, Photochrom

Pages 94/95 : le pont de Poughkeepsie (sur l'Hudson), photochrome
À droite : West Point, vue depuis l'Hudson
Ci-dessous : le casino au sommet du mont Beacon
En bas : le chemin de fer à crémaillère du mont Beacon, photochrome

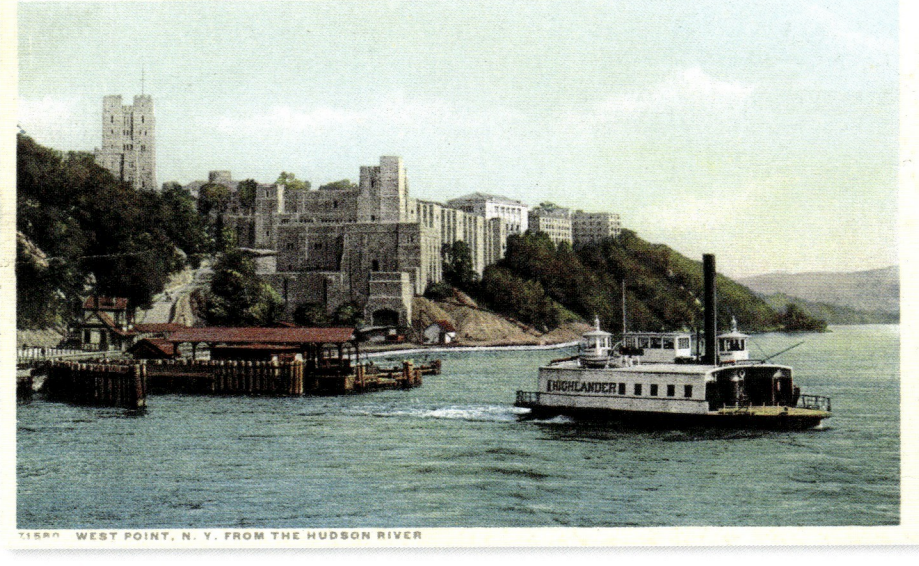

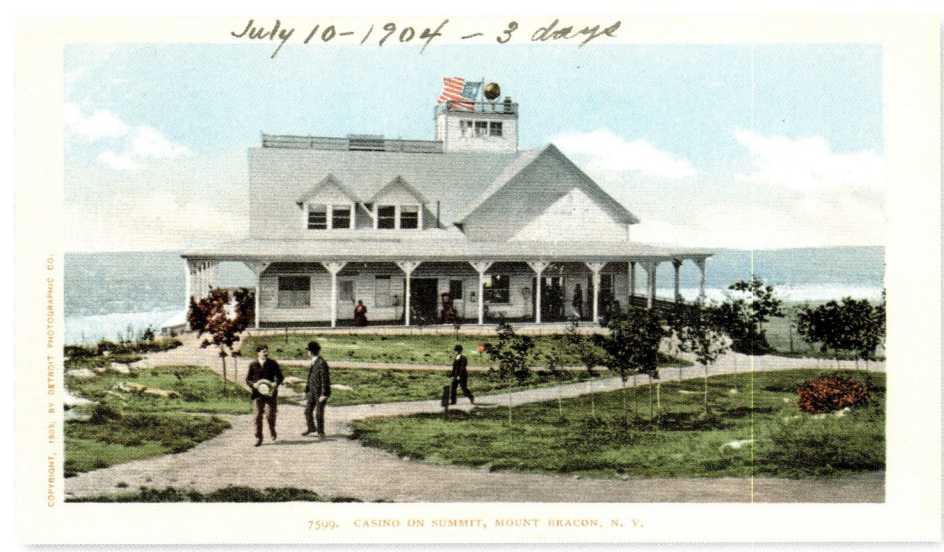

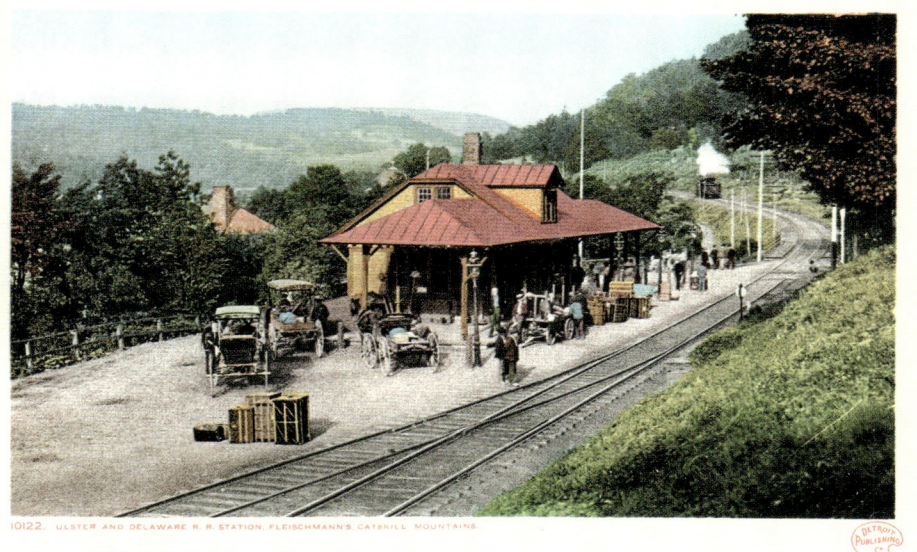
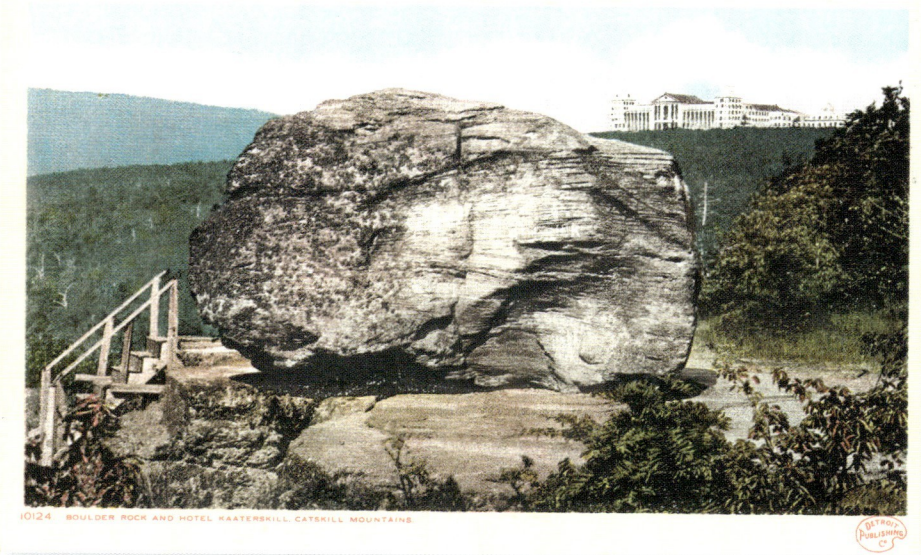

Top left: **Ulster & Delaware Railroad Station, Fleischmann, Catskill Mountains**
Top right: **Boulder Rock and Hotel Kaaterskill, Catskill Mountains**
Bottom: **The Otis Elevating Railway, Catskill Mountains, photochrom**
Page 98/99: **The home of Rip Van Winkle, Sleepy Hollow, photochrom**

Lying on the road leading up to the summit of South Mountain, at Sleepy Hollow in the Catskills, Rip Van Winkle's cabin became a tourist attraction in 1826. Popularized by Washington Irving's eponymous short story of 1819, the legend of old Rip Van Winkle waiting on his bench to recount his fabulous adventure to strangers passing through the village contributed to the success of the new hotel, opened in 1867. The Otis funicular, built in 1892, made it easy to reach the summit of South Mountain.

Oben links: **Bahnhof der Ulster & Delaware Railroad, Fleischmann, Catskill Mountains**
Oben rechts: **Boulder Rock und das Hotel Kaaterskill, Catskill Mountains**
Unten: **Die Otis-Seilbahn, Catskill Mountains, Photochrom**
Seite 98/99: **Das Haus von Rip Van Winkle, Sleepy Hollow, Photochrom**

Die Hütte von Rip Van Winkle, die auf dem Weg zum Gipfel des South Mountain in Sleepy Hollow in den Catskills lag, war seit 1826 eine Zwischenstation für die Reisenden. Die durch die 1819 erschienene Novelle von Washington Irving bekannt gewordene Legende des alten Rip Van Winkle, der auf seiner Bank die Touristen auf der Durchreise erwartete, um ihnen von seinem sagenhaften Abenteuer zu erzählen, trug mit zum Erfolg des neuen, 1867 eröffneten Hotels bei. Mit der 1892 in Betrieb genommenen Seilbahn der Firma Otis konnte man mühelos den Gipfel des South Mountain erreichen.

En haut à gauche : **la gare de chemin de fer de la compagnie Ulster & Delaware, Fleischmann, Catskill Mountains**
En haut à droite : **le rocher de Boulder et l'hôtel Kaaterskill, Catskill Mountains**
En bas : **le funiculaire Otis, Catskill Mountains, photochrome**
Pages 98/99 : **la maison de Rip Van Winkle, Sleepy Hollow, photochrome**

Sur la route qui mène au sommet de South Mountain, à Sleepy Hollow dans les Catskills, la cabane de Rip Van Winkle fut dès 1826 une halte pour les voyageurs. Popularisée par la nouvelle de Washington Irving parue en 1819, la légende du vieux Rip Van Winkle attendant sur son banc les touristes de passage pour leur raconter sa fabuleuse aventure contribua au succès du nouvel hôtel, ouvert en 1867. Le funiculaire de la compagnie Otis mis en service en 1892 permettait de gagner sans effort le sommet de South Mountain.

NEW YORK | CATSKILLS

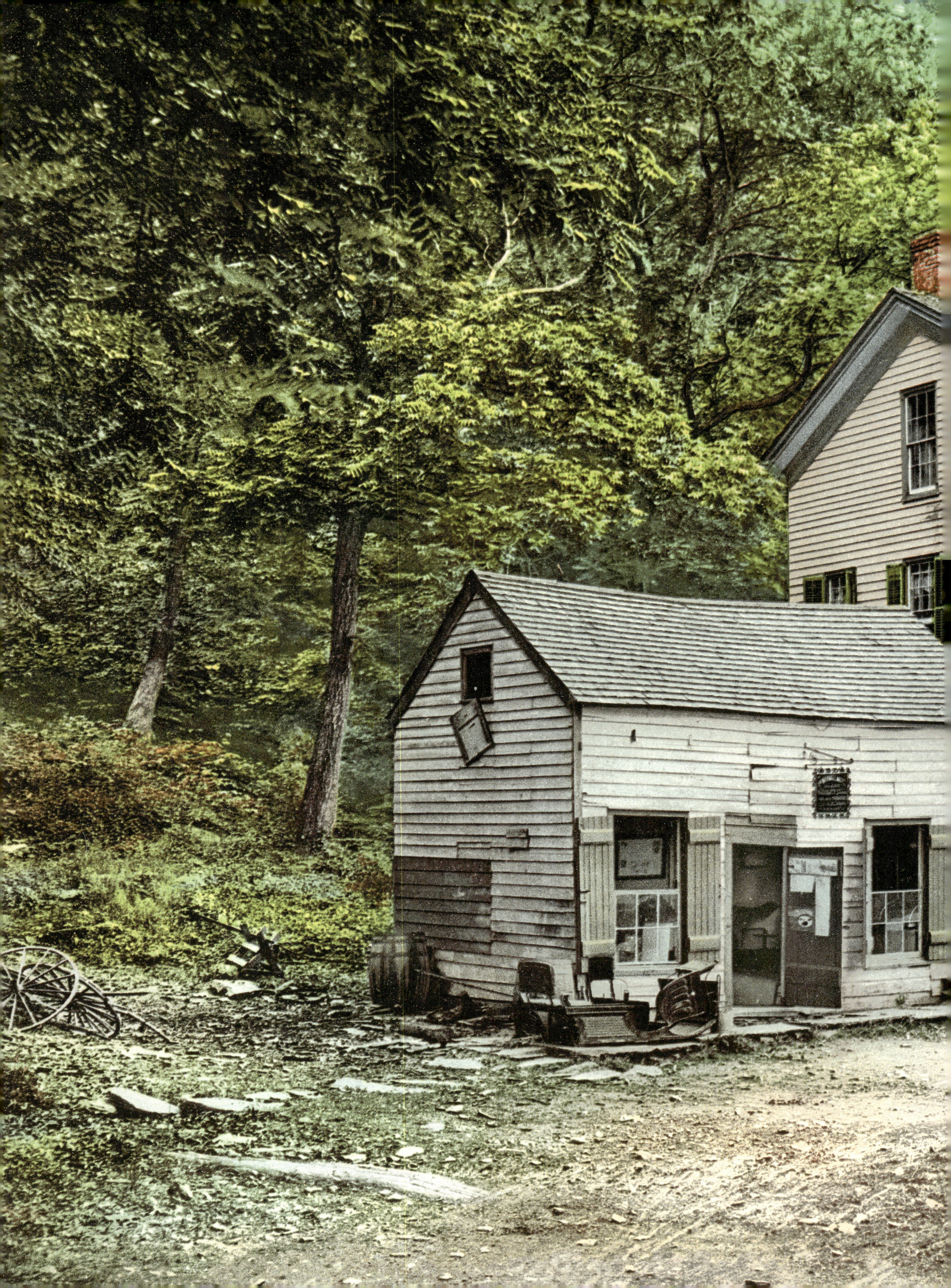

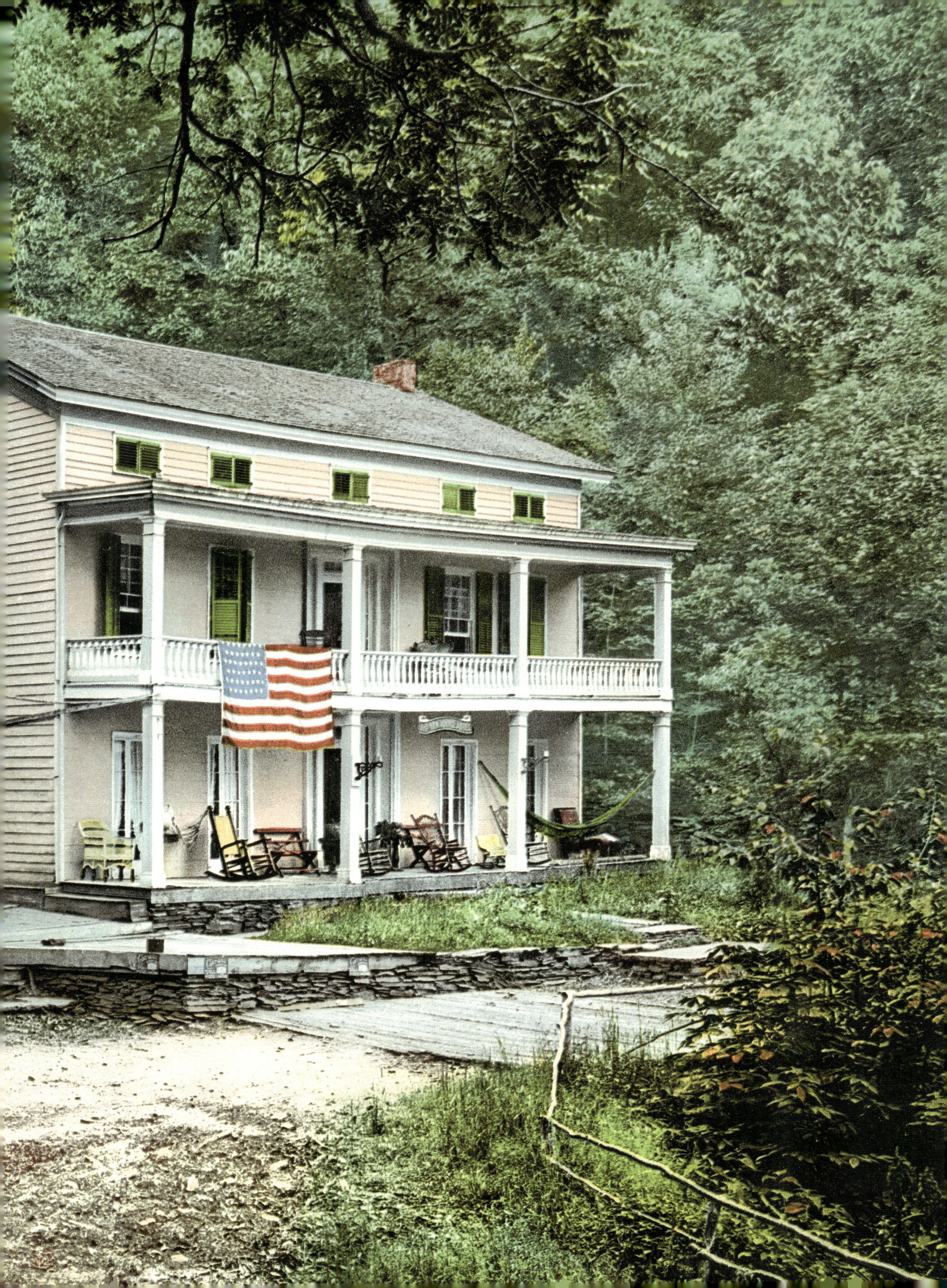

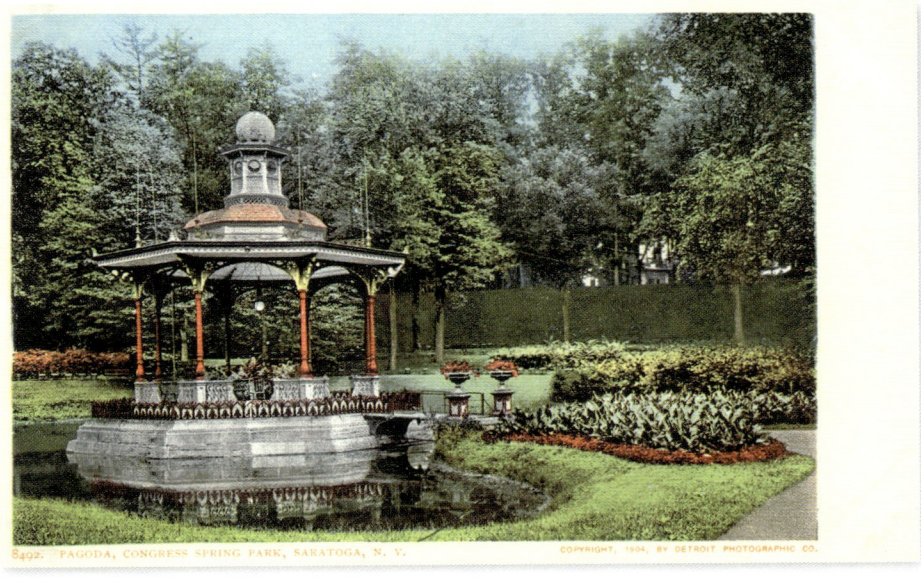
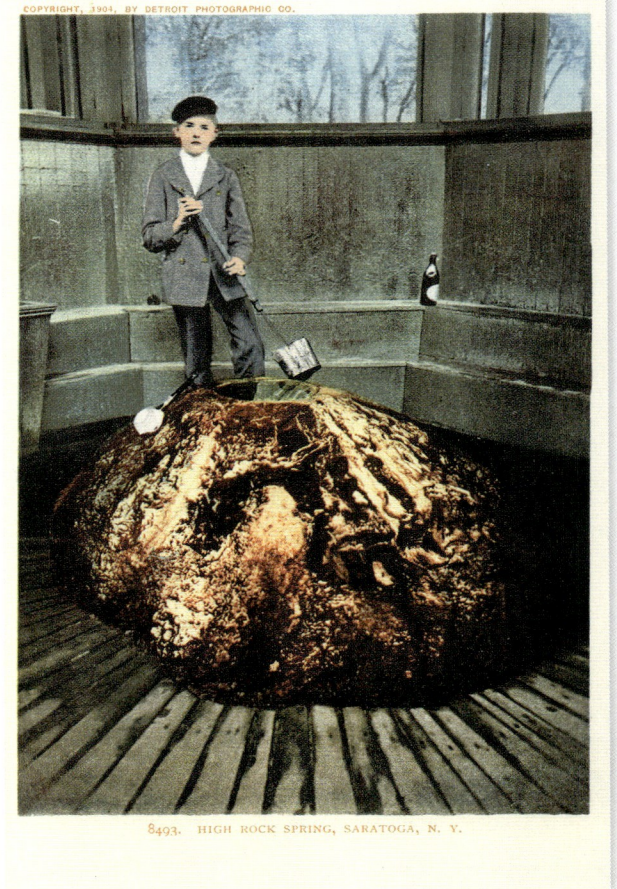

Above: Pagoda, Congress Spring Park, Saratoga
Right: High Rock Spring, Saratoga
Below: White Sulphur Spring, Saratoga Lake, glass negative, 1900–1910

Oben: Pagode, Congress Spring Park, Saratoga
Rechts: Die Quelle High Rock Spring, Saratoga
Unten: Die Quelle White Sulphur Spring, Saratoga Lake, Glasnegativ, 1900–1910

En haut : la Pagode, Parc des sources du Congrès, Saratoga
À droite : la source de High Rock, Saratoga
En bas : la source de White Sulphur Spring, lac de Saratoga, plaque de verre, 1900–1910

NEW YORK | SARATOGA

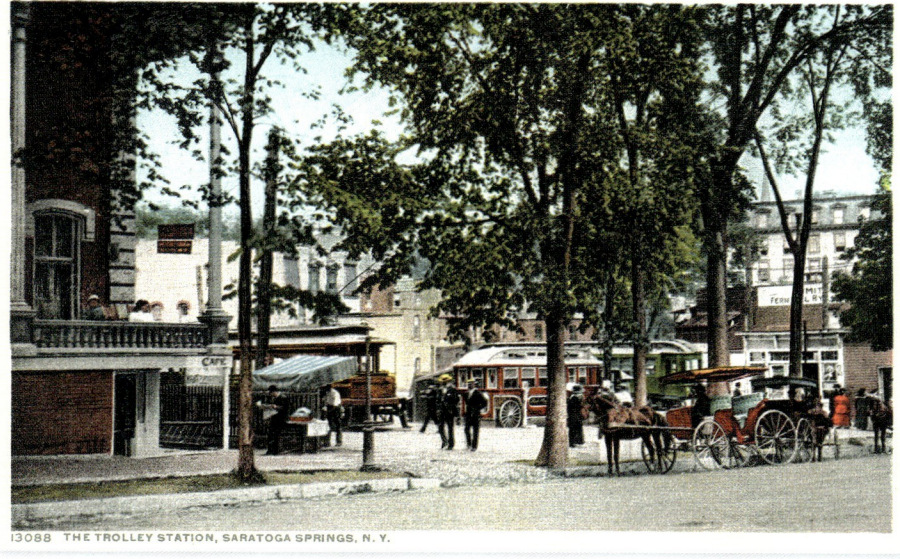
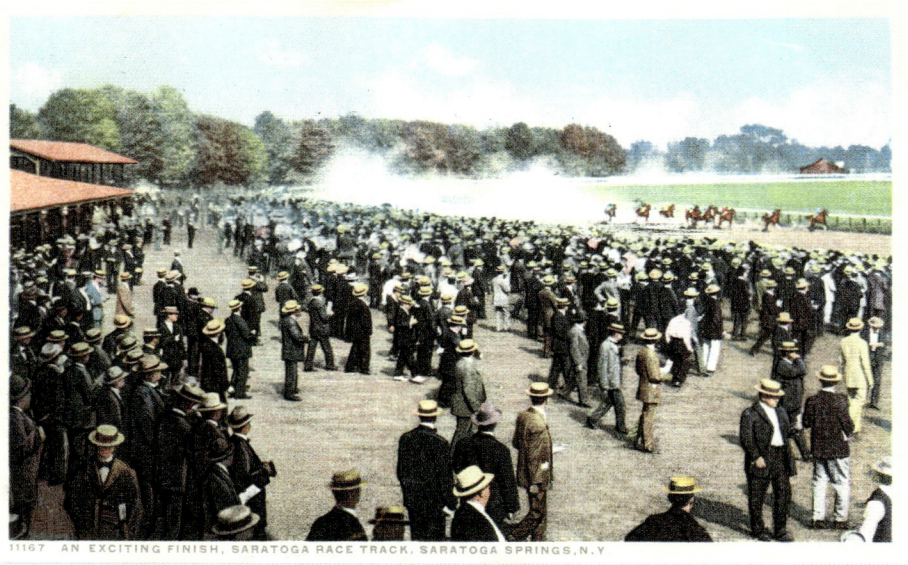

Top left: **The trolley station, Saratoga**
Top right: **An exciting finish, Saratoga race track, Saratoga**
Bottom: **Saratoga Race Course, Saratoga, glass negative, 1910**

The Mohawks drank the spring water of Saratoga well before the arrival of the first settlers, deeming its carbonated water a sacred medicine. It is said that, in 1783, General George Washington stopped at High Rock to taste the spring water. Saratoga is famous for its horse races. The first horse-race meeting in the Union took place there on August 3, 1863, a month after the Battle of Gettysburg.

Oben links: **Die Trolley-Station in Saratoga**
Oben rechts: **Ein aufregender Zieleinlauf, Pferderennbahn von Saratoga**
Unten: **Pferderennbahn von Saratoga, Glasnegativ, 1910**

Die Mohawk tranken schon lange vor der Ankunft der ersten Siedler Wasser aus den Quellen von Saratoga: Sie hielten es wegen seines Kohlensäuregehalts für heilige Medizin. Man sagt, General George Washington habe 1783 in High Rock haltgemacht, um das Quellwasser zu kosten. Saratoga ist für seine Pferderennen berühmt; das erste Pferdesportereignis der Union fand am 3. August 1863, einen Monat nach der Schlacht von Gettysburg, statt.

En haut à gauche : **la station de trolley, Saratoga**
En haut à droite : **une arrivée excitante, champ de courses de Saratoga**
En bas : **le champ de courses de Saratoga, plaque de verre, 1910**

Les Mohawks buvaient l'eau des sources de Saratoga bien avant l'arrivée des premiers colons : ils considéraient cette eau gazeuse comme une médecine sacrée. On dit qu'en 1783 le général George Washington fit une halte à High Rock pour la goûter. Saratoga est célèbre pour ses courses de chevaux ; le premier rassemblement sportif équestre de l'Union s'y déroula le 3 août 1863, un mois après la bataille de Gettysburg.

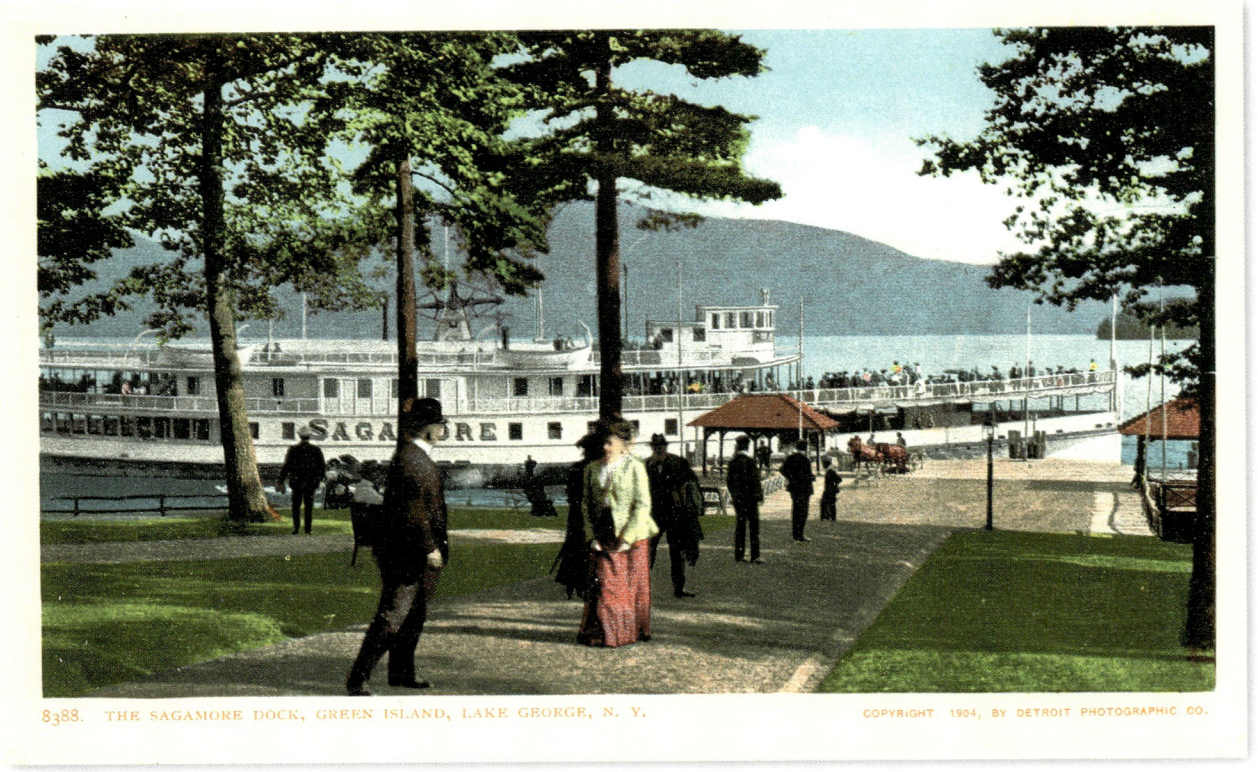

8388. THE SAGAMORE DOCK, GREEN ISLAND, LAKE GEORGE, N. Y. COPYRIGHT 1904, BY DETROIT PHOTOGRAPHIC CO.

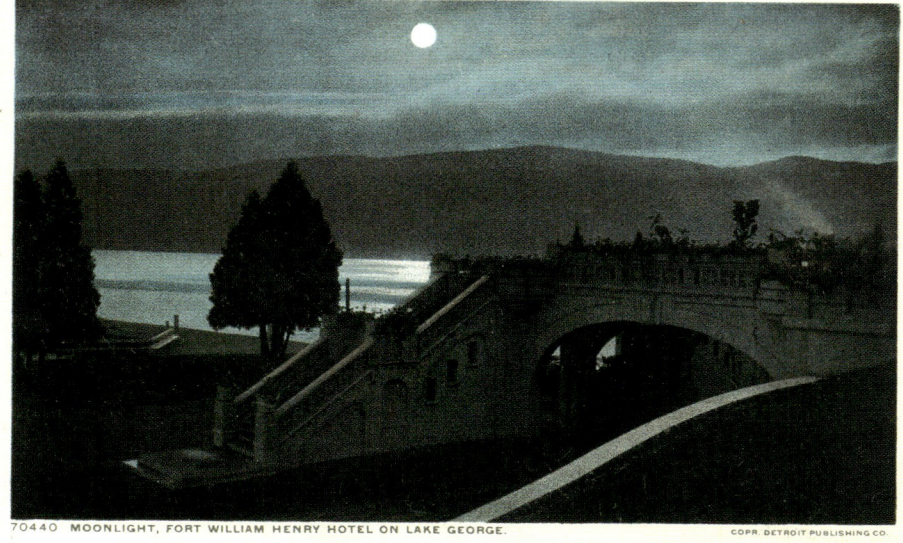

Top left: The Pergola Casino, Fort William Henry Hotel
Top right: Moonlight, Fort William Henry Hotel
Bottom: Among the Harbor Islands on Lake George, photochrom
Page 102:
Above: The Sagamore dock, Green Island, Lake George
Below: Approaching Sagamore dock, photochrom

From the early 19th century, the beauty of Lake George and the proximity of the major cities of New York State, Canada, New Hampshire, Maine, Vermont, and Massachusetts made it a celebrated holiday resort. It is also a place of historical significance: Fort William Henry, Fort Ticonderoga, and Fort Carillon, all on the banks of the lake, were major battlefields during the French and Indian War (the American theater of the Seven Years War).

Oben links: Das Pergola-Kasino und das Hotel Fort William Henry
Oben rechts: Mondschein, Hotel Fort William Henry
Unten: Entlang der Harbor Islands auf dem Lake George, Photochrom
Seite 102:
Oben: Der Anlegeplatz von Sagamore, Green Island, Lake George
Unten: Anfahrt zum Sagamore-Landesteg, Photochrom

Die Schönheit des Lake George und dessen Nähe zu den großen Städten des Staates New York, aber auch zu Kanada, New Hampshire, Maine, Vermont und Massachusetts machten den See zu Beginn des 19. Jahrhunderts zu einem sehr beliebten Ferienziel. Der Lake George ist zugleich auch ein äußerst geschichtsträchtiger Ort: Die an senen Ufern gelegenen Festungen Fort William Henry, Fort Ticonderoga und Fort Carillon waren während des Siebenjährigen Krieges Schauplatz großer Schlachten gewesen.

En haut à gauche : casino de la Pergola, hôtel Fort William Henry
En haut à droite : clair de lune, hôtel Fort William Henry
En bas : en passant par les îles d'Harbor sur le lac George, photochrome
Page 102:
En haut : le quai de Sagamore, Green Island, lac George
En bas : en vue du quai de Sagamore, photochrome

La beauté du lac George et la proximité de grandes villes de l'État de New York mais aussi du Canada, du New Hampshire, du Maine, du Vermont et du Massachusetts en ont fait un lieu de villégiature très renommé dès le début du xixe siècle. Le lac George est aussi un site chargé d'histoire : sur ses rives, Fort William Henry, Fort Ticonderoga, Fort Carillon ont été le théâtre de grandes batailles lors de la guerre de Sept Ans.

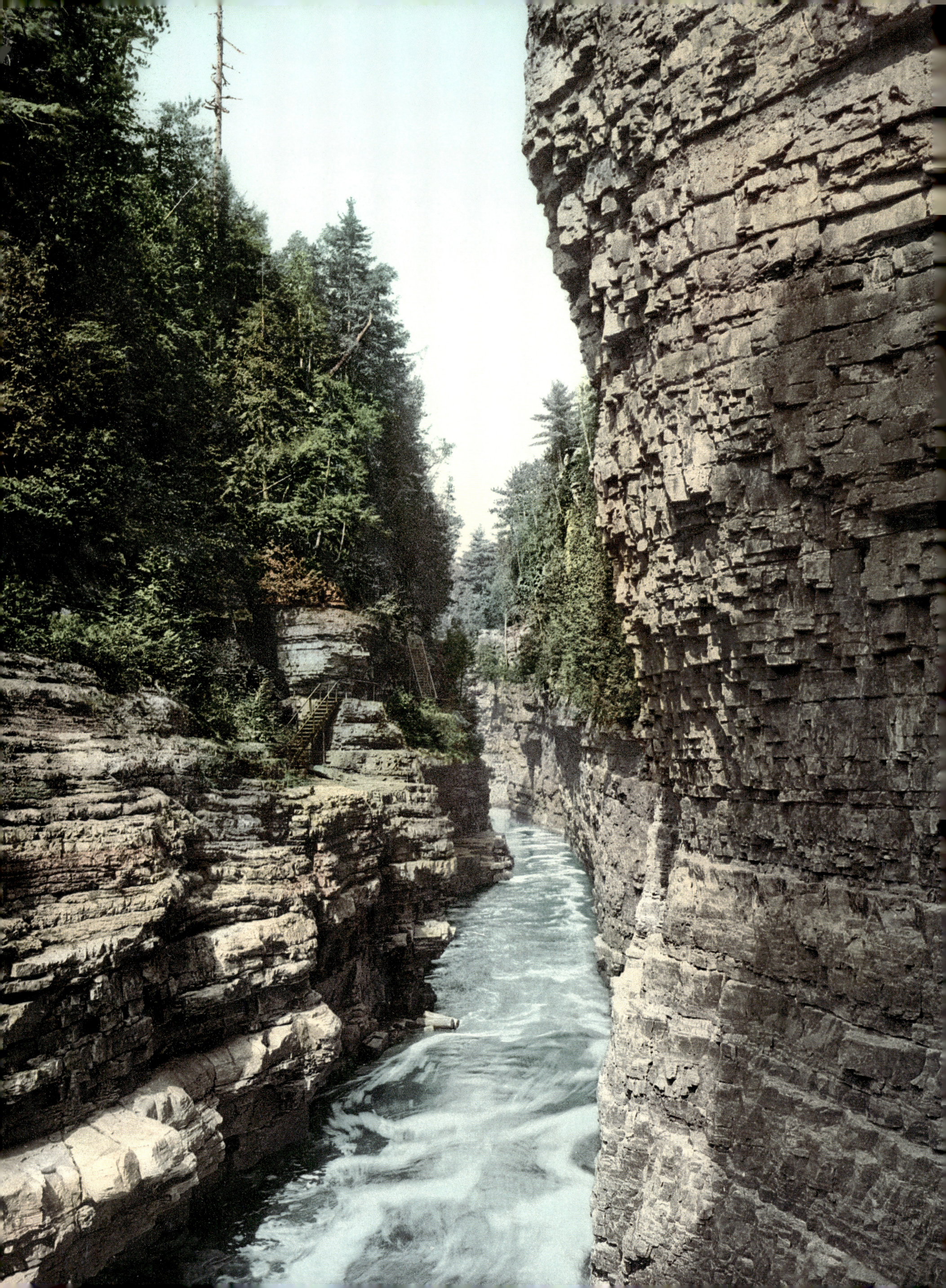

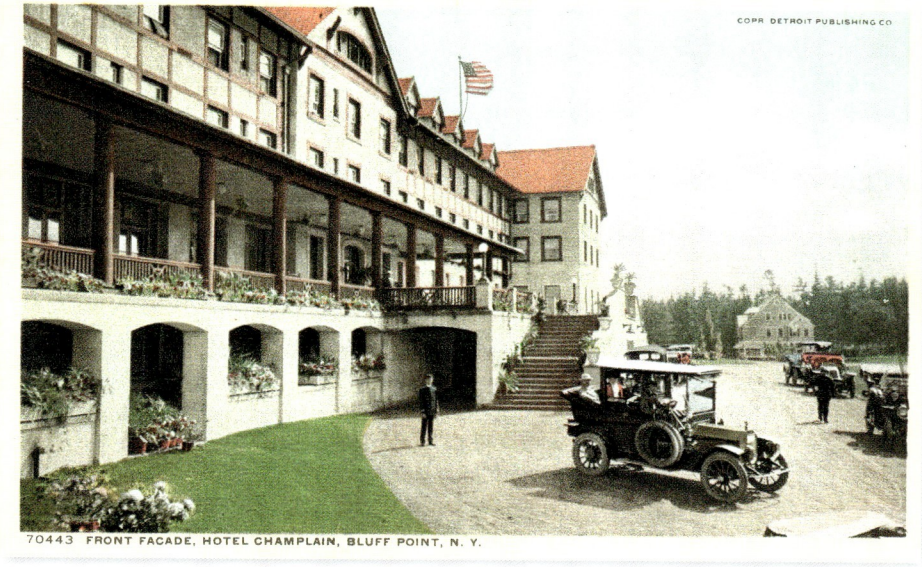
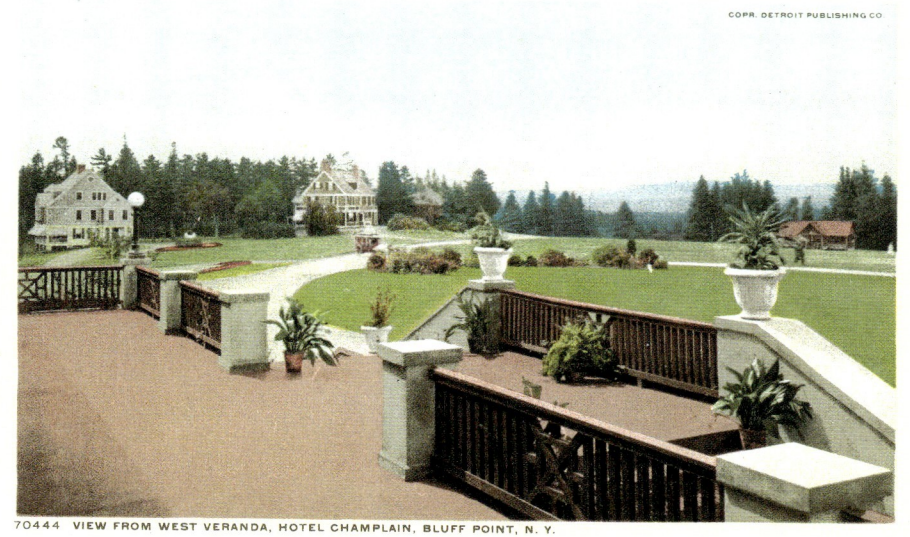
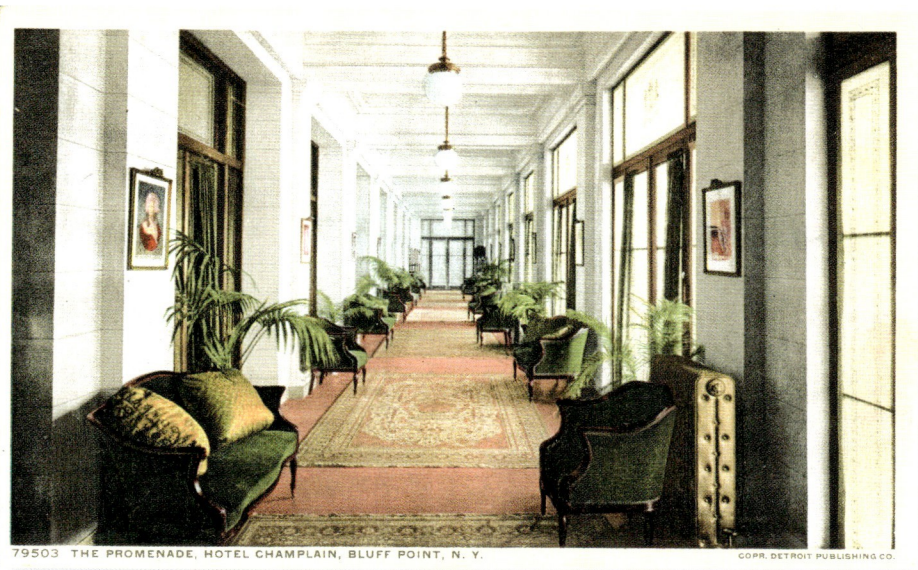

Page 104: Ausable Chasm, photochrom
Top left: Front facade, Hotel Champlain, Bluff Point
Top right: View from the west veranda, Hotel Champlain, Bluff Point
Right: The Promenade, Hotel Champlain, Bluff Point
Bottom: Running the rapids, Ausable Chasm

Ausable Chasm is said to have been discovered in the mid-18th century by William Gilliland, an Irish settler exploring the west bank of Lake Champlain. Steering his boat through the sandy mouth of the Ausable River, he followed the tranquil river upstream till he reached the rapids, where he perceived the gorge framed by its high cliffs.

Seite 104: Ausable Chasm (Ausable-Schlucht), Photochrom
Oben links: Eingangsfront des Hotels Champlain, Bluff Point
Oben rechts: Blick von der westlichen Veranda des Hotels Champlain, Bluff Point
Rechts: Die Promenade, Hotel Champlain, Bluff Point
Unten: Auf den Stromschnellen hinab, Ausable Chasm

Die Ausable-Schlucht soll Mitte des 18. Jahrhunderts von dem irischen Siedler William Gilliland entdeckt worden sein, der das westliche Seeufer des Lake Champlain erkundete. An der Flussmündung folgte sein Schiff dem sandigen Gewässer des Ausable River und fuhr den ruhigen Lauf des Flusses bis zu den Stromschnellen hinauf: Dort entdeckte William Gilliland den von hohen Felsen eingefassten Eingang zur Schlucht.

Page 104: Ausable Chasm (la gorge d'Ausable), photochrome
En haut à gauche: façade de l'hôtel Champlain, Bluff Point
En haut à droite: vue depuis la véranda de l'hôtel Champlain
À droite: la promenade, hôtel Champlain, Bluff Point
En bas: descente des rapides, Ausable Chasm

La gorge d'Ausable Chasm aurait été découverte au milieu du XVIIIe siècle par William Gilliland, un colon irlandais qui explorait la rive ouest du lac Champlain. Son bateau s'engagea dans les eaux sableuses de l'embouchure de la rivière Ausable, remonta son cours tranquille et atteignit les rapides: là, William Gilliland aperçut l'entrée de la gorge, encaissée entre de hautes falaises.

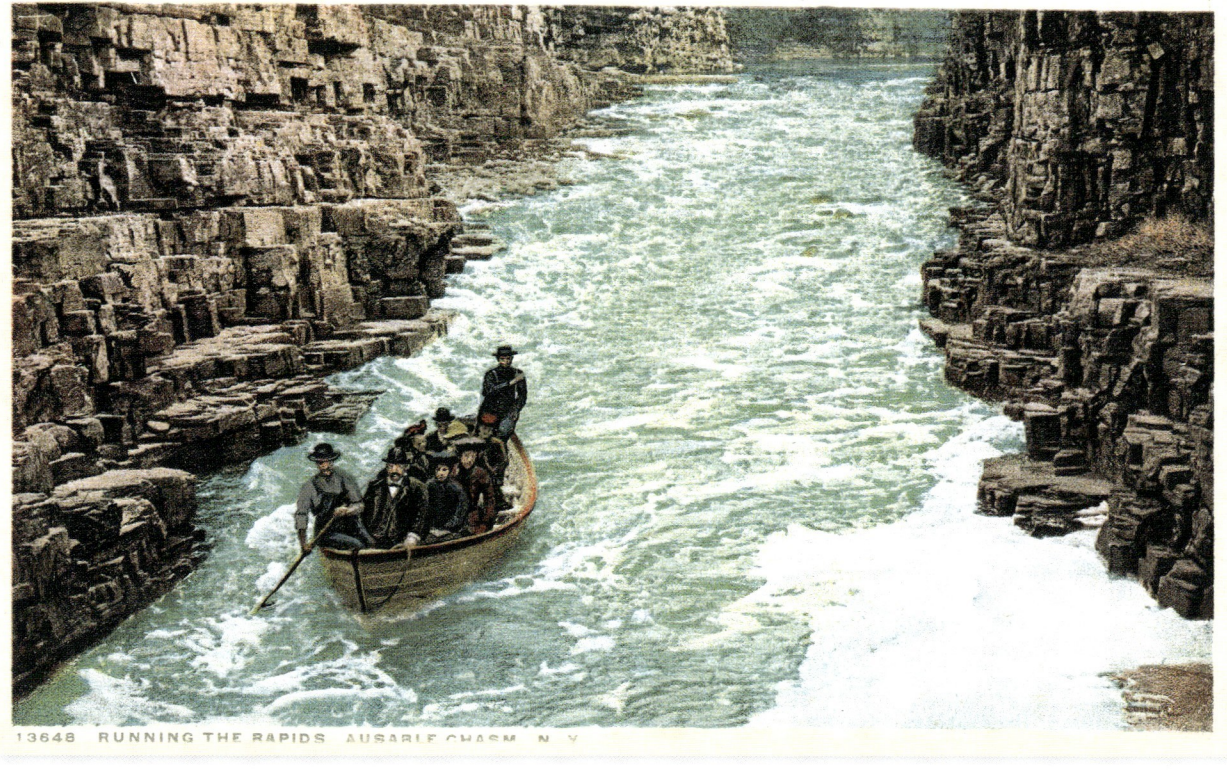

NEW YORK | AUSABLE CHASM | BLUFF POINT

Below: Steamer *Clearwater*, Fulton Chain
Bottom: An Adirondack hand cart carry, photochrom
Page 107:
Top: D & H (Delaware & Hudson) Station, Riverside
Bottom: Adirondack mountain stream, photochrom

The deforestation of the Adirondacks reached drastic proportions in the mid-19th century, when New York State unconditionally sold off some seven million acres (three million ha)—at a half a penny per acre—in the aftermath of the American Revolution. In 1872, engineer and lawyer Verplanck Colvin was appointed to undertake a geological survey of the Adirondacks; in the wake of his report, the forest was declared a protected area (1885) and subsequently a national park (1892).

Mitte: Der Dampfer *Clearwater*, Fulton Chain
Unten: Handwagen zum Kanu-Transport in die Adirondacks, Photochrom
Seite 107:
Oben: Bahnhof der D & H (Delaware & Hudson), Riverside
Unten: Wasserweg in den Adirondack Mountains, Photochrom

Die intensive Rodung in den Wäldern des Adirondack-Gebirges nahm Mitte des 19. Jahrhunderts ein dramatisches Ausmaß an. Nach dem Unabhängigkeitskrieg waren vom Bundesstaat New York rund drei Millionen Hektar – für einen Penny pro Hektar! – ohne jegliche Auflagen öffentlich verkauft worden. 1872 wurde der Ingenieur und Anwalt Verplanck Colvin offiziell mit einer Untersuchung der Adirondacks beauftragt; nach Abschluss seines Berichts wurde der Wald erst zum Schutzgebiet (1885) und später zum Nationalpark erklärt (1892).

Ci-dessous : le vapeur *Clearwater*, Fulton Chain
En bas : chariot pour transporter son canoë dans les Adirondacks, photochrome
Page 107 :
En haut : gare de la compagnie D & H (Delaware & Hudson), Riverside
En bas : cours d'eau dans les Adirondacks, photochrome

Le déboisement intensif des forêts des Adirondacks atteignit des proportions dramatiques au milieu du XIXe siècle, quelque 3 millions d'hectares ayant été vendus sans aucune restriction au public – au prix d'un penny l'hectare ! – par l'État de New York, après la guerre d'Indépendance. En 1872, l'ingénieur et homme de loi Verplanck Colvin fut officiellement chargé de l'inspection des Adirondacks ; à la suite de son rapport, la forêt fut déclarée zone protégée (1885), puis parc national (1892).

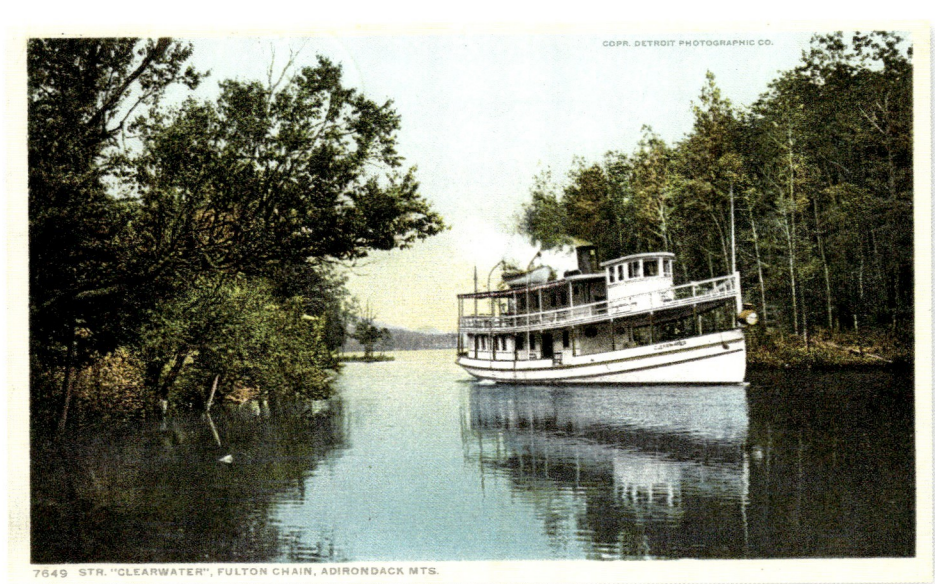

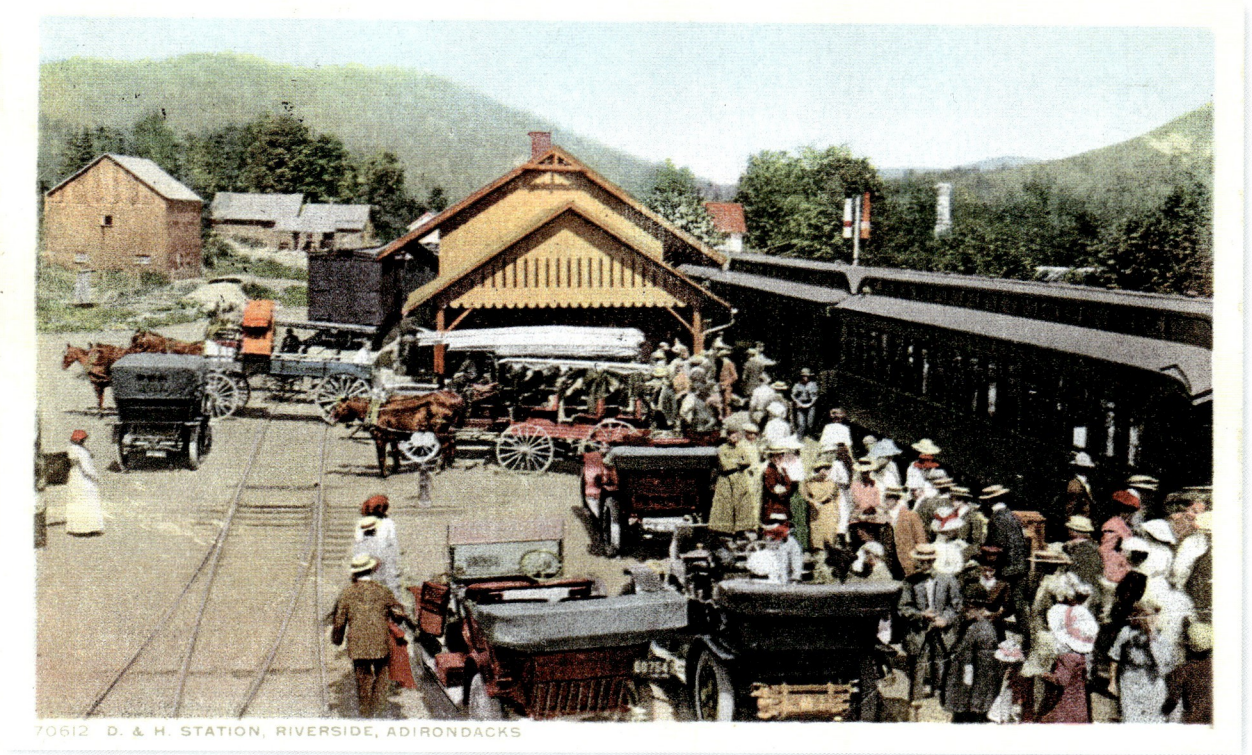

NEW YORK | ADIRONDACKS 107

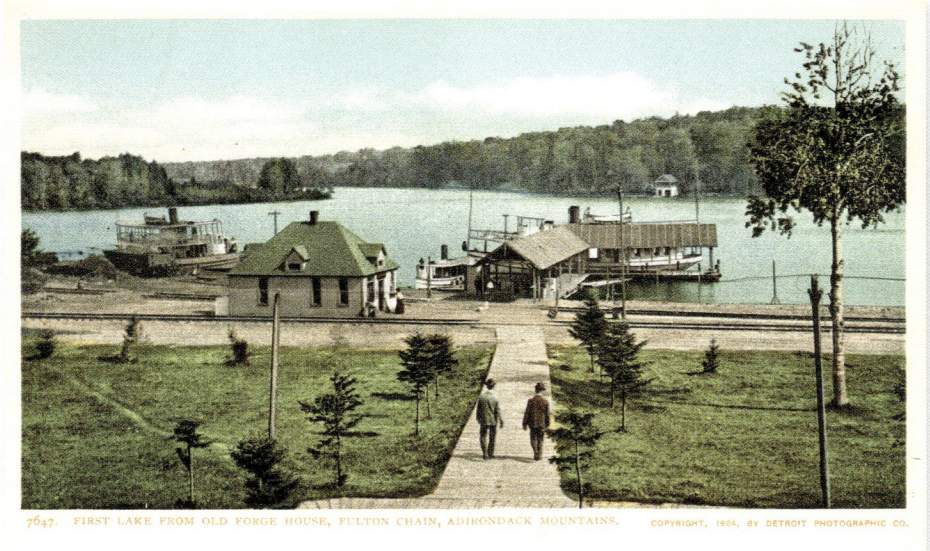
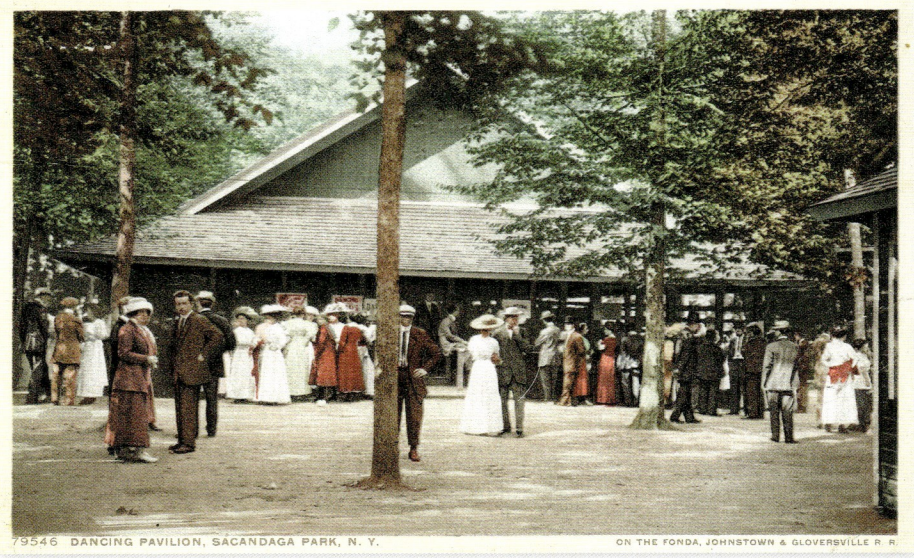

Top left: **First Lake from Old Forge House**
Top right: **Dancing Pavilion, Sacandaga Park**
Bottom: **Typical Adirondack open camp, photochrom**

In 1902, when William Henry Jackson made this photo reportage in the Adirondacks, the forest was a playground for hunters and fisherman. You could rent an "open camp" or fishing spot and practice your favorite sport without falling foul of the rules imposed by the park management.

Oben links: **First Lake von Old Forge House (der alten Schmiede) aus**
Oben rechts: **Tanzlokal, Sacandaga Park**
Unten: **Typisches offenes Lager in den Adirondacks, Photochrom**

Als William Henry Jackson 1902 diese Fotoreportage in den Adirondacks anfertigte, war der Wald ein beliebtes Gebiet für Jäger und Angler, die ein „offenes Lager" oder einen Platz zum Angeln mieten und gemäß den Regeln der Parkverwaltung ihrem Lieblingssport nachgehen konnten.

En haut à gauche : **le Premier Lac vu d'Old Forge House (la vieille forge)**
En haut à droite : **le dancing, Sacandaga Park**
En bas : **un camp ouvert typique des Adirondacks, photochrome**

En 1902, lorsque William Henry Jackson effectua ce reportage photographique dans les Adirondacks, la forêt était un espace privilégié pour les chasseurs et les pêcheurs qui pouvaient louer un « camp ouvert » ou un emplacement de pêche et pratiquer leur sport favori dans le respect des règles imposées par la direction du Parc.

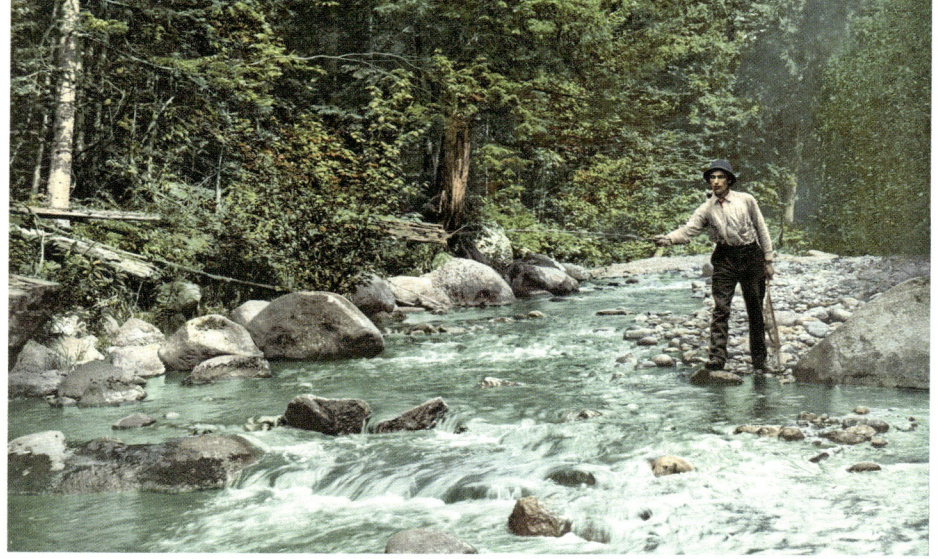

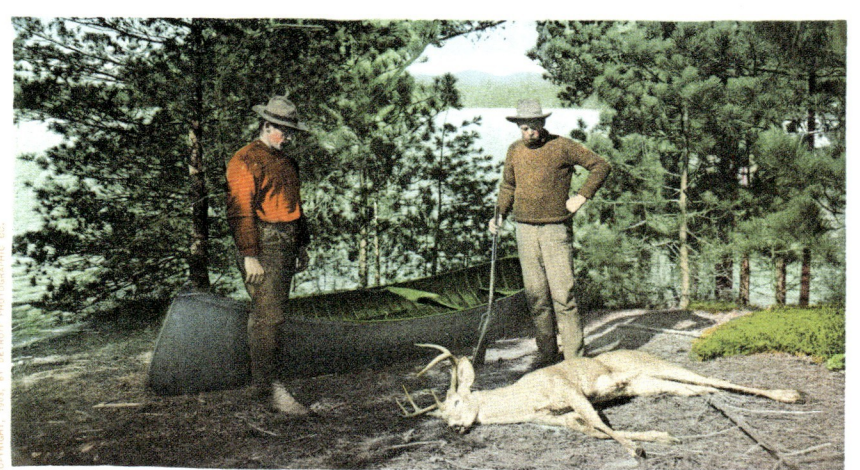

Left: **Fishing in the Adirondacks**, photochrom
Below: **Hunting in the Adirondacks**
Bottom: **Raquette Lake from St. Hubert's Isle**, photochrom

Links: **Angeln in den Adirondacks**, Photochrom
Mitte: **Jäger in den Adirondacks**
Unten: **Raquette Lake von St. Hubert's Isle aus**, Photochrom

À gauche : **pêche dans les Adirondacks**, photochrome
Ci-dessous : **chasseurs dans les Adirondacks**
En bas : **le lac Raquette de l'île de Saint-Hubert**, photochrome

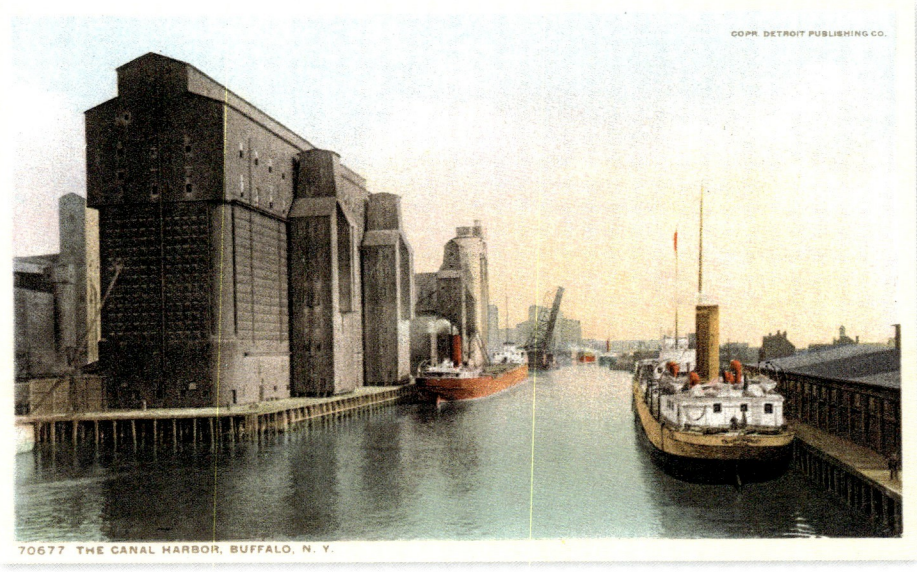
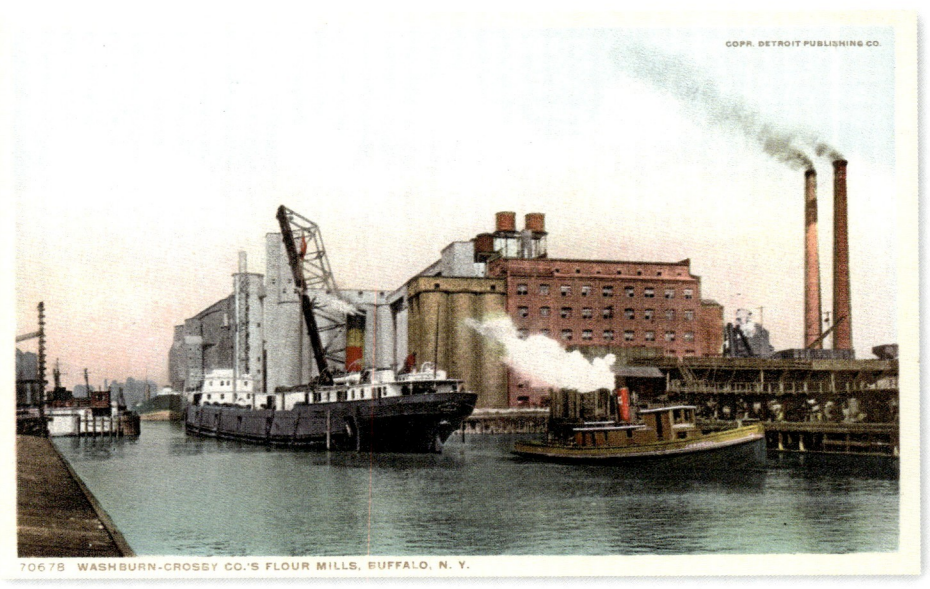

NEW YORK | BUFFALO | ROCHESTER

Below: Erie Canal at Salina Street, Syracuse, photochrom
Page 110:
Top left: The canal harbor, Buffalo
Top right: Washburn-Crosby Co. flour mills, Buffalo
Bottom: Upper Genesee Falls, Rochester, glass negative, ca. 1905
Page 112/113: Boat landing, Lake Chautauqua, photochrom

The construction of the Erie Canal, linking the Hudson River to Lake Erie and thus New York to Buffalo, lasted more than two years. Ox-drawn plows turned over the ground. The labor force was made up of underpaid and ill-equipped Irish workers fortified by large rations of whiskey. The canal was inaugurated by Governor DeWitt Clinton on October 26, 1825.

Unten: Der Eriekanal an der Salina Street, Syracuse, Photochrom
Seite 110:
Oben links: Kanalhafen, Buffalo
Oben rechts: Die Getreidemühlen der Washburn-Crosby Co., Buffalo
Unten: Upper Genesee Falls, Rochester, Glasnegativ, um 1905
Seite 112/113: Anlegestelle am Lake Chautauqua, Photochrom

Der Bau des Eriekanals, der den Hudson River mit dem Eriesee – und somit New York mit Buffalo – verband, dauerte über zwei Jahre. Man verwendete Ochsengespanne, um die Erde aufzuwerfen und abzutransportieren. Die Arbeitskräfte waren schlecht bezahlte und schlecht ausgerüstete irische Männer – die man jedoch mit großen Mengen Whiskey bei Laune hielt. Der Kanal wurde am 26. Oktober 1825 von Gouverneur DeWitt Clinton eingeweiht.

En bas : le canal Érié à Salina Street, Syracuse, photochrome
Page 110 :
En haut à gauche : le port sur le canal, Buffalo
En haut à droite : les moulins à farine de Washburn-Crosby Co., Buffalo
En bas : chutes d'Upper Genesee, Rochester, plaque de verre, vers 1905
Pages 112/113 : embarcadère sur le lac Chautauqua, photochrome

La construction du canal Érié, qui relie l'Hudson au lac Érié – et donc New York à Buffalo –, dura plus de deux ans. On utilisa des attelages de bœufs pour retourner et charrier la terre. La main-d'œuvre était constituée de travailleurs irlandais mal payés et mal équipés – mais soutenus par de larges rations de whisky. Le canal fut inauguré par le gouverneur DeWitt Clinton le 26 octobre 1825.

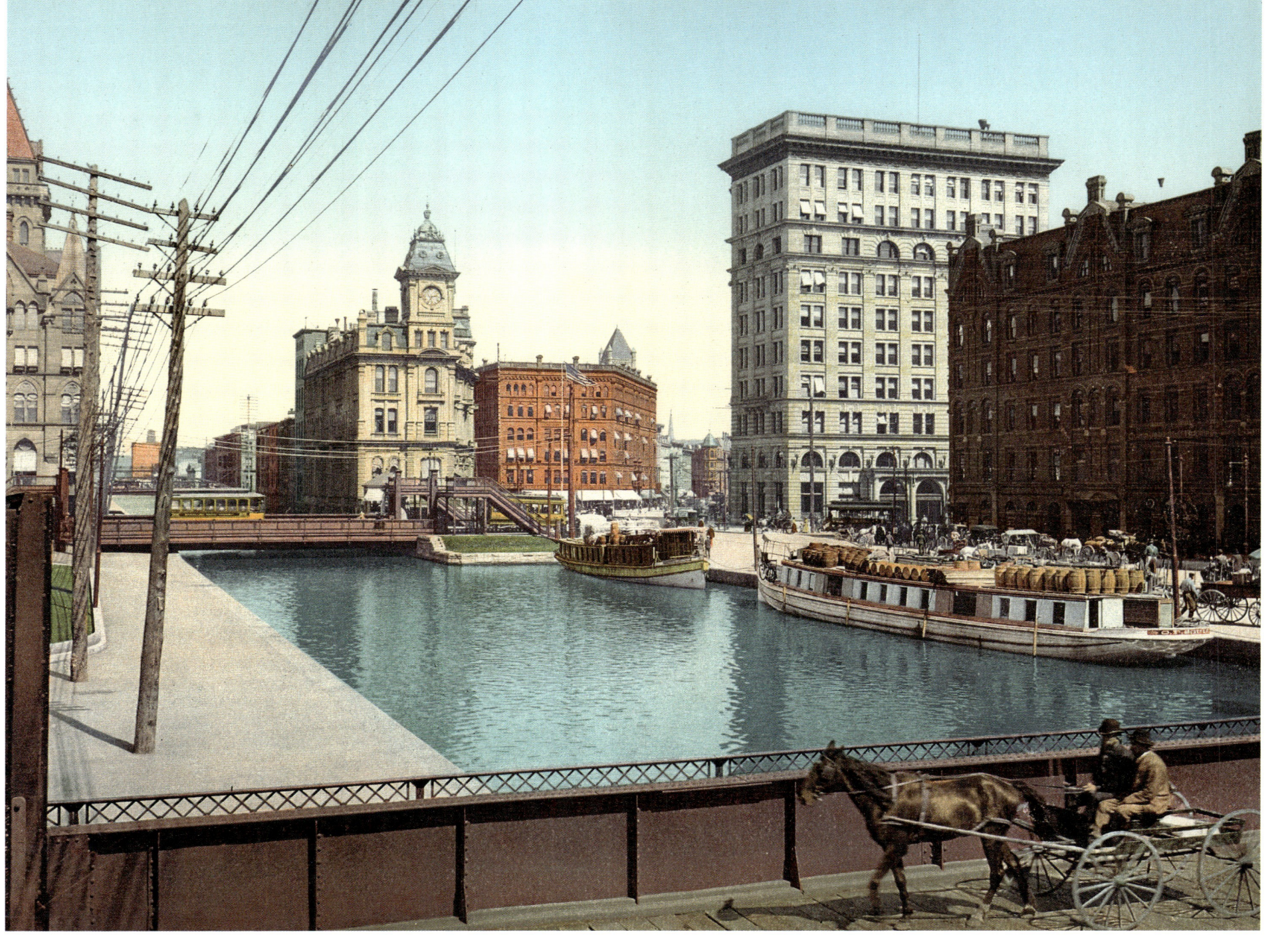

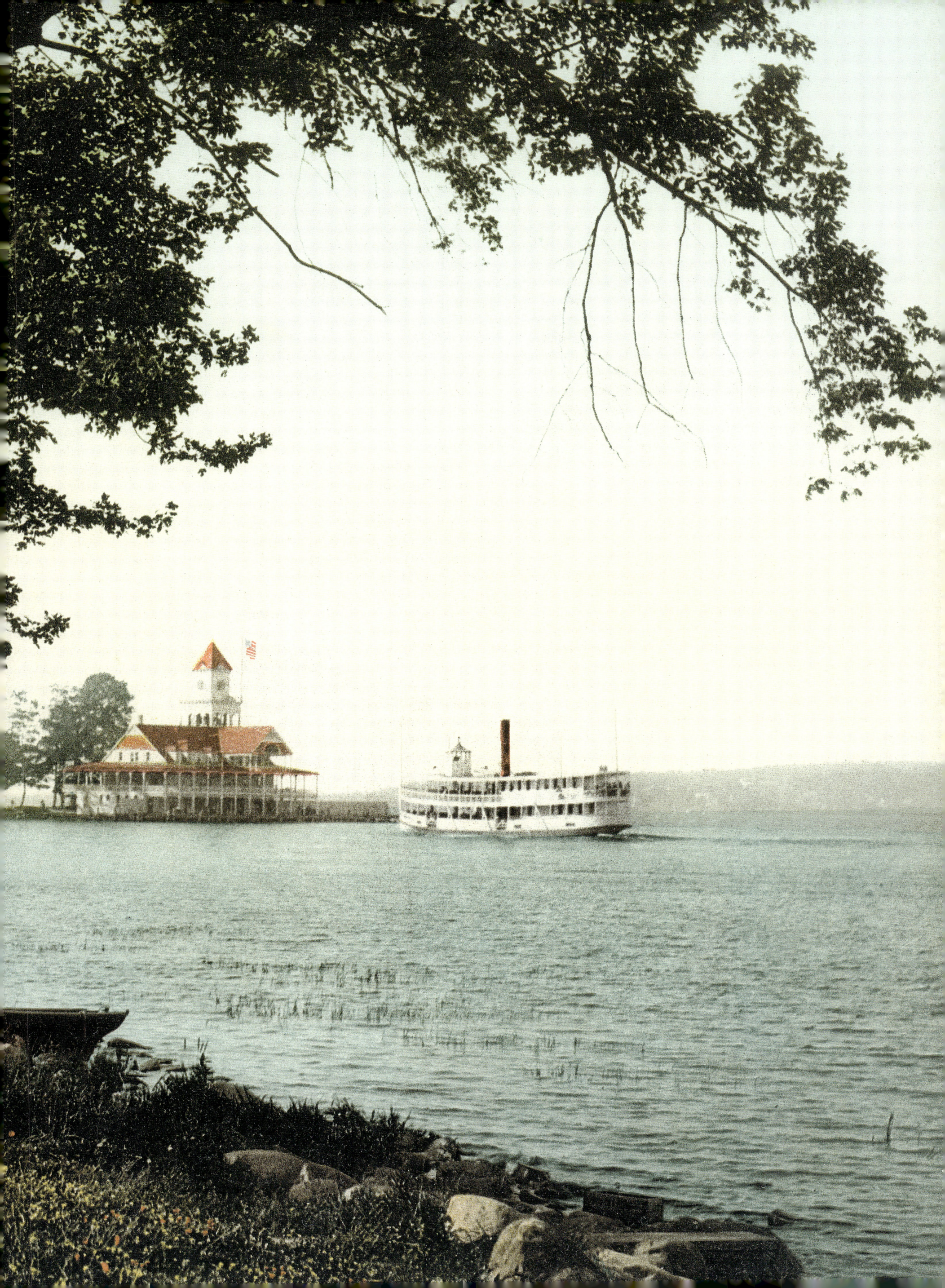

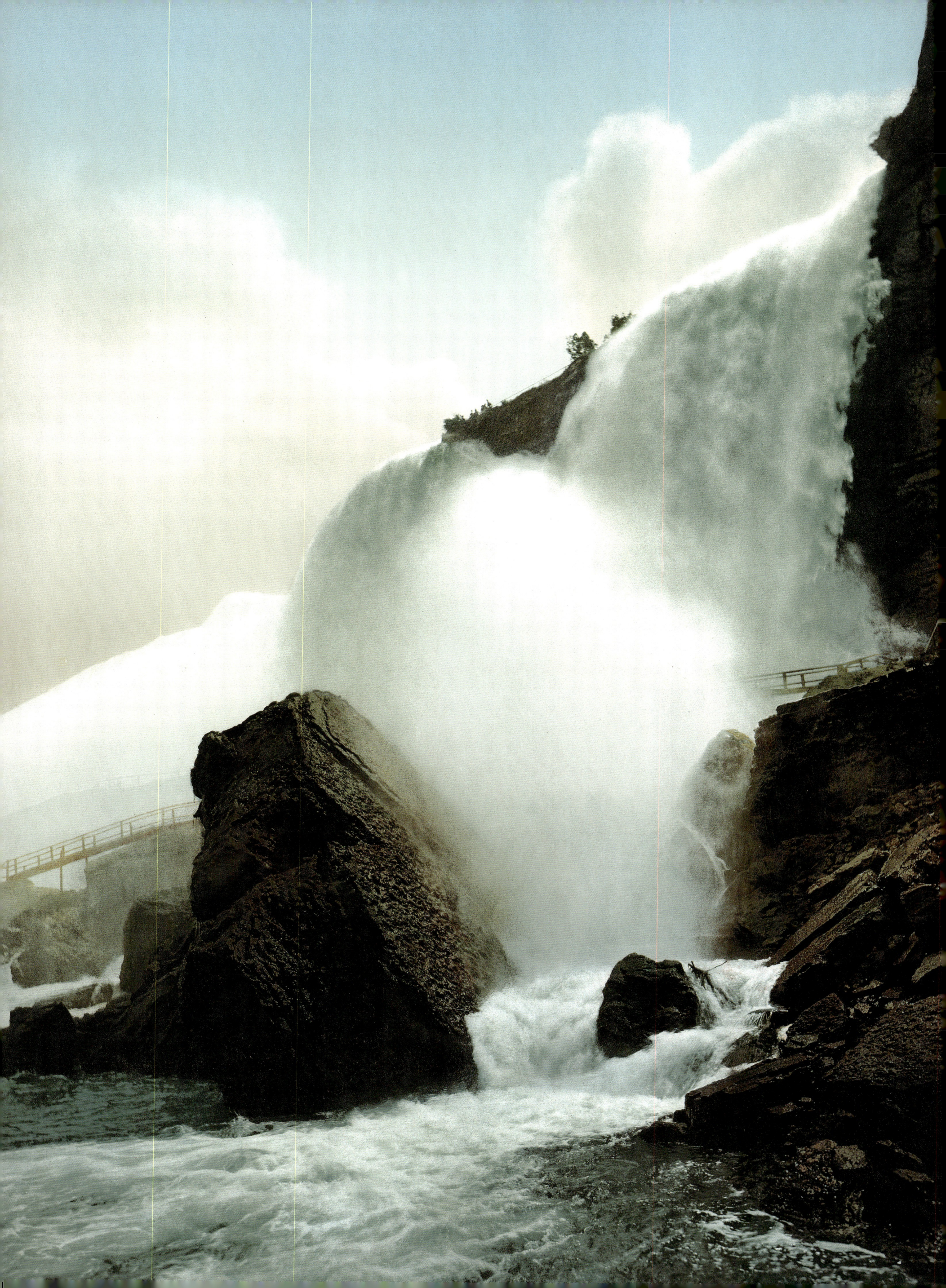

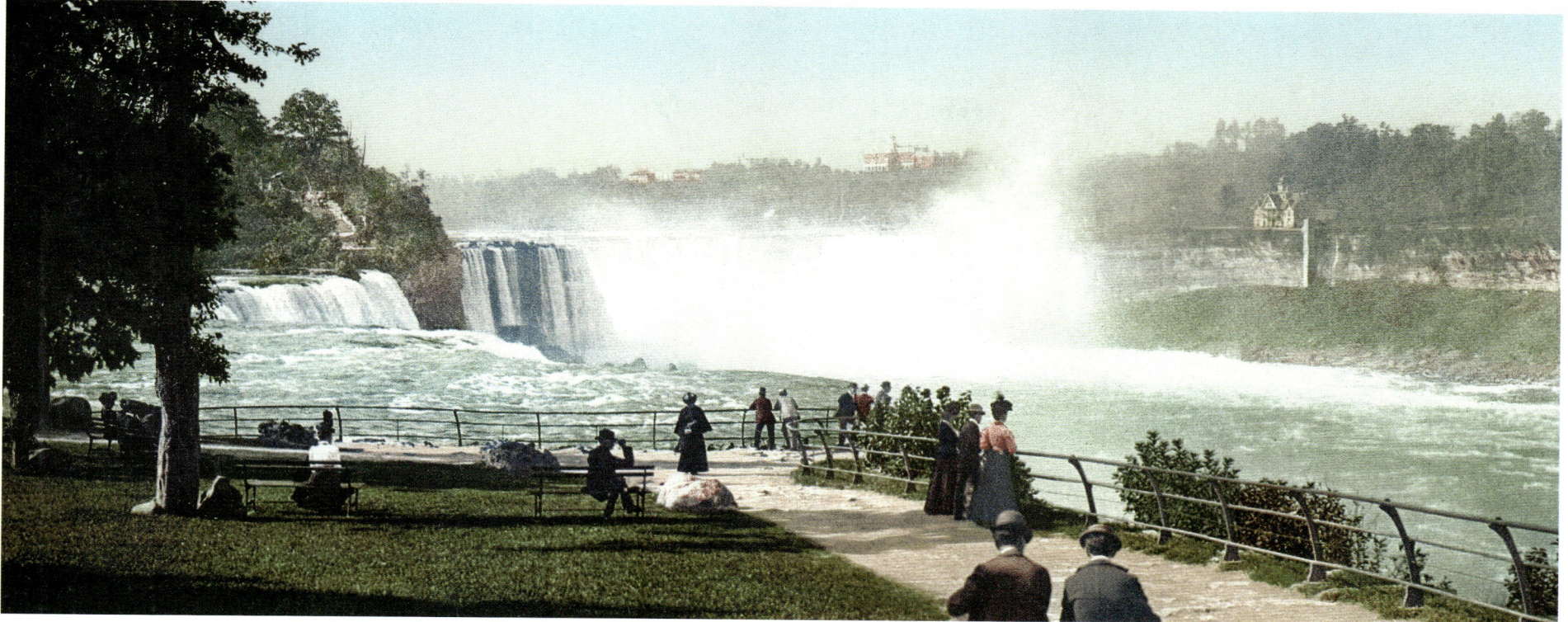

Page 114: **American Falls and Rock of Ages**, photochrom
Above: **Prospect Park, panoramic view**, photochrom
Below: **General view of Niagara Falls**, photochrom
Page 116/117: **Horseshoe Falls**, photochrom

In 1846, before the construction of the first suspension bridge near the falls, a ferry called *Maid of the Mist* transported tourists between the American and Canadian banks of the Niagara River, crossing the Whirlpool Rapids as it did so. In 1855, the suspension bridge was handed over to the railroad and *Maid of the Mist* became a tourist attraction, allowing visitors to get very close to the falls and indeed to sail under Horseshoe Falls.

Seite 114: **American Falls und Rock of Ages**, Photochrom
Oben: **Prospect Park, Rundblick**, Photochrom
Unten: **Niagarafälle, Gesamtansicht**, Photochrom
Seite 116/117: **Horseshoe Falls**, Photochrom

1846, vor dem Bau der ersten Hängebrücke, transportierte das Fährschiff *Maid of the Mist* die Touristen zwischen dem amerikanischen und dem kanadischen Ufer des Niagara River hin und her. Hierfür musste es die Stromschnellen des Whirlpool passieren. 1855 wurde die Brücke zur Eisenbahnbrücke und die *Maid of the Mist* zu einer Touristenattraktion, die es den Besuchern erlaubte, so nah wie möglich an die Wasserfälle heranzukommen – und unter den Horseshoe Falls (Hufeisenwasserfälle) durchzufahren.

Page 114 : **les chutes américaines et le Rock of Ages**, photochrome
Ci-dessus : **Prospect Park, vue panoramique**, photochrome
Ci-dessous : **chutes du Niagara, vue générale**, photochrome
Pages 116/117 : **les chutes du Fer à cheval**, photochrome

En 1846, avant la construction du premier pont suspendu, un ferry, le *Maid of the Mist*, transportait les touristes entre les rives américaine et canadienne de la Niagara River. Il devait pour cela franchir les rapides de Whirlpool. À partir de 1855, le pont devint ferroviaire et le *Maid of the Mist* une attraction touristique qui permettait aux visiteurs de s'approcher au plus près des chutes et de passer sous celles du Fer à cheval.

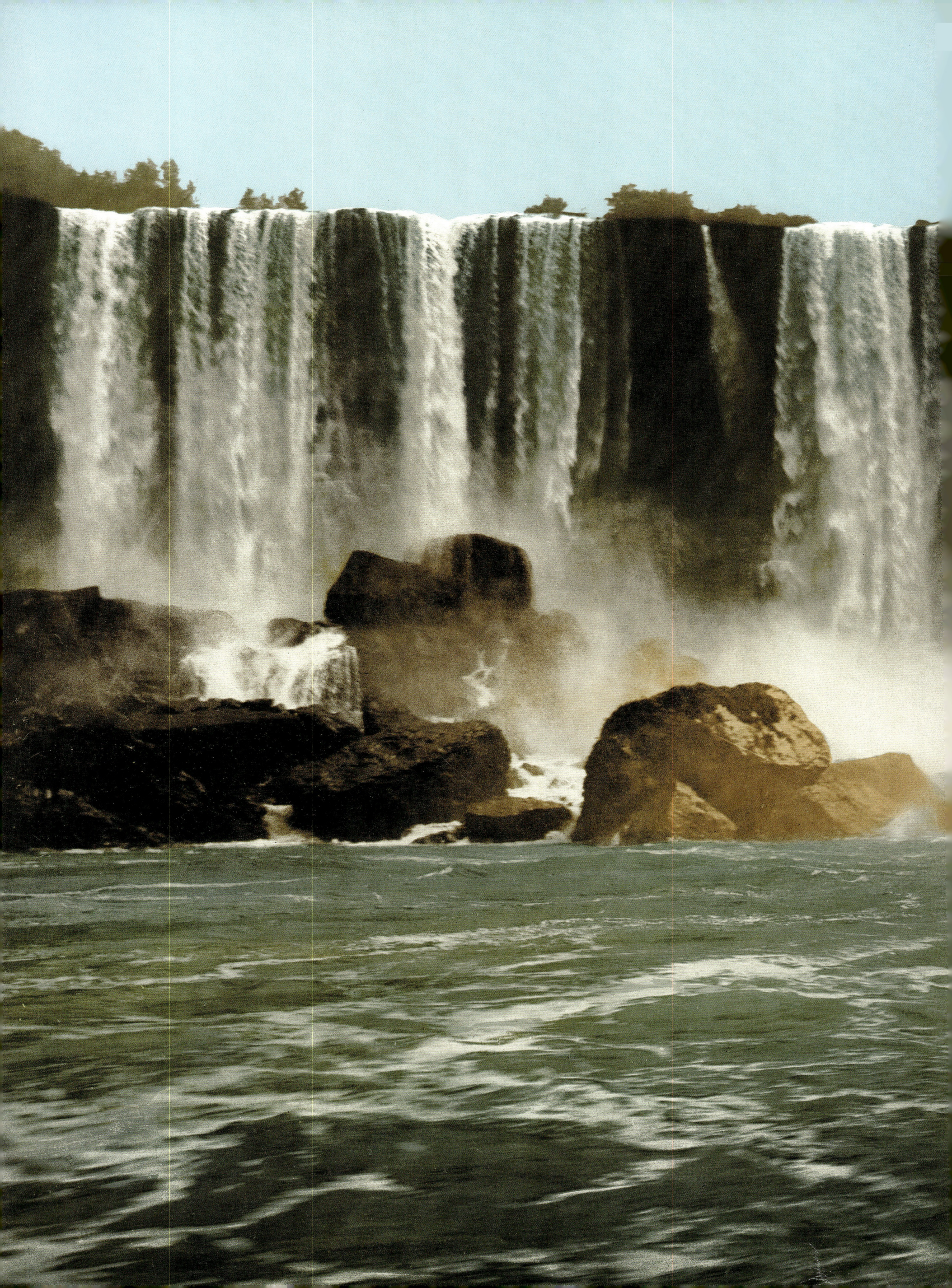

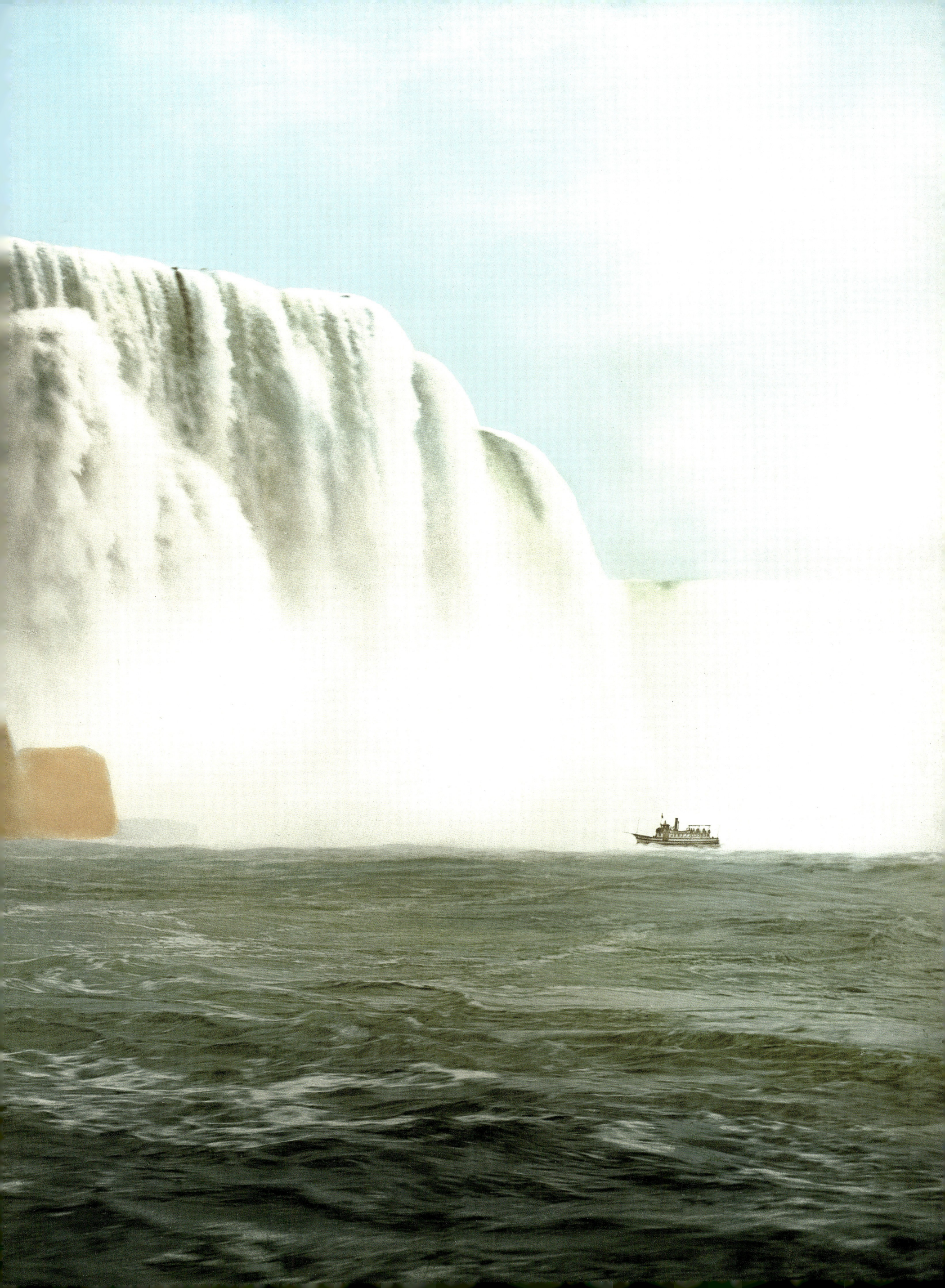

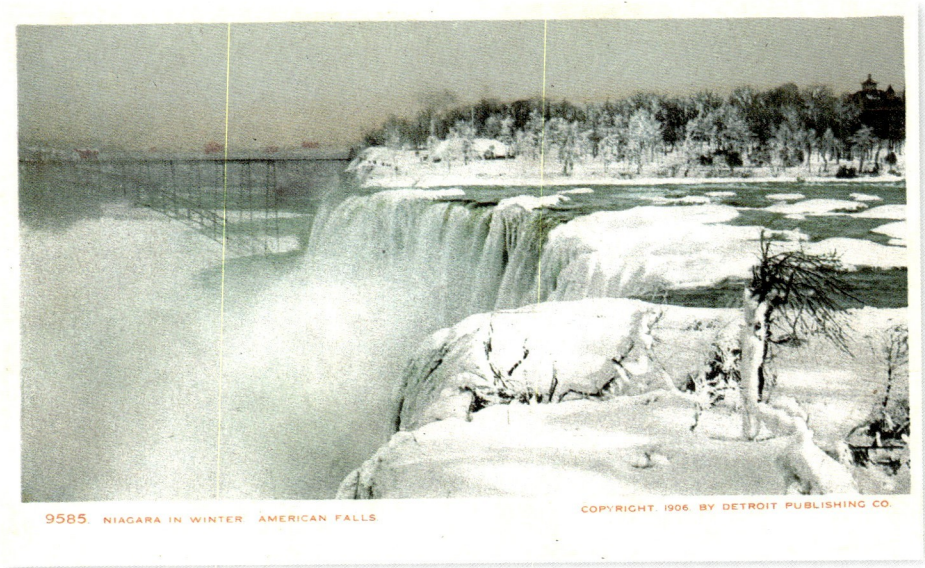

118

NEW YORK | NIAGARA FALLS

Page 118 left: **American Falls in winter**
Page 118 right: **Falls Street at night, Niagara Falls**
Below: **Whirlpool Rapids and Bridge, photochrom**

The Niagara Falls were first illuminated in 1860, with calcium lighting. In 1881, a direct-current generator made it possible to light the streets of Niagara Falls, two miles away from the falls themselves. The Niagara Falls Hydraulic Power and Manufacturing Co. then offered $100,000 to anyone who could find a way of transporting the current over longer distances. Working against the advice of Thomas Edison, a young Serbian researcher, Nikola Tesla, studied a system of transmission by alternating current. The industrialist George Westinghouse built Tesla's system and, in 1883, the falls were illuminated by alternating current. Finally, in 1896, the city of Buffalo was connected to the Niagara Power Station.

Seite 118 links: **Die American Falls im Winter**
Seite 118 rechts: **Falls Street bei Nacht, Niagara Falls**
Unten: **Die Whirlpool-Stromschnellen mit Brücke, Photochrom**

Ab 1860 wurden die Niagarafälle mithilfe einer Kalklicht-Beleuchtung angestrahlt. 1881 ermöglichte es ein Gleichstromgenerator, die Straßen von Niagara Falls bis zu zwei Meilen von den Wasserfällen entfernt zu beleuchten. Daraufhin bot die Niagara Falls Hydraulic Power and Manufacturing Co. demjenigen 100 000 Dollar, der herausfand, wie sich der Strom über eine größere Distanz leiten ließe. Entgegen dem Wunsch von Thomas Edison untersuchte der junge serbische Forscher Nikola Tesla ein Übertragungssystem für Wechselstrom. Der Industrielle George Westinghouse ließ es bauen, und 1883 wurden die Wasserfälle mit Wechselstrom angestrahlt. 1896 wurde schließlich die Stadt Buffalo an das Niagara-Kraftwerk angeschlossen.

Page 118, à gauche : **les chutes américaines en hiver**
Page 118, à droite : **Falls Street la nuit, ville de Niagara Falls**
Ci-dessous : **les rapides de Whirlpool et le pont, photochrome**

Les chutes du Niagara ont été illuminées dès 1860 grâce à un éclairage au calcium. En 1881, un générateur à courant continu permit d'éclairer les rues de Niagara Falls, à deux *miles* des chutes. La Niagara Falls Hydraulic Power and Manufacturing Co. offrit alors 100 000 dollars à qui trouverait le moyen d'acheminer le courant sur une longue distance. Contre l'avis de Thomas Edison, un jeune chercheur serbe, Nikola Tesla, étudia un système de transmission par courant alternatif. L'industriel George Westinghouse le réalisa et, en 1883, les chutes furent illuminées au courant alternatif. Enfin, en 1896, la ville de Buffalo fut raccordée à la centrale du Niagara.

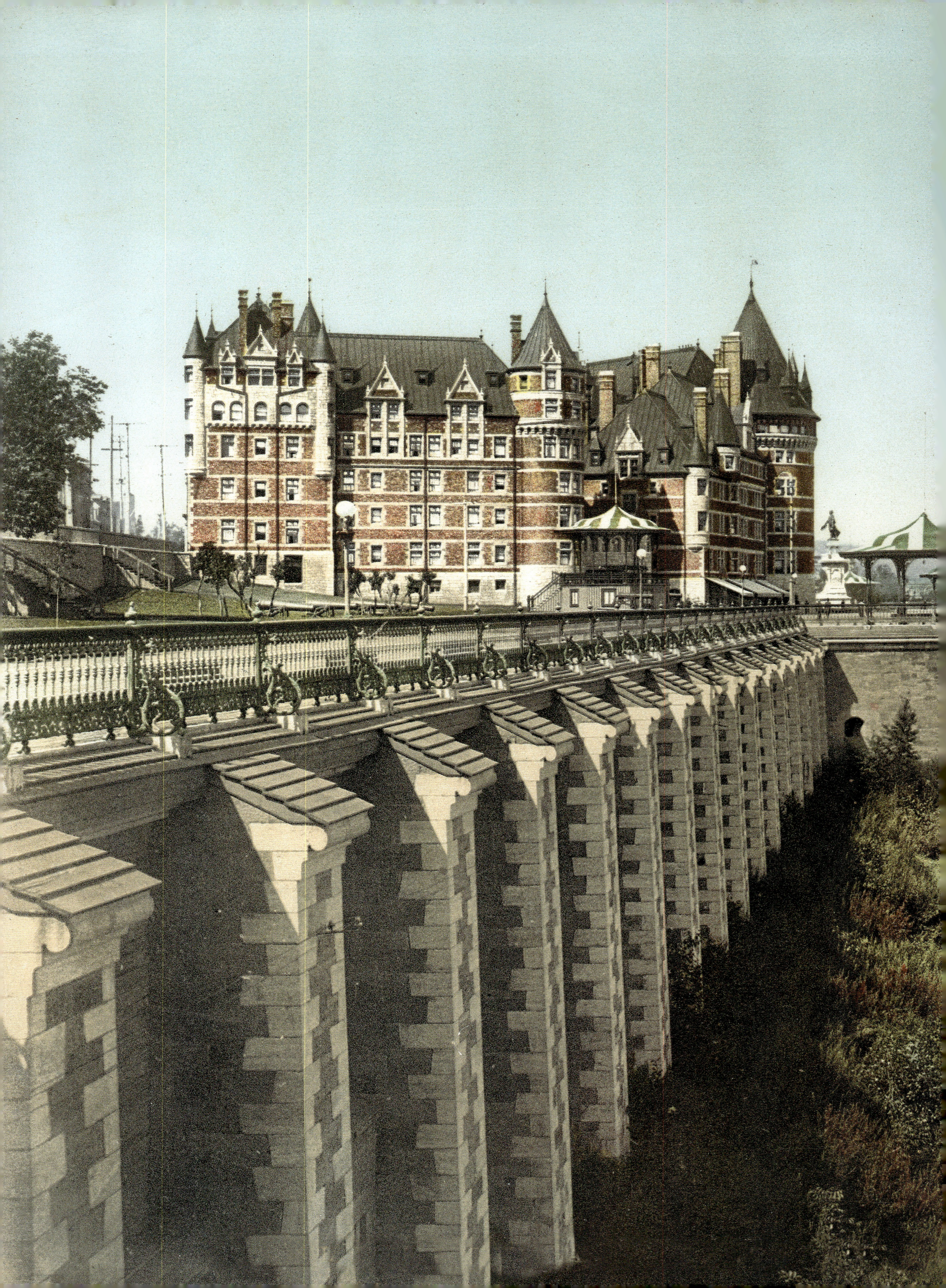

QUEBEC

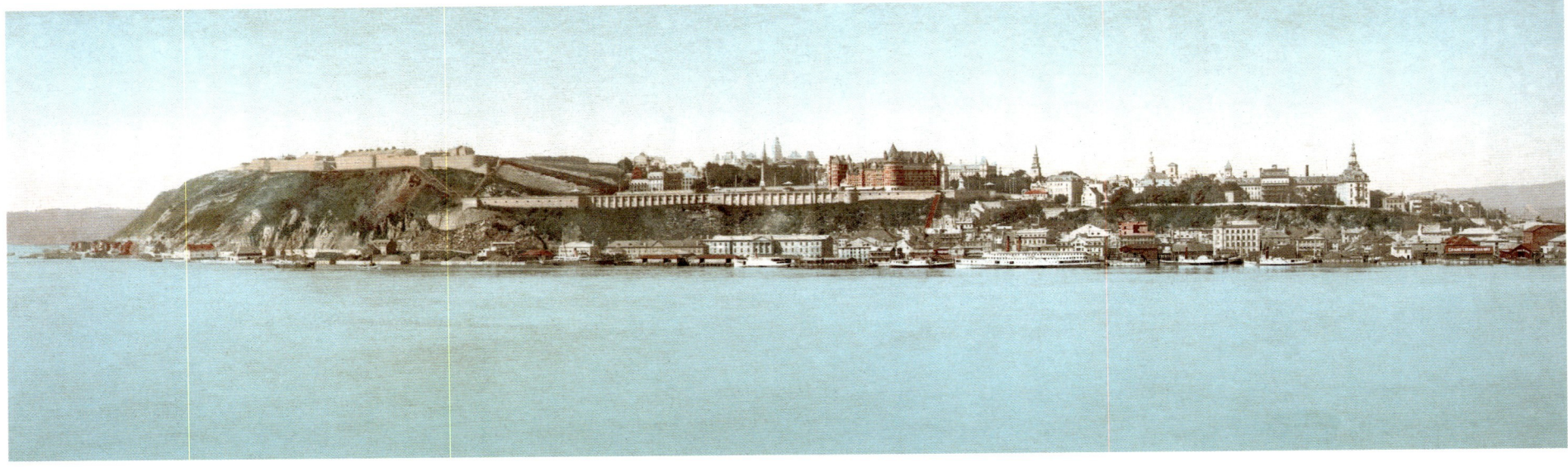

Page 120/121: Château Frontenac and Dufferin Terrace, photochrom
Above: Panoramic view of Quebec, photochrom
Below: Dufferin Terrace and Château Frontenac, photochrom
Page 123:
Top: A Quebec caleche, photochrom
Bottom: St. Louis Gate and the Grande Allée, photochrom

Standing above the Terrasse Dufferin that overlooks the St. Lawrence, the Château Frontenac Hotel was the first of the imposing chateauesque "palaces" built by the Canadian Pacific Railway Company. Designed by the architect of Montreal Railway Station, Bruce Price, the hotel was a huge success from the day of its opening in 1893. It began with just the one wing on the St. Lawrence side; four more wings and a central tower were added respectively in 1899, 1908, 1919, and 1920–24.

Seite 120/121: Château Frontenac und die Dufferin-Terrasse, Photochrom
Oben: Panoramablick auf Quebec, Photochrom
Unten: Dufferin-Terrasse und Château Frontenac, Photochrom
Seite 123:
Oben: Eine Kalesche in Quebec, Photochrom
Unten: Die Porte Saint-Louis und die Grande Allée, Photochrom

Das auf der den Sankt-Lorenz-Strom überragenden Dufferin-Aussichtsterrasse gelegene Hotel Château Frontenac ist der erste jener beeindruckenden Paläste im Stile eines Schlosses, die von der Canadian Pacific Railway Company errichtet wurden. Das von Bruce Price, dem Architekten des Bahnhofs von Montreal, entworfene Hotel war bereits bei seiner Eröffnung im Jahr 1893 ein riesiger Erfolg: Das Gebäude hatte anfangs nur einen Flügel auf der Flussseite; 1899, 1908, 1919 und zwischen 1920 und 1924 kamen dann sukzessive vier weitere Flügel und ein zentraler Turm hinzu.

Pages 120/121 : Château Frontenac et la Terrasse Dufferin, photochrome
Ci-dessus : vue panoramique de Québec, photochrome
En bas : la Terrasse Dufferin et le Château Frontenac, photochrome
Page 123 :
En haut : une calèche québecoise, photochrome
En bas : la porte Saint-Louis et la Grande Allée, photochrome

Sur la Terrasse Dufferin qui domine le Saint-Laurent, l'hôtel Château Frontenac est le premier des palaces imposants de style « château » édifiés par la Canadian Pacific Railway Company. Conçu par l'architecte de la gare de Montréal, Bruce Price, cet hôtel connut un énorme succès dès son ouverture en 1893 : le bâtiment comptait au départ une seule aile, du côté du fleuve ; quatre autres ailes et une tour centrale lui seront ajoutées, successivement en 1899, en 1908, en 1919 et entre 1920 et 1924.

CANADA | QUEBEC | QUEBEC

Below: **Champlain Street, Quebec, glass negative, ca. 1890–1901**
Page 125: **Sous-le-Cap Street, Quebec, photochrom**

Unten: **Champlain Street, Quebec, Glasnegativ, um 1890–1901**
Seite 125: **Sous-le-Cap Street, Quebec, Photochrom**

Ci-dessous : **rue Champlain, Québec, plaque de verre, vers 1890–1901**
Page 125 : **rue Sous-le-Cap, Québec, photochrome**

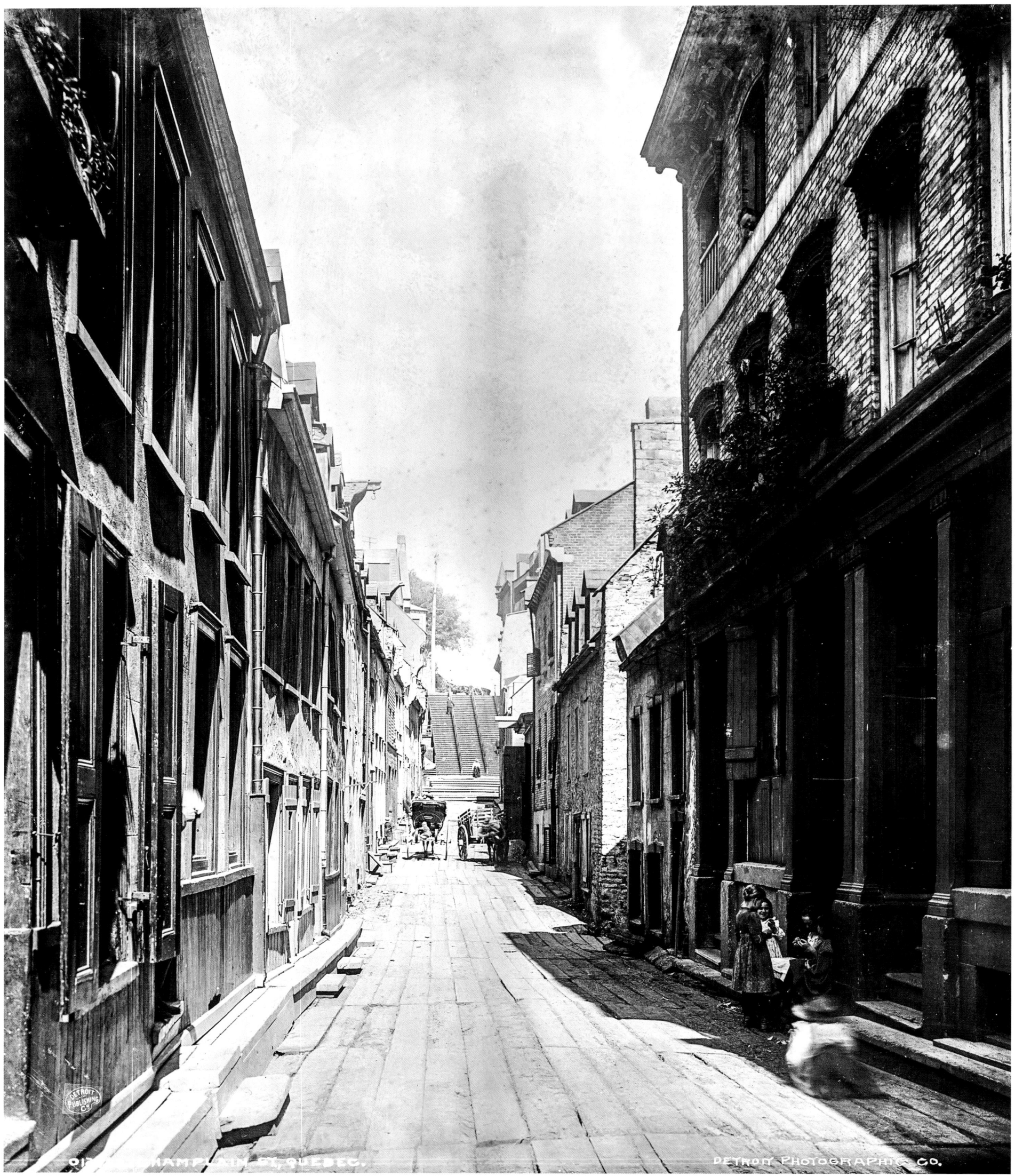

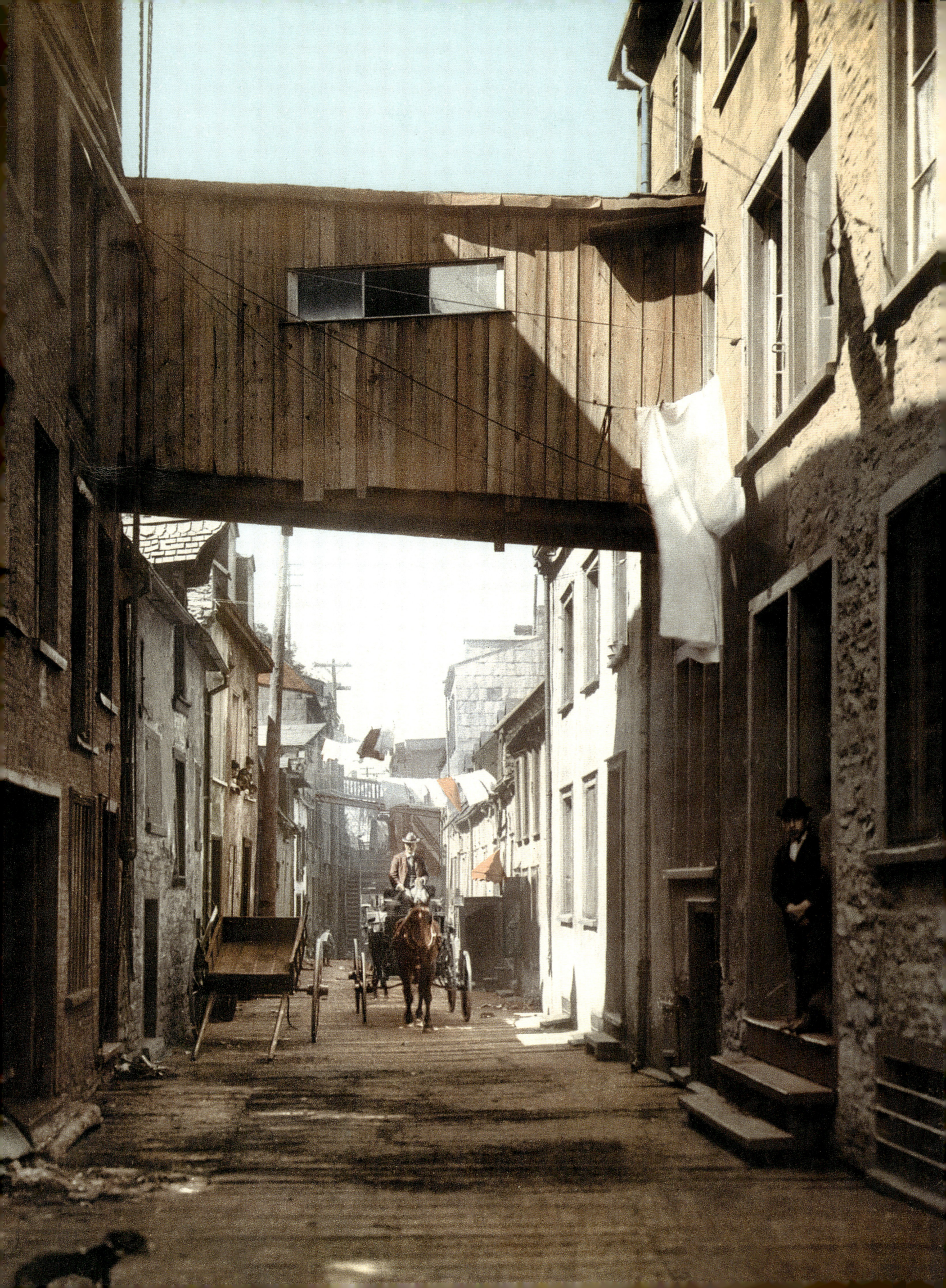

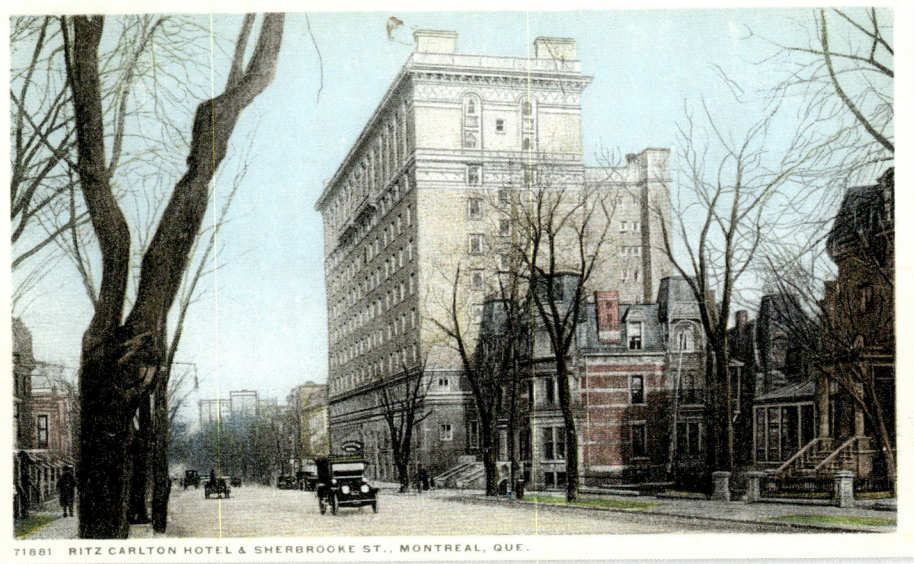
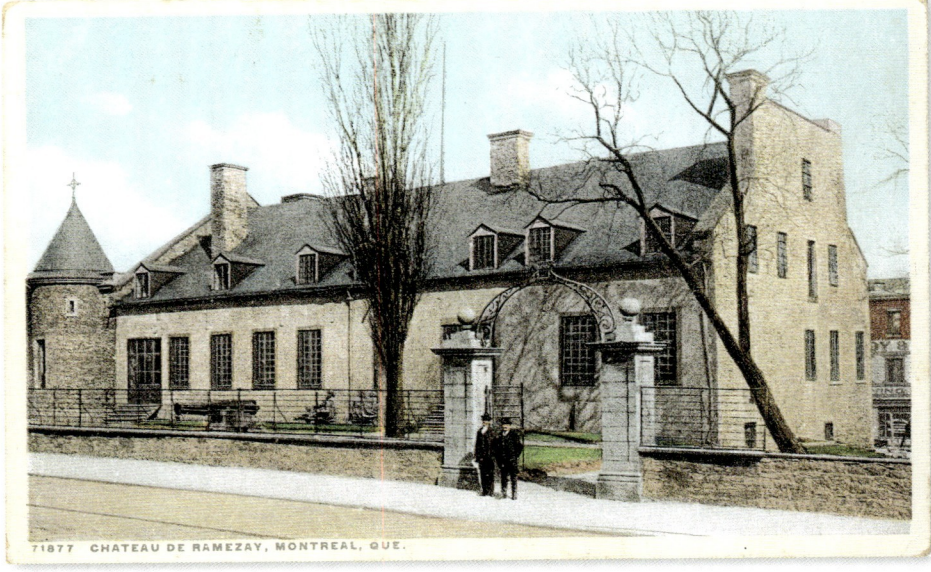

Top left: **Ritz-Carlton Hotel, Sherbrooke Street, Montreal**
Top right: **Château de Ramezay**
Bottom: **Jacques Cartier Square, photochrom**

At the confluence of the St. Lawrence and the Ottawa, the island of Montreal, explored by Jacques Cartier in 1535, takes its name from Mount Royal, the hill on which the city was established during the 17th century. The historic center of Montreal lies on the riverbank downstream of the Lachine Rapids (see the following pages). Built in the 1840s, Place Jacques Cartier housed the Bonsecours market. In the background of this image stands the column erected in memory of Admiral Nelson.

Oben links: **Das Hotel Ritz-Carlton, Sherbrooke Street, Montreal**
Oben rechts: **Château de Ramezay**
Unten: **Place Jacques Cartier, Markt, Photochrom**

Die 1535 von Jacques Cartier entdeckte Insel Montreal liegt am Zusammenfluss von Sankt-Lorenz-Strom und Ottawa-Fluss. Ihr Name leitet sich von „Mont Royal" ab, dem Hügel, auf dem im Laufe des 17. Jahrhunderts die Stadt entstand. Der historische Kern von Montreal befindet sich am Flussufer, unterhalb der Lachine-Stromschnellen (siehe folgende Seiten). Auf dem Jacques-Cartier-Platz, der in den 1840er-Jahren entstand, findet der Bonsecours-Markt statt; im Hintergrund des Bildes steht die Säule zum Gedenken an Admiral Nelson.

En haut à gauche : l'hôtel Ritz-Carlton, Sherbrooke Street, Montréal
En haut à droite : le château de Ramezay
En bas : place Jacques-Cartier, le marché, photochrome

Au confluent du Saint-Laurent et de la rivière des Outaouais, l'île de Montréal, explorée par Jacques Cartier en 1535, tire son nom du mont Royal, la colline sur laquelle la ville s'est établie au cours du XVIIᵉ siècle. Sur les rives du fleuve, le cœur historique de Montréal se situe en aval des rapides de Lachine (pages suivantes). Aménagée dans les années 1840, la place Jacques-Cartier accueille le marché Bonsecours ; à l'arrière-plan de notre image, la colonne élevée à la mémoire de l'amiral Nelson.

Right: Château Ramezay, photochrom
Bottom: Montreal seen from the Church of Notre-Dame, photochrom
Page 128/129: In the Lachine Rapids, St. Lawrence River, Quebec, photography by W. H. Jackson, ca. 1900

Rechts: Château Ramezay, Photochrom
Unten: Blick von der Kirche Notre-Dame auf Montreal, Photochrom
Seite 128/129: In den Lachine-Stromschnellen auf dem Sankt-Lorenz-Strom, Quebec, Fotografie von W. H. Jackson, um 1900

À droite : le Château Ramezay, photochrome
En bas : Montréal vue depuis l'église Notre-Dame, photochrome
Pages 128/129 : dans les rapides de Lachine, sur le Saint-Laurent, Québec, photographie de W. H. Jackson, vers 1900

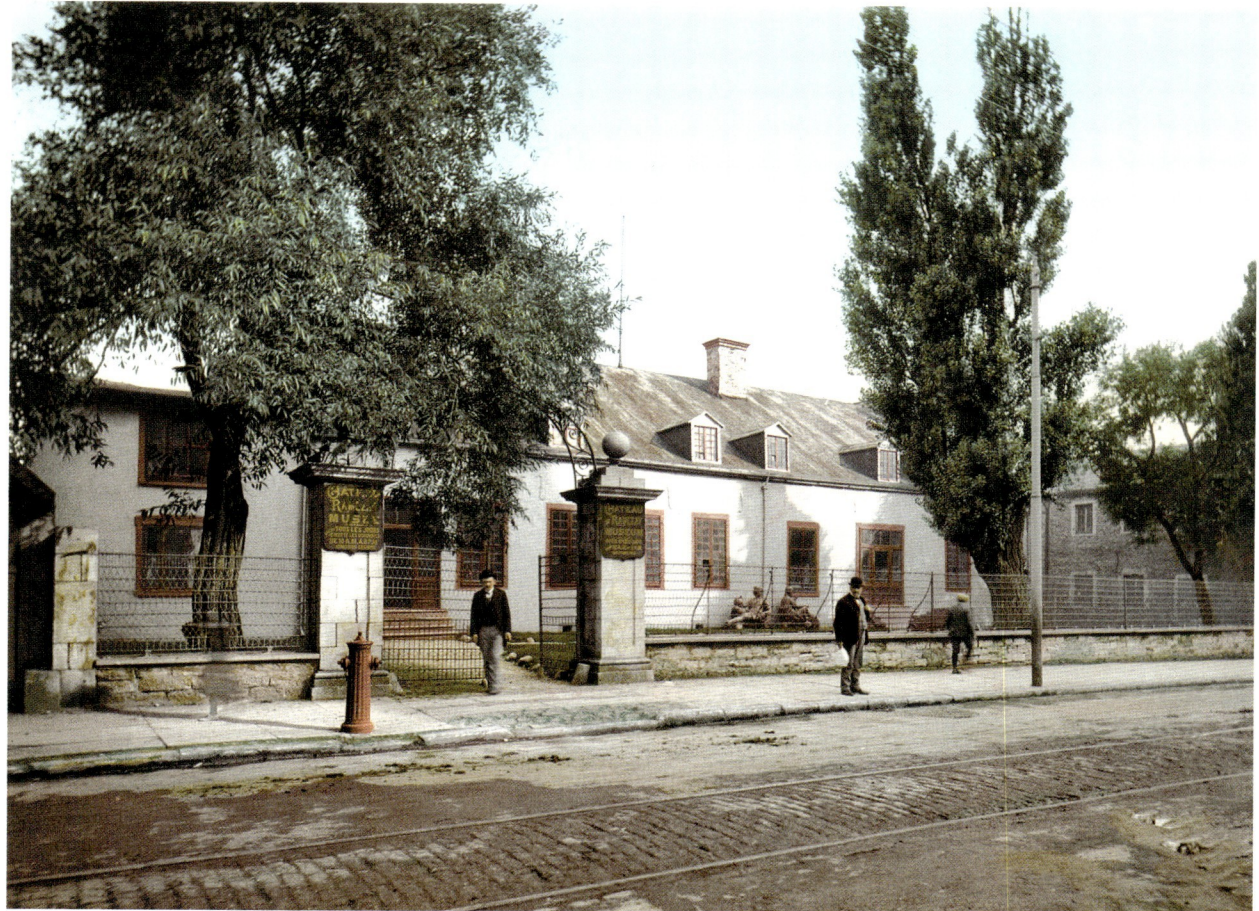

CANADA | QUEBEC | MONTREAL

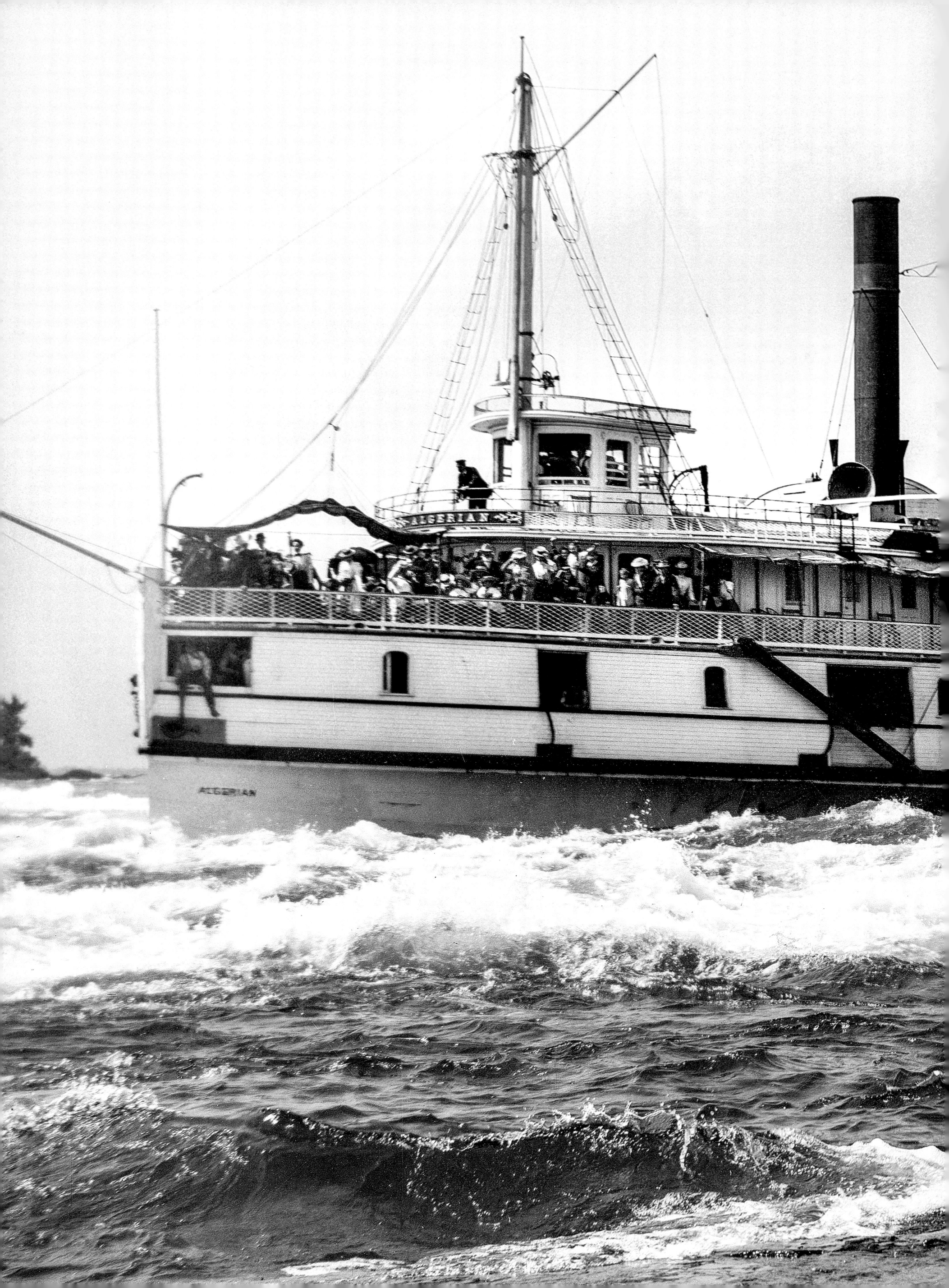

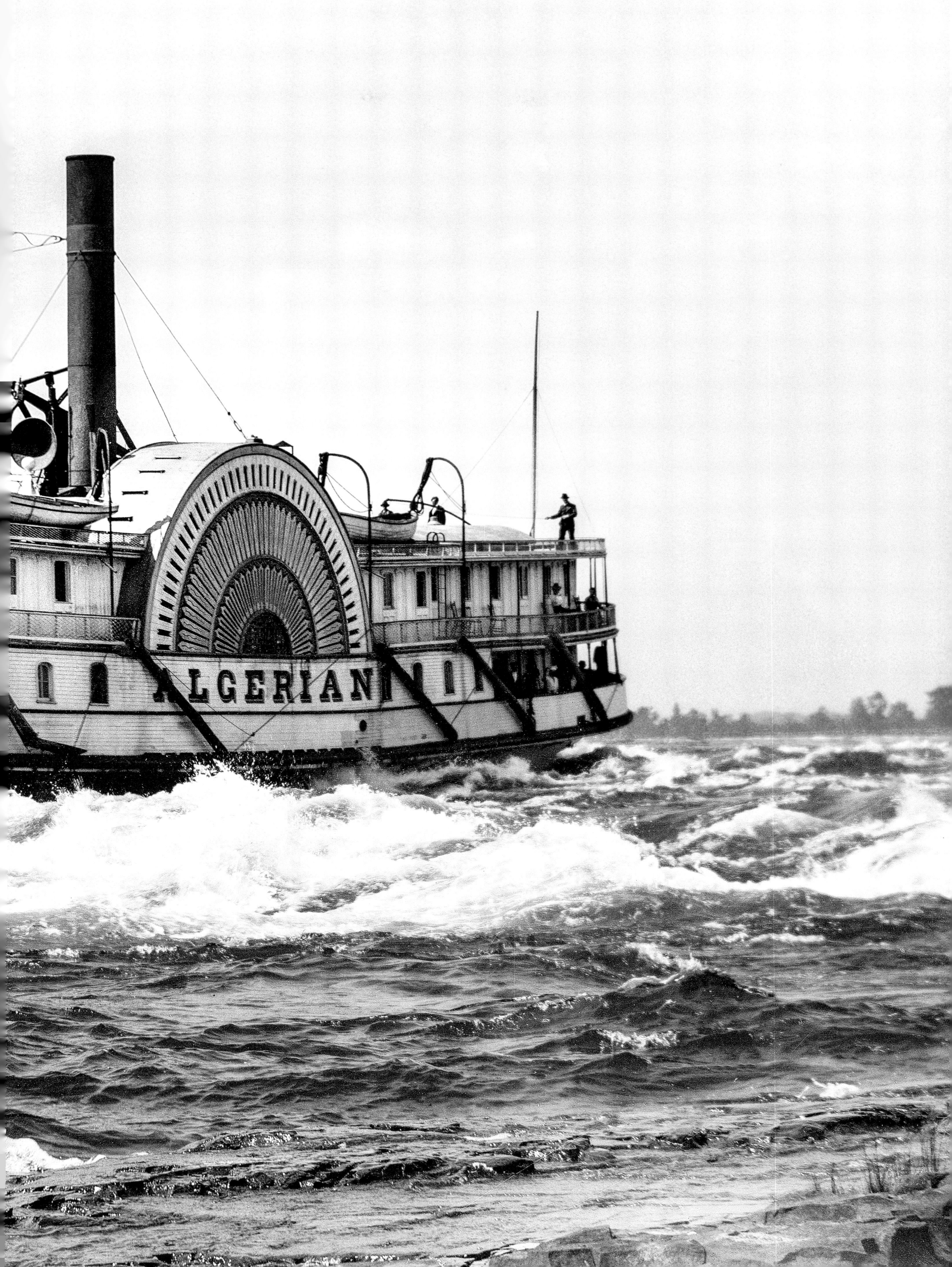

MAINE

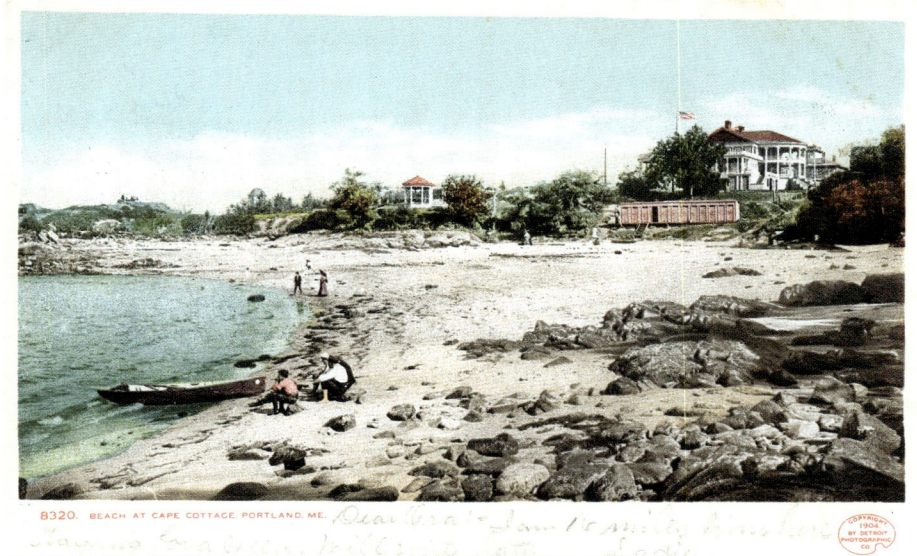

Page 130: Portland Head Light, photochrom
Top left: Forest Hill landing and Gem Theatre, Peak's Island
Top right: Beach at Cape Cottage
Bottom: Forest City Landing, Peak's Island, glass negative, 1905

Portland, the birthplace of the great poet Henry Wadsworth Longfellow, was the first capital of the state of Maine (1820–32). Early in the 20th century, its commercial port was one of the most active on the whole East Coast. Leaving from Forest City pier, little tourist steamers served Peak's Island just off the coast. The many trees planted along the streets of Portland have earned it the sobriquet of "Forest City."

Seite 130: Leuchtturm von Portland, Photochrom
Oben links: Landungssteg von Forest Hill und das Gem Theatre, Peak's Island
Oben rechts: Der Strand von Cape Cottage
Unten: Anlegestelle von Forest City, Peak's Island, Glasnegativ, 1905

Portland, der Geburtsort des großen Dichters Henry Wadsworth Longfellow, war die erste Hauptstadt des Bundesstaates Maine (1820–1832). Anfang des 20. Jahrhunderts zählte sein Handelshafen zu den betriebsamsten der Ostküste. Von der Anlegestelle Forest City aus fuhren kleine Touristendampfer das küstennahe Inselchen Peak's Island an. Die zahllosen Bäume, die man entlang der Straßen von Portland gepflanzt hatte, hatten der Stadt den Beinamen „Forest City" (Waldstadt) eingebracht.

Page 130 : le phare de Portland, photochrome
En haut à gauche : le ponton de Forest Hill et le théâtre Gem, Peak's Island
En haut à droite : la plage de Cape Cottage
En bas : l'embarcadère de Forest City, Peak's Island, plaque de verre, 1905

Portland, où naquit le grand poète Henry Wadsworth Longfellow, fut la première capitale de l'État du Maine (1820–1832). Au début du XXᵉ siècle, son port de commerce était l'un des plus actifs de la côte Est. Partant de l'embarcadère de Forest City, de petits steamers de tourisme desservaient l'îlot côtier de Peak's Island. Les nombreux arbres plantés le long des rues de Portland lui ont valu le surnom de « Forest City » (la Ville-forêt).

MAINE | PORTLAND

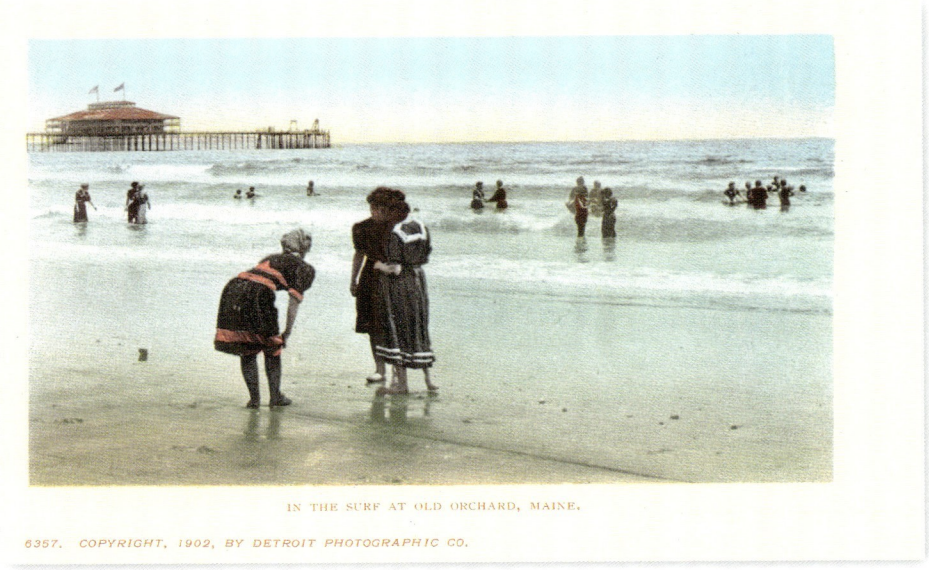

Left: In the surf at Old Orchard
Bottom: In the surf at Old Orchard, photochrom

Links: Brandung in Old Orchard
Unten: Brandung in Old Orchard, Photochrom

À gauche : vagues à Old Orchard
En bas : vagues à Old Orchard, photochrome

From top to bottom:
Ocean pier at Old Orchard
Old Orchard's beach
Alberta and Velvet Hotels, Old Orchard

Old Orchard Beach was one of the most beautiful and popular on the entire New England coastline. Several major hotels—the Belmont, Old Orchard Hotel, Seashore—were built to accommodate the tourists. The jetty of the casino, built in 1898, was damaged by a storm shortly after its construction; rebuilt in shortened form, it was again badly damaged. There is still a jetty at Portland, but the casino disappeared in 1970.

Von oben nach unten:
Pier von Old Orchard
Strandansicht von Old Orchard
Das Hotel Alberta und das Hotel Velvet, Old Orchard

Der Strand von Old Orchard zählte zu den schönsten und beliebtesten der Küste Neuenglands. Mehrere Grand Hotels – darunter das Belmont, das Old Orchard Hotel, das Seashore, das Velvet und das Alberta – empfingen dort die Touristen. Der 1898 errichtete Landungssteg des Kasinos wurde kurz nach dem Bau bei einem Sturm beschädigt; wieder aufgebaut, jedoch verkürzt, überstand der Steg einen weiteren heftigen Sturm. Noch immer gibt es einen Landungssteg in Portland, doch das Kasino wurde 1970 abgerissen.

De haut en bas :
La jetée d'Old Orchard
Vue de la plage d'Old Orchard
Les hôtels Alberta et Velvet, Old Orchard

La plage d'Old Orchard était l'une des plus belles et des plus populaires de la côte de Nouvelle-Angleterre. Plusieurs grands hôtels – tels le Belmont, l'Old Orchard Hotel, le Seashore, le Velvet ou l'Alberta – y accueillaient les touristes. La jetée du Casino, édifiée en 1898, fut endommagée par une tempête peu de temps après sa construction ; rebâtie, mais raccourcie, elle subit une autre tempête dévastatrice. Il y a toujours une jetée à Portland, mais le casino a disparu en 1970.

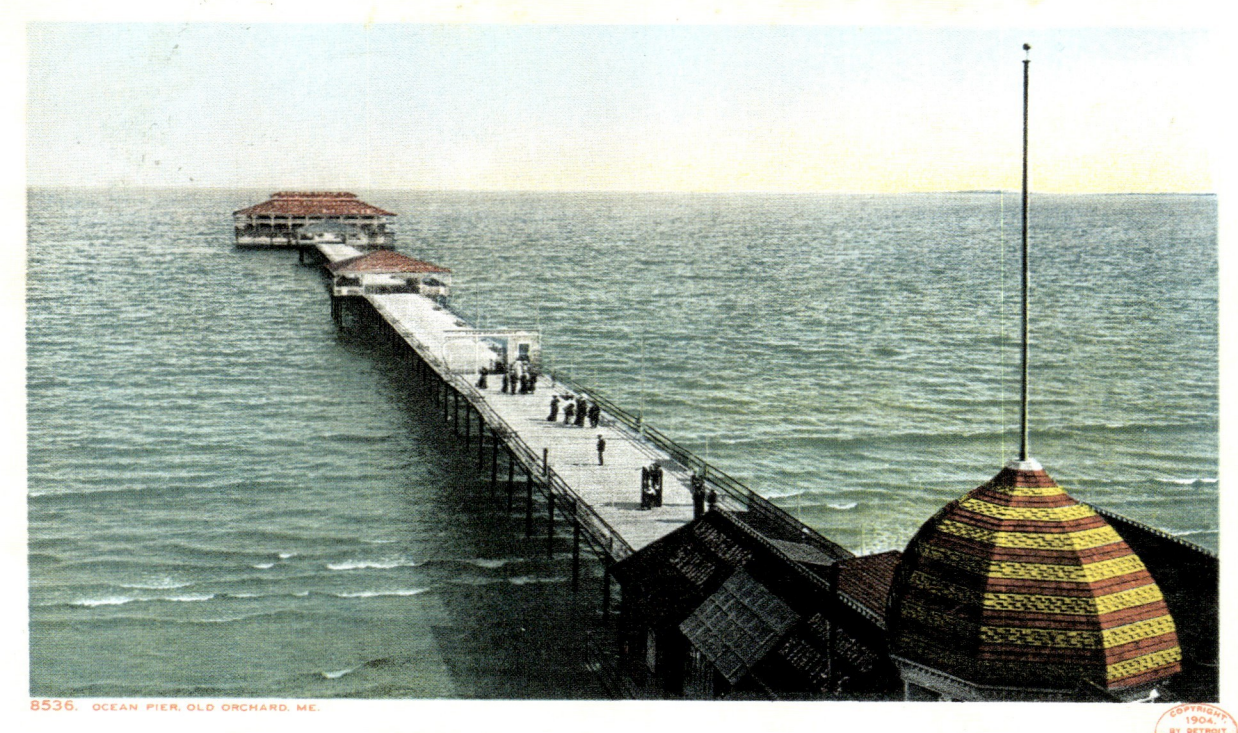

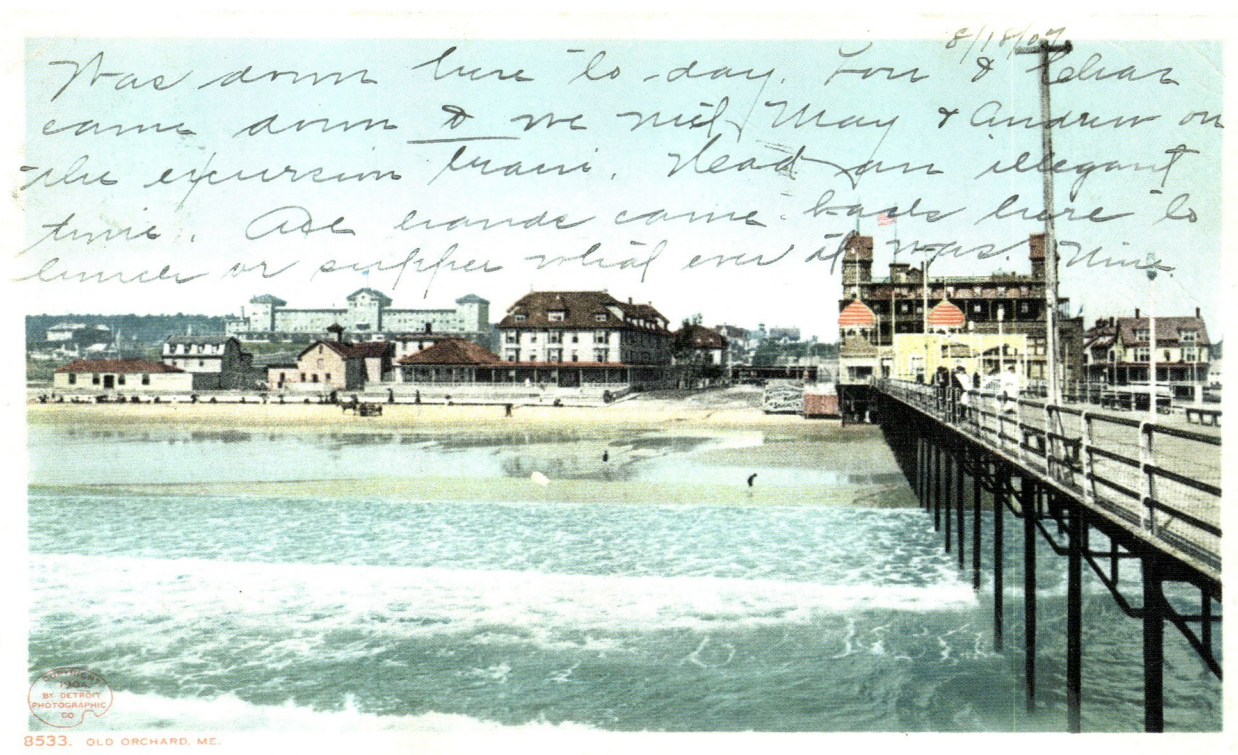

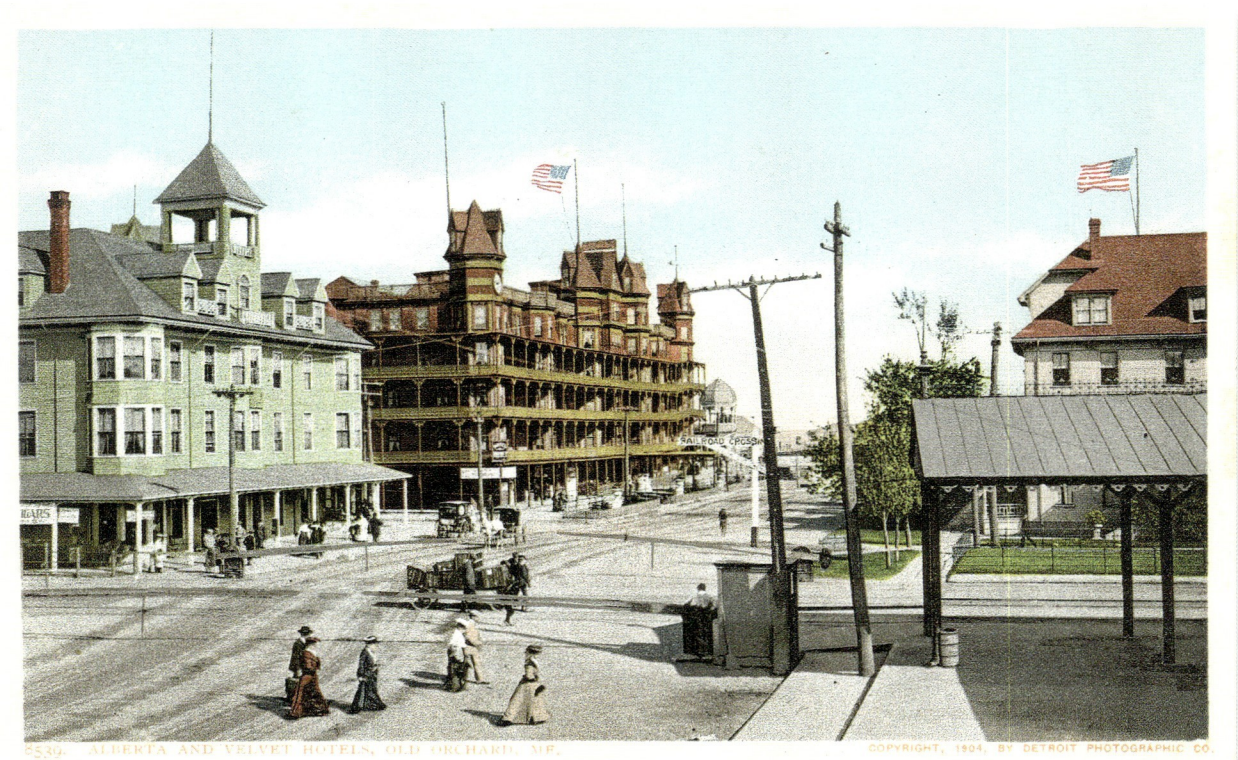

MAINE | OLD ORCHARD

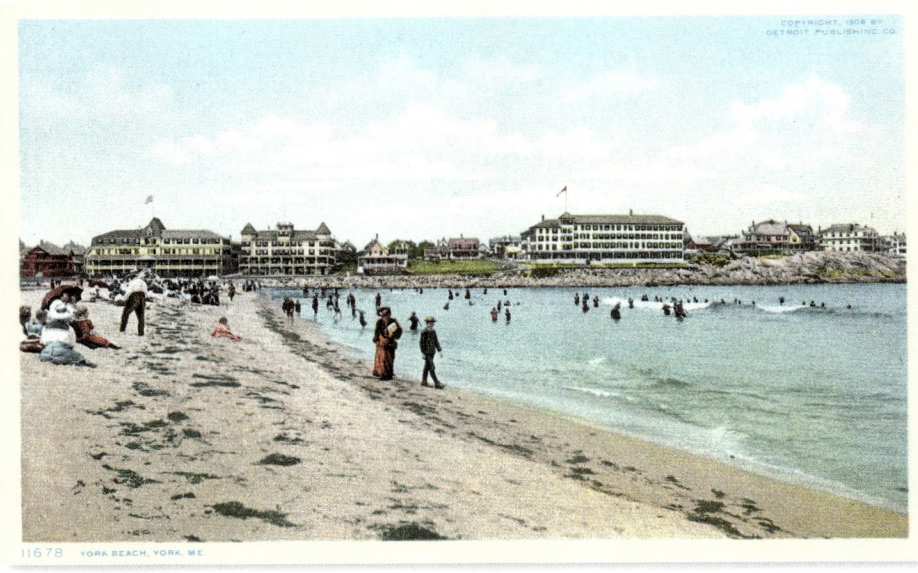

Above: **York Beach**
Below: **York, the beach, photochrom**

The Nubble Light—named after the rocky islet just off Cape Neddick, near York—came into service in 1879. The Maine coastline is very dangerous and shipwrecks have been numerous. Keepers lived in the lighthouse until its automation in 1987. Life on the Nubble was not always easy; in the 1960s, one of the keepers entrusted his children every morning to a kind of cable car that bridged the gap between island and continent so that they could go to school. When this was photographed by a journalist, the York authorities quickly put a stop to it.

Oben: **Der Strand von York**
Unten: **York, Strand, Photochrom**

Der Leuchtturm von Nubble Island – dem Inselchen vor Cape Neddick in der Nähe von York – wurde 1879 in Betrieb genommen. Die Küste von Maine ist hier besonders gefährlich, und es hatten sich schon zahlreiche Schiffbrüche ereignet. Mehrere Wärter lösten einander auf Nubble Island ab, bis das Leuchtfeuer 1987 automatisiert wurde. Das Leben auf Nubble war nicht immer einfach. In den 1960er-Jahren setzte ein Wärter jeden Morgen seine Kinder in einen Förderkorb, der über ein zwischen dem Festland und der Insel gespanntes Seil glitt, damit sie in die Schule gehen konnten! Das Foto eines Journalisten schreckte die Behörden von York auf, die dem originellen Transportmittel ein Ende setzten.

En haut : **la plage d'York**
En bas : **York, la plage, photochrome**

Le phare du « Nubble » – l'îlot de Cape Neddick, près d'York – a été mis en service en 1879. La côte du Maine est ici très dangereuse et de nombreux naufrages avaient endeuillé son rivage. Plusieurs gardiens se sont succédé au Nubble jusqu'en 1987, date à laquelle le phare a été automatisé. La vie sur le Nubble n'était pas toujours facile : dans les années 1960, l'un des gardiens mettait chaque matin ses enfants dans une benne glissant sur un câble suspendu entre le continent et l'île pour qu'ils aillent à l'école ! Un journaliste prit une photo qui alerta les autorités d'York, et celles-ci mirent un terme à ce mode de transport original.

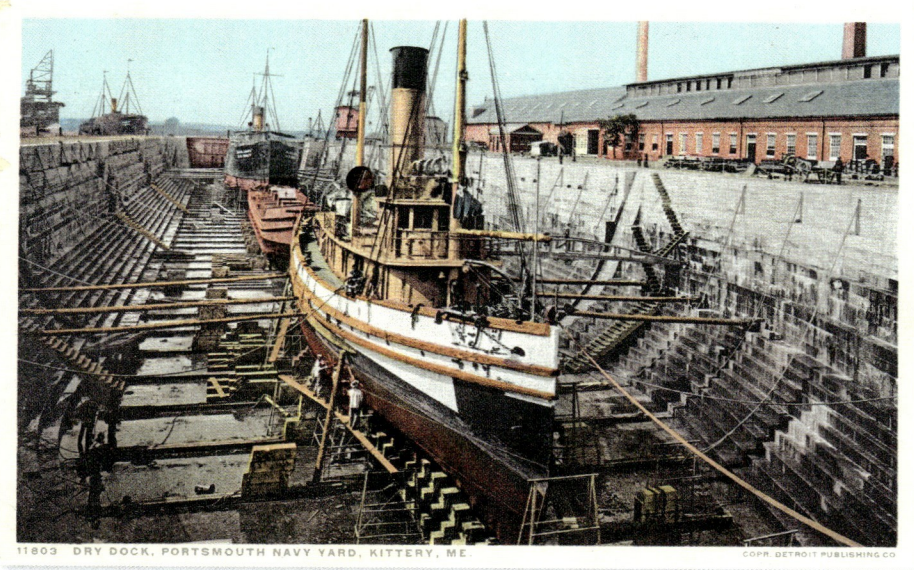
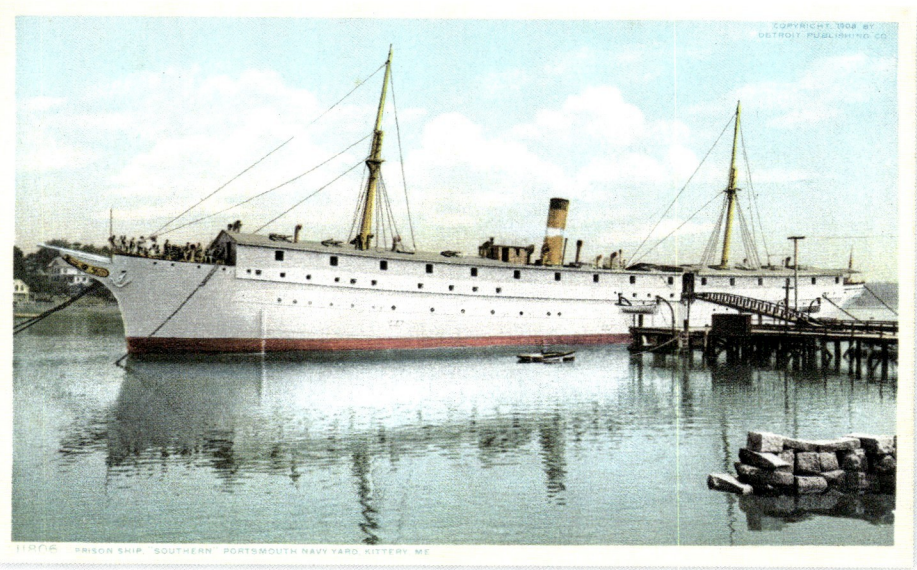

Top left: Dry dock, Portsmouth Navy Yard, Kittery
Top right: Prison ship *Southern*, Portsmouth Navy Yard, Kittery
Bottom: York, The Nubble (Cape Neddick Lighthouse), photochrom

Oben links: Trockendock, Portsmouth Navy Yard (Marinewerft), Kittery
Oben rechts: Das Gefängnisschiff *Southern*, Portsmouth Navy Yard, Kittery
Unten: York, der „Nubble" (Leuchtturm von Cape Neddick), Photochrom

En haut à gauche : cale sèche, Portsmouth Navy Yard (Arsenal maritime), Kittery
En haut à droite : le navire prison *Southern*, Portsmouth Navy Yard, Kittery
En bas : York, le « Nubble » (le phare de l'îlot de Cape Neddick), photochrome

NEW HAMPSHIRE

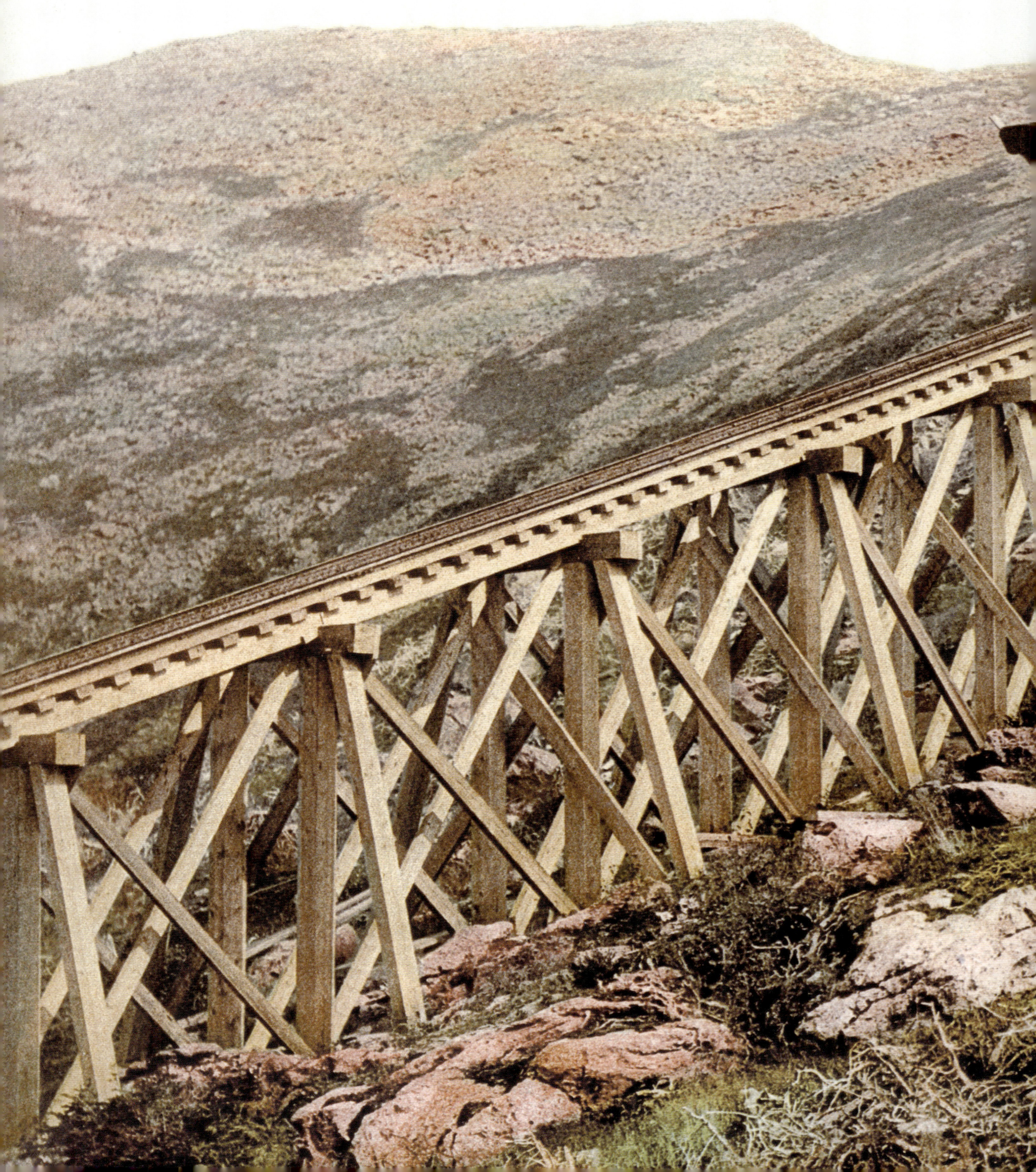

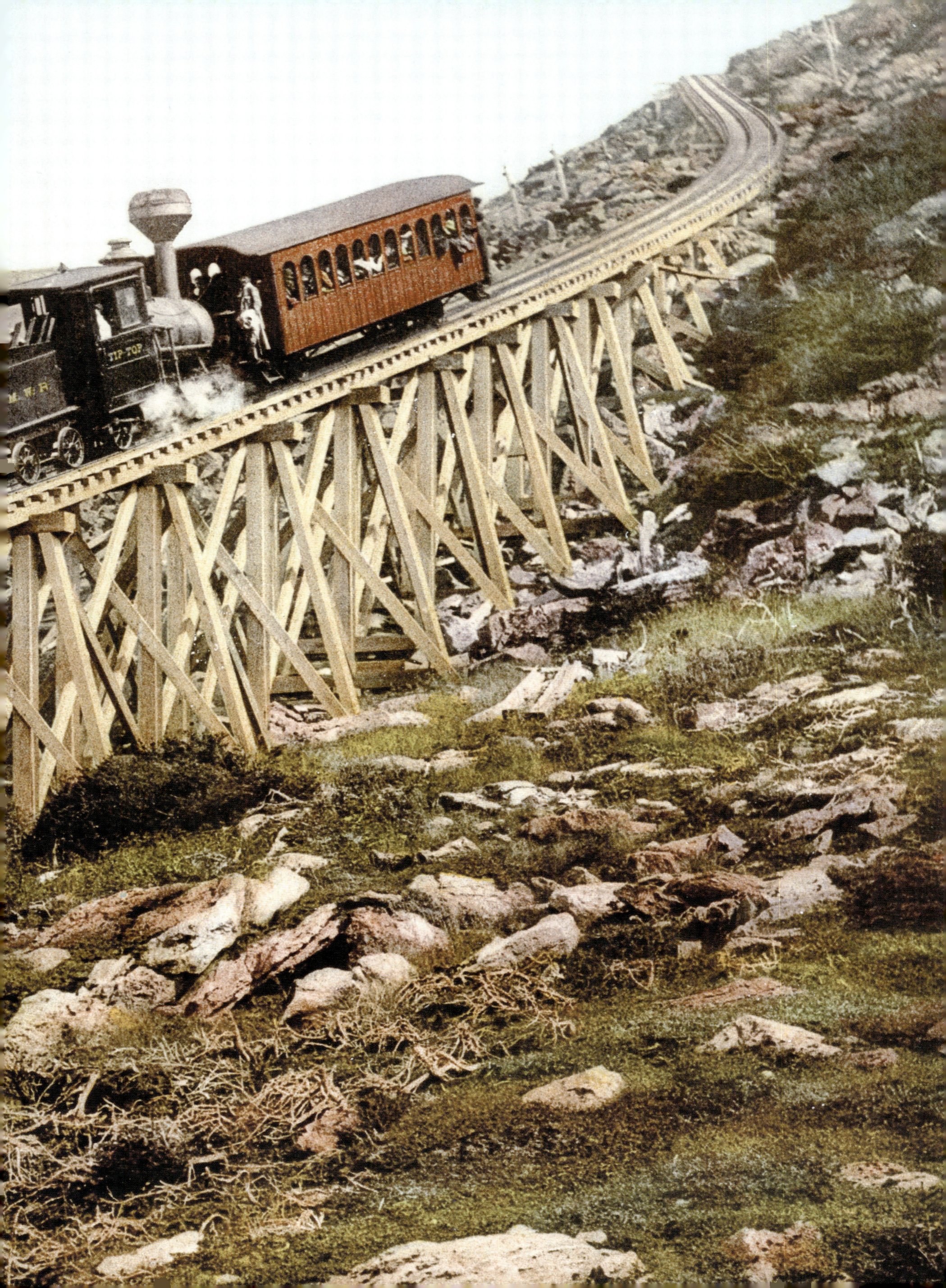

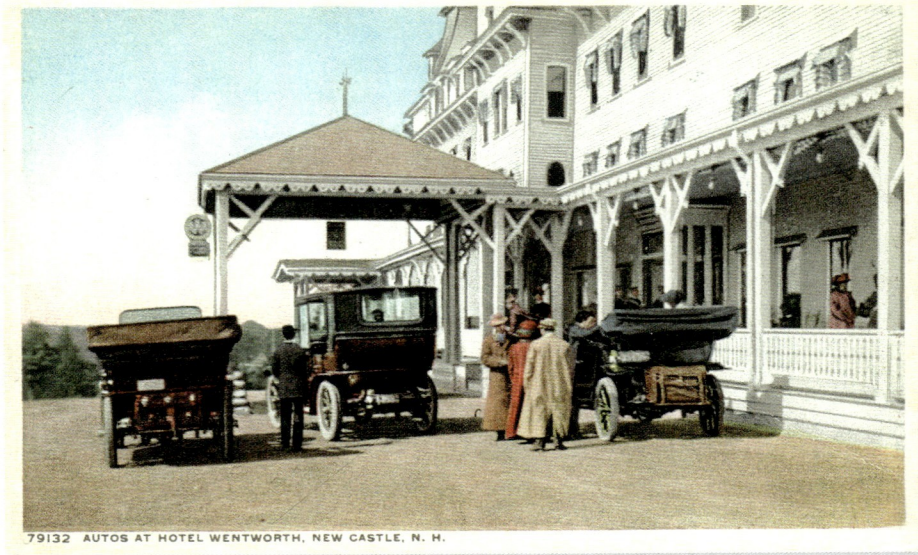

Page 136/137: Mount Washington Railway, Jacob's Ladder, photochrom
Top left: The Wentworth, New Castle
Top right: Autos at Hotel Wentworth, New Castle
Bottom: Isles of Shoals, the landing on Star Island, photochrom

The Shoals archipelago comprises nine little rocky islands, divided between the states of Maine and New Hampshire; by the time these photochroms were made, the isles were already much frequented. Visitors embarked on an hour-long crossing at Portsmouth and, en route, the steamers stopped at New Castle, a seaside resort renowned for its beautiful hotel, the Wentworth.

Seite 136/137: Zahnradbahn am Mount Washington, Jacob's Ladder, Photochrom
Oben links: Das Hotel Wentworth, New Castle
Oben rechts: Automobile vor dem Hotel Wentworth, New Castle
Unten: Isles of Shoals, Anlegestelle von Star Island, Photochrom

Der Shoals-Archipel umfasst neun kleine Felseninseln, die zu den Staaten Maine und New Hampshire gehören. In dem Sommer, in dem diese Photochrome entstanden, waren sie bereits gut besucht. Man gelangte per Schiff von Portsmouth aus dorthin; die Überfahrt dauerte eine Stunde. Unterwegs hielten die Dampfschiffe in dem Badeort New Castle, der wegen des schönen Hotels Wentworth besonderes Ansehen genoss.

Pages 136/137 : chemin de fer à crémaillère du mont Washington, « L'Échelle de Jacob », photochrome
En haut à gauche : l'hôtel Wentworth, New Castle
En haut à droite : automobiles devant l'hôtel Wentworth, New Castle
En bas : îles de Shoals, l'embarcadère de Star Island, photochrome

L'archipel de Shoals compte neuf petites îles rocheuses, réparties entre les États du Maine et du New Hampshire, et déjà bien fréquentées l'été à l'époque de nos photochromes. On s'y rendait en bateau depuis Portsmouth ; la traversée durait une heure. Sur la route, les steamers s'arrêtaient à New Castle, station balnéaire renommée pour son bel hôtel, le Wentworth.

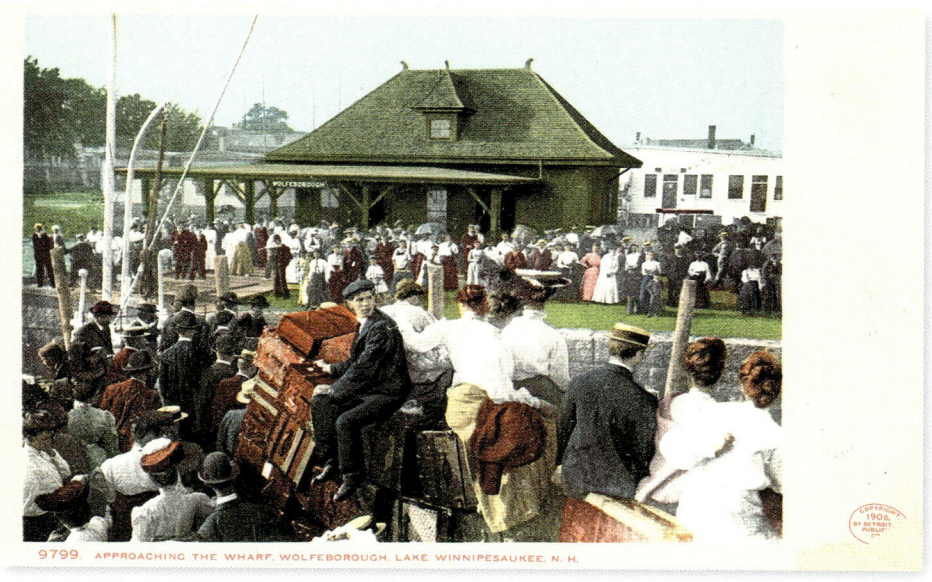
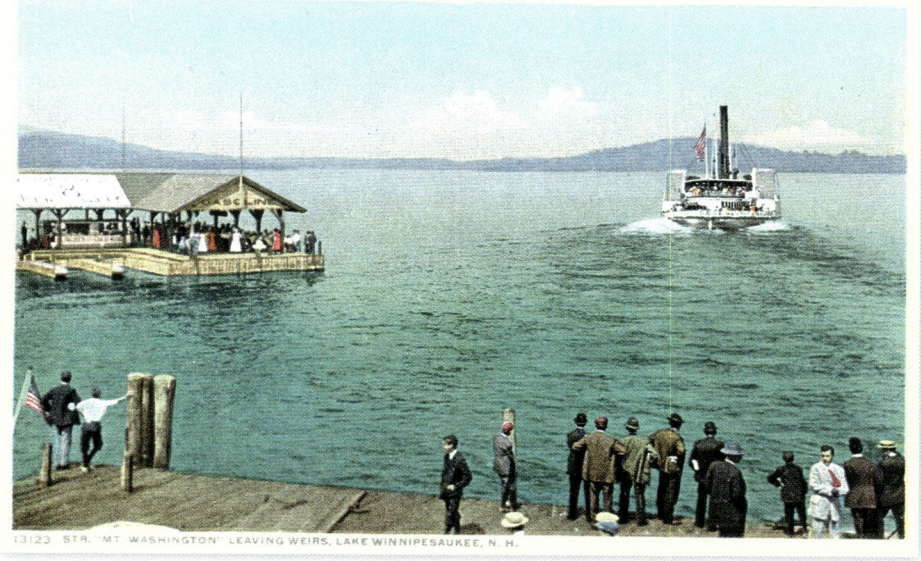

Top left: Approaching the wharf, Wolfeborough, Lake Winnipesaukee
Top right: Steamer *Mt. Washington* at Weirs, Lake Winnipesaukee
Bottom: *Mt. Washington* leaving Weirs, glass negative, 1906

The lake of the "Smile of the Great Spirit" is the largest in New Hampshire and the third largest in New England; it contains a multitude of islets and its waters are exceptionally transparent and abound with fish. The Winnipesaukee Indians lived and fished in the village of Acquadocton, which was renamed "Weirs" by the settlers because of the dams used to trap fish. The crossing between Wolfeborough and Weirs is known for its beautiful views of Mount Washington (see the following pages).

Oben links: Ankunft am Kai von Wolfeborough, Lake Winnipesaukee
Oben rechts: Das Dampfschiff *Mt. Washington* in Weirs, Lake Winnipesaukee
Unten: Abfahrt der *Mt. Washington* von Weirs, Glasnegativ, 1906

Der See des „Lächelns des Großen Geistes" ist der größte von New Hampshire und der drittgrößte von Neuengland. Er umschließt eine Vielzahl von Inselchen, und sein Wasser ist außergewöhnlich klar und reich an Fischen. Das Dorf Acquadocton, in dem die Winnipesaukee-Indianer lebten und Fischfang betrieben, wurde von den Siedlern in „Weirs" umbenannt – nach der Bezeichnung für die Wehre, die man zum Fischfang benutzte. Die Überfahrt mit dem Schiff zwischen Wolfeborough und Weirs bietet sehr schöne Blicke auf den Mount Washington (siehe folgende Seiten).

En haut à gauche : l'arrivée au quai de Wolfeborough, lac Winnipesaukee
En haut à droite : le vapeur *Mt. Washington* à Weirs, lac Winnipesaukee
En bas : le *Mt. Washington* quittant Weirs, plaque de verre, 1906

Le lac du « Sourire du Grand Esprit » est le plus grand du New Hampshire et le troisième de Nouvelle-Angleterre. Il enserre une multitude d'îlots et ses eaux sont exceptionnellement claires et poissonneuses. Les Indiens Winnipesaukee vivaient et pêchaient dans le village d'Acquadocton, rebaptisé « Weirs » par les colons, du nom donné aux barrages utilisés pour piéger les poissons. La traversée en bateau entre Wolfeborough et Weirs offre de très beaux points de vue sur le mont Washington (pages suivantes).

NEW HAMPSHIRE | LAKE WINNIPESAUKEE

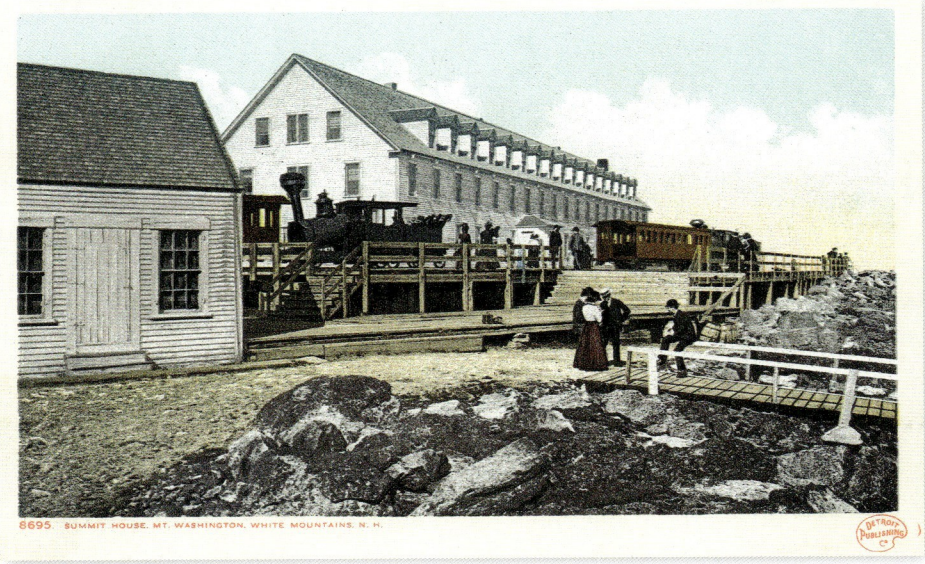
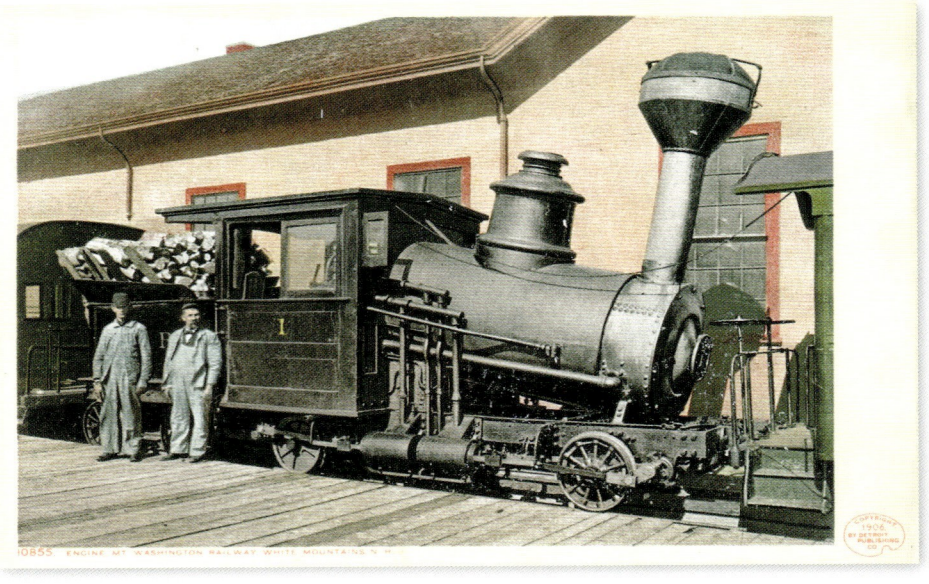
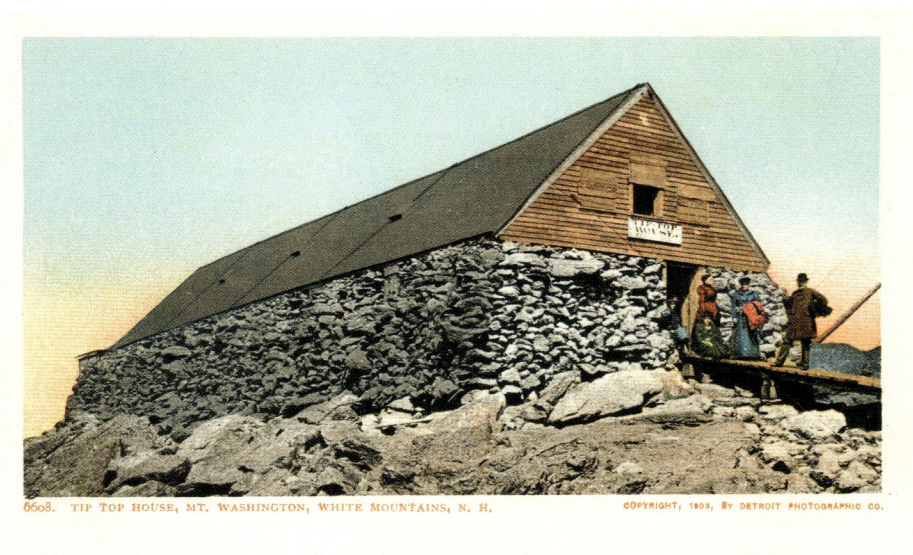

Top left: Summit House of Mt. Washington, White Mountains
Top right: Engine, Mt. Washington Railway
Left: Tip Top House, Mt. Washington
Below: Lizzie Bourne monument, glass negative, ca. 1902

Oben links: Bergstation der Zahnradbahn am Mount Washington, White Mountains
Oben rechts: Lokomotive, Mount Washington Railway
Links: Tip Top House, Schutzhütte auf dem Mount Washington
Unten: Lizzie-Bourne-Denkmal, Glasnegativ, um 1902

En haut à gauche : la gare d'arrivée du chemin de fer à crémaillère du mont Washington, White Mountains
En haut à droite : locomotive, chemin de fer du mont Washington
À gauche : « Tip Top House », le refuge du mont Washington
En bas : la stèle commémorative à Lizzie Bourne, plaque de verre, vers 1902

NEW HAMPSHIRE | WHITE MOUNTAINS

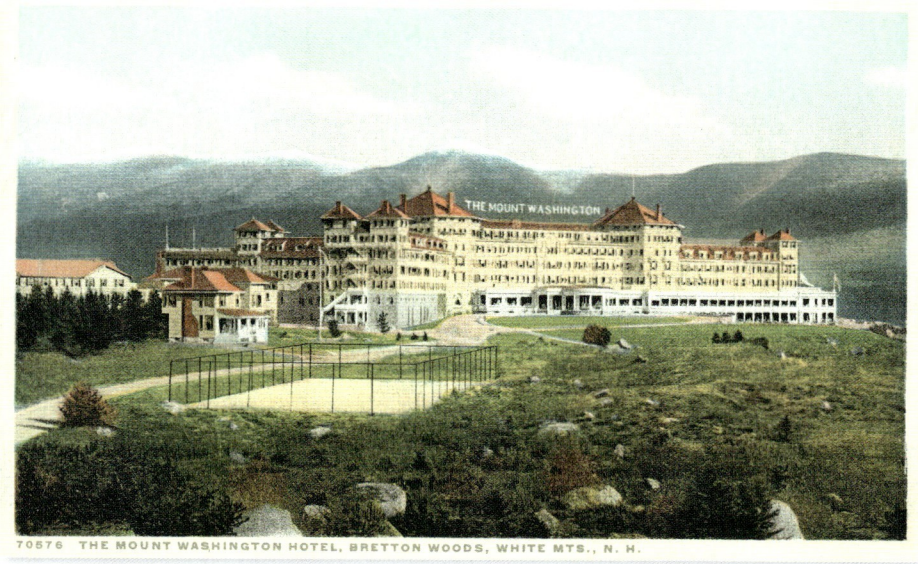
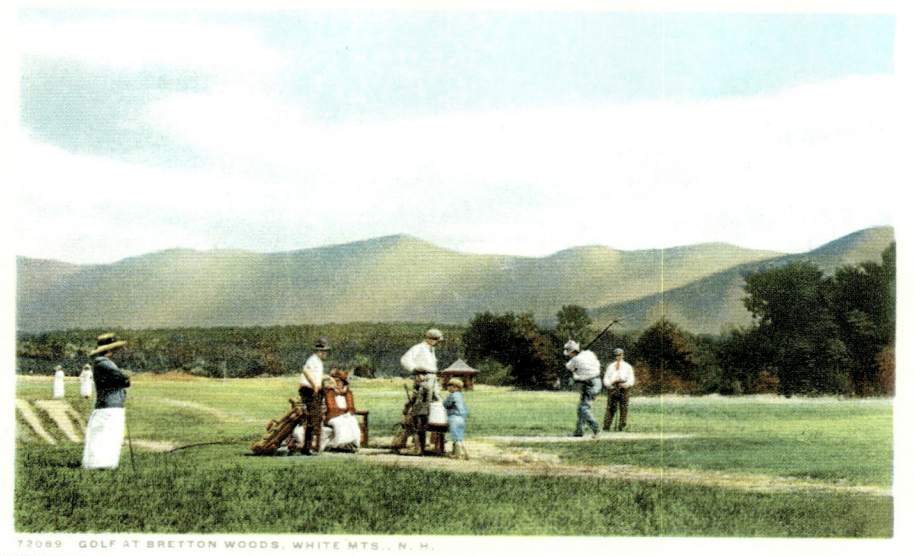
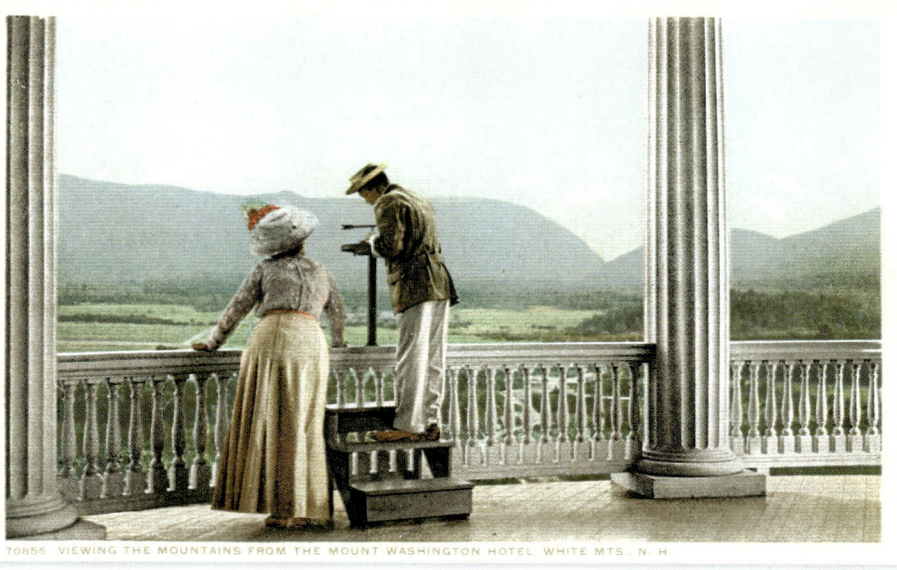
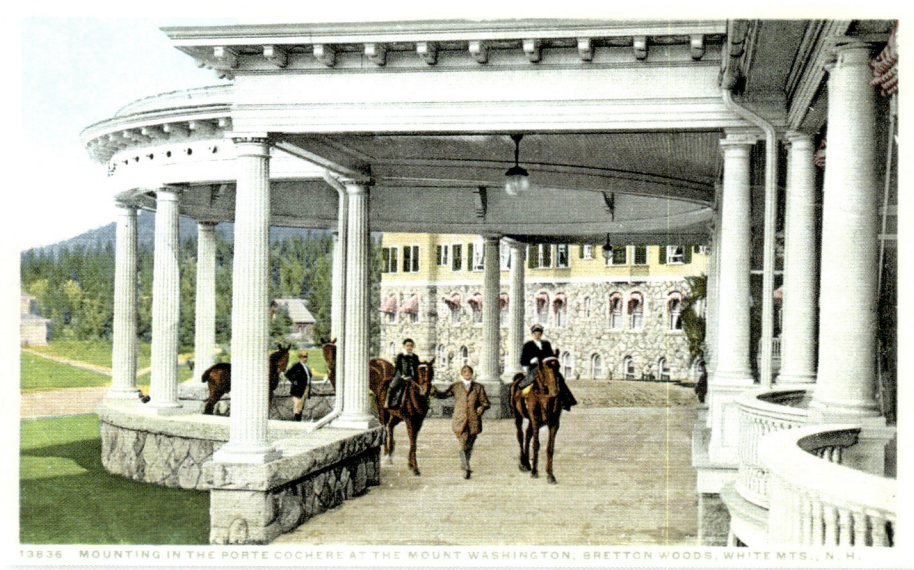

From left to right and top to bottom:
The Mount Washington Hotel, Bretton Woods
Golf at Bretton Woods
Viewing the mountains from the Mount Washington Hotel
Mounting in the porte cochère at the Mount Washington
Below: Bretton Woods rangers

The White Mountains have been a favored destination for tourists since the 1850s. They are dominated by Mount Washington at 6,288 feet (1,917 m). The young Lizzie Bourne died attempting to climb it on a foggy day; the monument raised by her father, Judge Bourne, has been moved to Kennebunk Cemetery and replaced by a simple cairn crowned with a cross, just beside the railway line constructed in 1868.

Von links nach rechts und von oben nach unten:
Das Hotel Mount Washington in Bretton Woods
Golf in Bretton Woods
Blick vom Hotel Mount Washington auf die Berge
Reiter am Eingang des Hotels Mount Washington
Unten: Die Rangers von Bretton Woods

Die White Mountains sind eine seit den 1850er-Jahren stark von Touristen frequentierte Region. Mit seinen 1917 Metern überragt der Mount Washington die anderen Berge. Bei dem Versuch, den Berg an einem nebligen Tag zu besteigen, kam die junge Lizzie Bourne ums Leben. Das Denkmal, das ihr Vater, der Richter Bourne, für sie errichtete, wurde auf den Friedhof von Kennebunk versetzt und durch einen schlichten Steinhügel mit einem Kreuz unmittelbar neben der 1868 gebauten Bahntrasse ersetzt.

De gauche à droite et de haut en bas :
L'hôtel Mount Washington à Bretton Woods
Le golfe de Bretton Woods
La vue sur les montagnes depuis l'hôtel Mount Washington
Cavaliers sous la porte cochère de l'hôtel Mount Washington
En bas : Les rangers de Bretton Woods

Les White Mountains sont une région très touristique depuis les années 1850. Le mont Washington les domine de ses 1917 mètres d'altitude. C'est en tentant l'ascension du mont un jour de brouillard que la jeune Lizzie Bourne trouva la mort. La stèle élevée à sa mémoire par son père, le juge Bourne, a été déplacée au cimetière de Kennebunk et remplacée par un simple tumulus de pierres surmonté d'une croix, juste au bord de la voie du chemin de fer construit en 1868.

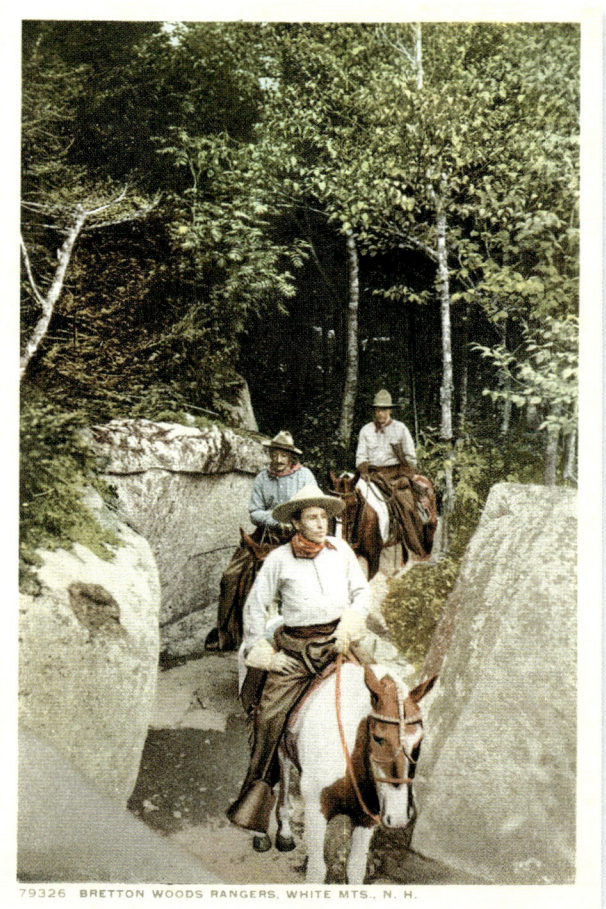

NEW HAMPSHIRE | WHITE MOUNTAINS

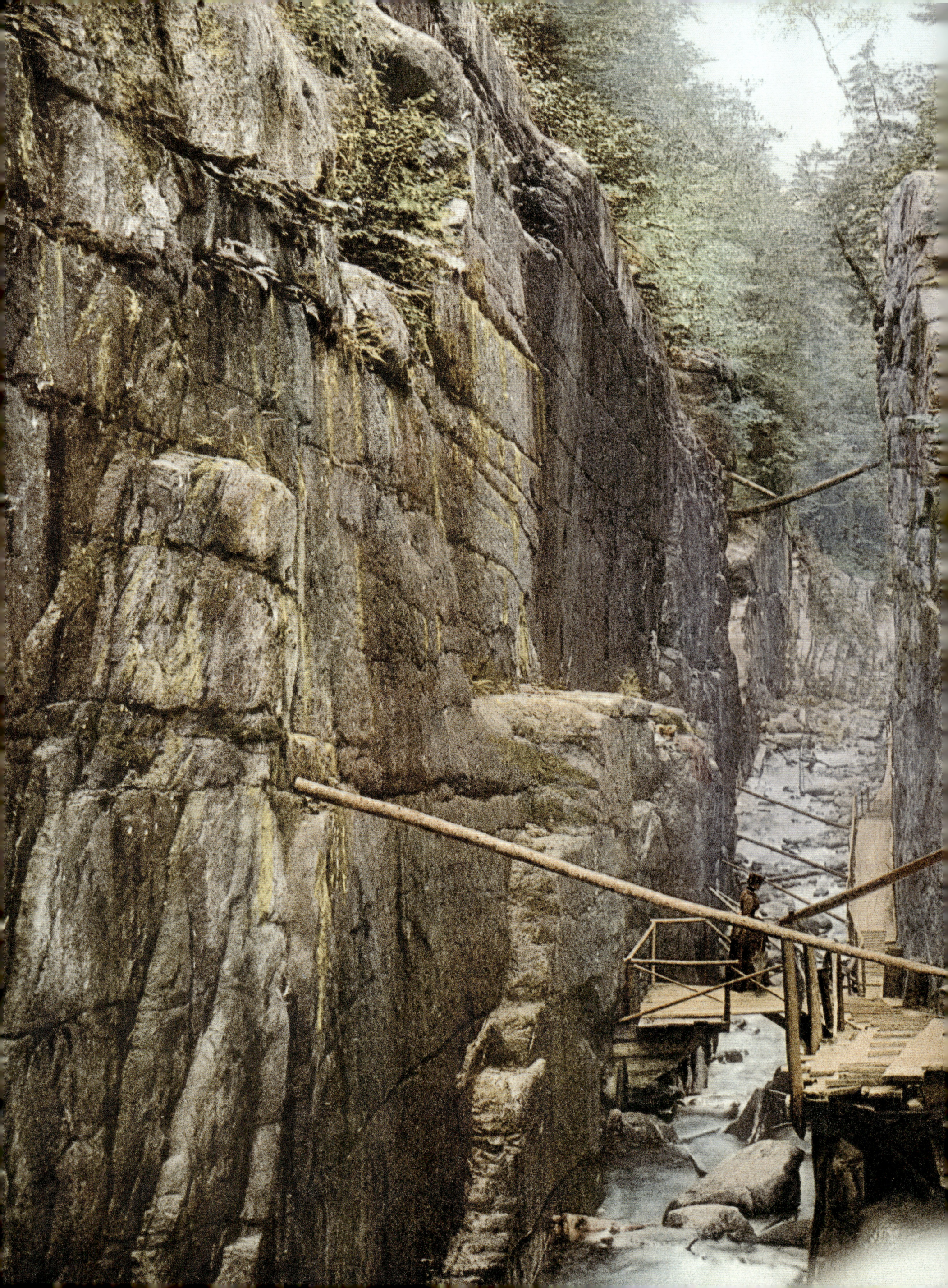

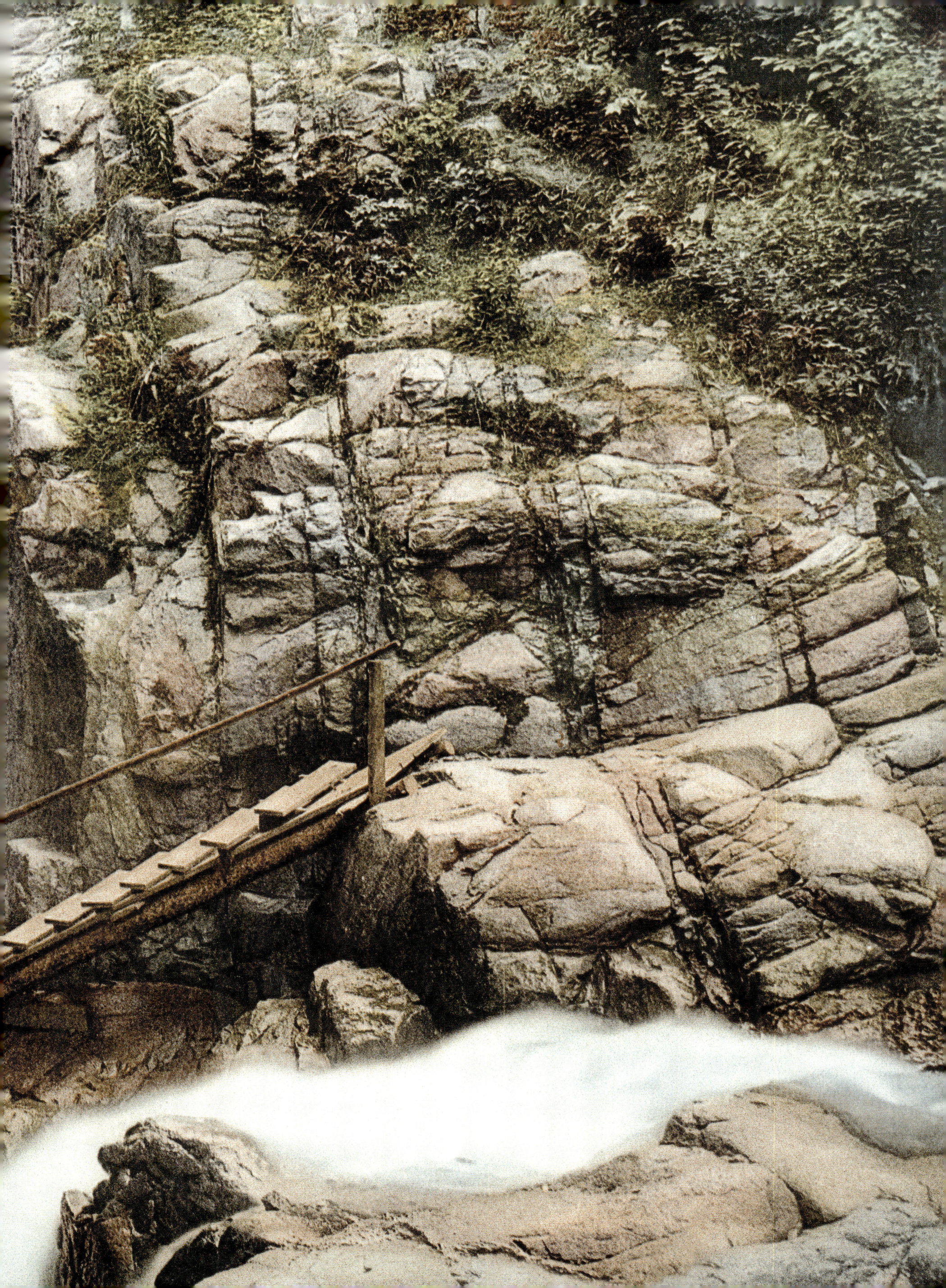

Page 142/143: **The Flume Gorge, Franconia Notch, White Mountains,** photochrom
Below: **Railway station, Bethlehem, White Mountains**
Bottom: **Franconia Notch, Indian Leap,** photochrom

A pathway was soon constructed through the Franconia Pass in the northwest of the White Mountains to allow tourists to reach the pretty Flume Gorge and the Pemigewasset River. Golf was introduced in the late 19th century in the White Mountains. The first clubs, those of Waumbek and Mount Pleasant, were founded in 1895. An 1899 article appearing in the magazine *Among the Clouds* (so called because it was printed in summer at the top of Mount Washington) speaks of the "golf-craze overrunning the mountain resorts as none of its sportive predecessors has done."

Seite 142/143: **Die Flume-Schlucht, Franconia Notch, White Mountains,** Photochrom
Mitte: **Der Bahnhof von Bethlehem, White Mountains**
Unten: **Franconia Notch, Indian Leap (Indianersprung),** Photochrom

In der Schlucht von Franconia (im Nordwesten der White Mountains) wurde schon früh ein Wanderweg angelegt, der zur malerischen Flume-Schlucht und zum Pemigewasset River führt. Ende des 19. Jahrhunderts hielt der Golfsport Einzug in die White Mountains. Die ersten Golfclubs, von Waumbek und Mount Pleasant, wurden 1895 gegründet. Ein Artikel, der 1899 in der (im Sommer auf dem Gipfel des Mount Washington gedruckten) Zeitschrift *Among the Clouds* erschien, berichtet von einer „nie da gewesenen Begeisterung für diesen Sport".

Pages 142/143 : **la gorge de Flume, Franconia Notch, White Mountains,** photochrome
Ci-dessous : **la gare de Bethlehem, White Mountains**
En bas : **Franconia Notch, Indian Leap (le saut de l'Indien), photochrome**

Dans le défilé de Franconia (au nord-ouest des White Mountains), un sentier de promenade a été aménagé très tôt, qui mène à la jolie gorge de Flume et à la rivière Pemigewasset. Le golf a été introduit à la fin du XIXe siècle dans les White Mountains : les premiers clubs, ceux de Waumbek et de Mount Pleasant, ont été créés en 1895. Un article paru en 1899 dans la revue *Among the Clouds* (imprimée l'été au sommet du mont Washington) fait état d'un « engouement sans précédent pour ce sport ».

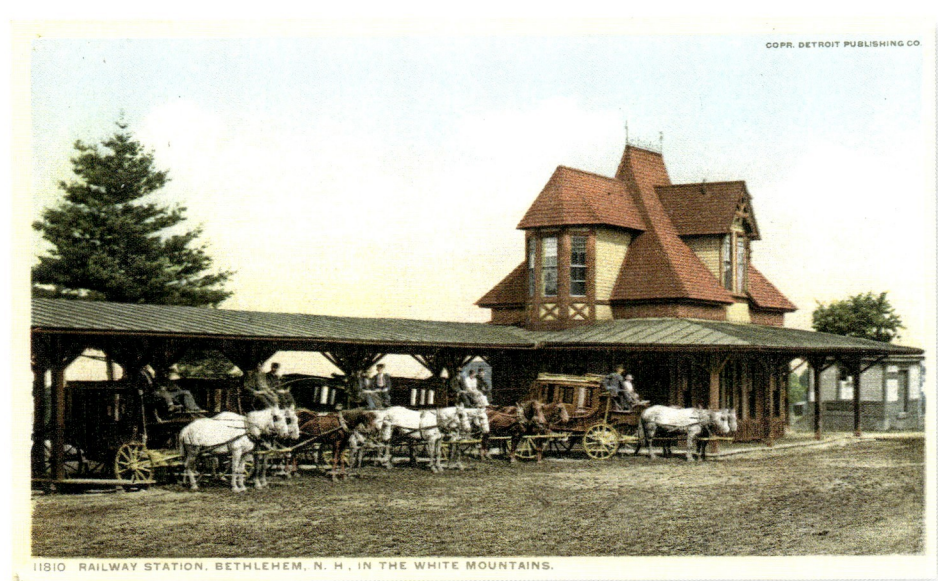

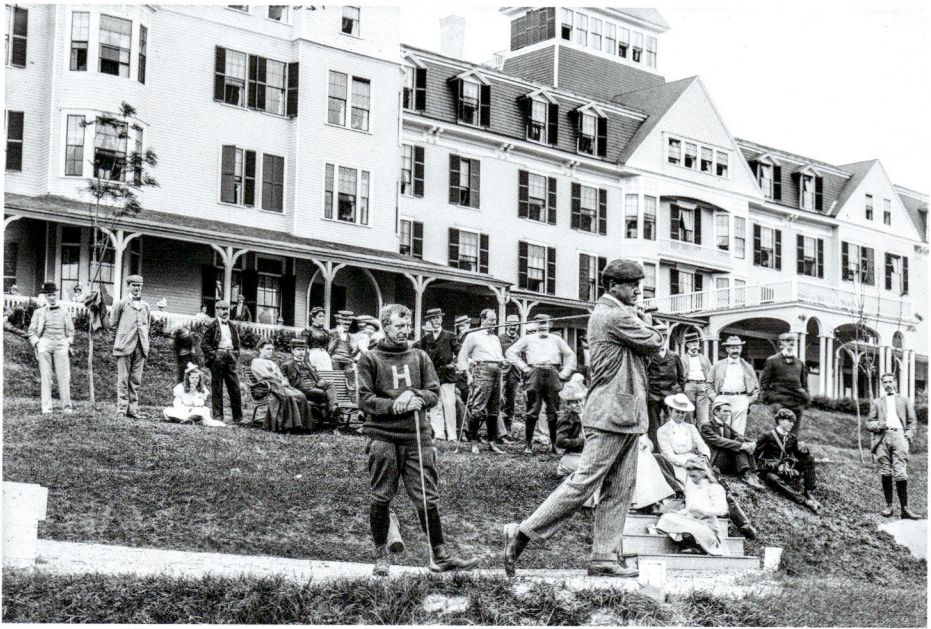
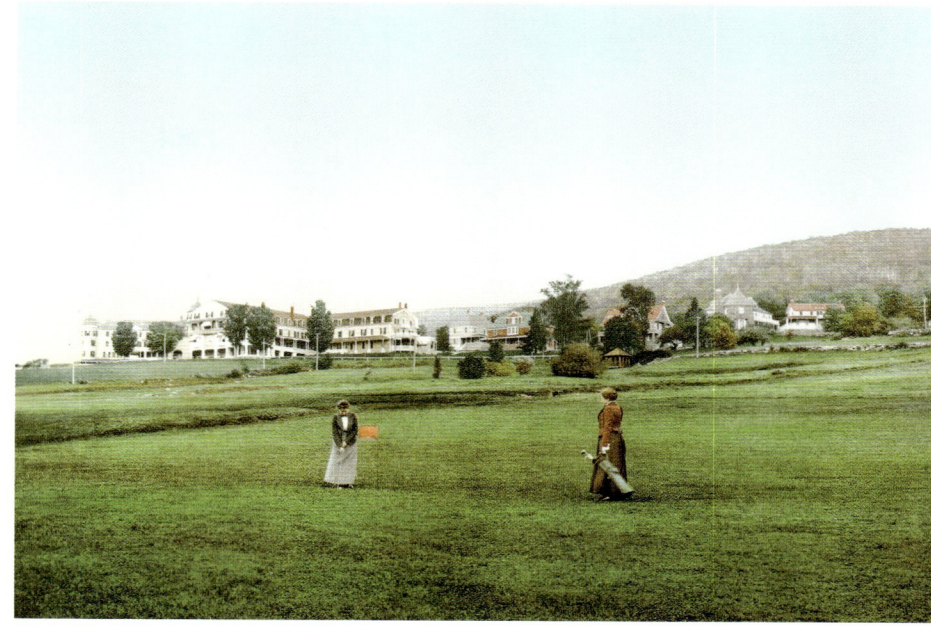

Top left: Final round for Stickney Cup, Mount Pleasant Course, Mount Washington, glass negative, ca. 1890–1901
Top right: The Waumbek Golf and Hotel, Mount Washington Valley, photochrom
Bottom: Crawford Notch from Crawford House, photochrom

Oben links: Schlussrunde beim Stickney Cup, Golfplatz von Mount Pleasant, Mount Washington, Glasnegativ, um 1890–1901
Oben rechts: Waumbek-Golfplatz und -Hotel, Mount Washington Valley, Photochrom
Unten: Blick vom Crawford House auf Crawford Notch, Photochrom

En haut à gauche : dernier tour de la Stickney Cup, golf de Mount Pleasant, Mount Washington, plaque de verre, vers 1890–1901
En haut à droite : le golf et l'hôtel Waumbek, Mount Washington Valley, photochrome
En bas : la vue vers Crawford Notch depuis Crawford House, photochrome

NEW HAMPSHIRE | WHITE MOUNTAINS

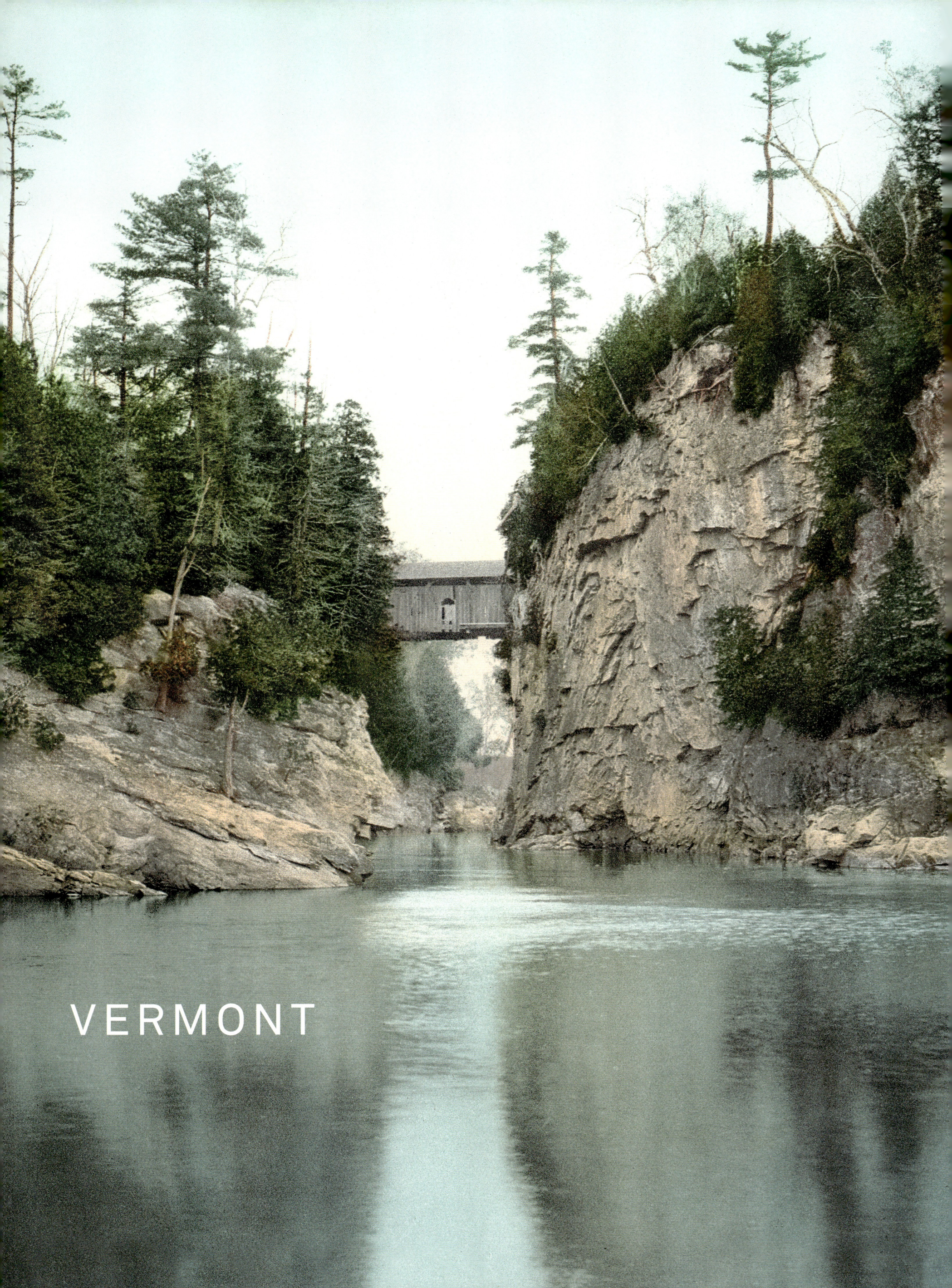

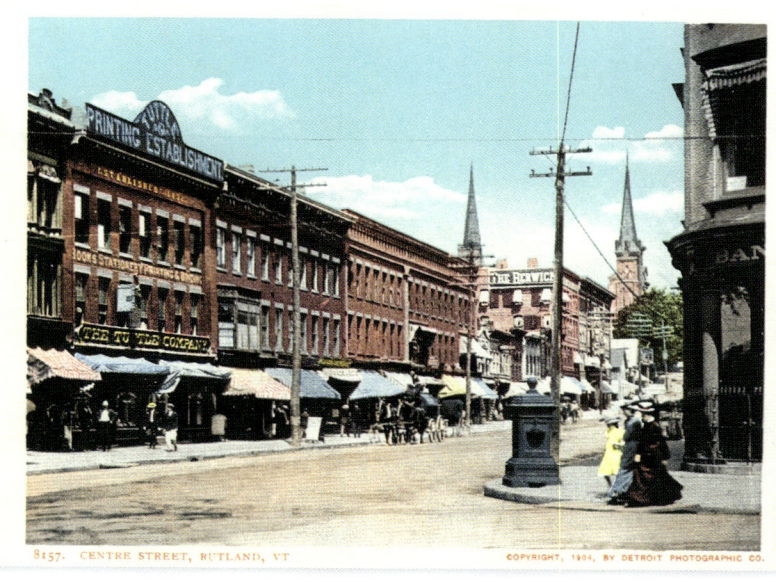

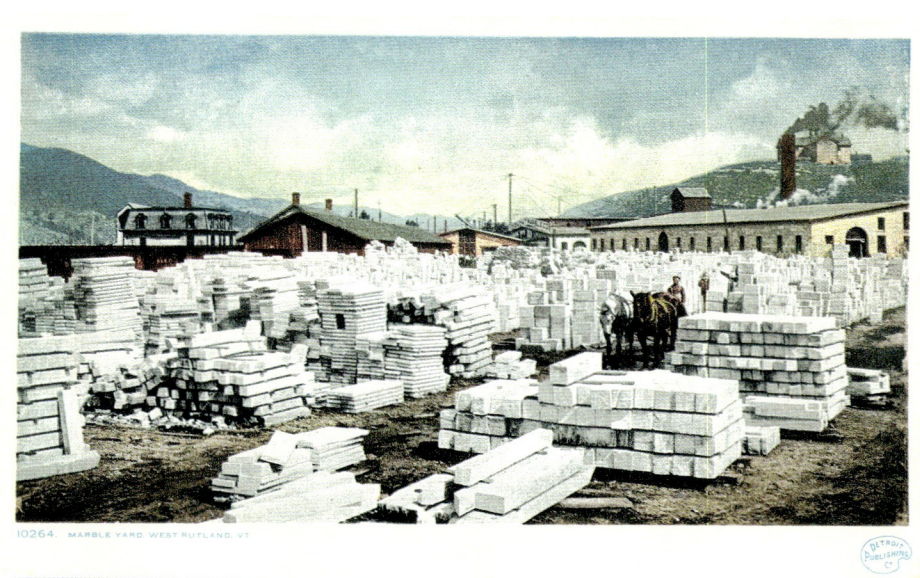

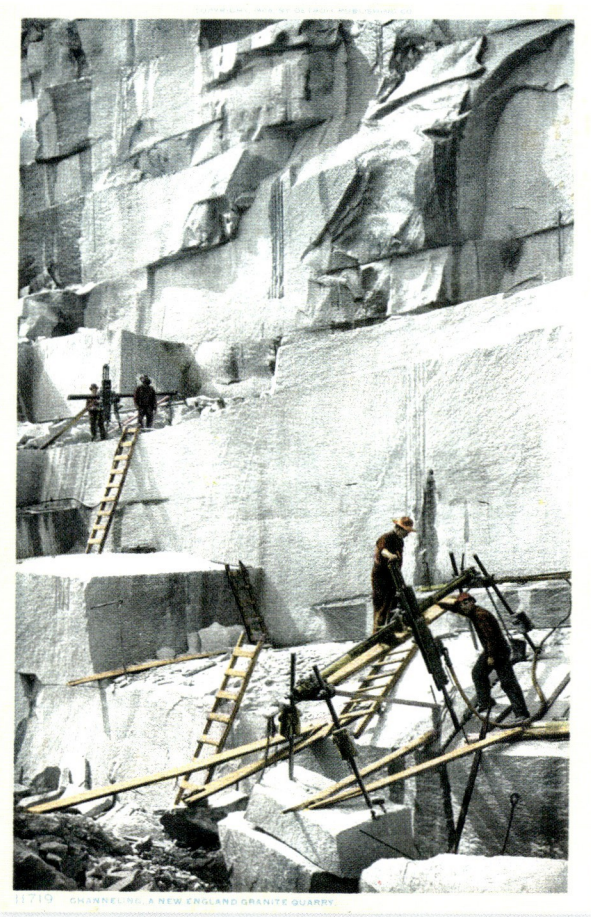

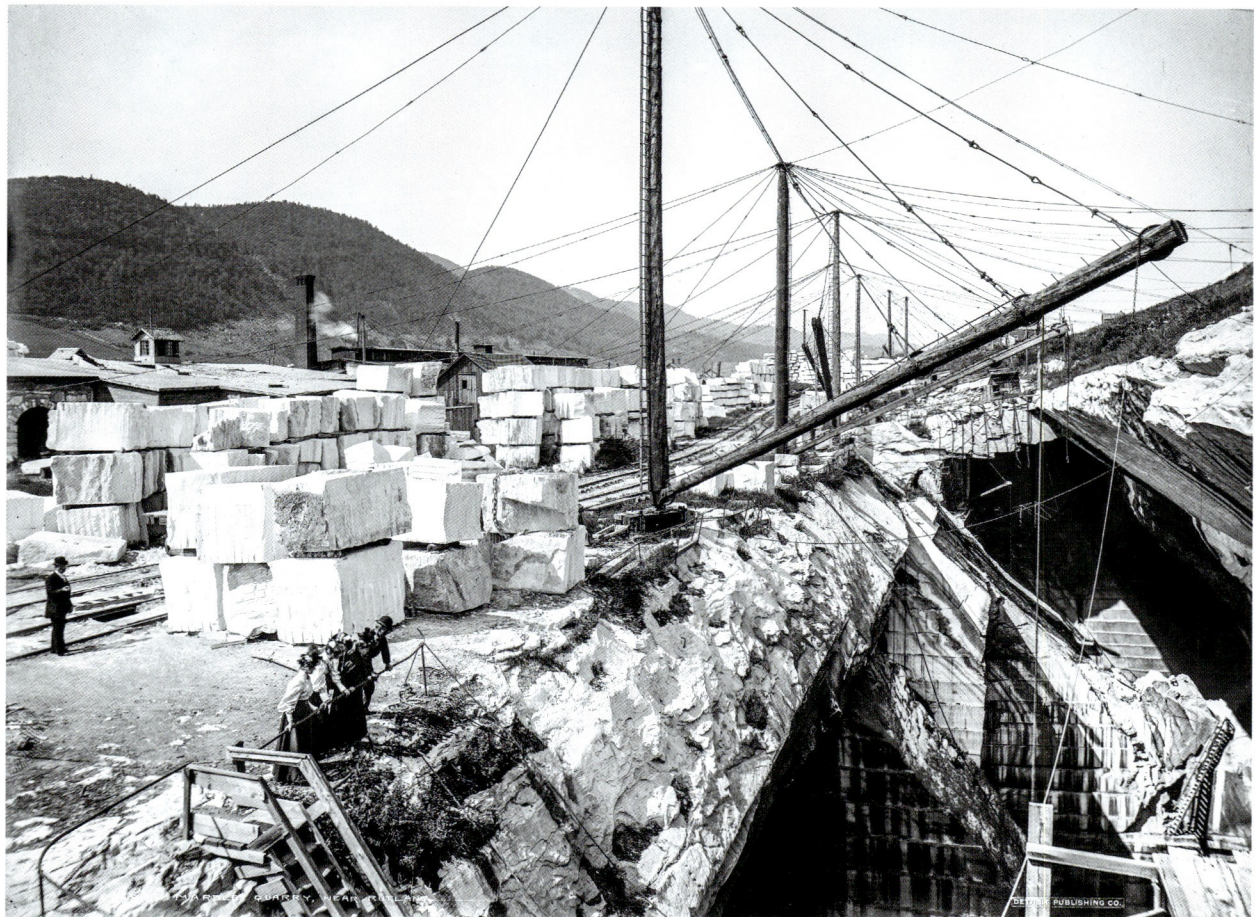

Page 146: Winooski Gorge, near Burlington, photochrom
Top right: Centre Street, Rutland
Middle right: Marble yard, West Rutland
Above: Channeling, a New England granite quarry
Right: Marble quarry near Rutland, Green Mountains, glass negative, 1901–1906

Seite 146: Die Winooski-Schlucht bei Burlington, Photochrom
Oben rechts: Centre Street, Rutland
Darunter: Marmorsteinbruch im Westen von Rutland
Oben: Granitsteinbruch in Neuengland
Rechts: Marmorsteinbruch bei Rutland, Green Mountains, Glasnegativ, 1901–1906

Page 146 : la gorge de Winooski près de Burlington, photochrome
En haut à droite : Centre Street, Rutland
En dessous : carrière de marbre à l'ouest de Rutland
Ci-dessus : une carrière de granit en Nouvelle-Angleterre
À droite : carrière de marbre près de Rutland, Green Mountains, plaque de verre, 1901–1906

VERMONT | RUTLAND

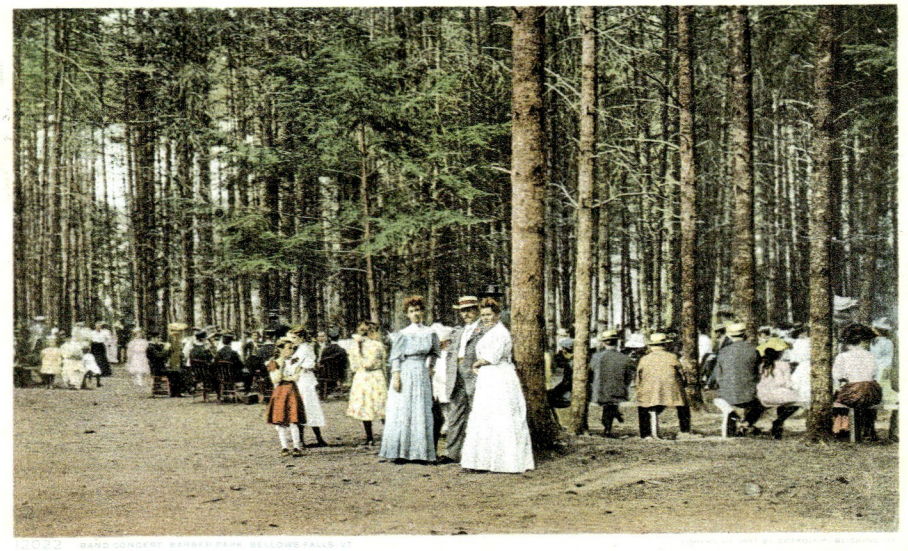
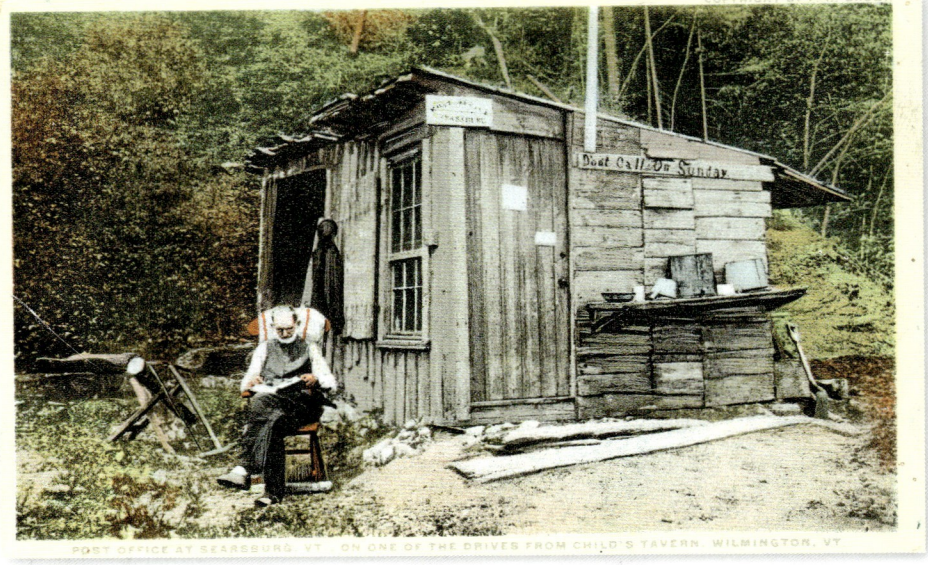
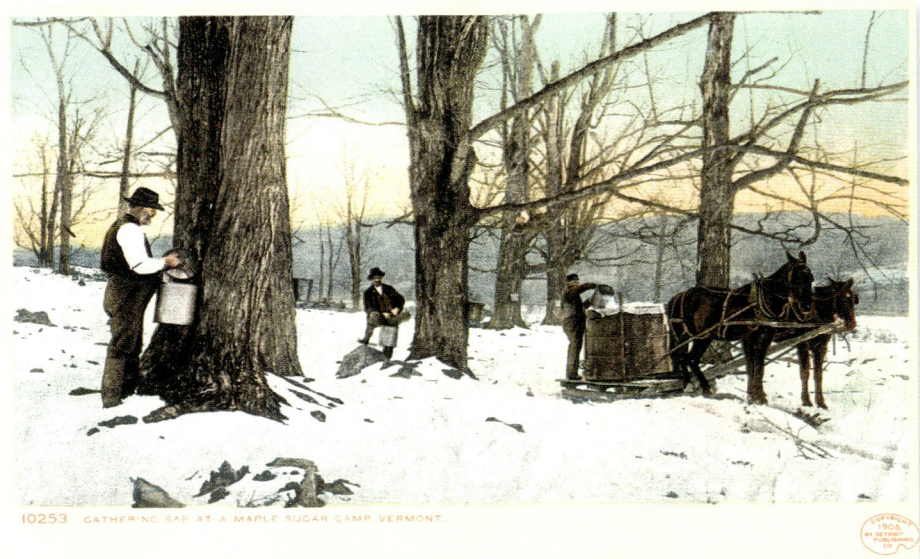
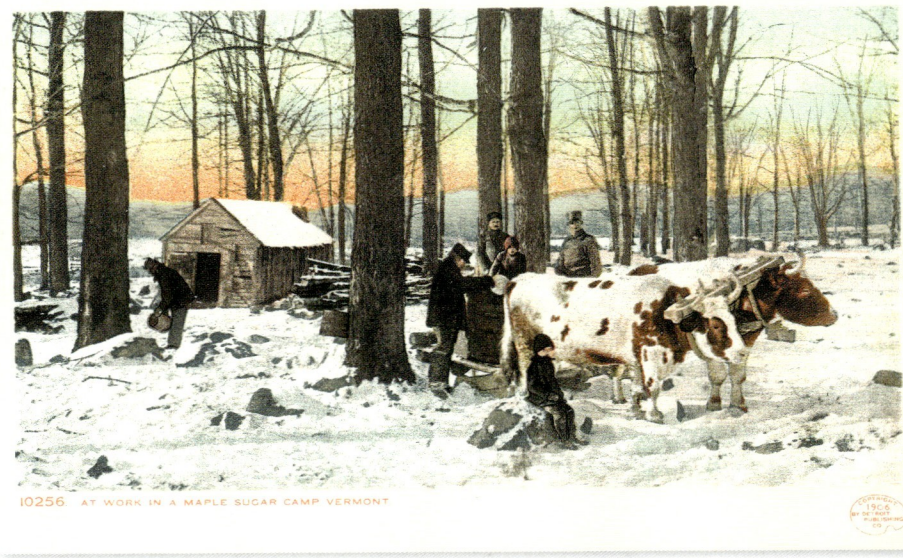

From left to right and top to bottom:
Band concert, Barber Park, Bellows Falls
Post office at Searsburg, Wilmington
Gathering sap at a maple sugar camp
At work in a maple sugar camp
Below: Making maple sugar the good old-fashioned way

Von links nach rechts und von oben nach unten:
Konzert im Barber Park, Bellows Falls
Das Postamt von Searsburg, Wilmington
Das Sammeln von Ahornsaft für die Herstellung von Ahornsirup
Bei der Arbeit in einem Betrieb zur Herstellung von Ahornsirup
Unten: Traditionelle Herstellung von Ahornsirup

De gauche à droite et de haut en bas :
Concert dans le parc (Barber Park), Bellows Falls
Le bureau de poste de Searsburg, Wilmington
Récolte de sève dans une exploitation de sirop d'érable
Au travail dans une exploitation de sirop d'érable
En bas : fabrication traditionnelle du sirop d'érable

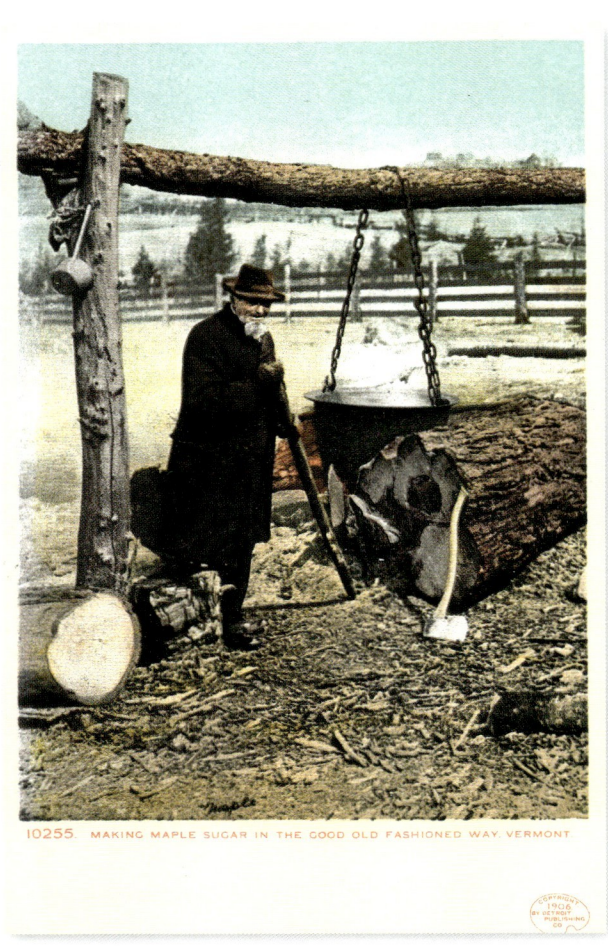

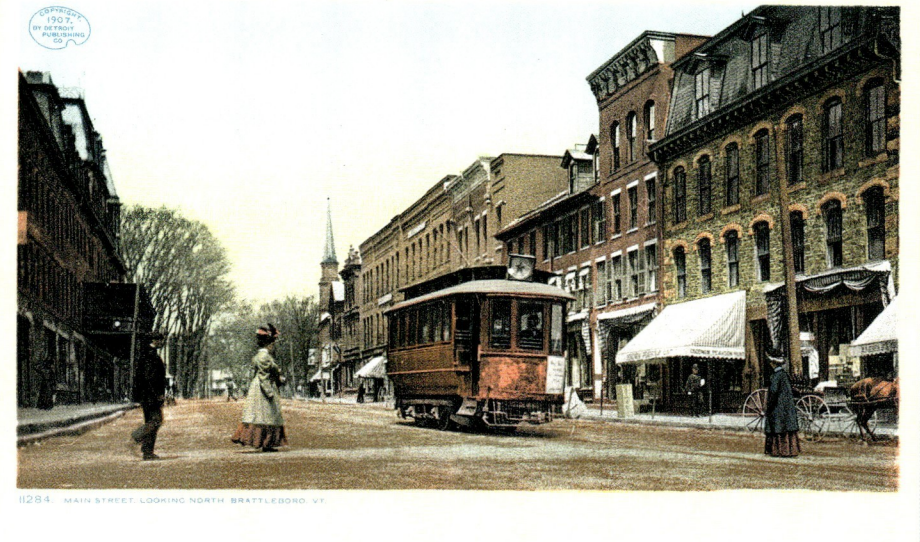
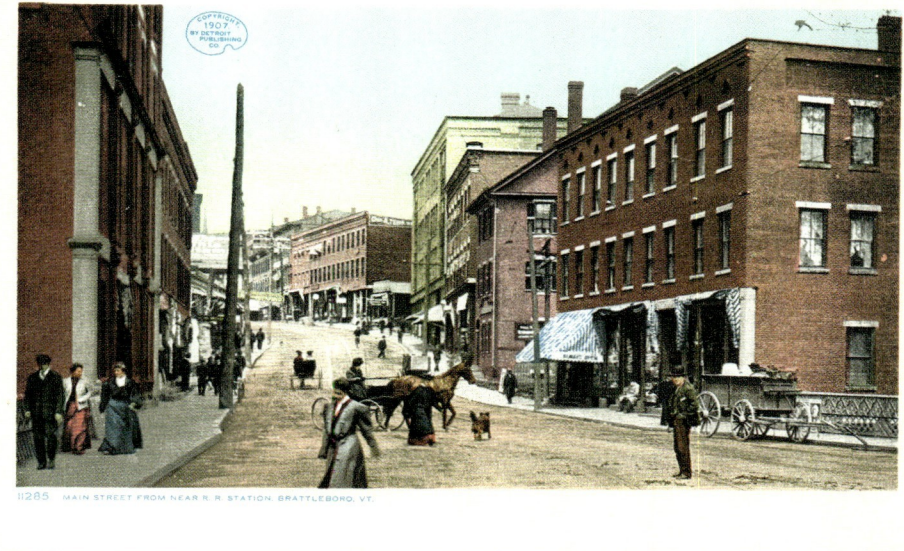

Top left: **Main Street looking north, Brattleboro**
Top right: **Main Street from near railroad station, Brattleboro**
Bottom: **Bellows Falls, the Square, glass negative, 1907**
Just before the arrival of the first buds, the smell of maple sap boiling in the pans of the maple-syrup farms signals the arrival of spring in the forests of Vermont. Its manufacture is a tradition that the settlers of New England borrowed from the Indian tribes, who used the syrup as a currency and taught the settlers how to make it.

Oben links: **Main Street in nördlicher Richtung, Brattleboro**
Oben rechts: **Main Street vom Bahnhof aus, Brattleboro**
Unten: **Bellows Falls, der zentrale Platz, Glasnegativ, 1907**
Noch bevor die ersten Knospen sprießen, kündigt in den Wäldern von Vermont der Duft von Ahornsaft, der in den Kesseln der Hersteller von Ahornsirup brodelt, den Frühling an. Die Herstellung von Ahornsirup ist eine Tradition, die die Siedler Neuenglands von den Indianerstämmen übernommen haben. Letztere tauschten den Sirup gegen andere Waren ein und vermittelten den Siedlern ihre Kenntnisse.

En haut à gauche : **Main Street, vue vers le nord, Brattleboro**
En haut à droite : **Main Street, vue prise depuis la gare, Brattleboro**
En bas : **Bellows Falls, la place, plaque de verre, 1907**
Avant l'apparition des premiers bourgeons, les effluves de la sève d'érable bouillant dans les marmites des exploitations de sirop d'érable signalent l'arrivée du printemps dans les forêts du Vermont. La fabrication de ce sirop est une tradition que les colons de Nouvelle-Angleterre ont empruntée aux tribus indiennes, qui le troquaient contre d'autres marchandises et leur ont enseigné leur savoir-faire.

MASSACHUSETTS

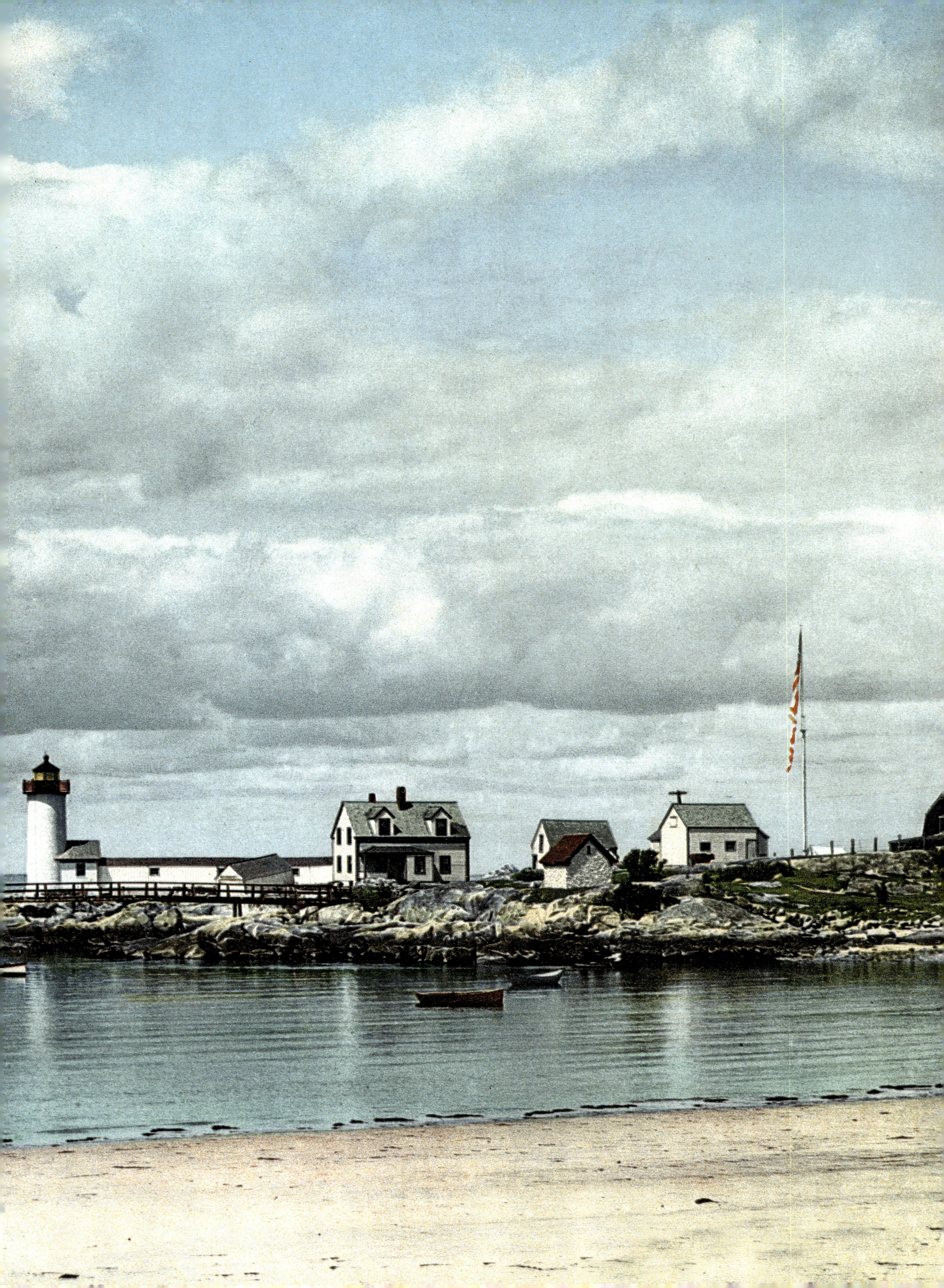

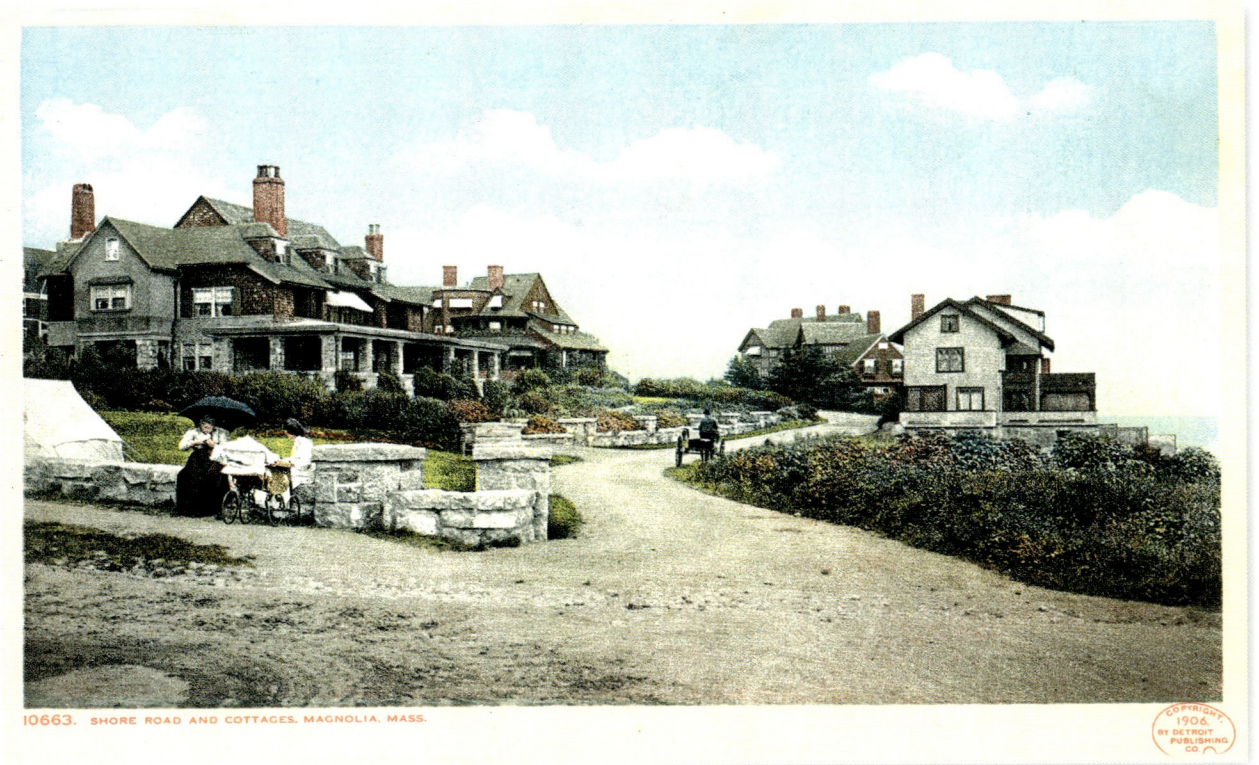

Page 150/151: Annisquam Light, Gloucester, photochrom
Above: Shore road and cottages, Magnolia
Below, from left to right and top to bottom:
Getting ready for a trip
A Cape Ann fisherman and dory
Unloading Gorton's codfish, Gloucester
Weighing up the catch, Gloucester
Page 153: A Cape Ann fisherman, glass negative, 1904

Founded on the rocky promontory of Cape Ann in 1623, earlier than either Salem or Boston, Gloucester is one of the oldest sites settled by the English pioneers, who set up the first fish-trading posts in Massachusetts. However the real fishing industry developed in Gloucester only in the years 1680–1700, reaching a peak in the 19th century. In 1831, Gloucester's production of salt cod exceeded that of all the other New England ports.

Seite 150/151: Leuchtturm von Annisquam, Gloucester, Photochrom
Oben: Küstenstraße und Häuser, Magnolia
Unten, von links nach rechts und von oben nach unten:
Vorbereitungen für den Fischfang
Ein Fischer von Cape Ann in seinem typischen kleinen Boot
Ausladen der Dorsche, Gloucester
Wiegen des Tagesfangs, Gloucester
Seite 153: Ein Fischer von Cape Ann, Glasnegativ, 1904

Gloucester wurde 1623 – noch vor Salem und Boston – auf der felsigen Landspitze Cape Ann gegründet und ist einer der ältesten von englischen Pionieren besiedelten Orte. Diese eröffneten hier die ersten Fischläden von Massachusetts. Doch die eigentliche gewerbliche Fischerei entwickelte sich in Gloucester erst in den Jahren 1680 bis 1700 und erreichte im 19. Jahrhundert schließlich ihren Höhepunkt. 1831 überstieg die Produktion von gesalzenem Stockfisch allein in der Stadt Gloucester die Produktion aller Häfen Neuenglands zusammen.

Pages 150/151 : le phare d'Annisquam, Gloucester, photochrome
En haut : la route côtière et les maisons de Magnolia
En bas, de gauche à droite et de haut en bas :
Avant le départ pour la pêche : les préparatifs
Un pêcheur de Cape Ann dans son doris (barque locale)
Déchargement de la morue à Gloucester
Pesée de la pêche du jour, Gloucester
Page 153 : un pêcheur de Cape Ann, plaque de verre, 1904

Fondé sur le promontoire rocheux de Cape Ann en 1623 – avant Salem et avant Boston –, Gloucester est l'un des plus anciens sites colonisés par les pionniers anglais, qui y ont établi les premiers comptoirs de pêche du Massachusetts. Une véritable industrie de la pêche ne s'est cependant développée à Gloucester que dans les années 1680–1700, pour atteindre un pic au xixe siècle. En 1831, la production de morue salée pour la seule ville de Gloucester dépassait celle de la totalité des ports de Nouvelle-Angleterre.

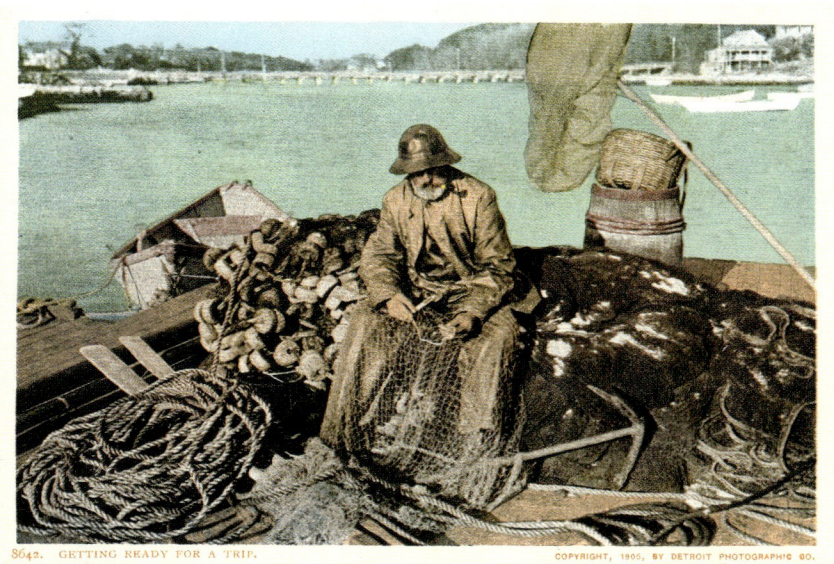
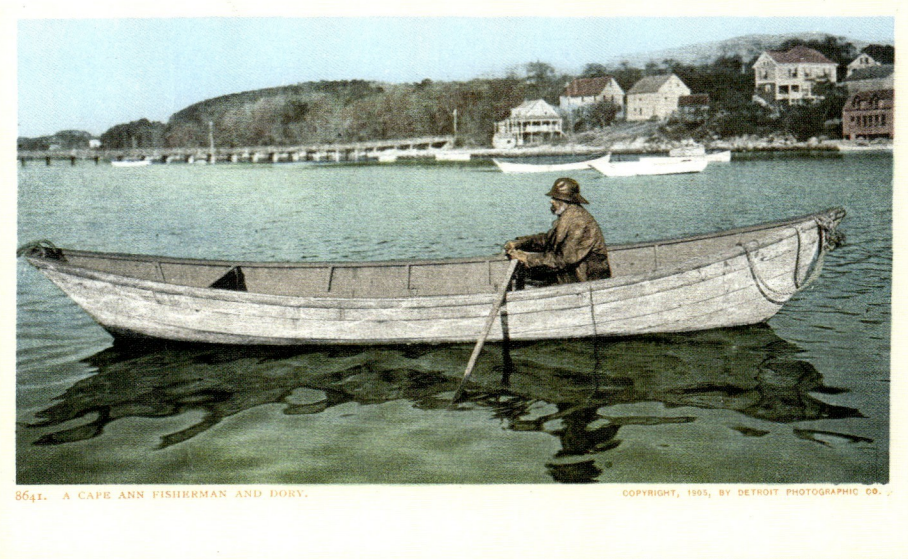
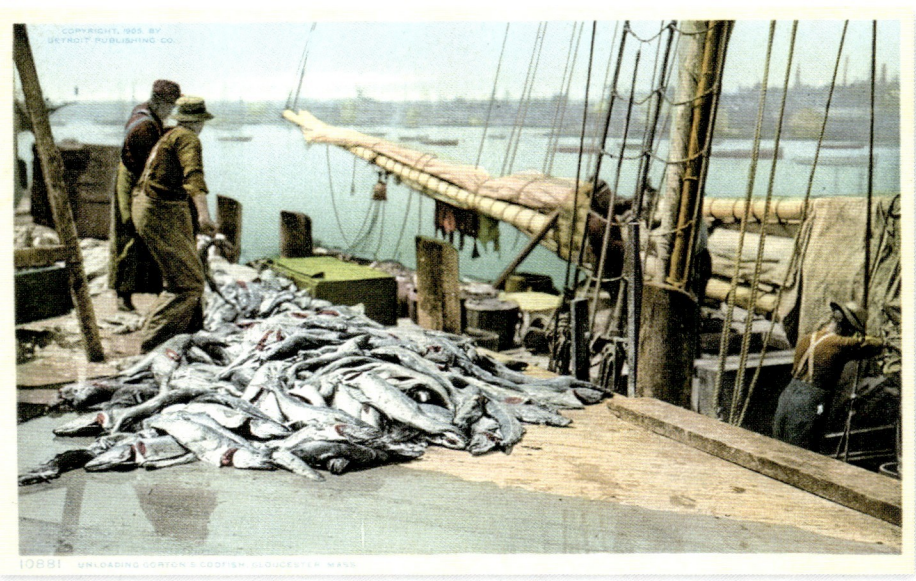
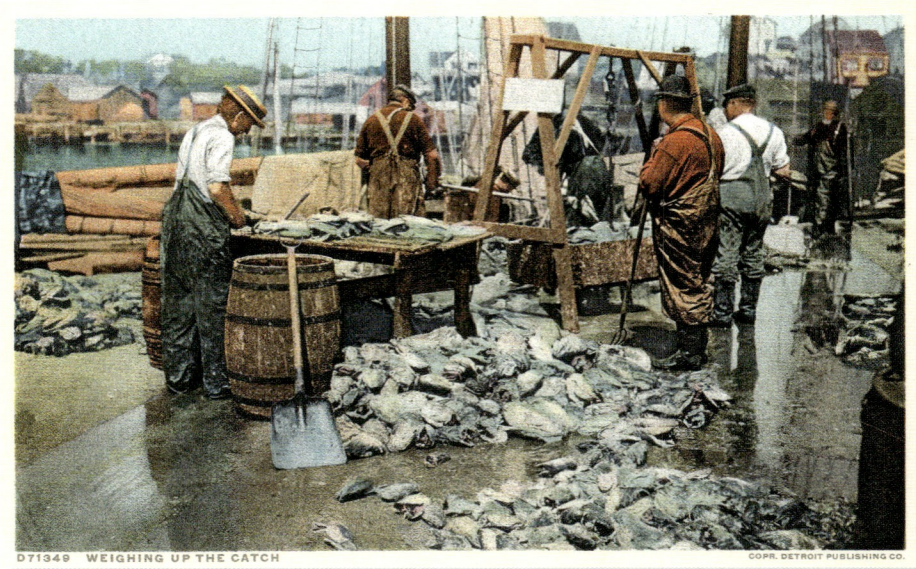

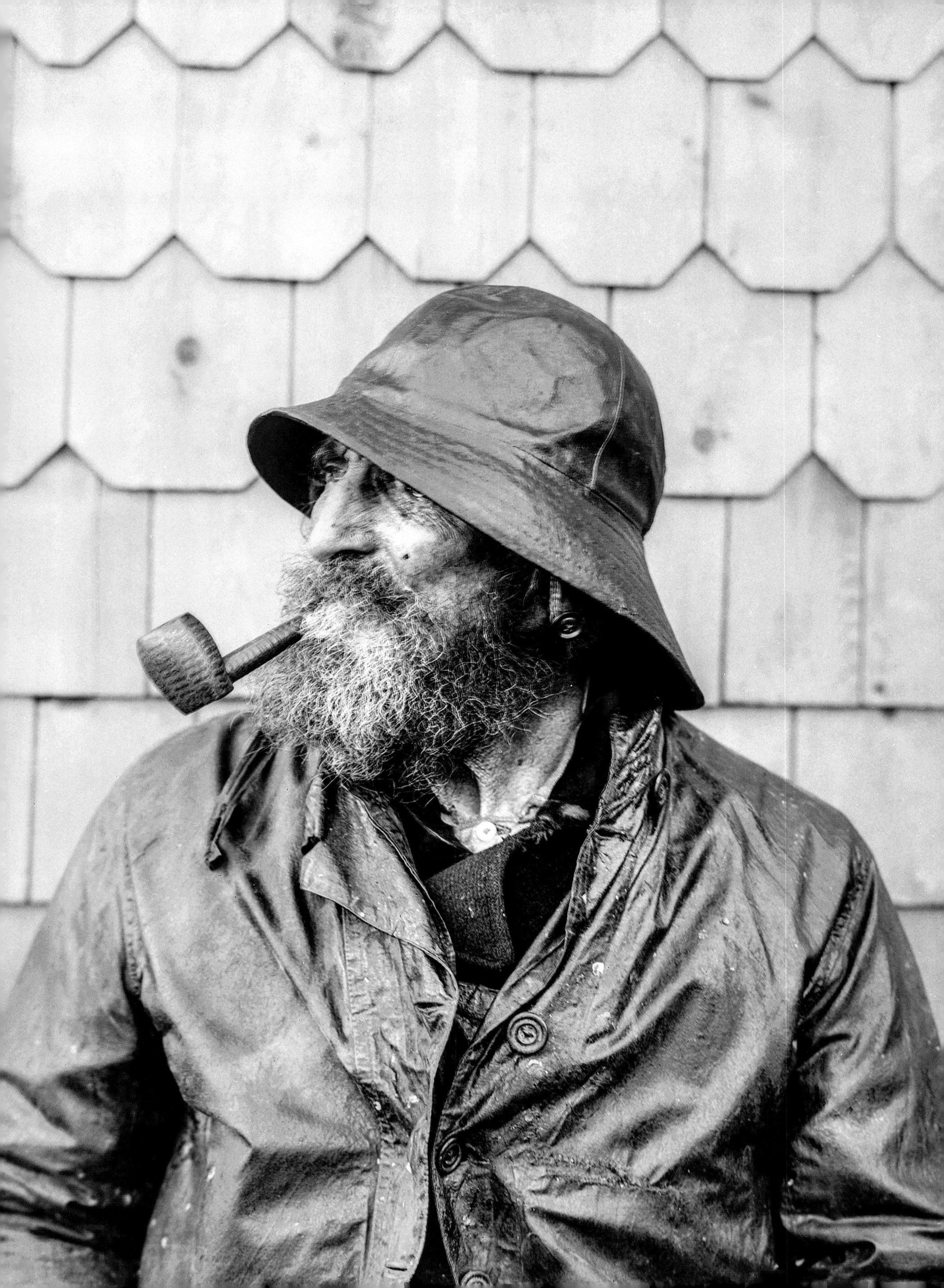

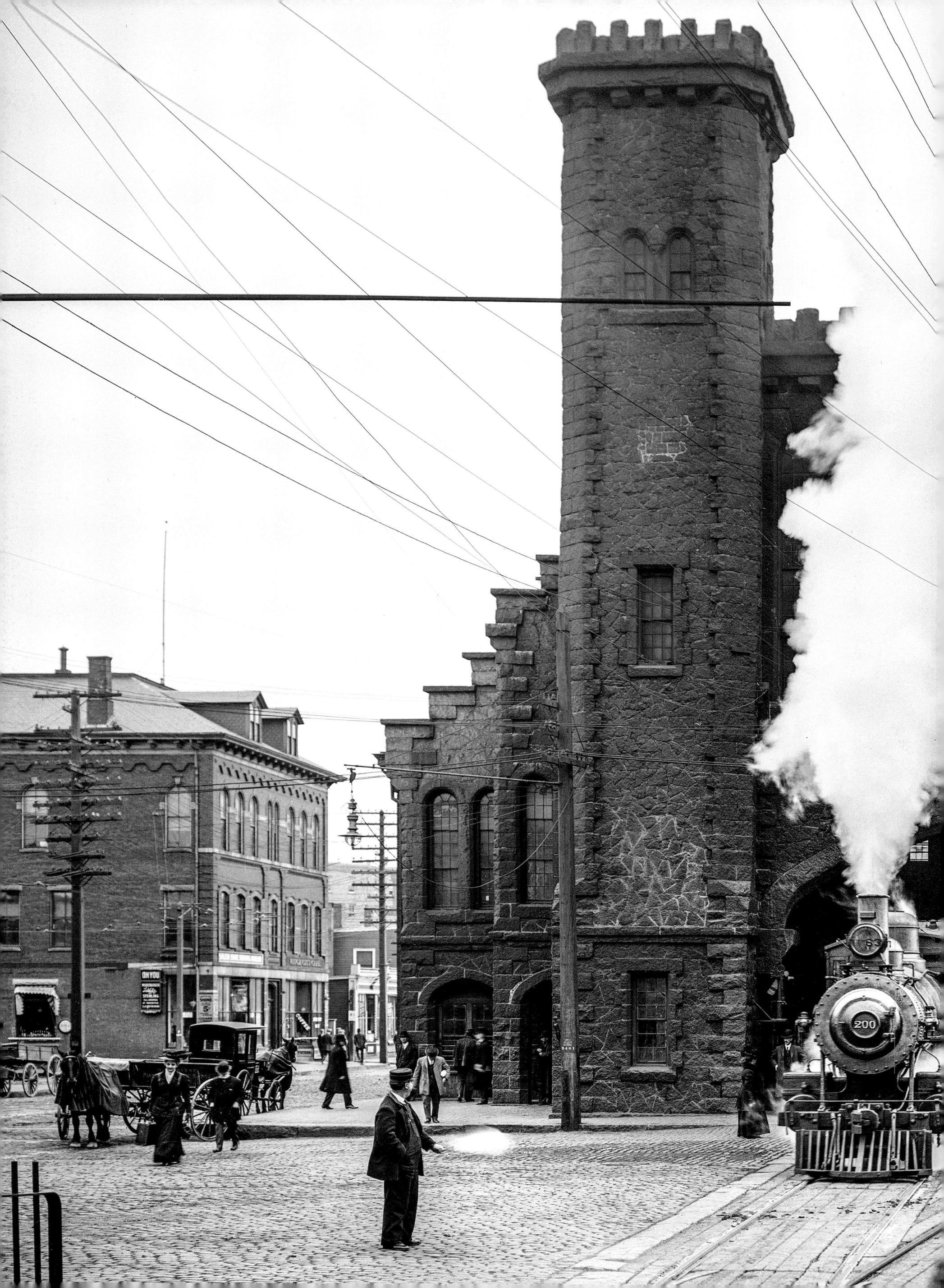

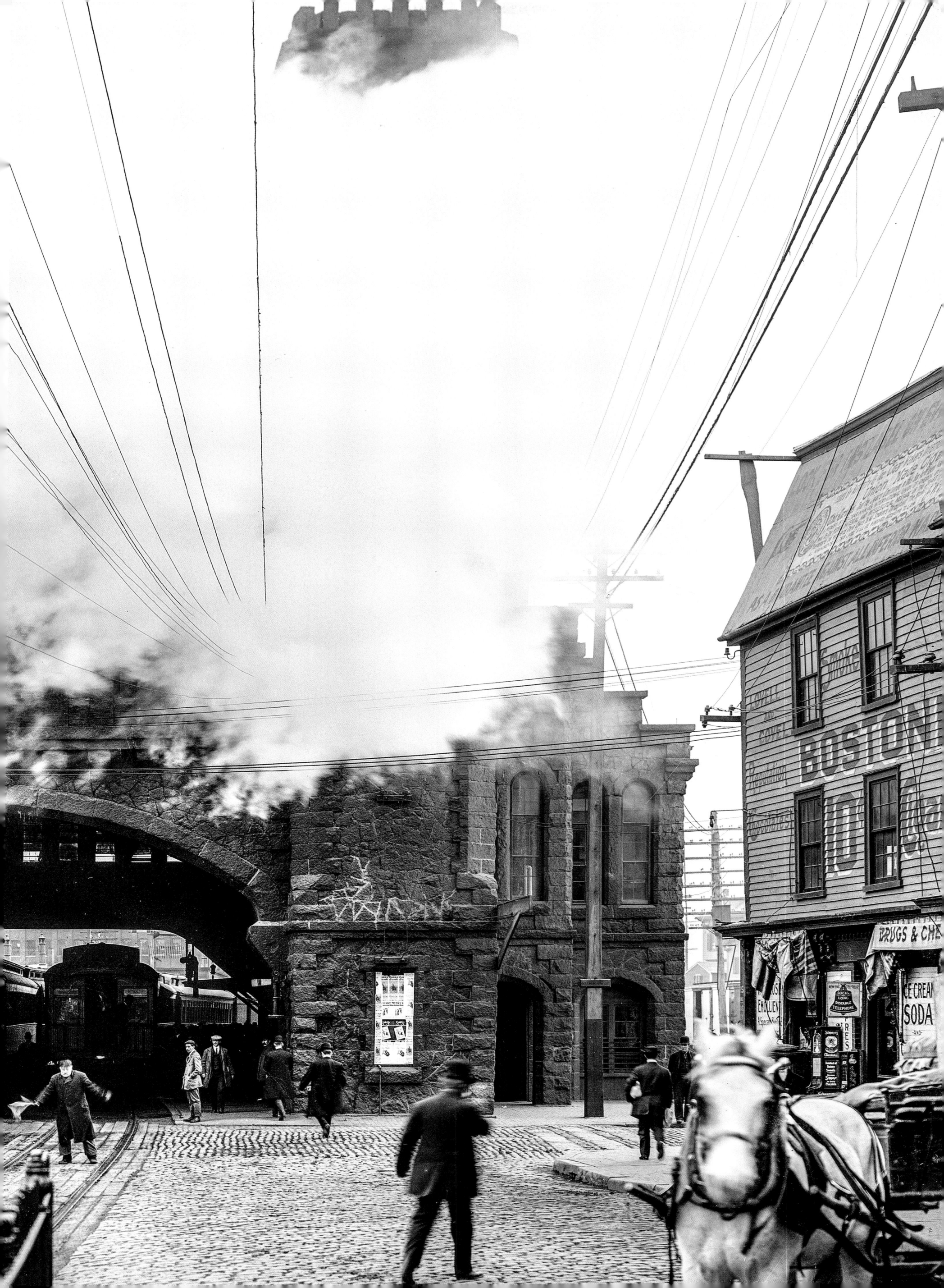

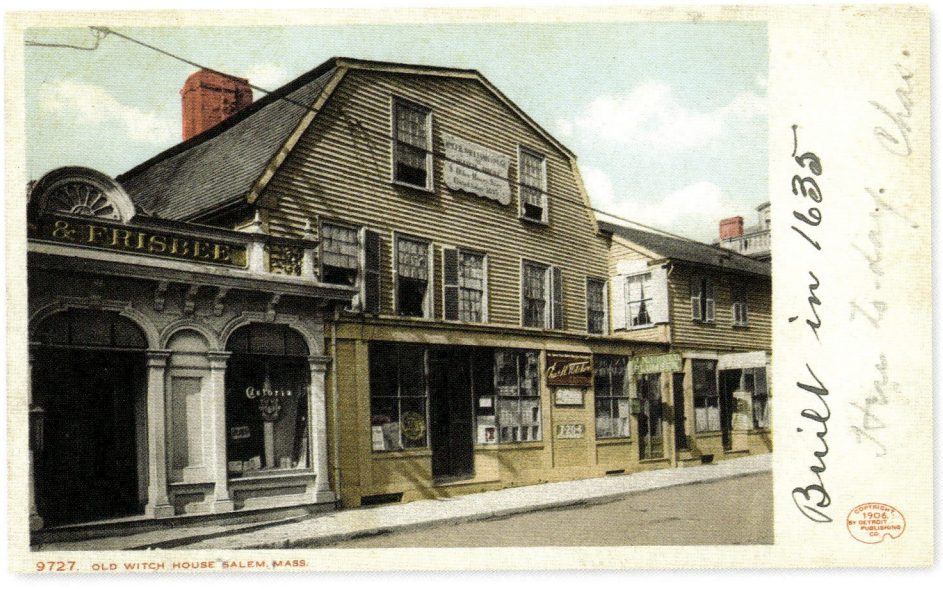
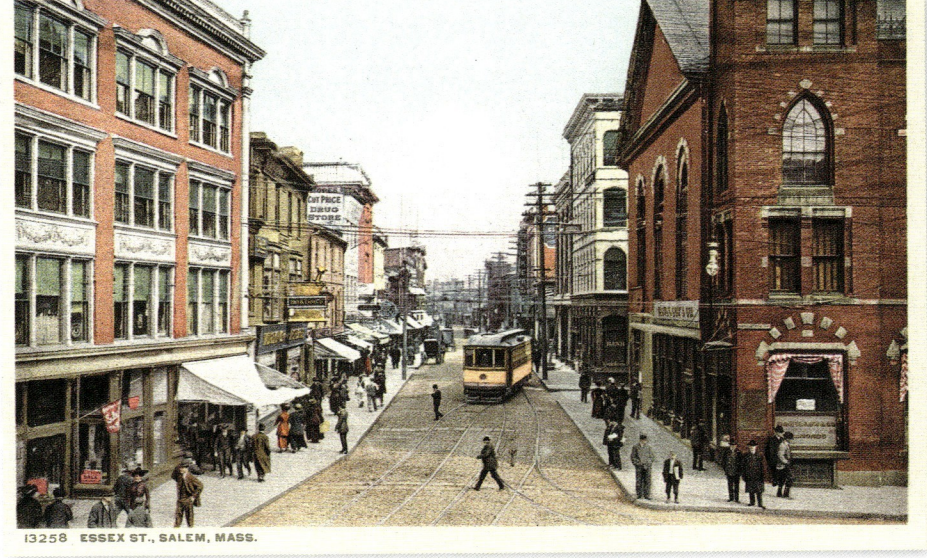

Page 154/155: Boston and Maine Railroad depot, Riley Plaza, Salem, glass negative, ca. 1910
Top left: **Old Witch House**
Top right: **Essex Street**
Bottom: **The Witch House**, photochrom

The Witch House in Salem houses the city's history museum. It belonged to Jonathan Corwin, one of the judges who in 1692 investigated the cases of supposed sorcery observed in Salem: the town was taken over by witch-hunting hysteria. As a result of these investigations, Governor William Phips instituted a special tribunal, the Court of Oyer and Terminer. During the trials, which took place in May 1693, 19 women were condemned to hang.

Seite 154/155: Bahnhof der Boston and Maine Railroad, Riley Plaza, Salem, Glasnegativ, um 1910
Oben links: **Das Hexenhaus**
Oben rechs: **Essex Street**
Unten: **Das Hexenhaus**, Photochrom

Das „Hexenhaus" von Salem – in dem sich das historische Museum der Stadt befindet – gehörte Jonathan Corwin, einem der Richter, die im Jahr 1692 eine Untersuchung zu den in Salem beobachteten Fällen mutmaßlicher Hexerei durchführten: Die Stadt war damals von einem regelrechten Wahn ergriffen. Am Ende dieser Untersuchungen berief Gouverneur William Phips das Sondertribunal „Oyer and Terminer" ein. In dem Prozess, der im Mai 1693 stattfand, wurden 19 unglückselige Frauen zum Tod durch den Strang verurteilt.

Pages 154/155 : la gare du Boston and Maine Railroad, place Riley, Salem, plaque de verre, vers 1910
En haut à gauche : **la maison des Sorcières**
En haut à droite : **Essex Street**
En bas : **la maison des Sorcières**, photochrome

La « maison des Sorcières » de Salem – qui abrite le Musée historique de la ville – appartenait à Jonathan Corwin, l'un des juges qui enquêtèrent en 1692 sur les cas de prétendue sorcellerie observés à Salem : une véritable frénésie s'était emparée de la ville. À l'issue de ces investigations, le gouverneur William Phips institua un tribunal spécial, le Oyer and Terminer. À l'issue du procès qui eut lieu en mai 1693, dix-neuf malheureuses furent condamnées à la pendaison.

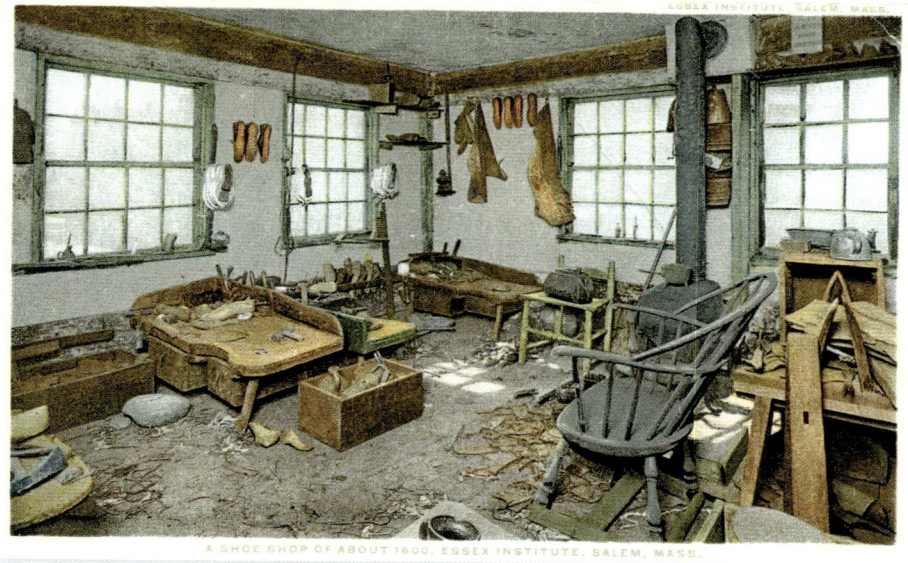
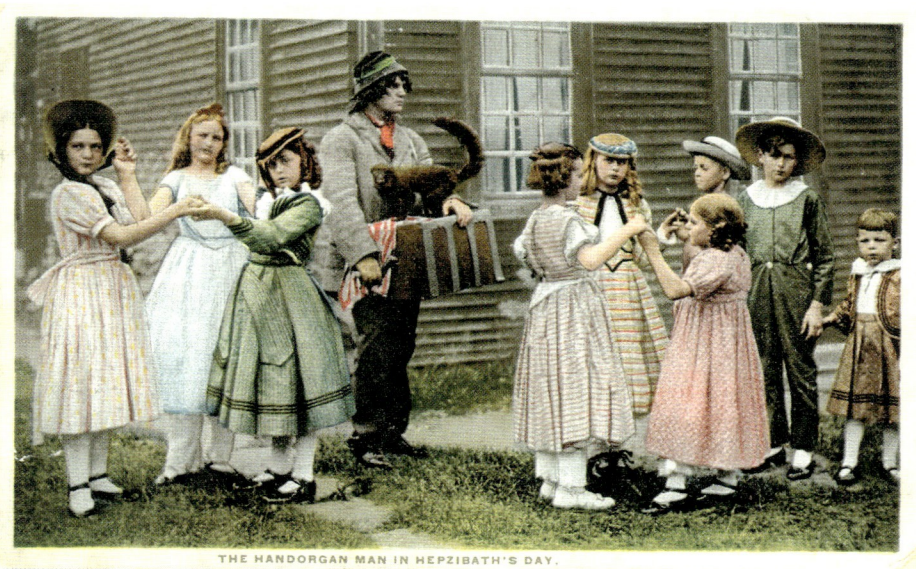

Top left: Kitchen in 17th century house, Essex Institute
Top right: A shoe shop of about 1800, Essex Institute
Middle: The handorgan man in Hepzibath's day
Near right: Girl in 17th century costume at well, Essex Institute
Far right: Phoebe arriving at the Seven Gables

Oben links: Küche in einem Haus aus dem 17. Jahrhundert, Essex Institute
Oben rechts: Schuhmacherei, um 1800, Essex Institute
Mitte: Drehorgelspieler am Hepzibath-Tag (Tag der Arbeit oder Vatertag)
Rechts: Mädchen am Brunnen in Kleidung aus dem 17. Jahrhundert, Essex Institute
Rechts außen: Phoebe kommt zum Haus der sieben Giebel (Seven Gables)

En haut à gauche: Cuisine dans une maison du XVIIe siècle, Essex Institute
En haut à droite: La boutique d'un cordonnier vers 1800, Essex Institute
Au centre: Le joueur d'orgue de Barbarie le jour de la fête d'Hepzibath (fête du travail, ou fête des pères)
Ci-contre: fille au puits en costume du XVIIe siècle, Essex Institute
À droite: Phoebe arrivant à la maison des Sept Pignons (Seven Gables)

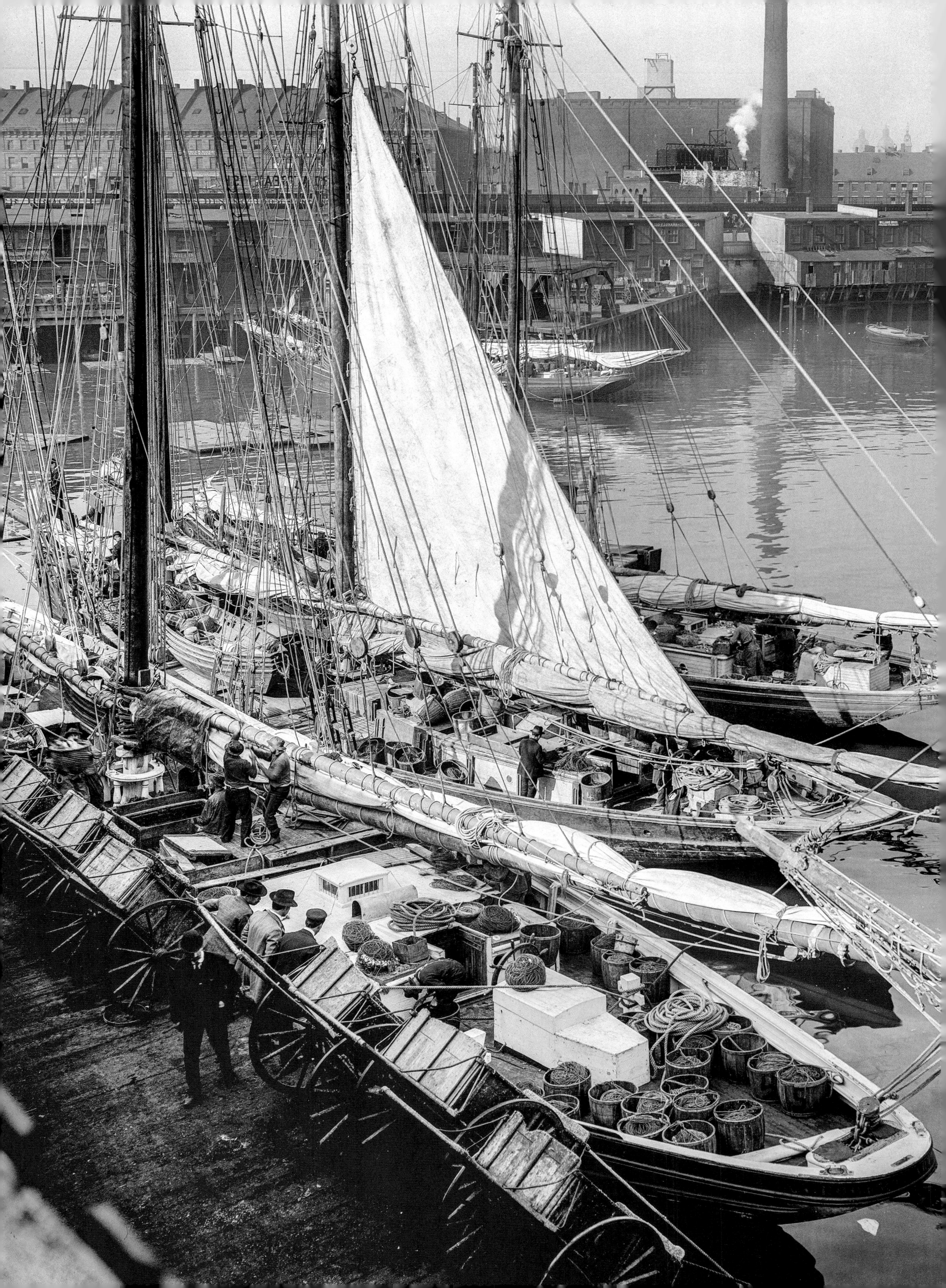

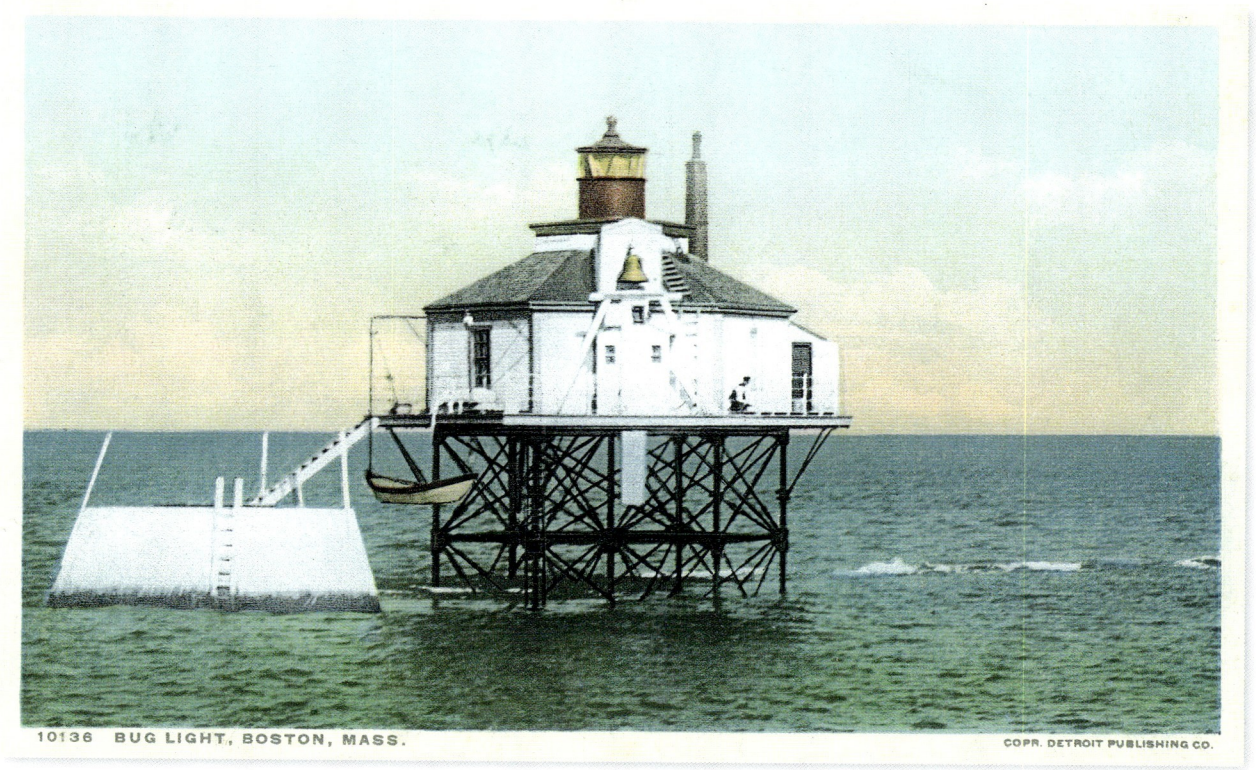

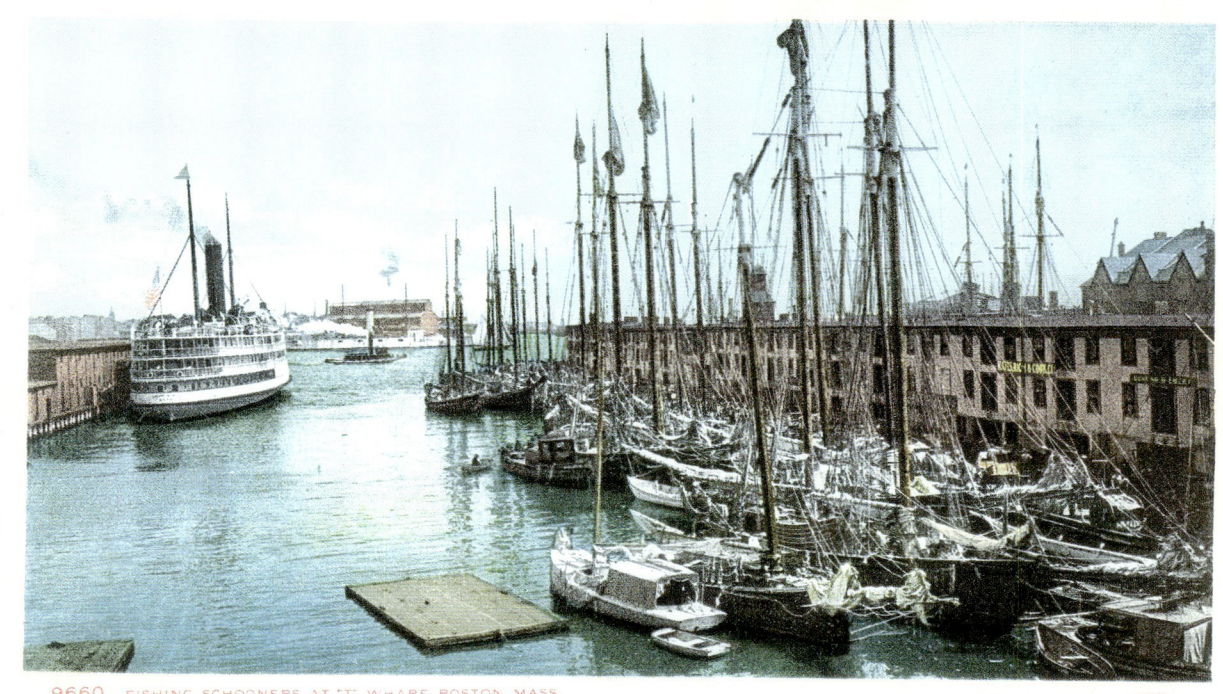

Page 158: Unloading fish at T-Wharf, glass negative, 1900–1910
From top to bottom:
Bug Light, Boston
Fishing schooners at T-Wharf
Warships and "Old Ironsides," Charlestown Navy Yard

Boston, birthplace of the revolution that gave rise to the 13 Colonies gaining their independence, and center of the antislavery movement in the 19th century, is often considered the intellectual and cultural capital of the East Coast, in competition with New York. In the 18th century, its port was one of the most important in the world. The T-Wharf or Long Wharf was built around 1710.

Seite 158: Entladen von Fisch am T-Kai, Glasnegativ, 1900–1910
Von oben nach unten:
Leuchtturm, Boston
Fischkutter am T-Kai
Gebäude und Kriegsschiffe, Marinewerft von Charlestown

Boston, die Wiege der Revolution, die den „dreizehn Kolonien" zu ihrer Unabhängigkeit verhalf und Anführer der Bewegung zur Abschaffung der Sklaverei im 19. Jahrhundert war, wird oft als intellektuelle und kulturelle Hauptstadt der Ostküste angesehen; in dieser Hinsicht war Boston immer der große Gegenspieler von New York. Sein Hafen zählte im 18. Jahrhundert zu den bedeutendsten der Welt. Der T-Wharf oder Long Wharf (Langer Kai) wurde um 1710 gebaut.

Page 158 : déchargement du poisson au quai T, plaque de verre, 1900–1910
De haut en bas :
Le fanal, Boston
Goélettes de pêche au quai T
Bâtiments et frégates de guerre, arsenal naval de Charlestown

Boston, berceau de la révolution qui mena les Treize Colonies à leur indépendance, leader du mouvement anti-esclavagiste au XIXe siècle, est souvent considérée comme la capitale intellectuelle et culturelle de la côte Est ; elle fut toujours en cela la grande rivale de New York. Son port était au XVIIIe siècle l'un des plus importants du monde. Le T-Wharf (ou Long Wharf) fut construit vers 1710.

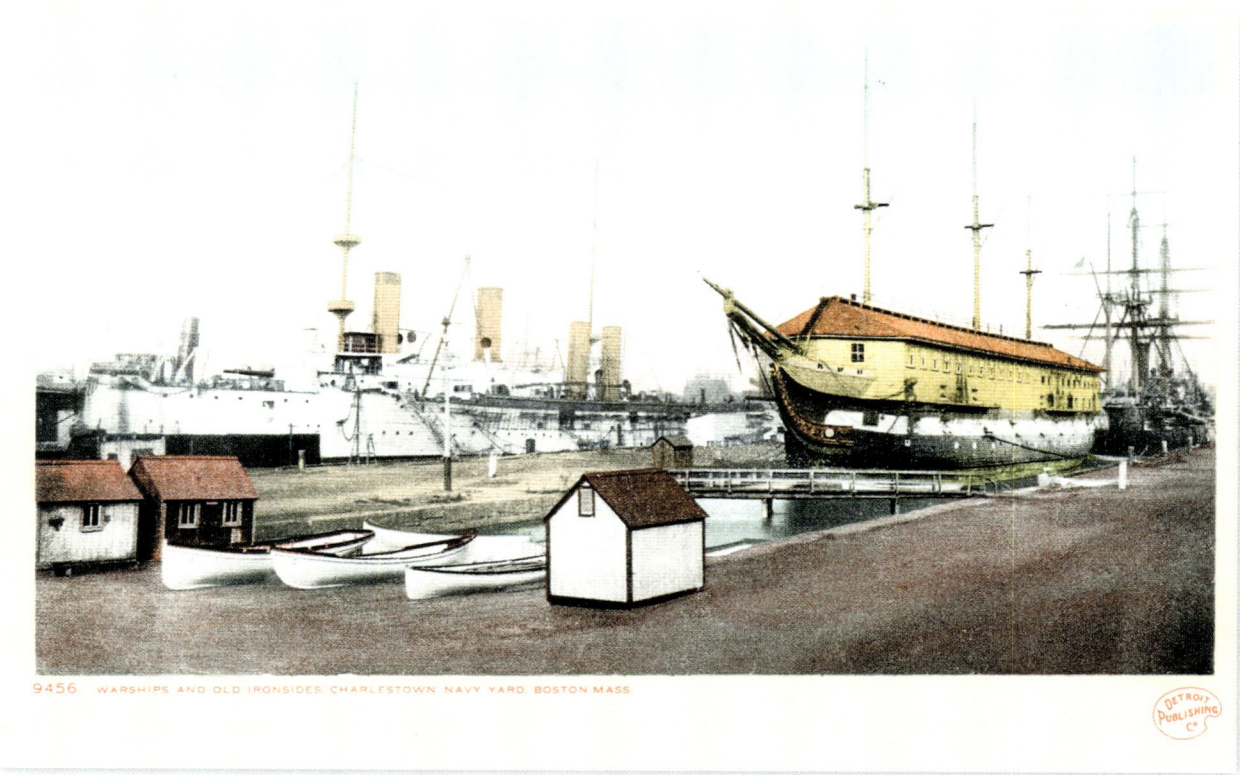

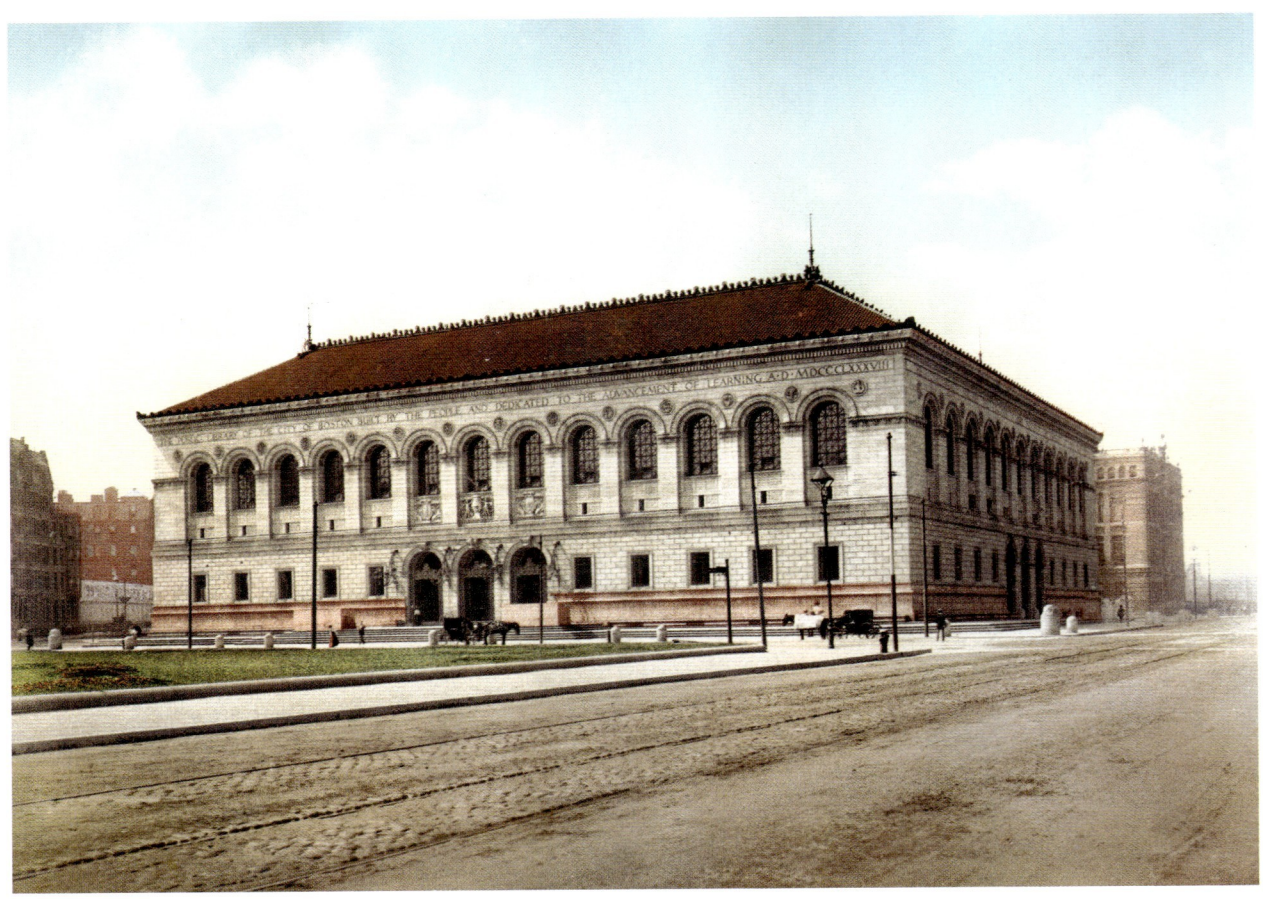

Above: **Boston Public Library, photochrom**
Below: **Panorama of Tremont Street and Boston Common, photochrom**
Page 161, from left to right and top to bottom:
The swan boats, Public Garden
Adams Square
United States Hotel
Quincy Market

Oben: **Boston Public Library, Photochrom**
Unten: **Panorama von Tremont Street und Boston Common, Photochrom**
Seite 161, von links nach rechts und von oben nach unten:
Die Schwanenboote, Public Garden
Adams Square
Das Hotel United States
Quincy Market

En haut : **la bibliothèque publique, photochrome**
En bas : **panorama de Tremont Street et Boston Common, photochrome**
Page 161, de gauche à droite et de haut en bas :
Les bateaux-cygnes du jardin public
Adams Square
L'hôtel United States
Le marché de Quincy Market

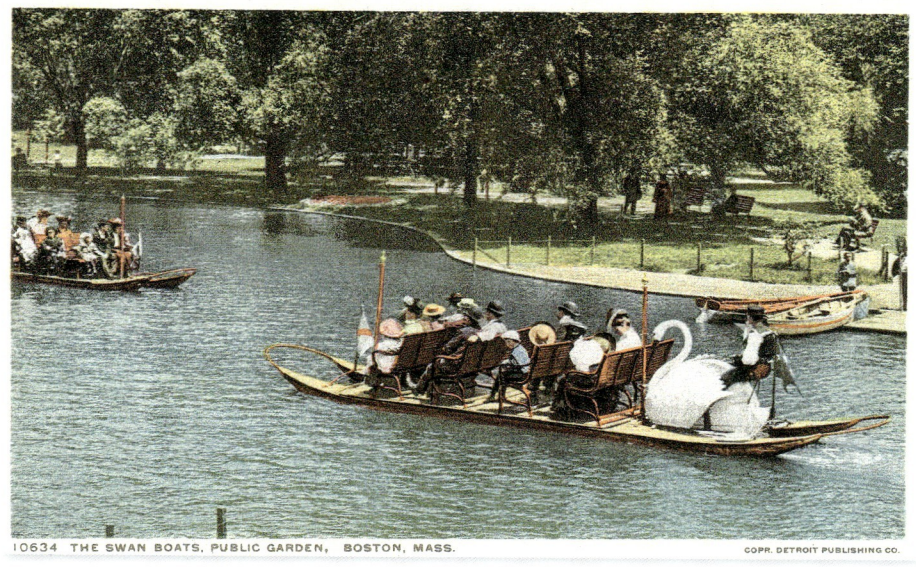
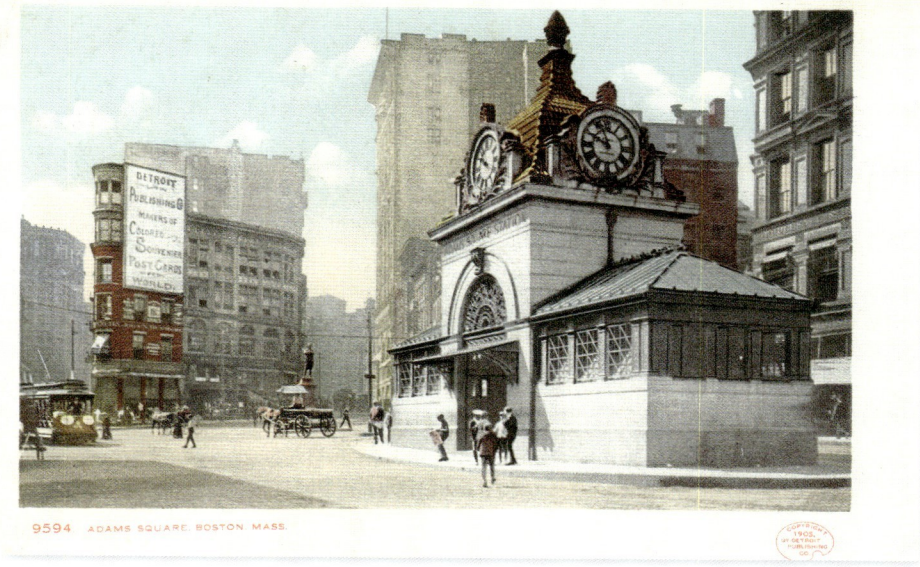

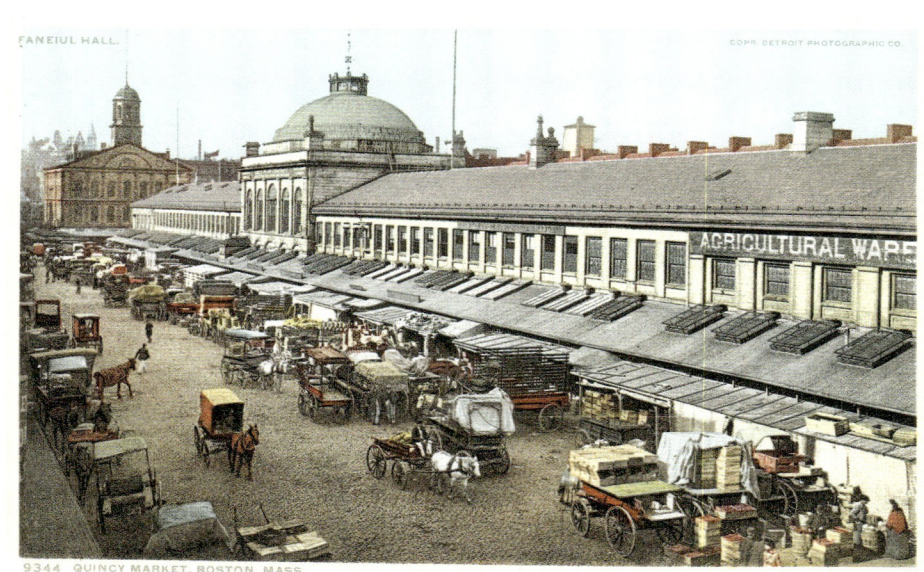

MASSACHUSETTS | BOSTON

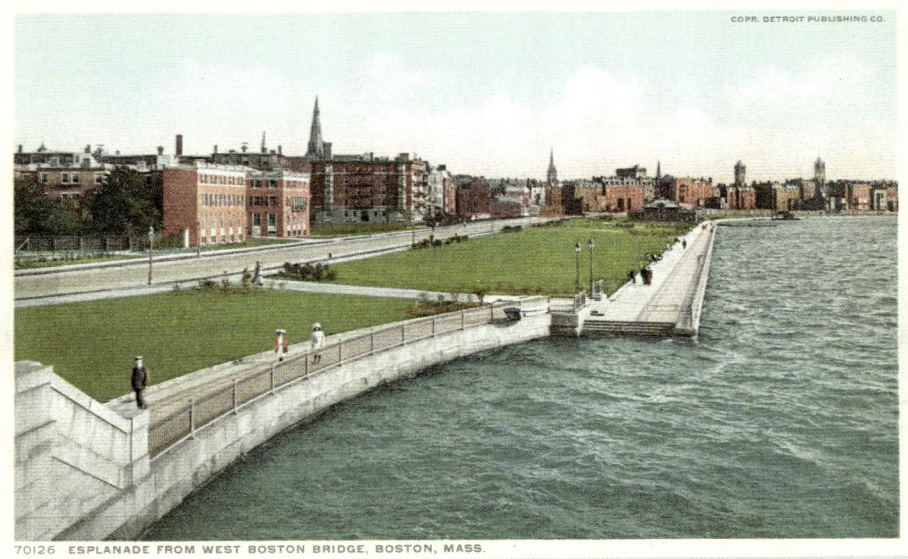
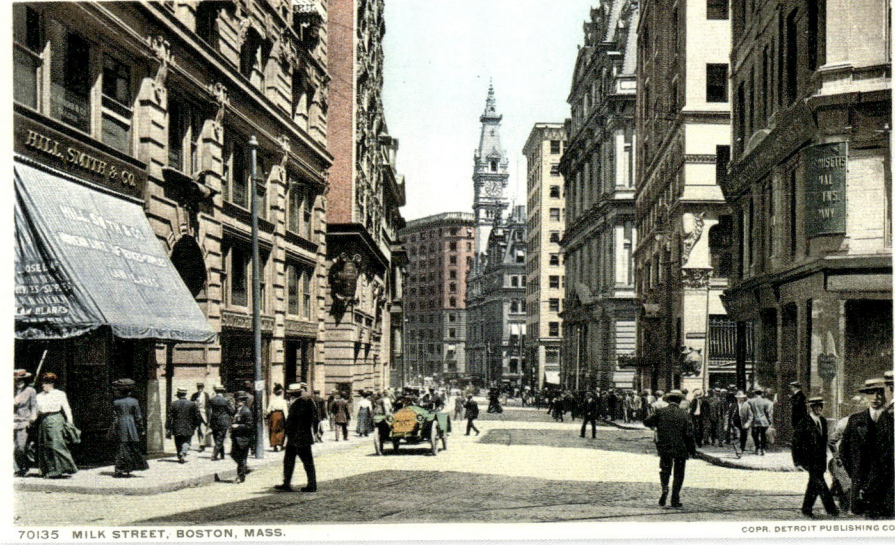
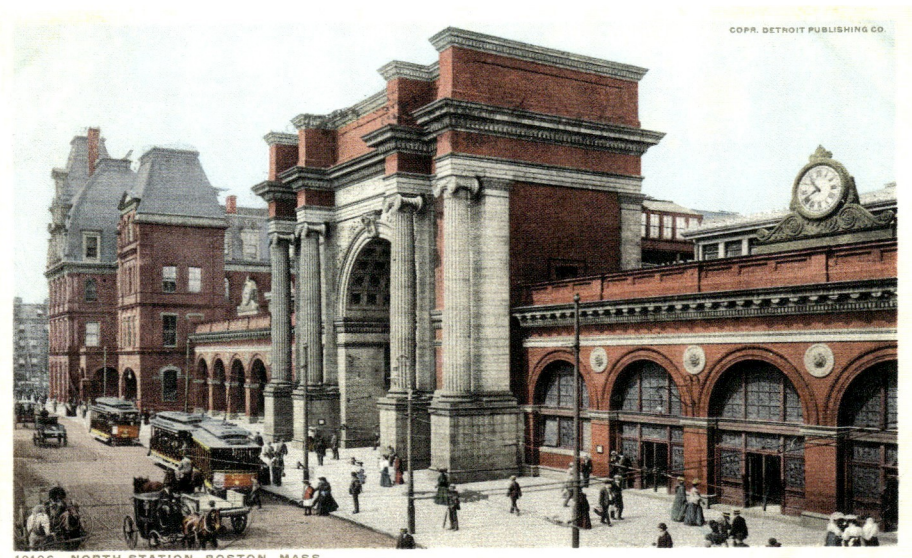

From left to right and top to bottom:
Esplanade from West Boston Bridge
Milk Street
North Station
The North Station drug store
Below left: The home of Paul Revere
Below right: Bromfield Street
Page 163: Old South Church, photochrom

Von links nach rechts und von oben nach unten:
Die Esplanade von der West Boston Bridge aus
Milk Street
Der Bahnhof North Station
Drugstore in der North Station
Unten links: Das Haus von Paul Revere
Unten rechts: Bromfield Street
Seite 163: Old South Church, Photochrom

De gauche à droite et de haut en bas :
L'Esplanade depuis le pont de West Boston Bridge
Milk Street
La gare de North Station (la gare du Nord)
Le drugstore de North Station
En bas à gauche : la maison de Paul Revere
En bas à droite : Bromfield Street
Page 163 : Old South Church (l'église du Sud), photochrome

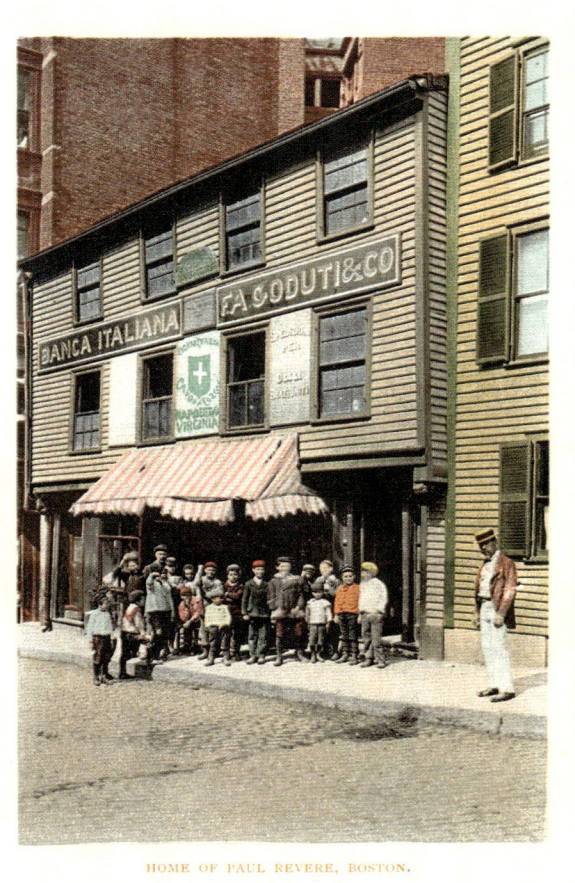
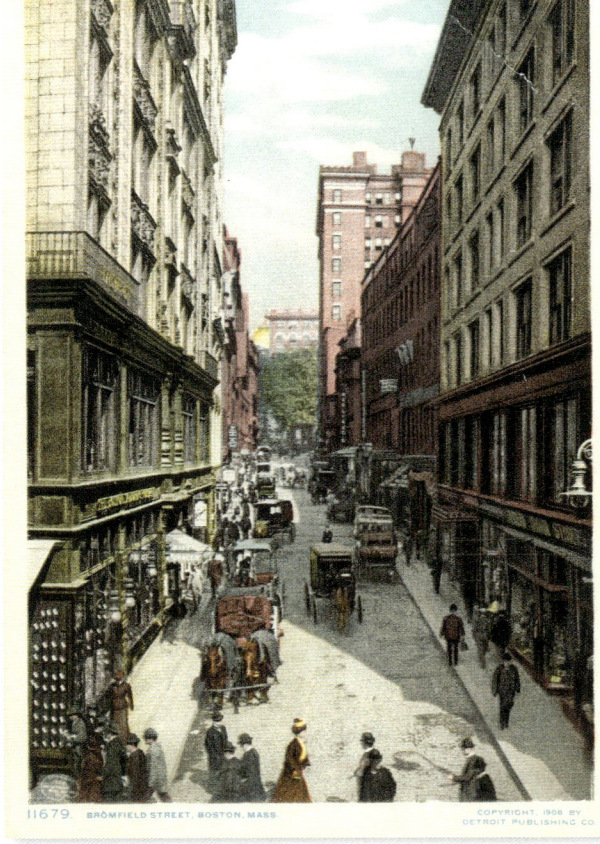

MASSACHUSETTS | BOSTON

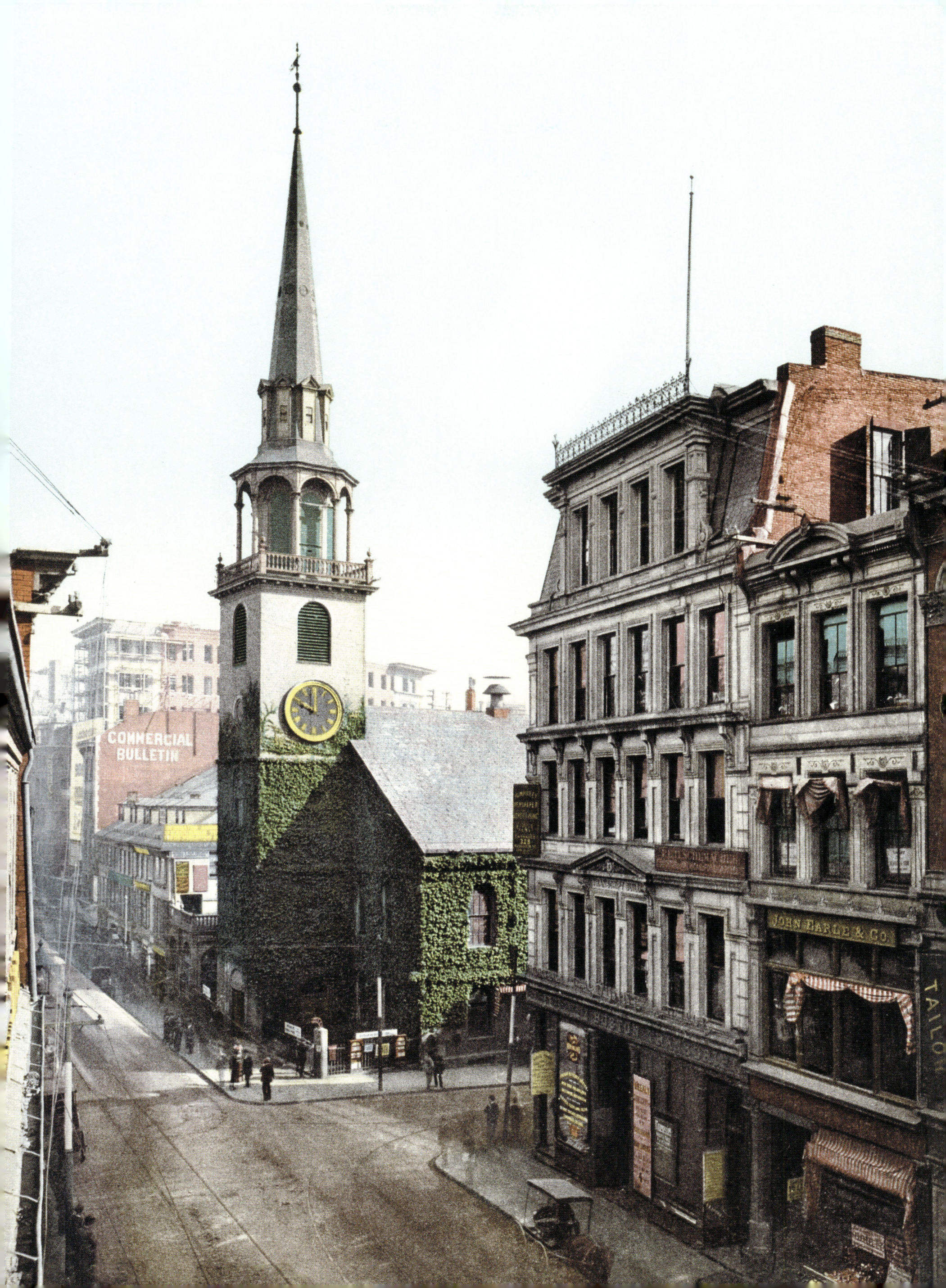

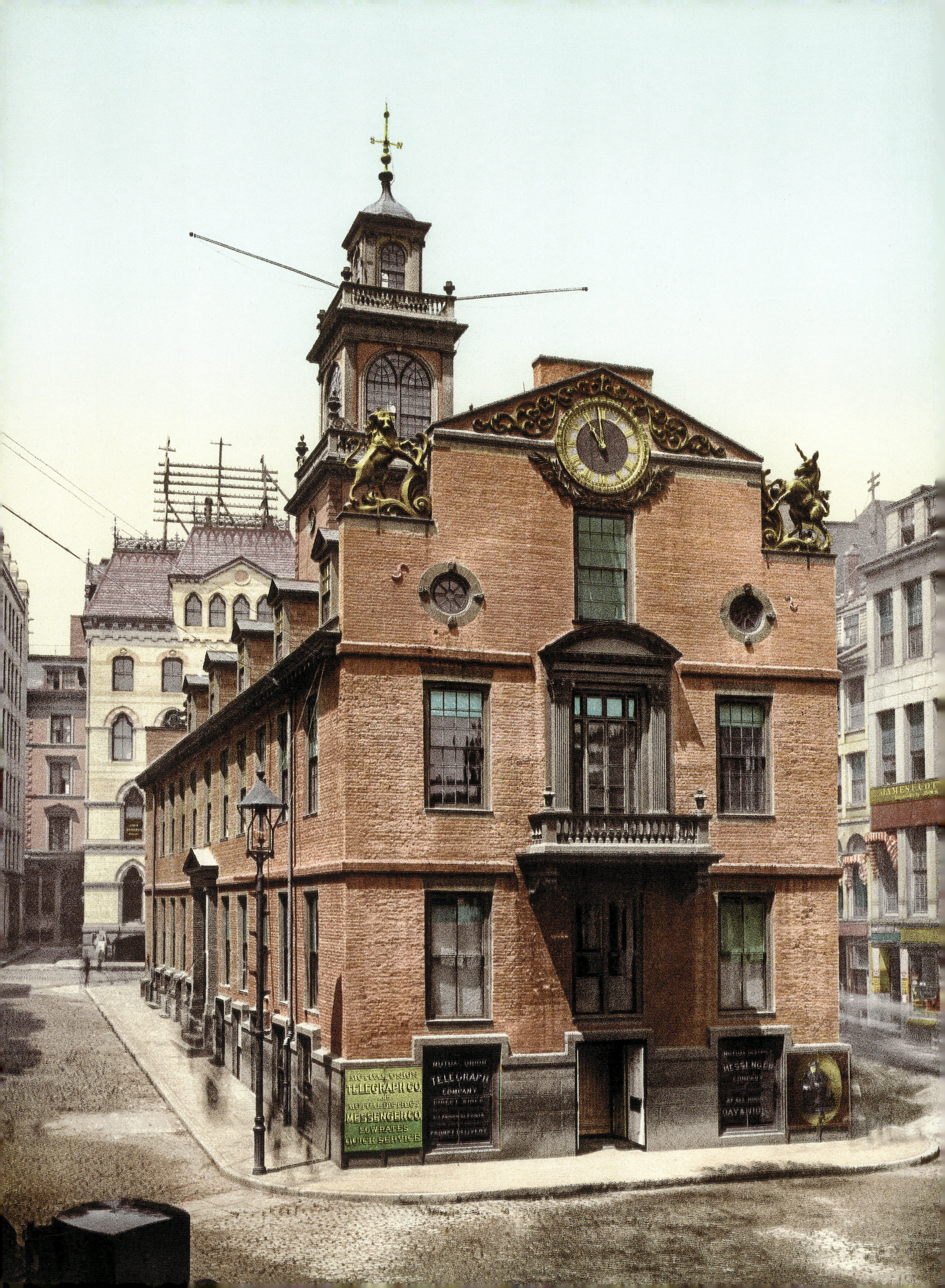

Page 164: **Old State House**, photochrom
Near right: **Hotel Essex**
Far right: **Faneuil Hall**
Below: **Beacon Street Mall**, photochrom

The Old State House is the historic heart of Boston. Within its walls, Samuel Adams, James Otis, John Hancock, and John Adams prepared the American Revolution. The Declaration of Independence was read to Bostonians from the balcony of the Old State House in 1776. The building was restored and converted into a museum in 1881.

Seite 164: **Old State House (ehemaliges Kapitol und Rathaus), Photochrom**
Rechts: **Das Hotel Essex**
Rechts außen: **Faneuil Hall**
Unten: **Beacon Street Mall**, Photochrom

Old State House ist das historische Zentrum von Boston. In diesen Mauern bereiteten Samuel Adams, James Otis, John Hancock und John Adams die amerikanische Revolution vor. Die Unabhängigkeitserklärung wurde den Einwohnern von Boston 1776 vom Balkon des Old State House aus verkündet. Das Gebäude wurde 1881 restauriert und in ein Museum umgewandelt.

Page 164: **Old State House (l'ancien capitole et hôtel de ville), photochrome**
Ci-contre: **l'hôtel Essex**
À droite: **Faneuil Hall**
En bas: **la promenade de Beacon Street Mall, photochrome**

Old State House est le cœur historique de Boston. Dans ses murs, Samuel Adams, James Otis, John Hancock et John Adams ont préparé la Révolution américaine. La déclaration de l'Indépendance a été annoncée aux Bostoniens du haut du balcon d'Old State House en 1776. Le bâtiment a été restauré et transformé en musée en 1881.

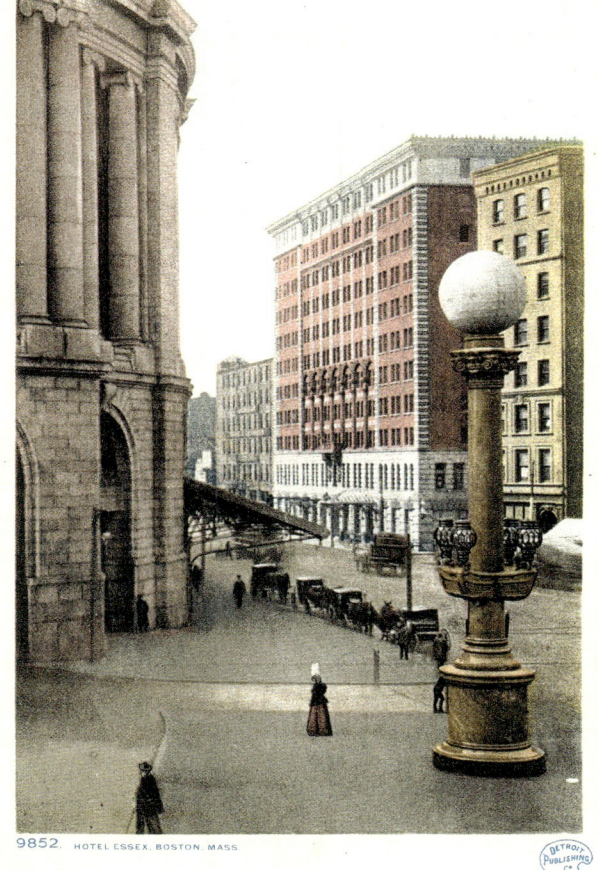
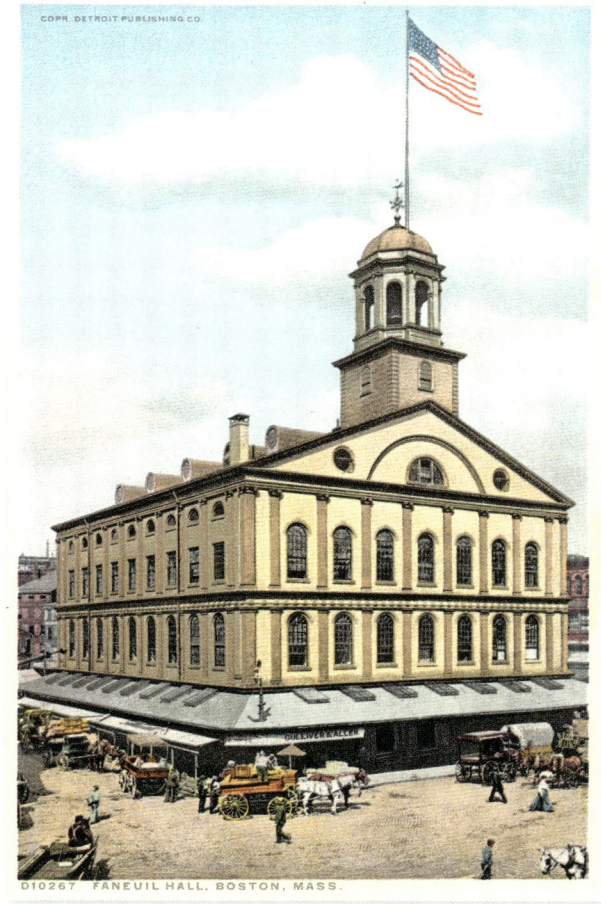

HARVARD

Harvard is the oldest university in the United States. It was founded in 1636, 65 years before Yale in Connecticut and 110 years before Princeton in New Jersey. At its founding, it was called New College; it became Harvard in 1639 in honor of the English priest John Harvard, who, in a generous donation, left it his library and half of his fortune. The French historian and philologist Jean-Jacques Ampère, who visited Harvard in 1874, was touched to learn that the college once received the modest donation of "a piece of cotton to the value of nine shillings" and a "pewter pot of the same price." "The names of those who made such offerings to knowledge have been recorded and rightly so," he concluded.

Die Harvard University ist die älteste der Vereinigten Staaten. Sie wurde 1636 – also 65 respektive 110 Jahre vor ihren Rivalen Yale (Connecticut) und Princeton (New Jersey) – unter dem Namen „New College" gegründet und 1639 in Harvard umbenannt, zu Ehren ihres großzügigen Stifters, des englischen Pastors John Harvard, der ihr die Hälfte seines Besitzes und seine gesamte Bibliothek hinterließ. Der französische Historiker und Philologe Jean-Jacques Ampère war bei seinem Besuch in Harvard 1874 sehr gerührt, als er erfuhr, dass das College einmal eine bescheidene Gabe in Form eines „Stücks Baumwollstoff im Wert von neun Schilling" und „einen Zinntopf von gleichem Wert" erhalten hatte. „Die Namen derer, die der Wissenschaft solche Spenden zukommen ließen, wurden dokumentiert und hatten dies auch verdient", schloss Ampère.

L'université Harvard est la plus ancienne des États-Unis. Elle fut fondée en 1636 – respectivement soixante-cinq ans et cent dix ans avant ses rivales, Yale (Connecticut) et Princeton (New Jersey) – sous le nom de « New College », et rebaptisée Harvard en 1639, en hommage à son généreux donateur, le pasteur anglais John Harvard, qui lui légua la moitié de ses biens et toute sa bibliothèque. L'historien et philologue français Jean-Jacques Ampère, en visite à Harvard en 1874, a été très touché d'apprendre que le *College* reçut un jour un modeste don d'une « pièce d'étoffe de coton d'une valeur de neuf shillings », et « un pot d'étain du même prix ». « Les noms de ceux qui firent à la science de telles offrandes ont été conservés et méritaient de l'être », conclut Ampère.

Below: Harvard University, seniors entering Sanders Theatre, Memorial Hall, glass negative, 1906
Page 167, from left to right and top to bottom:
North Gate '79
Memorial Hall and John Harvard statue
Harvard University, visitors on the way to the stadium
Harvard University stadium, glass negative, 1906

Unten: Der Abschlussjahrgang der Harvard University betritt das Sanders Theatre, Memorial Hall, Glasnegativ, 1906
Seite 167, von links nach rechts und von oben nach unten:
Das nördliche Tor Nr. 79
Memorial Hall und John-Harvard-Statue
Harvard University, Besucher auf dem Weg ins Stadion
Stadion der Harvard University, Glasnegativ, 1906

En bas : les seniors de l'université Harvard entrant au Sanders Theatre, Memorial Hall, plaque de verre, 1906
Page 167, de gauche à droite et de haut en bas :
La porte Nord n° 79
Memorial Hall et la statue de John Harvard
Université Harvard, les visiteurs en route pour le stade
Le stade de l'université Harvard, plaque de verre, 1906

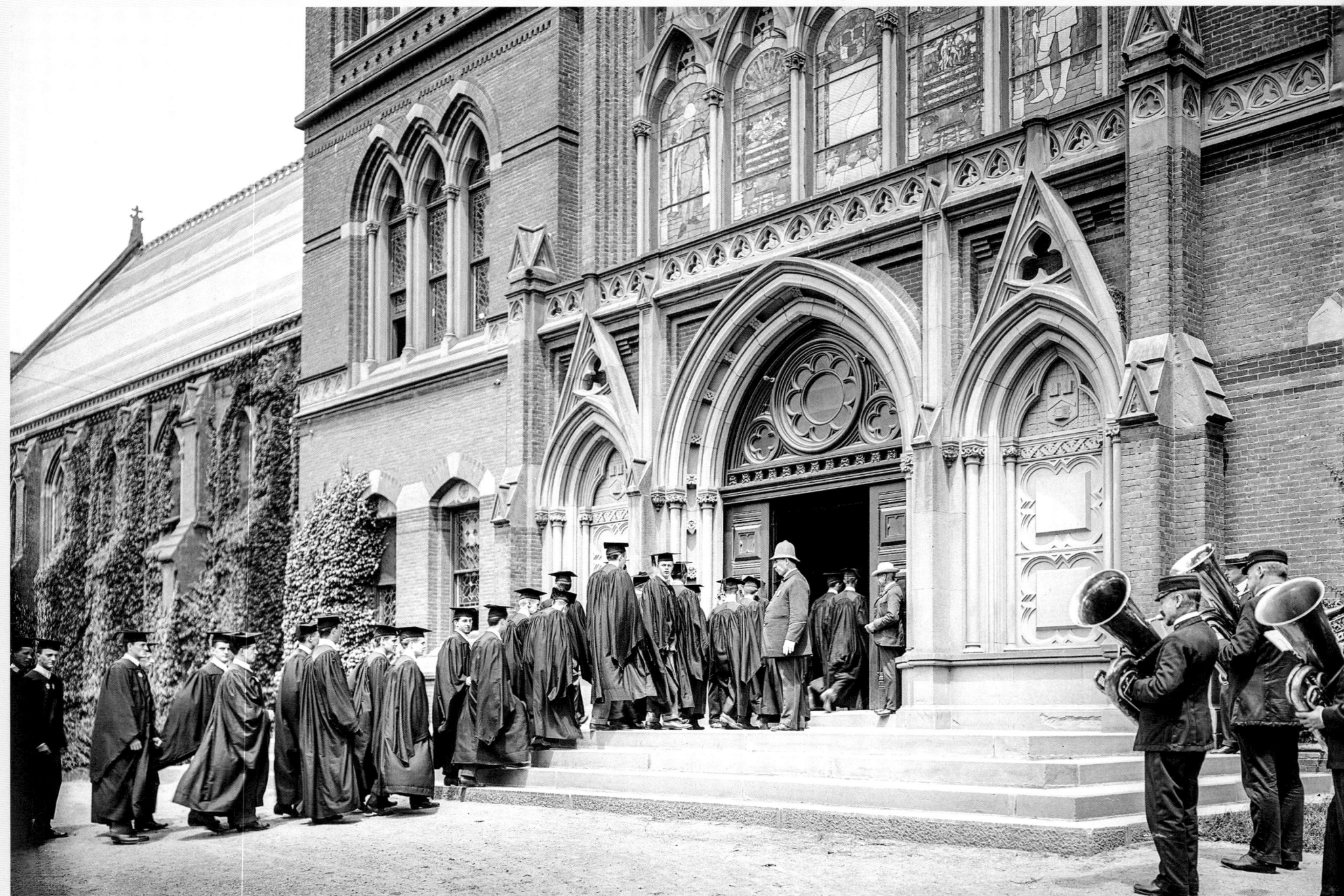

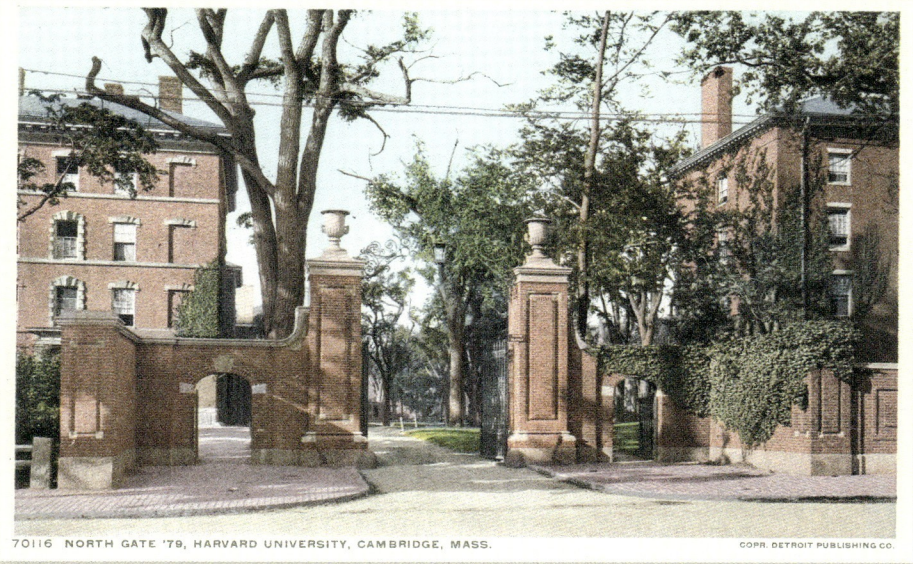
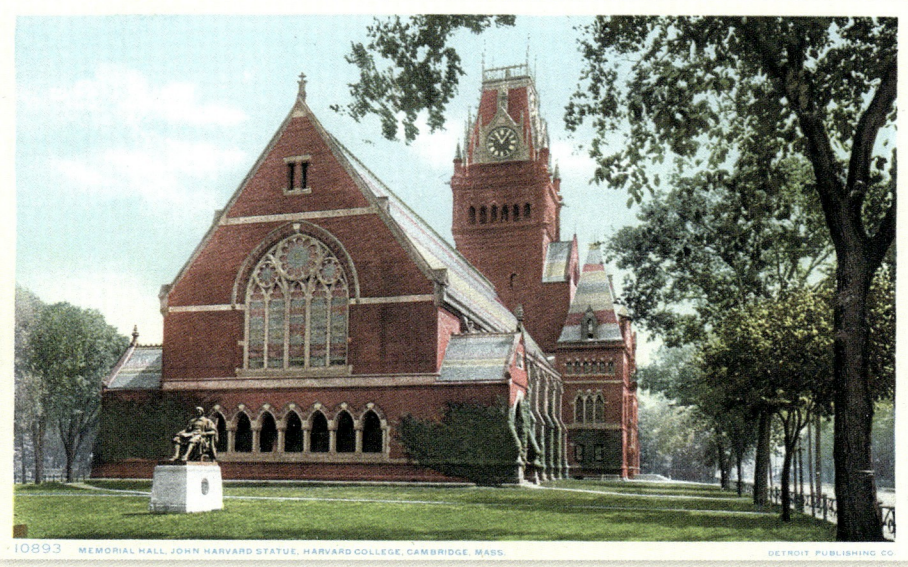
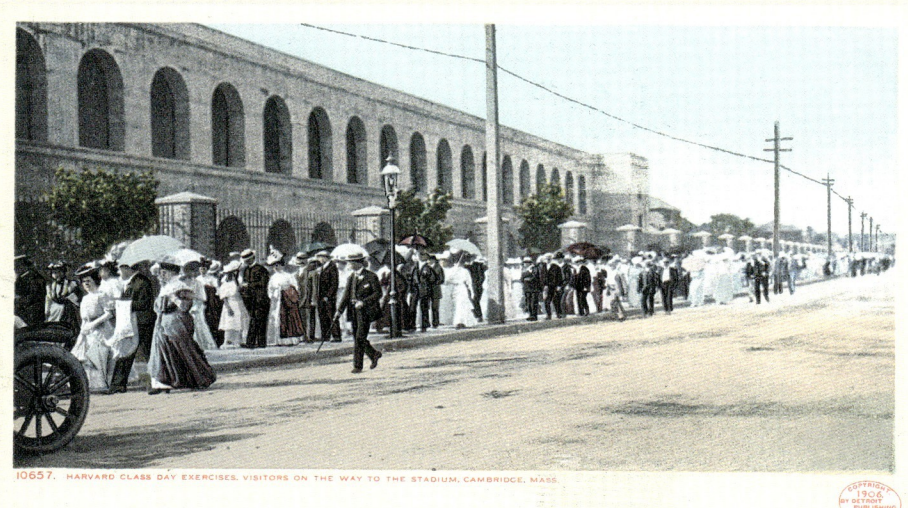

In 1639, Harvard University was named after its first benefactor, the English priest John Harvard, who, in a generous donation, left it his library and half of his fortune.

Die Harvard University erhielt 1639 ihren Namen zu Ehren ihres großzügigen Stifters, des englischen Pastors John Harvard, der ihr die Hälfte seines Besitzes und seine gesamte Bibliothek hinterließ.

L'université Harvard fut ainsi dénommée en 1639, en hommage à son généreux donateur, le pasteur anglais John Harvard, qui lui légua la moitié de ses biens et toute sa bibliothèque.

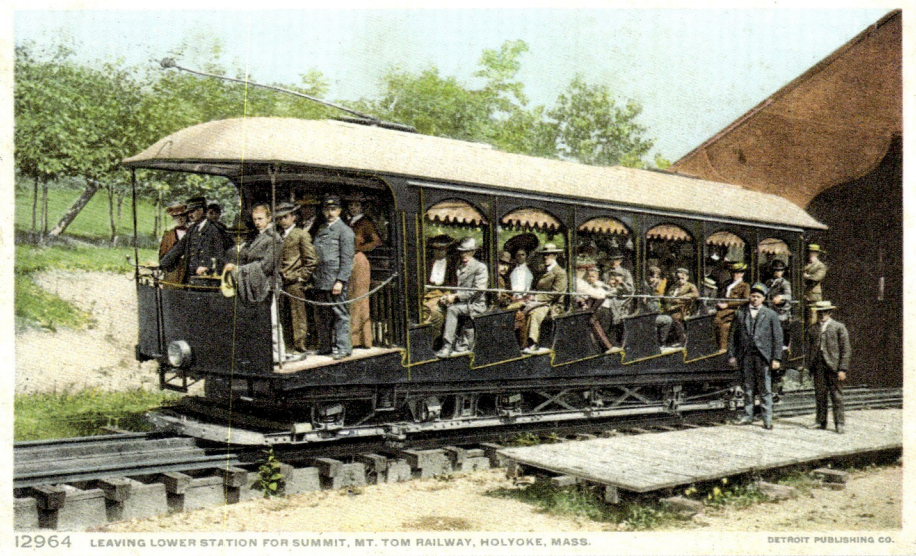 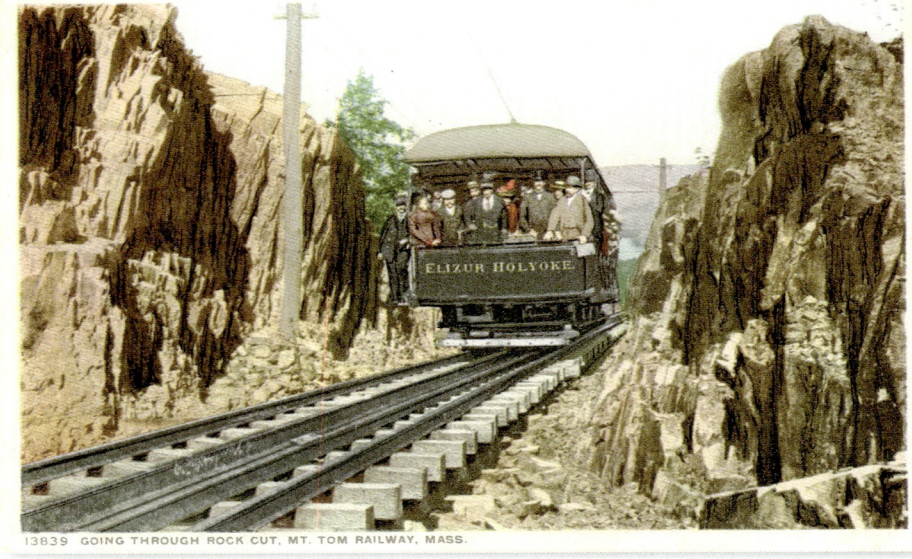

Top left: **Leaving lower station for summit, Mt. Tom Railway**
Top right: **Going through rock cut, Mt. Tom Railway**
Bottom: **Lower station, Mt. Tom Railway, Holyoke, glass negative, 1905–1915**
Page 169, from left to right and top to bottom:
Summit House, Mt. Tom
View from Mt. Tom
Looking south from Mt. Tom
Upper station, Mt. Tom Railway, glass negative, 1905–1915

In 1895, the Holyoke Street Railway Co. built an amusement park at the foot of Mt. Tom, "Mount Park." It was connected to the city of Holyoke by trolley car. The company then began construction of a cable-trolley track connecting the summit to the trolley-car terminus. This was completed in 1897. Constructed at the same time as the railway, the Summit House featured a restaurant and a large observation hall equipped with telescopes.

Oben links: **Abfahrt zum Gipfel des Mount Tom**
Oben rechts: **Anstieg zwischen Felswänden hindurch, Mount Tom Railway**
Unten: **Talstation der Mount Tom Railway, Holyoke, Glasnegativ, 1905–1915**
Seite 169, von links nach rechts und von oben nach unten:
Observatorium auf dem Mount Tom
Blick vom Gipfel des Mount Tom
Blick vom Gipfel des Mount Tom nach Süden
Bergstation der Mount Tom Railway, Glasnegativ, 1905–1915

1895 errichtete die Gesellschaft Holyoke Street Railway am Fuß des Mount Tom einen Vergnügungspark. Diesen erreichte man von der Stadt Holyoke aus mit dem Trolleybus. Die Gesellschaft begann daraufhin mit dem Bau einer Eisenbahn, die den Berggipfel mit der Bushaltestelle verbinden sollte. Sie wurde 1897 vollendet. Das Summit House, das im selben Jahr gebaut wurde wie die Eisenbahn, bestand aus zwei Sälen, dem großen, mit Teleskopen ausgestatteten Observatorium und einem Restaurant.

En haut à gauche : **départ pour le sommet du mont Tom**
En haut à droite : **la montée à travers les parois rocheuses, chemin de fer du mont Tom**
En bas : **la gare de départ du chemin de fer du mont Tom, Holyoke, plaque de verre, 1905–1915**
Page 169, de gauche à droite et de haut en bas :
L'observatoire du mont Tom
Vue depuis le sommet du mont Tom
La vue vers le sud depuis le sommet du mont Tom
La gare d'arrivée, plaque de verre, 1905–1915

En 1895, la compagnie Holyoke Street Railway avait installé un parc d'attractions au pied du mont Tom. On s'y rendait en trolley depuis la ville de Holyoke. La compagnie entama alors la construction du chemin de fer qui allait relier le sommet du mont à la station de trolley. Ce fut chose faite en 1897. Construite en même temps que le chemin de fer, la Summit House comprenait une grande salle d'observation munie de télescopes, et une salle de restaurant.

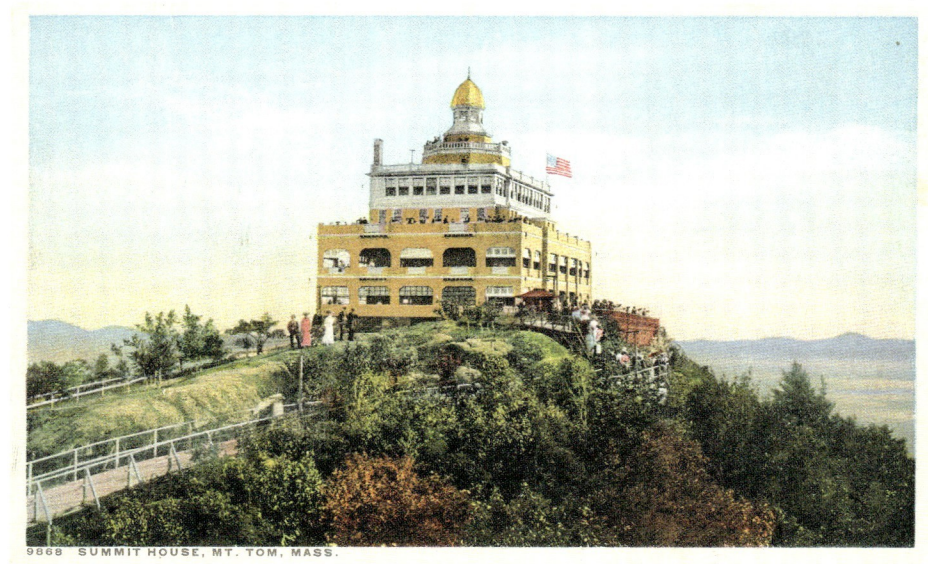
9868 SUMMIT HOUSE, MT. TOM, MASS.

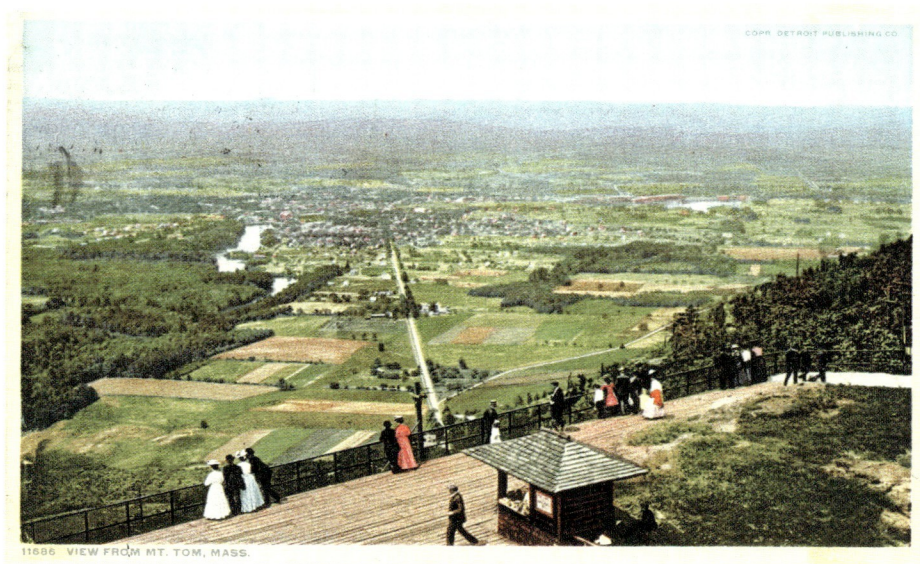
11686 VIEW FROM MT. TOM, MASS.

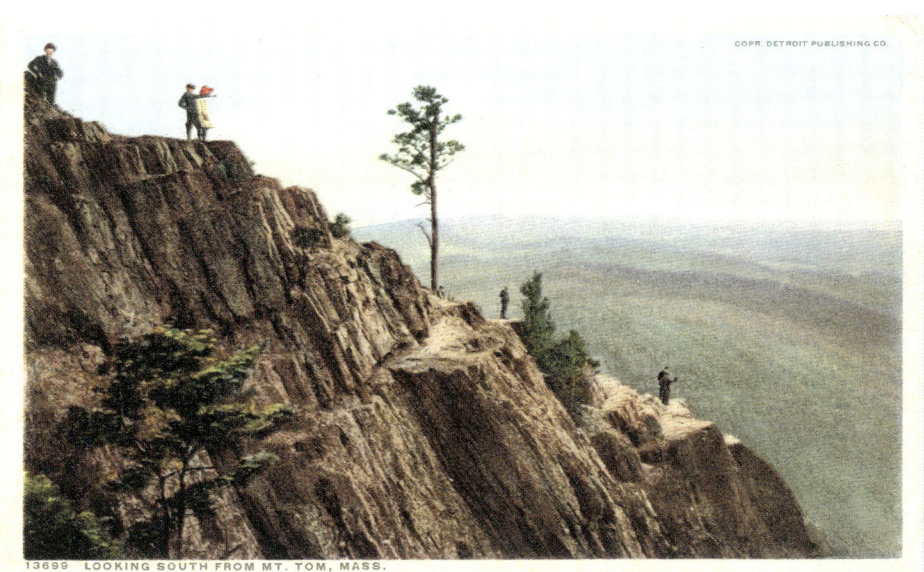
13699 LOOKING SOUTH FROM MT. TOM, MASS.

MASSACHUSETTS | MT. TOM

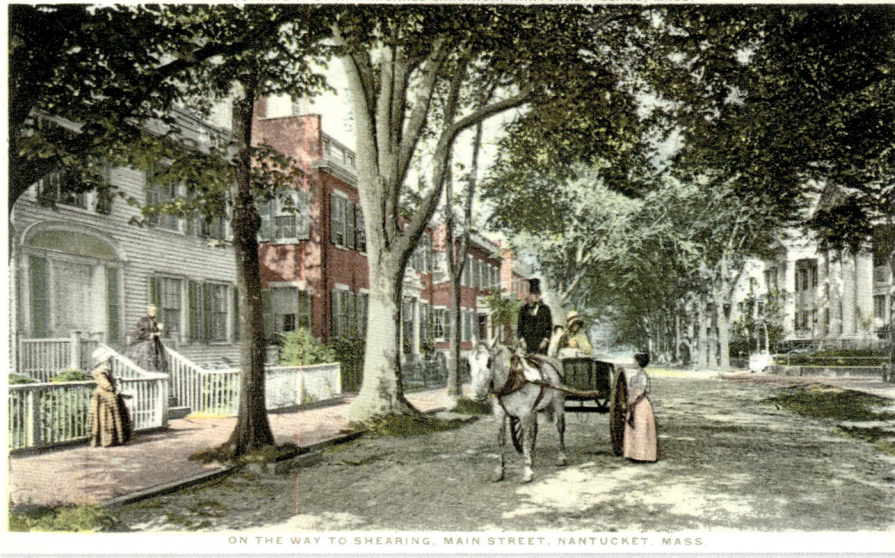
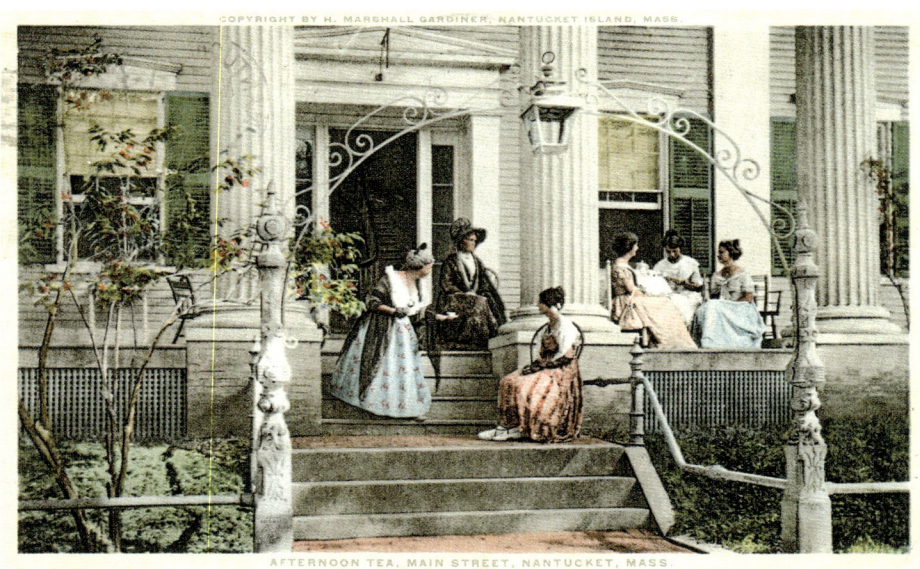
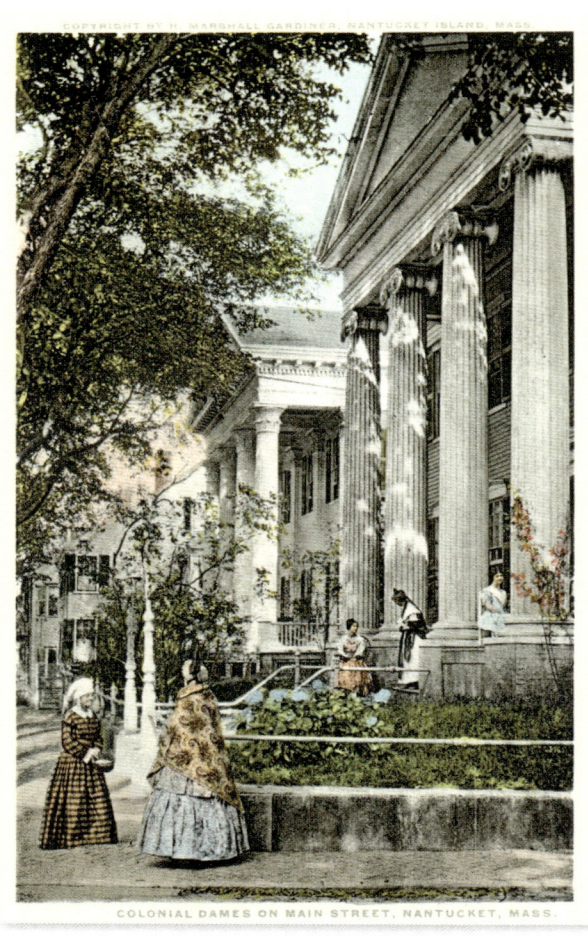
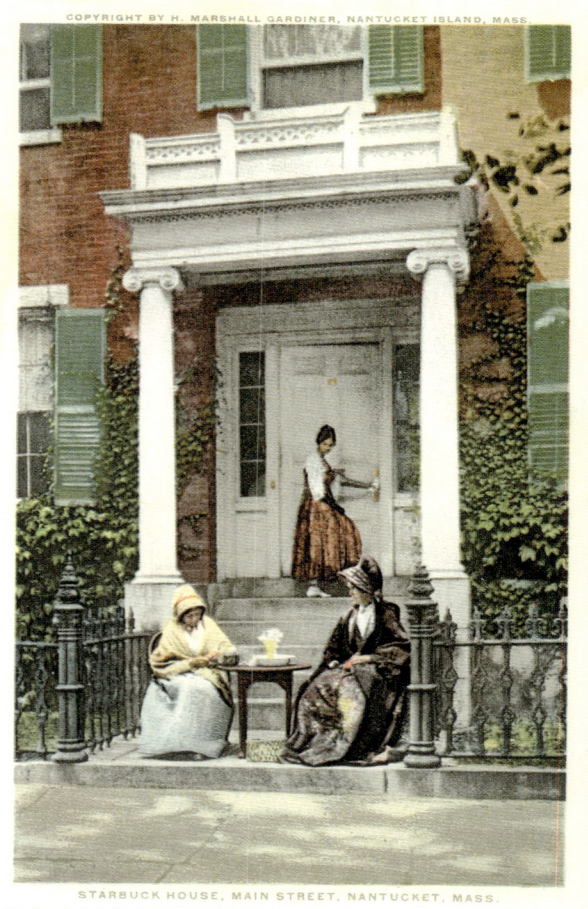

Above, from left to right and top to bottom:
Nantucket hydrangeas
On the way to shearing (Sheep Shearing Festival), Main Street
Afternoon tea, Main Street
Near right: Colonial ambience on Main Street
Far right: Starbuck House, Main Street

Oben, von links nach rechts und von oben nach unten:
Hortensien in Nantucket
Auf dem Weg zum Schafschurfest, Main Street
Nachmittagstee, Main Street
Rechts: Koloniales Ambiente auf der Main Street
Rechts außen: Das Starbuck-Haus, Main Street

En haut, de gauche à droite et de haut en bas :
Hortensias de Nantucket
En route pour la fête de la Tonte des moutons, Main Street
L'heure du thé, Main Street
Ci-contre : « Ambiance coloniale » sur Main Street
À droite : La maison Starbuck, Main Street

From top to bottom:
The torn net
The *Skipper* from Easy Street
North wharf

In 1602, the year in which it was explored by the Englishman Bartholomew Gosnold, the little island of Nantucket was inhabited by Wampanoag Indians, who lived by hunting and fishing. Fish—above all, cod—and shellfish were abundant in the waters of Massachusetts Bay, as were the whales that passed close by during their season of migration. From early in the 18th century and throughout the 19th century, Nantucket men went whaling on the high seas and a veritable industry developed on the island.

Von oben nach unten:
Das zerrissene Netz
Der *Skipper* von der Easy Street aus
Der Nordkai

Als 1602 die kleine Insel Nantucket von dem Engländer Bartholomew Gosnold entdeckt wurde, wohnten hier die von Jagd und Fischfang lebenden Wampanoag-Indianer. Die Gewässer der Bucht von Massachusetts waren reich an Fischen – besonders an Dorsch – und an Muscheln, doch zur Wanderungszeit kamen auch zahlreiche Wale vorbei. Ab dem beginnenden 18. und während des gesamten 19. Jahrhunderts betrieben die Fischer von Nantucket Hochseewalfang, und es entwickelte sich auf der Insel eine regelrechte Walverarbeitungsindustrie.

De haut en bas :
Le filet déchiré
Le *Skipper*, vu depuis Easy Street
Le quai nord

En 1602, date à laquelle elle fut explorée par l'Anglais Bartholomew Gosnold, la petite île de Nantucket était habitée par les Indiens Wampanoag, qui vivaient de chasse et de pêche. Les poissons – surtout la morue – et les coquillages abondaient dans les eaux de la baie du Massachusetts, mais aussi les baleines qui passaient à proximité durant la saison de la migration. À partir du début du XVIIIe siècle et durant tout le XIXe, les pêcheurs de Nantucket pratiquèrent la chasse à la baleine en haute mer, et une véritable industrie baleinière se développa sur l'île.

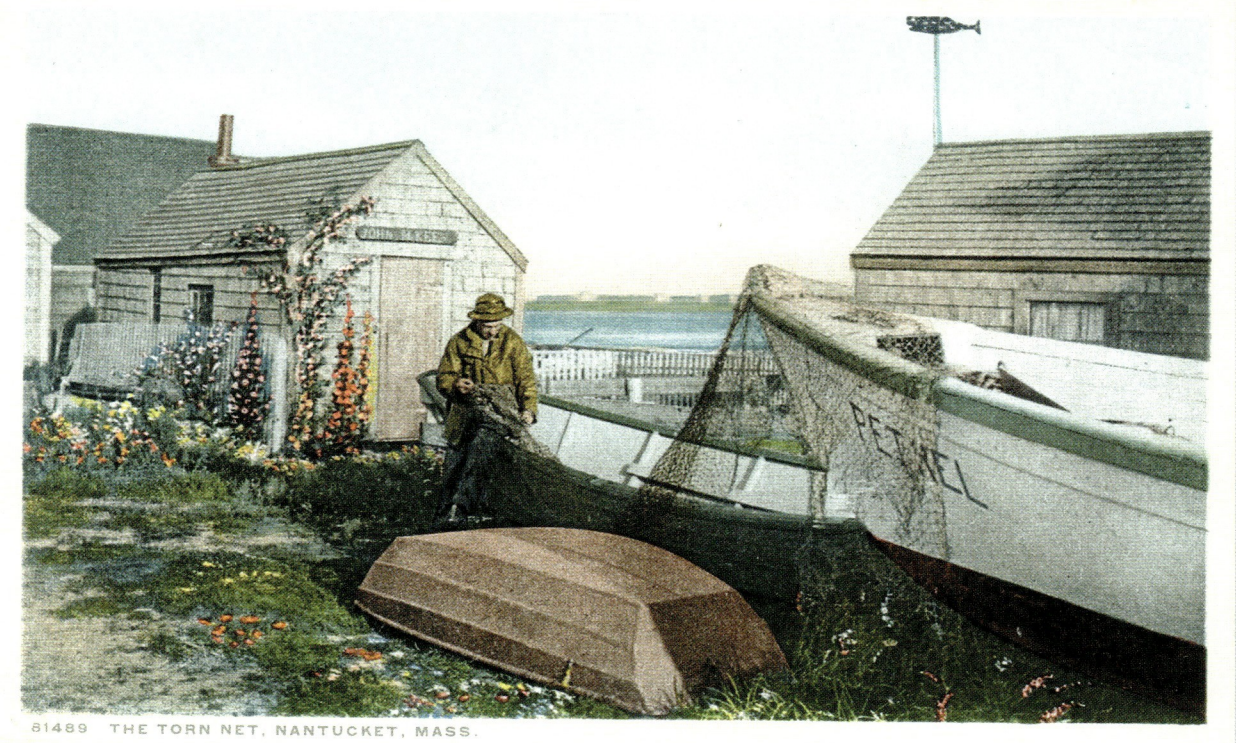

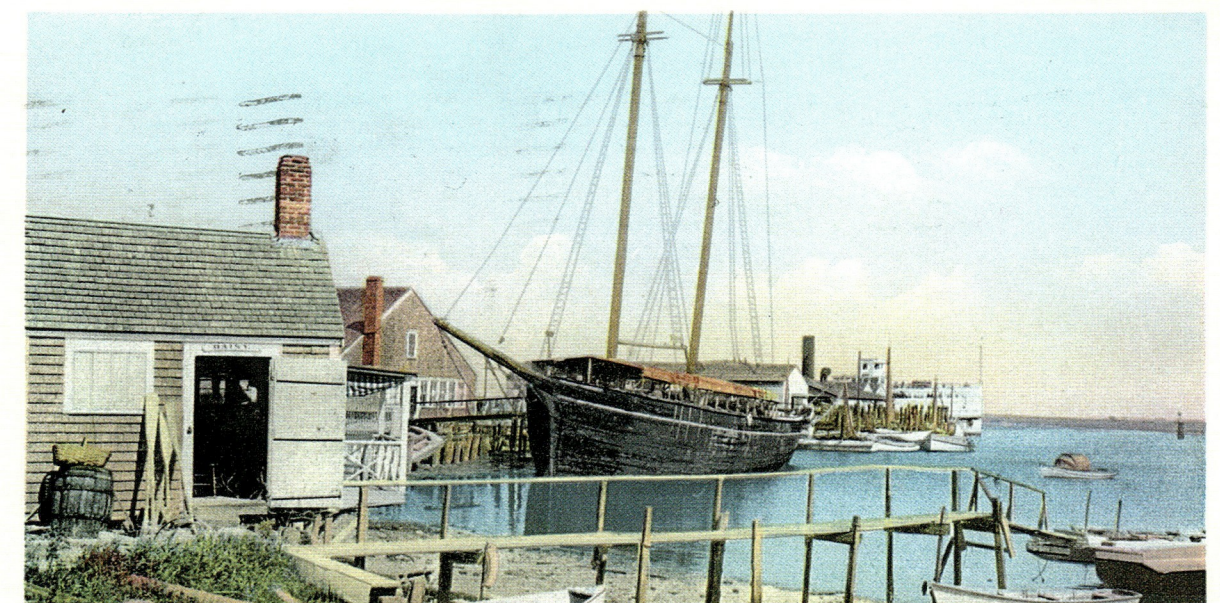

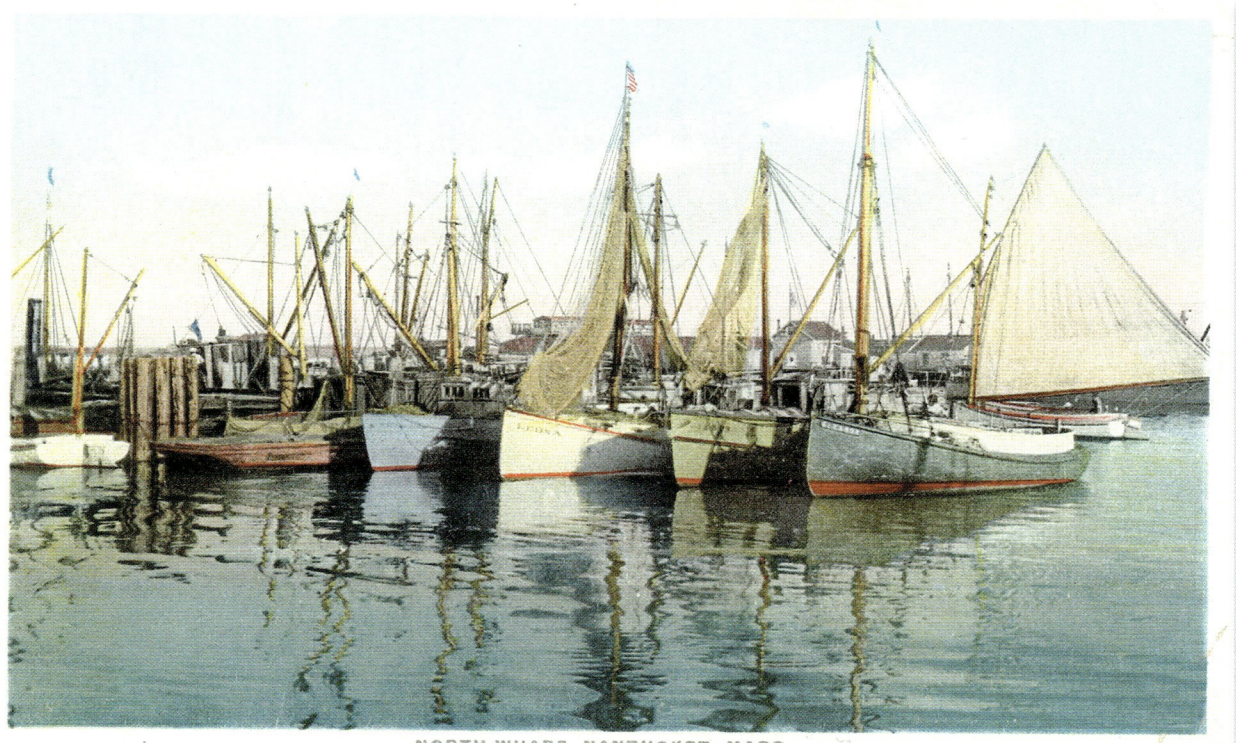

RHODE ISLAND

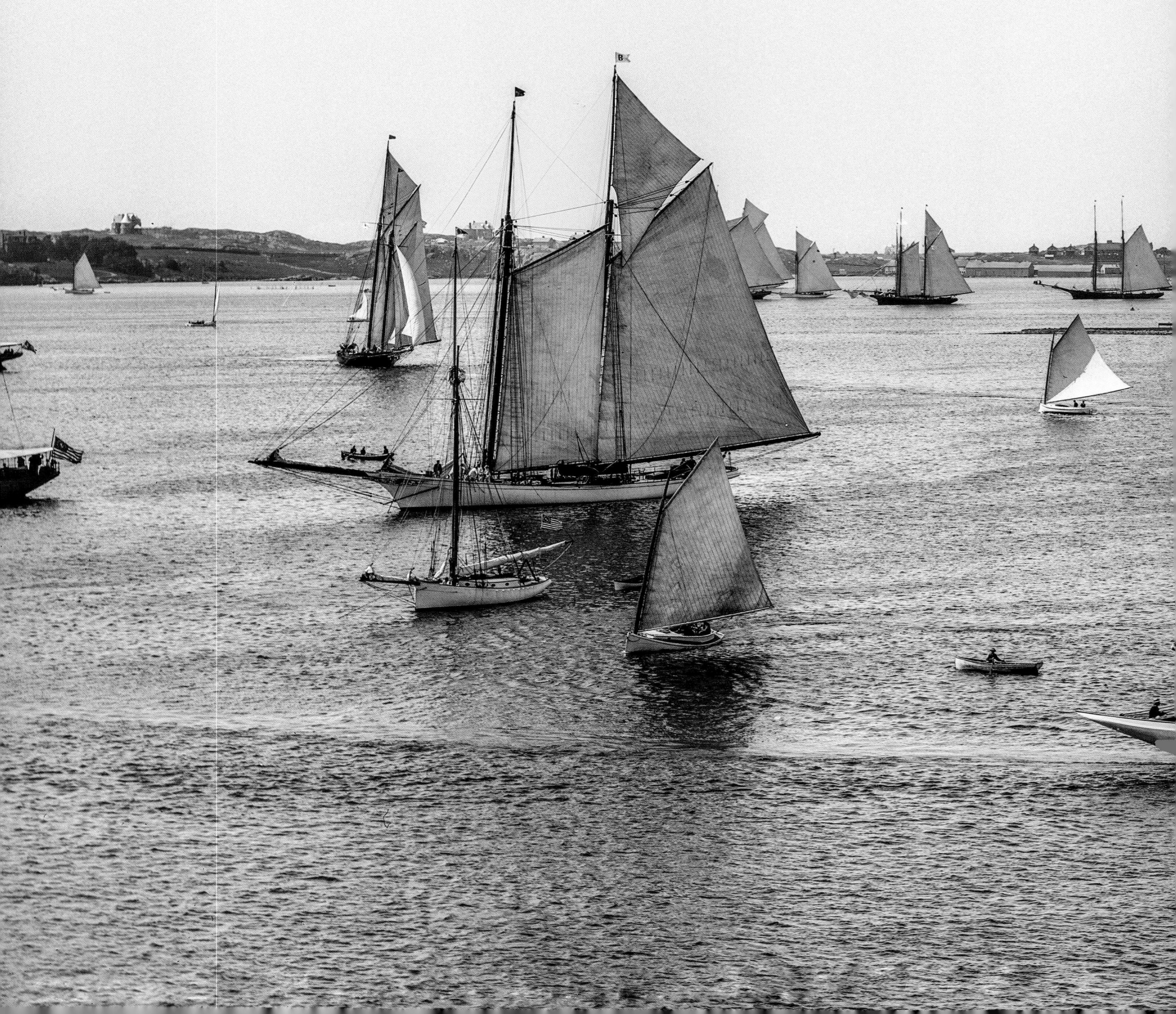

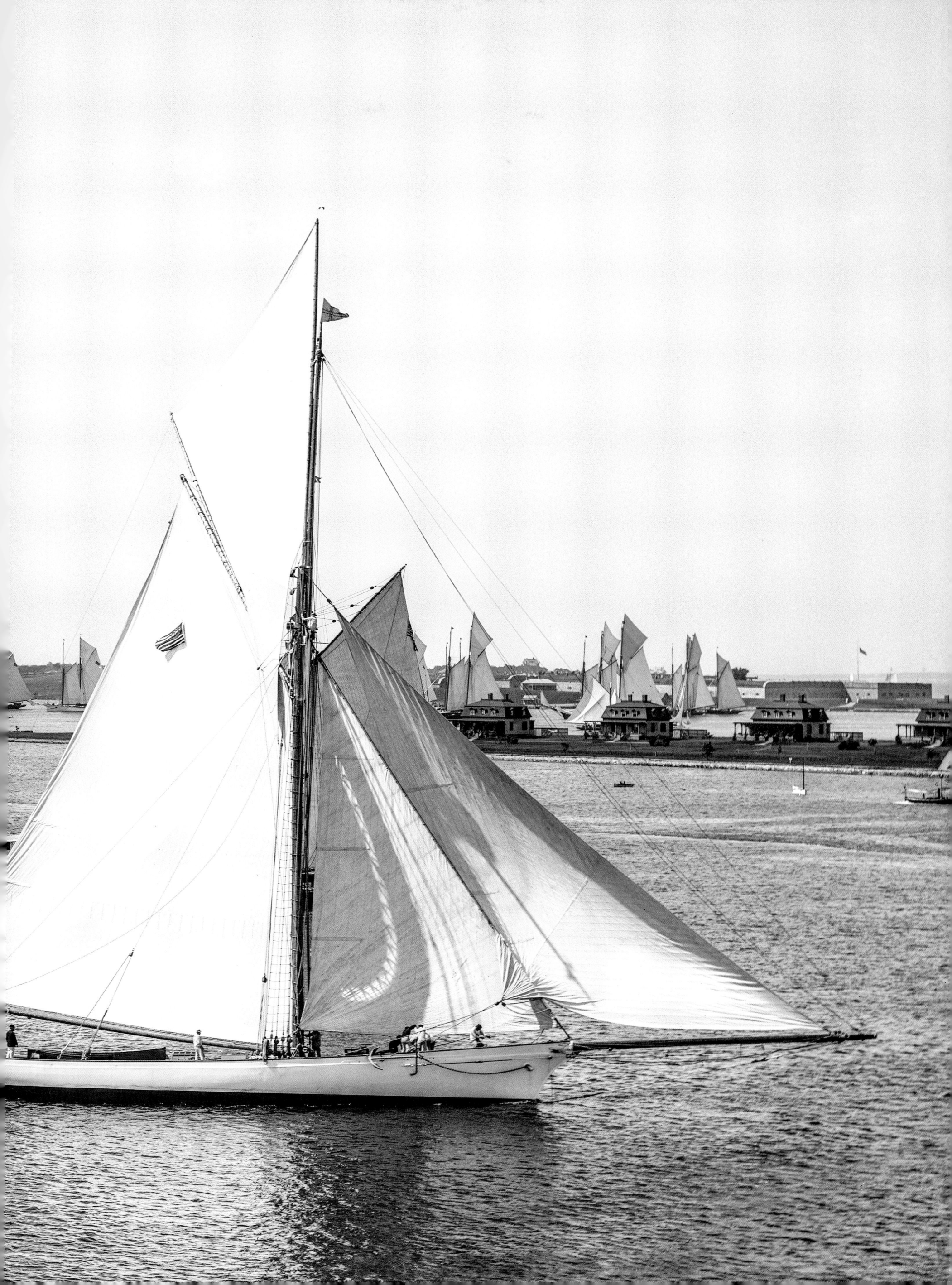

Page 172/173: N.Y.Y.C. (New York Yacht Club) fleet, Newport Harbor, glass negative, August 1888
Left: The old stone mill, Newport, photochrom
Below: Newport, Cliff Walk, photochrom

Seite 172/173: Die Flotte des New Yorker Yacht Clubs N.Y.Y.C. im Hafen von Newport, Glasnegativ, August 1888
Links: Die alte Steinmühle, Newport, Photochrom
Unten: Newport, Felsenpromenade, Photochrom

Pages 172/173 : la flottille du Yacht Club de New York (NYYC) dans le port de Newport, plaque de verre, août 1888
À gauche : le vieux moulin de pierre, Newport, photochrome
En bas : Newport, promenade de la Falaise, photochrome

Top left: **Ochre Point, Cliff Walk, Newport**
Top right: **Narragansett Pier**
Bottom: **Narragansett Pier, the casino, photochrom**

The city of Newport on Aquidneck Island was founded in 1639 by English settlers and is home to a strong Jewish community of Portuguese and Spanish origin, the second largest in the United States. Its members arrived in successive waves at the time of the Spanish Inquisition. A major colonial port during the 18th century and greatly enriched by the slave trade, Newport also played an important role in the War of Independence. In the 19th century, the city became a naval base (the Naval War College was established here in 1884) as well as a beach and yachting resort and the favored summer residence of rich American families.

Oben links: **Ochre Point, Felsenpromenade, Newport**
Oben rechts: **Der Narragansett-Pier**
Unten: **Der Narragansett-Pier, Kasino, Photochrom**

In der 1639 von englischen Siedlern auf der Insel Aquidneck gegründeten Stadt Newport ist eine große portugiesisch- und spanischstämmige jüdische Gemeinde zu Hause – die zweitgrößte in den USA. Sie war zur Zeit der Inquisition in mehreren Wellen hierher gekommen. Newport war im 18. Jahrhundert ein großer Kolonialhafen, in dem vor allem mit Sklaven gehandelt wurde, es spielte aber auch während des Unabhängigkeitskrieges eine bedeutende Rolle. Im Laufe des 19. Jahrhunderts wurde die Stadt gleichermaßen zum Marinestützpunkt (1884 wurde hier das Naval War College eingerichtet), zu einem Bade- und Segelort sowie zum Sommerwohnsitz reicher amerikanischer Familien.

En haut à gauche : **Ochre Point, promenade de la Falaise, Newport**
En haut à droite : **la jetée de Narragansett**
En bas : **la jetée de Narragansett, le casino, photochrome**

Sur l'île d'Aquidneck, Newport, fondée en 1639 par les colons anglais, abrite une forte communauté juive d'origine portugaise et espagnole – la deuxième des États-Unis –, arrivée par vagues successives à l'époque de l'Inquisition. Gros port colonial au XVIII siècle, pratiquant notamment la traite des esclaves, Newport joua également un rôle important lors de la guerre d'Indépendance. Au cours du XIX siècle, la ville devint une base navale (le Naval War College y fut établi en 1884), en même temps qu'une station balnéaire et de yachting, lieu de résidence estivale des riches familles américaines.

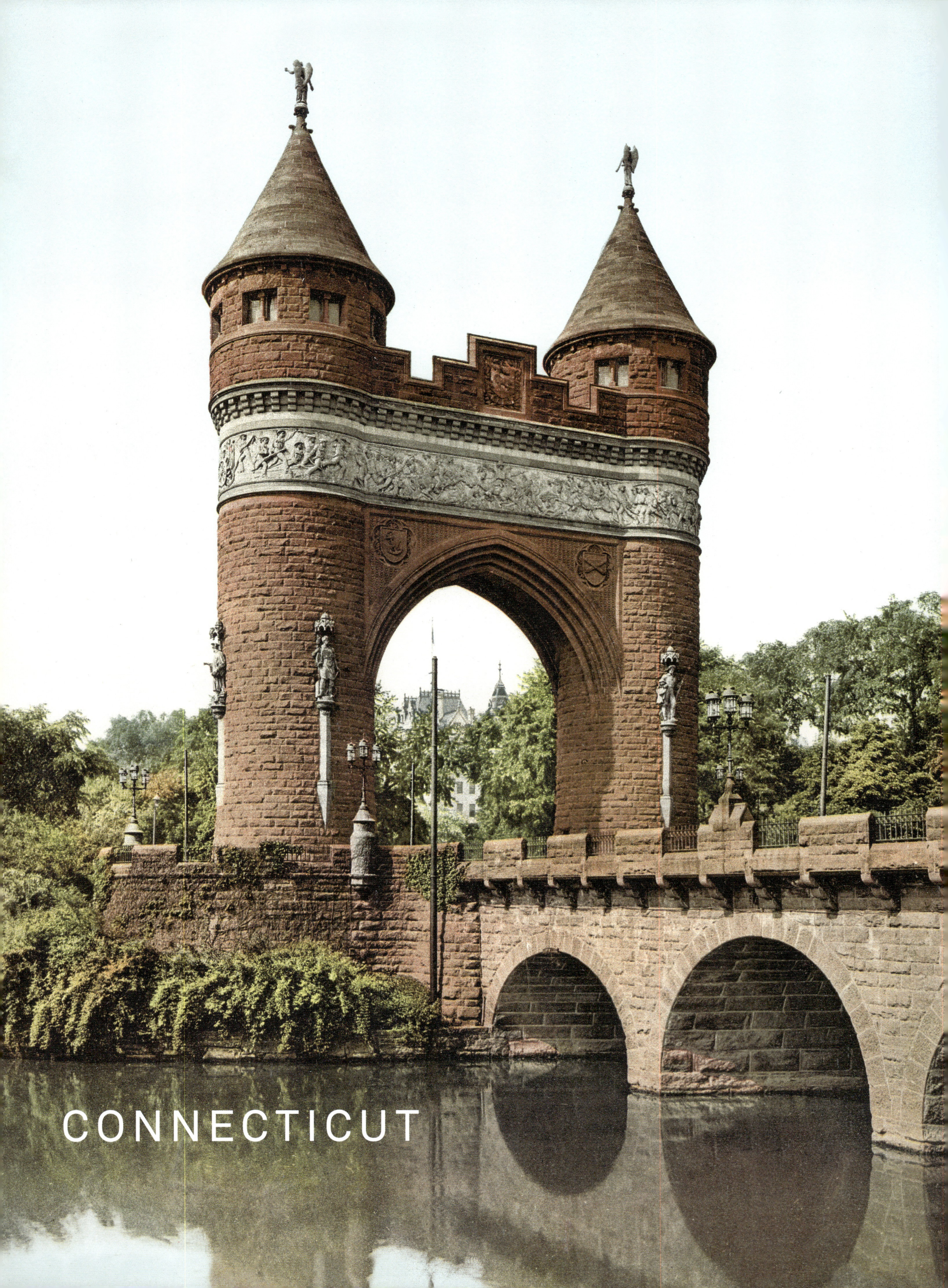

CONNECTICUT

Page 176: Memorial Arch, Hartford, photochrom
Above: **Yale-Harvard Varsity Race**
Below: **Osborn Hall, Yale College, New Haven, photochrom**

The English colony of New Haven established a college in 1701 at Saybrook, at the mouth of the Connecticut River. It moved to New Haven in 1716 and, two years later, took the name of Yale College in honor of the rich London merchant Elihu Yale, who had donated 417 books and a portrait of King George I. The oldest building at Yale, Connecticut Hall, was built in the early 1750s. Osborn Hall was built in the Victorian style by the New York architect Bruce Price in 1888 and demolished in 1926.

Seite 176: Memorial Arch, Hartford, Photochrom
Oben: **Die Universitätsregatta Yale-Harvard**
Unten: **Osborn Hall, Yale College, New Haven, Photochrom**

1701 wurde in Saybrook an der Mündung des Connecticut River das College der englischen Kolonie in New Haven gegründet. 1716 zog es nach New Haven um und wurde zwei Jahre später zu Ehren des reichen Londoner Kaufmanns Elihu Yale, der dem College 417 Bücher und ein Porträt von König George I. vermacht hatte, in Yale College umbenannt. Die Connecticut Hall, das älteste Gebäude von Yale, wurde Anfang der 1750er-Jahre errichtet. Die im viktorianischen Stil gehaltene Osborn Hall des New Yorker Architekten Bruce Price wurde 1888 errichtet; 1926 wurde sie abgerissen.

Page 176: Memorial Arch, Hartford, photochrome
En haut : **les régates universitaires Yale-Harvard**
En bas : **Osborn Hall, Yale College, New Haven, photochrome**

Le *College* de la colonie anglaise de New Haven fut fondé en 1701 à Saybrook, à l'embouchure du fleuve Connecticut. Il déménagea à New Haven en 1716 et prit le nom de Yale College deux ans plus tard, en hommage au riche marchand londonien Elihu Yale qui venait de lui faire don de 417 livres et d'un portrait du roi George Ier. Le plus ancien bâtiment de Yale, le Connecticut Hall, fut édifié au début des années 1750. D'architecture victorienne, Osborn Hall, dû à l'architecte new-yorkais Bruce Price, fut élevé en 1888 ; il a été démoli en 1926.

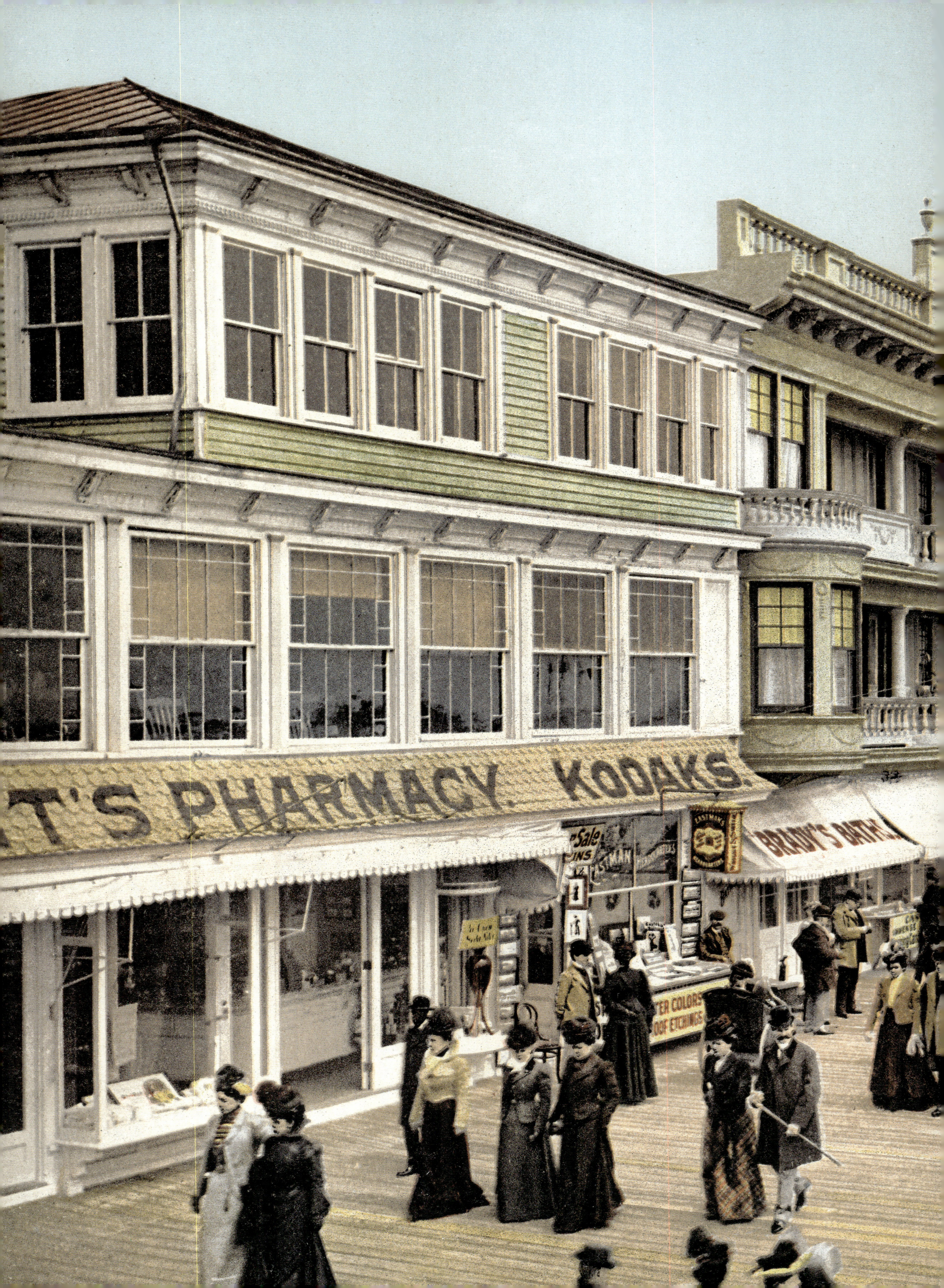

NEW JERSEY

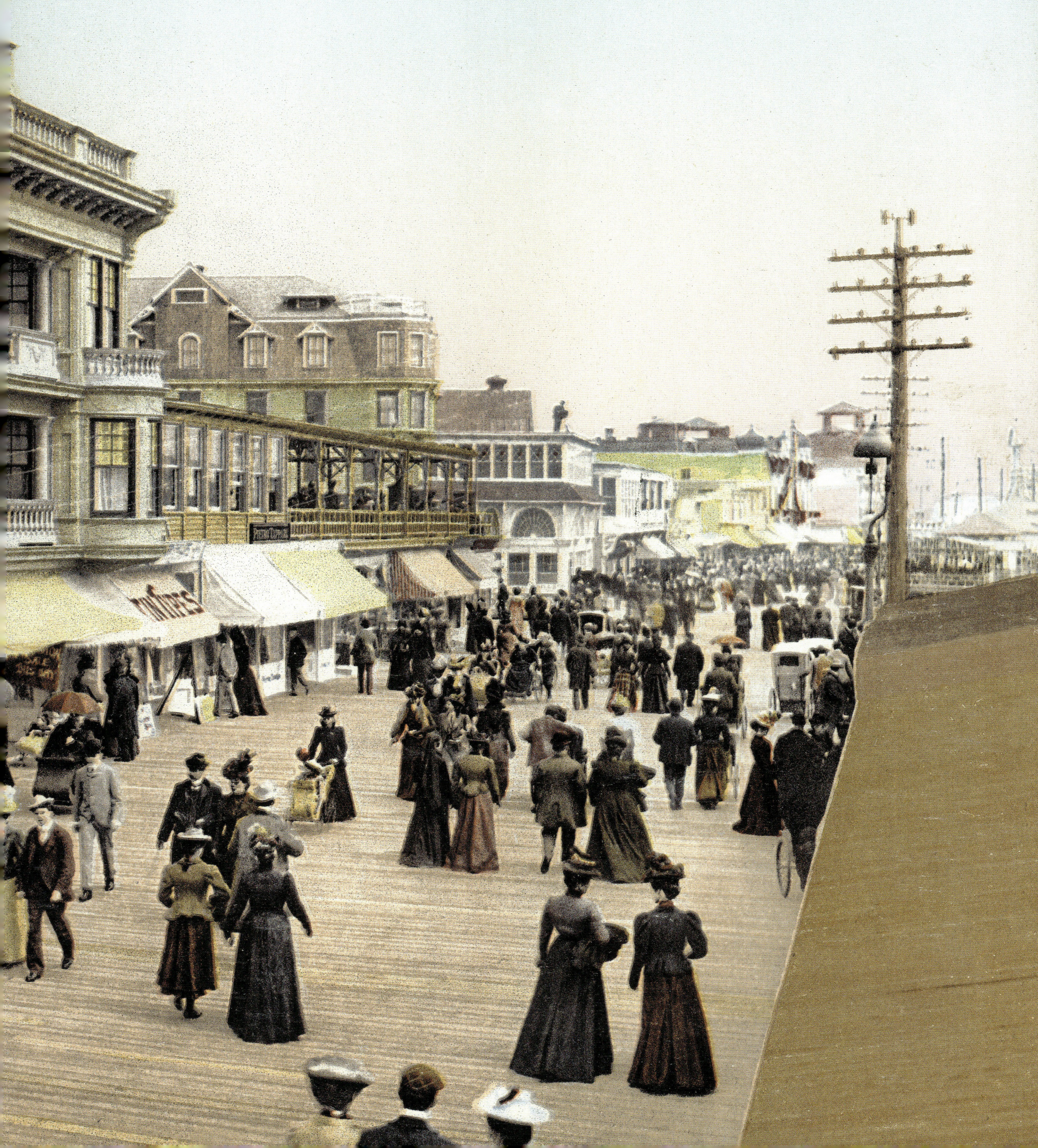

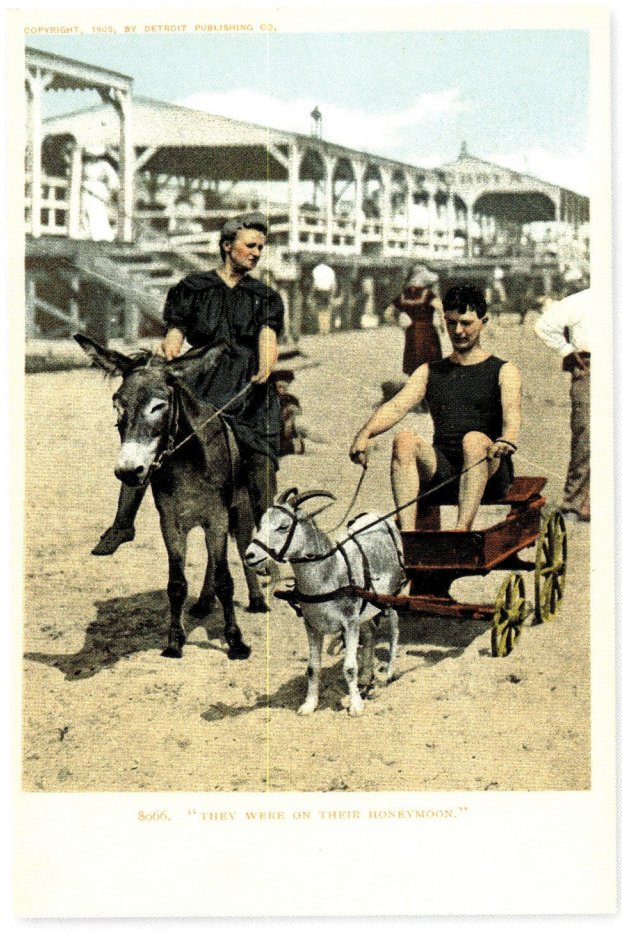

8066. "THEY WERE ON THEIR HONEYMOON."

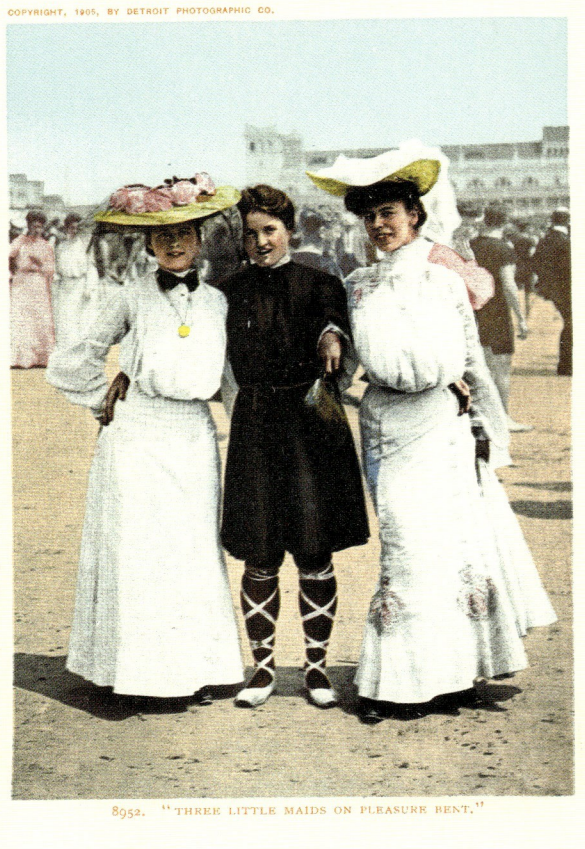

8952. "THREE LITTLE MAIDS ON PLEASURE BENT."

Page 178/179: Atlantic City, boardwalk and casino, photochrom
Far left: "They were on their honeymoon"
Near left: "Three little maids on pleasure bent"
Bottom: Boardwalk toward Steel Pier, photochrom

The famous Steel Pier was built in 1898. Many famous spectacles took place on the pier, not least of which was the "diving horse," one of the attractions of the show run by Al Carver. His father was "Doc" Carver, Buffalo Bill's sometime partner and subsequent bitter rival.

Seite 178/179: Atlantic City, Promenade und Kasino, Photochrom
Links außen: „Sie waren auf der Hochzeitsreise"
Links: „Drei gut gelaunte junge Damen"
Unten: Strandpromenade in Richtung Steel Pier, Photochrom

1898 wurde der berühmte Steel Pier errichtet; hier fanden unvergessliche Shows statt, darunter die des „tauchenden Pferdes", eine Attraktion von Al Carver, dem Sohn des einstigen Partners und späteren Rivalen von Buffalo Bill.

Pages 178/179 : Atlantic City, les « Planches » et le casino, photochrome
A gauche : « C'était leur lune de miel… »
Ci-contre : « Trois jeunes filles de bonne humeur »
En bas : les « Planches » en direction de la jetée métallique (Steel Pier), photochrome

La célèbre Steel Pier fut édifiée en 1898 ; des shows inoubliables s'y sont déroulés, tel celui du « cheval qui plonge », une attraction d'Al Carver, le fils de l'ex-partenaire et rival de Buffalo Bill.

NEW JERSEY | ATLANTIC CITY

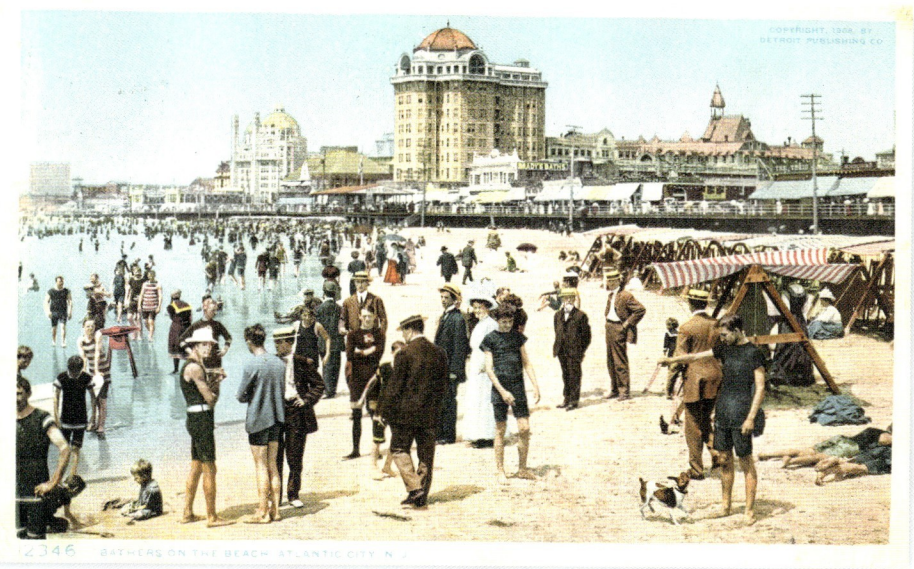
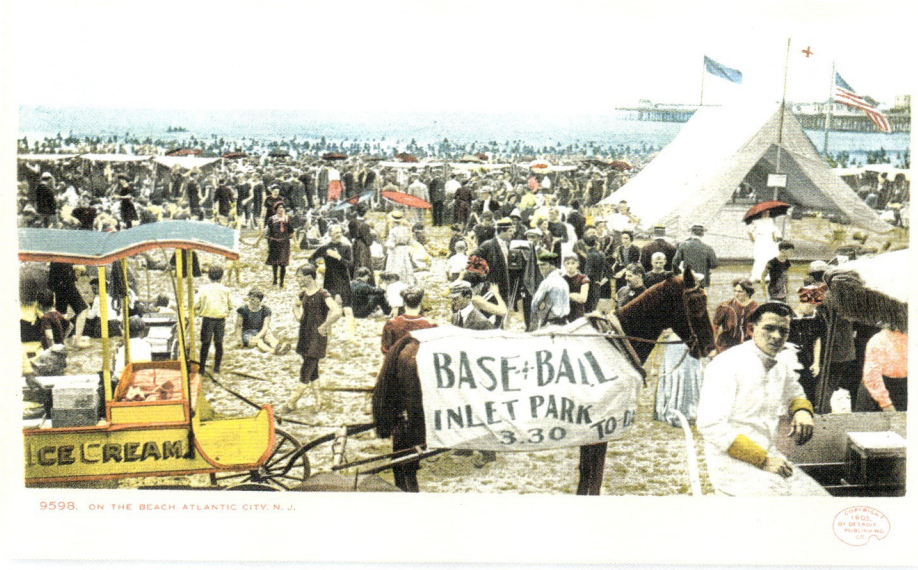
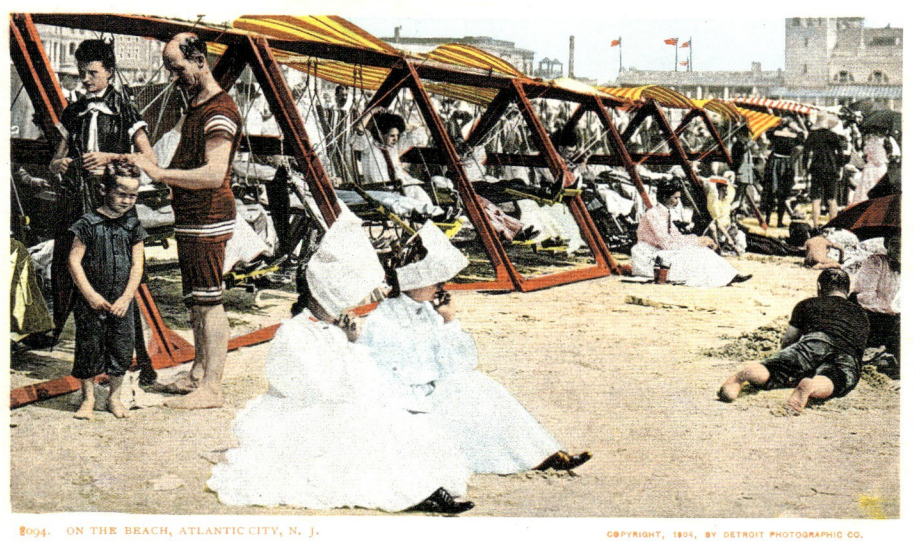
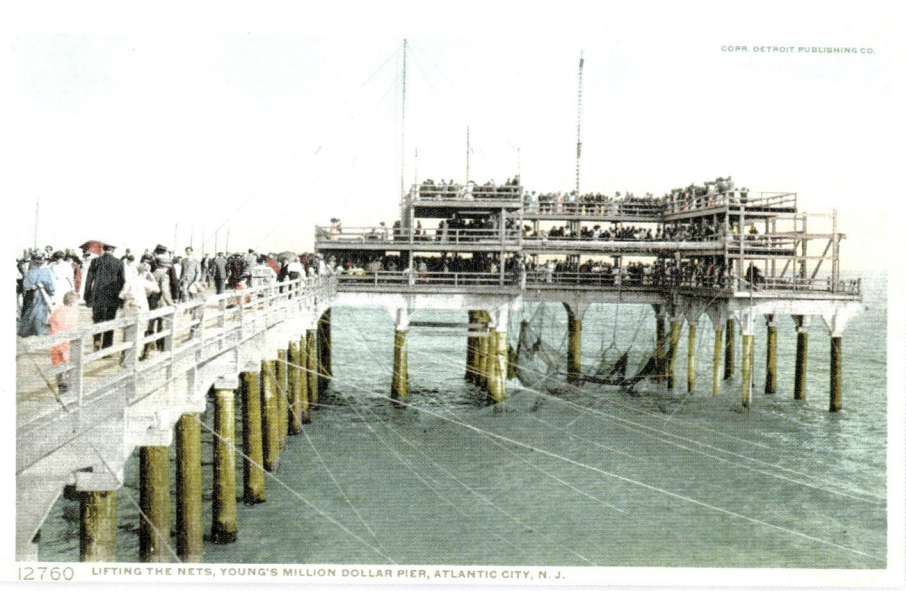

From left to right and top to bottom:
Bathers on the beach
On the beach of Atlantic City
On the beach of Atlantic City
Lifting the nets, Young's Million Dollar Pier
Near right: The boardwalk
Far right: Watching the bathers

Von links nach rechts und von oben nach unten:
Badende am Strand
Am Strand von Atlantic City
Am Strand von Atlantic City
Einholen der Netze am Young's Million Dollar Pier
Rechts: Die Strandpromenade
Rechts außen: Beim Anblick der Badenden

De gauche à droite et de haut en bas :
Baigneurs sur la plage
Sur la plage d'Atlantic City
Sur la plage d'Atlantic City
Levée des filets sur la jetée « qui coûta un million de dollars »
Ci-contre : les « Planches »
À droite : en regardant les baigneurs

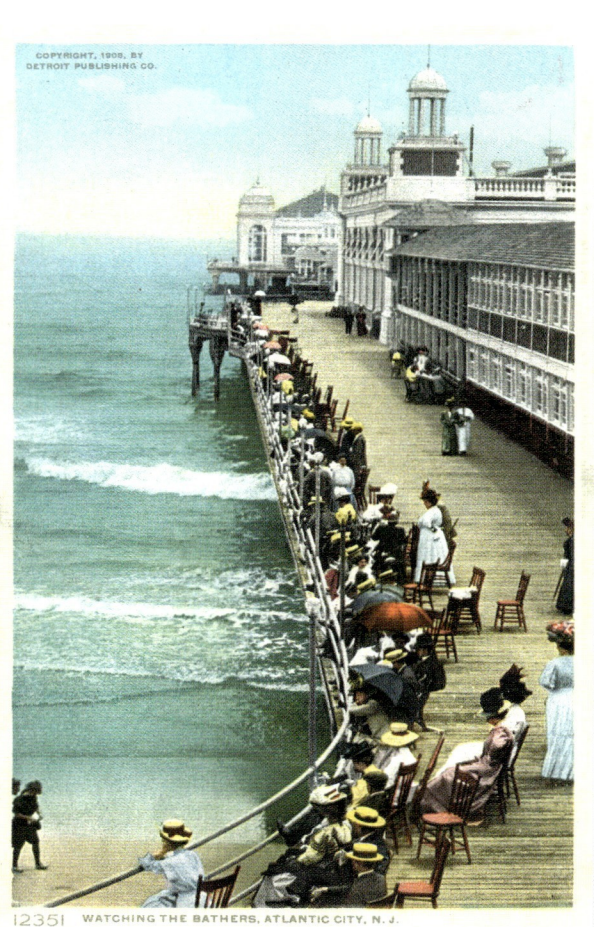

NEW JERSEY | ATLANTIC CITY

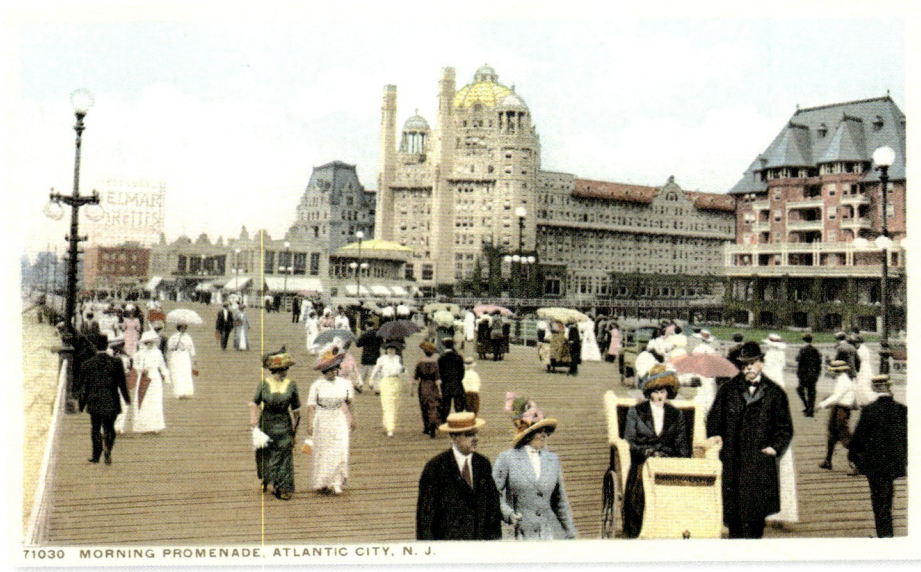
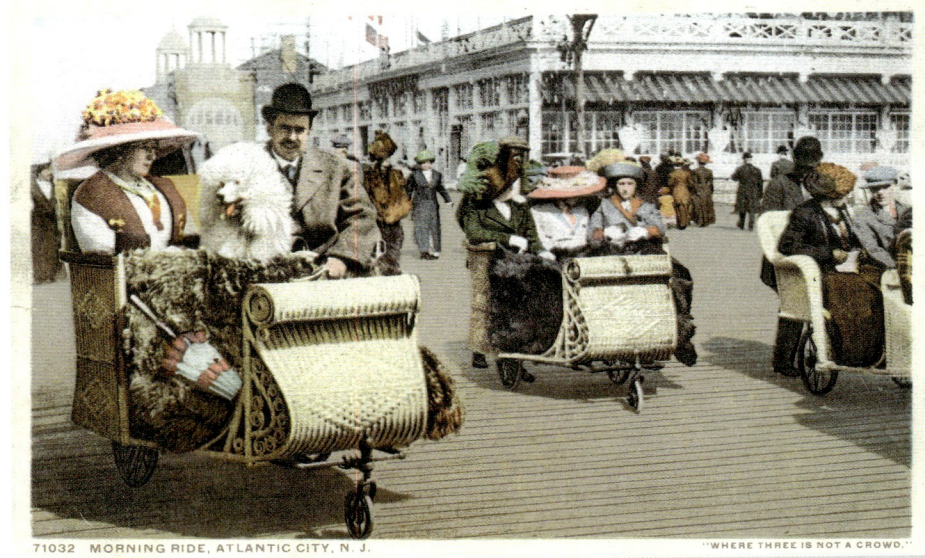
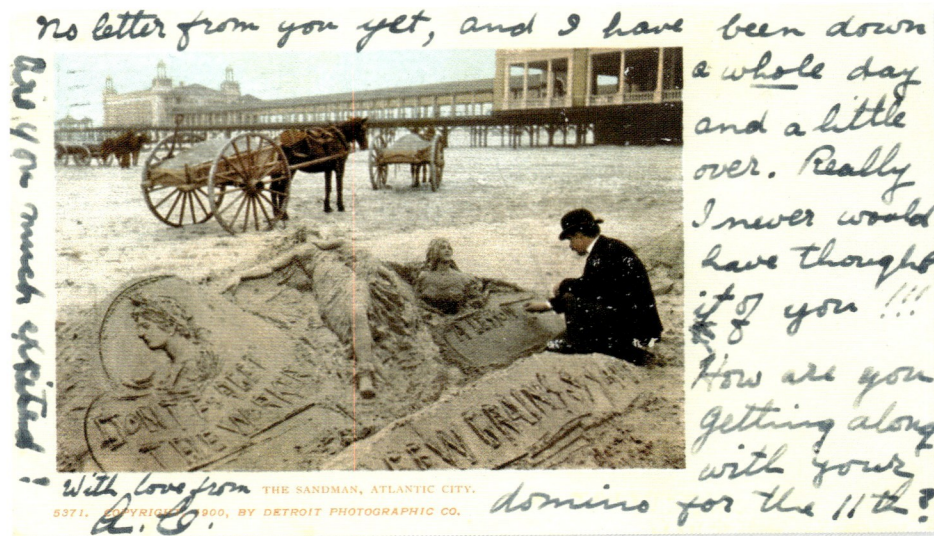

From left to right and top to bottom:
Morning promenade
Morning ride
The sandman
A sandman, Atlantic City, glass negative, ca. 1910

Von links nach rechts und von oben nach unten:
Die Promenade am Morgen
Morgendliche Spazierfahrt
Sandskulpteur
Ein Sandskulpteur am Strand von Atlantic City, Glasnegativ, um 1910

De gauche à droite et de haut en bas :
Le matin sur la Promenade
Balade matinale
Sculpteur sur sable
Un sculpteur sur sable sur la plage d'Atlantic City, plaque de verre, vers 1910

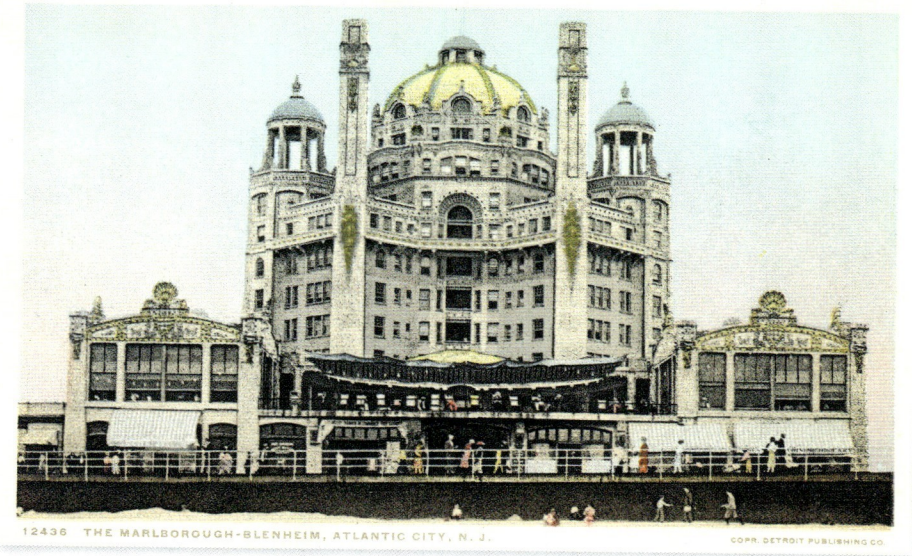 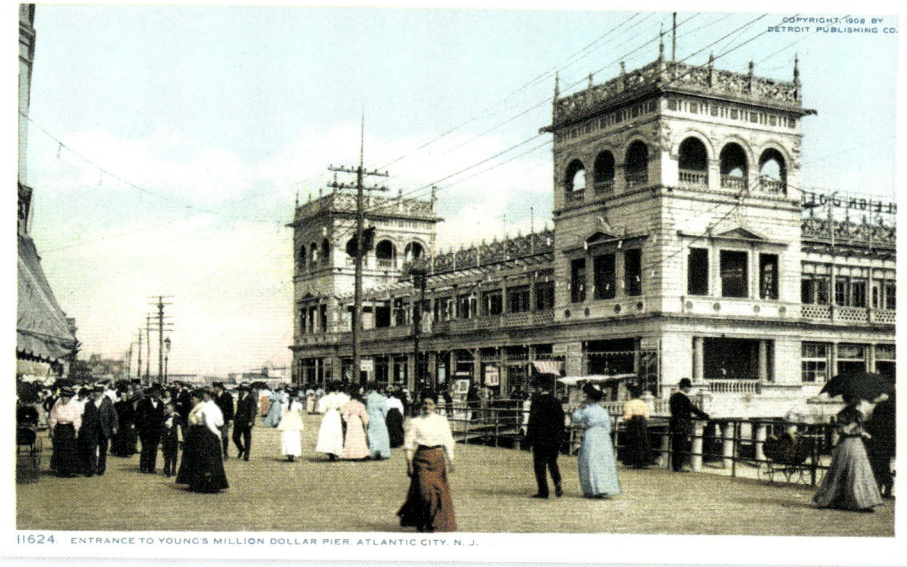

Top left: **The Marlborough-Blenheim Hotel**
Top right: **Entrance to Young's Million Dollar Pier**
Bottom: **Photographer taking picture of group with donkey at crowded beach, glass negative, ca. 1900**

In July 1854, the first Camden-Atlantic City Railroad entered the station of Atlantic City on Absecon Island. The line had been financed by Dr. Jonathan Pitney, who grasped the potential of the city's climate as a major tourist attraction. The resort grew rapidly and it became necessary to protect the hotels and stores from the sand on the beach: the first Boardwalk was constructed on June 16, 1870. It immediately became the entertainment center of the city. First enlarged in 1880, it was replaced several times, notably in 1944 in the aftermath of a hurricane.

Oben links: **Hotel Marlborough-Blenheim**
Oben rechts: **Zugang zu Young's Million Dollar Pier**
Unten: **Ein Fotograf nimmt am stark frequentierten Strand eine Gruppe mit Esel auf, Glasnegativ, um 1900**

Im Juli 1854 fuhr der erste Zug der Camden-Atlantic City Railroad in den Bahnhof von Atlantic City auf der Insel Absecon ein. Die Linie war von Dr. Jonathan Pitney finanziert worden, der an die klimatischen und touristischen Vorzüge der Stadt glaubte. Der Ort erlebte einen raschen Aufschwung, und die Hotels und Geschäfte mussten nun vor dem Sand der Strände geschützt werden: So entstand am 16. Juni 1870 die erste hölzerne Strandpromenade (Boardwalk). Sie wurde unverzüglich zum Vergnügungsort der Stadt. 1880 wurde sie erweitert und später mehrfach ersetzt, insbesondere nach dem Hurrikan von 1944.

En haut à gauche : **l'hôtel Marlborough-Blenheim**
En haut à droite : **la jetée dite «Young's Million Dollar Pier»**
En bas : **photographe faisant le portrait de touristes montant un âne, plaque de verre, vers 1900**

En juillet 1854, le premier train du Camden-Atlantic City Railroad entrait en gare d'Atlantic City, sur l'île d'Absecon. La ligne avait été financée par le docteur Jonathan Pitney, qui croyait à la vocation touristique de la ville. La station se développa rapidement et la nécessité d'isoler les hôtels et les boutiques du sable de la plage devint une priorité : la première promenade en planches (le Boardwalk) vit le jour le 16 juin 1870. Elle devint immédiatement le lieu de distraction de la ville. Elle fut agrandie en 1880 et remplacée plusieurs fois, notamment en 1944 à la suite d'un ouragan.

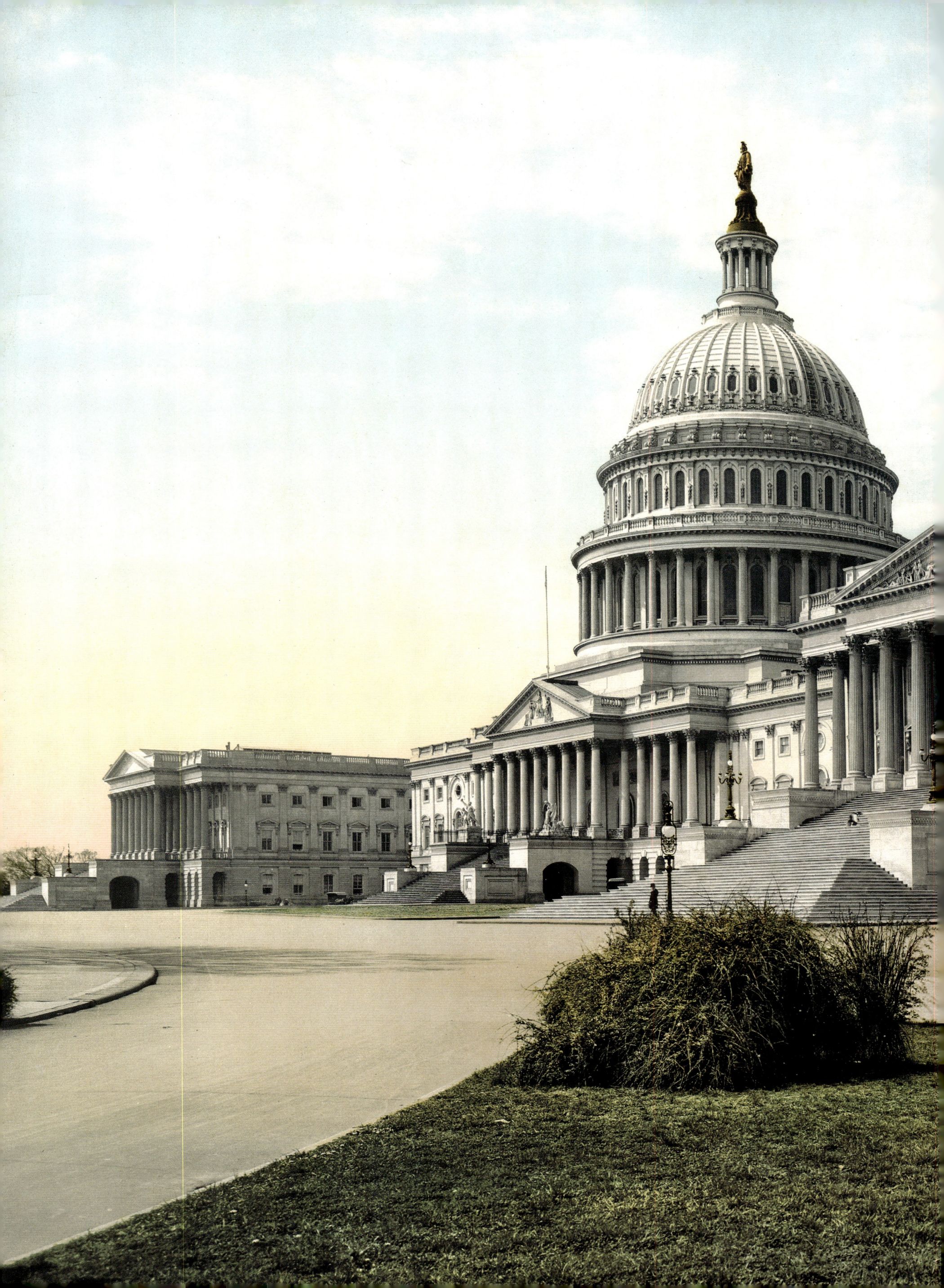

WASHINGTON, D.C.

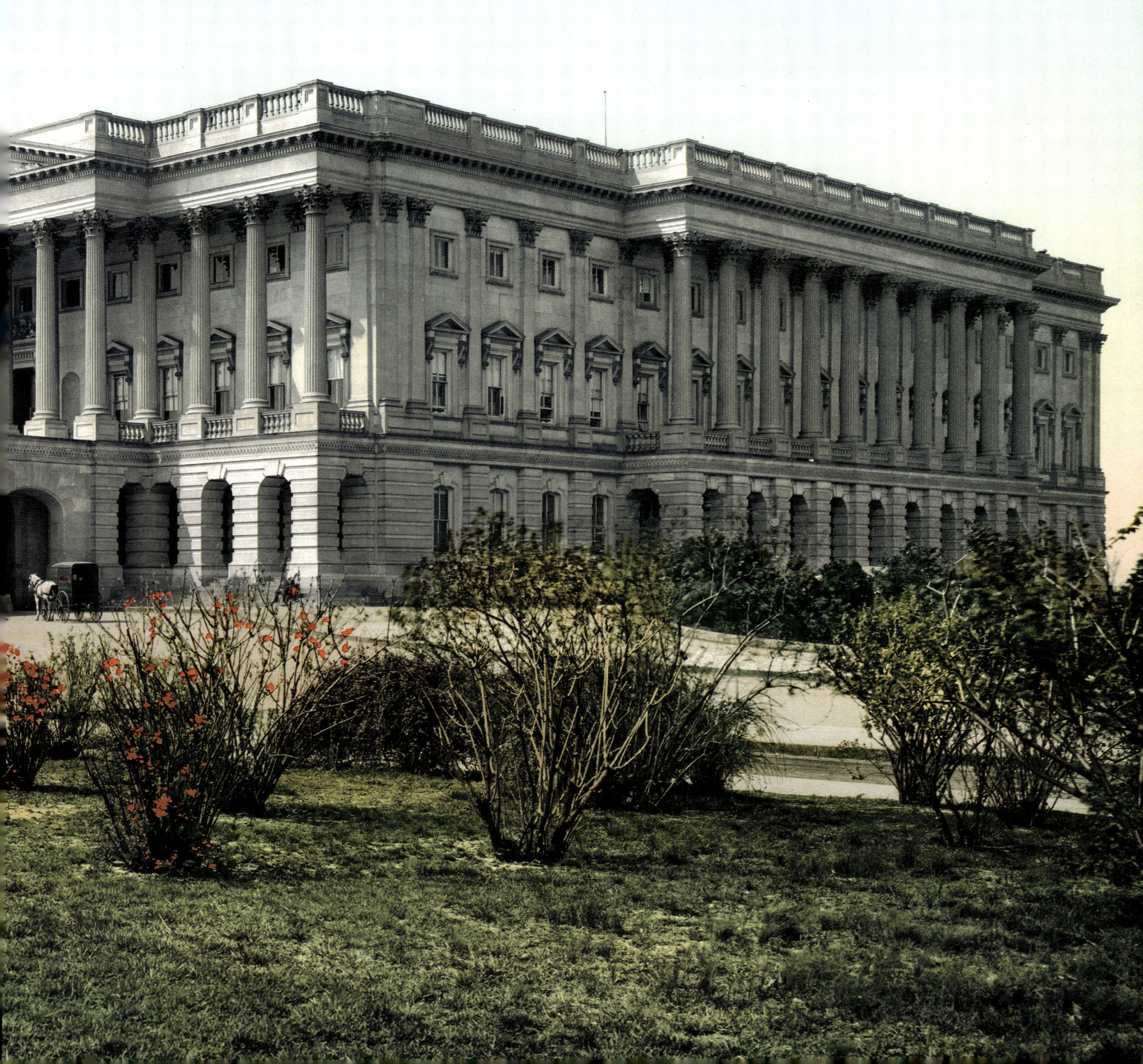

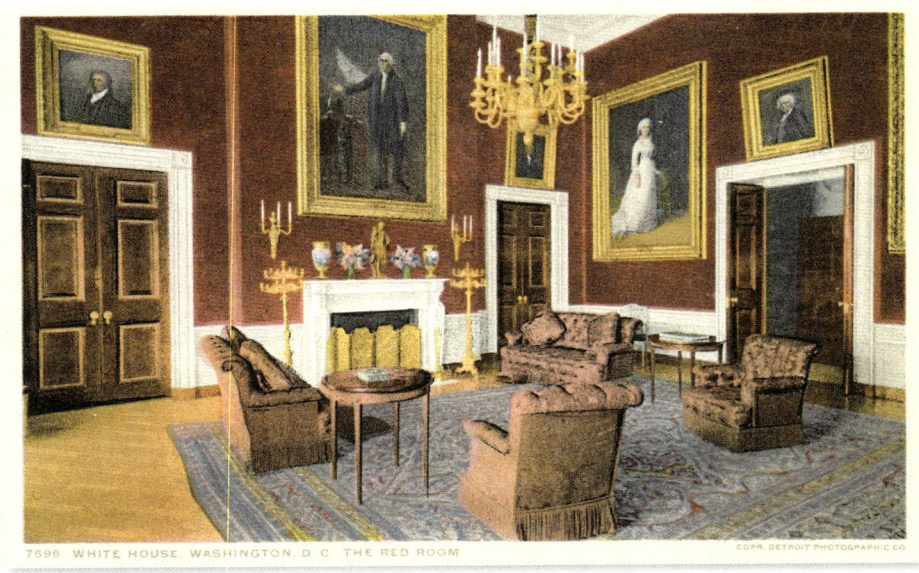
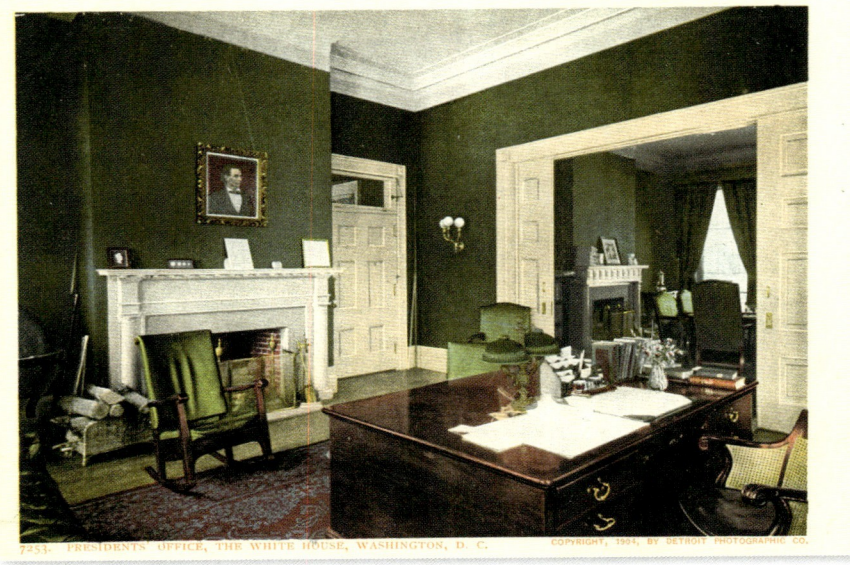

Page 184/185: **The Capitol**, photochrom
Top left: **The White House, the Red Room**
Top right: **The White House, the President's office**
Bottom: **The White House, South Point, photochrom**

The first stone of the Capitol was laid in 1793 by George Washington. It was also Washington who chose the site of the White House and, with his wife, Martha, inspected the completed building in 1799. All presidents of the United States since John Adams have made the White House their residence. The White House orchid collection was started by Martha Washington.

Seite 184/185: **Das Kapitol**, Photochrom
Oben links: **Der rote Salon des Weißen Hauses**
Oben rechts: **Das Büro des Präsidenten im Weißen Haus**
Unten: **Das Weiße Haus, Südseite, Photochrom**

1793 legte George Washington den Grundstein für das Kapitol. Er war es auch, der den Standort für das Weiße Haus auswählte und das Gebäude nach seiner Fertigstellung im Jahr 1799 mit seiner Ehefrau Martha begutachtete. Seit John Adams haben alle Präsidenten der Vereinigten Staaten im Weißen Haus gewohnt. Die Orchideensammlung wurde von Martha Washington angelegt.

Pages 184/185 : **le Capitole**, photochrome
En haut à gauche : **le salon rouge de la Maison Blanche**
En haut à droite : **Maison Blanche, le bureau du président**
En bas : **la Maison Blanche, côté sud, photochrome**

La première pierre du Capitole a été posée en 1793 par George Washington. C'est aussi Washington qui choisit le site de la Maison Blanche et inspecta le bâtiment terminé, avec son épouse, Martha, en 1799. Tous les présidents des États-Unis, depuis John Adams, ont fait de la Maison Blanche leur résidence. La collection d'orchidées a été constituée par Martha Washington.

WASHINGTON, D.C. | WASHINGTON, D.C.

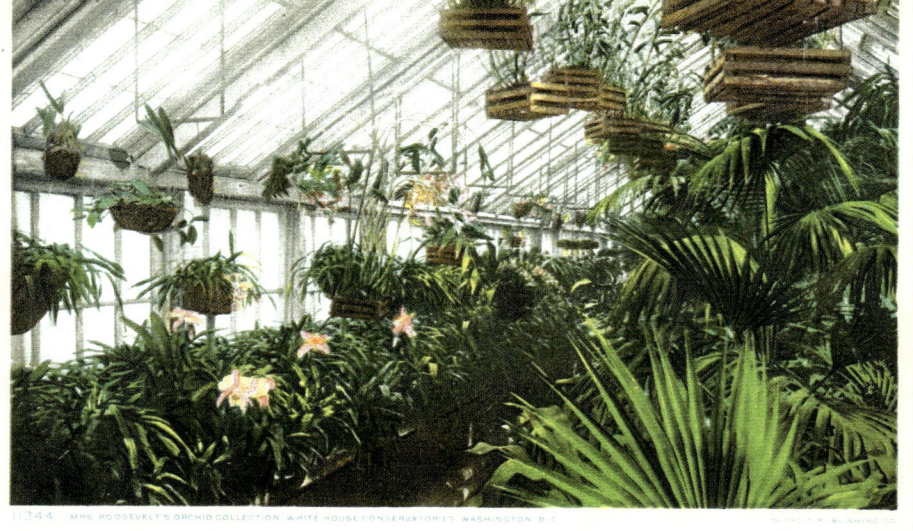
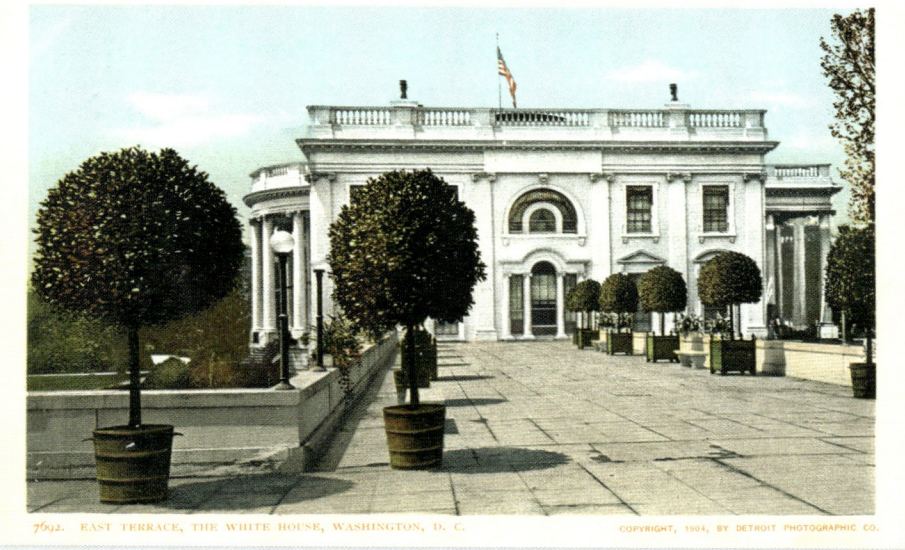

Top left: The White House orchid collection
Top right: East terrace of the White House
Bottom: U.S. Treasury currency wagon, Washington, glass negative, ca. 1906

The U.S. Department of the Treasury was founded by an act of Congress on September 2, 1789.

Oben links: Die Orchideensammlung des Weißen Hauses
Oben rechts: Die östliche Terrasse des Weißen Hauses
Unten: Geldtransport zum Finanzministerium (U.S. Treasury), Washington, Glasnegativ, um 1906

Das Finanzministerium wurde am 2. September 1789 durch den Kongress ins Leben gerufen.

En haut à gauche : la collection d'orchidées de la Maison Blanche
En haut à droite : la terrasse de la Maison Blanche, côté est
En bas : transport de fonds au ministère des Finances (U.S. Treasury), Washington, plaque de verre, vers 1906

Le ministère des Finances a été fondé par acte du Congrès, en date du 2 septembre 1789.

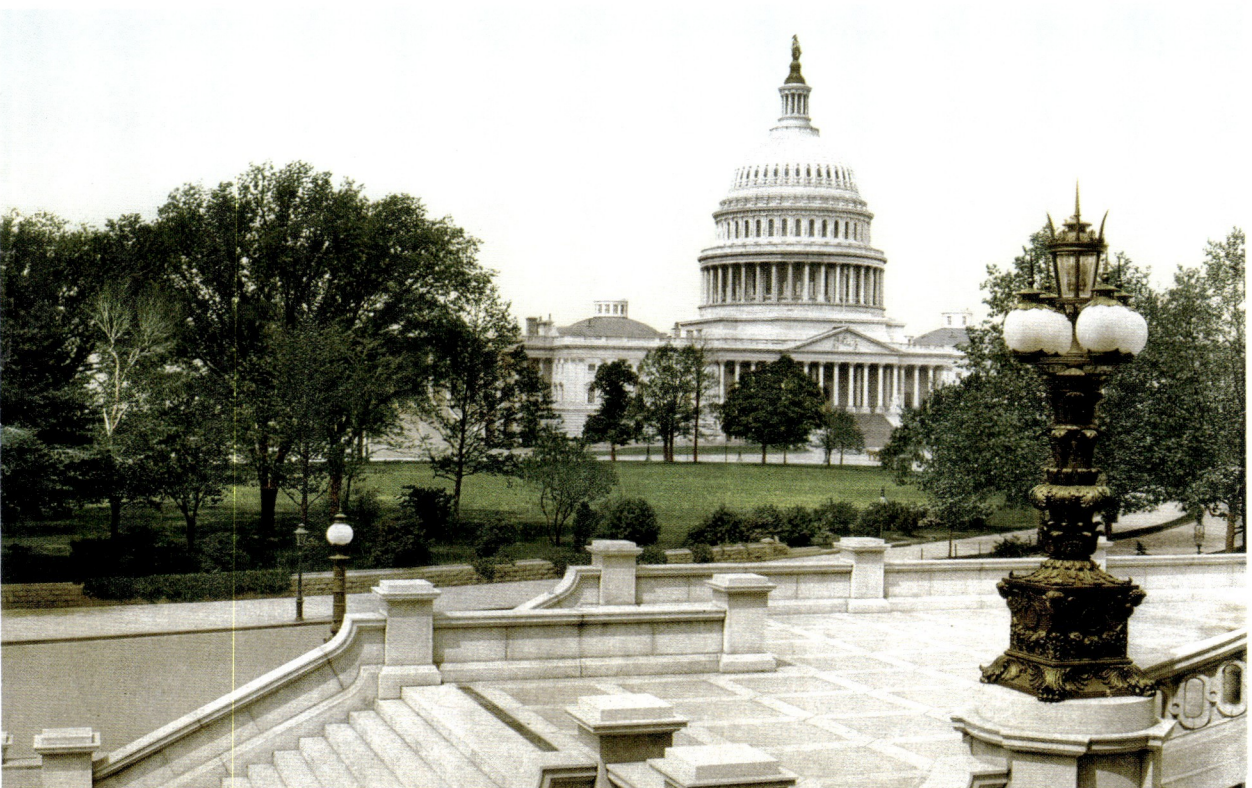

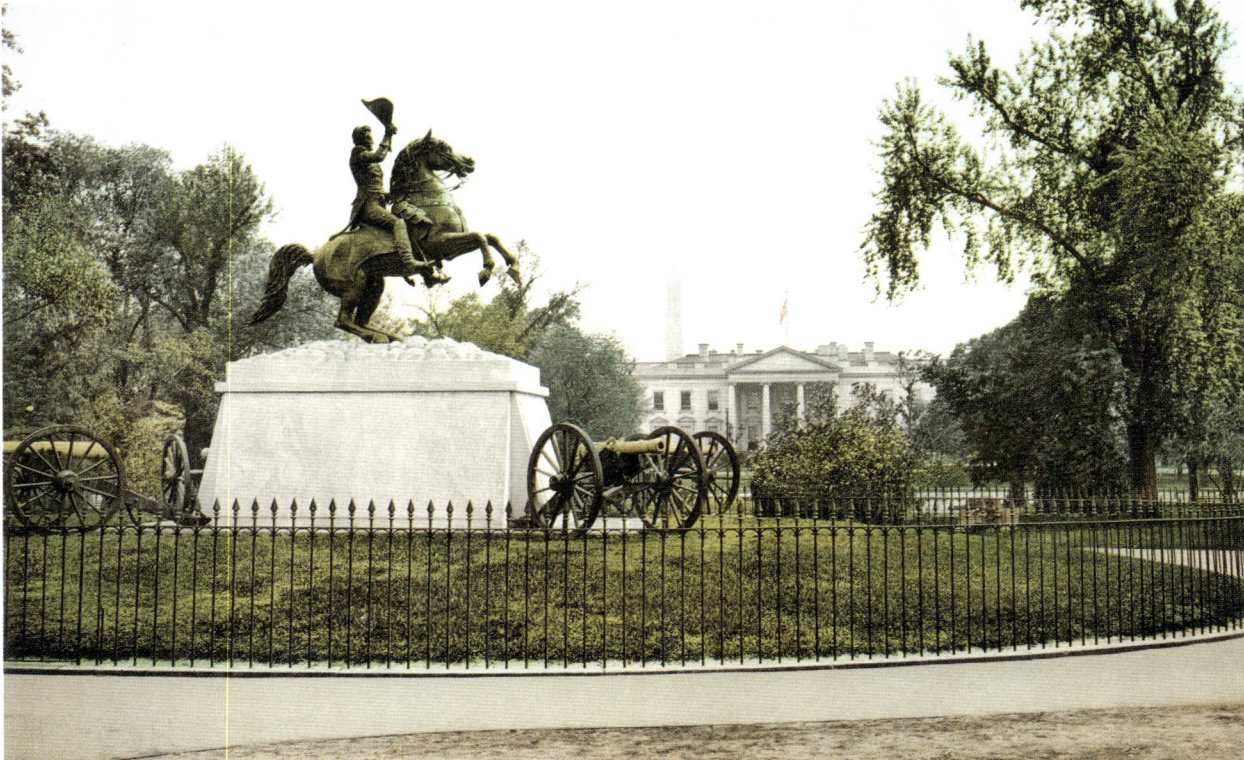

From top to bottom:
The Capitol from the Library of Congress steps, photochrom
Jackson Monument and White House, photochrom
Making laws for eighty million people, House of Representatives
Page 189: **Washington Monument**, photochrom

In 1850, two new wings were added to the Capitol to accommodate the House of Representatives and the Senate, whose membership was steadily increasing with the entry of new states into the Union. The architect was Thomas U. Walter.

Von oben nach unten:
Das Kapitol von den Stufen der Library of Congress aus, Photochrom
Jackson Monument und Weißes Haus, Photochrom
Das Repräsentantenhaus, in dem „Gesetze für 80 Millionen Amerikaner gemacht werden"
Seite 189: **Obelisk (Washington Monument)**, Photochrom

Nach 1850 wurde das Kapitol um zwei Flügel erweitert, um nicht nur dem Repräsentantenhaus, sondern auch dem Senat genügend Platz zu bieten, dessen Mitgliederzahl mit dem Eintritt neuer Staaten in die Union unaufhörlich anstieg. Die Erweiterungen des Gebäudes gehen auf den Architekten Thomas U. Walter zurück.

De haut en bas :
Le Capitole vu depuis les marches de la Bibliothèque du Congrès, photochrome
La statue de Jackson et la Maison Blanche, photochrome
La Chambre des représentants « où l'on fait les lois pour 80 millions d'Américains »
Page 189 : **l'Obélisque (Washington Monument)**, photochrome

Après 1850, deux nouvelles ailes furent ajoutées au Capitole, afin d'accueillir la Chambre des représentants et le Sénat, dont le nombre de membres ne cessait de croître avec l'entrée dans l'Union de nouveaux États. Les extensions du bâtiment sont dues à l'architecte Thomas U. Walter.

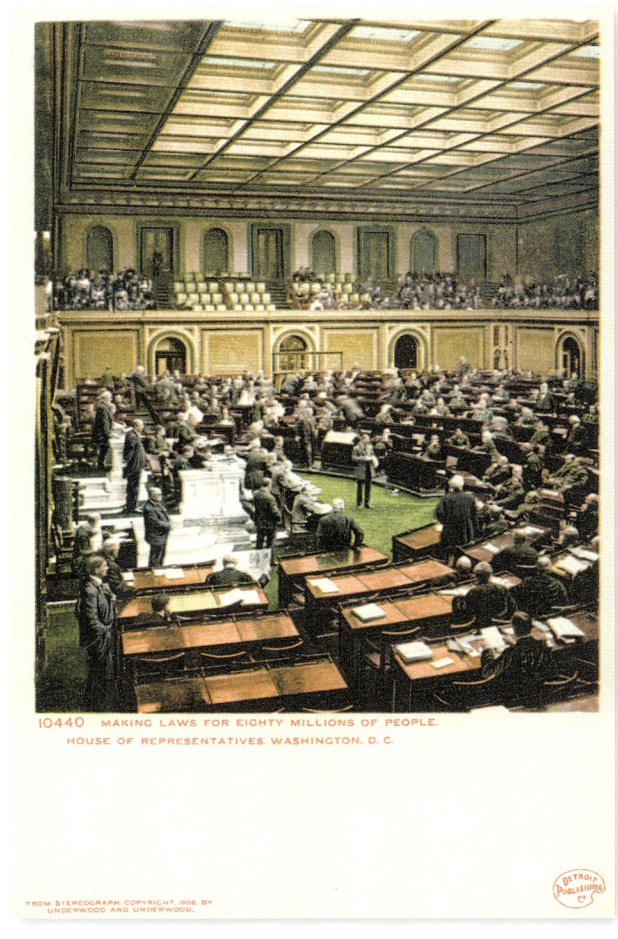

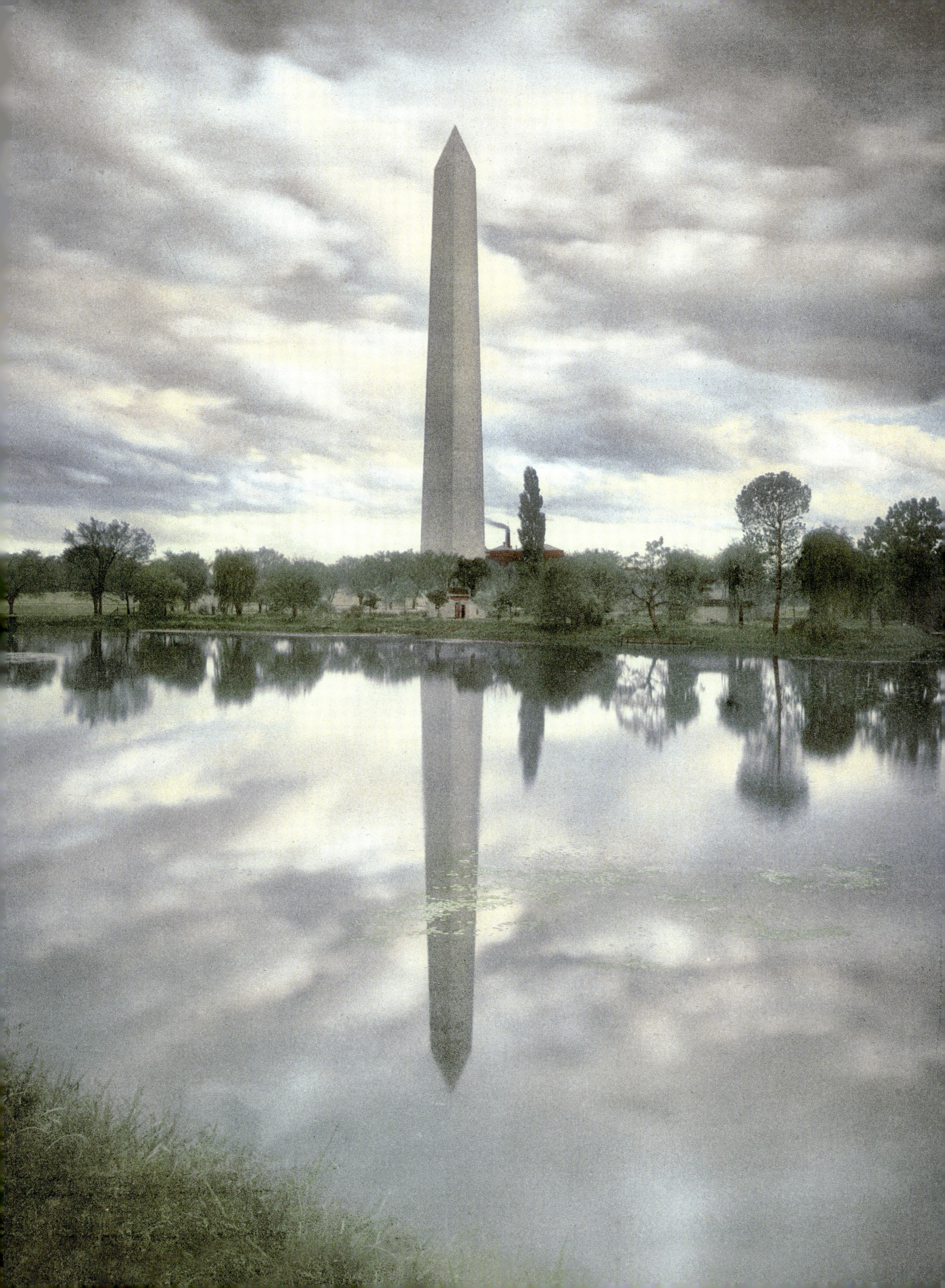

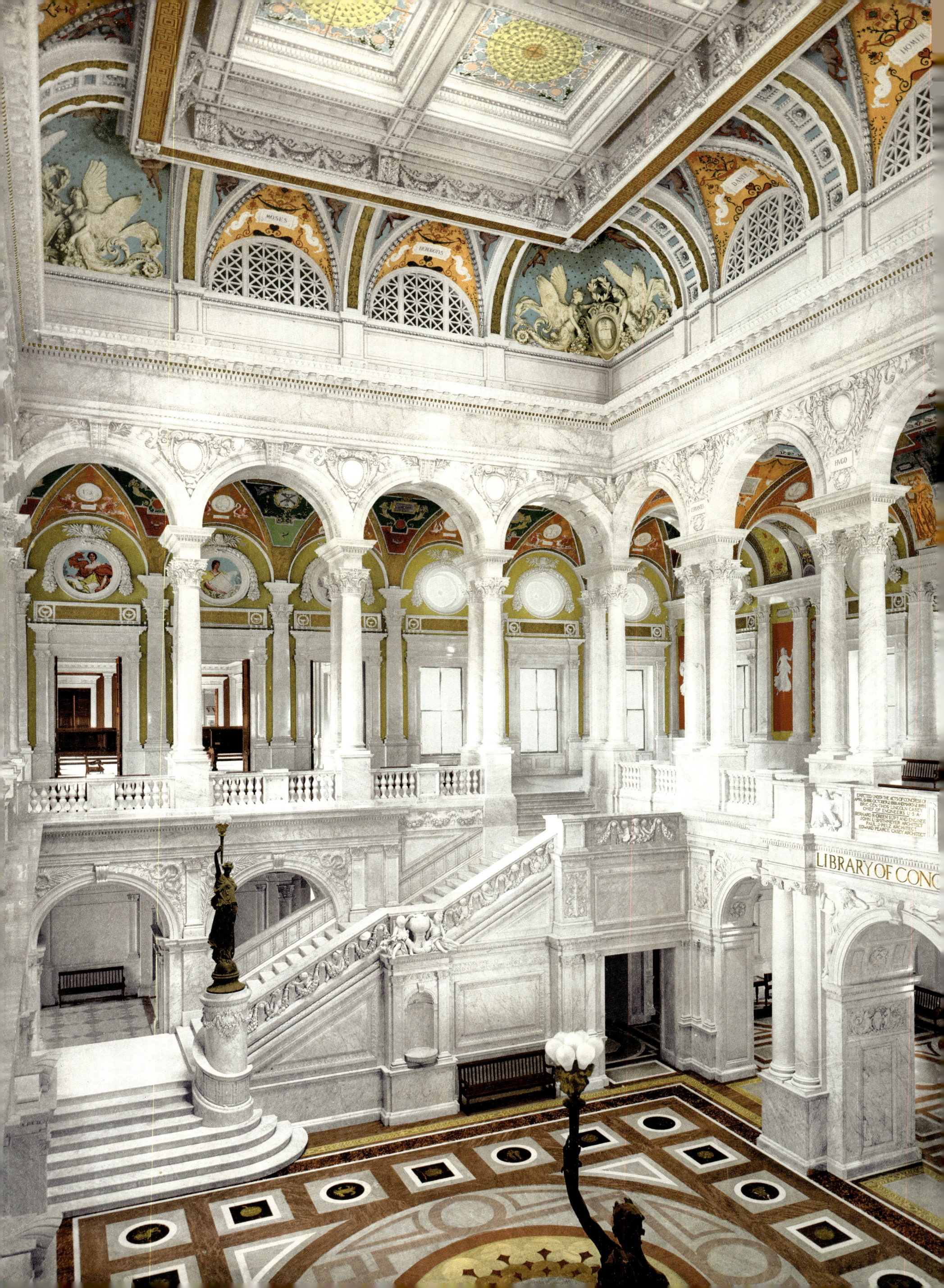

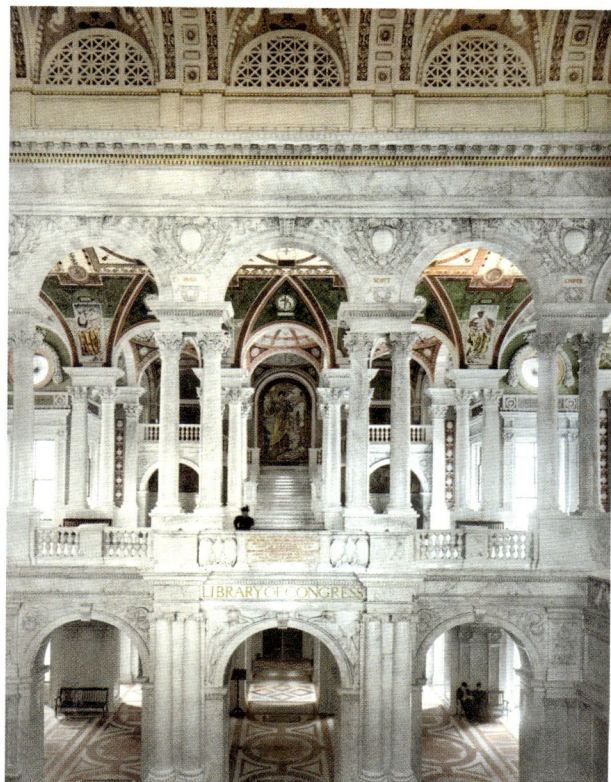
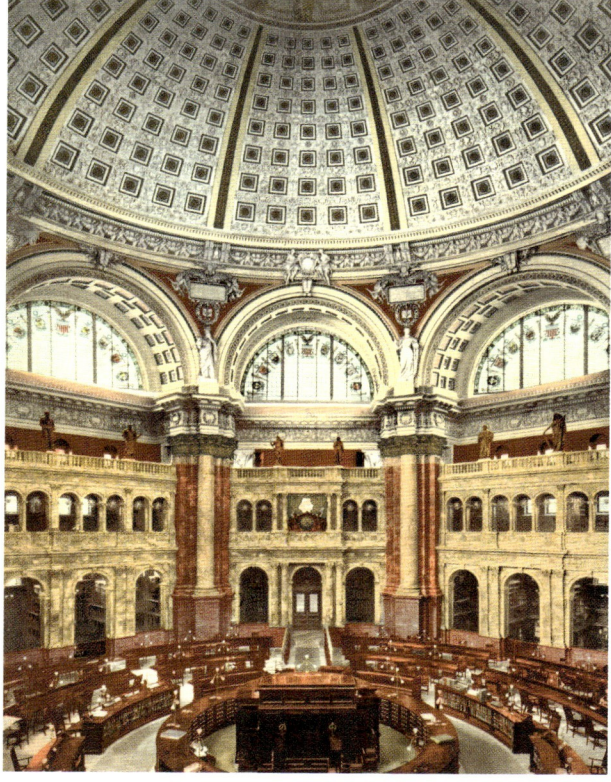

Page 190: **The grand staircase of the Library of Congress, photochrom**
Top left: **The north stair in the Library of Congress, photochrom**
Top right: **The Reading Room, photochrom**
Bottom: **Library of Congress, general view, photochrom**

The Library of Congress was first located inside the Capitol. But in 1814, the English set fire to the building and its holdings were entirely destroyed. President Jefferson then donated his own library to Congress. In 1886, Congress authorized the construction of a new building in the Italian Renaissance style to a design by John L. Smithmeyer and Paul J. Pelz. In 1892, a new architect, Edward Pearce Casey, was commissioned to design the interior of the building, in particular the statuary and the magnificent painted decoration on which more than 50 American artists worked.

Seite 190: **Das große Treppenhaus der Library of Congress, Photochrom**
Oben links: **Die Nordtreppe der Library of Congress, Photochrom**
Oben rechts: **Der Lesesaal, Photochrom**
Unten: **Library of Congress, Gesamtansicht, Photochrom**

Die Library of Congress war zunächst im Kapitol untergebracht, bis die Engländer das Gebäude 1814 in Brand steckten. Der Bestand wurde vollständig zerstört und Präsident Jefferson schenkte daraufhin dem Kongress seine eigene Bibliothek. Erst 1886 genehmigte der Kongress den Bau eines neuen Gebäudes, diesmal im Stil der italienischen Renaissance und nach den Plänen von John L. Smithmeyer und Paul J. Pelz. Ab 1892 wurde als neuer Architekt Edward Pearce Casey mit der Inneneinrichtung betraut, insbesondere mit den Skulpturen und den prächtigen gemalten Dekors, an denen über 50 amerikanische Künstler arbeiteten.

Page 190: **Bibliothèque du Congrès, le grand escalier, photochrome**
En haut à gauche: **Bibliothèque du Congrès, l'escalier nord, photochrome**
En haut à droite: **la salle de lecture, photochrome**
En bas: **Bibliothèque du Congrès, vue générale, photochrome**

La Bibliothèque du Congrès fut d'abord installée dans le Capitole ; elle y resta jusqu'à ce que les Anglais incendient le bâtiment, en 1814. Le fonds fut alors entièrement détruit et le président Jefferson fit don au Congrès de sa propre bibliothèque. Ce n'est qu'en 1886 que le Congrès autorisa la construction d'un nouveau bâtiment, de style Renaissance italienne, sur des plans dessinés par John L. Smithmeyer et Paul J. Pelz. À partir de 1892, un nouvel architecte, Edward Pearce Casey, fut chargé de l'agencement intérieur, notamment de la statuaire et des somptueux décors peints, auxquels travaillèrent plus de cinquante artistes américains.

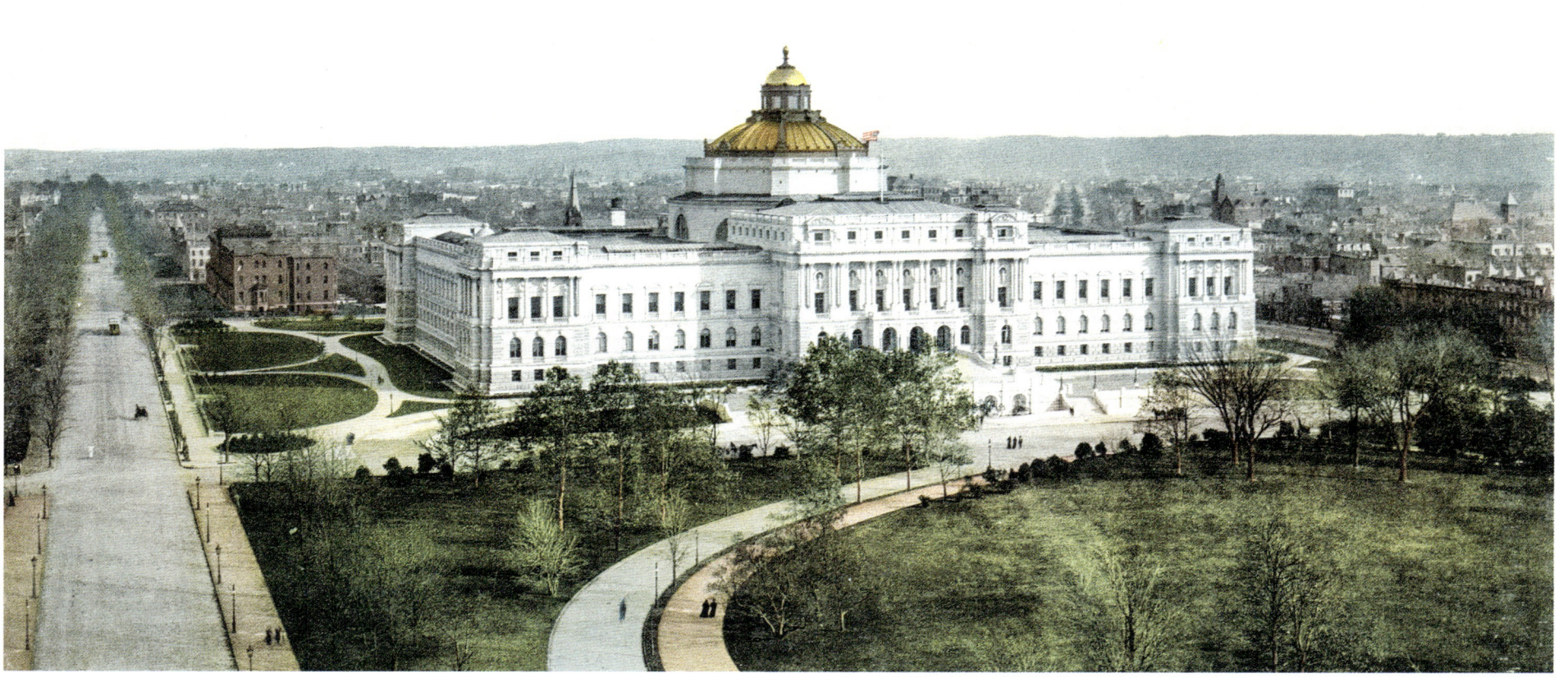

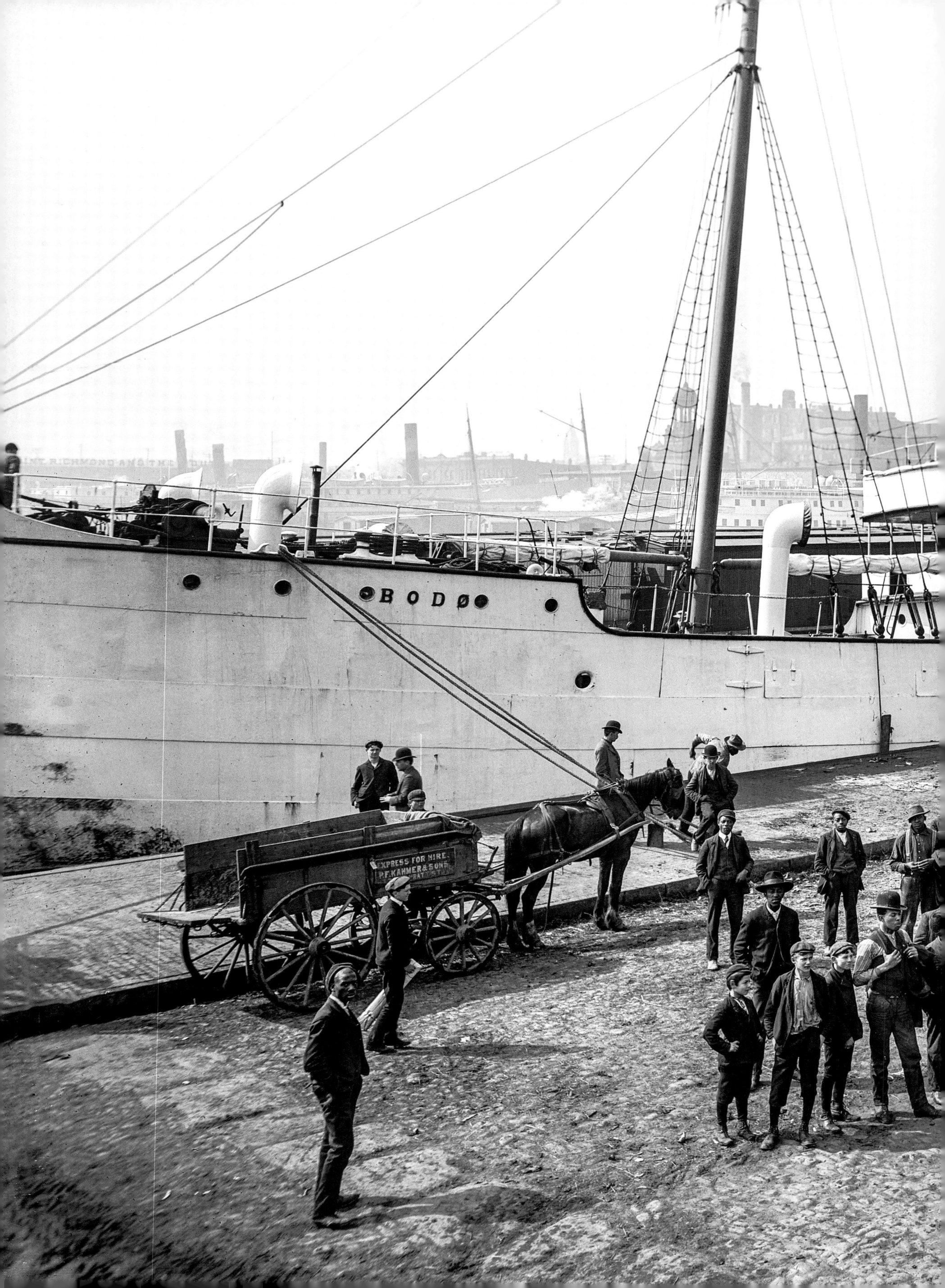

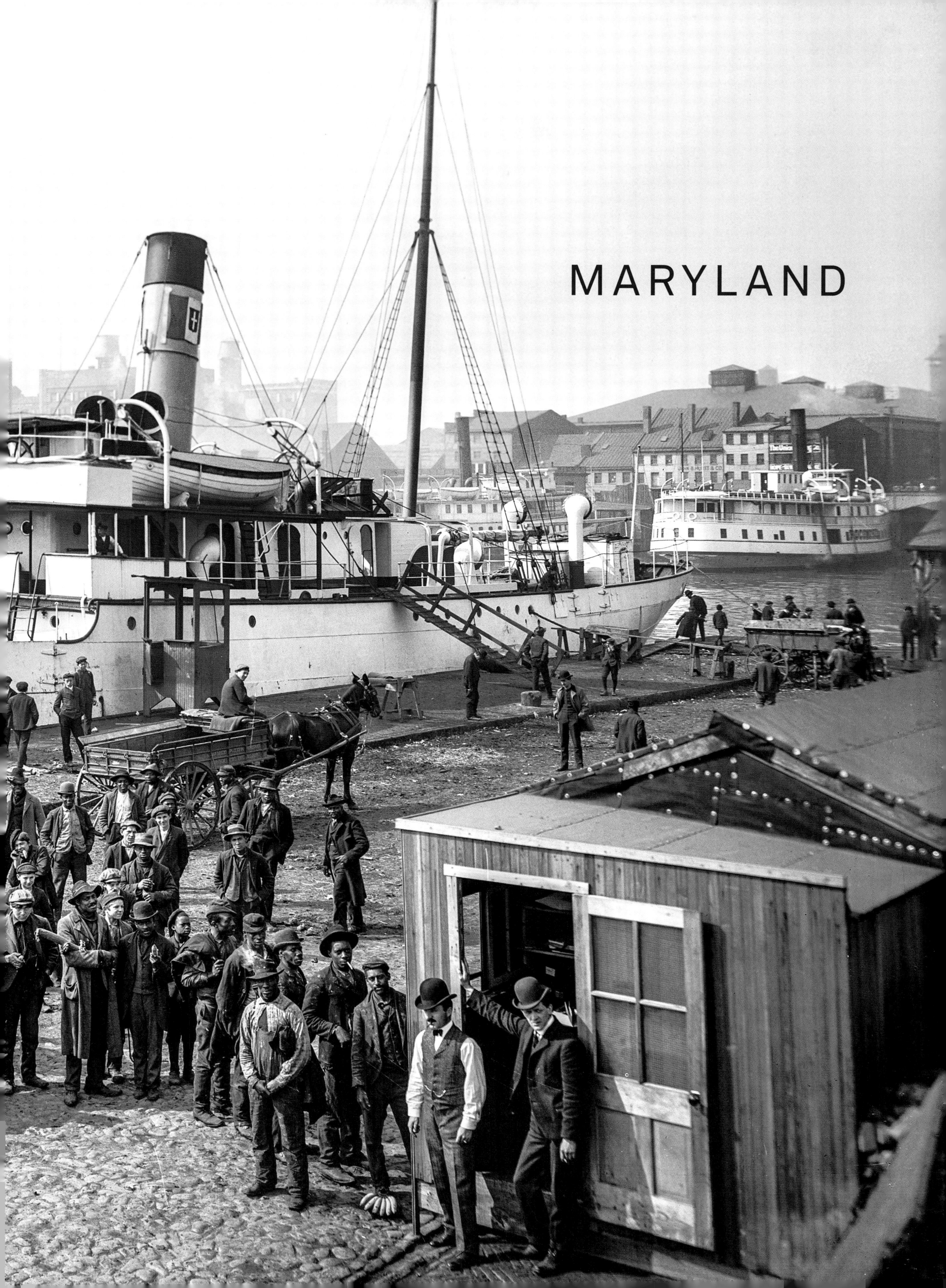

MARYLAND

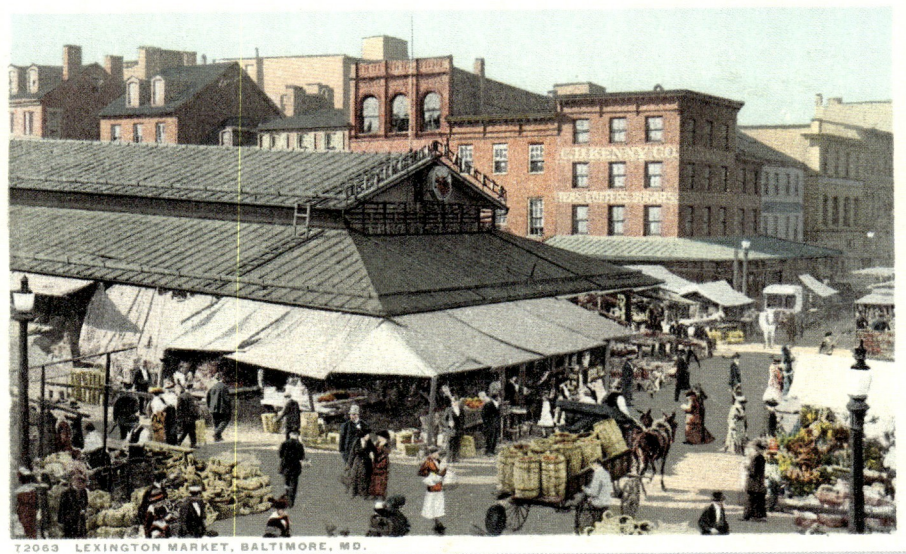
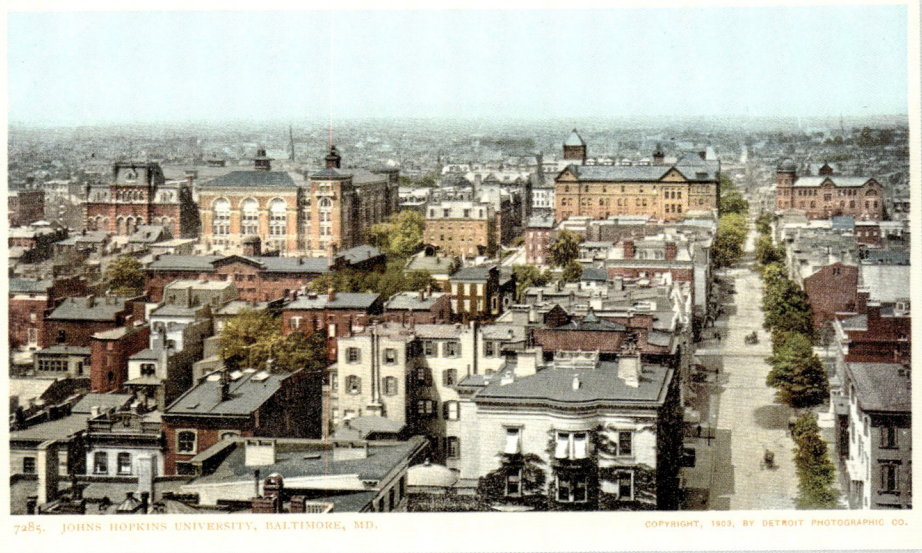

Page 192/193: Pay day for the stevedores, Baltimore, glass negative, 1905
Top left: **Lexington Market**
Top right: **Johns Hopkins University**
Bottom: **Unloading oyster luggers, glass negative, 1905**

Baltimore's central position on the Atlantic coast made it a major trading city and an important shipyard. Baltimore clippers began sailing the seas in the 18th century and the first American Navy vessel, the USS *Constellation*, was launched at Fell's Point on September 7, 1797. Another significant industry was oyster farming, which played a considerable role in the development and settlement of Baltimore. Between 1840 and 1870, immigrants from Pennsylvania, New York, and even from the American South came to work in the oyster canneries.

Seite 192/193: Zahltag für die Hafenarbeiter, Baltimore, Glasnegativ, 1905
Oben links: **Der Markt von Lexington**
Oben rechts: **Johns Hopkins University**
Unten: **Beim Entladen der Austernboote, Glasnegativ, 1905**

Dank der zentralen Lage seines Hafens an der Atlantikküste wurde Baltimore zu einer großen Handelsstadt und einem Schiffsbauzentrum ersten Ranges. Die Baltimore Clippers befuhren seit dem 18. Jahrhundert die Weltmeere, und die USS *Constellation*, das erste Kriegsschiff der Navy, wurde am 7. September 1797 in Fell's Point zu Wasser gelassen. Die Austernzucht, ein weiterer sehr wichtiger Erwerbszweig, war von großer Bedeutung für die Entwicklung und Besiedelung von Baltimore. Zwischen 1840 und 1870 kamen zahlreiche Emigranten aus Pennsylvania, New York und sogar aus dem Süden, um in den Konservenfabriken der Austernindustrie zu arbeiten.

Pages 192/193 : jour de paie des dockers, Baltimore, plaque de verre, 1905
En haut à gauche : **le marché de Lexington**
En haut à droite : **l'université Johns Hopkins**
En bas : **déchargement des huîtres, plaque de verre, 1905**

La position centrale de son port sur la côte atlantique a fait de Baltimore une grande cité de commerce et un centre de construction navale primordial. Les *Baltimore clippers* ont sillonné les océans dès le XVIIIe siècle et le premier vaisseau de la Navy, le USS *Constellation*, a été mis à la mer à Fell's Point le 7 septembre 1797. Autre activité très importante, l'ostréiculture a joué un rôle capital dans le développement et le peuplement de Baltimore. Entre 1840 et 1870, des émigrants venus de Pennsylvanie, de New York et même du Sud arrivèrent nombreux pour travailler dans les conserveries d'huîtres.

Right: **Looking north from High Rock, Pen Mar Park**, photochrom
Below: **Glen Afton Spring**, photochrom

Financed and managed by the Western Maryland Railroad Co., Pen Mar Park was founded in 1877–78. Horse-drawn cabs, licensed by the Western Railroad, drove visitors through the park and up to the High Rock Scenic Lookout. For some 50 years, the park remained a very popular holiday and entertainment location. Hotels such as the Blue Mountain House and Buena Vista Spring opened alongside boarding houses and restaurants, which had a ready water supply in Glen Afton Spring.

Rechts: **Der Blick vom Felsen High Rock im Pen Mar Park nach Norden**, Photochrom
Unten: **Die Glen-Afton-Quelle**, Photochrom

Der von der Eisenbahngesellschaft Western Maryland Railroad finanzierte und verwaltete Pen Mar Park entstand in den Jahren 1877–1878. Von der Western Railroad eingesetzte Droschkenkutscher fuhren die Besucher zum Belvedere von High Rock und durch den gesamten Park, der ein halbes Jahrhundert lang ein äußerst beliebter Ort zum Entspannen und Verweilen war. Dort waren Hotels wie das Blue Mountain House oder das Buena Vista Spring, Familienpensionen und Restaurants eröffnet worden, die mit dem Quellwasser der Glen-Afton-Quelle versorgt wurden.

À droite : **la vue vers le nord depuis le rocher de High Rock, parc de Pen Mar**, photochrome
En bas : **la source de Glen Afton Spring**, photochrome

Financé et géré par la compagnie du Western Maryland Railroad, le parc de Pen Mar fut créé en 1877–1878. Des cochers de fiacre, licenciés par la Western Railroad, conduisaient les visiteurs au belvédère de High Rock et à travers tout le parc qui fut, pendant un demi-siècle, un lieu de loisirs et de promenade très populaire. Des hôtels, le Blue Mountain House, le Buena Vista Spring, etc., des pensions de famille et des restaurants y avaient été ouverts ; ils étaient alimentés en eau par la source de Glen Afton.

MARYLAND | PEN MAR | GLEN AFTON SPRING

PENNSYLVANIA

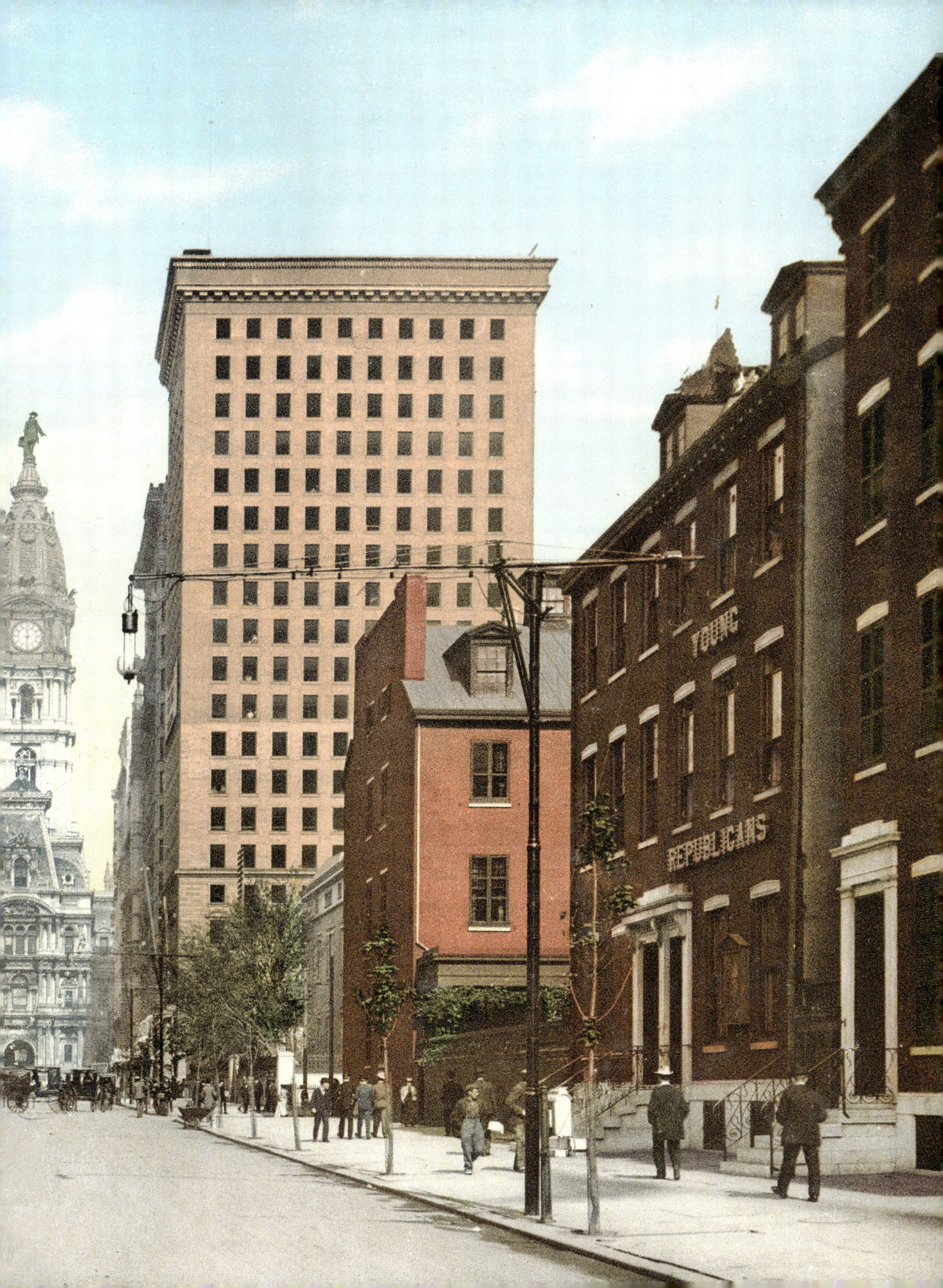

Page 196/197: South Broad Street, Philadelphia, photochrom
Top left: Liberty Bell and stairway, Independence Hall
Top right: Friends meeting house (Quakers' meeting house) on Arch Street
Bottom: Carpenters' Hall, photochrom

It was in Philadelphia, city of "fraternal love," as its name declares, that George Washington was named commander-in-chief of the American army in June 1775. The First Continental Congress met in Philadelphia at Carpenters' Hall in September 1775. It was in that city, on July 4, 1776, that the Declaration of Independence was proclaimed while the Liberty Bell rang. And also where Betsy Ross sewed the first American flag.

Seite 196/197: South Broad Street, Philadelphia, Photochrom
Oben links: Independence Hall, Freiheitsglocke und Treppenhaus
Oben rechts: Das Quäker-Haus (Haus der Freunde) auf der Arch Street
Unten: Carpenters' Hall, Photochrom

In Philadelphia, der Stadt der „Bruderliebe", wurde George Washington im Juni 1775 zum Oberkommandeur der Armee ernannt. Ebenfalls in Philadelphia, in der Carpenters' Hall, tagte im September 1775 der erste Kontinentalkongress. Am 4. Juli 1776 wurde in Philadelphia die Unabhängigkeitserklärung verkündet, während die Freiheitsglocke (Liberty Bell) läutete. Und in dieser Stadt nähte Betsy Ross die erste amerikanische Flagge.

Pages 196/197: South Broad Street, Philadelphie, photochrome
En haut à gauche : Independence Hall, la cloche de la Liberté (Liberty Bell) et l'escalier
En haut à droite : la maison des Quakers (maison des Amis) sur Arch Street
En bas : Carpenters' Hall, photochrome

C'est à Philadelphie, la cité de l'« amour fraternel », que George Washington a été nommé commandant en chef des armées en juin 1775. C'est à Philadelphie, dans le Carpenters' Hall, que le premier Congrès continental s'est réuni en septembre 1775. C'est là aussi que, le 4 juillet 1776, la déclaration d'Indépendance a été proclamée tandis que sonnait la cloche de la Liberté (Liberty Bell). Et c'est à Philadelphie que Betsy Ross a cousu le premier drapeau américain.

Right: **Betsy Ross House, photochrom**
Below: **Independence Hall, photochrom**
Page 200/201: **Betsy Ross House, 239 Arch Street, glass negative, 1900**

The house of Elizabeth Griscom Ross Ashburn Claypoole, known as Betsy Ross, at 239 Arch Street, was built around 1740. It was successively occupied by a cobbler, a pharmacist, and an upholsterer, John Ross, whose showroom and store were on the ground floor. Betsy and John Ross are said to have lived there between 1773 and 1786. Since 1876, on the report of certain members of the Ross family, the house has been (rightly or wrongly) presumed to be the place where Betsy was living when she sewed the first American flag.

Rechts: **Das Haus von Betsy Ross, Photochrom**
Unten: **Independence Hall, Photochrom**
Seite 200/201: **Das Haus von Betsy Ross, Arch Street Nr. 239, Glasnegativ, 1900**

Um 1740 wurde in der Arch Street Nr. 239 das Haus von Elizabeth Griscom Ross Ashburn Claypoole, genannt Betsy Ross, gebaut. Dort wohnten nacheinander ein Schuster, ein Apotheker und der Polsterer John Ross, wobei das Erdgeschoss als Ladengeschäft und als Ausstellungsraum diente. Betsy und John Ross sollen hier zwischen 1773 und 1786 gewohnt haben. Seit 1876 glaubt man nach Auskunft verschiedener Angehöriger der Familie Ross – ob zu Recht oder zu Unrecht –, dass Betsy in diesem Haus lebte, als sie die erste amerikanische Flagge nähte.

À droite : **la maison de Betsy Ross, photochrome**
En bas : **Independence Hall, photochrome**
Pages 200/201 : **la maison de Betsy Ross, 239 Arch Street, plaque de verre, 1900**

La maison d'Elizabeth Griscom Ross Ashburn Claypoole, dite Betsy Ross, au 239 Arch Street, a été construite vers 1740. Elle a été successivement occupée par un cordonnier, un pharmacien et un tapissier – John Ross –, le rez-de-chaussée faisant office de boutique et de showroom. Betsy et John Ross y auraient habité entre 1773 et 1786. Depuis 1876, aux dires de certains membres de la famille Ross, la maison est considérée – à tort ou à raison – comme étant celle où vivait Betsy lorsqu'elle cousit le premier drapeau américain.

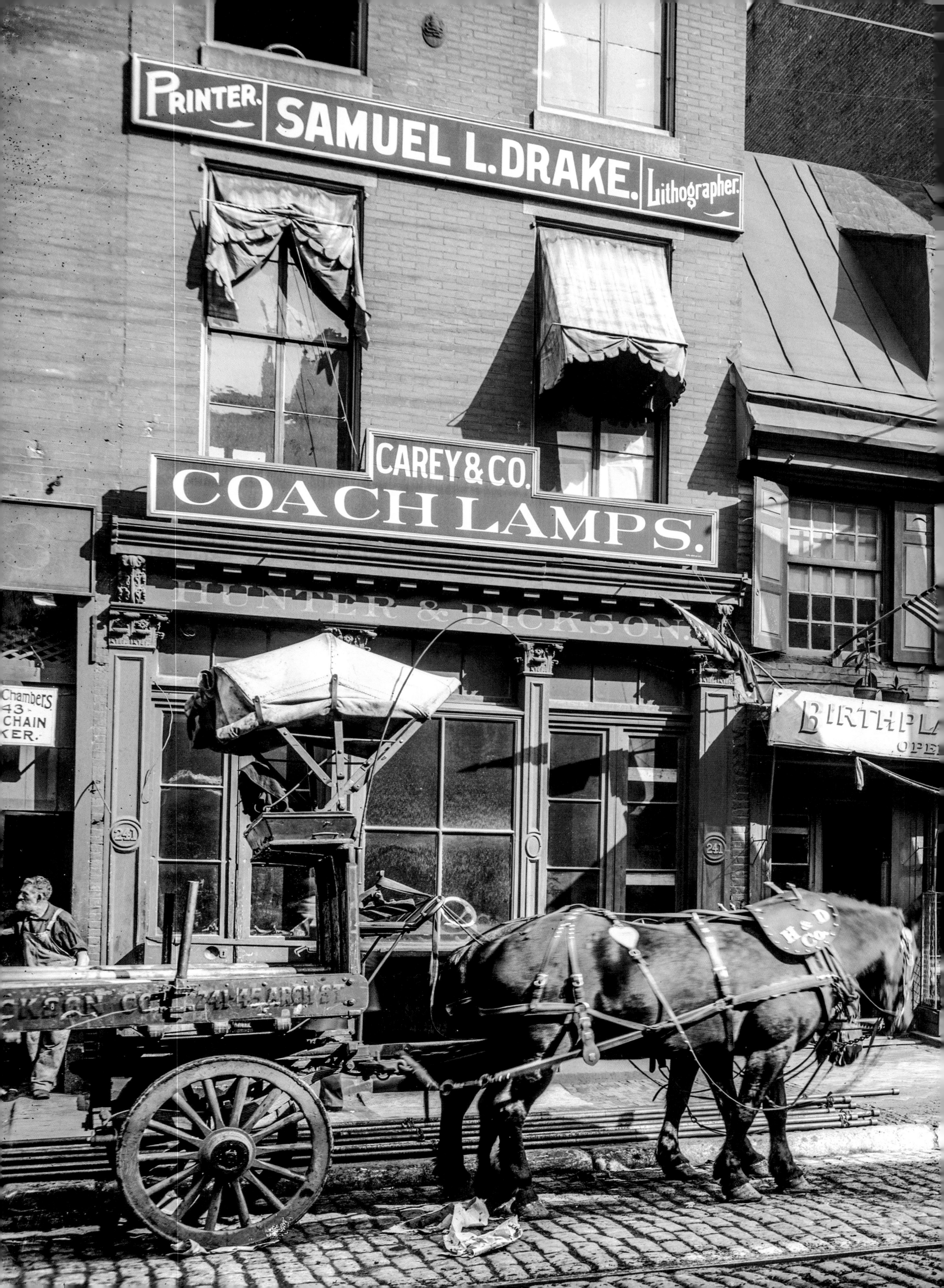

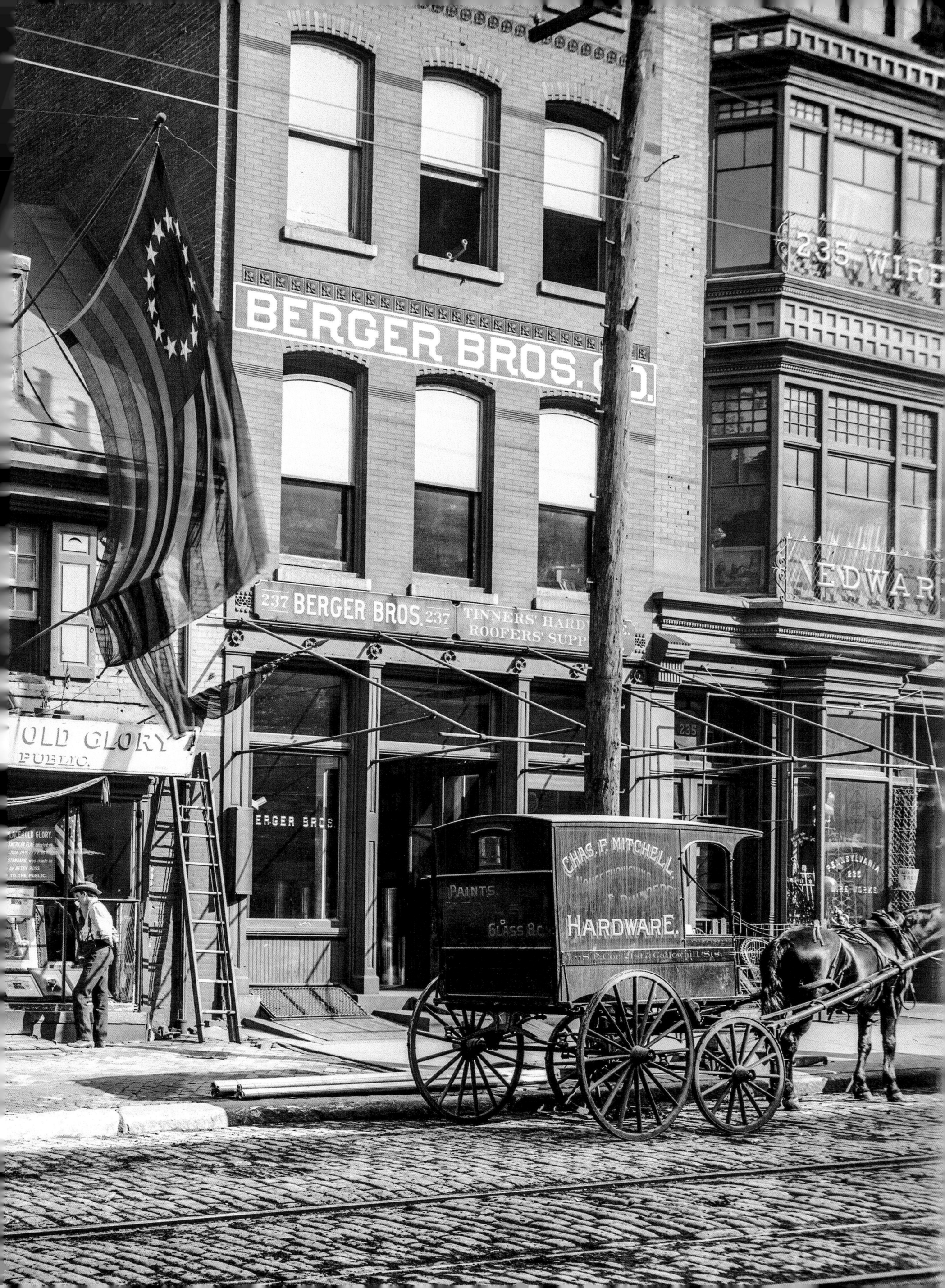

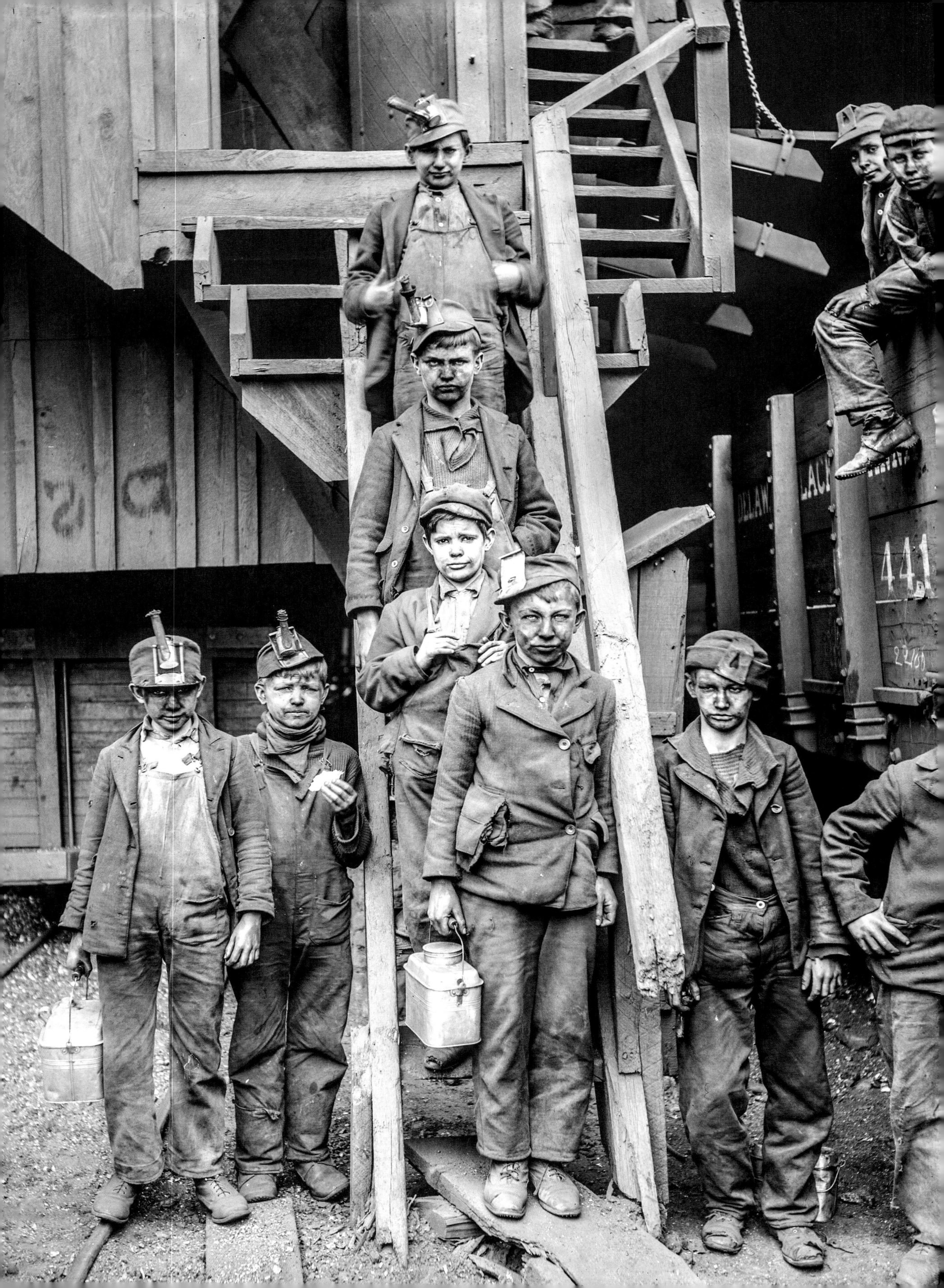

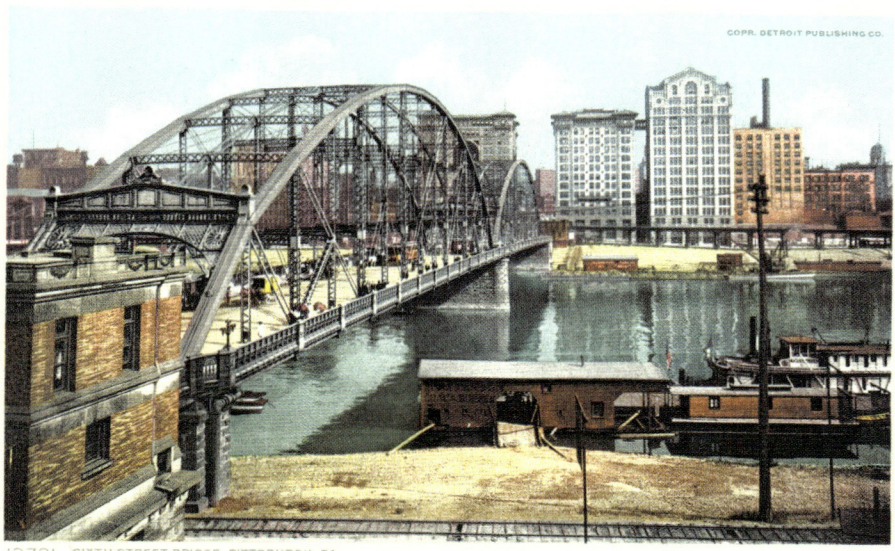
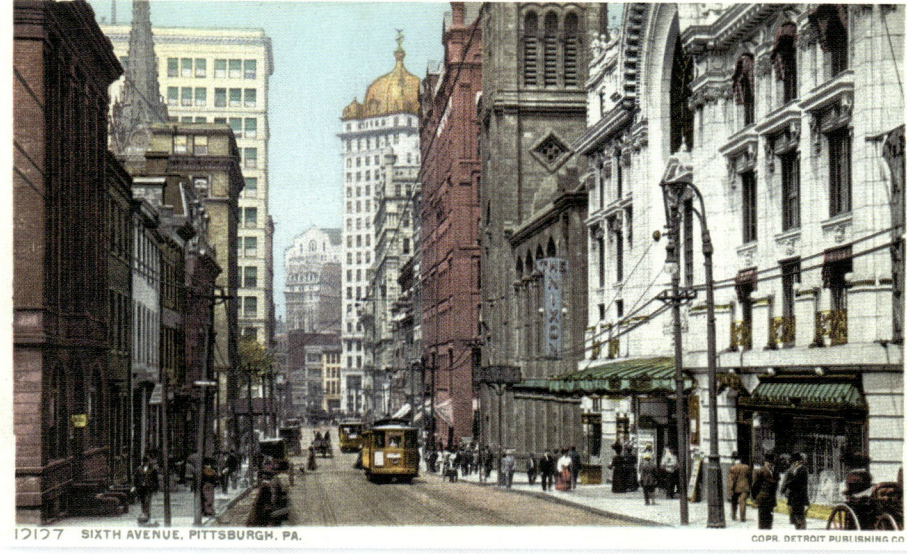
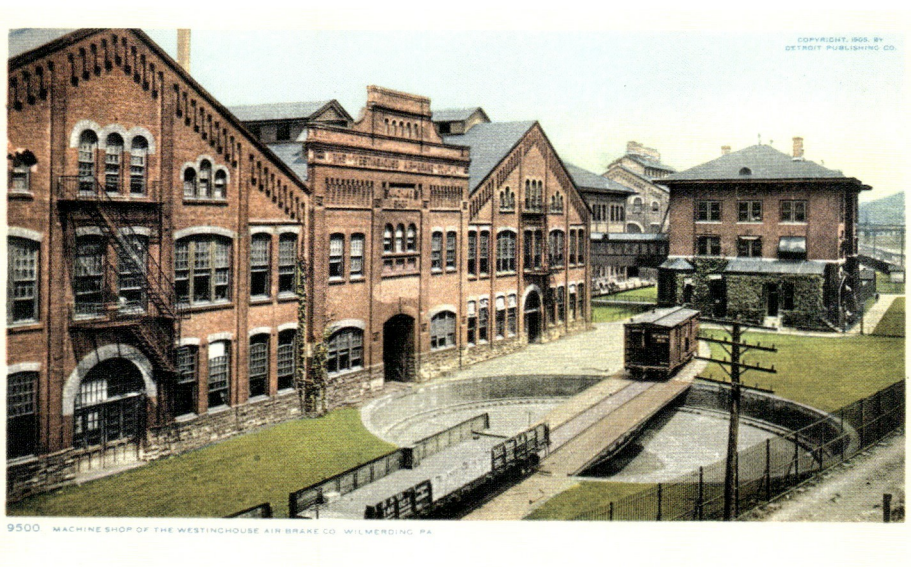
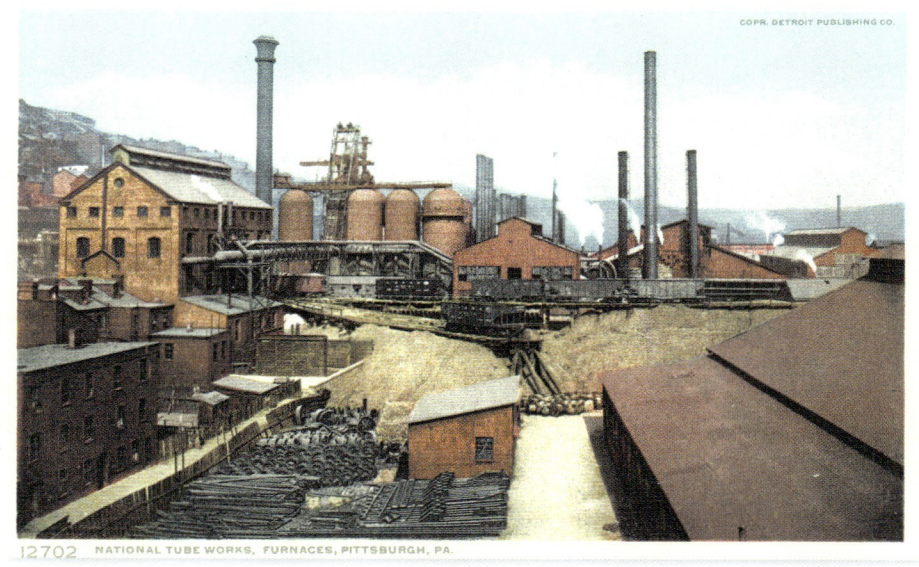

Page 202: **Breaker boys, Woodward Coal Mines, Kingston, glass negative, ca. 1900**
Industrialization overtook Pennsylvania in the 19th century. Coal mining, which began in the middle of the 18th century, boomed in the 19th and early 20th centuries. Steel production also rose dramatically, particularly after the invention of the Bessemer converter. "Breaker boys," theoretically at least 12 years old, had the job of breaking up the coal and removing its impurities by hand; boys could still be found doing this dangerous and arduous work in the 1910s.

Seite 202: **Breaker Boys, Kohlebergwerk von Woodward, Kingston, Glasnegativ, um 1900**
Pennsylvania war im 19. Jahrhundert stark industrialisiert. Der Kohleabbau, mit dem man Mitte des 18. Jahrhunderts begonnen hatte, erlebte einen Boom, der sich noch auf das folgende Jahrhundert und das beginnende 20. Jahrhundert auswirkte. Die Stahlproduktion explodierte gleichermaßen, vor allem seit der Erfindung des Bessemer-Konverters. Die „Breaker Boys" – die im Allgemeinen älter als zwölf Jahre alt waren –, mussten Kohleblöcke zerschlagen und mit bloßen Händen die nicht verwendbaren Bestandteile aussortieren, eine mühsame und gefährliche Arbeit, die im großen Stil bis in die 1910er-Jahre fortgeführt wurde.

Page 202: **jeunes cribleurs des mines de charbon de Woodward, Kingston, plaque de verre, vers 1900**
La Pennsylvanie était fortement industrialisée au xixe siècle. L'extraction du charbon, qui avait commencé au milieu du xviiie siècle, connut un boom retentissant au siècle suivant et au début du xxe siècle. La production d'acier explosa également, notamment après l'invention du convertisseur Bessemer. Les *breaker boys* – en principe âgés de plus de 12 ans – étaient chargés de casser les blocs de charbon et de les débarrasser, à la main, de leurs impuretés ; un travail très pénible et dangereux qui perdura à grande échelle jusque dans les années 1910.

From left to right and top to bottom:
Sixth Street Bridge, Pittsburgh
Sixth Avenue, Pittsburgh
Machine Shop of the Westinghouse Air Brake Co., Wilmerding
National Tube Works, furnaces, Pittsburgh
Below: A Bessemer steel converter, Pittsburgh

Von links nach rechts und von oben nach unten:
Sixth Street Bridge, Pittsburgh
Sixth Avenue, Pittsburgh
Maschinenhalle der Westinghouse Air Brake Co., Wilmerding
Fabriken der National Tube, Hochöfen, Pittsburgh
Unten: Bessemerbirne, Pittsburgh

De gauche à droite et de haut en bas :
Le pont de la 6e Rue (Sixth Street Bridge), Pittsburgh
La 6e Avenue (Sixth Avenue), Pittsburgh
L'entrepôt de la Westinghouse Air Brake Co., Wilmerding
Les usines de la National Tube, hauts-fourneaux, Pittsburgh
En bas : un convertisseur Bessemer, Pittsburgh

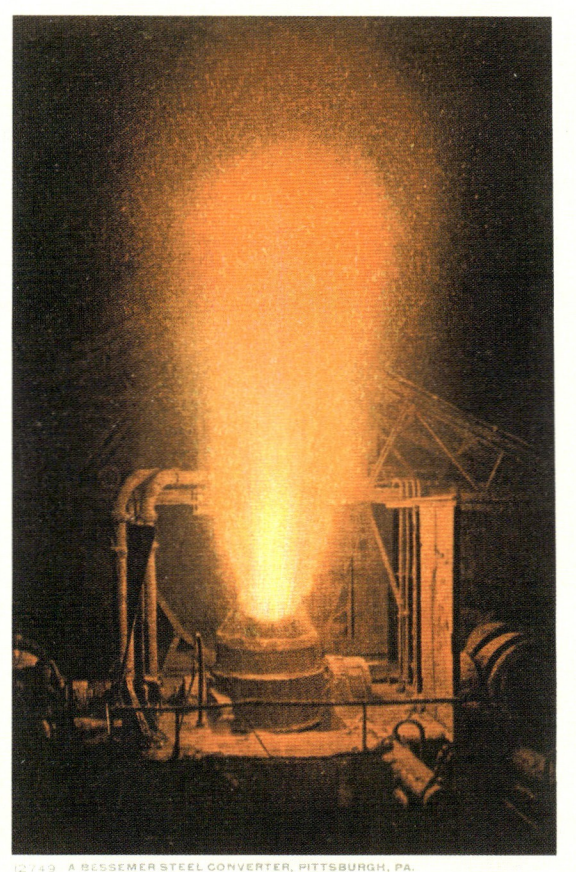

PENNSYLVANIA | KINGSTON | PITTSBURGH

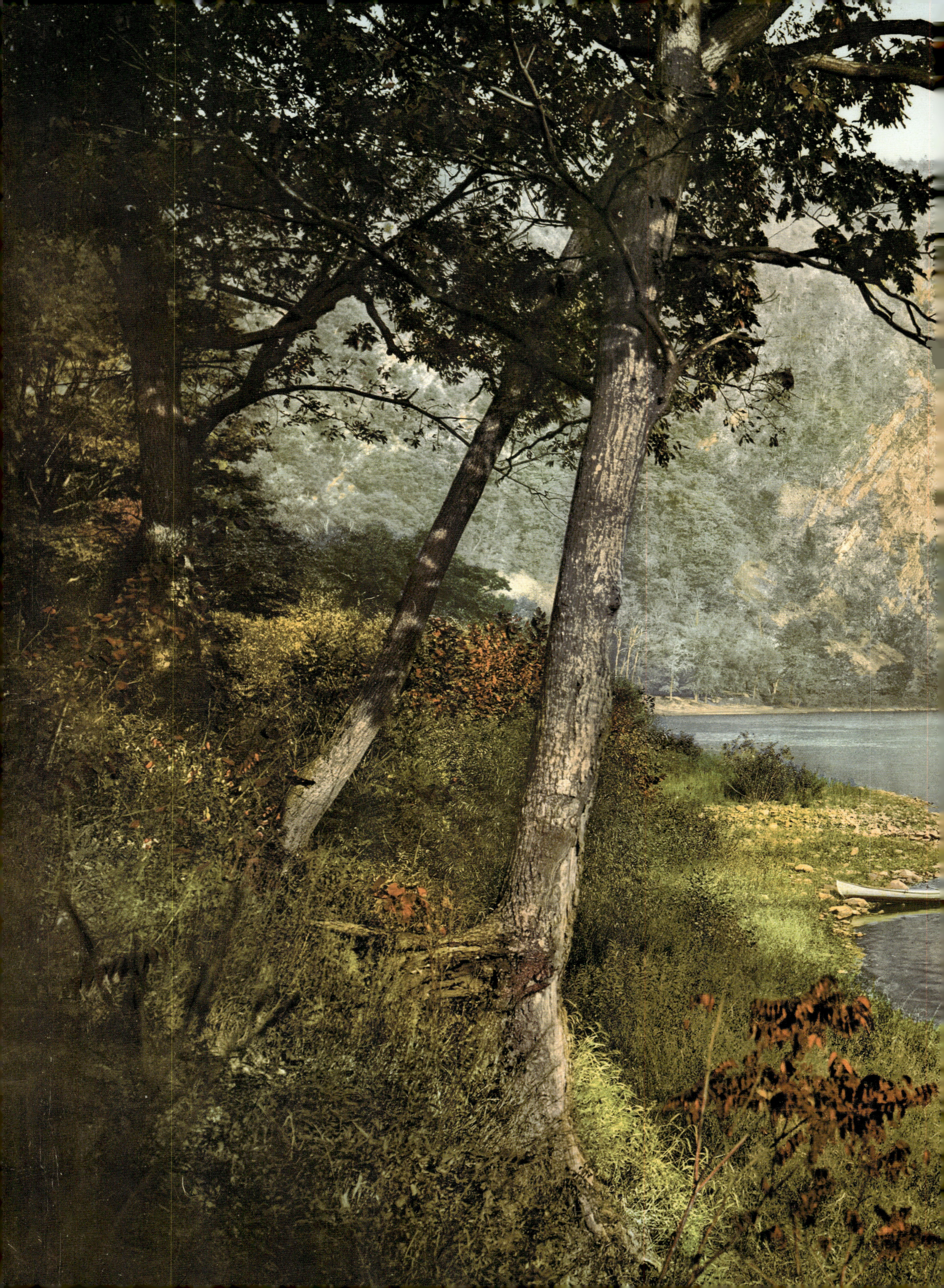

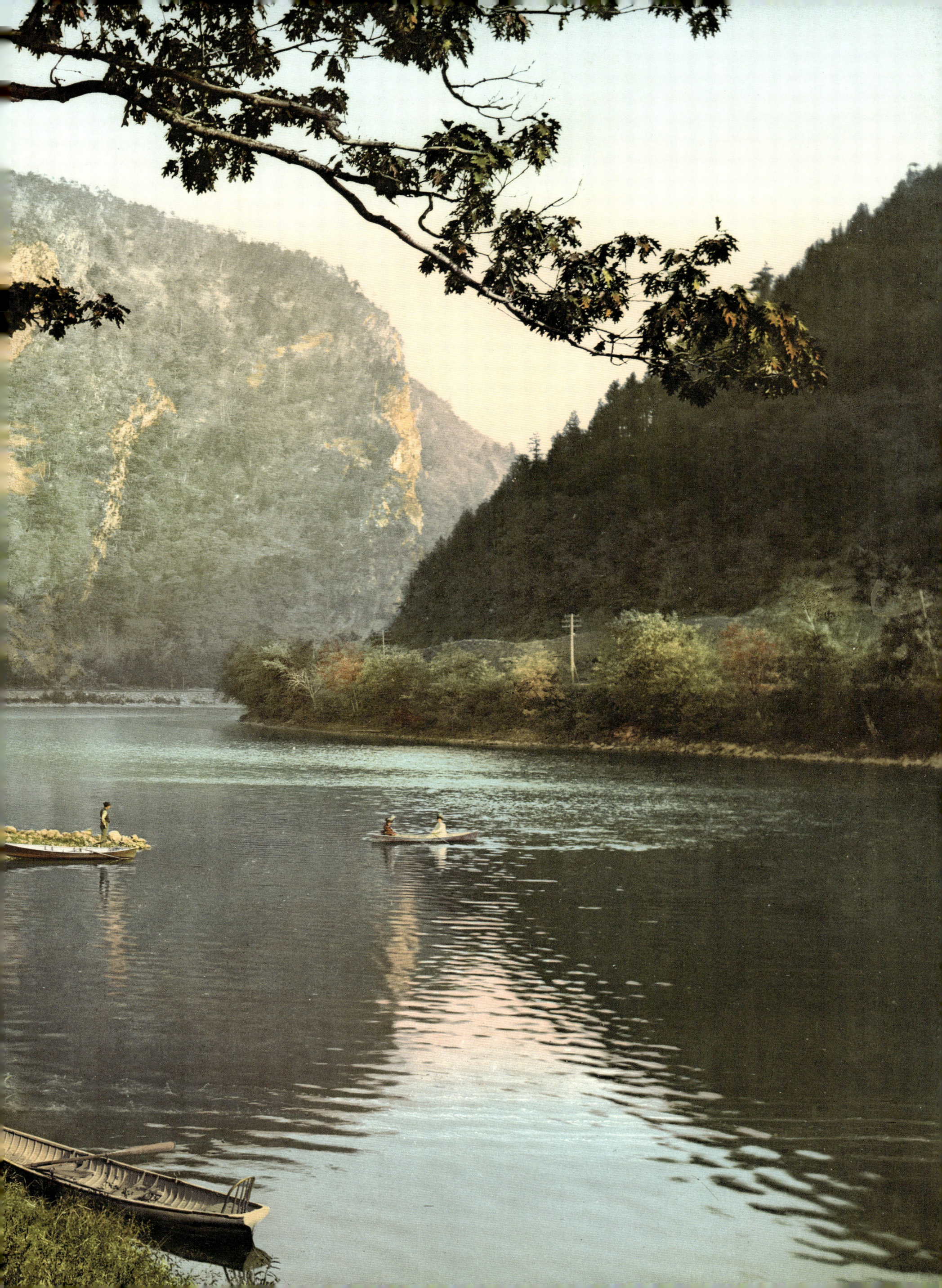

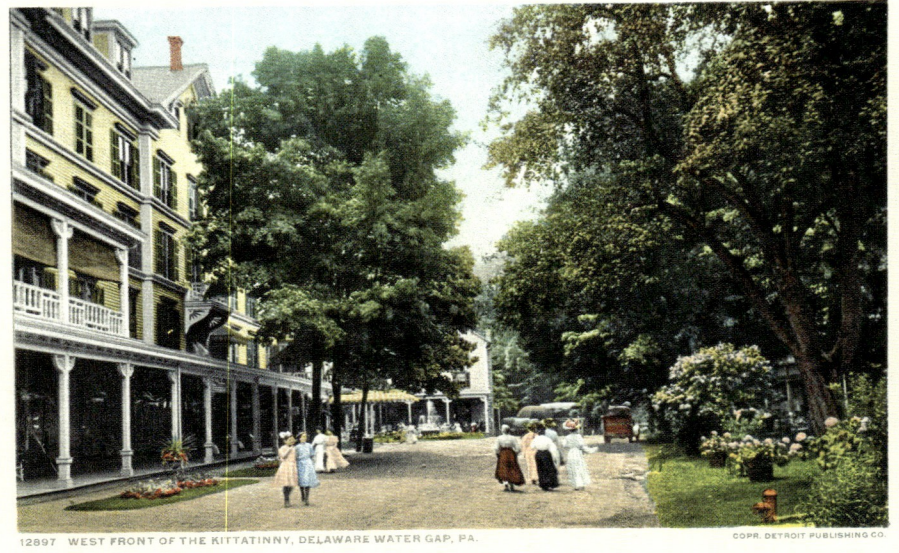
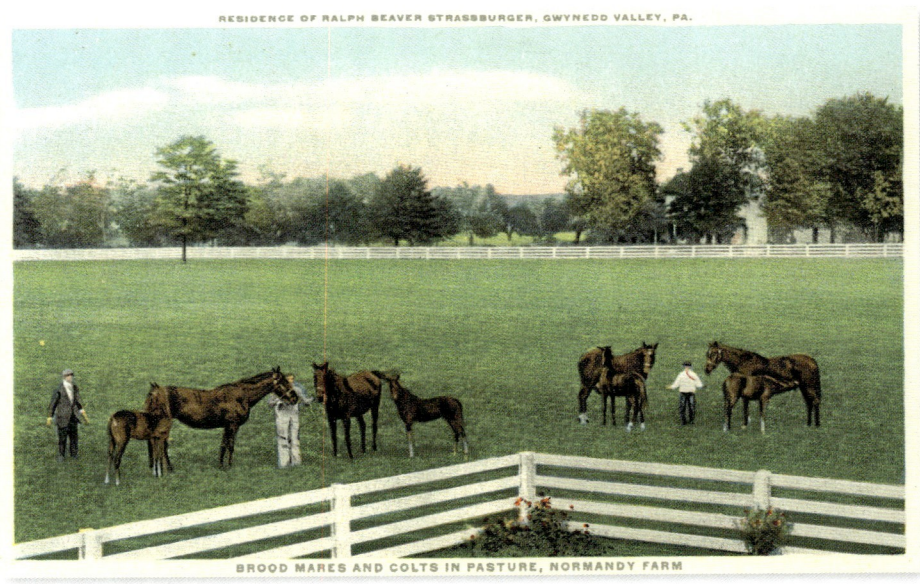

Page 204/205: The Delaware Water Gap from the New Jersey shore, photochrom
Top left: **West front of the Kittatinny Hotel, Delaware Water Gap**
Top right: **Residence of Ralph Beaver, Gwynedd Valley**
Bottom: **Delaware Water Gap Riverside Drive, photochrom**
Page 207: **Pocono Mountains, Rhododendron Walk, photochrom**

The beautiful Delaware Water Gap lies on the boundaries of three states: Pennsylvania, New Jersey, and New York. A wooded valley in the Pocono Mountains through which the Delaware River flows offers offers many different points of view on the surrounding mountains. Thanks to its admirable situation, the Gap has been a holiday resort since the early 19th century; the Kittatinny Hotel opened there in the early 1840s.

Seite 204/205: Das Durchbruchstal des Delaware River (Delaware Water Gap) vom Ufer in New Jersey aus, Photochrom
Oben links: **Westfassade des Hotels Kittatinny, Delaware Water Gap**
Oben rechts: **Das Anwesen von Ralph Beaver, Gwynedd Valley**
Unten: **Uferstraße entlang des Delaware Water Gap, Photochrom**
Seite 207: **Pocono Mountains, Rhododendren-Allee, Delaware-Nationalpark, Photochrom**

Das Delaware Water Gap liegt an der Grenze der drei Staaten Pennsylvania, New Jersey und New York und ist von besonderer Schönheit. Das waldreiche Tal in den Pocono Mountains, durch das der Delaware River fließt, bietet dem Besucher ganz unterschiedliche Ausblicke auf die umliegenden Berge. Aufgrund seiner großartigen Lage ist das „Gap" seit Anfang des 19. Jahrhunderts ein Ort für die Sommerfrische; zu Beginn der 1840er-Jahre wurde hier das Hotel Kittatinny eröffnet.

Pages 204/205 : La cluse du fleuve Delaware (Delaware Water Gap), vue de la rive du New Jersey, photochrome
En haut à gauche : façade ouest de l'hôtel Kittatinny, Delaware Water Gap
En haut à droite : la « ferme normande » de Ralph Beaver, vallée de Gwynedd
En bas : le chemin dominant le Delaware Water Gap, photochrome
Page 207 : allée de rhododendrons dans les Pocono Mountains, parc national du Delaware, photochrome

À la limite de trois États, la Pennsylvanie, le New Jersey et l'État de New York, le site du Delaware Water Gap est d'une grande beauté. Cette vallée boisée des monts Pocono, au fond de laquelle coule le fleuve Delaware, offre au visiteur des points de vue tous différents sur les montagnes alentour. Admirablement situé, le « Gap » est un lieu de villégiature depuis le début du XIXe siècle ; l'hôtel Kittatinny y ouvrit ses portes vers 1840.

THE GREAT LAKES AND THE MIDWEST

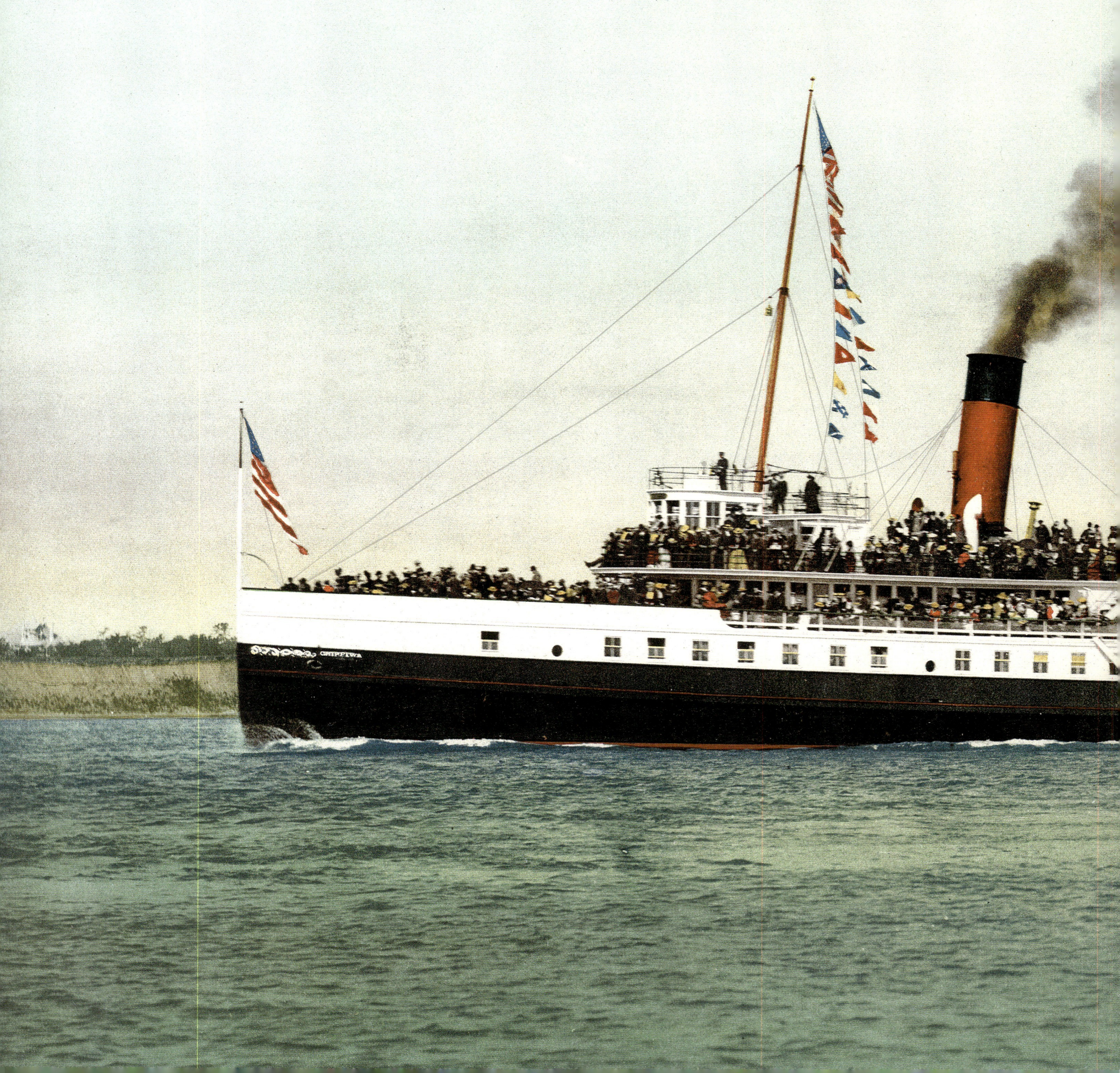

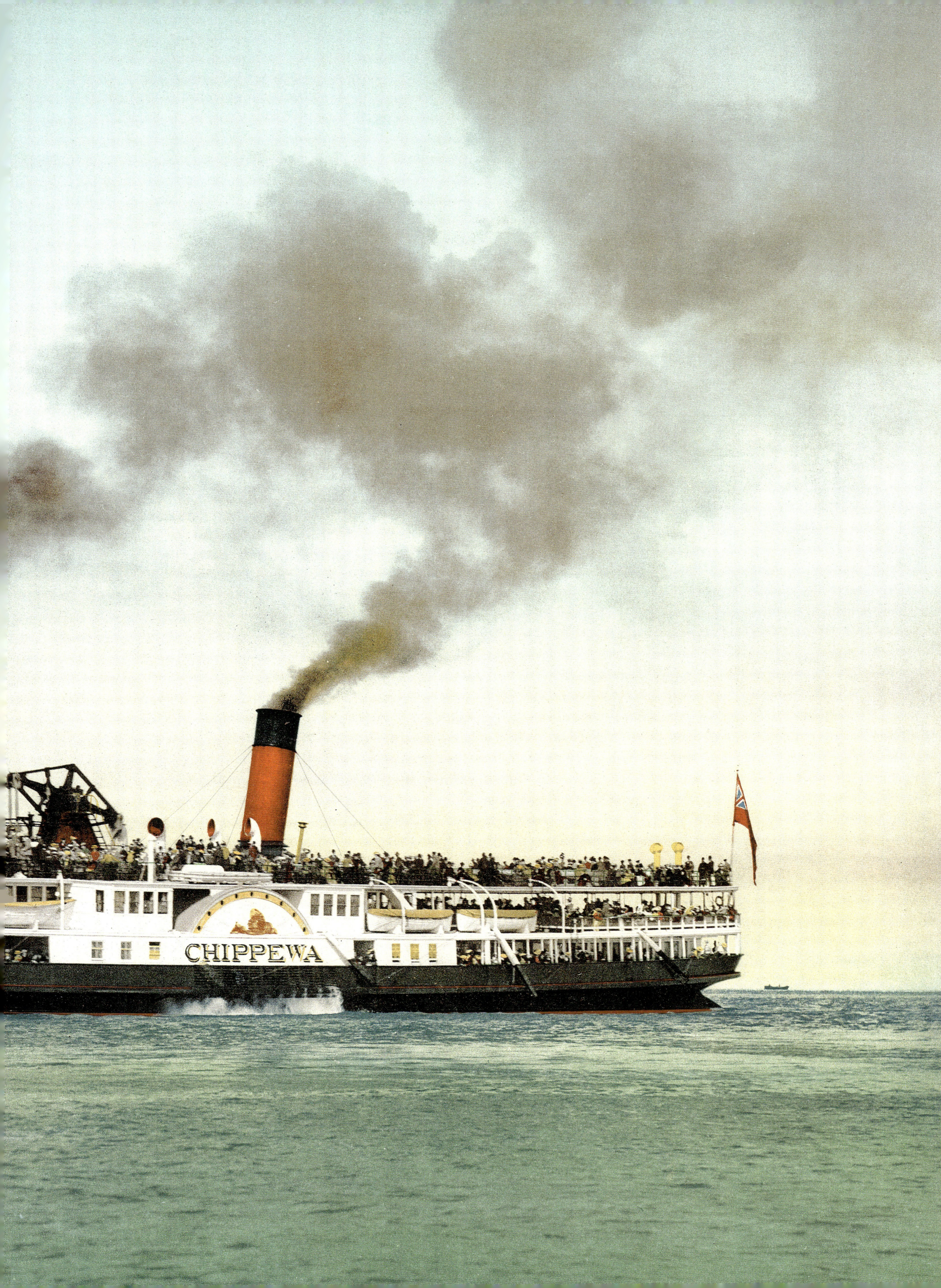

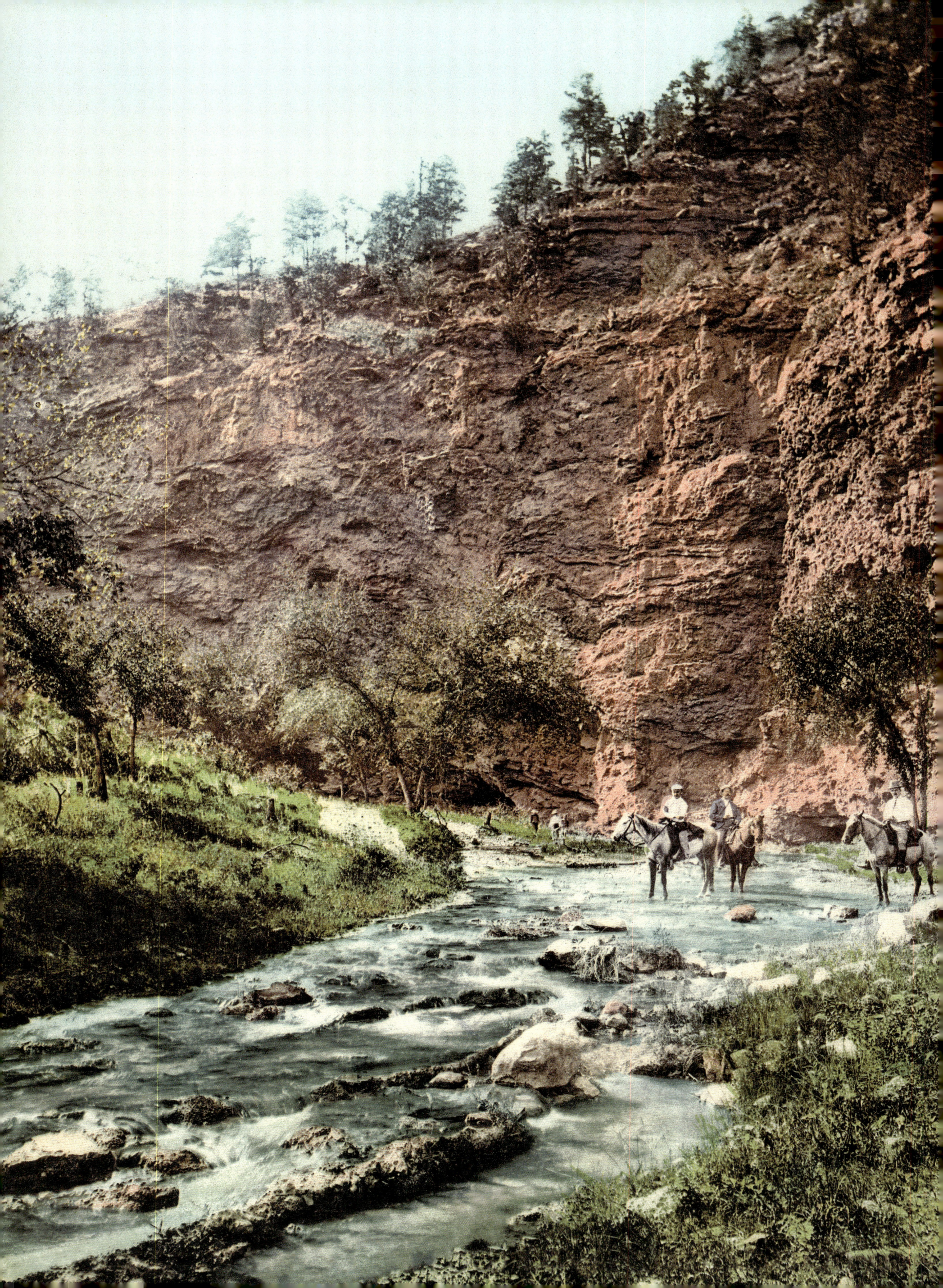

Page 208/209: Steamer *Chippewa* on Lake Ontario, photochrom
Page 210: In the vale Minne-ka-ta, South Dakota, photochrom
Top right: Off for the upper lakes
Below right: A lumber raft, Duluth, Minnesota

Seite 208/209: Der Dampfer *Chippewa* auf dem Ontariosee, Photochrom
Seite 210: Im Minne-ka-ta-Tal, South Dakota, Photochrom
Oben rechts: Abfahrt in Richtung Obere Seen
Unten rechts: Flößerei in Duluth, Minnesota

Pages 208/209 : le vapeur *Chippewa* sur le lac Ontario, photochrome
Page 210 : dans la vallée de Minne-ka-ta, Dakota du Sud, photochrome
À droite en haut : départ pour les lacs Supérieurs
À droite en bas : flottage de bois à Duluth, Minnesota

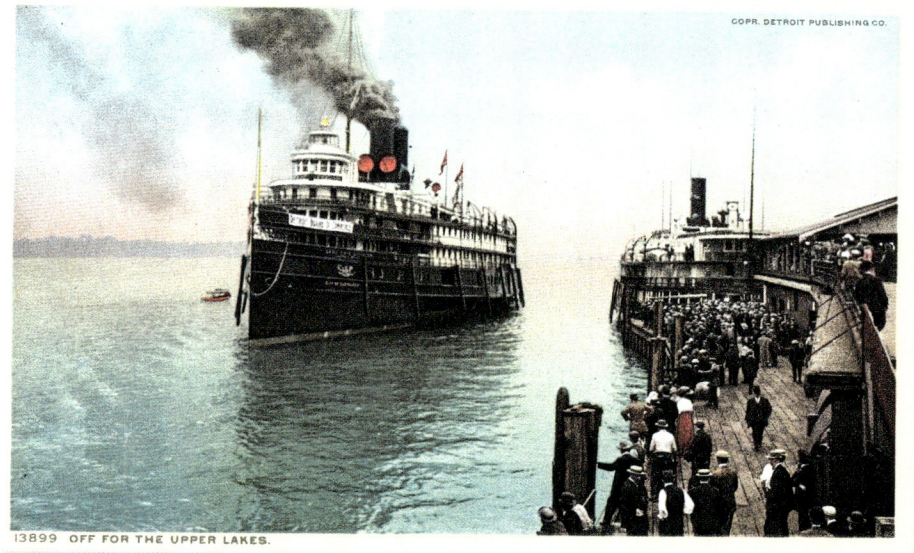

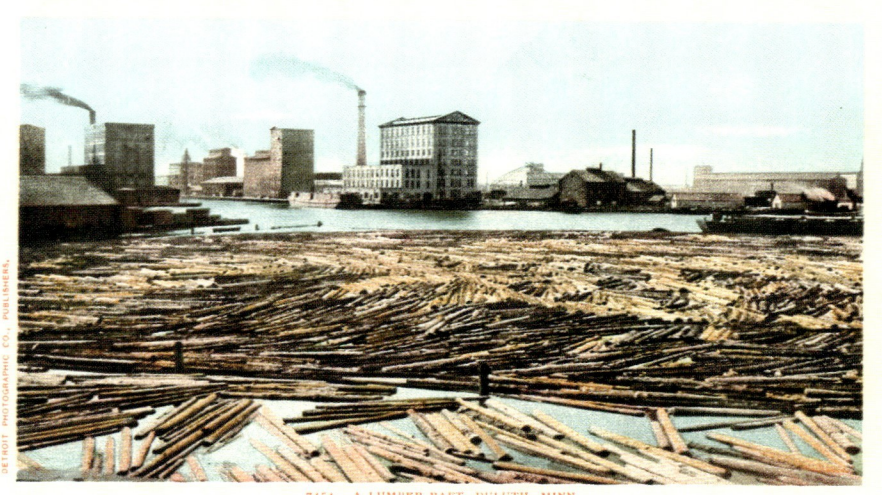

THE GREAT LAKES AND THE MIDWEST

The first ship to navigate the Great Lakes of North America was probably *Le Griffon*, a 40- to 45-ton sailing vessel armed with seven cannons that had been commissioned by the French explorer Cavelier de La Salle in the autumn of 1678 in a bid to discover the Northwest Passage to China and Japan. It was laden with goods to be exchanged for furs with the Native Americans in the trading posts of Lakes Huron and Michigan.

The expedition financed by La Salle left Cayuga Creek on the Niagara River in July 1679; on board was the missionary priest Louis Hennepin. *Le Griffon* was warped over the rapids and then navigated Lake Erie as far as the Detroit River. It traversed Lake St. Clair and the rapids of the St. Clair River, moored at Saginaw Bay in Lake Huron, and reached the Michilimakinac (Mackinac Island) mission post in late August 1679 after weathering a severe storm. It then set course for the Green Bay trading post on Lake Michigan. "From there," writes the Canadian historian Céline Dupré, "despite the fact that he had been explicitly forbidden by the king to practice 'any commerce with the Savages called Outaouacs and others who bring their beaver and other hides to Montreal,' he sent *Le Griffon* back to Niagara with a considerable cargo of furs." La Salle never saw his ship again: it disappeared without trace at some point after September 12, 1679, in the first known shipwreck on the Great Lakes.

Storms on these inland seas are indeed as violent as they are sudden; the most dangerous points are Thunder Bay in the north of Lake Superior and the shoreline around Whitefish—the "graveyard of the Great Lakes"— to the south, just outside the locks of Sault Ste. Marie, where waves can reach a height of 30 feet (10 m). Storms of this kind caused the loss of the *Invincible* in 1816 and, more recently, of the SS *Edmund Fitzgerald* in 1975. A terrible shipwreck took place in Lake Michigan in September 1860 when the *Lady Elgin*, driven off course by the wind, collided with the *Augusta* and sank between Milwaukee and Chicago with some 400 passengers on board, of whom only 100 were saved.

The development of the Midwest, of the "granary states"—including those that did not have direct access to the Great Lakes (such as Kansas and Missouri)—and "meatpacking" cities was always dependent on their connections with the Mississippi, Missouri, and Ohio Rivers. Before the arrival of the railroad, these were the only means of transport for their produce. The opening in 1825 of the Erie Canal, which linked New York through the Hudson River to Lake Erie, was largely responsible for the great wave of immigration that, continuing and gathering force until 1920–30 with the assistance of the railway, greatly expanded the populations of Chicago, Detroit, Toledo, Cleveland, Cincinnati, St. Louis, Kansas City, Milwaukee, Saint Paul, Minneapolis, and so on. We should also note that the American historian Richard White believes that the exchanges between the French and the Native Americans in the *Pays d'en Haut* (the northern parts of Louisiana between 1604 and 1763) were not simply commercial but left a permanent mark on both communities by creating links and a degree of intermarriage that was exceptional in the North American territory.

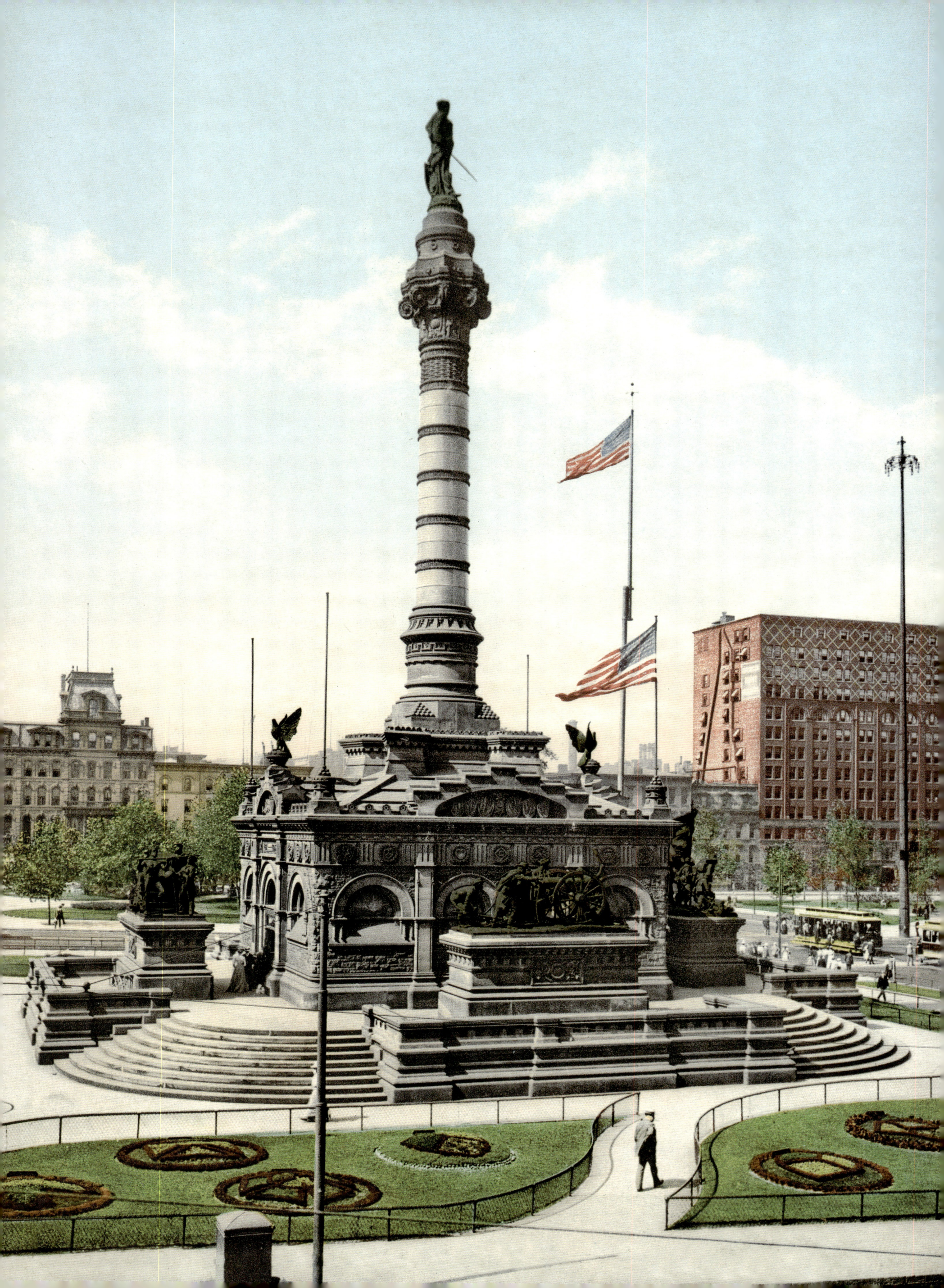

Page 212: Soldiers and Sailors Monument, Cleveland, photochrom
Near right: Lake Erie and Wheeling Bridge, Cleveland, Ohio
Far right: Twilight on the St. Clair River, Michigan

Seite 212: Denkmal für die Soldaten und Seeleute, Cleveland, Photochrom
Rechts: Eriesee und Hebebrücke, Cleveland, Ohio
Rechts außen: Dämmerung am Saint Clair River, Michigan

Page 212 : le monument aux soldats et aux marins, Cleveland, photochrome
Ci-contre : le lac Érié et le pont basculant, Cleveland, Ohio
À droite : crépuscule sur la rivière Sainte-Claire, Michigan

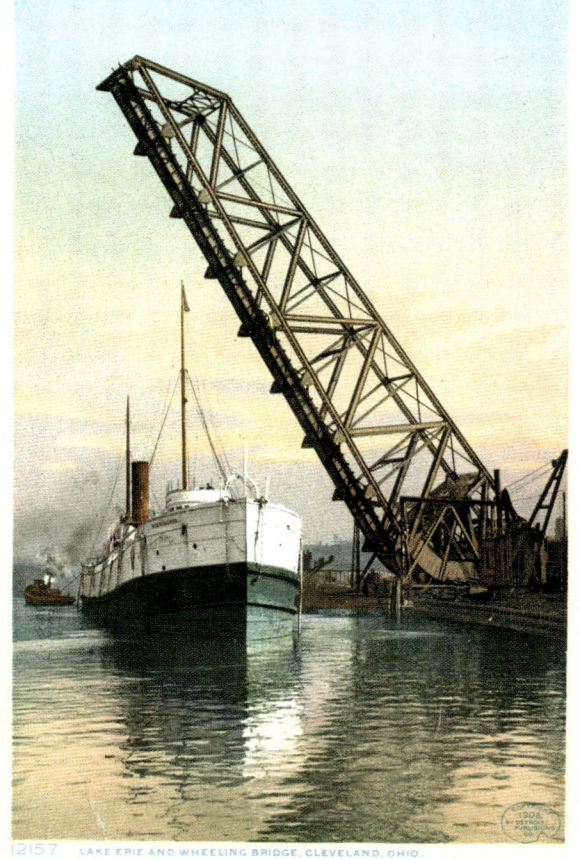
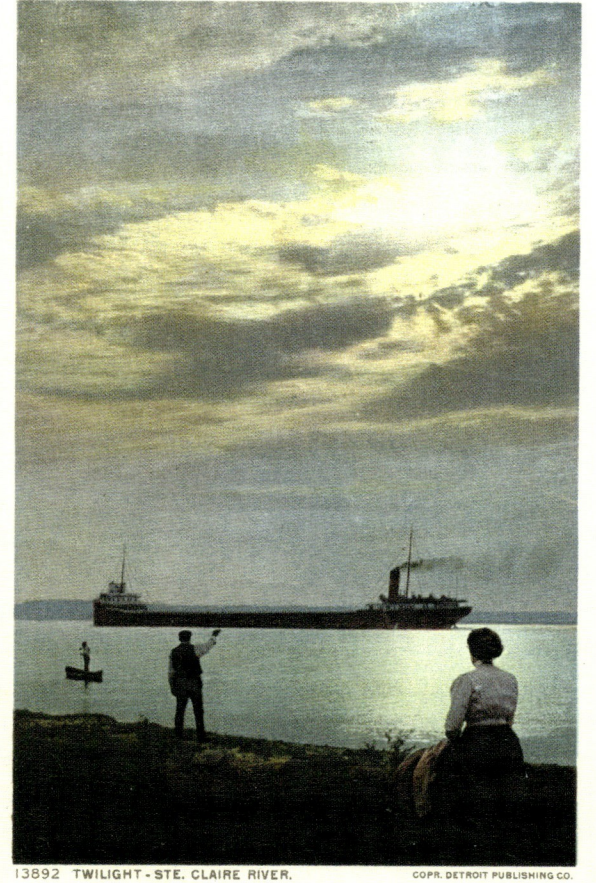

DIE GROSSEN SEEN UND DER MITTLERE WESTEN

Das erste Schiff, das die Großen Seen Nordamerikas befahren hat, war vermutlich die *Le Griffon*, ein 40 bis 45 Tonnen schweres, mit sieben Kanonen ausgestattetes Segelschiff, das der französische Entdecker Cavelier de La Salle im Herbst 1678 mit dem Ziel bauen ließ, die Route von Nordwesten nach China und Japan zu entdecken. Das Schiff war mit Waren beladen, die an den Handelsposten des Huronsees und des Michigansees gegen Felle der Indianer eingetauscht werden sollten.

Die von La Salle finanzierte Expedition, an der auch der Missionar Pater Louis Hennepin teilnahm, verließ Cayuga Creek im Juli 1679 auf dem Niagara River. Die *Le Griffon* wurde durch die Stromschnellen gezogen und segelte anschließend auf dem Eriesee bis zum Detroit River, passierte den Lake Saint Clair und die Stromschnellen des Saint Clair River, ging in Saginaw Bay im Huronsee vor Anker und erreichte Ende August 1679 die Missionsstation von Michilimakinac (Mackinac Island), musste aber zuvor noch ein schweres Unwetter über sich ergehen lassen. Anschließend nahm sie Kurs auf den Handelsposten von Green Bay (Michigan Lake). „Von dort", so schreibt die kanadische Historikerin Céline Dupré, „schickt er die *Le Griffon* ungeachtet der ausdrücklichen Anweisung durch den König, ‚mit den Outaouacs genannten Wilden und anderen, die ihre Biber und andere Pelzwaren nach Montréal bringen, keinerlei Handel zu treiben', mit einer beträchtlichen Ladung von Pelzen nach Niagara zurück." La Salle sollte sein Schiff nie wiedersehen, es verschwand mit Mann und Maus nach dem 12. September 1679 bei dem ersten Schiffbruch, der in der Geschichte der Großen Seen verzeichnet ist.

Auf den Großen Seen, die Binnenmeeren gleichen, treten Unwetter ebenso heftig wie plötzlich auf, wobei die gefährlichsten Stellen die Bucht von Thunder Bay nördlich des Oberen Sees und die Gegend von Whitefish Point – dem „Friedhof der Großen Seen" – im Süden, am Ausgang der Schleusen von Sault Ste. Marie, sind, wo sich bis zu zehn Meter hohe Wellen bilden können. Ein solcher Sturm verursachte 1816 den Verlust der *Invincible* (Unbesiegbare) und in jüngerer Zeit, nämlich 1975, den der SS *Edmund Fitzgerald*. Ein anderer tödlich endender Schiffbruch, diesmal auf dem Michigan Lake, ereignete sich im September 1860, als ein Touristendampfer, die *Lady Elgin*, durch den Wind von seinem Kurs abgebracht wurde, mit der *Augusta* zusammenstieß und zwischen Milwaukee und Chicago mit 400 Passagieren an Bord kenterte, von denen 300 nicht mehr gerettet werden konnten.

Die Entwicklung der Staaten des Mittleren Westens, „Kornkammer" und „Schlachthöfe" der Vereinigten Staaten, selbst derjenigen ohne direkten Zugang zu den Großen Seen (wie Kansas oder Missouri), war schon immer abhängig von ihrer Verbindung zu eben diesen Seen über die Flüsse Mississippi, Missouri und Ohio, die die einzigen Transportwege für ihre Waren darstellten, bevor es die Eisenbahn gab. Die Eröffnung des Eriekanals im Jahr 1825, der New York über den Hudson River mit dem Eriesee verbindet, ist der Grund für die große Einwanderungswelle, die dazu beitrug, Chicago, Detroit, Toledo, Cleveland, Cincinnati, St. Louis, Kansas City, Milwaukee, Saint Paul, Minneapolis und andere Städte zu bevölkern. Sie setzte sich dank der Eisenbahn bis in die 1920er- und 1930er-Jahre in zunehmendem Maße fort. Hervorzuheben ist auch, dass der amerikanische Historiker Richard White die Ansicht vertritt, der Austausch zwischen Franzosen und Indianern in den Oberen Ländern (der Norden Louisianas zwischen 1604 und 1763) sei nicht allein kommerzieller Natur gewesen, sondern habe die beiden Volksgruppen zugleich dauerhaft geprägt, indem sie auf dem nordamerikanischen Territorium ungewöhnliche Beziehungen geknüpft und eine besondere ethnische Vermischung herbeigeführt haben.

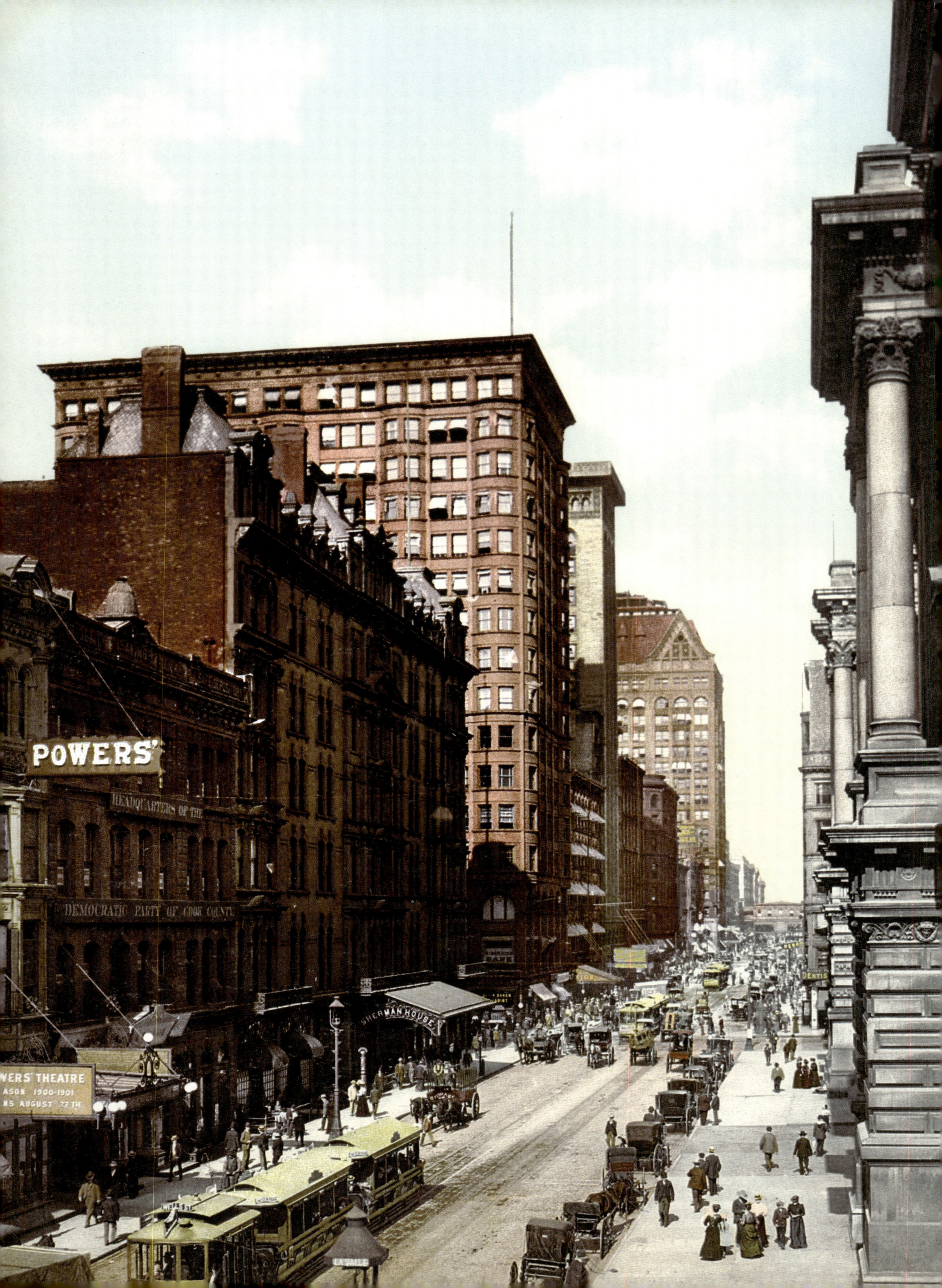

Page 214: Randolph Street east from LaSalle (Street), Chicago, Illinois, photochrom
Near right: The Blackstone Hotel, Chicago, Illinois
Far right: Vine Street and Union Central Life Insurance Building, Cincinnati, Ohio

Seite 214: Die Randolph Street östlich von der (Straße) LaSalle, Chicago, Illinois, Photochrom
Rechts: Das Blackstone Hotel in Chicago, Illinois
Rechts außen: Vine Street und das Gebäude der Union Central Life Insurance, Cincinnati, Ohio

Page 214 : Randolph Street à l'est de (la rue) LaSalle, Chicago, Illinois, photochrome
Ci-contre : l'hôtel Blackstone à Chicago, Illinois
À droite : Vine Street et l'immeuble de l'Union Central Life Insurance, Cincinnati, Ohio

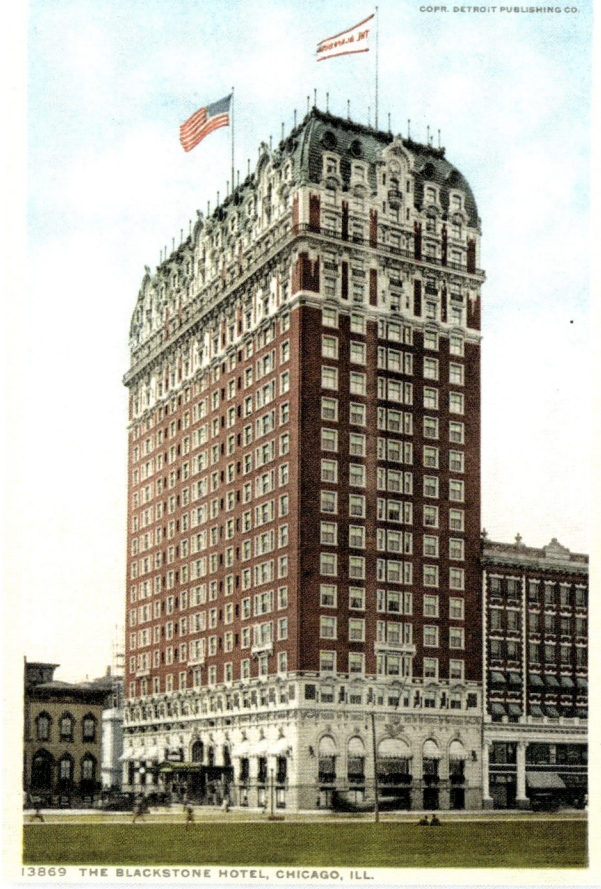
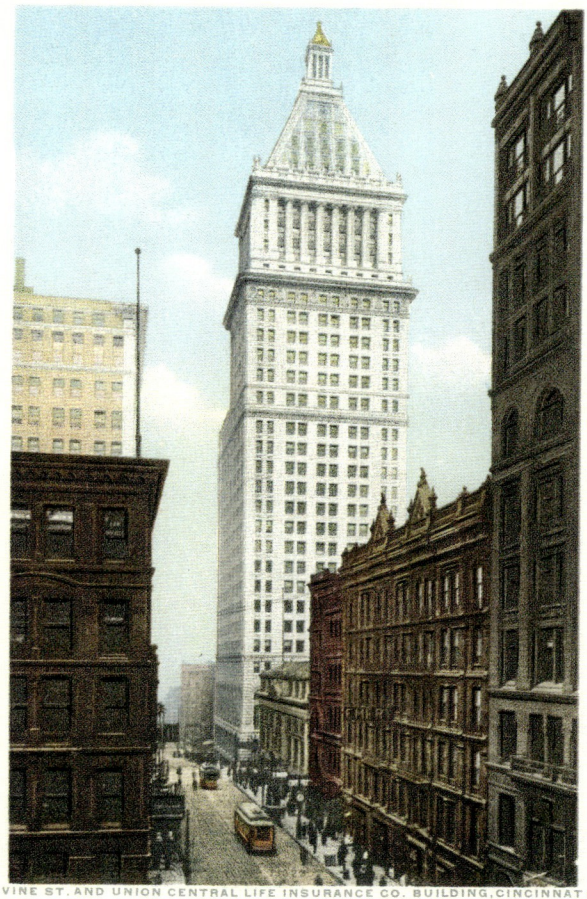

LES GRANDS LACS ET LE MIDDLE WEST

Le premier vaisseau qui ait navigué sur les Grands Lacs d'Amérique du Nord est probablement *Le Griffon*, une barque à voiles de 40 à 45 tonneaux armée de sept canons, que l'explorateur français Cavelier de La Salle fit construire à l'automne 1678 dans le but de découvrir le passage du Nord-Ouest vers la Chine et le Japon. L'embarcation était chargée de marchandises destinées à être échangées avec les Indiens contre des fourrures, dans les postes de traite des lacs Huron et Michigan.

L'expédition financée par La Salle, à laquelle participe le père missionnaire Louis Hennepin, quitte Cayuga Creek sur la rivière Niagara en juillet 1679. *Le Griffon* est halé à travers les rapides puis navigue sur le lac Érié jusqu'à la rivière de Detroit, passe le lac Sainte-Claire et les rapides de la rivière Sainte-Claire, mouille à Saginaw Bay sur le lac Huron et atteint la mission de Michilimakinac (Mackinac Island) à la fin du mois d'août 1679 non sans avoir essuyé une sévère tempête. Il met ensuite le cap sur le poste de traite de Green Bay (lac Michigan). « De là, écrit l'historienne canadienne Céline Dupré, au mépris de l'interdiction explicite que lui a faite le roi de pratiquer "aucun commerce avec les Sauvages appelés Outaouacs et autres qui apportent leurs castors et autres pelleteries à Montréal", il renvoie *Le Griffon* à Niagara chargé d'une cargaison de fourrures considérable. » La Salle ne reverra jamais son navire, disparu corps et biens après le 12 septembre 1679 dans le premier naufrage connu de l'histoire des Grands Lacs.

Sur ces mers intérieures que sont les Grands Lacs, les tempêtes sont en effet aussi violentes que soudaines, les points les plus dangereux étant la baie de Thunder Bay, au nord du lac Supérieur, et la zone de Whitefish Point – le « cimetière des Grands Lacs » – au sud, à la sortie des écluses de Sault Sainte-Marie, où peuvent se former des vagues de près de 10 mètres de haut. C'est une telle tempête qui causa la perte de l'*Invincible* en 1816 et, plus près de nous, celle du SS *Edmund Fitzgerald* en 1975. Un autre naufrage meurtrier, sur le lac Michigan cette fois, eut lieu en septembre 1860 lorsqu'un steamer de tourisme, le *Lady Elgin*, déporté de sa route par le vent, heurta l'*Augusta* et sombra entre Milwaukee et Chicago avec 400 passagers à son bord, dont 300 ne purent être sauvés.

Le développement des États du Middle West, « greniers à blé » et « cités abattoirs » des États-Unis, même ceux qui n'ont pas d'accès direct aux Grands Lacs (tels le Kansas ou le Missouri), fut toujours lié à leur connexion avec eux via les fleuves Mississippi, Missouri et Ohio, qui, avant l'arrivée du chemin de fer, étaient les seules voies de transport de leur production. L'ouverture en 1825 du canal Érié, qui relie New York par l'Hudson au lac Érié, est quant à elle responsable de la grande vague d'immigration qui, se poursuivant et s'amplifiant jusqu'aux années 1920–1930 par le biais du chemin de fer, contribua au peuplement de Chicago, Detroit, Toledo, Cleveland, Cincinnati, Saint Louis, Kansas City, Milwaukee, Saint-Paul, Minneapolis. Signalons aussi que l'historien américain Richard White estime que les échanges entre Français et Indiens dans les « Pays d'en haut » (partie nord de la Louisiane entre 1604 et 1763) ne furent pas seulement de nature commerciale, mais qu'ils ont durablement marqué les deux communautés en créant des liens et un métissage exceptionnels sur le territoire nord-américain.

KENTUCKY

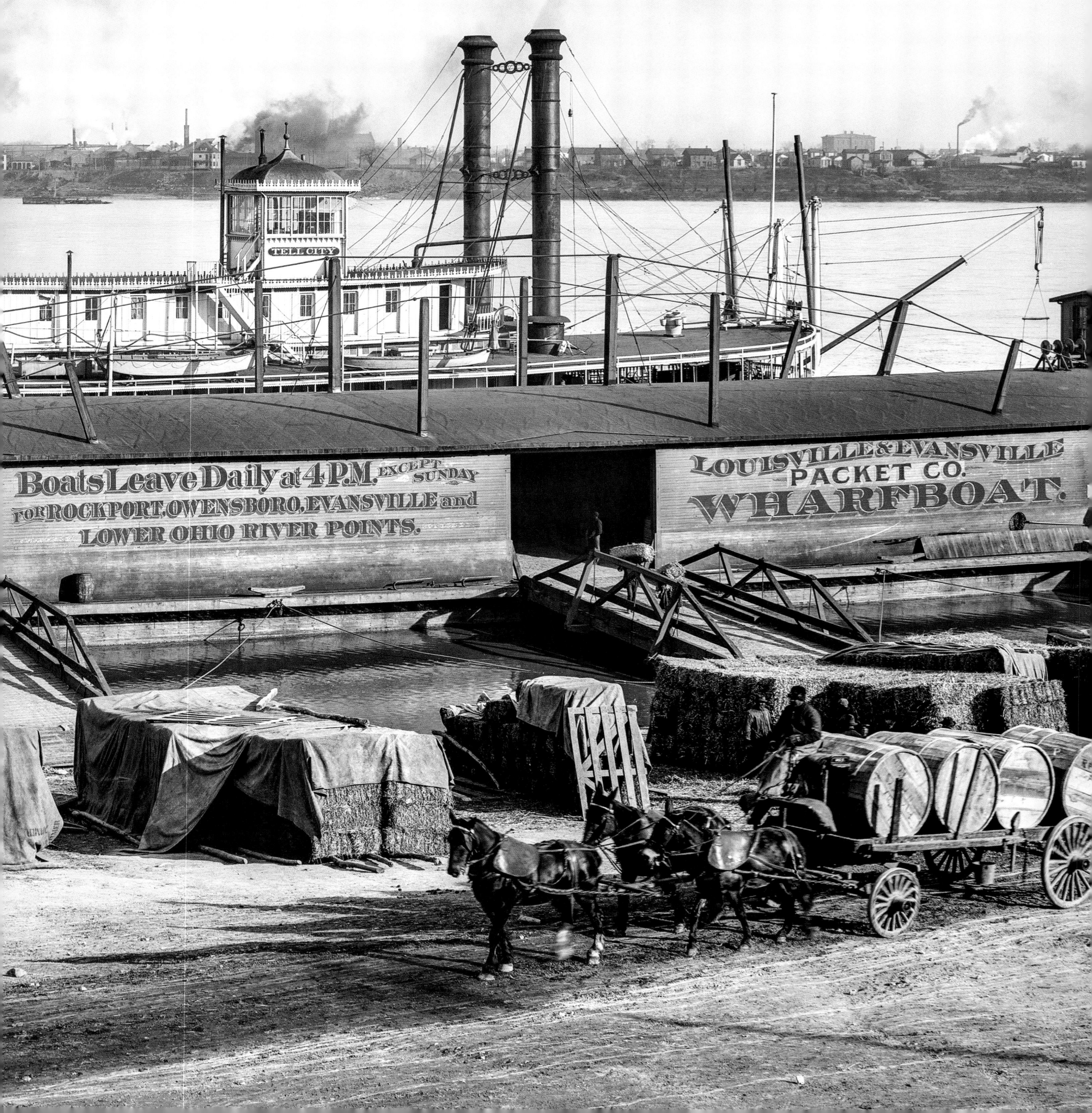

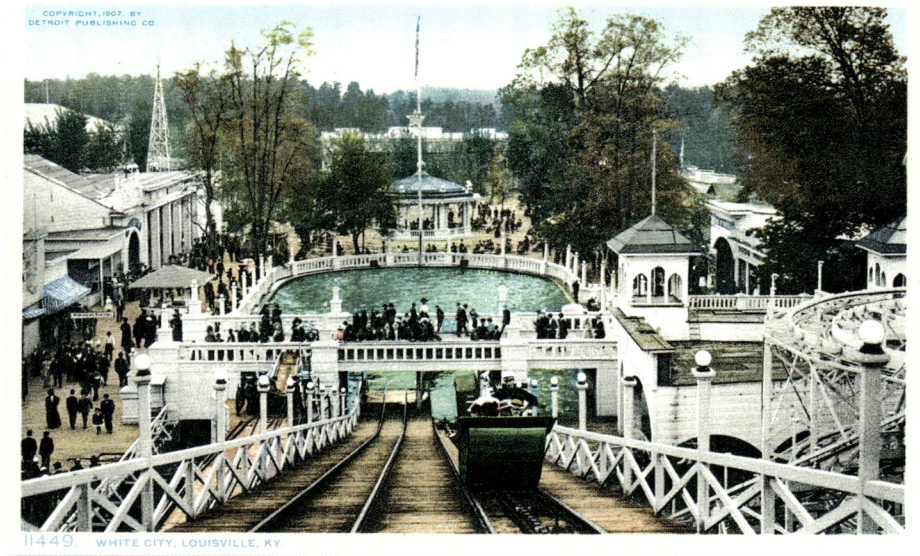
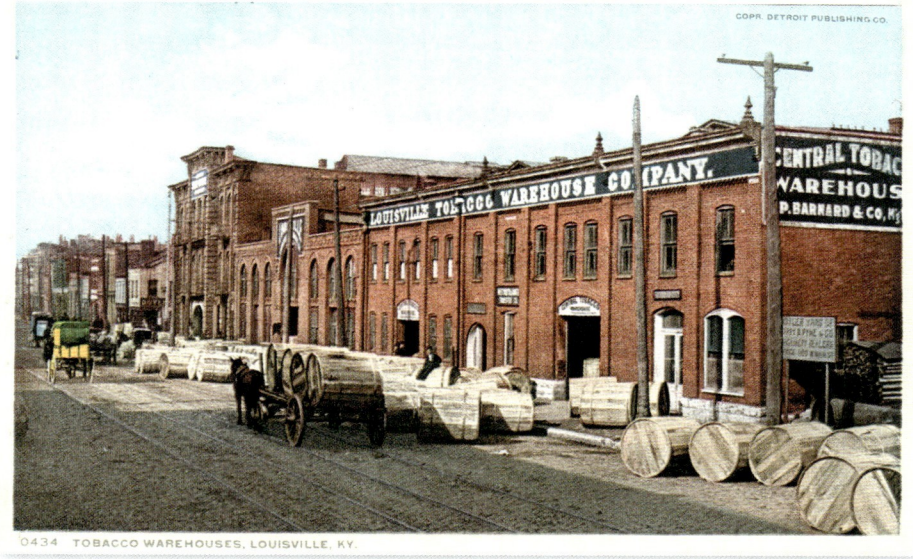

Page 216: The Levee, Louisville, glass negative, 1900–1906
Top left: White City
Top right: Tobacco warehouses
Bottom: A tobacco market, glass negative, ca. 1906

In the 18th century, the site of Louisville was occupied by the camps of European settlers unable to cross the natural barrier formed by the Ohio rapids. The founder of the city was Colonel George Rogers Clark, 1778–1780. The arrival of the first steamship from New Orleans in 1811 changed the destiny of Louisville. Before the American Civil War, the city exported its tobacco and excess slaves to the Southern states, where they were sold to cotton and sugarcane planters; a commemorative plaque was set up in the lower town on the corner of Second and Main Street.

Seite 216: Anlegestelle von Louisville, Glasnegativ, 1900–1906
Oben links: Der White City Park
Oben rechts: Tabakspeicher in Louisville
Unten: Tabakmarkt, Glasnegativ, um 1906

Louisville war im 18. Jahrhundert Sitz verschiedener Lager der europäischen Siedler, die von dem natürlichen Hindernis der Stromschnellen des Ohio auf ihrem Vormarsch gestoppt wurden. Gründer der Stadt war 1778–1780 Oberst George Rogers Clark. Die Ankunft des ersten Dampfschiffes aus New Orleans im Jahr 1811 veränderte die Geschicke von Louisville. Vor dem Sezessionskrieg exportierte die Stadt ihren Tabak – und ihre überzähligen Sklaven – in die Südstaaten, wo sie an Baumwoll- und Zuckerrohrplantagenbesitzer weiterverkauft wurden; im Stadtzentrum an der Ecke Second Street und Main Street wurde eine Gedenktafel errichtet.

Page 216 : le quai de Louisville, plaque de verre, 1900–1906
En haut à gauche : le parc de White City
En haut à droite : entrepôts de tabac à Louisville
Ci-dessous : un marché au tabac, plaque de verre, vers 1906

Le site de Louisville fut au XVIIIe siècle le siège de divers campements de colons européens arrêtés dans leur progression par la barrière naturelle des rapides de l'Ohio. La ville a été fondée en 1778–1780 par le colonel George Rogers Clark. L'arrivée du premier bateau à vapeur en provenance de La Nouvelle-Orléans en 1811 changea le destin de Louisville. Avant la guerre de Sécession, la ville exportait son tabac – et ses esclaves en surnombre – vers les États du Sud, où ils étaient revendus aux planteurs de coton et de canne à sucre ; une plaque commémorative a été installée dans la ville basse, à l'angle de Second Street et de Main Street.

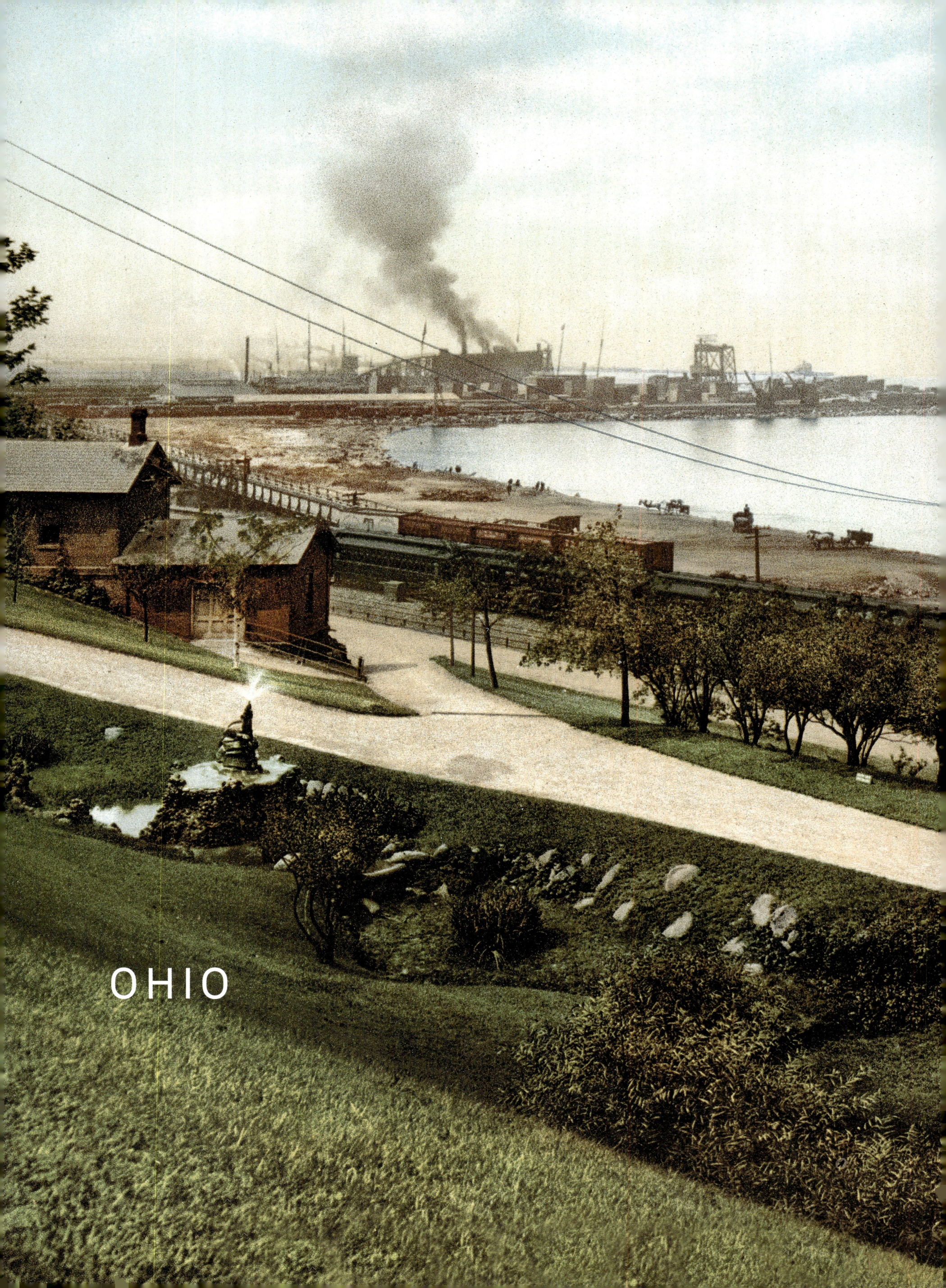
OHIO

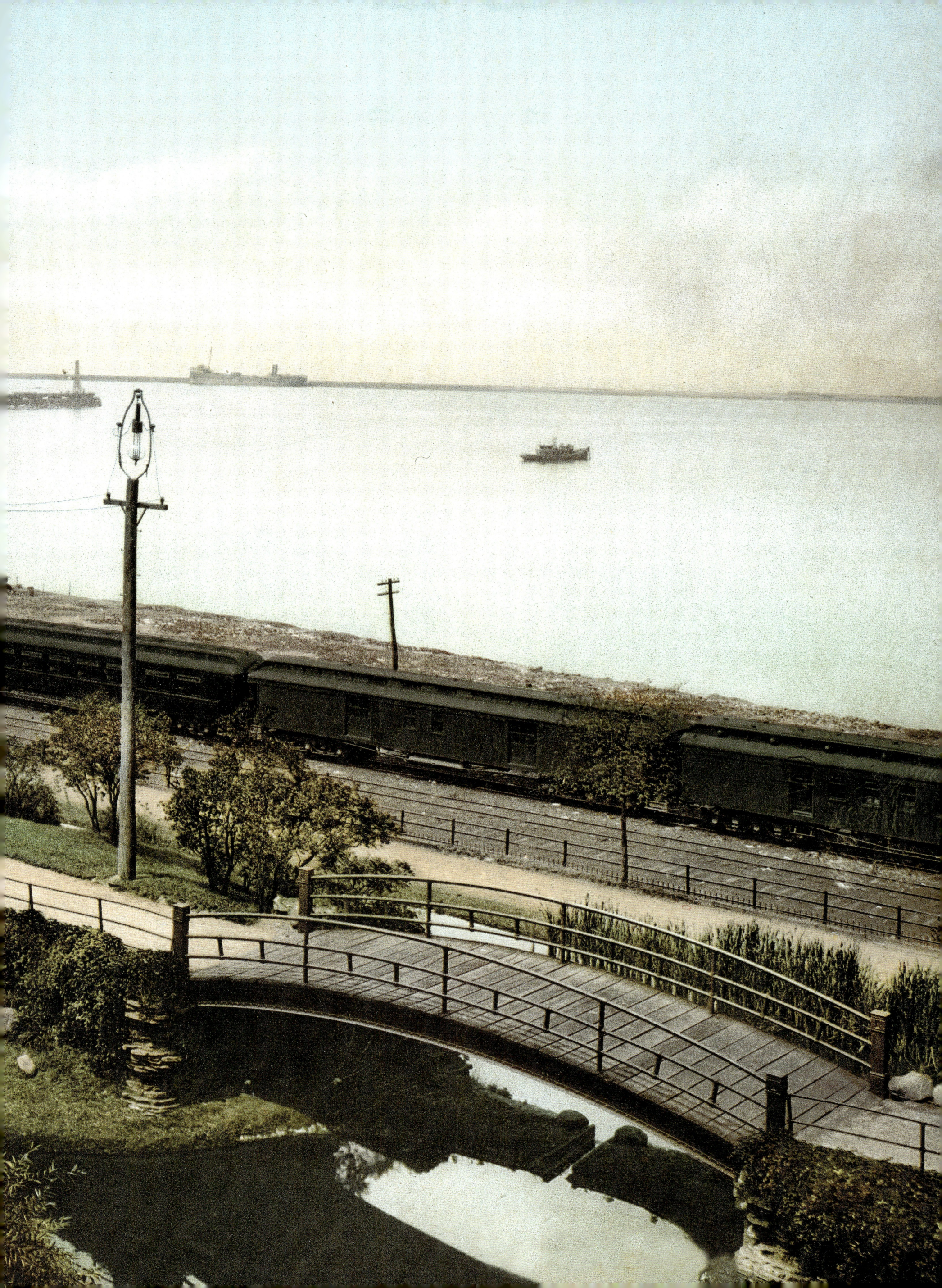

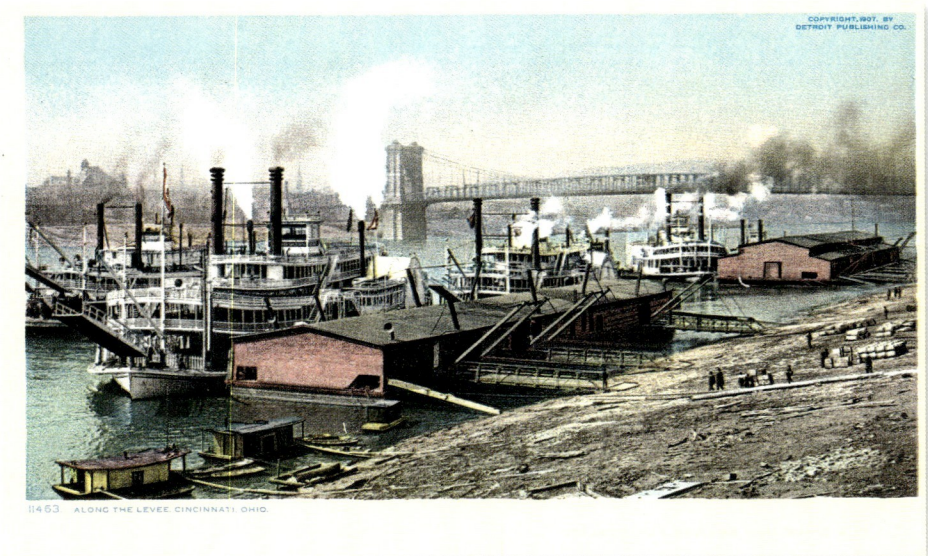
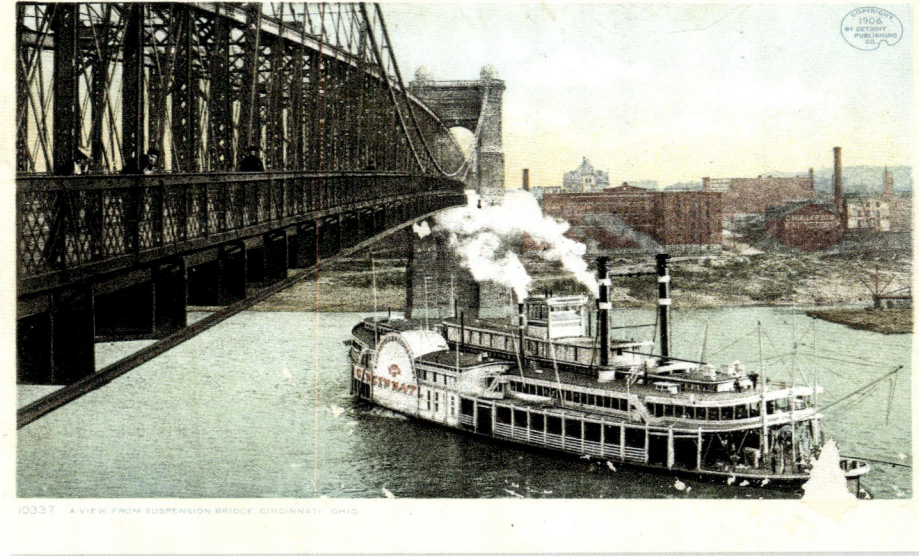

Page 218/219: Harbor from Lake View Park, Cleveland, photochrom
Top left: Along the levee, Cincinnati
Top right and bottom: A view from suspension bridge, Cincinnati, postcard and original glass negative, 1906

Seite 218/219: Der Hafen von Cleveland vom Lake View Park aus, Photochrom
Oben links: An der Anlegestelle von Cincinnati
Oben rechts und unten: Blick von der Suspension Bridge (Hängebrücke), Cincinnati, Postkarte und Originalglasnegativ, 1906

Pages 218/219 : le port de Cleveland vu depuis le parc de Lake View, photochrome
En haut à gauche : sur les quais de Cincinnati
En haut à droite et ci-dessous : vue depuis le pont suspendu (Suspension Bridge), Cincinnati, carte postale et plaque de verre originale, 1906

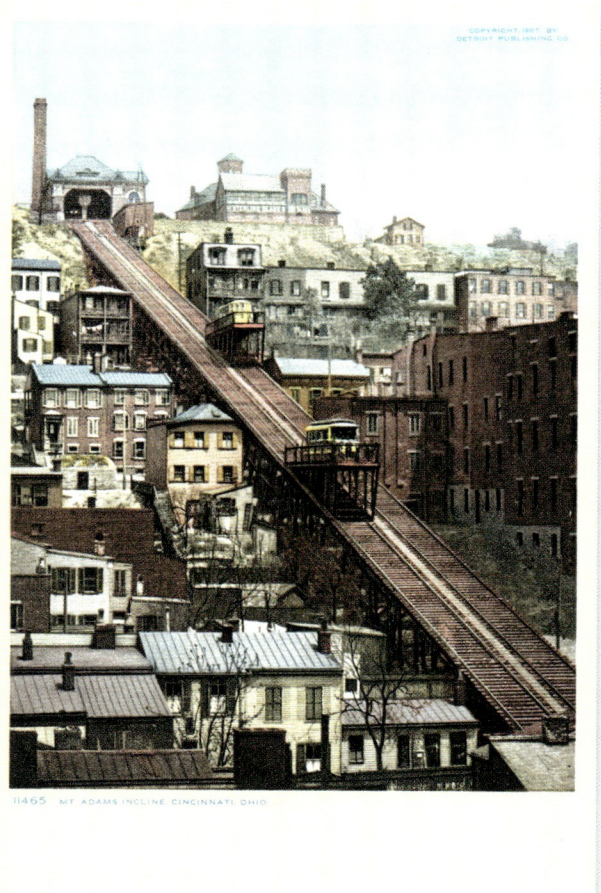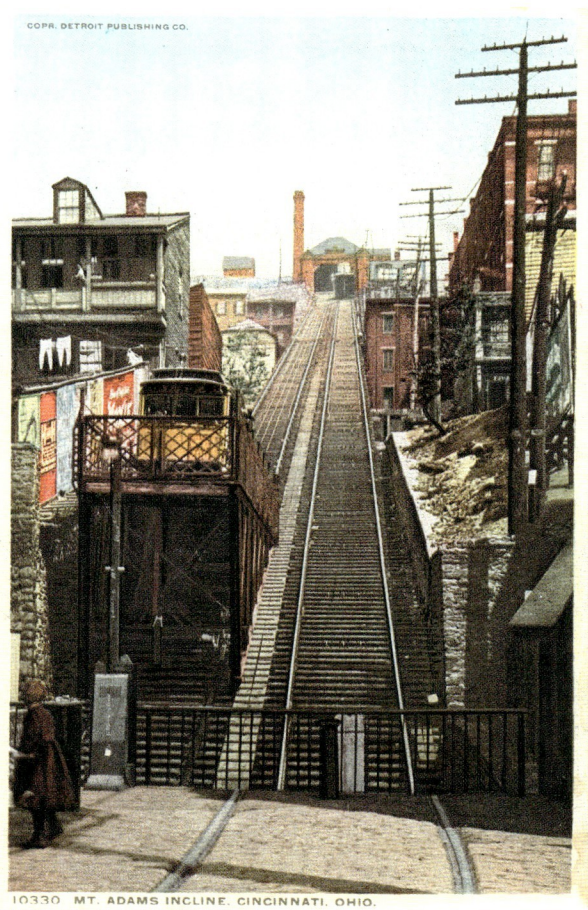

Far left and near left: **Mount Adams Incline**
Below: **Up the hill by trolley, glass negative, 1900–1910**

Built on two terraces dominating the Ohio, Cincinnati in 1900 was a dynamic city of 300,000 inhabitants, a third of whom were of German origin and lived in the Over-the-Rhine quarter. Though an industrial and trading city, it was renowned for its architecture and art museum and was sometimes dubbed the "Paris of America." The suspension bridge was one of five connecting the city to the left bank of the Ohio in Kentucky.

Links außen und links: **Die Standseilbahn am Mount Adams**
Unten: **Mit dem Trolley den Berg hinauf, Glasnegativ, 1900–1910**

Das auf zwei Terrassen oberhalb des Ohio errichtete Cincinnati war 1900 eine dynamische Stadt mit 300 000 Einwohnern, von denen ein Drittel deutschstämmig war und in einem Viertel namens „Over-the-Rhine" (Über dem Rhein) wohnte. Die Industrie- und Handelsstadt, die auch für ihre Architektur und ihr Kunstmuseum bekannt war, wurde gerne das „Paris Amerikas" genannt. Die Hängebrücke war eine von fünf Brücken, die die Stadt mit ihren Nachbarn in Kentucky am linken Ufer des Ohio verbanden.

Ci-contre et à gauche : **le chemin de fer à crémaillère du mont Adams**
Ci-dessous : **le trolley de la colline, plaque de verre, 1900–1910**

Bâtie sur deux terrasses dominant l'Ohio, Cincinnati était en 1900 une cité dynamique de 300 000 habitants, dont un tiers d'origine allemande résidant dans le quartier dit « Over-the-Rhine » (« Au-dessus du Rhin »). Ville industrielle et commerçante, mais aussi réputée pour son architecture et son musée, l'Art Museum, Cincinnati était volontiers appelée le « Paris de l'Amérique ». Le pont suspendu était l'un des cinq ponts qui reliaient la ville à ses voisines de la rive gauche de l'Ohio, dans le Kentucky.

OHIO | CINCINNATI

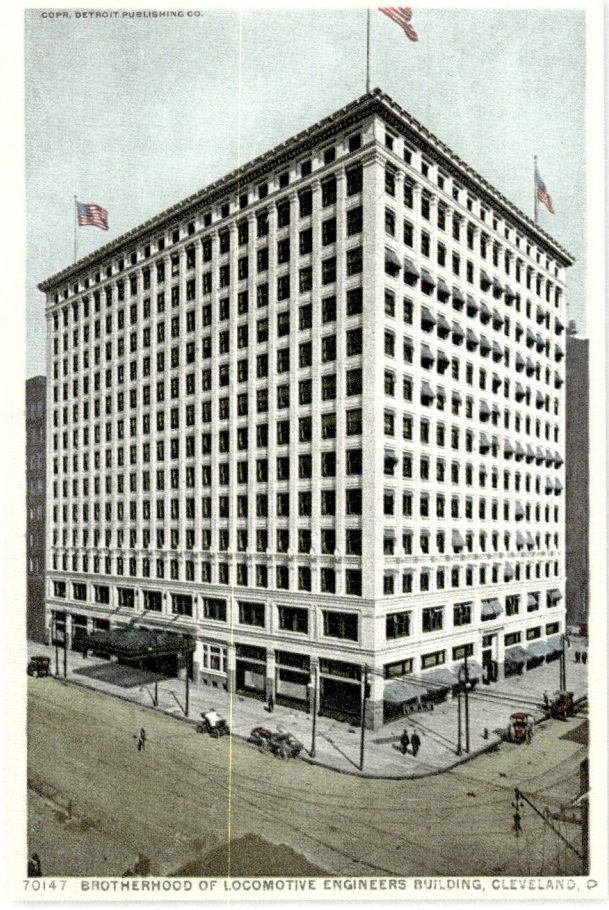
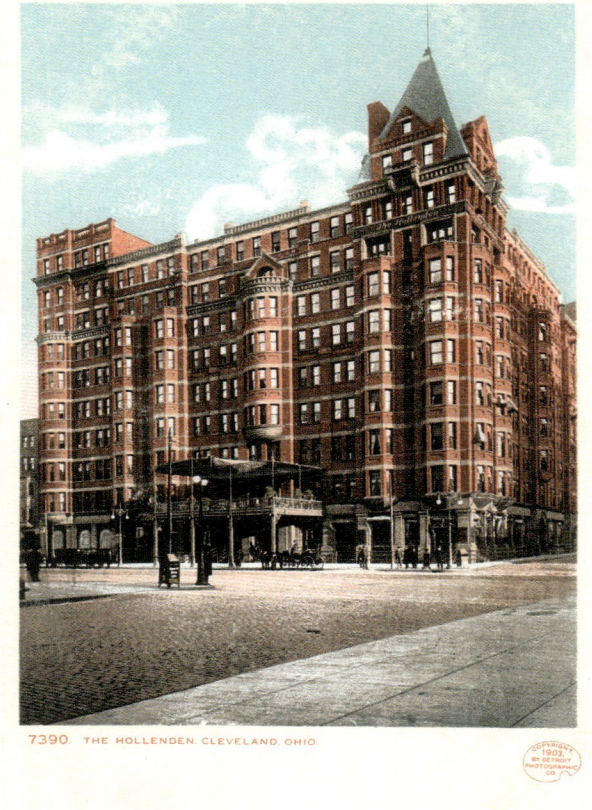

Far left: **Brotherhood of Locomotive Engineers building**
Near left: **The Hollenden Hotel**
Below: **The inside of the Arcade, photochrom**
Page 223: **The Arcade Building, glass negative, ca. 1900**
Page 224/225: **Colonial Arcade, glass negative, ca. 1908**

In 1890, Cleveland was the second-largest town in Ohio and home to the Standard Oil Co. West Cleveland, at the mouth of the Cuyahoga River, was a major industrial port on Lake Erie; its factories employed some 50,000 people—nearly a fifth of the city's population. The city center was both very animated and very spacious, since it was a mixture of business district, shopping streets, galleries, and parks with lakeside gardens.

Links außen: **Gebäude der Bruderschaft der Lokomotivingenieure**
Links: **Hotel Hollenden**
Unten: **Innenansicht des Arcade Building, Photochrom**
Seite 223: **Eingang des Arcade Building, Glasnegativ, um 1900**
Seite 224/225: **Innenansicht der Colonial Arcade, Glasnegativ, um 1908**

1890 war Cleveland die zweitgrößte Stadt von Ohio und Sitz der Standard Oil Co. Sie besaß einen großen Industriehafen am Eriesee an der Mündung des Cuyahoga River, und in den Fabriken von West Cleveland arbeiteten um die 50 000 Menschen, also etwa ein Fünftel der Bevölkerung. Das Stadtzentrum war gleichzeitig sehr geschäftig und sehr aufgelockert, bestand es doch einerseits aus einem Geschäftsviertel, großen Einkaufsstraßen und Ladenpassagen und andererseits aus Parks und Gärten am Seeufer.

À gauche : **l'immeuble de la Confrérie des ingénieurs de locomotive**
Ci-contre : **l'hôtel Hollenden**
Ci-dessous : **intérieur de L'Arcade, photochrome**
Page 223 : **entrée de L'Arcade, plaque de verre, vers 1900**
Pages 224/225 : **intérieur de L'Arcade coloniale, plaque de verre, vers 1908**

En 1890, Cleveland était la deuxième ville de l'Ohio et le siège de la Standard Oil Co. Dans ce grand port industriel sur le lac Érié, à l'embouchure de la rivière Cuyahoga, les usines de West Cleveland employaient quelque 50 000 personnes, soit un cinquième de la population environ. Le centre-ville était à la fois très animé et très aéré, partagé entre le quartier d'affaires, les avenues commerçantes, les grandes galeries marchandes et de parcs et jardins sur les bords du lac.

OHIO | CLEVELAND

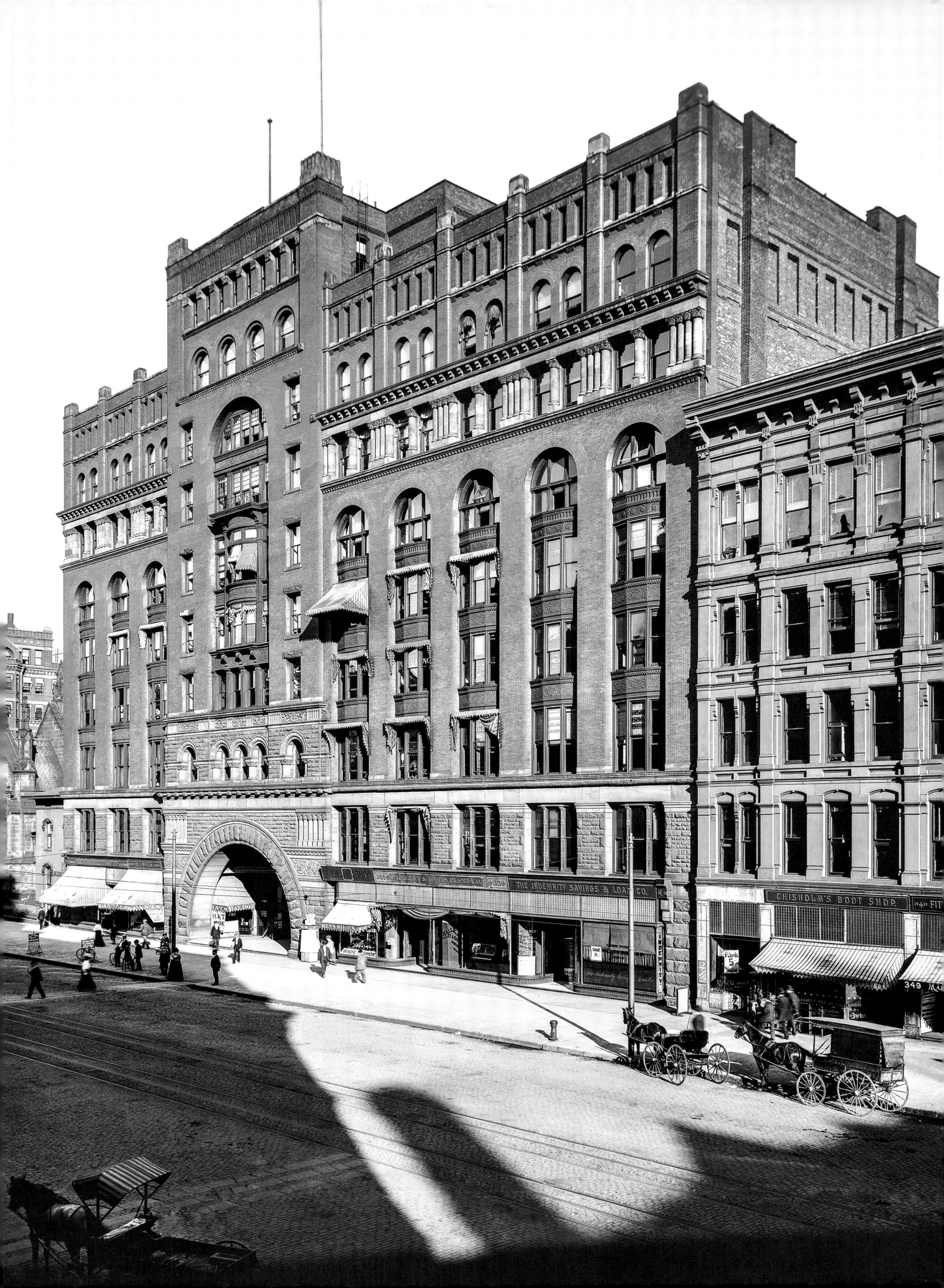

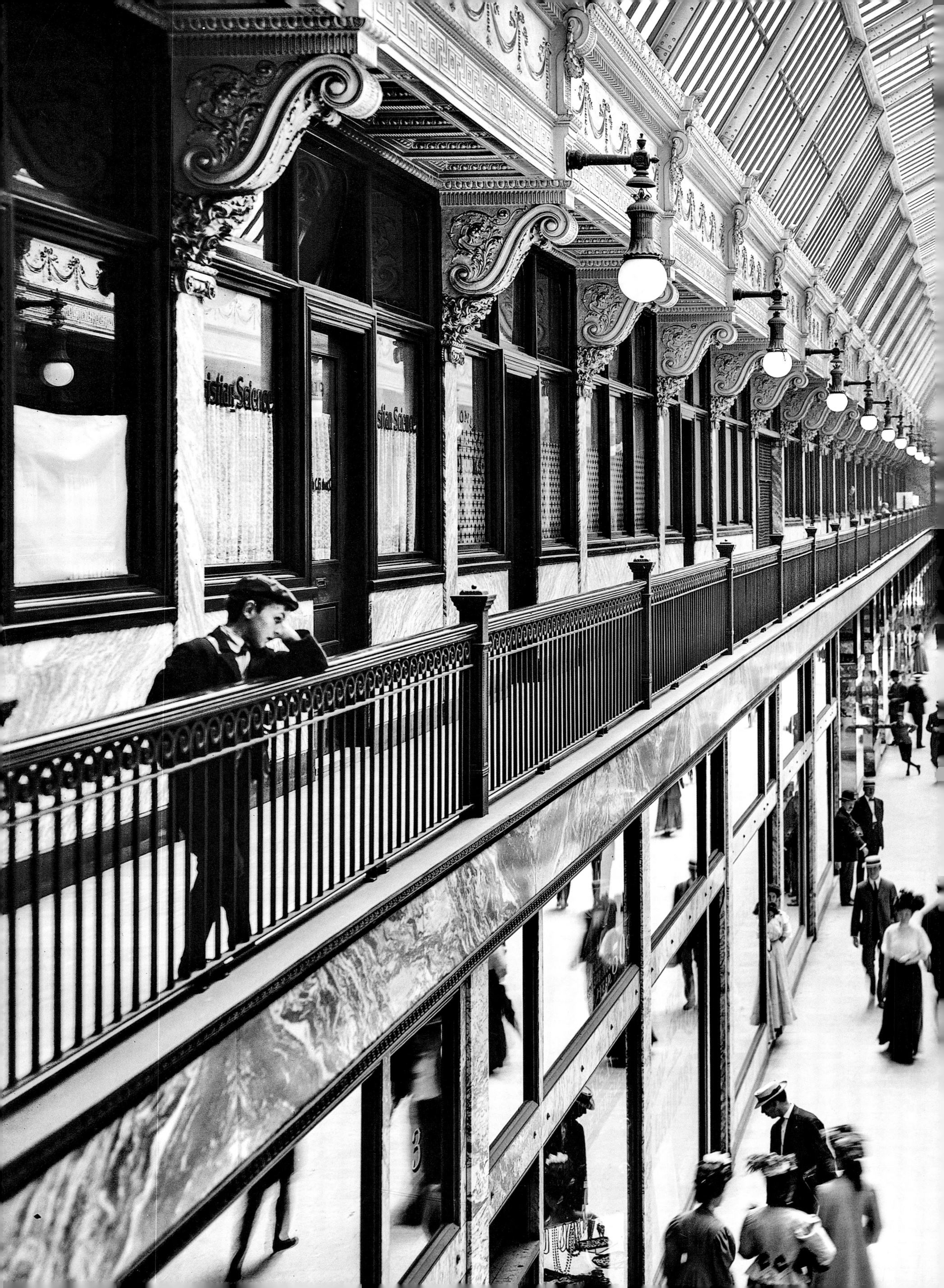

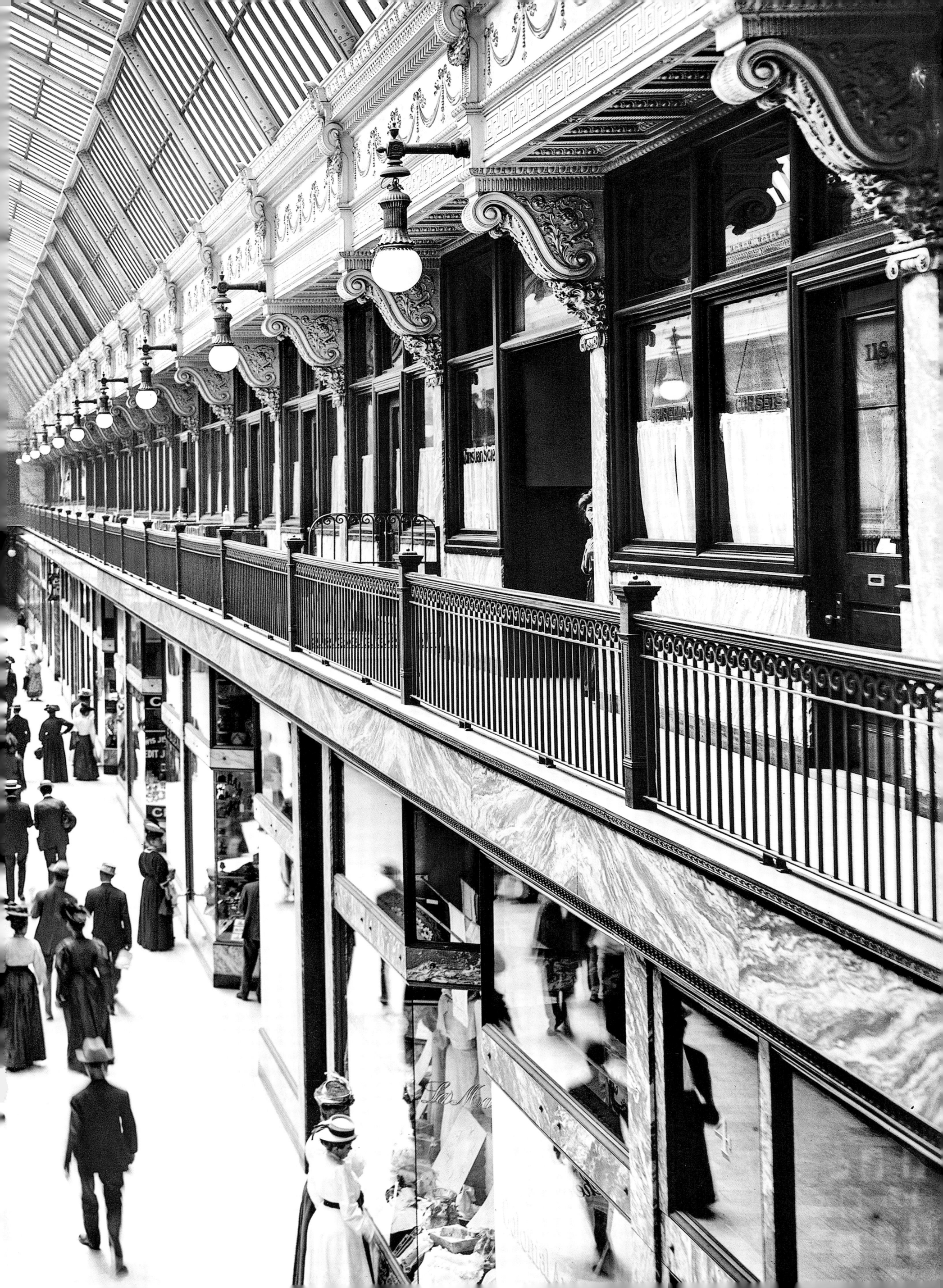

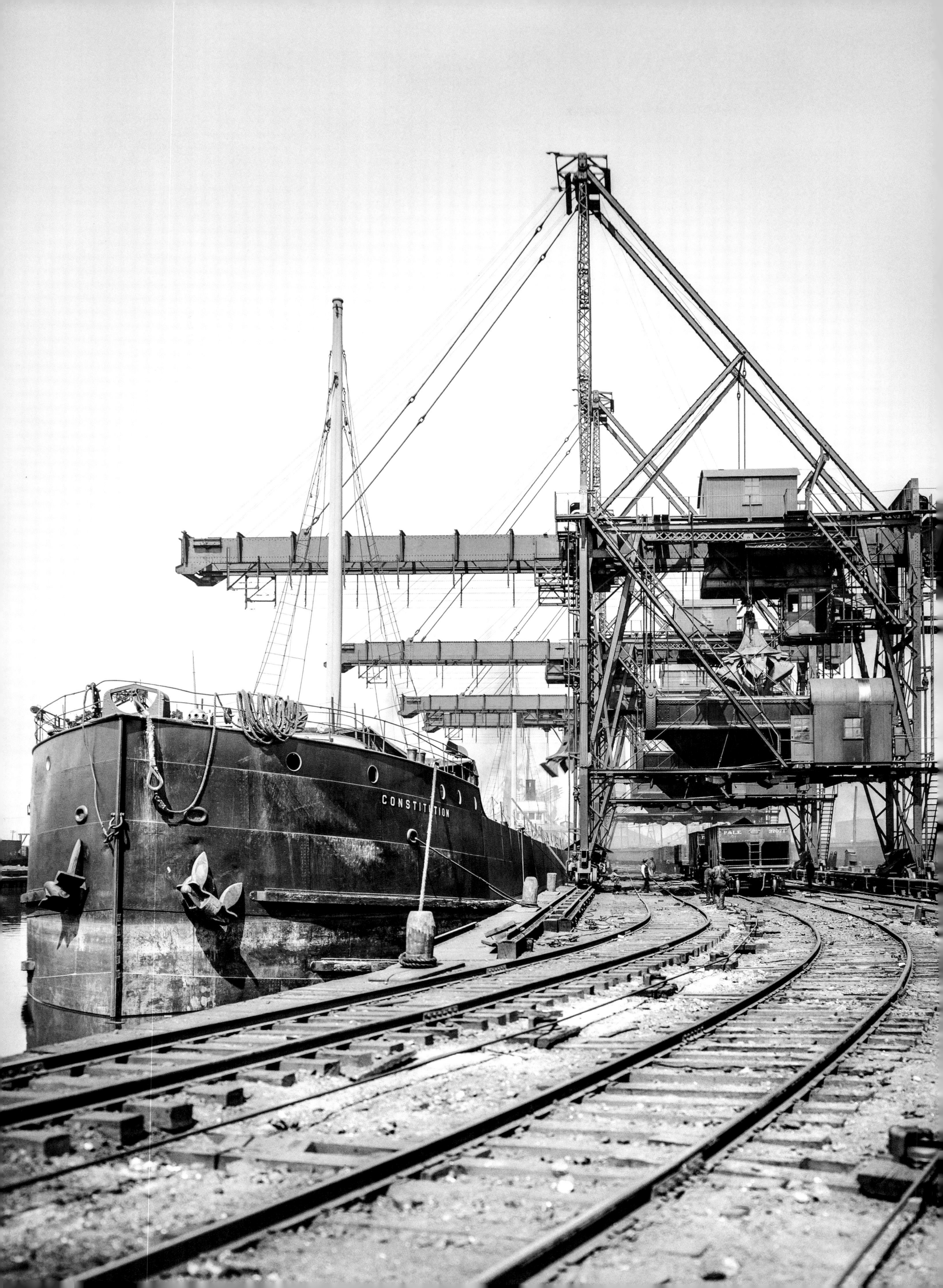

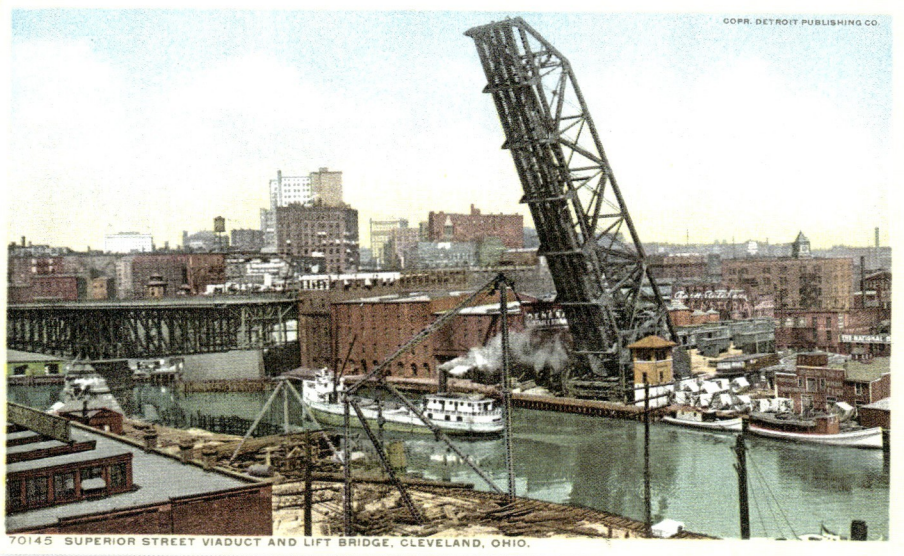
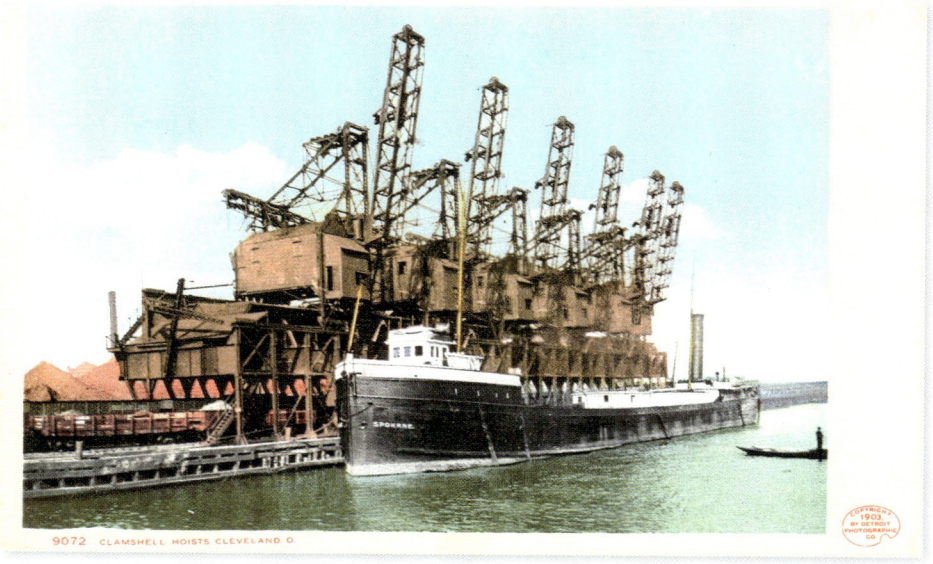

Page 226: Brown electric hoist unloading freighter *Constitution*, glass negative, 1900–1910
Top left: Superior Street Viaduct and lift bridge
Top right: Clamshell hoists
Bottom: American Steel & Wire Co. plant, photochrom

A huge road bridge, the Superior Street Viaduct, linked the industrial district of West Cleveland to the heart of the city; the central part of the viaduct opened to allow ships through. The view by night over the industrial area from the top of the viaduct was very impressive, according to the 1893 Baedeker. The Cleveland docks could store up to two million tons of ore.

Seite 226: Eine elektrische Hebebühne von Brown entlädt den Frachter *Constitution*, Glasnegativ, 1900–1910
Oben links: Das Superior-Street-Viadukt und die Hebebrücke
Oben rechts: Die Clamshell-Hubwerke entladen einen Frachter
Unten: Fabrikgebäude der American Steel & Wire Company, Photochrom

Das riesige Superior-Street-Viadukt verband das Industrieviertel West Cleveland mit dem Stadtzentrum; in seinem mittleren Teil ließ sich das Viadukt öffnen, um den Schiffsverkehr passieren zu lassen. Der Baedeker von 1893 spricht davon, dass man von dem Viadukt aus nachts einen äußerst beeindruckenden Blick auf das Industrieviertel hatte. Die Docks im Hafen von Cleveland konnten bis zu zwei Millionen Tonnen Erz fassen.

Page 226 : grue portuaire Brown déchargeant le cargo *Constitution*, plaque de verre, 1900–1910
En haut à gauche : le viaduc de Superior Street et le pont à bascule
En haut à droite : grues portuaires déchargeant un cargo
En bas : l'usine de la compagnie American Steel & Wire, photochrome

Un gigantesque viaduc, le Superior Street Viaduct, reliait le quartier industriel de West Cleveland au cœur de la cité ; la partie centrale de ce viaduc s'ouvrait pour laisser passer les navires. La vue que l'on avait depuis le viaduc sur la zone industrielle était des plus impressionnantes la nuit, précise le guide Baedeker de 1893. Les docks du port de Cleveland pouvaient contenir jusqu'à 2 millions de tonnes de minerai.

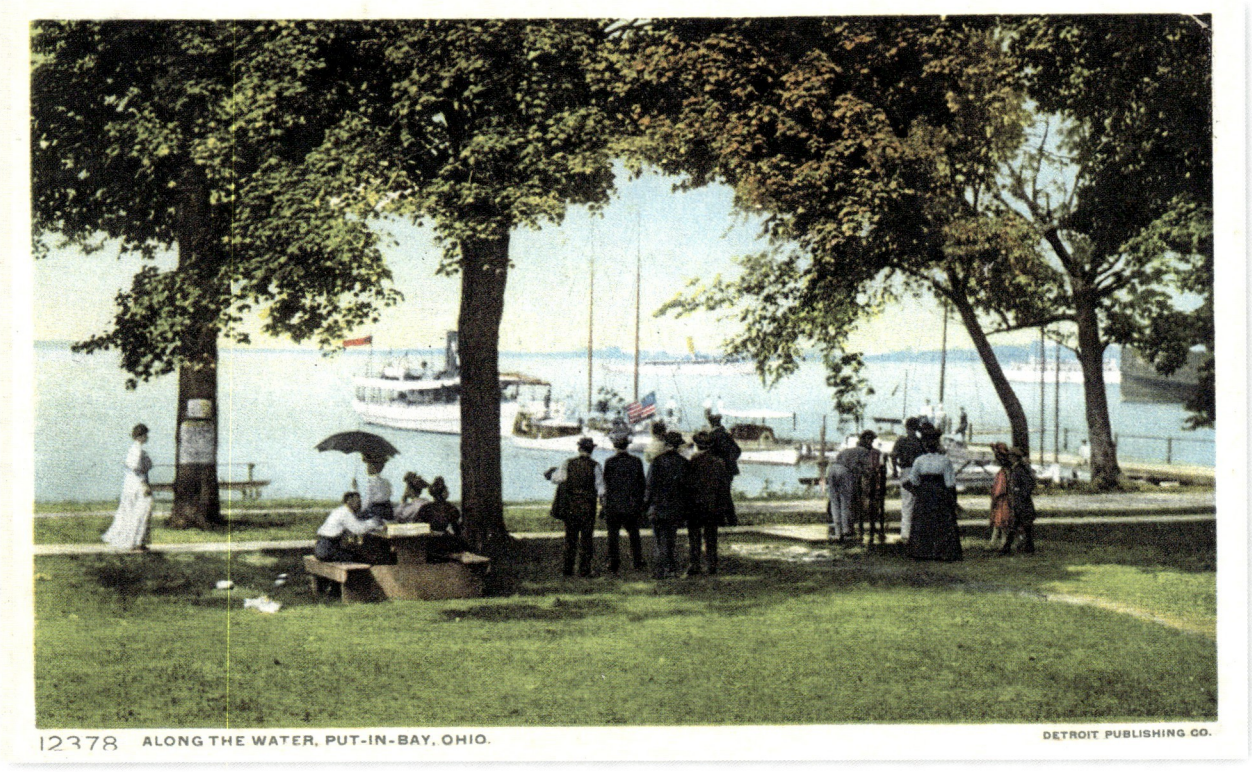

12378 ALONG THE WATER, PUT-IN-BAY, OHIO. DETROIT PUBLISHING CO.

228 OHIO | PUT-IN-BAY

Page 228, top: Along the water, Put-in-Bay
Page 228, below: Landing of the Cleveland-Toledo boats, Put-in-Bay, glass negative, ca. 1904
Right: Delaware Avenue, Put-in-Bay
Below: Boardwalk casino, Toledo, glass negative, 1905

Every day, steamers from Toledo and Cleveland to South Bass Island, not far from the mouth of the Detroit River on Lake Erie, tied up at Put-in-Bay dock to disembark their contingent of tourists. One of the biggest hotels in the world, the Victory, opened at Put-in-Bay in 1892; it boasted 625 guest rooms and its dining room could accommodate 1,000 people.

Seite 228, oben: Am Ufer, Put-in-Bay
Seite 228, unten: Anlegestelle der Schiffe nach Cleveland und Toledo, Put-in-Bay, Glasnegativ, um 1904
Rechts: Delaware Avenue, Put-in-Bay
Unten: Das Kasino auf der Promenade, Toledo, Glasnegativ, 1905

Jeden Sommer entluden die aus Toledo und Cleveland kommenden Dampfschiffe ihr Kontingent an Touristen im Hafen des Dorfes Put-in-Bay auf der kleinen Insel South Bass Island, unweit der Mündung des Detroit River in den Eriesee. Das Victory, eines des größten Hotels der Welt, eröffnete 1892 in Put-in-Bay; es umfasste 625 Zimmer und bot in seinem Speisesaal 1 000 Gästen Platz.

Page 228 en haut : au bord de l'eau, Put-in-Bay
Page 228 en bas : ponton d'accostage des bateaux pour Cleveland et Toledo, île de Put-in-Bay, plaque de verre, vers 1904
En haut : Delaware Avenue, Put-in-Bay
En bas : le casino de la Promenade, Toledo, plaque de verre, 1905

Sur la petite île de South Bass Island – non loin de l'embouchure de la Detroit River, dans le lac Érié –, les steamers en provenance de Toledo et de Cleveland débarquaient chaque été leur contingent de touristes dans le port du village de Put-in-Bay. L'un des plus grands hôtels du monde, le Victory, ouvrit ses portes à Put-in-Bay en 1892 ; il comptait 625 chambres et sa salle à manger pouvait accueillir 1 000 convives.

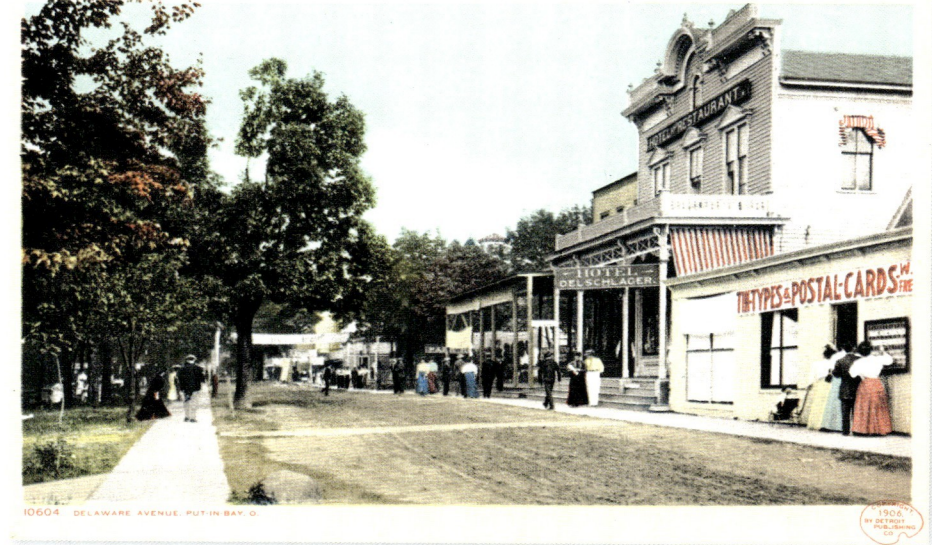

OHIO | PUT-IN-BAY | TOLEDO

MICHIGAN

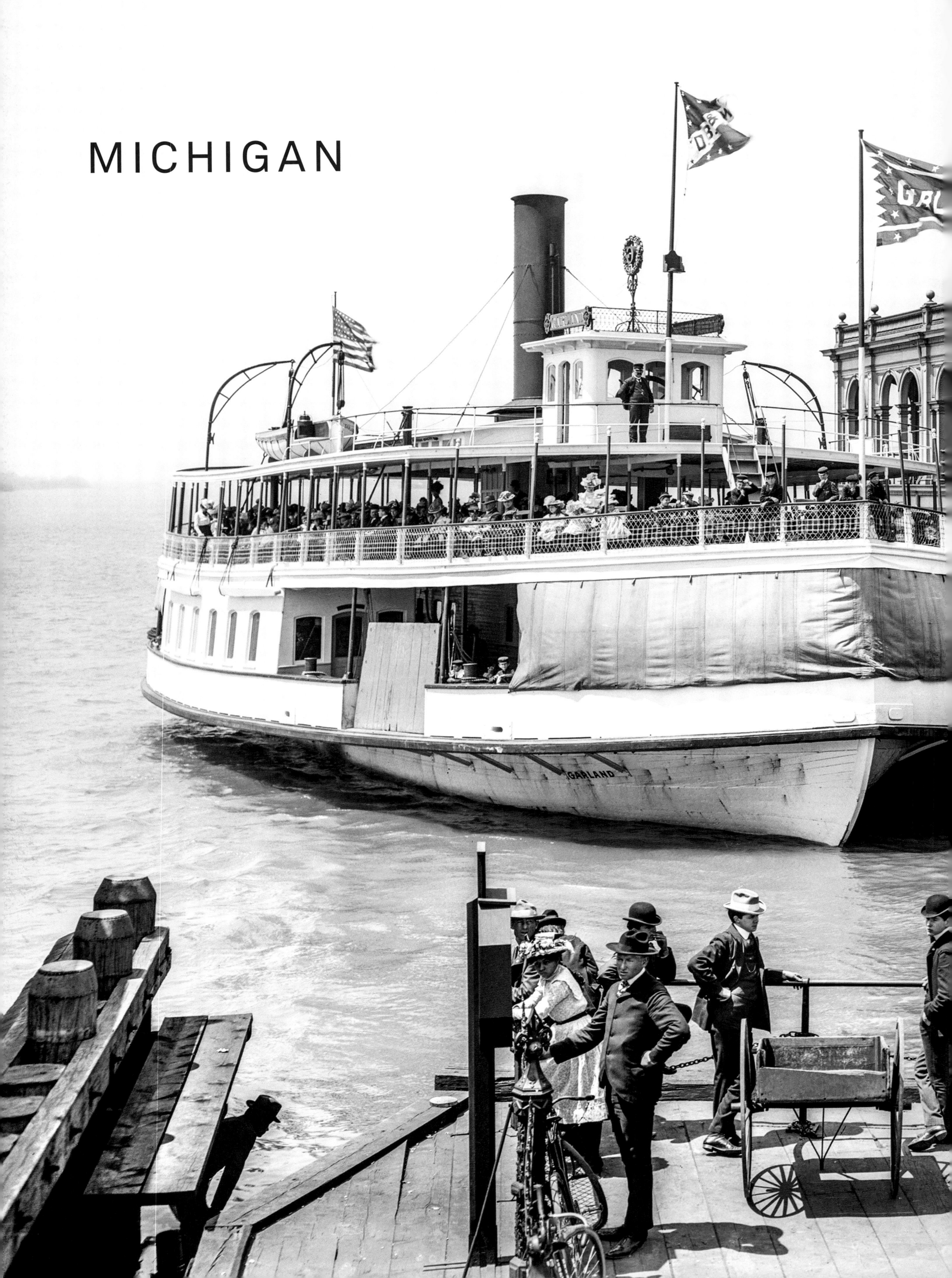

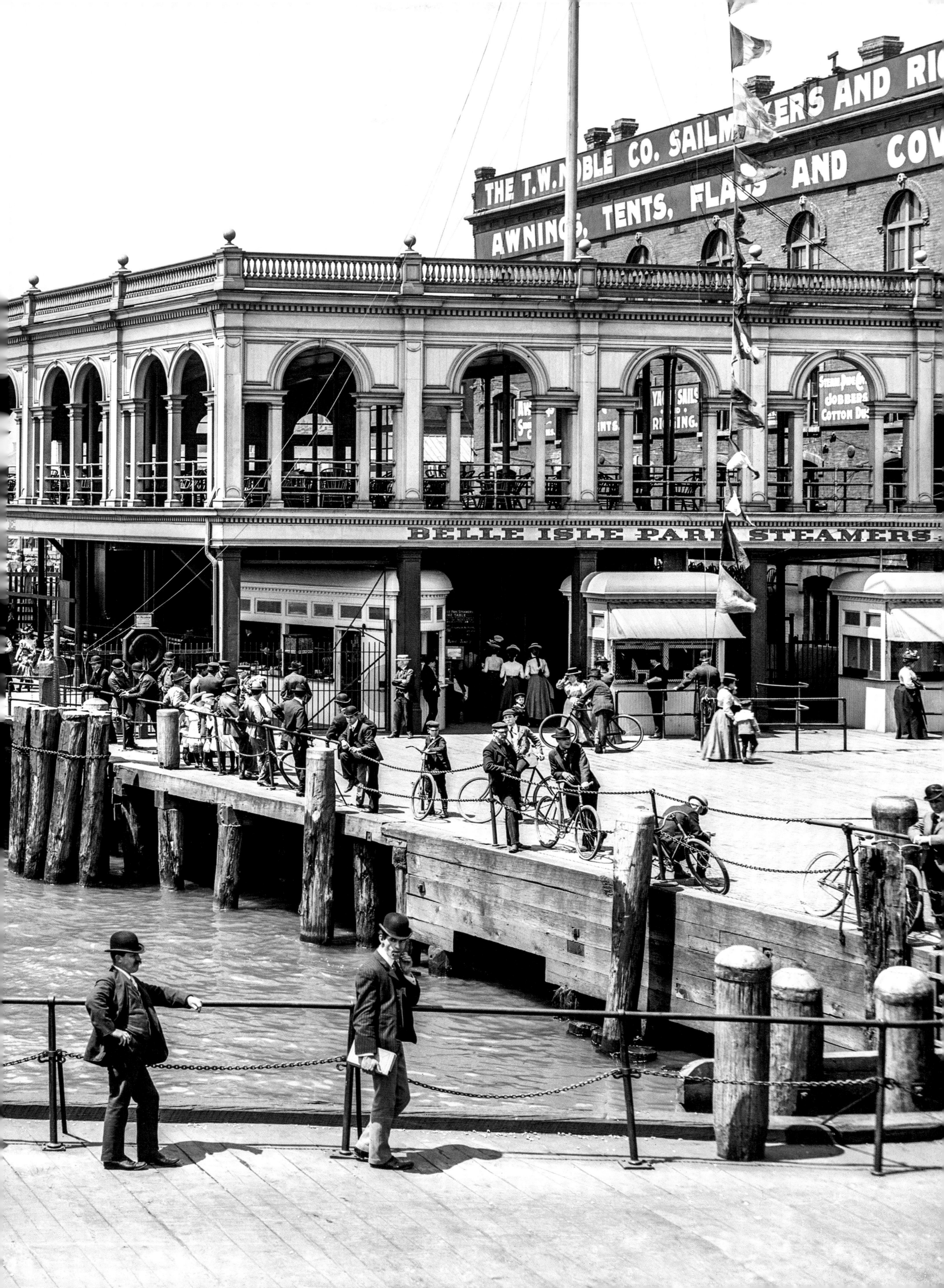

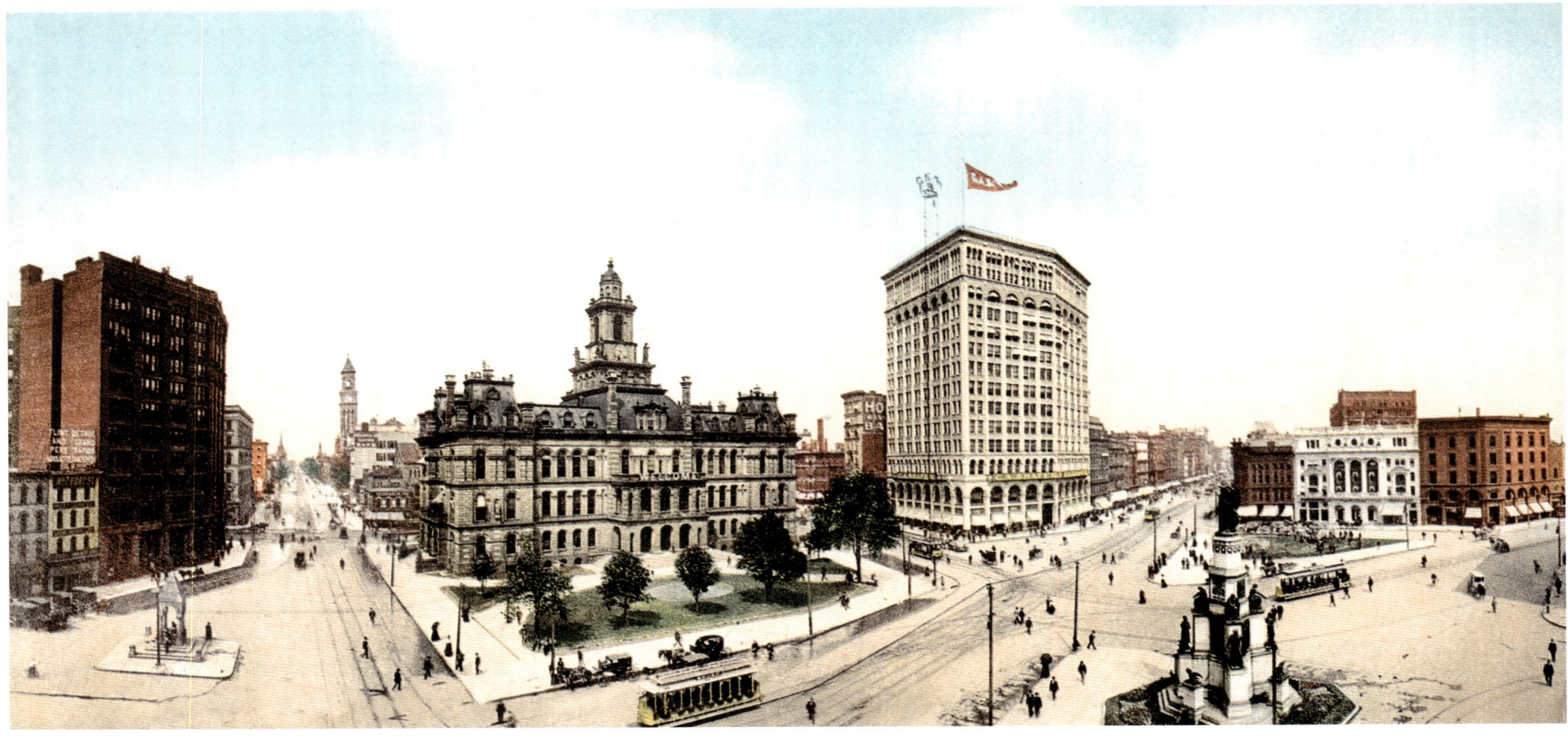

Page 230/231: Belle Isle ferry dock, Detroit, glass negative, 1900–1906
Above: Panorama of Campus Martius, photochrom
Below, From left to right and top to bottom:
The Italian winter garden of Book-Cadillac Hotel
Detroit News Building, news room, and editorial offices
Dime Savings Bank, safe deposit vaults
Detroit News Building, press and mailing rooms

Seite 230/231: Fähranleger von Belle Isle, Detroit, Glasnegativ, 1900–1906
Oben: Gesamtansicht des Marsfeldes von Detroit, Photochrom
Unten, von links nach rechts und von oben nach unten:
Der italienische Wintergarten des Hotels Book-Cadillac
Die Redaktionsräume im Detroit News Building
Dime Savings Bank, Tresorraum
Detroit News Building, Druckerei und Abfertigungshalle

Pages 230/231 : le quai des ferries de Belle-Isle, Detroit, plaque de verre, 1900–1906
Ci-dessus : panorama du Champ-de-Mars, Detroit, photochrome
Ci-dessous, de gauche à droite et de haut en bas :
Le jardin d'hiver italien de l'hôtel Book-Cadillac
Les bureaux de la rédaction des *Detroit News*
Dime Savings Bank, la salle des coffres
L'imprimerie et la salle d'expédition des *Detroit News*

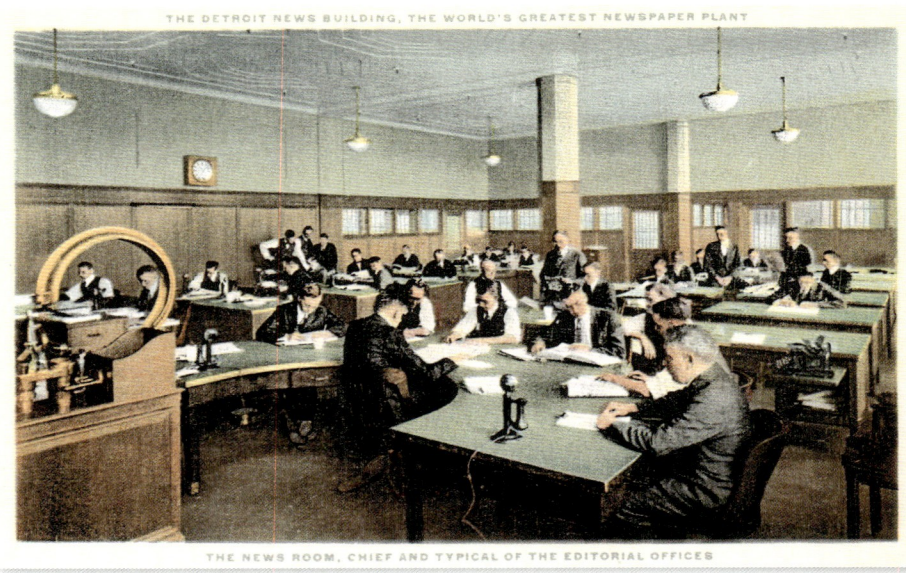
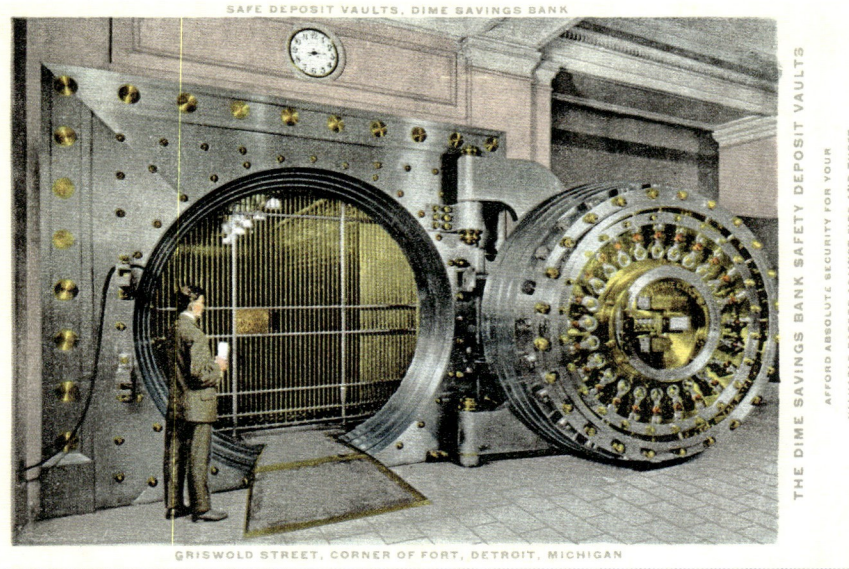
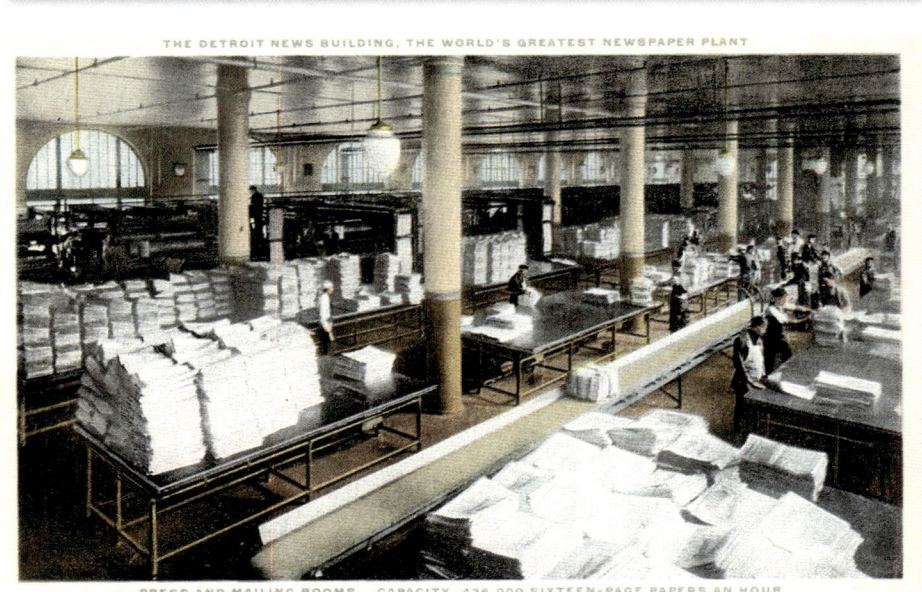

Right: **Ice fountain, Washington Boulevard**
Below: **Waterworks Park, lake and monument, photochrom**

The Detroit News was founded in 1873 by James E. Scripps, former manager of the *Detroit Tribune* and *Detroit Daily Advertiser*. A popular paper that offered its readers pages of free advertisements, it was first established on the premises of the *Free Press* before moving in 1917 to a building designed by Albert Kahn.
The minaret-shaped water tower of the Waterworks pumping station, built in 1879, formed part of Detroit's tourist heritage. Like the car manufacturer Cadillac, the Westin Book Cadillac Hotel, then the Book-Cadillac, owed its name to the city's founder, Antoine de Lamothe-Cadillac.

Rechts: **Eisbrunnen, Washington Boulevard**
Unten: **Waterworks Park, See und Denkmal, Photochrom**

James E. Scripps, der ehemalige Herausgeber der *Detroit Tribune* und des *Detroit Daily Advertiser* gründete 1873 die Zeitung *Les Nouvelles de Detroit*, die bei ihren Lesern wegen ihrer Seiten mit Gratisanzeigen beliebt war. Sie richtete sich zuerst in den Räumen von *Free Press* ein, bevor sie 1917 in ein Gebäude von Albert Kahn umzog.
Der minarettartige Wasserturm der 1879 gegründeten Pumpstation Waterworks gehört zum touristischen Erbe Detroits. Der Name des Hotels Book-Cadillac geht ebenso wie die Automarke Cadillac auf den Stadtgründer, Antoine de Lamothe-Cadillac, zurück.

À droite : **fontaine de glace, Washington Boulevard**
Ci-dessous : **parc de Waterworks, le lac et le monument, photochrome**

Le journal *The Detroit News* fut fondé en 1873 par James E. Scripps, ancien directeur du *Detroit Tribune* et du *Detroit Daily Advertiser*. Ce journal populaire, qui offrait à ses lecteurs des pages d'annonces gratuites, s'installa dans les locaux du *Free Press* avant d'occuper, en 1917, un immeuble conçu par Albert Kahn.
Le château d'eau en forme de minaret de la station de pompage de Waterworks, créée en 1879, fait partie du patrimoine touristique de Detroit. Comme la marque automobile Cadillac, l'hôtel Book-Cadillac doit son nom au fondateur de la ville, Antoine de Lamothe-Cadillac.

MICHIGAN | DETROIT

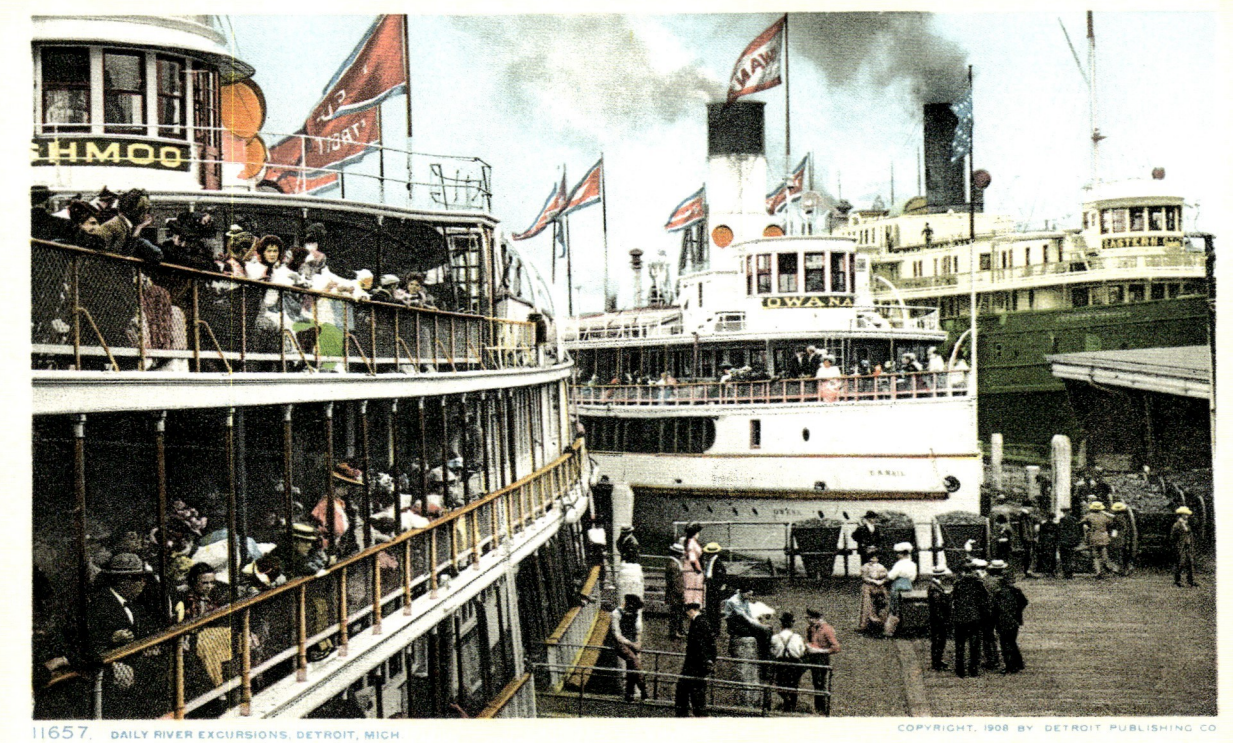

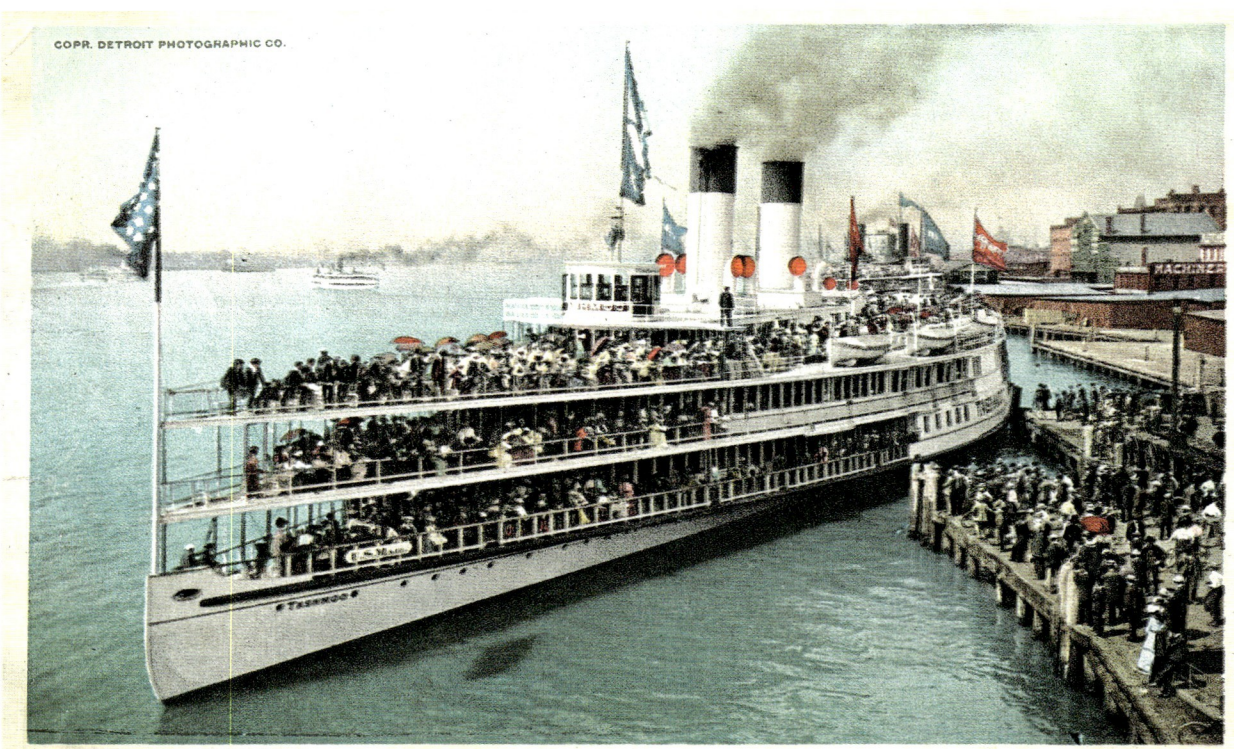

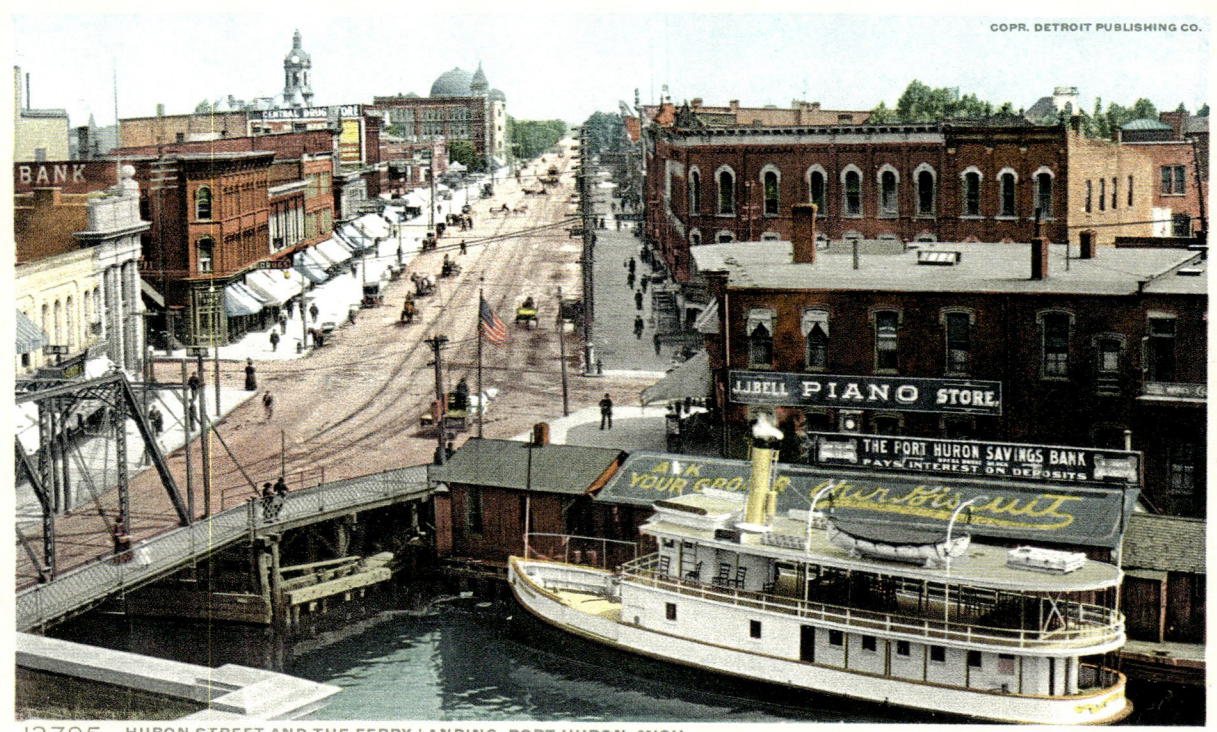

From top to bottom:
Daily river excursions, Detroit
Off for a river trip, Detroit
Huron Street and the ferry landing, Port Huron
Page 235:
Top left: Foot of Woodward Avenue and Griswold Street, Detroit
Top right: Detroit River tunnel
Bottom: The launch of steamer *Frank J. Hecker*, glass negative, 1905
Page 236/237: Car ferry *Michigan Central* entering slip, Detroit River, glass negative, 1880–1901

Detroit's exceptional location on the shores of both Lake Erie and Lake St. Clair, which connects with Lake Huron, made its port one of the most important in the Great Lakes and the city one of the most active in the United States. The site was explored in 1670 by French missionaries. Then, in 1701, Antoine de Lamothe-Cadillac established Fort Pontchartrain here. It was known as the fort "du Détroit" (meaning "of the straits") because the site dominated the straits of Lake Erie.

Von oben nach unten:
Ablegen zu den Tagesexkursionen, Detroit
Abfahrt zu einem Ausflug auf dem Fluss, Detroit
Huron Street und Fähranleger, Port Huron
Seite 235:
Oben links: Das untere Ende von Woodward Avenue und Griswold Street, Detroit
Oben rechts: Detroit River Tunnel
Unten: Der Stapellauf des Dampfschiffs *Frank J. Hecker*, Glasnegativ, 1905
Seite 236/237: Die Autofähre *Michigan Central* in der Hafeneinfahrt, Detroit River, Glasnegativ, 1880–1901

Die außergewöhnliche Lage von Detroit am Eriesee und zugleich am Saint-Clair-See (der mit dem Huronsee verbunden ist) hat seinen Hafen zu einem der wichtigsten der Großen Seen gemacht und die Stadt zu einer der betriebsamsten der Vereinigten Staaten. 1670 entdeckten französische Missionare den Ort, bevor 1701 Antoine de Lamothe-Cadillac hier den Stützpunkt Fort Pontchartrain gründete, der wegen seiner Lage an der See-Enge des Eriesees „du Détroit" (an der Meerenge) genannt wurde.

De haut en bas :
Départ des excursions à la journée, Detroit
Steamer quittant le quai de Detroit
Huron Street et le quai d'accostage du ferry, Port Huron
Page 235 :
En haut à gauche : le bas de l'avenue Woodward et de la rue Griswold, Detroit
En haut à droite : le tunnel de la Detroit River
En bas : lancement du steamer *Frank J. Hecker*, plaque de verre, 1905
Pages 236/237 : le ferry *Michigan Central* entrant dans la passe, Detroit River, plaque de verre, 1880–1901

L'exceptionnelle situation de Detroit sur le lac Érié et le lac Sainte-Claire (qui communique avec le lac Huron) a fait de son port l'un des plus importants des Grands Lacs, et de la ville l'une des plus actives des États-Unis. Le site fut exploré dès 1670 par des missionnaires français ; en 1701, Antoine de Lamothe-Cadillac y fonda le fort Pontchartrain, dit « du Détroit » car il domine le détroit du lac Érié.

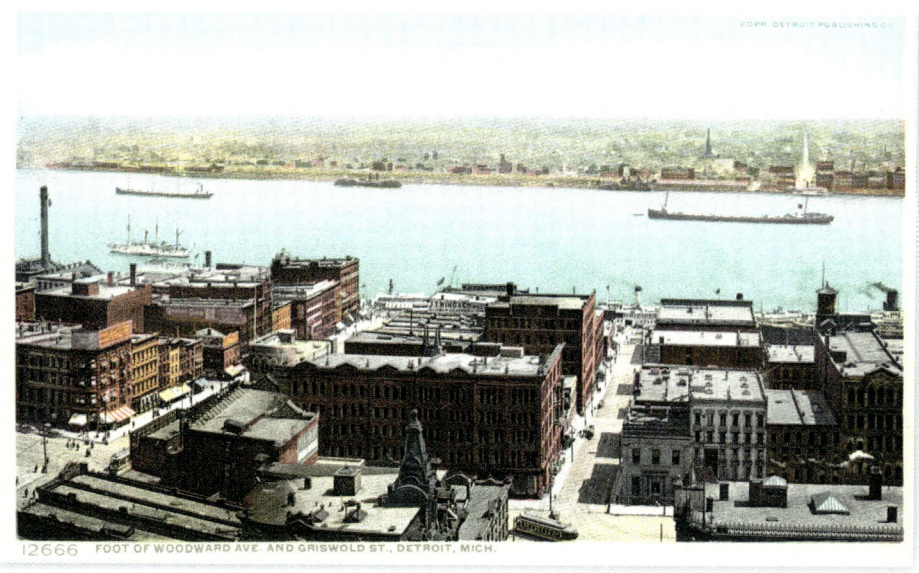
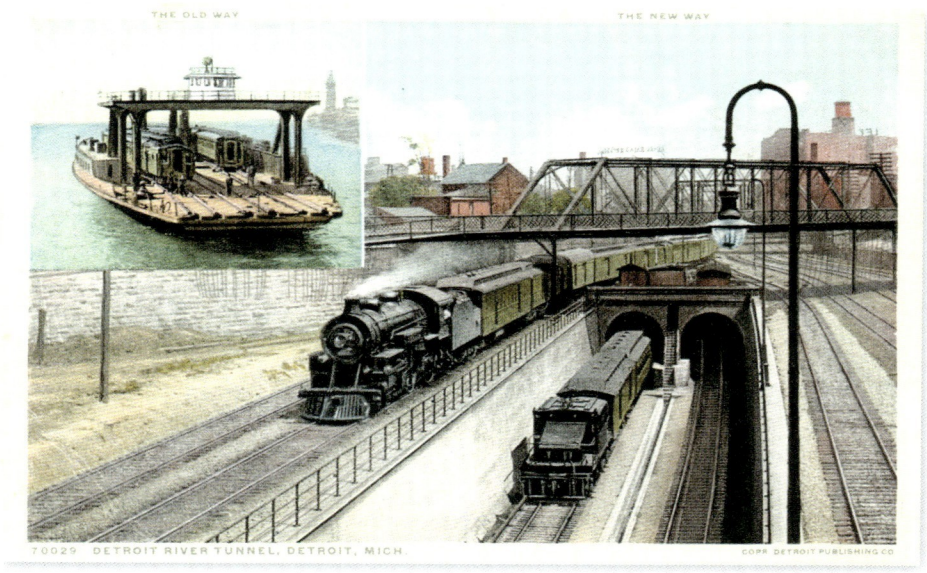

MICHIGAN | DETROIT 235

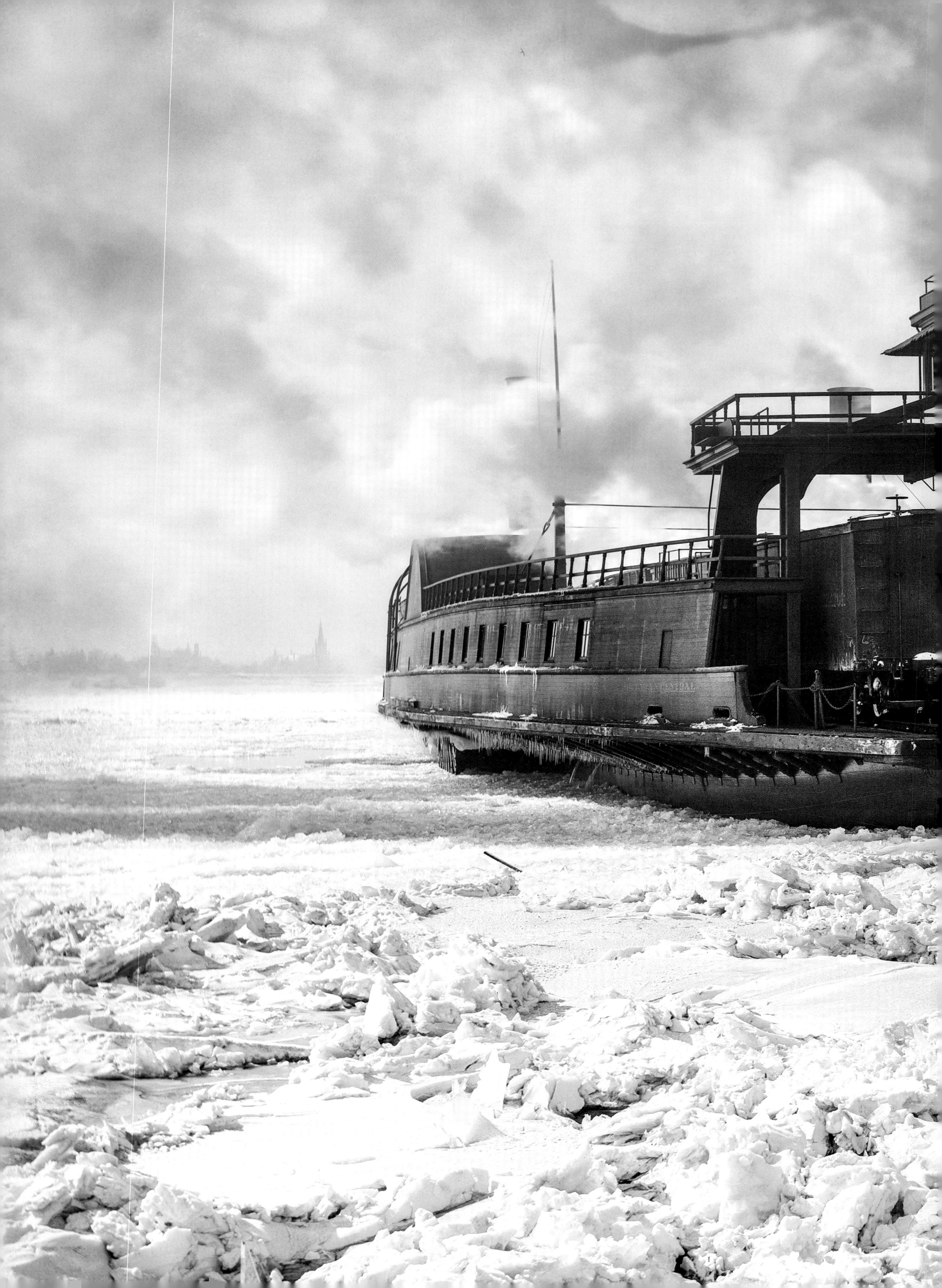

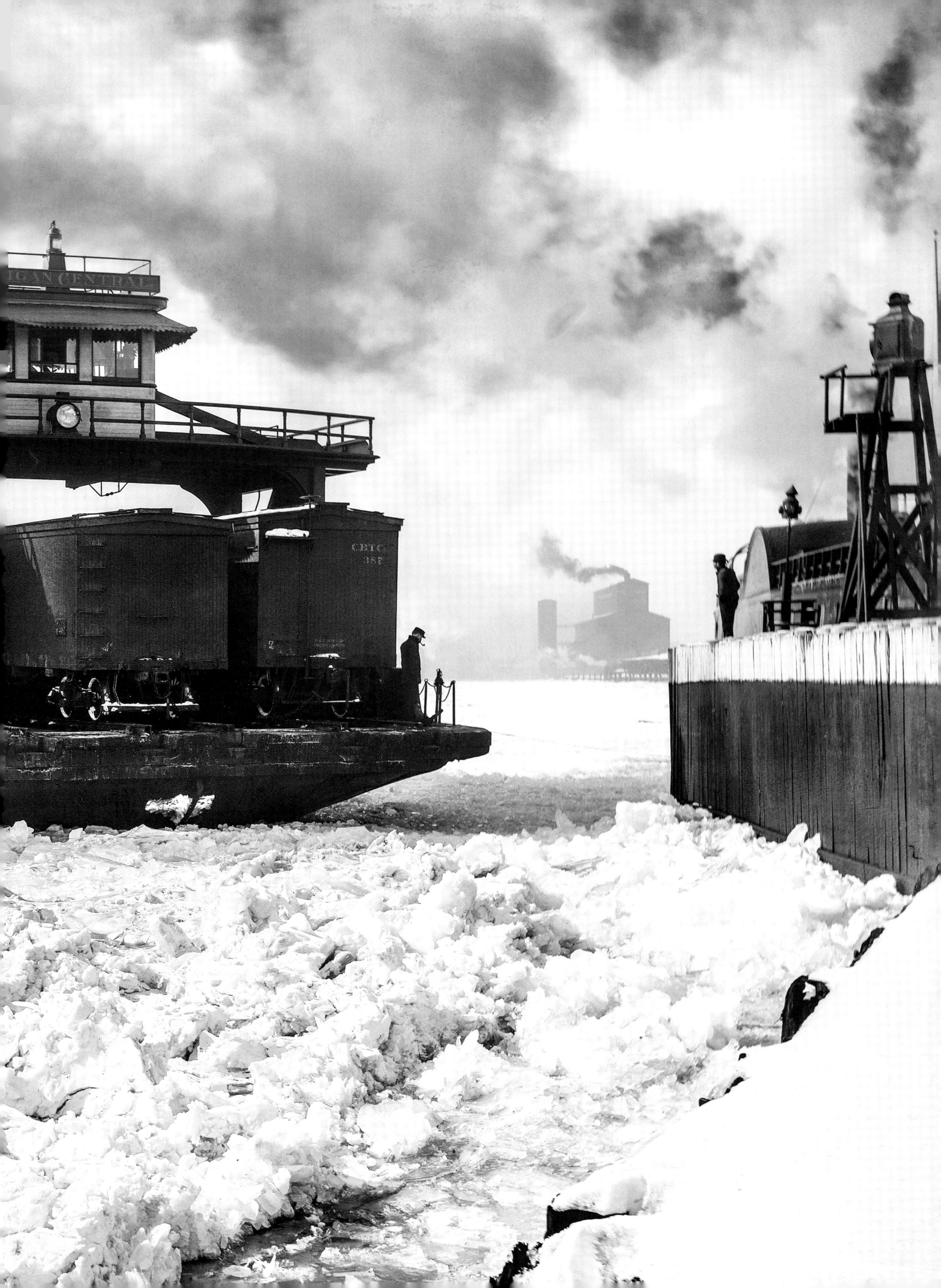

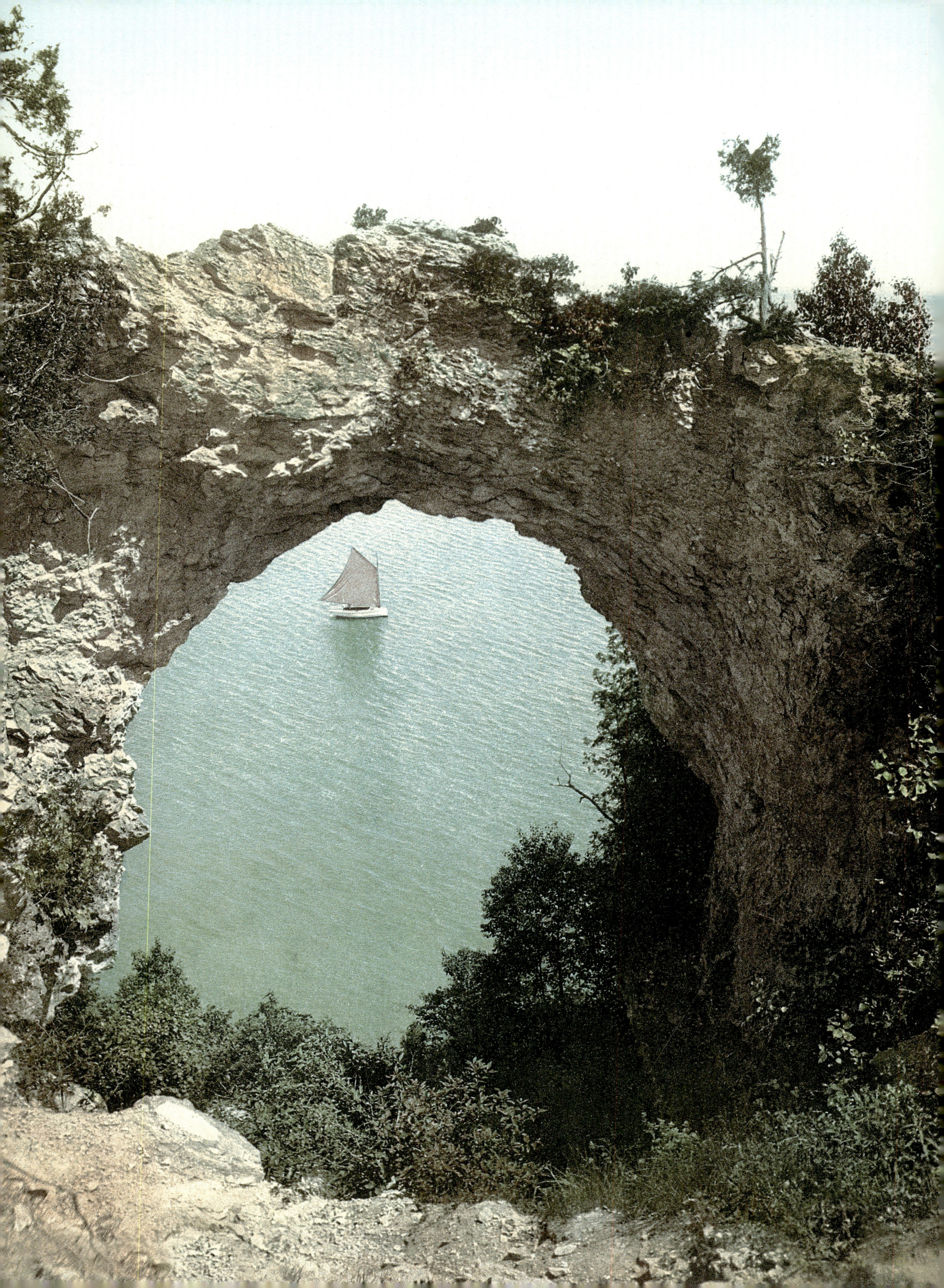

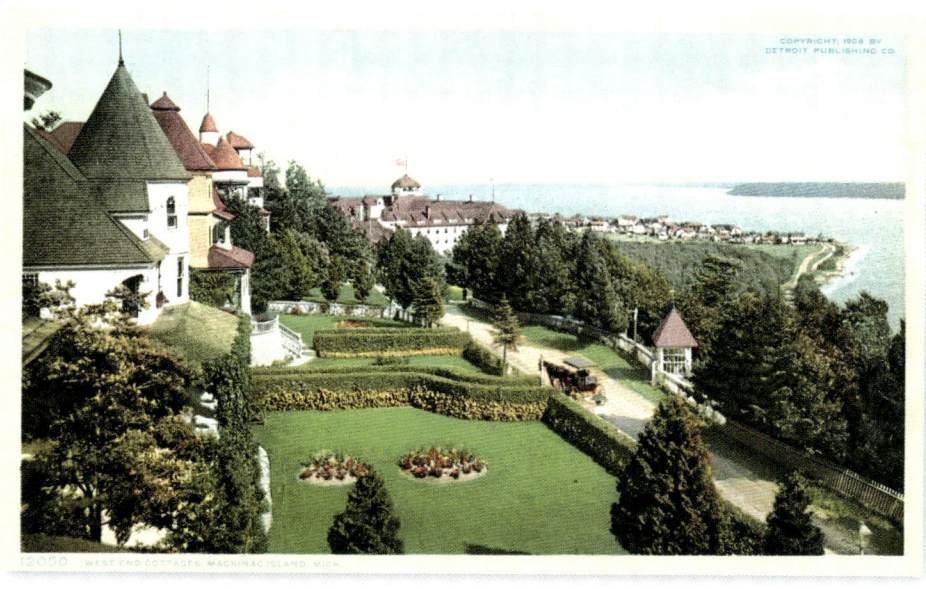

Page 238: Arch Rock, Mackinac Island, photochrom
Above: West End cottages, Mackinac Island
Middle: New Mackinac and New Murray Hotels
Below: Main Street

Mackinac Island lies in Lake Huron in the far north of Michigan. Its position on the Mackinac Straits between Lake Michigan and Lake Huron made it a strategic point for the fur trade in the 17th century. In the early 20th century, it became a summer resort much loved by tourists who found the romantic beauty of its rocky coasts appealing.

Seite 238: Arch Rock, Mackinac Island, Photochrom
Oben: Die Villen am West End, Mackinac Island
Mitte: Das neue Mackinac und das neue Murray Hotel
Unten: Die Hauptstraße

Im äußersten Norden von Michigan liegt Mackinac Island, eine kleine Insel im Huronsee. Dank ihrer Lage in der See-Enge von Mackinac, die den Michigansee mit dem Huronsee verbindet, war sie seit dem 17. Jahrhundert ein strategischer Punkt für den Pelzhandel. Anfang des 20. Jahrhunderts wurde sie zu einem Sommerurlaubsort, der besonders wegen der romantischen Schönheit seiner Felsküste beliebt war.

Page 238: Arch Rock, Mackinac Island, photochrome
En haut : les villas de la pointe ouest
Au centre : les nouveaux hôtels Mackinac et Murray
En bas : la rue Principale (Main Street)

À l'extrême nord du Michigan, Mackinac Island est une petite île du lac Huron. Sa position dans le détroit de Mackinac, qui relie le lac Michigan au lac Huron, a fait d'elle dès le XVIIe siècle un point stratégique pour la traite des fourrures. Au début du XXe siècle, elle est devenue un lieu de séjour estival très prisé des voyageurs sensibles à la beauté romantique de ses côtes rocheuses.

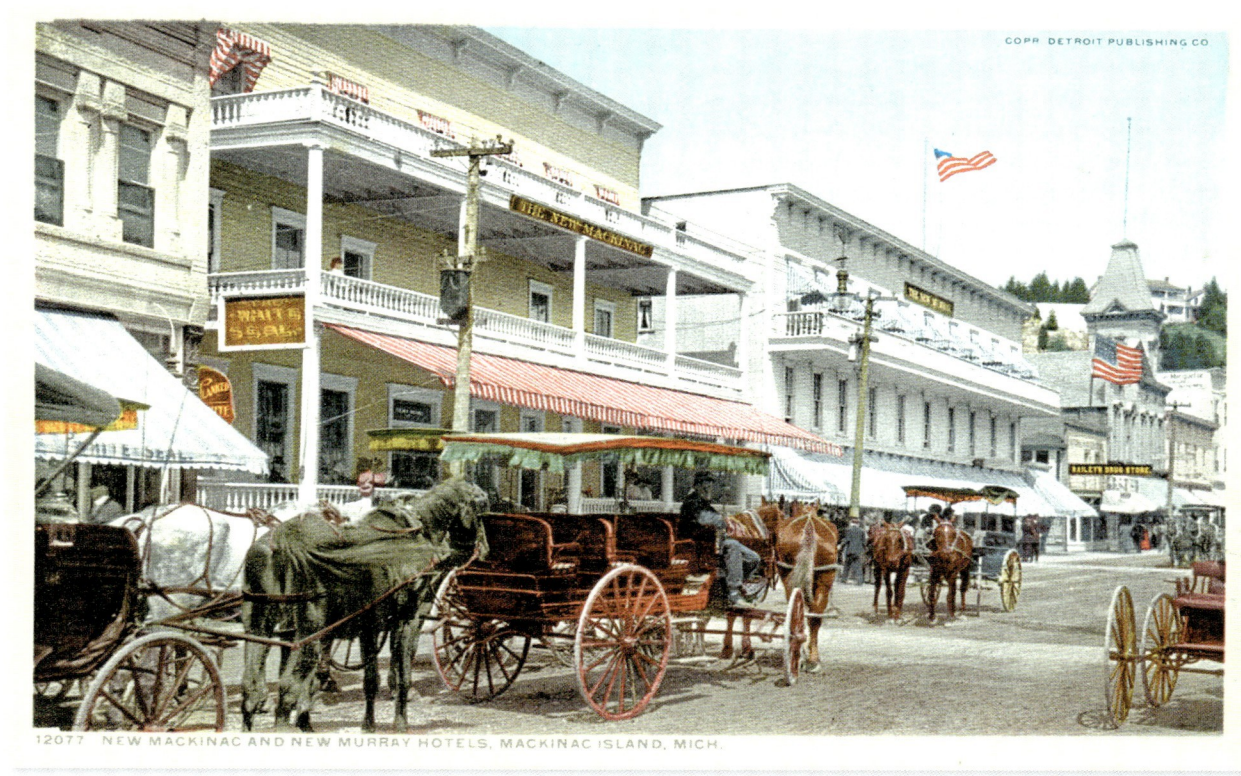

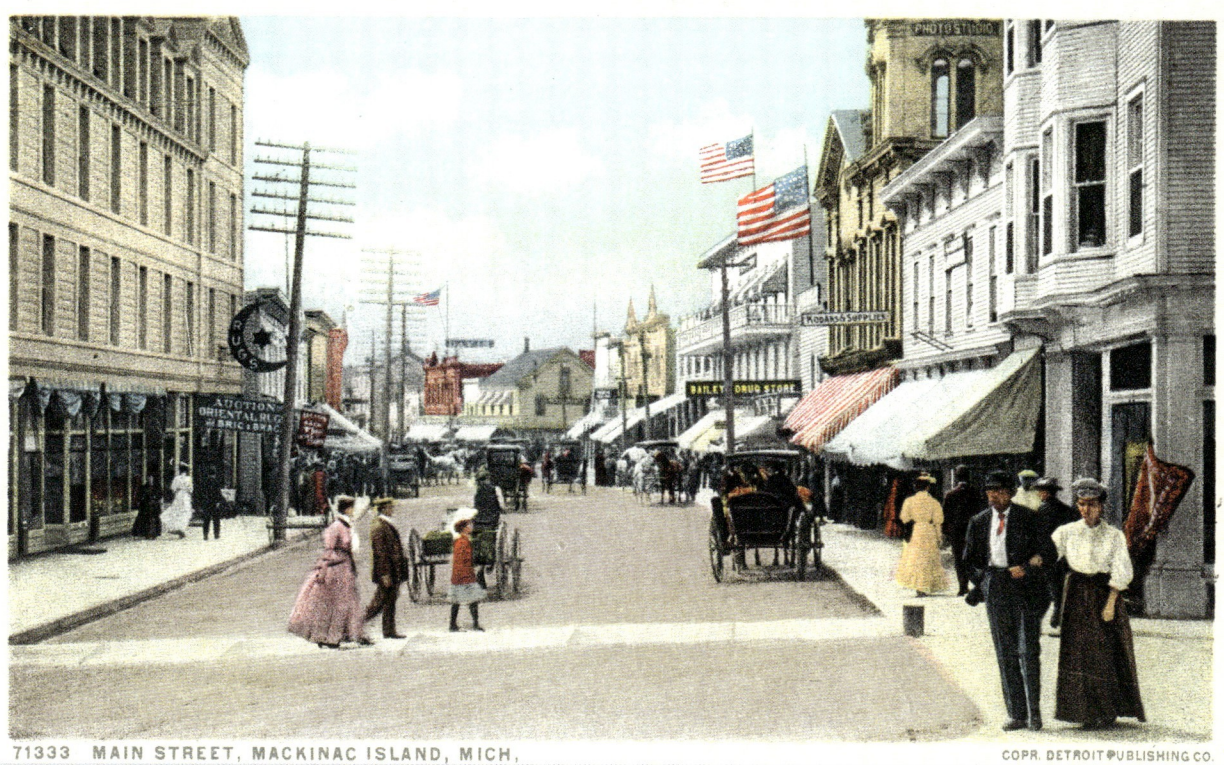

MICHIGAN | MACKINAC ISLAND

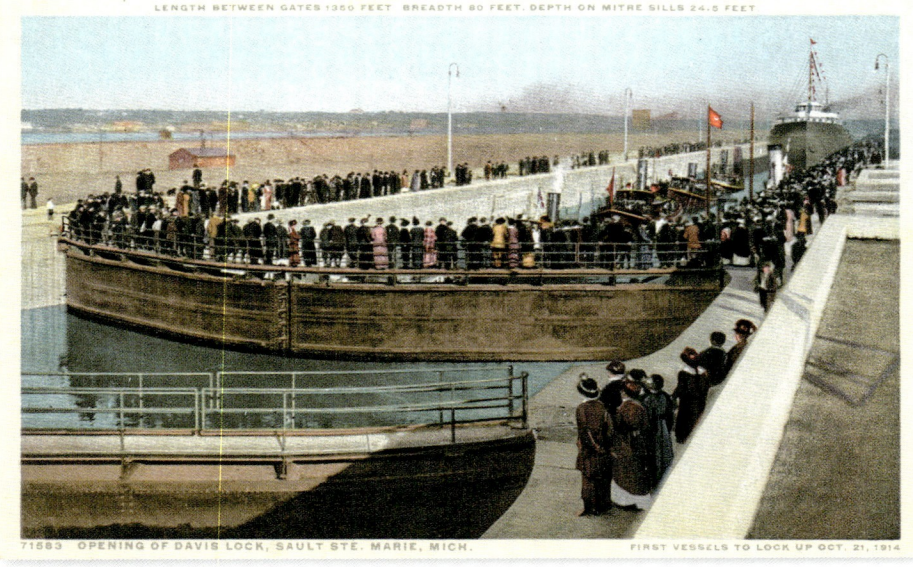
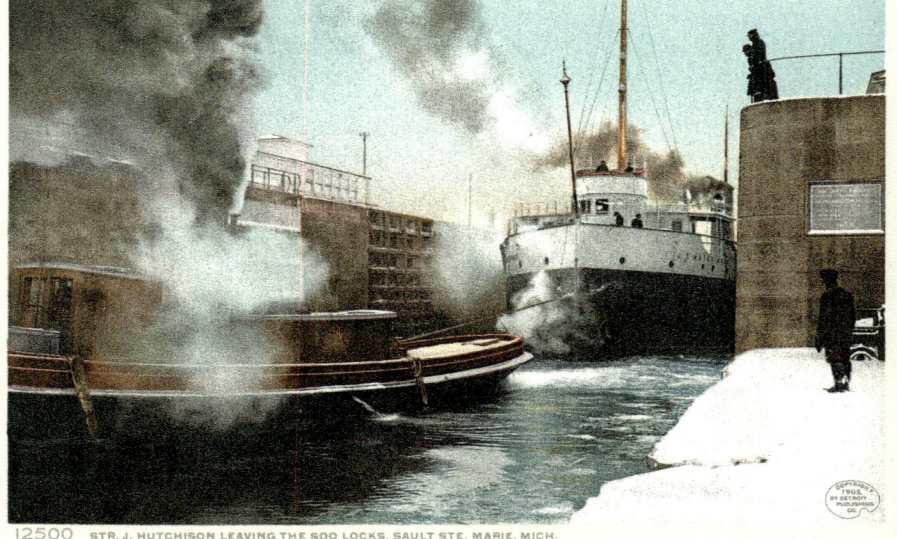
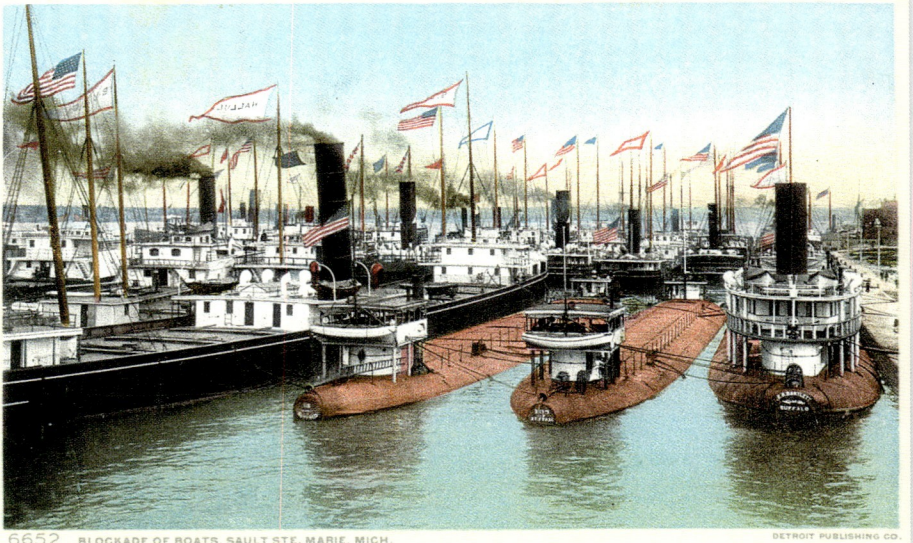

Top left: **Opening of Davis Lock**
Top right: **Steamer** *Hutchison* **leaving the Soo Locks**
Right: **Blockade of boats**
Bottom: **Sault Ste. Marie, the locks, photochrom**

Oben links: **Eröffnung der Schleuse Davis Lock**
Oben rechts: **Das Dampfschiff** *Hutchison* **beim Verlassen der Schleusen von Soo**
Rechts: **Schiffsstau in der Schleuse**
Unten: **Die Schleusen von Sault Ste. Marie, Photochrom**

En haut à gauche : **ouverture de l'écluse de Davis (Davis Lock)**
En haut à droite : **le steamer** *Hutchison* **quittant les écluses de Soo**
À droite : **embouteillage à l'écluse**
Ci-dessous : **Sault-Sainte-Marie, les écluses, photochrome**

From top to bottom:
Indians fishing at the Soo, photochrom
Rapids of the St. Marys River, photochrom
"Whaleback" leaving Poe Lock, photochrom

Before the construction of the Soo Locks was completed in 1855, the Ojibwa Native Americans ran the rapids of the St. Marys River in their canoes; it was the only channel between Lake Superior and Lake Huron.
The "whaleback" was a type of cargo ship specially designed for navigation on the Great Lakes; when it was fully loaded with grain or ore, only the rounded upper part of its hold could be seen on the surface of the water, whence its name.

Von oben nach unten:
Indianer beim Fischfang vor der Soo-Schleuse, Photochrom
Die Stromschnellen auf dem St. Marys River, Photochrom
"Whaleback" (Schiff in der Form eines Walrückens) beim Verlassen der Schleuse von Poe, Photochrom

Bevor 1855 in Sault die Schleusenanlage Soo Locks gebaut wurde, überwanden die Ojibwa-Indianer die Stromschnellen des St. Marys River, der einzigen Verbindung zwischen dem Oberen See und dem Huronsee, mit dem Kanu.
Der *whaleback* (wörtlich Walrücken) war ein speziell für die Schifffahrt auf den Großen Seen konzipierter Frachter; wenn er randvoll mit Weizen oder Erz beladen war, ragte nur noch der runde Teil seines Schiffskörpers aus dem Wasser – daher der Name.

De haut en bas :
Indiens pêchant à l'écluse de Soo, photochrome
Les rapides de la rivière Sainte-Marie, photochrome
« Whaleback » (bateau à « dos de baleine ») quittant l'écluse de Poe, photochrome

Avant la construction des écluses de Sault, les Soo Locks, en 1855, les Indiens Ojibwés franchissaient en canoë les rapides de la rivière Sainte-Marie, unique voie de passage entre le lac Supérieur et le lac Huron.
Le « whaleback » (littéralement « bateau à dos de baleine ») était un cargo spécialement conçu pour la navigation sur les Grands Lacs ; lorsqu'il était chargé à plein, de blé ou de minerai, on ne voyait plus que la partie arrondie de sa coque à la surface de l'eau – d'où son nom.

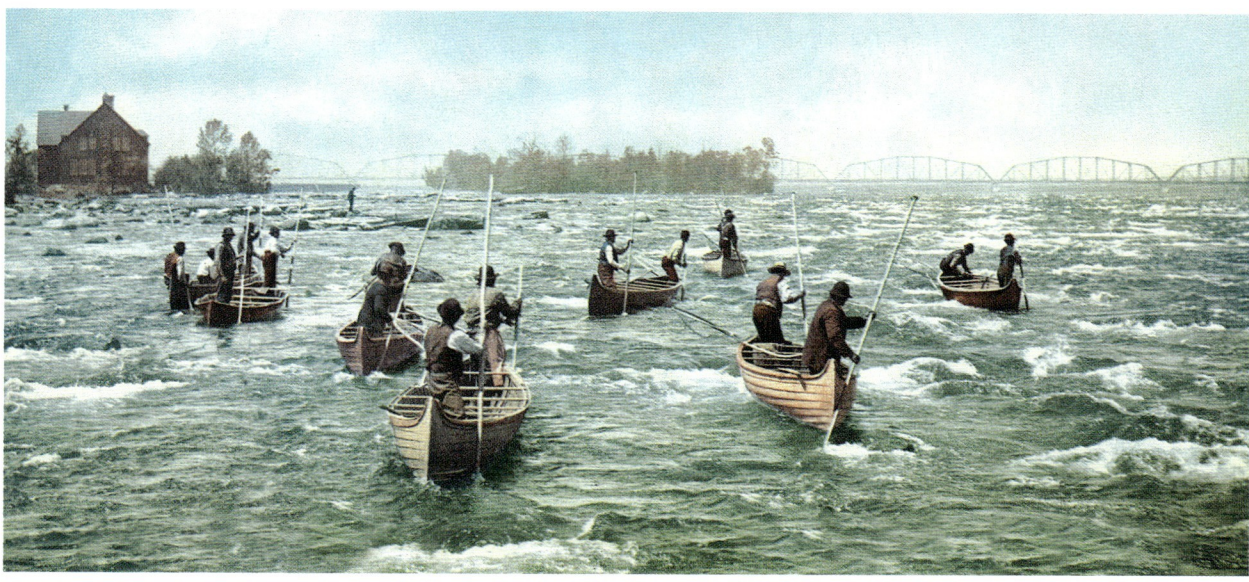

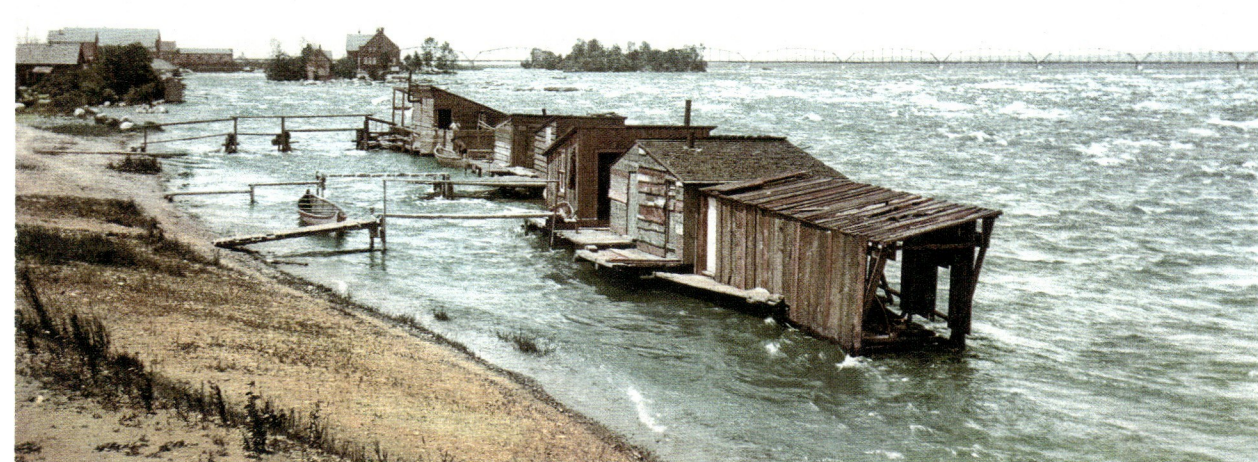

MICHIGAN | SAULT STE. MARIE

MICHIGAN | MARQUETTE

Page 242, above: **Marquette, Lighthouse Point**, photochrom
Page 242, below: **Arch Rock, Lake Superior**, photochrom
Right: **Lake Gogebic, black bass fishing**, glass negative, 1898
Below: **Gogebic Lake**, photochrom

Fishing in the Great Lakes was and, to some extent, remains a lucrative activity. Some 150 different species of fish are found in their waters, among them myriads of trout and salmon. 1889 and 1899 were record years for fishing in the Great Lakes, with a haul of 67,000 tons of fish.

Seite 242, oben: **Marquette, Leuchtturm**, Photochrom
Seite 242, unten: **Arch Rock, Oberer See**, Photochrom
Rechts: **Schwarzbarschfischer am Gogebic-See**, Glasnegativ, 1898
Unten: **Lake Gogebic**, Photochrom

Der Fischfang auf den Großen Seen war und ist noch immer, wenn auch heute in geringerem Maße, äußerst lukrativ; in ihrem Gewässer fand man 150 verschiedene Fischarten, darunter große Mengen an Forellen und Lachsen. In den Rekordjahren 1889 und 1899 fing man auf den Großen Seen insgesamt 67 000 Tonnen Fisch.

Page 242 en haut: **Marquette, le phare**, photochrome
Page 242 en bas: **Arch Rock, lac Supérieur**, photochrome
À droite: **pêcheurs de perches noires au lac Gogebic**, plaque de verre, 1898
En bas: **Le lac Gogebic**, photochrome

La pêche dans les Grands Lacs était – et reste, dans une moindre mesure – une activité particulièrement lucrative. On trouvait dans leurs eaux cent cinquante espèces différentes de poissons, parmi lesquelles des truites et des saumons en abondance. En 1889 et 1899, années record, on pêcha dans l'ensemble des Grands Lacs 67 000 tonnes de poisson.

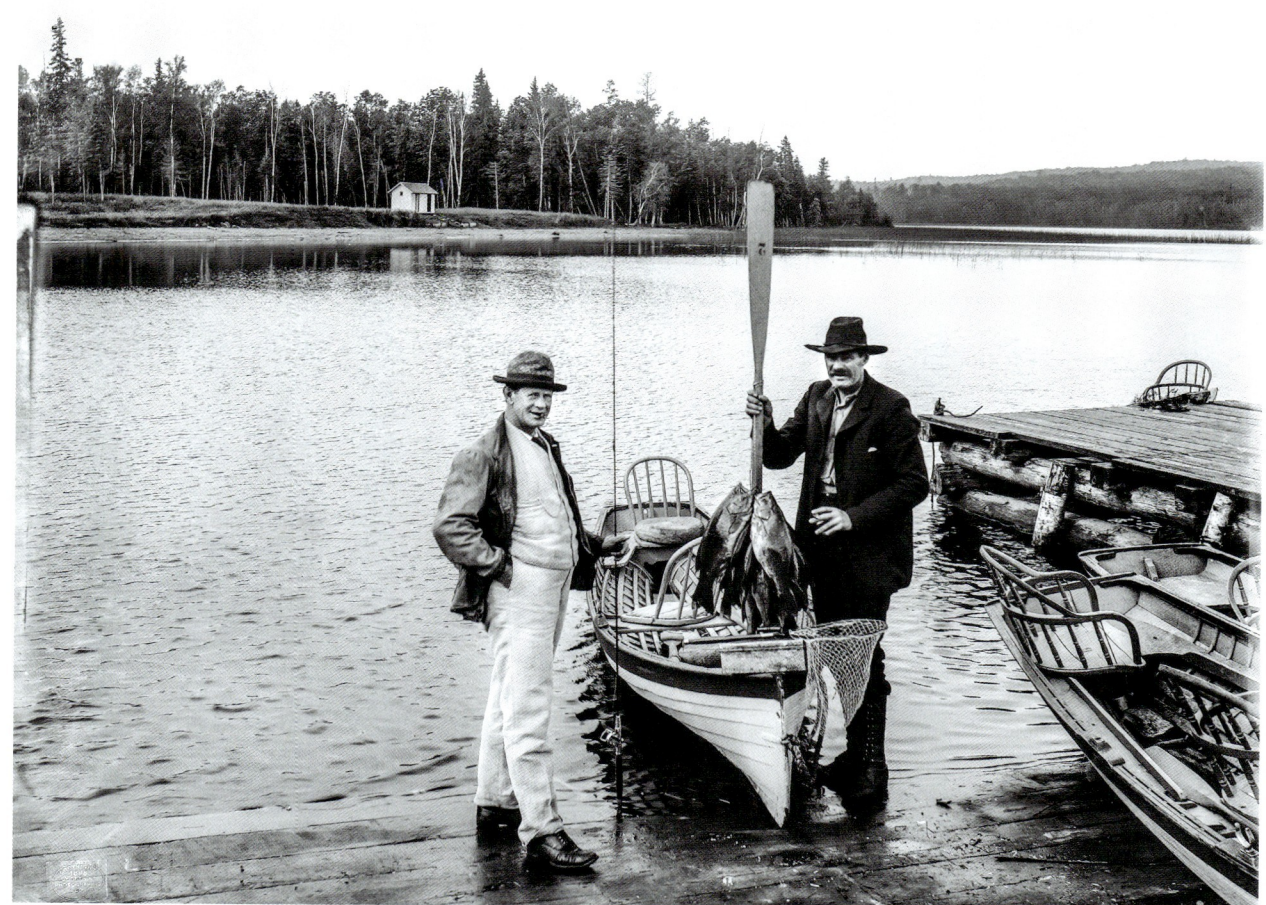

MICHIGAN | LAKE GOGEBIC

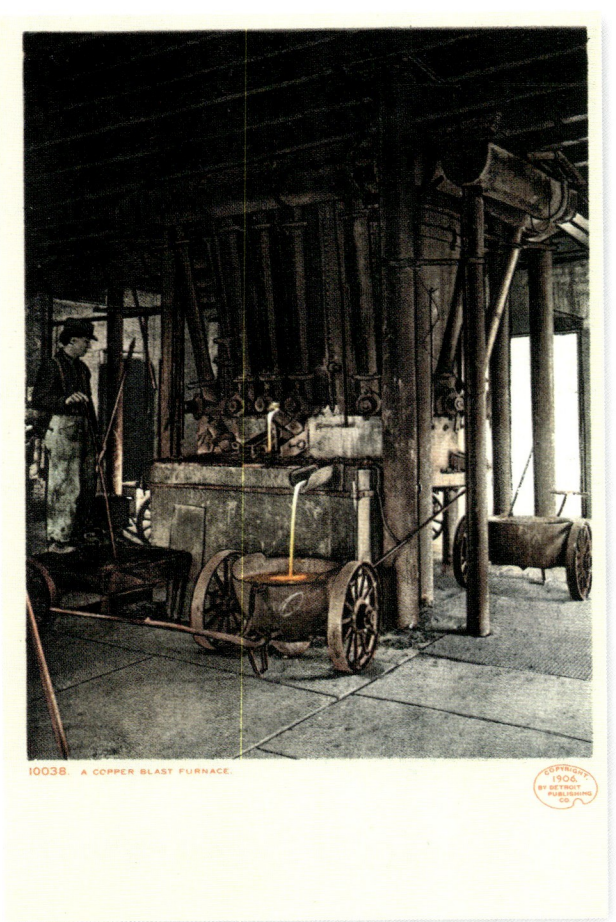

Left: A copper blast furnace
Below, From left to right and top to bottom:
**Calumet and Hecla Co. smelters, Lake Linden
Copper for shipment, Houghton
Pouring copper
Loading copper on steamer at Houghton**
Page 245: Calumet and Hecla Mine, shaft No. 2, glass negative, 1906

The Upper Peninsula of Michigan is rich in copper, which the Native Americans were exploiting well before the arrival of the first Europeans. Finnish and Cornish immigrants working in the Houghton mines called the region "Copper Island." In 1887, a fire broke out in Calumet Mine, razing 75 percent of the village.

Links: Kupferschmelzofen
Unten, von links nach rechts und von oben nach unten:
**Die Gießerei Calumet and Hecla, Lake Linden
Zur Verschiffung bereites Kupfer, Houghton
Kupfergießen
Verladen von Kupfer auf ein Dampfschiff in Houghton**
Seite 245: Die Mine von Calumet and Hecla, Schacht Nr. 2, Glasnegativ, 1906

Die Obere Halbinsel von Michigan ist reich an Kupfer. Die Indianer bauten dieses Erz bereits lange vor der Ankunft der ersten Europäer ab. Die Emigranten aus Finnland und Cornwall, die in den Minen von Houghton arbeiteten, nannten die Region „Copper Island" (Kupferinsel). In der Mine von Calumet brach 1887 ein Feuer aus, das 75 % des Dorfes vernichtete.

À gauche : Un four à fondre le cuivre
Ci-dessous, de gauche à droite et de haut en bas :
**Fonderie Calumet et Hecla, sur le lac Linden
Cuivre prêt à être embarqué, Houghton
Coulage du cuivre
Chargement de cuivre sur un steamer à Houghton**
Page 245 : mine de Calumet et Hecla, équipe n° 2, plaque de verre, 1906

La péninsule Supérieure du Michigan est riche en cuivre. Les Indiens exploitaient ce minerai bien avant l'arrivée des premiers Européens. Les émigrants finlandais et cornouaillais qui travaillaient dans les mines d'Houghton appelaient la région « Copper Island » (« île du cuivre »). Dans la mine de Calumet, en 1887, un incendie éclata qui dévasta 75 % du village.

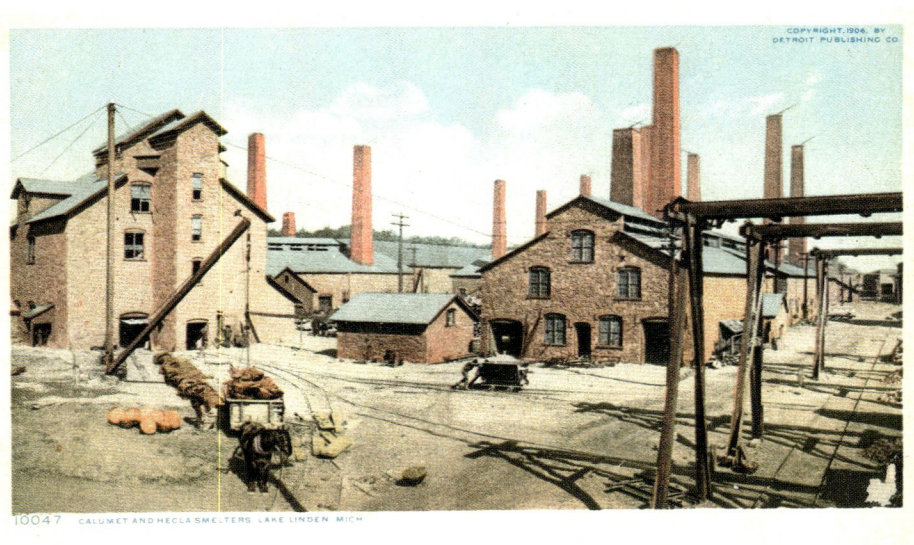

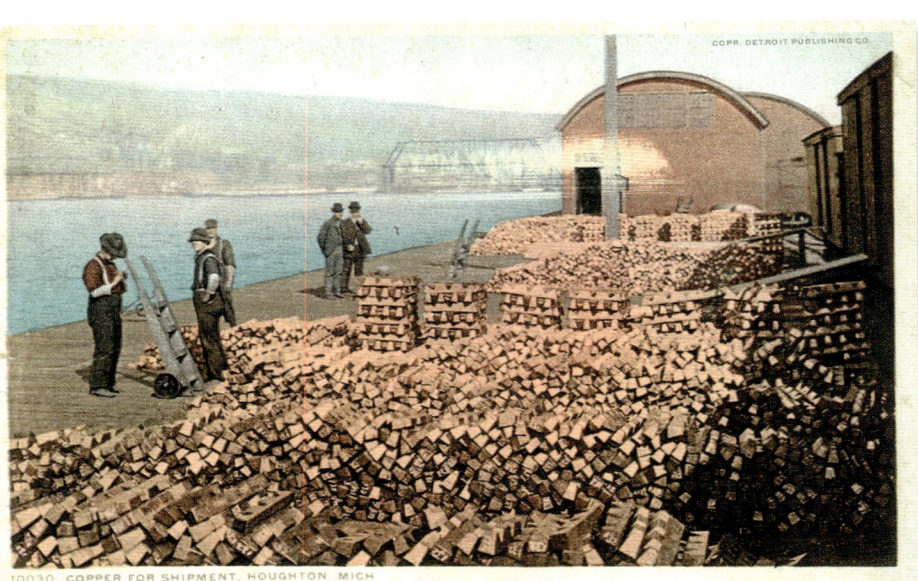

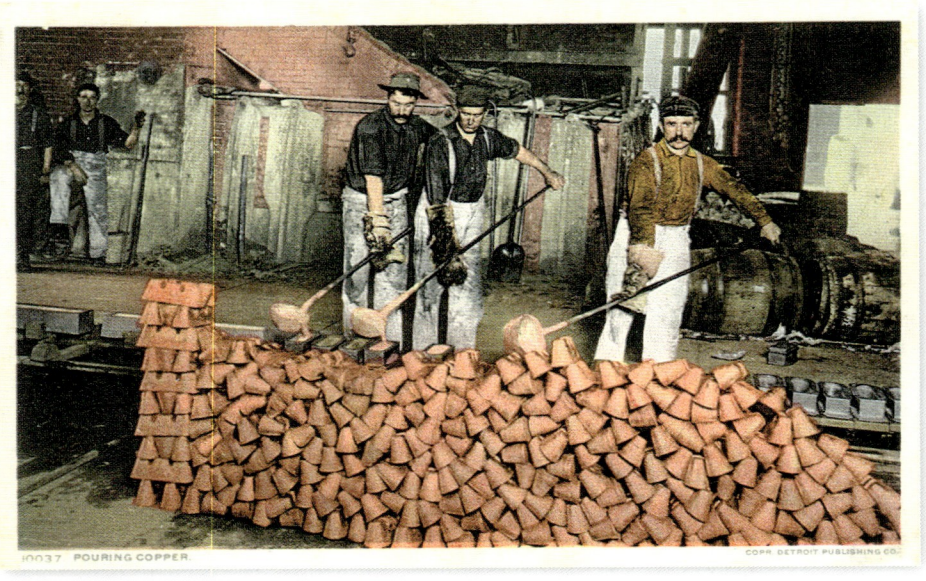

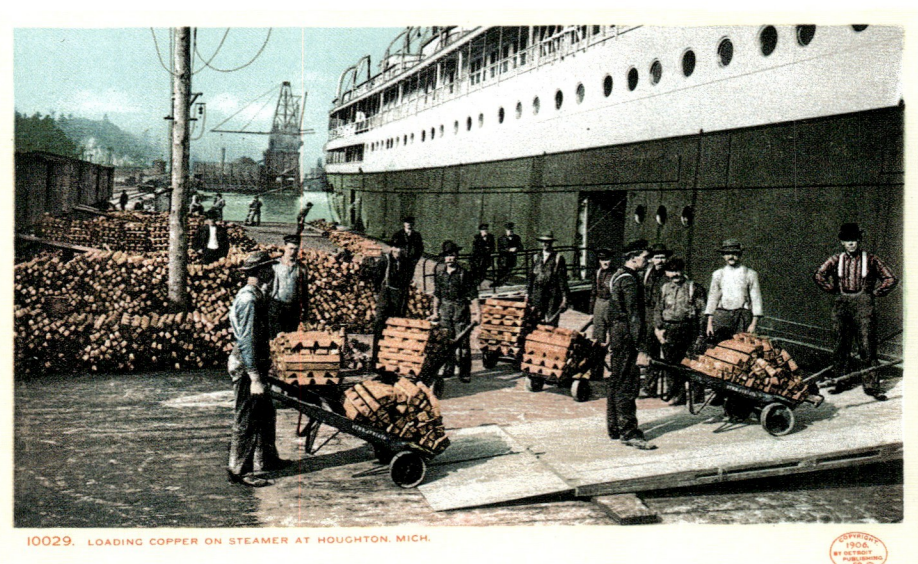

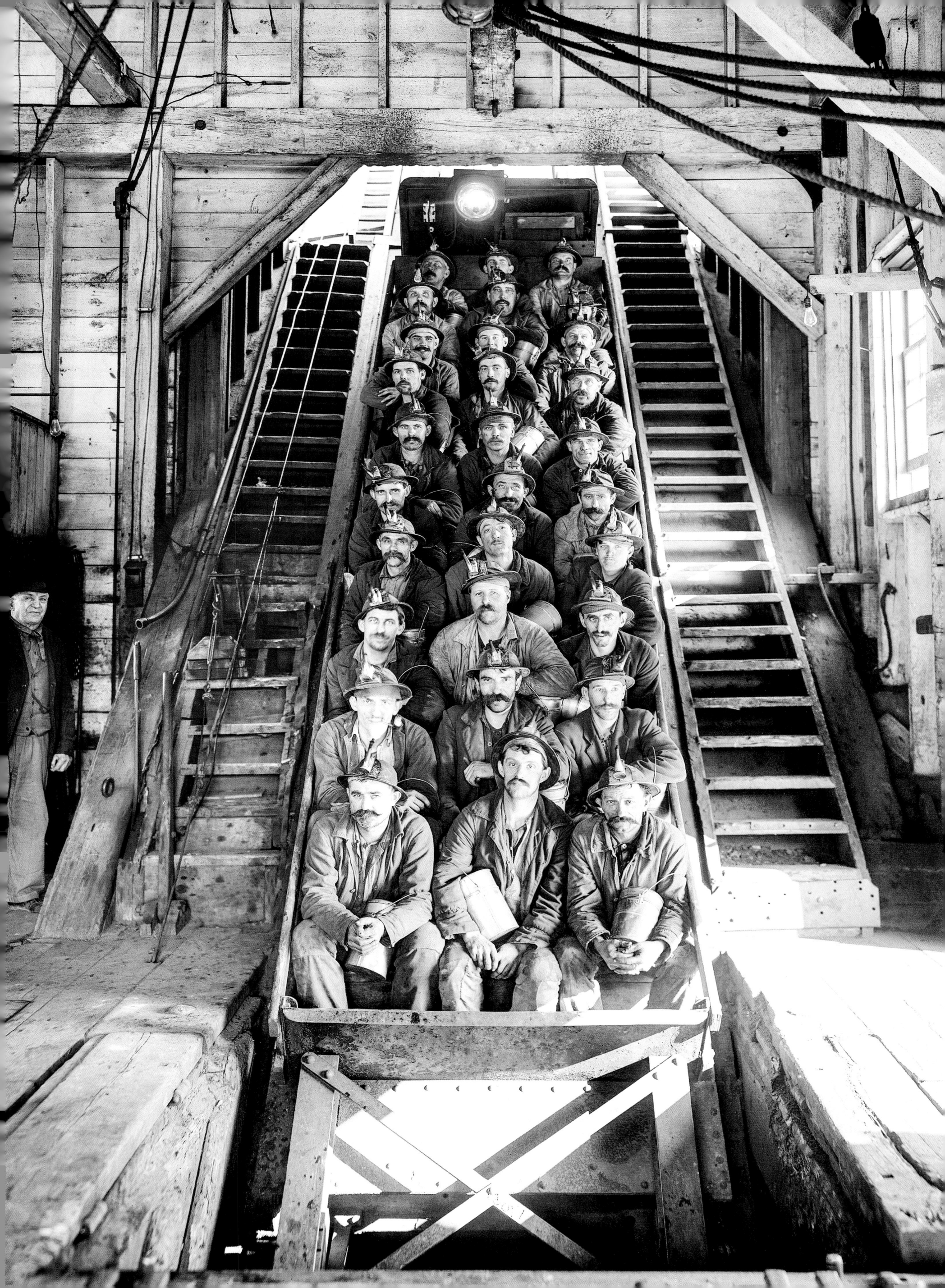

ILLINOIS

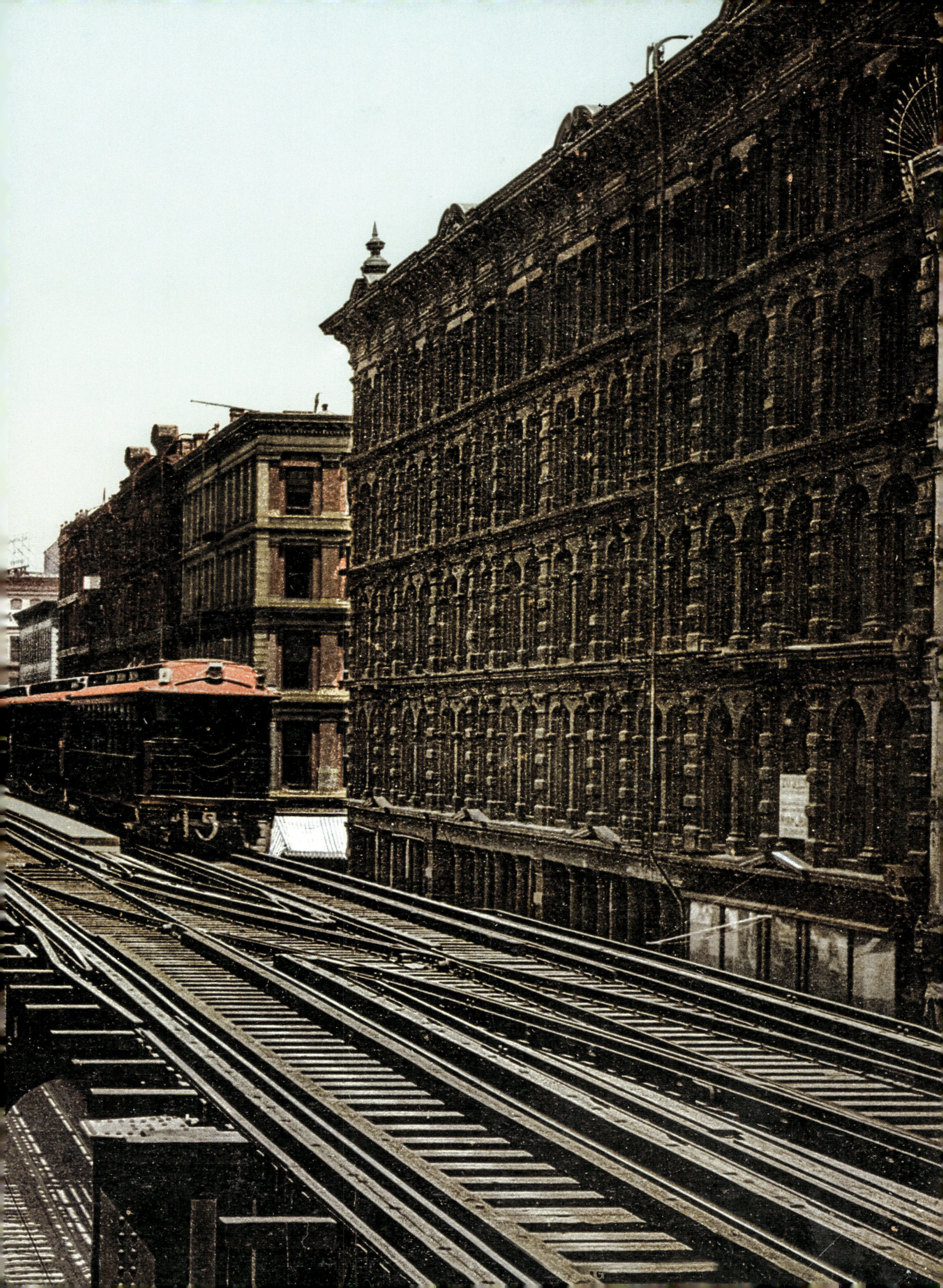

Page 246/247: **Wabash Avenue north from Adams Street, photochrom**
Top left: **Conservatory and gardens, Lincoln Park, Chicago**
Top right: **Lake Shore Drive, Lincoln Park**
Bottom: **Michigan Avenue, glass negative, ca. 1910–1920**

In 1900, Chicago was a city of contrasts: Downtown was the industrial inferno, the port and the slums; on the shores of Lake Michigan stood luxury hotels and palatial residences before a magnificent promenade, while in the center of the city there was the clatter of the streetcars and the bustle of business. It was in the business district that the Adams/Wabash station was opened in 1896 on the "El" (short for "elevated") section of the Chicago metro line.

Seite 246/247: **Die Wabash Avenue nördlich der Adams Street, Photochrom**
Oben links: **Gewächshaus und Gartenanlage, Lincoln Park, Chicago**
Oben rechts: **Die Straße am Seeufer, Lincoln Park**
Unten: **Michigan Avenue, Glasnegativ, um 1910–1920**

1900 war Chicago eine Stadt der Gegensätze: „Downtown" – die industrielle Hölle, der Hafen und die Armenquartiere; am Ufer des Michigansees – Luxushotels, herrliche Anwesen und eine wunderschöne Promenade; im Stadtzentrum – der Lärm der Straßenbahnen und das geschäftige Treiben. In diesem Geschäftsviertel wurde 1896 die Station Adams/Wabash der Chicagoer Hochbahnlinie „El" (Kurzform für „elevated") eröffnet.

Pages 246/247 : **Wabash Avenue au nord d'Adams Street, photochrome**
En haut à gauche : **la serre et les jardins, Lincoln Park, Chicago**
En haut à droite : **la route du bord du lac, Lincoln Park**
Ci-dessous : **Michigan Avenue, plaque de verre, vers 1910–1920**

En 1900, Chicago était une ville de contrastes : *downtown*, l'enfer industriel, le port et les taudis ; au bord du lac Michigan, des hôtels de luxe, de somptueuses résidences et une promenade magnifique ; au cœur de la ville, le fracas des tramways et l'agitation des affaires. C'est dans ce dernier quartier que passait la ligne du métro aérien (the «El») ; la station d'Adams/Wabash fut ouverte sur cette ligne en 1896.

Near right: **Arriving from the suburbs**
Far right: **Illinois Central Railroad station**
Below: **Chicago & North Western Railway Co. Station, photochrom**

The Illinois Central Station was built by the New York architect Bradford Gilbert in preparation for the World's Columbian Exposition of 1893. Its three-level marble waiting room looked out over Lake Michigan.
In 1898, the Pacific Express left the North Western Railway Co. Station for Denver and Portland, Oregon.

Rechts: **Ankunft der Vorortzüge**
Rechts außen: **Der Bahnhof Illinois Central Railroad Station**
Unten: **Bahnhof der Chicago & North Western Railway Co., Photochrom**

Der Bahnhof Illinois Central wurde von dem New Yorker Architekten Bradford Gilbert in Vorbereitung auf die World's Columbian Exposition von 1893 erbaut. Der dreistöckige Wartesaal aus Marmor war zum Michigansee hin ausgerichtet.
1898 fuhr der Pacific Express von dem Bahnhof der North Western Railway Co. nach Denver und Portland (Oregon).

Ci-contre : **arrivée des lignes de banlieue**
À droite : **la gare du chemin de fer Illinois Central Railroad**
Ci-dessous : **gare du chemin de fer Chicago & North Western Railroad, photochrome**

La gare du chemin de fer Illinois Central a été élevée par l'architecte new-yorkais Bradford Gilbert en prévision de la World's Columbian Exposition de 1893. Sa salle d'attente en marbre, sur trois niveaux, donnait sur le lac Michigan.
En 1898, le Pacific Express partait de la gare de la North Western Railway Co. pour gagner Denver et Portland (Oregon).

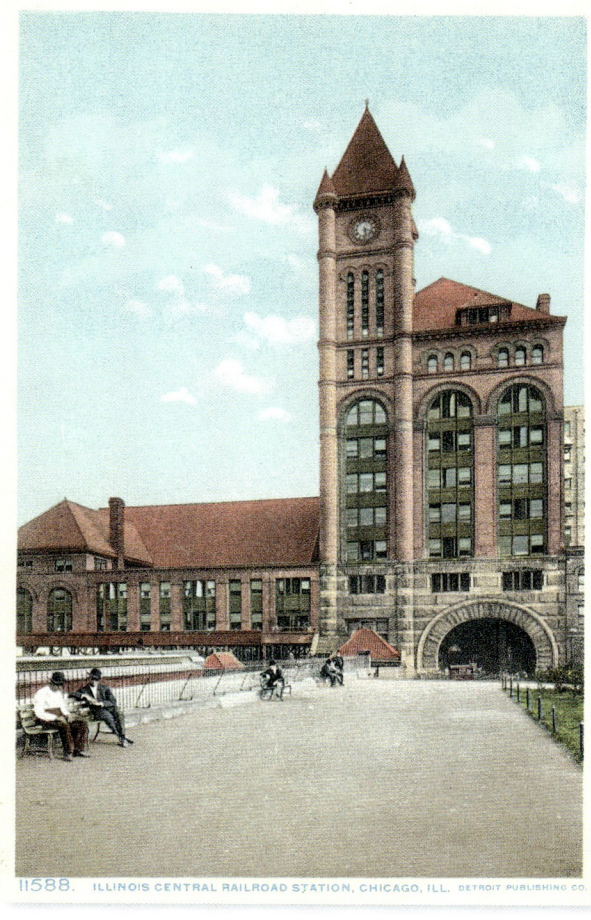

ILLINOIS | CHICAGO

CHICAGO & ALTON RAILROAD

The Chicago & Alton Railroad (C & A) was founded in 1862 in succession to the Alton Railroad, itself built in 1847 to link Alton on the Mississippi with Springfield, the capital of Illinois. The line was taken over by the Chicago & Mississippi (C & M), which provided a continuous connection as far as Joliet and, later, Chicago. In 1864, the C & A line reached first St. Louis, Missouri, then Kansas City. Most C & A trains included luxurious sleeping cars and dining cars designed by George Pullman. The first dining car, the Delmonico, went into service between Chicago and St. Louis.

Die Eisenbahngesellschaft Chicago & Alton Railroad (C & A) wurde 1862 ins Leben gerufen; sie war die Nachfolgerin der 1847 gegründeten Alton Railroad, die Alton über den Mississippi mit Springfield, der Hauptstadt des Staates Illinois, verbinden sollte. Die Linie wurde von der Chicago & Mississippi (C & M) wieder aufgenommen, die eine durchgehende Verbindung bis nach Joliet, später bis Chicago sicherstellte. 1864 reichte die Linie der C & A bis nach St. Louis (Missouri), dann bis Kansas City. Die meisten Züge der C & A waren mit luxuriösen, von George Pullman entworfenen Schlafwagen (*sleeping cars*) und Speisewagen (*dining cars*) ausgestattet. Der erste Speisewagen, der Delmonico, wurde zwischen Chicago und St. Louis eingesetzt.

La compagnie de chemin de fer Chicago & Alton Railroad (C & A) fut créée en 1862 ; elle succéda à l'Alton Railroad, fondée en 1847 pour relier Alton, sur le Mississippi, à Springfield, capitale de l'État d'Illinois. La ligne fut reprise par la compagnie Chicago & Mississippi (C & M), qui assura la liaison en continu jusqu'à Joliet, puis Chicago. En 1864, la ligne de la C & A atteignit Saint Louis (Missouri), puis Kansas City. La plupart des trains de la C & A étaient équipés de luxueuses voitures-lits (*sleeping cars*) et de voitures-restaurants (*dining cars*) conçues par George Pullman. Le premier *dining car*, le Delmonico, fut mis en service entre Chicago et Saint Louis.

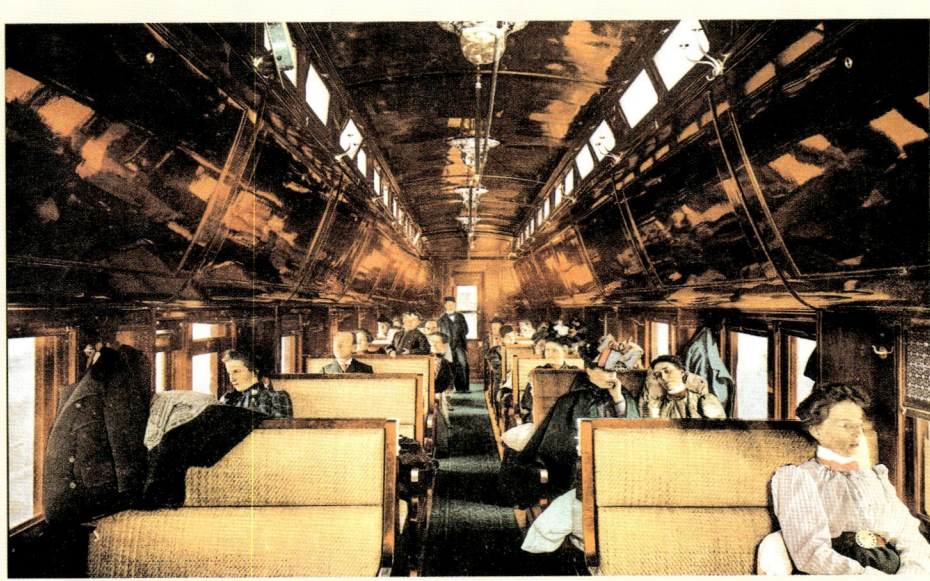

Left: Interior of a railroad day coach (Chicago & Alton Railroad), photochrom
Below: Locomotive number 501 and tender, Chicago & Alton railroad, photochrom
Page 251, top: Advertisement for The Alton Limited, "the handsomest train in the world," 1900–1905

Links: Innenraum eines Passagierabteils (Chicago & Alton Railroad), Photochrom
Unten: Lokomotive Nr. 501 mit Kohlentender, Chicago & Alton Railroad, Photochrom
Seite 251, oben: Werbung für den Zug Alton Limited, „den elegantesten Zug der Welt", 1900–1905

À gauche : intérieur d'un wagon de voyageurs en position « jour » (Chicago & Alton Railroad), photochrome
Ci-dessous : la locomotive n° 501 et son tender, chemin de fer Chicago & Alton Railroad, photochrome
Page 251, en haut : publicité pour le train Alton Limited, « le plus élégant du monde », vers 1900–1905

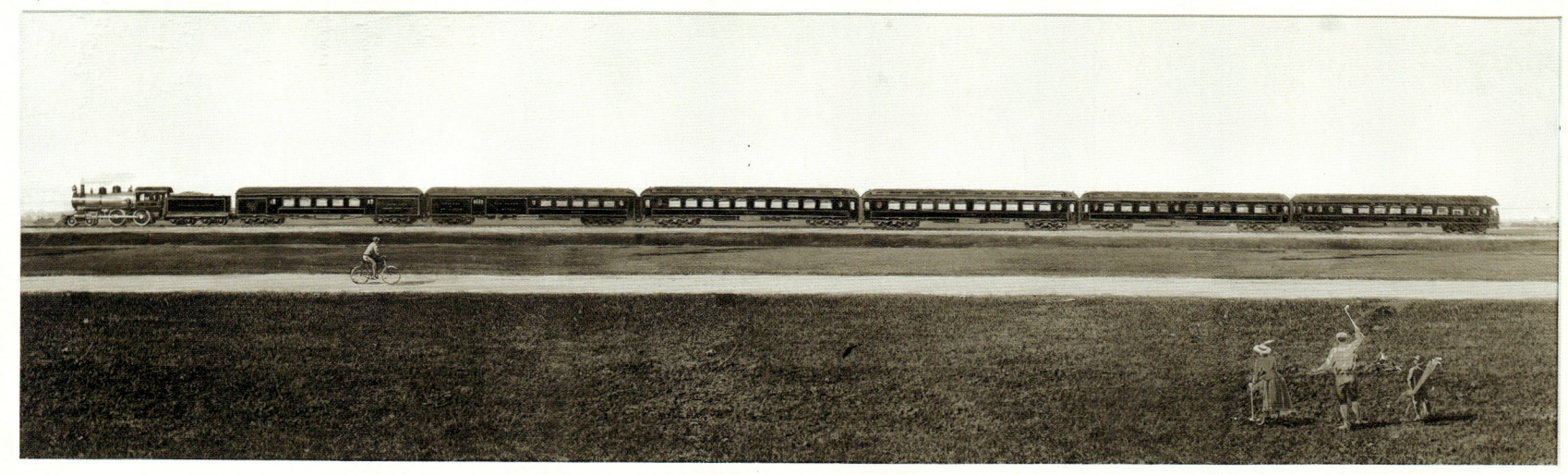

THE ALTON LIMITED.
THE HANDSOMEST TRAIN IN THE WORLD.

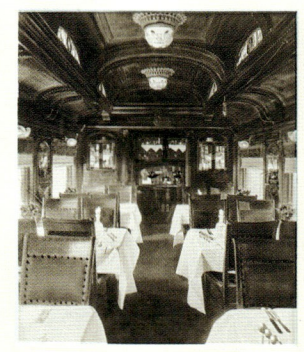 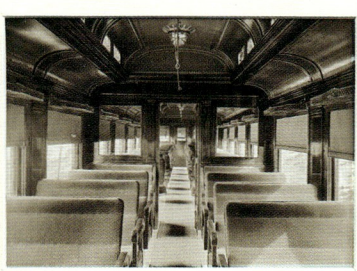 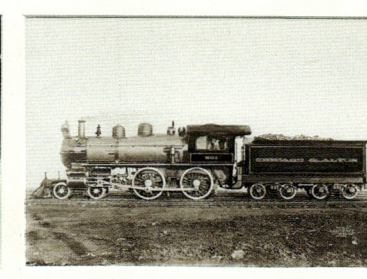 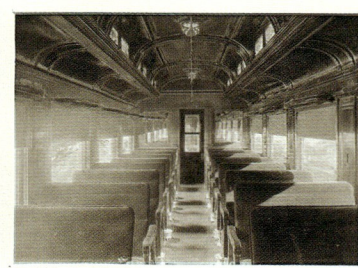 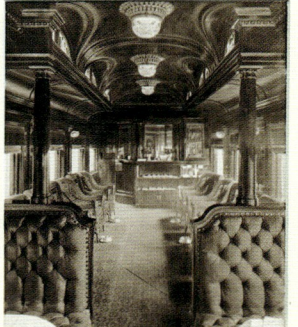

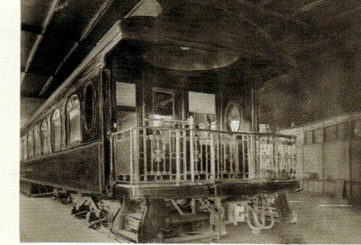 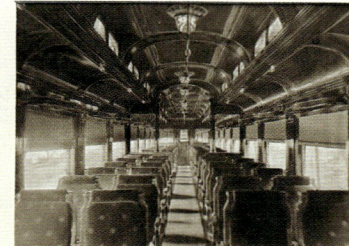

DAILY BETWEEN
CHICAGO
&
ST. LOUIS

VIA THE
CHICAGO
&
ALTON.

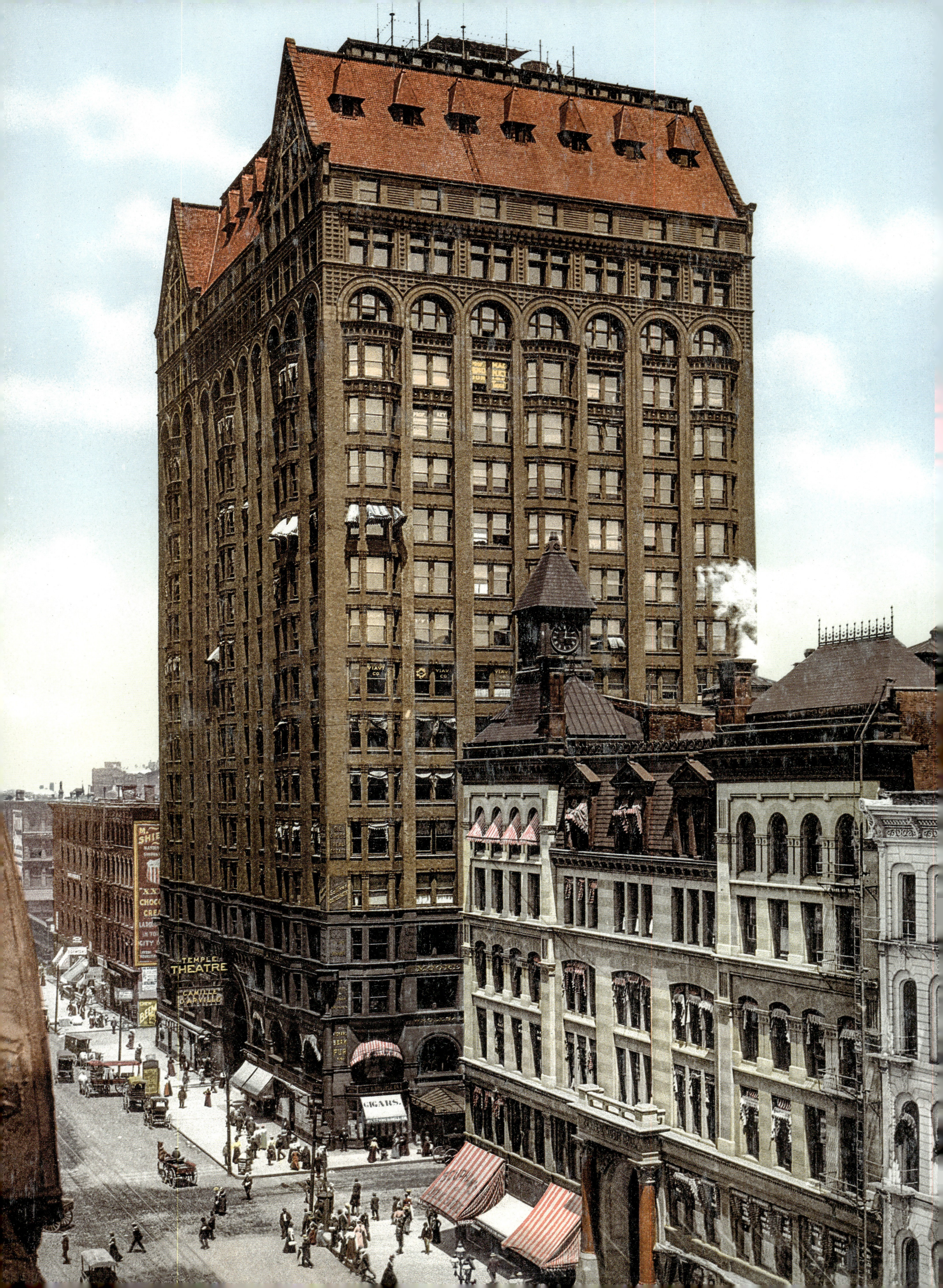

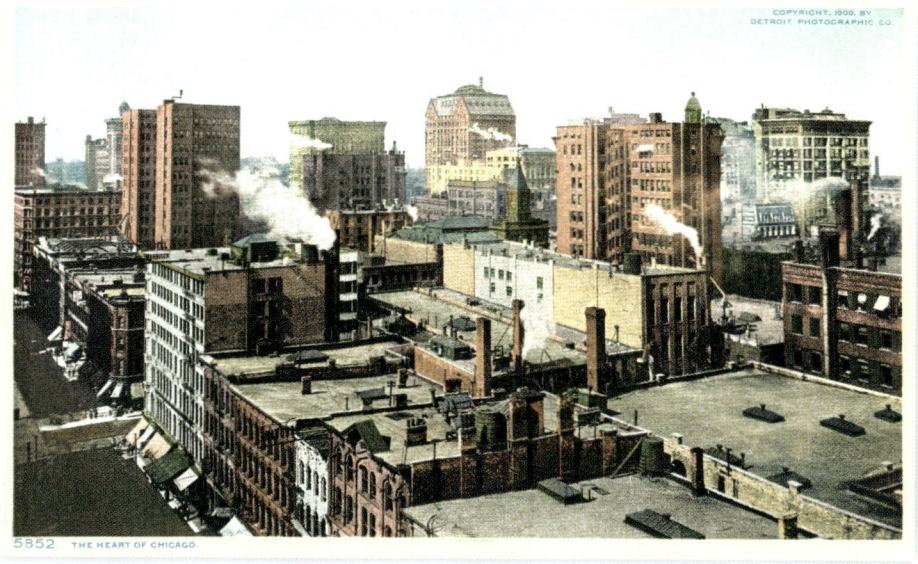 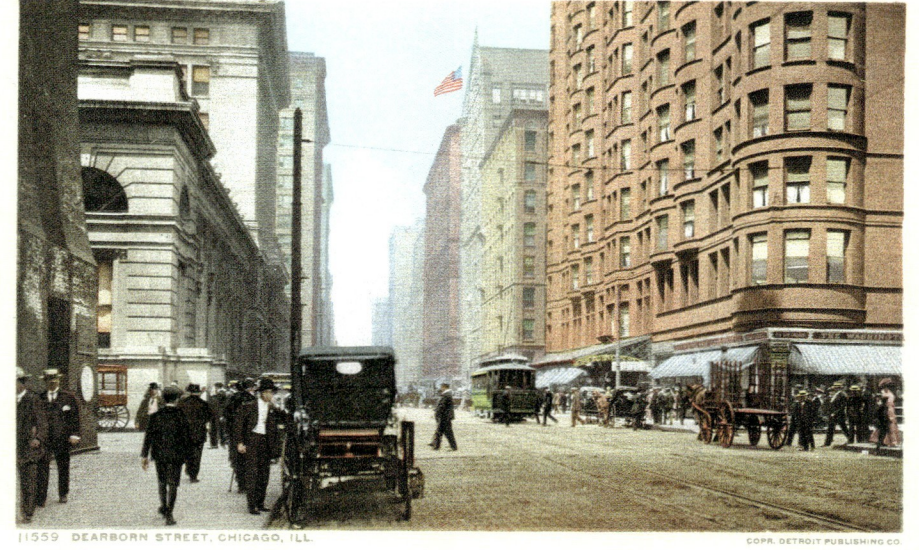

Page 252: **Masonic Temple, photochrom, 1900**
Top left: **The heart of Chicago**
Top right: **Dearborn Street**
Bottom: **Illinois Trust and Savings Bank, photochrom**

Seite 252: **Freimaurertempel, Photochrom, 1900**
Oben links: **Das Stadtzentrum von Chicago**
Oben rechts: **Dearborn Street**
Unten: **Die Illinois Trust and Savings Bank, Photochrom**

Page 252 : **le Temple maçonnique, photochrome, 1900**
En haut à gauche : **le cœur de Chicago**
En haut à droite : **Dearborn Street**
Ci-dessous : **la banque Illinois Trust and Savings Bank, photochrome**

ILLINOIS | CHICAGO

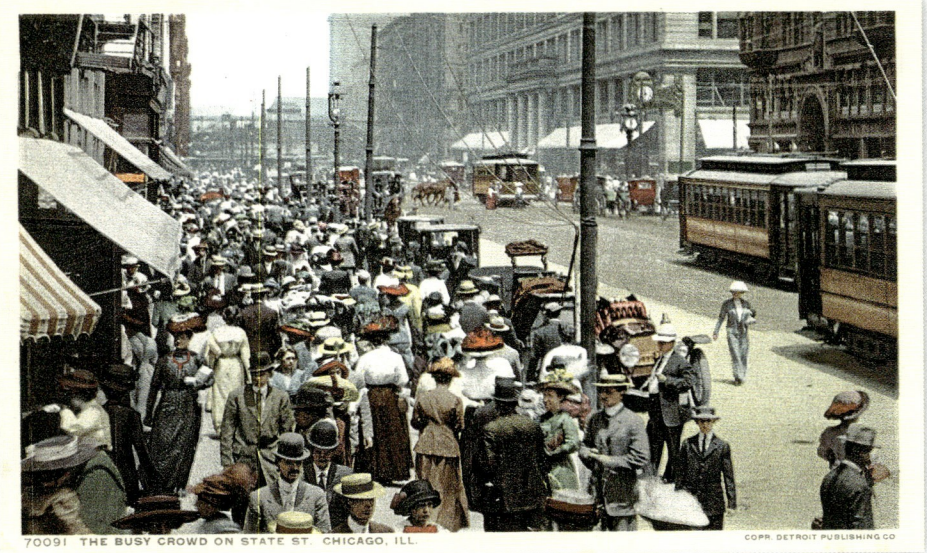

Left: Busy crowd on State Street
Below: Seeing Chicago, auto at Monroe near State, glass negative, 1910–1915
Page 255: State Street, north from Madison Street, photochrom

The famous department store Marshall Field's opened in 1897 on the corner of Washington and State Street. The sign was created by Potter Palmer, owner of the Palmer House Hotel, which burned down in 1871 in the Great Chicago Fire. State Street was and remains one of the great shopping streets of Chicago.

Links: Geschäftiges Treiben auf der State Street
Unten: Stadtrundfahrt mit dem Auto durch Chicago, Monroe Street nahe State Street, Glasnegativ, 1910–1915
Seite 255: State Street nördlich der Madison Street, Photochrom

Das berühmte Kaufhaus Marshall Field's wurde 1897 an der Ecke Washington Street und State Street eröffnet. Das Ladenschild hatte Potter Palmer entworfen, der Eigentümer des Hotels Palmer House, das 1871 bei dem großen Brand von Chicago zerstört wurde. State Street war (und ist noch immer) eine der Hauptgeschäftsstraßen von Chicago.

À gauche : foule sur State Street
Ci-dessous : visite de Chicago en voiture, Monroe Street près de State Street, plaque de verre, 1910–1915
Page 255 : State Street, au nord de Madison Street, photochrome

Le célèbre grand magasin Marshall Field's ouvrit ses portes en 1897 au coin de Washington Street et de State Street. L'enseigne avait été créée par Potter Palmer, propriétaire de l'hôtel Palmer House, qui brûla en 1871 dans le grand incendie de Chicago. State Street est aujourd'hui encore l'une des rues les plus commerçantes de Chicago.

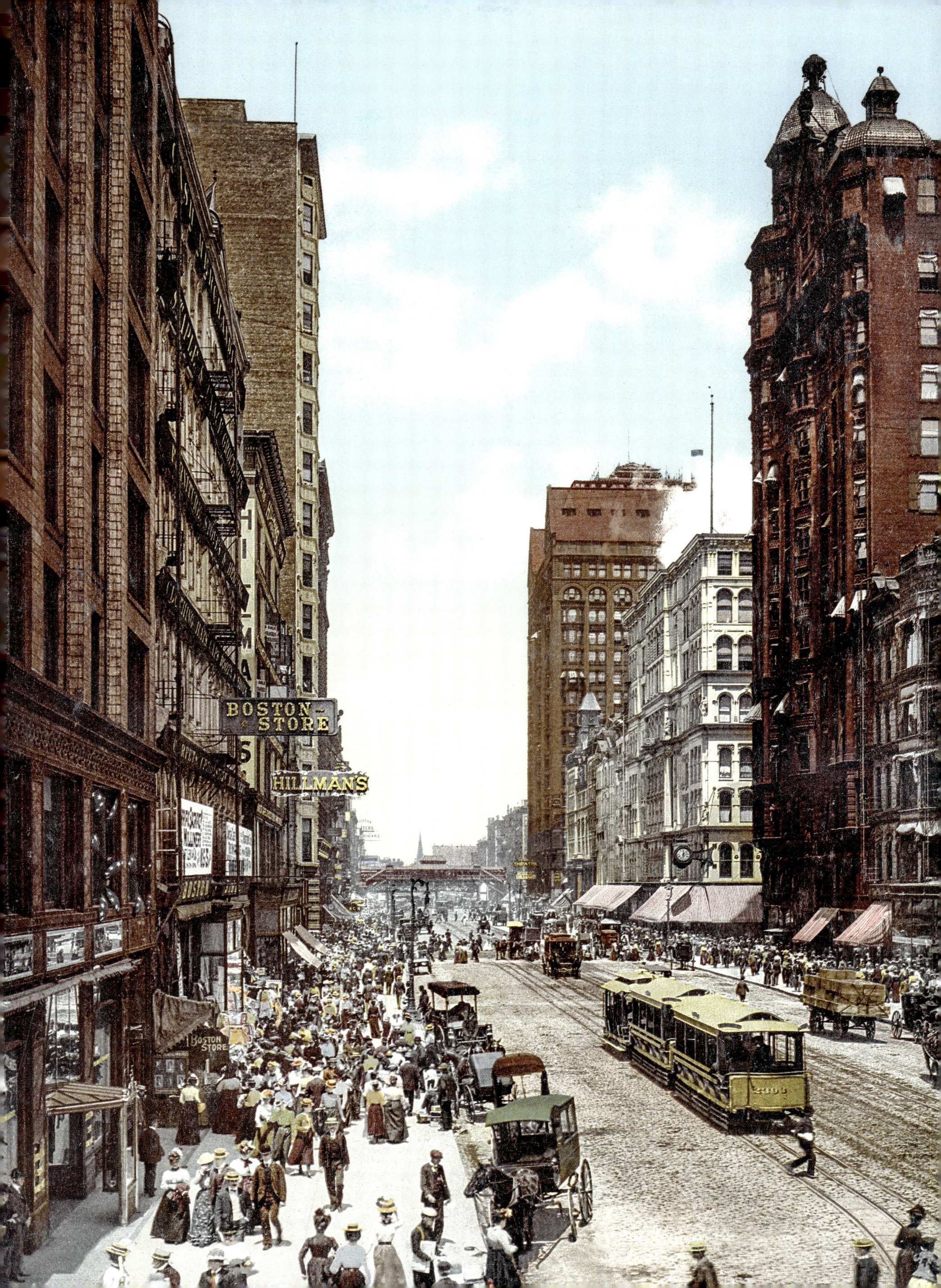

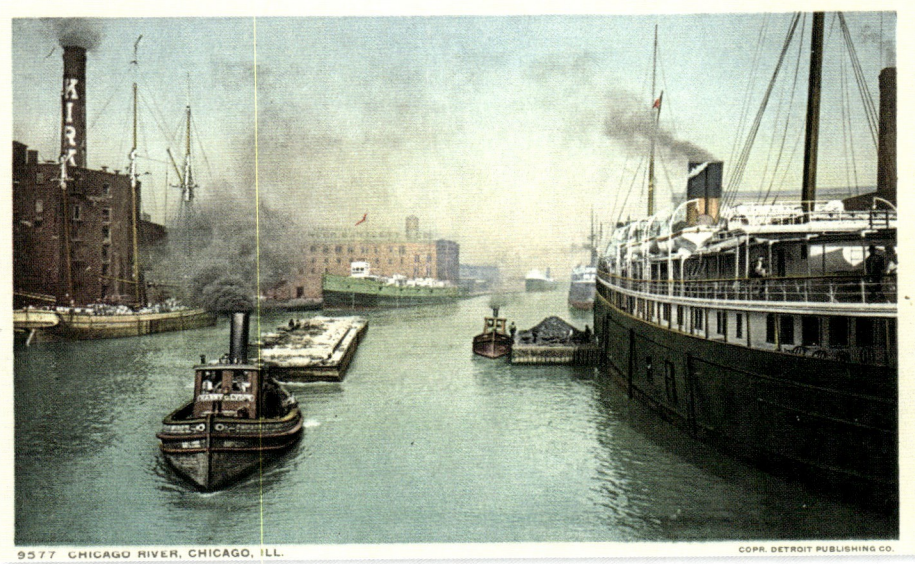
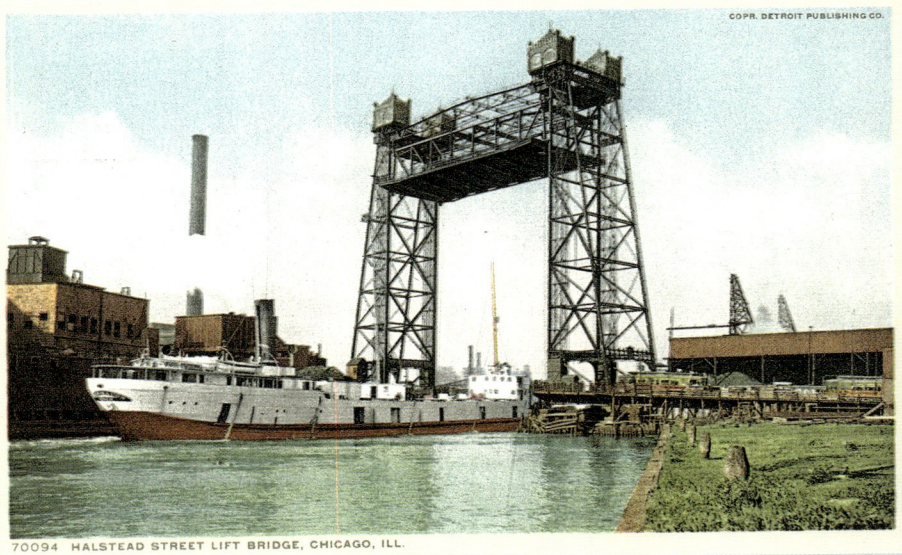

Top left: Chicago River
Top right: Halstead Street lift bridge
Bottom: Chicago River elevators, photochrom
Page 257:
Above: Rush Street Bridge
Below: Jackknife Bridge, glass negative, ca. 1907

All along the quays of the Chicago River, immense grain elevators unloaded the wheat from the plains of the Midwest. They pumped the grain out of the cargo ships into silos 65 feet (20 m) deep. Swing bridges over the river opened to let the grain carriers through.

Oben links: Chicago River
Oben rechts: Hubbrücke an der Halstead Street
Unten: Schiffshebewerk am Chicago River, Photochrom
Seite 257:
Oben: Rush-Street-Brücke
Unten: Jackknife-Brücke, Glasnegativ, um 1907

An den Kais des Chicago River entluden riesige Schiffshebewerke den Weizen aus den Ebenen des Mittleren Westens. Sie pumpten das Getreide aus den Frachtschiffen und lagerten es in 20 Meter tiefen Speichern. Drehbrücken überspannten den Fluss und öffneten sich, wenn Schiffe passieren wollten.

En haut à gauche : la « rivière de Chicago » (Chicago River)
En haut à droite : le pont levant de Halstead Street
En bas : les élévateurs à grains de la Chicago River, photochrome
Page 257 :
En haut : le pont de Rush Street
En bas : le pont de Jackknife, plaque de verre, vers 1907

Le long des quais de la Chicago River, d'immenses élévateurs à grains déchargeaient le blé des plaines du Middle West. Ils pompaient le grain stocké dans les cargos, puis le déposaient dans des réservoirs de 20 mètres de profondeur. Des ponts tournants franchissaient la rivière, s'ouvrant pour laisser le passage aux bateaux.

ILLINOIS | CHICAGO

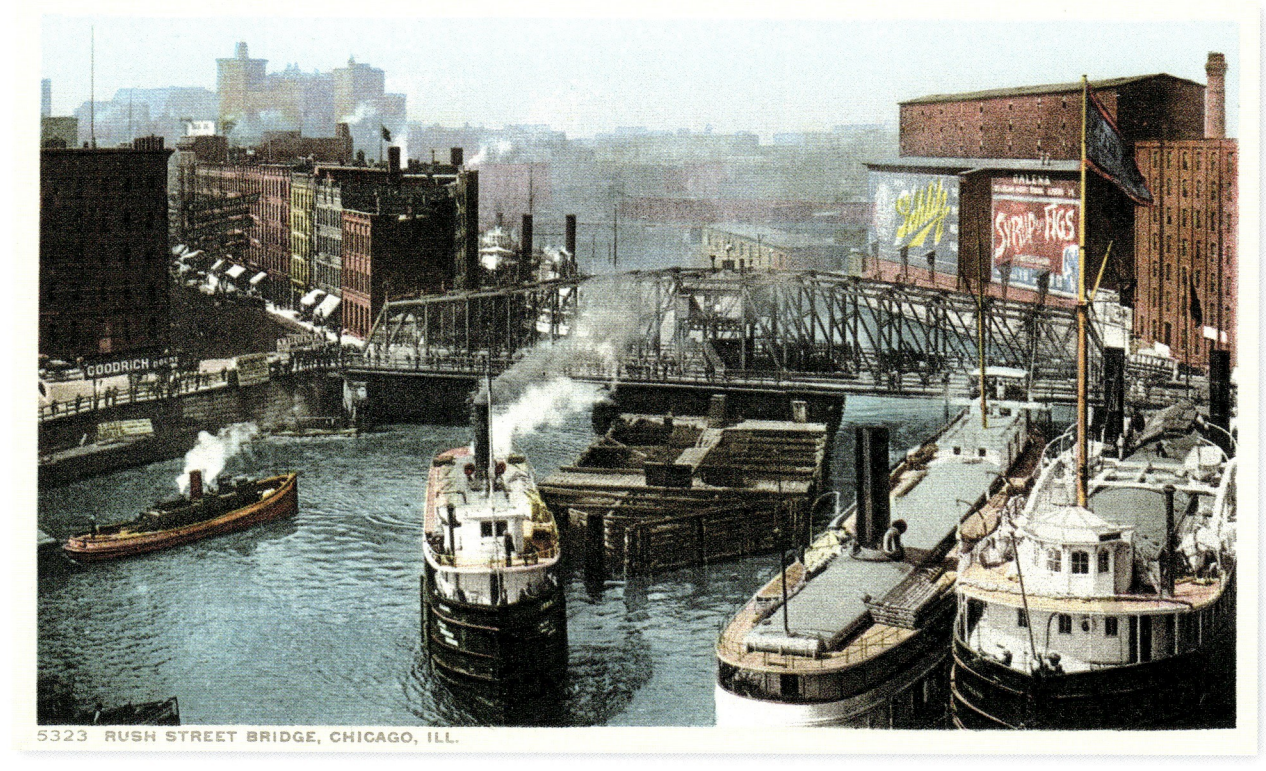

WISCONSIN

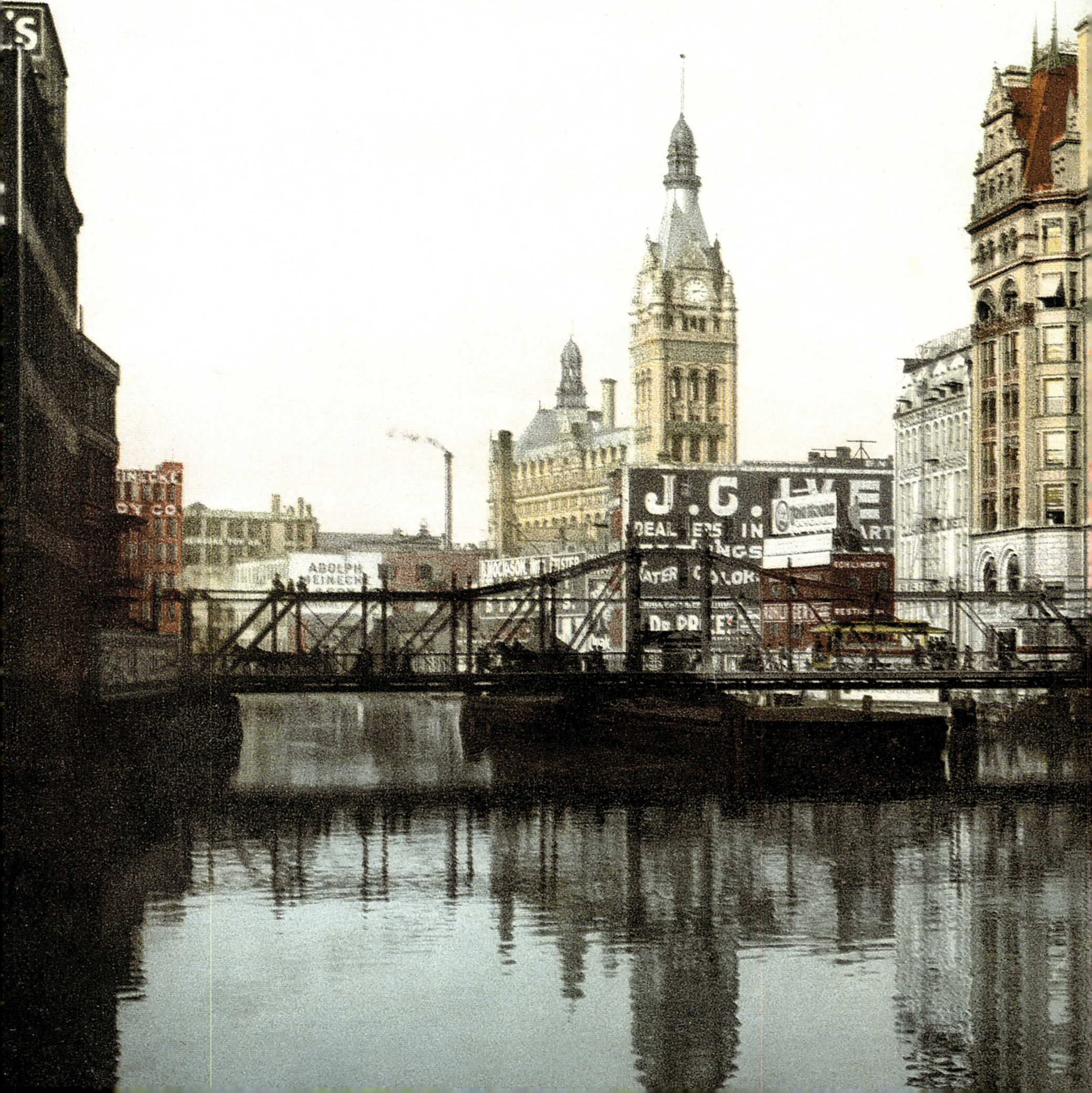

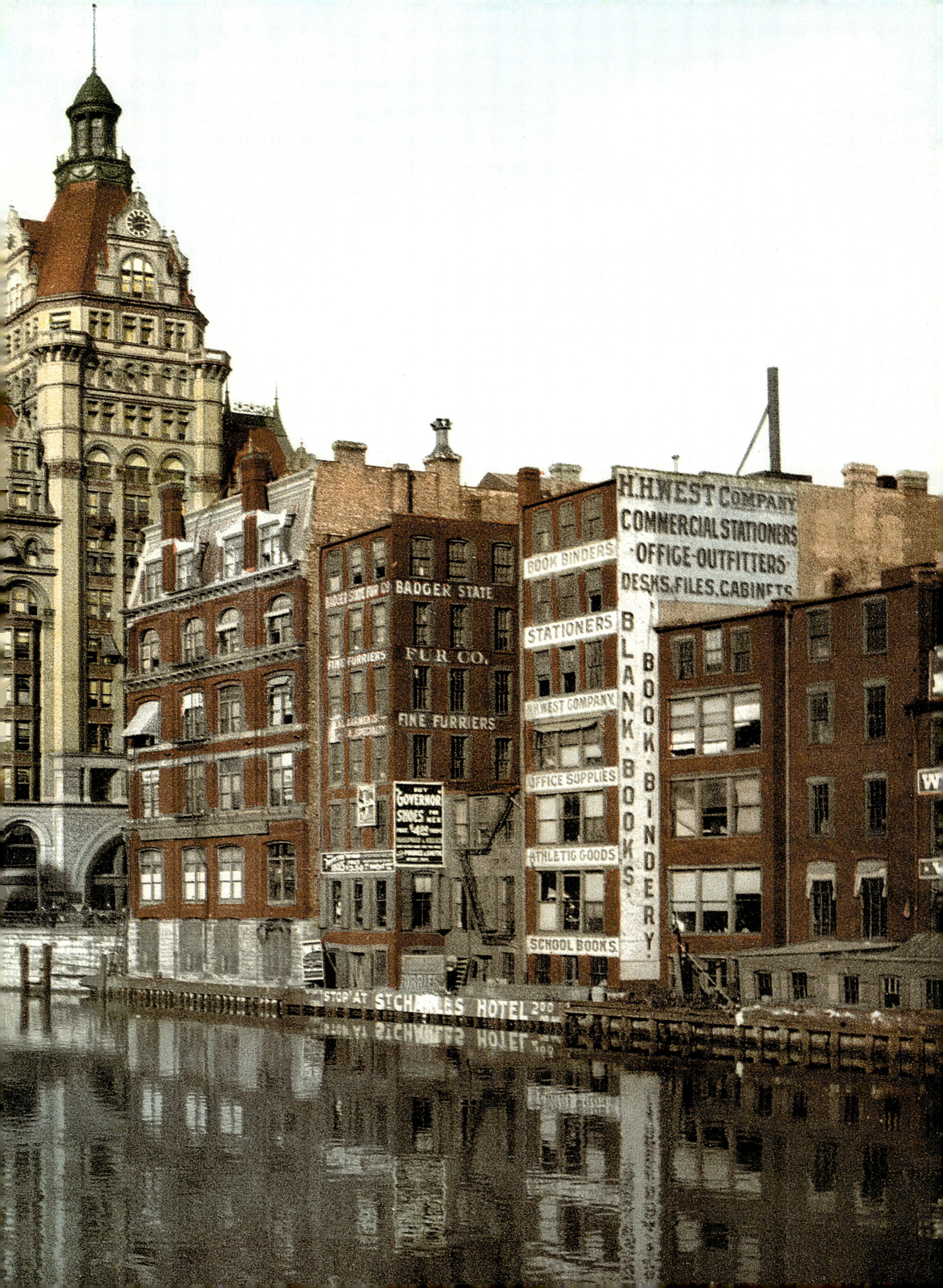

Page 258/259: The River from Sycamore Street, Milwaukee, photochrom
Left: Leif Ericson Statue, Milwaukee, photochrom
Below: Pabst Brewery, glass negative, 1890–1901

Wisconsin's main city was founded by the French-Canadian Solomon Juneau in 1818; in the mid-19th century it was one of the favored destinations of German immigrants fleeing the Revolution of 1848. Social circles, religious communities, and associations helped to reinforce the town's Germanic identity. The first skyscraper in Milwaukee, the Pabst Building, was constructed in 1895 by the New York architect Solon S. Beman for Frederick Pabst, president of the Pabst Brewing Co., the immensely wealthy Milwaukee beer baron; it was demolished in 1980.

Seite 258/259: Der Fluss von der Sycamore Street aus, Milwaukee, Photochrom
Links: Leif-Ericson-Statue, Milwaukee, Photochrom
Unten: Die Brauerei Pabst, Glasnegativ, 1890–1901

Milwaukee, die wichtigste Stadt von Wisconsin, wurde 1818 von dem Frankokanadier Solomon Juneau gegründet. Sie war Mitte des 19. Jahrhunderts eines der bevorzugten Ziele der deutschen Immigranten auf der Flucht vor der Märzrevolution (1848). Clubs, Religionsgemeinschaften und Vereine trugen dazu bei, die deutsche Identität der Stadt zu verfestigen. Der erste Wolkenkratzer in Milwaukee, das Pabst Building, wurde 1895 von dem New Yorker Architekten Solon S. Beman für Frederick Pabst, Präsident der Pabst Brewing Co. und steinreicher Bierbaron, erbaut; 1980 wurde er abgerissen.

Pages 258/259 : la rivière depuis Sycamore Street, Milwaukee, photochrome
En haut : la statue de Leif Ericson, Milwaukee, photochrome
Ci-dessous : la brasserie Pabst, plaque de verre, 1890–1901

Principale cité du Wisconsin, fondée par le Franco-Canadien Solomon Juneau en 1818, Milwaukee fut au milieu du XIXᵉ siècle l'une des destinations privilégiées des immigrants allemands fuyant la révolution de Mars (1848). Cercles, communautés religieuses et associations contribuèrent à renforcer l'identité germanique de la ville.
Le premier gratte-ciel, Pabst Building, a été construit en 1895 par l'architecte new-yorkais Solon S. Beman pour Frederick Pabst, président de la Pabst Brewing Co. et richissime baron de la bière à Milwaukee ; il a été démoli en 1980.

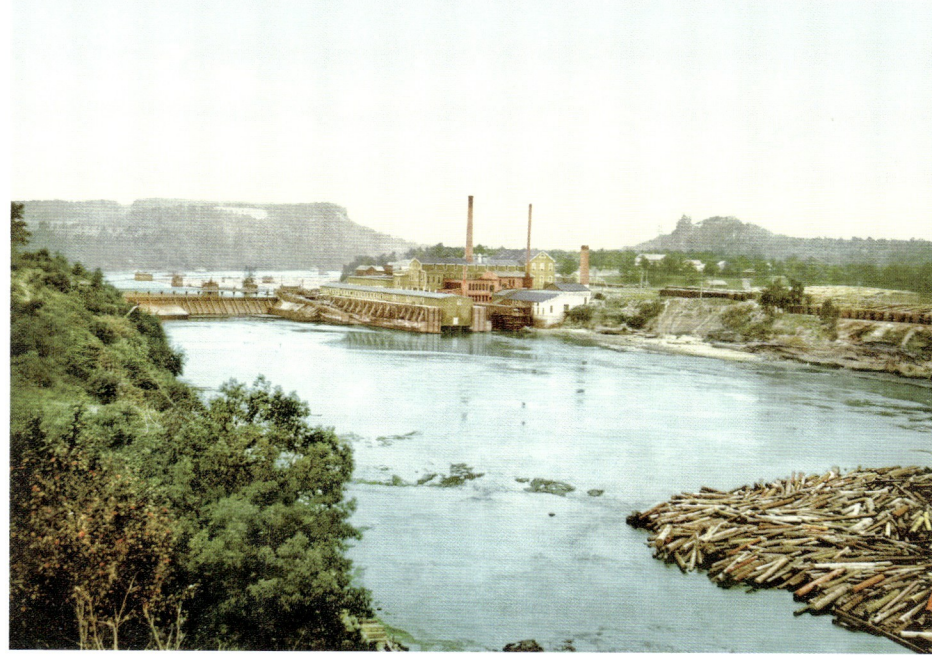
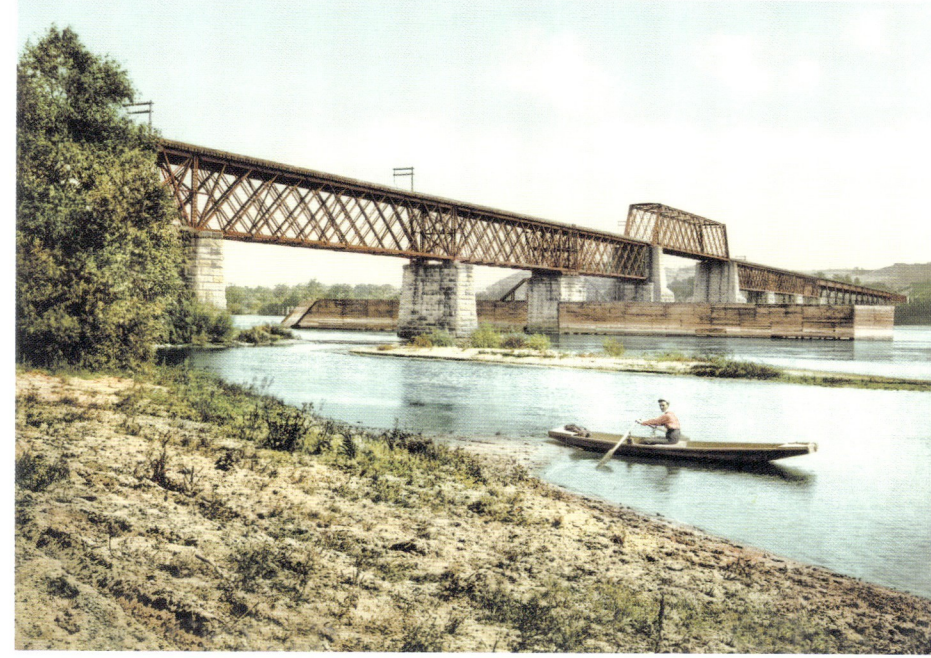

Top left: **Eau Claire, general view, photochrom**
Top right: **Wisconsin River, near Merrimac, photochrom**
Bottom: **Lake Superior, Apostle Islands, Stella Cove, Presque Isle, photochrom**

In the far north of Wisconsin, the Apostle Islands lie in Lake Superior and were originally inhabited by the Ojibwa people. Then European fur traders came to the islands. The natural beauty of the archipelago, its rich historic heritage, and the presence of 150 species of bird led to its classification in 1970 as a protected zone of the National Lakeshore. This beautiful coast enjoys a grim reputation for the many ships wrecked on its rocks.

Oben links: **Eau Claire, Gesamtansicht, Photochrom**
Oben rechts: **Wisconsin River bei Merrimac, Photochrom**
Unten: **Oberer See, Apostle Islands, Bucht Stella Cove, Presque Isle, Photochrom**

Die Apostel-Inseln im Oberen See, im äußersten Norden von Wisconsin, waren der Lebensraum der Ojibwa-Indianer und wurden sehr bald von Europäern aufgesucht, die mit Fellen handelten. Die landschaftliche Schönheit dieses Archipels, seine reiche historische Vergangenheit und die 150 hier heimischen Vogelarten führten dazu, dass es 1970 zum Naturschutzgebiet des nationalen Küstengebiets (National Lakeshore) erklärt wurde. Dieser schöne felsige Küstenabschnitt erlangte durch die zahlreichen Schiffsunglücke, die sich hier ereigneten, allerdings auch traurige Berühmtheit.

En haut à gauche : **Eau Claire, vue générale, photochrome**
En haut à droite : **le fleuve Wisconsin près de Merrimac, photochrome**
Ci-dessous : **lac Supérieur, îles Apostle, la crique de Stella, Presque Isle, photochrome**

À l'extrême nord du Wisconsin, sur le lac Supérieur, les îles Apostle, où vivaient les Indiens Ojibwés, furent très tôt visitées par les Européens qui pratiquaient la traite des fourrures. La beauté naturelle de l'archipel, son riche passé historique, la présence de 150 espèces d'oiseaux lui ont valu d'être classé en 1970 comme zone protégée du littoral national (National Lakeshore). Cette belle partie rocheuse de la côte est aussi tristement célèbre en raison des nombreux naufrages qui s'y sont produits.

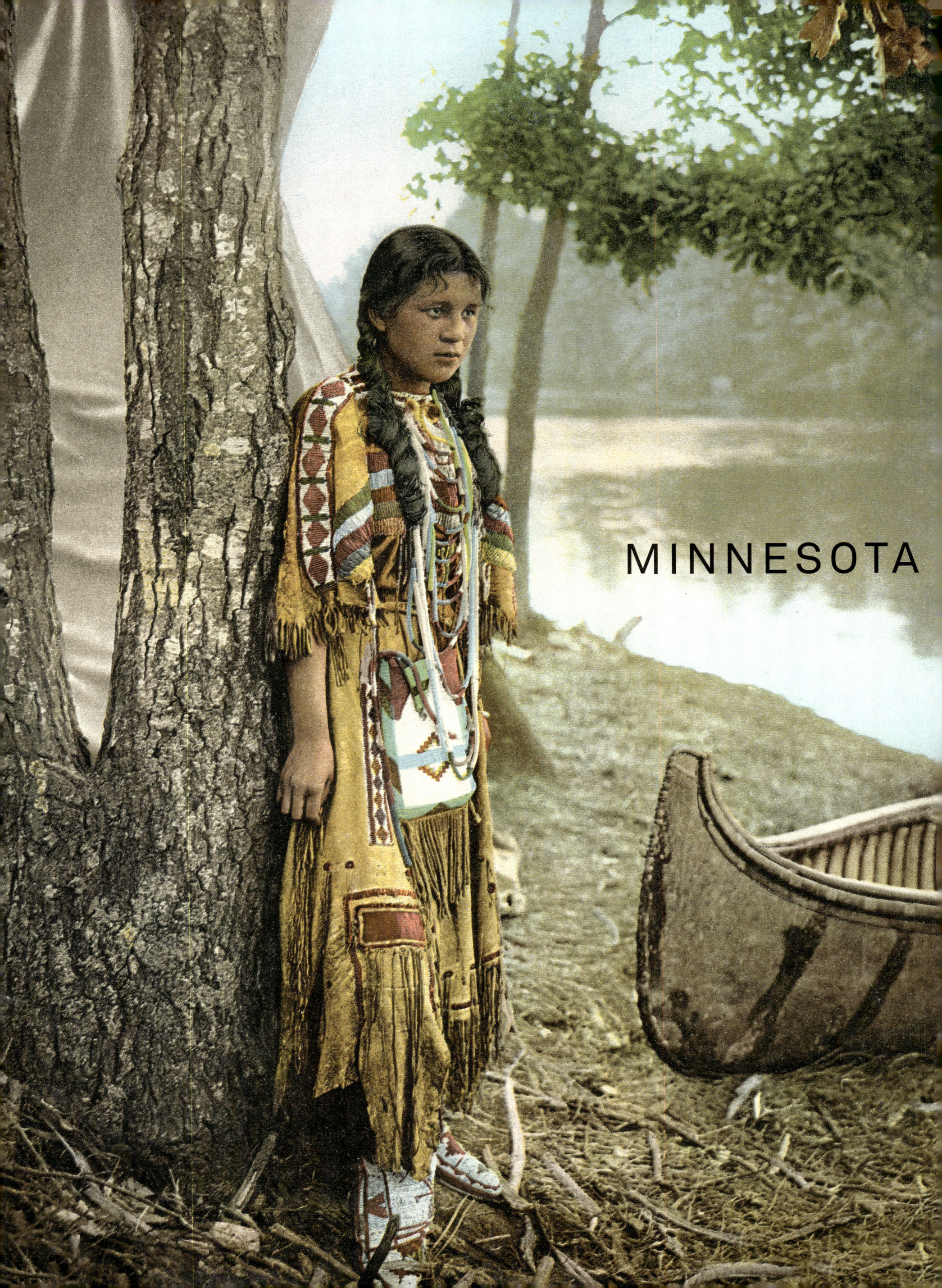

Page 262: **Native American Minnehaha, photochrom**
Right: **Minnehaha Falls postcard with Henry Wadsworth Longfellow**
Below: **Minnehaha Falls, photochrom**

Minnehaha Falls ("minnehaha" means "waterfall" in the Dakota language, not, as is often thought, "laughing water") became a major tourist attraction in 1855 after the publication of Henry Wadsworth Longfellow's epic poem *The Song of Hiawatha* which features the Indian hero Hiawatha and his fiancée Minnehaha. In Minnehaha Park, a replica of Longfellow's residence in Cambridge, Massachusetts, was constructed in 1906 by one of his admirers; it was a posthumous tribute to the poet, who had died in 1882.

Seite 262: **Porträt der Indianerin Minnehaha, Photochrom**
Rechts: **Die Minnehaha-Fälle, Hommage an den Dichter Henry Wadsworth Longfellow**
Unten: **Die Minnehaha-Fälle, Photochrom**

Die Wasserfälle von Minnehaha (das Wort bedeutet in der Dakota-Sprache Wasserfall – und nicht etwa lachendes Wasser, wie häufig angenommen wird) wurden 1855 nach der Veröffentlichung von Henry Wadsworth Longfellows epischem Gedicht *Das Lied von Hiawatha*, das von dem Indianerhelden Hiawatha und seiner Verlobten Minnehaha handelt, sehr touristisch. Im Park von Minnehaha errichtete 1906 einer seiner Bewunderer das Longfellow-Haus – eine Replik des Dichter-Anwesens in Cambridge (Massachusetts) und eine posthume Hommage an diesen bedeutenden Mann, der 1882 starb.

Page 262 : **portrait de l'Indienne Minnehaha, photochrome**
En haut : **les chutes de Minnehaha, hommage au poète Henry Wadsworth Longfellow**
Ci-dessous : **les chutes de Minnehaha, photochrome**

Les chutes de Minnehaha (le mot signifie « chute d'eau » en langue Dakota, et non pas « eau qui rit », comme on le croit souvent) sont devenues très touristiques en 1855, après la publication du poème épique d'Henry Wadsworth Longfellow, *Le Chant de Hiawatha*, qui met en scène le héros indien Hiawatha et sa fiancée, Minnehaha. Dans le parc de Minnehaha, la maison de Longfellow – réplique de la demeure du poète à Cambridge (Massachusetts) – a été construite en 1906 par l'un de ses admirateurs. Hommage posthume rendu au grand homme, disparu en 1882.

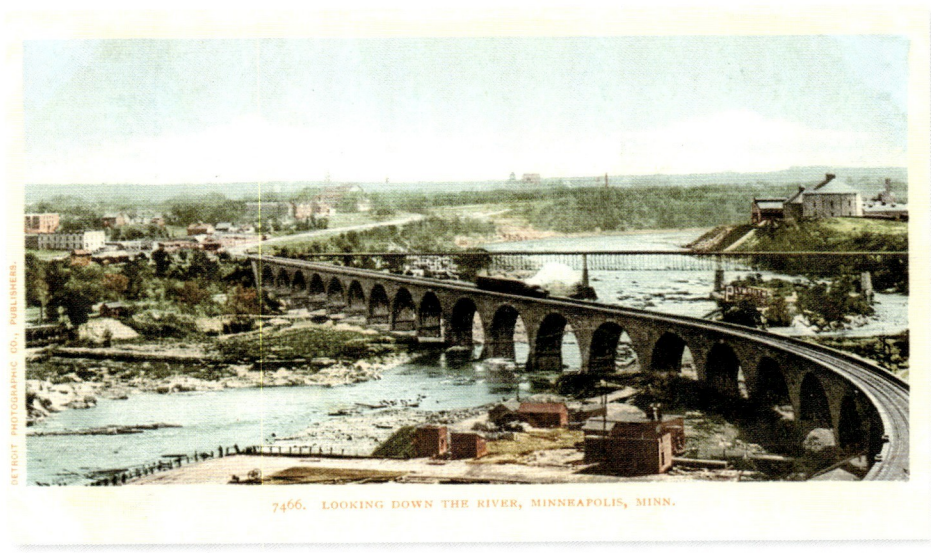

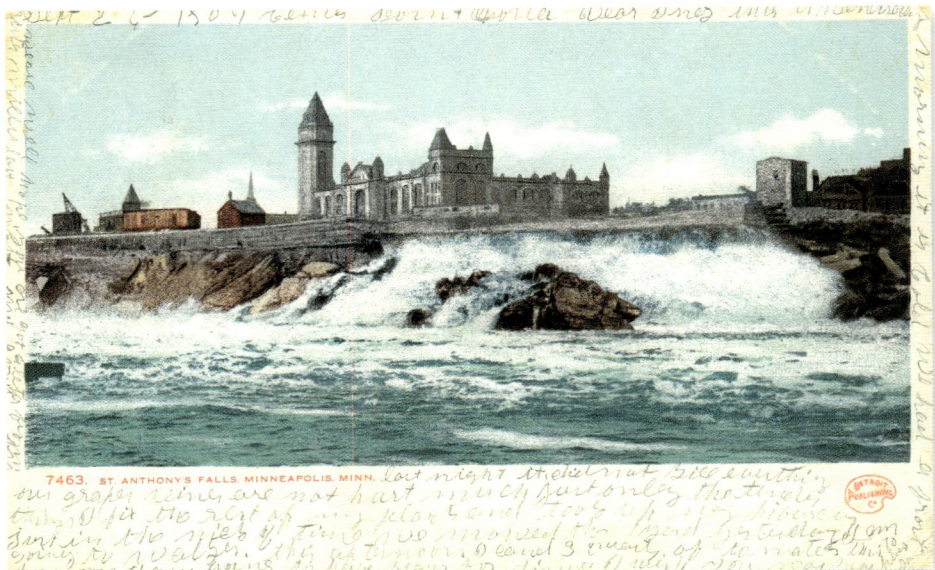

Top left: Looking down the Mississippi River, Minneapolis
Top right: View of Minneapolis
Right: St. Anthony Falls, Minneapolis
Bottom: View of Saint Paul, photochrom

Oben links: Der Mississippi aus der Vogelperspektive, Minneapolis
Oben rechts: Ansicht von Minneapolis
Rechts: Die Saint Anthony-Fälle, Minneapolis
Unten: Ansicht von Saint Paul, Photochrom

En haut à gauche : Minneapolis, vue plongeante sur le fleuve Mississippi
En haut à droite : vue de Minneapolis
À droite : les chutes de Saint Anthony, Minneapolis
Ci-dessous : vue de Saint Paul, photochrome

MINNESOTA | MINNEAPOLIS | SAINT PAUL

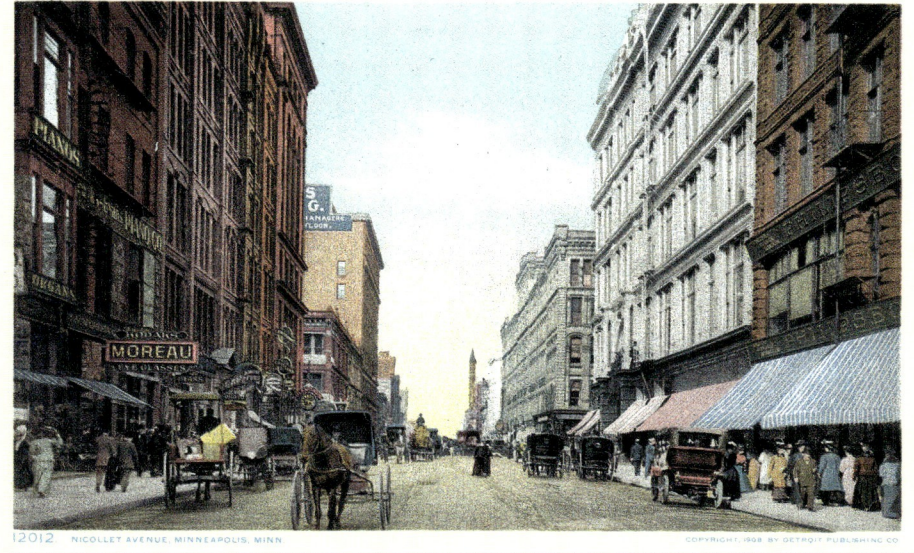
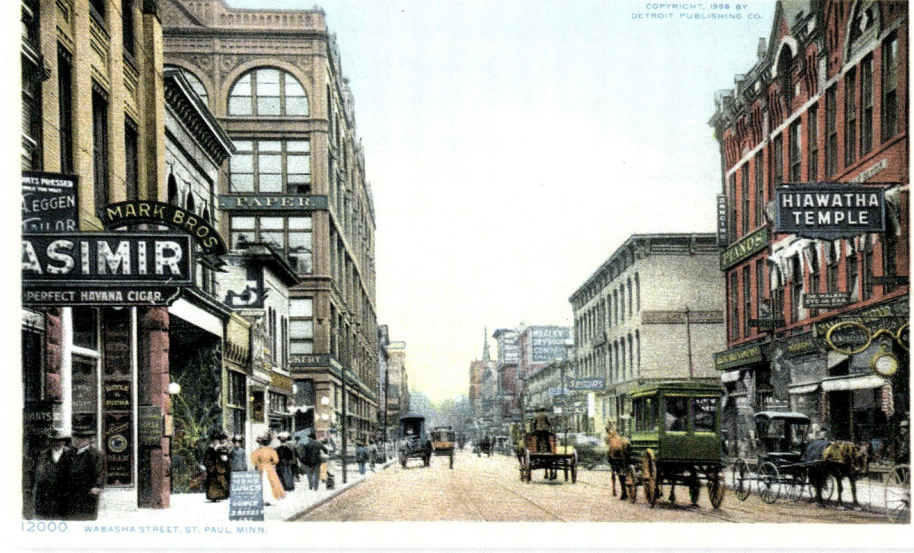

Top left: Nicollet Avenue, Minneapolis
Top right: Wabasha Street, Saint Paul
Bottom: Steamboat landing and Union Station, Saint Paul, glass negative, ca. 1908

Minneapolis's prosperity lay in its mills, which were turned by the St. Anthony Falls, the highest on the Mississippi; from 1871 onward, grain from the Great Plains was brought by rail to the city's flour mills. Downstream, Saint Paul was at this period a very important port, the last landing point on the Upper Mississippi for settlers coming from the East and looking to make their homes on the Minnesota frontier or in the Dakota Territory. Saint Paul, capital of Minnesota, and Minneapolis are often called the "Twin Cities."

Oben links: Nicollet Avenue, Minneapolis
Oben rechts: Wabasha Street, Saint Paul
Unten: Anlegestelle für Dampfschiffe und Union Station, Saint Paul, Glasnegativ, um 1908

Minneapolis entwickelte sich dank der von den Saint-Anthony-Fällen, den höchsten des Mississippi, betriebenen Mühlen; ab 1871 wurde der Weizen aus den Great Plains per Eisenbahn zu den Mühlen der Stadt befördert. Das flussabwärts gelegene Saint Paul war zur selben Zeit ein bedeutender Hafen, der letzte Entladungshafen am Oberlauf des Mississippi für Siedler aus dem Osten, die sich an der Grenze von Minnesota oder in Dakota niederlassen wollten. Saint Paul, die Hauptstadt Minnesotas, und Minneapolis werden gemeinhin als „Twin cities" (Zwillingsstädte) bezeichnet.

En haut à gauche : avenue Nicollet, Minneapolis
En haut à droite : Wabasha Street, Saint Paul
Ci-dessous : Saint Paul, le quai des vapeurs et la gare d'Union Station, plaque de verre, vers 1908

Minneapolis s'est développée grâce aux moulins alimentés par les chutes de Saint Anthony, les plus hautes du Mississippi ; dès 1871, le blé des Grandes Plaines était acheminé par le chemin de fer vers les minoteries de la ville. En aval du fleuve, Saint Paul était à la même époque un port très important, dernier point de débarquement sur le haut Mississippi pour les colons venus de l'Est qui désiraient s'établir à la frontière du Minnesota ou dans le Dakota. Saint Paul, capitale du Minnesota, et Minneapolis sont communément appelées les *twin cities* (cités jumelles).

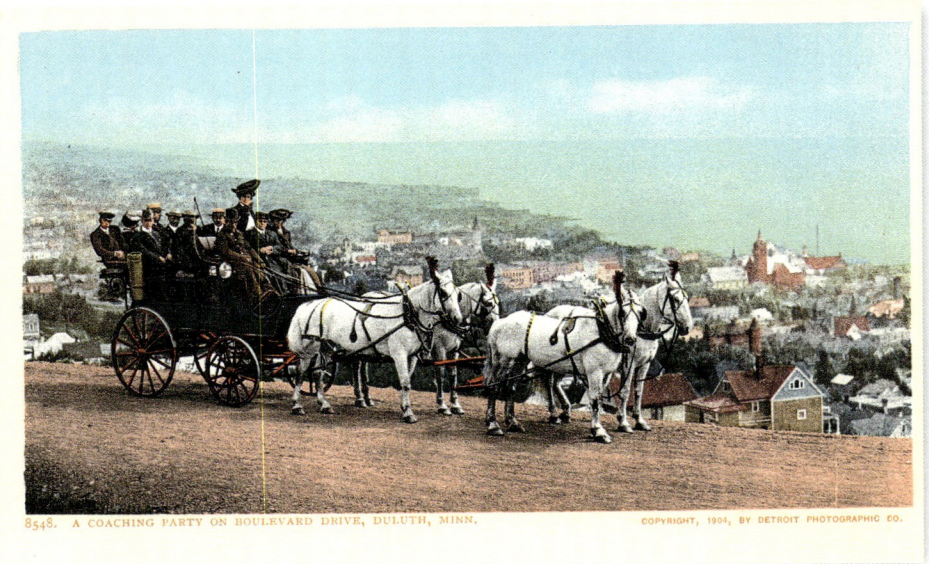
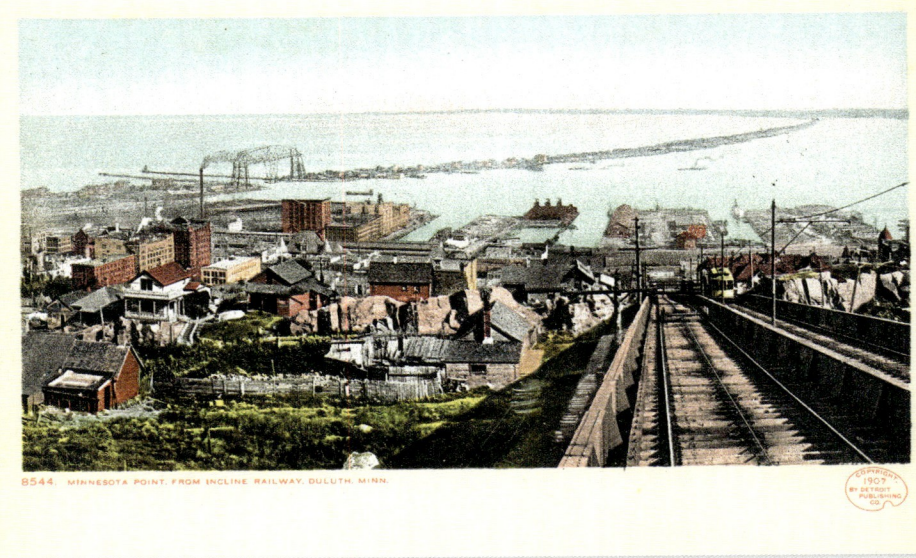

Top left: **A coaching party on Boulevard Drive, Duluth**
Top right: **Minnesota Point from Incline Railway**
Bottom: **The Incline Railway, glass negative, ca. 1904**

With its privileged position on Lake Superior at the mouth of the St. Louis River, Duluth began to develop still faster in the last decades of the 19th century, when the railroad reached the town. In the 1890s, it had become a navigation head for the Great Lakes; some 2,000 cargo boats passed through it annually, unloading grain from the Midwest and iron ore from the hills of Vermilion and Mesabi. According to the Baedeker guide, the population of Duluth increased tenfold between 1880 and 1890 (from 3,470 to 33,115).

Oben links: **Mit der Kutsche auf dem Boulevard Drive, Duluth**
Oben rechts: **Minnesota Point von der Bergstation der Standseilbahn**
Unten: **Die Standseilbahn, Glasnegativ, um 1904**

Duluth, in privilegierter Lage am Oberen See an der Mündung des St. Louis River, entwickelte sich besonders stark in den letzten Jahrzehnten des 19. Jahrhunderts, als die Stadt an die Eisenbahn angebunden wurde. In den 1890er-Jahren passierten jährlich rund 2 000 Frachter seinen Hafen, die Schifffahrtszentrale der Großen Seen, und luden den Weizen aus dem Mittleren Westen und das Eisenerz aus den Bergen von Vermilion und Mesabi aus. Zwischen 1880 und 1890 verzehnfachte sich nach Angaben des Baedekers die Bevölkerung von Duluth (3 470 Bewohner im Jahr 1880, 33 115 im Jahr 1890).

En haut à gauche : **en diligence sur Boulevard Drive, Duluth**
En haut à droite : **la vue depuis la plate-forme du funiculaire**
Ci-dessous : **le funiculaire, plaque de verre, vers 1904**

Jouissant d'une position privilégiée sur le lac Supérieur à l'embouchure de la St. Louis River, Duluth connut un fort développement dans les dernières décennies du XIXe siècle, lorsque la ville fut reliée au chemin de fer. Dans les années 1890, son port, tête de navigation des Grands Lacs, voyait passer quelque 2 000 cargos par an, qui déchargeaient le blé du Middle West et le minerai de fer des collines de Vermilion et de Mesabi. Entre 1880 et 1890, selon les chiffres du Baedeker, la population de Duluth fut multipliée par dix (3 470 habitants en 1880, 33 115 en 1890).

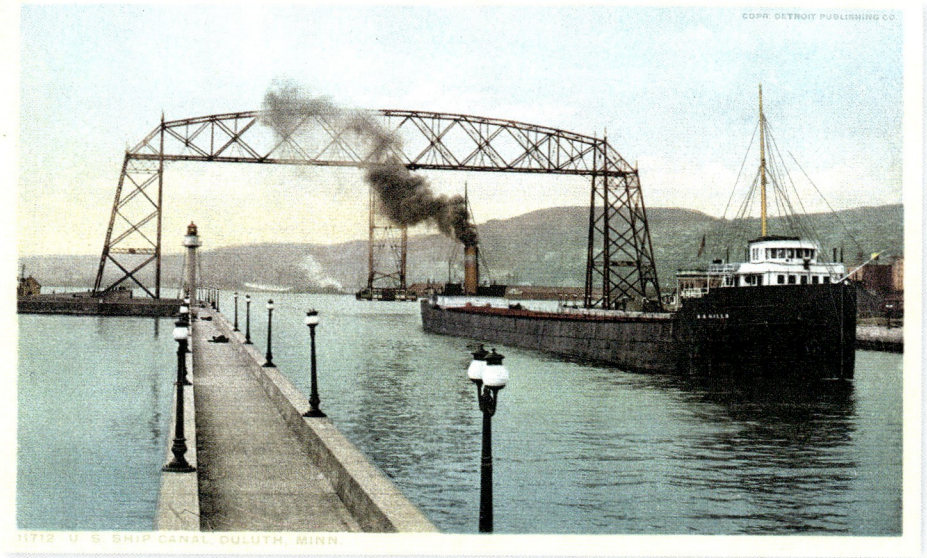

Above: U.S. Ship Canal, Duluth
Right: Aerial bridge car, Duluth
Below: Aerial bridge car, glass negative, ca. 1908

Oben: Der Kanal von Duluth
Rechts: Der Wagen der Schwebefähre, Duluth
Unten: Der Wagen der Schwebefähre, Glasnegativ, um 1908

Ci-dessus : le canal de Duluth
À droite : le wagon du pont transbordeur, Duluth
Ci-dessous : le wagon du pont transbordeur, plaque de verre, vers 1908

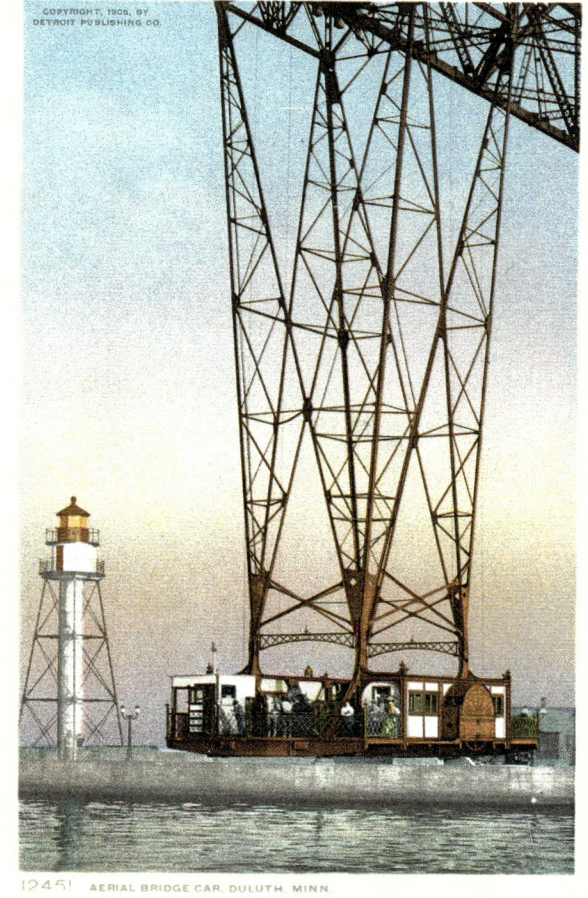

MINNESOTA | DULUTH

SOUTH DAKOTA

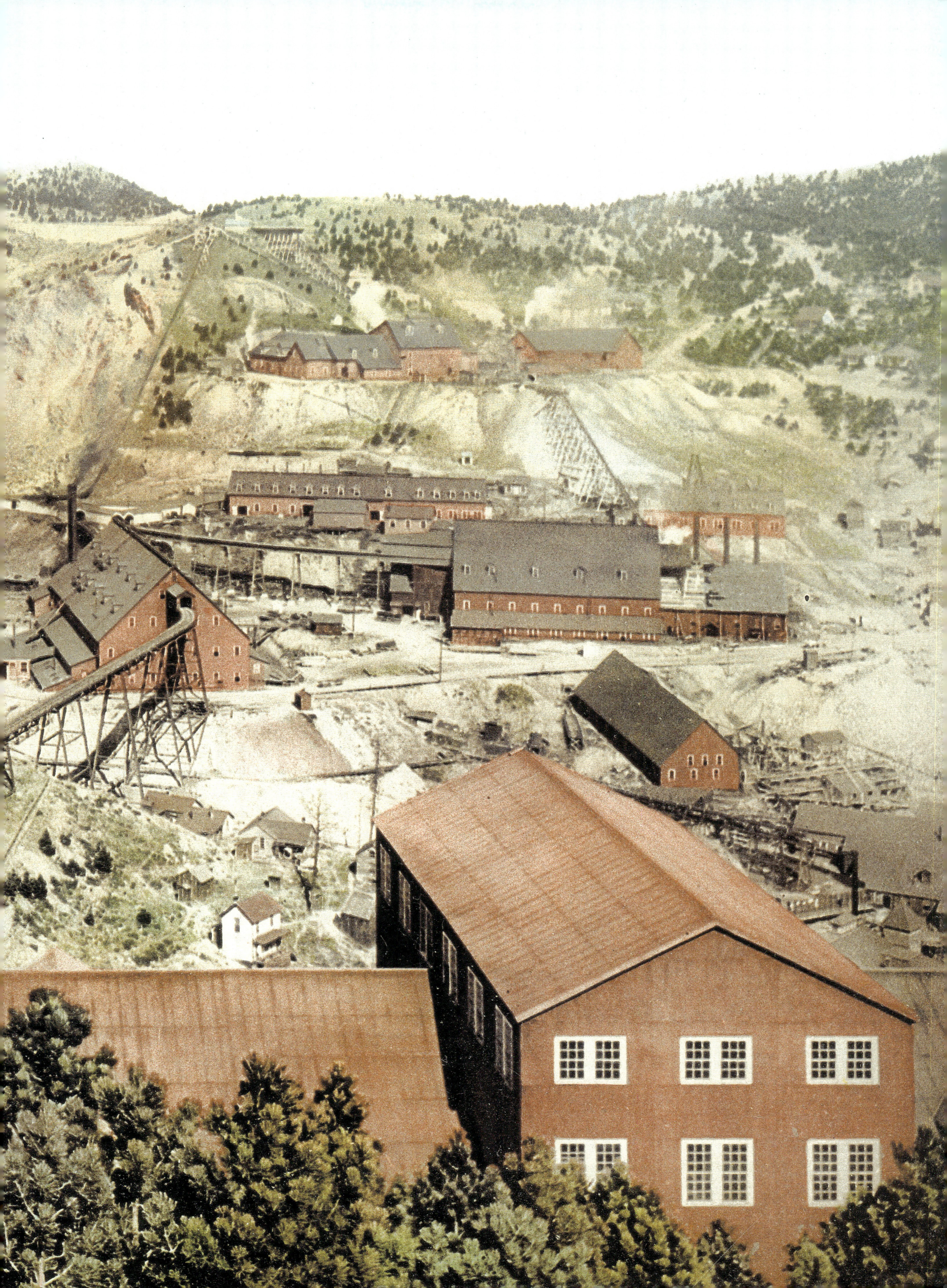

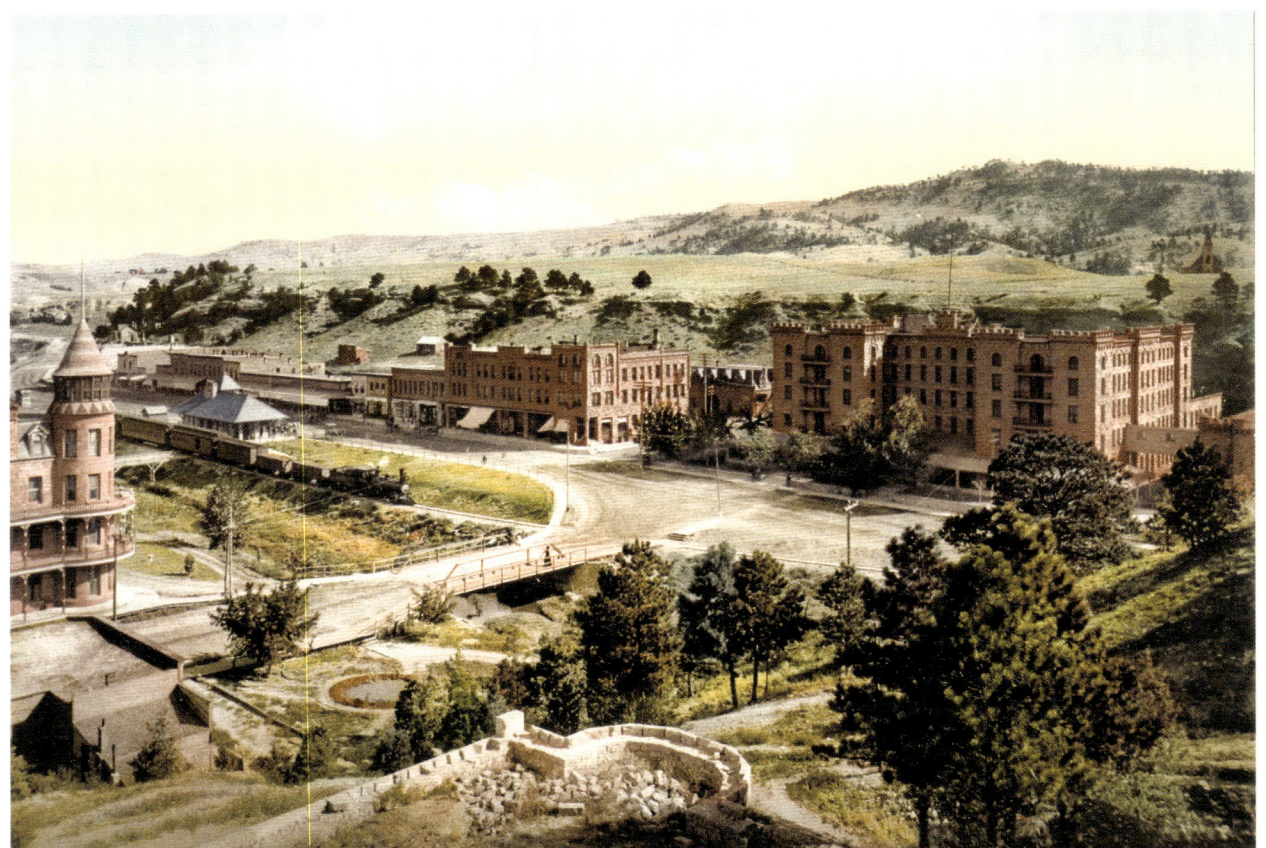

Page 268/269: **Homestake Mine, photochrom**
Above: **Approach to Spearfish Canyon, photochrom**
Left: **Hot Springs, Evan's Hotel, photochrom**
Page 271, below: **Sylvan Lake and Hotel, photochrom**

The hot springs to which this spa town in the Black Hills owes its name were a tourist attraction during the 19th century and as late as the 1950s. The Evans Hotel, built in 1892 of pink sandstone, gallantly survived two fires. In 1974, it was converted into a home for old and handicapped people. Recently, Hot Springs has again become a tourist destination thanks to the opening of its Mammoth Site: 120 mammoth tusks along with an entire skeleton were discovered here, buried in a "giant's kettle."

Seite 268/269: **Das Bergwerk von Homestake, Photochrom**
Oben: **Die Straße zum Spearfish Canyon, Photochrom**
Links: **Hot Springs, Hotel Evans, Photochrom**
Seite 271, unten: **Der Sylvan-See mit Hotel, Photochrom**

Die Thermalstadt Hot Springs in den Black Hills verdankt ihren Namen den warmen Quellen, die im 19. Jahrhundert und bis in die 1950er-Jahre hinein stark genutzt wurden. Das 1892 aus rosafarbenem Sandstein errichtete Hotel Evans hat zwei Bränden trutzig standgehalten. 1974 wurde es geschlossen und zu einer Wohneinrichtung für Senioren und Menschen mit Behinderung umgestaltet. Hot Springs wurde unlängst mit der Eröffnung des Mammoth Site wieder zu einer Touristenattraktion: 120 Stoßzähne von Mammuts und ein ganzes Skelett wurden hier am Grunde eines Eisbeckens entdeckt.

Pages 268/269 : la mine de Homestake, photochrome
Ci-dessus : **la route du canyon de Spearfish, photochrome**
Page 270, en bas : **Hot Springs, l'hôtel Evans, photochrome**
À droite : **le lac Sylvan et l'hôtel, photochrome**

Hot Springs, ville thermale des Black Hills, doit son nom à des sources chaudes largement exploitées au XIXe siècle et jusque dans les années 1950. L'hôtel Evans bâti en 1892, en grès rose, a vaillamment résisté à deux incendies. Fermé depuis 1974, l'établissement a été reconverti en résidence pour personnes âgées et handicapées. Hot Springs est récemment redevenu un site touristique grâce à l'ouverture de son « Mammoth Site » : cent vingt défenses de mammouths et un squelette entier, enfouis au fond d'une cuvette glaciaire, y ont été découverts.

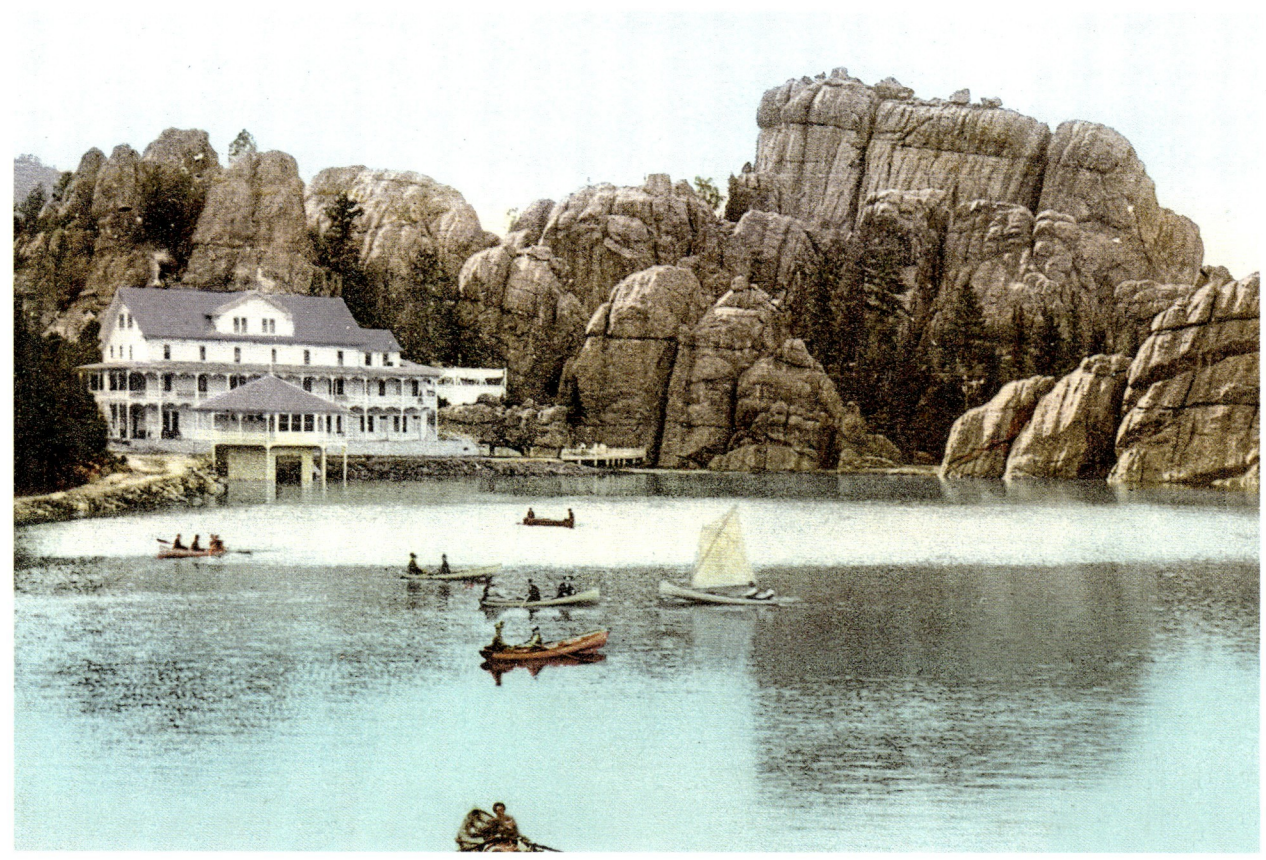

SOUTH DAKOTA | SPEARFISH CANYON | SYLVAN LAKE

IOWA

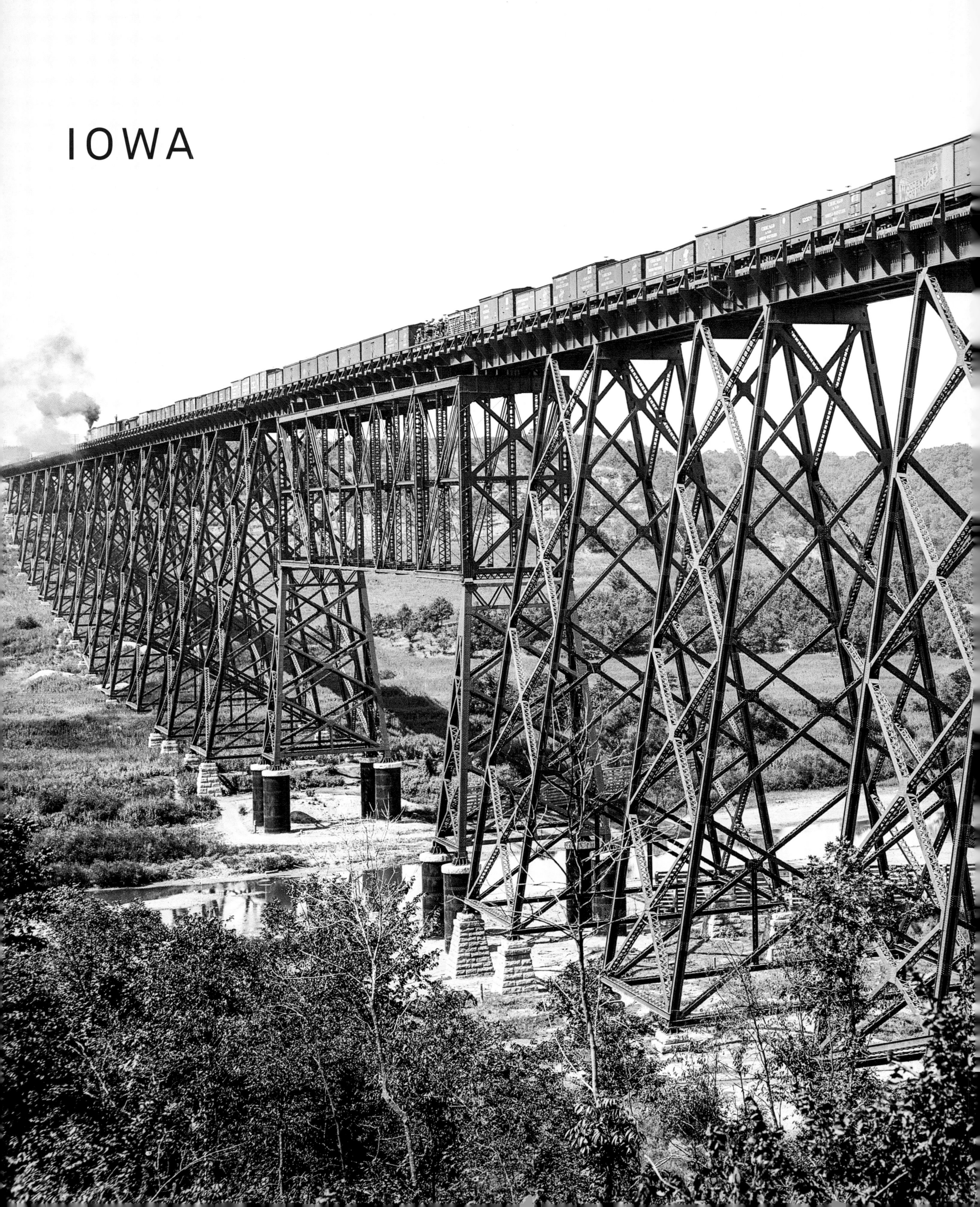

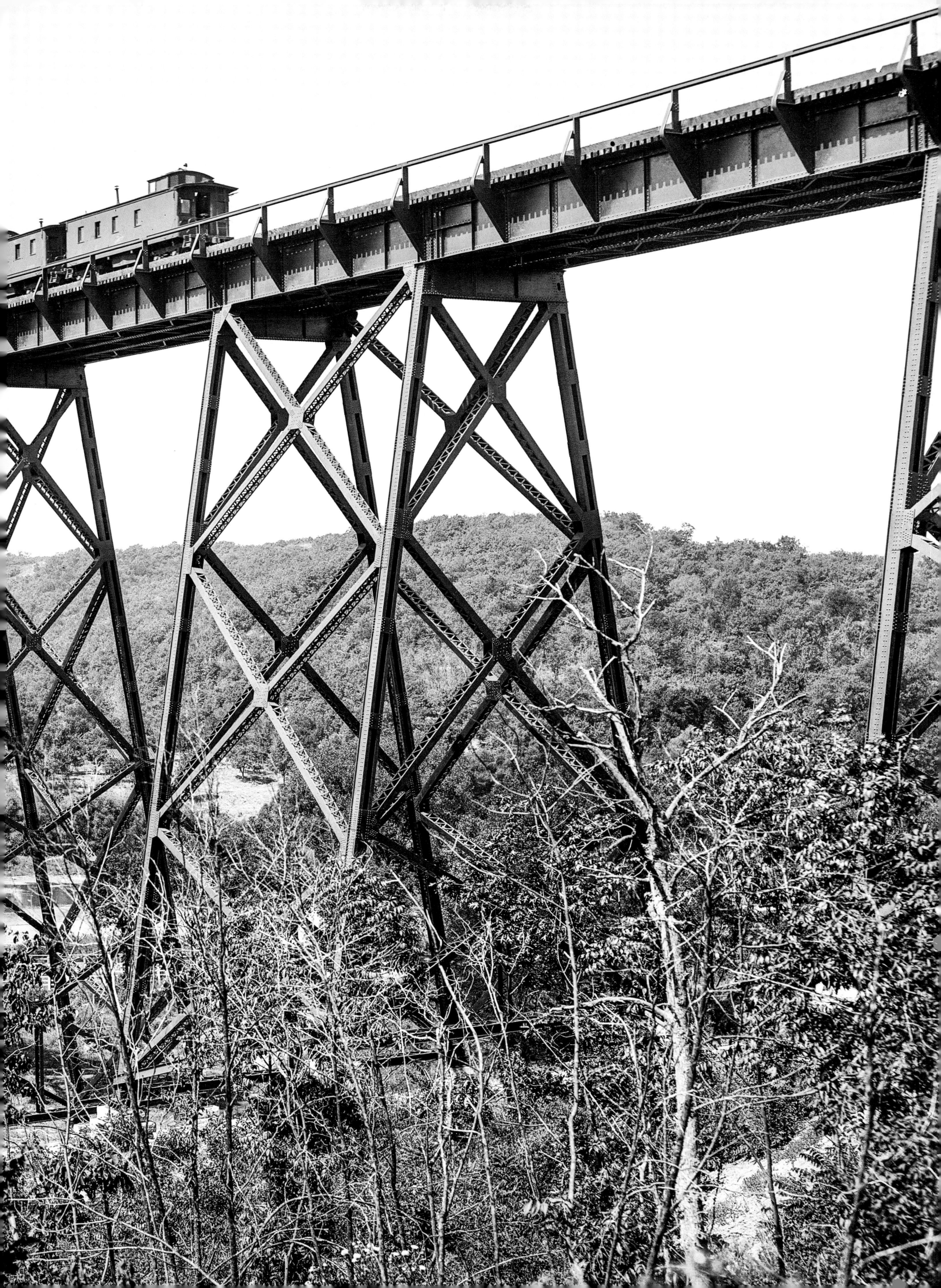

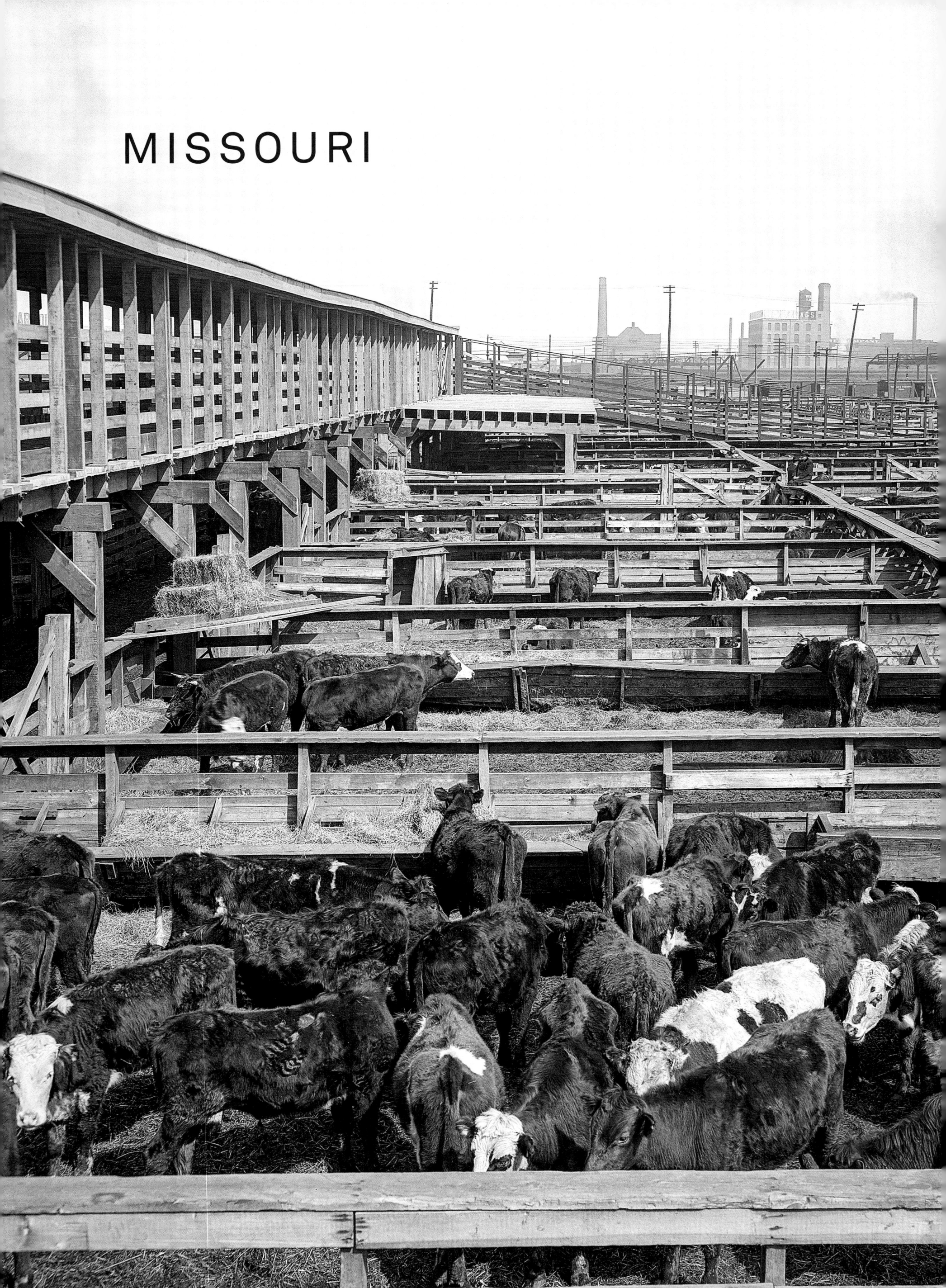

MISSOURI

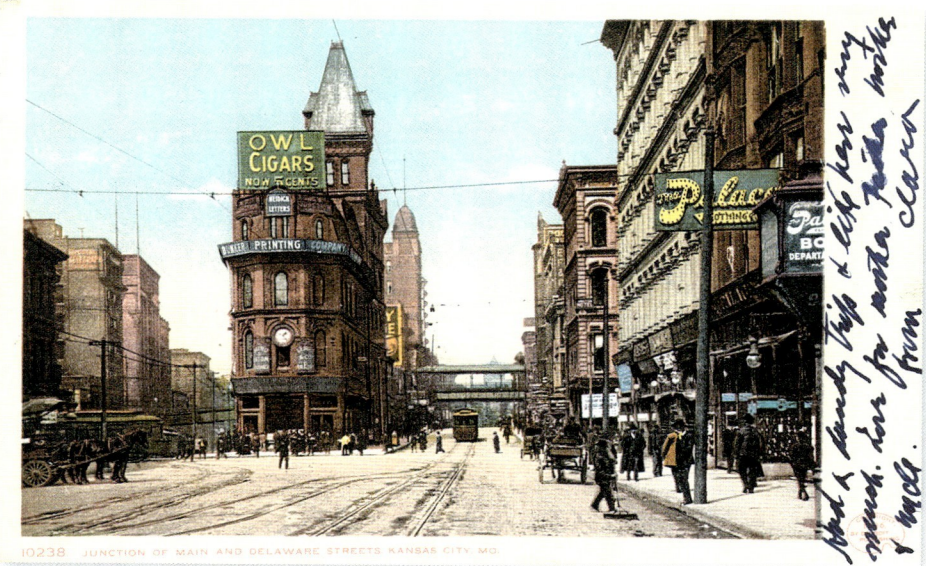
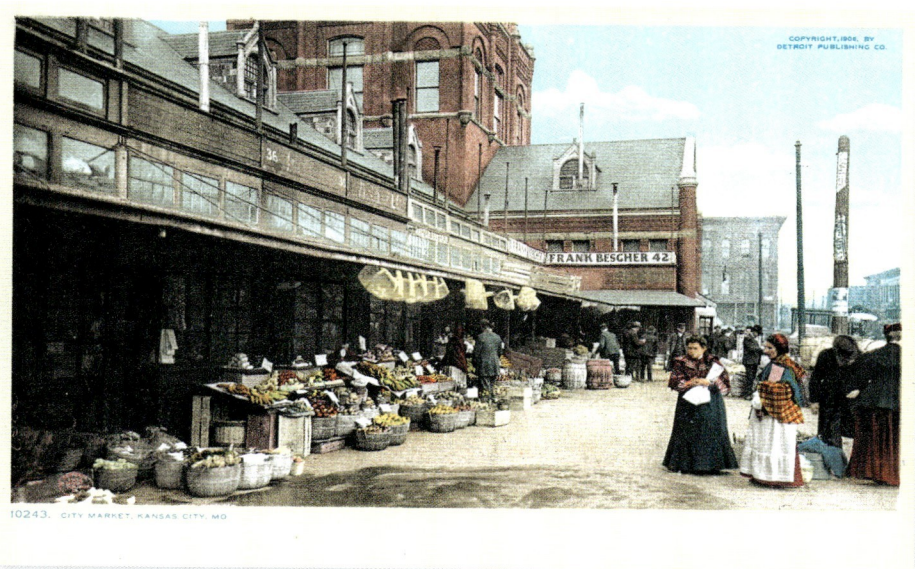

Page 272/273: **Iowa, viaduct over Des Moines River, glass negative, 1900**
Page 274: **Stockyards, Kansas City, glass negative, 1906**
From left to right and top to bottom:
Stockyards, general view
Stock Exchange Building
Junction of Main and Delaware Streets
City Market
Below: **The Owl drugstore**

On the south bank of the Missouri, downstream of its confluence with the Kansas River, Kansas City was connected to the Union Pacific Railway in 1870 by the Missouri, Kansas & Texas Railway; known as the "Katy," the line reached Dallas in 1886, Houston in 1893, and San Antonio in 1901. In 1896, an MKT general passenger agent named William George Crush decided to stage a train wreck as a publicity stunt. The planned collision took place in Crush, Texas, in front of 40,000 spectators, but unexpectedly caused the boilers of both locomotives to explode, which resulted in three fatalities and a number of injuries. The photographer hired to cover the event lost one of his eyes.

Seite 272/273: **Iowa, Viadukt über den Des Moines River, Glasnegativ, 1900**
Seite 274: **Viehhof, Kansas City, Glasnegativ, 1906**
Von links nach rechts und von oben nach unten:
Viehhof, Gesamtansicht
Warenbörse
An der Kreuzung von Main Street und Delaware Street
Markt
Unten: **Der Owl-Drugstore**

Die Stadt Kansas City am Südufer des Missouri, unterhalb des Zusammenflusses mit dem Kansas River, wurde 1870 von der Missouri, Kansas & Texas Railway an das Netz der Union Pacific Railroad angeschlossen; die Linie mit dem Namen „Katy" erreichte 1886 Dallas, 1893 Houston und 1901 San Antonio. 1896 hatte der für den Personenverkehr verantwortliche William George Crush die Idee „zu Werbezwecken eine Kollision" zwischen zwei Lokomotiven zu verursachen. Bei dem Zusammenstoß, der sich in Texas vor 40 000 Zuschauern ereignete, explodierten die Dampfkessel beider Lokomotiven. Dabei wurden drei Schaulustige getötet und zahlreiche verletzt; der Fotograf, der beauftragt worden war, das Ereignis zu begleiten, verlor ein Auge.

Pages 272/273 : **Iowa, viaduc de la Des Moines River, plaque de verre, 1900**
Page 274 : **parcs à bestiaux, Kansas City, plaque de verre, 1906**
De gauche à droite et de haut en bas :
Parcs à bestiaux, vue d'ensemble
La Bourse de commerce (Stock Exchange)
Au carrefour des rues Main et Delaware
Le marché
Ci-dessous : **le drugstore Owl**

Sur la rive sud du Missouri, en aval du confluent avec le fleuve Kansas, la ville de Kansas City fut reliée en 1870 au réseau de l'Union Pacific Railroad par le Missouri, Kansas & Texas Railway ; la ligne, baptisée « Katy », atteint Dallas en 1886, Houston en 1893 et San Antonio en 1901. En 1896, un contrôleur de la ligne, William George Crush, eut l'idée d'organiser une « collision publicitaire » entre deux locomotives : lors du crash, qui se déroula au Texas devant 40 000 spectateurs, les chaudières des locomotives explosèrent, faisant trois morts et plusieurs blessés parmi les badauds ; le photographe mandaté pour couvrir l'événement perdit un œil.

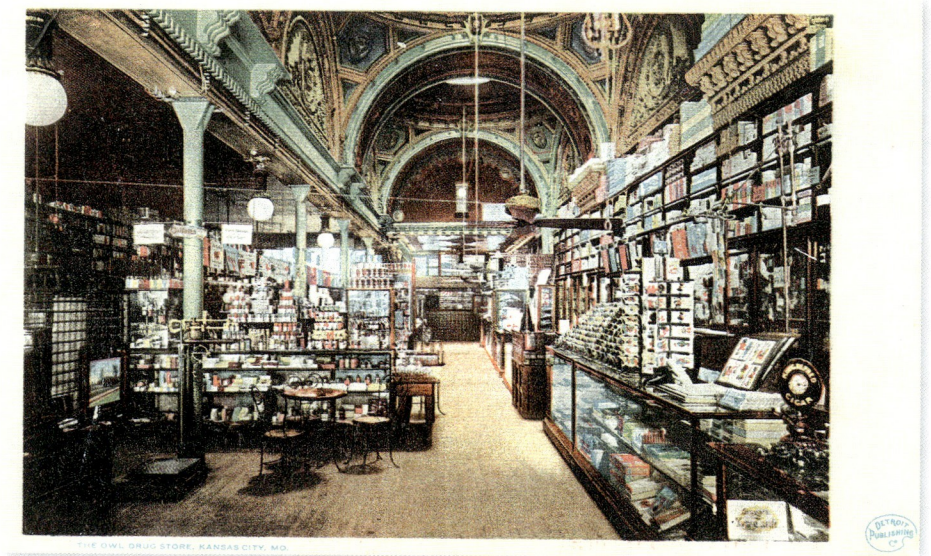

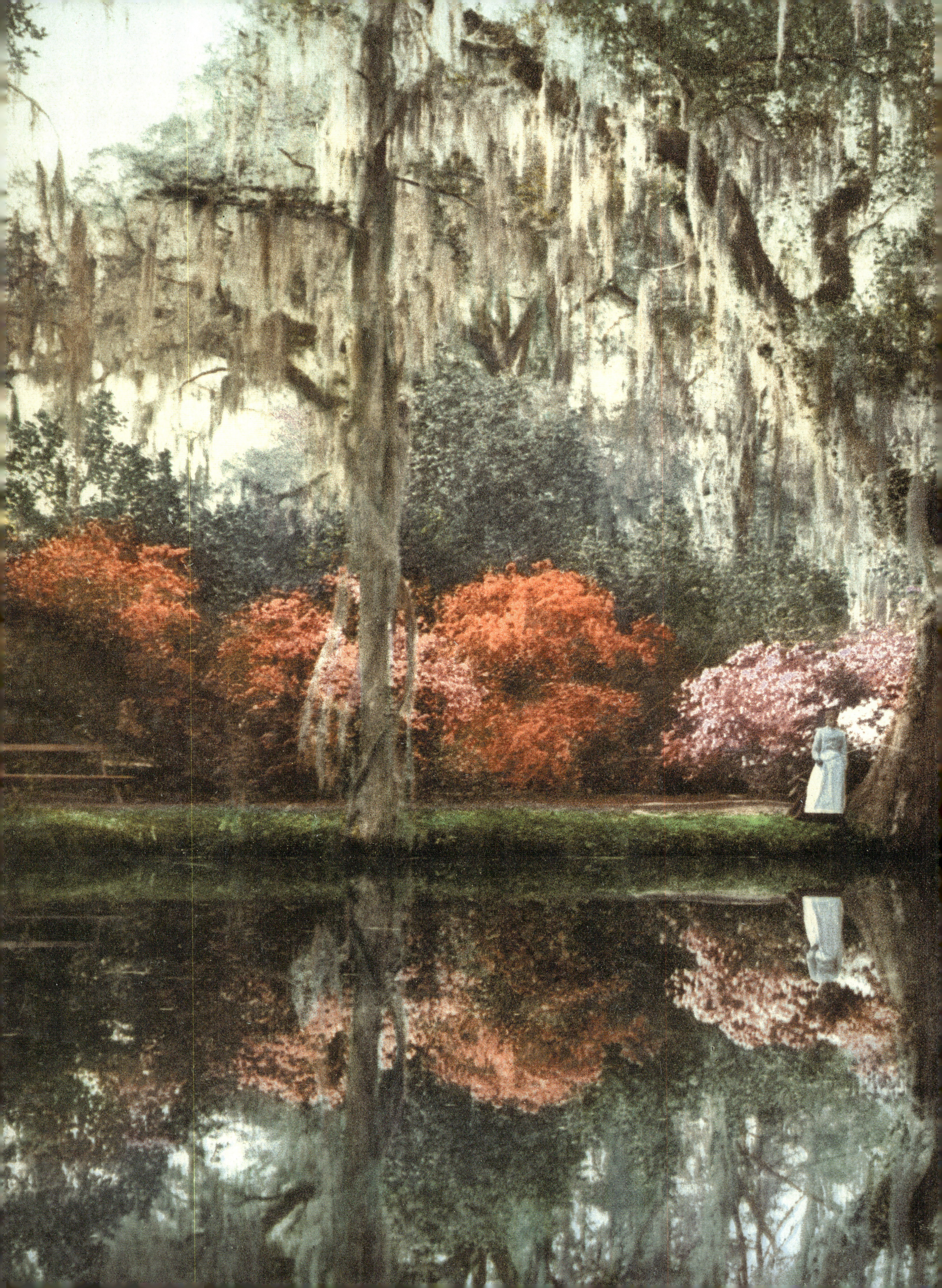

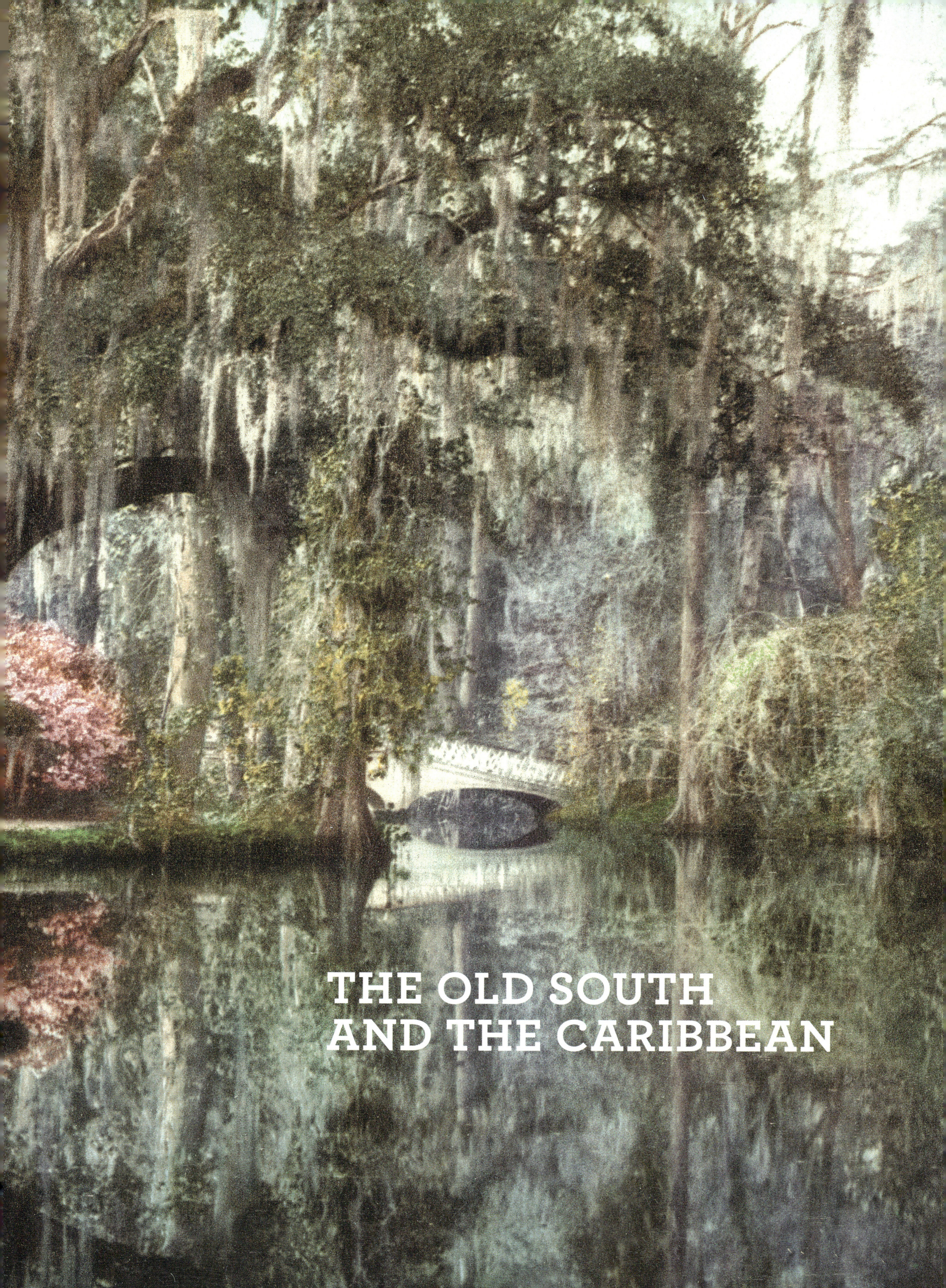

THE OLD SOUTH AND THE CARIBBEAN

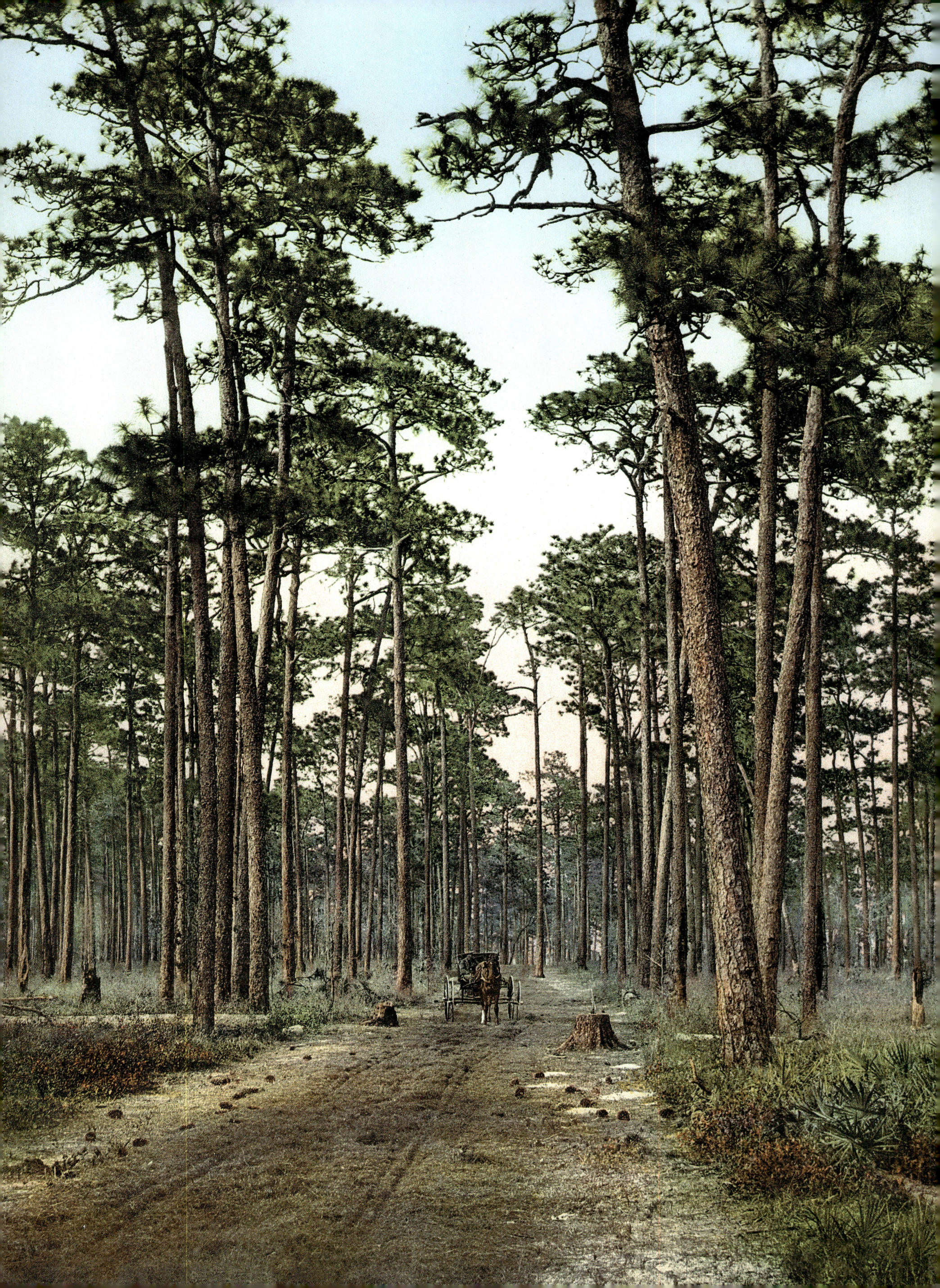

Page 276/277: Charleston, Magnolia-on-the-Ashley, photochrom
Page 278: In the pine woods, Florida, photochrom
Right: Old Black Joe

Seite 276/277: Charleston, Magnolia-on-the-Ashley, Photochrom
Seite 278: Im Kiefernwald, Florida, Photochrom
Rechts: Old Black Joe

Pages 276/277 : Charleston, Magnolia-on-the-Ashley, photochrome
Page 278 : dans la pinède, Floride, photochrome
À droite : Old Black Joe

THE OLD SOUTH AND THE CARIBBEAN

The Southern states of the USA are unanimously considered the most archetypal of the North American continent. Explored in the 16th century by Spanish conquistadors in quest of gold, coveted by various European nations, colonized by the French, retaken and relost by the English during the 18th-century wars waged between the French, English, and Spanish, the South boasts a tumultuous and multicultural past whose traces are still clearly perceptible. The Southern states have in common the heavy historical burden of slavery, which was first perpetrated by the Spanish on the local Native American populations, then, starting in the 17th century, by the English and French plantation owners (the former in Virginia), who were responsible for the massive deportation of Africans to the Caribbean and to the South of the United States.

A researcher at the University of Washington, Ernest Rubin, estimated that, in 1860, black slaves represented 12.6 percent of the total population of the country, amounting to more than three million, of whom six-sevenths were in the South. As is well known, the situation led to tension between the abolitionist and slave states, tensions unalleviated between the American Declaration of Independence on July 4, 1776, and the victory of Abraham Lincoln in the presidential elections of 1860. This was the point at which South Carolina seceded from the Union. In March 1861, Mississippi, Florida, Alabama, Louisiana, Georgia, and Texas followed suit and adopted their own constitution. In April 1861, the Confederates attacked a Union fort, Fort Sumter at Charleston in South Carolina. Virginia, Arkansas, Tennessee, and North Carolina joined the Confederates and the American Civil War broke out. It lasted four years, until General Lee, head of the Confederate army, surrendered to General Grant at Appomattox, Virginia, on April 9, 1865.

The war left the South on its knees. Its economy had been ravaged and its plantations devastated while the proclamation on December 18, 1865, of the 13th Amendment of the Constitution outlawing slavery had profound repercussions in the South. Dissident planters left for the Caribbean with their slaves while freed slaves fled to the West or the North to avoid white reprisals. After the election of the former general, President Ulysses S. Grant (1868), the Union turned a blind eye to the maneuvering of the "carpetbaggers," northern adventurers who settled in the South and were accused of large-scale corruption. Then, in 1883, the U.S. Supreme Court decreed that Congress did not have the power to forbid racial segregation to private persons and organizations and, in 1896, authorized states began to practice segregation as long as the conditions afforded to the different races were "separate but equal"; this was not officially abolished until 1964.

The images of the Detroit Photographic Co. are eloquent testimony to the nature of the South in the early 20th century, when it had finished licking its wounds and was waking up to the modern world. It still lived by cotton and tobacco, but industrialization had begun and the region was beginning to open up to a new industry: tourism.

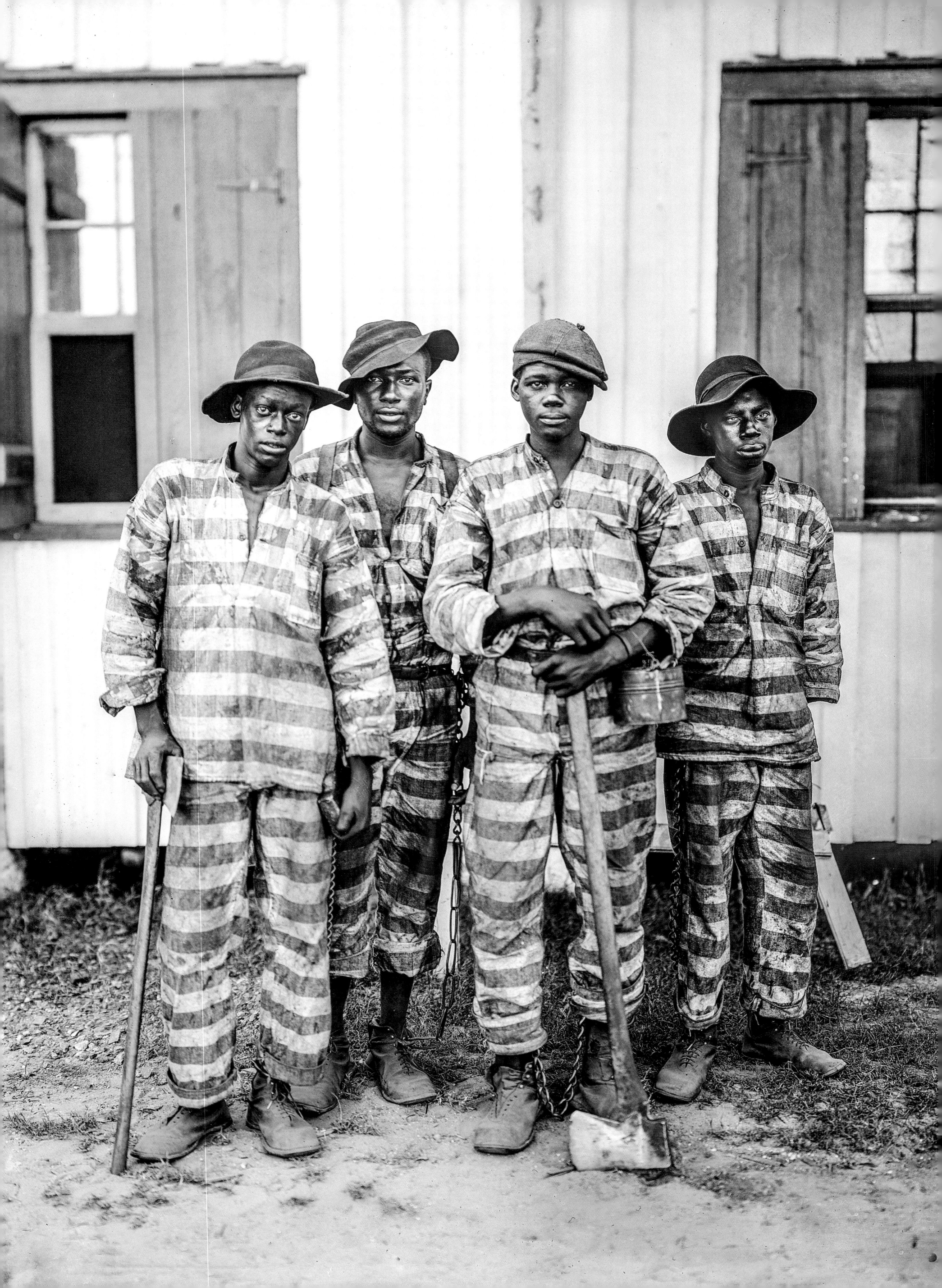

Page 280: A Southern chain gang, New Orleans, glass negative, 1900–1905
Right: "Mammy"

Seite 280: Sträflinge, New Orleans, Glasnegativ, 1900–1905
Rechts: „Mammy"

Page 280: bagnards, La Nouvelle-Orléans, plaque de verre, 1900–1905
À droite : « Mammy »

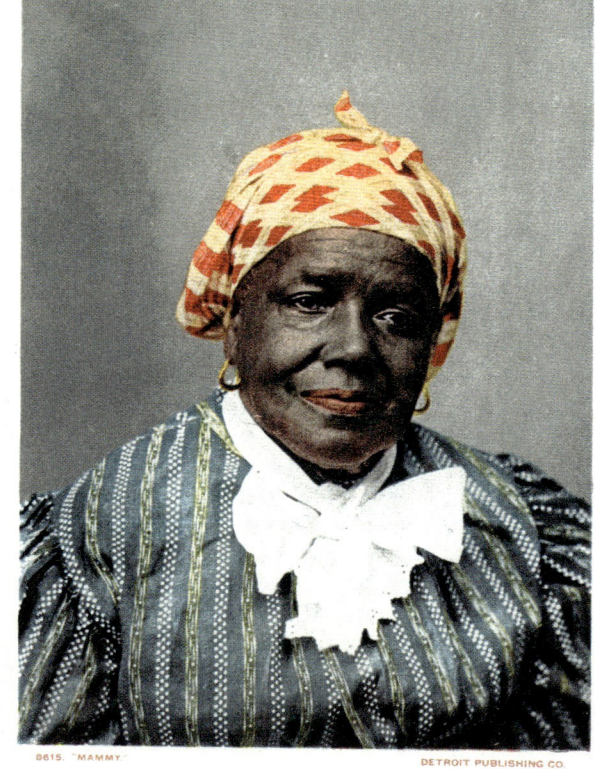

DER ALTE SÜDEN UND DIE KARIBIK

Die Südstaaten der USA werden einhellig als die „typischsten" des nordamerikanischen Kontinents angesehen. Im 16. Jahrhundert von den spanischen Eroberern auf ihrer Suche nach Gold entdeckt, weckten sie das Interesse verschiedener europäischer Länder, wurden von den Franzosen kolonisiert und im 18. Jahrhundert in den zwischen Franzosen, Engländern und Spaniern geführten Kriegen von den Engländern erobert und dann wieder verloren. Ihre stürmische und multikulturelle Vergangenheit hat Spuren hinterlassen, die noch heute deutlich zu erkennen sind. Allen Südstaaten gemeinsam ist das Erbe der Sklaverei. Sie begann mit den Spaniern, die die örtliche indianische Bevölkerung versklavten, später dann, ab dem 17. Jahrhundert, waren die englischen (in Virginia) und französischen Plantagenbesitzer für die massenhafte Deportation von Afrikanern in die Karibik und in den gesamten Süden der Vereinigten Staaten verantwortlich. Ernest Rubin, Forscher an der Universität von Washington, schätzt (in: *Les esclaves aux États-Unis de 1790 à 1860*, erschienen 1959), dass 1860 der Bevölkerungsanteil der schwarzen Sklaven 12,6 % der Gesamtbevölkerung des Landes ausmachte, also mehr als drei Millionen, wobei sechs von sieben im Süden lebten. Man weiß, dass hierin die Ursache für die Spannungen zwischen den die Sklaverei ablehnenden und den sie befürwortenden Staaten lag, die sich nach der amerikanischen Unabhängigkeitserklärung vom 4. Juli 1776 und bis zum Sieg Abraham Lincolns bei den Präsidentschaftswahlen von 1860 noch verschärften. In dieser Situation entschied sich South Carolina für eine Sezession und gegen die Union. Im März 1861 schlossen sich Mississippi, Florida, Alabama, Louisiana, Georgia und Texas an und verabschiedeten ihre eigene Verfassung. Im April 1861 griffen die Konföderierten Staaten mit Fort Sumter in Charleston (South Carolina) eine Festung der Union an. Virginia, Arkansas, Tennessee und North Carolina traten der Konföderation bei, und der Amerikanische Bürgerkrieg (der sogenannte Sezessionskrieg) brach aus. Er dauerte vier Jahre, bis zur Kapitulation General Lees, des Befehlshabers der Konföderierten, vor General Grant in Appomattox (Virginia) am 9. April 1865.

Der Krieg ließ den Süden kraftlos zurück. Seine Wirtschaft lag danieder, seine Plantagen waren verwüstet, und die Abschaffung der Sklaverei durch die Verfassung vom 18. Dezember 1865 brachte große Umwälzungen mit sich. Die sich widersetzenden Plantagenbesitzer zogen mit ihren Sklaven in die Karibik, und freigelassene Sklaven flohen vor den Repressalien der Weißen nach Westen oder Norden. Nach der Wahl des ehemaligen Generals Ulysses S. Grant zum Präsidenten (1868) ignorierte die Union die Aktivitäten durch die „carpetbaggers", jene opportunistischen Abenteurer aus dem Norden, die sich im Süden niederließen und ihre Macht mithilfe von Korruption erhielten. 1883 verfügte der Oberste Gerichtshof, dass der Kongress „Privatpersonen und Privatunternehmen" die Rassentrennung nicht verbieten könne, und genehmigte 1896 den Staaten, selbst die Rassentrennung durchzuführen, vorausgesetzt, es herrschten für die unterschiedlichen Gruppen „getrennte, aber gleiche" Bedingungen. Dies wurde erst 1964 offiziell aufgehoben!

Die Bilder der Detroit Photographic Co. erzählen vom Süden zu Beginn des 20. Jahrhunderts, dessen Wunden nun verheilt sind und der sich der modernen Welt zuzuwenden beginnt. Von jenem Süden also, der noch von Baumwolle und Tabak lebt, sich aber bereits der Industrie und dem Tourismus öffnet.

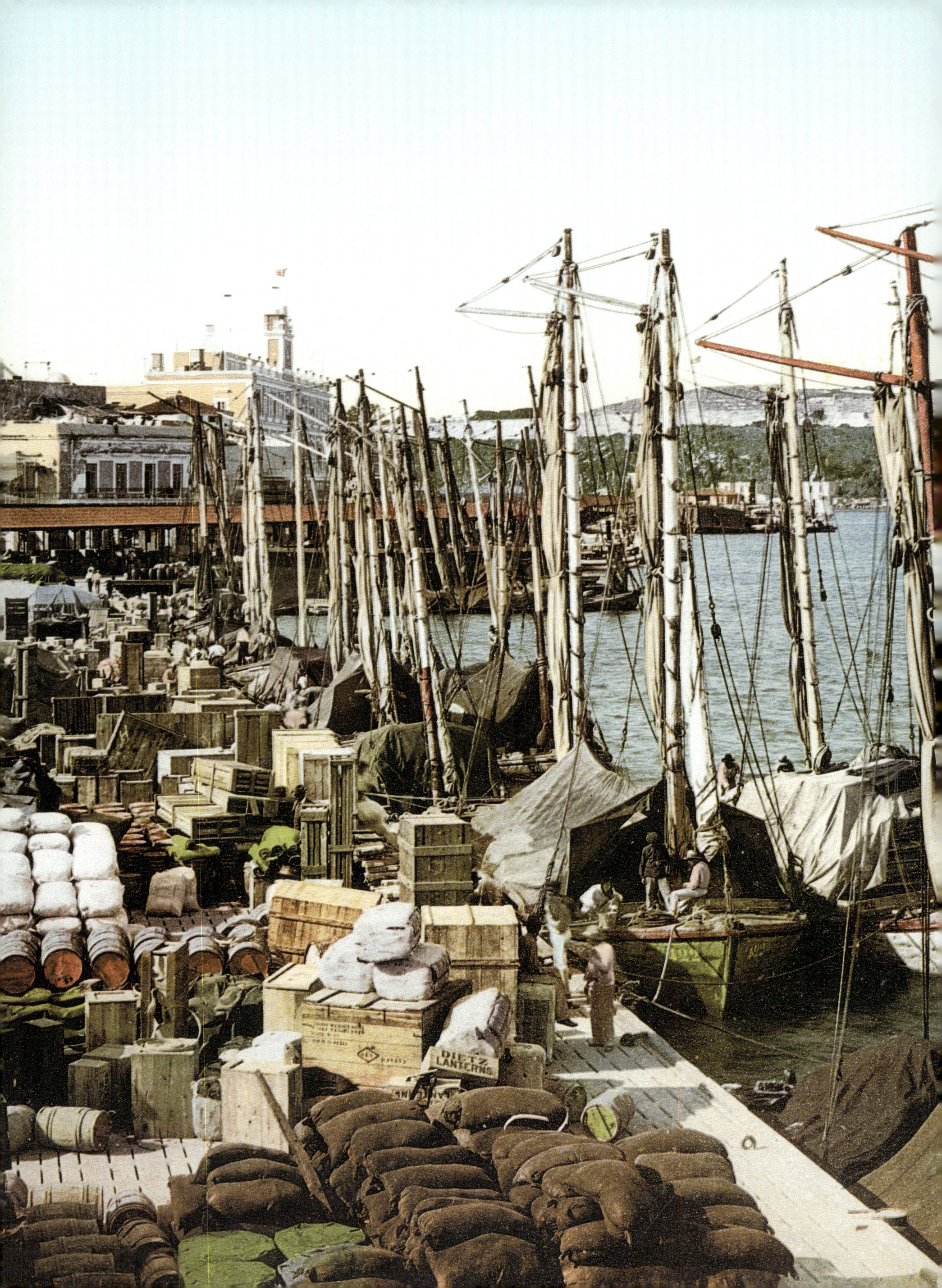

Page 282: Muelle San Francisco, Havana, Cuba, photochrom
Top right: Saving sinners, scene along the Mississippi
Below right: African American boys playing marbles

Seite 282: San-Francisco-Mole, Havanna, Kuba, Photochrom
Oben rechts: Die Reinigung von Sündern im Mississippi
Unten rechts: Afroamerikanische Jungen beim Murmelspiel

Page 282 : le môle San Francisco, La Havane, Cuba, photochrome
À droite en haut : scène de purification dans le fleuve Mississippi
À droite en bas : garçons afro-américains jouant aux billes

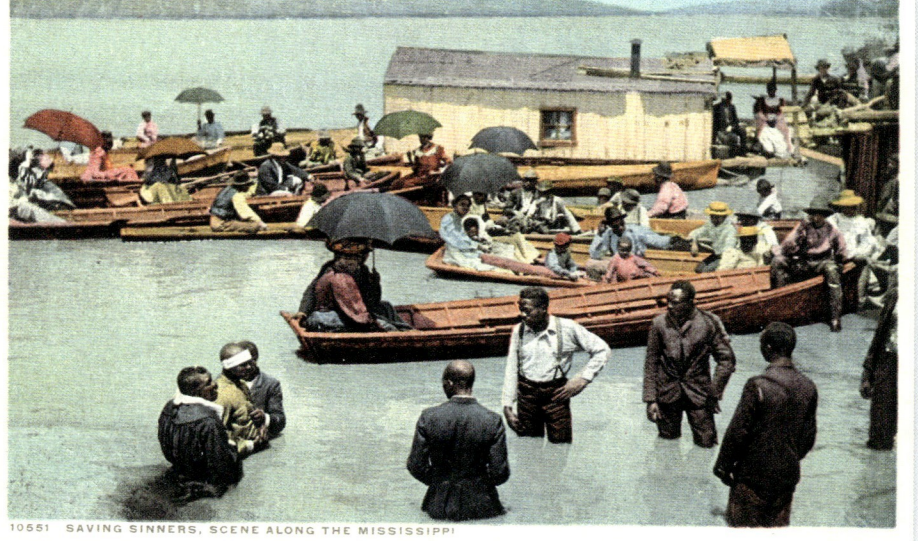

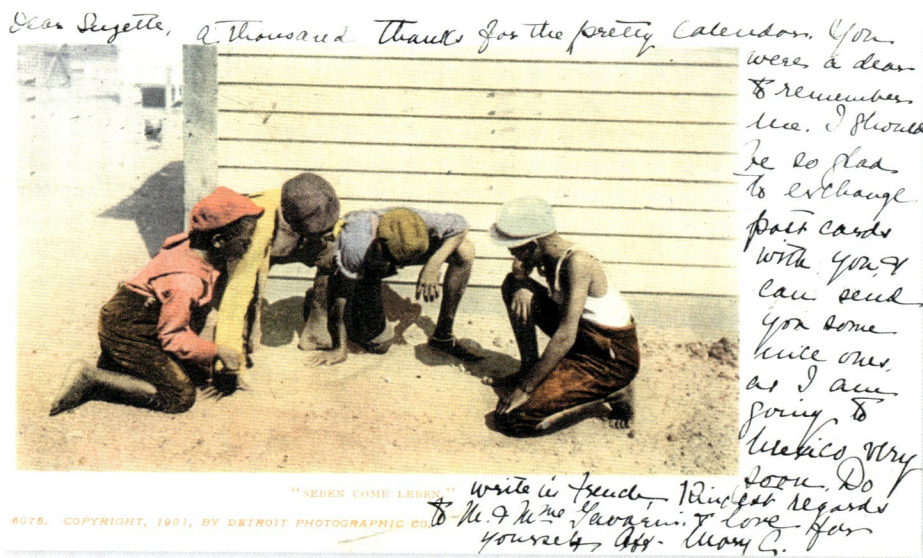

LE VIEUX SUD ET LES CARAÏBES

Les États du Sud des États-Unis sont unanimement considérés comme les plus « typés » du continent nord-américain. Explorés au XVIe siècle par les conquérants espagnols en quête d'or, convoités par les différentes nations européennes, colonisés par les Français, repris puis perdus par les Anglais au gré des guerres menées au XVIIIe siècle entre Français, Anglais et Espagnols, ils ont un passé tumultueux et multiculturel qui a laissé des traces encore bien perceptibles. Ils ont en commun le lourd héritage de l'esclavagisme, d'abord perpétré par les Espagnols sur les populations indiennes locales, puis, dès le XVIIe siècle, par les planteurs anglais (en Virginie) et français, responsables de la déportation massive des Africains dans les Caraïbes et dans tout le Sud des États-Unis.

Un chercheur de l'université de Washington, Ernest Rubin (in *Les esclaves aux États-Unis de 1790 à 1860*, paru en 1959), estime qu'en 1860 la population d'esclaves noirs représentait 12,6 % de la population totale du pays, soit plus de 3 millions de personnes, dont les 6/7e dans le Sud. On sait que cette situation est à l'origine des tensions entre États abolitionnistes et esclavagistes, qui vont aller croissant après la déclaration de l'Indépendance américaine le 4 juillet 1776 jusqu'à la victoire d'Abraham Lincoln à l'élection présidentielle en 1860 : la Caroline du Sud entre dès lors en sécession. En mars 1861, le Mississippi, la Floride, l'Alabama, la Louisiane, la Géorgie et le Texas la rejoignent et adoptent leur propre Constitution. En avril 1861, les Confédérés attaquent un fort de l'Union, Fort Sumter à Charleston, en Caroline du Sud. La Virginie, l'Arkansas, le Tennessee et la Caroline du Nord entrent dans la Confédération et la guerre civile américaine (dite guerre de Sécession) éclate. Elle durera quatre ans, jusqu'à ce que le général Lee, chef de l'armée des Confédérés, se rende au général Grant à Appomattox, le 9 avril 1865. La guerre laisse le Sud exsangue. Son économie est ravagée, les plantations dévastées ; l'abolition de l'esclavage par la Constitution, le 18 décembre 1865, entraîne des bouleversements. Des planteurs contestataires se rendent avec leurs esclaves dans les Caraïbes, des esclaves affranchis fuient, vers l'Ouest ou vers le Nord, les représailles des Blancs. Après l'élection à la présidence de l'ancien général Ulysses Grant (1868), l'Union ferme les yeux sur les exactions des *carpetbaggers*, ces aventuriers opportunistes du Nord qui s'implantent dans le Sud et font régner la corruption. En 1883, la Cour suprême décrète que le Congrès ne peut interdire la ségrégation aux « personnes et entreprises privées » et, en 1896, elle autorise les États eux-mêmes à pratiquer la ségrégation pourvu que les conditions proposées aux différentes races soient « séparées mais égales »… Une ségrégation qui ne sera officiellement abolie qu'en 1964 !

Les images de la Detroit Photographic Co. parlent de ce Sud du début du XXe siècle qui a fini de panser ses plaies et s'éveille au monde moderne. De ce Sud qui vit encore du coton et du tabac, mais qui déjà s'industrialise et s'ouvre au tourisme.

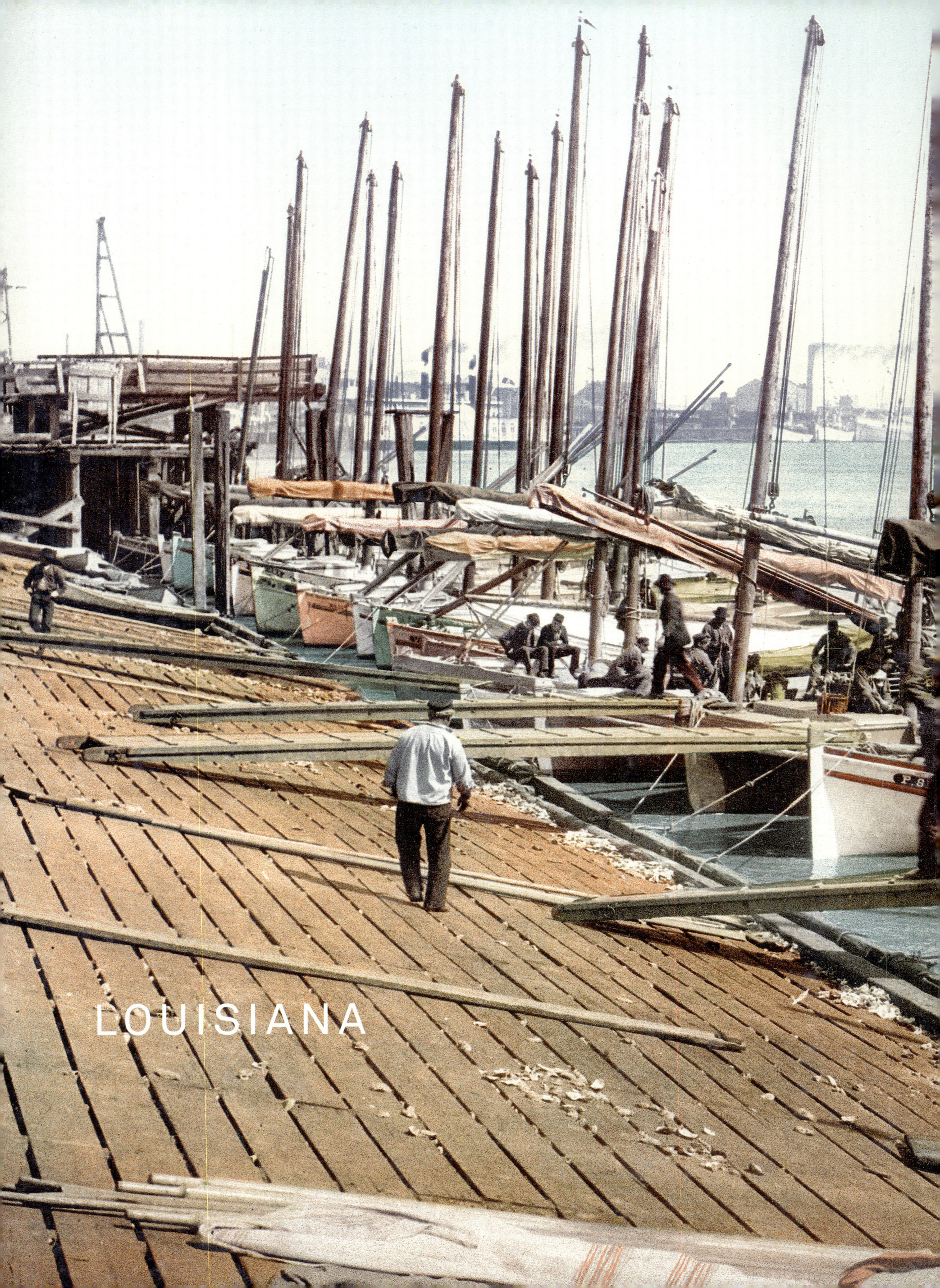
LOUISIANA

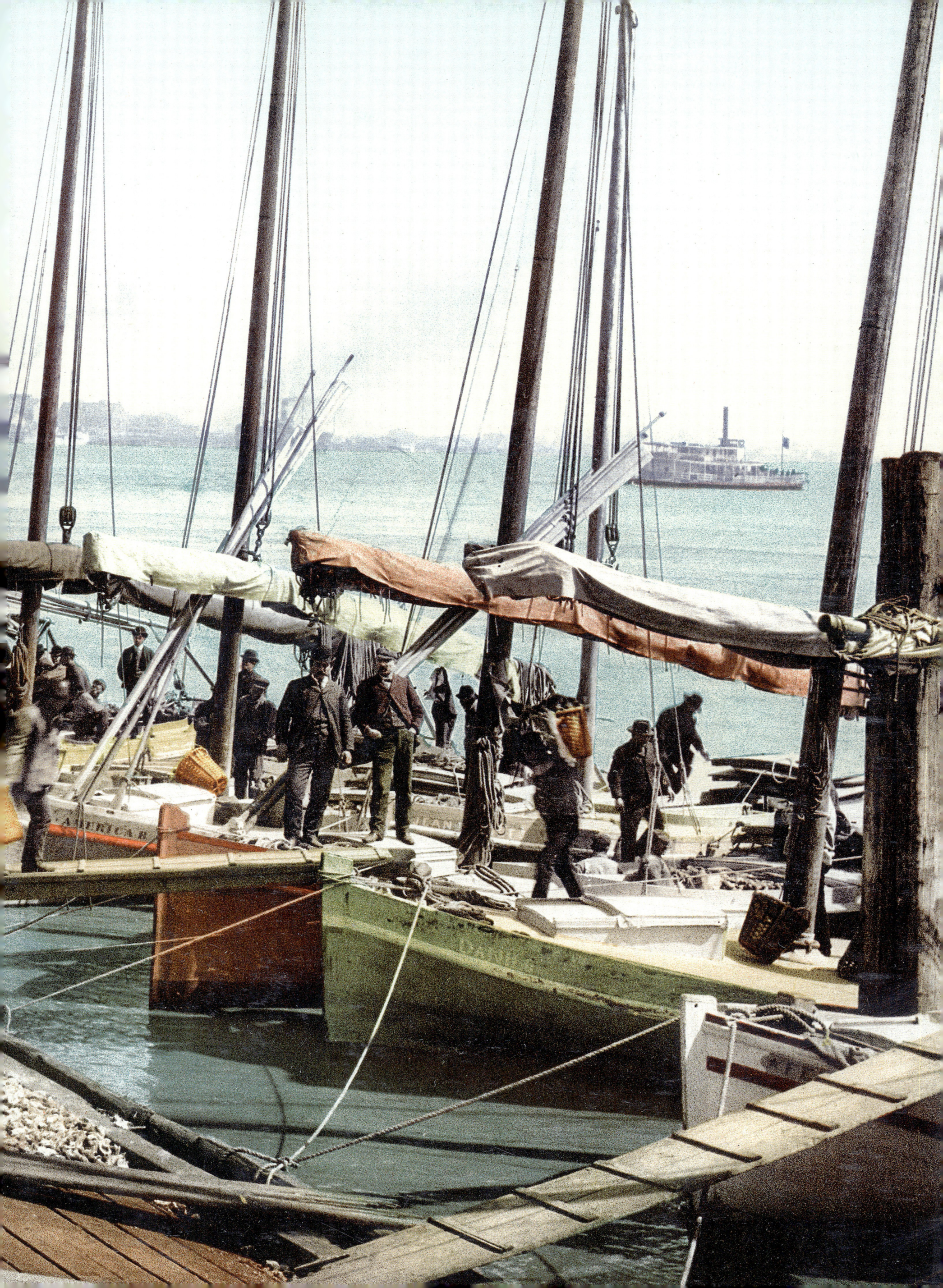

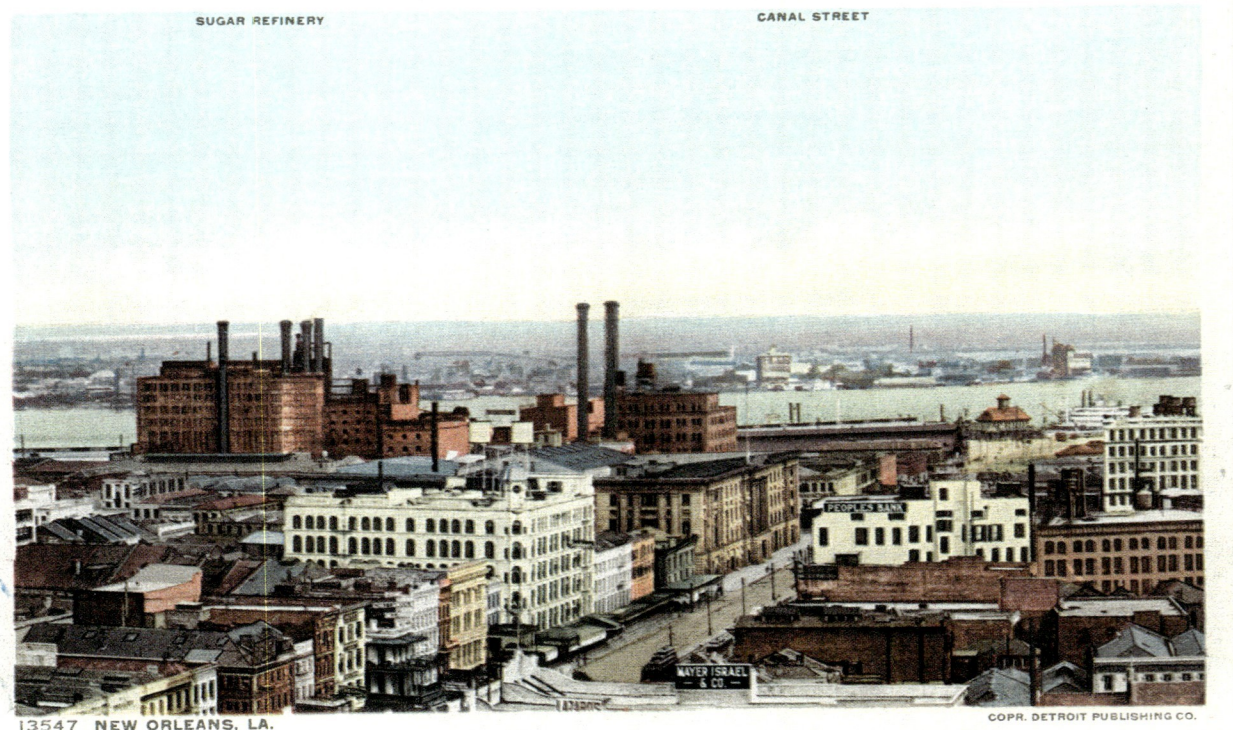

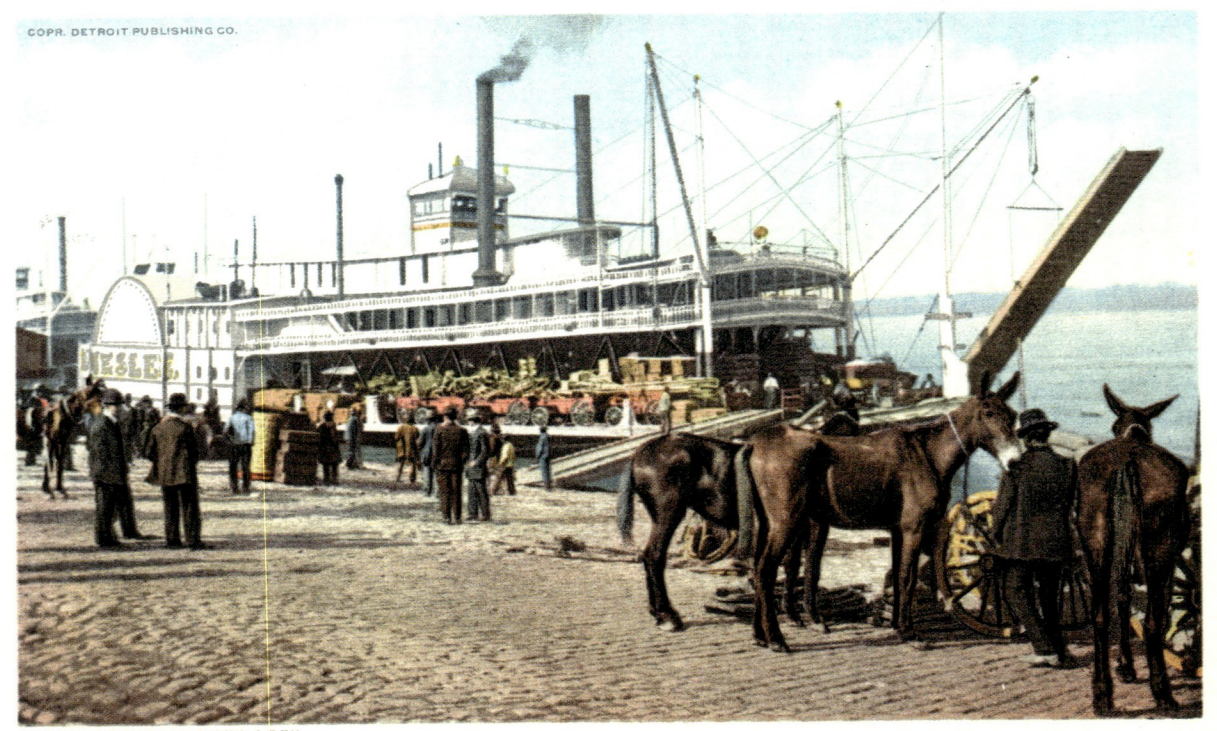

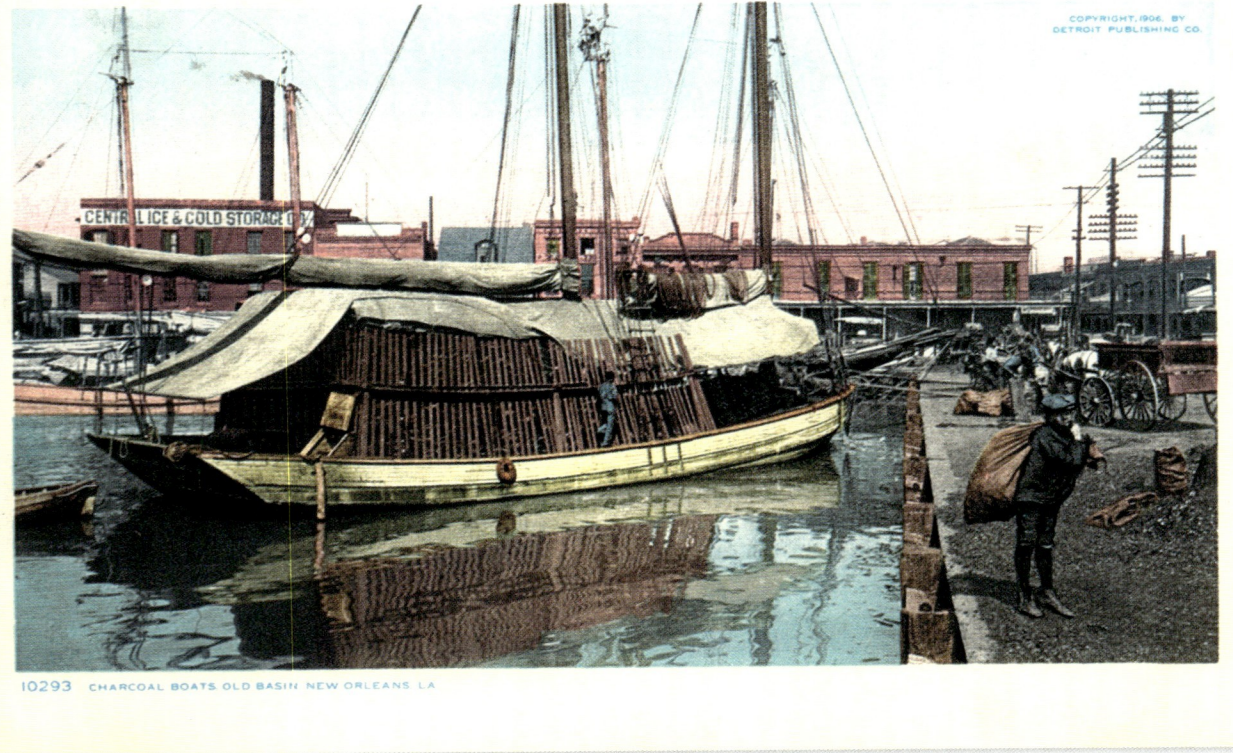

Page 284/285: Oyster luggers in New Orleans, photochrom
From top to bottom:
Panoramic view of New Orleans
Packet *James Lee*
Charcoal boats in the old basin

Since a large part of the city lies below the high-water level of the Mississippi River, the quay at New Orleans was protected by a large, raised jetty, the levee, at which steamers moored.

Seite 284/285: Austernkutter im Hafen von New Orleans, Photochrom
Von oben nach unten:
Panorama von New Orleans
Der Passagierdampfer *James Lee* **am Kai**
Kohleboote im alten Hafenbecken

Da ein Großteil der Stadt unter dem Hochwasserniveau des Mississippi lag, wurde der Kai von New Orleans durch eine breite, hohe Mole geschützt, den Damm, an dem die Dampfschiffe anlegten.

Pages 284/285 : bateaux huîtriers dans le port de La Nouvelle-Orléans, photochrome
De haut en bas :
Vue panoramique de La Nouvelle-Orléans
Le paquebot *James Lee* **à quai**
Bateaux charbonniers dans le vieux bassin

Une grande partie de la ville se trouvant en dessous du niveau des hautes eaux du Mississippi, le quai de La Nouvelle-Orléans était protégé par une large jetée surélevée, la levée, à laquelle venaient mouiller les steamers.

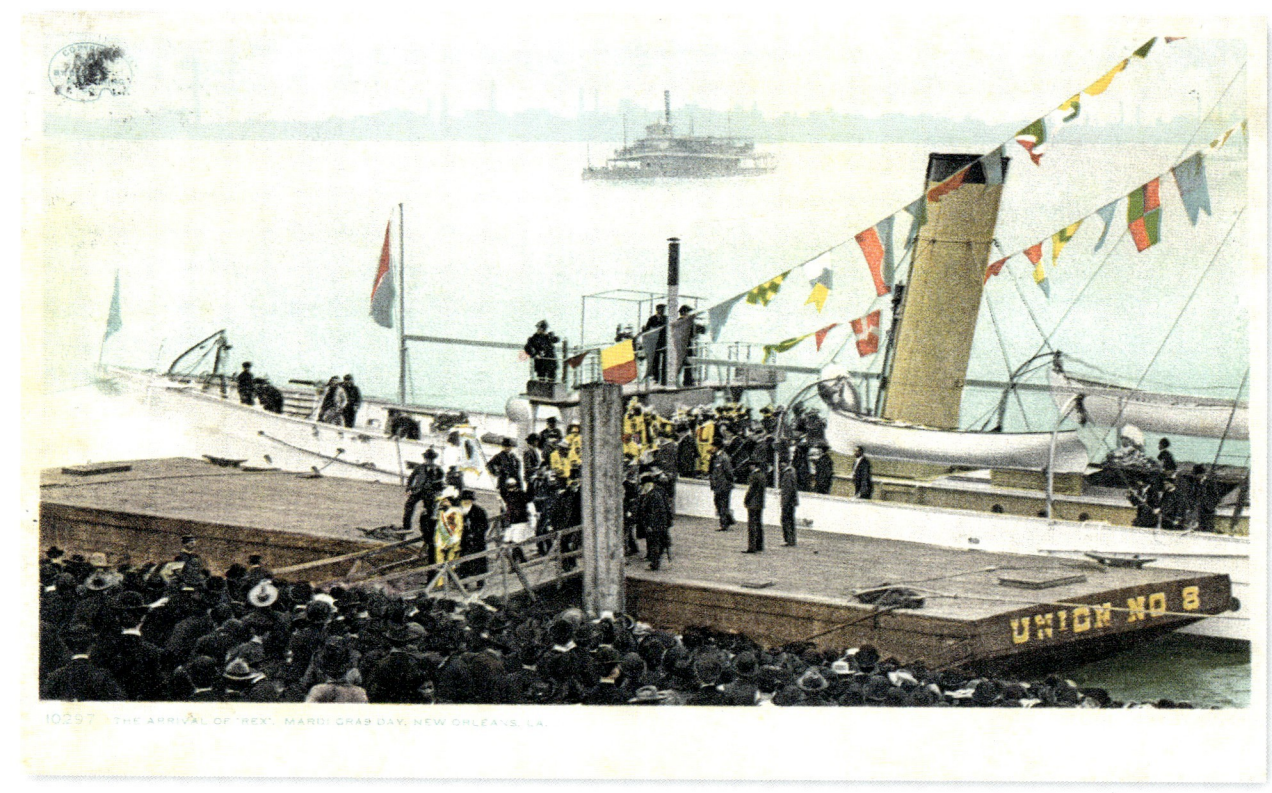

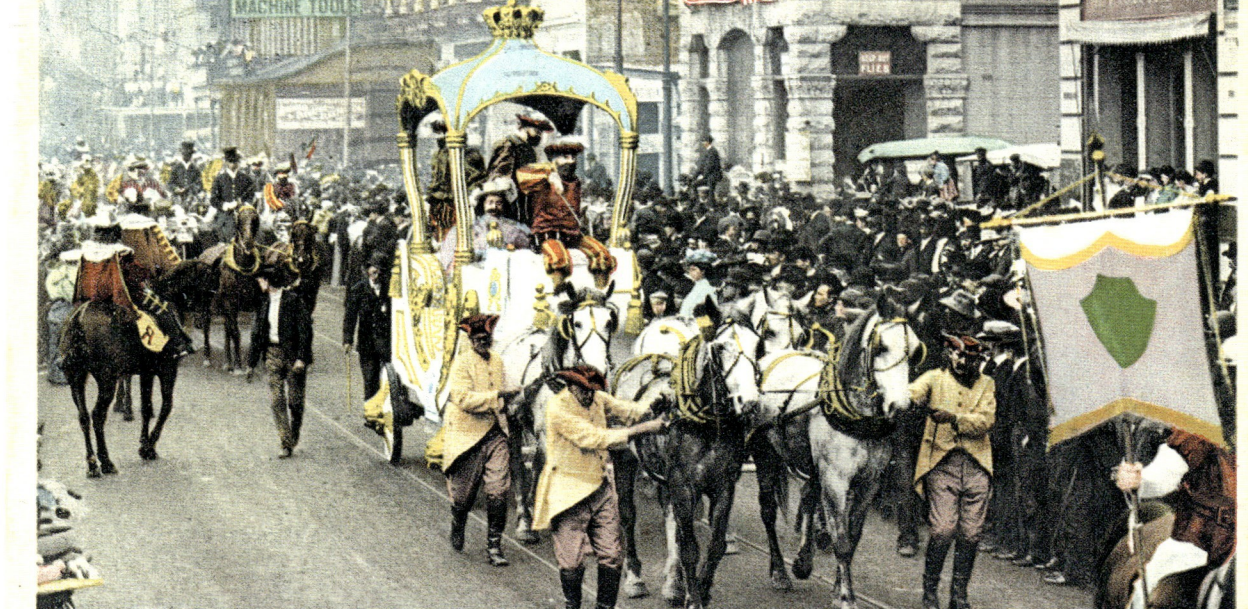

From top to bottom:
The arrival of Rex, Mardi Gras Day
Rex passing through Camp Street
Scene during Mardi Gras carnival
Page 288/289: **The levee at Canal Street, photochrom**

The Mardi Gras in New Orleans is very famous in the United States. The first Mardi Gras celebrations in Louisiana in fact took place at Mobile in 1703, four years after the Franco-Canadian Jean-Baptiste Le Moyne de Bienville disembarked at Mardi Gras Point, so named because the expedition arrived there on that day. Founded in 1718, New Orleans began to celebrate Mardi Gras in the early 1730s, but it was not until 1872, and the visit of the Russian Grand Duke, that the king of the carnival, Rex, first appeared.

Von oben nach unten:
Die Ankunft des Rex (König) an Mardi Gras
Der Rex auf der Camp Street an Mardi Gras
Straßenszene während des Karnevals
Seite 288/289: **Der Kai an der Canal Street, Photochrom**

Der Karneval von New Orleans ist in den gesamten USA berühmt. Tatsächlich wurde der erste Mardi Gras (Faschingsdienstag) 1703 in Mobile gefeiert, vier Jahre nachdem der Frankokanadier Jean-Baptiste Le Moyne de Bienville am Point du Mardi Gras (so benannt nach dem Tag, an dem die Expedition ankam) von Bord ging. New Orleans wurde 1718 gegründet und begann in den 1730er-Jahren, den Mardi Gras zu feiern, doch erst 1872, anlässlich des Besuchs des russischen Großherzogs, trat Rex, der König des Karnevals, dort zum ersten Mal auf.

De haut en bas :
L'arrivée du roi (Rex), le jour de mardi gras
Rex à Camp Street, le jour de mardi gras
Scène de rue pendant le Carnaval
Pages 288/289 : **le quai de Canal Street, photochrome**

Le carnaval de La Nouvelle-Orléans est très fêté aux États-Unis. En réalité, le premier mardi gras fêté en Louisiane le fut à Mobile, en 1703, quatre ans après le débarquement du Franco-canadien Jean-Baptiste Le Moyne de Bienville à la pointe de Mardi Gras (ainsi nommée car l'expédition y arriva ce jour-là). Fondée en 1718, La Nouvelle-Orléans commença à célébrer mardi gras à partir des années 1730, mais ce n'est qu'en 1872, à l'occasion de la visite du grand-duc russe, que le roi du carnaval, Rex, fit son apparition.

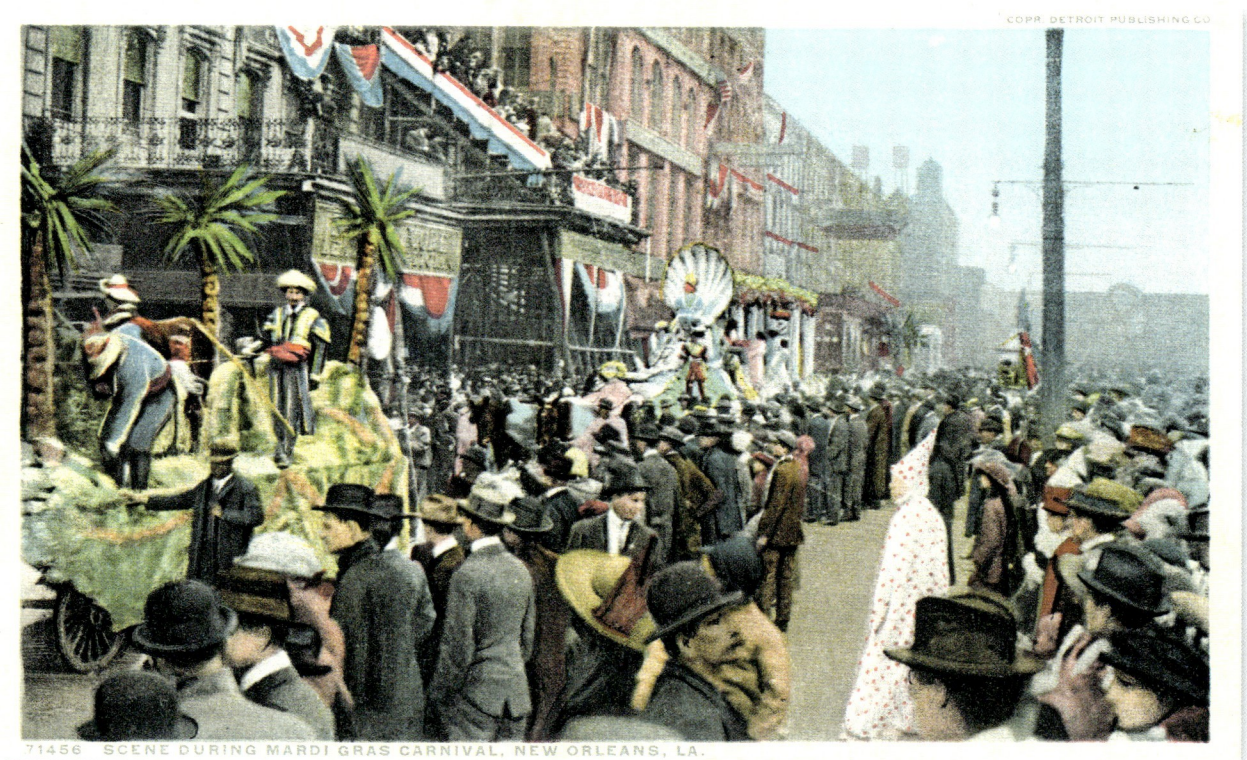

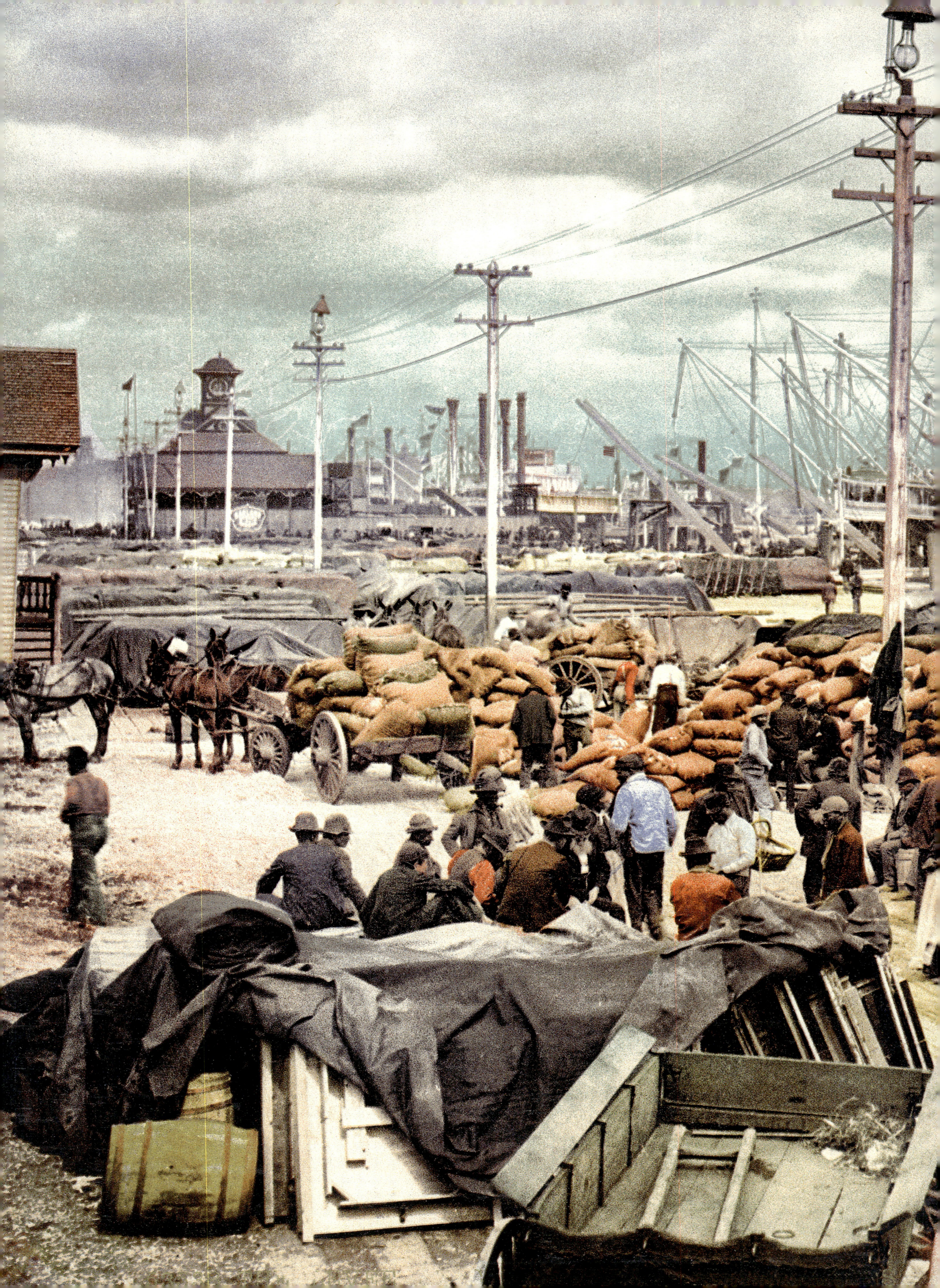

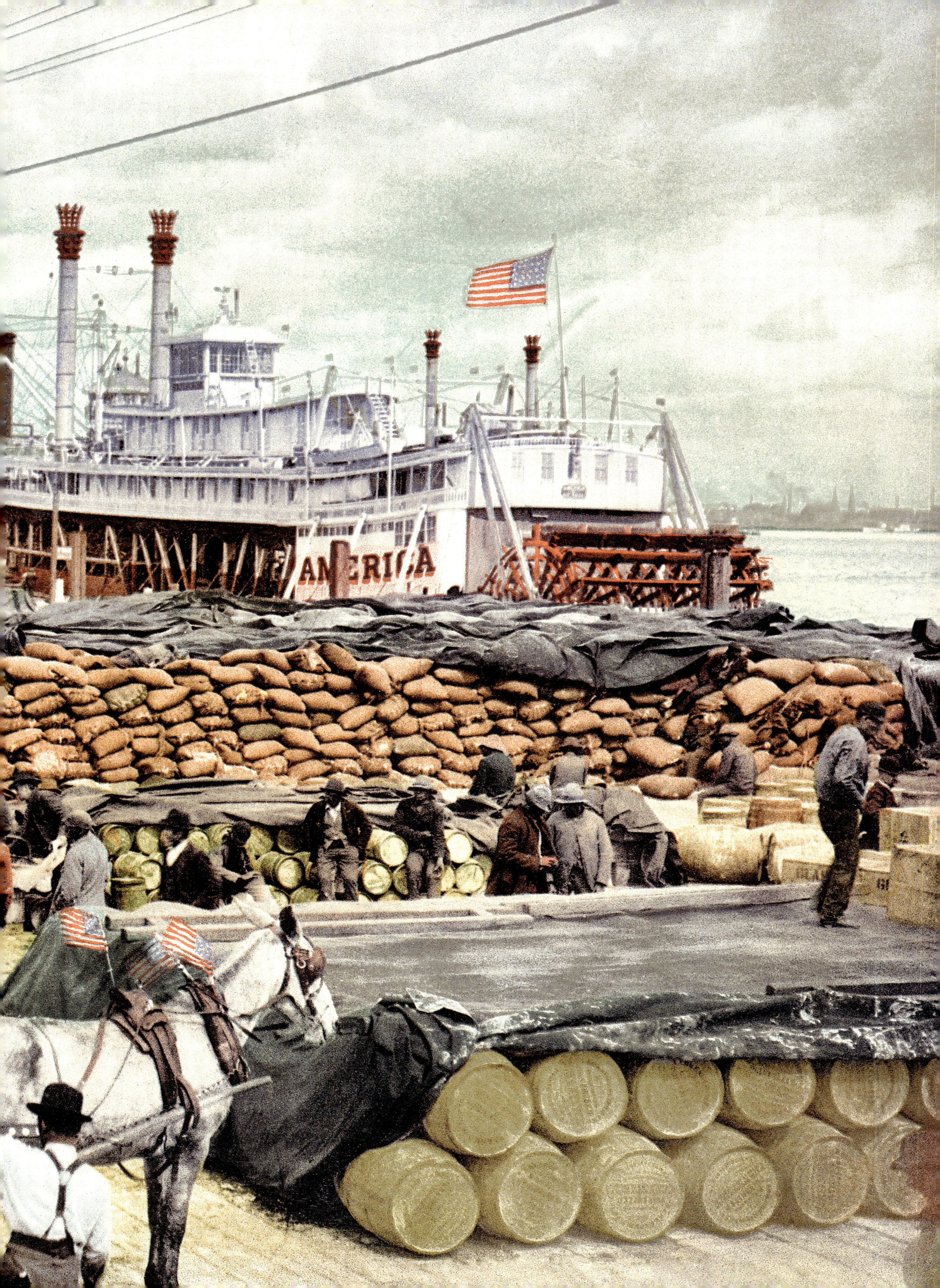

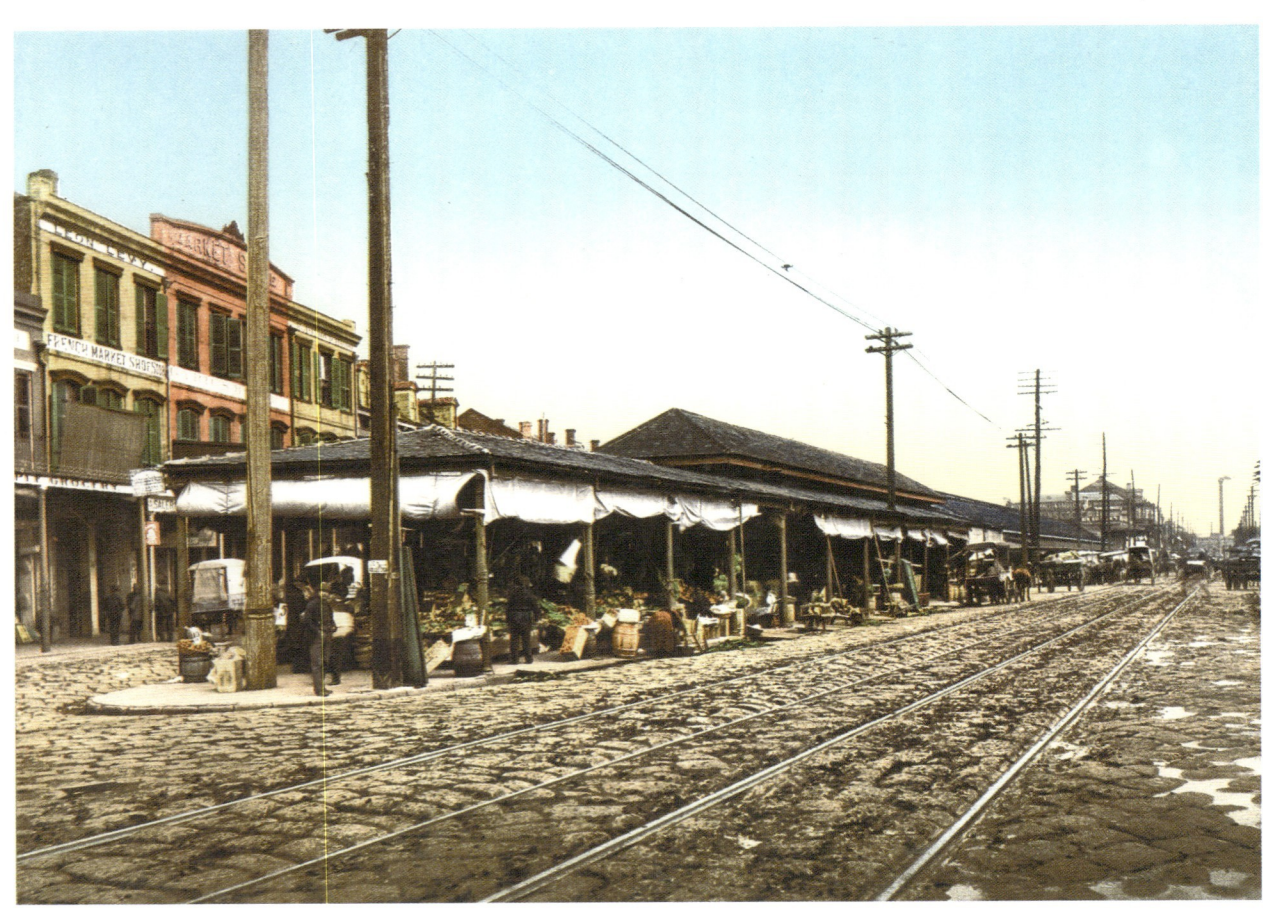

LOUISIANA | NEW ORLEANS

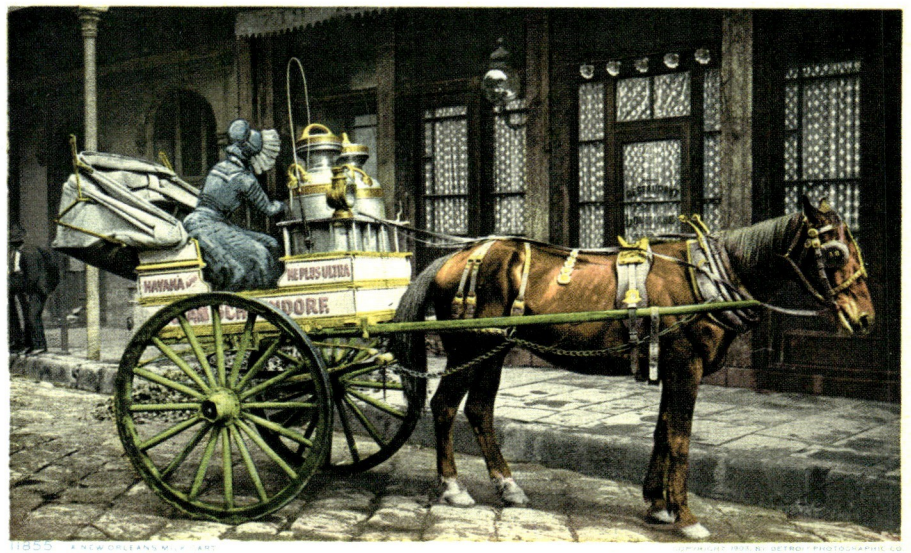
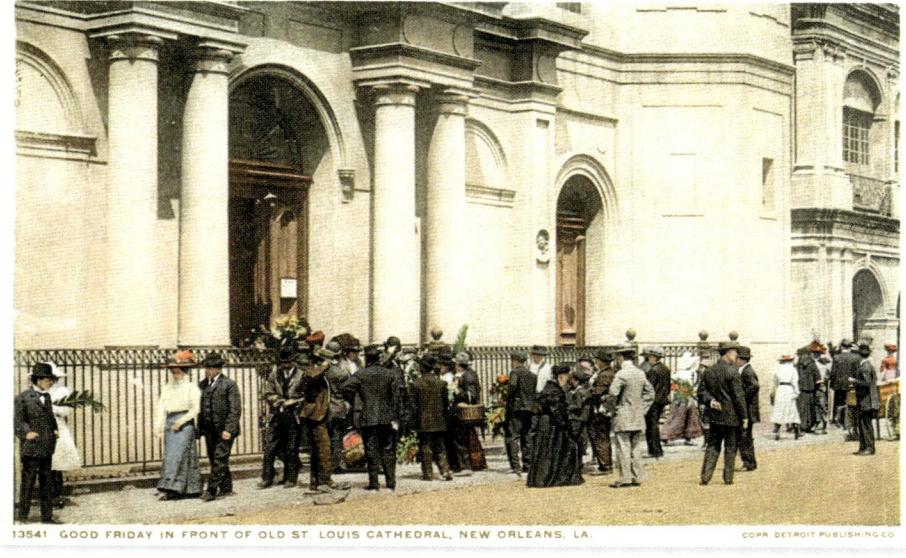

Page 290, above: A corner of the French Market, New Orleans, glass negative, 1900–1910
Page 290, below: French Market, photochrom
Top: Royal Street, photochrom
Above left: A New Orleans milk cart
Above right: Good Friday, St. Louis Cathedral

Above: **Italian quarter, Madison Street, New Orleans, glass negative,** 1906
Below left: **The old slave block, St. Louis Hotel**
Below right: **Chartres Street, Vieux Carré**
Page 293:
Above: **The old French courtyard, Royal Street, glass negative,** 1906
Below: **The old French courtyard, photochrom**

Oben: **Das Italienische Viertel, Madison Street, New Orleans, Glasnegativ,** 1906
Unten links: **Ehemaliger Sklavenblock, Hotel St. Louis**
Unten rechts: **Chartres Street, Vieux Carré**
Seite 293:
Oben: **Der alte Französische Hof, Royal Street, Glasnegativ,** 1906
Unten: **Der alte Französische Hof, Photochrom**

Ci-dessus : **le quartier italien, Madison Street, La Nouvelle-Orléans, plaque de verre,** 1906
Ci-dessous à gauche : **l'ancien bloc des esclaves, hôtel St. Louis**
Ci-dessous à droite : **Chartres Street, Vieux Carré**
Page 293 :
En haut : **la vieille cour française, Royal Street, plaque de verre,** 1906
En bas : **la vieille cour française, photochrome**

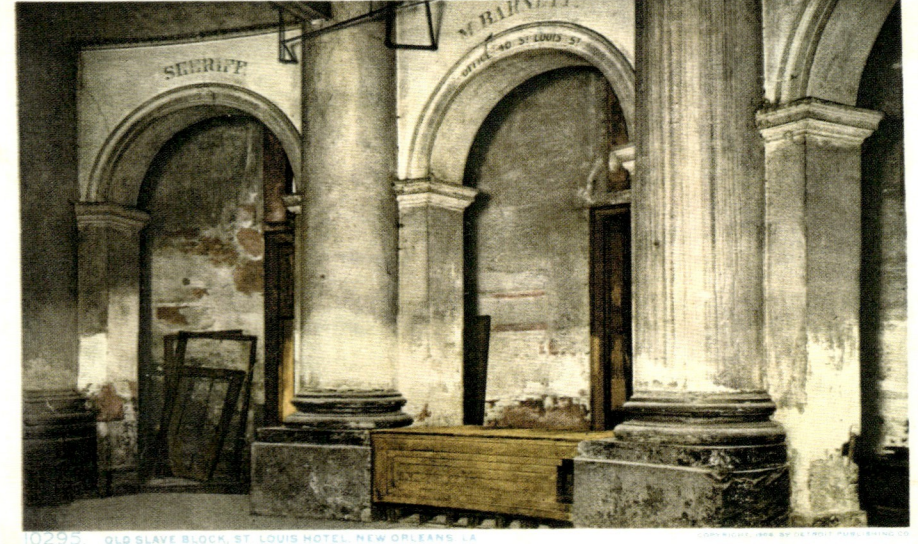
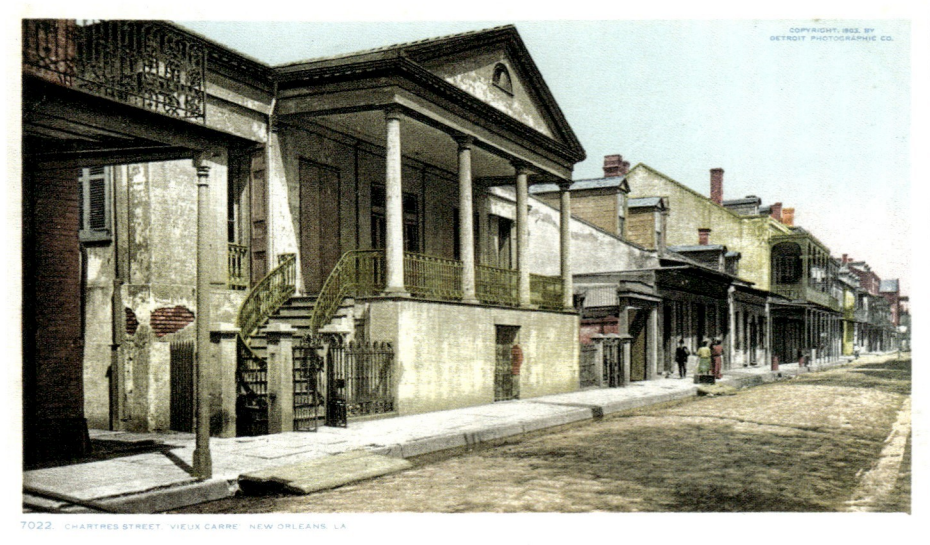

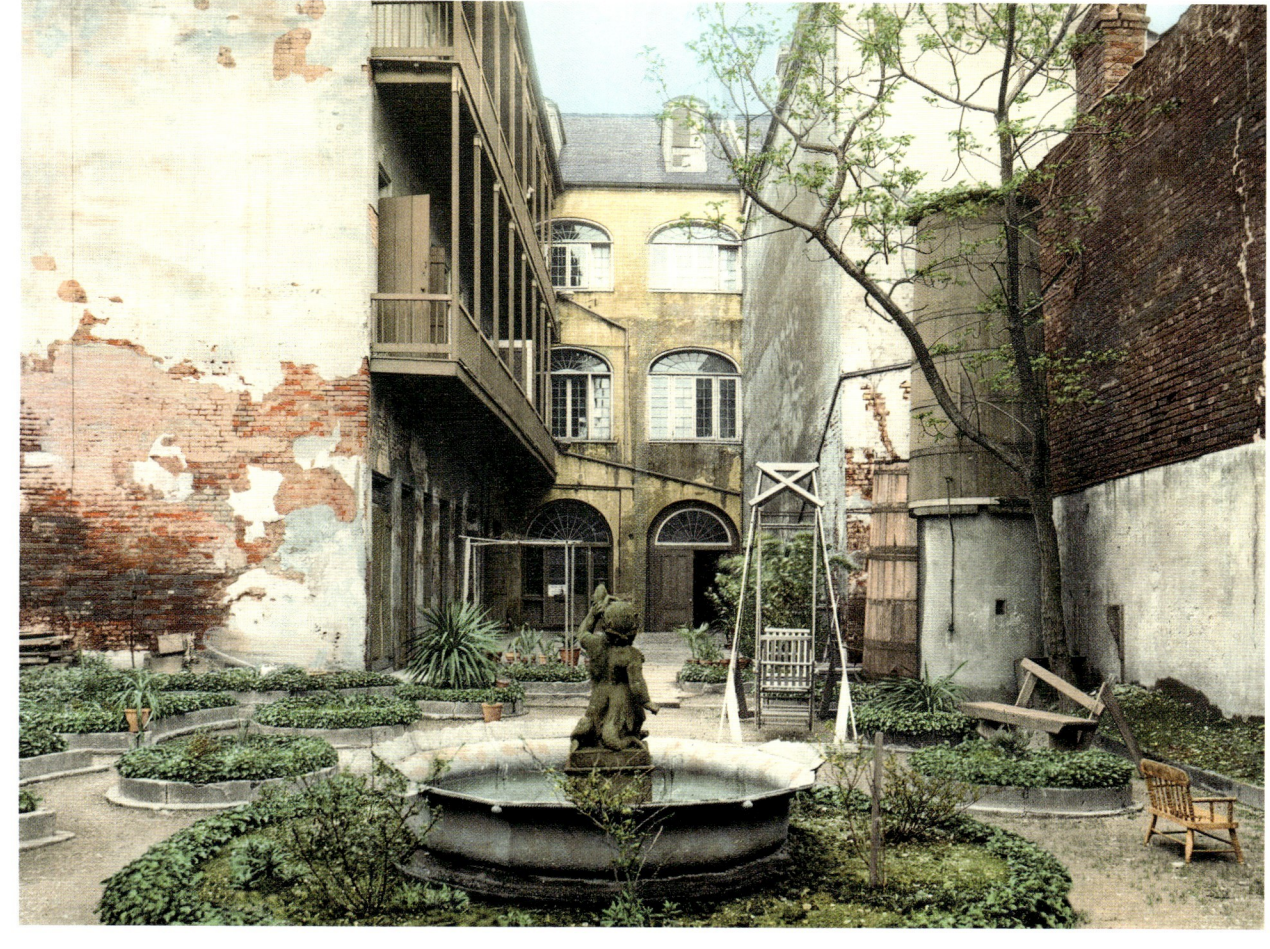

LOUISIANA | NEW ORLEANS

293

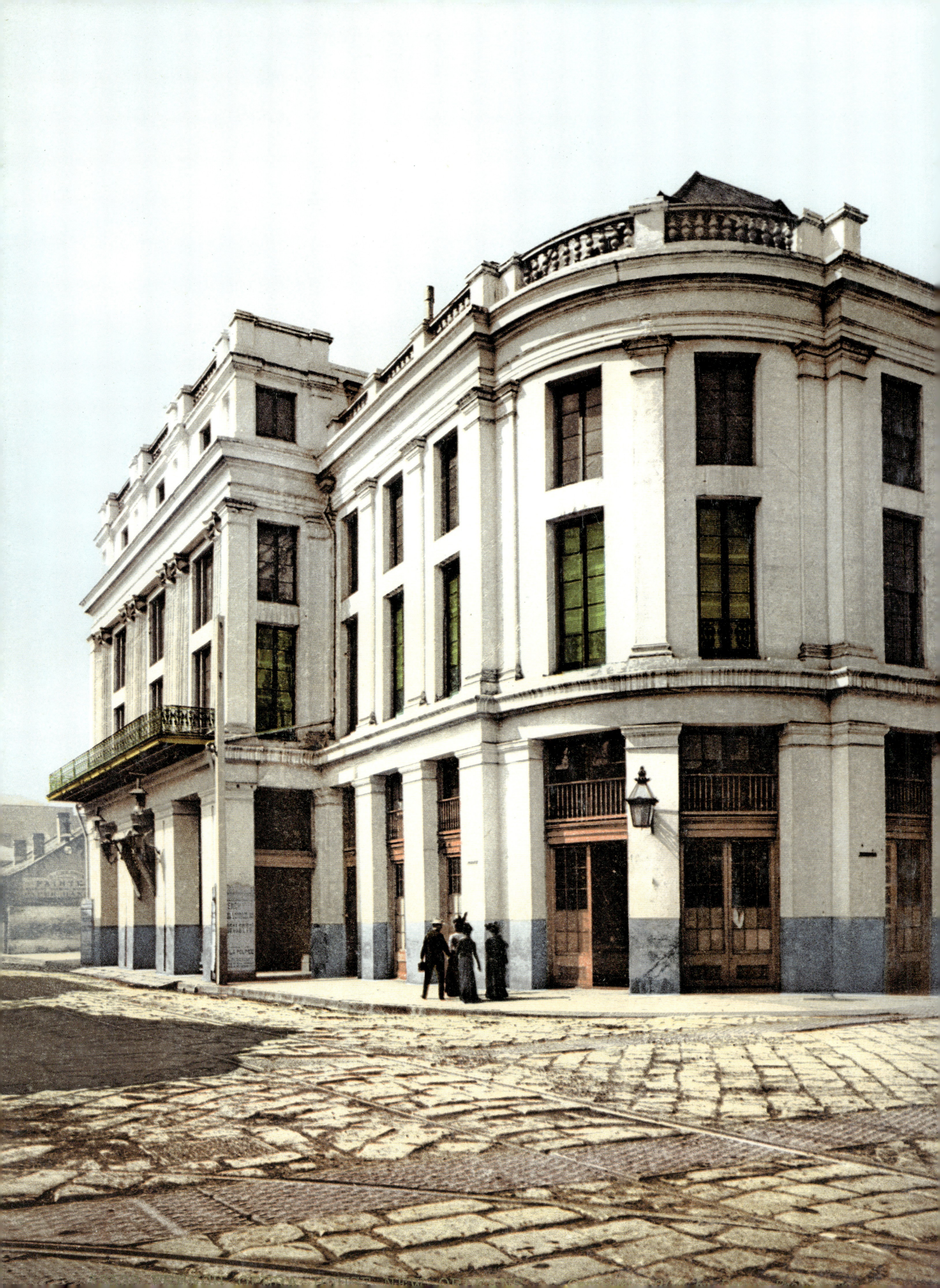

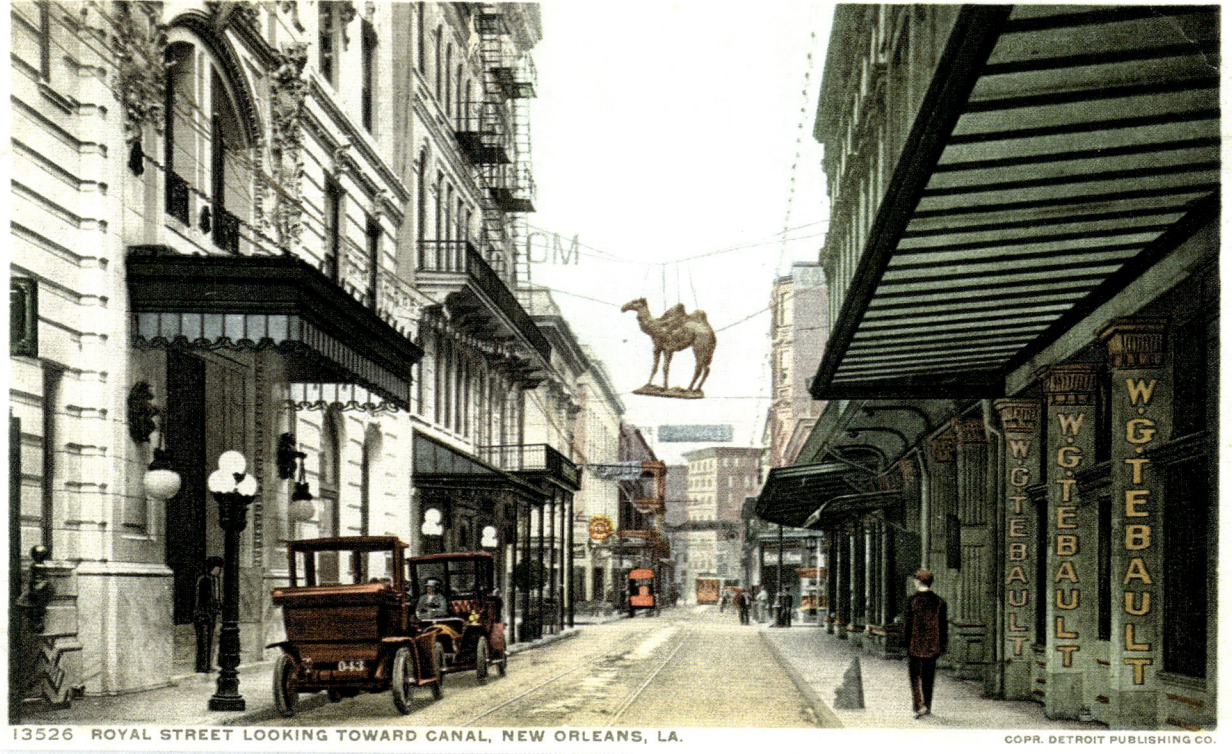

Page 294: **French Opera House, New Orleans**, photochrom
Above: **Royal Street looking toward Canal Street**
Below: **Canal Street**, photochrom

The French Opera House of New Orleans was built by the architect James Gallier Jr.; it opened in 1859 on the corner of Bourbon Street in the French Quarter and burned down in 1919. The French Quarter, or Vieux Carré, was the Creole residential area, but most of its buildings, including St. Louis Cathedral, were in the Spanish or Hispano-Creole style.

Seite 294: **Französische Oper, New Orleans**, Photochrom
Oben: **Royal Street, Blick in Richtung Canal Street**
Unten: **Canal Street**, Photochrom

Die Französische Oper von New Orleans wurde von dem Architekten James Gallier jr. errichtet und 1859 an der Ecke der Bourbon Street im Französischen Viertel eröffnet. 1919 brannte sie ab. Im Französischen Viertel, genannt Vieux Carré, wohnten die Kreolen. Die meisten Gebäude des Vieux Carré, wie etwa die Kathedrale Saint Louis, sind jedoch im spanischen oder hispano-kreolischen Stil errichtet.

Page 294: **l'Opéra français, La Nouvelle-Orléans**, photochrome
Ci-dessus: **Royal Street, vue vers Canal Street**
Ci-dessous: **Canal Street**, photochrome

L'Opéra français de La Nouvelle-Orléans, édifié par l'architecte James Gallier Jr., ouvrit ses portes en 1859 au coin de Bourbon Street, dans le quartier français. Il brûla en 1919. Le quartier français, dit le Vieux Carré, était le lieu de résidence des créoles. La plupart des bâtiments du Vieux Carré, la cathédrale Saint-Louis par exemple, sont cependant de style espagnol, ou hispano-créole.

MISSISSIPPI

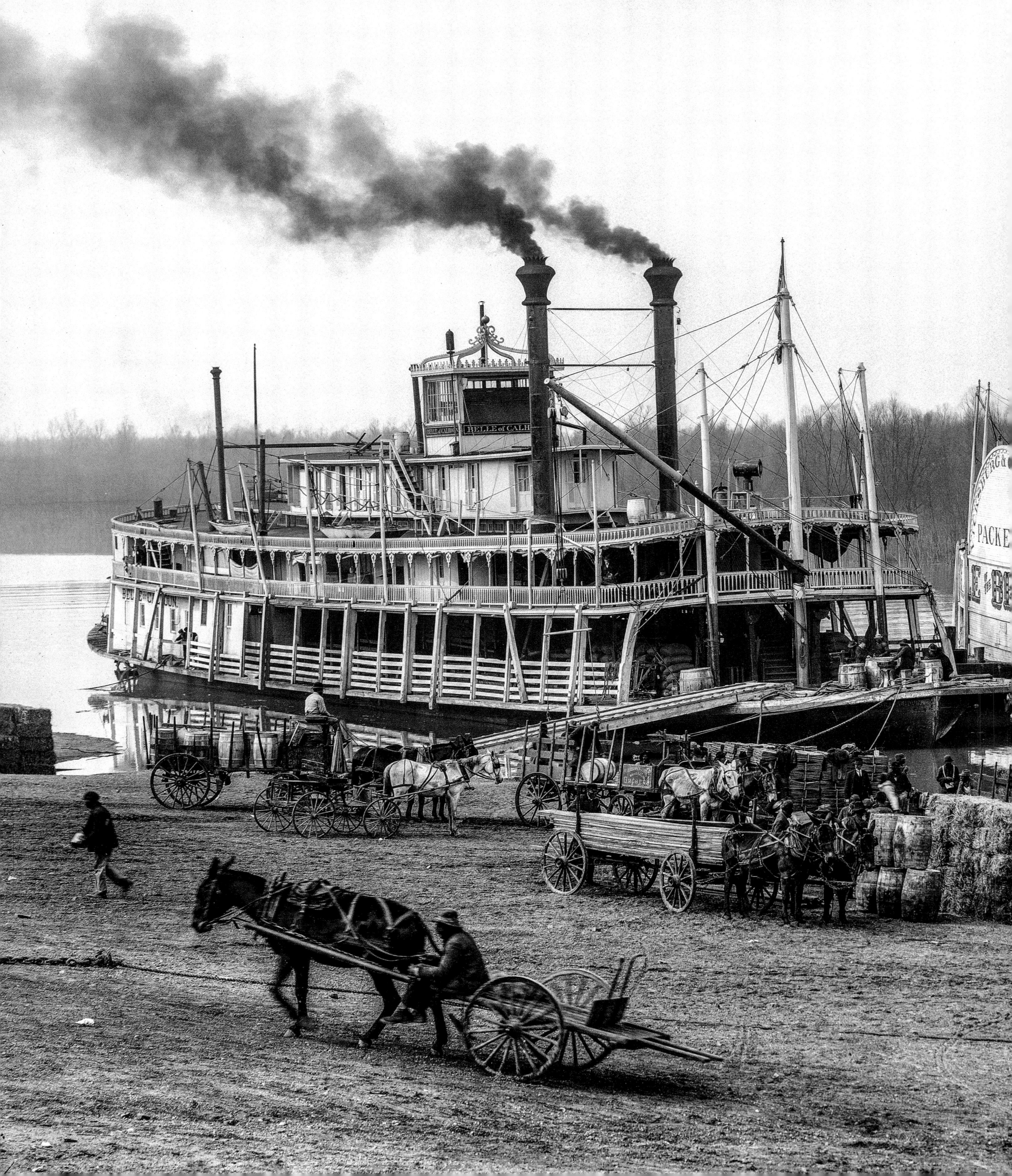

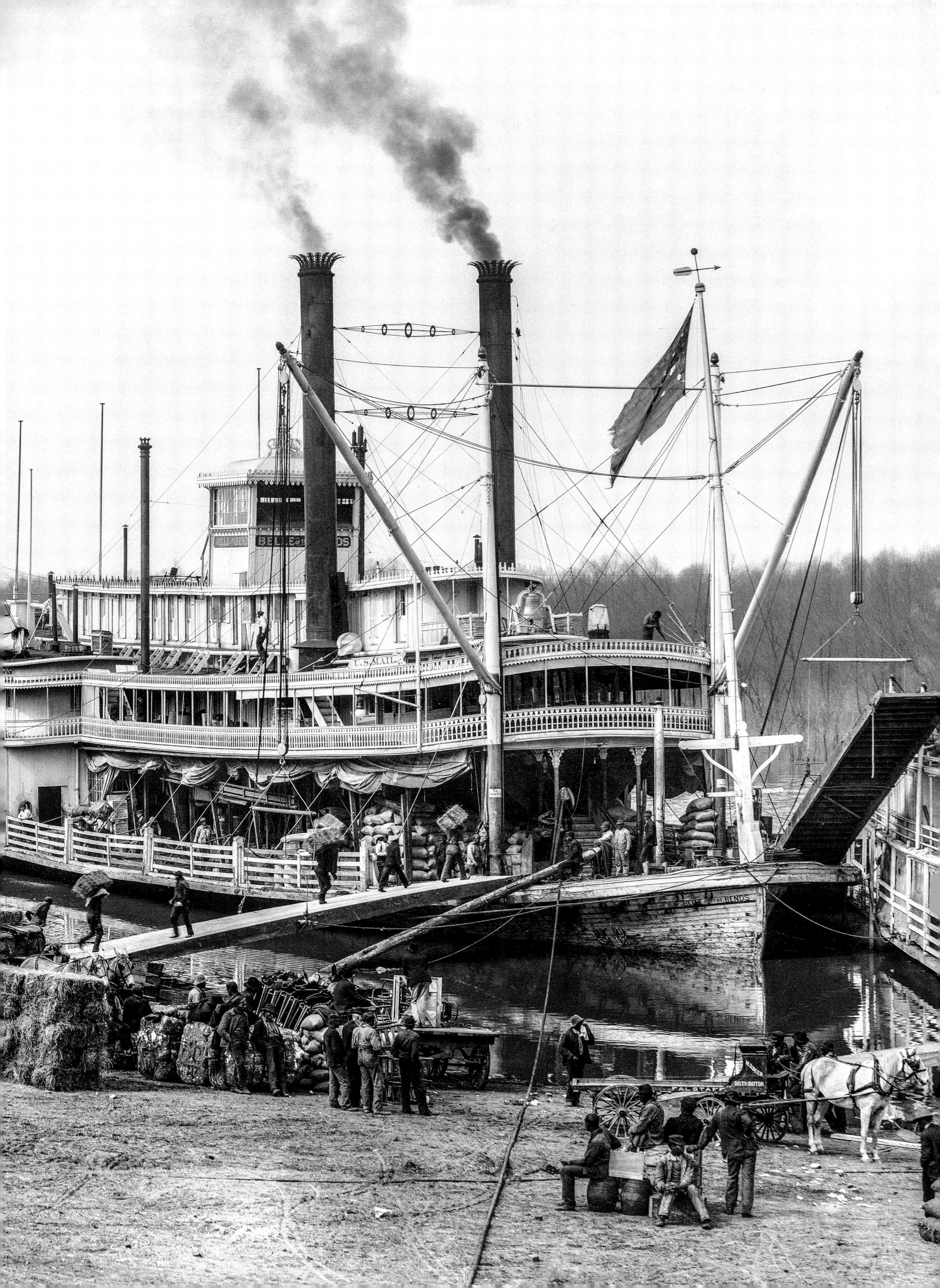

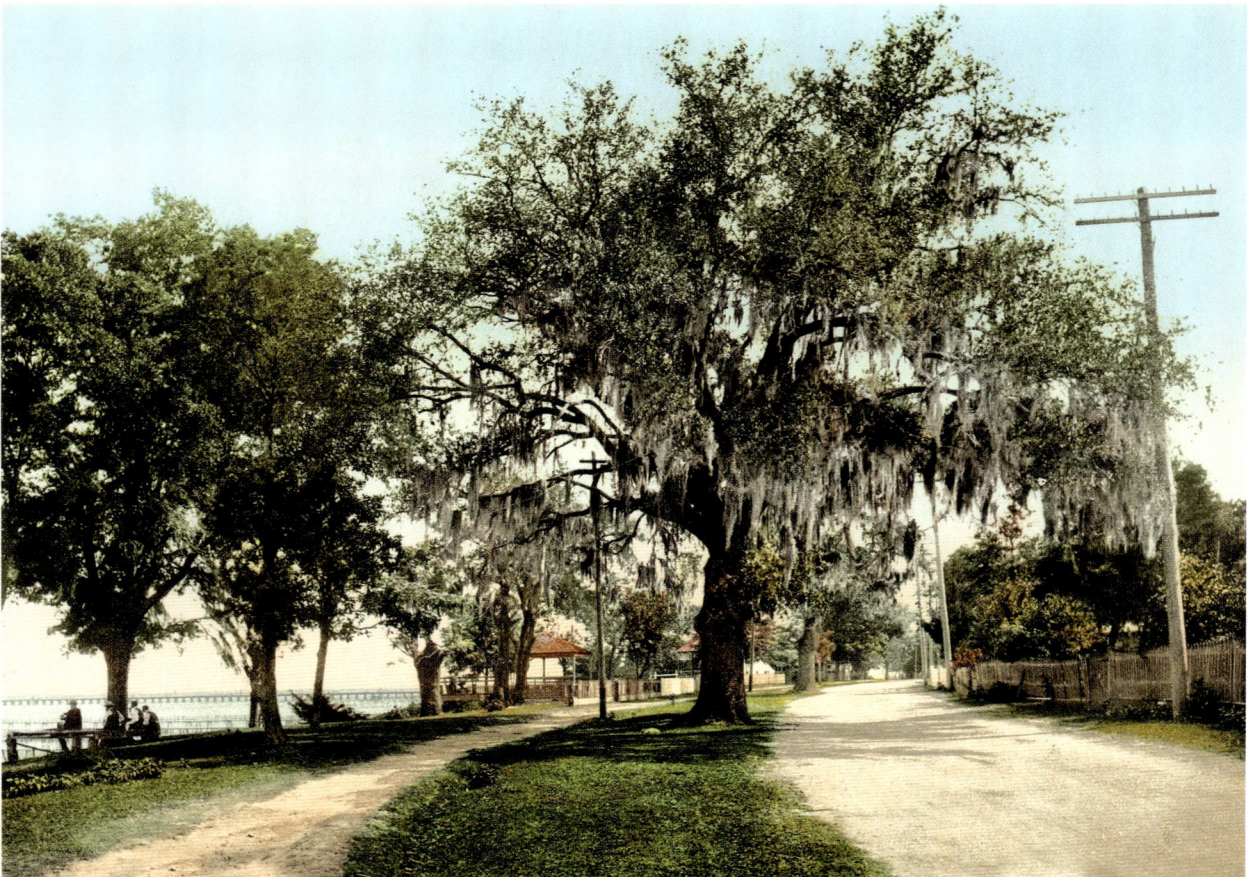

Page 296/297: A Mississippi landing, Vicksburg, glass negative, 1900–1906
Above: Ocean Springs, site of Old Fort Bayou, photochrom
Below: St. Louis Bay, along the bay, photochrom

The site of Old Fort Bayou at Ocean Springs lies close to that of Fort Maurepas, built in 1699 by the explorers Jean-Baptiste Le Moyne de Bienville and Pierre Le Moyne d'Iberville where the bayou meets the Biloxi Bay.
St. Louis Bay was named after the saint's day on which d'Iberville arrived in the bay: August 5, 1699. André Pénicaut, master carpenter on d'Iberville's ship, noted in his journal the many wild buffalo and deer to be seen there.

Seite 296/297: Verladung am Mississippi, Vicksburg, Glasnegativ, 1900–1906
Oben: Ocean Springs, das Gelände des Old Fort Bayou, Photochrom
Links: Saint Louis Bay, Uferstraße, Photochrom

Die Anlage von Fort Bayou in Ocean Springs befindet sich in der Nähe des Fort Maurepas, das die Entdecker Jean-Baptiste Le Moyne de Bienville und Pierre Le Moyne d'Iberville 1699 an der Mündung des Bayou in die Bucht von Biloxi erbauen ließen. Die Anlage von Bay Saint Louis wiederum wurde nach dem Tag benannt, an dem Pierre Le Moyne d'Iberville in der Bucht ankam, nämlich am 5. August 1699, dem Saint-Louis-Tag. In seinem Tagebuch hielt André Pénicaut, der Tischlermeister des Schiffs von Iberville, fest, dass es vor Ort zahlreiche wilde Büffel und Hirsche gab.

Pages 296/297 : embarquement sur le Mississippi, Vicksburg, plaque de verre, 1900–1906
En haut : Ocean Springs, le site d'Old Fort Bayou, photochrome
Ci-contre : Bay St. Louis, route le long de la baie, photochrome

Le site de Fort Bayou, à Ocean Springs, s'étend près du Fort Maurepas, construit en 1699 par les explorateurs Jean-Baptiste Le Moyne de Bienville et Pierre Le Moyne d'Iberville, au confluent du bayou et de la baie de Biloxi.
Le site de Bay St. Louis a été nommé d'après la date d'arrivée de Pierre Le Moyne d'Iberville dans la baie, le 5 août 1699, jour de la Saint-Louis. Dans son journal, le maître charpentier du vaisseau d'Iberville, André Pénicaut, signale la présence sur place de buffles et daims sauvages.

Above: **The Biloxi Light, photochrom**
Below left: **Point oyster houses, Biloxi**
Below right: **Oyster schooners unloading at canning factory, Biloxi**
Page 300/301: **Old oak at Montross Hotel, Biloxi, photochrom**

Biloxi soon became a fashionable seaside resort. In March 1888, the *Biloxi Herald* lamented the fact that the view over the gulf was spoiled by stinking piles of oysters and filthy quays, which shamed the town.
The Biloxi Lighthouse is a tough customer. It has resisted more than 150 years of storms and hurricanes—including Katrina.

Oben: **Der Leuchtturm von Biloxi, Photochrom**
Unten links: **Hafen der Austernfischer, Biloxi**
Unten rechts: **Austernkutter in Biloxi**
Seite 300/301: **Die alte Eiche des Hotels Montross, Biloxi, Photochrom**

Biloxi war schon sehr bald ein beliebter Badeort. Im März 1888 beklagte die Zeitung *Biloxi Herald*, dass der Blick auf den Golf durch die (ekelerregenden) Berge von Austern und durch verschmutzte Uferanlagen verdorben sei. „Das ist eine Schande für unsere Stadt", schloss der Artikel.
Der Leuchtturm von Biloxi ist ein Wunderwerk. Seit über 150 Jahren trotzt er tapfer den Stürmen und Hurrikanen: Sogar Katrina konnte ihn nicht zum Einsturz bringen.

Ci-dessus : **le phare de Biloxi, photochrome**
En bas à gauche : **port huîtrier, Biloxi**
En bas à droite : **bateaux huîtriers à Biloxi**
Pages 300/301 : **le vieux chêne de l'hôtel de Montross, Biloxi, photochrome**

Biloxi fut très tôt une station balnéaire en vogue. En mars 1888, le journal *Biloxi Herald* déplorait que la vue sur le golfe soit gâchée par la présence (nauséabonde !) de piles d'huîtres et de quais malpropres. « C'est une honte pour notre ville », concluait l'article.
Le phare de Biloxi est un miraculé. Il résiste vaillamment depuis plus de cent cinquante ans aux tempêtes et aux ouragans : même Katrina n'a pas réussi à l'abattre.

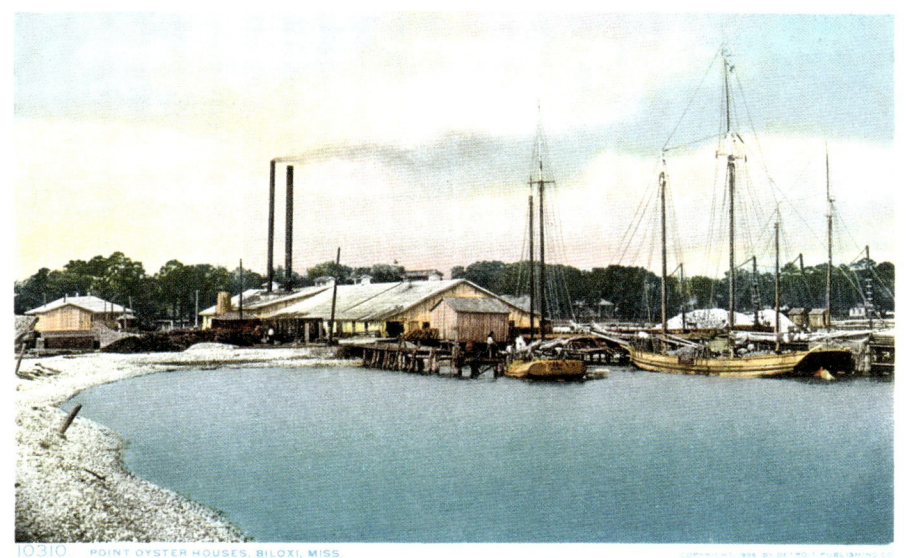

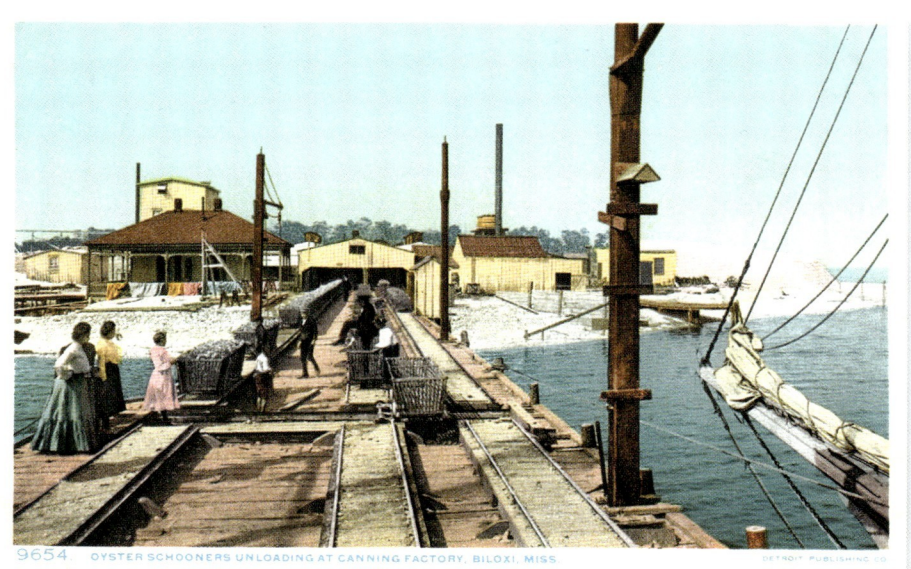

MISSISSIPPI | BILOXI

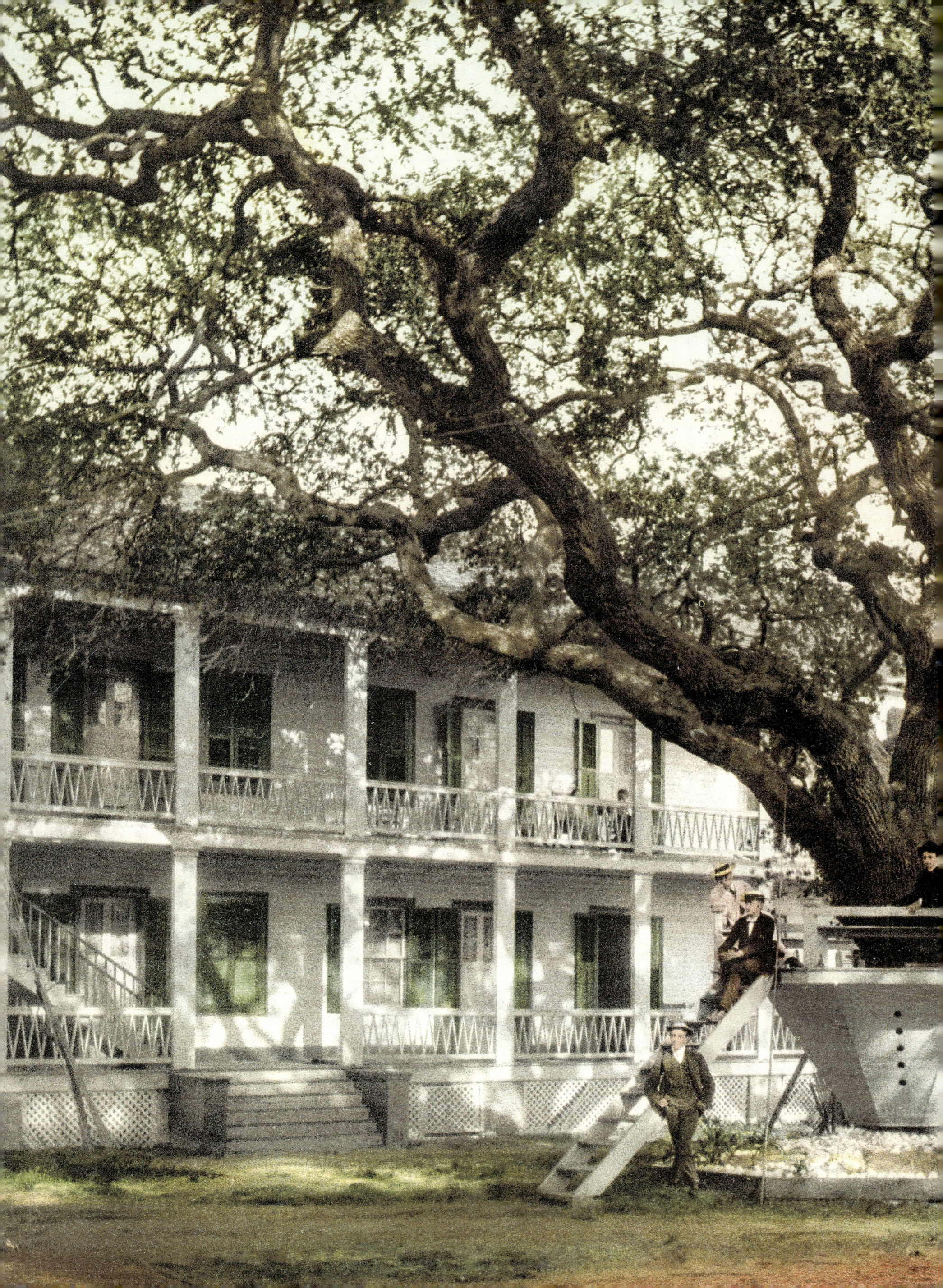

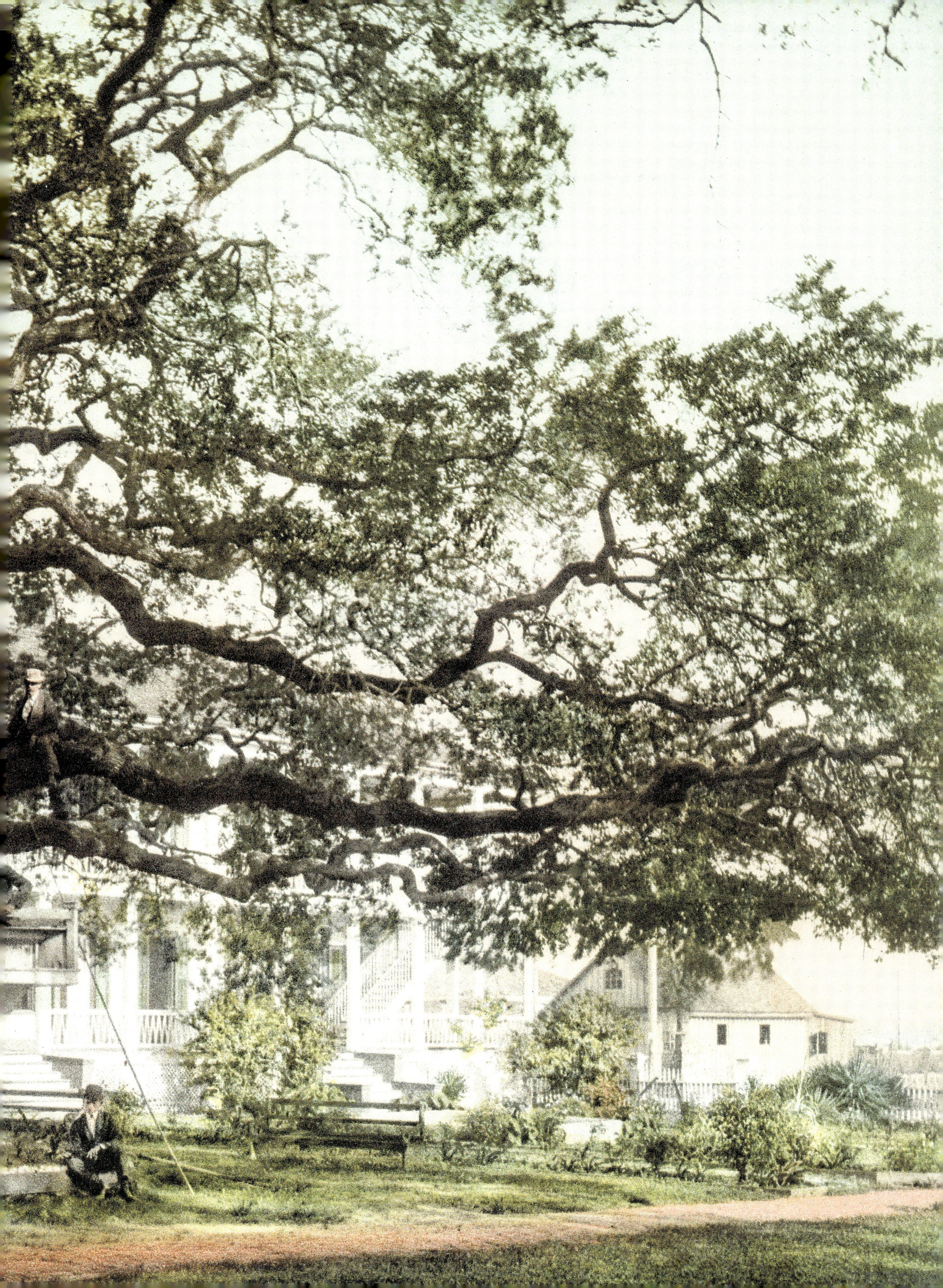

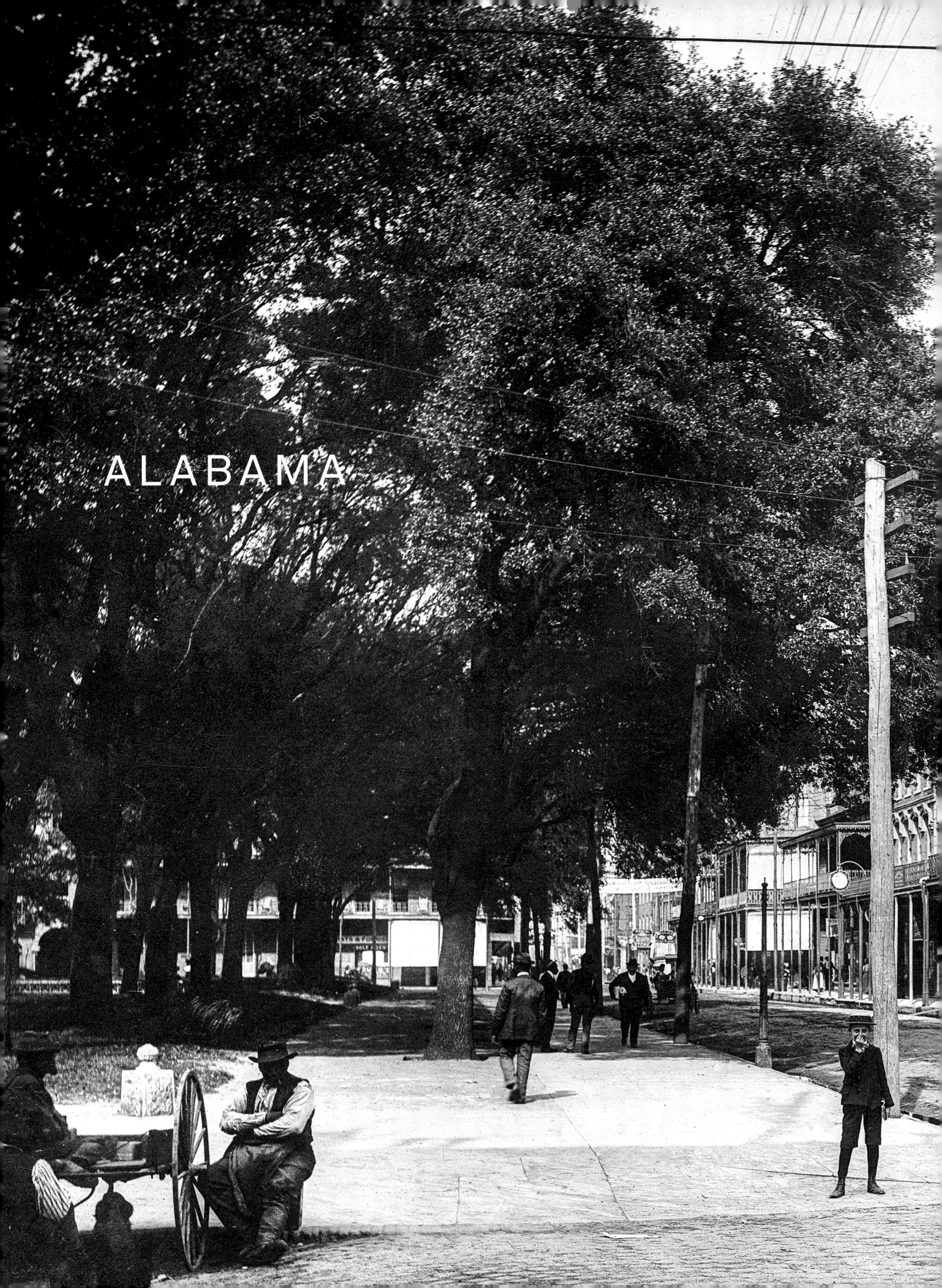
ALABAMA

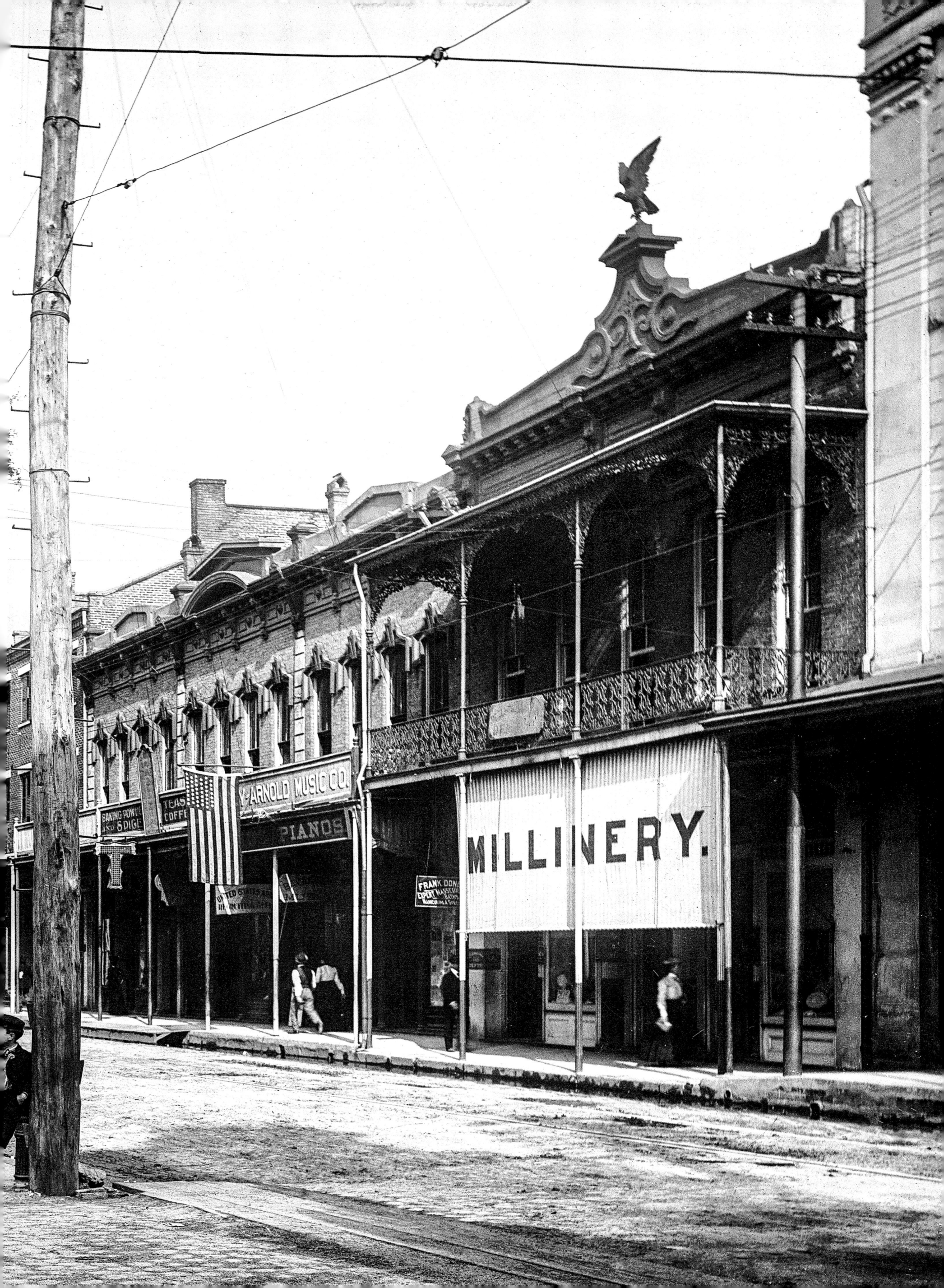

Page 302/303: Dauphin Street, Mobile, Alabama, glass negative, 1901
Above: Unloading bananas, Mobile, glass negative, 1900
Below: Royal Street, looking north, Mobile

Seite 302/303: Dauphin Street, Mobile, Alabama, Glasnegativ, 1901
Oben: Das Entladen von Bananen, Mobile, Glasnegativ, 1900
Unten: Royal Street, Blick in Richtung Norden, Mobile

Pages 302/303: Dauphin Street, Mobile, Alabama, plaque de verre, 1901
Ci-dessus : déchargement de bananes, Mobile, plaque de verre, 1900
En bas : Royal Street, vue vers le nord, Mobile

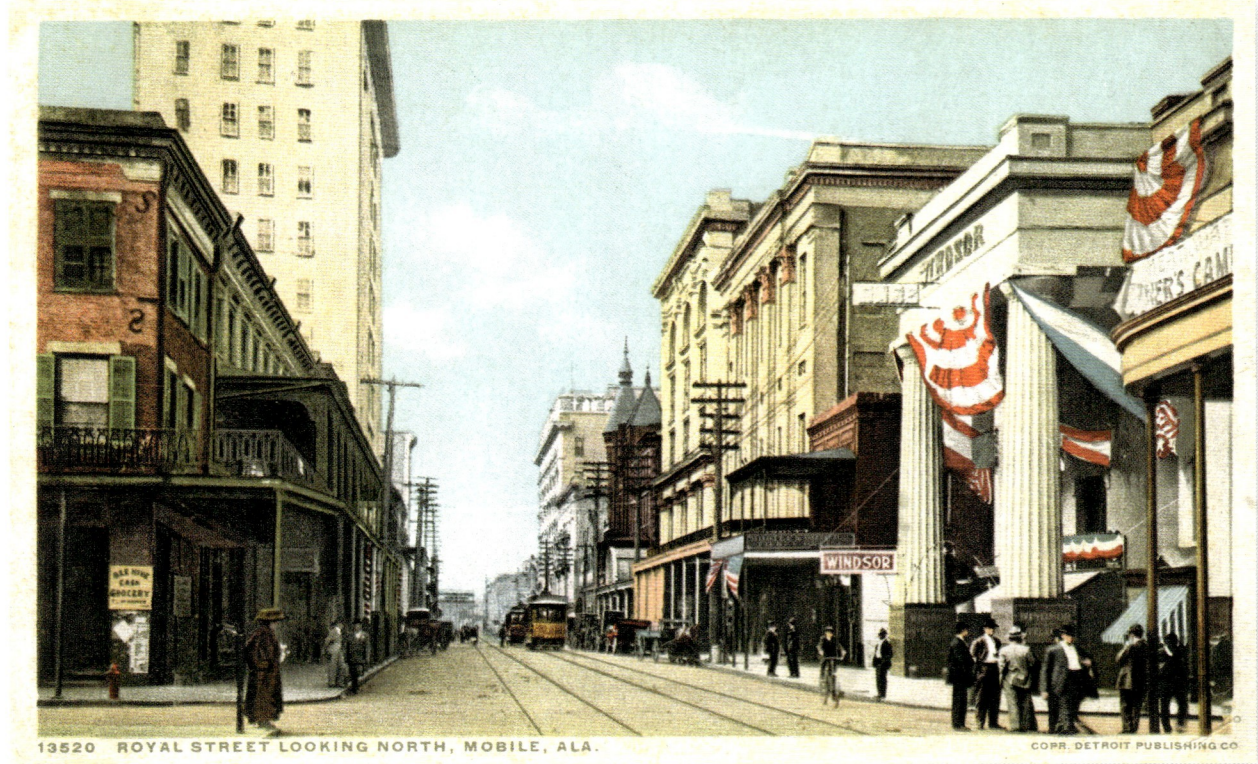

Page 305, from left to right and top to bottom :
Water front, Mobile
Loading cotton for Liverpool
Unloading bananas (steam conveyers)
Unloading bananas (steam conveyers)
Unloading a banana steamer, Mobile
Unloading bananas, Mobile
Unloading bananas from steamer
Waiting for the Sunday boat

Seite 305, von links nach rechts und von oben nach unten:
Die Küstenlinie, Mobile
Baumwollladung für Liverpool
Das Entladen von Bananen mit einem Förderband
Das Entladen von Bananen mit einem Förderband
Löschen einer Fracht Bananen, Mobile
Das Entladen von Bananen, Mobile
Das Entladen eines Bananenfrachters
Beim Warten auf das Sonntagsschiff

Page 305, de gauche à droite et de haut en bas :
Le front de mer, Mobile
Chargement de coton pour Liverpool
Déchargement mécanique de bananes
Déchargement mécanique de bananes
Déchargement d'une cargaison de bananes, Mobile
Déchargement de bananes, Mobile
Déchargement d'une cargaison de bananes
En attendant le bateau du dimanche

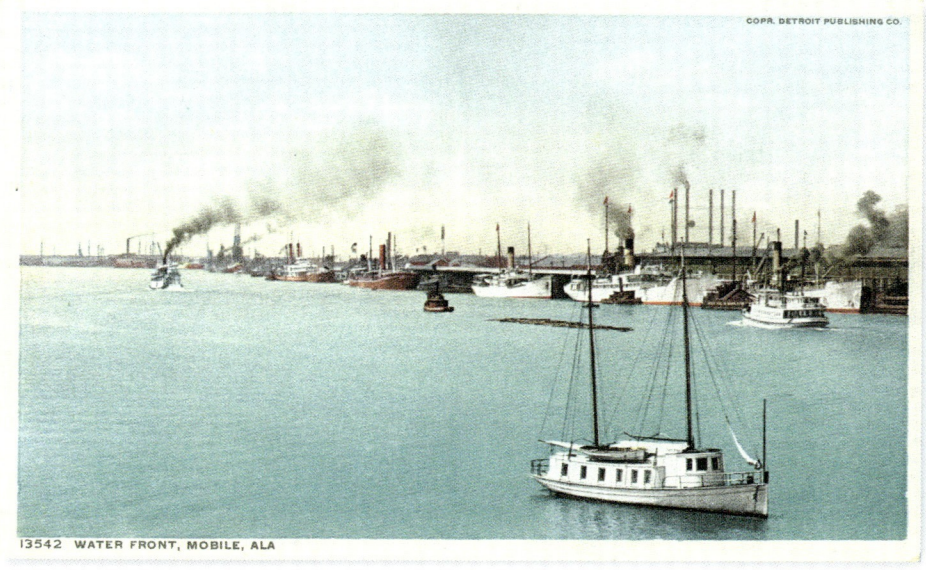
13542 WATER FRONT, MOBILE, ALA

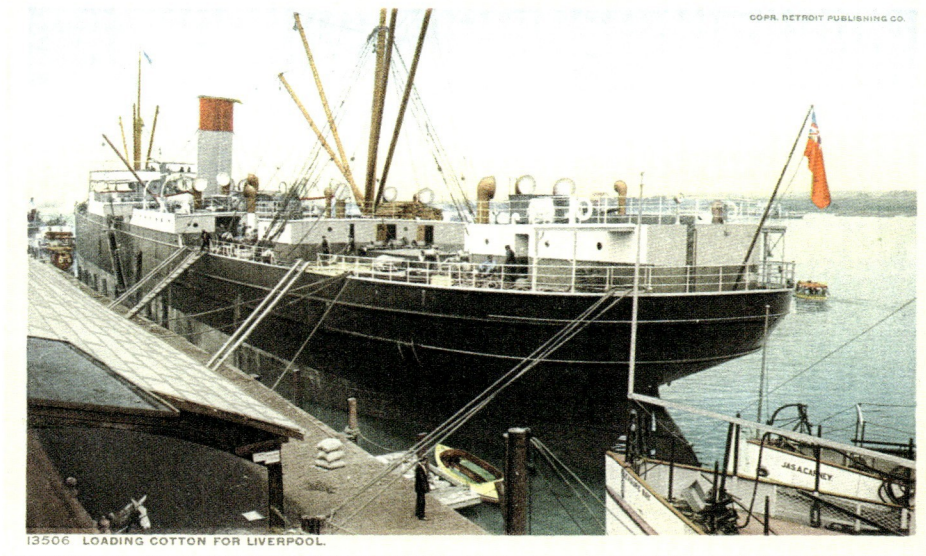
13506 LOADING COTTON FOR LIVERPOOL

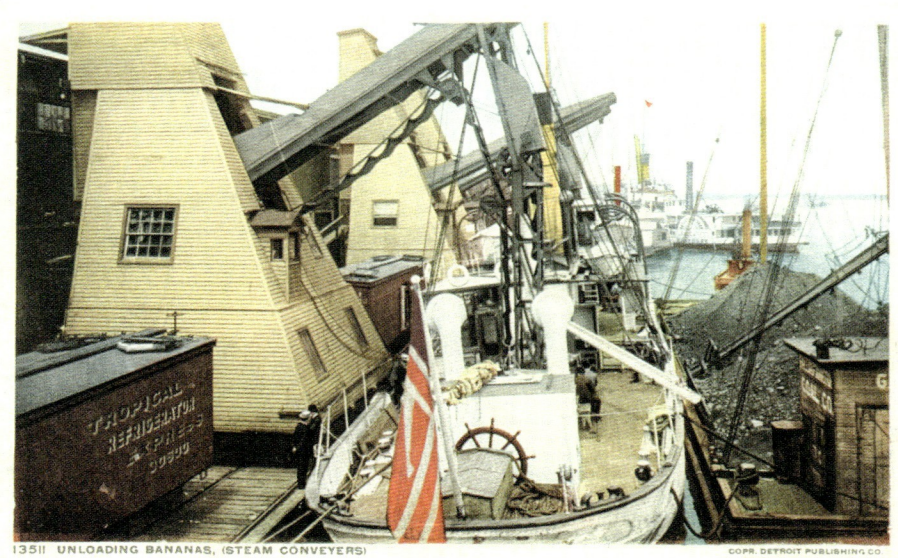
13511 UNLOADING BANANAS, (STEAM CONVEYERS)

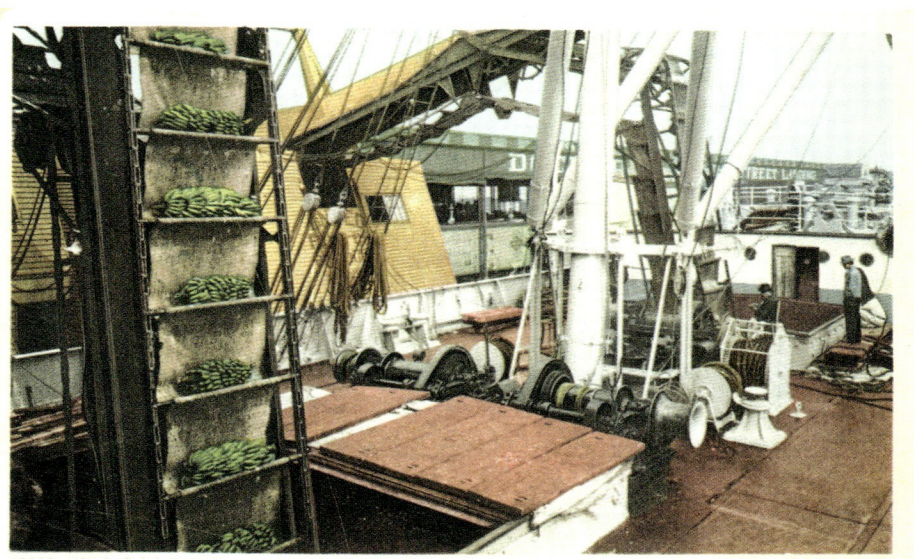
UNLOADING BANANAS, STEAM CONVEYERS

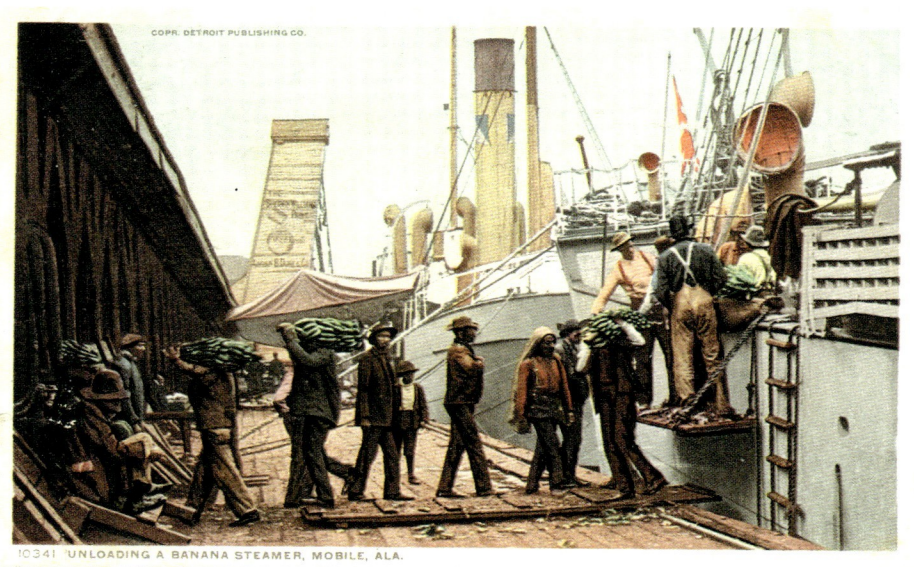
10341 UNLOADING A BANANA STEAMER, MOBILE, ALA.

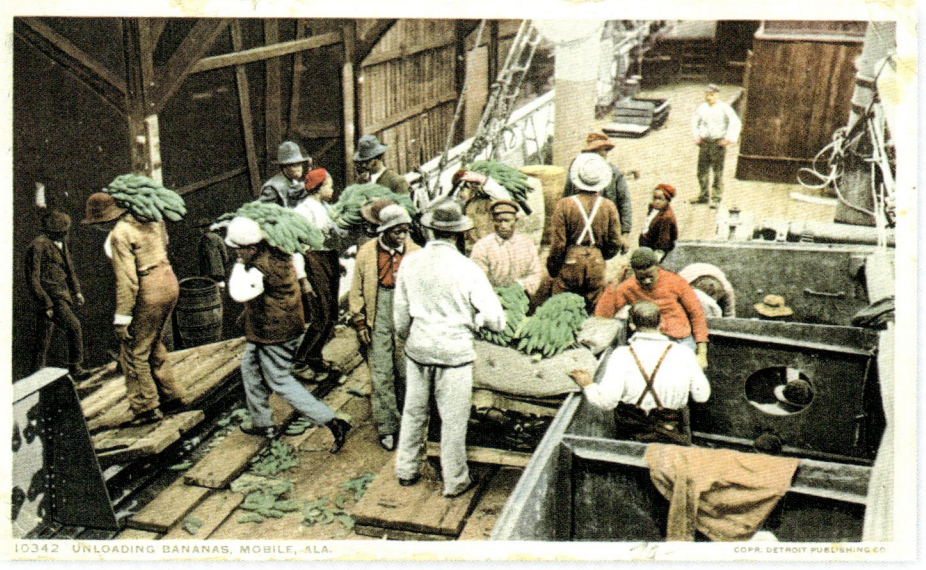
10342 UNLOADING BANANAS, MOBILE, ALA.

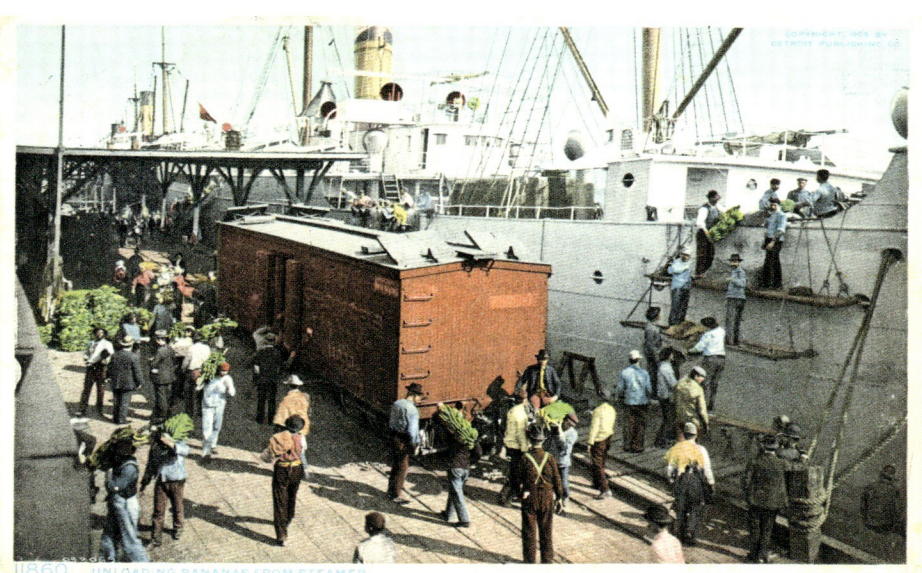
11860 UNLOADING BANANAS FROM STEAMER

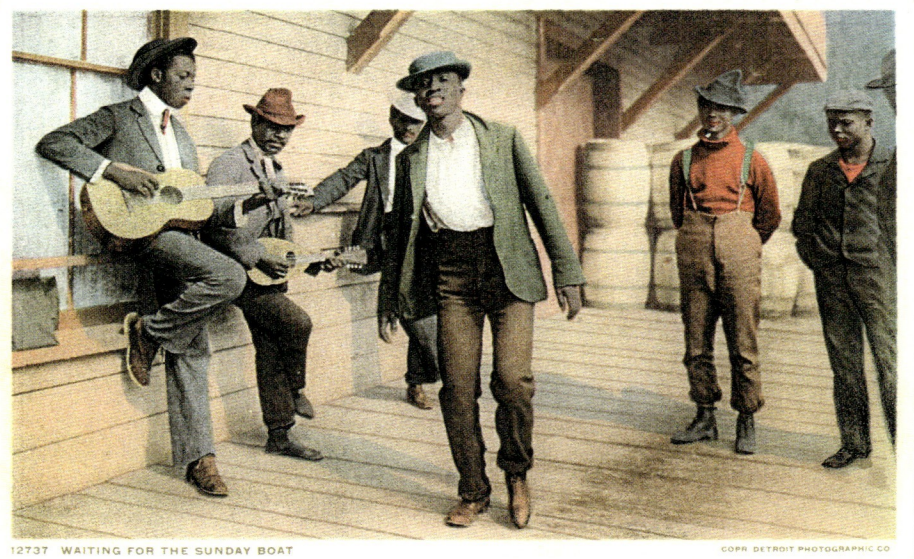
12737 WAITING FOR THE SUNDAY BOAT

ALABAMA | MOBILE

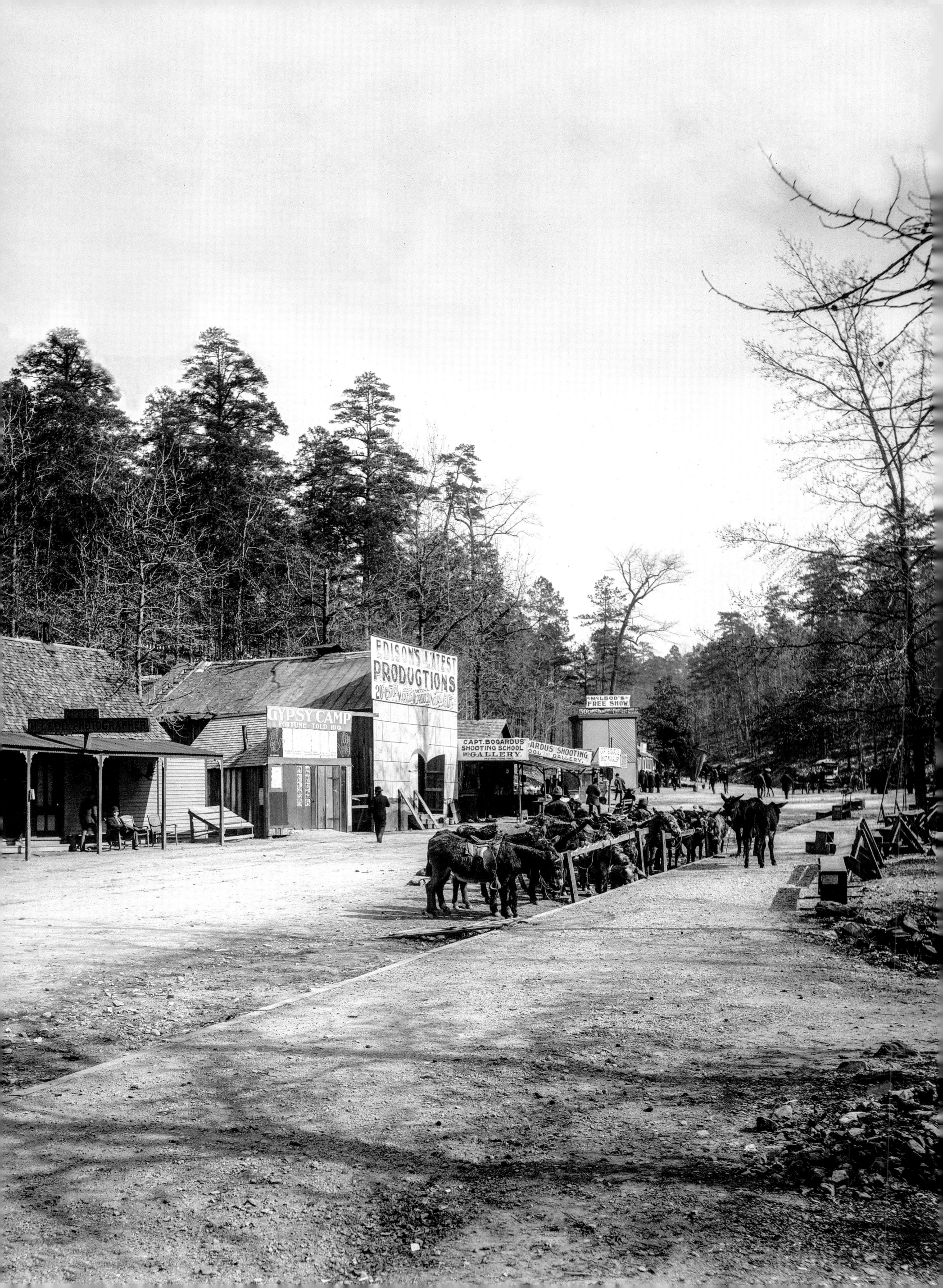

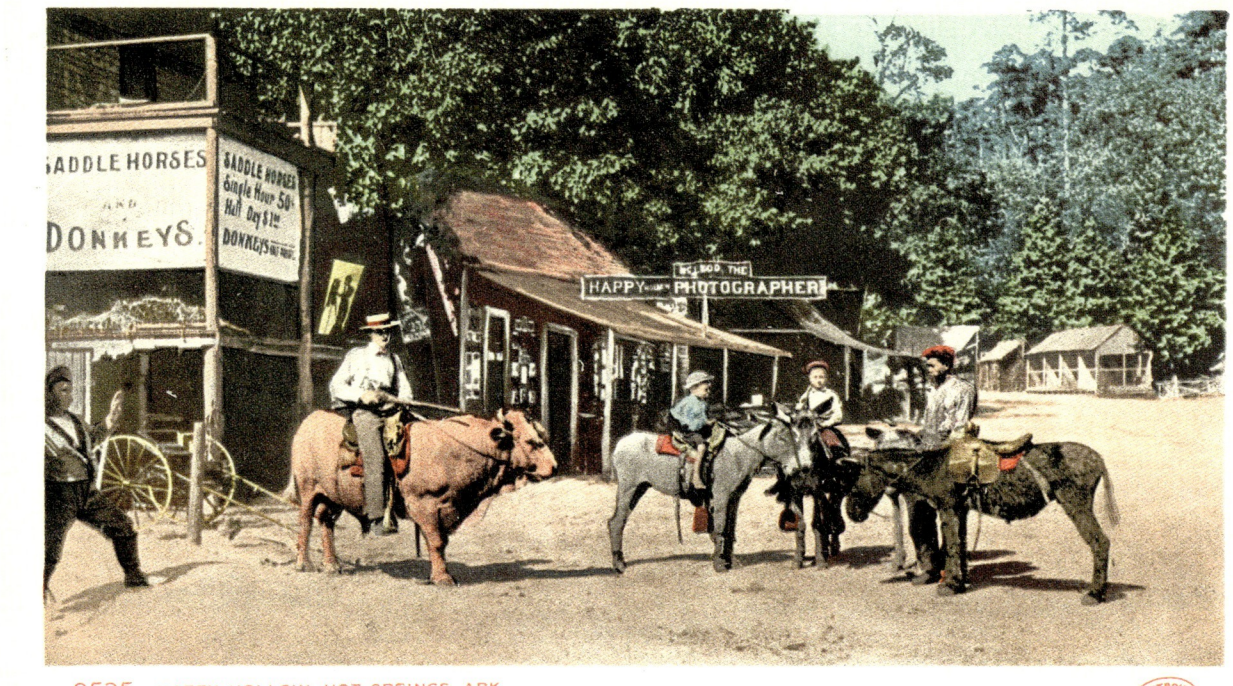

9525. HAPPY HOLLOW. HOT SPRINGS. ARK.

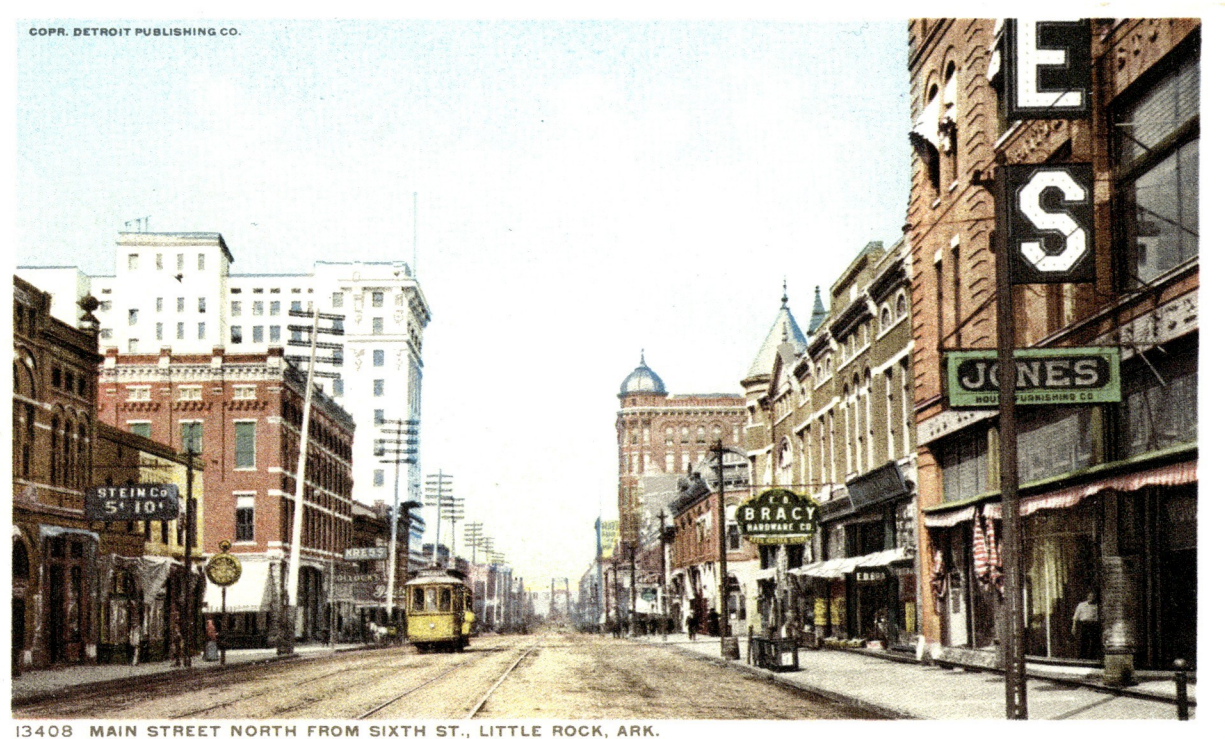

13408 MAIN STREET NORTH FROM SIXTH ST., LITTLE ROCK, ARK.

Page 306: **Happy Hollow, Hot Springs, glass negative, 1901**
From top to bottom:
Happy Hollow, Hot Springs
Main Street north from Sixth Street, Little Rock
Little Rock, from the Free Bridge

In the late 19th century, Hot Springs was a famous spa town in the Ozarks and Happy Hollow was an amusement park reached by a donkey-powered trolley bus from Hot Springs. The park began when photographer Norman McLeod opened a studio there in 1888 for humorous photographs. It was not, in fact, McLeod who named Happy Hollow, but local African Americans who every Sunday held religious gatherings and sang hymns at the spring.

Seite 306: **Happy Hollow, Hot Springs, Glasnegativ, 1901**
Von oben nach unter:
Happy Hollow, Hot Springs
Der nördliche Teil der Main Street ab der Sixth Street, Little Rock
Little Rock von der Free Bridge aus

Hot Springs war Ende des 19. Jahrhunderts ein angesehenes Thermalbad im Ozark-Gebirge und Happy Hollow ein Vergnügungspark, zu dem man von Hot Springs aus mit einem von Eseln gezogenen Wagen gelangte. Der Fotograf Norman McLeod eröffnete den Park 1888, als er dort ein Studio für humoristische Fotografie einrichtete. „Happy Hollow" (Fröhliches Tal) verdankt seinen Namen jedoch nicht McLeod: Der Ort wurde so genannt, weil Afroamerikaner aus der Umgebung von Hot Springs sonntags zur Quelle hinuntergingen, um dort mit Gesang die Messe zu feiern.

Page 306 : **Happy Hollow, Hot Springs, plaque de verre, 1901**
Ci-contre de haut en bas :
Happy Hollow, Hot Springs
Partie nord de Main Street depuis la 6e Rue, Little Rock
Little Rock vu du pont de Free Bridge

Hot Springs était à la fin du XIXe siècle une station thermale renommée des monts Ozarks et Happy Hollow un parc d'amusements où l'on se rendait en trolley tiré par des ânes depuis Hot Springs. C'est un photographe, Norman McLeod, qui inaugura le site en 1888 en y ouvrant un studio de photographie humoristique. « Happy Hollow » cependant ne doit pas son nom à McLeod : l'endroit fut nommé ainsi parce que les Noirs américains des environs de Hot Springs descendaient le dimanche à la source célébrer la messe en chantant des cantiques.

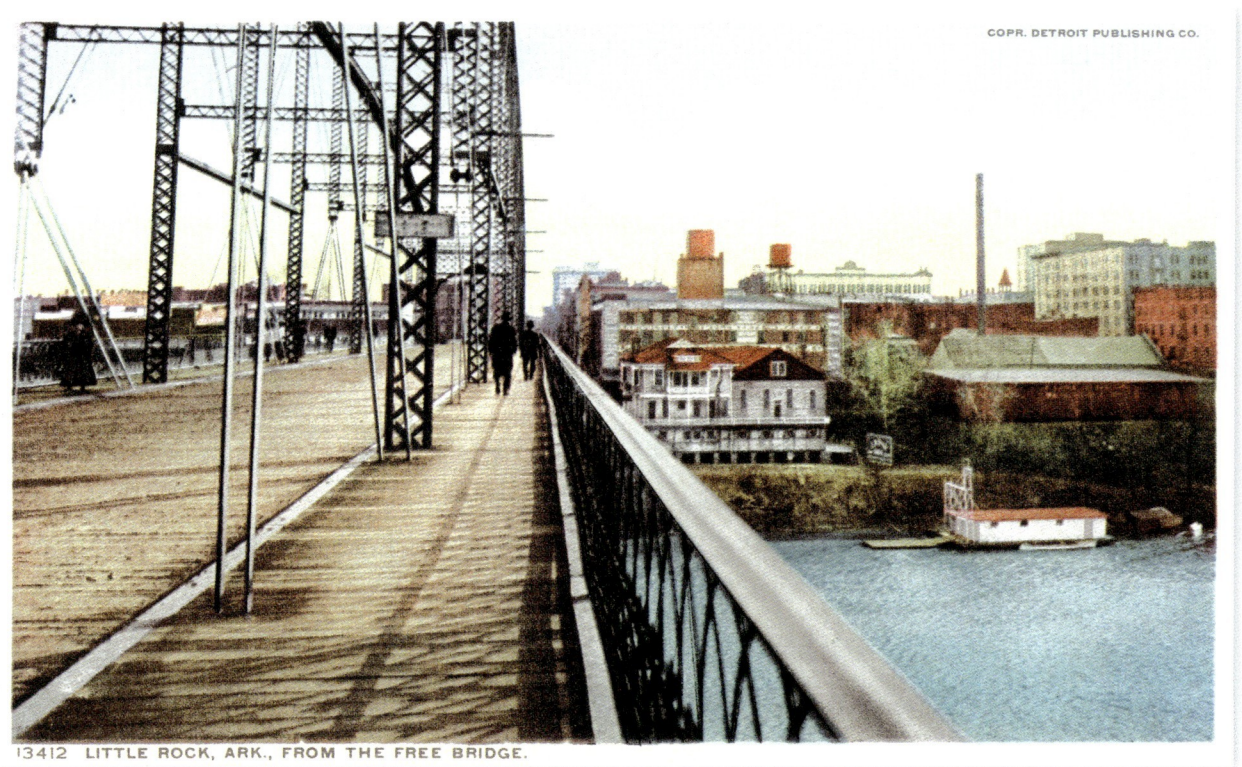

13412 LITTLE ROCK, ARK., FROM THE FREE BRIDGE.

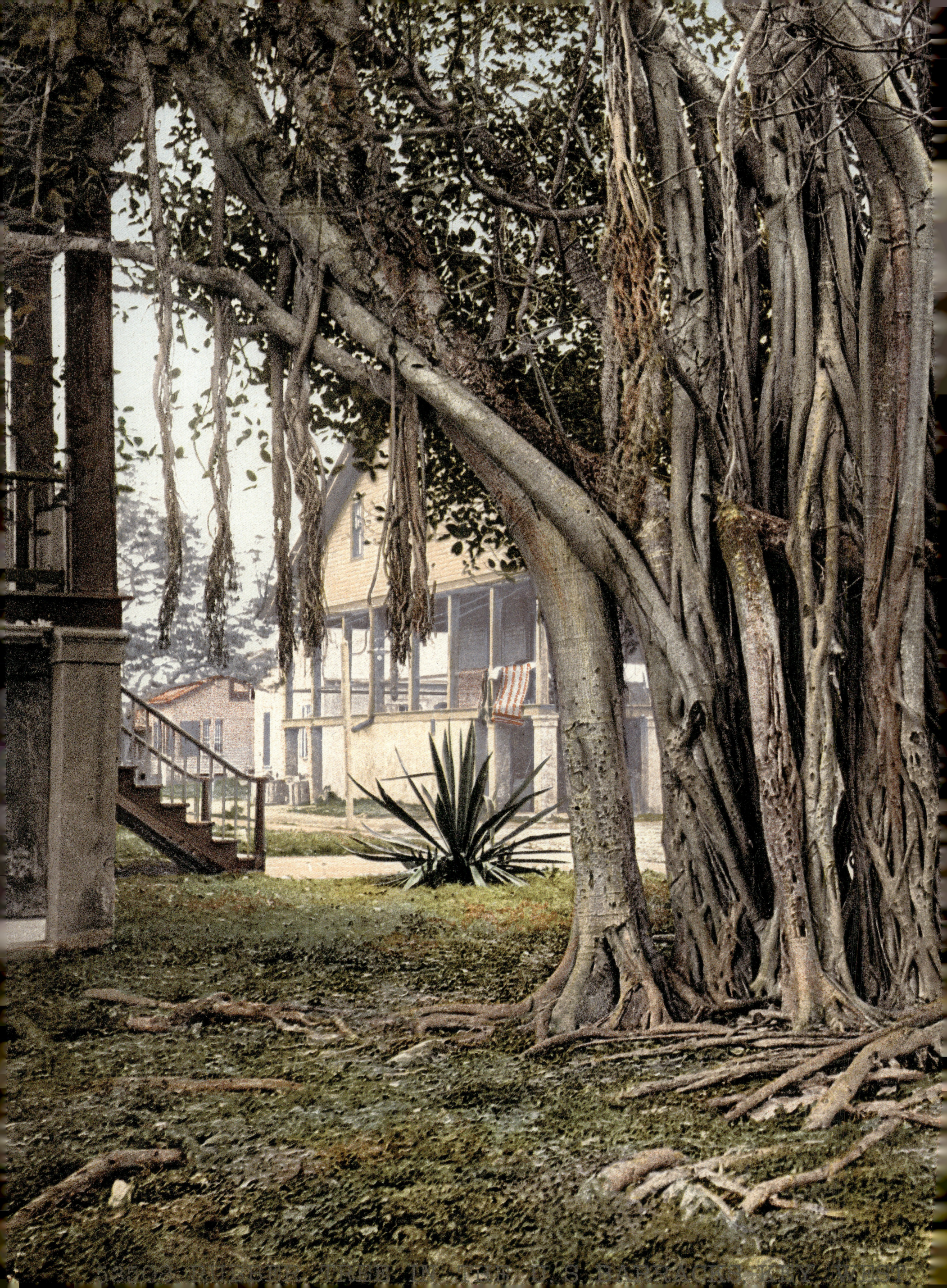

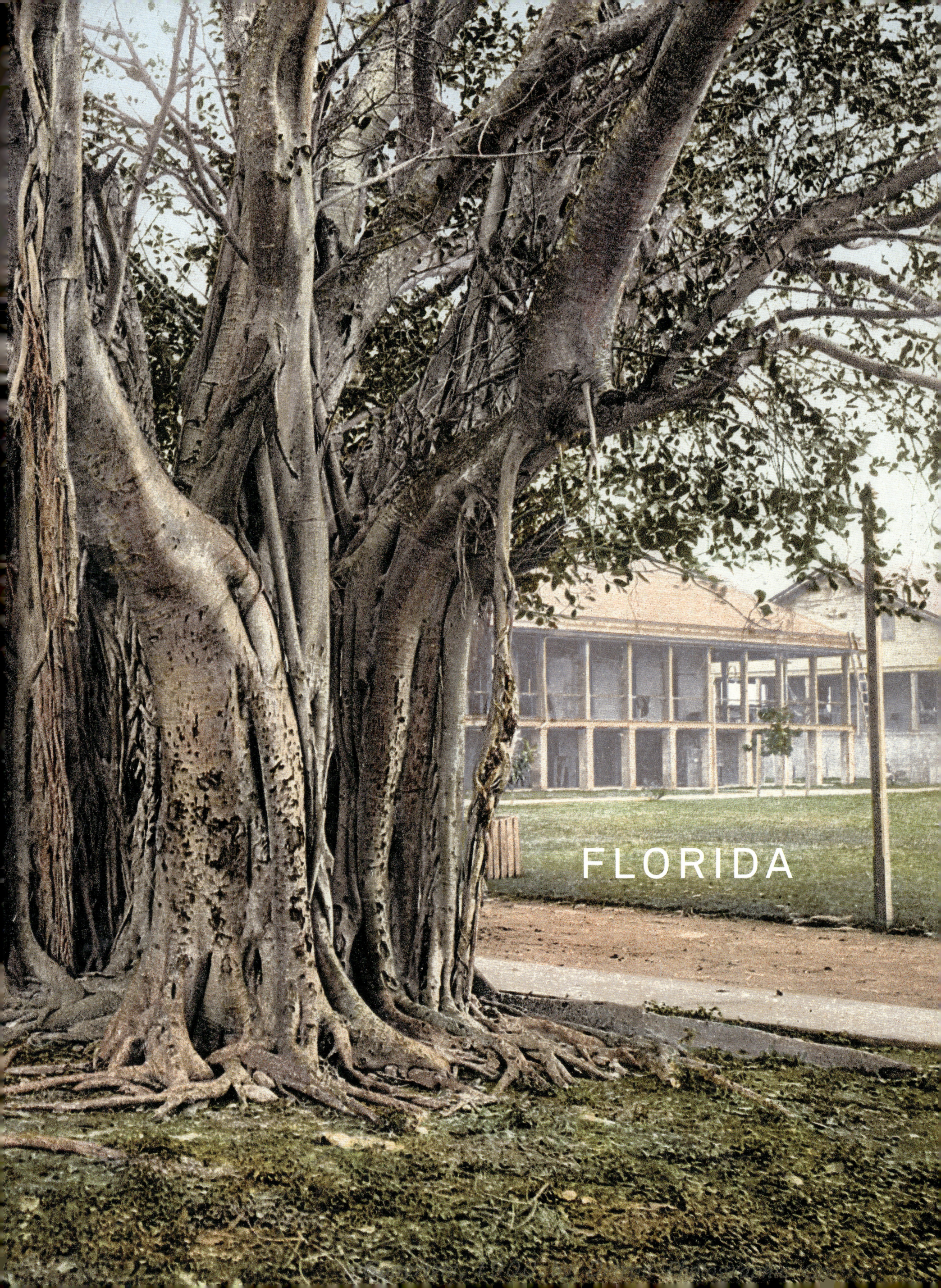

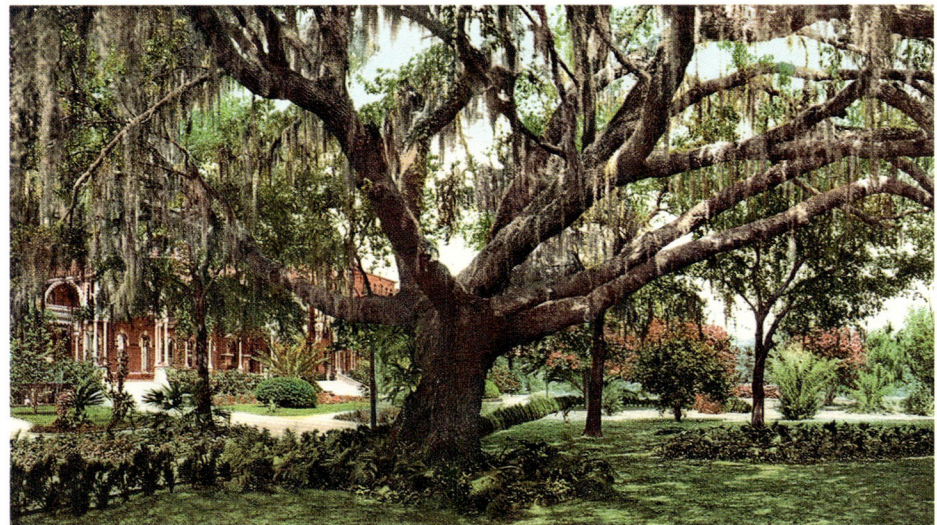

5734. PORCH OF TAMPA BAY HOTEL, TAMPA, FLA.

Page 308/309: **Rubber tree at Key West**, photochrom
Page 310, from top to bottom:
Tampa Bay Hotel, glass negative, 1902
Old oak, Tampa Bay Hotel, photochrom
Porch of Tampa Bay Hotel

Above: **A Florida landscape**, photochrom
Below left: **Port Tampa and Tampa Inn**
Below right: **Fishing on Tampa pier**

Seite 308/309: **Kautschukbaum in Key West**, Photochrom
Seite 310, von oben nach unten:
Das Hotel Tampa Bay, Glasnegativ, 1902
Die alte Eiche des Hotels Tampa Bay, Photochrom
Eingangsbereich des Hotels Tampa Bay

Oben: **Landschaft von Florida**, Photochrom
Unten links: **Port Tampa und Tampa Inn**
Unten rechts: **Angeln am Landesteg von Tampa**

Pages 308/309 : **arbre à caoutchouc à Key West**, photochrome
Page 310, de haut en bas :
L'hôtel Tampa Bay, plaque de verre, 1902
Le vieux chêne de l'hôtel Tampa Bay, photochrome
Le porche de l'hôtel Tampa Bay

Ci-dessus : **paysage de Floride**, photochrome
En bas à gauche : **Port Tampa et Tampa Inn**
En bas à droite : **pêche sur la jetée de Tampa**

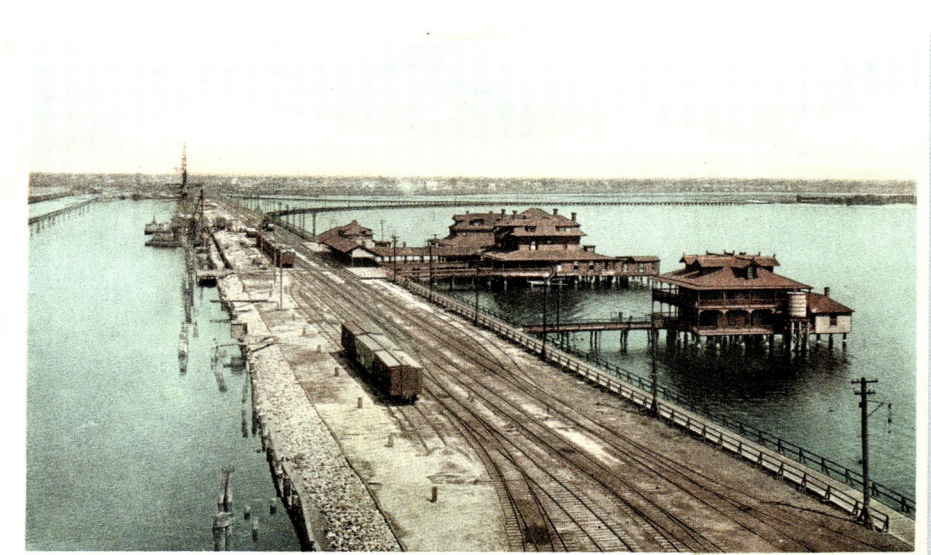

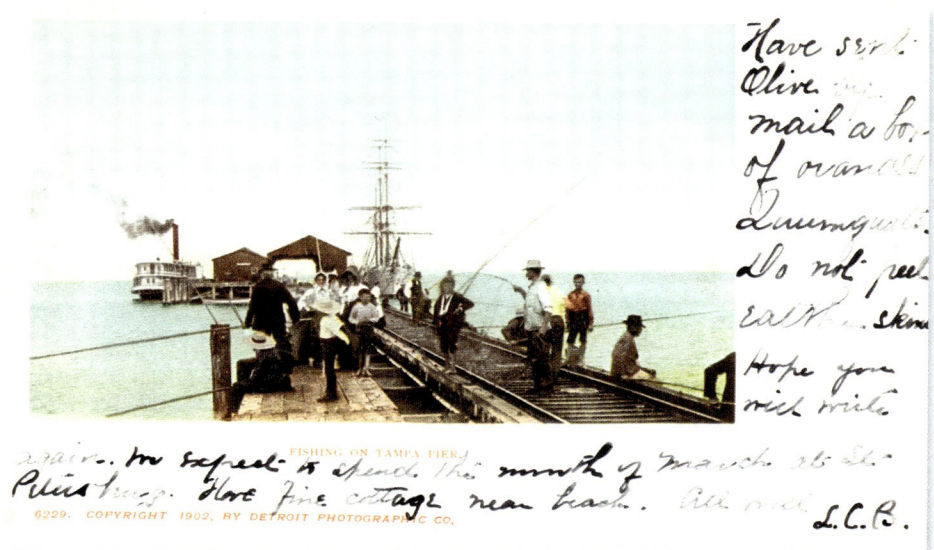

Above: **Custom House and harbor, photochrom**
Below: **The sponge fleet, photochrom**
Page 313: **Sponge exchange on wharf, Key West, glass negative, 1890–1901**

In the early 19th century, after a major storm, the fishermen of Key West discovered a large quantity of sponges thrown up on the beach by the waves. A local industry grew up with the creation of a fleet of "hook boats" that could harvest sponges in shallow water. It was a lucrative business: by the 1890s, the Key West hook fleet comprised no less than 350 boats and employed 1,400 men.

Oben: **Zollhaus und Hafen, Photochrom**
Unten: **Die Boote der Schwammfischer, Photochrom**
Seite 313: **Schwammmarkt am Kai von Key West, Glasnegativ, 1890–1901**

Nach einem großen Sturm Anfang des 19. Jahrhunderts entdeckten die Fischer von Key West eine Vielzahl von Schwämmen, die von den Wellen an den Strand gespült worden waren. Man errichtete ein kleines regionales Gewerbe und baute eine Flottille auf, die Hook Boats – Schiffe mit einem Haken, mit dem sich Schwämme in flachem Gewässer sammeln ließen. Das Geschäft wuchs stark an, denn die Flottille von Key West zählte in den 1890er-Jahren nicht weniger als 350 Schiffe und 1 400 Angestellte.

Ci-dessus : **le bâtiment de la douane et le port, photochrome**
En bas : **les bateaux des pêcheurs d'éponges, photochrome**
Page 313 : **marché aux éponges sur le quai de Key West, plaque de verre, 1890–1901**

Au début du XIXe siècle, après une grosse tempête, des pêcheurs de Key West découvrirent une grande quantité d'éponges rejetées sur la plage par les vagues. Une petite industrie locale se mit en place avec la création d'une flottille, les *hook boats* – bateaux équipés d'un crochet permettant de récolter les éponges dans les eaux peu profondes. Ce commerce prit ensuite une grande ampleur puisque, dans les années 1890, la flottille de Key West comptait pas moins de 350 navires et employait 1 400 hommes.

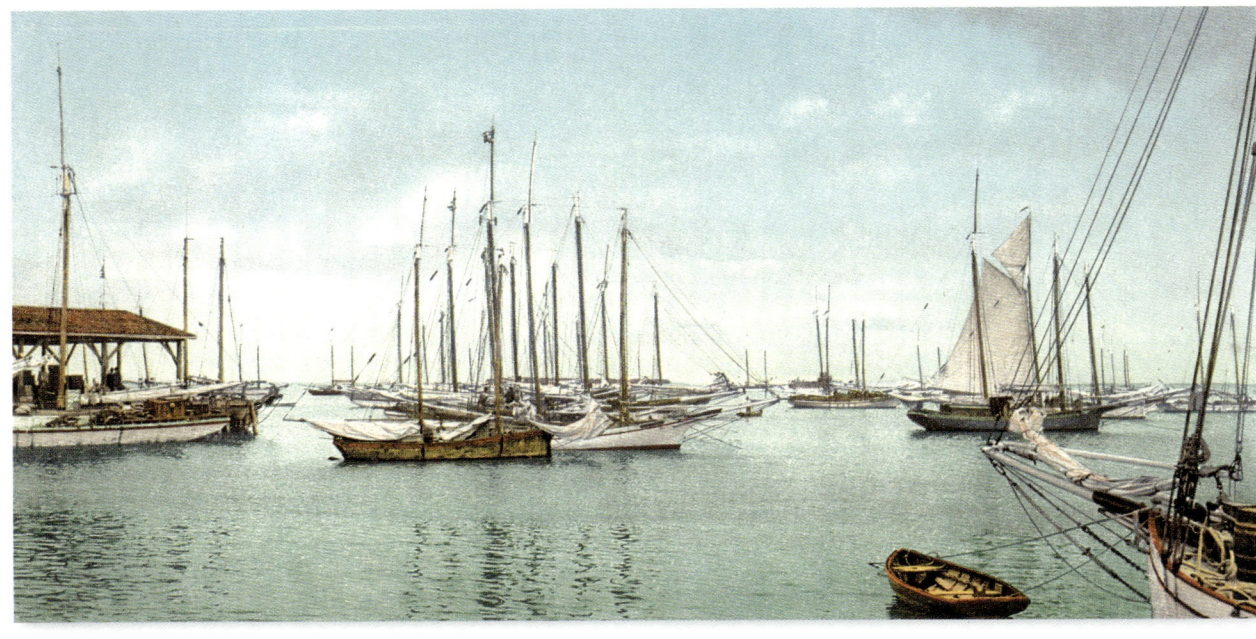

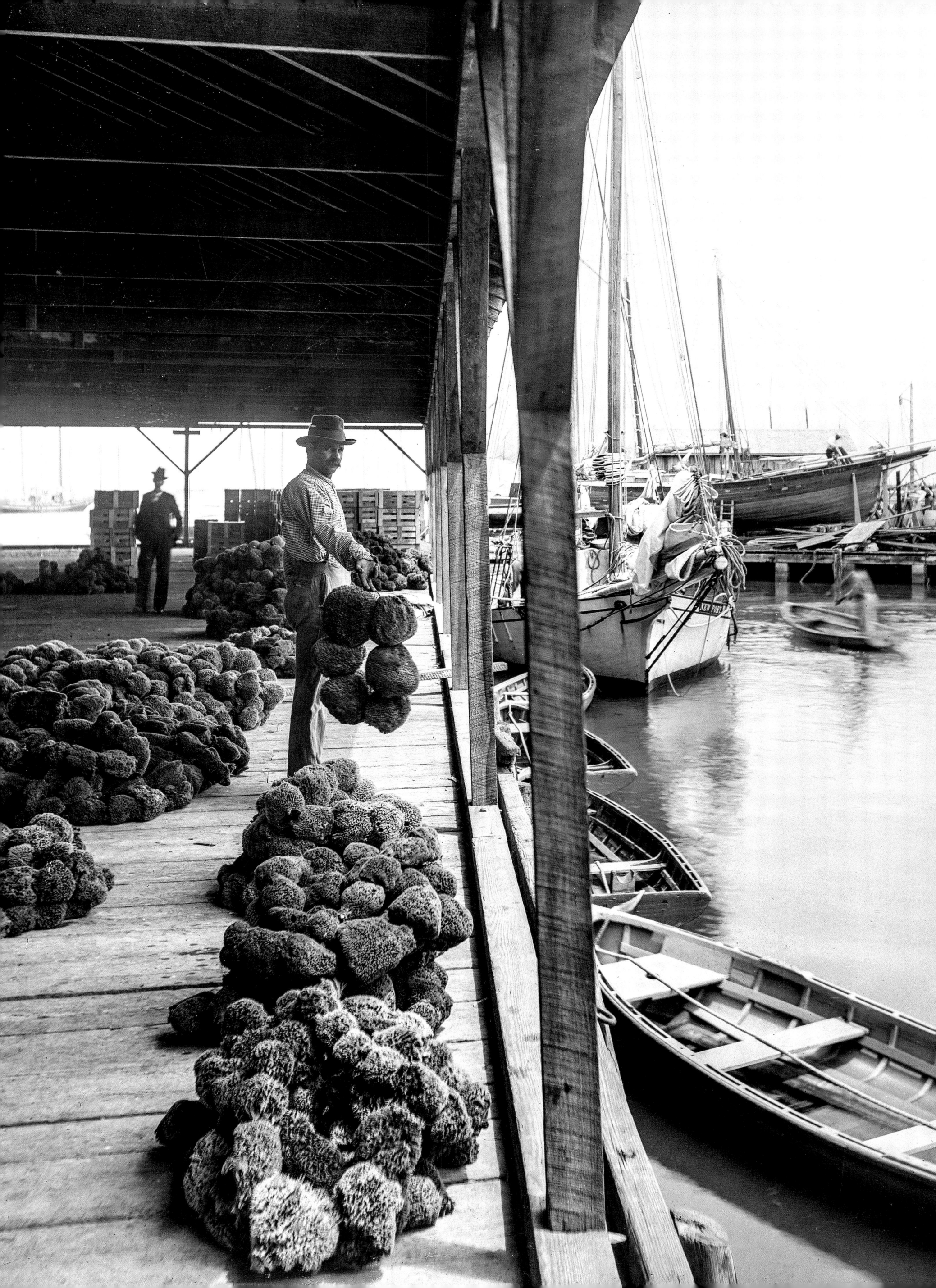

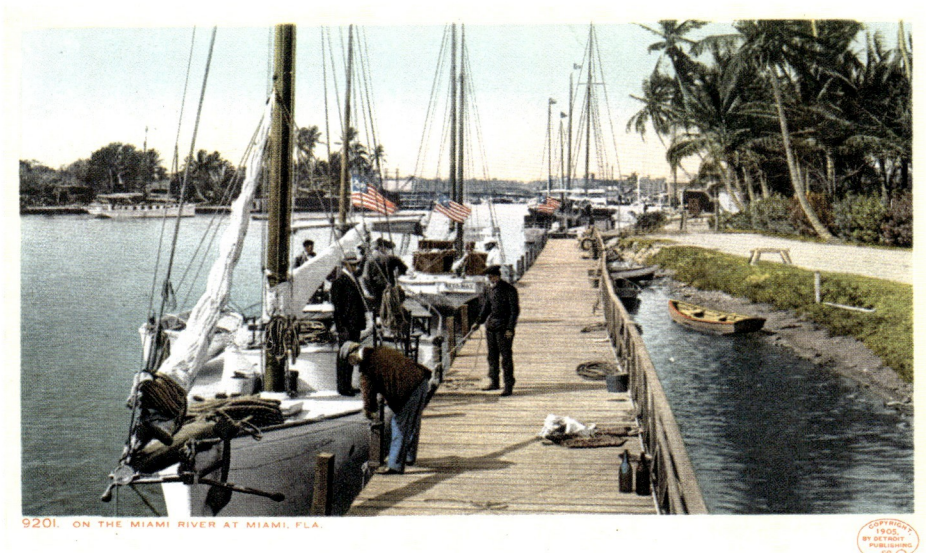

9201. ON THE MIAMI RIVER AT MIAMI, FLA.

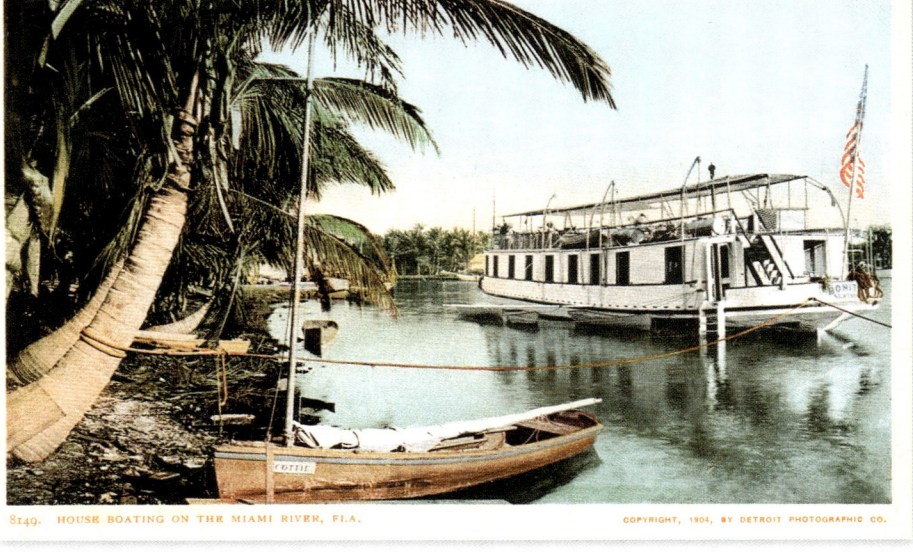

8149. HOUSE BOATING ON THE MIAMI RIVER, FLA.

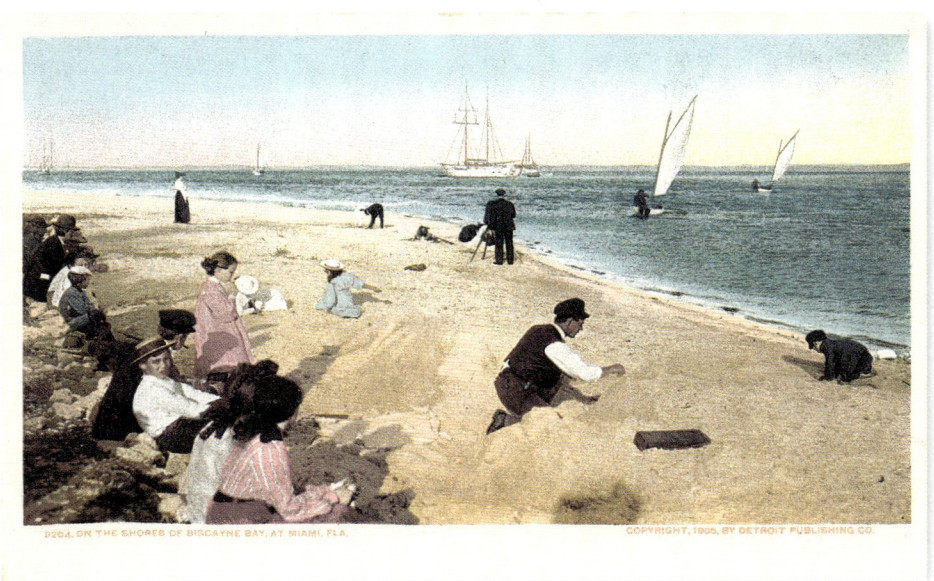

9202. ON THE SHORES OF BISCAYNE BAY, AT MIAMI, FLA.

Page 314, from top to bottom and left to right:
Evening on the Miami River, photochrom
On the Miami River at Miami
House boating on the Miami River
On the shores of Biscayne Bay, at Miami

Above: The Royal Palm Hotel from Miami River, photochrom
Below left: The Royal Palm, Miami
Below right: Veranda of the Royal Palm

Seite 314, von oben nach unten und von links nach rechts:
Abend über dem Miami River, Photochrom
Auf dem Miami River bei Miami
Schiff auf dem Miami River
An der Küste der Biscayne Bay in Miami

Oben: Das Hotel Royal Palm vom Miami River aus, Photochrom
Unten links: Das Hotel Royal Palm, Miami
Unten rechts: Die Veranda des Hotels Royal Palm

Page 314, de haut en bas et de gauche à droite :
Tombée du jour sur la Miami River, photochrome
Sur la Miami River à Miami
Bateau sur la Miami River
Sur le rivage de la baie de Biscayne, à Miami

Ci-dessus : l'hôtel Royal Palm vu depuis la Miami River, photochrome
En bas à gauche : l'hôtel Royal Palm, Miami
En bas à droite : la véranda de l'hôtel Royal Palm

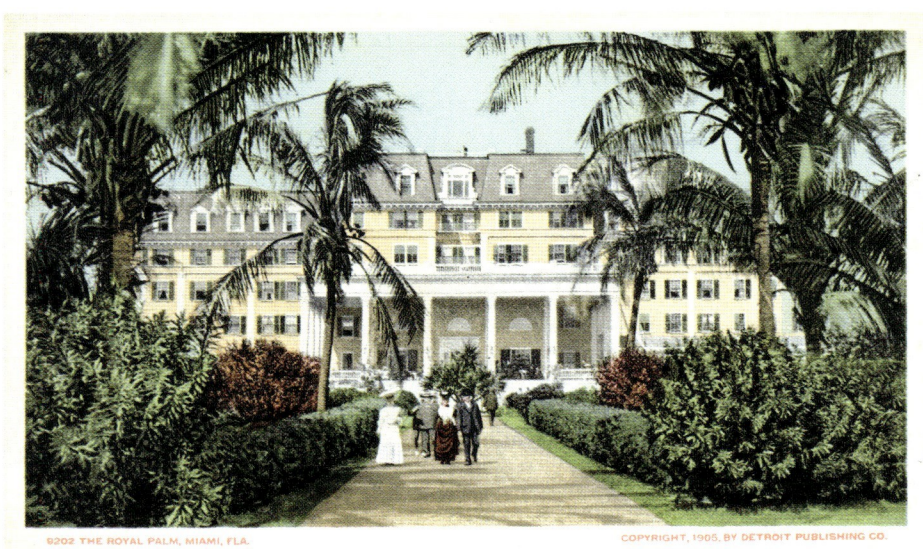
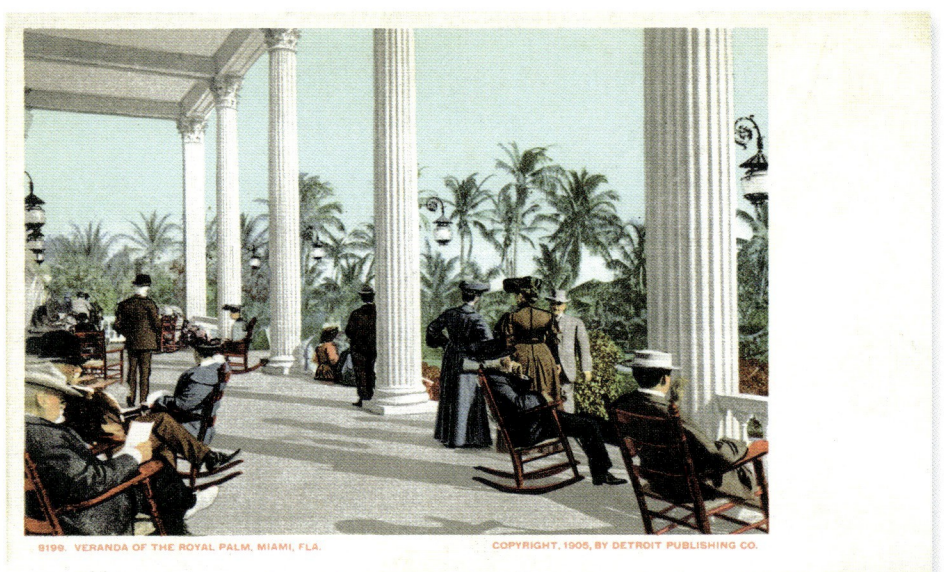

FLORIDA | MIAMI

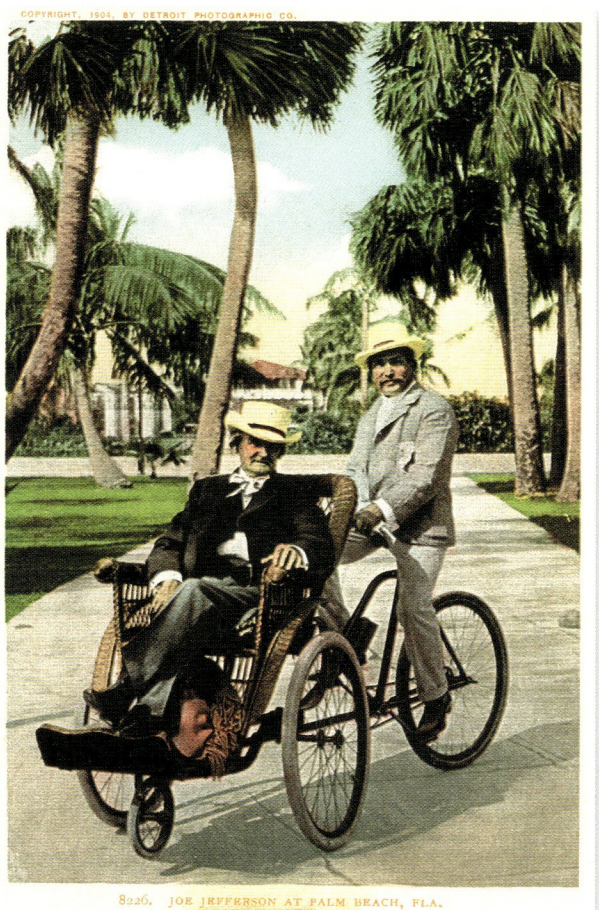

Above: Afternoon concert hour, Royal Poinciana, Palm Beach, glass negative, 1904
Left: Joe Jefferson at Palm Beach

The resort of Palm Beach owes its existence to Henry Flagler, a founder of Standard Oil. He linked the town to the railway and financed the construction of the grand Royal Poinciana Hotel on the banks of Lake Worth in 1894. In 1896, he bought the Palm Beach Inn, which was renamed Breakers Hotel in 1902. Joseph Jefferson, a once celebrated actor, was its star guest.

Oben: Nachmittagskonzert im Royal Poinciana, Palm Beach, Glasnegativ, 1904
Links: Joe Jefferson in Palm Beach

Der Badeort Palm Beach entstand dank Henry Flagler, einem der Gründer der Standard Oil Company. Er schloss die Stadt an den Schienenverkehr an und finanzierte den Bau des Grand Hotels Royal Poinciana am Ufer des Lake Worth (1894); später kaufte er das Palm Beach Inn auf (1896), das 1902 in Breakers Hotel umbenannt wurde. Der seinerzeit berühmte Schauspieler Joseph Jefferson war ein treuer Kunde des Breakers.

En haut : le concert de l'après-midi au Royal Poinciana, Palm Beach, plaque de verre, 1904
À gauche : Joe Jefferson à Palm Beach

La station de Palm Beach fut lancée grâce à Henry Flagler, l'un des actionnaires de la Standard Oil Company. Il relia la ville au chemin de fer et finança la construction du grand hôtel Royal Poinciana, sur la rive du lac Worth (1894) ; puis il racheta le Palm Beach Inn (1896), qui fut renommé hôtel Breakers en 1902. Célèbre en son temps, l'acteur Joseph Jefferson était un fidèle client du Breakers.

Right: The beach, Palm Beach
Below, from left to right and top to bottom:
The Royal Poinciana from Lake Worth
Watching the boat races
The Palm Beach trolley
Bathing pool in the casino

Rechts: Der Strand von Palm Beach
Unten, von links nach rechts und von oben nach unten:
Das Hotel Royal Poinciana vom Lake Worth aus
Beim Beobachten der Regatten
Der Trolley von Palm Beach
Das Schwimmbad im Kasino

À droite : la plage de Palm Beach
En bas, de gauche à droite et de haut en bas :
L'hôtel Royal Poinciana vu depuis Lake Worth
En regardant les régates
Le trolley de Palm Beach
La piscine du casino

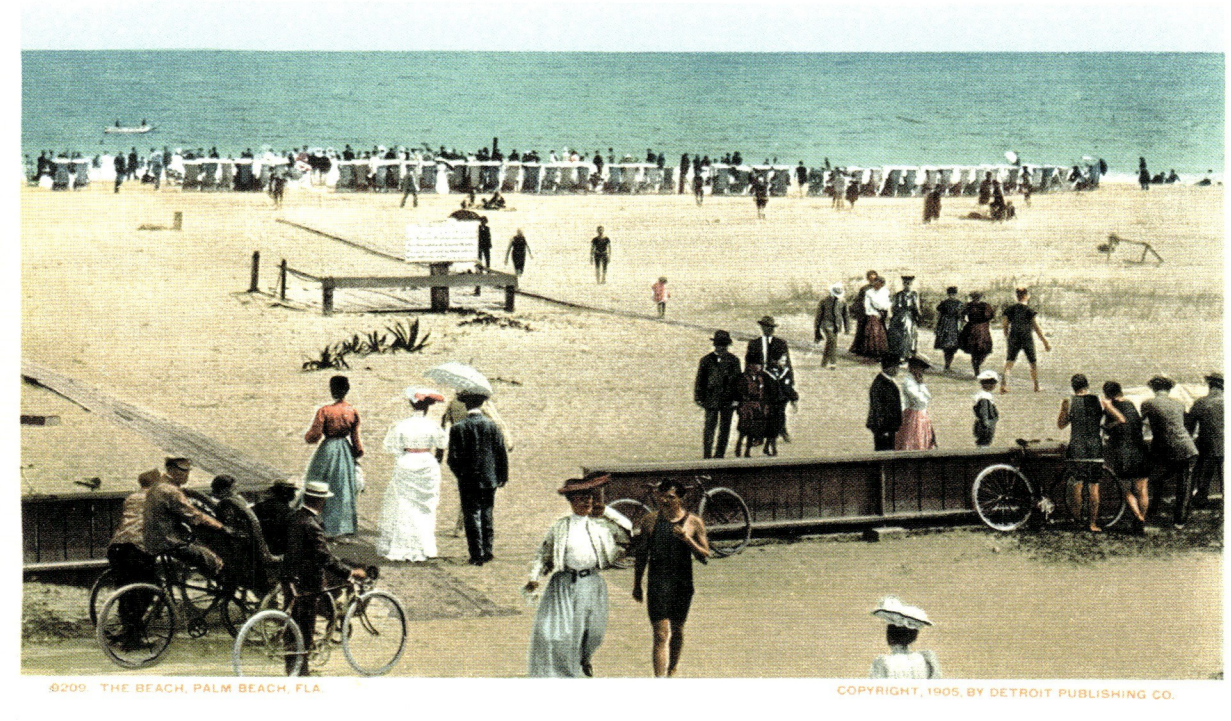

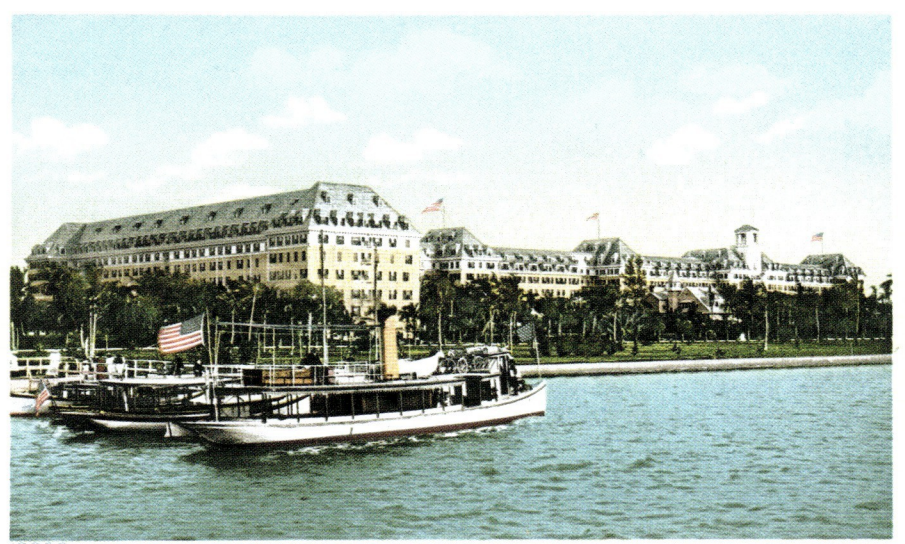

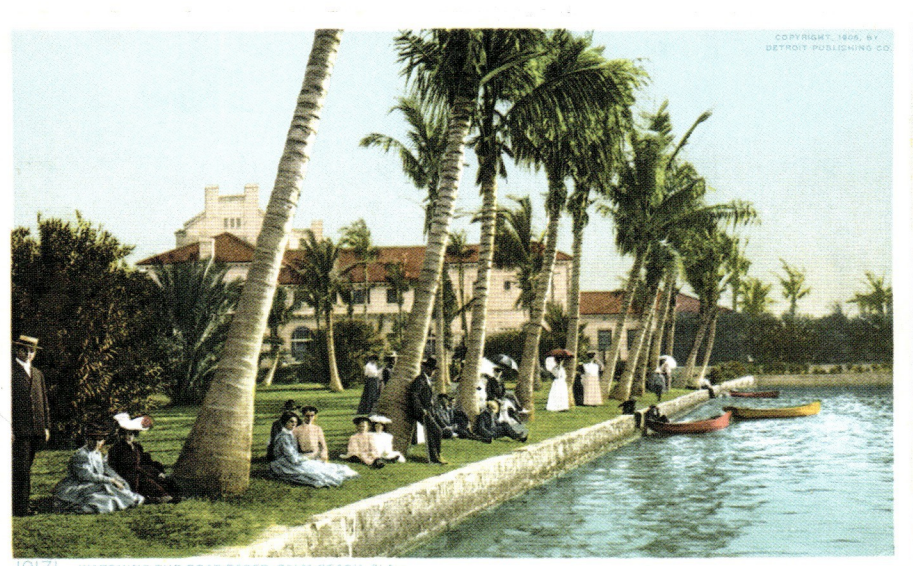

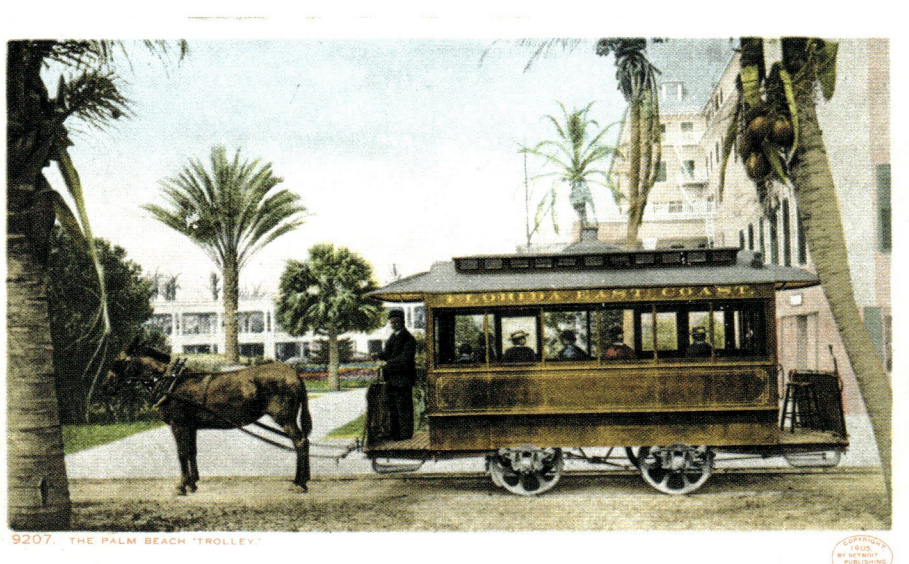

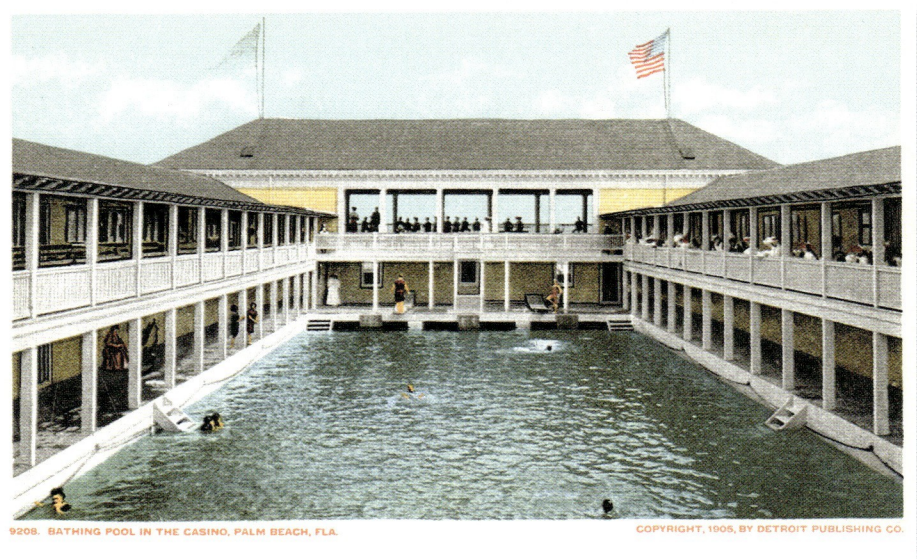

Above: **On the Tomoka**, glass negative, 1897
Below left: **The Jungle Trail, Palm Beach**
Below right: **On the Jungle Trail, Palm Beach**
Page 319:
Above: **Day's fishing, Palm Beach**, glass negative, 1894
Below: **A day's catch**

Oben: **Auf dem Tomoka River**, Glasnegativ, 1897
Unten links: **Der Dschungelpfad, Palm Beach**
Unten rechts: **Auf dem Dschungelpfad, Palm Beach**
Seite 319:
Oben: **Der Tagesfang, Palm Beach**, Glasnegativ, 1894
Unten: **Der Fischfang des Tages**

Ci-dessus : **sur la rivière Tomoka**, plaque de verre, 1897
En bas à gauche : **la Jungle Trail (« piste de la jungle »), Palm Beach**
En bas à droite : **sur la Jungle Trail (« piste de la jungle »), Palm Beach**
Page 319 :
En haut : **Pêche du jour à Palm Beach**, plaque de verre, 1894
En bas : **Prise du jour**

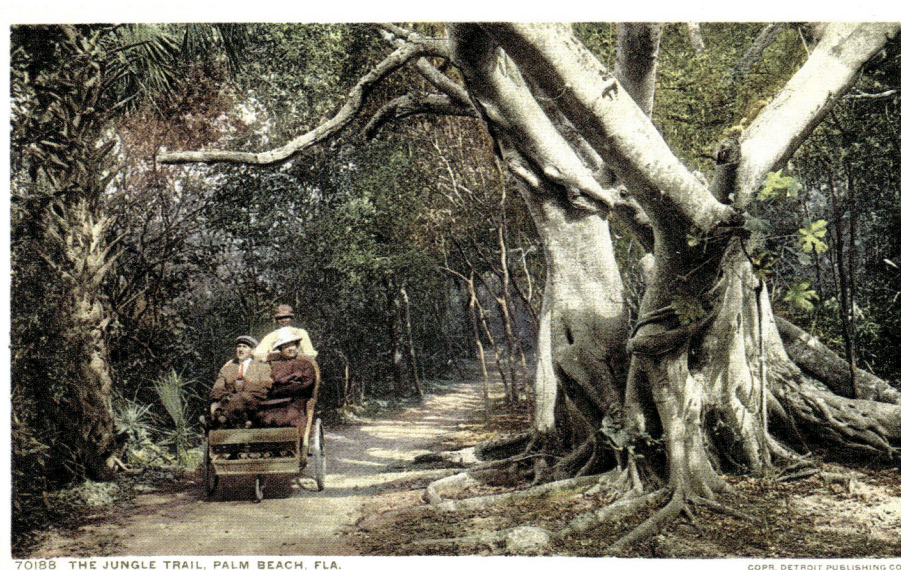

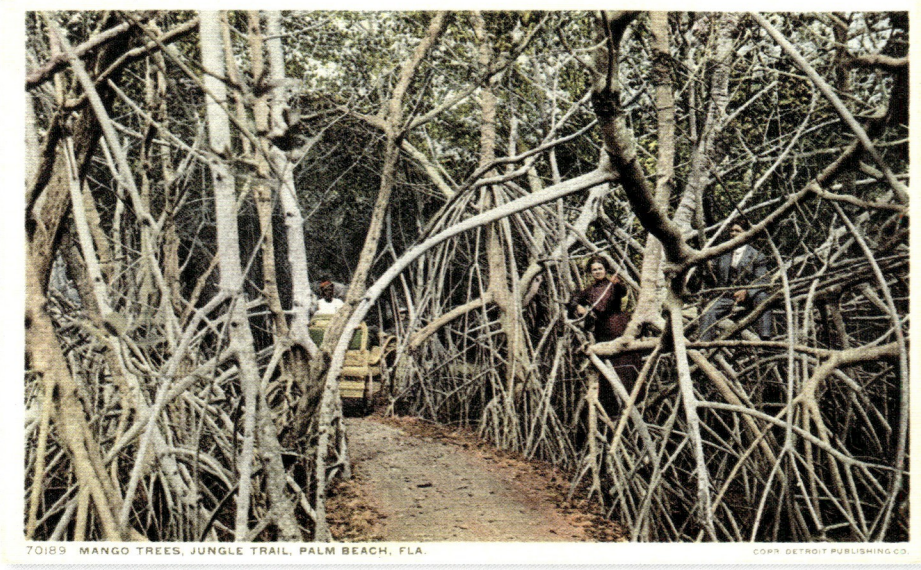

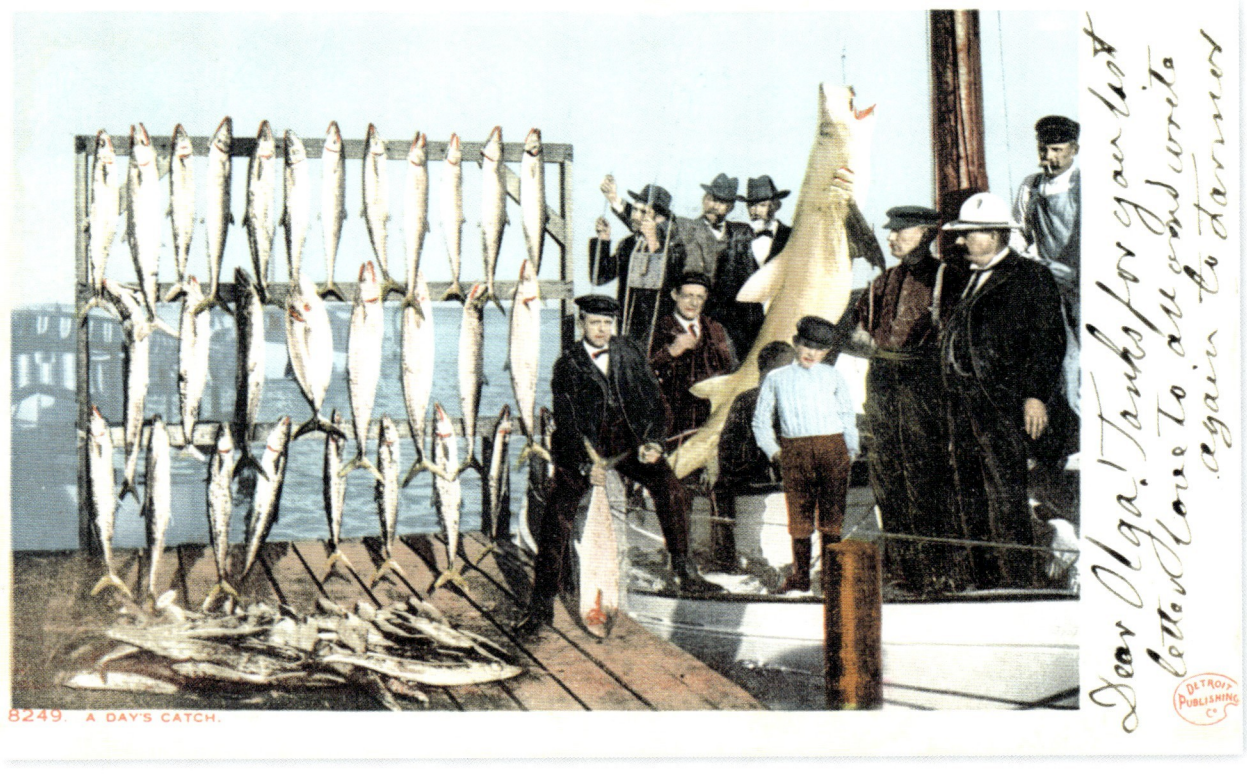

8249. A DAY'S CATCH.

FLORIDA | PALM BEACH

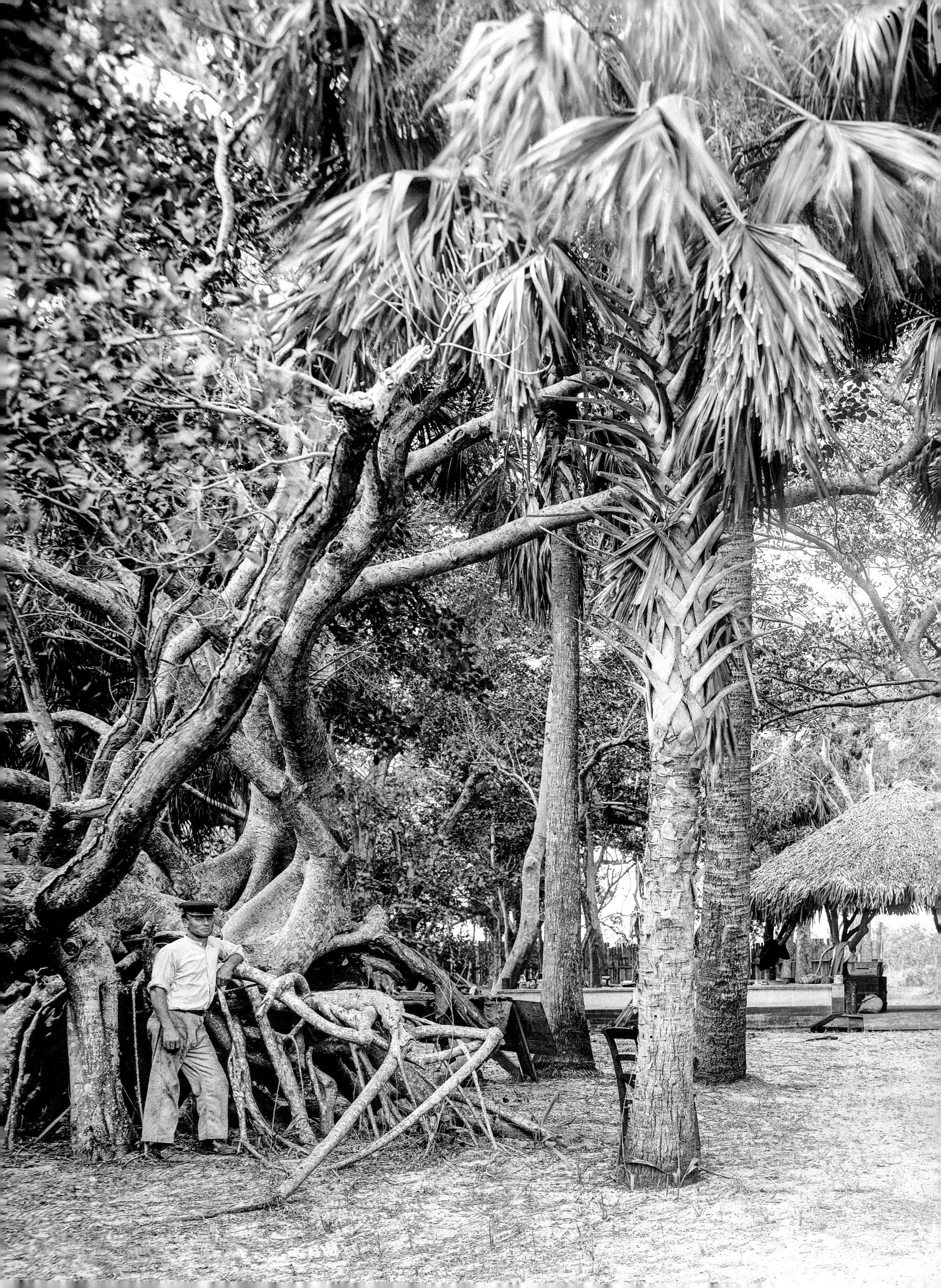

Page 320: Alligator Joe's bungalow, glass negative, 1910
Above: Alligator Joe and his pets, 1904
Below: "White Tiger" and his alligators

Seite 320: Der Bungalow von Alligator Joe, Glasnegativ, 1910
Oben: Alligator Joe und seine Haustiere, 1904
Unten: „White Tiger" und seine Alligatoren

Pages 320 : le bungalow d'Alligator Joe, plaque de verre, 1910
Ci-dessus : Alligator Joe et ses animaux familiers, 1904
En bas : « White Tiger » (« Tigre blanc ») et ses alligators

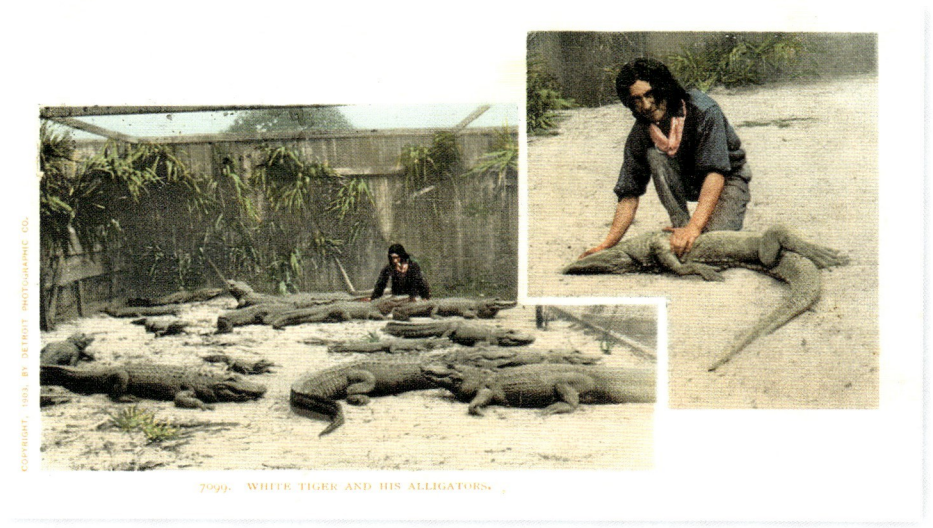

FLORIDA | PALM BEACH

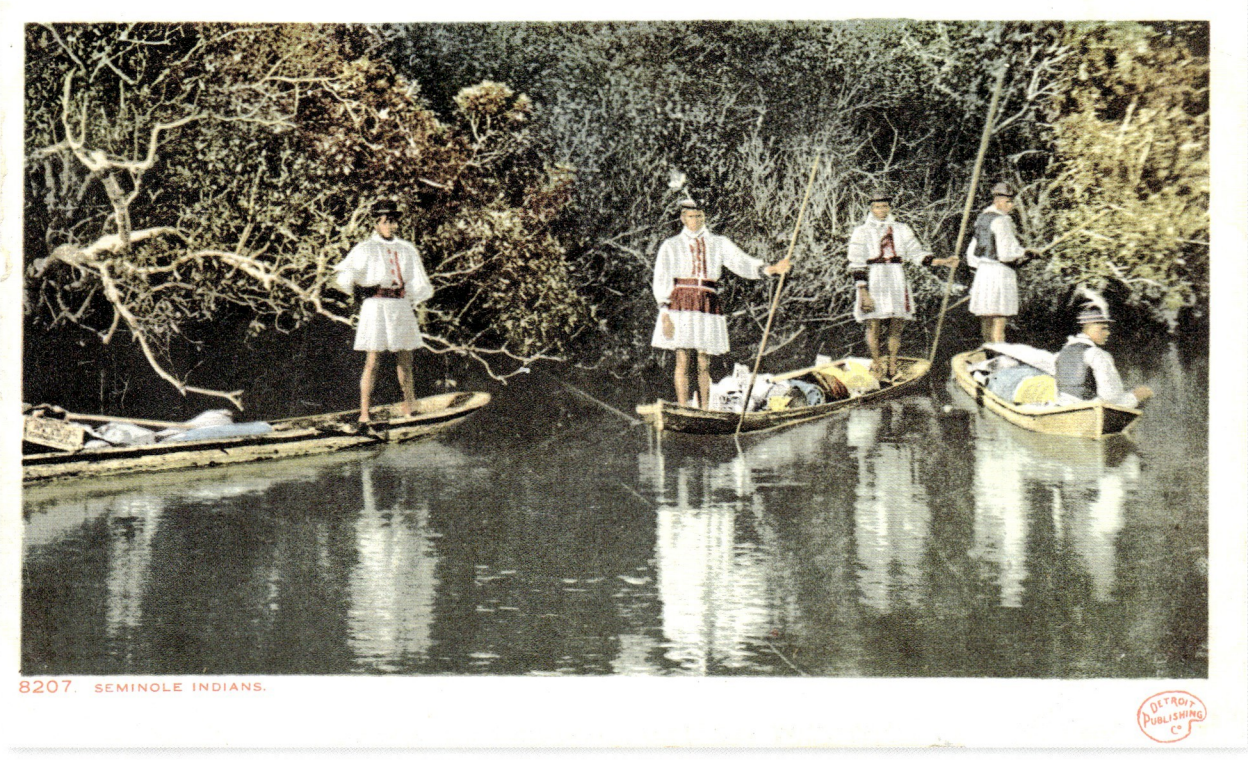

8207. SEMINOLE INDIANS.

Above: Sunset on the Ocklawaha, photochrom
Page 322, below: Seminole Indians
Below left: Seminole Indian family in dugout canoe, Miami River
Below right: A Seminole Indian mother and children

The Seminoles are descended from the Creek, who had been deported by the Spanish in the 16th century from Georgia to the north of Florida, in a vain effort to convert them. Between 1812 and 1858, three Creek wars and three Seminole wars decimated the tribes holed up in the Florida marshes. The survivors were confined to reservations and reduced to the status of a tourist attraction.

Oben: Sonnenuntergang über dem Ocklawaha River, Photochrom
Seite 322, unten: Seminolen-Indianer
Unten links: Seminolenfamilie in ihrem Kanu, Miami River
Unten rechts: Eine Seminolin mit ihren Kindern

Die Seminolen sind Nachfahren der Creek, die im 16. Jahrhundert von den Spaniern von Georgia in den Norden Floridas deportiert wurden, wo man sie vergeblich zu christianisieren versuchte. Zwischen 1812 und 1858 dezimierten drei Creek-Kriege und drei Seminolen-Kriege die Stämme, die sich im Sumpfgebiet von Florida verschanzt hatten. Die Überlebenden wurden anschließend in Reservaten zusammengepfercht, wo sie das traurige Schicksal als Touristenattraktion ereilte.

Ci-dessus : coucher de soleil sur la rivière Ocklawaha, photochrome
Page 322, en bas : Indiens Séminoles
En bas à gauche : famille indienne Séminole dans son canoë, Miami River
En bas à droite : une Indienne Séminole et ses enfants

Les Séminoles sont des descendants des Creeks déportés de Géorgie au XVIe siècle par les Espagnols vers le nord de la Floride pour y être christianisés. En vain. Entre 1812 et 1858, trois guerres Creeks plus trois guerres Séminoles décimèrent les tribus retranchées dans les marais de Floride. Les survivants furent ensuite parqués dans des réserves, réduits au triste sort d'attraction touristique.

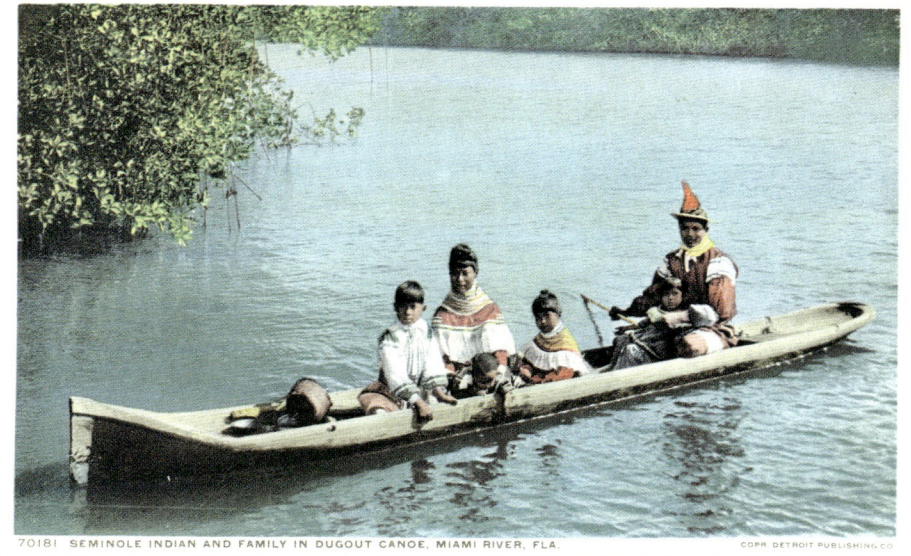

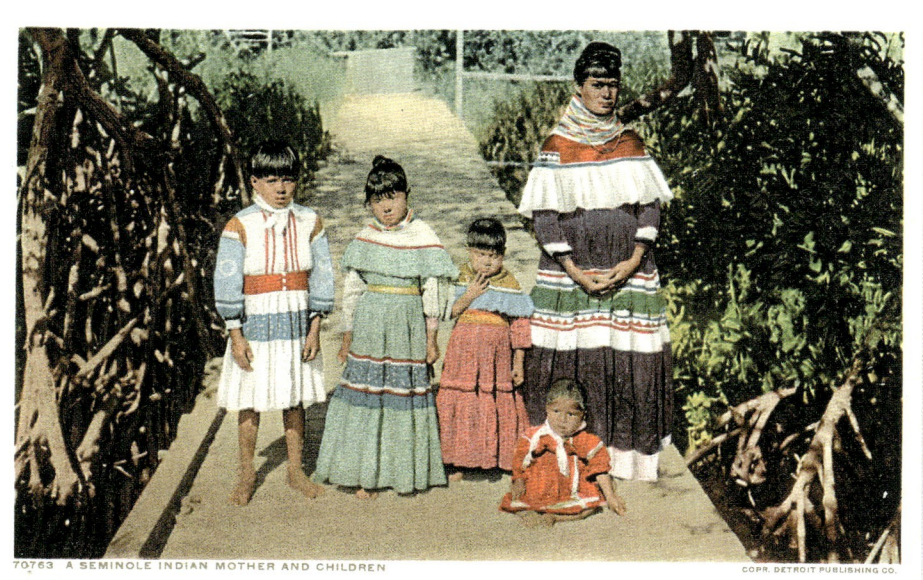

FLORIDA | OCALA | OCKLAWAHA

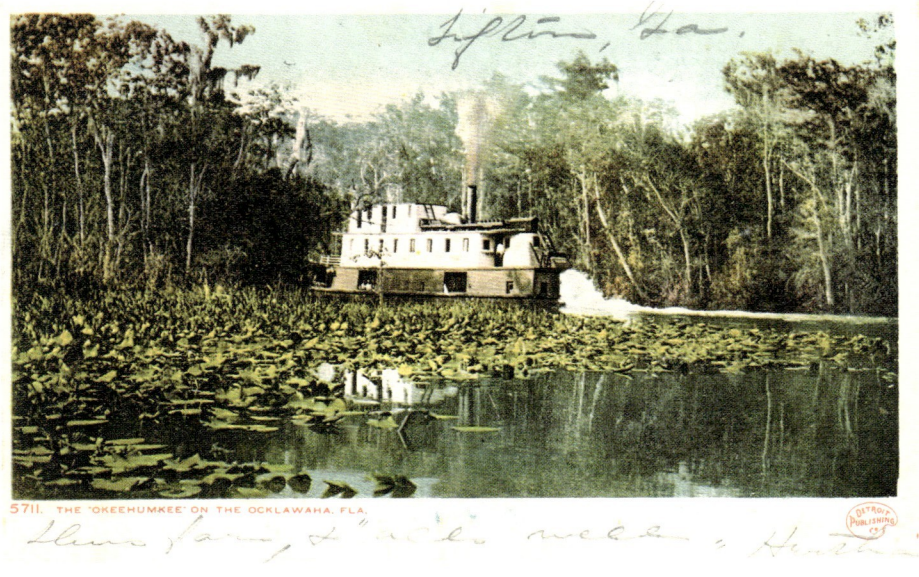

Top: On the Ocklawaha River, photochrom
Above: The *Okeehumkee* on the Ocklawaha

Page 325:
Top: Rice Creek, photochrom
Right: A ferry on the Ocklawaha, glass negative, 1902
Page 326/327: The Tomoka landing, Ormond, photochrom

The Ocklawaha River in northeast Florida forms the boundary of the Ocala National Forest. Its rich fauna and flora were ravaged during the Indian wars of the mid-19th century by American army vessels transporting troops. The boats in our images served peaceful ends but polluted nonetheless; these tourist steamships plied the river at the turn of the 19th century.

Oben: Auf dem Ocklawaha River, Photochrom
Mitte: Der Dampfer *Okeehumkee* auf dem Ocklawaha River

Seite 325:
Oben: Rice Creek, Photochrom
Rechts: Eine Fähre auf dem Ocklawaha River, Glasnegativ, 1902
Seite 326/327: Ormond, Anlegestelle am Tomoka River, Photochrom

Der Fluss Ocklawaha im Nordosten Floridas ist heute ein Schutzgebiet innerhalb des Ocala National Forest. Seiner besonders reichen Flora und Fauna war während der Indianerkriege in der Mitte des 19. Jahrhunderts schwerer Schaden zugefügt worden, denn die Truppen der amerikanischen Armee wurden auf seinem Lauf transportiert. Die friedlicheren, aber nicht weniger die Umwelt verschmutzenden Schiffe auf diesen Bildern sind Dampfschiffe für Touristen, wie sie an der Wende zum 20. Jahrhundert benutzt wurden.

En haut : sur la rivière Ocklawaha, photochrome
En bas : l'*Okeehumkee* sur la rivière Ocklawaha

Page 325 :
Ci-dessus : Rice Creek, photochrome
À droite : un ferry sur l'Ocklawaha, plaque de verre, 1902
Pages 326/327 : Ormond, embarcadère sur la rivière Tomoka, photochrome

Au nord-est de la Floride, la rivière Ocklawaha est aujourd'hui une aire protégée du parc forestier d'Ocala. Sa faune et sa flore, particulièrement riches, avaient été gravement atteintes lors des guerres indiennes du milieu du xixe siècle car le transport des troupes de l'armée américaine s'effectuait sur son cours. Les bateaux de nos images, plus pacifiques mais tout aussi polluants, sont des vapeurs de tourisme utilisés au tournant du xxe siècle.

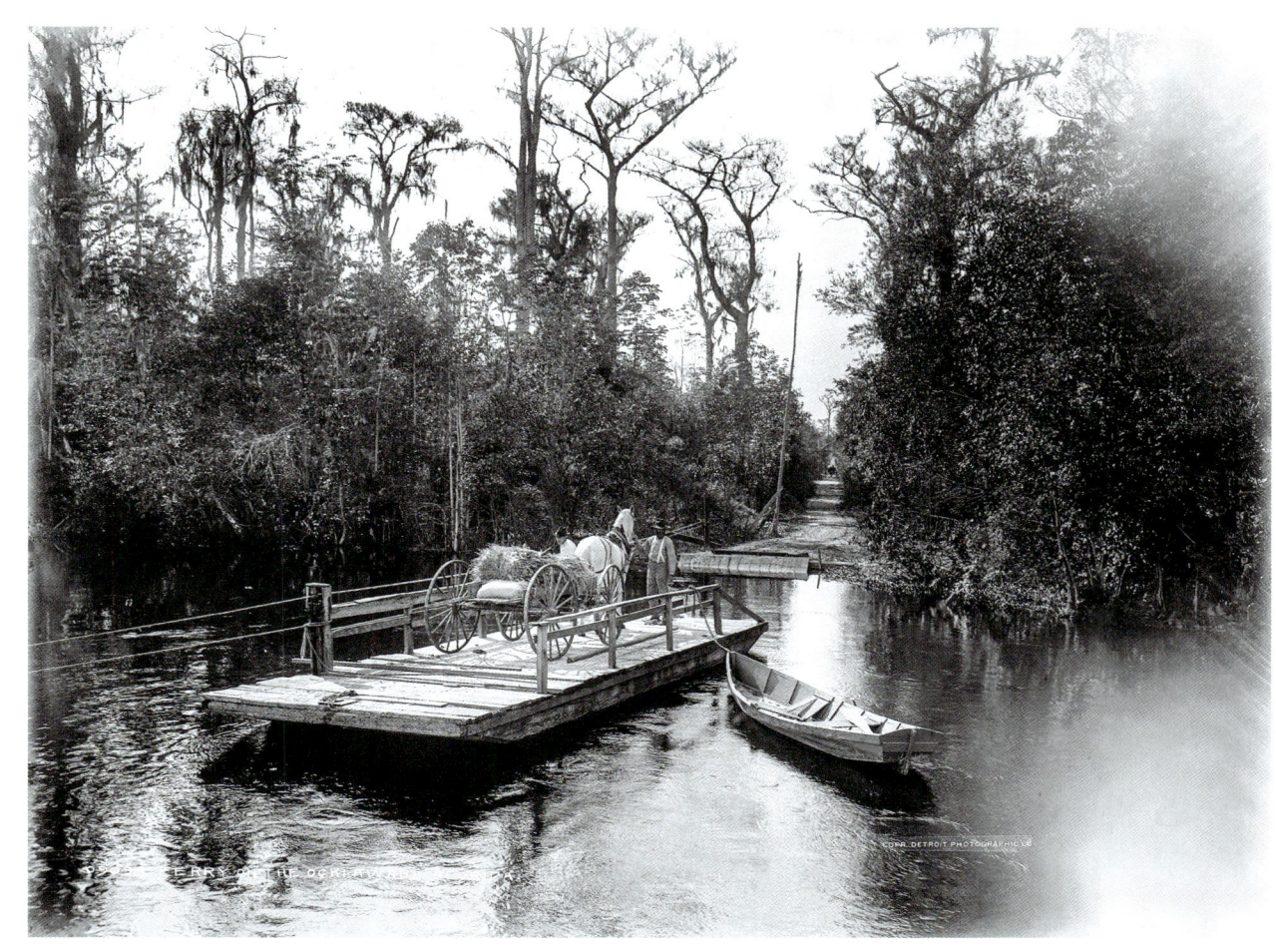

FLORIDA | OCALA | OCKLAWAHA

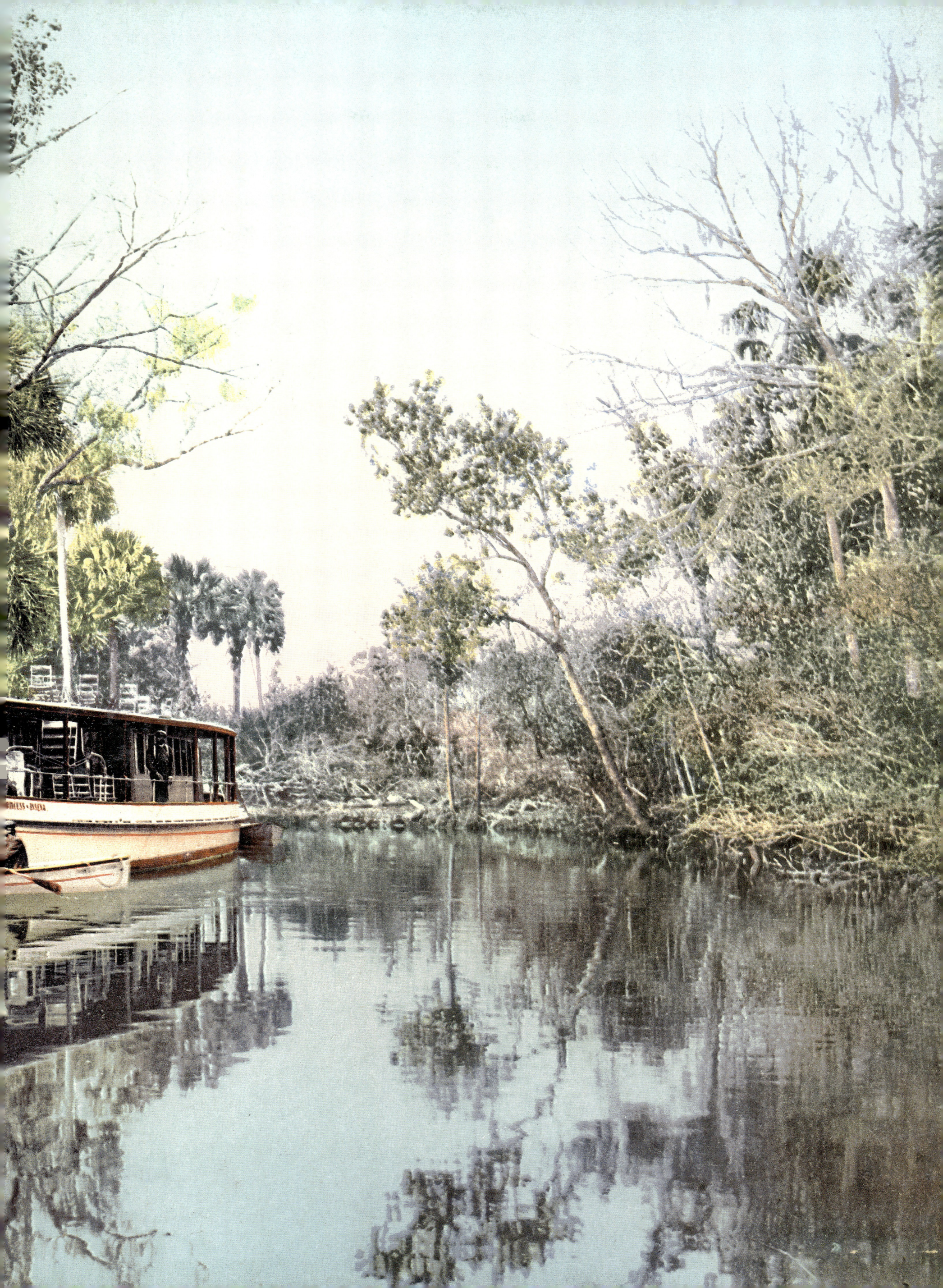

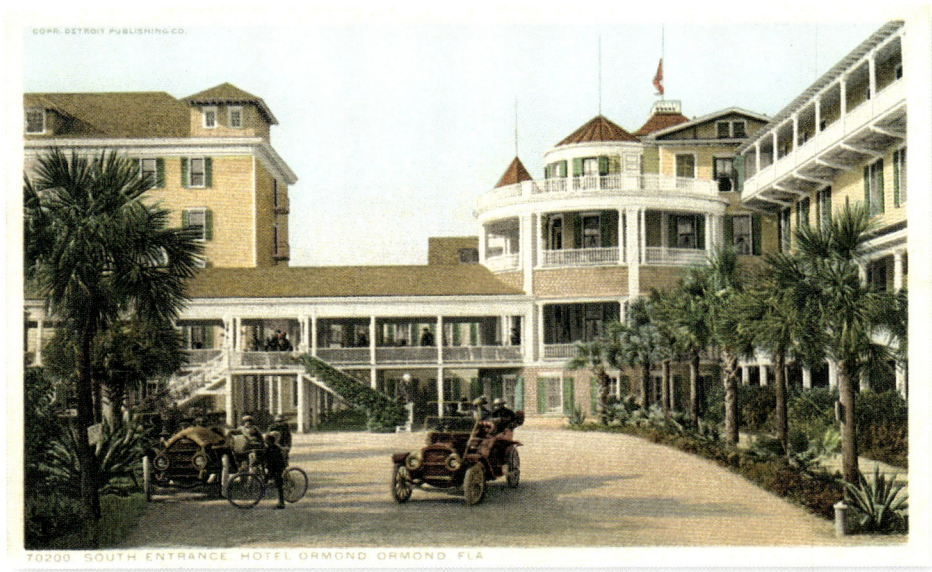

70200. SOUTH ENTRANCE, HOTEL ORMOND, ORMOND, FLA.

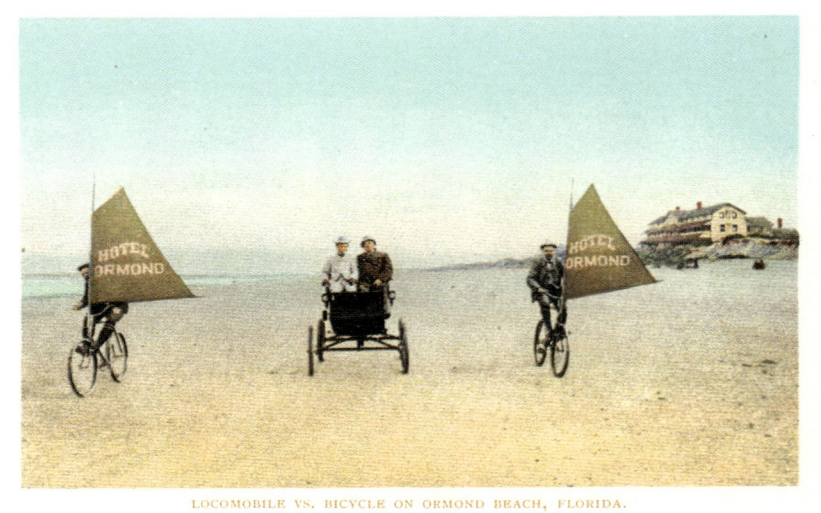

LOCOMOBILE VS. BICYCLE ON ORMOND BEACH, FLORIDA.

6680. DETROIT PHOTOGRAPHIC CO., PUBLISHERS.

Page 328, from top to bottom:
Hotel Ormond, photochrom
South entrance, Hotel Ormond
Locomobile vs. bicycle on Ormond Beach

Above: Bathing hour on the beach, Daytona, glass negative, 1902
Below left: Beach at Seabreeze
Below right: The "line-up," Ormond-Daytona Beach

The immense beaches of Ormond and Daytona are long bands of white sand stretching along the Atlantic between the Tomoka and Halifax Rivers. Their popularity coincided with the arrival of the railroad in Ormond in 1886.
Their status as seaside resorts took off after the purchase by Henry Flagler of the Ormond Hotel in 1890 and the extension of the railroad along the banks of the Halifax. One of the landlords of the Ormond Hotel, J. F. Hathaway, was the first to drive a car on Ormond Beach, paving the way for the first race, which took place in March 1903.

Seite 328, von oben nach unten:
Das Hotel Ormond, Photochrom
Südeingang des Hotels Ormond
Lokomobil versus Fahrräder am Strand von Ormond

Oben: Badezeit in Daytona Beach, Glasnegativ, 1902
Unten links: Strand in Seabreeze
Unten rechts: „In Reih und Glied" am Strand von Ormond-Daytona

Lange weiße Sandstrände erstrecken sich zwischen dem Atlantik, dem Tomoka River und dem Halifax River. Die breiten Strände von Ormond und Daytona bevölkerten sich mit der Ankunft der Eisenbahn in Ormond im Jahr 1886.
Nach der Übernahme des Hotels Ormond durch Henry Flagler im Jahr 1890 und der Verlängerung der Bahnstrecke entlang des Halifax River erlebten die zwei Badeorte ihren Aufschwung. J. F. Hathaway, einer der Gäste des Hotels Ormond, war der Erste, der mit einem Automobil am Strand von Ormond entlangfuhr, und machte damit den Weg frei für das erste Rennen im März 1903.

Pages 328, de haut en bas :
L'hôtel Ormond, photochrome
L'entrée sud de l'hôtel Ormond
Locomobile contre bicyclettes sur la plage d'Ormond

Ci-dessus : l'heure du bain à Daytona Beach, plaque de verre, 1902
En bas à gauche : la plage de Seabreeze
En bas à droite : « En ligne » sur la plage d'Ormond-Daytona

Longues bandes de sable blanc qui s'étirent entre l'Atlantique et les rivières Tomoka et Halifax, les immenses plages d'Ormond et de Daytona furent fréquentées à partir de l'arrivée du chemin de fer à Ormond en 1886.
Avec le rachat de l'hôtel Ormond par Henry Flagler en 1890 et la prolongation de la ligne ferroviaire le long de la rivière Halifax, les deux stations prirent leur essor. L'un des hôtes de l'hôtel Ormond, J. F. Hathaway, fut le premier à conduire une automobile sur la plage d'Ormond, ouvrant la voie à la première course qui se déroula en mars 1903.

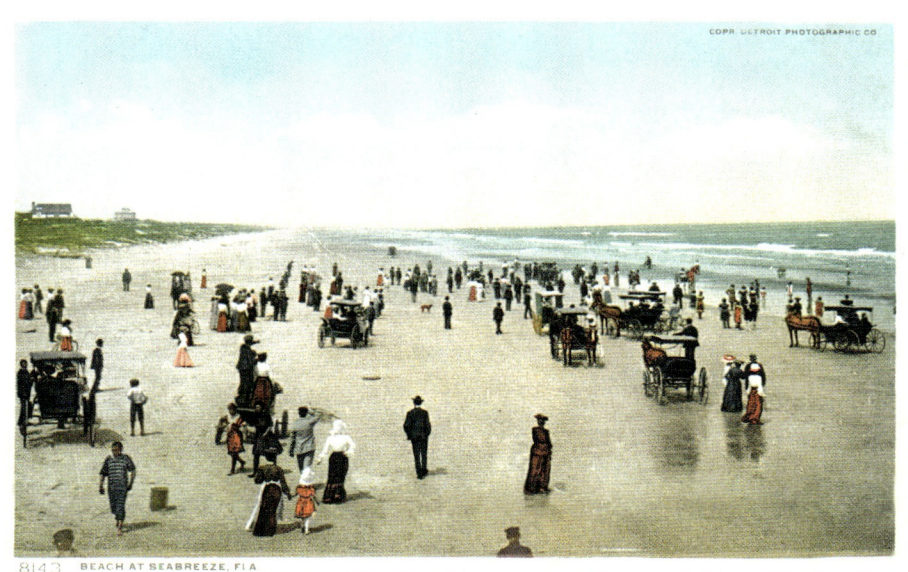

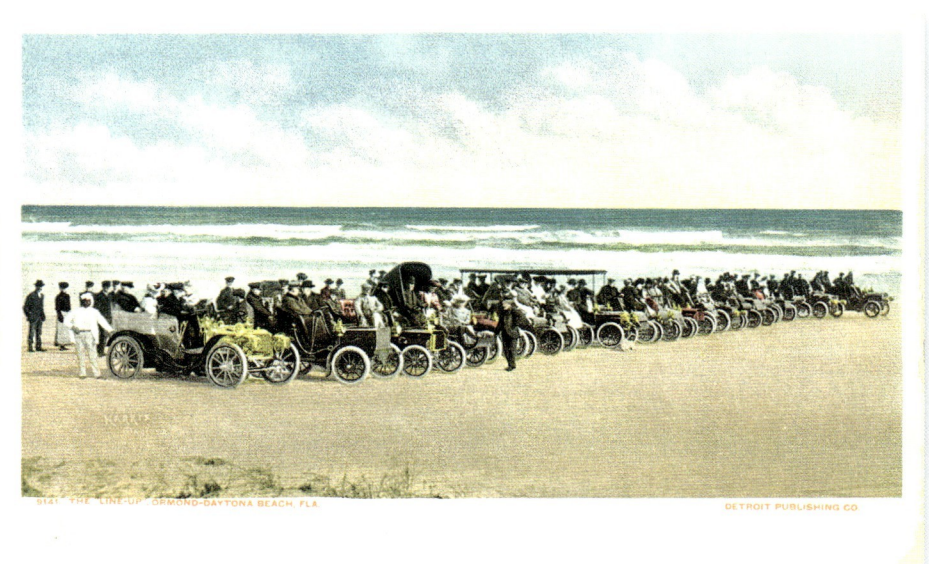

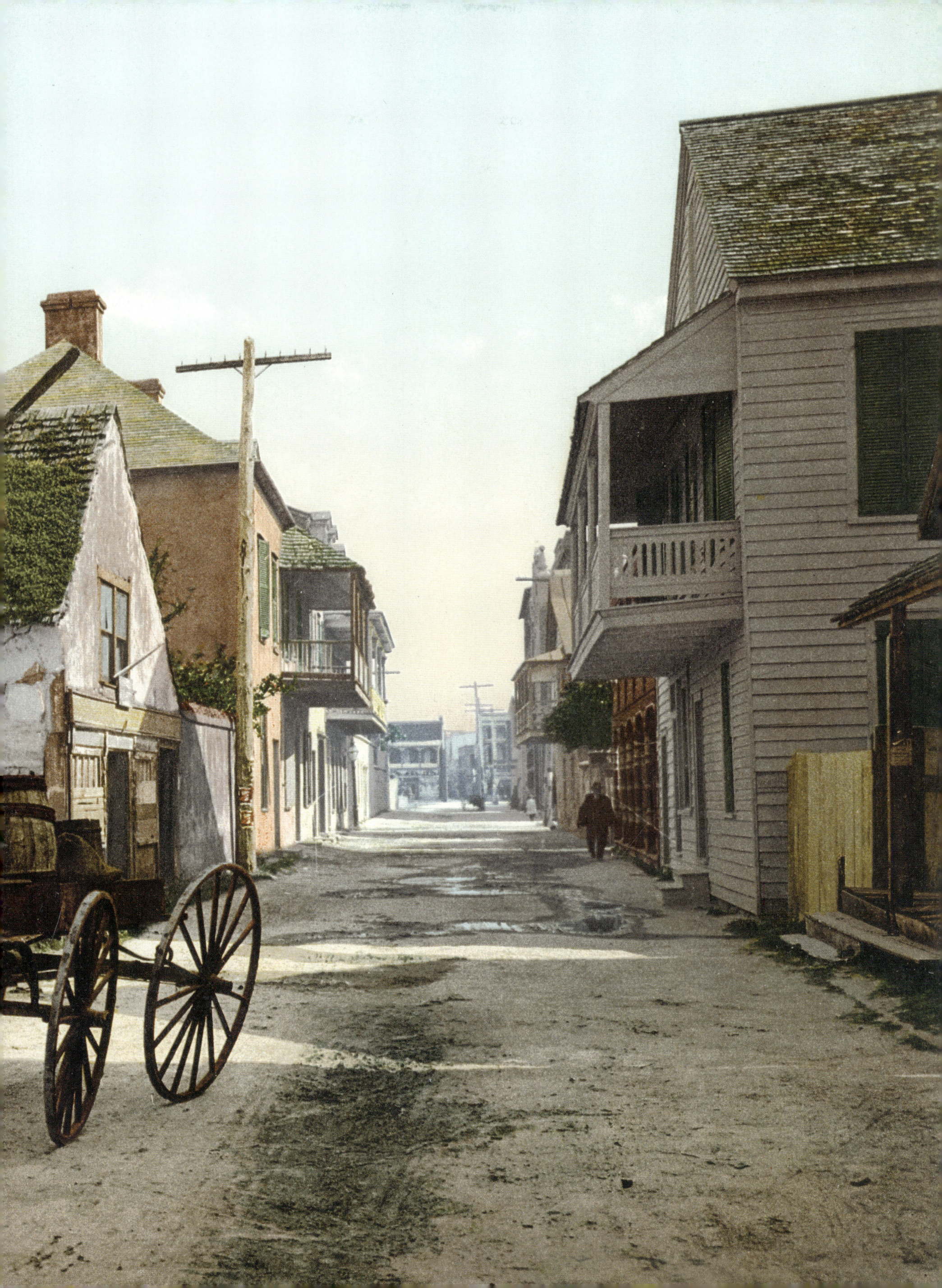

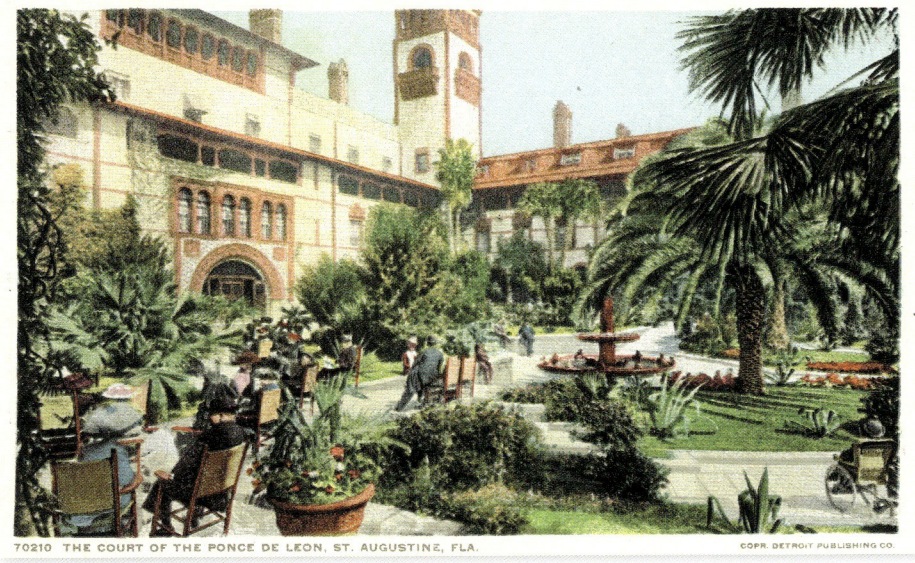

70210 THE COURT OF THE PONCE DE LEON, ST. AUGUSTINE, FLA.

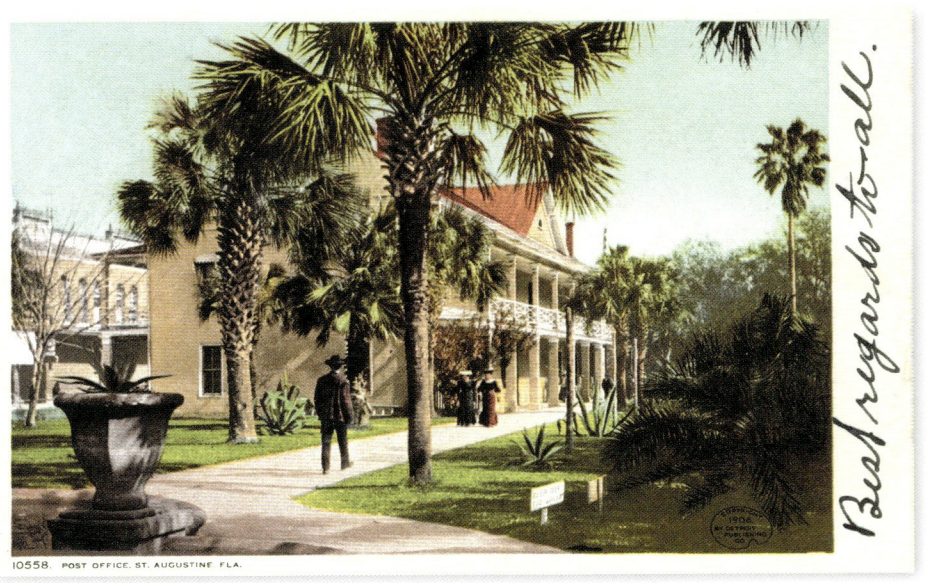

10558 POST OFFICE, ST. AUGUSTINE, FLA.

Page 330/331: **St. Augustine, Charlotte Street, photochrom**
Page 332, from top to bottom:
The Ponce de León Hotel, photochrom
The court of the Ponce de León
Post office, St. Augustine
Above and below:
The Alcazar Hotel, photochrom and postcard

Founded in the early 16th century by the Spaniard Pedro Menéndez de Avilés, St. Augustine is the oldest city in the United States. The architecture of the houses on Charlotte Street is typical of the vernacular style adopted by the Crackers, the Anglo-American pioneers who settled in Florida when the colony was bought from Spain in the late 18th century. The Ponce de León Hotel was the first built by Henry Flagler in Florida and opened its doors in 1888.

Seite 330/331: **St. Augustine, Charlotte Street, Photochrom**
Seite 332, von oben nach unten:
Das Hotel Ponce de León, Photochrom
Der Hof des Hotels Ponce de León
Postamt von St. Augustine
Oben und unten:
Das Hotel Alcazar, Photochrom und Postkarte

St. Augustine, die älteste Stadt der Vereinigten Staaten, wurde Anfang des 16. Jahrhunderts von dem Spanier Pedro Menéndez de Avilés gegründet. Die Architektur der Häuser in der Charlotte Street ist typisch für den regionalen Stil, den die Cracker übernommen haben, die angloamerikanischen Pioniere, die sich in Florida niederließen, als die Kolonie Ende des 18. Jahrhunderts von den Spaniern an die Briten überging. Das Hotel Ponce de León ist das erste, das Henry Flagler in Florida errichtete; es öffnete 1888 seine Pforten.

Pages 330/331 : **Saint Augustine, Charlotte Street, photochrome**
Pages 328, de haut en bas :
L'hôtel Ponce de León, photochrome
La cour de l'hôtel Ponce de León
Le bureau de poste de Saint Augustine
Ci-dessus et en bas :
L'hôtel Alcazar, photochrome et carte postale

Fondée au début du XVIe siècle par l'Espagnol Pedro Menéndez de Avilés, Saint Augustine est la plus ancienne cité des États-Unis. L'architecture des maisons de Charlotte Street est typique du style vernaculaire adopté par les Crackers, les pionniers anglo-américains qui s'installèrent en Floride au moment du rachat de la colonie aux Espagnols à la fin du XVIIIe siècle. L'hôtel Ponce de León est le premier édifié par Henry Flagler en Floride ; il ouvrit ses portes en 1888.

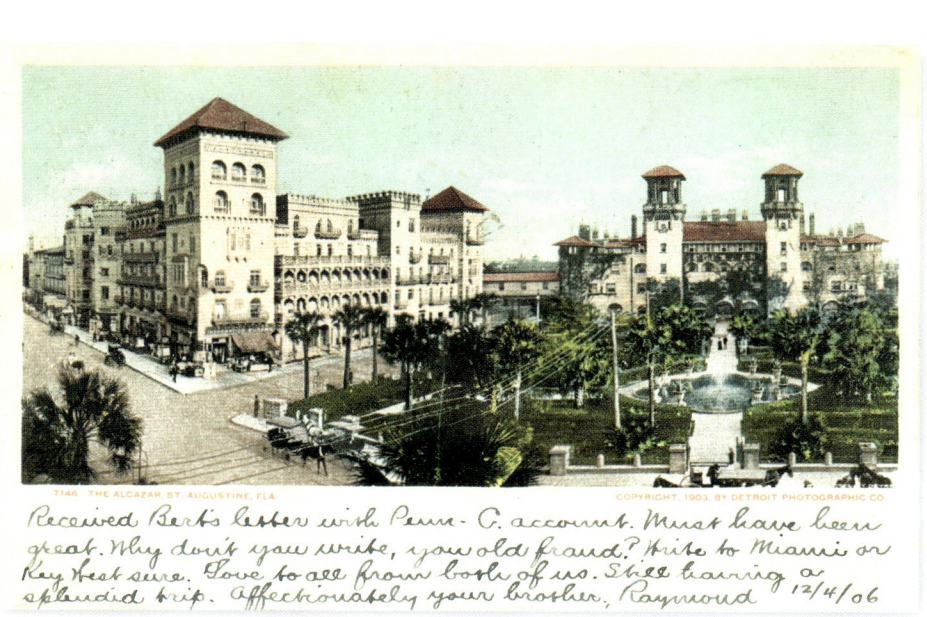

FLORIDA | ST. AUGUSTINE

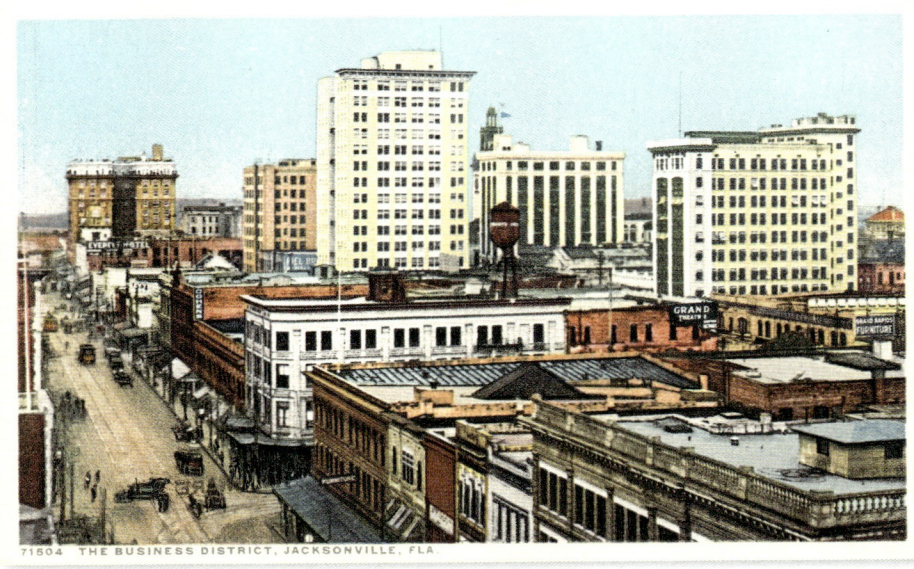
71504 THE BUSINESS DISTRICT, JACKSONVILLE, FLA.

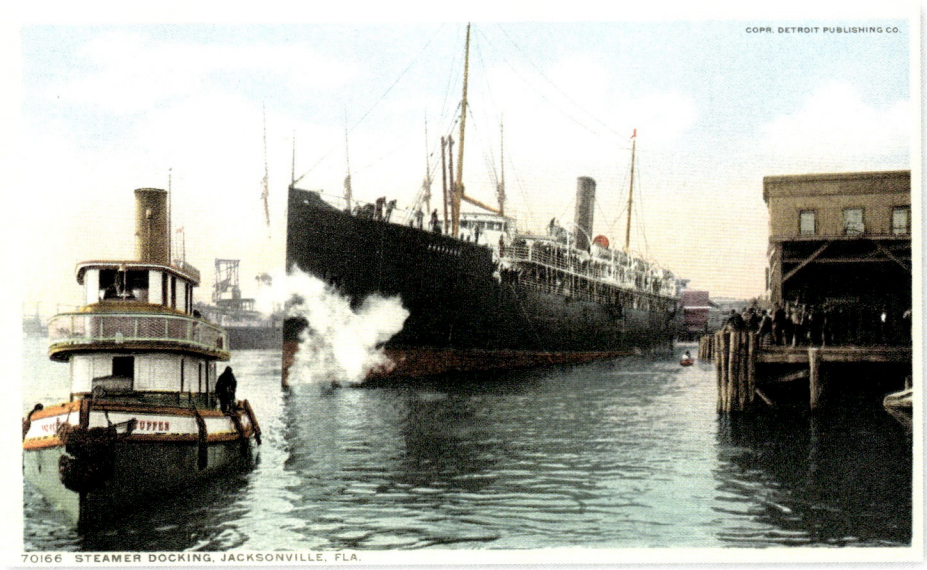
70166 STEAMER DOCKING, JACKSONVILLE, FLA.

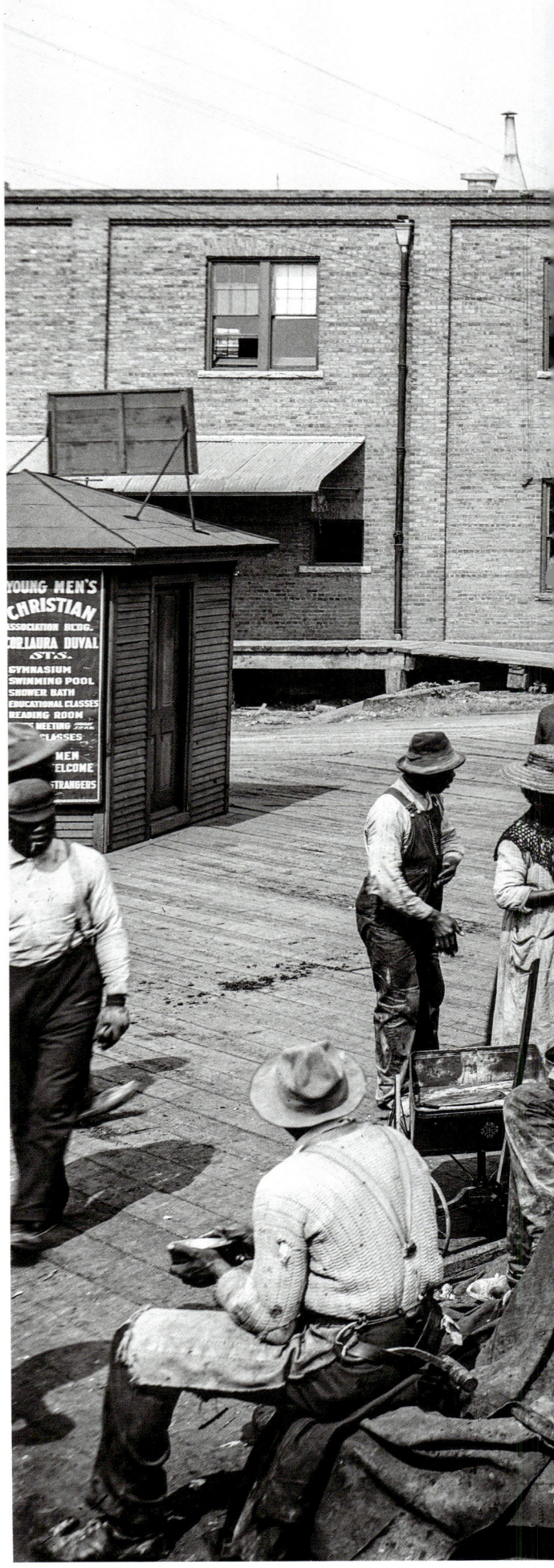

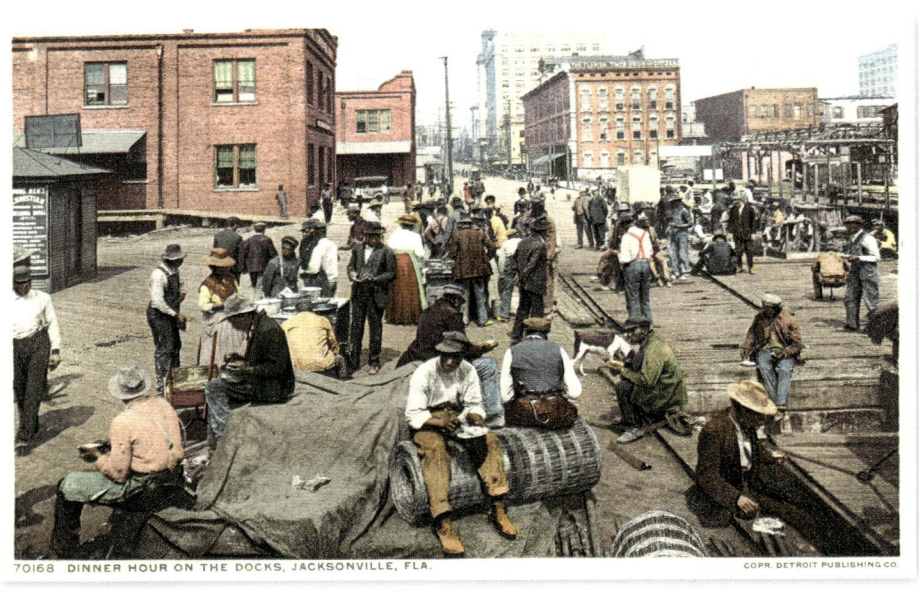
70168 DINNER HOUR ON THE DOCKS, JACKSONVILLE, FLA.

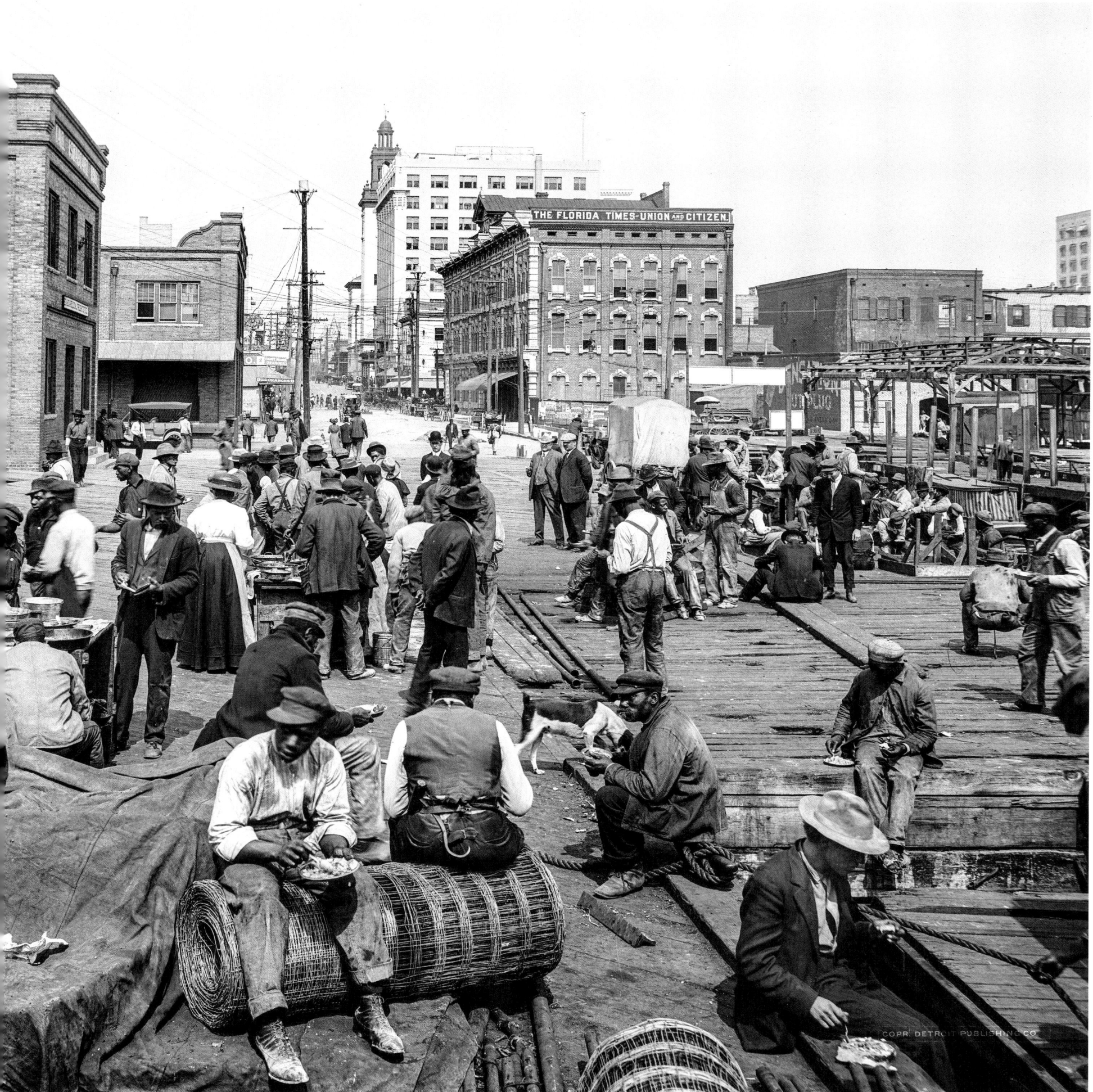

Page 334:
Top: The business district
Middle: Steamer docking
Bottom: Dinner hour on the docks, Jacksonville

Above: Dinner hour on the docks, Jacksonville, glass negative, ca. 1905

Seite 334:
Oben: Geschäftsviertel
Mitte: Passagierdampfer im Hafen
Unten: Mittagspause an den Docks, Jacksonville

Oben: Mittagspause an den Docks, Jacksonville, Glasnegativ, um 1905

Page 334 :
En haut : le quartier des affaires
Au centre : paquebot arrivant à quai
En bas : l'heure du déjeuner sur les docks, Jacksonville

Ci-dessus : l'heure du déjeuner sur les docks, Jacksonville, plaque de verre, vers 1905

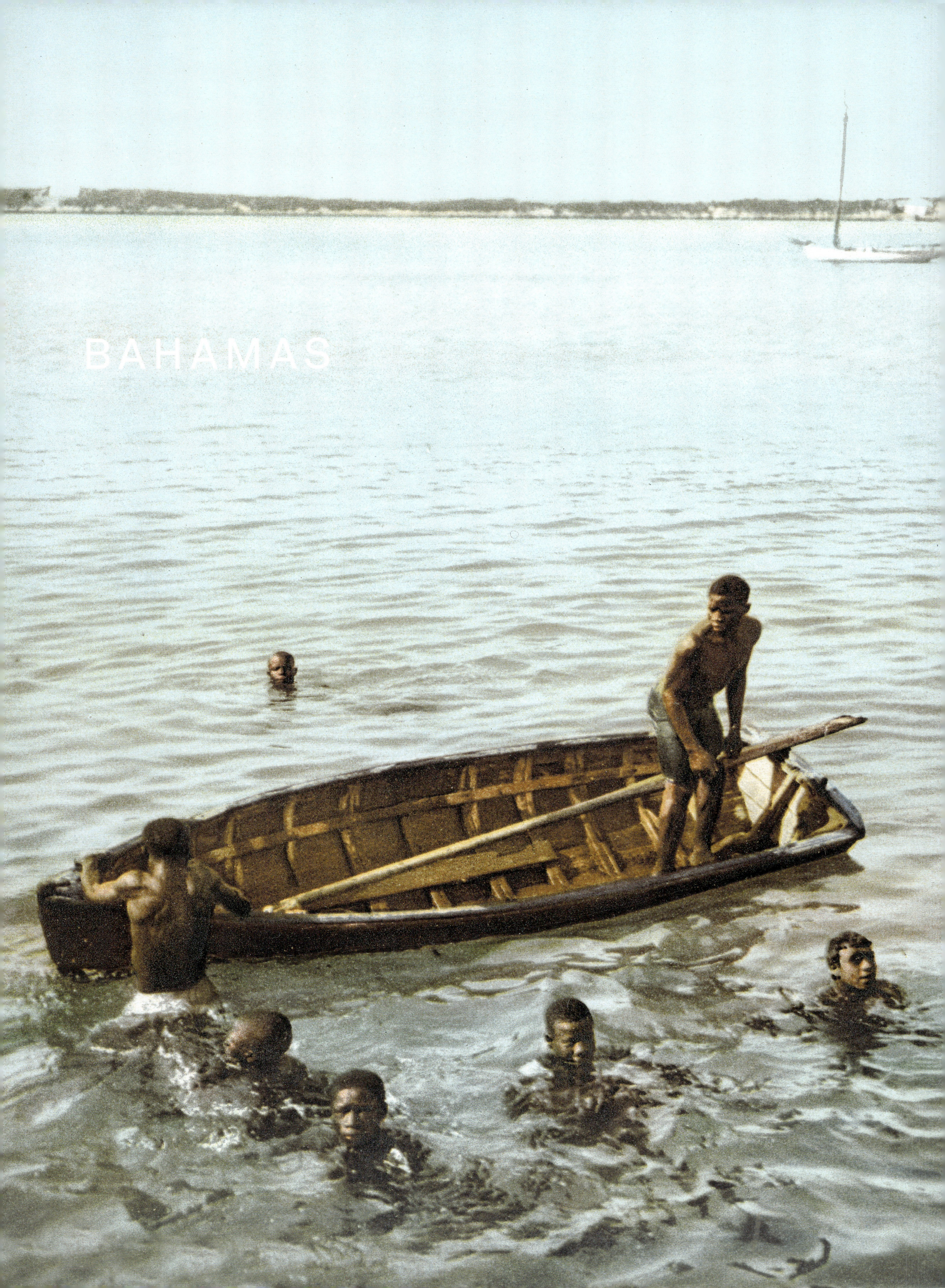
BAHAMAS

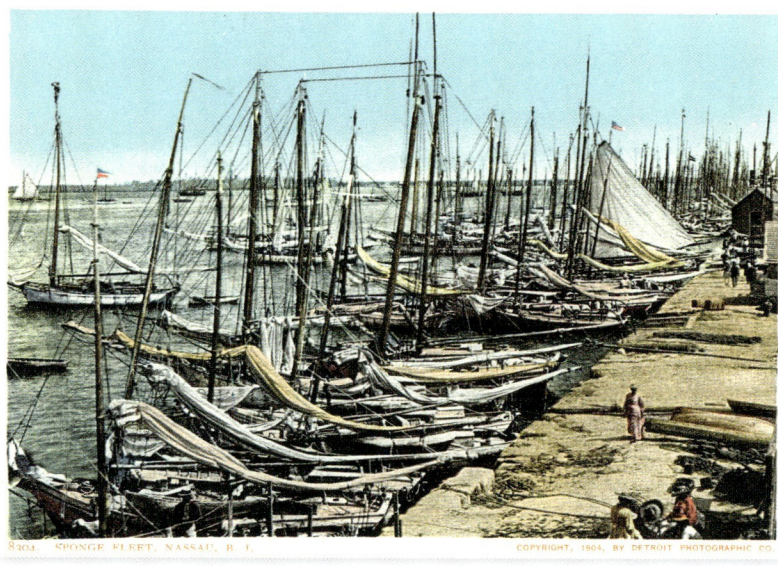

Page 336: **Diving for coins, photochrom**
Above and right: **Sponge fleet, Nassau**
Below: **Sponge yard along the docks**

The Amerindians who welcomed Christopher Columbus in 1492, the Lucayans, are the source of the name Lucayan Islands given to the Bahamas archipelago. A refuge for the Caribbean pirates and a British colony for 300 years—regularly attacked by the Spanish—and an asylum for American Loyalists who came to settle here with their African American slaves at the end of the American Civil War, the Bahamas have inherited a multiethnic and multicultural past. Its capital, Charles Town, on the island of New Providence, was burned down by the Spanish in 1684 and subsequently renamed Nassau in honor of Duke William III of Orange-Nassau, the future king of England.

Seite 336: **Münztaucher, Photochrom**
Oben und rechts: **Die Flottille der Schwammfischer, Nassau**
Unten: **Schwämme auf den Docks**

Auf die Lucayan, die Indianer, die 1492 Christoph Kolumbus empfingen, geht der Name Lucayan Islands zurück, den man dem Inselarchipel der Bahamas gegeben hatte. Rückzugsort der Piraten, über 300 Jahre lang britische Kolonie – dabei regelmäßigen Angriffen durch die Spanier ausgesetzt –, Zufluchtsort für die amerikanischen Loyalisten, die sich am Ende des Sezessionskrieges mit ihren afroamerikanischen Sklaven hierhin zurückzogen, ist der Archipel Erbe einer multiethnischen und -kulturellen Vergangenheit. Charles Town, ihre auf New Providence Island gelegene Hauptstadt, wurde 1684 von den Spaniern in Brand gesteckt, bevor sie 1695 zu Ehren des Herzogs Wilhelm III. von Oranien-Nassau, des zukünftigen Königs von England, in Nassau umbenannt wurde.

Page 336 : **« pêcheurs de pièces », photochrome**
En haut et à droite : **la flottille des pêcheurs d'éponges, Nassau**
Ci-contre : **éponges dans les docks**

Les Amérindiens qui accueillirent Christophe Colomb en 1492, les Lucayens, sont à l'origine du nom d'« îles Lucayes », donné aux îles de l'archipel des Bahamas. Refuge des pirates des Caraïbes, colonie britannique pendant trois siècles – régulièrement soumise aux attaques des Espagnols –, terre d'asile pour les loyalistes américains venus s'y retrancher avec leurs esclaves afro-américains à la fin de la guerre de Sécession, l'archipel est héritier d'un passé multiethnique et multiculturel. Sur l'île de New Providence, sa capitale, Charles Town, fut incendiée par les Espagnols en 1684 avant d'être rebaptisée Nassau en 1695 en l'honneur du duc Guillaume III d'Orange-Nassau, futur roi d'Angleterre.

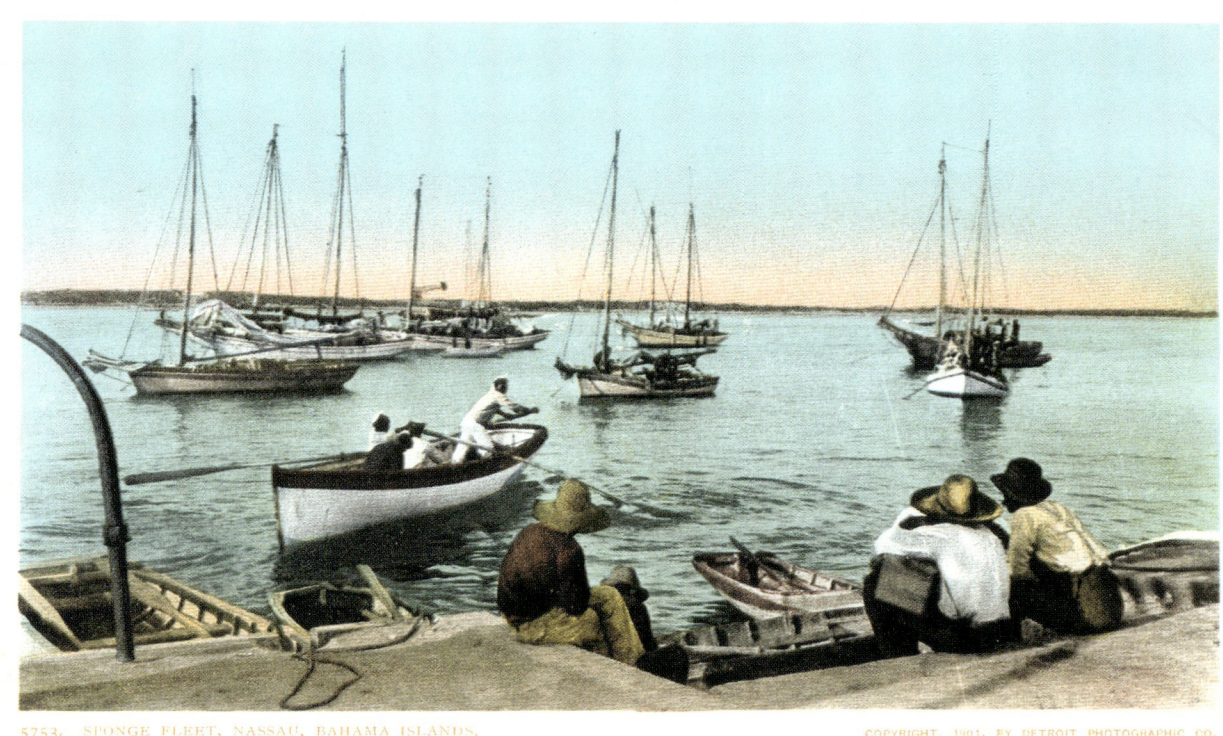

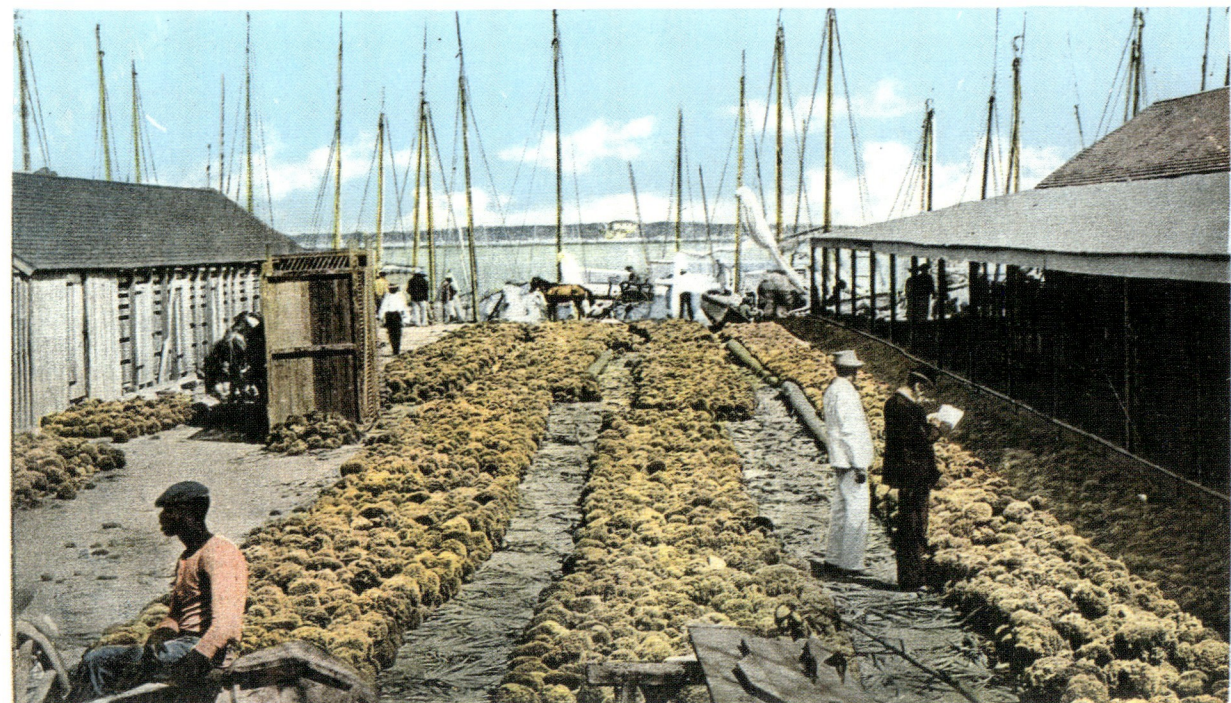

BAHAMAS | NASSAU

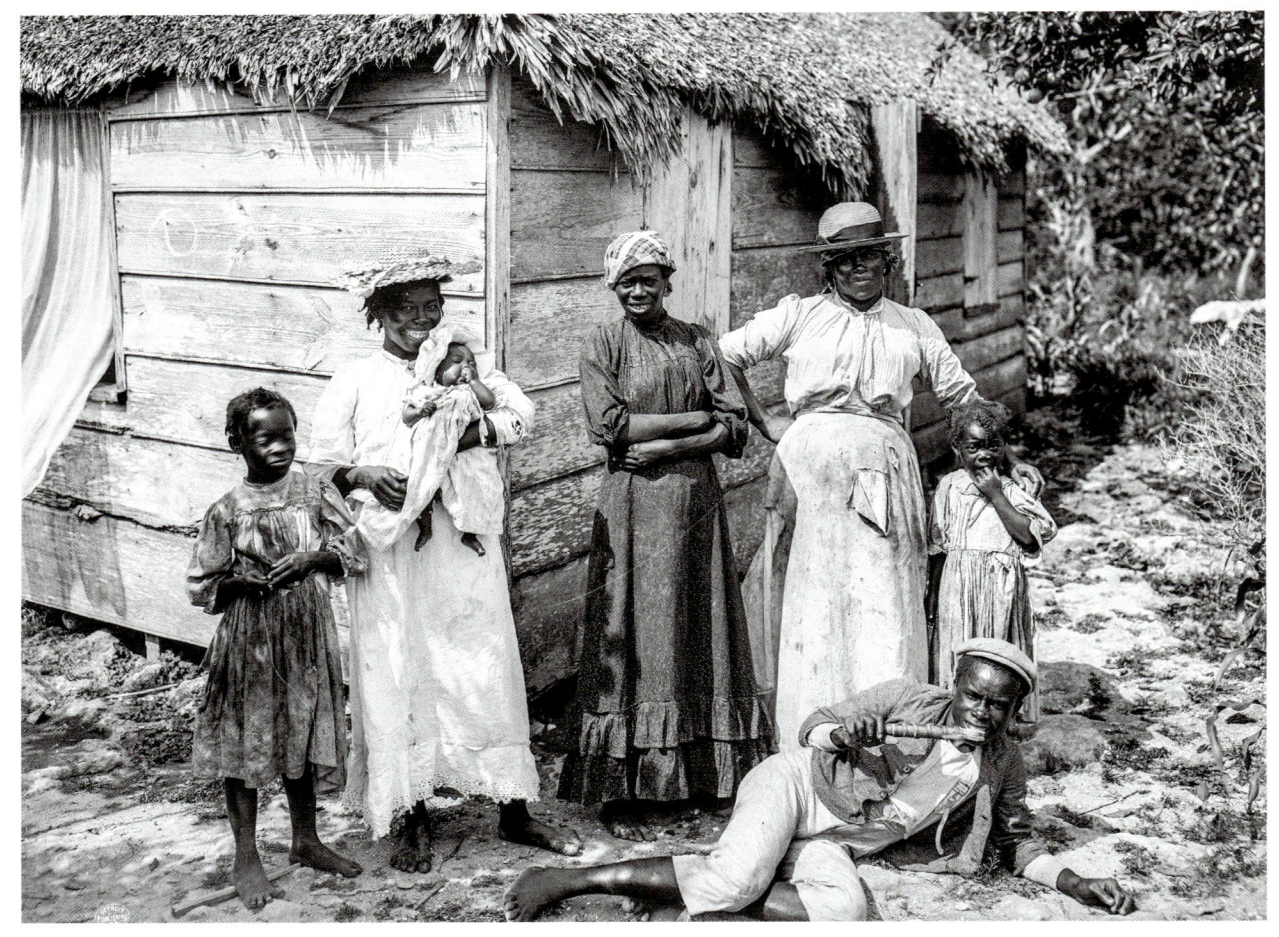

BAHAMAS | NASSAU

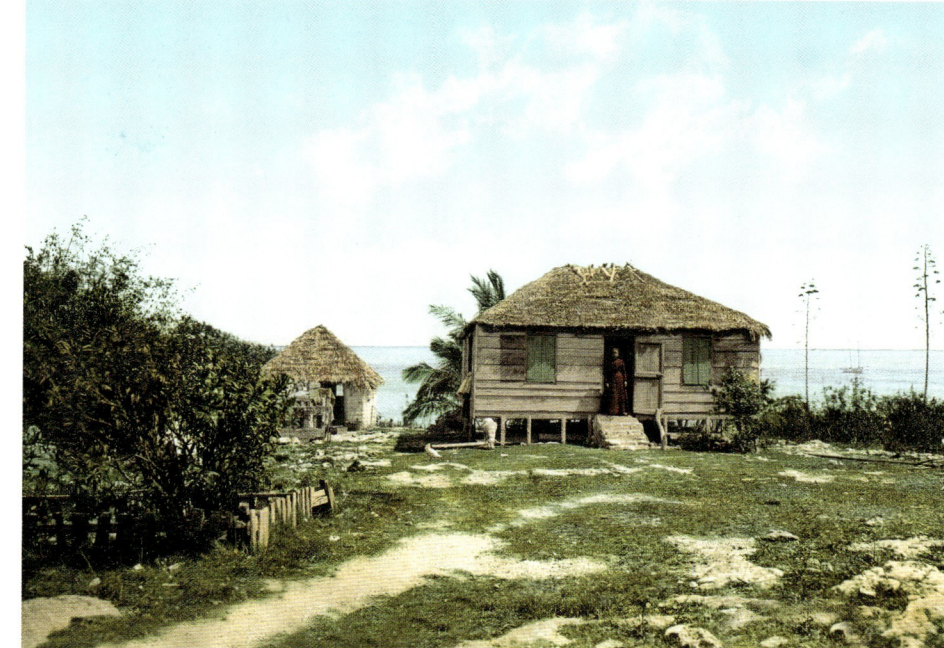

Page 338, from top to bottom:
An African American family, Grant's Town, Nassau, glass negative, 1901
East Street
Above: A traditional cabin, photochrom
Below: "Hostilities" (boys will be boys), photochrom

Seite 338, von oben nach unten:
Schwarze Familie, Grant's Town, Nassau, Glasnegativ, 1901
East Street
Oben: Eine traditionelle Hütte, Nassau, Photochrom
Unten: „Feindseligkeiten" (Jungen bleiben einfach Jungen), Photochrom

Page 338, de haut en bas :
Famille noire, Grant's Town, Nassau, plaque de verre, 1901
East Street
Ci-dessus : une cabane traditionnelle, Nassau, photochrome
En bas : « Hostilités » (les garçons restent des garçons), photochrome

BAHAMAS | NASSAU

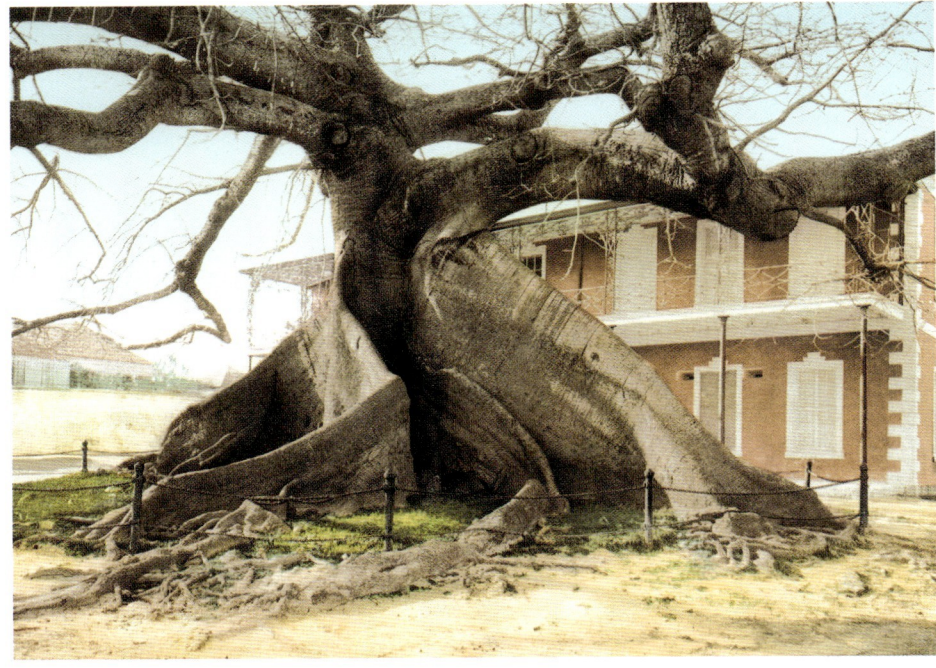

Above: Ceiba, silk cotton tree
Below: The market delivery, Nassau, photochrom
Page 341: The Queen's Staircase, Nassau, photochrom

Oben: Ceiba, Wollbaum
Unten: Auf dem Weg zum Markt, Nassau, Photochrom
Seite 341: Königinnentreppe, Nassau, Photochrom

Ci-dessus : ceiba, arbre à coton
Ci-dessous : sur la route du marché, Nassau, photochrome
Page 341 : l'escalier de la reine, Nassau, photochrome

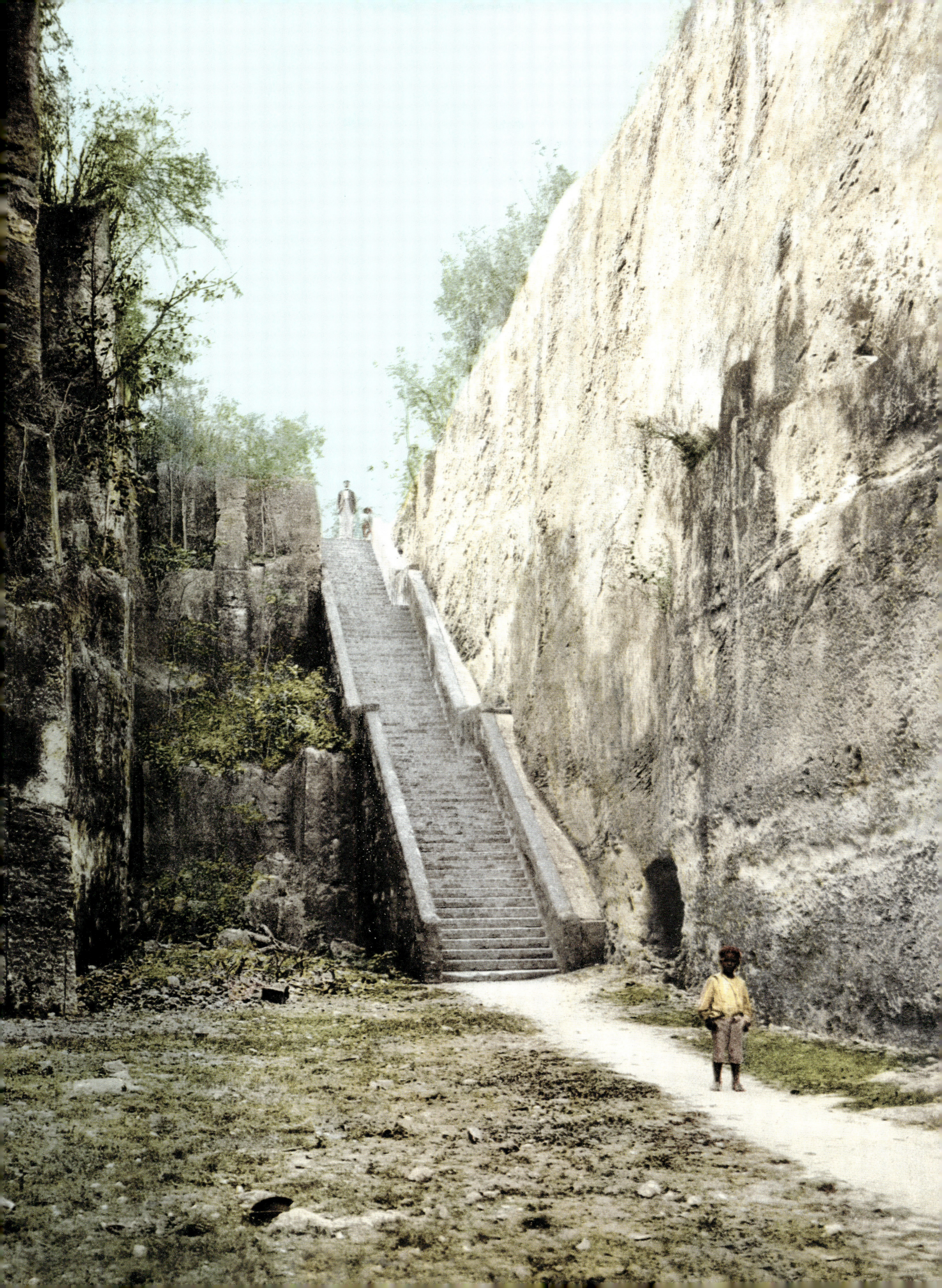

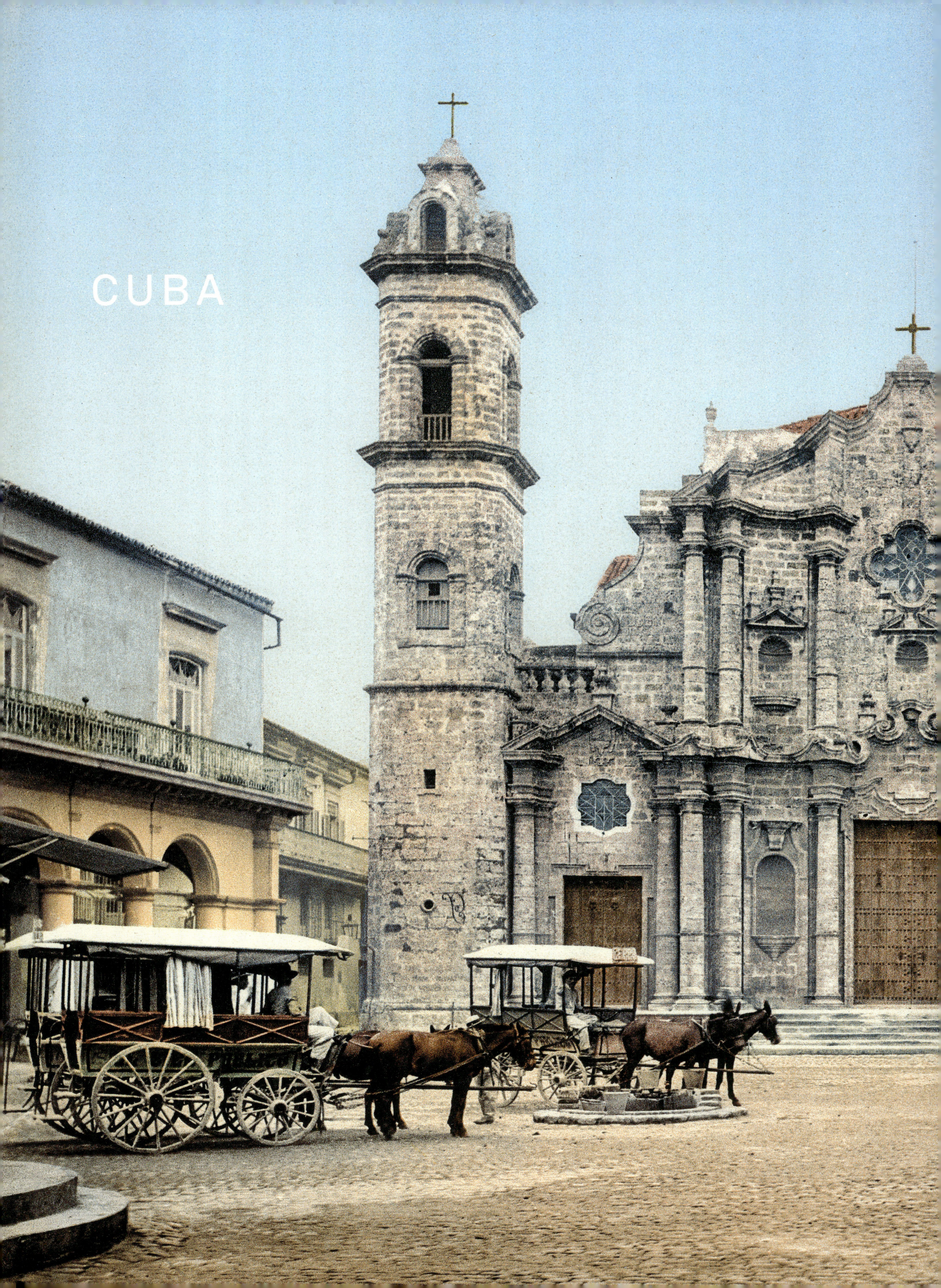

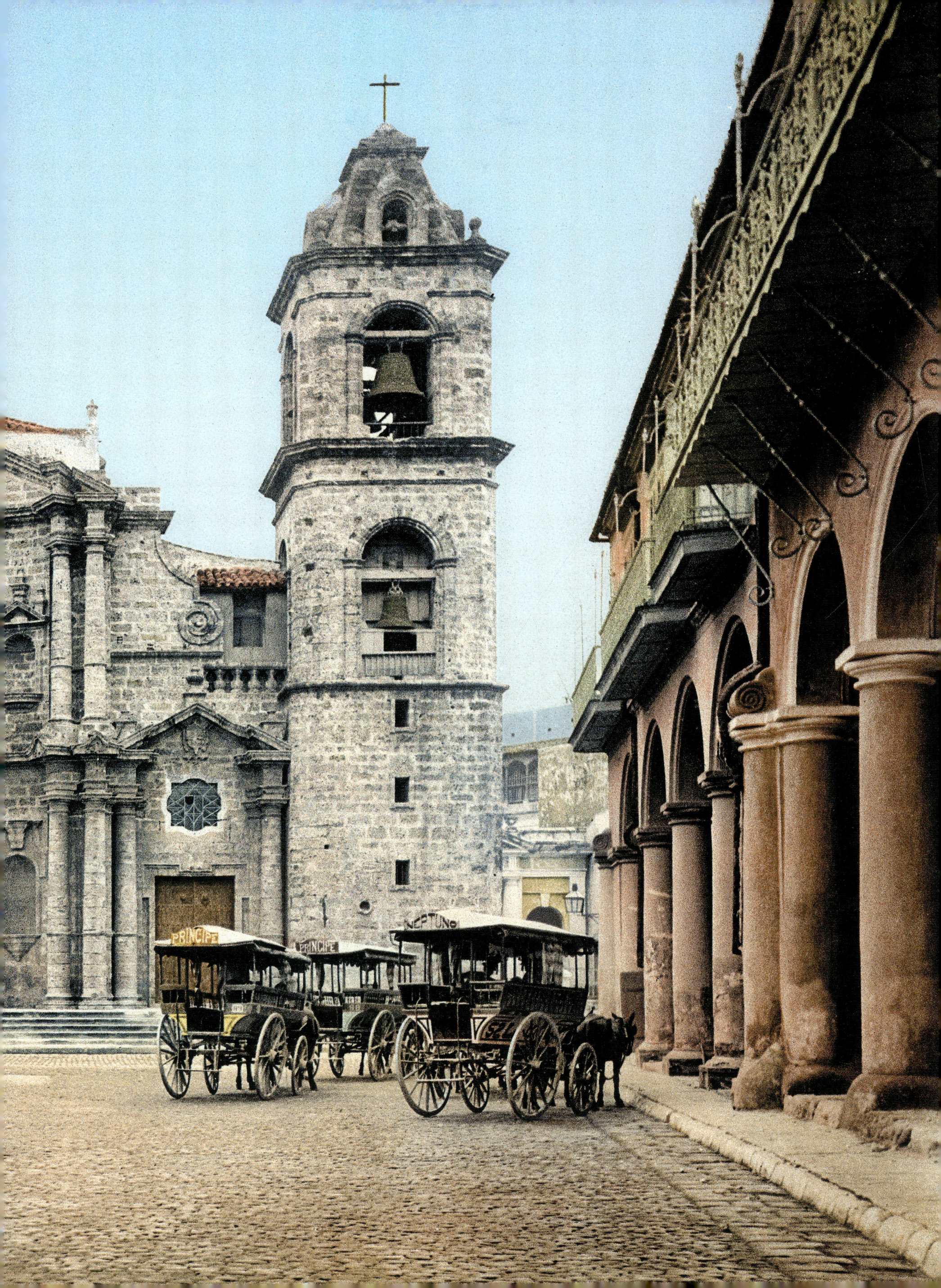

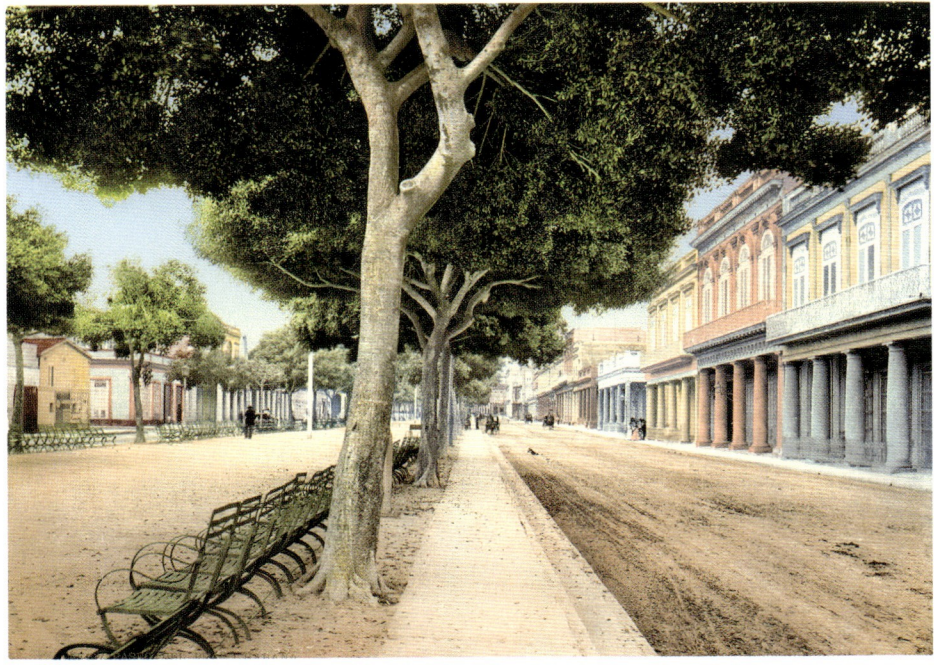

Page 342/343: Havana Cathedral, photochrom
Above: Paseo del Prado, photochrom
Below: A Havana mule, photochrom
Page 345: A street in Havana, photochrom
Page 346/347: Tacón Theater, photochrom

Seite 342/343: Die Kathedrale von Havanna, Photochrom
Oben: Paseo del Prado, Photochrom
Unten: Maultiergespann, Havanna, Photochrom
Seite 345: Eine Straße in Havanna, Photochrom
Seite 346/347: Teatro Tacón, Photochrom

Pages 342/343 : la cathédrale de La Havane, photochrome
Ci-dessus : allée du Prado, photochrome
Ci-dessous : mule attelée, La Havane, photochrome
Page 345 : rue de La Havane, photochrome
Pages 346/347 : théâtre Tacón, photochrome

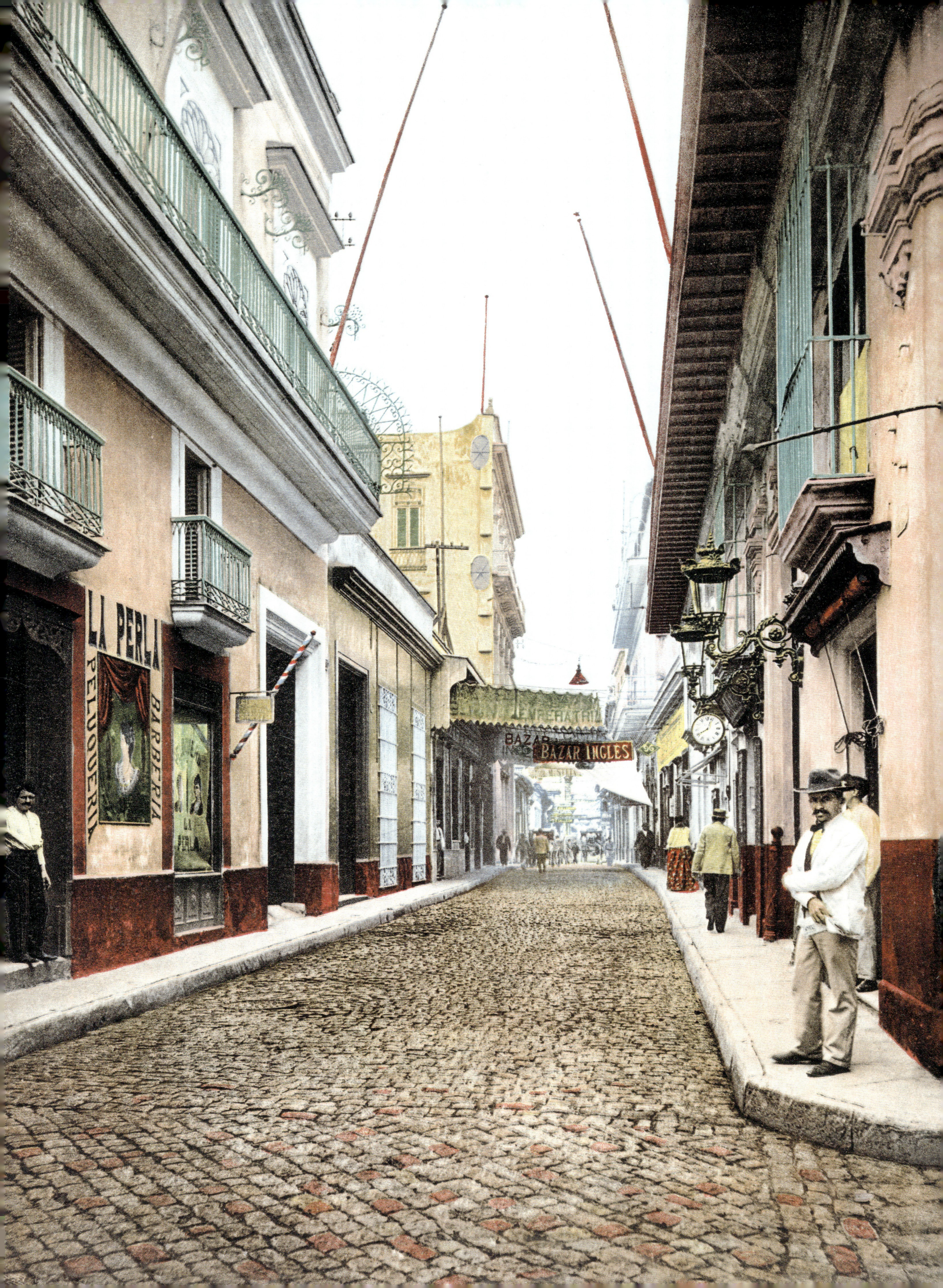

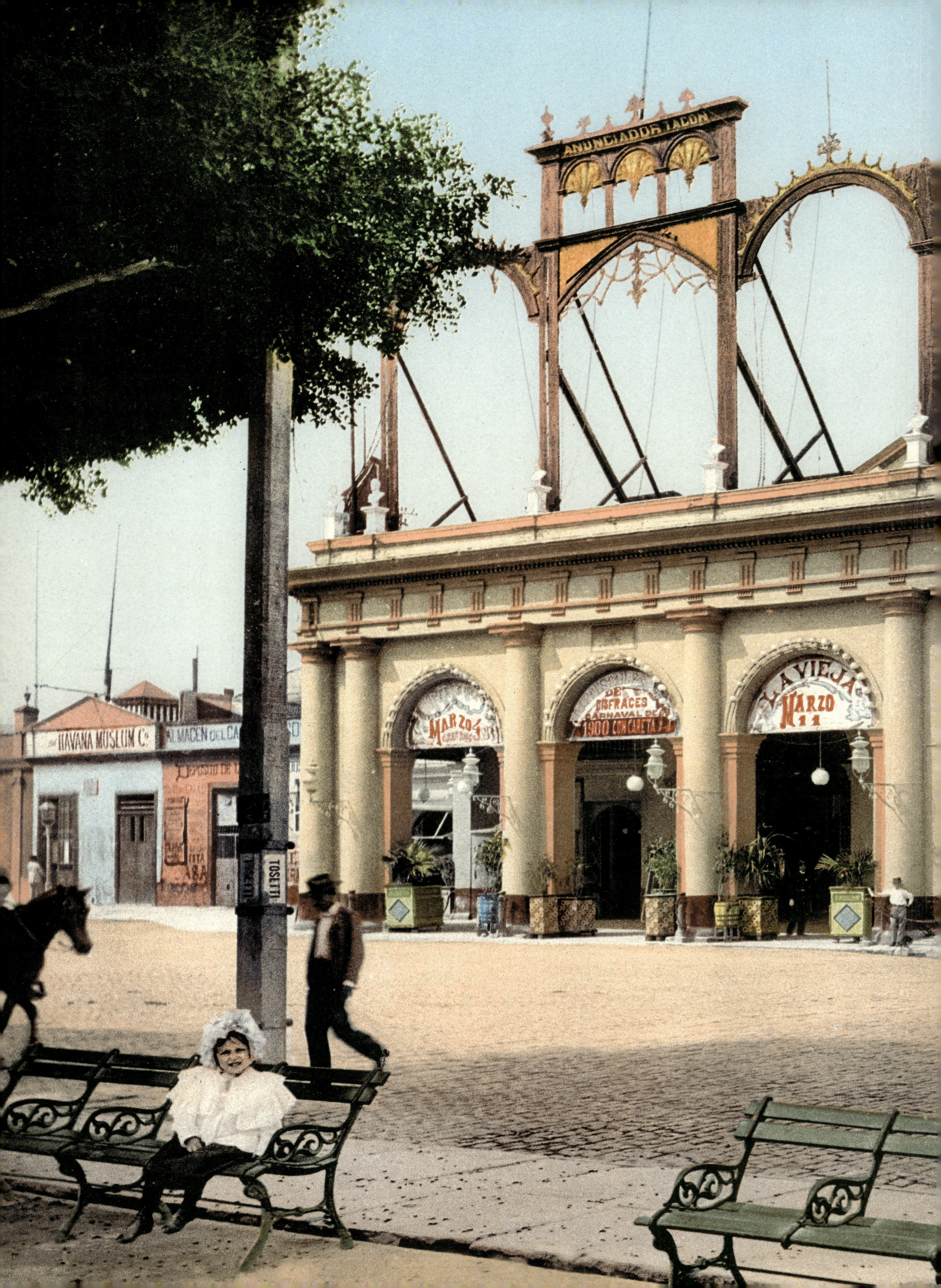

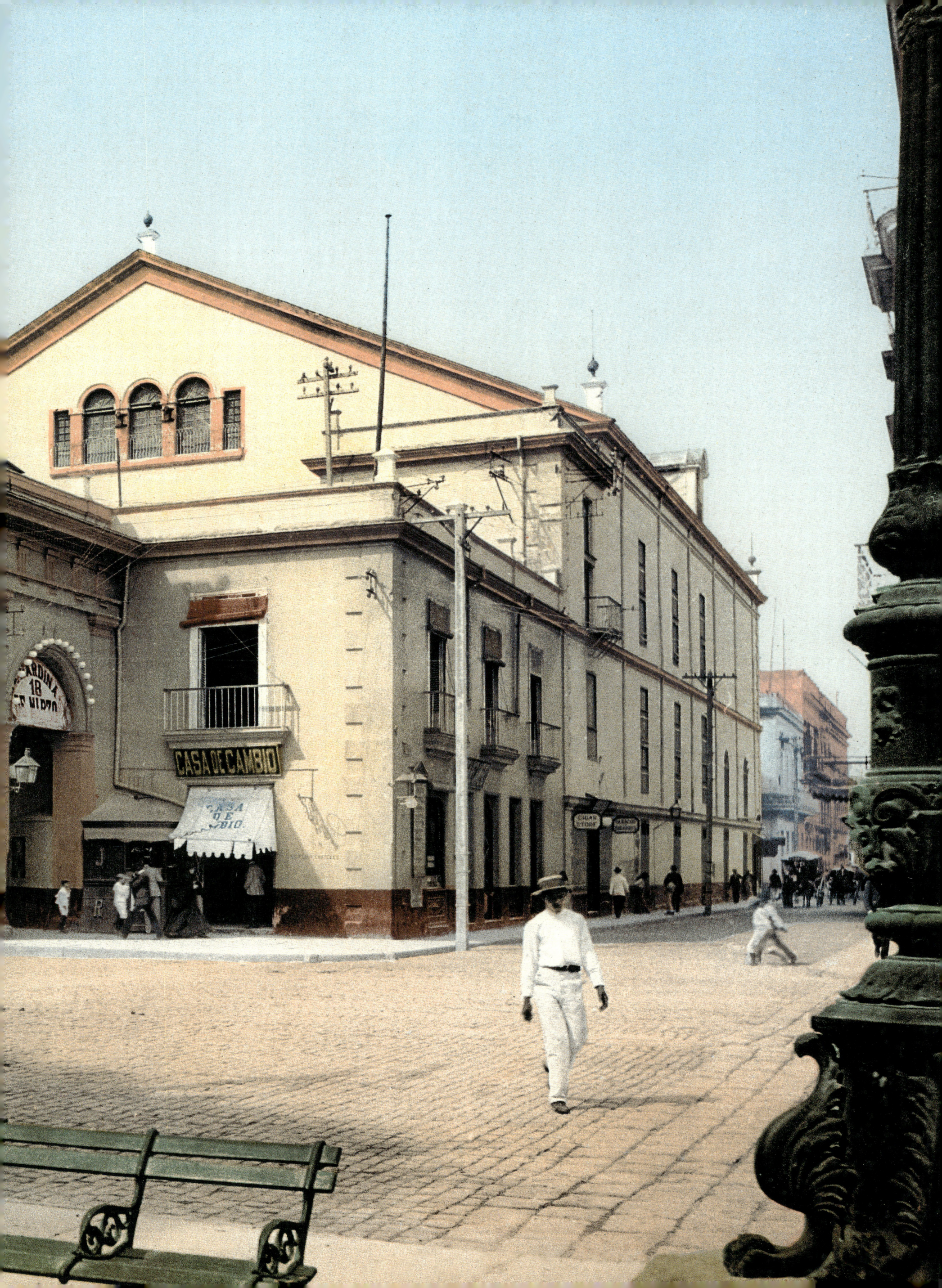

Above: **Parapet of Fortress San Carlos de la Cabaña, photochrom**
Right: **Wreck of the USS *Maine***
Below: **Mounted policeman**
Page 349, from top to bottom:
Muelle del Gobierno, photochrom
The Tempietto, photochrom

The port of Havana was occupied by the Spanish in the 16th century; through it passed the gold plundered from Mexico and Peru by the conquistadors. The city prospered over the following centuries on account of the slave trade; thousands of Africans were brought in to work on the sugar plantations. The brief British occupation of 1762–63 ended with Cuba being restored to Spain in exchange for Florida. An impregnable fortress was then built in Havana alongside the Cathedral of the Virgin Mary of the Immaculate Conception—or San Cristobal—a jewel of the Spanish Baroque. The explosion of the cruiser USS *Maine* in the port of Havana on February 15, 1898, was used as a pretext for the Spanish-American War.

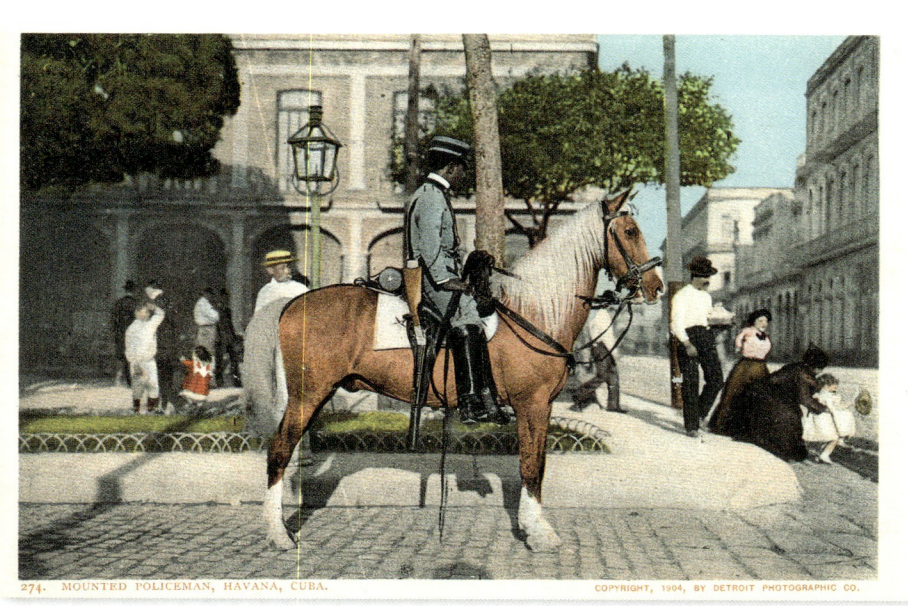

CUBA | HAVANA

Seite 348, von oben nach unten:
Die Brüstung der Festung San Carlos de la Cabaña, Photochrom
Das Wrack der USS Maine im Hafen von Havanna
Berittener Polizist
Oben: **Muelle del Gobierno, Photochrom**
Unten: **Der Tempietto, Photochrom**

Das von den Konquistadoren in Mexiko und Peru geraubte Gold wurde ab dem 16. Jahrhundert von den Spaniern im besetzten Hafen von Havanna verladen. Die Stadt prosperierte in den folgenden Jahrhunderten aufgrund des Handels mit Sklaven, die zu Tausenden auf die Zuckerrohrplantagen verschleppt wurden. Die kurzzeitige Belagerung durch die Briten in den Jahren 1762–1763 endete mit der Restitution Kubas an Spanien im Tausch gegen Florida. Havanna erhielt damals eine uneinnehmbare Festung, und man errichtete die Kathedrale der Jungfrau Maria der Unbefleckten Empfängnis – oder Catedral San Cristobal –, ein Schmuckstück des spanischen Barock. Als am 15. Februar 1898 im Hafen von Havanna der Kreuzer USS Maine explodierte, diente dies als Vorwand für den Spanisch-Amerikanischen Krieg.

Page 348, de haut en bas :
Le parapet du fort San Carlos de la Cabaña, photochrome
L'épave de l'USS Maine dans le port de La Havane
La police montée
En haut : **quai du Gouvernement, photochrome**
À droite : **le Tempietto, photochrome**

Par le port de La Havane, occupée par les Espagnols à partir du XVIe siècle, transitait l'or pillé au Mexique et au Pérou par les conquistadors. La ville prospéra aux siècles suivants grâce au trafic des esclaves, amenés par milliers dans les plantations de canne à sucre. La brève occupation britannique de 1762–1763 s'acheva par la restitution de Cuba à l'Espagne en échange de la Floride. La Havane fut alors dotée d'une imprenable forteresse et l'on édifia la cathédrale de la Vierge Marie de l'Immaculée Conception – ou cathédrale San Cristobal –, joyau de l'art baroque hispanisant.
Le 15 février 1898, l'explosion du croiseur USS Maine dans le port servit de prétexte au déclenchement de la guerre hispano-américaine.

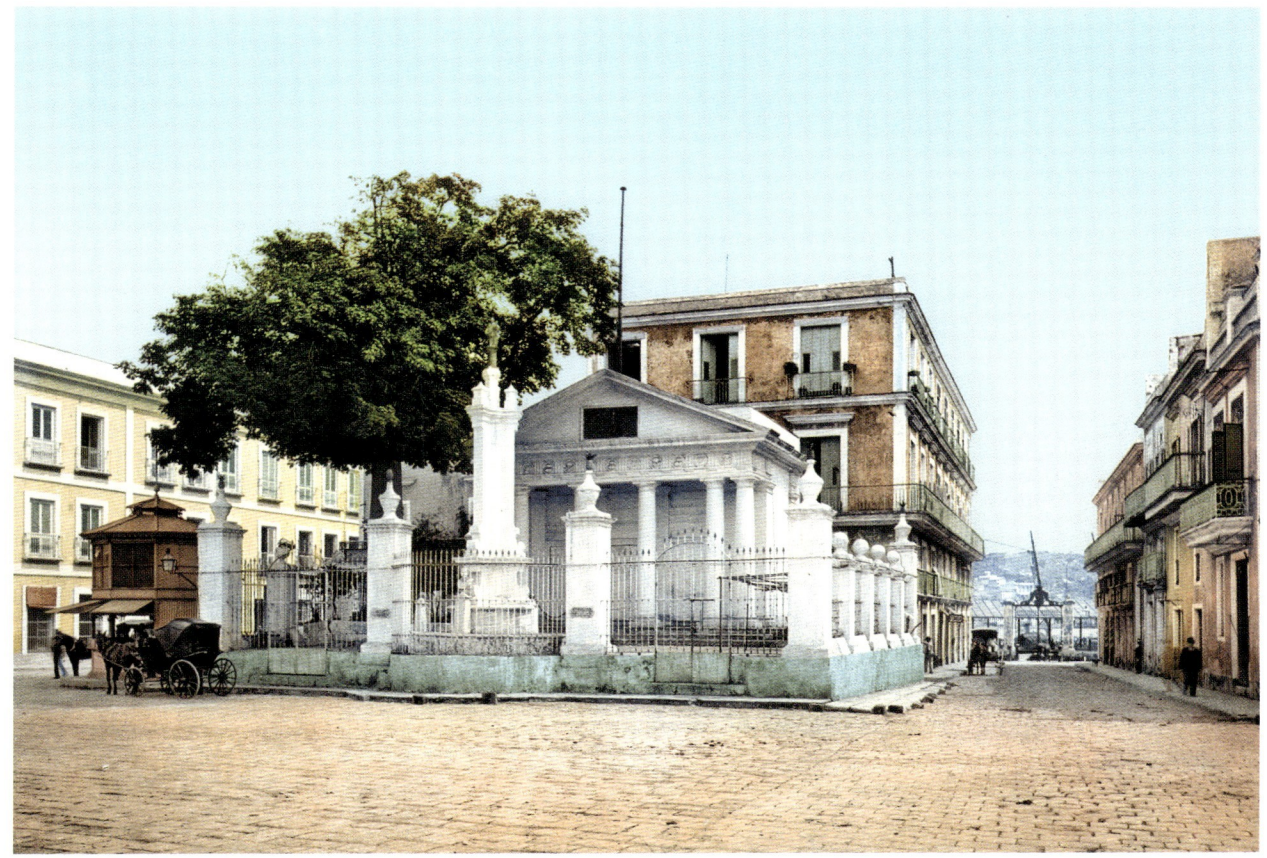

CUBA | HAVANA

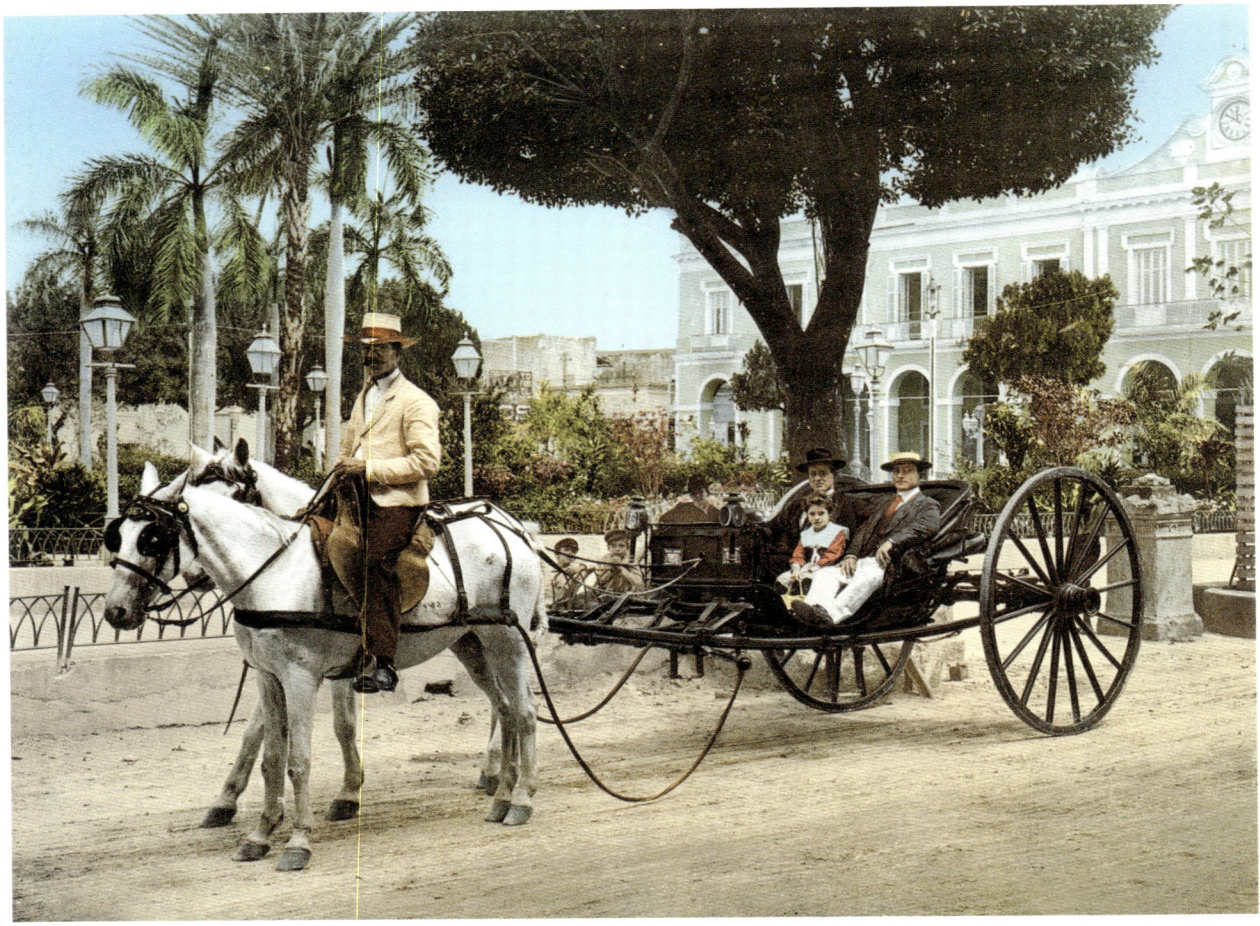

Above: **A Cuban** *volante*, **photochrom**
Right: **Fruit and poultry vendor**
Below right: **Vegetable men**
Page 351: **Avenue of the Palms, photochrom**
Page 352/353: **Weighing sugar cane, photochrom**

In the second half of the 19th century, while rich settlers promenaded in *volantes* on the Prado, attended performances at the Tacón Theater (p. 346/347) and lived lives of opulence, the Afro-Cuban and Creole peasants were exploited in the sugar plantations, and consigned to slum quarters. In 1868, the Cuban planters rebelled against the Spanish occupation and declared the island independent. This first war lasted ten years. A further war broke out in 1895, during which the rural population was confined to *reconcentrados*, fortified towns akin to concentration camps. Finally, in 1898, the Spanish-American War ended Spanish domination.

Oben: **Eine kubanische Kalesche, Photochrom**
Rechts: **Obst- und Geflügelverkäufer**
Unten rechts: **Gemüseverkäufer**
Seite 351: **Palmenallee, Photochrom**
Seite 352/353: **Abwiegen von Zuckerrohr, Photochrom**

Während in der zweiten Hälfte des 19. Jahrhunderts die reichen Siedler in einer Kalesche über den Prado fuhren, das Teatro de Tacón (S. 346/347) besuchten und im Überfluss lebten, wurden die afrokubanischen und kreolischen Bauern auf den Zuckerrohrplantagen ausgebeutet und in die Slums verbannt. 1868 lehnten sich die kubanischen Plantagenbesitzer gegen die spanischen Besatzer auf und riefen die Unabhängigkeit für die Insel aus. Dieser erste Krieg dauerte zehn Jahre. Ein weiterer brach 1895 aus. In seinem Verlauf wurden die Aufständischen in mit Stacheldraht umzäunte Lager gesperrt; 1898 setzte der Spanisch-Amerikanische Krieg der spanischen Herrschaft schließlich ein Ende.

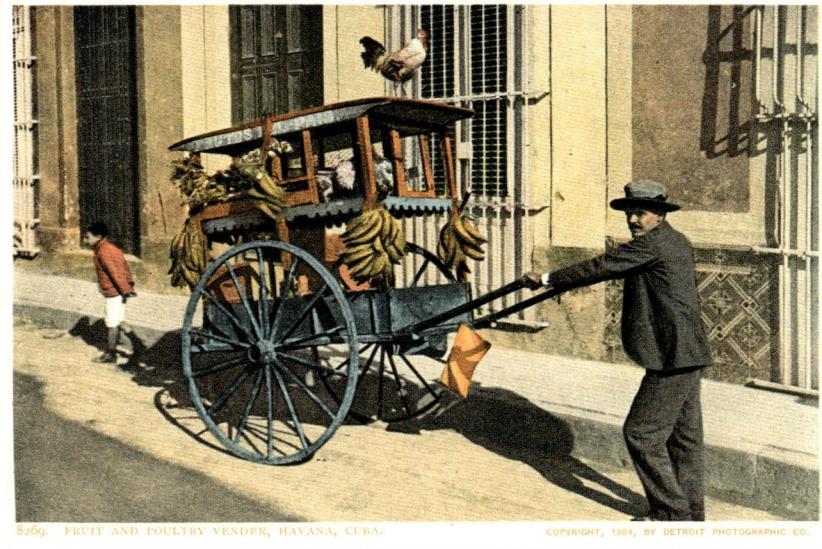

En haut : **une « volante » cubaine, photochrome**
À droite : **marchand de fruits et de volaille**
À droite en bas : **vendeurs de légumes**
Page 351 : **avenue des Palmes, photochrome**
Pages 352/353 : **pesage de la canne à sucre, photochrome**

Dans la seconde moitié du XIXe siècle, tandis que les riches colons déambulaient en « volante » sur le Prado, fréquentaient le théâtre de Tacón (p. 346/347) et vivaient dans l'opulence, les paysans afro-cubains et créoles étaient exploités dans les plantations de canne à sucre, relégués dans les quartiers défavorisés. En 1868, des planteurs cubains se rebellèrent contre l'occupant espagnol et déclarèrent l'indépendance de l'île. Cette première guerre dura dix ans. Une autre éclata en 1895, au cours de laquelle les rebelles furent enfermés dans des camps clos de barbelés. En 1898, la guerre hispano-américaine mit fin à la domination espagnole.

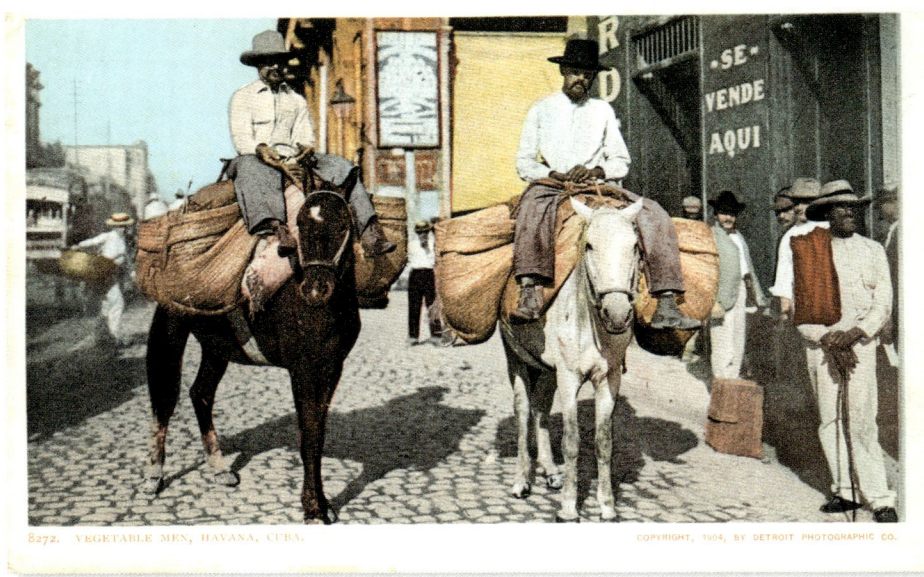

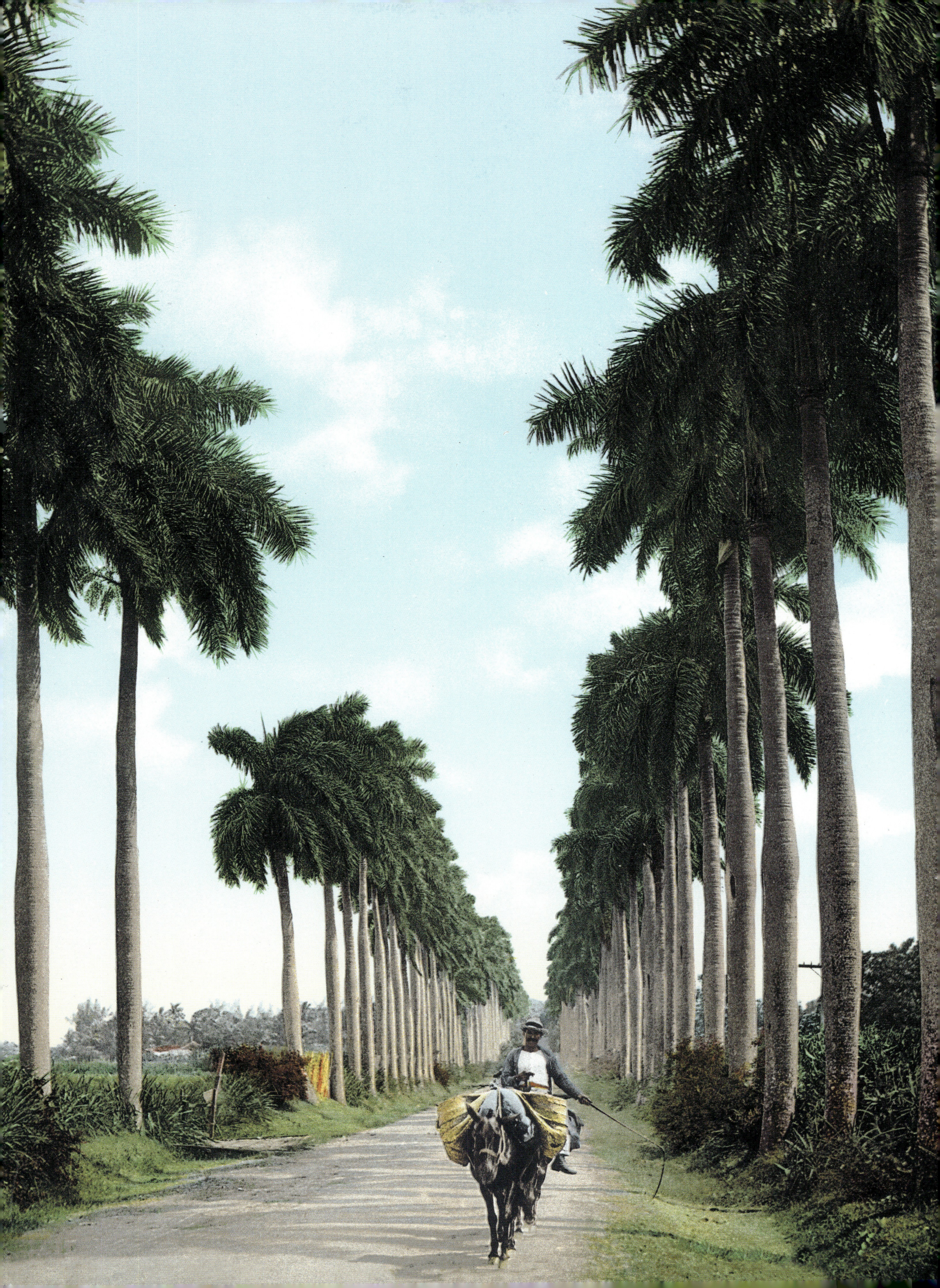

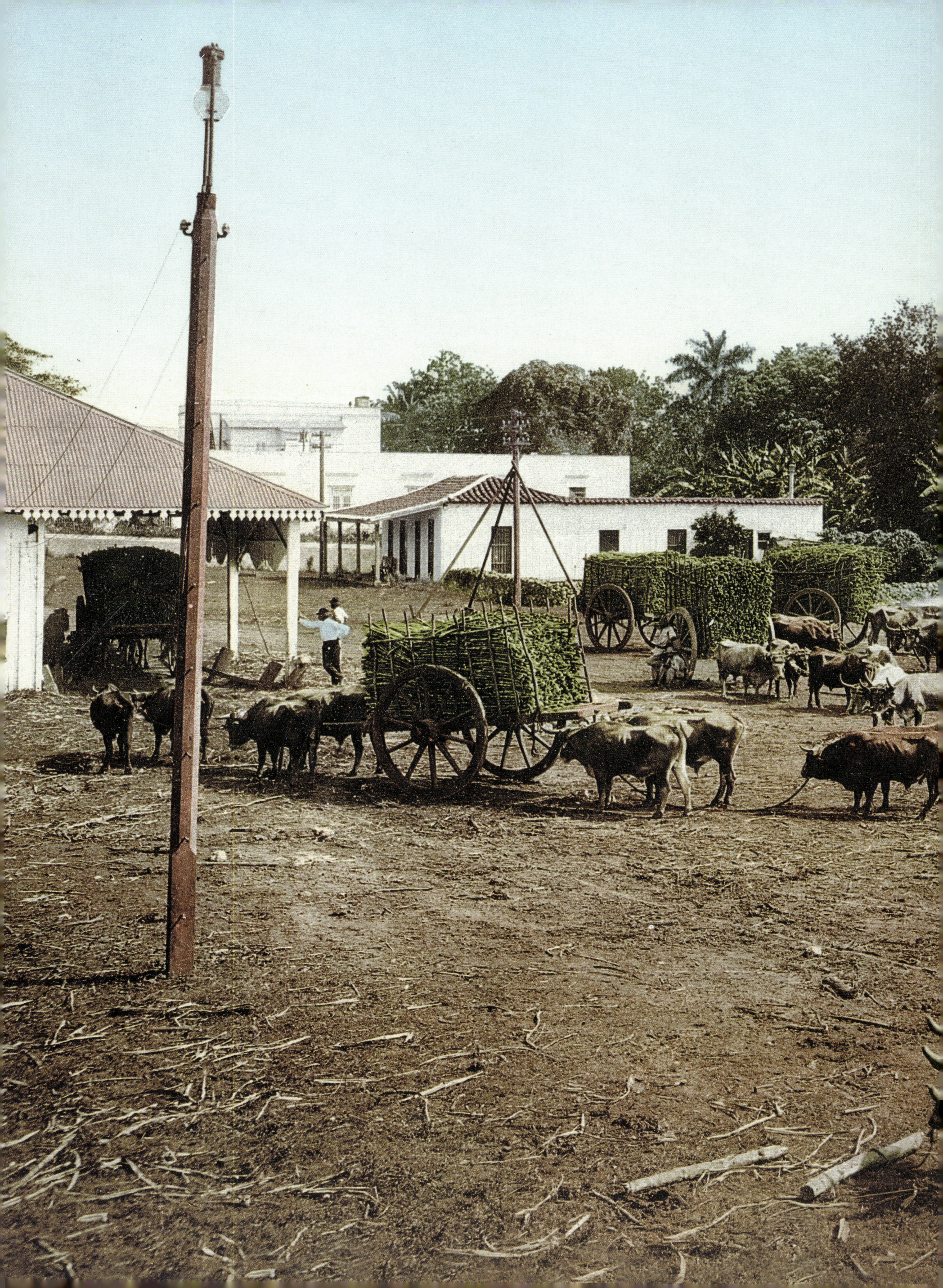

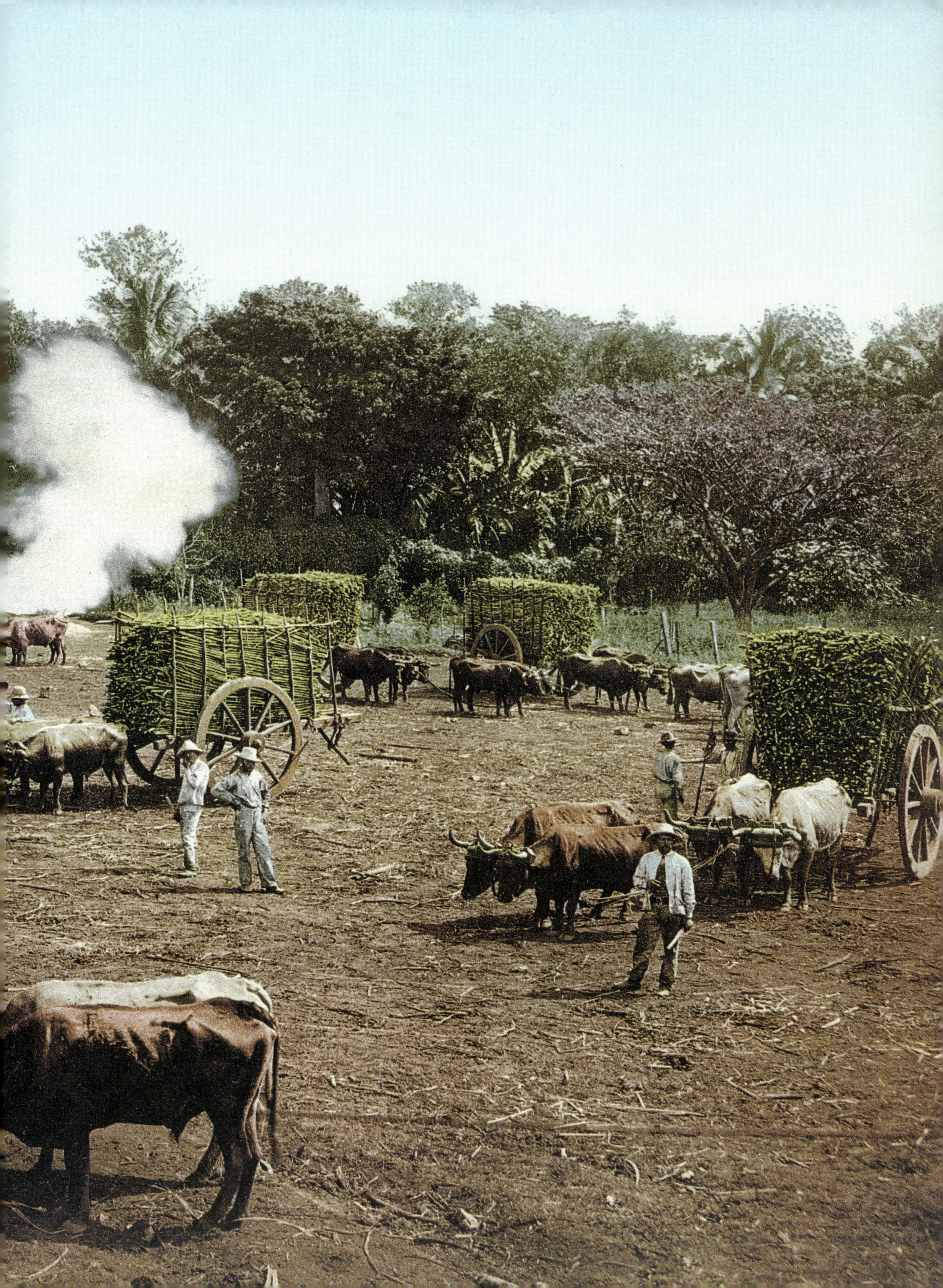

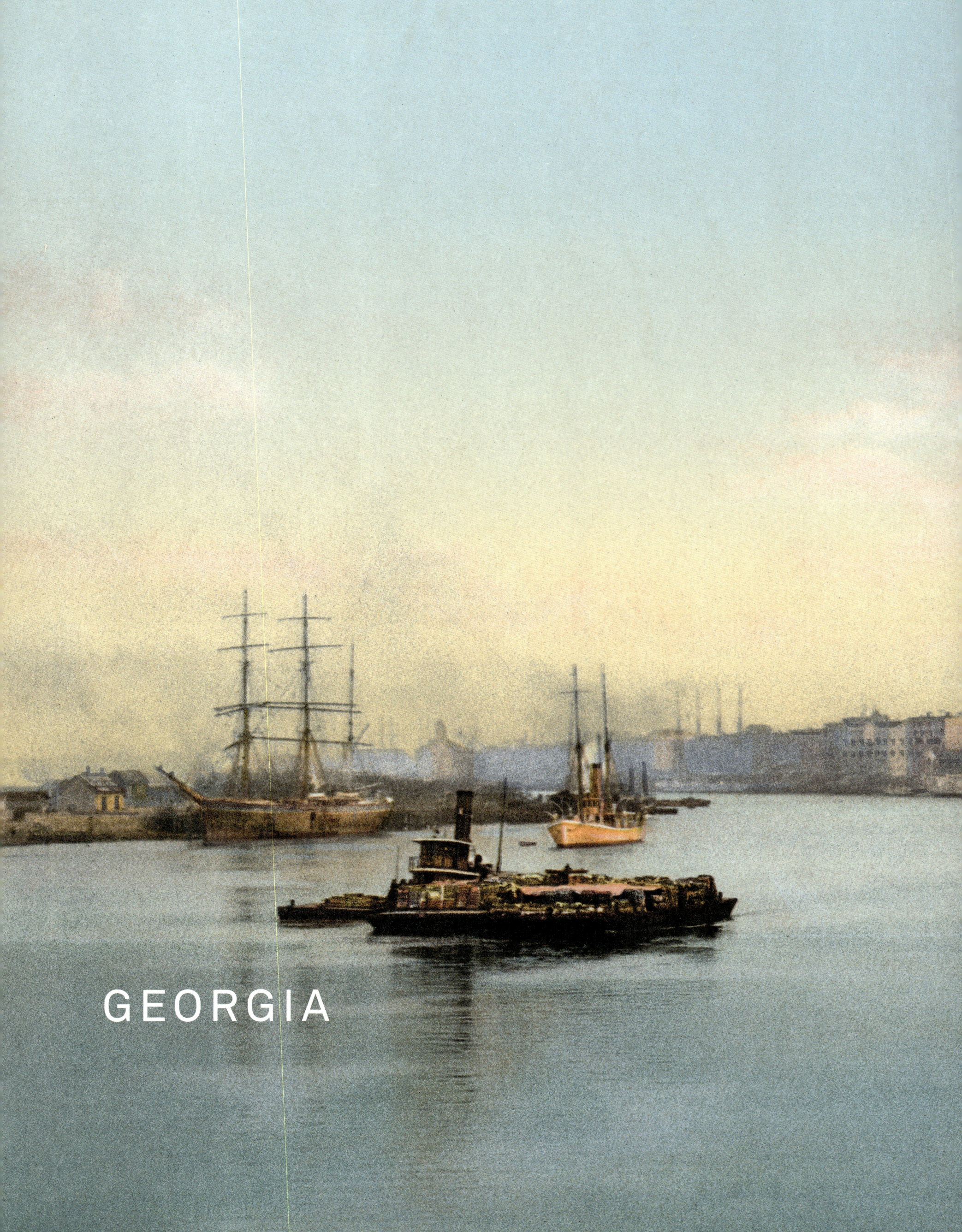

GEORGIA

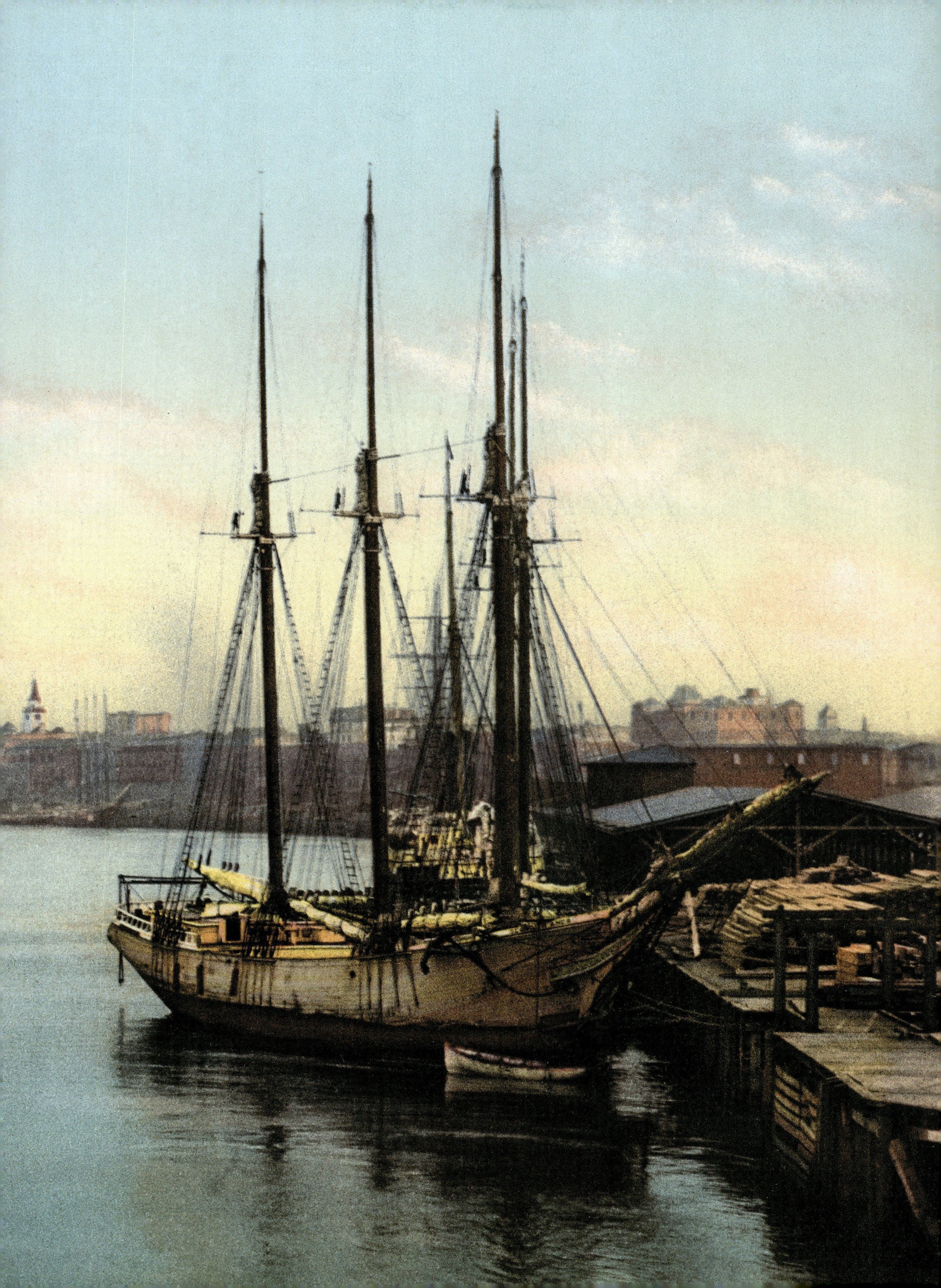

Page 354/355: Savannah River from Steamship Wharf, photochrom
Right: Down the river, Savannah
Below: Gordon's wharves, Savannah
Bottom left: Cotton docks, Savannah
Bottom right: Naval stores at Savannah
Page 357: Fish vendor (Augusta?), glass negative, 1903

Built on the banks of the eponymous river, the old town of Savannah enjoyed "beautiful semi-tropical vegetation" and "many shady parks," according to the Baedeker of 1893. The port had been blockaded during the war of independence but had subsequently regained its strategic status, exporting rice and cotton to Europe.

Seite 354/355: Der Savannah River vom Kai der Dampfschiffe aus, Photochrom
Rechts: Den Fluss entlang, Savannah
Mitte: Gordon's Kai, Savannah
Unten links: Baumwolldocks, Savannah
Unten rechts: Marinelager in Savannah
Seite 357: Fischverkäufer (Augusta?), Glasnegativ, 1903

Wie man im Baedeker von 1893 lesen kann, erfreute sich die am Flussufer gelegene Altstadt von Savannah einer „schönen halbtropischen Vegetation" und „zahlreicher Parks, die viel Schatten spenden". Der Hafen war nach der Blockade während des Sezessionskrieges wieder sehr aktiv geworden und exportierte nun hauptsächlich Reis und Baumwolle nach Europa.

Pages 354/355 : la rivière de Savannah depuis le quai des navires à vapeur, photochrome
À droite : le long de la rivière, Savannah
Ci-dessous : quai Gordon's, Savannah
En bas à gauche : les docks de coton, Savannah
En bas à droite : les entrepôts maritimes à Savannah
Page 357 : marchand de poisson (Augusta ?), plaque de verre, 1903

Au bord de sa rivière, la vieille ville de Savannah bénéficie d'une « belle végétation semi-tropicale » et de « nombreux parcs bien ombragés », lit-on dans le guide Baedeker de 1893. Son port, qui avait subi un blocus durant la guerre de Sécession, était redevenu très actif, exportant principalement du riz et du coton vers l'Europe.

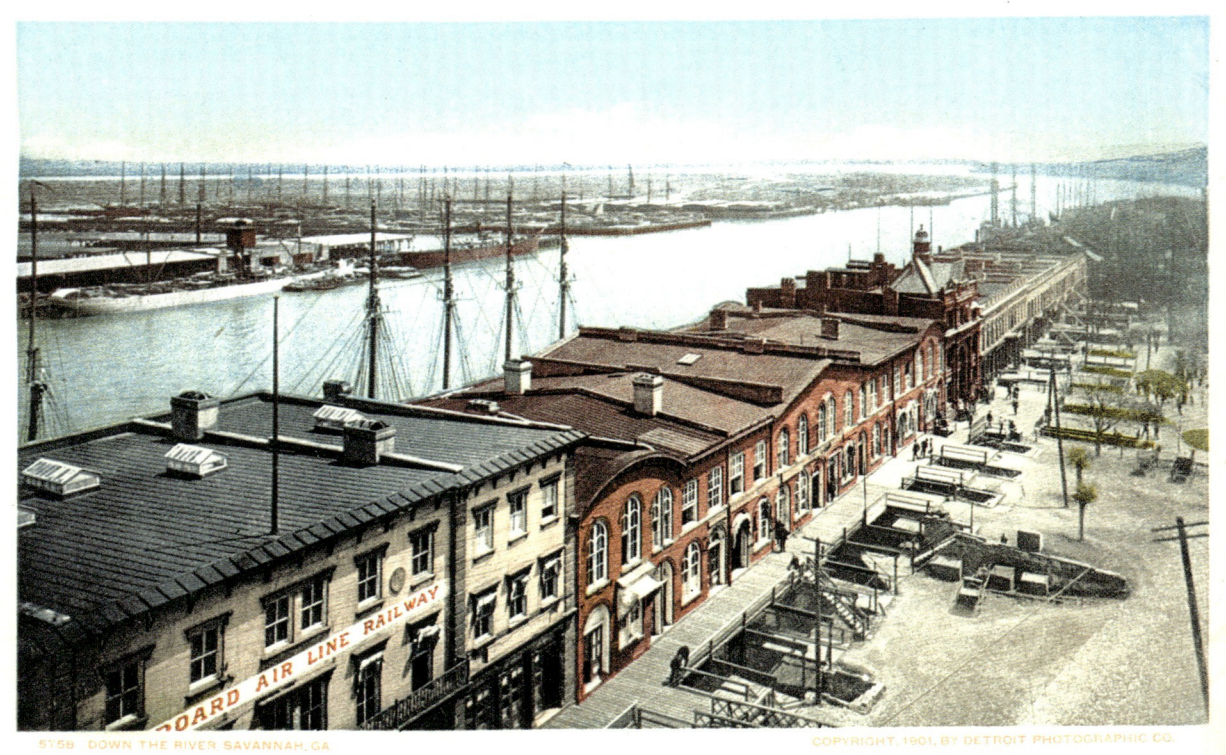

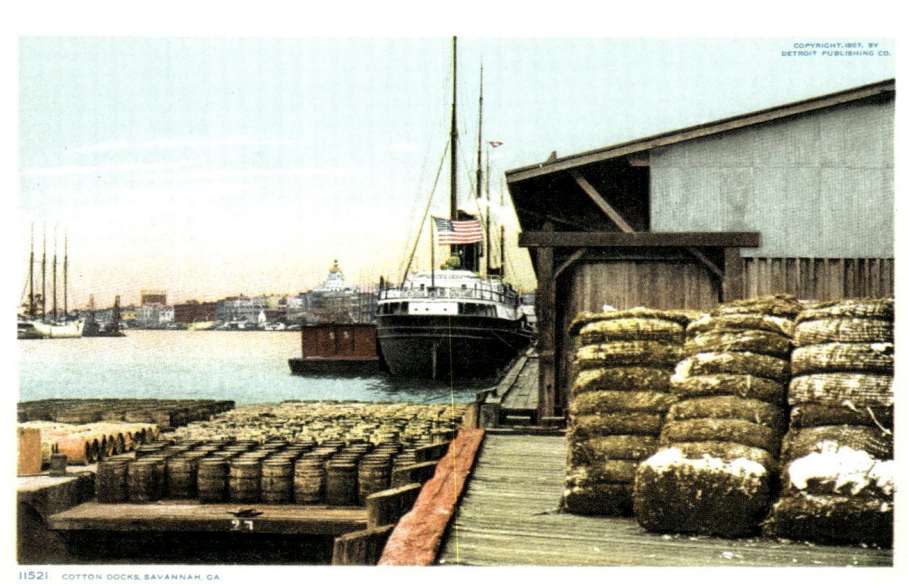

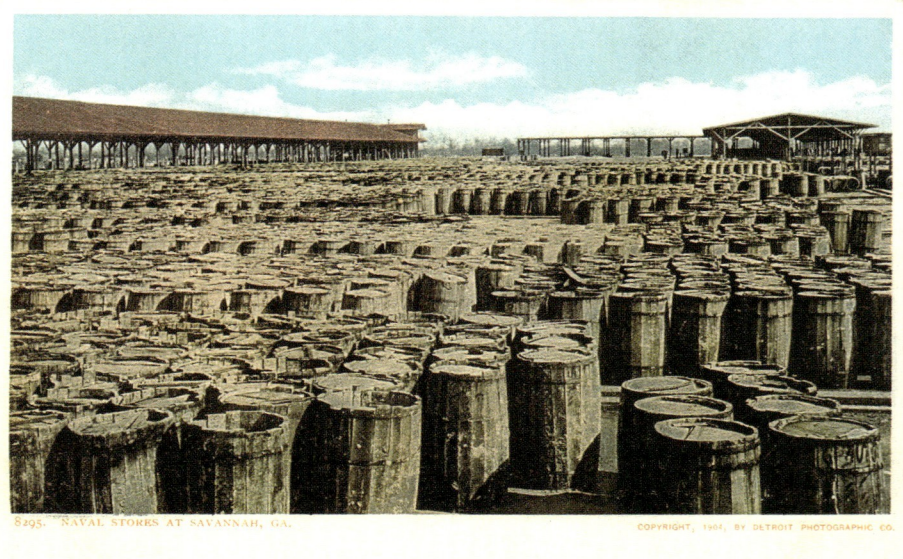

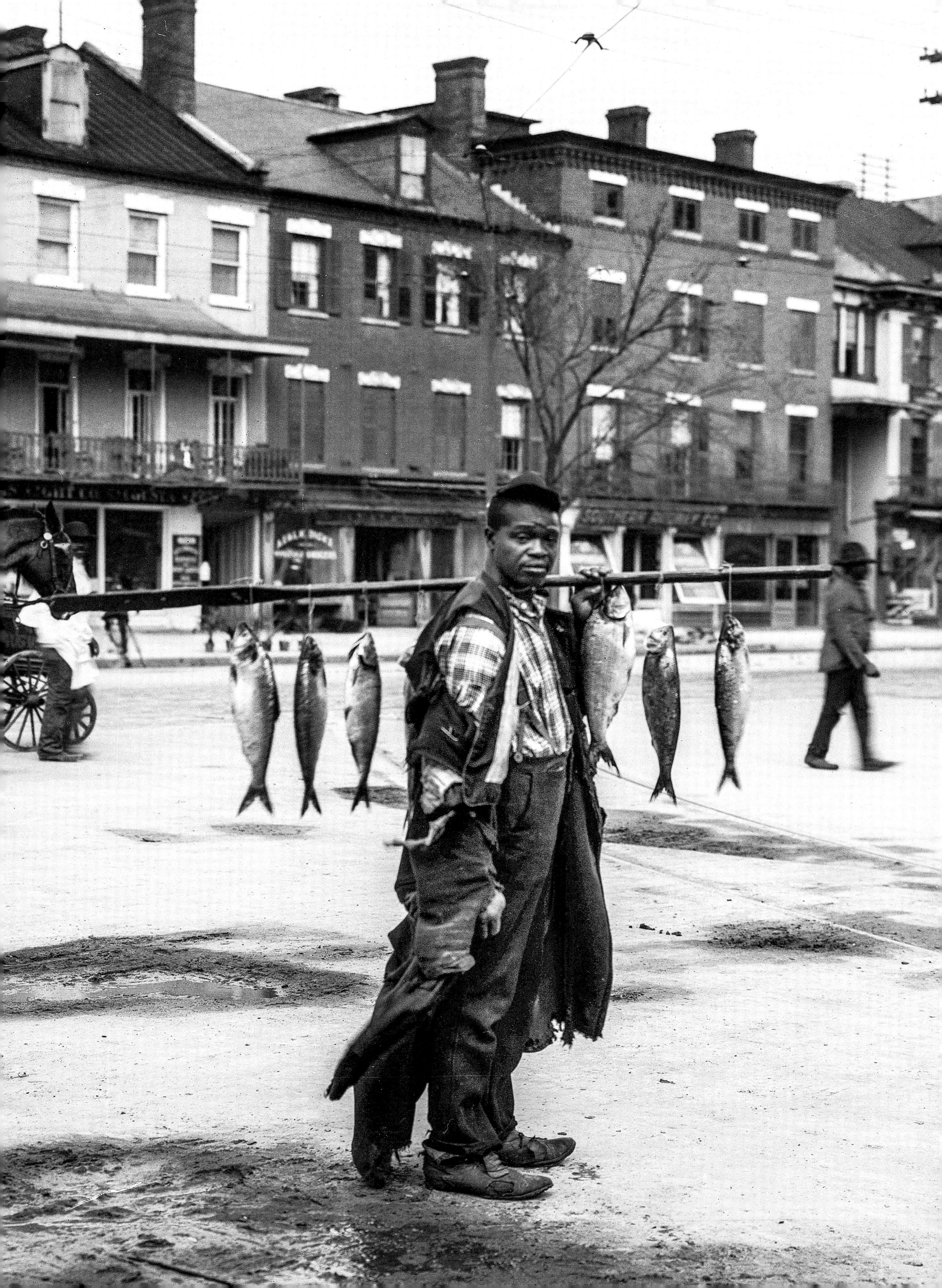

Above: **The Hermitage in Savannah, photochrom**
Below: **Bonaventure Cemetery, photochrom**

Henry McAlpin's plantation in Savannah, the Hermitage, was a typical example of the dual-purpose plantation, both agricultural and industrial. From early in the 19th century, African American slaves cultivated rice and labored in the brickworks, which was renowned throughout the South for the quality of its gray brick. Many of Savannah's historical buildings were made with Hermitage bricks.

Oben: **Die Hermitage in Savannah, Gesamtansicht, Photochrom**
Unten: **Der Friedhof von Bonaventure, Photochrom**

Die Plantage Hermitage von Henry McAlpin in Savannah war ein typisches Beispiel für eine Plantage, die zwei verschiedenen Zwecken diente, einem landwirtschaftlichen und einem industriellen: Seit Beginn des 19. Jahrhunderts bauten die afroamerikanischen Sklaven Reis an und arbeiteten in der Ziegelei. Die Fabrik war im gesamten Süden für die besondere Qualität ihrer „gray bricks" (graue Ziegel) bekannt. Zahlreiche historische Gebäude von Savannah wurden aus Ziegeln der Hermitage erbaut.

Ci-dessus : **l'Hermitage à Savannah, vue d'ensemble, photochrome**
Ci-dessous : **le cimetière de Bonaventure, photochrome**

L'Hermitage, la plantation d'Henry McAlpin à Savannah, était un exemple typique de plantation à double vocation, agricole et industrielle : depuis le début du xixᵉ siècle, les esclaves afro-américains cultivaient le riz et travaillaient à la briqueterie. L'usine était renommée dans tout le Sud pour la qualité particulière de ses « briques grises » (gray bricks). De nombreux édifices historiques de Savannah ont été construits en briques de l'Hermitage.

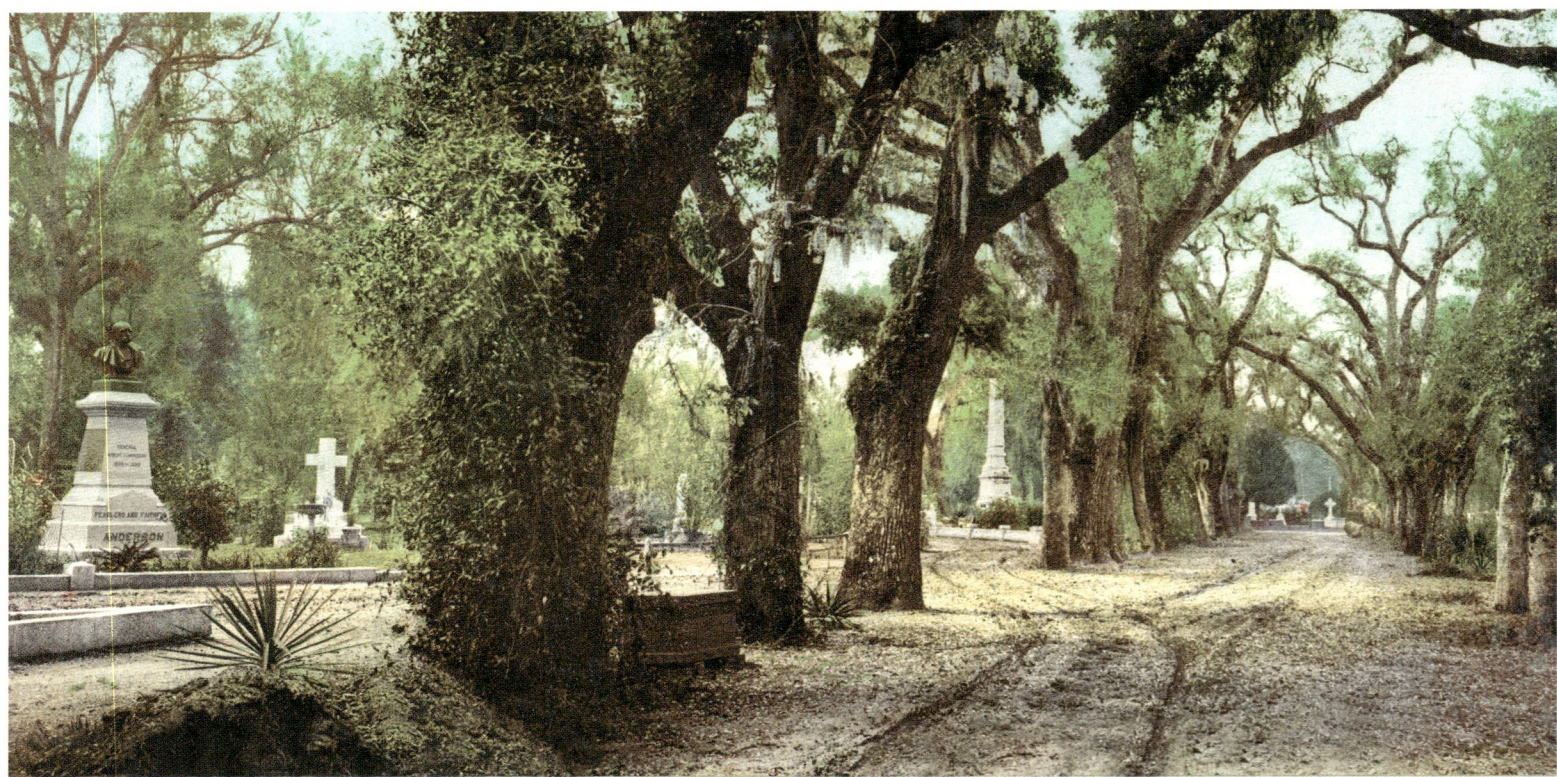

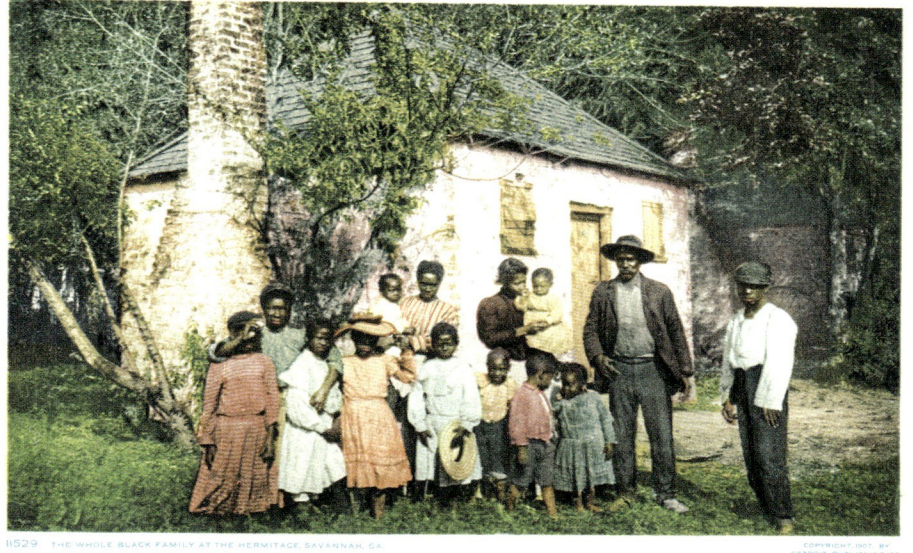
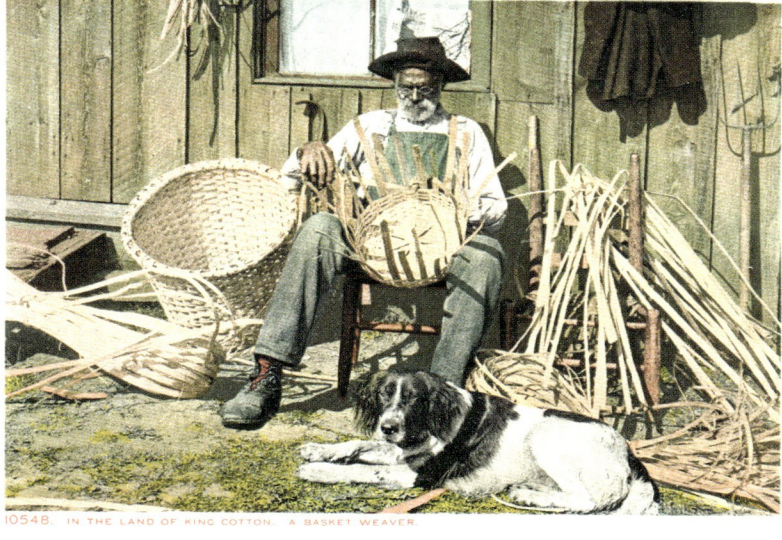
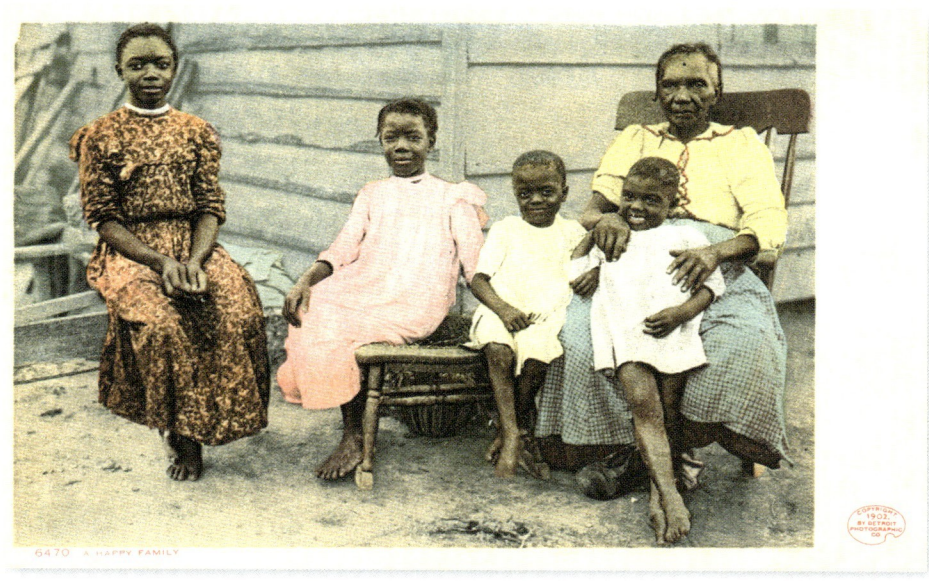
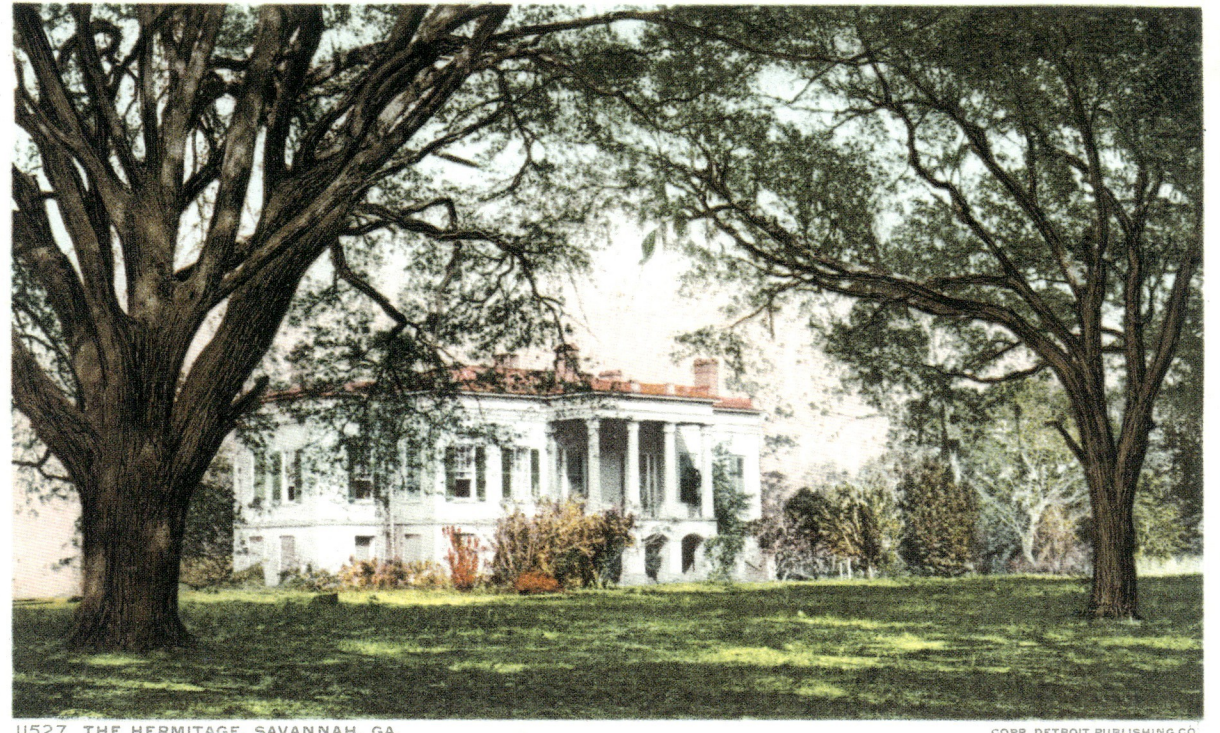

From left to right and top to bottom:
The whole family at the Hermitage slave quarters
In the land of "King Cotton," a basket weaver
A happy family
The Hermitage (plantation owner's house), Savannah

Von links nach rechts und von oben nach unten:
Eine Familie im Sklavenquartier der Hermitage
Im Land des „Baumwollkönigs", ein Korbmacher
Eine glückliche Familie
Die Hermitage (das Haus des Plantagenbesitzers), Savannah

De gauche à droite et de haut en bas :
Une famille dans le quartier des esclaves de l'Hermitage
Au pays du « Roi coton », un vannier
Une famille heureuse
L'Hermitage (la maison du planteur), Savannah

GEORGIA | SAVANNAH

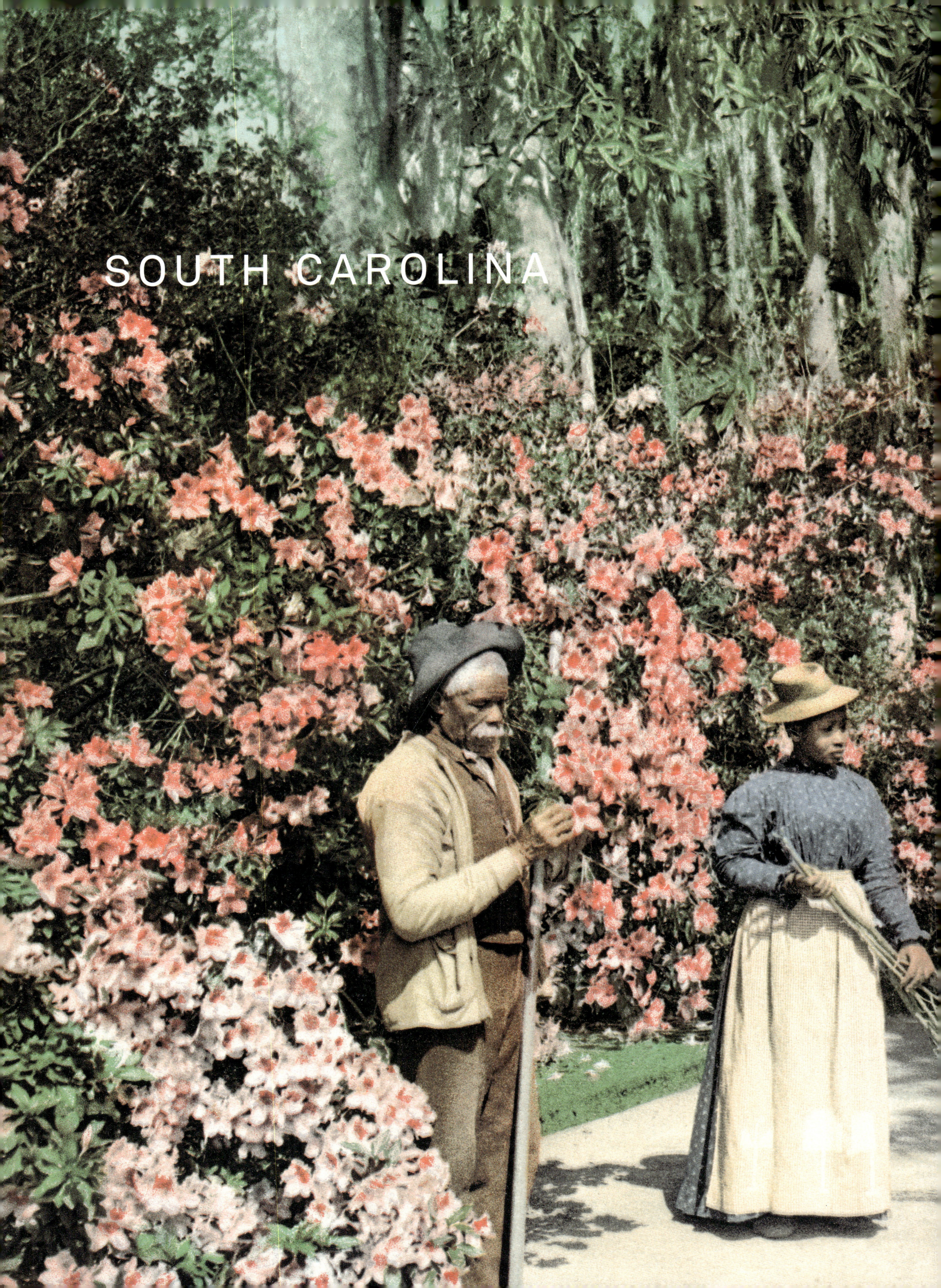

SOUTH CAROLINA

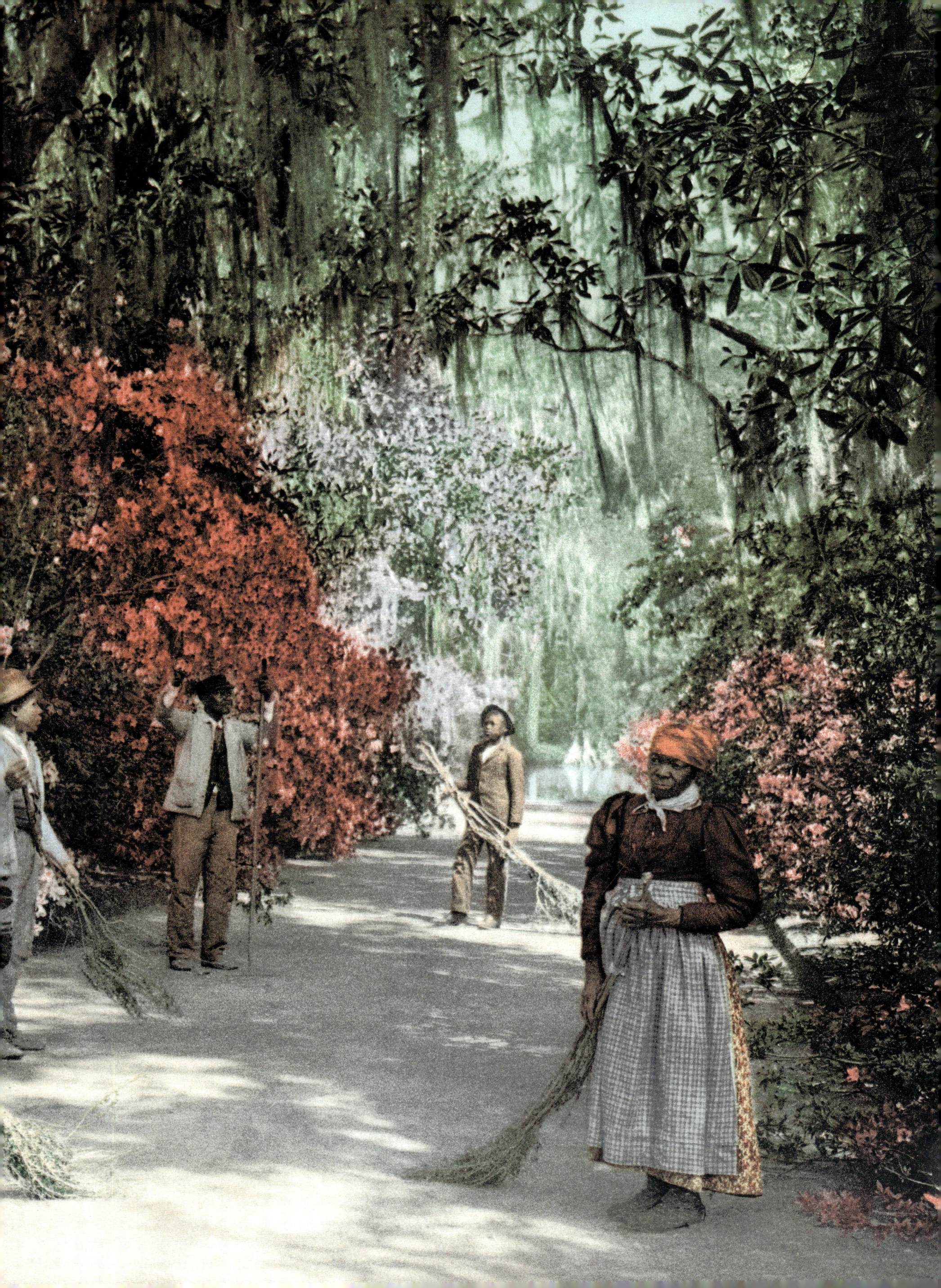

Page 360/361: **The caretakers, Magnolia-on-the-Ashley, photochrom**
Below: **Walk by the lake, photochrom**
Page 363: **The glory of the azaleas, photochrom**

Founded in 1676–79 by Thomas and Ann Drayton on the banks of the Ashley River, the Magnolia Plantation owed its prosperity to rice cultivation. The first gardens were created in the early 18th century, but in the following century the Drayton heirs introduced from Japan the azaleas and camellias that are still among the glories of the gardens. They were opened to the public after the Civil War, in 1870.

Seite 360/361: **Gärtner, Magnolia-on-the-Ashley, Photochrom**
Unten: **Weg am Seeufer, Photochrom**
Seite 363: **Die Pracht der Azaleen, Photochrom**

Die zwischen 1676 und 1679 von Thomas und Ann Drayton am Ufer des Ashley Rivers gegründete Plantage Magnolia verdankte ihren Wohlstand dem Reisanbau. Die ersten Gärten entstanden Anfang des 18. Jahrhunderts, doch erst im darauffolgenden Jahrhundert führten die Drayton-Erben dort die ersten Azaleen und Kamelien aus Japan ein, die den Anlagen noch heute eine besondere Pracht verleihen. Die Gärten wurden der Öffentlichkeit 1870 nach dem Sezessionskrieg zugänglich gemacht.

Pages 360/361 : **les jardiniers, Magnolia-on-the-Ashley, photochrome**
En bas : **chemin au bord du lac, photochrome**
Page 363 : **splendeur des azalées, photochrome**

Fondée en 1676–1679 par Thomas et Ann Drayton au bord de la rivière Ashley, la plantation de Magnolia dut sa prospérité à la culture du riz. Les premiers jardins virent le jour au début du XVIIIe siècle mais c'est au siècle suivant que les héritiers Drayton y introduisirent les premières azalées et les camélias du Japon qui font aujourd'hui encore sa splendeur. Les jardins furent ouverts au public après la guerre de Sécession, en 1870.

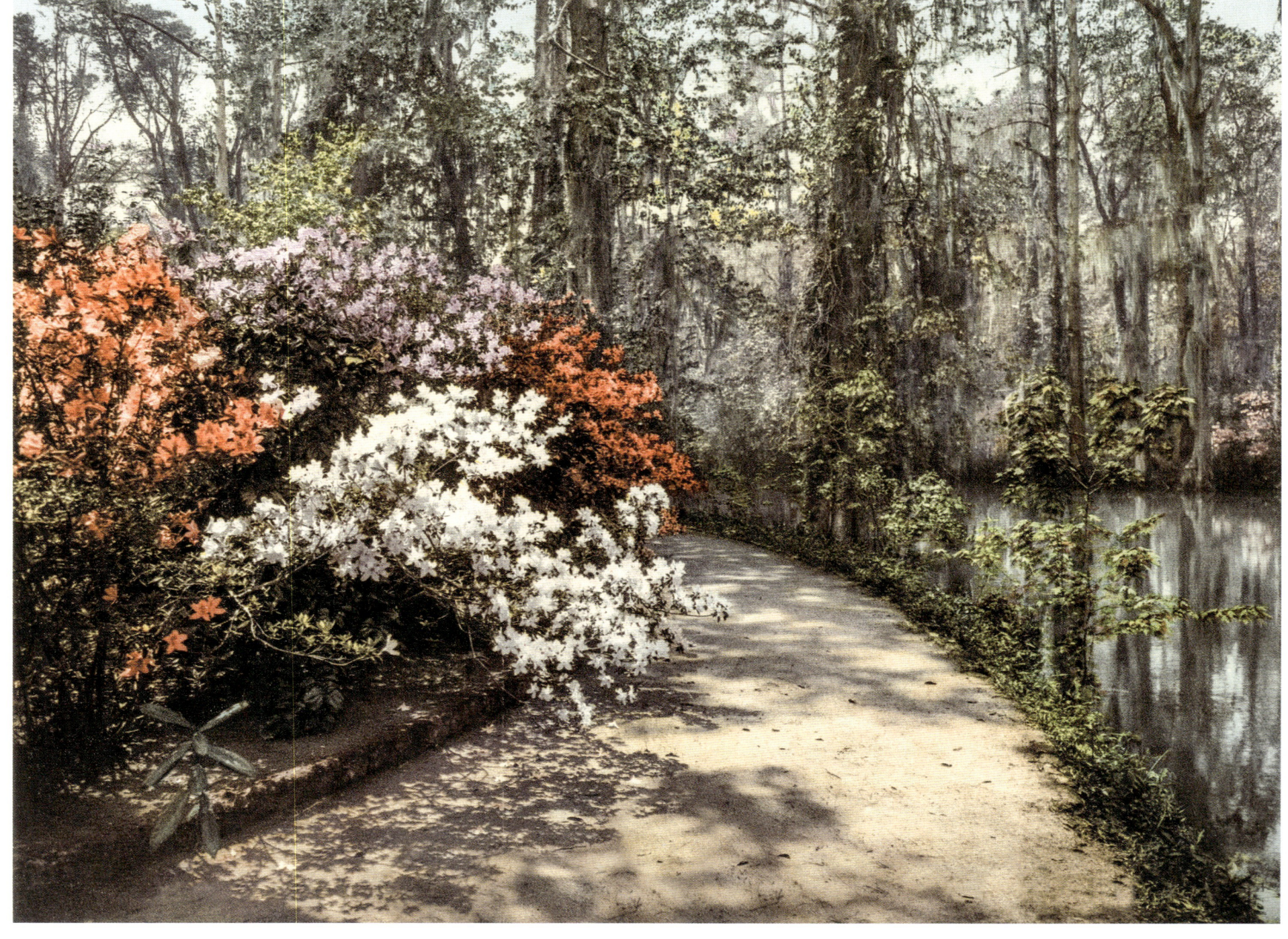

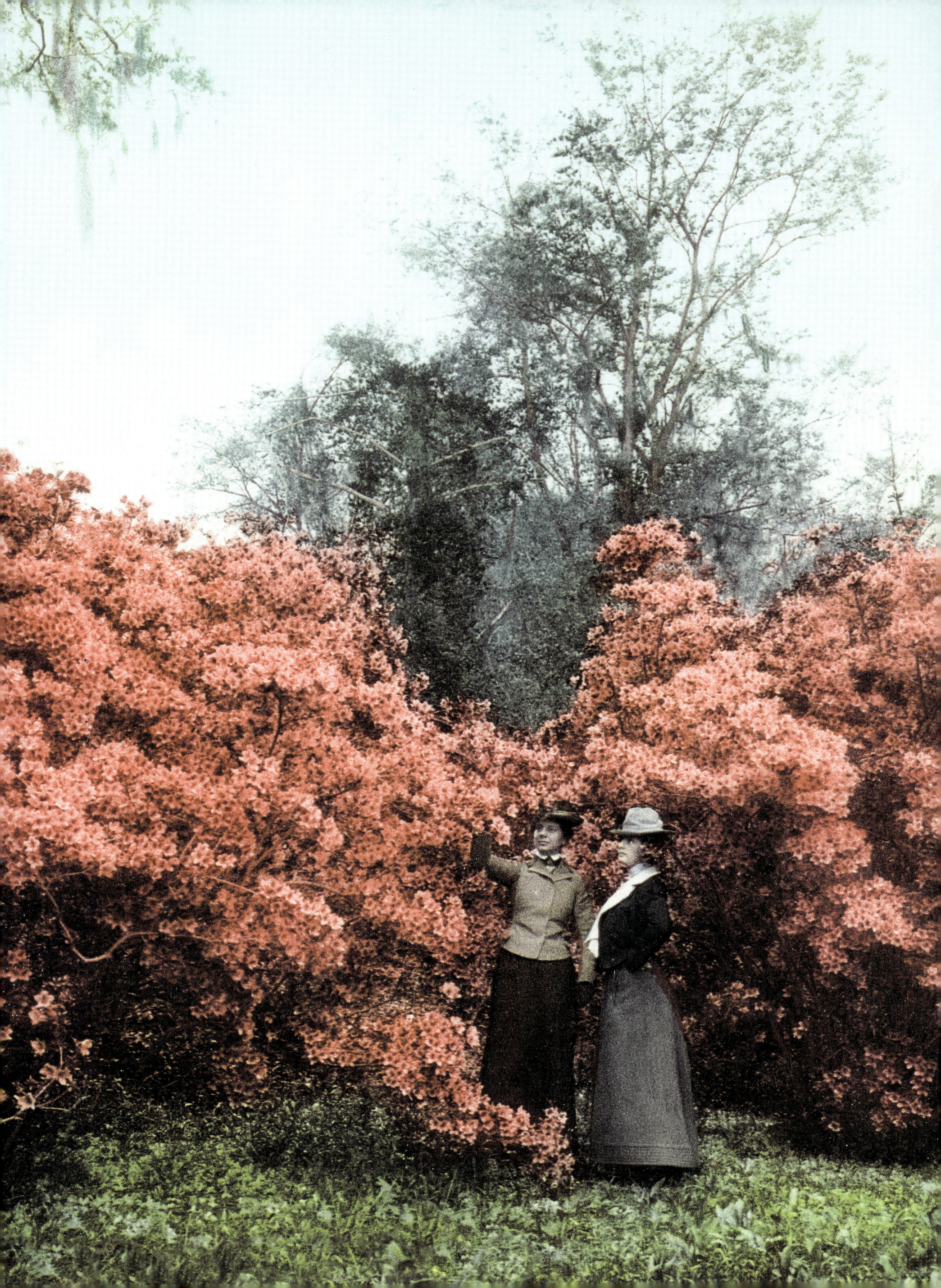

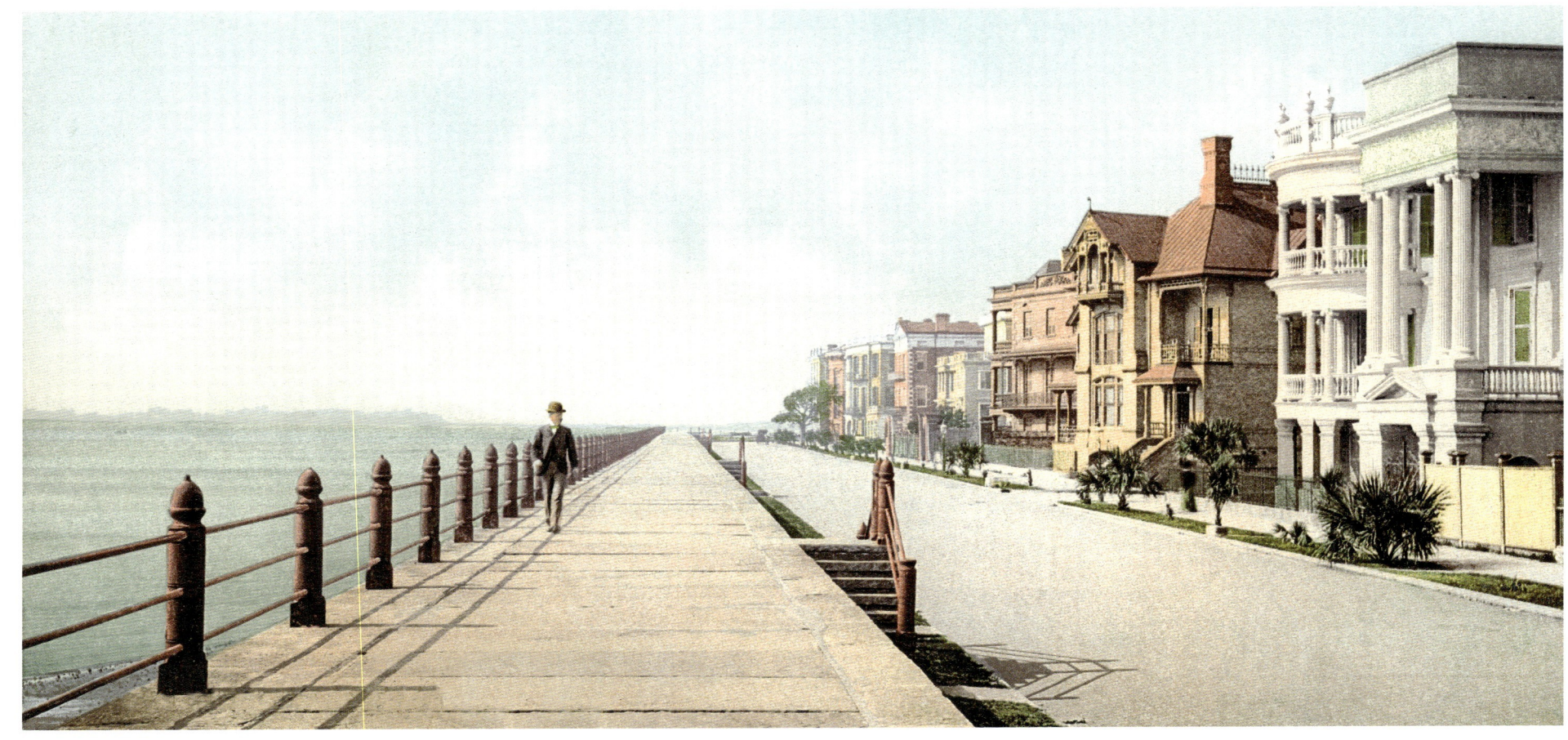

Top: **East Battery Parade**, photochrom
Middle: **The old slave market**
Bottom: **Old Charleston**
Page 365: **St. Michael's Church**, photochrom

Oben: **The Battery (östlicher Teil der Promenade)**, Photochrom
Mitte: **Ehemaliger Sklavenmarkt**
Unten: **Das alte Charleston**
Seite 365: **Die St.-Michaels-Kirche**, Photochrom

Ci-dessus : **la Batterie (partie est)**, photochrome
Ci-dessous : **l'ancien marché aux esclaves**
En bas : **le Vieux Charleston**
Page 365 : **l'église Saint-Michael**, photochrome

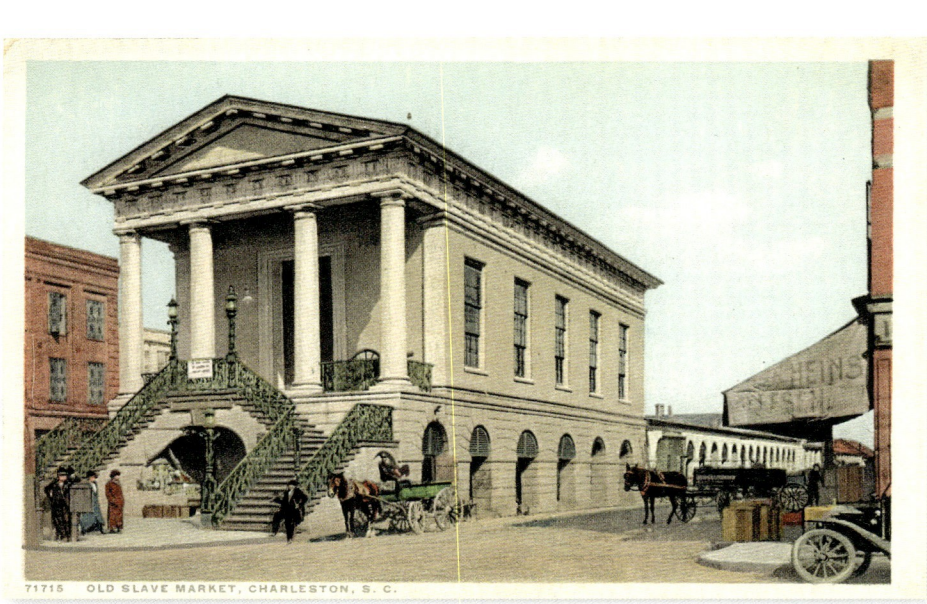

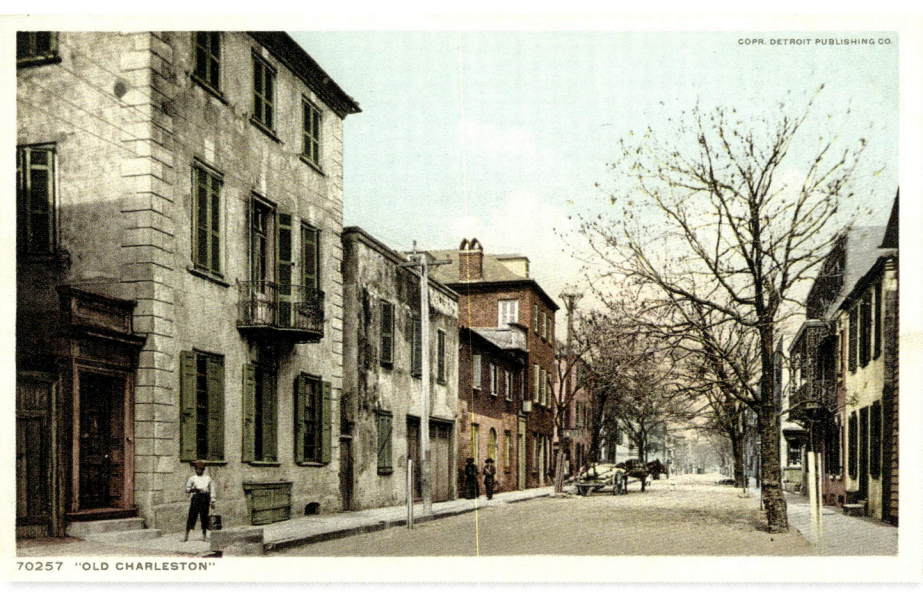

364

SOUTH CAROLINA | CHARLESTON

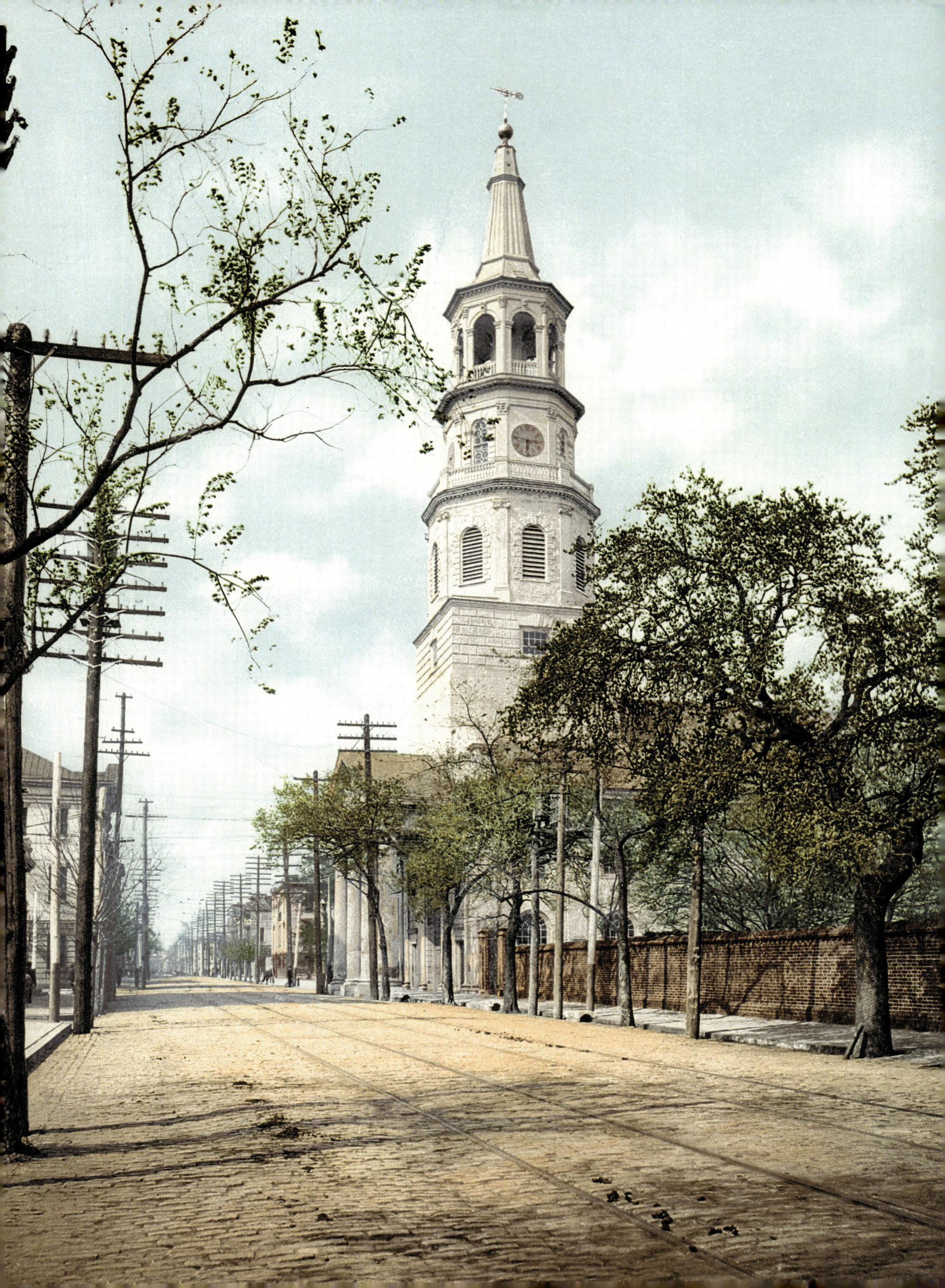

COTTON / BAUMWOLLE / LE COTON

Intensive cultivation of cotton in the United States due to the growing demand in the European market for printed calico in the 18th century. The fashion for this fabric, which was cheaper and easier to tint than silk, brought with it considerable profits. As a result, cotton was introduced to the French colony of Saint-Domingue (Saint Domingo). This, in turn, produced an enormous increase in the African slave trade. Soon, plantations extended throughout the Southern states: Georgia,

Der intensive Baumwollanbau in Amerika war der wachsenden Nachfrage auf dem europäischen Markt nach bedruckten Baumwollstoffen im 18. Jahrhundert geschuldet. Die Vorliebe für diese Stoffe, die günstiger und leichter zu färben waren als Seide – und die Profite, die die Händler daraus schlugen –, führte zur ersten Kultivierung der Baumwollpflanze in der französischen Kolonie Saint-Domingue (Santo Domingo), mit der Folge, dass der Handel mit afrikanischen Sklaven enorm zunahm. Die Plantagen weiteten

La culture intensive du coton en Amérique naît de la demande croissante du marché européen des indiennes au XVIIIe siècle. La vogue de ces tissus meilleur marché et plus faciles à teindre que la soie – et les profits qu'en tirent les négociants –, entraîne d'abord l'introduction de la plante dans la colonie française de Saint-Domingue, avec pour conséquence une énorme augmentation du trafic d'esclaves africains. Les plantations s'étendent bientôt aux États du Sud des États-Unis : Géorgie, Alabama,

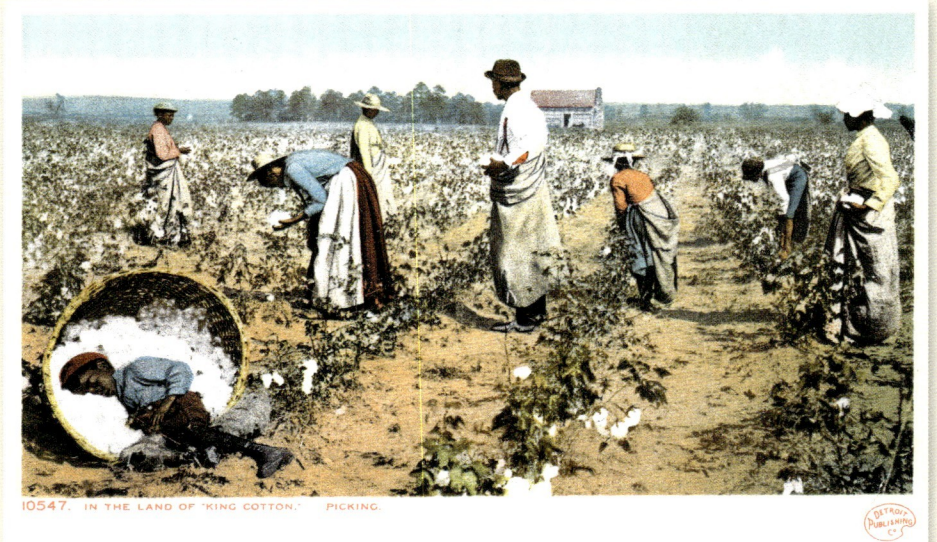
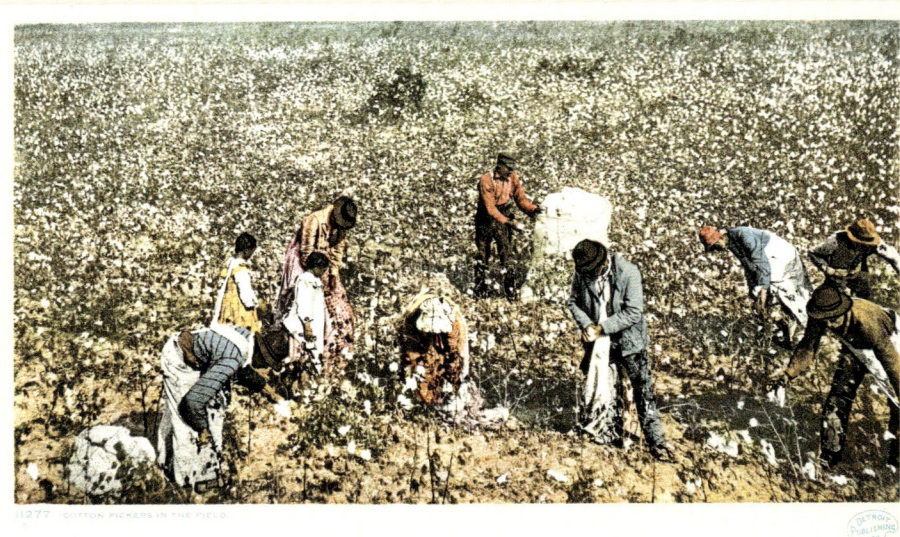

Page 366, from left to right and top to bottom:
Cotton pickers in the field
In the land of "King Cotton," picking
Boys in a cotton shed, photochrom
Near right: Out on cotton bale
Far right: Cotton compress
Below: Cotton gin at Dahomey, Mississippi, photochrom

Seite 366, von links nach rechts und von oben nach unten:
Baumwollpflücker auf dem Feld
Im Land des „Baumwollkönigs", beim Pflücken
Jungen in einem Baumwolllager, Photochrom
Rechts: Junge auf einem Baumwollballen
Rechts außen: Baumwollpresse
Unten: Baumwollentkörnung in Dahomey, Mississippi, Photochrom

Page 366, de gauche à droite et de haut en bas :
Cueilleurs de coton dans un champ
Au pays du « Roi coton », cueillette
Jeunes travailleurs dans un hangar à coton, photochrome
Ci-contre : jeune garçon assis sur une balle de coton
À droite : pressage du coton
En bas : égrenage du coton à Dahomey, Mississippi, photochrome

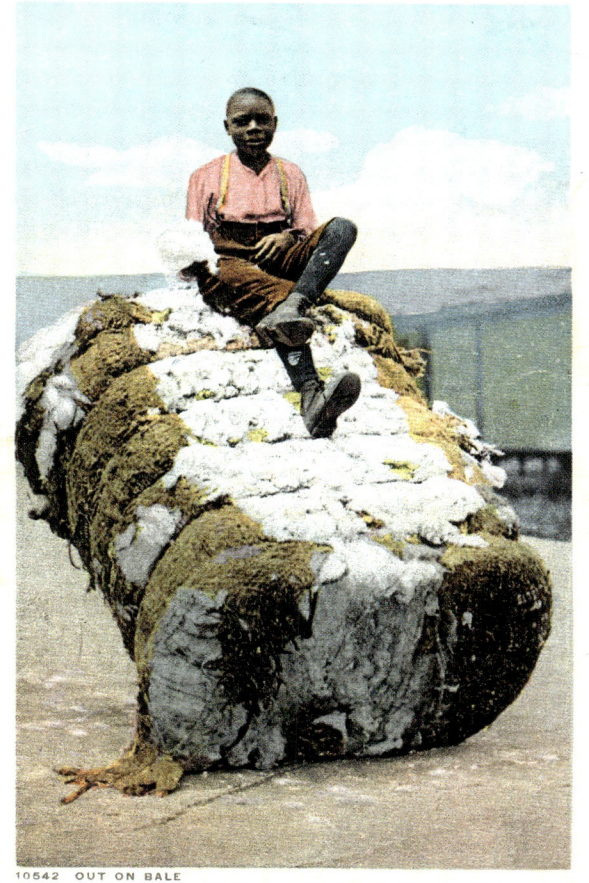

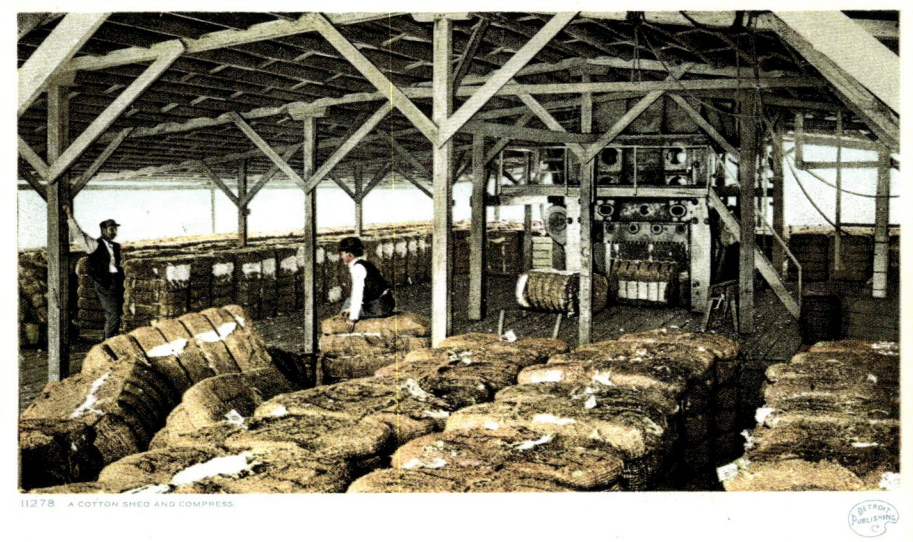
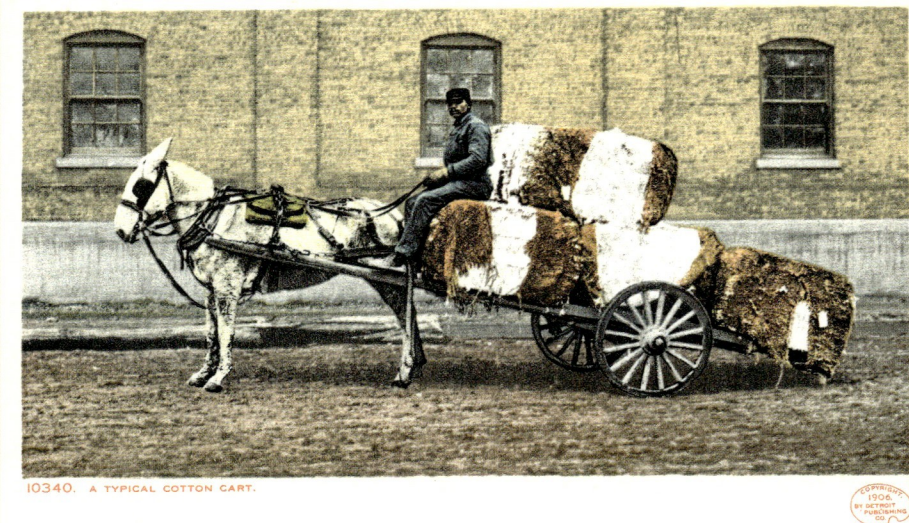
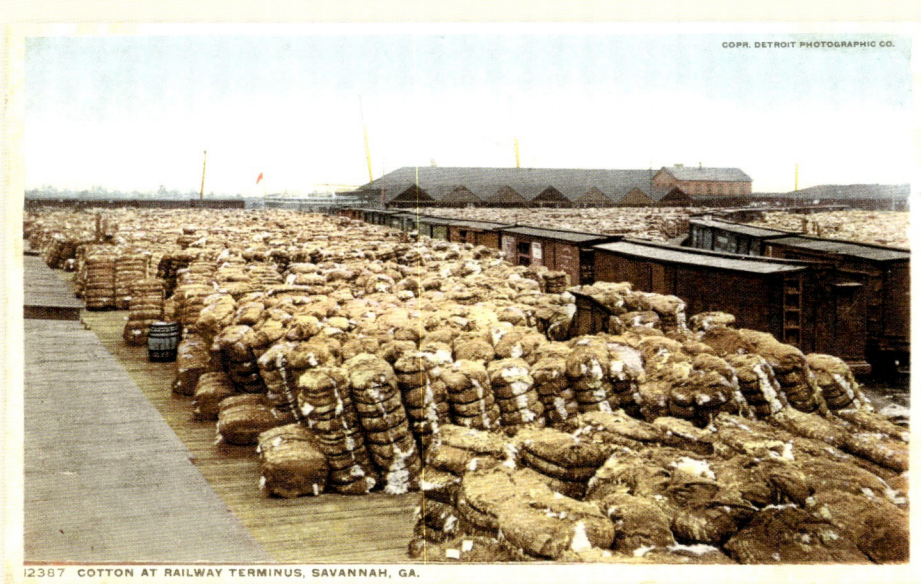
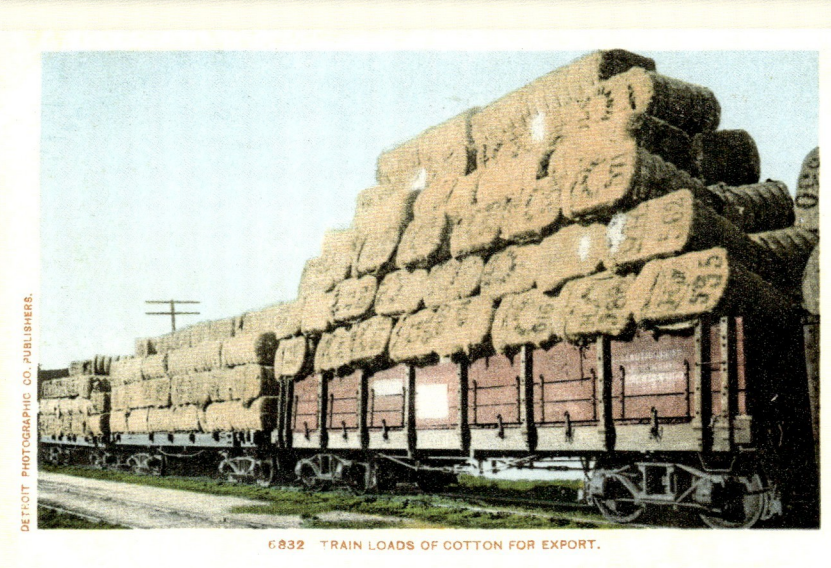
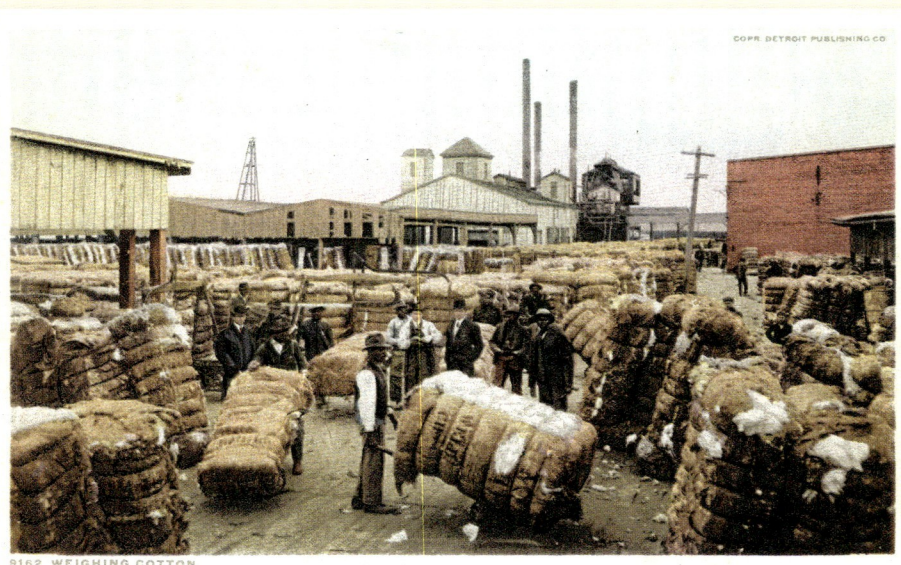
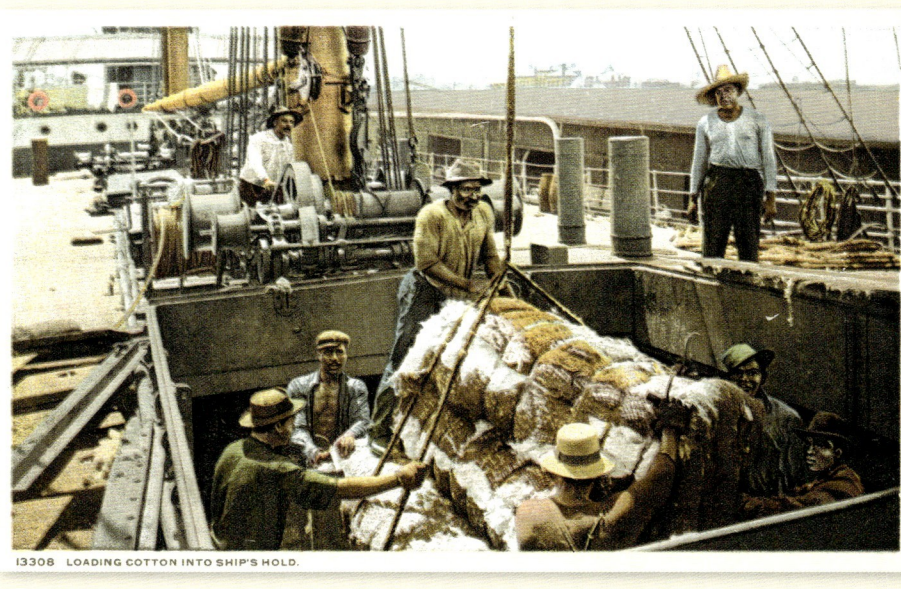

Alabama, Mississippi, Louisiana, South Carolina, Arkansas, Tennessee, southern Virginia, Texas, the north of Florida, and the southern regions of Kentucky and Missouri. The production of the Cotton Belt reached its peak in the early 19th century thanks to Eli Whitney's invention of the cotton gin in 1793, which separated the seeds and fibers of the plant automatically. However, automation had some perverse side effects. Use of the cotton gin was taxed and, to keep it supplied and make it profitable, harvests had to be larger and quicker. The number of African slaves brought to the United States between 1790 and 1808 (the year in which the slave trade was banned) is estimated at around a 250,000.

sich bald auf die Südstaaten der USA, auf Georgia, Alabama, Mississippi, Louisiana, South Carolina, Arkansas, Tennessee, den Süden Virginias, Texas, den Norden Floridas und die südlichen Gebiete von Kentucky und Missouri aus. Die Produktion des „Cotton Belt" erreichte Anfang des 19. Jahrhunderts dank der von Eli Whitney 1793 erfundenen Baumwollentkörnungsmaschine einen Höhepunkt. Diese ermöglichte die automatische Trennung von Baumwollsamen und -fasern. Dieser technische Fortschritt hatte dramatische Folgen. Um die Maschinen, die der Steuer unterlagen, wirtschaftlich zu unterhalten, musste man mehr und schneller ernten: Schätzungsweise 250 000 afrikanische Sklaven wurden zwischen 1790 und 1808 – dem Jahr, in dem der Sklavenhandel gesetzlich verboten wurde – auf amerikanischen Boden gebracht.

Mississippi, Louisiane, Caroline du Sud, Arkansas, Tennessee, sud de la Virginie, Texas, nord de la Floride et régions méridionales du Kentucky et du Missouri. La production de ce « Cotton Belt » atteint un pic au début du XIXe siècle grâce à l'invention d'Eli Whitney (1793), l'égreneuse à coton, qui permet la séparation automatique des graines et des fibres de la plante. Ce progrès technique s'accompagne d'effets pervers : pour alimenter et rentabiliser les égreneuses, qui font l'objet de taxes, il faut récolter plus, et plus vite : on estime à 250 000 le nombre des esclaves africains introduits sur le sol américain entre 1790 et 1808 – année du décret d'interdiction de la traite négrière.

Page 368, from left to right and top to bottom:
A cotton shed and compress
A typical cotton cart
Cotton at railway terminus, Savannah, Georgia
Trainloads of cotton for export
Weighing cotton
Loading cotton into ship's hold
Right: Cotton Exchange, New Orleans, Louisiana
Below: Unloading cotton, Memphis, Tennessee,
glass negative, 1905

Page 368, de gauche à droite et de haut en bas :
Entrepôt et presse à coton
Transport traditionnel du coton
Balles de coton à la gare de Savannah, Géorgie
Train transportant du coton destiné à l'exportation
Pesage du coton
Chargement de coton dans les cales d'un bateau
À droite : bourse du coton, La Nouvelle-Orléans, Louisiane
En bas : déchargement de coton à Memphis, Tennessee,
plaque de verre, 1905

Seite 368, von links nach rechts und von oben nach unten:
Baumwollschuppen und -presse
Typischer Baumwollkarren
Baumwolle am Bahnhof von Savannah, Georgia
Für den Export bestimmte Baumwollladung auf einem Zug
Abwiegen der Baumwolle
Die Baumwolle wird in den Frachtraum verladen
Rechts: Baumwollbörse, New Orleans, Louisiana
Unten: Beim Ausladen von Baumwolle, Memphis, Tennessee,
Glasnegativ, 1905

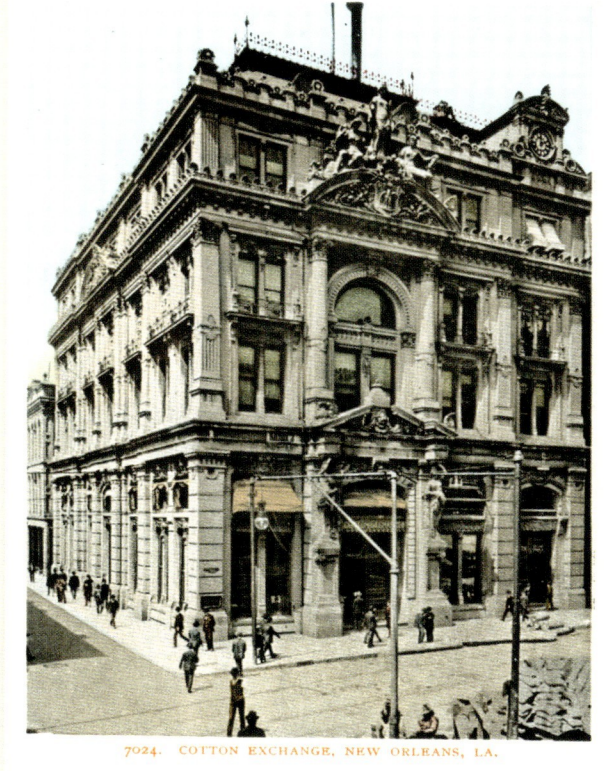

Intensive cultivation of cotton in the United States was due to of the growing demand in the European market for printed calico in the 18th century.

Der intensive Baumwollanbau in Amerika war der wachsenden Nachfrage auf dem europäischen Markt nach bedruckten Baumwollstoffen im 18. Jahrhundert geschuldet.

La culture intensive du coton en Amérique naît de la demande croissante du marché européen des indiennes au XVIIIᵉ siècle.

TENNESSEE

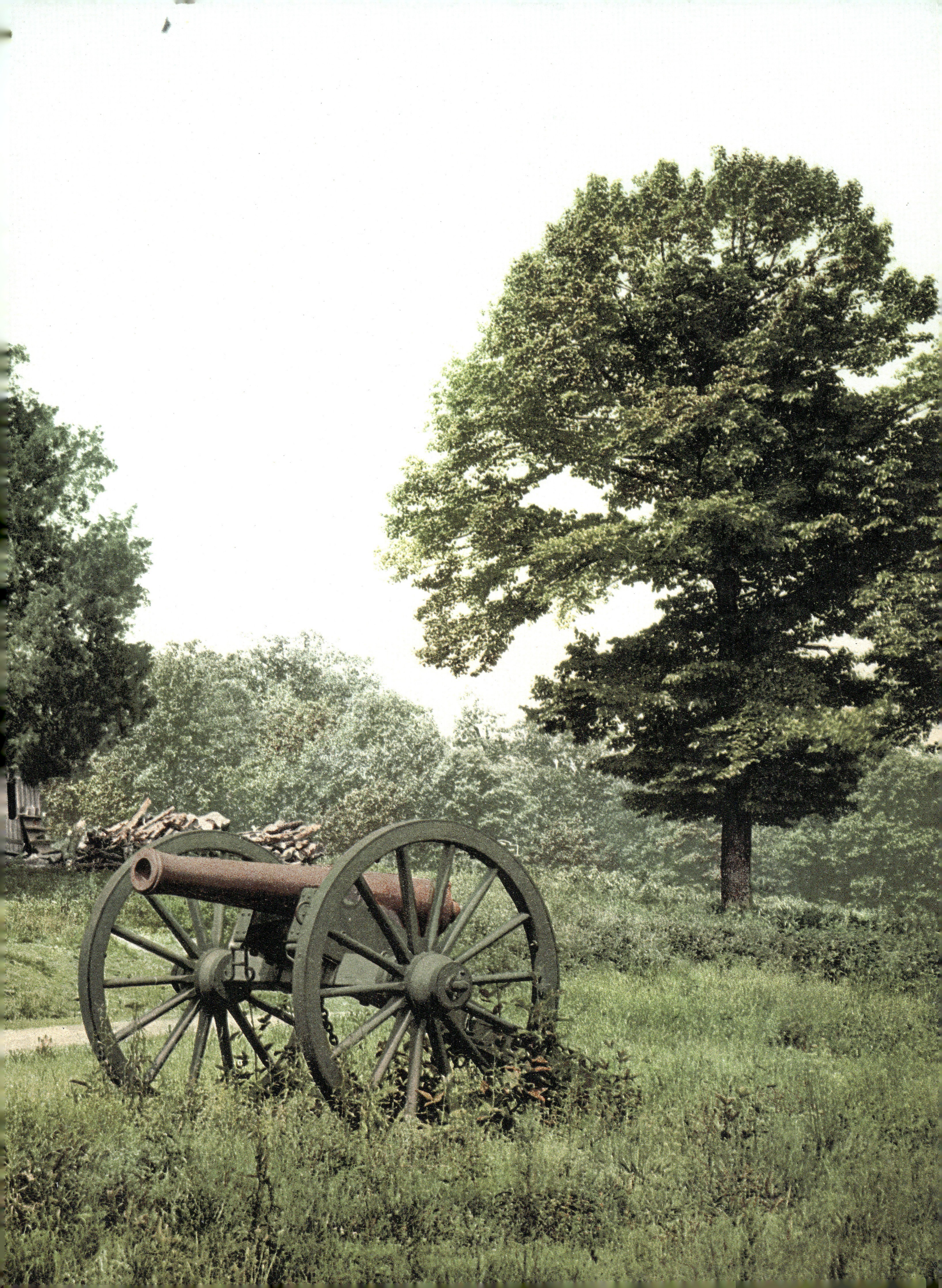

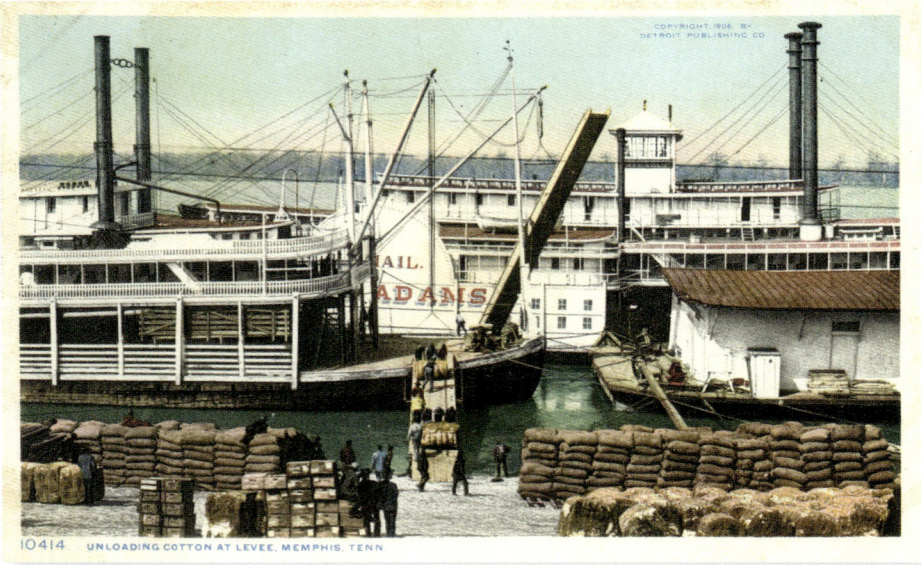

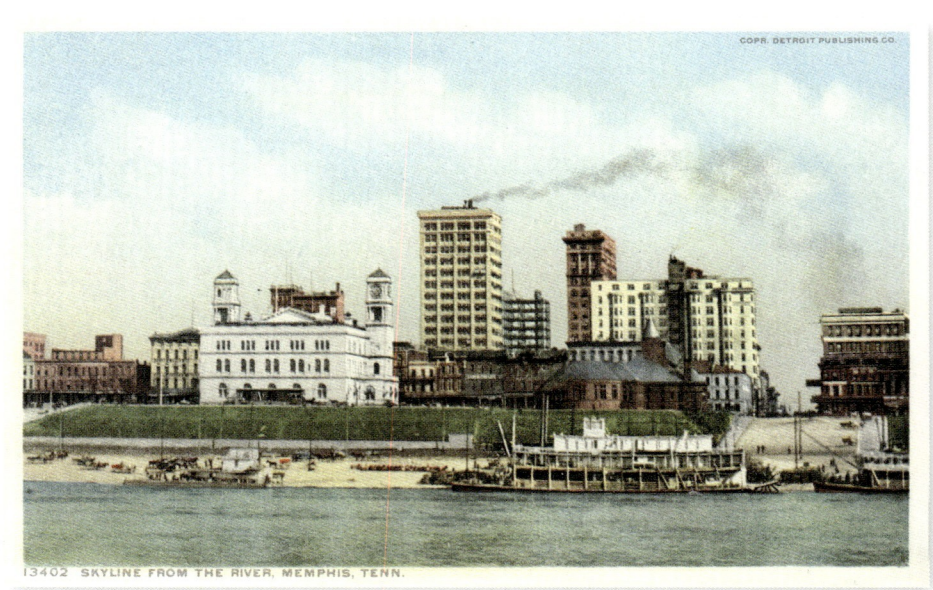

Page 370/371: Chickamauga Battlefield, the Snodgrass House, General Thomas's Headquarters, photochrom
Above: Steamer *Chas. H. Organ* landing at Mound City, Memphis, glass negative, 1910
Left: Unloading cotton at levee, Memphis
Below: Skyline from the river, Memphis

Seite 370/371: Schlachtfeld von Chickamauga, Snodgrass House, Hauptquartier von General Thomas, Photochrom
Oben: Das Dampfer *Chas. H. Organ* legt in Mound City an, Memphis, Glasnegativ, 1910
Links: Ausladen von Baumwolle am Kai von Memphis
Unten: Blick auf Memphis vom Mississippi aus

Pages 370/371 : champ de bataille de Chickamauga, Snodgrass House, QG du général Thomas, photochrome
Ci-dessus : le vapeur *Chas. H. Organ* accostant à Mound City, Memphis, plaque de verre, 1910
À gauche : déchargement du coton sur le quai de Memphis
Ci-dessous : vue de Memphis depuis le fleuve Mississippi

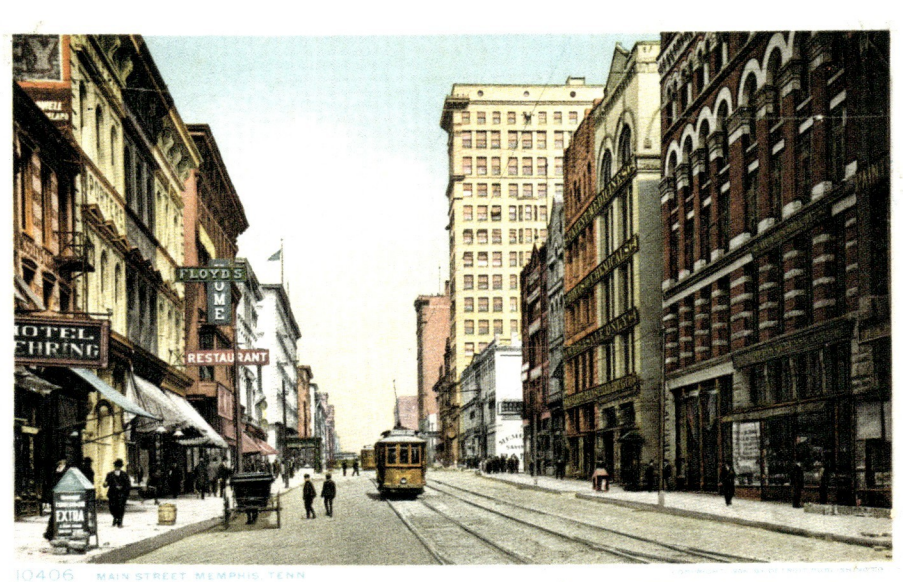

Above: Roller skating in Forrest Park, Memphis, glass negative, 1906
Below left: Main Street, Memphis
Below right: Gayoso Hotel, Memphis

Memphis was founded in 1819 after the federal government purchased the western territories of Tennessee from the Chickasaw Indian nation. The town quickly became one of the most prosperous centers for the processing of cotton grown downstream in the Mississippi Delta.
The first Gayoso Hotel, designed by the architect James H. Dakin in 1842, was a superb Neo-Gothic building with fabulous views over the Mississippi. It burned down twice, in 1879 and 1899, and was reconstructed on its foundations in 1904.

Oben: Rollschuhlaufen im Forrest Park, Memphis, Glasnegativ, 1906
Unten links: Main Street, Memphis
Unten rechts: Das Hotel Gayoso, Memphis

Memphis wurde 1819 gegründet, nachdem die US-Regierung von der Nation der Chickasaw-Indianer die westlichen Gebiete Tennessees übernommen hatte. Die Stadt wurde schnell zu einem der prosperierendsten Zentren zur Weiterverarbeitung der stromabwärts im Mississippi-Delta produzierten Baumwolle.
Das von dem Architekten James H. Dakin 1842 erbaute Hotel Gayoso, das erste am Platz, war ein herrlicher neugotischer Bau mit einem großartigen Blick auf den Mississippi. Es brannte zweimal ab, 1879 und 1899, und wurde 1904 auf seinem Fundament wieder aufgebaut.

Ci-dessus : patin à roulettes à Forrest Park, Memphis, plaque de verre, 1906
En bas à gauche : Main Street, Memphis
En bas à droite : l'hôtel Gayoso, Memphis

Memphis fut fondée en 1819, après le rachat par le Gouvernement fédéral à la nation indienne Chickasaw des territoires occidentaux du Tennessee. La ville devint rapidement l'un des centres de traitement les plus prospères du coton produit en aval du fleuve, dans le delta du Mississippi.
Le premier hôtel Gayoso, édifié par l'architecte James H. Dakin en 1842, était un superbe bâtiment néogothique, avec une vue grandiose sur le Mississippi. Il brûla deux fois, en 1879 et en 1899, et fut reconstruit sur ses fondations en 1904.

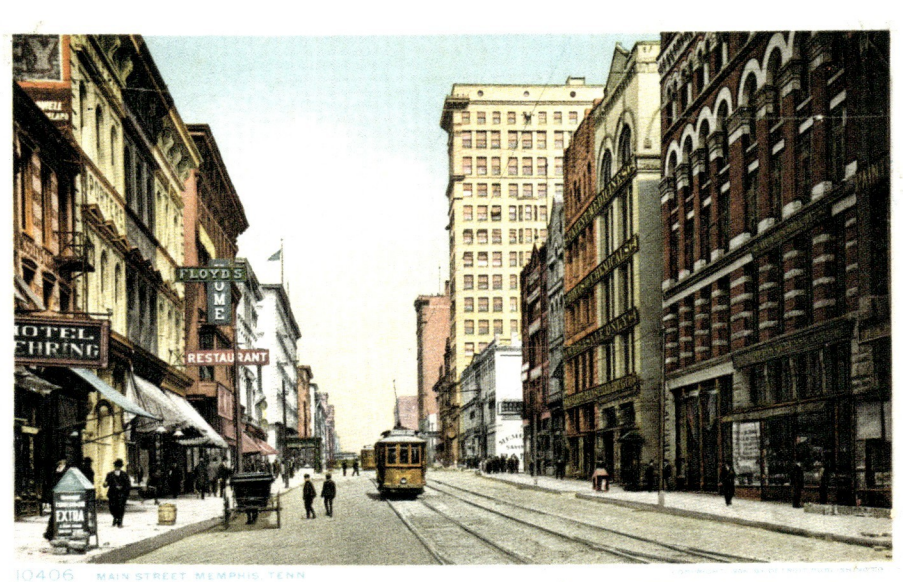

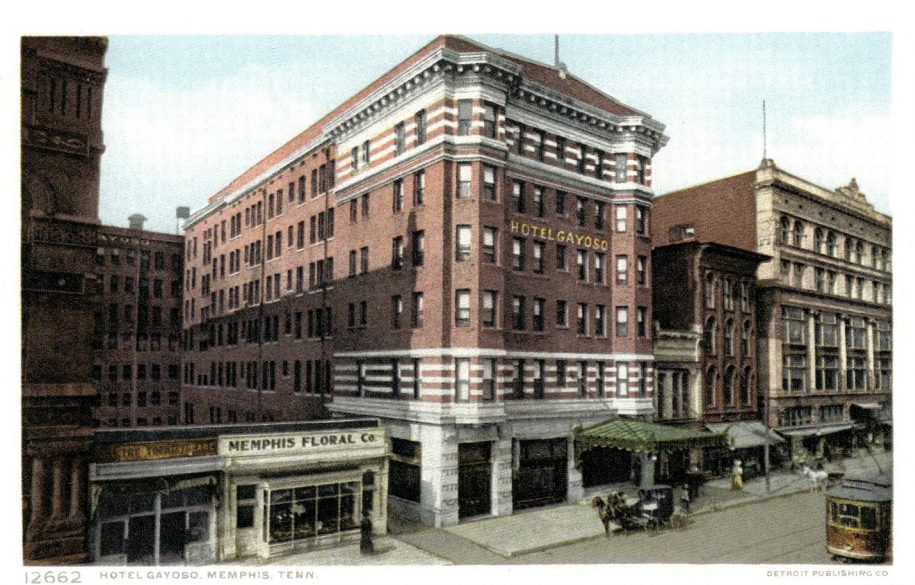

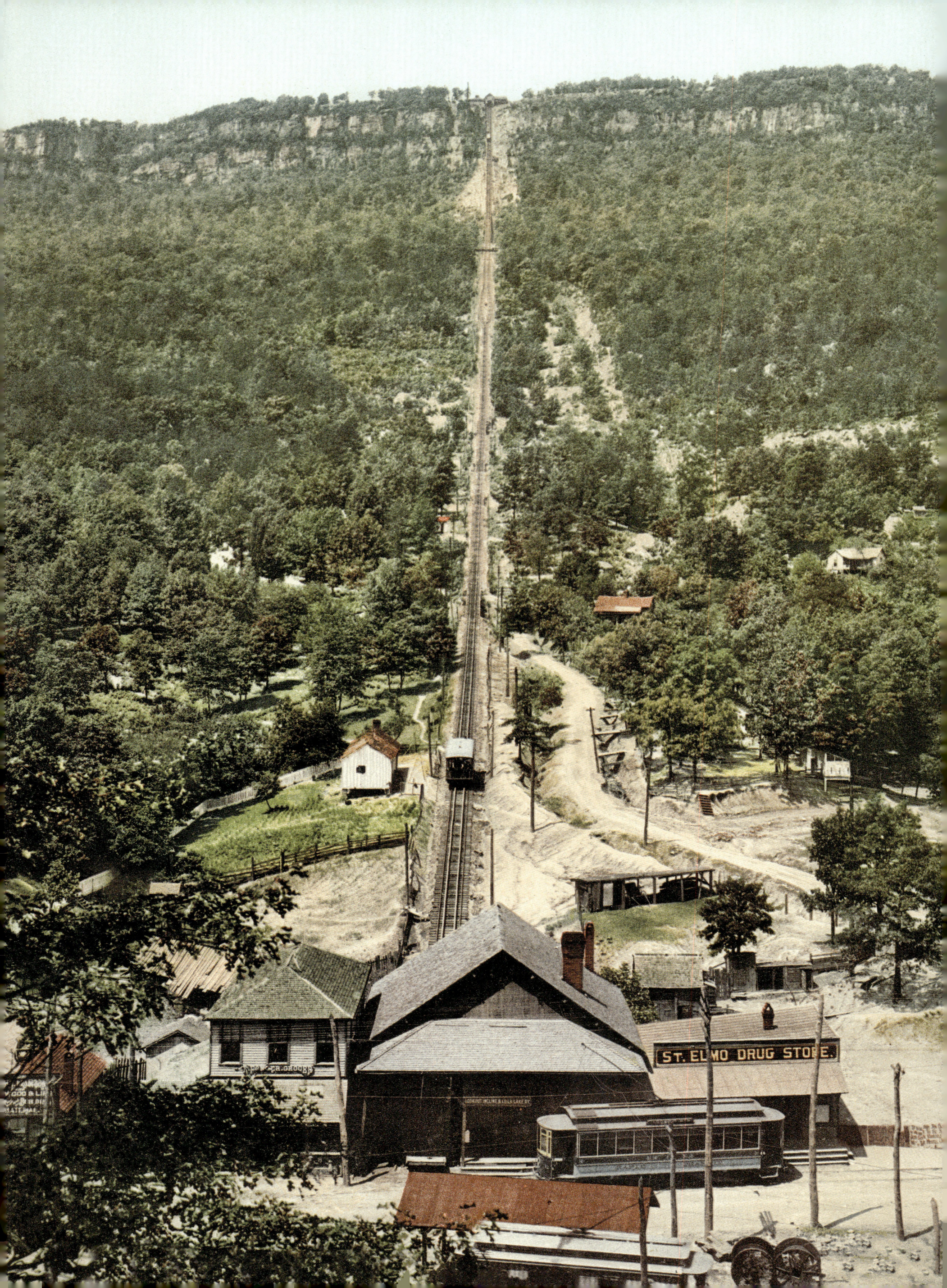

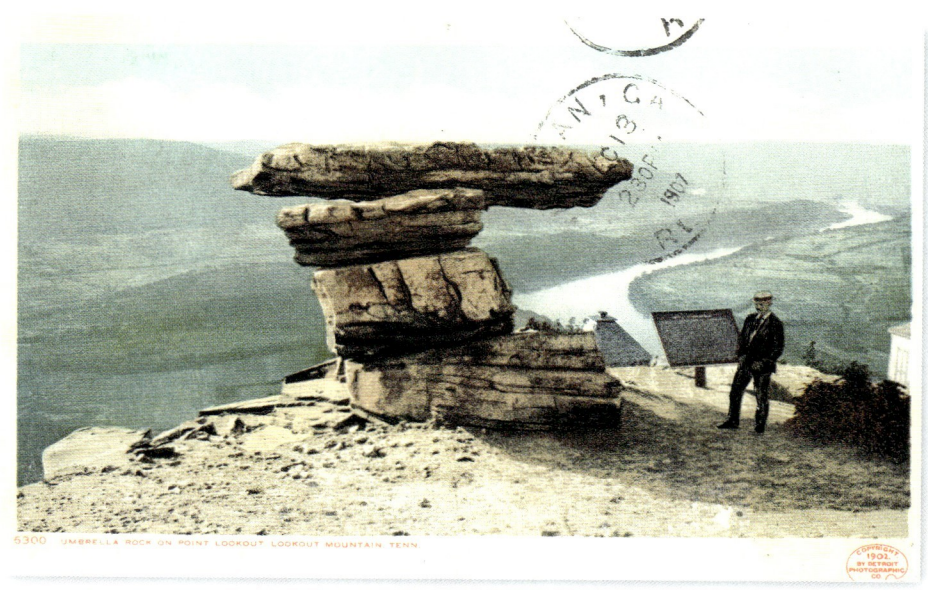

Page 374: **The cable incline up Lookout Mountain, photochrom**
Above: **Umbrella Rock on Point Lookout, Chattanooga**
Below: **Point Hotel and the battlefield, Lookout Mountain, photochrom**

In the 18th century, Chattanooga was a Cherokee village built at a creek at the foot of the cliffs of Lookout Mountain—the name Chattanooga meaning "get fish out of the water" in Cherokee. Three Civil War battles took place near Chattanooga in 1863: Chickamauga, Missionary Ridge, and Lookout Mountain.

Seite 374: **Die Zahnradbahn zum Lookout Mountain, Photochrom**
Oben: Der „Schirmfelsen" am Point Lookout, Chattanooga
Unten: **Das Point Hotel und das Schlachtfeld, Lookout Mountain, Photochrom**

Im 18. Jahrhundert war Chattanooga ein kleines Cherokee-Dörfchen in einer Bucht unterhalb der Felswand des Lookout Mountain – der Name „Chattanooga" bedeutet in der Sprache der Cherokee „den Fisch aus dem Wasser holen". Während des Sezessionskrieges wurden 1863 drei Schlachten um Chattanooga geschlagen: eine in Chickamauga, eine am Missionary Ridge und eine am Lookout Mountain.

Page 374 : **le chemin de fer à crémaillère de Lookout Mountain, photochrome**
Ci-dessus : **le « rocher parapluie » de Point Lookout, Chattanooga**
Ci-dessous : **le Point Hotel et le champ de bataille de Lookout Mountain, photochrome**

Chattanooga était au XVIIIe siècle un hameau Cherokee installé dans une crique, au pied des falaises de la Lookout Mountain – le nom « Chattanooga » signifie « sortir le poisson de l'eau » en langue Cherokee. Trois batailles eurent lieu autour de Chattanooga durant la guerre de Sécession en 1863 : à Chickamauga, à Missionary Ridge et à Lookout Mountain.

TENNESSEE | CHATTANOOGA

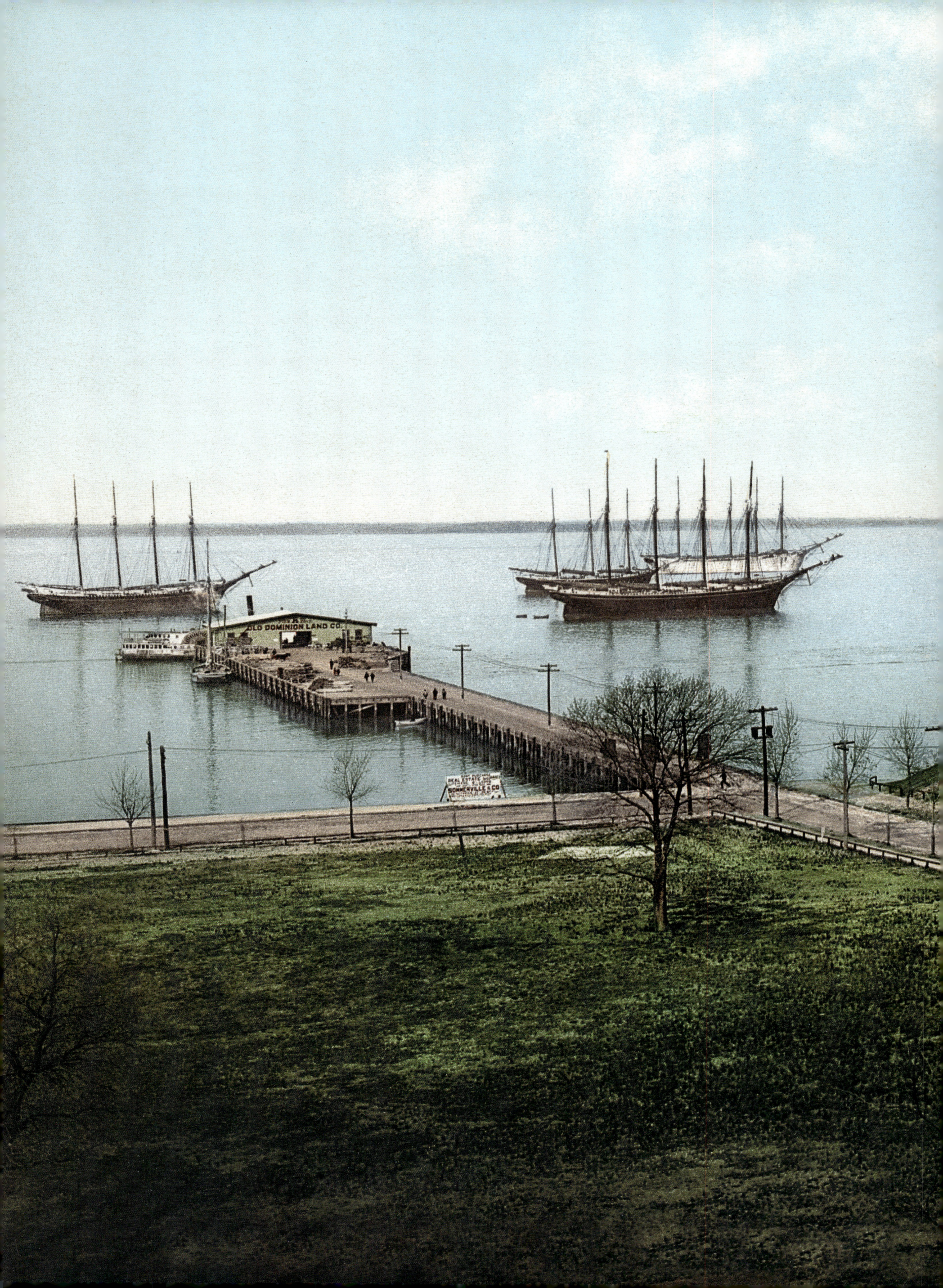

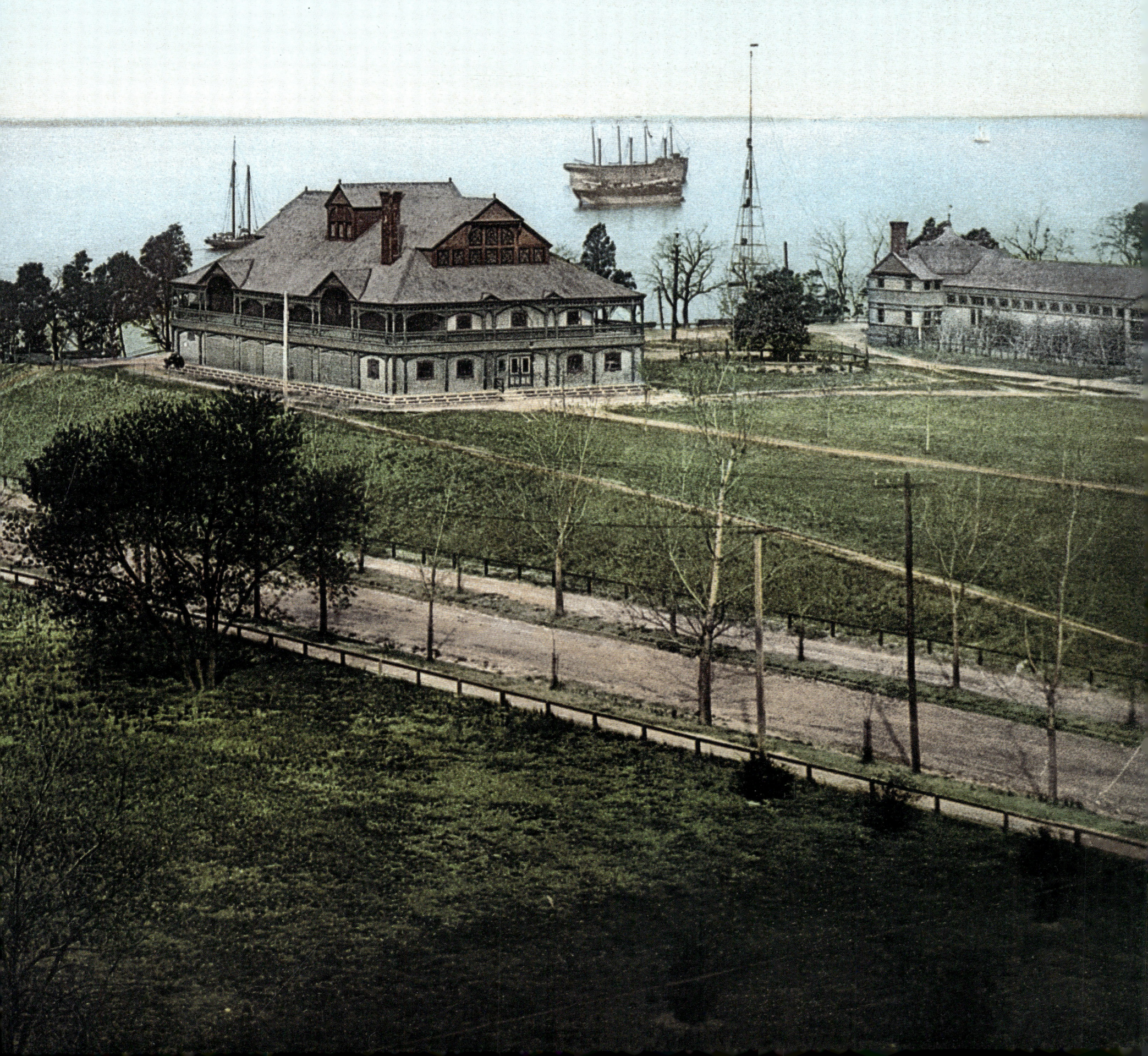

VIRGINIA

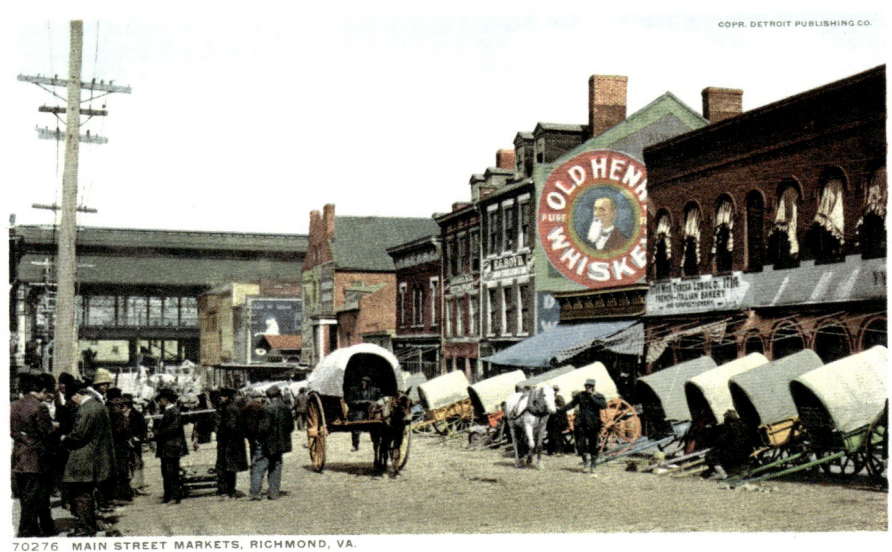
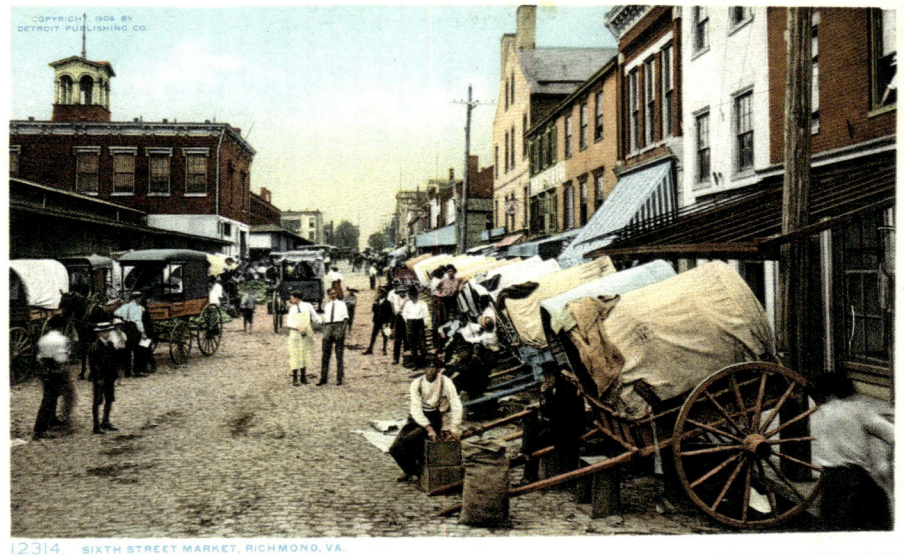

Page 376/377: Newport News, Warwick Casino, and the James River, photochrom
Top left: Main Street Market, Richmond
Top right: Sixth Street Market
Bottom: Sixth Street Market (typical vegetable men), glass negative, 1908

Seite 376/377: Newport News, Warwick Kasino und James River, Photochrom
Oben links: Markt auf der Main Street, Richmond
Oben rechts: Markt auf der Sixth Street
Unten: Markt auf der Sixth Street (typische Gemüsehändler), Glasnegativ, 1908

Pages 376/377 : Newport News, le Warwick Casino et la James River, photochrome
En haut à gauche : le marché de la rue Principale, Richmond
En haut à droite : le marché de la Sixième Rue
En bas : le marché de la 6ᵉ Rue (vendeurs de légumes), plaque de verre, 1908

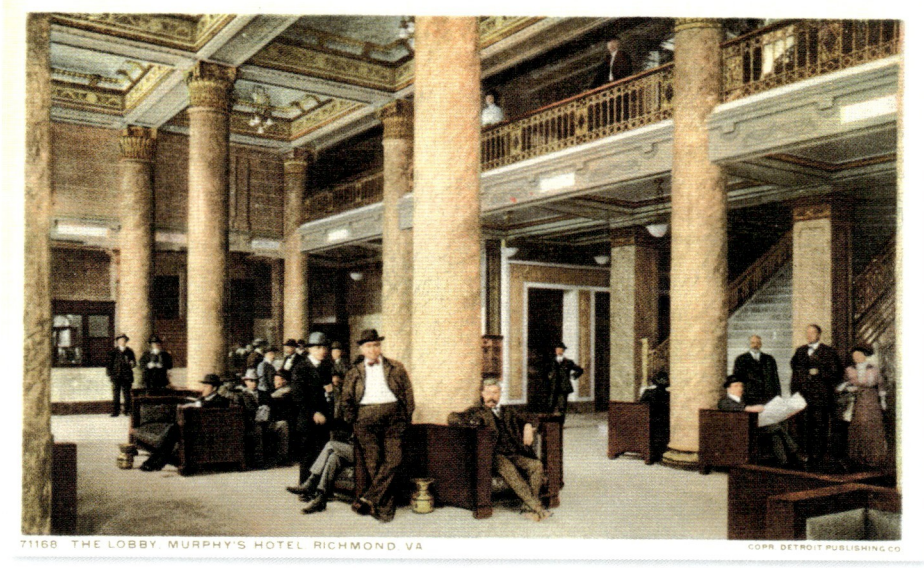

Above: **The lobby, Murphy's Hotel**
Below: **Emancipation Day, glass negative, 1905**

Richmond was one of the first places colonized by the English, who went up the James River from Jamestown in 1607. The town itself was founded in the middle of the 18th century. The capital of the Confederacy during the Civil War, Richmond was besieged and conquered on April 3, 1865, by Union troops. Emancipation Day takes on its full significance in this city of planters (they mostly cultivated tobacco), whose wealth was made on the backs of slaves from Africa. The parade of April 3, 1905, marked the 40th anniversary of the celebration of emancipation in Richmond and brought the entire African American community of the city and its surroundings together in a peaceful demonstration.

Oben: **Eingangshalle von Murphy's Hotel**
Unten: **Befreiungsfest, Glasnegativ, 1905**

Richmond war der erste 1607 von den Engländern, die den James River von Jamestown aufwärts fuhren, kolonisierte Ort; die Stadt selbst wurde in der Mitte des 18. Jahrhunderts gegründet. Richmond, im Sezessionskrieg Hauptstadt der Konföderierten, wurde von den Truppen der Union belagert und am 3. April 1865 erobert. Der Tag der Befreiung hatte für diese Stadt der (vor allem Tabak-) Plantagenbesitzer, die dank der afrikanischstämmigen Sklaven zu Reichtum gekommen waren, eine besondere Bedeutung. Die Parade vom 3. April 1905 – dem 40. Jahrestag der Befreiungsfeier in Richmond –, zu der sich die gesamte afroamerikanische Gemeinschaft der Stadt und des Umlands versammelt hatte, verlief friedlich.

Ci-dessus : **le hall de l'hôtel Murphy**
En bas : **fête de l'Émancipation, plaque de verre, 1905**

Le site de Richmond a été le premier colonisé par les Anglais, remontant la James River depuis Jamestown en 1607 ; la ville elle-même fut fondée au milieu du XVIIIe siècle. Capitale des Confédérés lors de la guerre de Sécession, Richmond fut assiégée et conquise le 3 avril 1865 par les troupes de l'Union. Le jour de l'Émancipation prend tout son sens dans cette ville de planteurs (de tabac, notamment) qui s'étaient enrichis grâce aux esclaves originaires d'Afrique. La parade du 3 avril 1905 – date du quarantième anniversaire de la célébration de l'Émancipation à Richmond –, qui rassembla toute la communauté afro-américaine de la ville et de ses environs, se déroula dans un calme impressionnant.

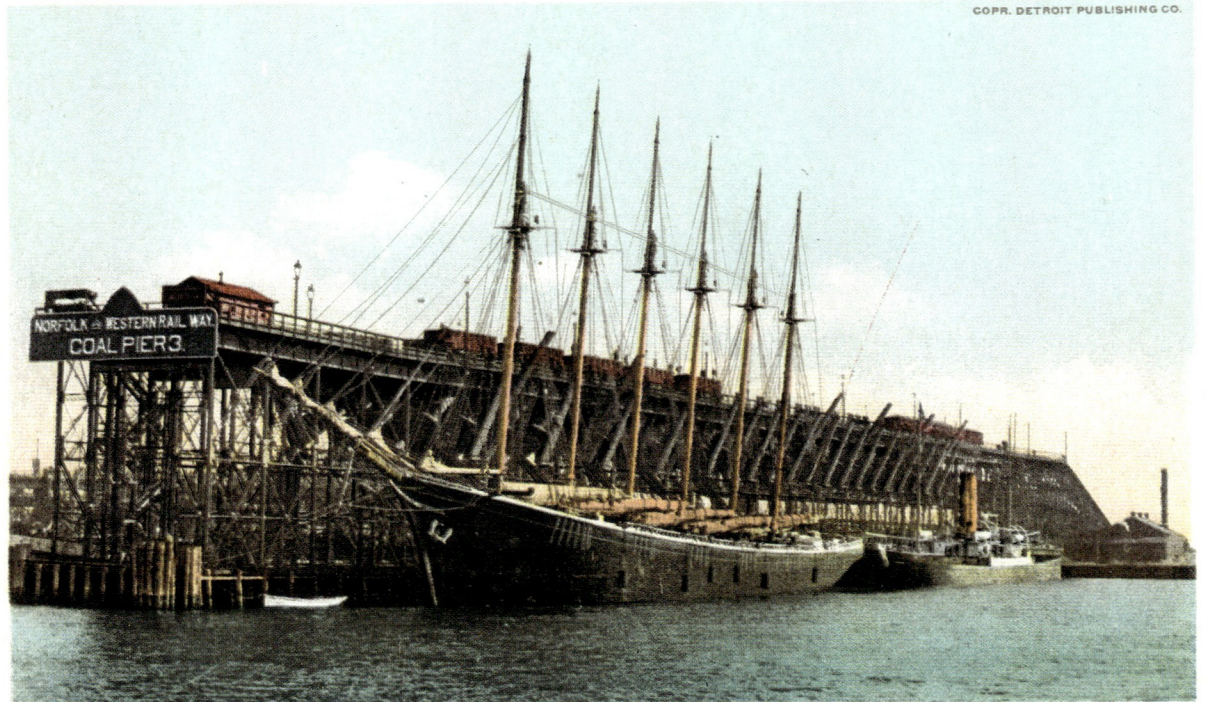

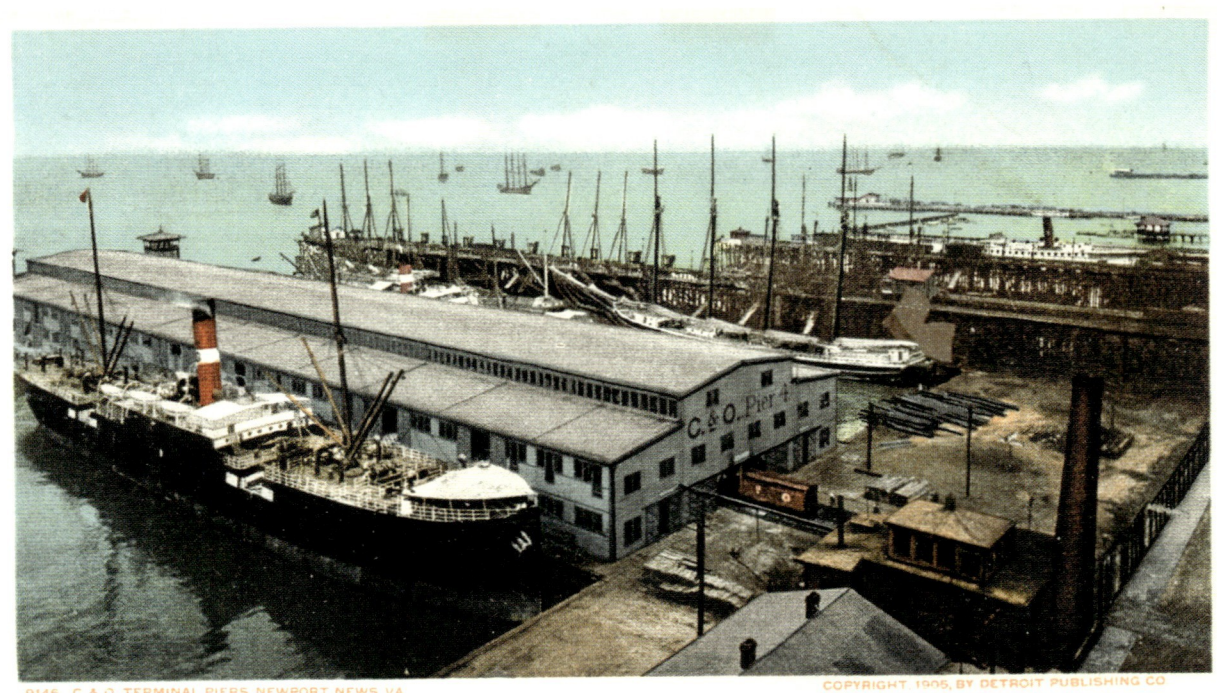

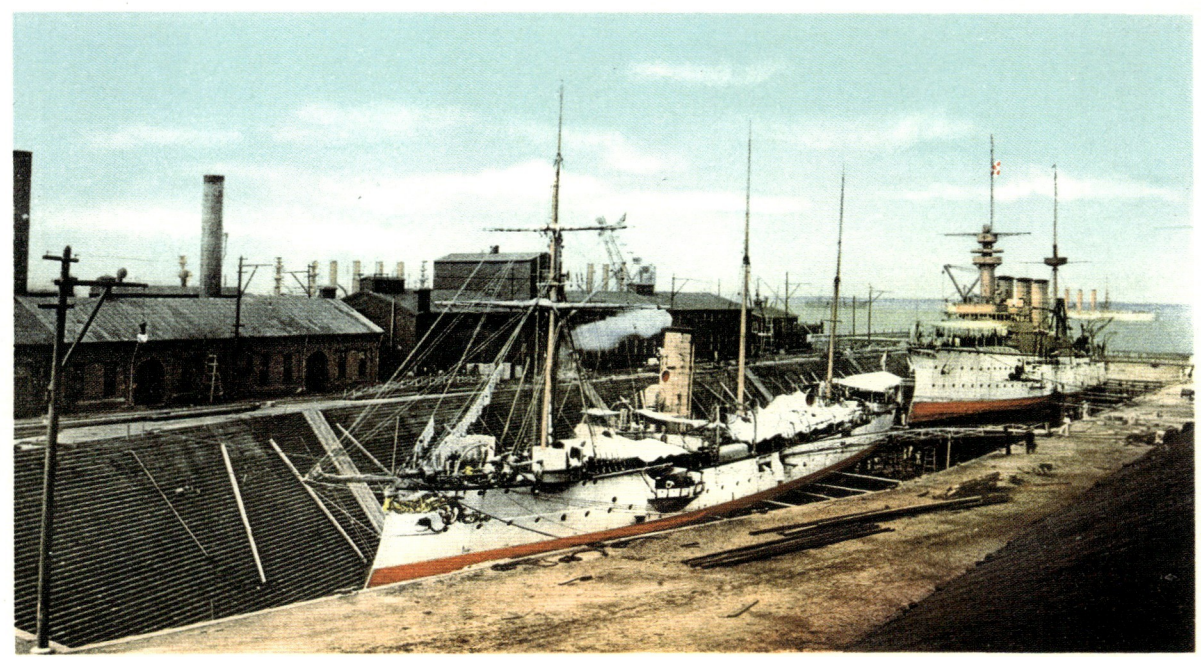

From top to bottom:
Norfolk and Western coal piers, Norfolk
C & O (Chesapeake & Ohio Railway) terminal piers, Newport News
The big dry docks, Newport News shipyard

Von oben nach unten:
Kohleverladeeinrichtung der Norfolk and Western, Norfolk
Terminal der Eisenbahngesellschaft C & O (Chesapeake & Ohio Railway), Newport News
Die großen Trockendocks, Schiffswerft Newport News

De haut en bas :
Le ponton des charbonnages Norfolk and Western, Norfolk
Terminal de la compagnie de chemin de fer C & O (Chesapeake & Ohio Railway), Newport News
Les grandes cales sèches, chantiers navals de Newport News

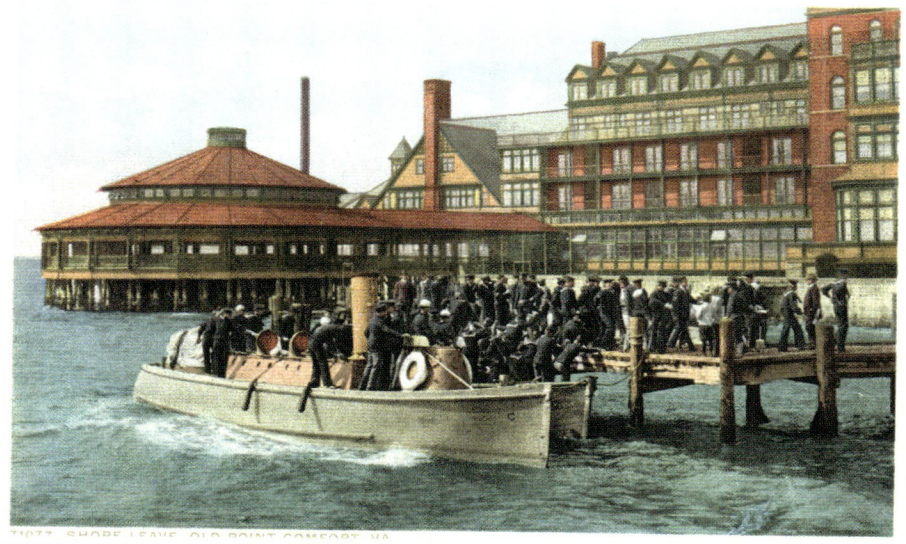
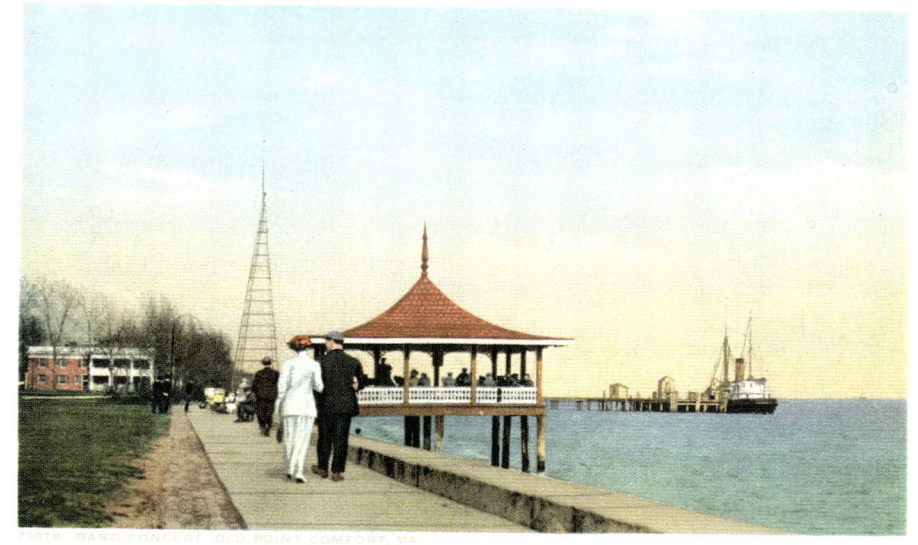

Top left: Shore leave, Old Point Comfort
Top right: Band concert, Old Point Comfort
Bottom: USS *New York*, band going aboard at Hampton Roads, between 1893 and 1901
Page 382/383: Fortress Monroe, Old Point Comfort, photochrom

Constructed in 1834 to secure the fairway between Chesapeake Bay and Hampton Roads, Fort Monroe was occupied by the Union army at the outset of the Civil War in an attempt to prevent its seizure by the Confederates. Union troops then burned down Norfolk's shipyards; the Confederates occupied the devastated site and reequipped it. The fort subsequently served as a refuge for fugitive slaves. It was decommissioned in 2011.

Oben links: Ankunft in Old Point Comfort
Oben rechts: Konzert im Pavillon, Old Point Comfort
Unten: Das Orchester der USS *New York* geht in Hampton Roads an Bord, zwischen 1893 und 1901
Seite 382/383: Die Festung Monroe, Old Point Comfort, Photochrom

Die 1834 zur Sicherung der Fahrrinne zwischen der Chesapeake Bay und Hampton Roads errichtete Festung Monroe wurde seit Beginn des Sezessionskrieges von der Unionsarmee mit dem Ziel besetzt, ihre Einnahme durch die Konföderierten zu verhindern. Die Streitkräfte der Union setzten schließlich die Schiffswerften von Norfolk in Brand; die Konföderierten besetzten das verwüstete Terrain und bauten es wieder auf. Die Festung diente danach als Rückzugsort für entflohene Sklaven. 2011 verlor Fort Monroe seine militärische Funktion.

En haut à gauche : l'arrivée à Old Point Comfort
En haut à droite : concert sous le kiosque, Old Point Comfort
En bas : l'orchestre du navire USS *New York*, embarquant à Hampton Roads, entre 1893 et 1901
Pages 382/383 : la forteresse Monroe, Old Point Comfort, photochrome

Construite en 1834 pour sécuriser le chenal compris entre la baie de Chesapeake et Hampton Roads, la forteresse militaire Monroe fut occupée par l'armée fédérale dès le début de la guerre de Sécession, dans le but d'empêcher les Confédérés de s'en emparer. Les forces de l'Union incendièrent ensuite les chantiers navals de Norfolk ; les Confédérés occupèrent le terrain dévasté qu'ils réarmèrent. Le fort servit ensuite de refuge aux esclaves fuyant leur condition. Le fort Monroe a été désarmé en 2011.

VIRGINIA | OLD POINT COMFORT

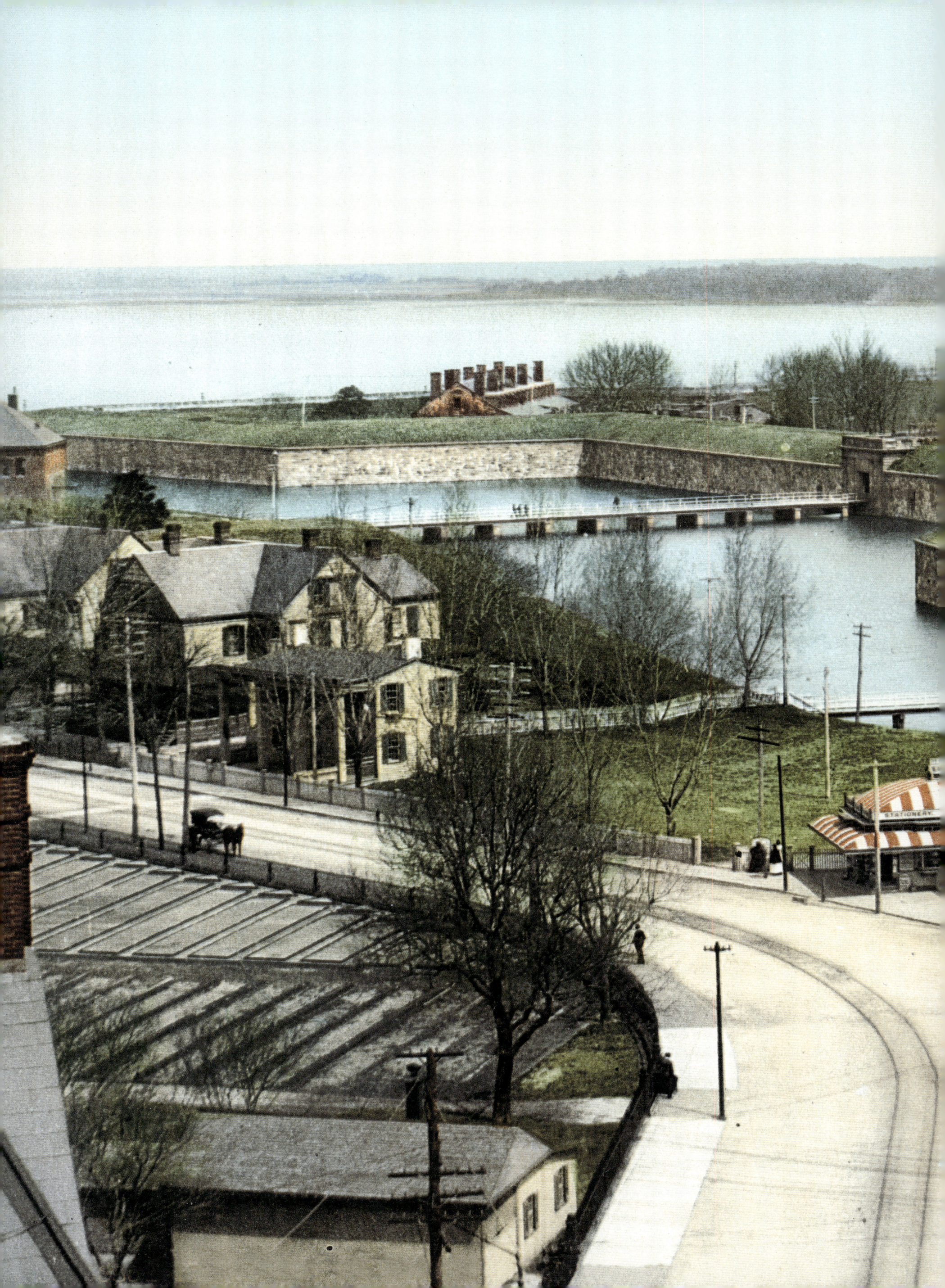

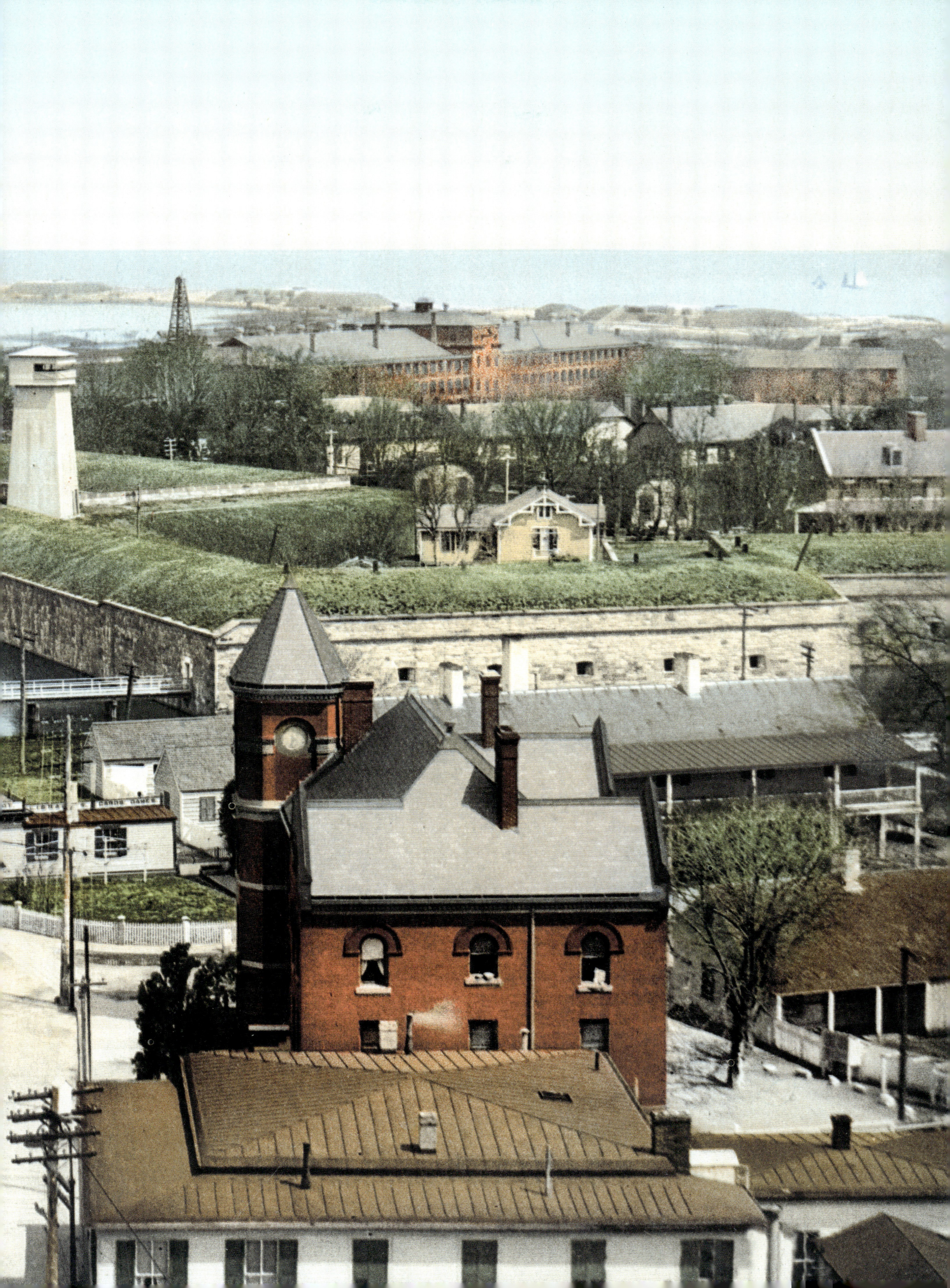

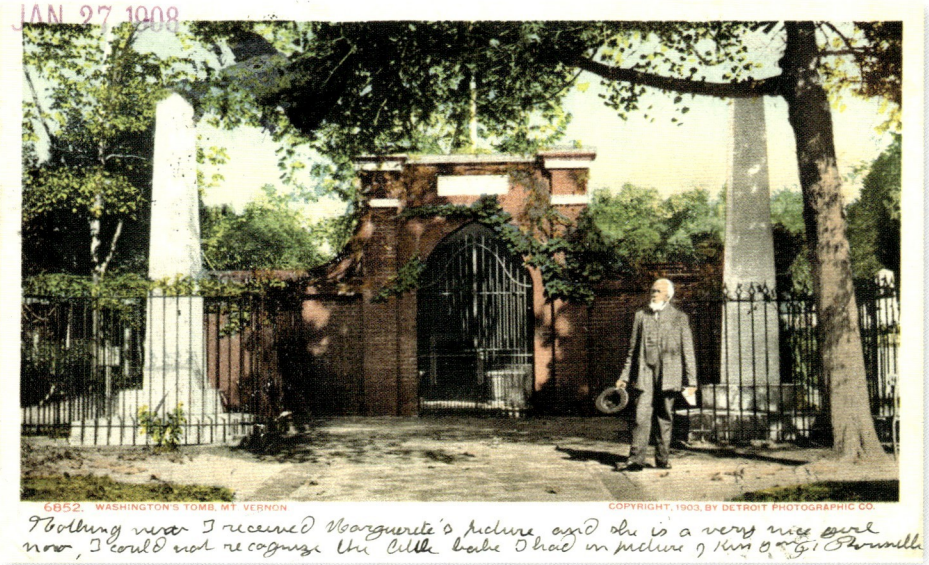

Top left: Washington's Tomb, Mt. Vernon
Top right: Bowling green at Mount Vernon
Bottom: Mt. Vernon, the mansion, photochrom

Mount Vernon came into George Washington's hands between 1754 and 1757, the plantation having previously been owned by his half-brother Lawrence. He had the main house entirely reconstructed; the architect was probably John Ariss, who also built Paynes Church in neighboring Fairfax County. Over the 40 years following his acquisition of the property, Washington took pains to improve the estate, introducing new crops and building a whiskey distillery. George and Martha Washington lie in the tomb built in 1831, after Washington's death, and according to his will.

Oben links: Das Grab Washingtons, Mount Vernon
Oben rechts: Der Bowling Green von Mount Vernon
Unten: Mount Vernon, das Anwesen, Photochrom

Zwischen 1754 und 1757 wurde George Washington zum Eigentümer von Mount Vernon, der Plantage seines Halbbruders Lawrence. Er ließ das Hauptgebäude vollständig neu errichten. Der Architekt, auf den das neue Gebäude zurückging, war vermutlich John Ariss, der leitende Architekt der Paynes Church im benachbarten Fairfax County. Während der 40 Jahre nach dem Ankauf von Mount Vernon war Washington sehr daran gelegen, sein Anwesen so auszubauen, dass neue Nutzpflanzen Eingang fanden, und eine Whiskeybrennerei entstand. George und Martha Washington sind in der Grabstätte beigesetzt, die seinem Testament entsprechend nach dem Tod des ehemaligen Präsidenten 1831 errichtet wurde.

En haut à gauche : le tombeau de Washington, Mount Vernon
En haut à droite : le Bowling Green de Mount Vernon
En bas : Mount Vernon, la maison, photochrome

C'est entre 1754 et 1757 que George Washington devient propriétaire de Mount Vernon, la plantation de son demi-frère Lawrence. Il fait alors reconstruire entièrement la maison principale. L'architecte à qui l'on doit le nouveau bâtiment est sans doute John Ariss, maître d'œuvre de l'église de Paynes dans le comté voisin de Fairfax. Pendant les quarante années qui suivirent l'acquisition de Mount Vernon, Washington eut à cœur d'aménager sa propriété, introduisant de nouvelles cultures, installant une distillerie de whisky. George et Martha Washington reposent dans le tombeau édifié, après la mort et selon la volonté de l'ancien président, en 1831.

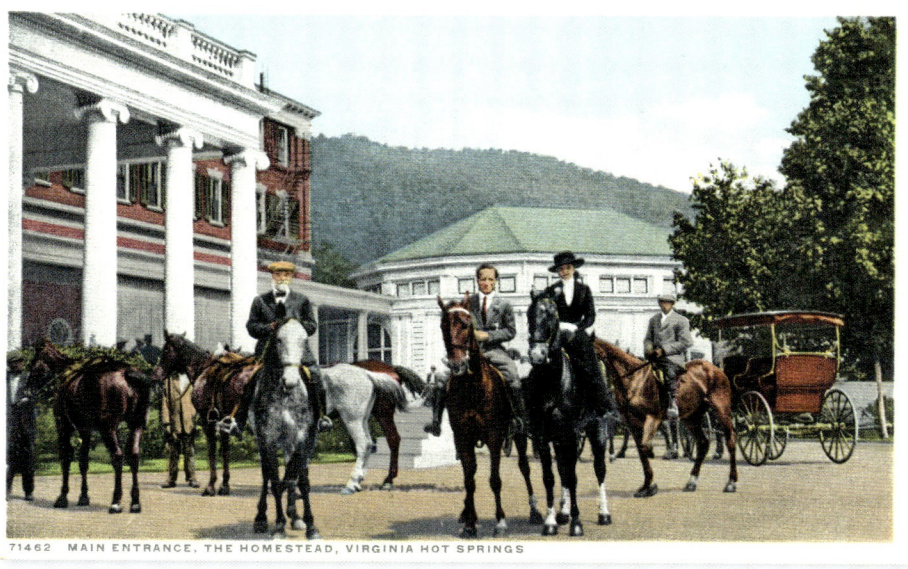
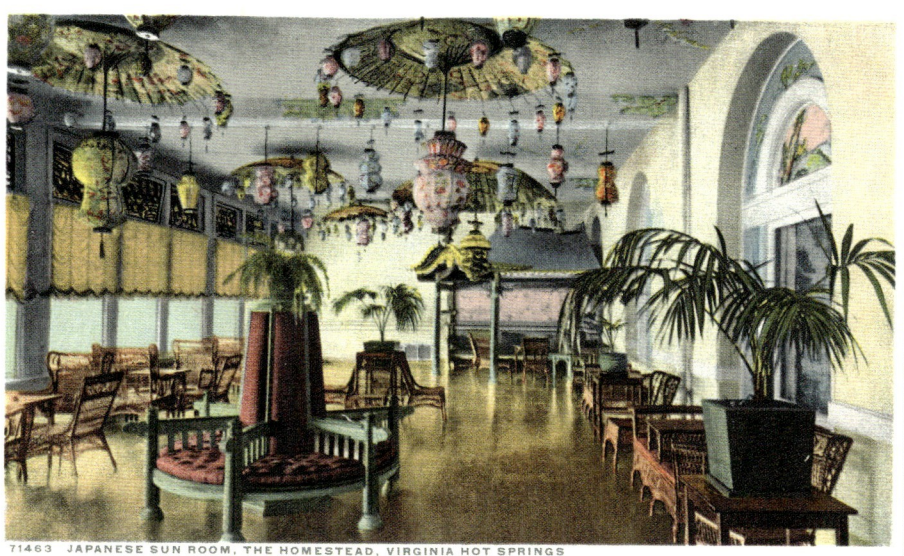

From top to bottom and left to right:
The Homestead from Sunset Hill
Main entrance of the Homestead
The Japanese sun parlor (postcard and original glass negative), ca. 1905–1910

Von oben nach unten und von links nach rechts:
Das Hotel Homestead von Sunset Hill aus
Haupteingang des Hotels Homestead
Die japanische Veranda im Hotel Homestead (Postkarte und Original-Glasnegativ), um 1905–1910

De haut en bas et de gauche à droite :
L'hôtel Homestead depuis la colline de Sunset Hill
L'entrée principale de l'hôtel Homestead
La véranda japonaise du Homestead (carte postale et plaque de verre originale), vers 1905–1910

VIRGINIA | HOT SPRINGS

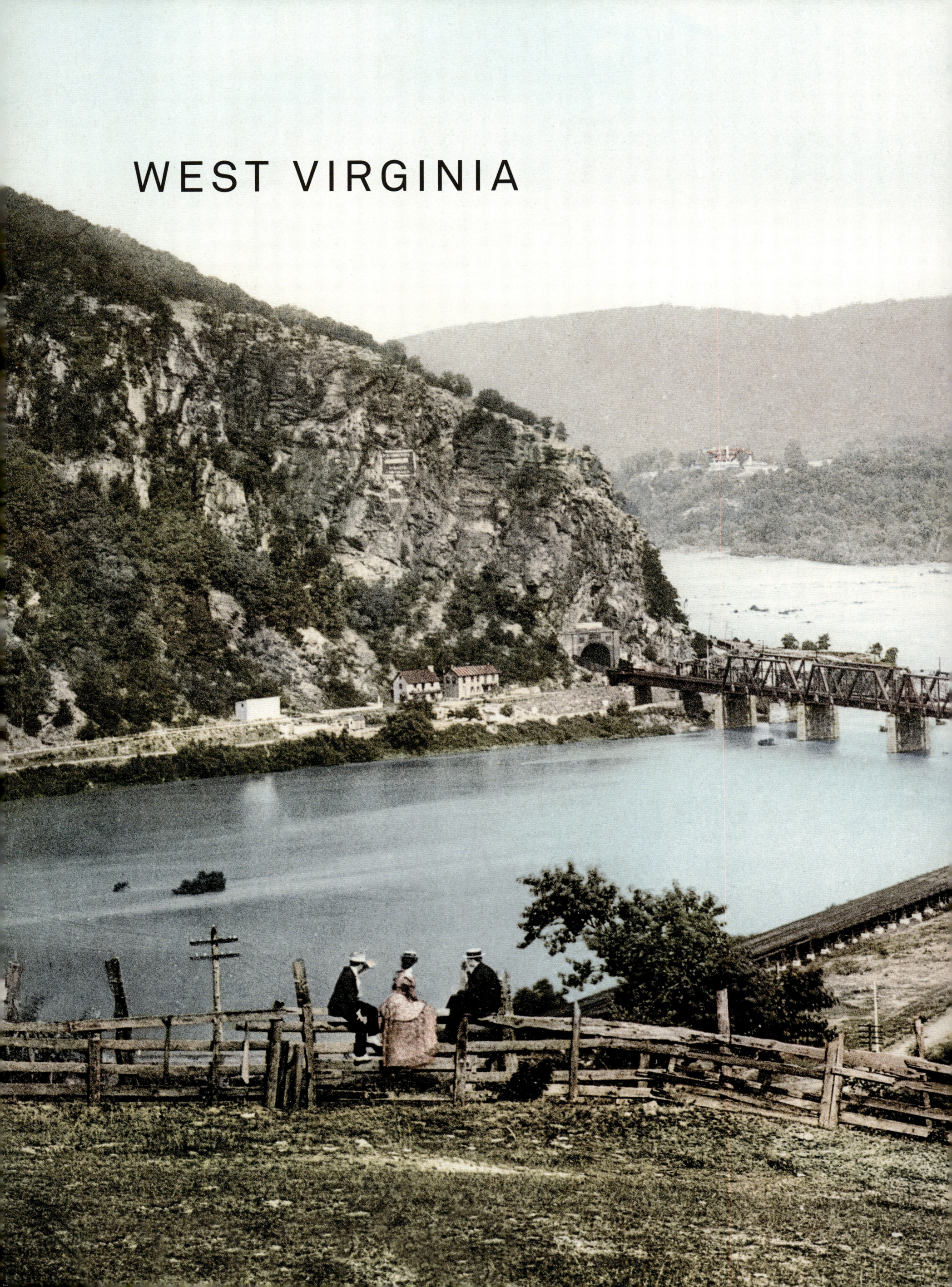
WEST VIRGINIA

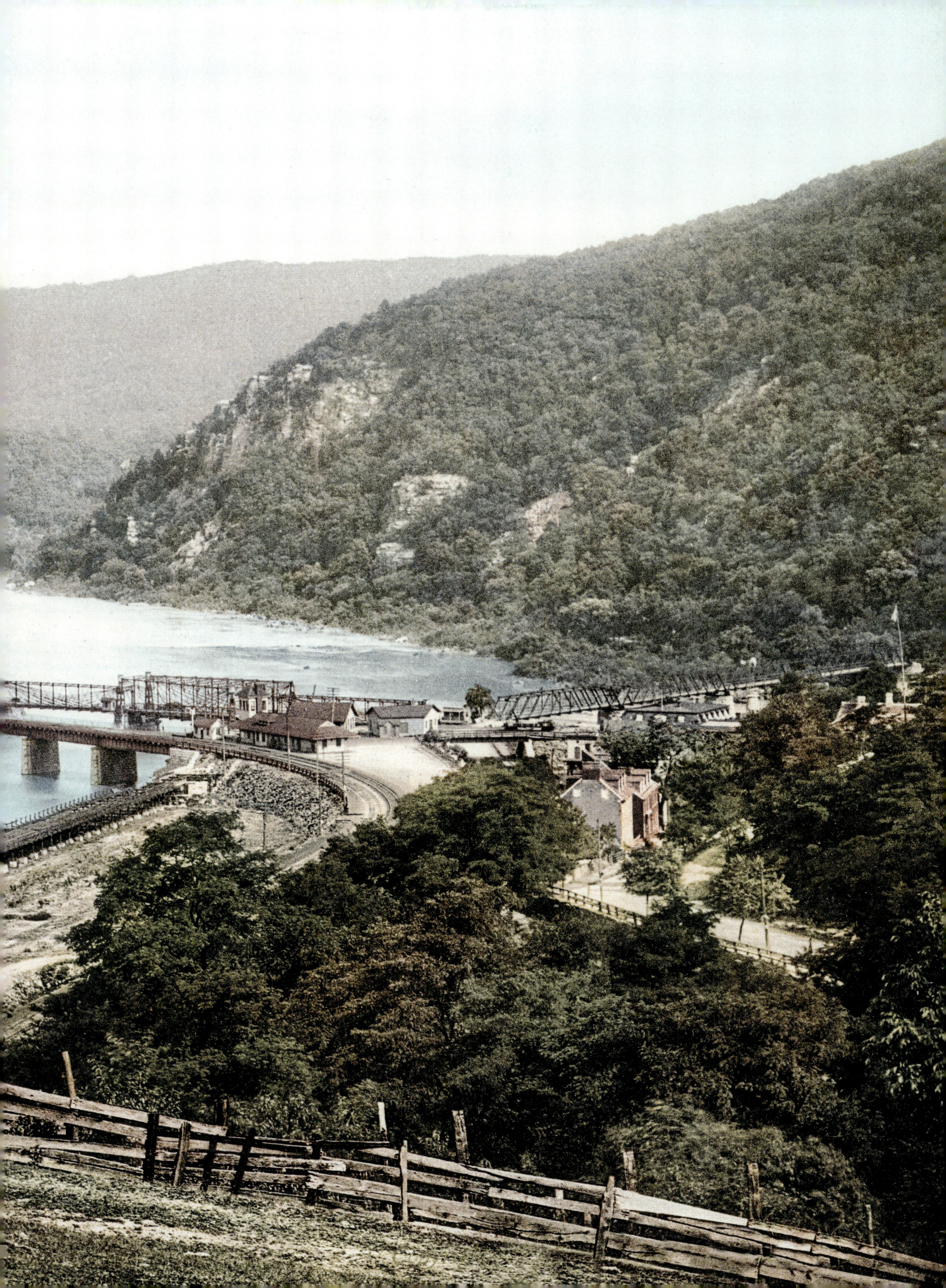

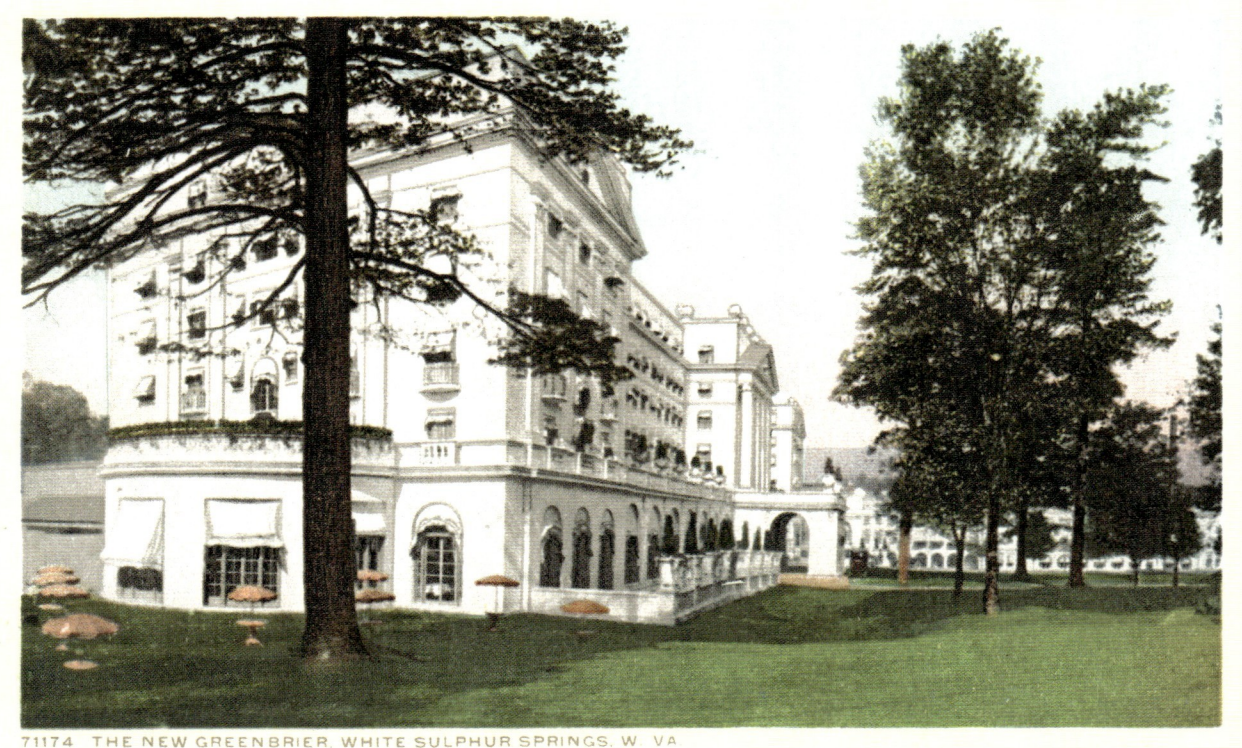

71174 THE NEW GREENBRIER, WHITE SULPHUR SPRINGS, W. VA.

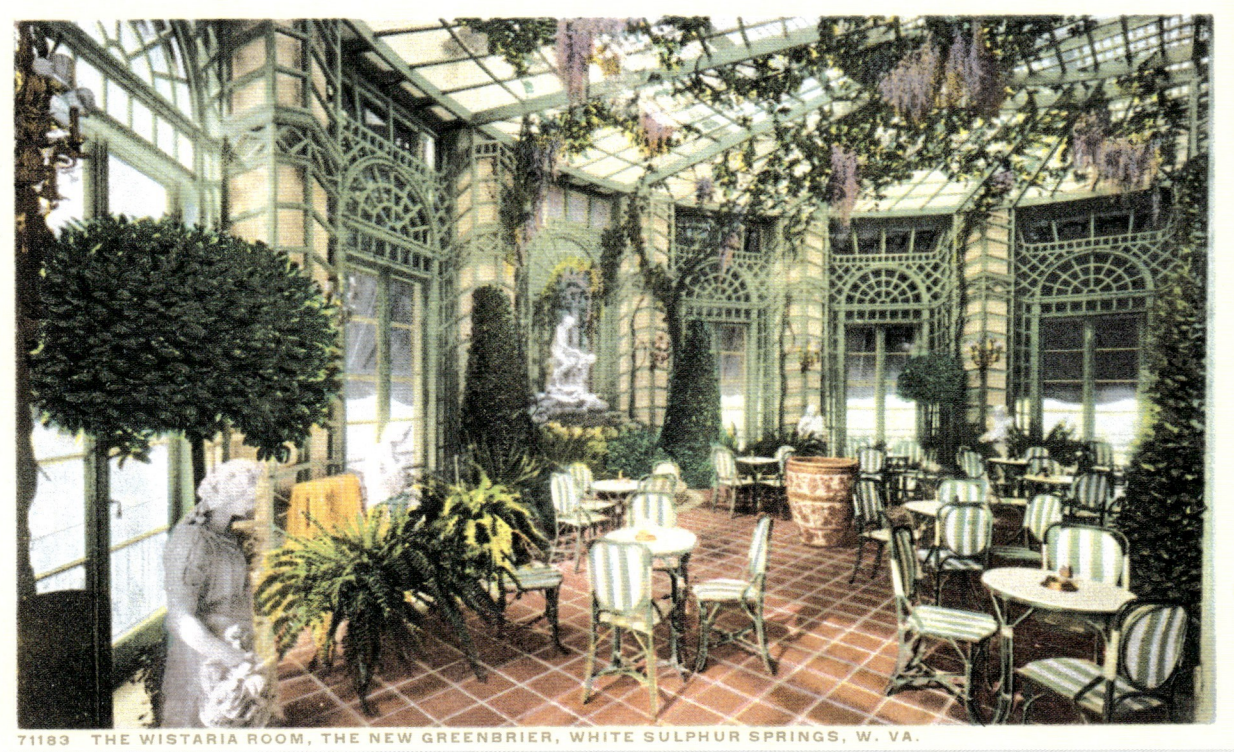

71183 THE WISTARIA ROOM, THE NEW GREENBRIER, WHITE SULPHUR SPRINGS, W. VA.

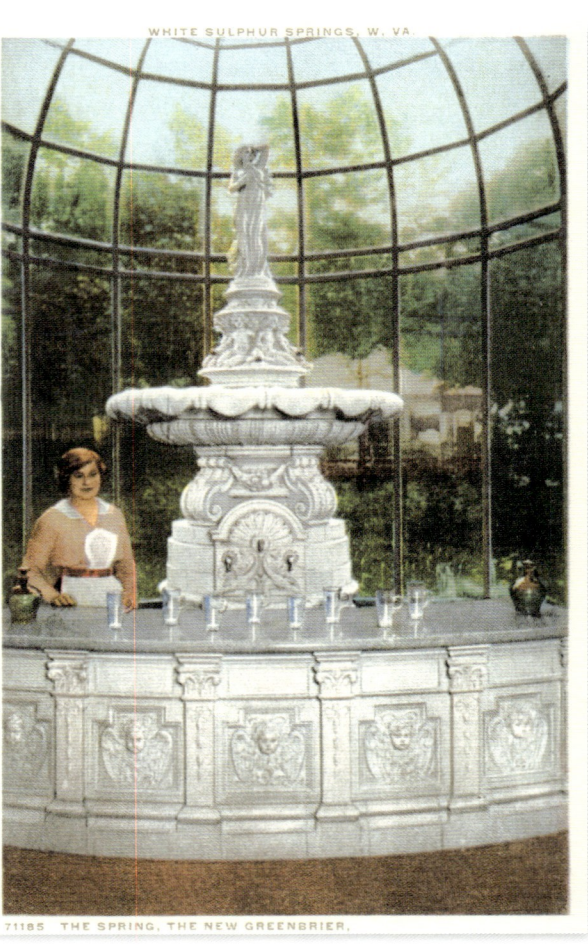

71185 THE SPRING, THE NEW GREENBRIER.

Page 386/387: Harper's Ferry, photochrom
Top: The New Greenbrier, White Sulphur Springs
Above: The New Greenbrier, the Wistaria (wisteria) room
Right: The New Greenbrier, the spring
Page 389: The swimming pool of the New Greenbrier, postcard and glass negative, 1910

In 1859, a commando directed by abolitionist John Brown seized the federal arsenal at Harper's Ferry. The company commanded by Robert E. Lee, future commander of the Confederate army, attacked the arsenal and arrested Brown and his followers. The episode was a contributing factor in the outbreak of the Civil War.
The Greenbrier Hotel is a luxurious colonial-style establishment that opened in 1910 in the White Sulphur Springs spa town. It remains one of the most prestigious hotels in the United States.

Seite 386/387: Harper's Ferry, Photochrom
Oben: Das Hotel New Greenbrier in White Sulphur Springs
Mitte: Der Glyziniensaal im Hotel New Greenbrier
Rechts: Der Brunnen des Hotels New Greenbrier
Seite 389: Das Schwimmbad im Hotel New Greenbrier, Postkarte und Glasnegativ, 1910

1859 eroberte ein von dem Sklaveneigner John Brown geleitetes Kommando das Waffenarsenal von Harper's Ferry. Eine Kompanie unter dem Kommando von Robert Lee, dem späteren General der Konföderierten-Armee, griff Brown an und nahm ihn und seine Mitstreiter fest. Diese Episode gehörte zu den Auslösern des Sezessionskrieges.
Das luxuriöse, im Kolonialstil errichtete Hotel Greenbrier öffnete 1910 seine Pforten in dem Thermalbad White Sulphur Springs. Es ist noch immer eines der prächtigsten Luxushotels der Vereinigten Staaten.

Pages 386/387 : Harper's Ferry, photochrome
En haut : l'hôtel New Greenbrier à White Sulphur Springs
Ci-dessus : la salle aux glycines du New Greenbrier
À droite : la buvette de l'hôtel New Greenbrier
Page 389 : la piscine de l'hôtel New Greenbrier, carte postale et plaque de verre, 1910

En 1859, un commando dirigé par l'anti-esclavagiste John Brown s'empara de l'arsenal fédéral de Harper's Ferry. Une compagnie commandée par Robert Lee, futur général de l'armée des Confédérés, donna l'assaut et arrêta Brown et ses comparses. Cet épisode est à l'origine de la guerre de Sécession.
Luxueux établissement de style colonial, l'hôtel Greenbrier ouvrit ses portes en 1910 dans la station thermale de White Sulphur Springs. C'est toujours l'un des palaces les plus prestigieux des États-Unis.

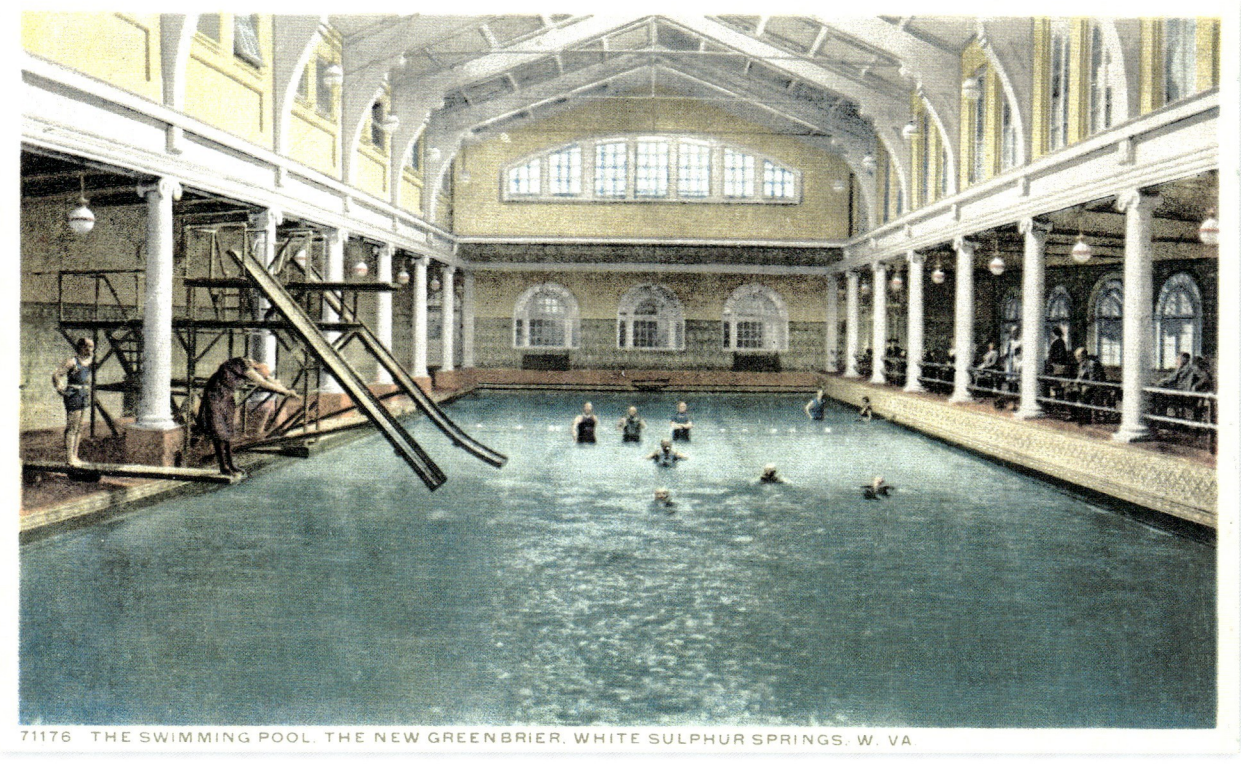

71176 THE SWIMMING POOL, THE NEW GREENBRIER, WHITE SULPHUR SPRINGS, W. VA.

WEST VIRGINIA | WHITE SULPHUR SPRINGS

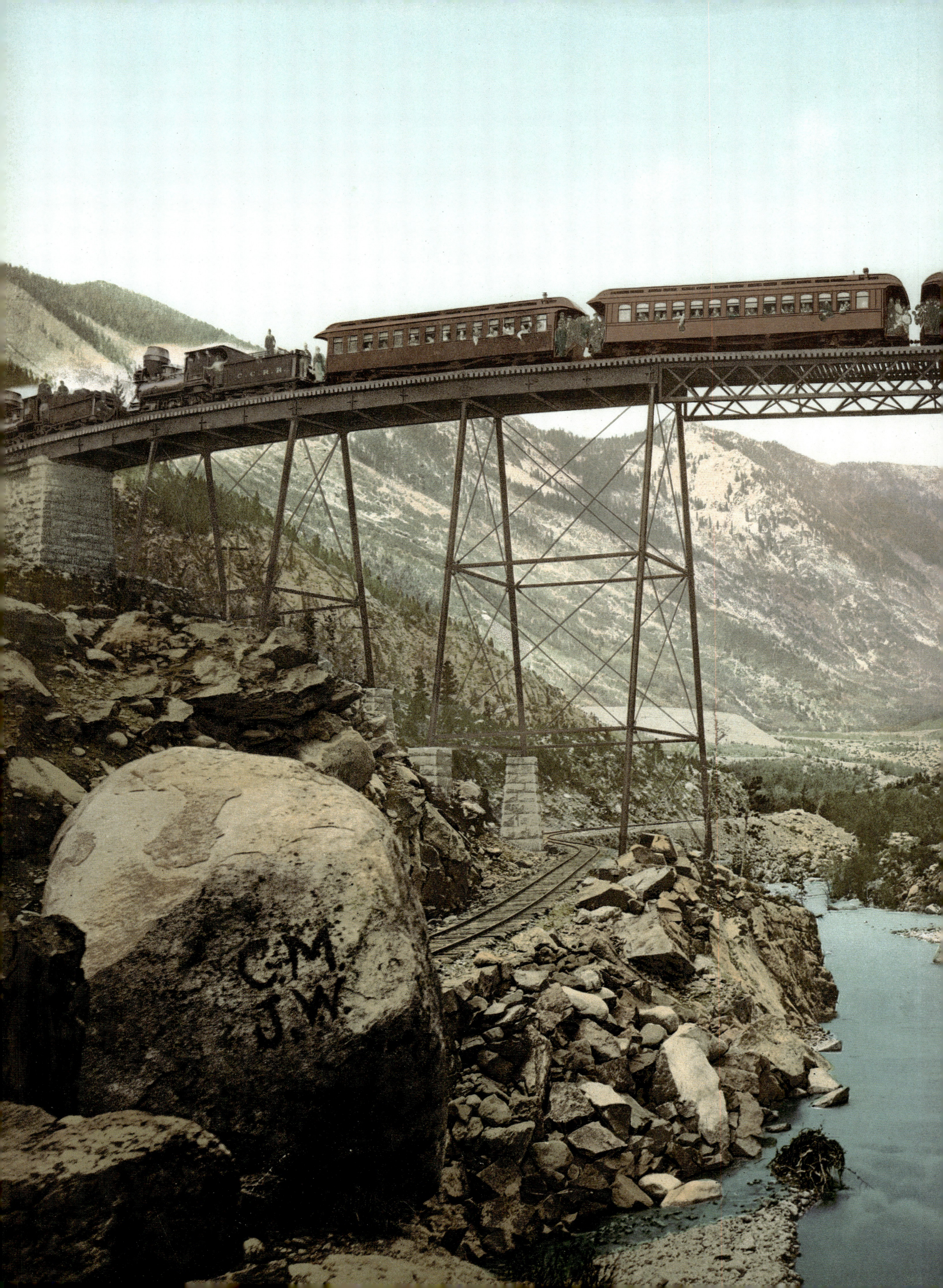

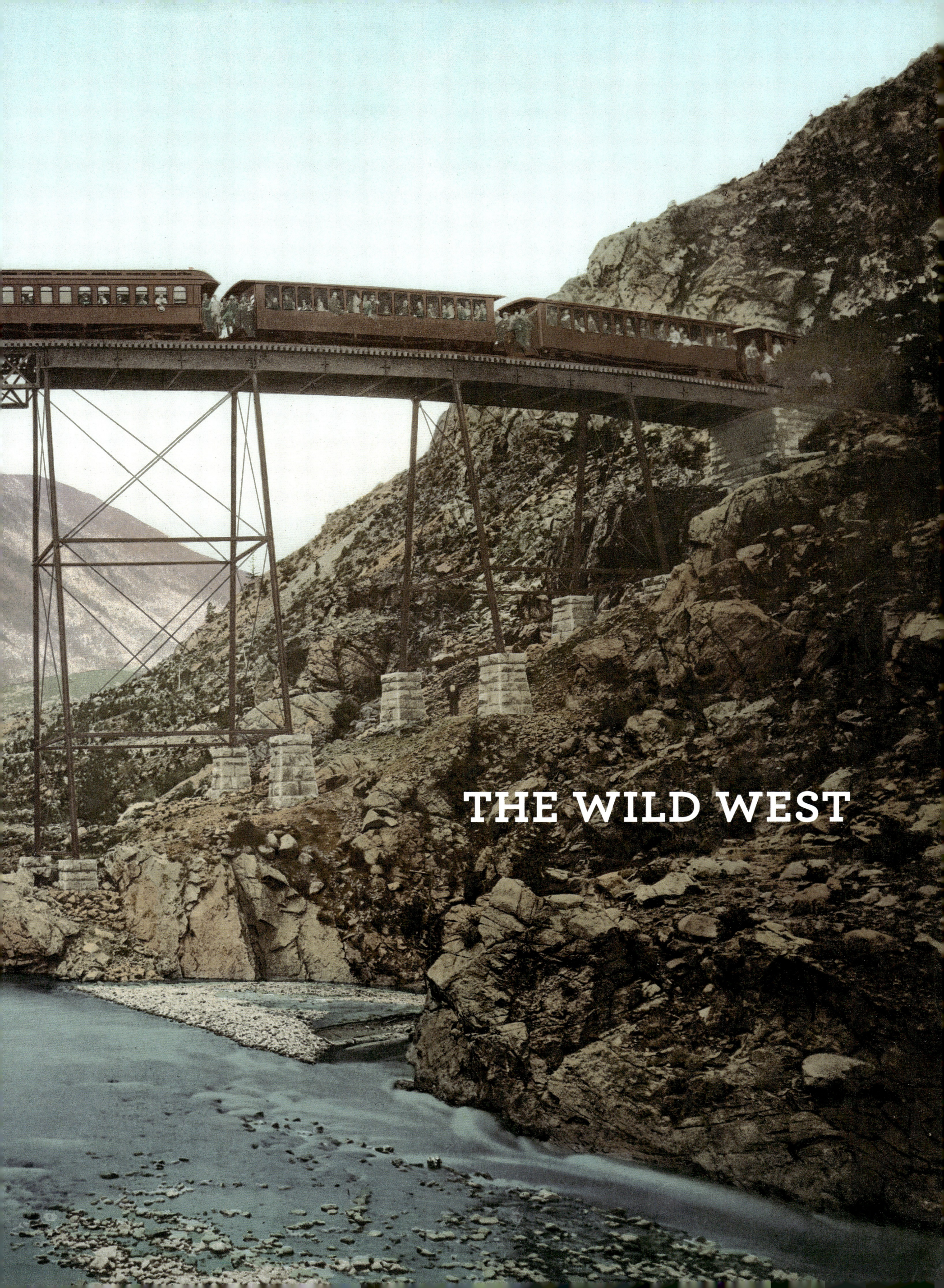
THE WILD WEST

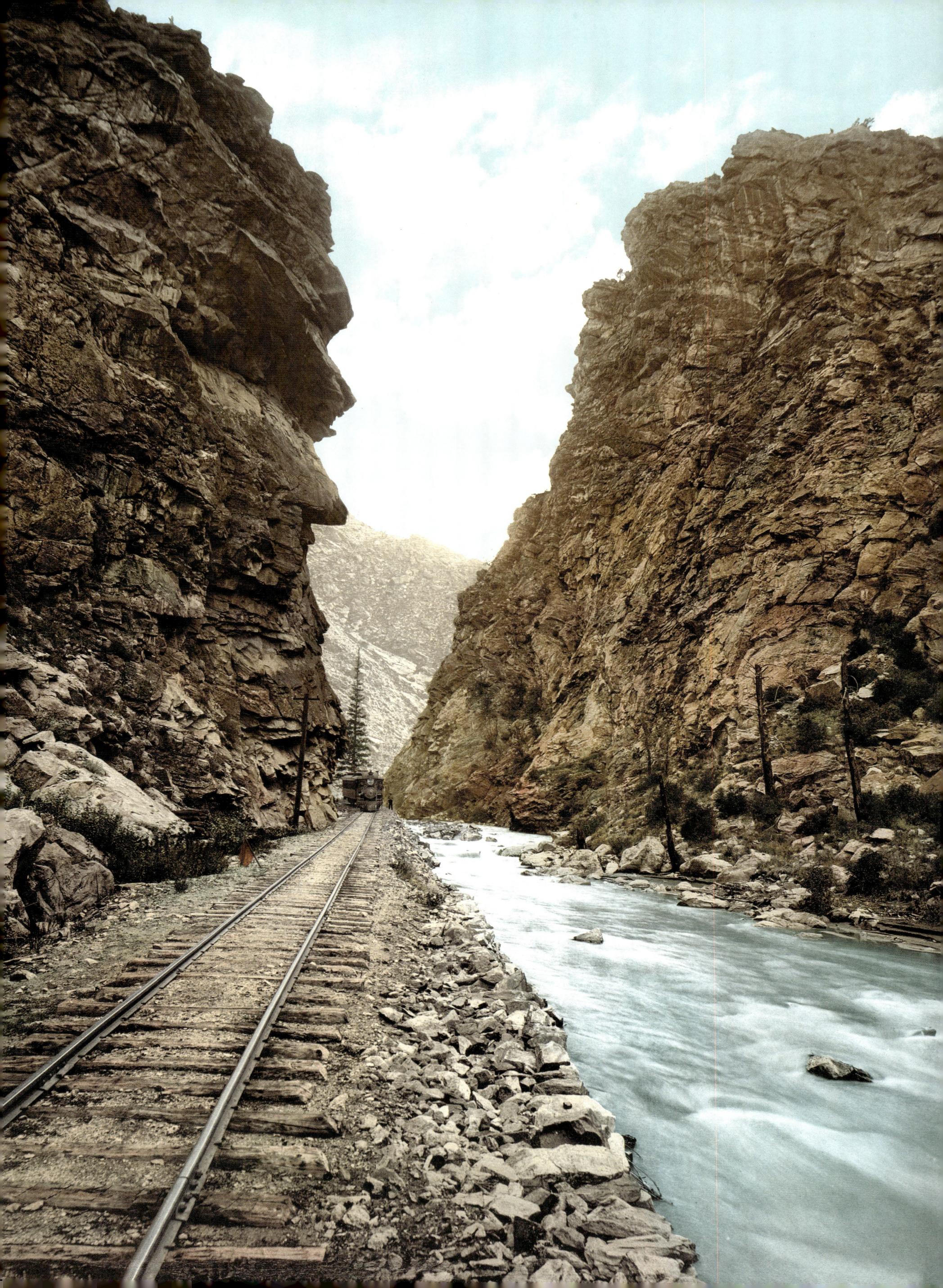

Page 390/391: Clear Creek Canyon, Georgetown Loop, Colorado, photochrom
Page 392: Clear Creek Canyon, photochrom
Right: The "cow-boy girl"

Seite 390/391: Clear Creek Canyon, Georgetown Loop (Schleife), Colorado, Photochrom
Seite 392: Clear Creek Canyon, Photochrom
Rechts: „Cowboy-Mädchen"

Pages 390/391: Clear Creek Canyon, le virage de Georgetown, Colorado, photochrome
Page 392: Clear Creek Canyon, photochrome
À droite: la «fille cow-boy»

THE WILD WEST

Four hundred years after the discovery of the American continent, the Wild West had finally been pacified. This included all the land west of the Mississippi from the Rio Grande to the Rockies and from the Rockies to the Pacific. The "frontier," that "continually advancing frontier line" showing the "meeting point between savagery and civilization"—so defined in 1893 by Professor Frederick Jason Turner in *The Annual Report of the American Historical Association*—no longer existed and the last states to enter the Union, with the sole exception of Alaska and Hawaii, were the Indian Territory of Oklahoma (1907), Arizona, and New Mexico (the latter two in 1912). The era of the pioneers was at an end, the very last wagons laden with settlers were following the course of the railways, and the buffalo had been largely exterminated. Consigned to the least productive land, the surviving Indians were impotent witnesses to the disappearance of their natural environment, much of which was swallowed up by urban expansion, intensive agriculture in the Great Plains, and the creation of the national parks of Yellowstone (1872), Sequoia and Yosemite (1890), and, finally, the Grand Canyon (1919). As the sands ran out for this epoch of American history, nostalgia for it began and the legend of the West was born.

An entire folklore came into being, popularized by songs, plays, and, subsequently, by the first silent Western movies. In 1903, *The Great Train Robbery*, a 12-minute film, appeared; its star was Gilbert M. "Broncho Billy" Anderson, soon to become the star of the genre. Audiences were thrilled by the exploits of the trapper Davy Crockett (1786–1836), "the first living and original god of the pantheon of the great forests to the west of the Appalachians" (Jean-Louis Rieupeyrout, *La Grande Aventure du Far West,* 1969) and by the more dubious exploits of outlaws such as William Bonney, a.k.a. Billy the Kid (1859–1881), "dead at twenty-one after having killed twenty-one men...," or Samuel Bass, known as Sam Bass, king of the hold-up, who was killed by the Texas Rangers in 1878.

But the great hero of the Far West, whose legend spread throughout the world, was, of course, William F. Cody, known as Buffalo Bill. This former bison hunter for the Kansas City Railway organized in 1883 a popular spectacle, "Buffalo Bill's Wild West Show," whose participants notably included the Sioux Indian chief Sitting Bull. In 1886 in New York, a million people went to see the show; in 1893, the show was performed in the context of the World's Columbian Exposition in Chicago; in 1905, it crossed the Atlantic and was performed in Paris at the foot of the Eiffel Tower. Though the staging of the show was undoubtedly impressive—"Down to its smallest details, the show is genuine," as Mark Twain wrote in a letter to Cody in 1884—it was controversial in systematically representing Native Americans as aggressors. Spreading the idea that Native Americans were nothing more than hostile warriors was by no means innocuous in a time and place where the *Nebraska City Press*, for example, was still proclaiming "we should exterminate the whole fraternity of redskins."

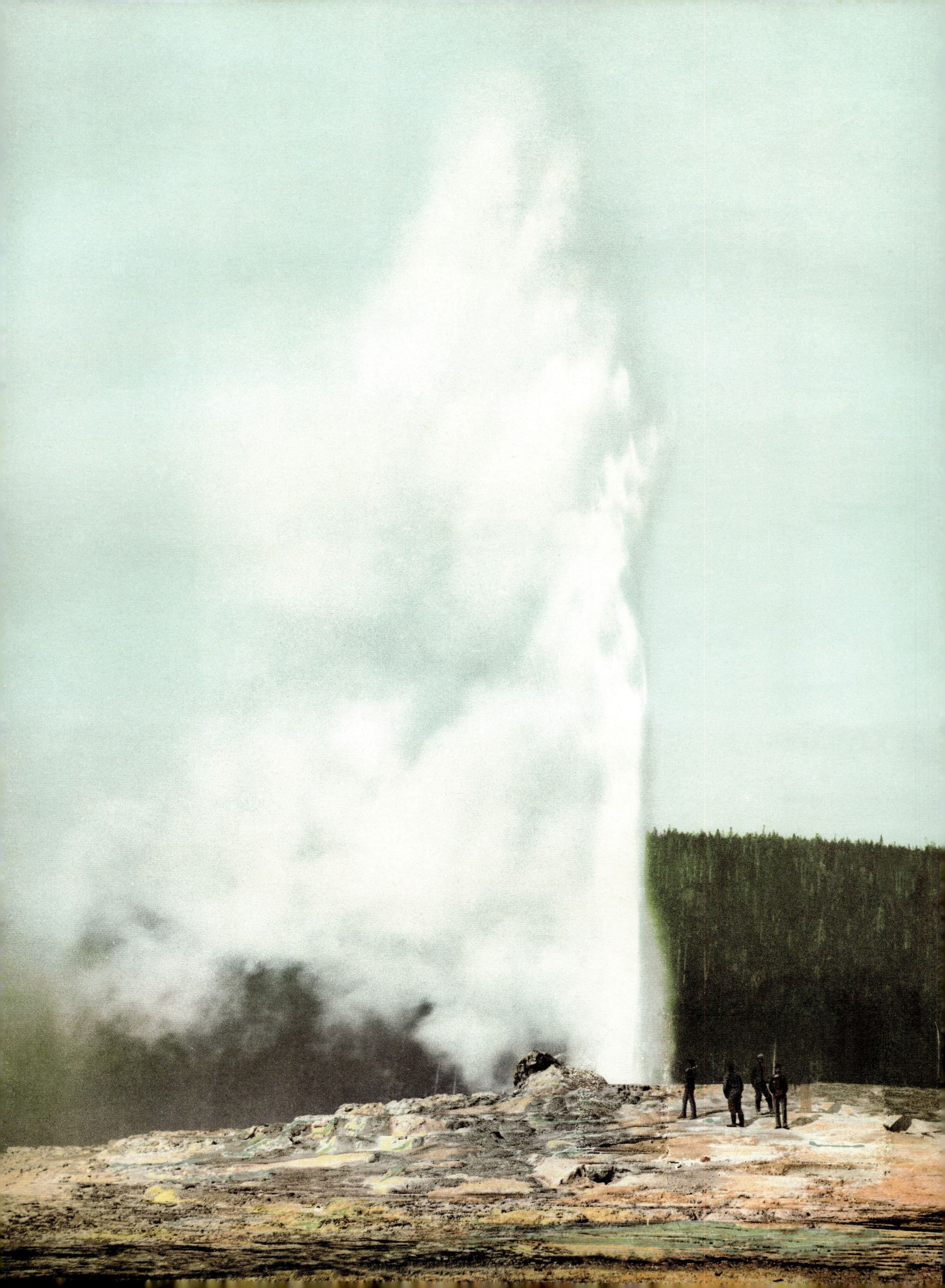

Page 394: Old Faithful geyser, Yellowstone Park, Wyoming, photochrom
Right: Buffalo herd near Fort Yellowstone

Seite 394: Geysir von Old Faithful, Yellowstone Park, Wyoming, Photochrom
Rechts: Büffelherde in der Nähe von Fort Yellowstone

Page 394: le geyser d'Old Faithful, parc de Yellowstone, Wyoming, photochrome
À droite: troupeau de bisons près du Fort Yellowstone

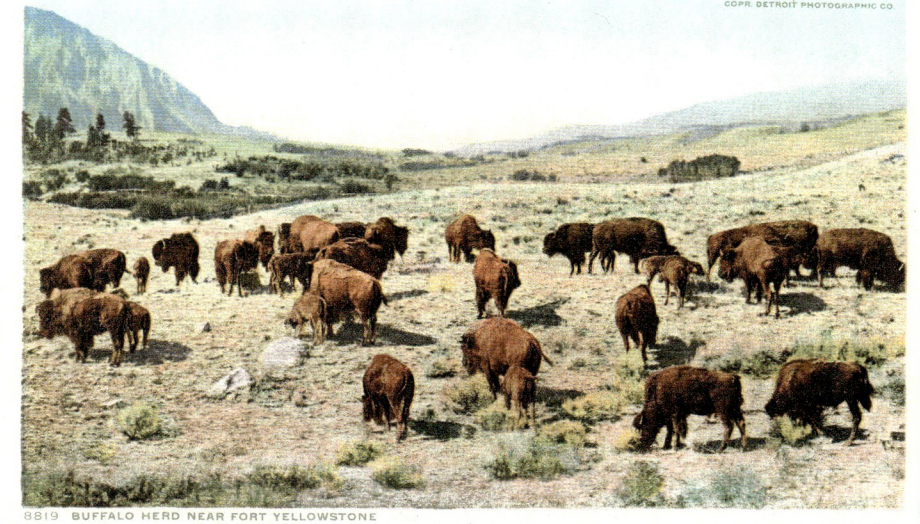

DER WILDE WESTEN

Vierhundert Jahre nach der Entdeckung des amerikanischen Kontinents ist der Wilde Westen, zu dem alle Gebiete westlich des Mississippi gehörten, vom Rio Grande bis zu den Rocky Mountains und von dort bis zum Pazifik, endgültig erobert. Die „frontier", der vage und nicht festgeschriebene Grenzverlauf, jener „Berührungspunkt zwischen der Wildnis und der Zivilisation" – wie ihn 1893 Professor Frederick Jason Turner in *The Annual report of the American Historical Association* bezeichnete, existierte nicht mehr, und die letzten Staaten, die der Union beitraten, wenn man von Alaska und Hawaii absieht, waren das indianische Gebiet von Oklahoma (1907), Arizona (1912) und New Mexico (1912). Die Ära der Pioniere war vorüber, die letzten mit Siedlern beladenen Wagen folgten den Eisenbahntrassen, und die Bisons waren ausgerottet. Die überlebenden Indianer waren in die ärmsten Landstriche verbannt worden und sahen machtlos zu, wie ihr natürliches Umfeld durch urbane Expansion, intensiven Ackerbau in den Great Plains und die Einrichtung der Nationalparks von Yellowstone (1872), Sequoia und Yosemite (1890), später auch des Grand Canyon (1919), verschwand. Während ein Kapitel in der amerikanischen Geschichte endete, machte sich zugleich Sehnsucht breit, und die Legende vom Westen begann.

Es entstand eine eigene Folklore, die durch Lieder und Komödien und später durch Stummfilmwestern verbreitet wurde: 1903 erschien *The Great Train Robbery*, ein zwölfminütiger Film, dessen Hauptdarsteller Gilbert M. „Broncho Billy" Anderson hieß und der der Star des ganzen Genres werden sollte. Das Publikum begeisterte sich für die Heldentaten des Trappers Davy Crockett (1786–1836), „des ersten lebendigen und echten Gottes aus dem Pantheon der großen Wälder westlich der Appalachen" (so Jean-Louis Rieupeyrout in *La Grande Aventure du Far West*, 1969), die etwas fragwürdigeren Großtaten von Gesetzlosen wie William Bonney, genannt Billy the Kid (1859–1881), „im Alter von 21 Jahren gestorben, nachdem er 21 Menschen getötet hatte", oder die von Samuel Bass, genannt Sam Bass, dem König des Raubüberfalls, der 1878 von Texas Rangers getötet wurde.

Doch der große Held des Wilden Westens, dessen Legende in der ganzen Welt Verbreitung fand, war natürlich William F. Cody, genannt Buffalo Bill. Dieser ehemalige Bisonjäger (Bisons heißen auf Englisch „buffalos") der Kansas City Railway organisierte ab 1883 das Volksschauspiel *Buffalo Bill's Wild West Show*, an der bemerkenswerterweise der Indianerhäuptling Sitting Bull teilnahm. 1886 besuchten eine Million Menschen das Stück in New York, 1893 wurde es im Rahmen der Columbia-Ausstellung in Chicago aufgeführt, 1905 über den Atlantik nach Paris exportiert und dort am Fuß des Eiffelturms gezeigt. Die Grundstimmung dieser zweifellos beeindruckend inszenierten – wie von Mark Twain in einem Brief an Cody 1884 formuliert: „bis ins kleinste Detail hinein authentischen" – Show ist jedoch fragwürdig, da die Indianer darin systematisch als Aggressoren dargestellt wurden. Die Vorstellung zu verbreiten, die Indianer seien nichts als blutrünstige Krieger, war in einem Land und in einer Epoche, da beispielsweise die *Nebraska City Press* die Ansicht vertrat, man müsse „jegliche Form von Brüderschaft mit den Rothäuten ausmerzen", alles andere als harmlos.

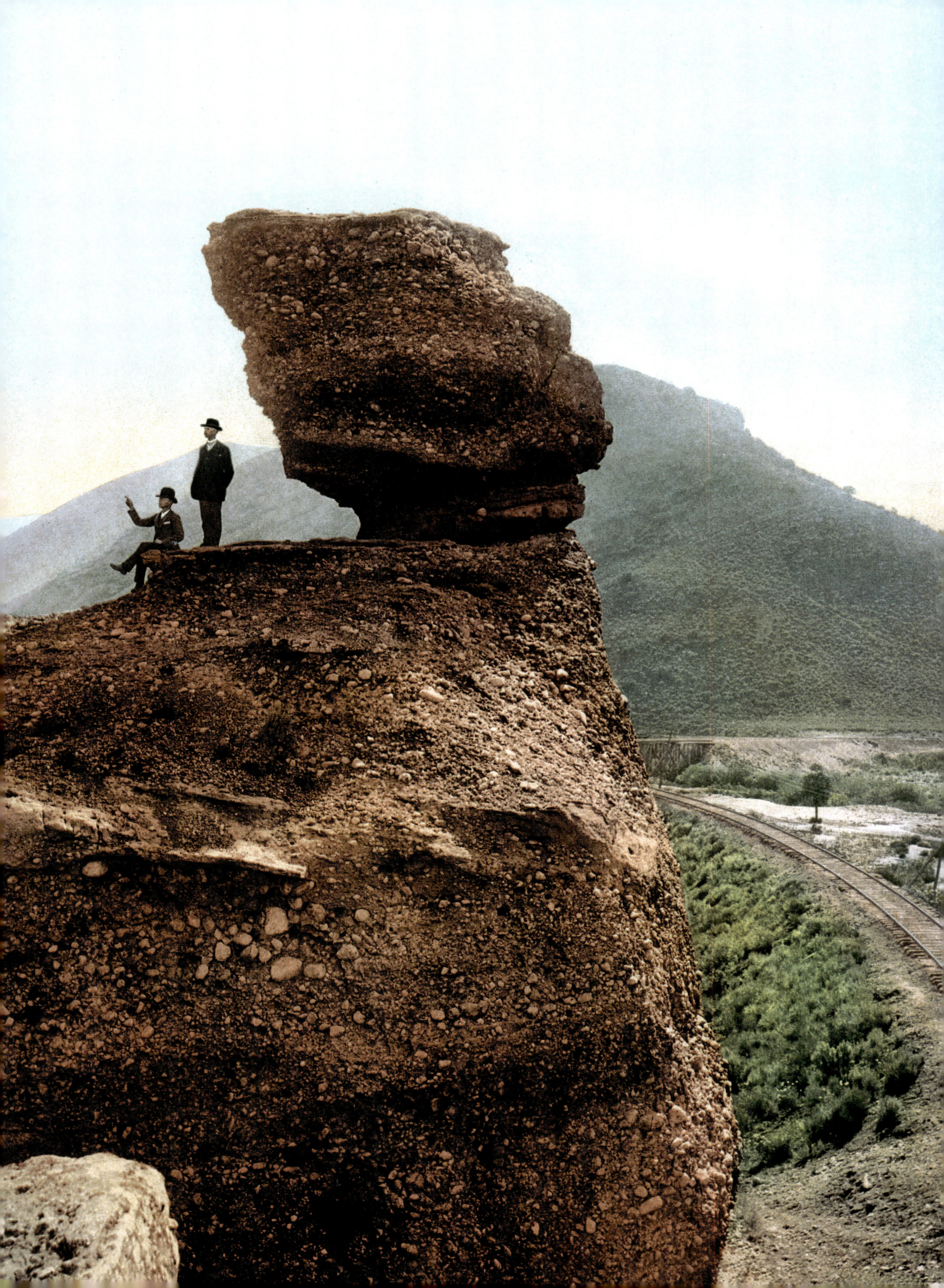

Page 396: Pulpit Rock, Utah, photochrom
Top right: El Porvenir Hotel, near Las Vegas, New Mexico
Below right: "Anxious moments," gambling scene, Colorado

Seite 396: Pulpit Rock, Utah, Photochrom
Oben rechts: Das Hotel El Porvenir, bei Las Vegas, New Mexico
Unten rechts: „Spannende Momente", am Spieltisch, Colorado

Page 396: Pulpit Rock (le « rocher chaire »), photochrome
À droite en haut : L'hôtel El Porvenir, près de Las Vegas, Nouveau-Mexique
À droite en bas : « Moments d'anxiété », scène de jeu, Colorado

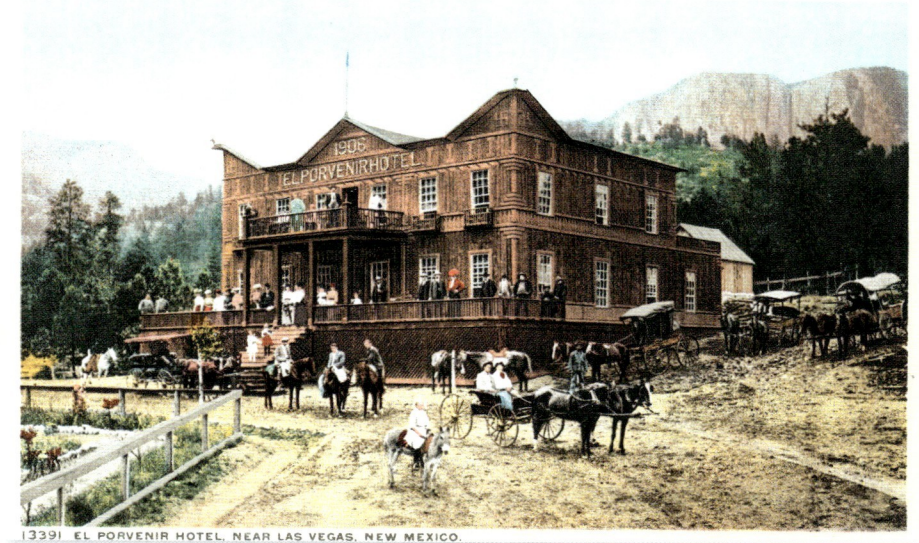

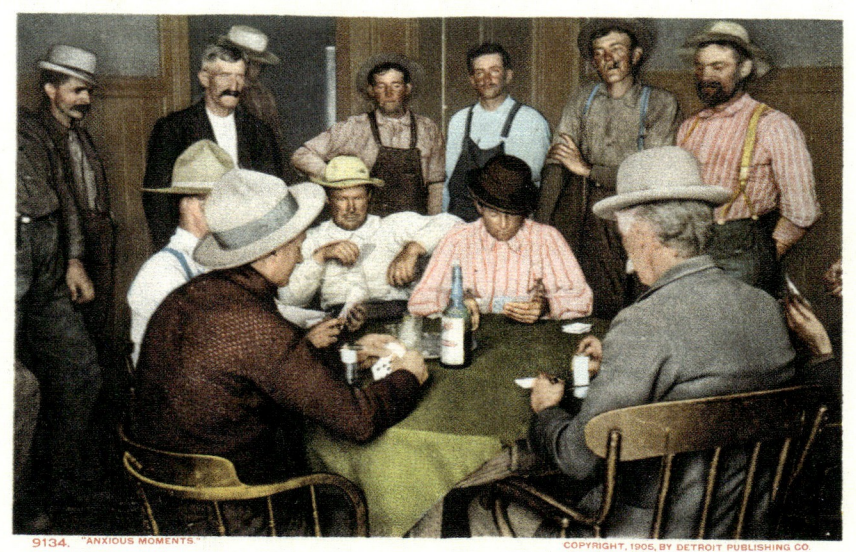

LE FAR WEST

Ce que nous nommons « Far West », l'« Ouest lointain », les Américains l'appellent « Wild West », l'« Ouest sauvage ». Quatre cents ans après la découverte du continent américain, l'Ouest sauvage donc, qui comprenait tous les territoires situés à l'ouest du Mississippi, du Rio Grande aux Rocheuses et des Rocheuses au Pacifique, est enfin conquis. La « Frontière », cette ligne indécise et mouvante, ce « point de contact entre la sauvagerie et la civilisation » – comme la définit en 1893 le professeur Frederick Jason Turner dans The Annual Report of the American Historical Association –, n'existe plus et les derniers États à entrer dans l'Union, si l'on excepte l'Alaska et Hawaii, seront le territoire indien de l'Oklahoma (1907), l'Arizona (1912) et le Nouveau-Mexique (1912). L'ère des pionniers est révolue, les derniers chariots chargés d'émigrants longent les voies de chemin de fer, les bisons ont été exterminés. Relégués sur les terres les plus pauvres, les Indiens survivants assistent, impuissants, à la disparition de leur milieu naturel : expansion urbaine, agriculture intensive dans les Grandes Plaines, création des parcs nationaux de Yellowstone (1872), Sequoia et Yosemite (1890), avant celui du Grand Canyon (1919). En même temps qu'une page de l'histoire américaine se tourne, la nostalgie s'installe et la légende de l'Ouest commence.

Tout un folklore naît, popularisé par des chansons, des comédies, puis par les premiers westerns muets : en 1903 sort The Great Train Robbery, un film de douze minutes dont la vedette est Gilbert M. « Broncho Billy » Anderson, appelé à devenir la star du genre. Le public se passionne pour les exploits du trappeur Davy Crockett (1786–1836), « premier dieu vivant et original du panthéon des grands bois, à l'ouest des Appalaches » (Jean-Louis Rieupeyrout, La Grande Aventure du Far West, 1969), et pour ceux, plus contestables, de hors-la-loi comme William Bonney, dit Billy the Kid (1859–1881), « mort à vingt et un ans après avoir tué vingt et un hommes… », ou Samuel Bass, dit Sam Bass, le roi du hold-up, éliminé par les Texas Rangers en 1878.

Mais le grand héros du Far West, celui dont la légende s'exporta dans le monde entier, c'est bien sûr William F. Cody, dit Buffalo Bill. Cet ancien chasseur de bisons (buffalos en anglais) pour le Kansas City Railway organise, à partir de 1883, un spectacle populaire, le Buffalo Bill's Wild West Show, auquel participera, notamment, le chef indien Sitting Bull. En 1886, à New York, un million de personnes y assistent ; en 1893, il est représenté dans le cadre de l'Exposition de Columbia à Chicago ; en 1905, il s'exporte outre-Atlantique, à Paris, au pied de la tour Eiffel. L'esprit du show, dont la mise en scène est, certes, impressionnante – « authentique dans ses moindres détails », dira Mark Twain dans une lettre à Cody datée de 1884 –, est cependant sujet à controverse, car les Indiens y sont systématiquement représentés comme agresseurs. Répandre l'idée que les Indiens n'étaient que des guerriers agressifs n'était pas anodin dans un pays et à une époque où le Nebraska City Press, par exemple, estimait qu'il fallait « éradiquer toute forme de fraternité avec les Peaux-Rouges ».

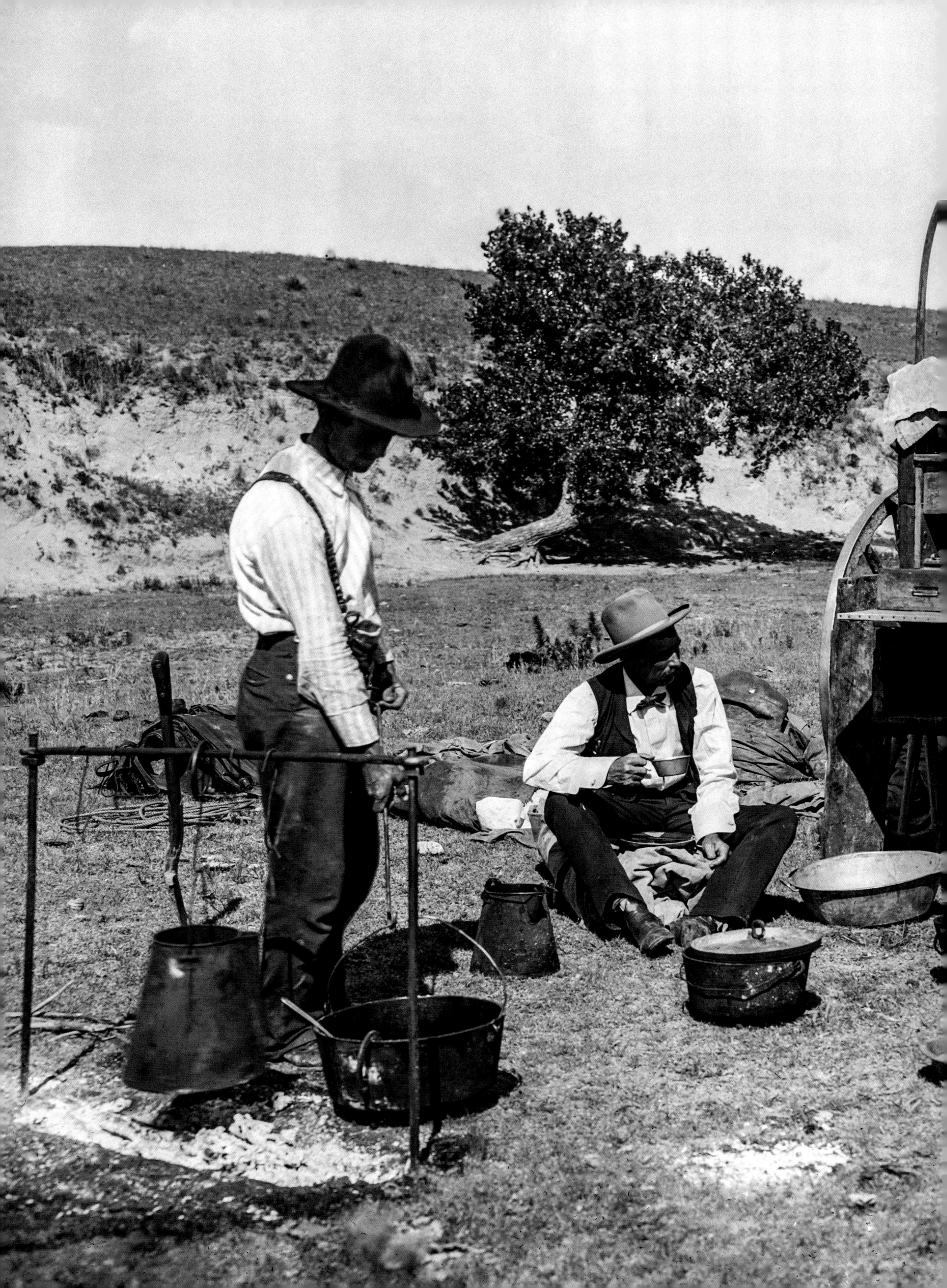

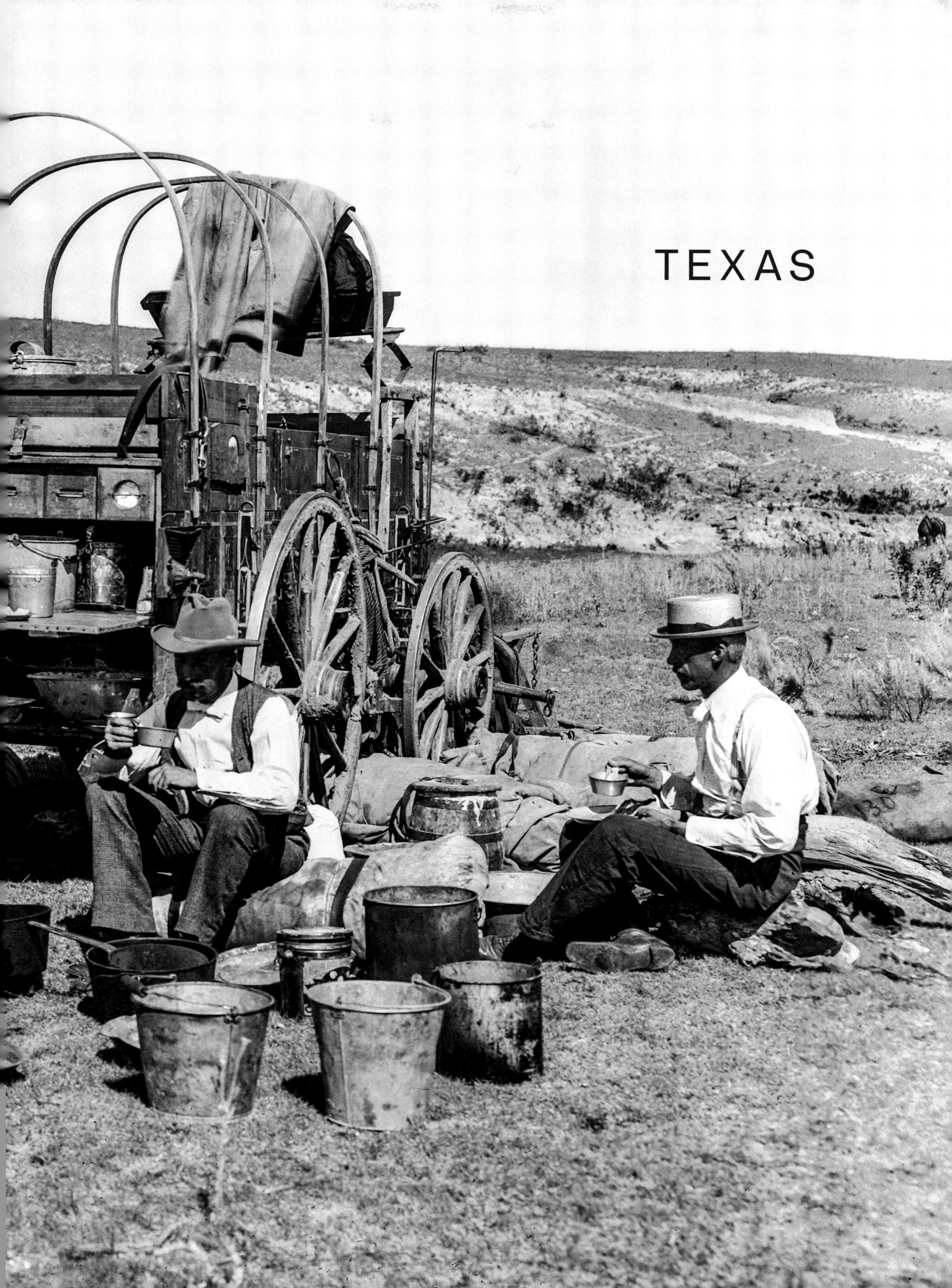

TEXAS

Page 398/399: Camp wagon on a Texas roundup, photograph by W. H. Jackson, glass negative, 1900
Top left: **General view, Galveston**
Top right: **Texas Bank & Trust Co., Galveston**
Bottom: **El Paso Street, El Paso, glass negative, 1900**

Lying on the Rio Grande, on the frontier between Texas and New Mexico, El Paso is a frontier city with Hispanic roots, having been Texan only since the Compromise of 1850. It is a city with a tumultuous, if not to say a sulphurous, past. With the arrival of the railroad in the early 1880s, immigration reached its culminating point: traders, entrepreneurs, and traffickers of all nationalities were attracted by the possibilities for self-enrichment in this free-trade zone.

Seite 398/399: Kampierwagen bei einem Zusammentrieb in Texas, fotografiert von W. H. Jackson, Glasnegativ, 1900
Oben links: **Gesamtansicht von Galveston**
Oben rechts: **Texas Bank & Trust Co., Galveston**
Unten: **Straße in El Paso, Glasnegativ, 1900**

Die am Rio Grande zwischen Texas und New Mexico gelegene Grenzstadt El Paso – die spanische Wurzeln hat und seit dem Kompromiss von 1850 texanisch ist – ist eine Stadt mit bewegter, wenn nicht gar aufrührerischer Vergangenheit. Mit dem Anschluss an das Eisenbahnnetz Anfang der 1880er-Jahre erlebte die Immigration hier einen Höhepunkt: Kaufleute, Unternehmer und Schwarzhändler aller Nationalitäten wurden angezogen von den Möglichkeiten, in dieser Freihandelszone reich zu werden.

Pages 398/399 : campement au Texas, photographie par W. H. Jackson, plaque de verre, 1900
En haut à gauche : **vue générale de Galveston**
En haut à droite : **Texas Bank & Trust Co., Galveston**
En bas : **rue à El Paso, plaque de verre, 1900**

Sur le Rio Grande, à la limite du Texas et du Nouveau-Mexique, ville-frontière aux racines hispaniques – texane depuis le Compromis de 1850 –, El Paso est une cité au passé tumultueux, voire sulfureux. Avec l'arrivée du chemin de fer au début des années 1880, la ville connut un pic d'immigration : marchands, entrepreneurs, trafiquants de toutes nationalités s'y installent, avides de faire fortune dans cette zone de libre-échange.

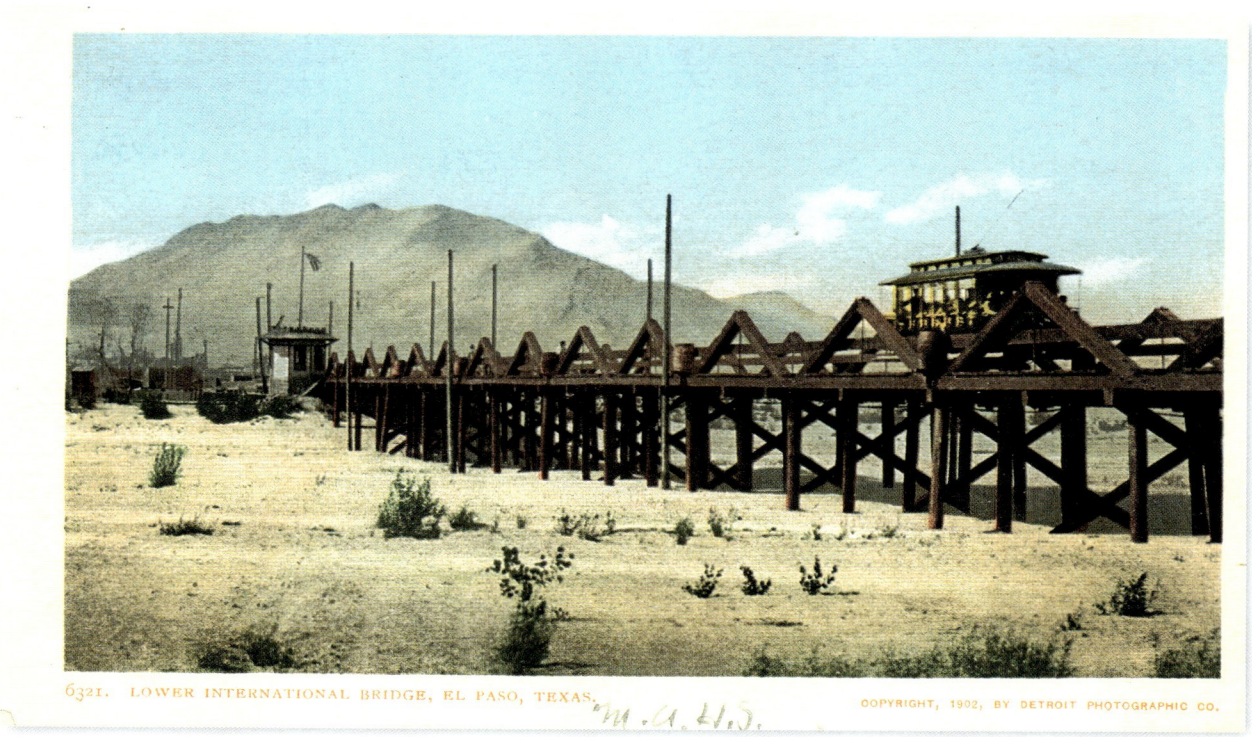

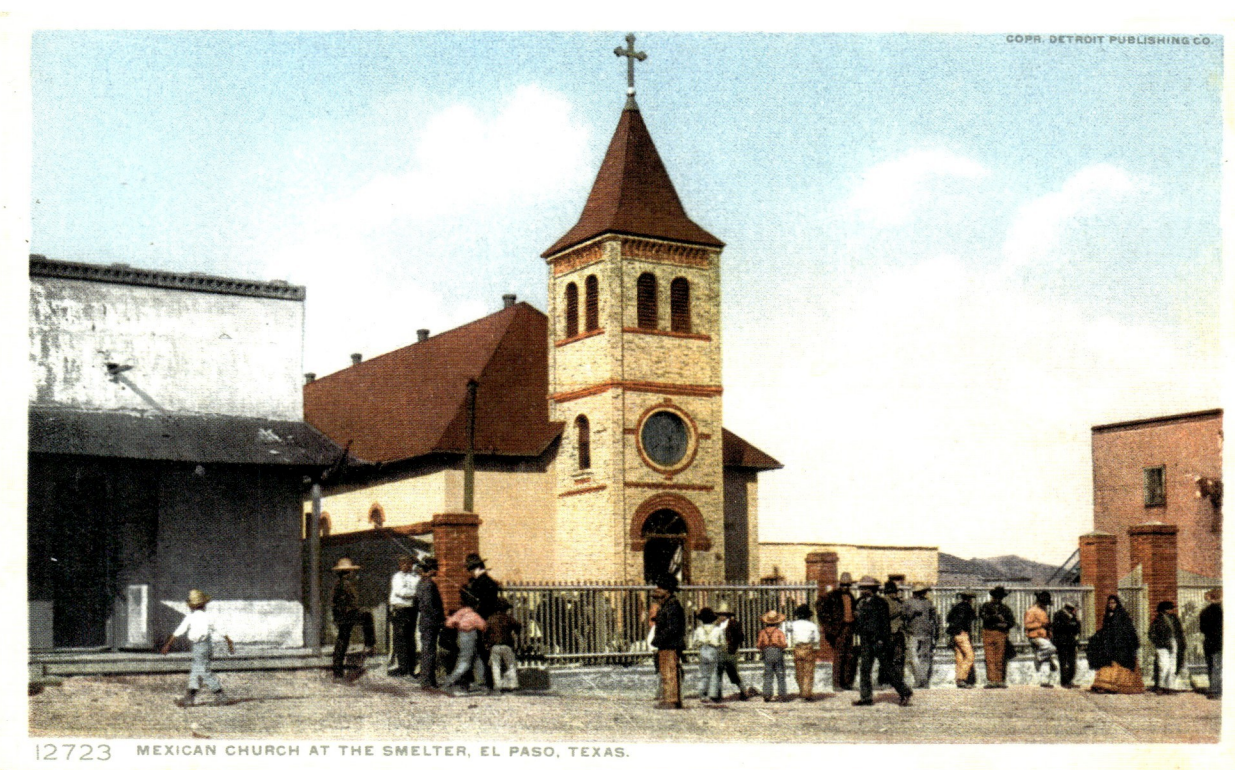

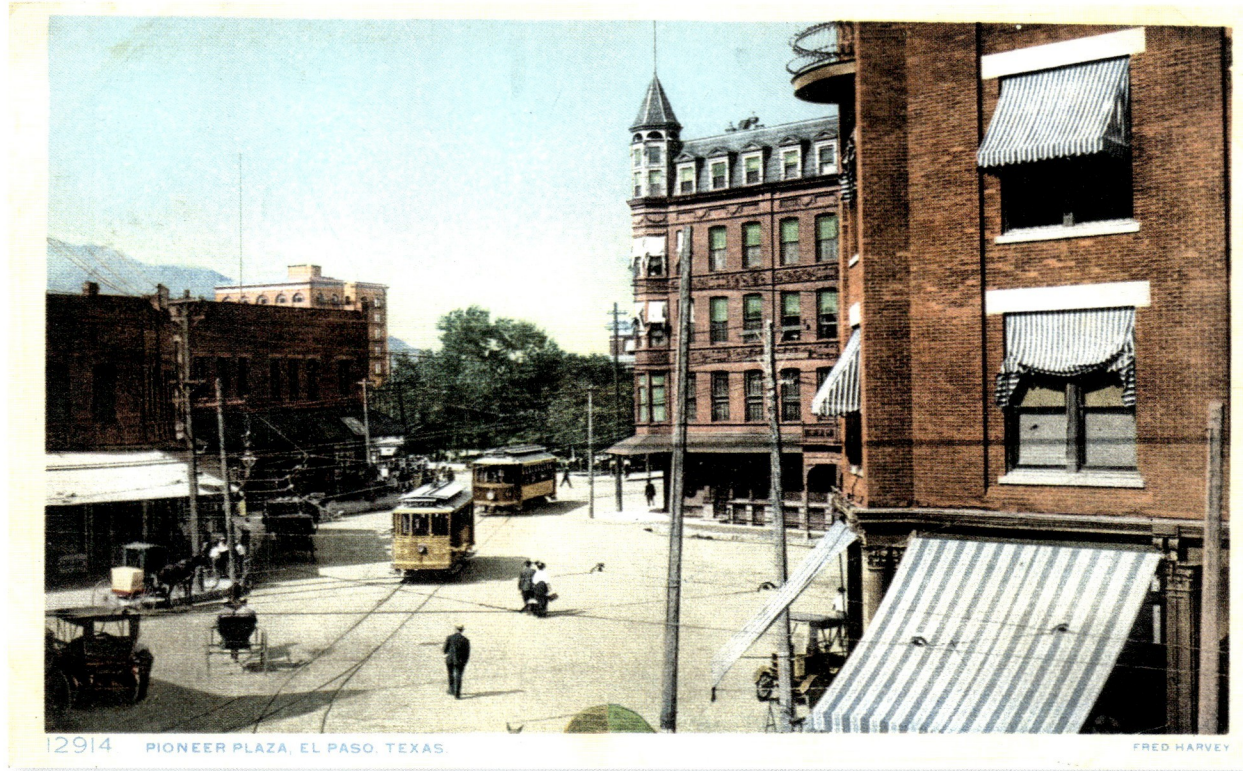

From top to bottom:
Lower International Bridge, El Paso
Mexican church at the smelter, El Paso
Pioneer Plaza, El Paso

Von oben nach unten:
Die Brücke Lower International Bridge, El Paso
Mexikanische Kirche an der Schmelzhütte, El Paso
Pionier-Platz, El Paso

De haut en bas :
Le pont Lower International Bridge, El Paso
Église mexicaine « à la fonderie », El Paso
Place Pioneer, El Paso

COWBOYS / COW-BOYS

The myth of the cowboy was born in the years 1880–90, at a time when the seasonal movement of cattle in the West was coming to an end, largely as a result of the development of the railroads. Cowboys crisscrossed the Great Plains from Texas to Dakota and from Wyoming to Montana between 1860 and 1890. They succeeded the Mexican *vaqueros*, who had worked in New Mexico and Texas when those states were under Spanish occupation; from them they inherited their horses, lassos, and hats (the Stetson replaced the sombrero). They hired out their services to ranch owners and accompanied herds of several thousand steers to the railheads of Abilene in Kansas or Kansas City in Missouri, from which the animals were sent to the abattoirs of Chicago or Cincinnati. Some 35,000–40,000 men, including many freed African Americans or people of mixed race rejected by the Southern states, followed the Cattle Trail—stretching 620 miles (1,000 km) from Texas to Kansas—every year between March and October. They were poorly paid, underfed, and allowed to drink only in saloons.

Der Cowboy-Mythos entstand in den Jahren 1880–1890, zu der Zeit, als insbesondere wegen der Entwicklung der Eisenbahn der Rindertrieb gen Westen zum Erliegen kam. Zwischen 1860 und 1890 durchkämmten die „Kuhhirten" die Great Plains von Texas bis Dakota und von Wyoming bis Montana. Die Cowboys waren Nachfolger der *vaqueros* in den von Spaniern besetzten Staaten Mexiko, New Mexico und Texas, denen sie ihre Pferde, ihr Lasso und ihren Sombrero, den sie durch einen Stetson ersetzten, verdankten. Sie boten Ranchbesitzern ihre Dienste an, um Herden von mehreren Tausend Rindern bis zu den Endbahnhöfen in Abilene (Kansas) oder Kansas City (Missouri) zu treiben. Von dort aus wurden die Tiere zu den Schlachthöfen in Chicago oder Cincinnati befördert. Es waren zwischen 35 000 und 40 000 Männer – viele von ihnen freigelassene Schwarze oder aus den Südstaaten vertriebene Mischlinge –, die, schlecht bezahlt und unterernährt, von März bis Oktober dem tausend Kilometer langen Cattle Trail (Viehweg) zwischen Texas und Kansas folgten und in den Saloons haltmachten, wo sie endlich Alkohol trinken konnten, was ihnen in der übrigen Zeit verboten war.

Le mythe du cow-boy est né dans les années 1880–1890, au moment où, notamment à cause du développement du chemin de fer, la transhumance du bétail dans l'Ouest tombe en désuétude. C'est entre 1860 et 1890 que les « garçons vachers » sillonnèrent les Grandes Plaines, du Texas au Dakota, du Wyoming au Montana. Héritiers des *vaqueros* du Mexique, du Nouveau-Mexique et du Texas sous occupation espagnole, auxquels ils doivent leur cheval, leur lasso et leur sombrero – remplacé par le Stetson –, les cow-boys louaient leurs services aux propriétaires des ranches afin d'accompagner des troupeaux de plusieurs milliers de têtes jusqu'aux dépôts d'Abilene au Kansas, ou de Kansas City dans le Missouri, d'où les bêtes étaient expédiées vers les abattoirs de Chicago ou de Cincinnati. Ils furent 35 à 40 000 hommes – dont beaucoup de Noirs affranchis ou de métis rejetés des États du Sud –, mal payés, mal nourris, à parcourir de mars à octobre la Cattle Trail, mille kilomètres entre le Texas et le Kansas, s'arrêtant dans les saloons où ils pouvaient enfin boire de l'alcool – interdit le reste du temps.

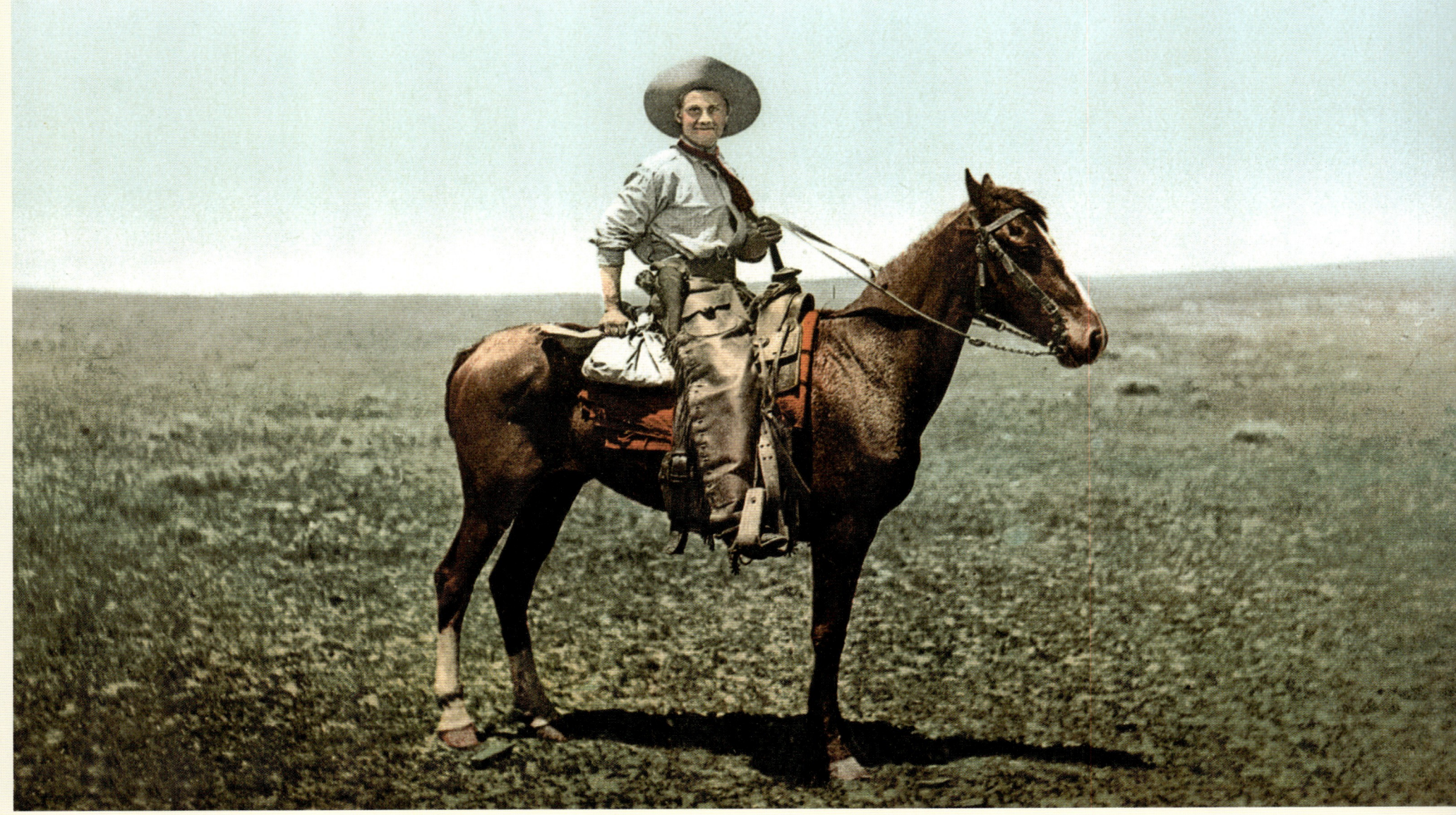

Above: A cowboy, photochrom
Page 403, from top to bottom and left to right:
Fording the Santa Inez River, photochrom
Cowboys racing to dinner
Day herds
The lure of the trail…
Broncho busting
Cowboys at lunch
Cowboys shooting craps

Oben: Ein Cowboy, Photochrom
Seite 403, von oben nach unten und von links nach rechts:
Flussdurchquerung am Santa Inez River, Photochrom
Cowboys preschen zum Mittagessen
Tägliche Kontrolle der Herden
Die Verlockung des Pfades …
Rodeo
Cowboys beim Mittagessen
Cowboys beim Craps-Spiel

Ci-dessus : un cow-boy, photochrome
Page 403, de haut en bas et de gauche à droite :
Passage de la Santa Inez River, photochrome
Cow-boys se ruant vers leur déjeuner
Surveillance quotidienne des troupeaux
L'attrait de la piste…
Rodéo
Cow-boys en train de déjeuner
Cow-boys jouant au craps

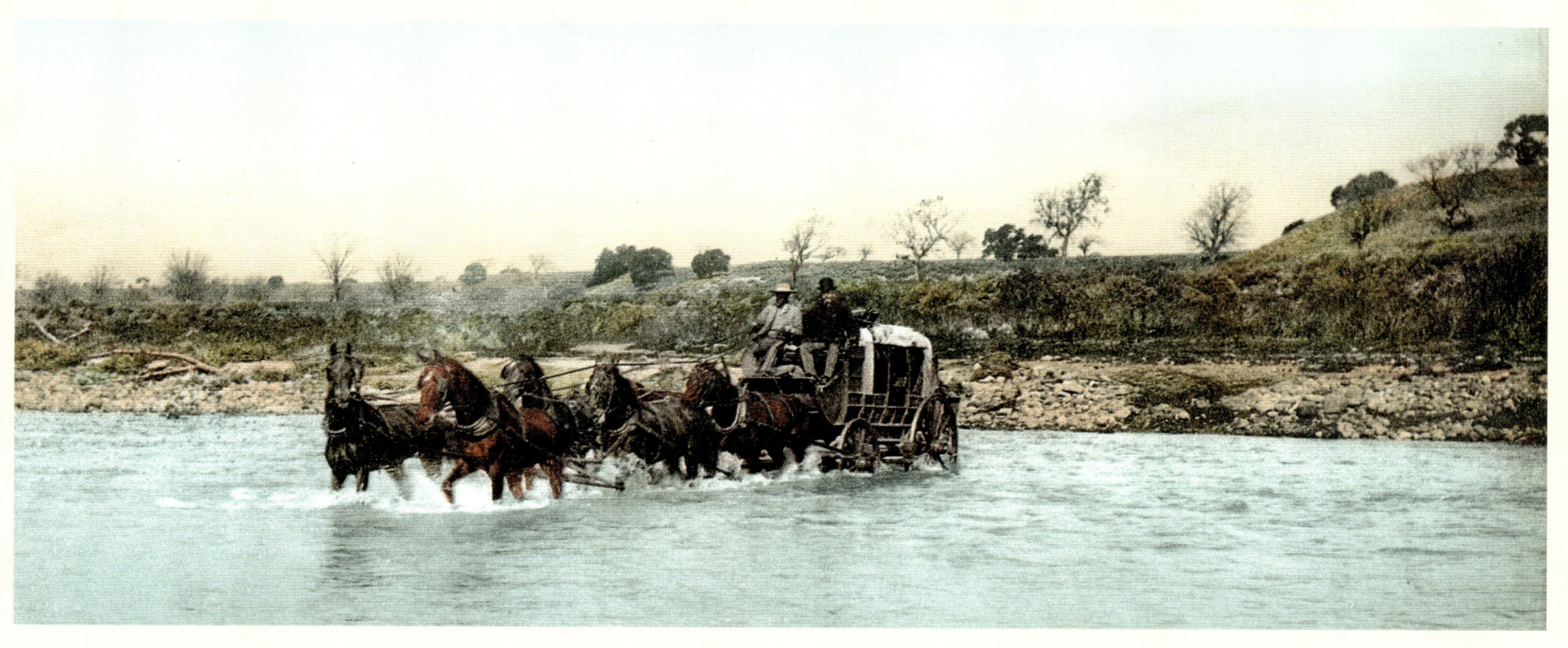
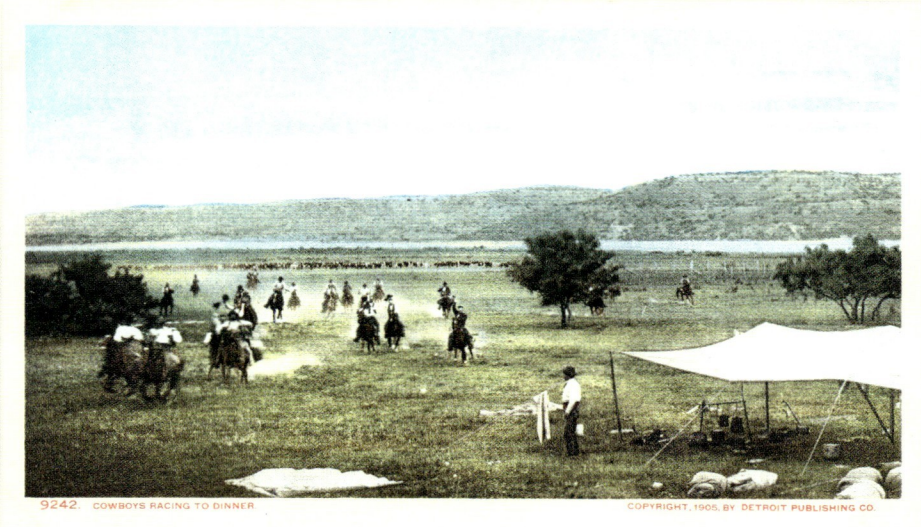
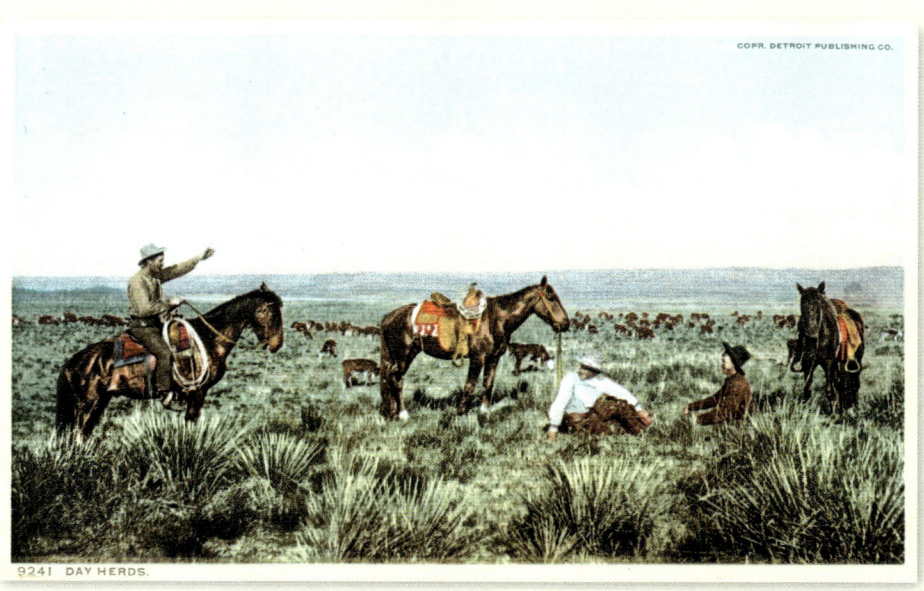
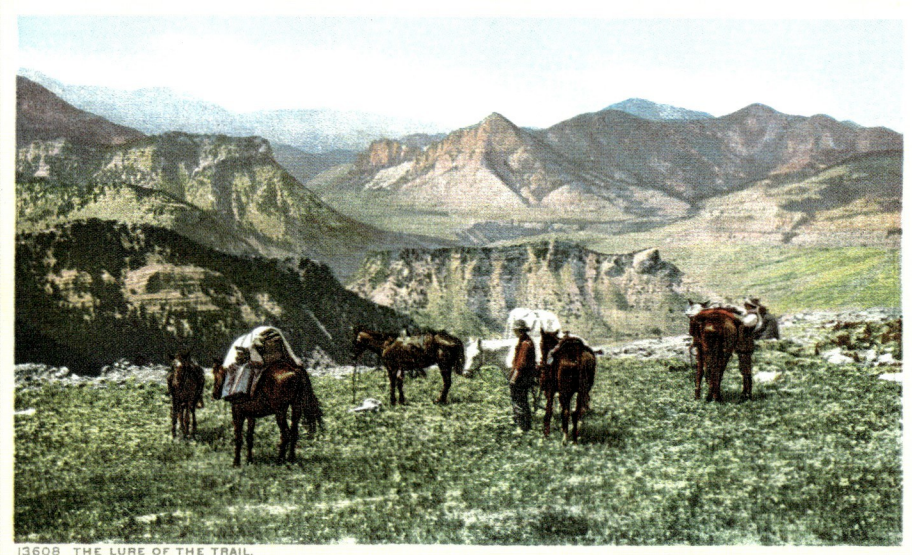
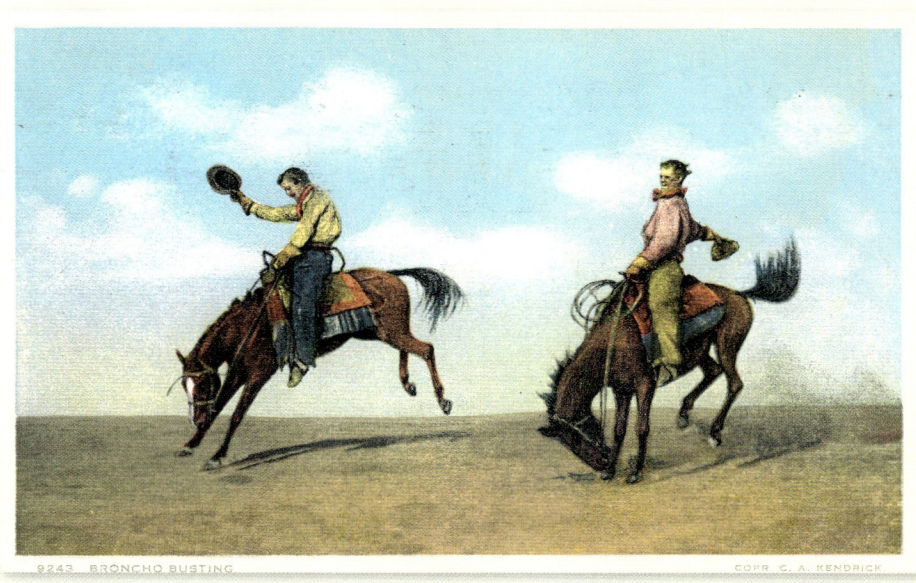
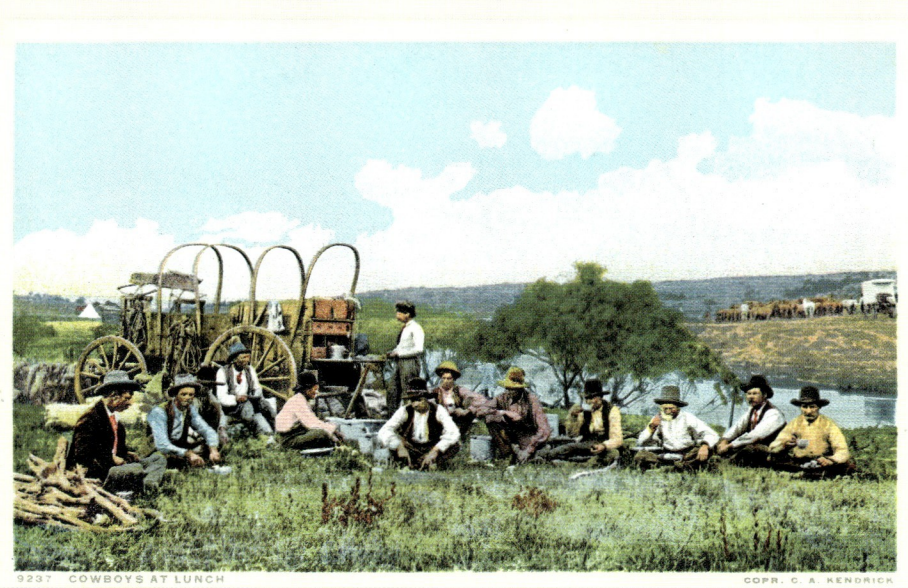
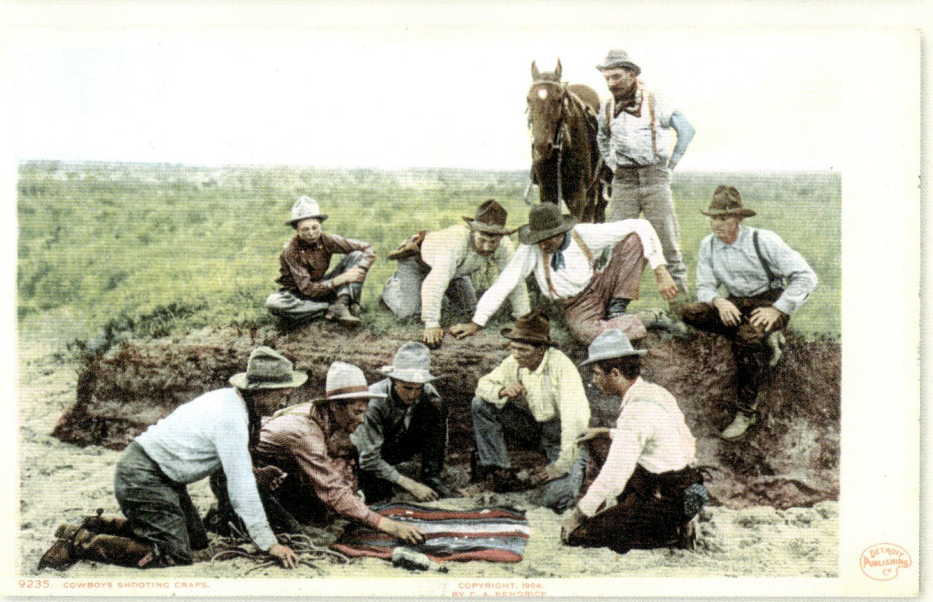

From left to right and top to bottom:
Bunching the herd, photochrom
In the corral, Colorado, photochrom
A cowboy throwing a lariat, photochrom
Roping a steer, Colorado, photochrom
Branding the calves, photochrom
Cowboys sitting by the grub pile, photochrom
Rounding up a herd on a Texas ranch, photochrom

Von links nach rechts und von oben nach unten:
Zusammentrieb der Herde, Photochrom
Im Viehpferch, Colorado, Photochrom
Ein Cowboy wirft sein Lasso, Photochrom
Fesseln eines Rinds, Colorado, Photochrom
Markierung der Kälber, Photochrom
Die Cowboys sitzen beim Essen, Photochrom
Zusammentrieb einer Herde auf einer texanischen Ranch, Photochrom

De gauche à droite et de haut en bas :
Rassemblement du troupeau, photochrome
Dans le corral, Colorado, photochrome
Cow-boy jetant son lasso, photochrome
Encordage d'un bœuf, Colorado, photochrome
Marquage des veaux, photochrome
Cow-boys à l'heure de la « soupe », photochrome
Rassemblement d'un troupeau dans un ranch du Texas, photochrome

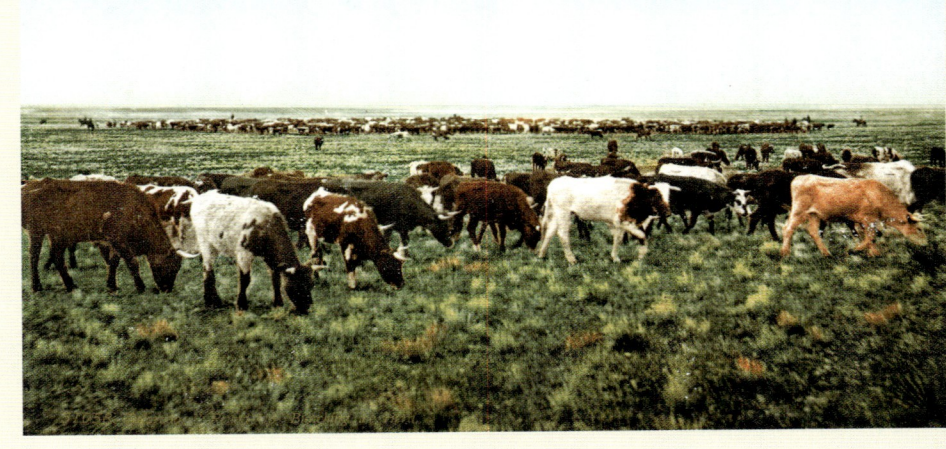

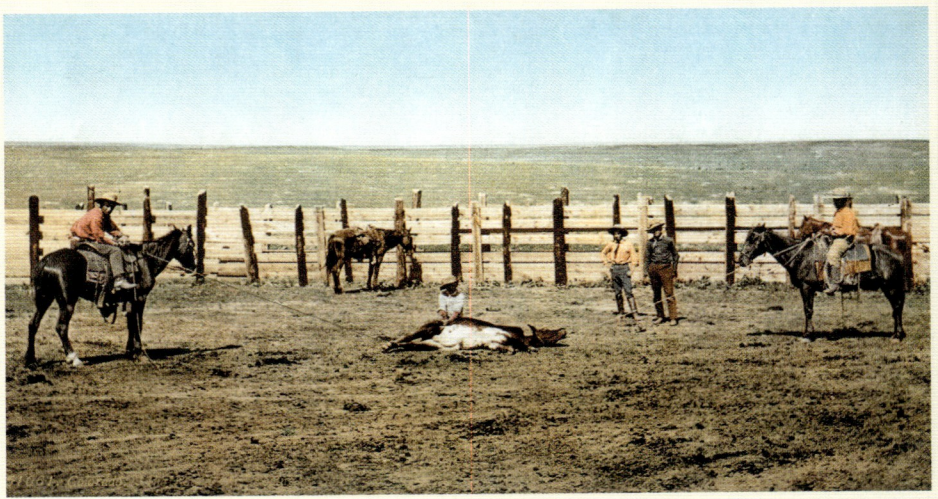

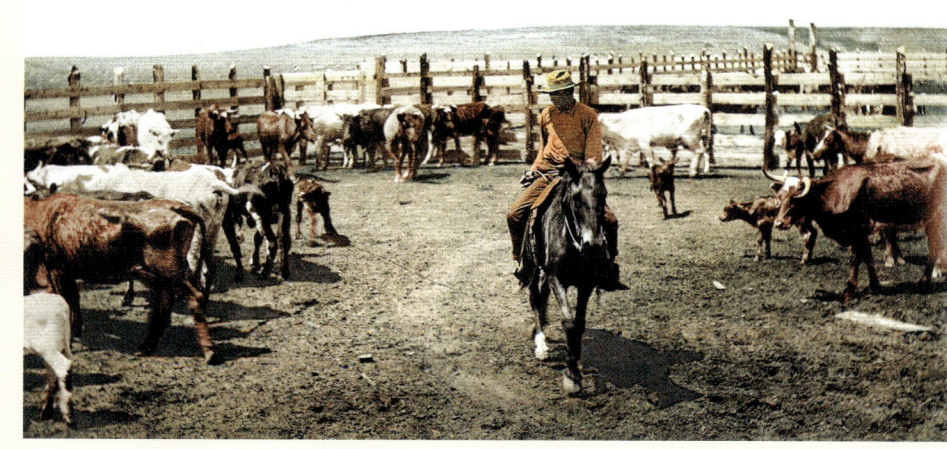
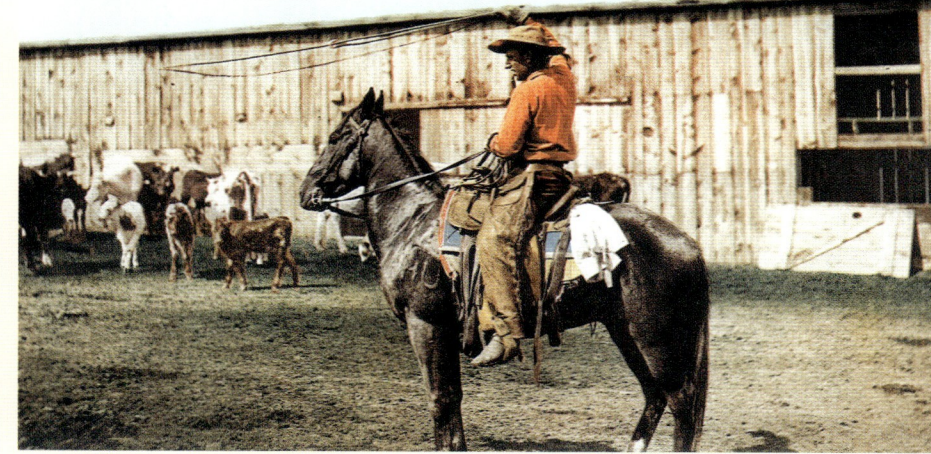
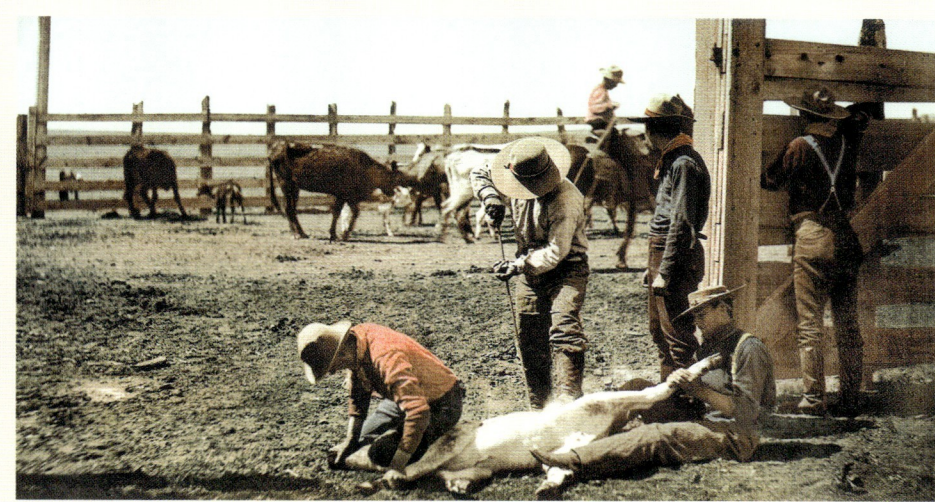
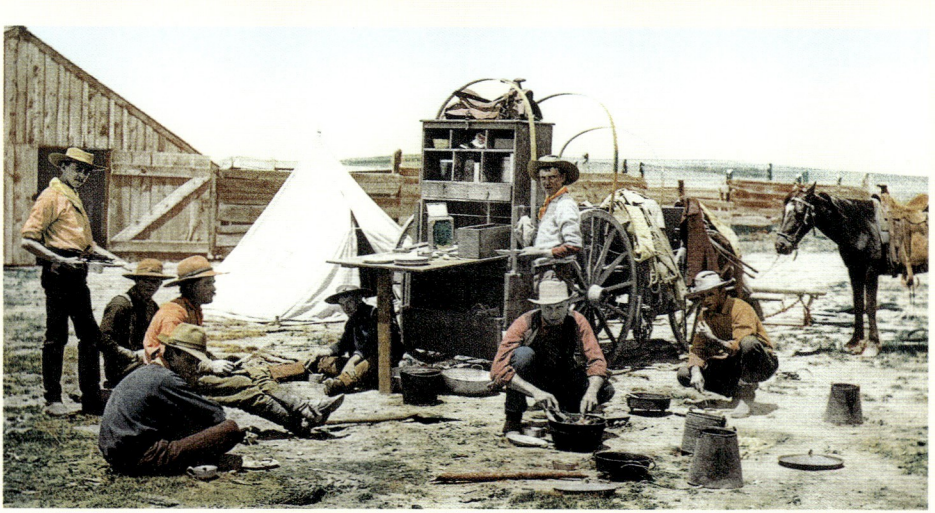

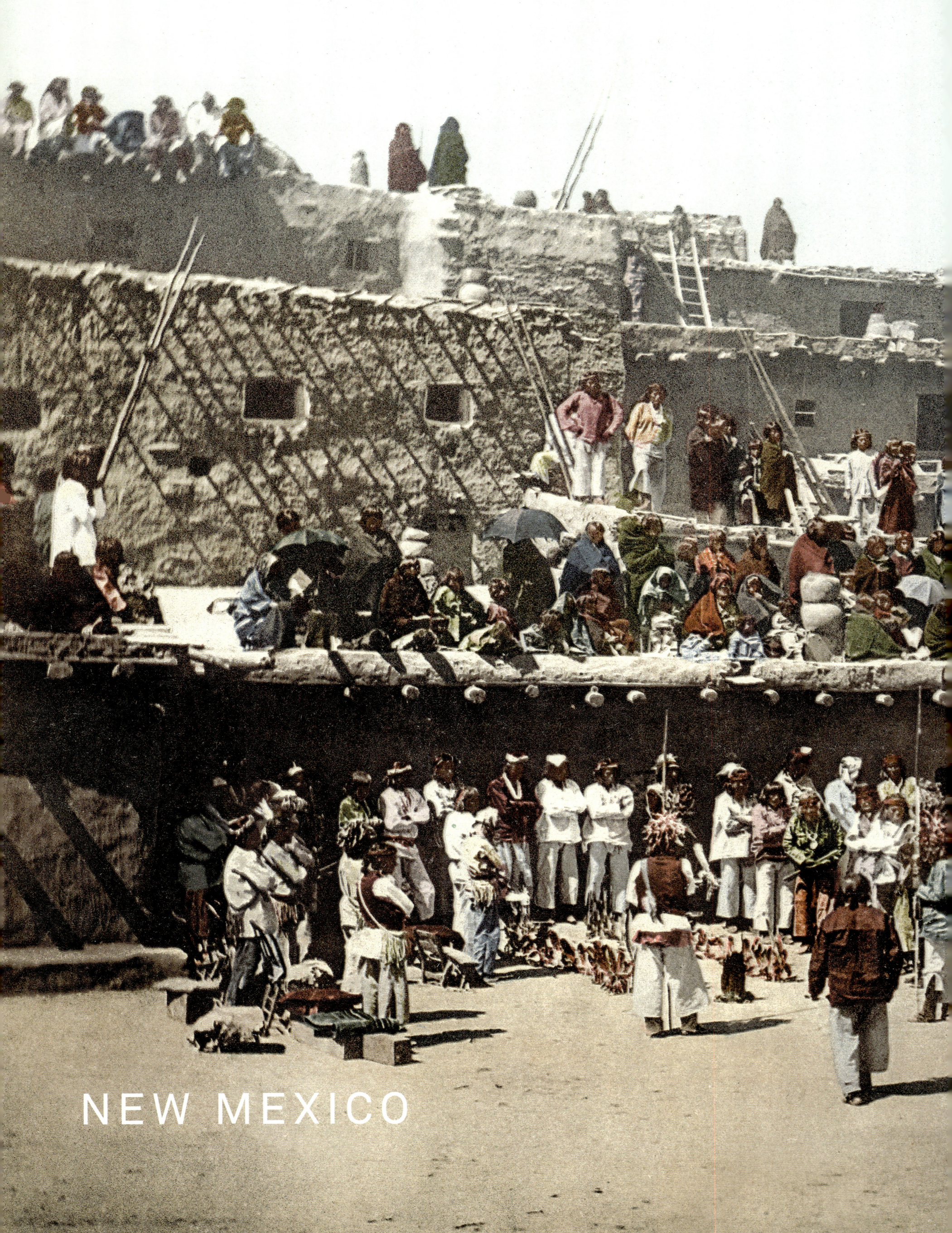
NEW MEXICO

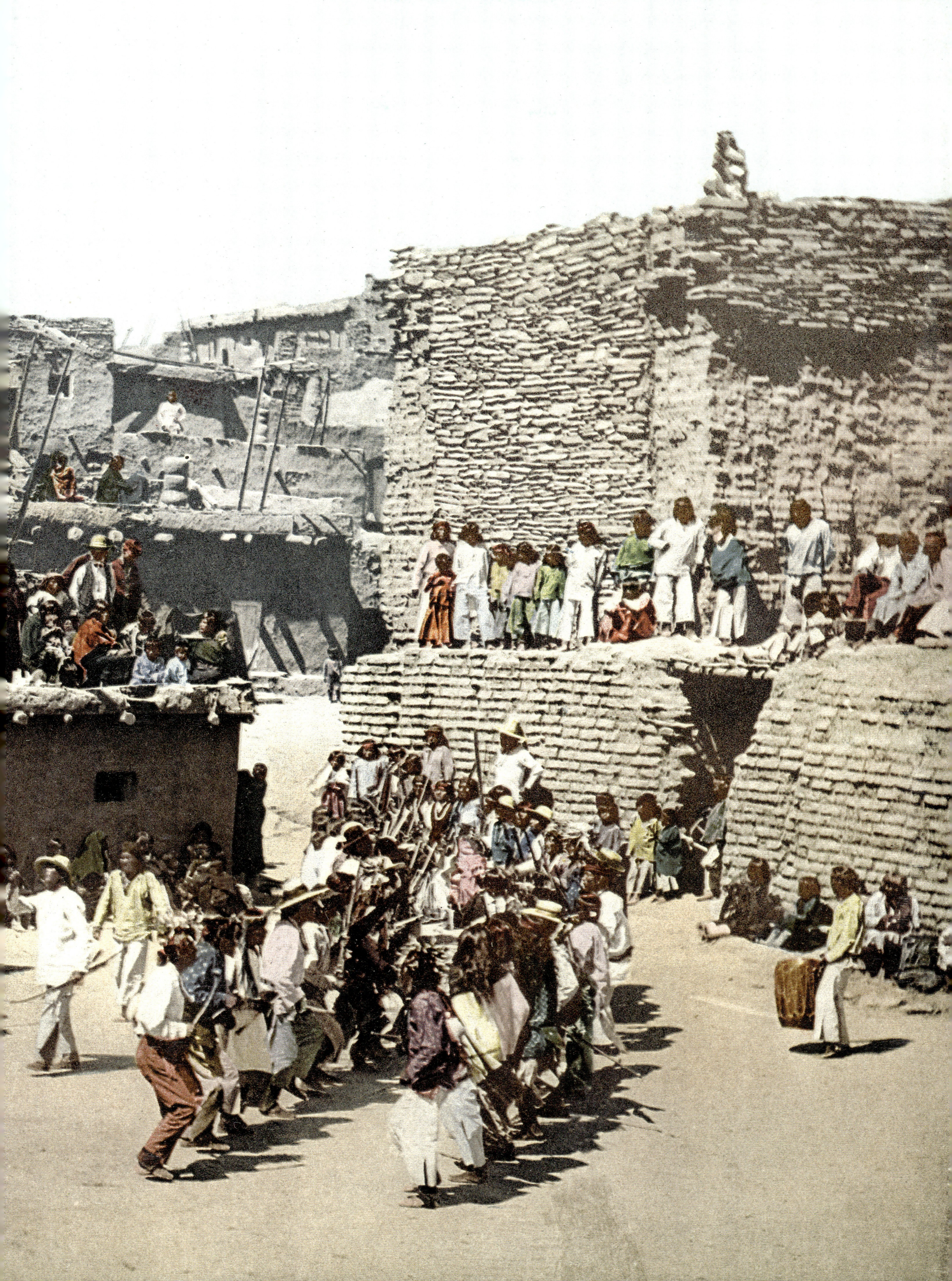

 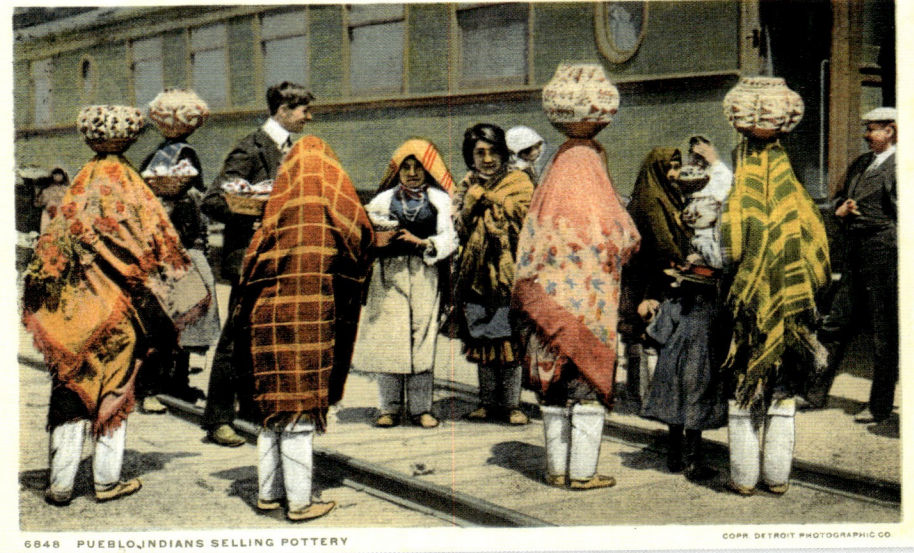

Page 406/407: Zuni Pueblo Indians, the Rain Dance, photochrom
Top left: **Mallet compound engine**
Top right: **Pueblo Indians selling pottery**
Bottom: **Indian building in Albuquerque**
Opened in 1902, the luxurious Alvarado Hotel in Albuquerque was created by the partnership between the Santa Fe Railway company and the hotel magnate Fred Harvey. At the time, the city was rapidly expanding and lived off its railway depot and tourism. The Indian Museum devoted to Pueblo culture and craftsmanship was an annex of the hotel and, like the hotel, was demolished in 1970.

Seite 406/407: Zuni-Pueblo-Indianer, Regentanz, Photochrom
Oben links: **Mallet-Dampflokomotive**
Oben rechts: **Pueblo-Indianer beim Verkauf von Töpferwaren**
Unten: **Indianermuseum in Albuquerque**
Das 1902 eröffnete Luxushotel Alvarado in Albuquerque gründete auf einer Partnerschaft zwischen der Eisenbahngesellschaft Santa Fe Railway und dem Hotelmagnaten Fred Harvey. Zu jener Zeit lebte die in Expansion begriffene Stadt von ihrem Eisenbahndepot und dem Tourismus. Ein der Kultur und dem Kunsthandwerk der Pueblo-Indianer gewidmetes Museum war an das Hotel angegliedert. Das Hotel und das Museum wurden 1970 abgerissen.

Pages 406/407 : Indiens Zuni Pueblos, danse de la pluie, photochrome
En haut à gauche : **locomotive à vapeur Mallet**
En haut à droite : **Indiens Pueblos vendant des poteries**
En bas : **le Musée indien d'Albuquerque**
Ouvert en 1902, le luxueux hôtel Alvarado d'Albuquerque est né d'un partenariat entre la compagnie du Santa Fe Railway et le magnat de l'hôtellerie Fred Harvey. À cette époque, la ville en pleine expansion vivait de son dépôt ferroviaire et du tourisme. Consacré à la culture et à l'artisanat Pueblos, le Musée indien était une annexe de l'hôtel. L'hôtel comme le musée ont été démolis en 1970.

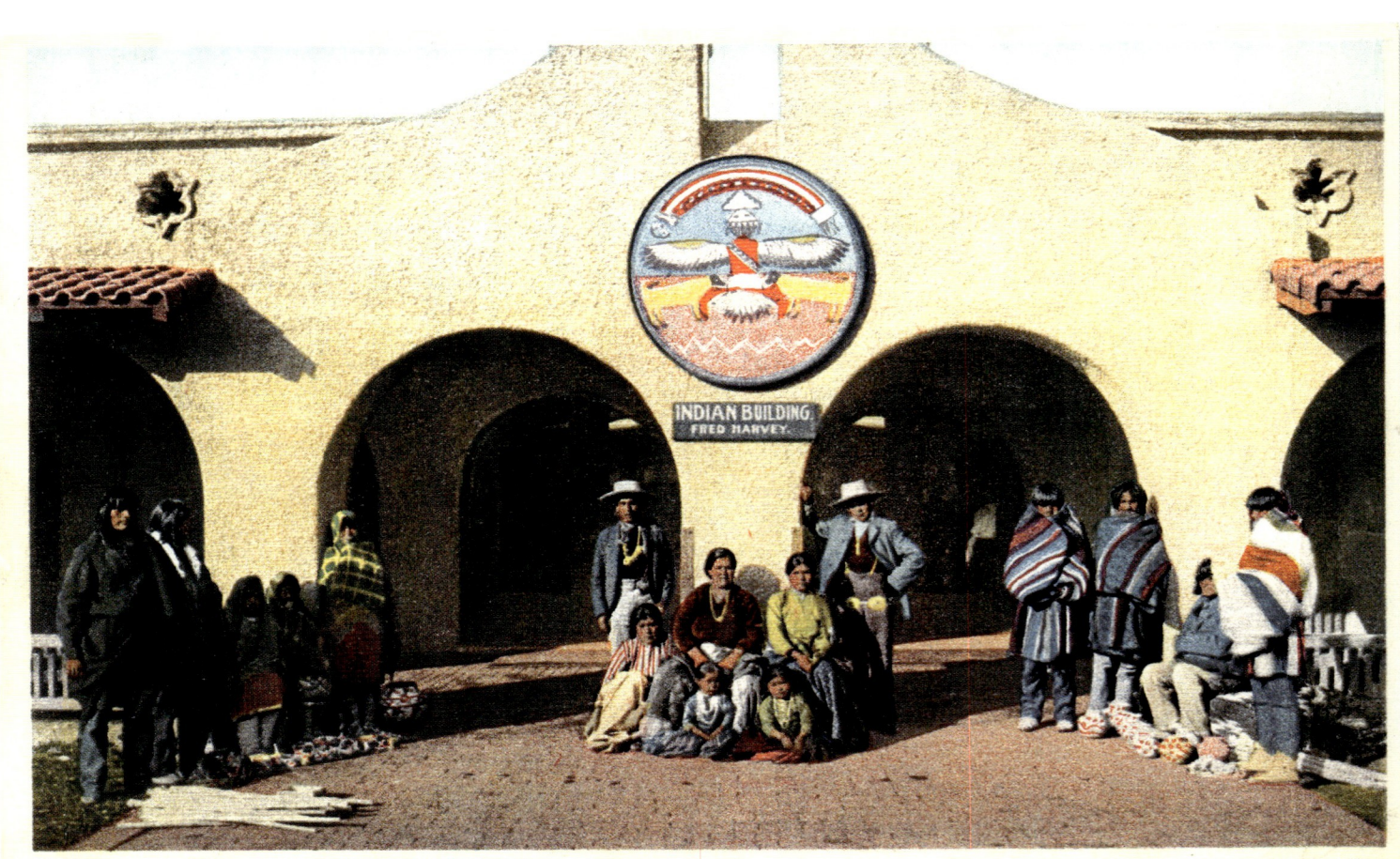

NEW MEXICO | ALBUQUERQUE

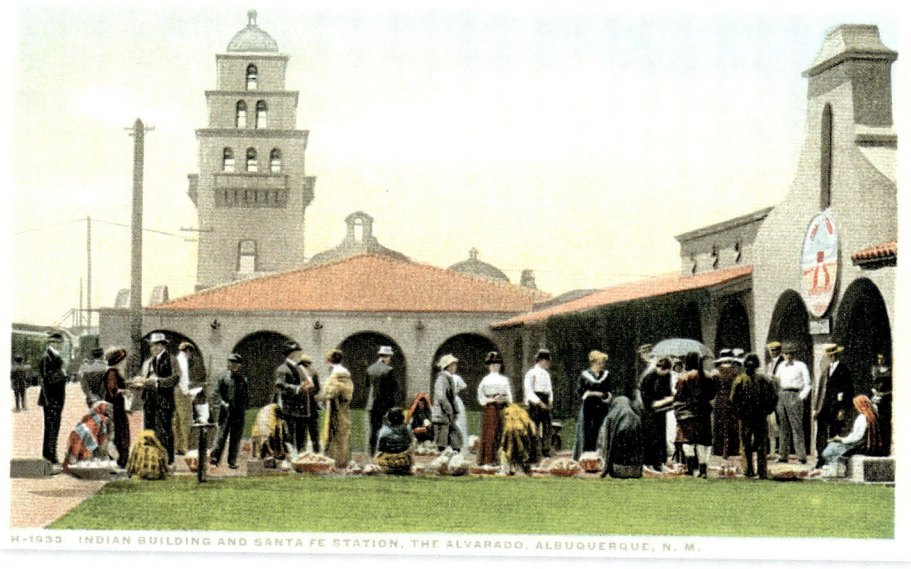
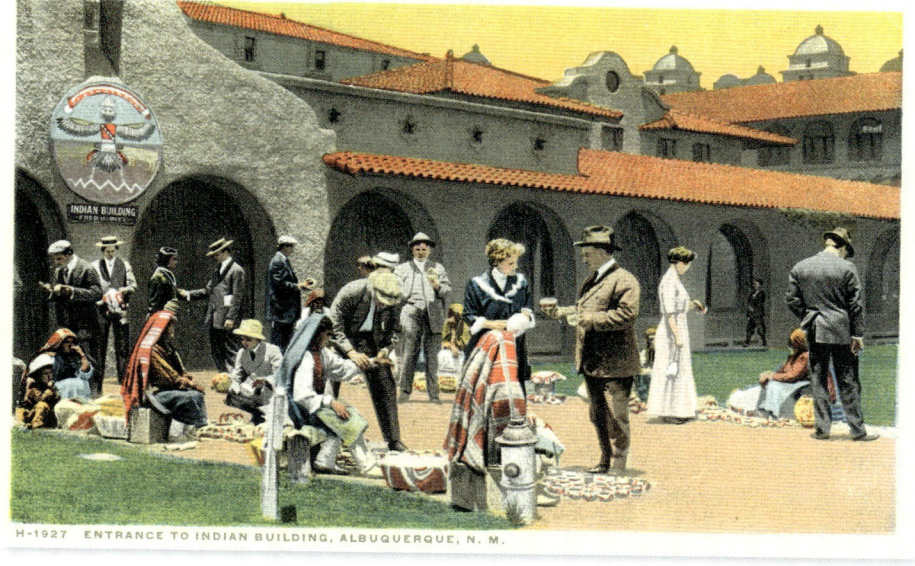
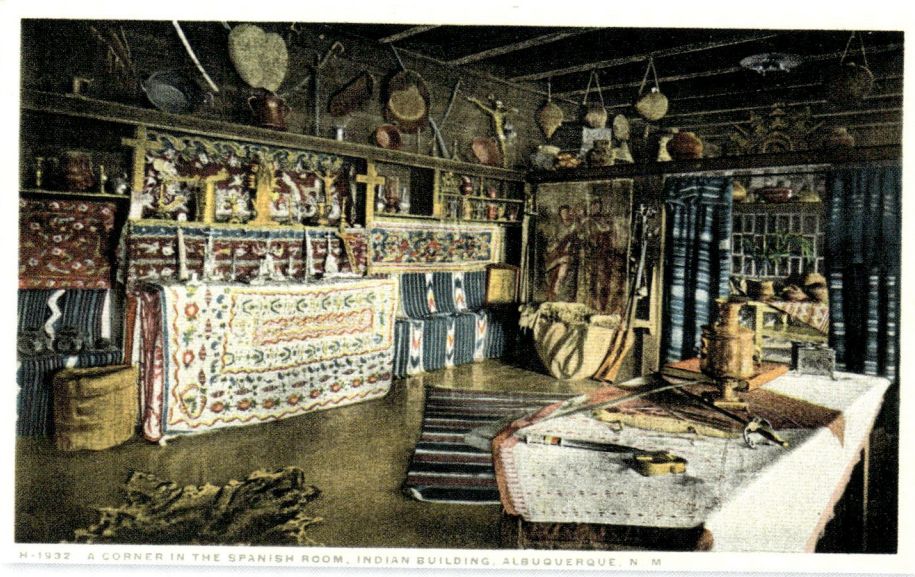

Above, from left to right and top to bottom:
Indian Building and Santa Fe Station, the Alvarado Hotel, Albuquerque
Entrance to Indian Building
A corner in the Spanish room, Indian Building
Below, from left to right:
Elle of Ganado, Navajo Indian woman
Yaz-Yah, a Navajo girl
Tom of Ganado, Navajo Indian

Oben, von links nach rechts und von oben nach unten:
Indianermuseum, Bahnhof der Santa Fe Railway und das Hotel Alvarado in Albuquerque
Eingang des Indianermuseums
Eine Ecke im spanischen Raum, Indianermuseum
Unten, von links nach rechts:
Elle aus Ganado, Navajo-Indianerin
Yaz-Yah, Navajo-Mädchen
Tom aus Ganado, Navajo-Indianer

En haut, de gauche à droite et de haut en bas :
Le Musée indien, la gare du Santa Fe Railway et l'hôtel Alvarado à Albuquerque
Entrée du Musée indien
Un coin de la salle espagnole, musée Indien
En bas, de gauche à droite :
Elle de Ganado, Indienne Navajo
Yaz-Yah, fillette Navajo
Tom de Ganado, Indien Navajo

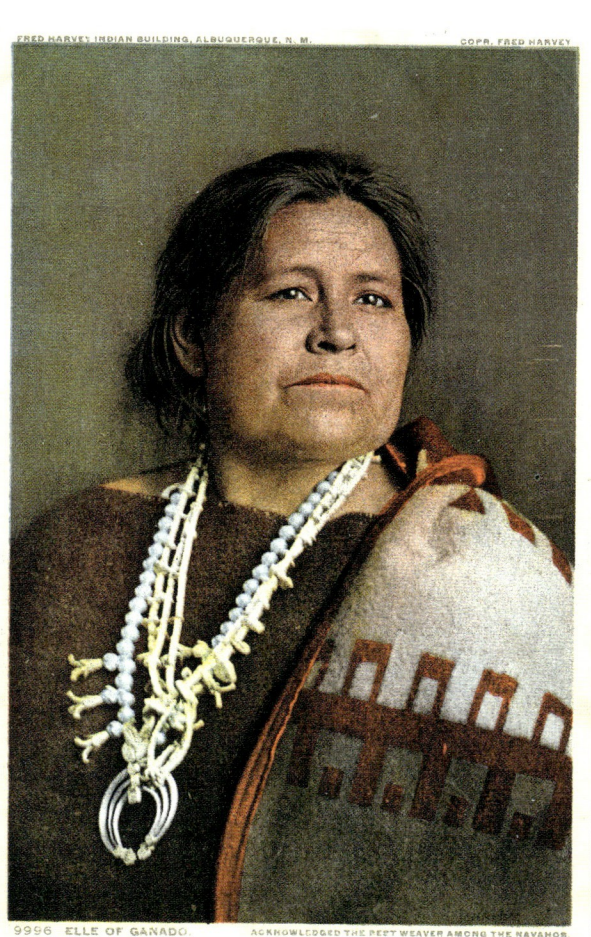
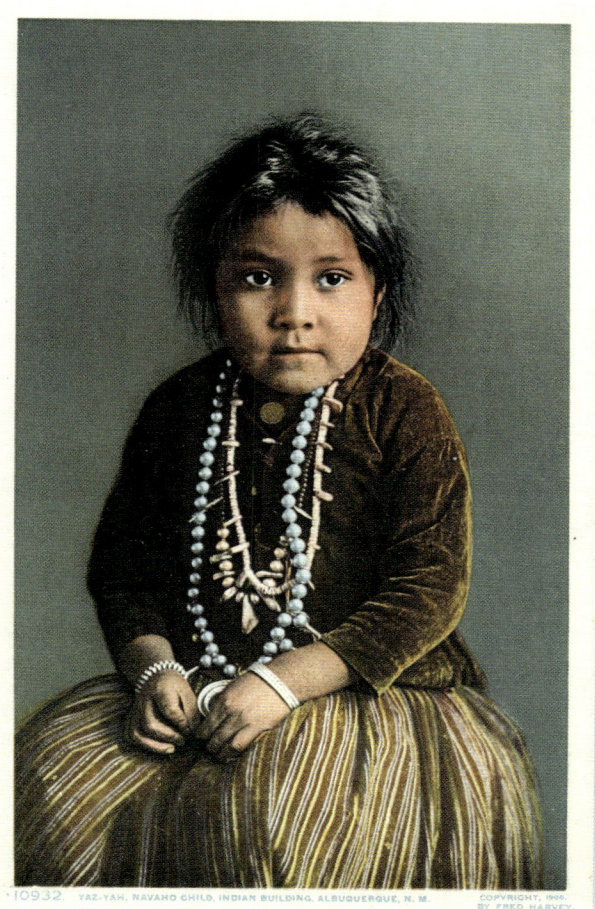
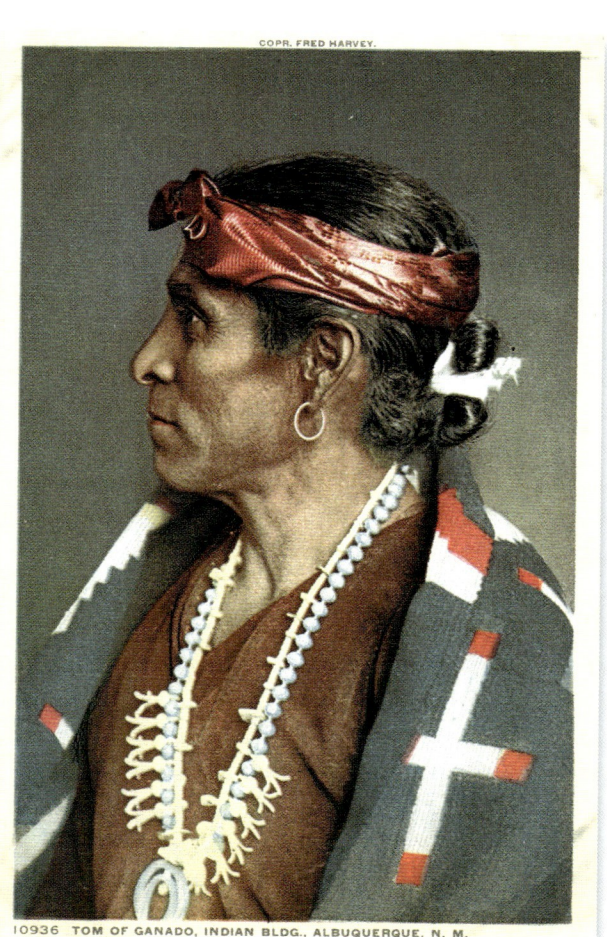

NEW MEXICO | ALBUQUERQUE

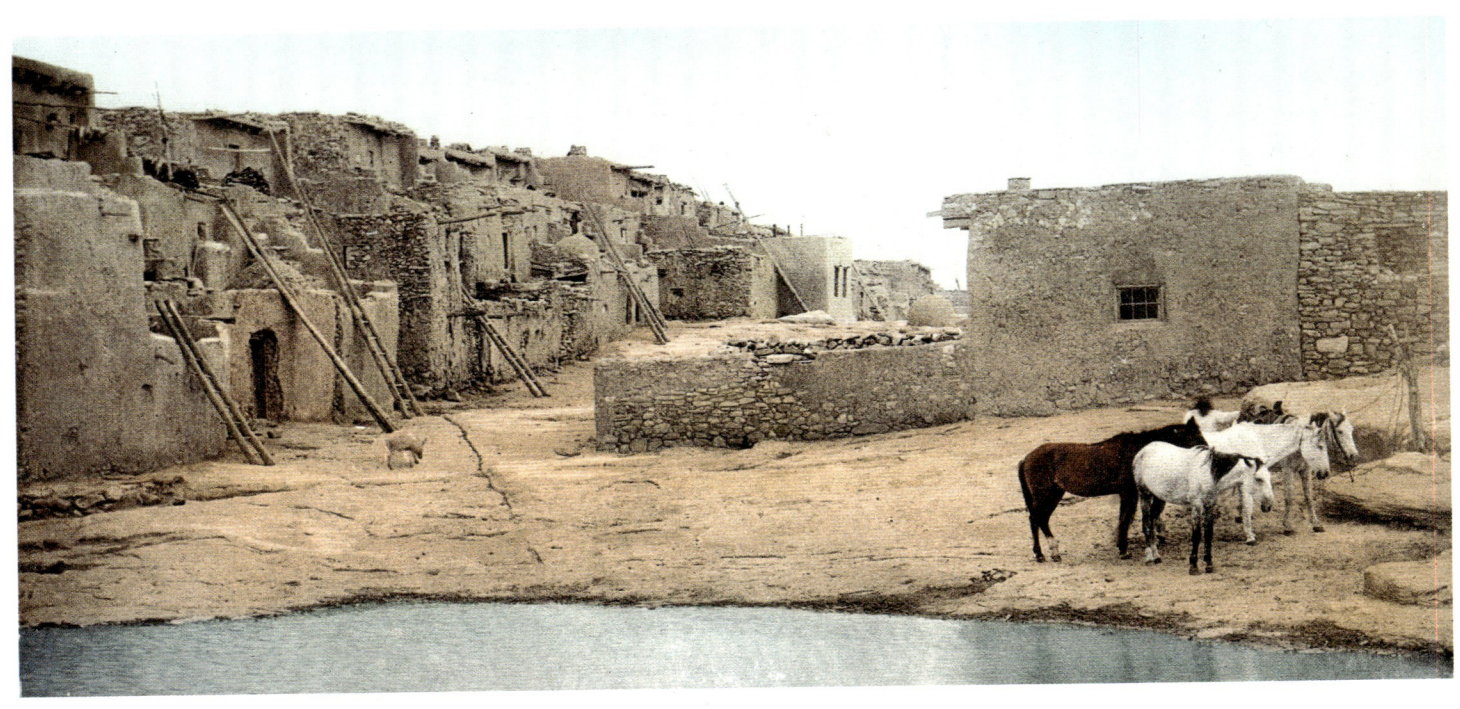

NEW MEXICO | ACOMA

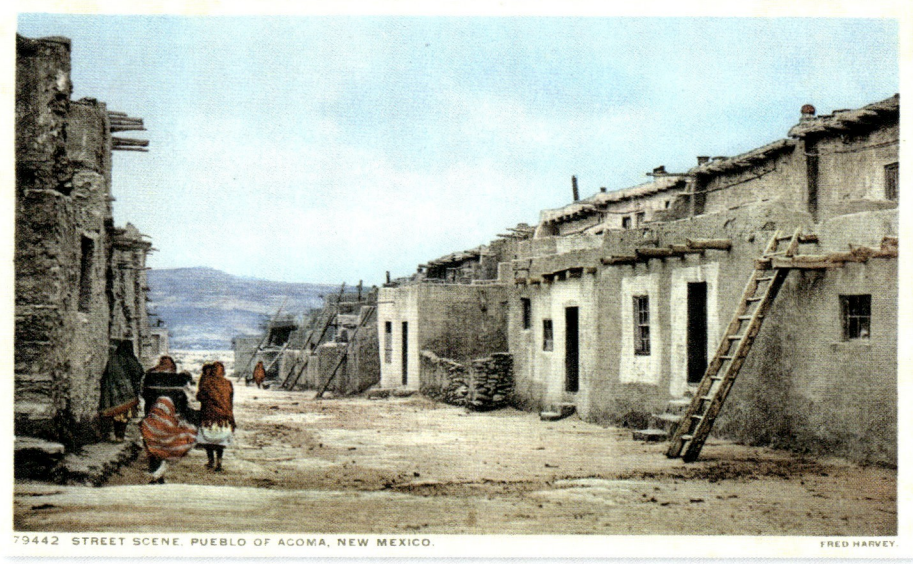

Above: Street scene, pueblo of Acoma
Below: The old church at pueblo of Acoma, photochrom
Page 410:
Above: Acoma, a street view, photochrom
Below: Mesa Encantada ("enchanted plateau") from Acoma Pueblo, photochrom

Built on a high plateau, the village of Acoma is one of the oldest Amerindian villages in the United States. All but exterminated by Spanish soldiers in the 16th century, the Acoma Pueblos (Acoma means "of the white rock") were partly converted by the Franciscan monks from the San Esteban Mission, whose adobe church is still open today. Acoma Pueblo has been designated a U.S. National Historic Landmark site.

Oben: Straßenszene in Acoma Pueblo
Unten: Die alte Kirche von Acoma Pueblo, Photochrom
Seite 410:
Oben: Eine Straße in Acoma, Photochrom
Unten: Mesa Encantada (verzauberte Hochebene) von Acoma Pueblo aus, Photochrom

Das auf einer Hochebene errichtete Dorf Acoma ist eines der ältesten Indianerdörfer der Vereinigten Staaten. Die Indianer von Acoma Pueblo („Acoma" bedeutet „vom weißen Felsen"), die im 16. Jahrhundert von den spanischen Soldaten fast gänzlich vernichtet worden waren, wurden teilweise von den Franziskanermönchen der Mission San Esteban bekehrt, deren Kirche aus Lehmziegeln noch heute geöffnet ist. Acoma Pueblo wurde zur Nationalen Historischen Stätte erklärt.

En haut : scène de rue au village d'Acoma
En bas : la vieille église du village d'Acoma, photochrome
Page 410 :
En haut : une rue d'Acoma, photochrome
En bas : vue de Mesa Encantada (le « plateau enchanté ») depuis le village de Pueblo, photochrome

Édifié sur un haut plateau, le village d'Acoma est l'un des plus anciens villages amérindiens des États-Unis. Quasi exterminés par les soldats espagnols au xvie siècle, les Indiens Pueblos Acoma (nom qui signifie « du rocher blanc ») ont été en partie convertis par les moines franciscains de la mission San Esteban, dont l'église, construite en pisé, est toujours ouverte. Acoma Pueblo a été classé comme site historique national.

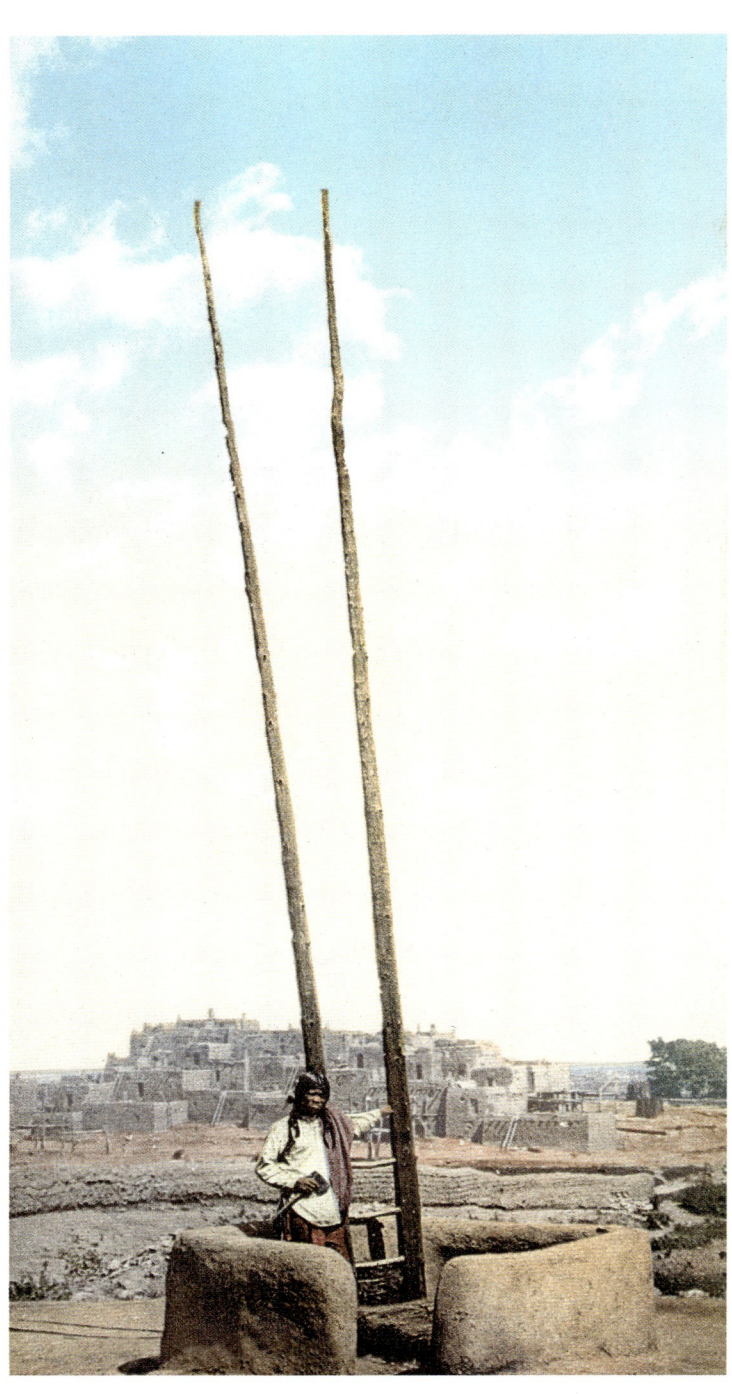

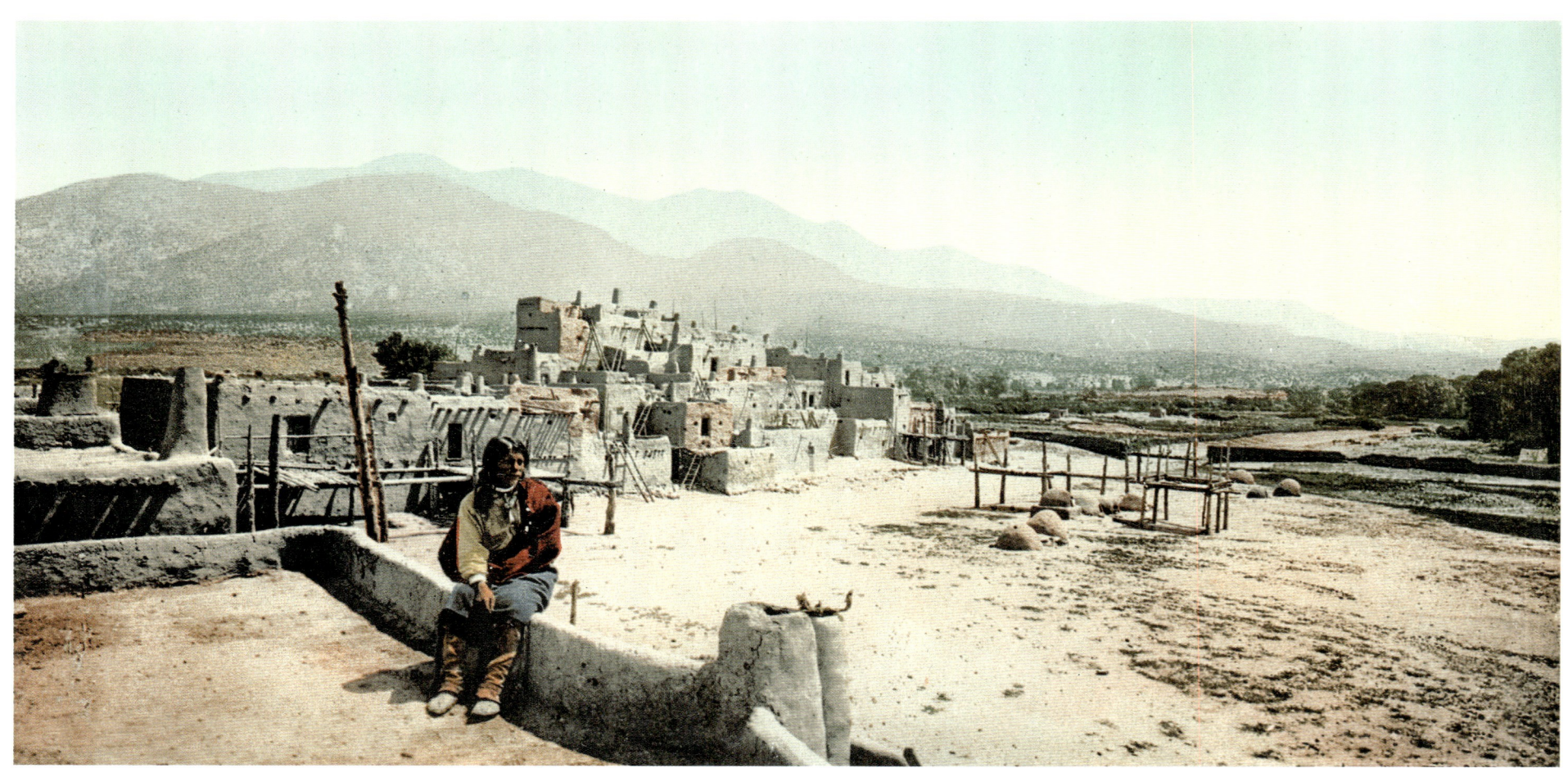

Left: **An estufa, Taos, photochrom**
Bottom: **Taos, the North Pueblo, photochrom**
The Indians of Mesa Encantada are said to have abandoned their "enchanted plateau" for the nearby one of Acoma after a devastating landslide that occurred shortly after the arrival of the Spanish.
The dwellings of Taos village are among the most remarkable examples of traditional Pueblo architecture in North America.

Links: **Mexikanischer Ofen, Taos, Photochrom**
Unten: **Taos, das nördlichste Dorf, Photochrom**
Die Indianer von Mesa Encantada haben – angeblich als Reaktion auf einen kurz nach der Ankunft der Spanier eingetretenen verheerenden Erdrutsch – ihre „verzauberte Hochebene" zugunsten der nahe gelegenen Hochebene von Acoma aufgegeben.
Die Behausungen des Dorfes Taos stellen eines der bemerkenswertesten Beispiele für die traditionelle Pueblo-Architektur Nordamerikas dar.

À gauche : **un four mexicain, Taos, photochrome**
En bas : **Taos, le village nord, photochrome**
Les Indiens de Mesa Encantada auraient abandonné leur « Plateau enchanté » pour celui, voisin, d'Acoma à la suite d'un glissement de terrain dévastateur survenu peu de temps après l'arrivée des Espagnols.
Les habitations du village de Taos constituent l'un des exemples les plus remarquables de l'architecture traditionnelle Pueblo en Amérique du Nord.

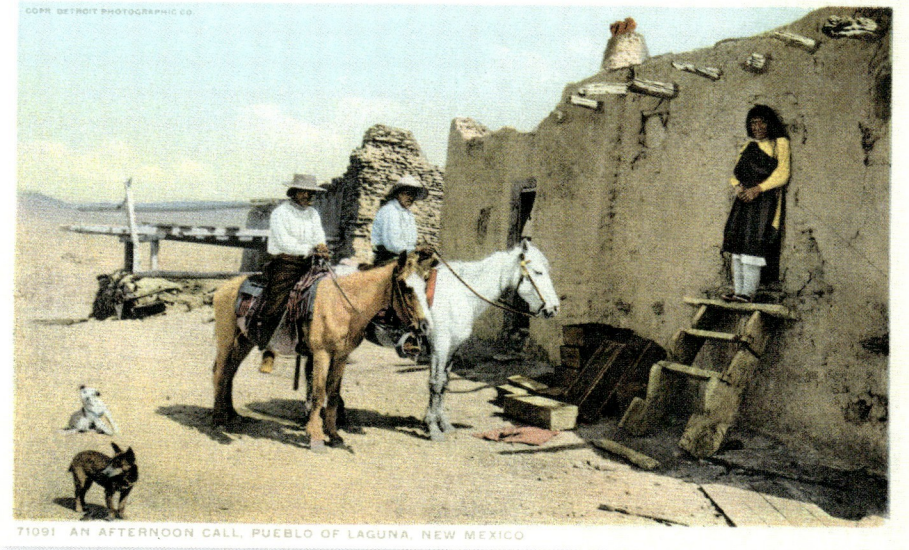

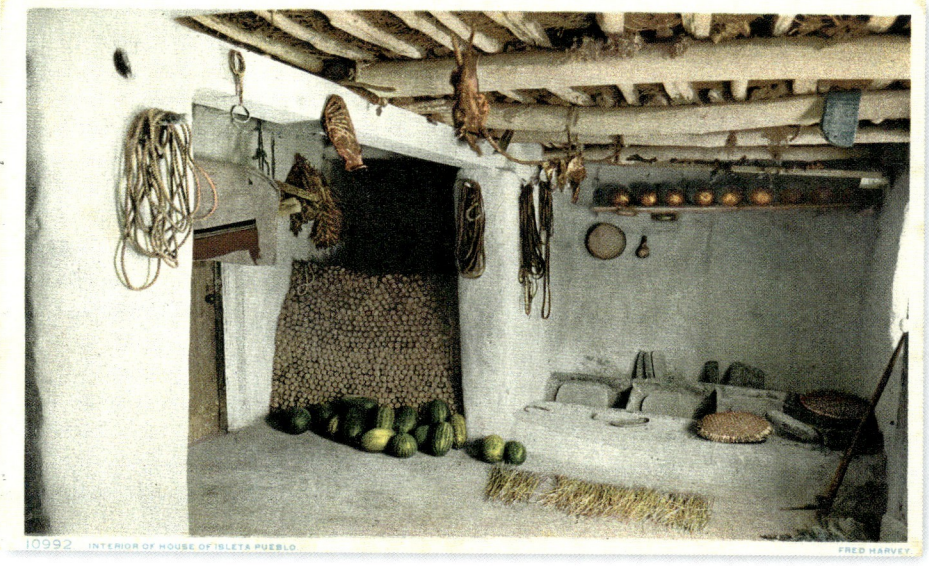

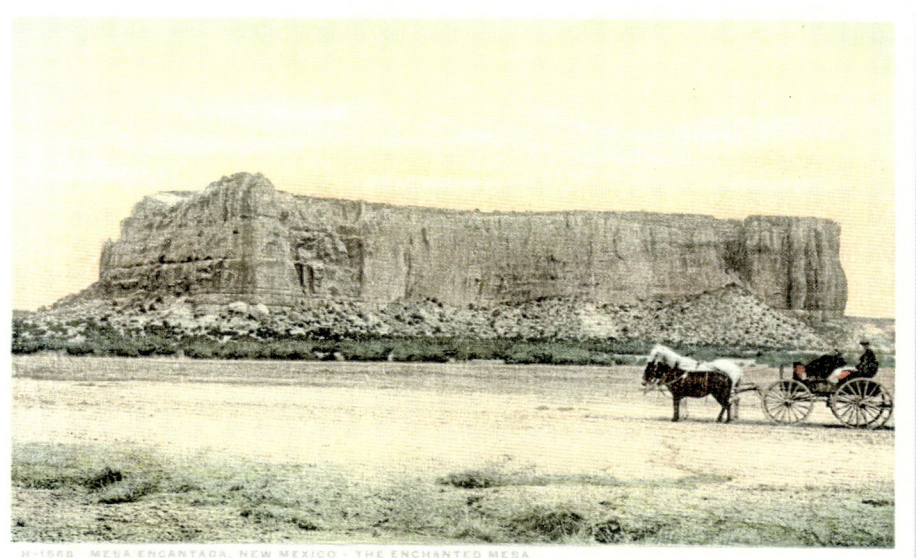

Above, from left to right and top to bottom:
An afternoon call, Pueblo of Laguna
Interior of a house of Isleta Pueblo
Mesa Encantada, the "enchanted plateau"
Below: On the road to Mesa Encantada, photochrom

Oben, von links nach rechts und von oben nach unten:
Nachmittäglicher Besuch, Laguna Pueblo
Innenraum eines Hauses in Isleta Pueblo
Mesa Encantada, die „verzauberte Hochebene"
Unten: Unterwegs zur Mesa Encantada, Photochrom

En haut, de gauche à droite et de haut en bas :
Un après-midi au village de Laguna
Intérieur de maison au village d'Isleta
Mesa Encantada, le « plateau enchanté »
Ci-dessous : sur la route de Mesa Encantada, photochrome

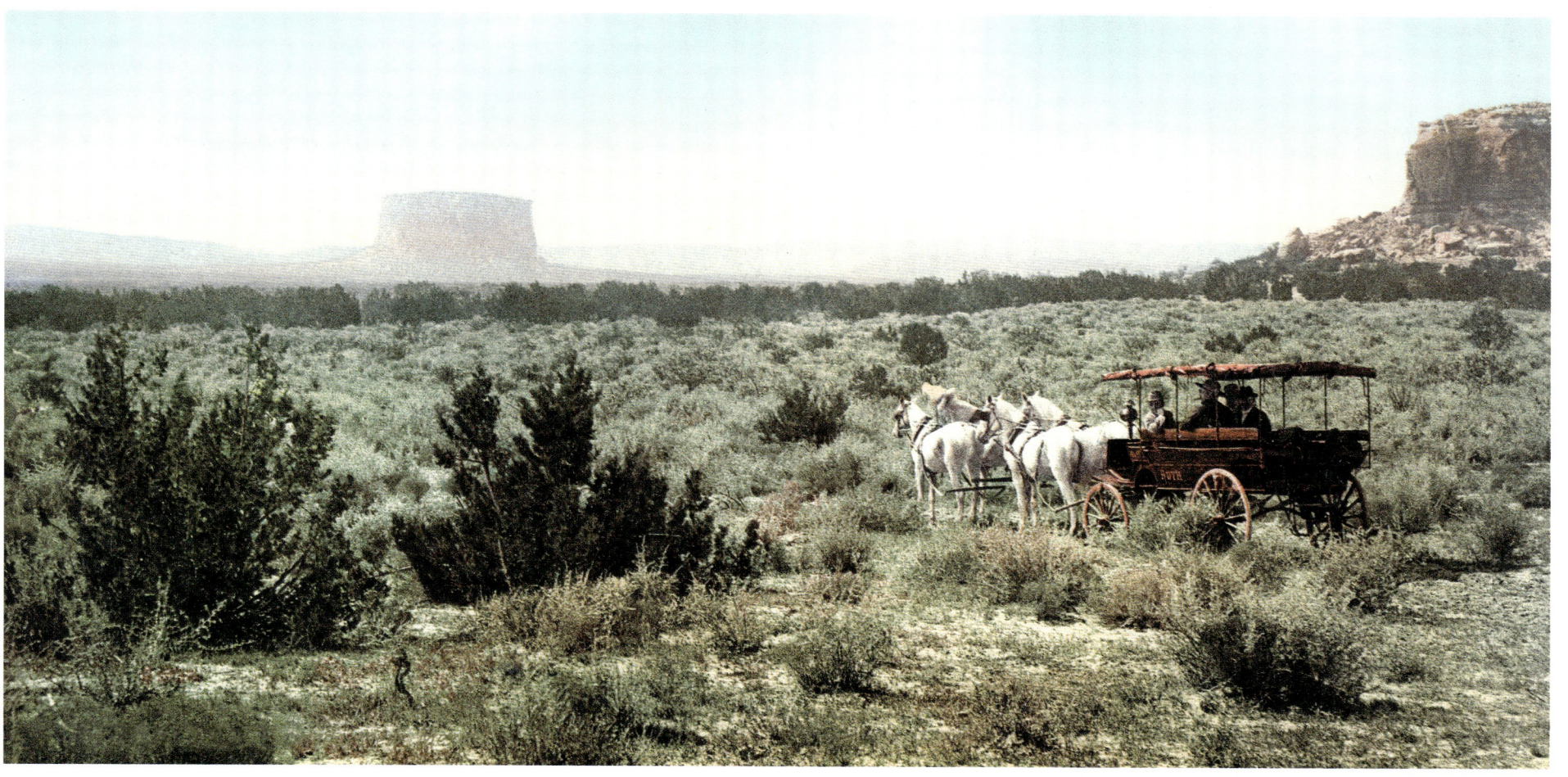

NEW MEXICO | LAGUNA | ISLETA | MESA ENCANTADA

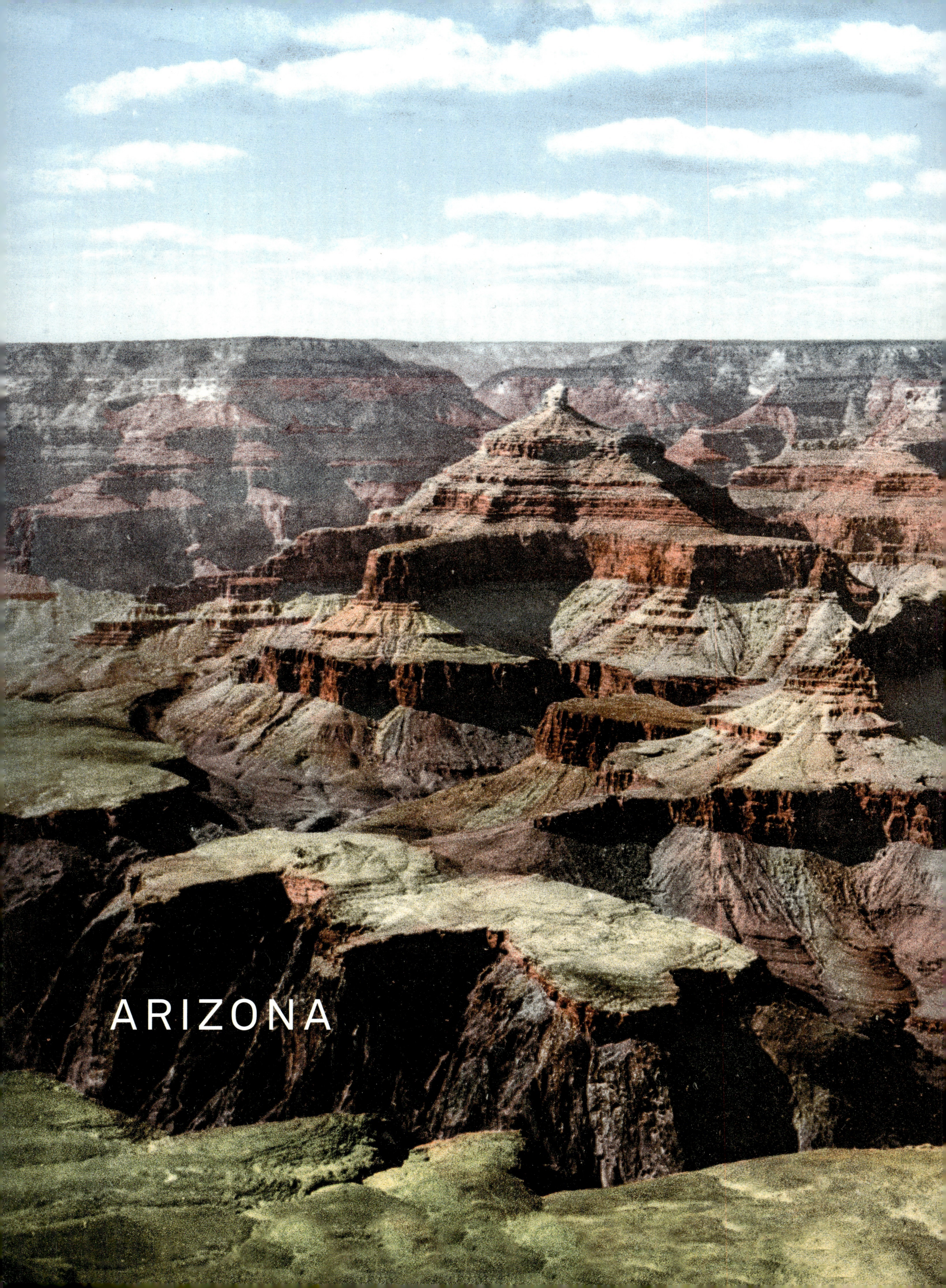

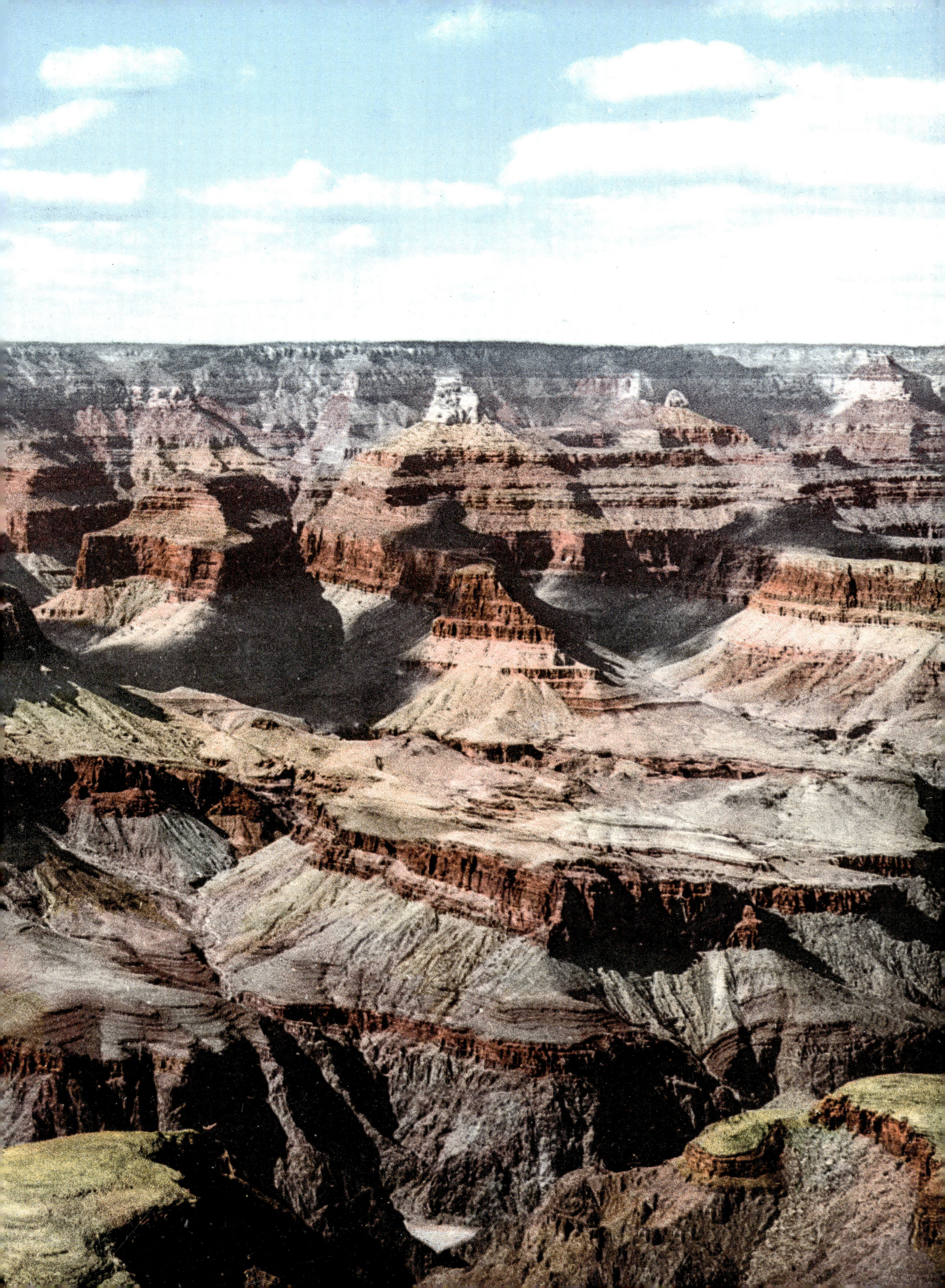

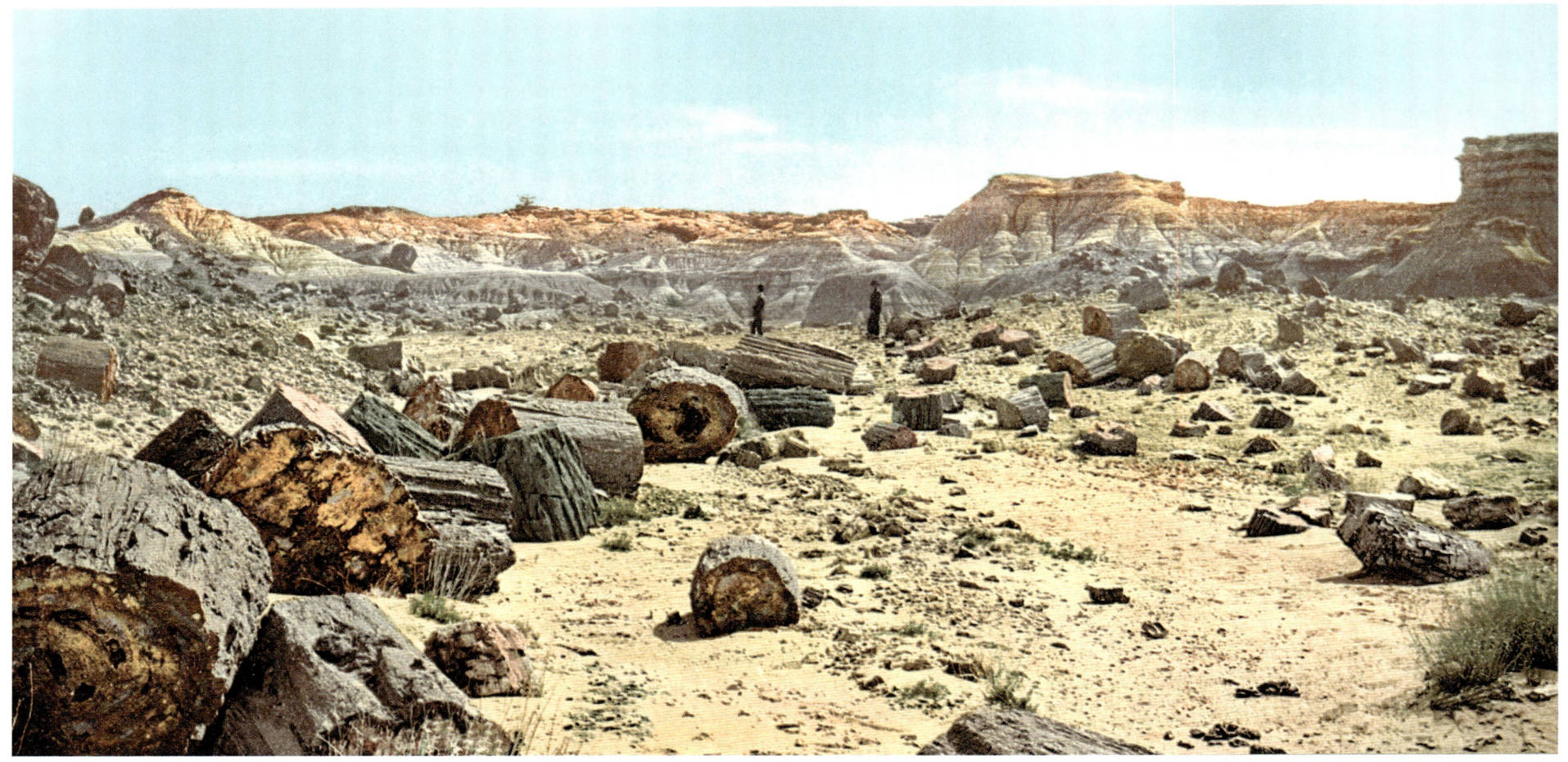

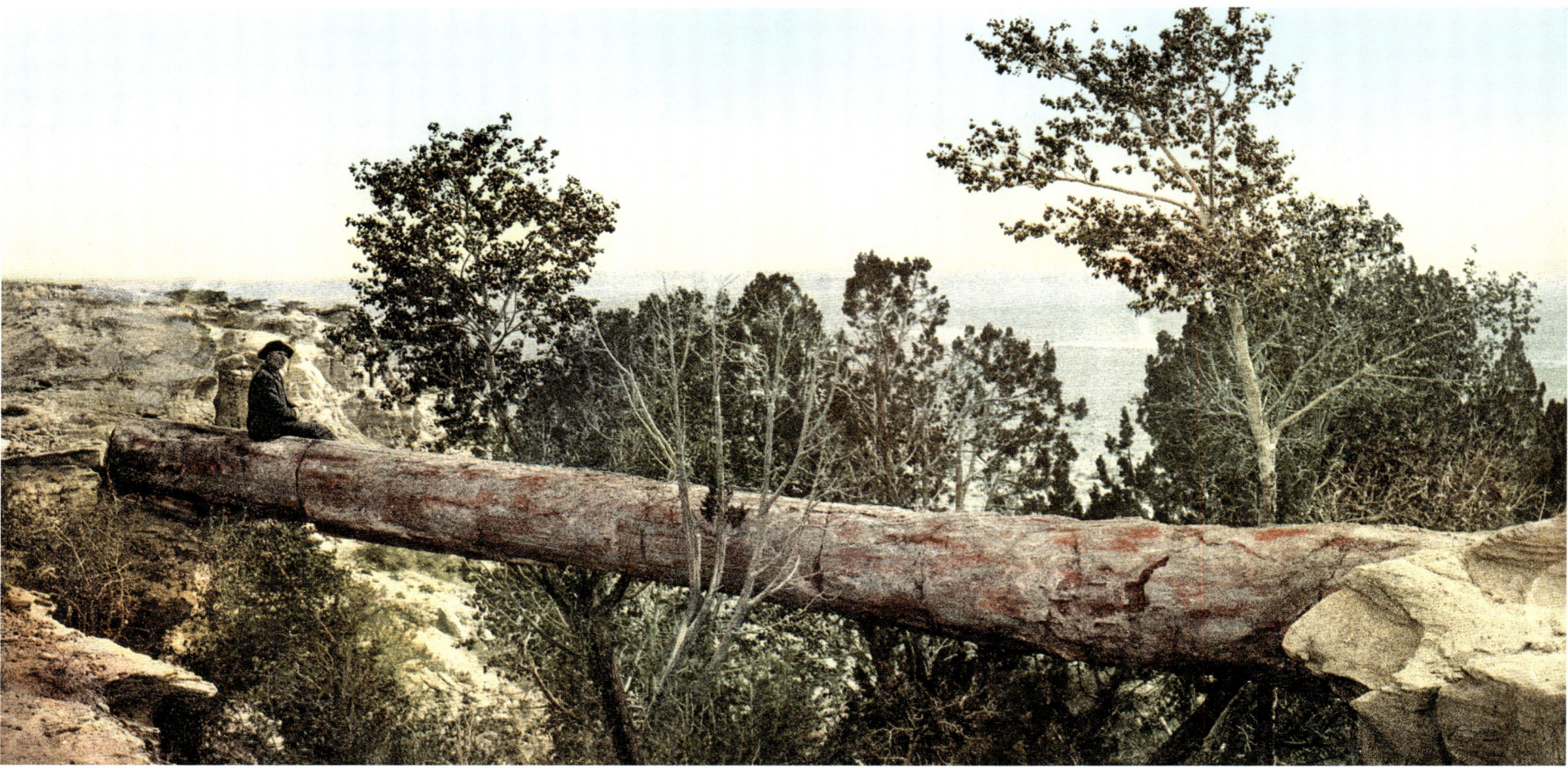

Page 414/415: Grand Canyon, view from O'Neill's Point, photochrom
Top: The Petrified Forest, near Adamana, photochrom
Above: Natural bridge (or "Agate Bridge") in the Petrified Forest, near Adamana, photochrom

The fossilized trees of the Petrified Forest are between 200 and 250 million years old. Layers of volcanic sediment rich in silica buried them and ensured their preservation. These days, the Agate Bridge is held up by a concrete beam.

Seite 414/415: Grand Canyon, Blick vom O'Neill's Point, Photochrom
Oben: Petrified Forest (versteinerter Wald) bei Adamana, Photochrom
Mitte: Agate Bridge (natürliche Brücke) im Petrified Forest bei Adamana, Photochrom

Die fossilen Bäume des versteinerten Waldes sind zwischen 200 und 250 Millionen Jahre alt. Die kieselsäurehaltigen vulkanischen Sedimentschichten, unter denen sie begraben wurden, haben ihre Konservierung ermöglicht. Die Agate Bridge wird heute von einem Betonträger gestützt.

Pages 414/415 : vue du Grand Canyon depuis O'Neill's Point, photochrome
En haut : la Forêt pétrifiée près d'Adamana, photochrome
Ci-dessus : pont naturel (dit « pont d'Agate ») dans la Forêt pétrifiée près d'Adamana, photochrome

Les arbres fossilisés de la Forêt pétrifiée ont entre 200 et 250 millions d'années. Ce sont les couches de sédiments volcaniques riches en silice sous lesquelles ils ont été enfouis qui ont permis leur préservation. Le pont d'Agate (Agate Bridge) est aujourd'hui soutenu par une poutre de béton.

From top to bottom:
In Apache land
In Navajo land
Giant cactus, Phoenix

Von oben nach unten:
Im Land der Apachen
Im Land der Navajo
Riesenkaktus, Phoenix

De haut en bas :
En pays Apache
En pays Navajo
Cactus géant, Phoenix

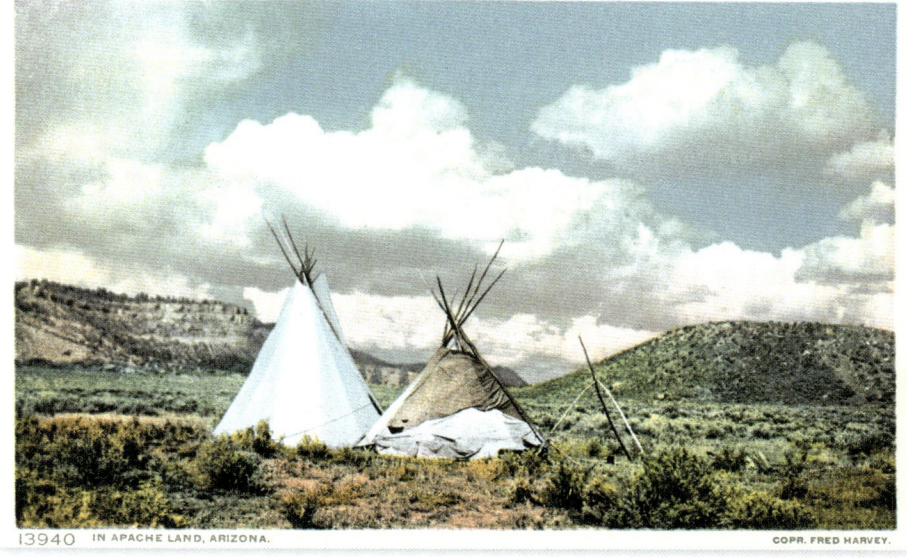
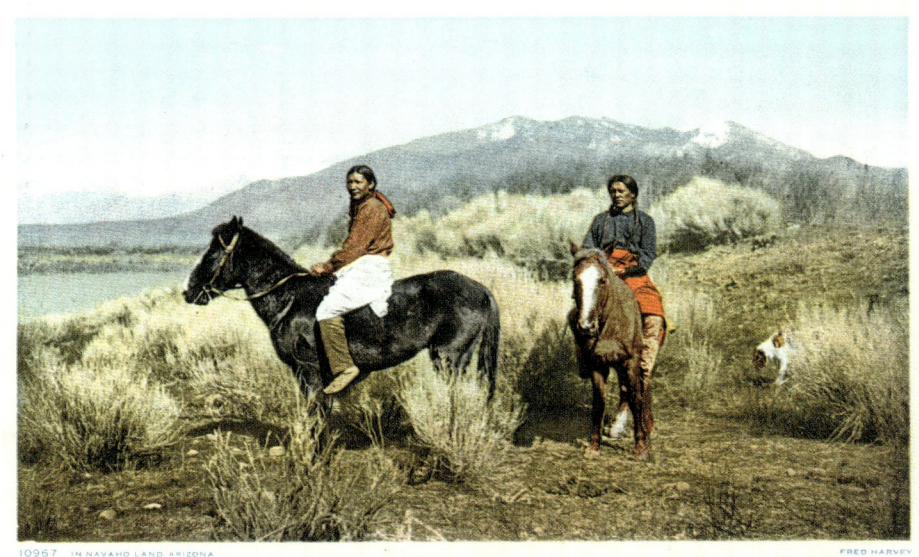
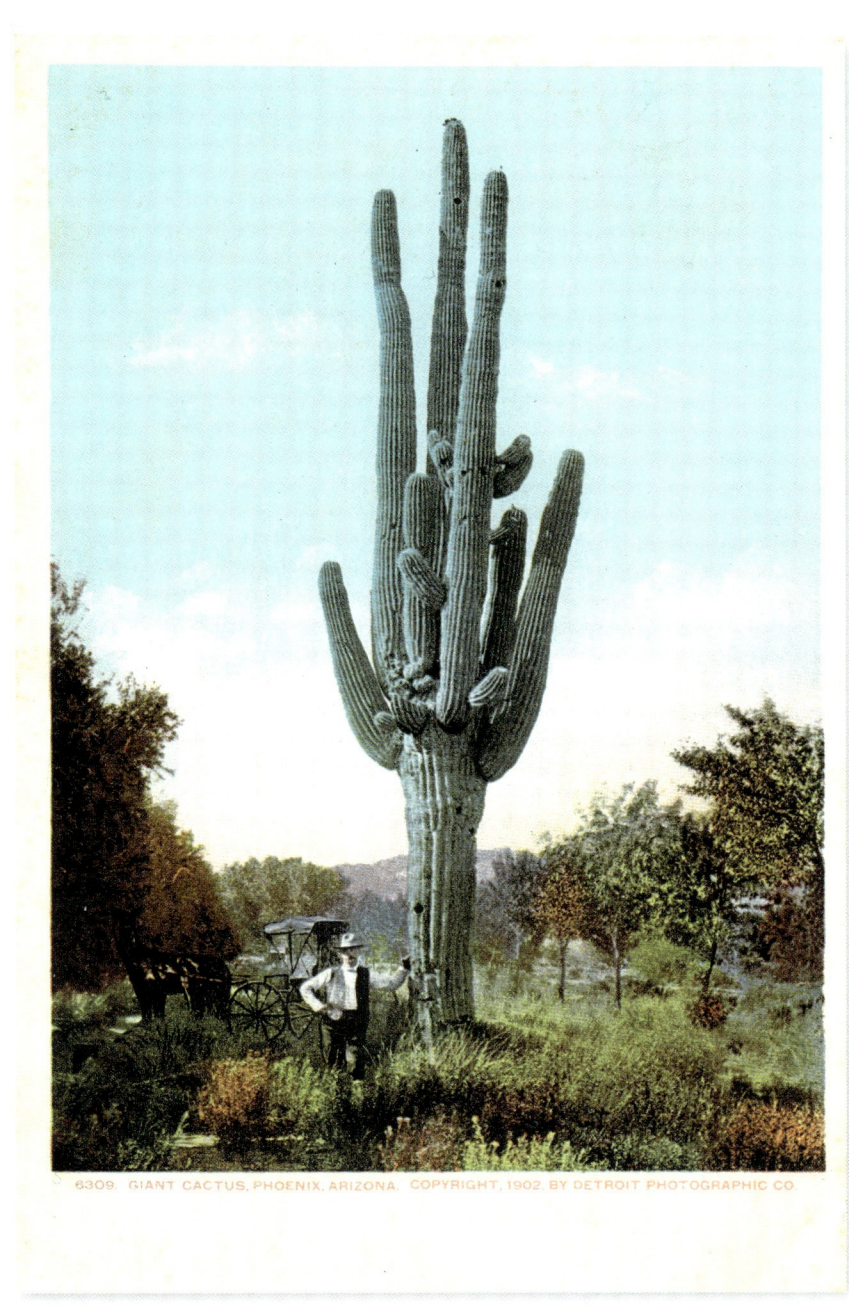

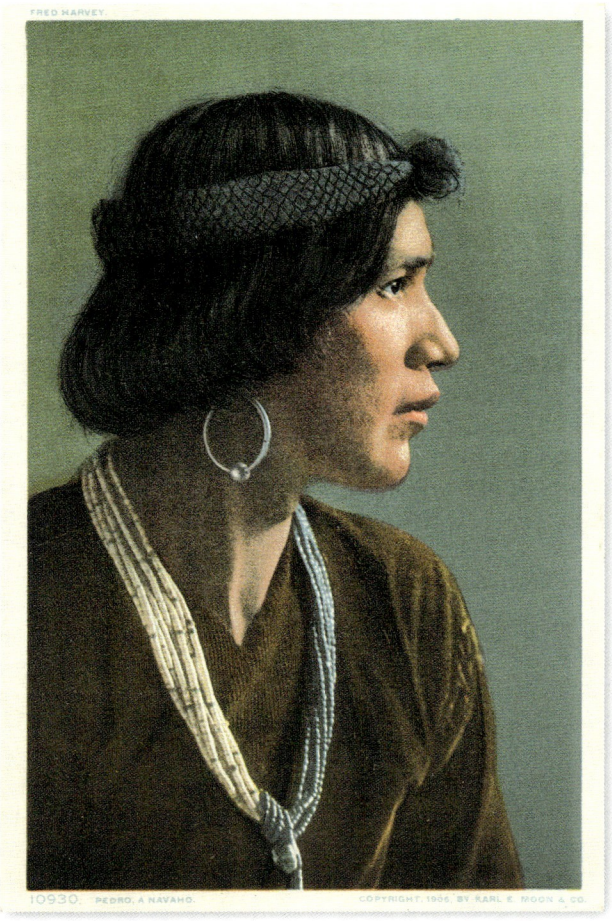
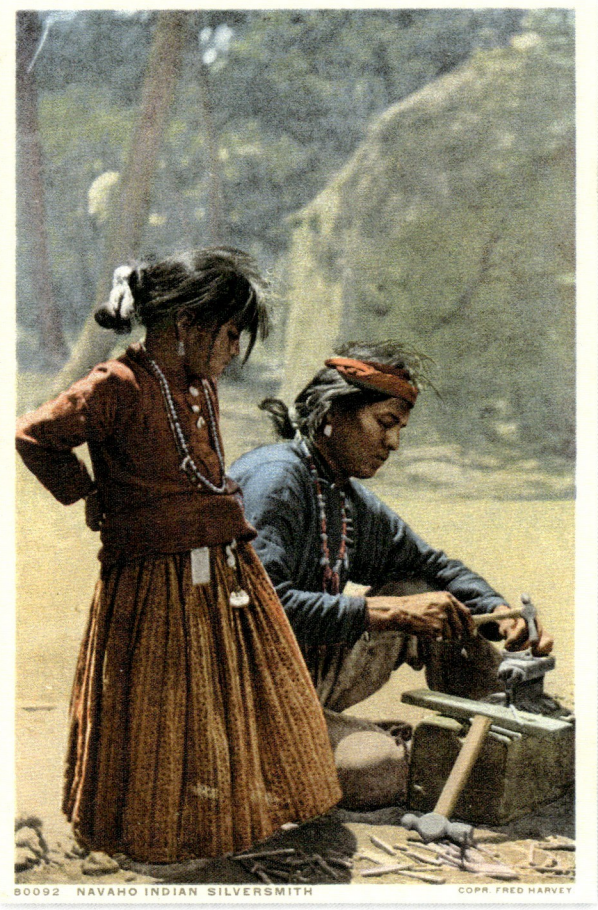

Far left: **Pedro, a Navajo Indian**
Near left: **Navajo Indian silversmith**
Below: **San Xavier Mission, near Tucson, photochrom**
Page 419: **The man with the hoe, photochrom**

The San Xavier del Bac Mission was founded in 1692 by the Italian-born Jesuit Eusebio Francisco Kino in the heart of the Sonoran Desert on the site of a village where a large community of Tohono O'odham Indians lived; they were known to the Spanish as Pimas or Papagos. Father Kino laid the foundations of a church, which was built 100 years later by the architect Ignacio Gaona in the 18th-century Spanish Baroque style and is today a National Historic Landmark.

Ganz links: **Pedro, ein Navajo-Indianer**
Links: **Ein Navajo-Schlosser**
Unten: **Die Mission San Xavier bei Tucson, Photochrom**
Seite 419: **Mann mit Hacke, Photochrom**

Die Mission San Xavier del Bac wurde 1692 von dem italienischen Jesuitenpater Eusebio Francisco Kino mitten in der Wüste von Sonoran gegründet, wo eine sehr große Gemeinschaft von Tohono-O'odham-Indianern – von den Spaniern Pimas oder Papagos genannt – lebte. Pater Kino legte den Grundstein für eine Kirche. Diese wurde jedoch erst 100 Jahre später von dem Architekten Ignacio Gaona im spanischen Barockstil des 18. Jahrhunderts erbaut und steht heute unter Denkmalschutz.

À gauche : **Pedro, un Indien Navajo**
Ci-contre : **un serrurier Navajo**
En bas : **la mission San Xavier, près de Tucson, photochrome**
Page 419 : **l'homme à la houe, photochrome**

La mission San Xavier del Bac a été fondée en 1692 par le père jésuite d'origine italienne Eusebio Francisco Kino au cœur du désert de Sonoran, où vivait une très importante communauté d'Indiens Tohono O'odham – appelés Pimas, ou Papagos par les Espagnols. Le père Kino posa les fondations d'une église. Elle sera élevée cent ans plus tard par l'architecte Ignacio Gaona dans le style baroque espagnol du XVIIIe siècle. Elle est aujourd'hui classée.

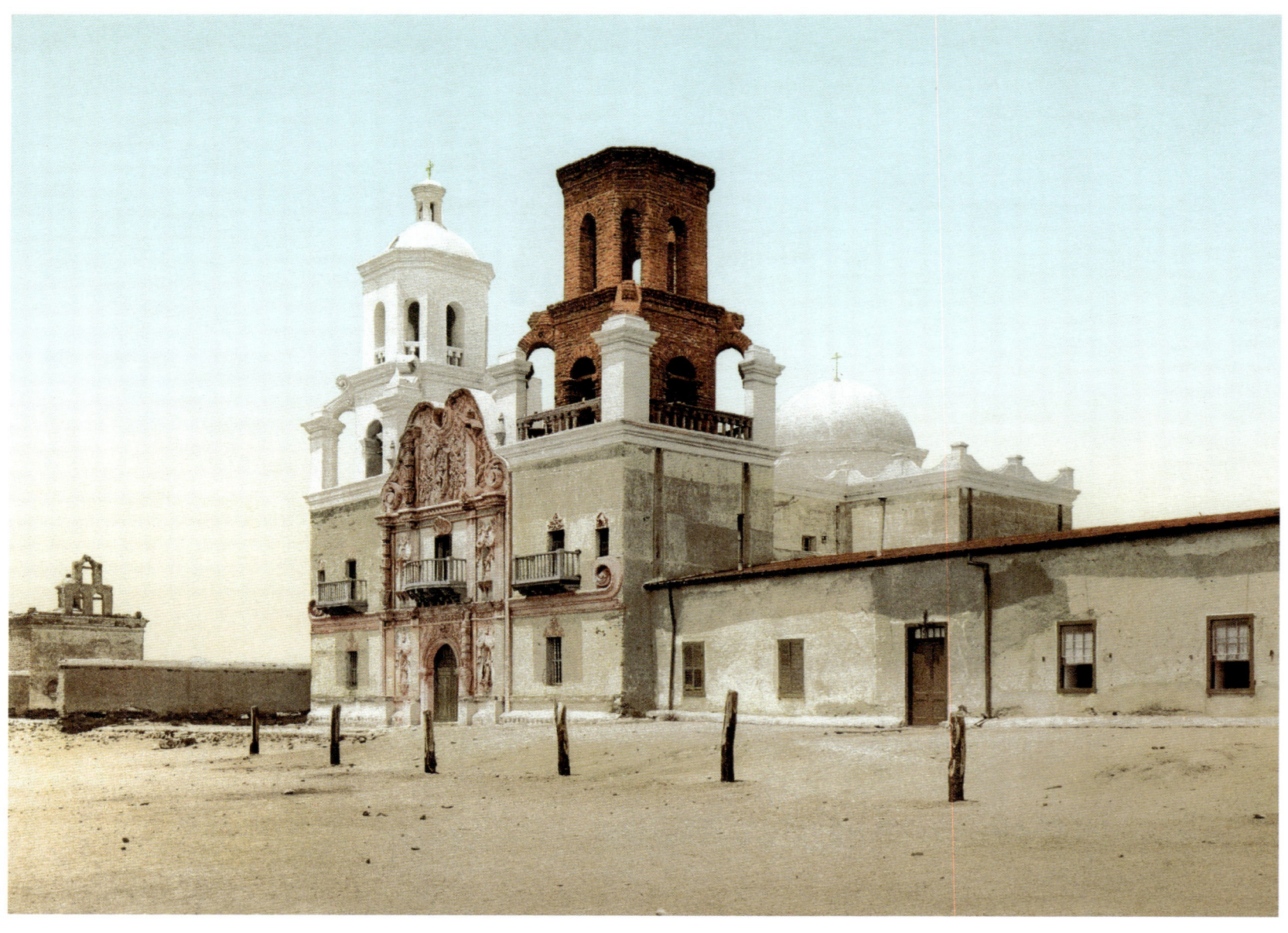

ARIZONA | TUCSON

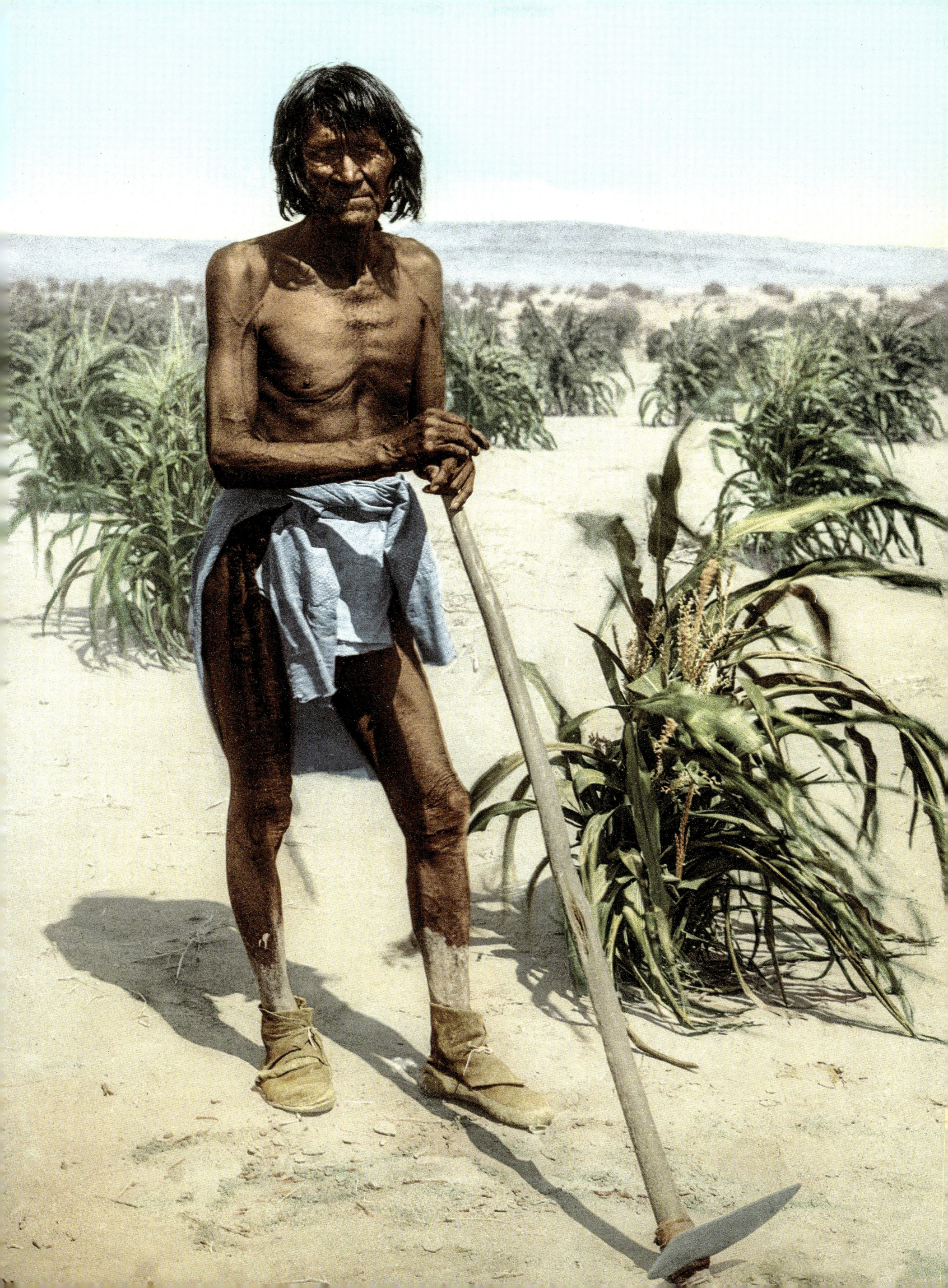

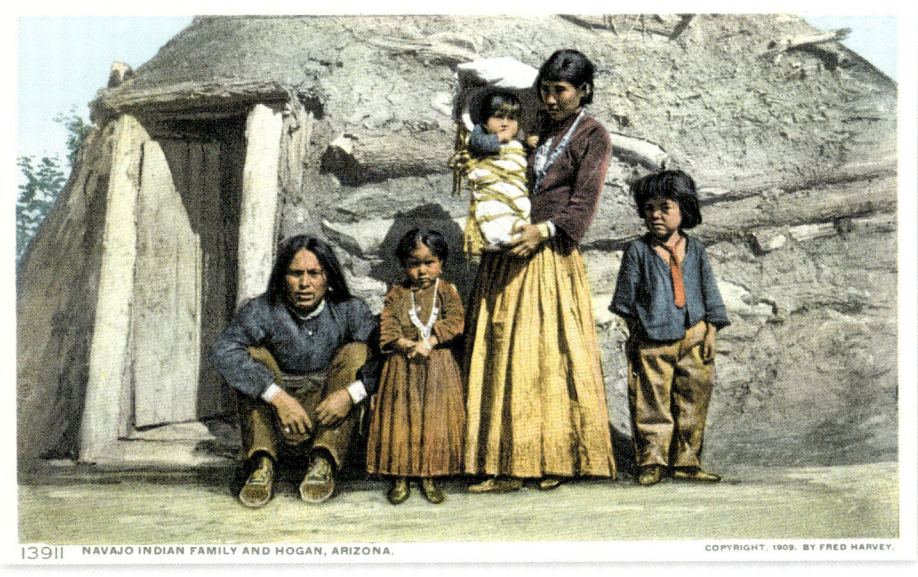

Above: Navajo Indian family and hogan
Below: Navajo woman weaving, photochrom
Page 421: Old Moki basket weaver, photochrom

Oben: Navajo-Familie vor ihrem Hogan (traditionelles Haus)
Unten: Navajo-Frau beim Weben, Photochrom
Seite 421: Moki-Indianerin beim Korbflechten, Photochrom

En haut : famille Navajo devant sa maison traditionnelle (*hogan*)
Ci-dessous : femme Navajo tissant, photochrome
Page 421 : Indienne Moki tressant un panier, photochrome

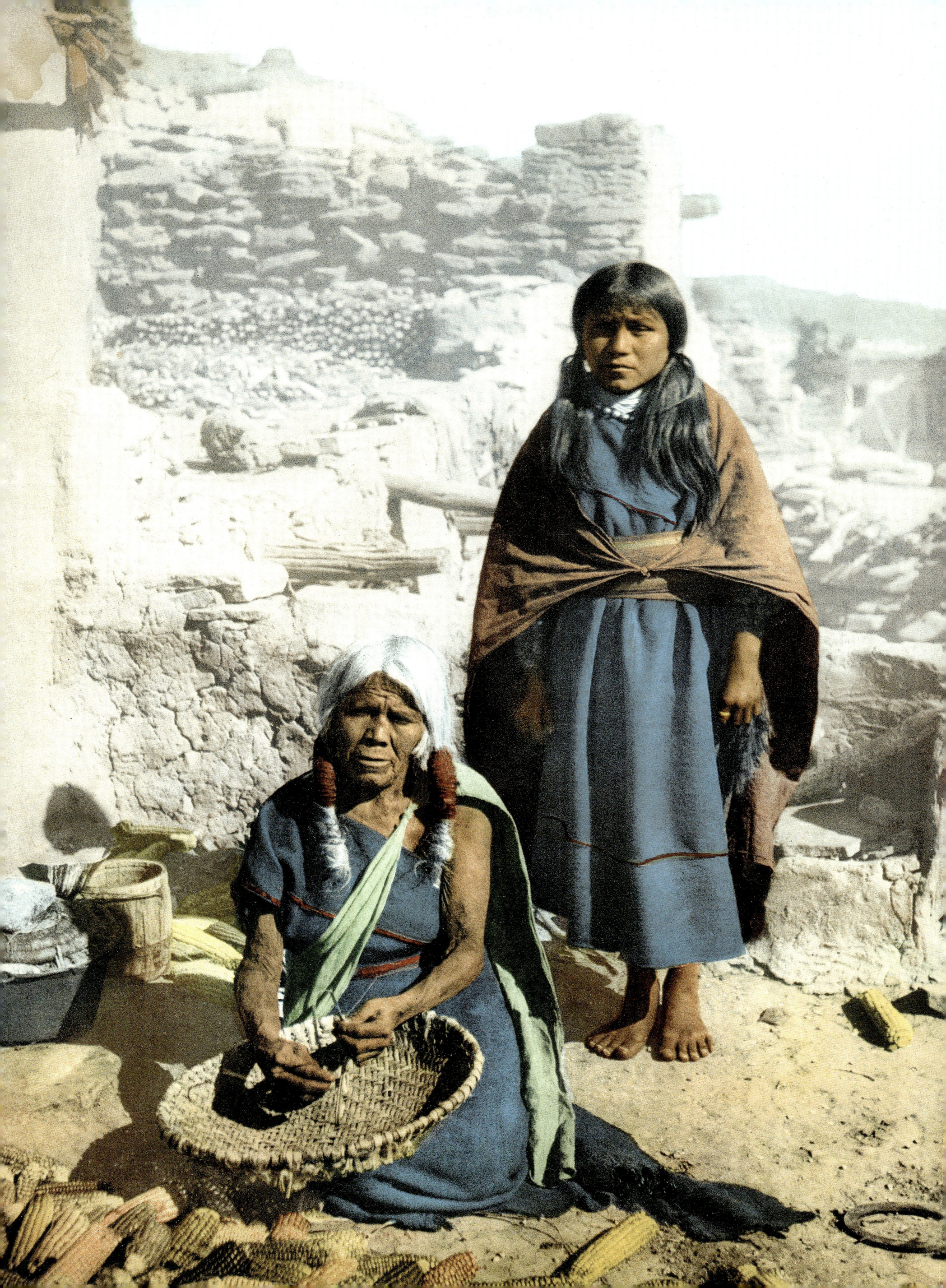

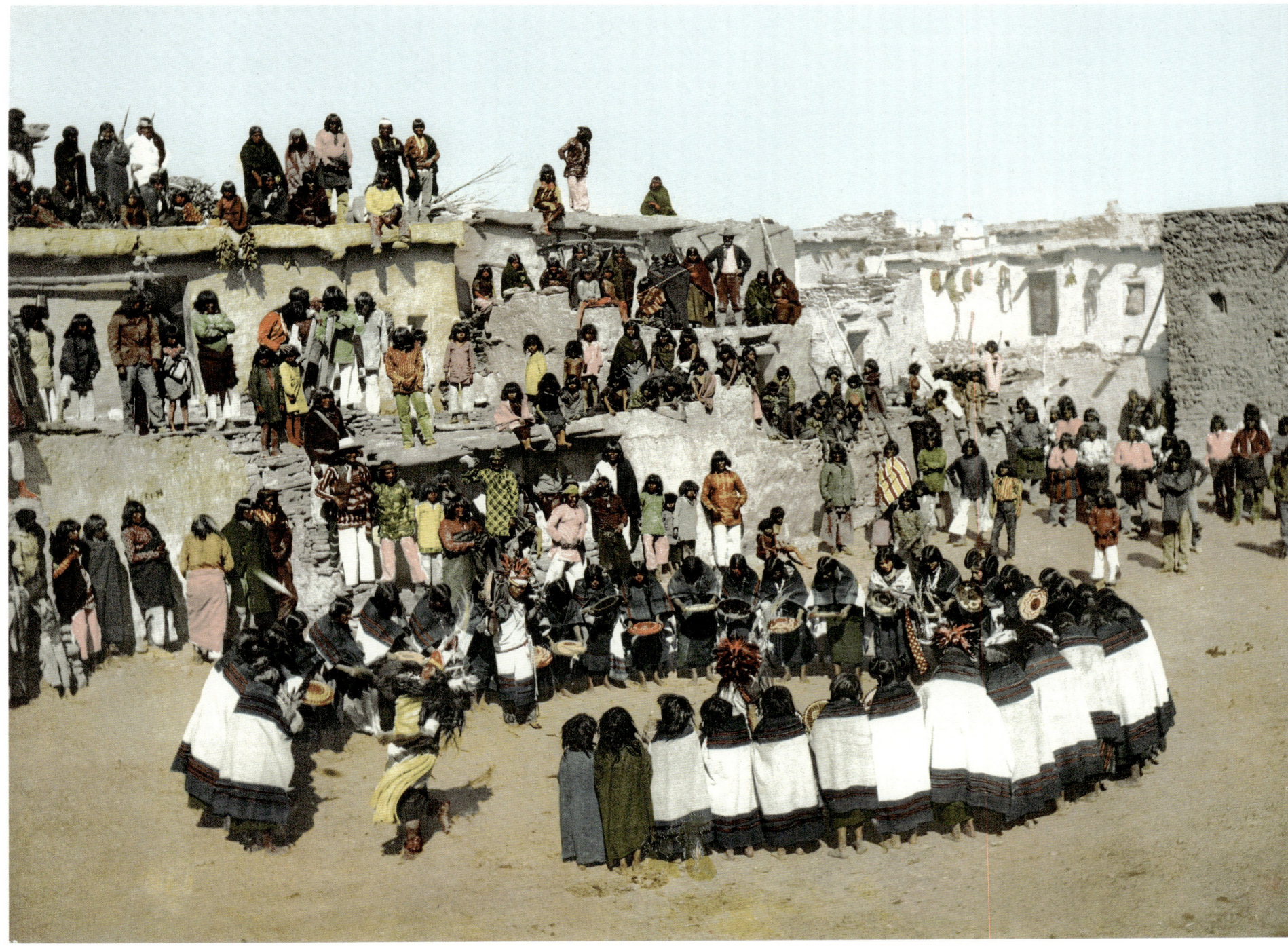

Above: **Thanksgiving dance, photochrom**
Page 423:
Top: **Pueblo Indians, Moki Snake Dance, Antelope Priests, photochrom**
Bottom: **Papago Indians, photochrom**

Oben: **Thanksgiving-Tanz, Photochrom**
Seite 423:
Oben: **Pueblo-Indianer, Moki-Schlangentanz, Antilopenpriester, Photochrom**
Unten: **Papago-Indianer, Photochrom**

Ci-dessus : **danse de Thanksgiving, photochrome**
Page 423 :
En haut : **Indiens Moki Pueblos, la danse du Serpent, « prêtres antilopes », photochrome**
En bas : **Indiens Papagos, photochrome**

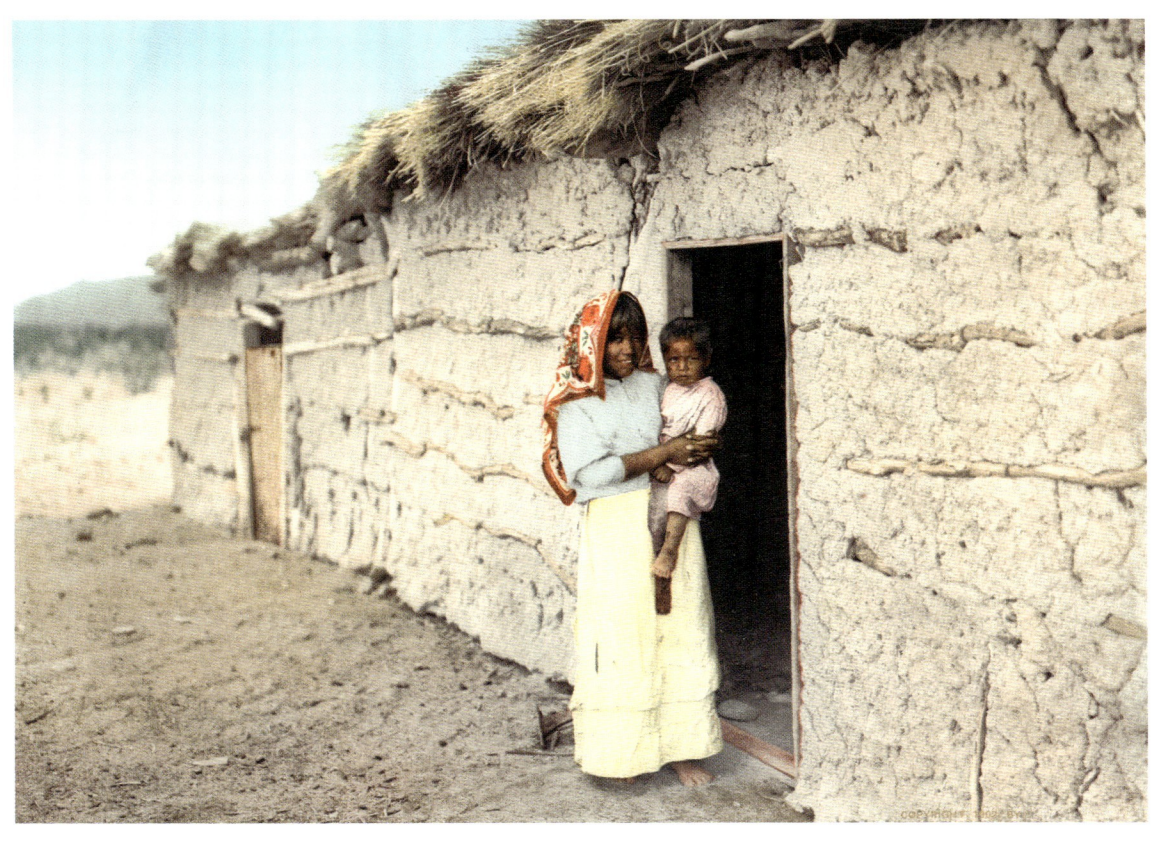

ARIZONA

From top to bottom:
Sunrise in Grand Canyon
Grand Canyon from Yavapai Point
Bright Angel Canyon from O'Neill's Point, photochrom

Von oben nach unten:
Sonnenaufgang über dem Grand Canyon
Blick vom Yavapai Point auf den Grand Canyon
Bright Angel Canyon vom O'Neill's Point aus, Photochrom

De haut en bas :
Lever de soleil sur le Grand Canyon
Vue du Grand Canyon depuis Yavapai Point
Bright Angel Canyon depuis O'Neill's Point, photochrome

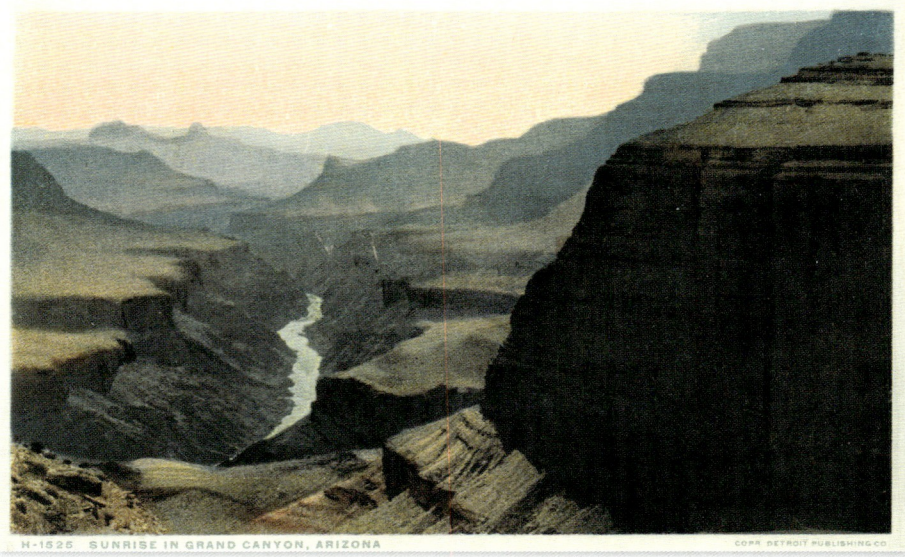
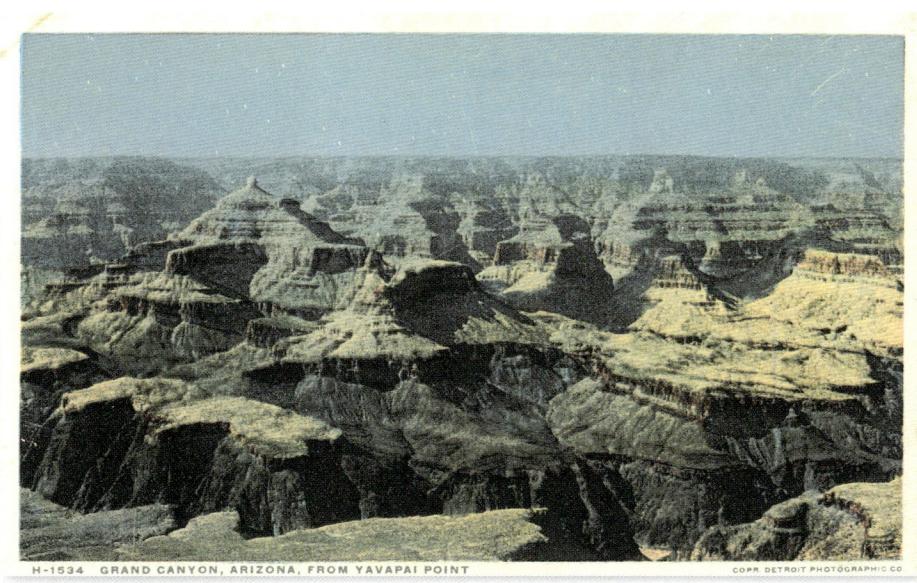

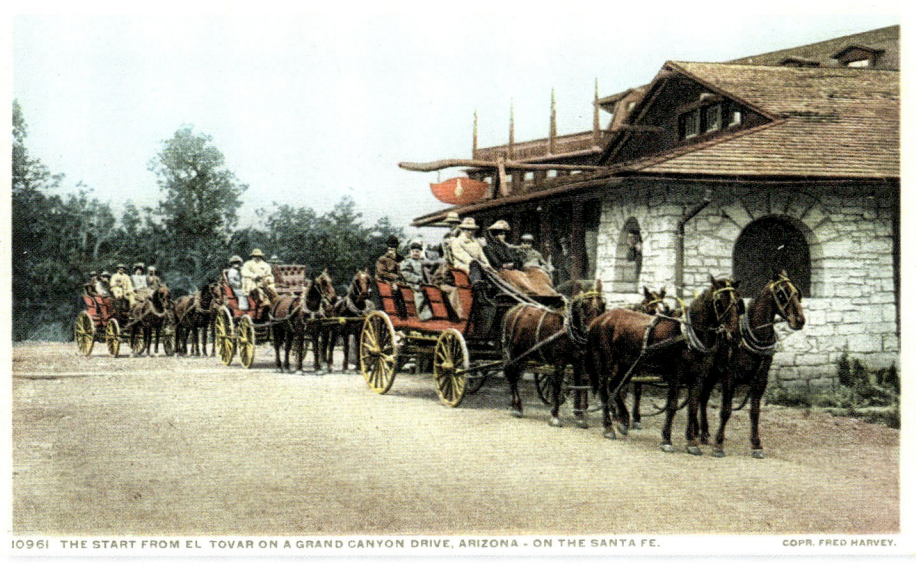

From left to right and top to bottom:
Grand Canyon, front porch, Hermit's Rest
Hotel El Tovar
Private dining room, Hotel El Tovar
The start from El Tovar on a Grand Canyon drive
Below: Lobby of Hotel El Tovar

Lying on the south rim of the Grand Canyon, El Tovar Hotel was built by the architect Charles Whittlesey for the Fred Harvey chain and the Santa Fe Railway. It opened in January 1905 and is the oldest hotel in the Grand Canyon. A luxury establishment, it was designed to match the extraordinary grandeur of its environment in a mixture of styles: "Southwestern," Spanish, and chalet.

Von links nach rechts und von oben nach unten:
Grand Canyon, Eingangsbereich zum Hermit's Rest
Das Hotel El Tovar
Privates Esszimmer im Hotel El Tovar
Abfahrt von El Tovar zu einer Exkursion in den Grand Canyon
Unten: Eingangshalle des Hotels El Tovar

Ganz am Rande des Grand Canyon auf dessen Südseite errichtete der Architekt Charles Whittlesey im Auftrag der Hotelkette Fred Harvey und der Santa Fe Railway das Hotel El Tovar. Es wurde im Januar 1905 eröffnet. Diese älteste Hotelanlage des Grand Canyon war einerseits luxuriös und passte sich andererseits mit ihrer Mischung aus „southwestern", spanischem, Chalet- und anderen Stilen der großartigen und schroffen Natur ihrer Umgebung an.

De gauche à droite et de haut en bas :
Le porche d'Hermit's Rest dans le Grand Canyon
Vue de l'hôtel El Tovar
Salle à manger privée, hôtel El Tovar
Départ pour une excursion dans le Grand Canyon
Ci-dessous : le hall de l'hôtel El Tovar

Juste au bord du Grand Canyon, du côté sud, l'hôtel El Tovar a été édifié par l'architecte Charles Whittlesey pour le compte de la chaîne Fred Harvey et du Santa Fe Railway. Il a ouvert ses portes en janvier 1905. C'est la plus ancienne résidence hôtelière du Grand Canyon et il a été conçu en tant que tel, à la fois luxueux et dans un mélange de styles – « Southwestern », espagnol, chalet, etc. – adapté à la grandeur sauvage de son environnement.

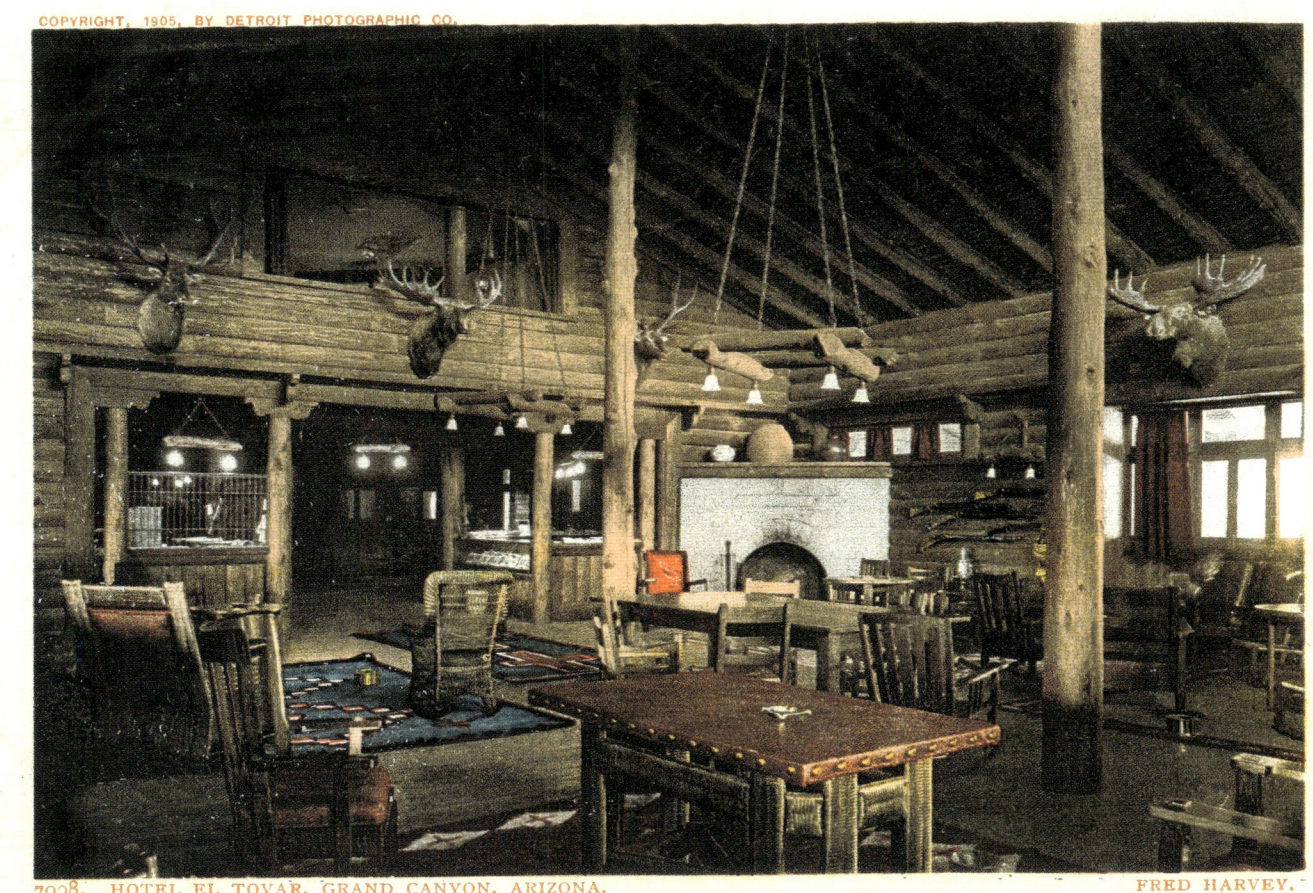

ARIZONA | GRAND CANYON

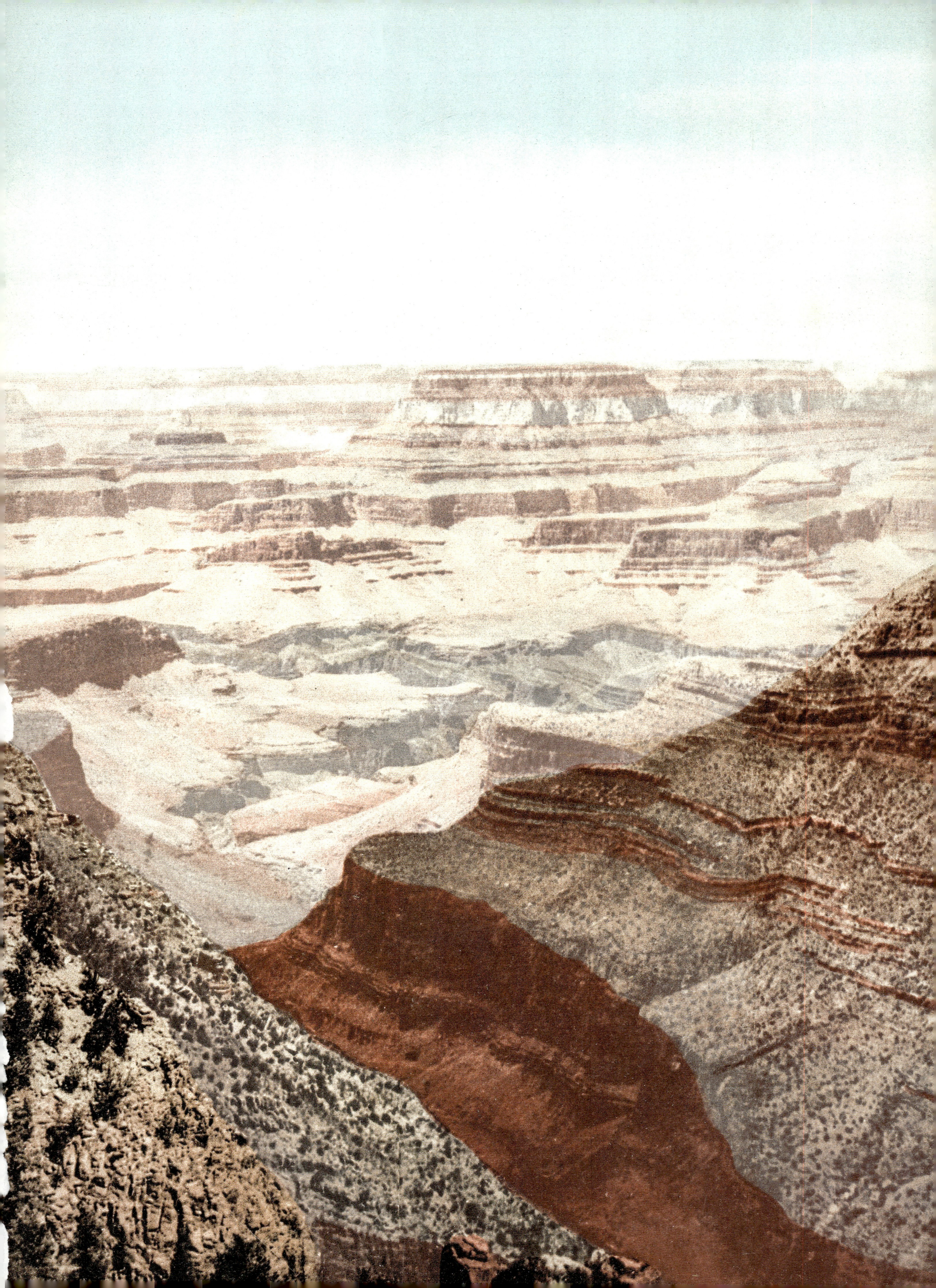

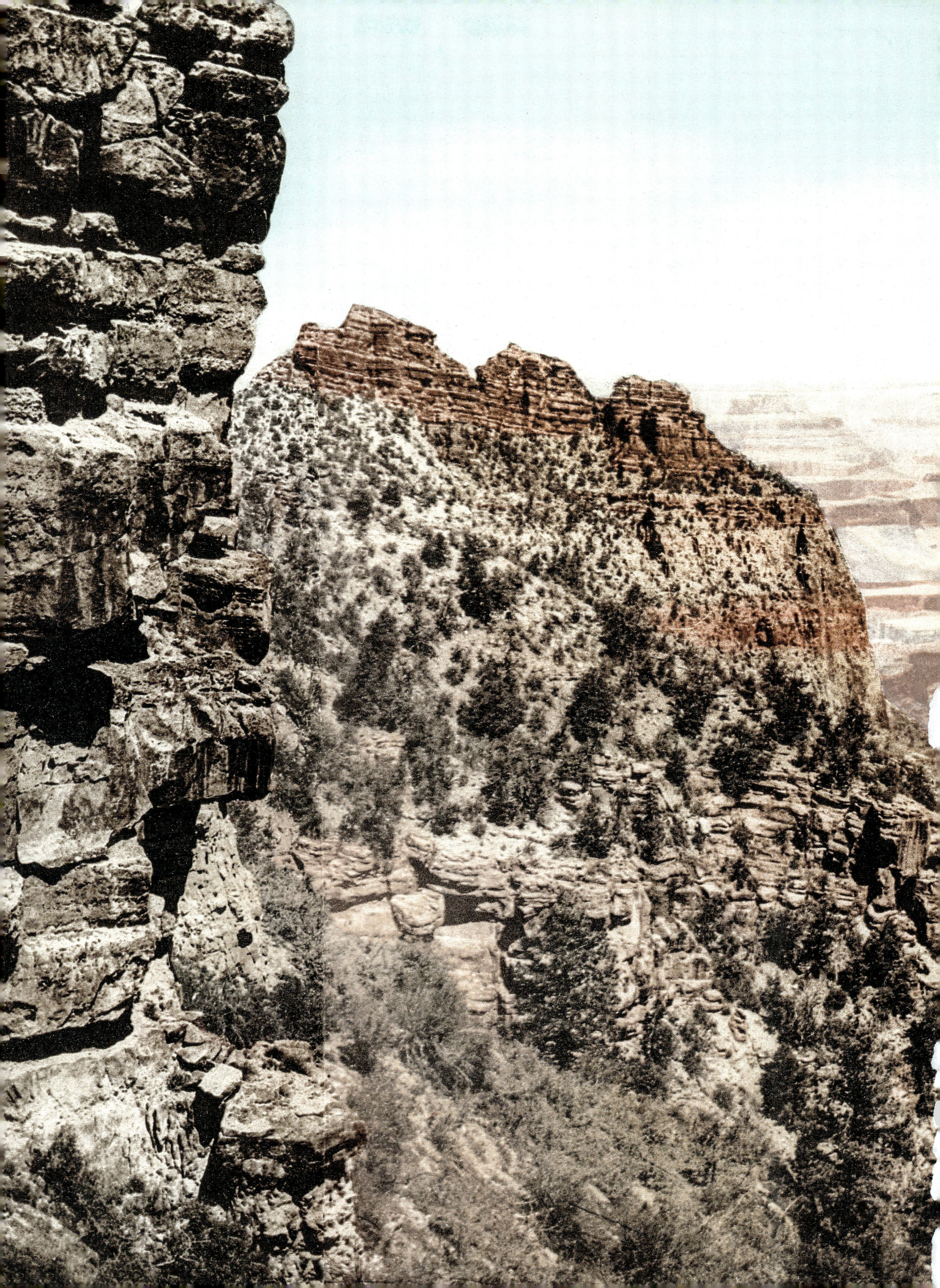

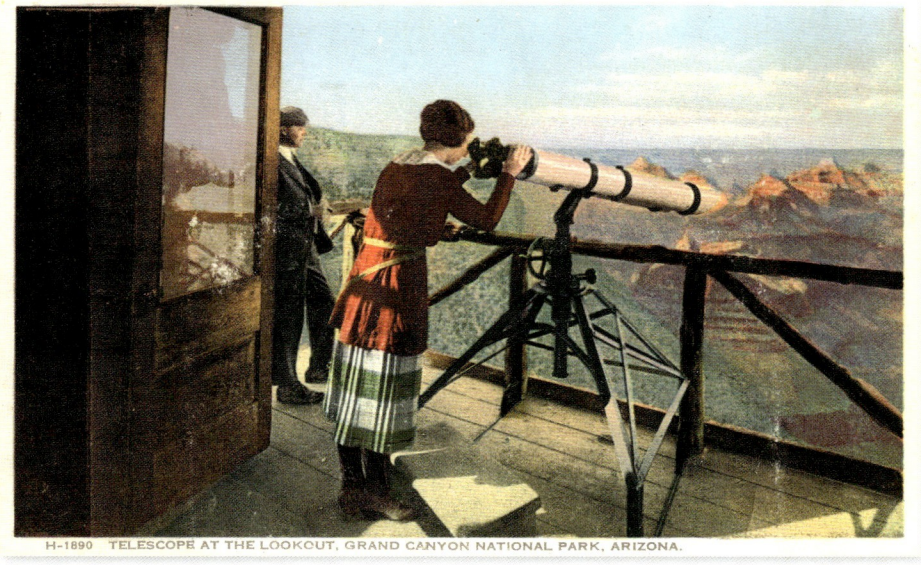
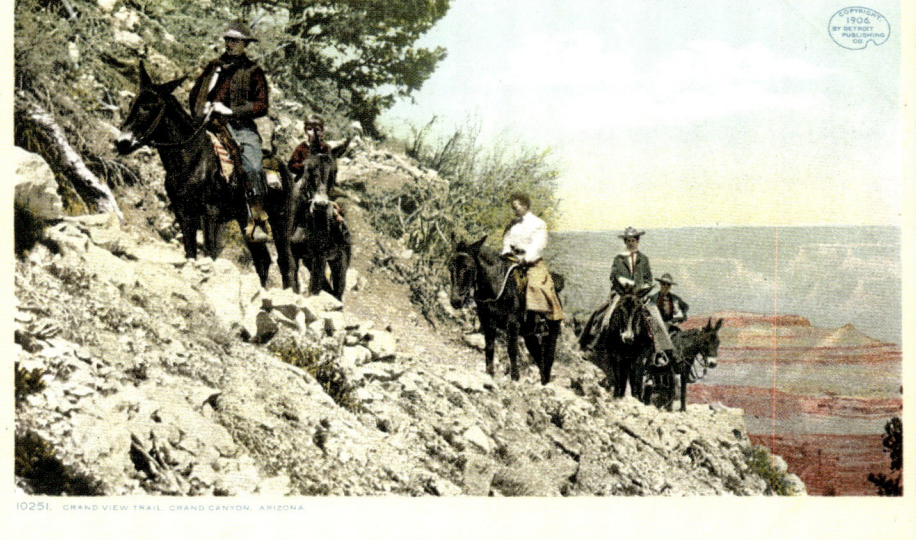
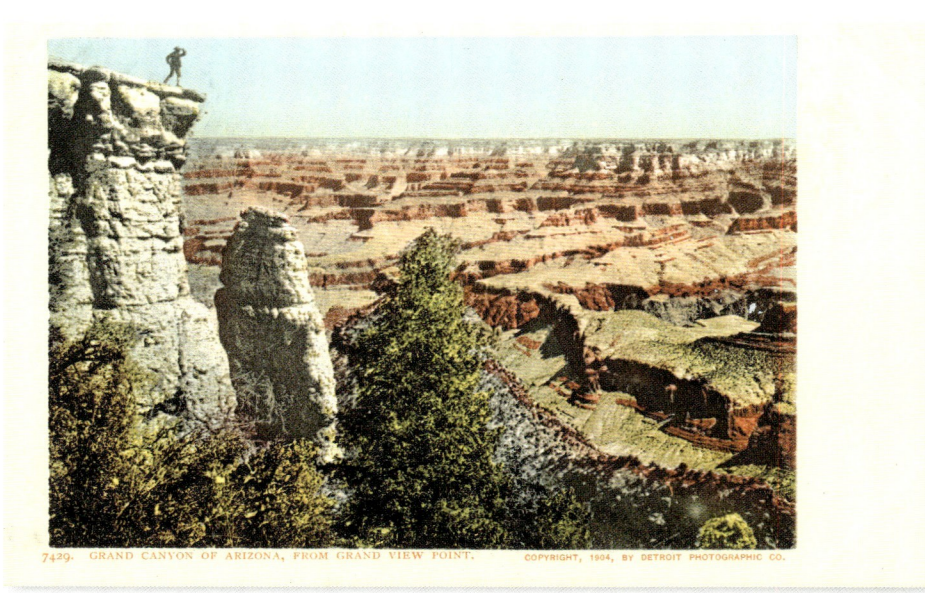

Top left: Telescope at the Lookout
Top right: Grand Canyon, Grand View Trail
Right: Grand Canyon from Grand View Point
Bottom left: Scene near Bright Angel Cove
Bottom right: Climbing the great cliffs near head of Bright Angel Trail

Oben links: Teleskop am Aussichtspunkt Lookout
Oben rechts: Grand Canyon, der Grand View Trail
Rechts: Blick vom Grand View Point auf den Grand Canyon
Unten links: Szene in der Nähe von Bright Angel Cove
Unten rechts: Klettertour auf den großen Felsen nahe dem Gipfel des Bright Angel Trail

En haut à gauche : télescope au point Lookout
En haut à droite : Grand Canyon, la piste de Grand View
À droite : vue du Grand Canyon depuis Grand View Point
En bas à gauche : scène près de Bright Angel Cove
En bas à droite : escalade des grandes falaises près du sommet de la piste de Bright Angel

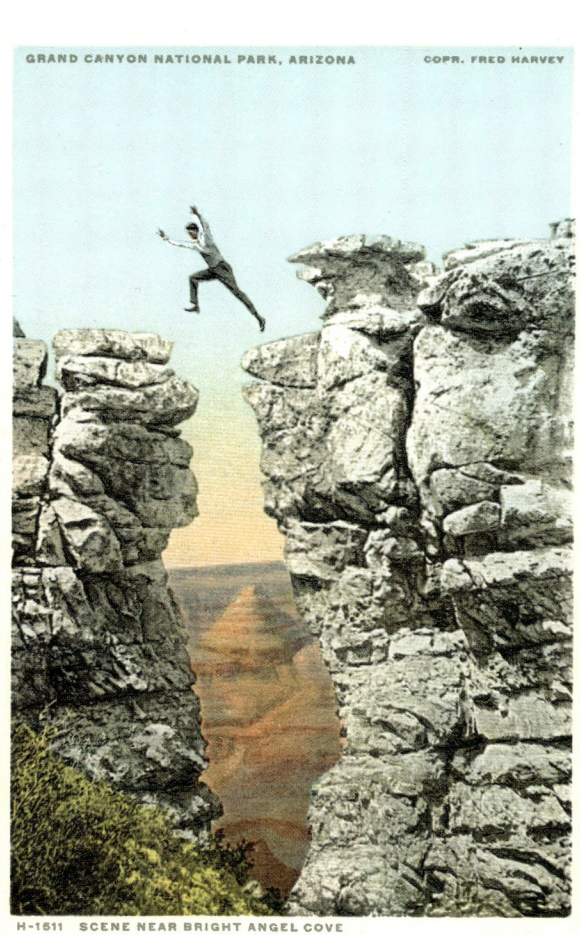
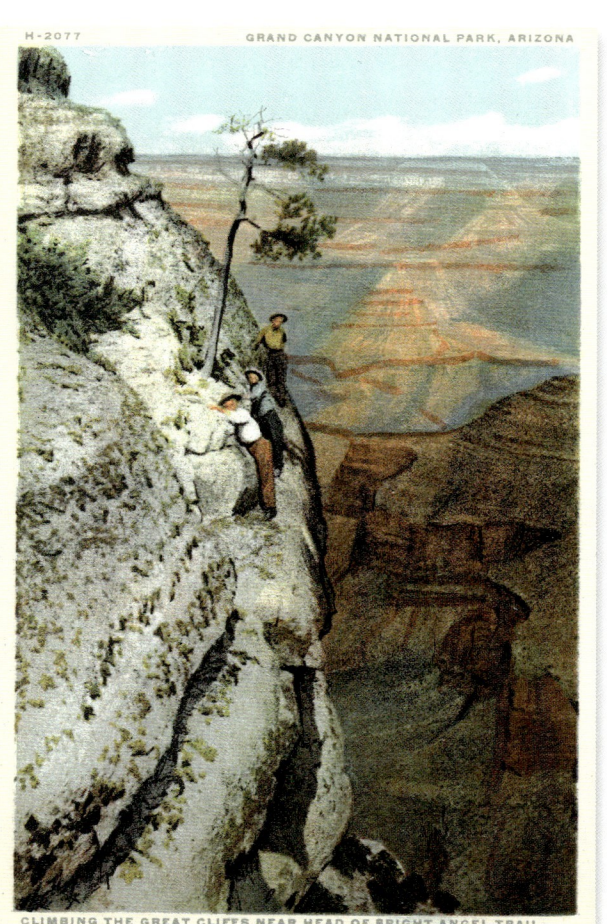

Page 427–430: Grand Canyon, general view from Hance Trail, photochrom
Right: Jacob's Ladder, Bright Angel Trail
Below and page 432/433: Bright Angel Trail, on the zigzags, photochroms

The Bright Angel Trail leads from the south rim of the Grand Canyon to the Colorado River, the descent of 4,380 feet (1,340 m) presenting an average gradient of 10 percent; it is the route of choice for hikers. Serious problems caused by encounters between hikers and mules—tourists continue to follow the track on muleback—have led the National Park Service to publish a brochure informing hikers of the appropriate behavior when a mule train is passing.

Seite 427–430: Gesamtansicht des Grand Canyon vom Hance Trail aus, Photochrom
Rechts: Jacob's Ladder (Jakobsleiter), Bright Angel Trail
Unten und Seite 432/433: Bright Angel Trail, Verlauf im Zickzack, Photochrome

Der Pfad von Bright Angel führt von der Südseite des Grand Canyon bis zum Colorado River hinunter. Der Höhenunterschied von 1 340 Metern und das durchschnittliche Gefälle von 10 % wird heute besonders von Bergwanderern geschätzt. Ernsthafte Probleme beim Zusammentreffen von Wanderern und Maultieren – die noch immer die Touristen nach unten und nach oben tragen – haben die Verwaltung der Nationalparks dazu veranlasst, ein Faltblatt herauszugeben, in dem die Wanderer darüber informiert werden, wie sie sich zu verhalten haben, wenn sie einem Maultiertross begegnen.

Pages 427–430: vue du Grand Canyon depuis la piste de Hance, photochrome
À droite: l'échelle de Jacob (Jacob's Ladder), Bright Angel Trail
En bas et pages 432/433: la piste de Bright Angel, les «zigzags», photochromes

La piste de Bright Angel descend depuis le côté sud du Grand Canyon jusqu'au fleuve Colorado. Un dénivelé de 1 340 mètres avec une pente moyenne de 10 % qu'affectionnent aujourd'hui les randonneurs. Des problèmes causés par la rencontre de ces hikers et des mulets – qui continuent de promener les touristes sur la piste –, ont conduit le service des Parcs nationaux à éditer un dépliant qui informe les hikers de la conduite à adopter lorsqu'ils croisent un train de mulets.

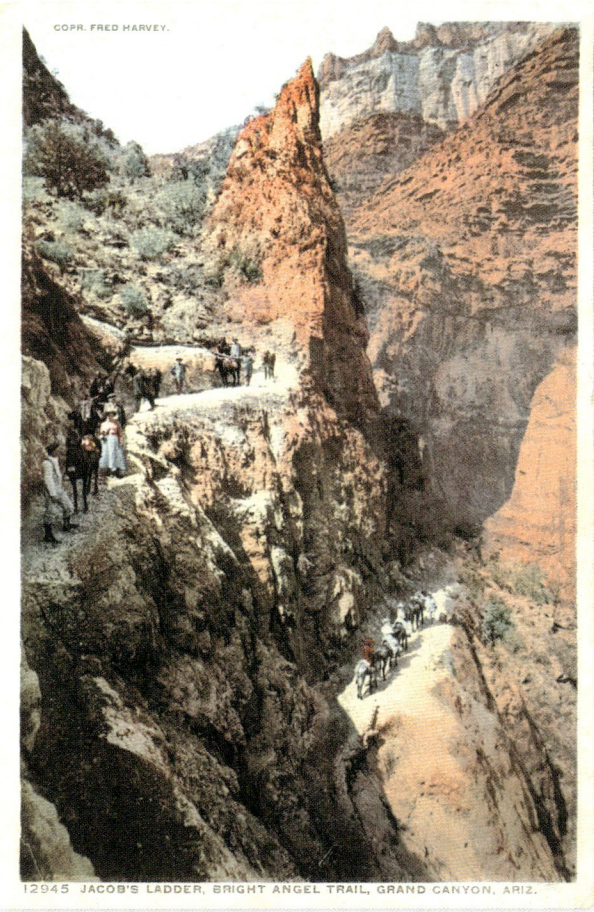

ARIZONA | GRAND CANYON

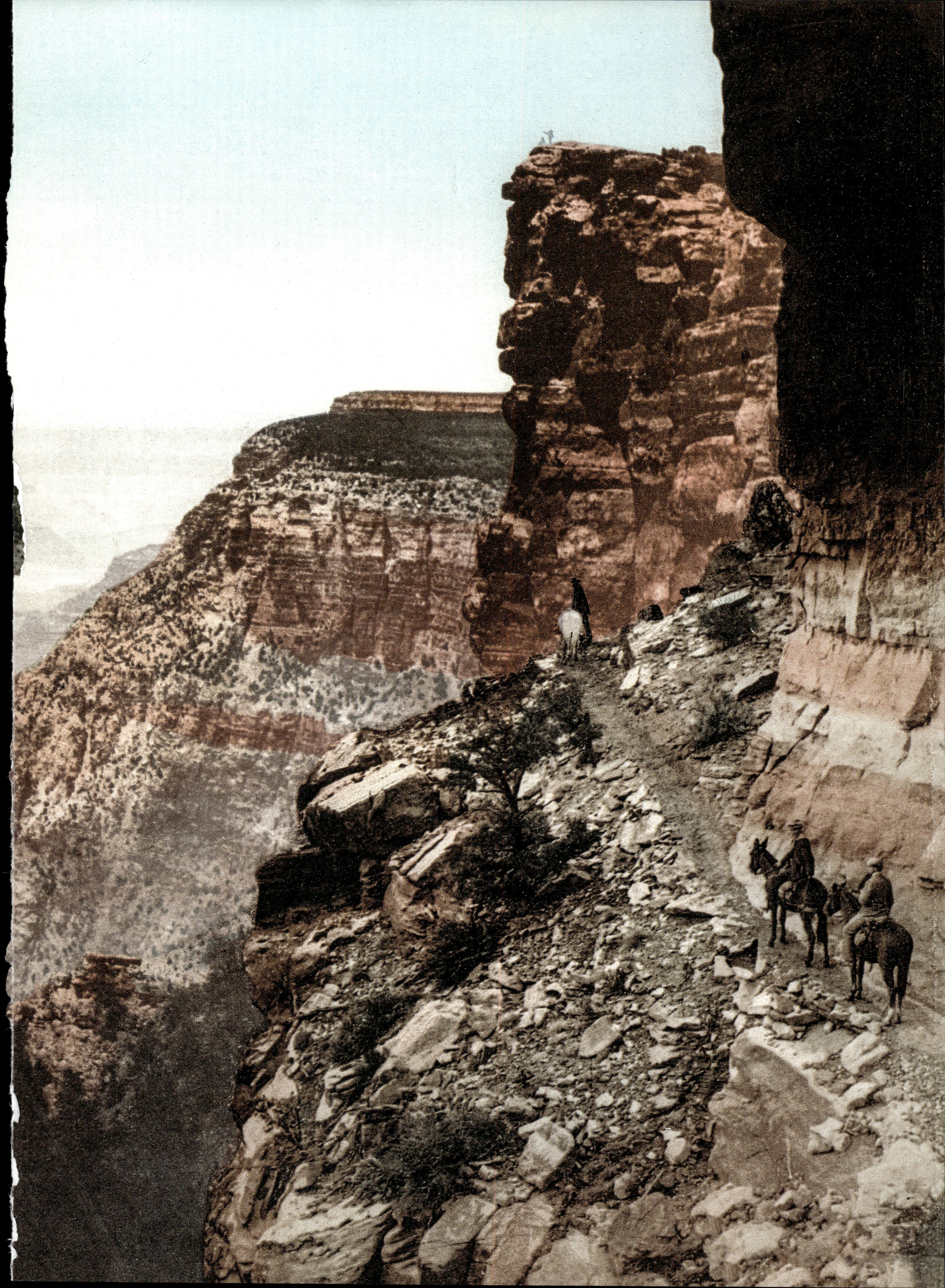

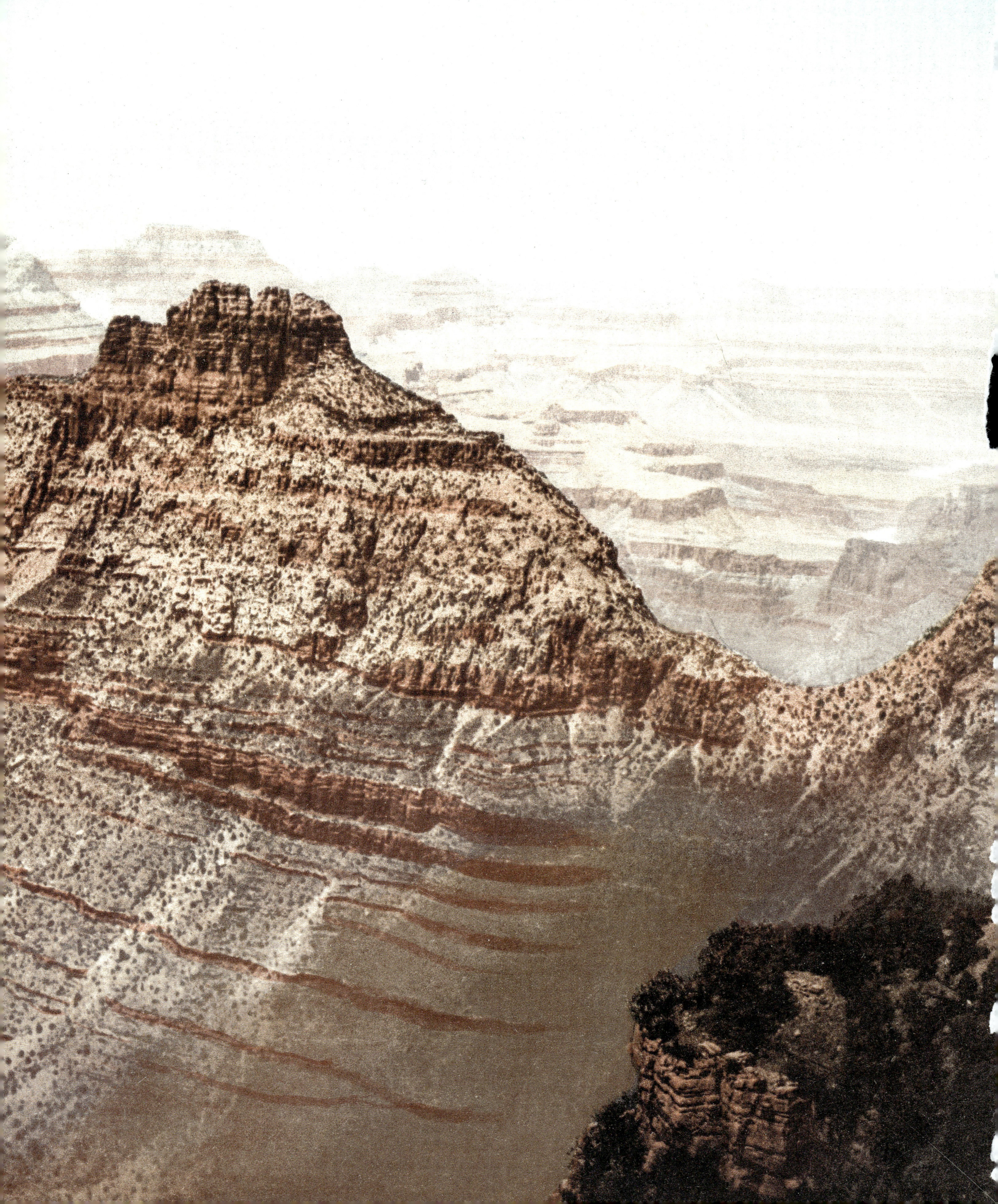

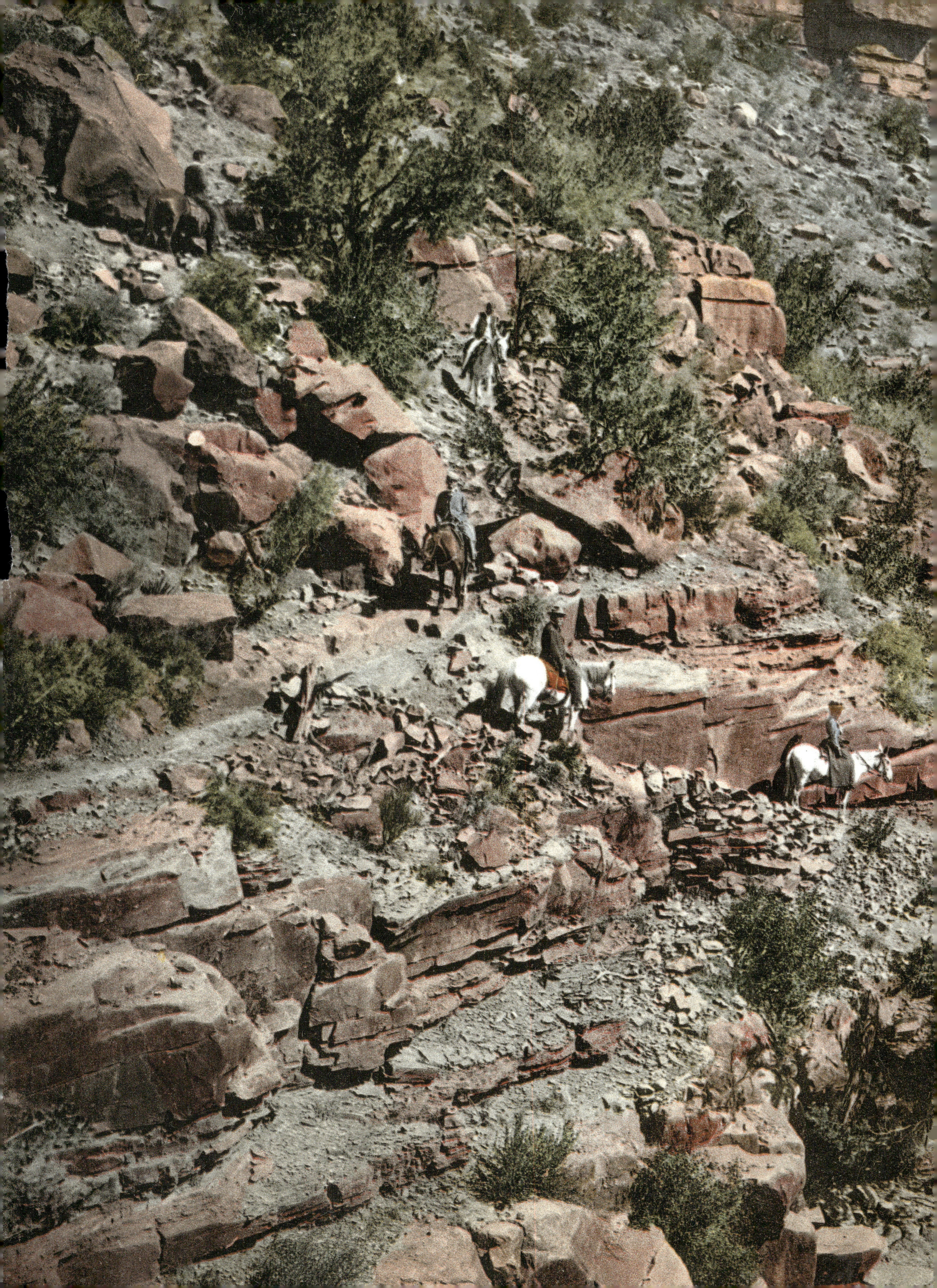

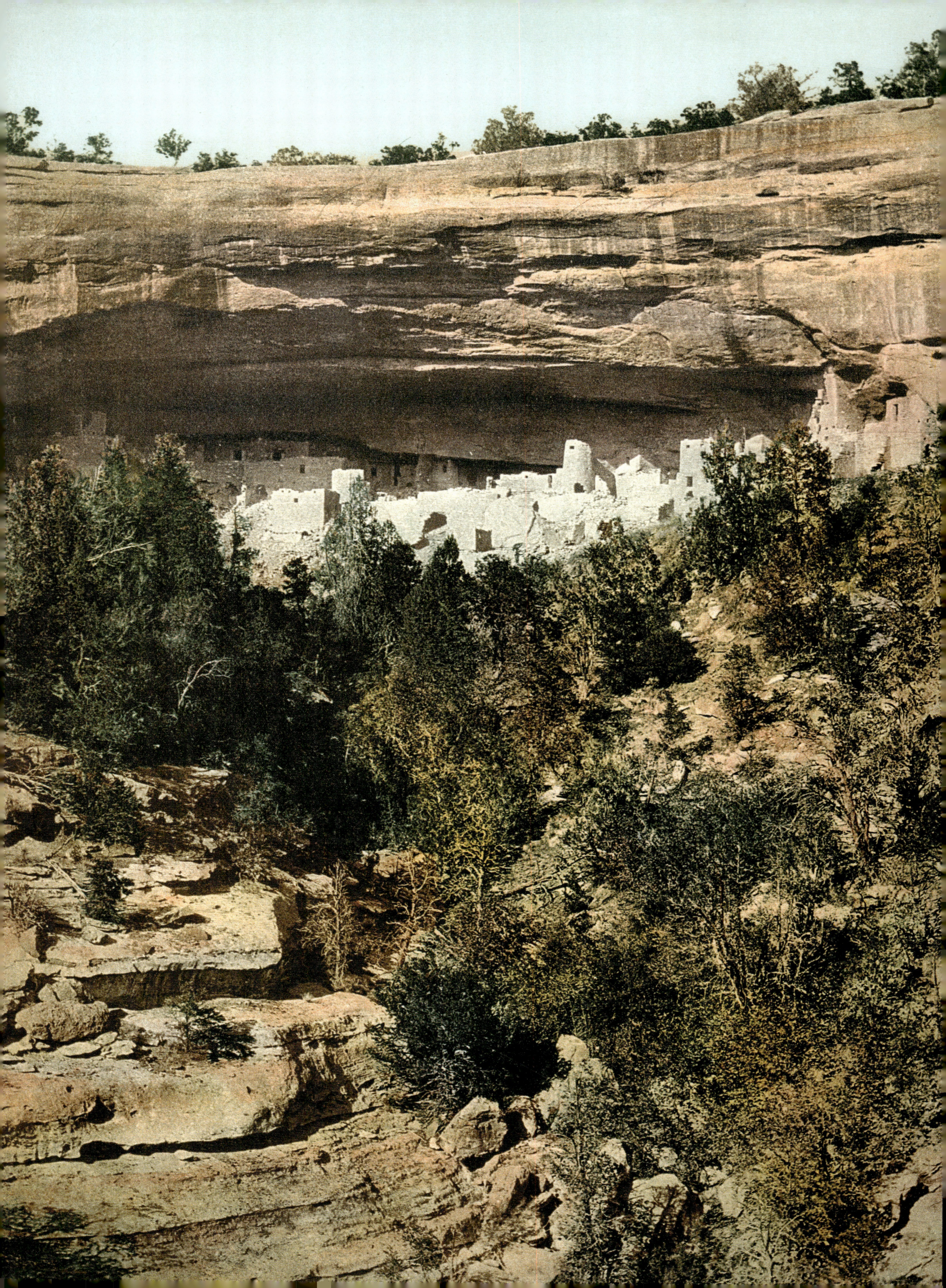

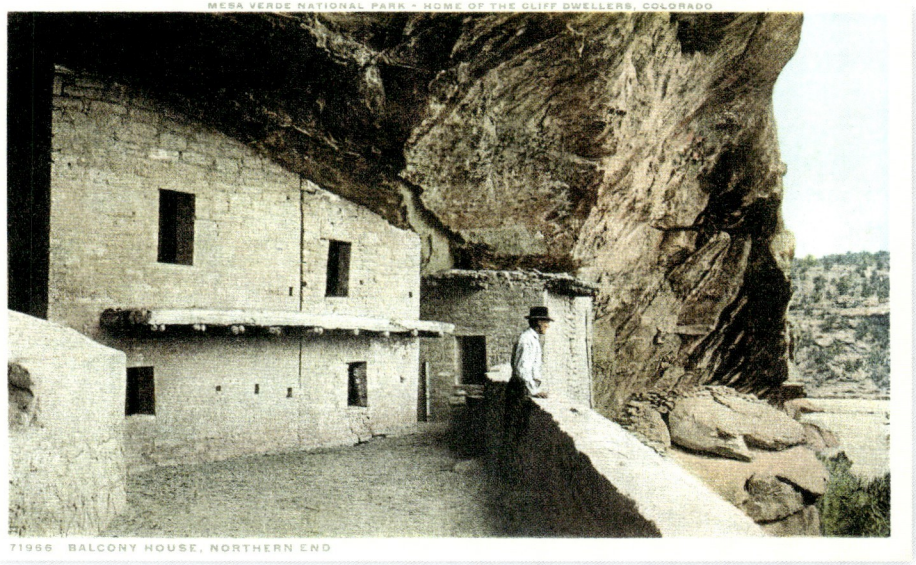

Page 434/435: Echo Cliffs, Grand River Canyon, Colorado, photochrom
Page 436: Mesa Verde (the green plateau), general view of "Cliff Palace," photochrom
Above: Mesa Verde, home of the cliff dwellers, Balcony House
Below: Mesa Verde, "Cliff Palace," photochrom

The Mesa Verde National Park was created in 1906 in fulfillment of President Theodore Roosevelt's desire to "preserve the works of man," in this case, the traditional cliff dwellings of the Pueblo Indians in this part of Colorado. The adobe buildings of Mesa Verde date from the late 12th century and constitute an extraordinary representation of Pueblo culture.

Seite 434/435: Echo Cliffs, Grand River Canyon, Colorado, Photochrom
Seite 436: Mesa Verde (grünes Hochplateau), Gesamtansicht von Cliff Palace (Felsenpalast), Photochrom
Oben: Mesa Verde, Heimat der Felsenbewohner, Balkonhaus
Unten: Mesa Verde, Cliff Palace, Photochrom

Der Nationalpark Mesa Verde wurde 1906 gegründet. Man folgte damit dem Wunsch von Präsident Theodore Roosevelt, „die vom Menschen geschaffenen Werke zu bewahren", so etwa die traditionellen Häuser im Felsen der Pueblo-Indianer in diesem Teil von Colorado. Die Lehmziegelhäuser von Mesa Verde datieren vom Ende des 12. Jahrhunderts und repräsentieren auf großartige Weise die Pueblo-Kultur.

Pages 434/435 : Echo Cliffs, le canyon de Grand River, Colorado, photochrome
Page 436 : Mesa Verde (le Plateau vert), vue générale de « Cliff Palace » (le palais de la falaise), photochrome
En haut : Mesa Verde, la « maison au balcon »
Ci-dessous : Mesa Verde, vues de « Cliff Palace », photochrome

Le parc national de Mesa Verde a été créé en 1906 selon le vœu du président Theodore Roosevelt de « préserver les œuvres humaines » (*preserve the works of man*), en l'occurrence les *cliff dwellings* – les « demeures sur la falaise » traditionnelles des Indiens Pueblo de cette partie du Colorado. Les habitations en adobe de Mesa Verde, qui datent de la fin du XIIe siècle, sont un brillant témoignage de la culture Pueblo.

COLORADO | MESA VERDE

Below: **Grand River Canyon, second tunnel of the Denver & Rio Grande Railway**, photochrom
Page 439: **Toltec Gorge, the gorge and tunnel**, photochrom

Unten: **Grand River Canyon, zweiter Tunnel der Denver & Rio Grande Railway**, Photochrom
Seite 439: **Toltec Gorge, Schlucht und Tunnel**, Photochrom

En bas : **canyon de Grand River, deuxième tunnel du Denver & Rio Grande Railway**, photochrome
Page 439 : **la gorge et le tunnel de Toltec**, photochrome

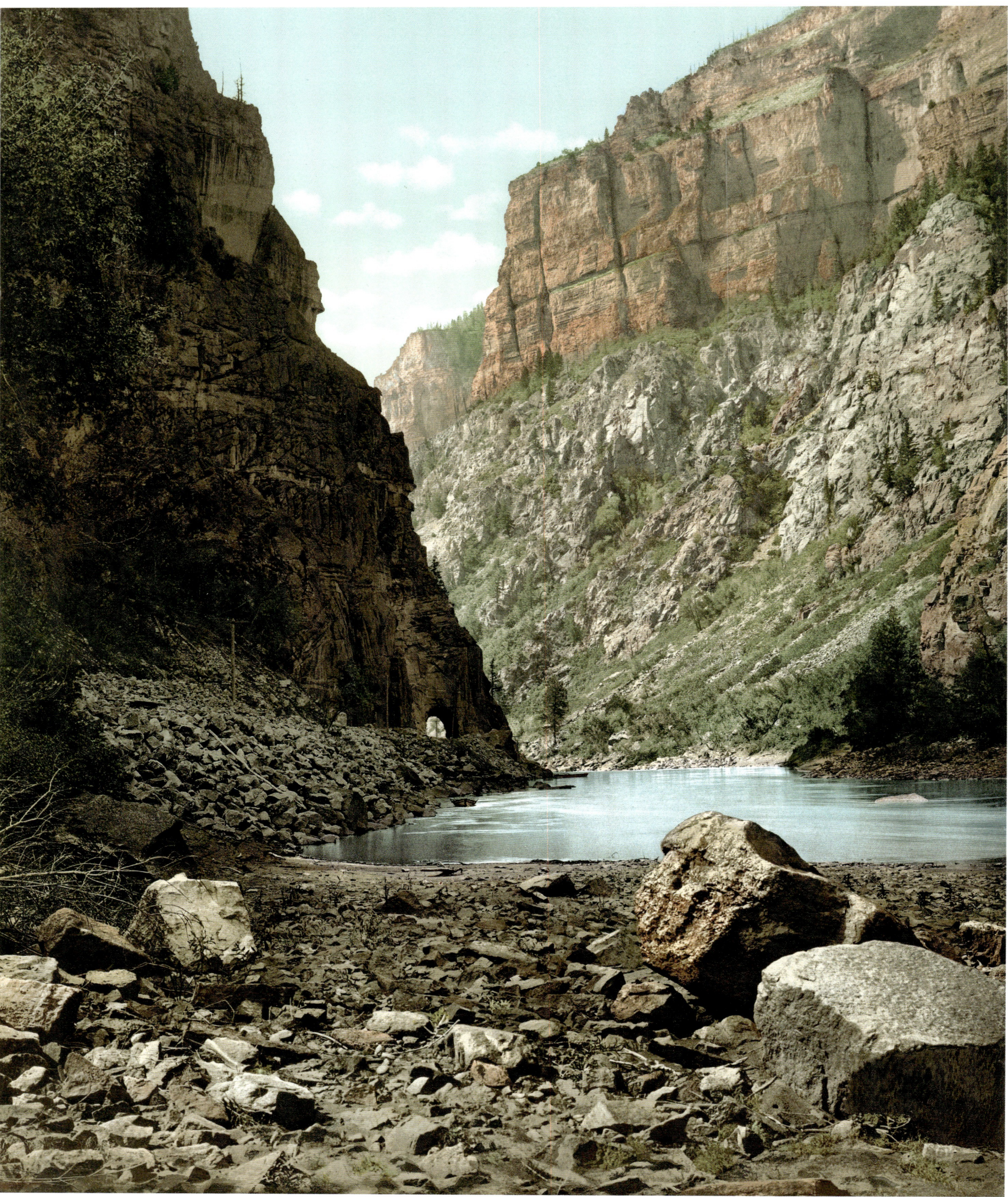

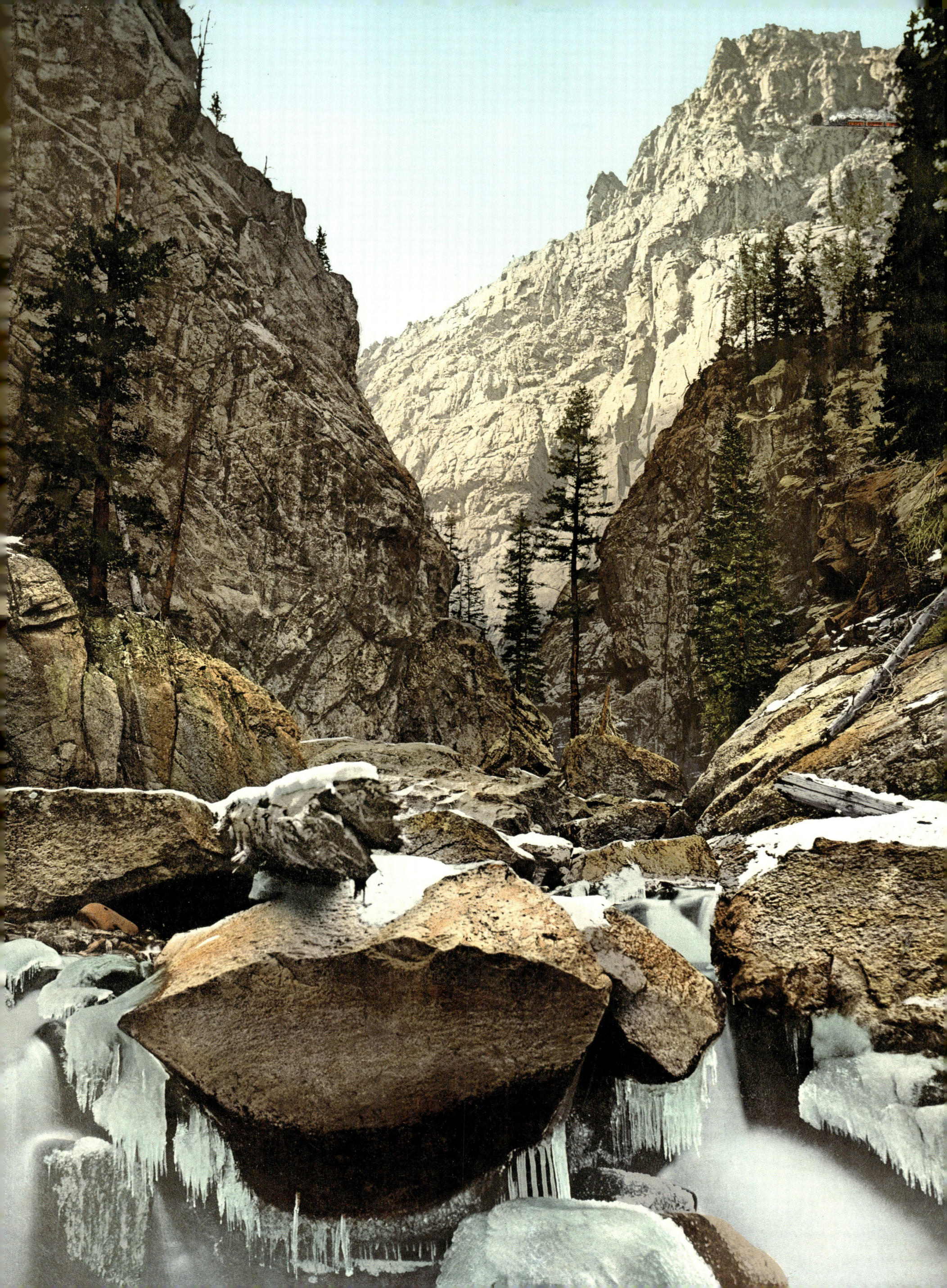

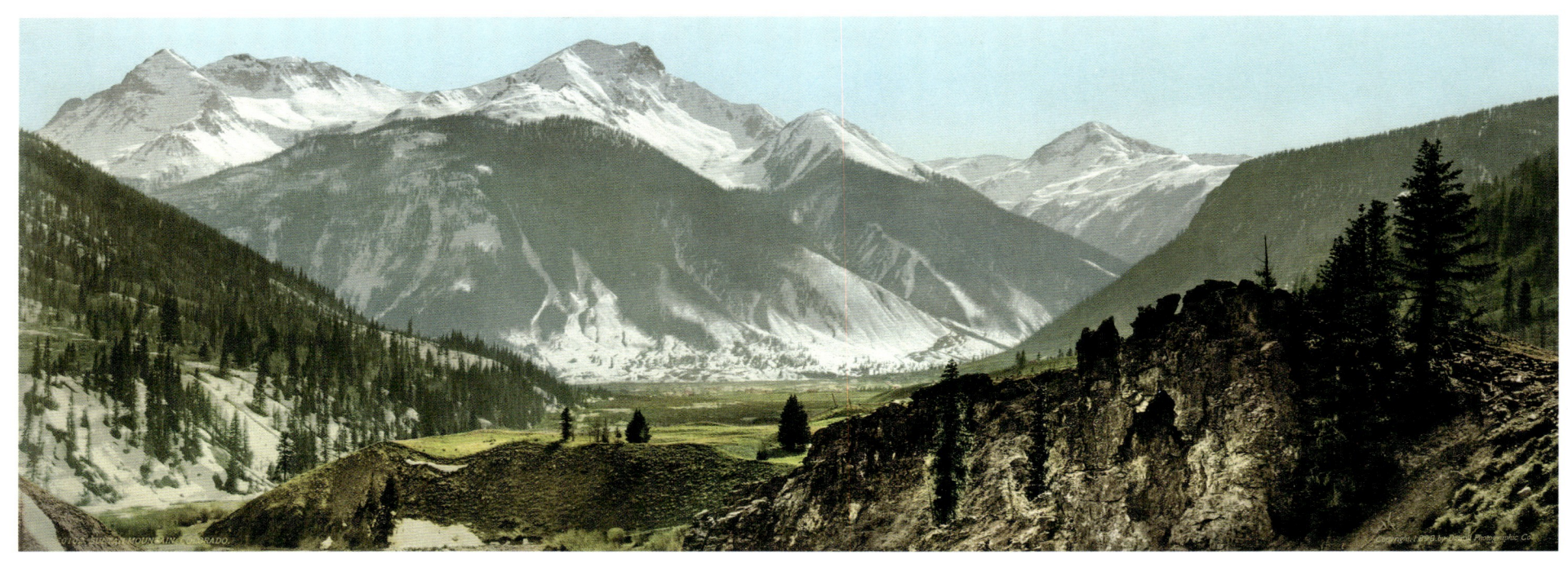

COLORADO | SULTAN'S MOUNTAIN | MT. SNEFFELS

Right: The village of Eureka, photography by
W. H. Jackson, 1900
Below: Needle Mountains from Animas Canyon, photochrom
Page 440:
Top: Sultan's Mountain, photochrom
Bottom: Coasting down Mt. Sneffels, photography
by W. H. Jackson, 1890–1910
Page 442/443: Lake San Cristobal, photochrom

Rechts: Das Dorf Eureka, fotografiert von W. H. Jackson, 1900
Unten: Needle Mountains vom Animas Canyon aus,
Photochrom
Seite 440:
Oben: Sultan's Mountain, Photochrom
Unten: Im Leerlauf vom Mount Sneffels abwärts,
fotografiert von W. H. Jackson, 1890–1910
Seite 442/443: Der San-Cristobal-See, Photochrom

À droite : le village d'Eureka, photographie
par W. H. Jackson, 1900
En bas : les monts Needle depuis le canyon d'Animas,
photochrome
Page 440 :
En haut : le mont Sultan, photochrome
En bas : en roue libre devant la chaîne du mont Sneffels,
photographie par W. H. Jackson, 1890–1910
Pages 442/443 : le lac San Cristobal, photochrome

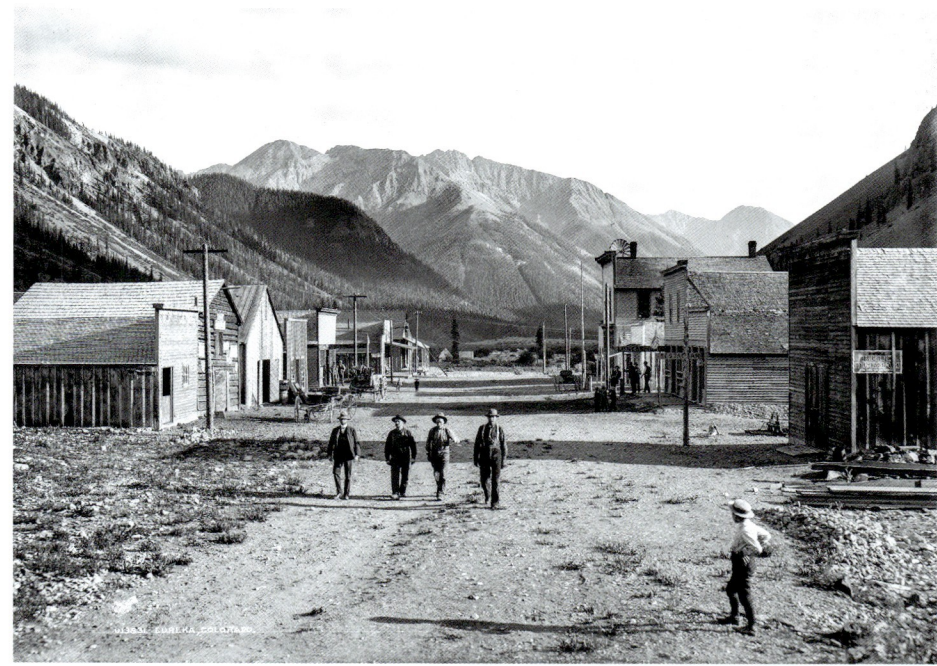

COLORADO | EUREKA | NEEDLE MOUNTAINS

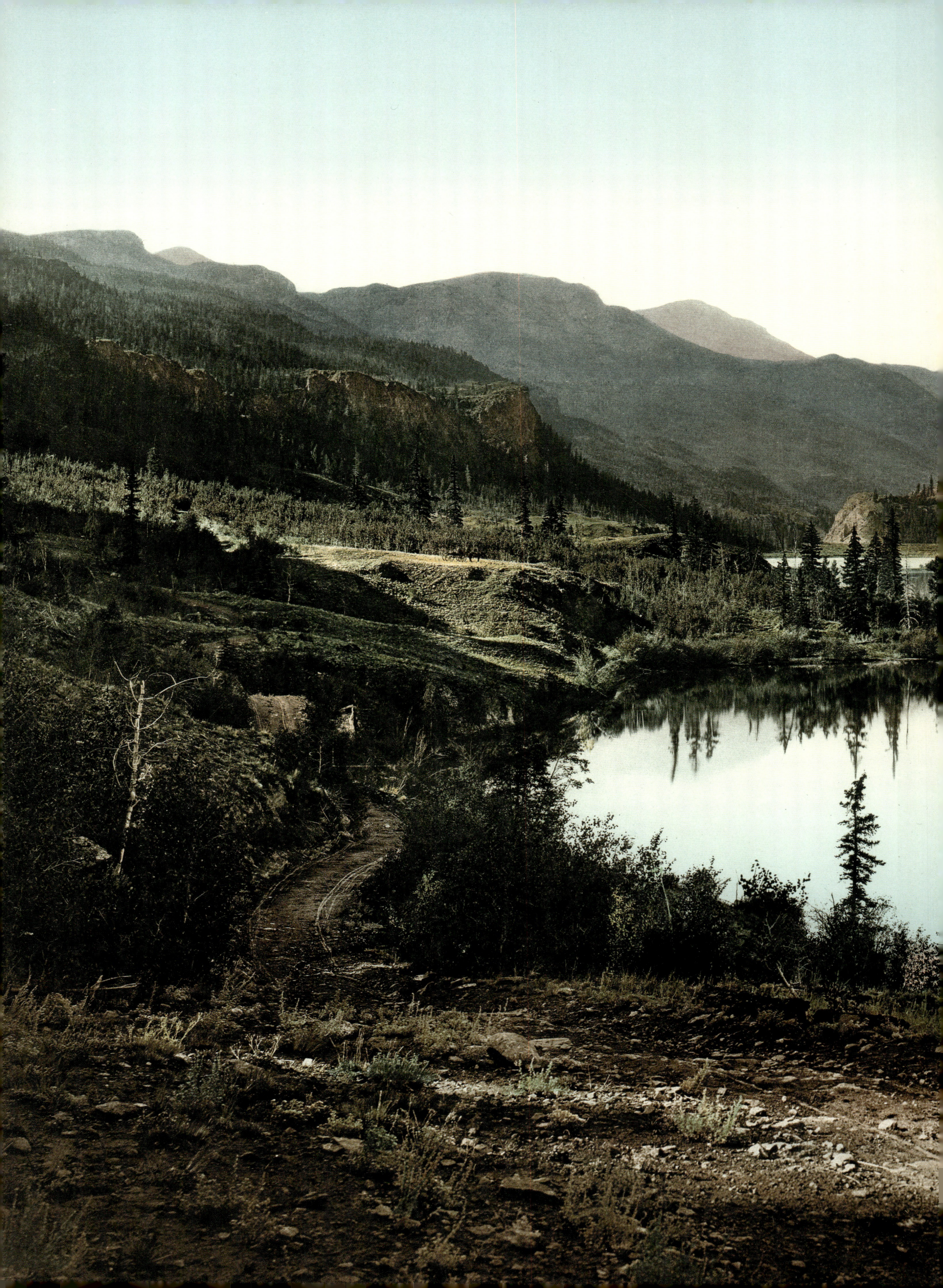

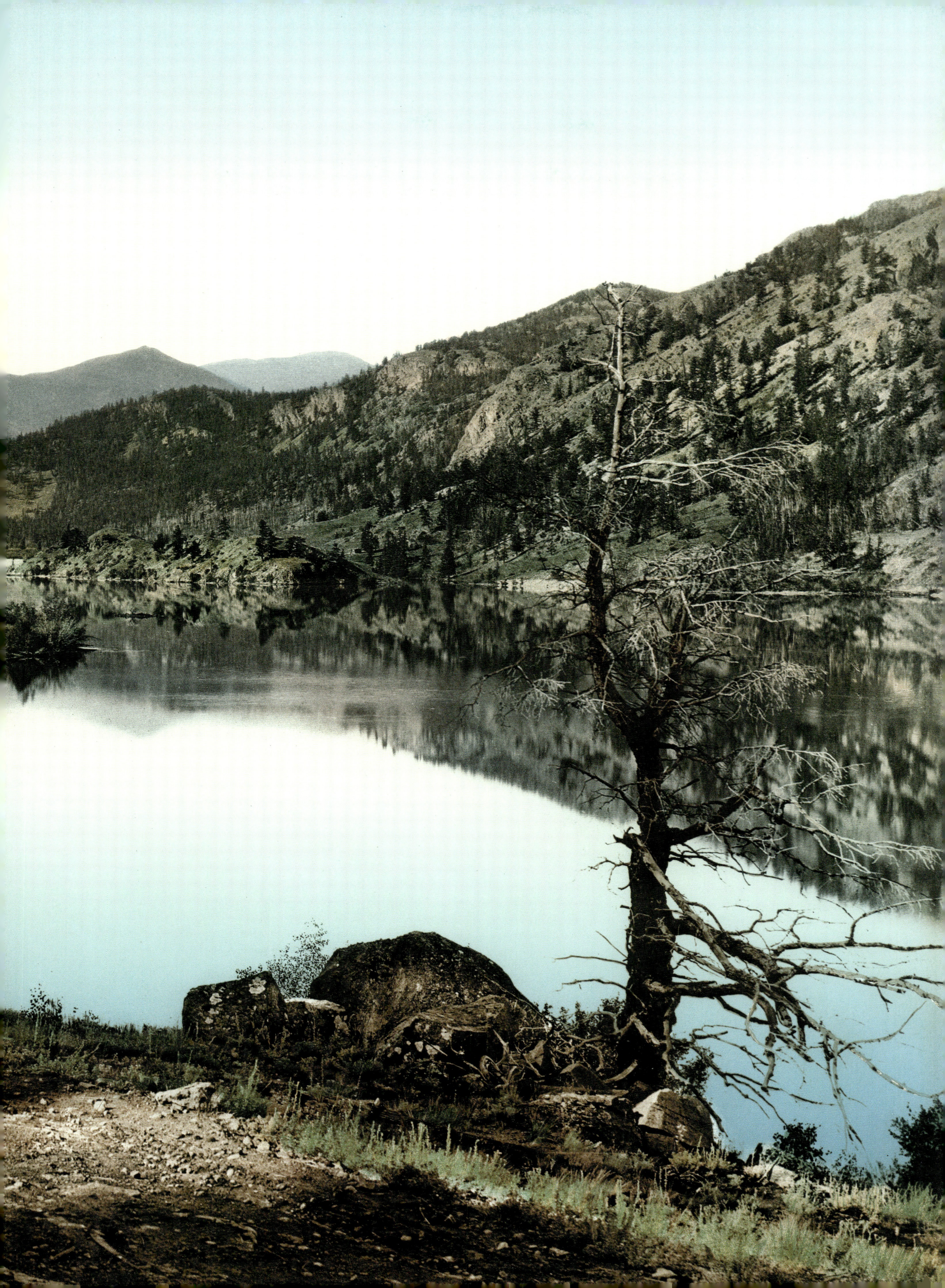

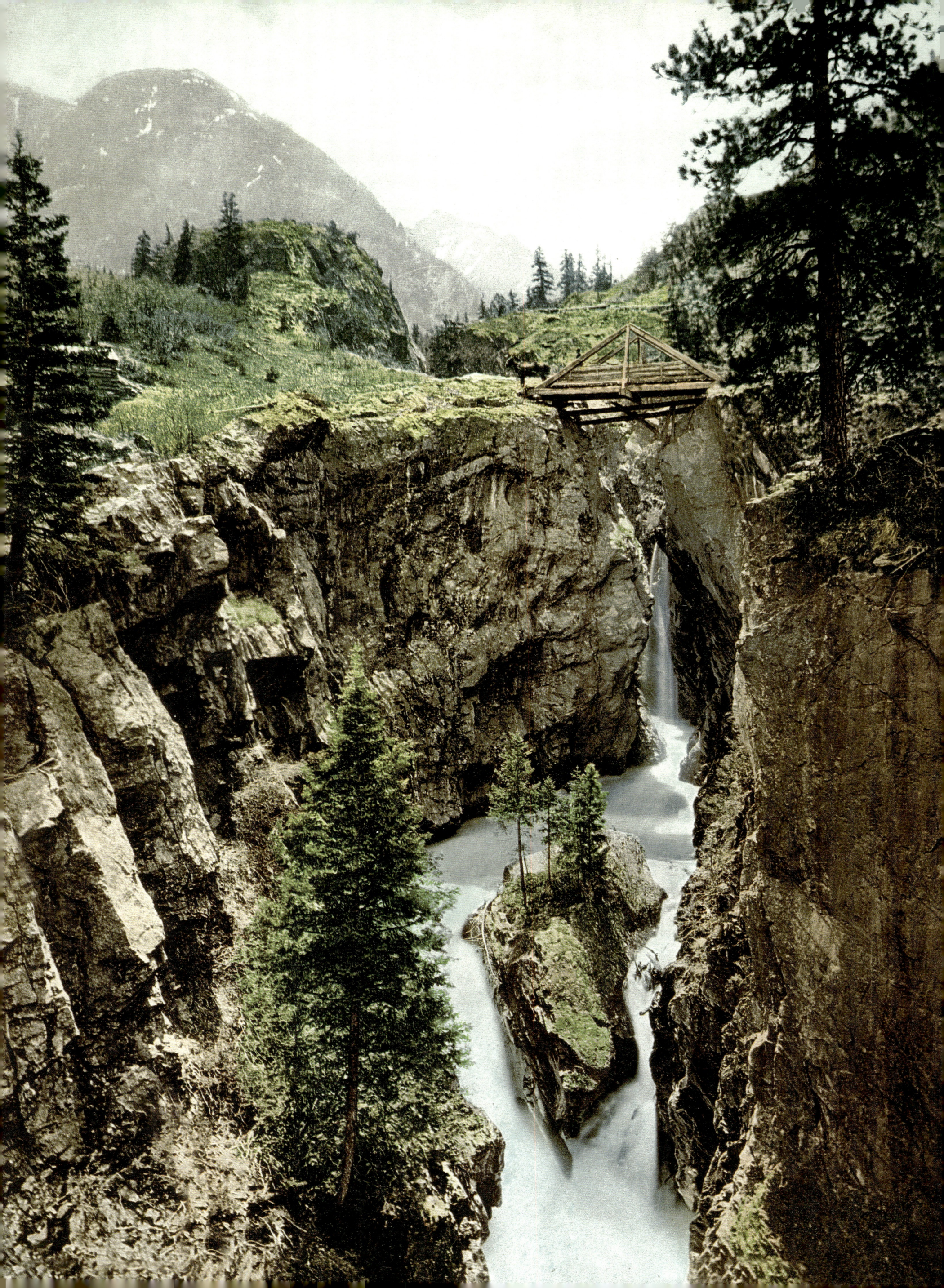

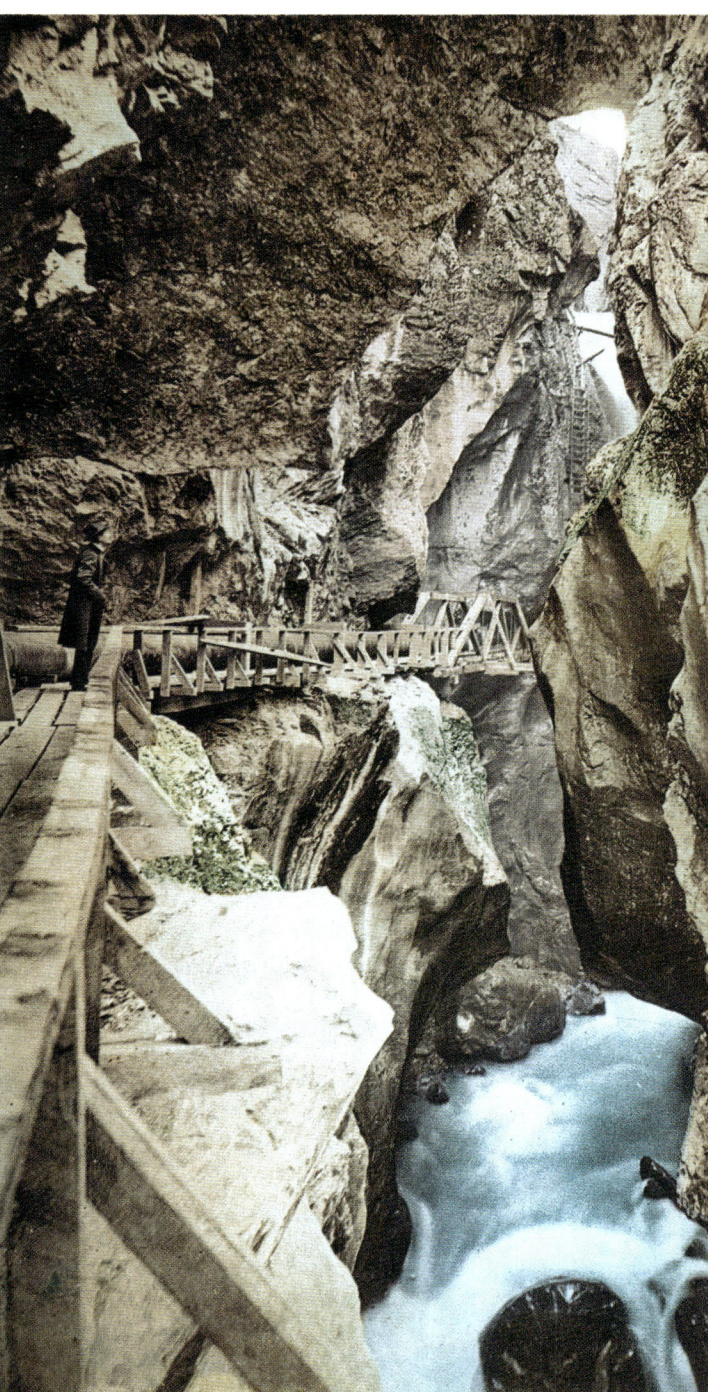

Page 444: Uncompahgre Bridge, Ouray-Silverton stage road, photochrom
Above: Miner's blacksmith, photochrom
Left: Ouray, Box Canyon, photochrom
Page 446/447: Ouray-Silverton toll road, photochrom

Seite 444: Brücke über den Uncompahgre River, Strecke von Ouray nach Silverton, Photochrom
Oben: Der Grubenschmied, Photochrom
Links: Ouray, Box Canyon, Photochrom
Seite 446/447: Mautstraße von Ouray nach Silverton, Photochrom

Page 444 : pont sur la rivière Uncompahgre, route d'Ouray à Silverton, photochrome
En haut : le forgeron de la mine, photochrome
À gauche : Ouray, Box Canyon, photochrome
Pages 446/447 : la route à péage d'Ouray à Silverton, photochrome

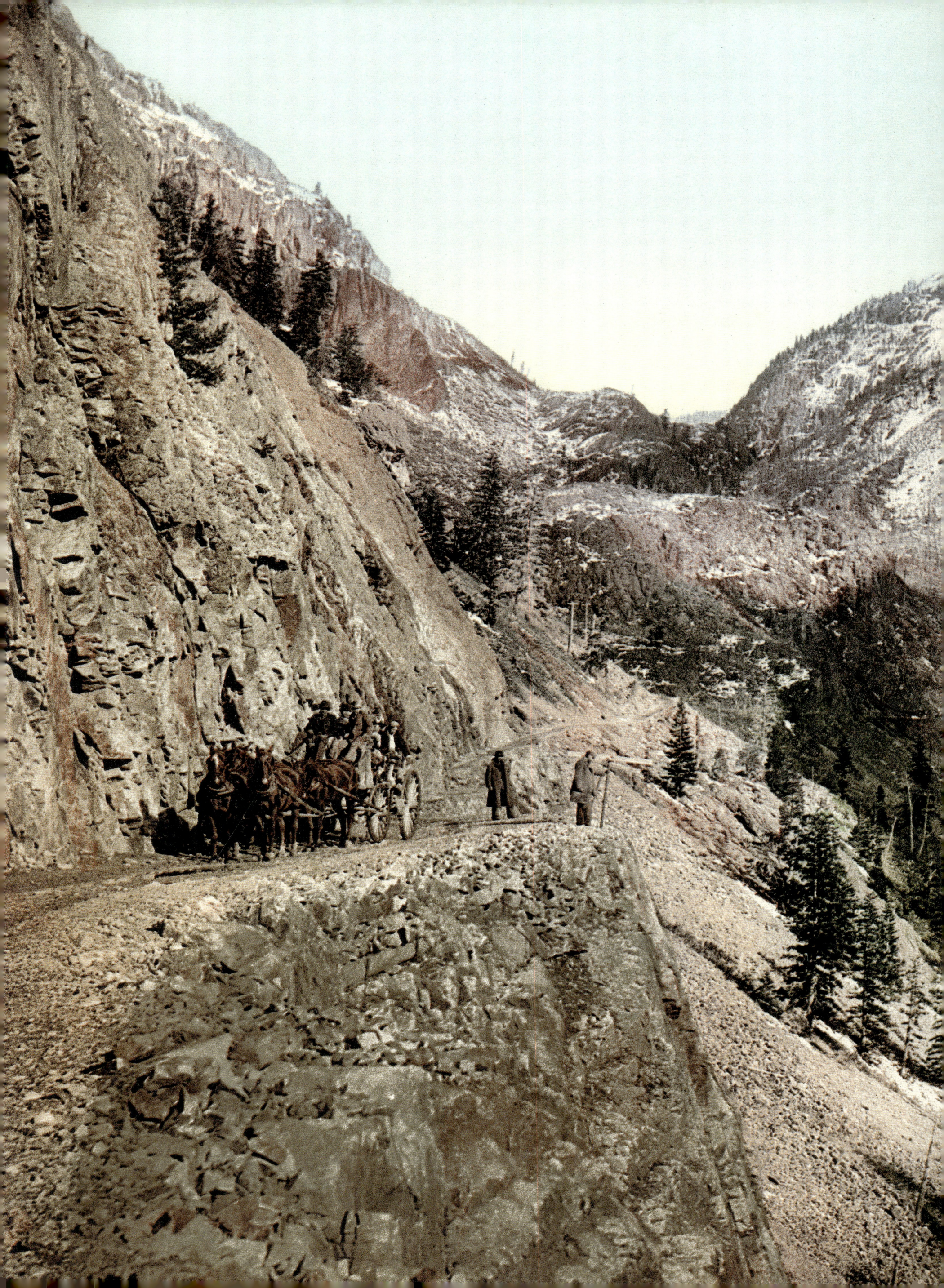

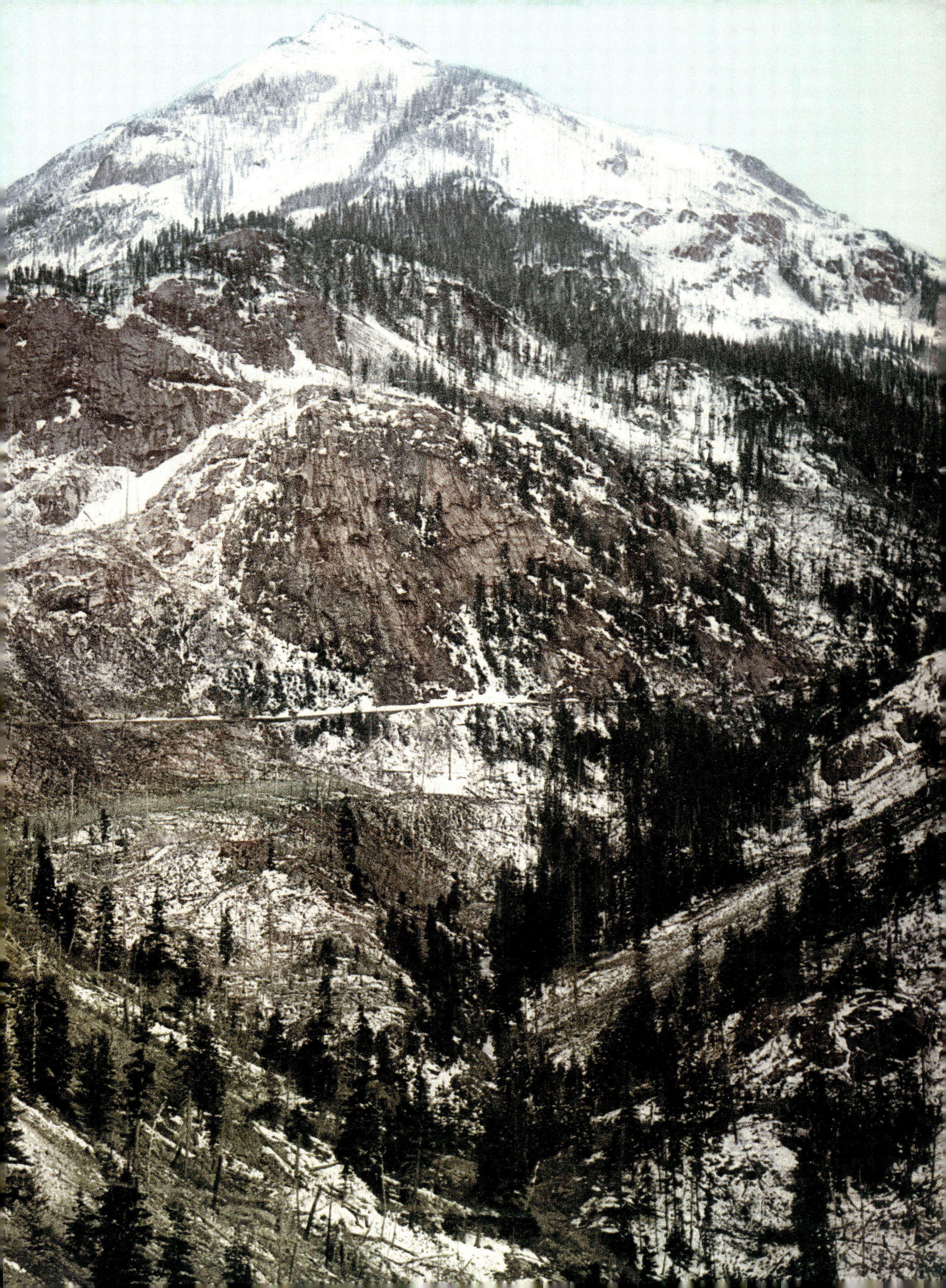

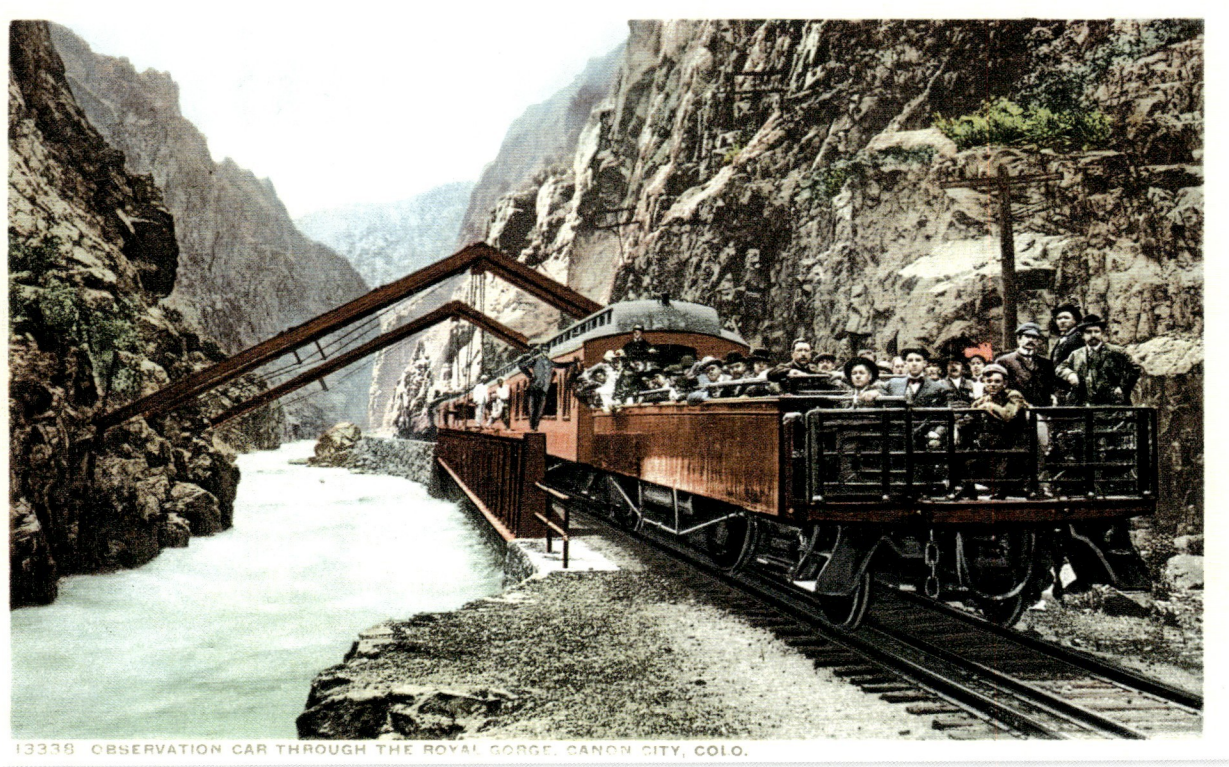

Above: **Observation car through the Royal Gorge**
Below, from left to right:
Royal Gorge, the crevice
Royal Gorge
Seven Falls, Cheyenne Canyon
Page 449: **Royal Gorge, bridge and pinnacle, photochrom**

A bitter dispute arose between the Denver & Rio Grande Western and Santa Fe Railway companies about ownership of the line between Leadville and Pueblo (near Canon City), which had to pass through Royal Gorge, a canyon so narrow that only a single line could be built. The line was eventually built by the Santa Fe Railway in 1879 and sold to the D & RGW for a pretty sum. Panoramic "vintage" trains today run touristic trips through Royal Gorge.

Oben: **Panoramawagen in der Royal Gorge**
Unten, von links nach rechts:
Royal Gorge, die Felsspalte
Royal Gorge
Seven Falls, Cheyenne Canyon
Seite 449: **Royal Gorge, Brücke und Gipfel, Photochrom**

Die Gesellschaften der Denver & Rio Grande Western und der Santa Fe Railway stritten erbittert um den Besitz der Eisenbahnlinie zwischen Leadville und Pueblo (bei Canon City), die durch die Royal Gorge führen sollte: Die Schlucht war so eng, dass nur eine einzige Bahnspur darin Platz fand. Die Sante Fe Railway baute die Linie 1879 und verkaufte sie dann für einen stattlichen Betrag an die D & RGW. Touristen können heute in Vintage-Panoramazügen die Royal Gorge besichtigen.

En haut : **wagon d'« observation » dans la Royal Gorge**
En bas, de gauche à droite :
Royal Gorge, la « fissure »
La Royal Gorge (Gorge royale)
Seven Falls (les Sept Chutes), Cheyenne Canyon
Page 449 : **vue de la Royal Gorge, photochrome**

Les compagnies du Denver & Rio Grande Western et du Santa Fe Railway se disputèrent âprement la propriété de la ligne de chemin de fer entre Leadville et Pueblo (près de Canon City), qui devait traverser la Royal Gorge : la gorge était si étroite qu'on ne pouvait y faire passer qu'une seule voie. Le Santa Fe Railway construisit la ligne (1879) et la revendit à la D & RGW moyennant une coquette somme. Des trains panoramiques « vintage » effectuent aujourd'hui des visites touristiques de la Royal Gorge.

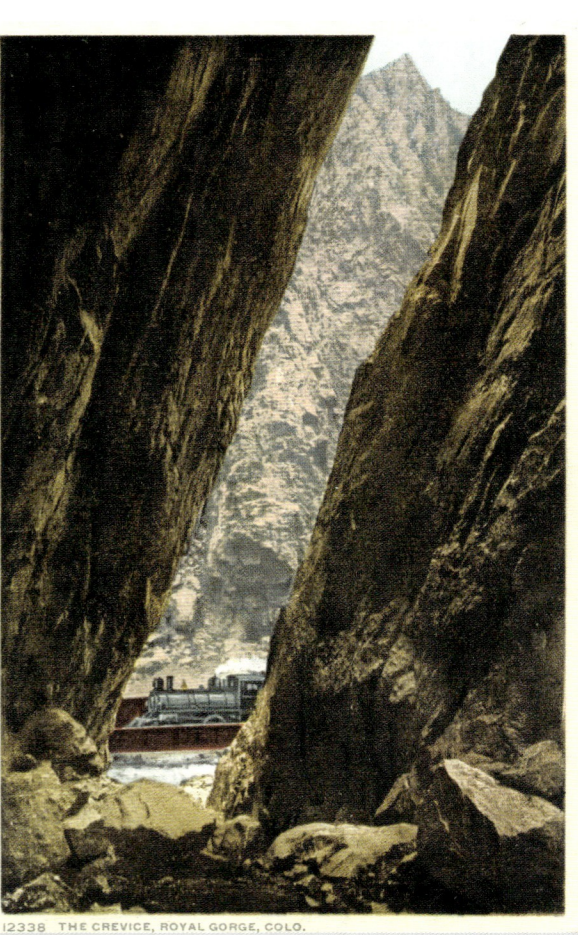
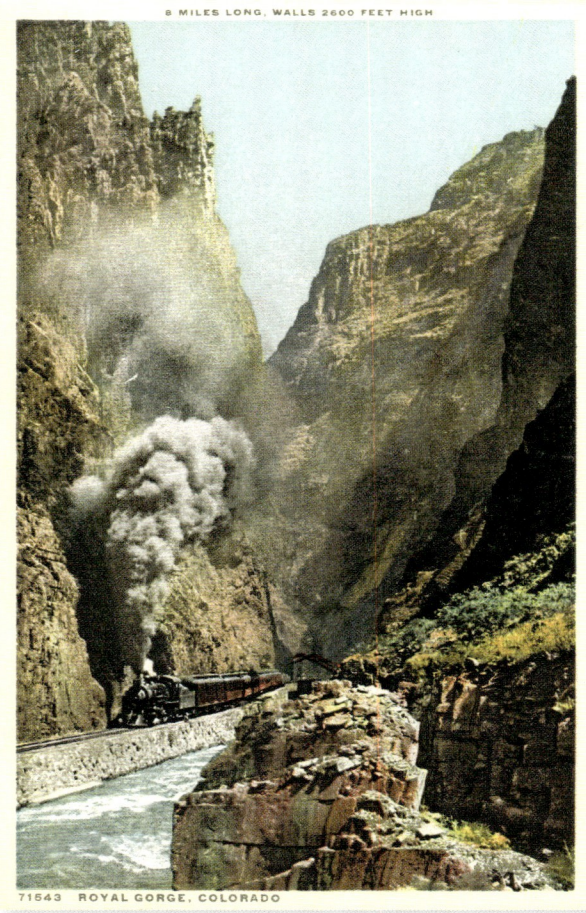
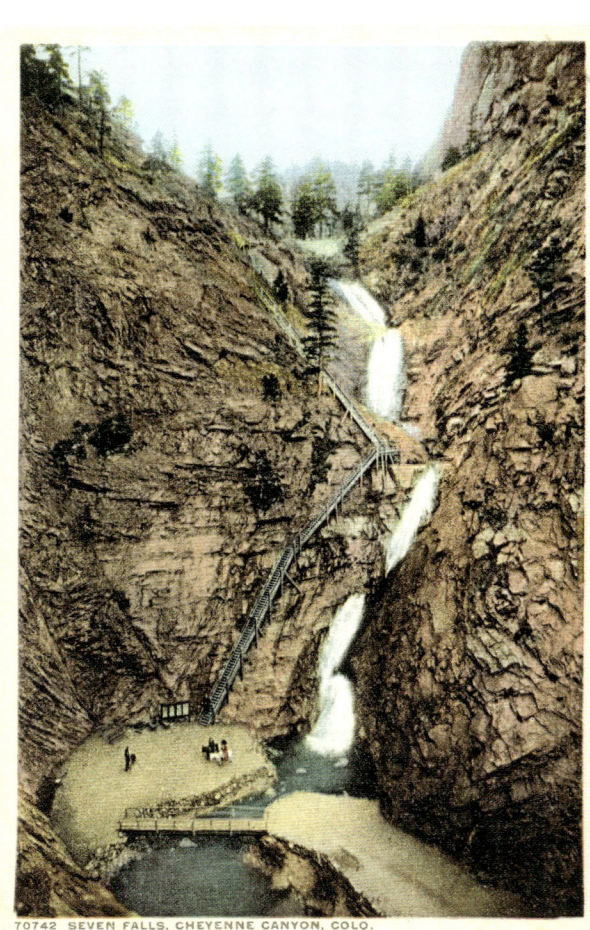

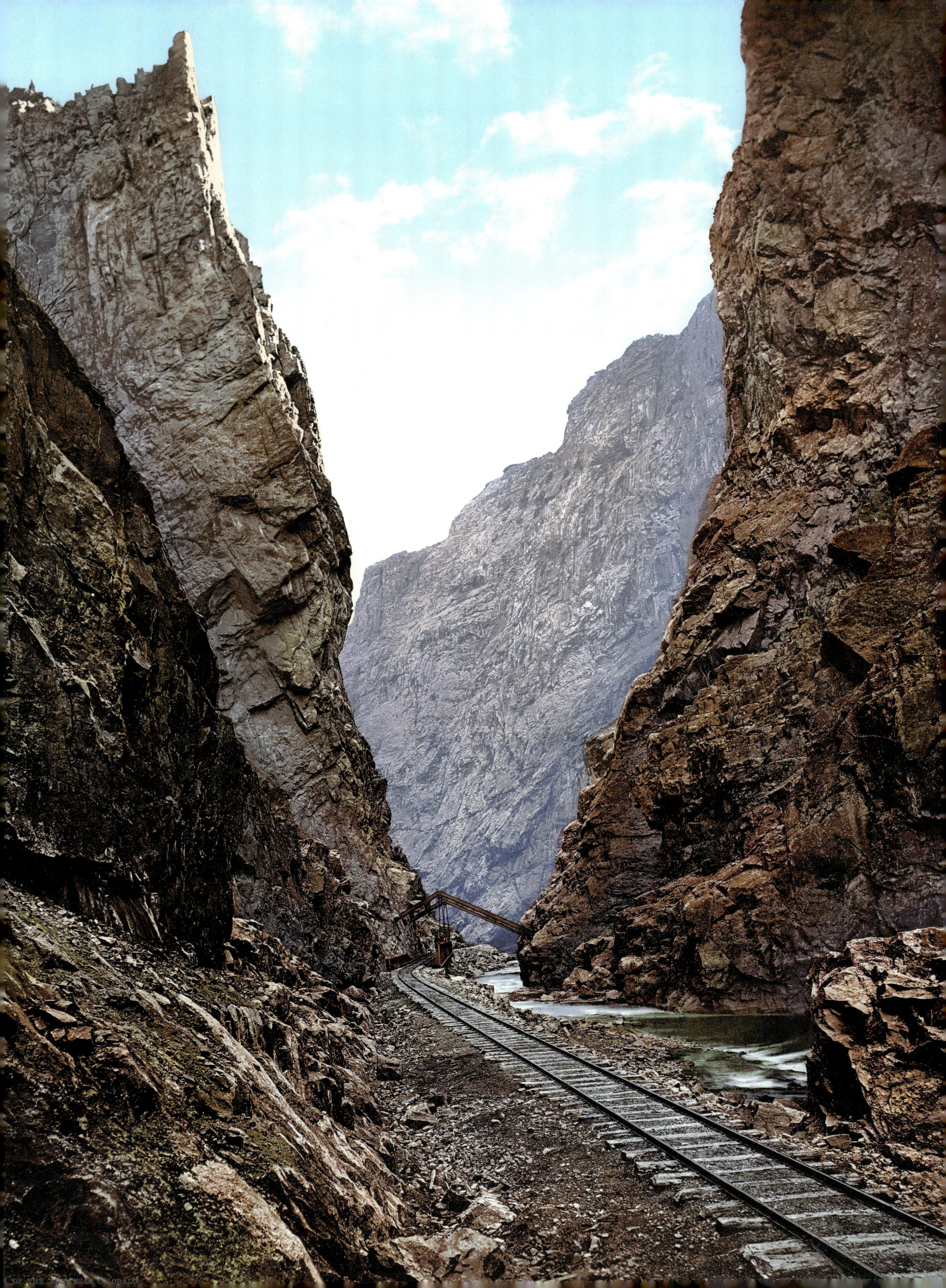

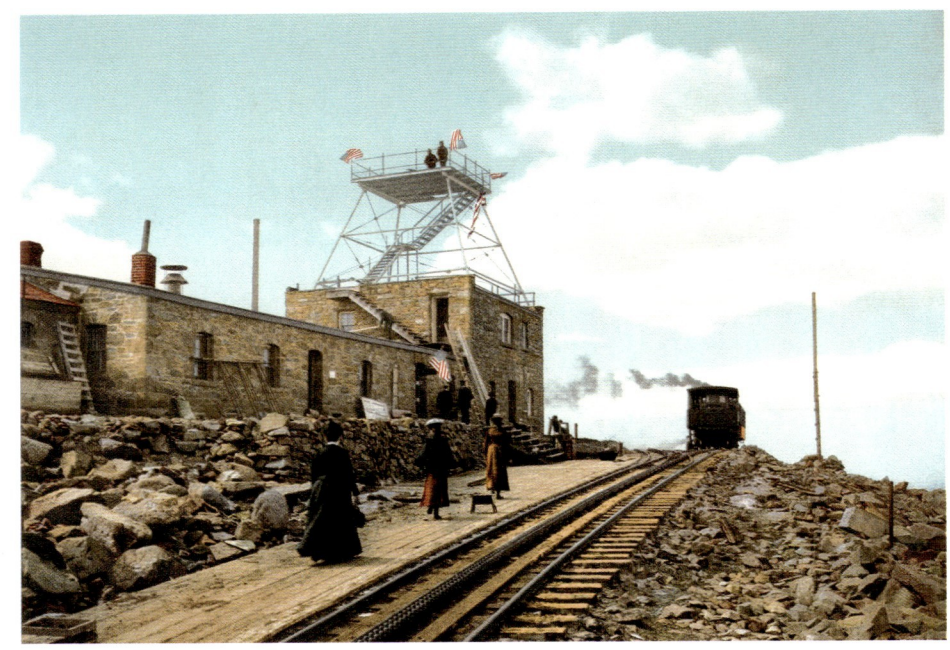

Page 450 above: **The station at the summit of Pike's Peak, photochrom**
Below: **The summit of Pike's Peak, photochrom**
Page 452/453: **Pike's Peak from Austin Bluffs, photochrom**
Zalmon Simmons, the inventor of the mattress that carries his name—and many other things, too—was the financier for the Manitou & Pike's Peak Cog Railway. Having spent two days on the back of a mule going to check on some telegraph-wire insulators of his own invention at the summit, Simmons was thrilled by the view over Manitou Springs, Colorado Springs, and the Garden of the Gods and decided to invest in the construction of a railroad.

Seite 450 oben: **Bergstation auf dem Pike's Peak, Photochrom**
Unten: **Gipfel von Pike's Peak, Photochrom**
Seite 452/453: **Blick von Austin Bluffs auf Pike's Peak, Photochrom**
Die Zahnradbahn zum Pike's Peak wurde von Zalmon Simmons, unter anderem Erfinder der gleichnamigen Matratze, finanziert. Nachdem Simmons zwei Tage auf dem Rücken eines Maultiers gesessen hatte, um den Isolator eines von ihm erfundenen Telegrafenkabels zu überprüfen, der auf dem Berggipfel installiert war, und er von der Aussicht auf Manitou Springs, Colorado Springs und Garden of the Gods geradezu überwältigt war, beschloss er, in den Bau einer Eisenbahn zu investieren.

Page 450 en haut : **la gare au sommet de Pike's Peak, photochrome**
En bas : **le sommet de Pike's Peak, photochrome**
Pages 452/453 : **vue de Pike's Peak depuis Austin Bluffs, photochrome**
L'homme qui finança le chemin de fer à crémaillère de Pike's Peak est Zalmon Simmons, inventeur, entre autres, du matelas qui porte son nom. C'est après avoir passé deux jours à dos de mulet pour aller vérifier un isolateur de câble télégraphique de son invention, installé au sommet du pic, que M. Simmons, subjugué par la vue sur Manitou Springs, Colorado Springs et Garden of the Gods, décida d'investir dans la construction d'un chemin de fer.

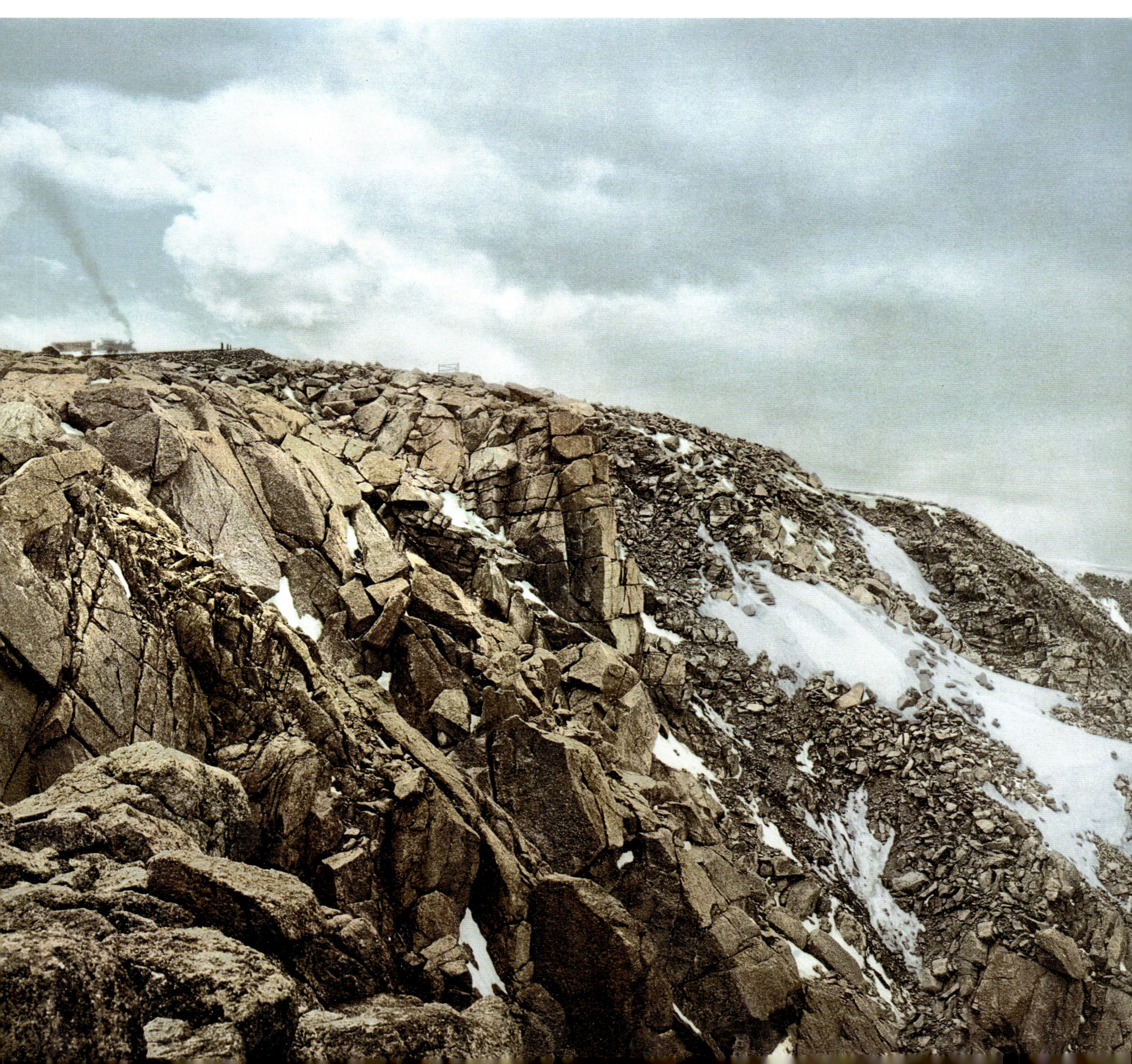

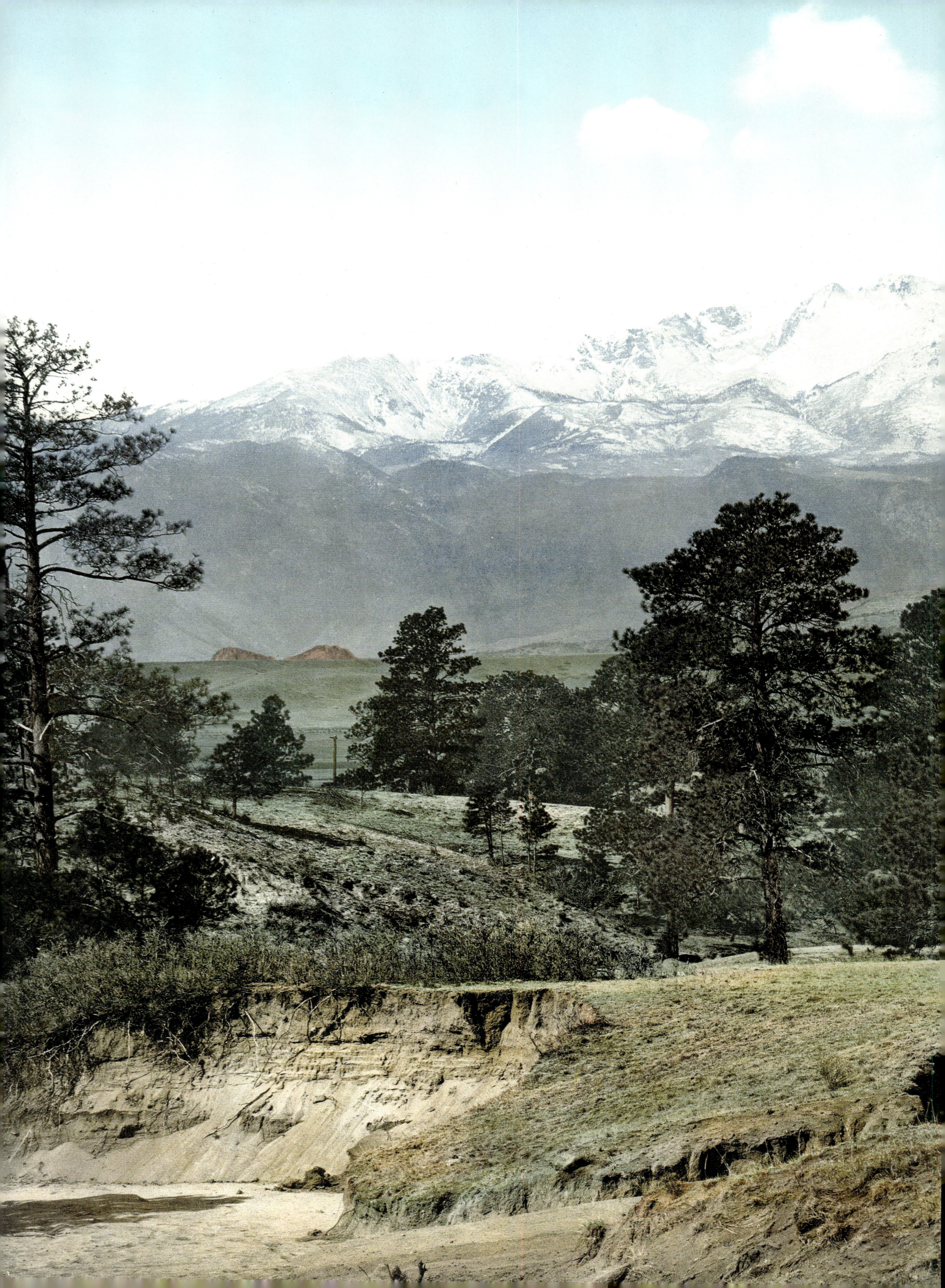

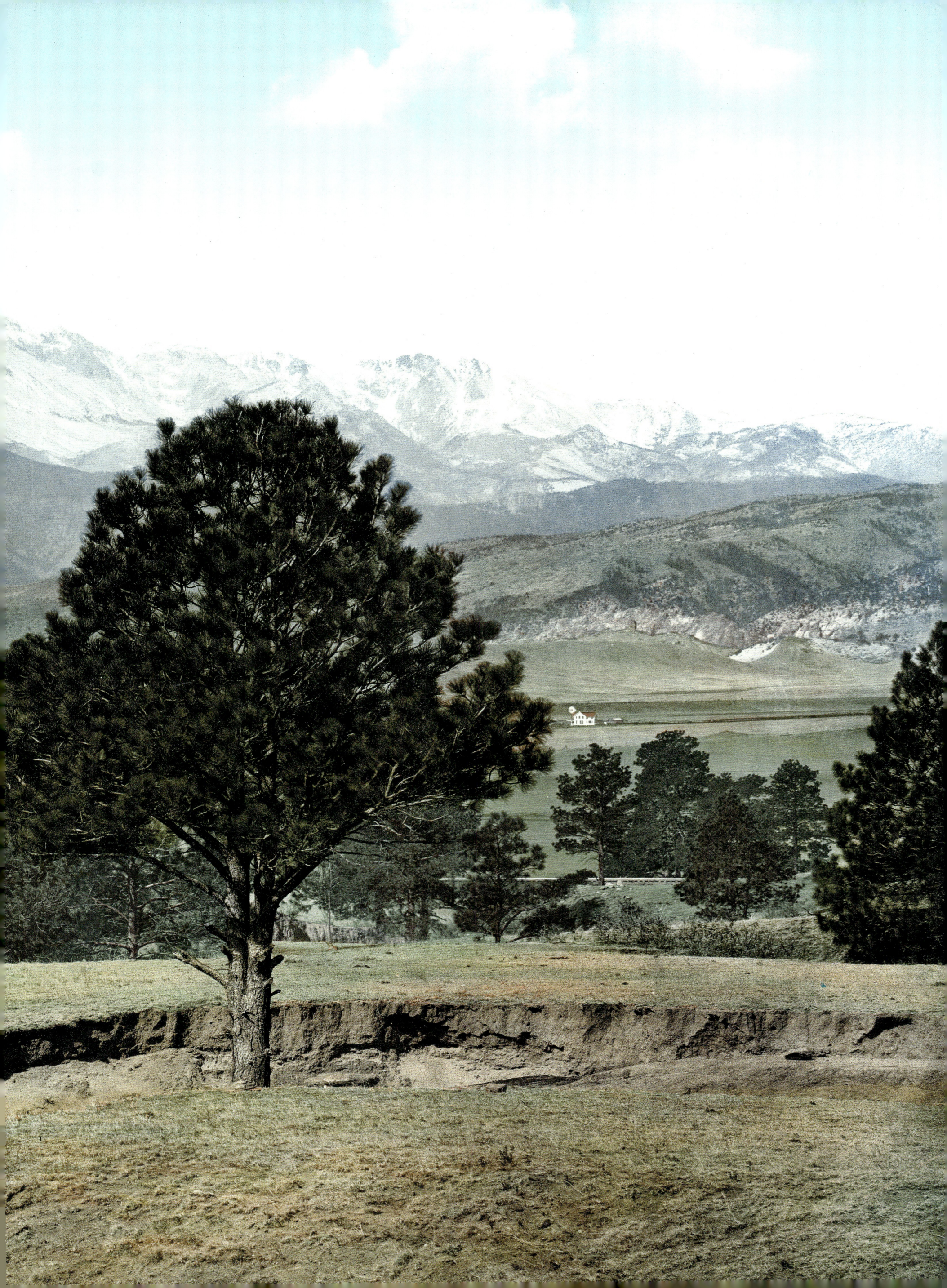

MINING / MINEN / MINES

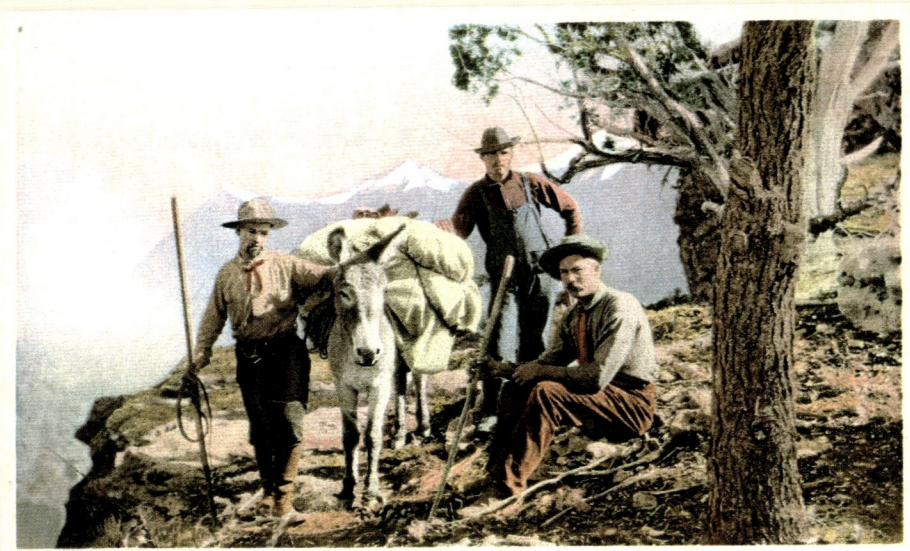
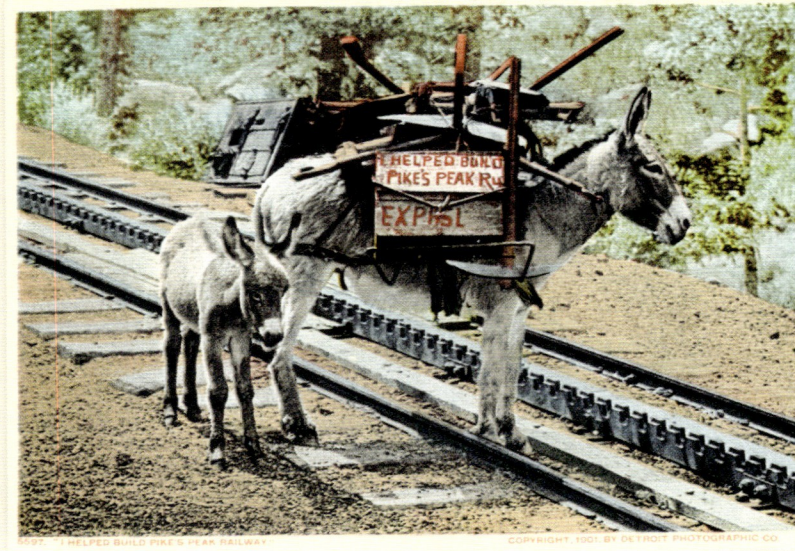

In 1848, the discovery of gold at Sutter's Mill, near Sacramento, marked the advent of the California Gold Rush. The news went out by telegraph and attracted tens of thousands of adventurers of all nationalities to California. They disembarked in San Francisco, whose population increased by a factor of 25 between 1848 and 1850: The port was soon full of ships abandoned by crews who had left to seek their fortune. The most accessible deposits were quickly exhausted and gold fever now struck the Rockies: Montana (Butte, 1852), Colorado (in particular, the Pike's Peak region, 1858–59), Idaho (1860), and the Black Hills of South Dakota (Deadwood, Homestake, 1876). Baron Edmond de Mandat-Grancey described the living conditions of the prospectors in the Deadwood and Homestake mines in 1884: "At every step, we find traces of prospectors—a shaft or a broken-down tunnel—and beside it, the ruins of a miserable hut in which some unfortunate miner came to sleep having emerged soaking wet from the hole in which he expected to make his fortune and from which, nine times out of ten, he harvested only disappointment and ruin."

Die Entdeckung von Gold in Sutter's Mill bei Sacramento im Jahr 1848 war der Beginn des kalifornischen Goldrausches. Die telegrafisch verbreitete Nachricht lockte Zehntausende von Abenteurern sämtlicher Nationalitäten nach Kalifornien. Sie gingen in San Francisco von Bord, wo die Bevölkerung zwischen 1848 und 1850 um das 25-fache wuchs und der Hafen bald voll von Schiffen war, die von ihrer Besatzung auf der Suche nach dem großen Reichtum verlassen worden waren! Als die am leichtesten zugänglichen Lagerstätten erschöpft waren, griff das Goldfieber auf die Rocky Mountains über: Montana (Butte, 1852), Colorado – vor allem die Region von Pike's Peak (1858–1859) –, Idaho (1860) und die Black Hills in South Dakota (Deadwood, Homestake, 1876). Baron Edmond de Mandat-Grancey beschrieb die Lebensbedingungen der Goldschürfer in den Minen von Deadwood und Homestake 1884: „Auf Schritt und Tritt stoßen wir auf Spuren von Goldsuchern, einen Brunnenschacht, einen eingestürzten Tunnel, daneben die Reste einer ärmlichen Hütte, in der sich irgendein armseliger Minenarbeiter schlafen legte, wenn er völlig durchnässt aus dem Loch herauskam, in dem er Reichtum zu finden hoffte und stattdessen in neun von zehn Fällen nur Enttäuschung und Ruin erntete."

La découverte d'or à Sutter's Mill, près de Sacramento, marqua en 1848 le début de la ruée vers l'or en Californie. La nouvelle, répandue par le télégraphe, attira dans la région des dizaines de milliers d'aventuriers de toutes nationalités ; ils débarquaient à San Francisco, dont la population fut multipliée par vingt-cinq entre 1848 et 1850 et dont le port fut bientôt plein de navires abandonnés par leurs équipages partis chercher fortune ! Les gisements les plus faciles d'accès étant épuisés, la fièvre de l'or gagna les Rocheuses : le Montana (Butte, 1852), le Colorado – notamment la région de Pike's Peak (1858–1859) –, l'Idaho (1860) et les Black Hills du Dakota du Sud (Deadwood, Homestake, 1876). Le baron Edmond de Mandat-Grancey a décrit en 1884 les conditions de vie des prospecteurs dans les mines de Deadwood et de Homestake : « À chaque pas, nous trouvons des traces de prospecteurs, un puits creusé, un tunnel effondré, et, à côté, les débris d'une pauvre hutte où quelque malheureux mineur venait se coucher en sortant tout humide du trou où il espérait trouver fortune et où, neuf fois sur dix, il n'a récolté que désappointement et ruine… »

Top left: Prospectors
Top right: "I helped build Pike's Peak railway"
Right: A pioneer merchant, Colorado, photochrom
Page 455: A Pike's Peak prospector, photography by W. H. Jackson, 1900

Oben links: Goldgräber
Oben rechts: „Ich war am Bau der Eisenbahn von Pike's Peak beteiligt"
Rechts: Pionierladen, Colorado, Photochrom
Seite 455: Ein Goldgräber am Pike's Peak, Fotografie von W. H. Jackson, 1900

En haut à gauche : chercheurs d'or
En haut à droite : « J'ai participé à la construction du chemin de fer de Pike's Peak »
Ci-contre : la boutique d'un pionnier, Colorado, photochrome
Page 455 : un chercheur d'or de Pike's Peak, photographie par W. H. Jackson, 1900

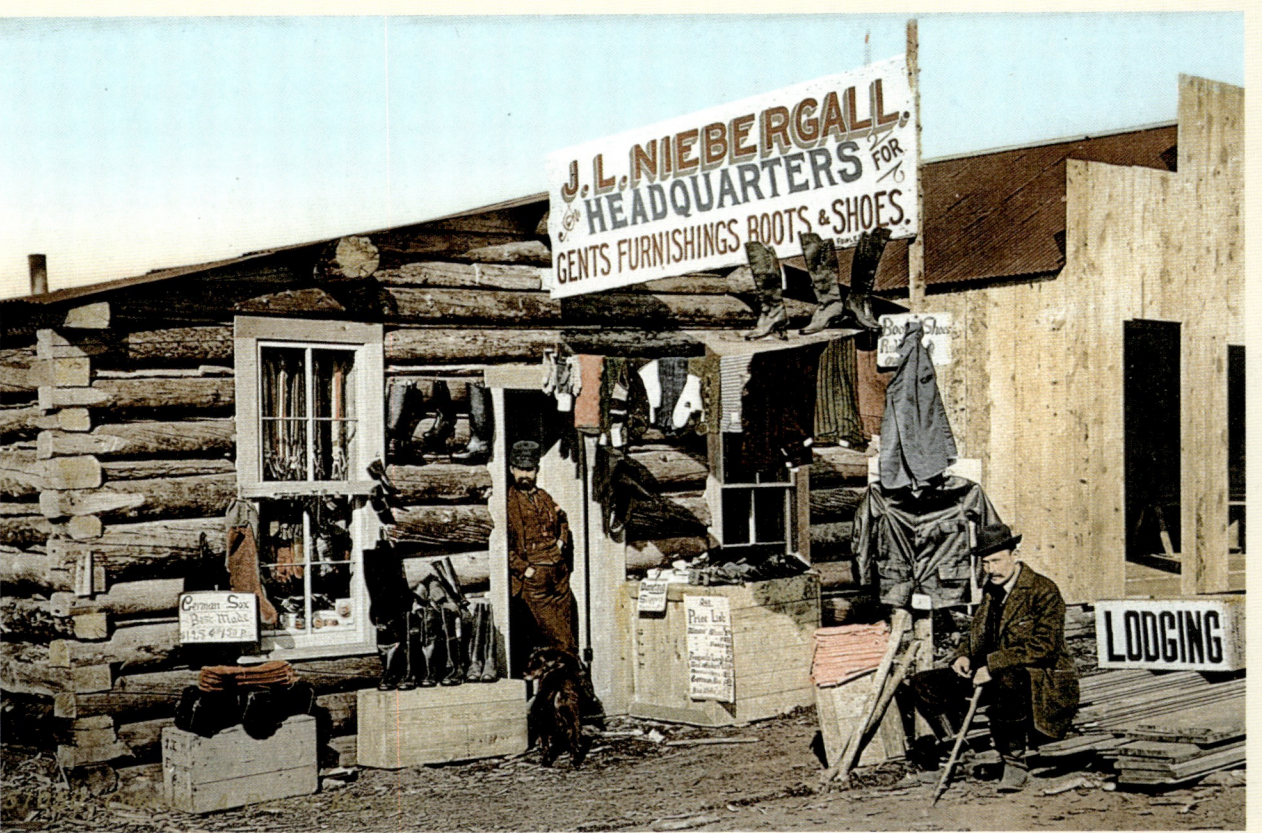

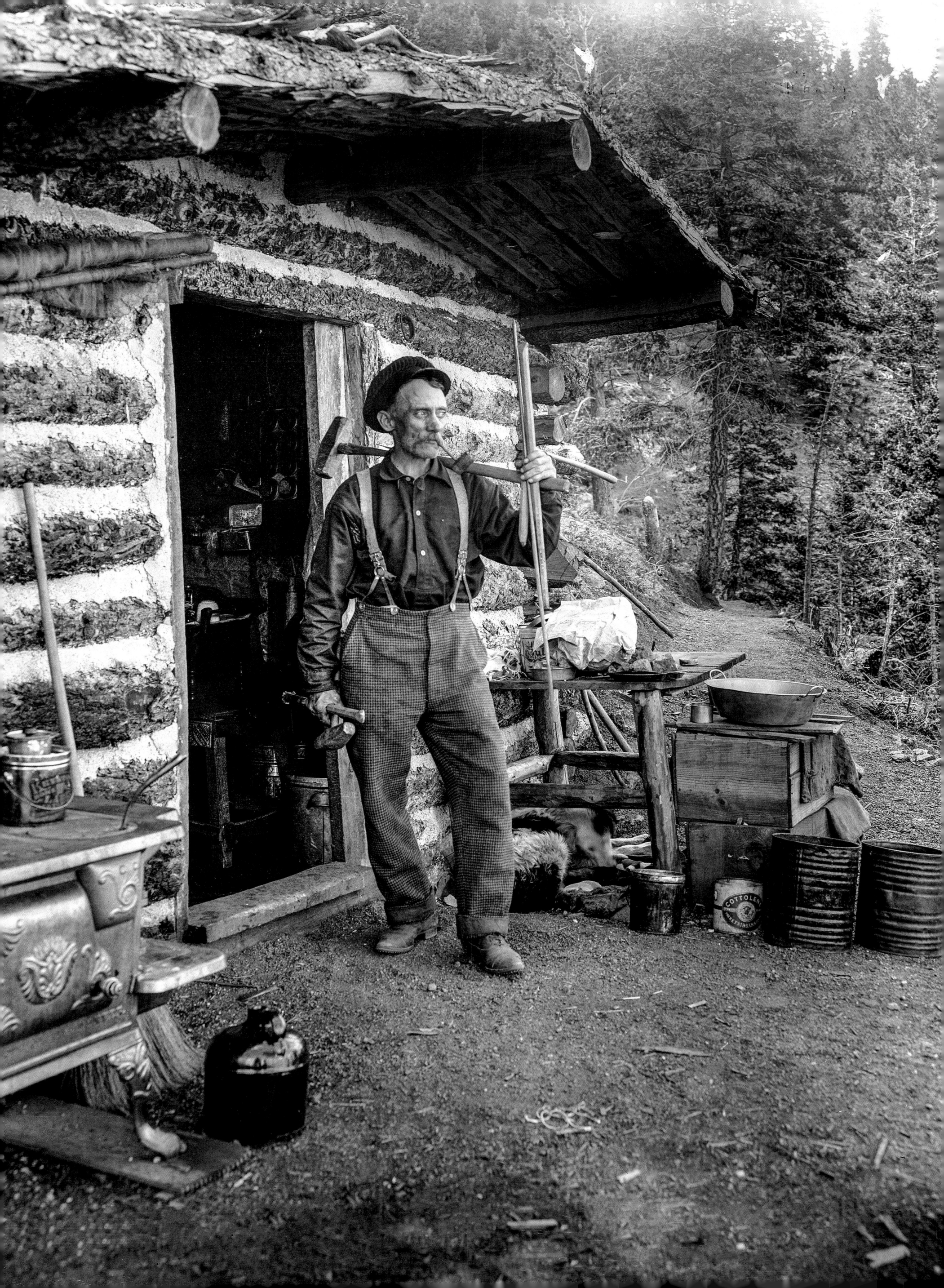

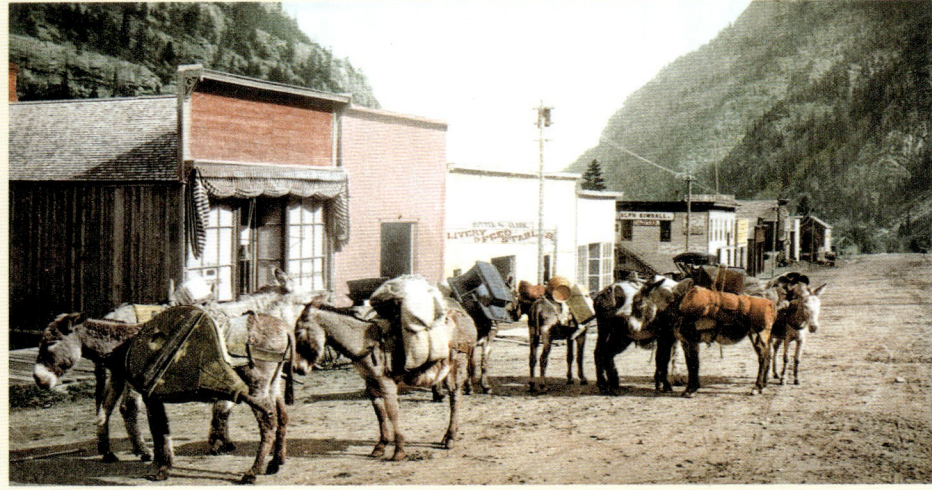
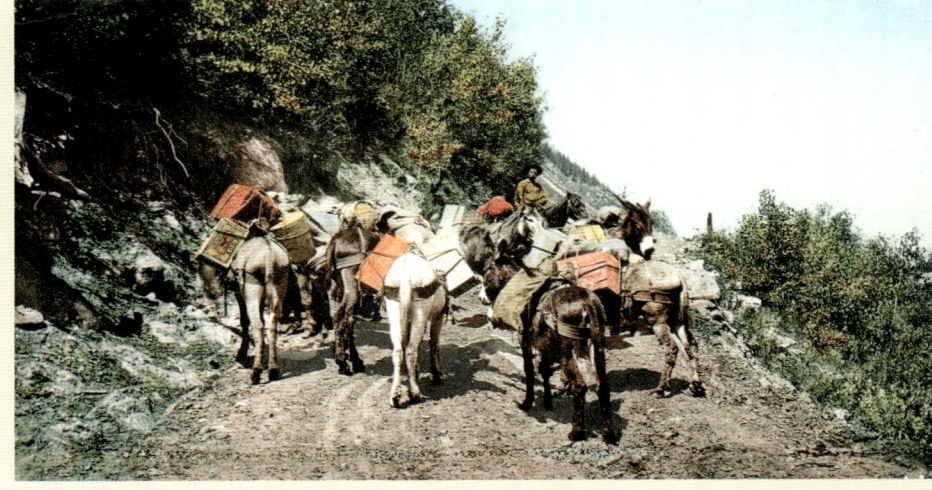
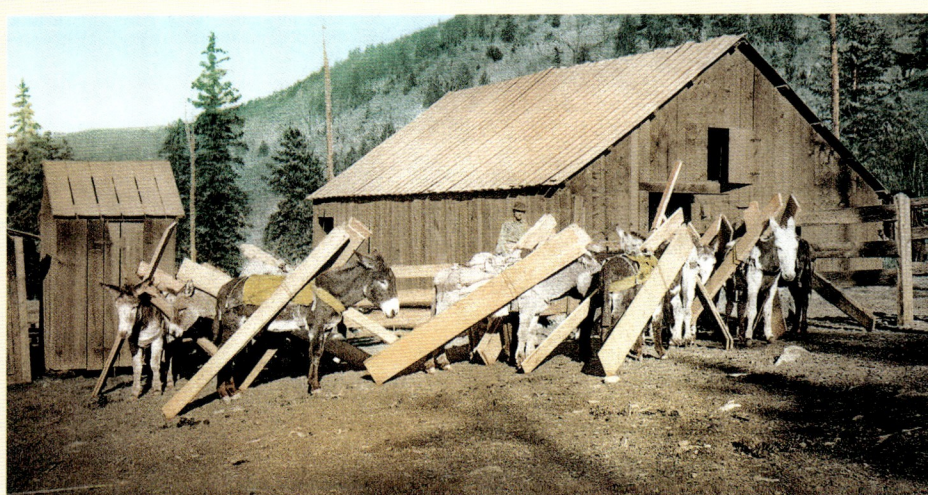
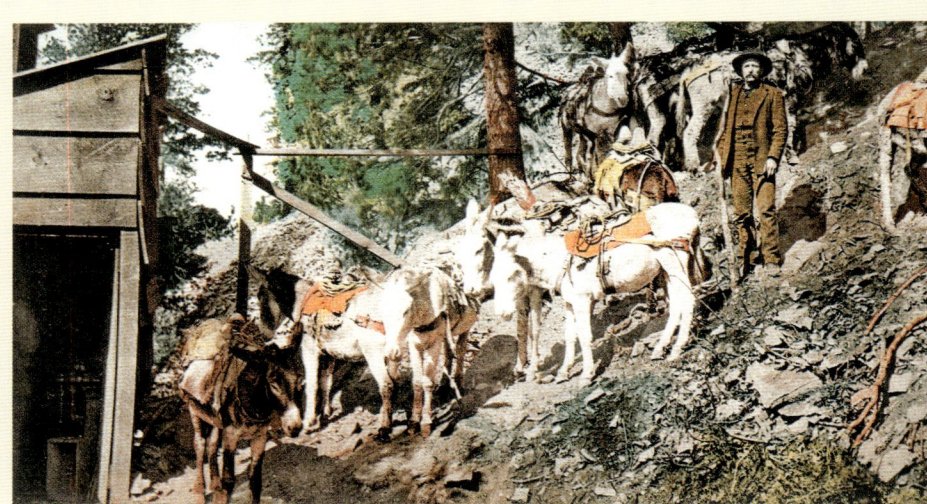

From left to right and top to bottom:
Pack train ready for mines, Colorado, photochrom
Colorado pack train, photochrom
Burros loaded with lumber, Colorado, photochrom
Burros at silver mines, Colorado, photochrom
Page 456/457, bottom:
Cripple Creek, Colorado, photochrom
Page 457, from left to right and top to bottom:
Placer mining, photochrom
A prospect shaft, Colorado, photochrom
Dug out cabins, Colorado, photochrom
Miner's cabin in winter, Colorado, photochrom
Placer mining, the flume, Colorado, photochrom
Silver bullion, Colorado, photochrom

Von links nach rechts und von oben nach unten:
Eine Lasttierkolonne vor dem Aufbruch zu den Minen, Colorado, Photochrom
Colorado pack train, photochrom
Eine Lasttierkolonne auf dem Weg zu den Minen, Colorado, Photochrom
Mit Brettern beladene Esel, Colorado, Photochrom
Lastesel in den Silberminen, Colorado, Photochrom
Seite 456/457, unten:
Cripple Creek, Colorado, Photochrom
Seite 457, von links nach rechts und von oben nach unten:
Mineralvorkommen, Photochrom
Erkundungsschacht, Colorado, Photochrom
Erdhütten, Colorado, Photochrom
Hütte eines Grubenarbeiters im Winter, Colorado, Photochrom
Fundort, Klamm, Colorado, Photochrom
Silberbarren, Colorado, Photochrom

De gauche à droite et de haut en bas :
Avant le départ pour les mines, Colorado, photochrome
Équipage en route pour les mines, Colorado, photochrome
Ânes chargés de planches, Colorado, photochrome
Ânes dans les mines d'argent, Colorado, photochrome
Page 456/457, en bas :
Cripple Creek, Colorado, photochrome
Page 457, de gauche à droite et de haut en bas :
Gisement de minerai, photochrome
Un puits, Colorado, photochrome
Cabane enterrée, Colorado, photochrome
Cabane de mineur en hiver, Colorado, photochrome
Gisement, la conduite d'eau, Colorado, photochrome
Barres d'argent, Colorado, photochrome

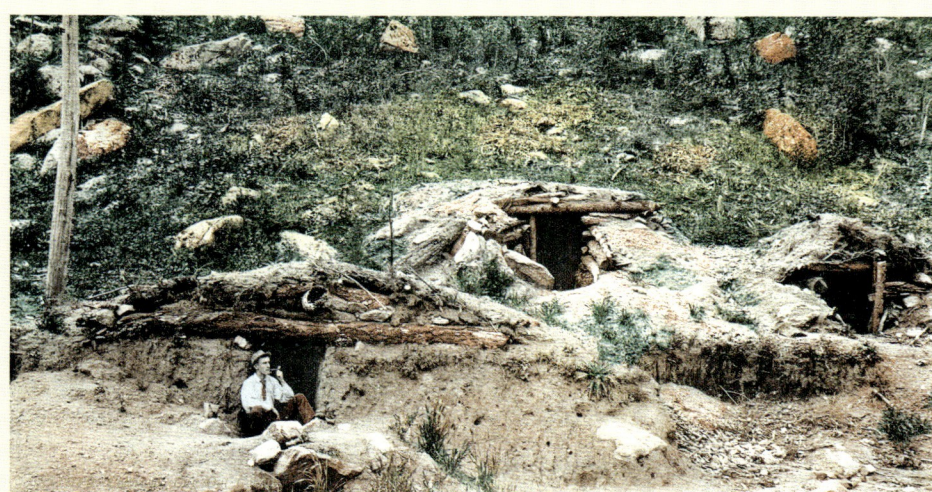

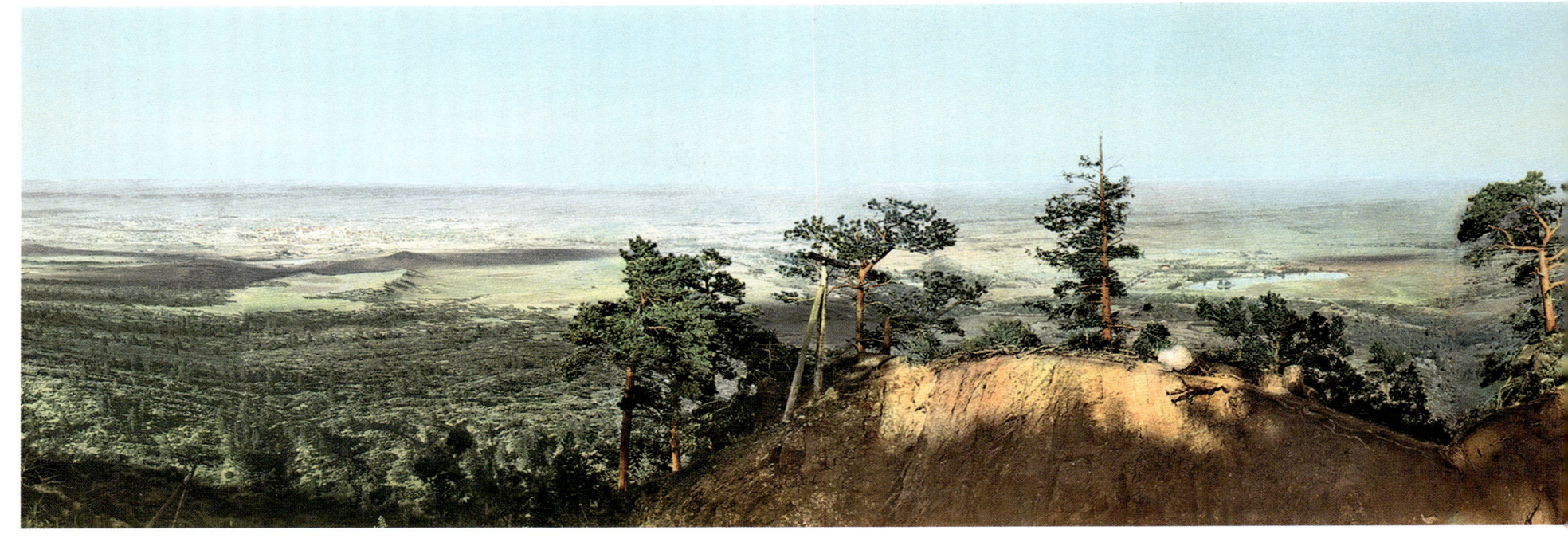

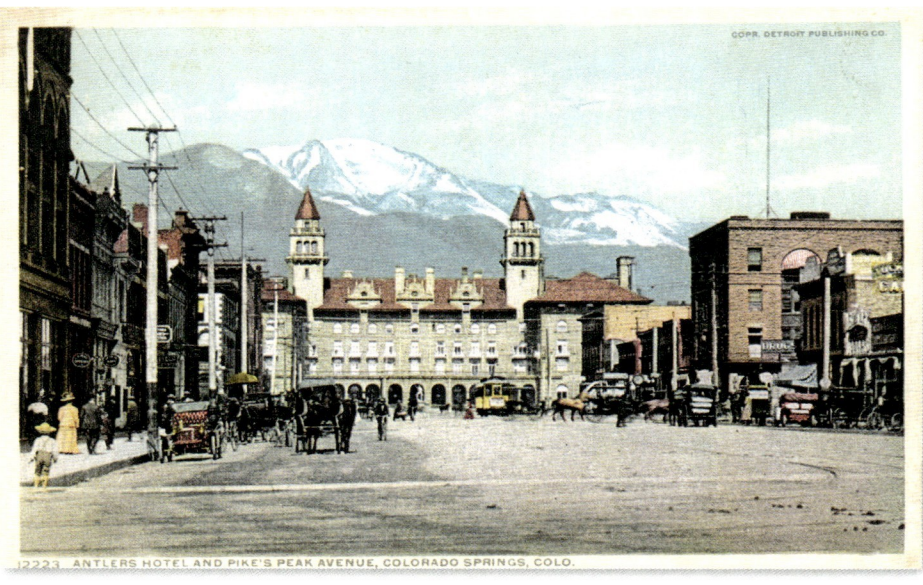

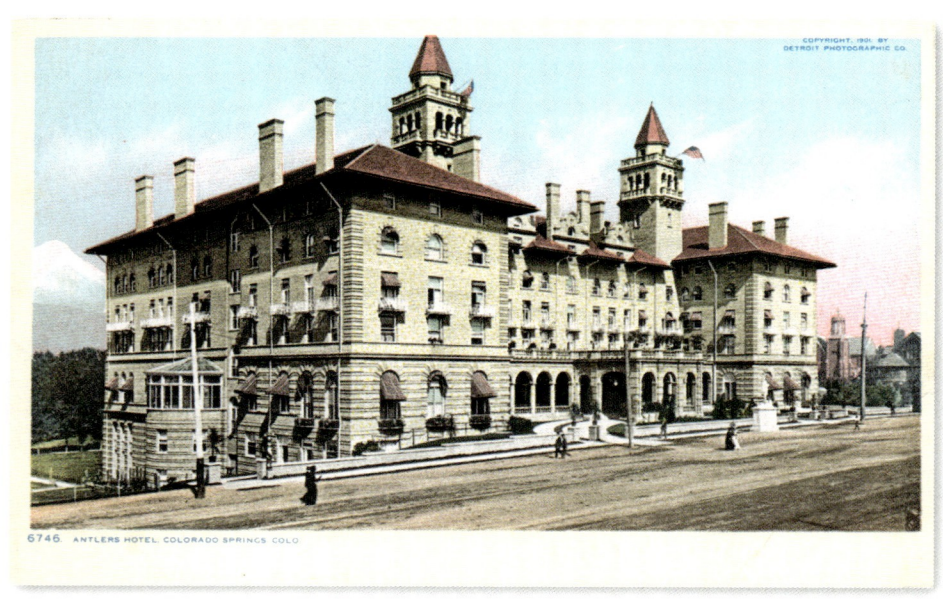

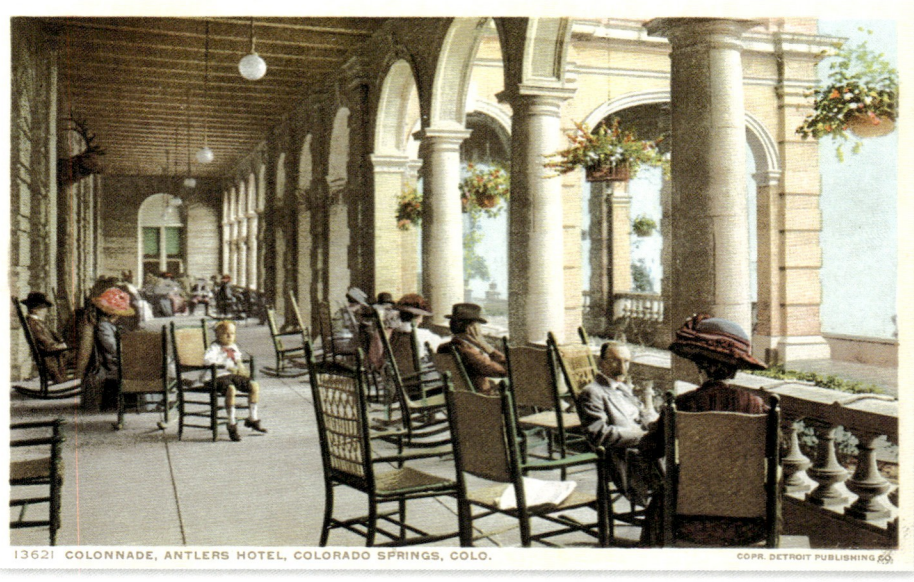

COLORADO | POINT SUBLIME | COLORADO SPRINGS

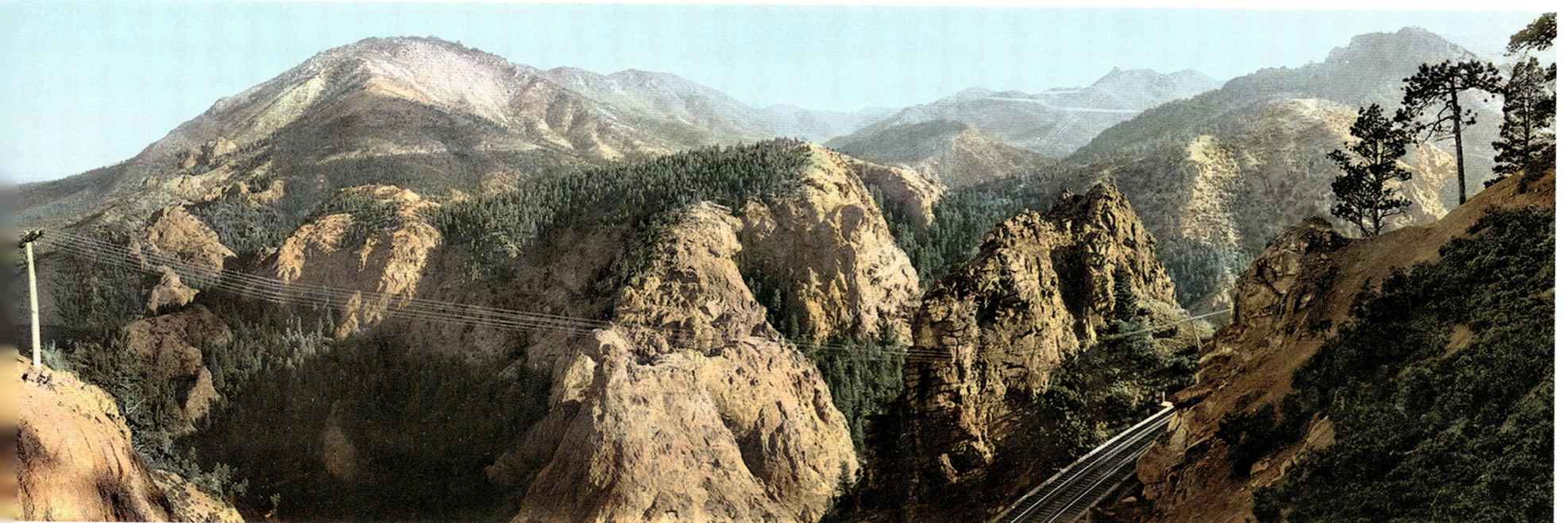

Above: **View from Point Sublime, photochrom**
Page 458, from top to bottom and left to right:
Ruins of the John Hay Cabin, Colorado Springs
Antlers Hotel and Pike's Peak Avenue
Antlers Hotel
The colonnade of Antlers Hotel
Below: **Pike's Peak Avenue, Colorado Springs, photochrom**

Built in the early 1880s by the founder of Colorado Springs, General William Palmer, Antlers Hotel burned to the ground in 1898. These photochroms show it as it was before the fire. It was reconstructed in 1901 in the Victorian style, then replaced in the 1960s by a wholly discordant modern building.

Oben: **Die Aussicht vom Point Sublime, Photochrom**
Seite 458, von oben nach unten und von links nach rechts:
Ruinen der John-Hay-Hütte, Colorado Springs
Das Hotel Antlers und die Pike's Peak Avenue
Das Hotel Antlers
Die Kolonnade des Hotels Antlers
Unten: **Die Pike's Peak Avenue, Colorado Springs, Photochrom**

Das Anfang der 1880er-Jahre von General William Palmer, dem Gründer der Stadt Colorado Springs, errichtete Antlers Hotel brannte 1898 vollständig ab. Diese Photochrome zeigen es so, wie es vor dem Brand aussah. Es wurde 1901 im viktorianischen Stil wieder aufgebaut und später, in den 1960er-Jahren, durch ein modernes Gebäude ersetzt und völlig entstellt.

Ci-dessus : **la vue depuis Point Sublime, photochrome**
Page 458, de haut en bas et de gauche à droite :
Ruines de la cabane de John Hay, Colorado Springs
L'hôtel Antlers et l'avenue de Pike's Peak
L'hôtel Antlers
La colonnade de l'hôtel Antlers
En bas : **l'avenue de Pike's Peak, Colorado Springs, photochrome**

Créé au début des années 1880 par le fondateur de la ville de Colorado Springs, le général William Palmer, l'Antlers brûla entièrement en 1898 : nos photochromes le montrent tel qu'il était avant l'incendie. Il fut rebâti en 1901 dans un style victorien, puis remplacé et totalement dénaturé dans les années 1960 par un édifice moderne.

Below: Cathedral Park, photochrom
Bottom: Colorado Springs, Pike's Peak and Garden of the Gods, photochrom
Page 461: Garden of the Gods, "Balanced Rock," photochrom
Page 462/463: Garden of the Gods, "Cathedral Spires," photochrom

Mitte: Cathedral Park, Photochrom
Unten: Colorado Springs, Pike's Peak und Garden of the Gods (Garten der Götter), Photochrom
Seite 461: Garden of the Gods, Balanced Rock (ausbalancierter Fels), Photochrom
Seite 462/463: Garden of the Gods, die „Kirchturmspitzen", Photochrom

Ci-dessous : Cathedral Park (parc de la Cathédrale), photochrome
En bas : Colorado Springs, Pike's Peak et Garden of the Gods (le Jardin des dieux), photochrome
Page 461 : Garden of the Gods, Balanced Rock (le « rocher qui se balance »), photochrome
Pages 462/463 : Garden of the Gods, les « flèches de cathédrale », photochrome

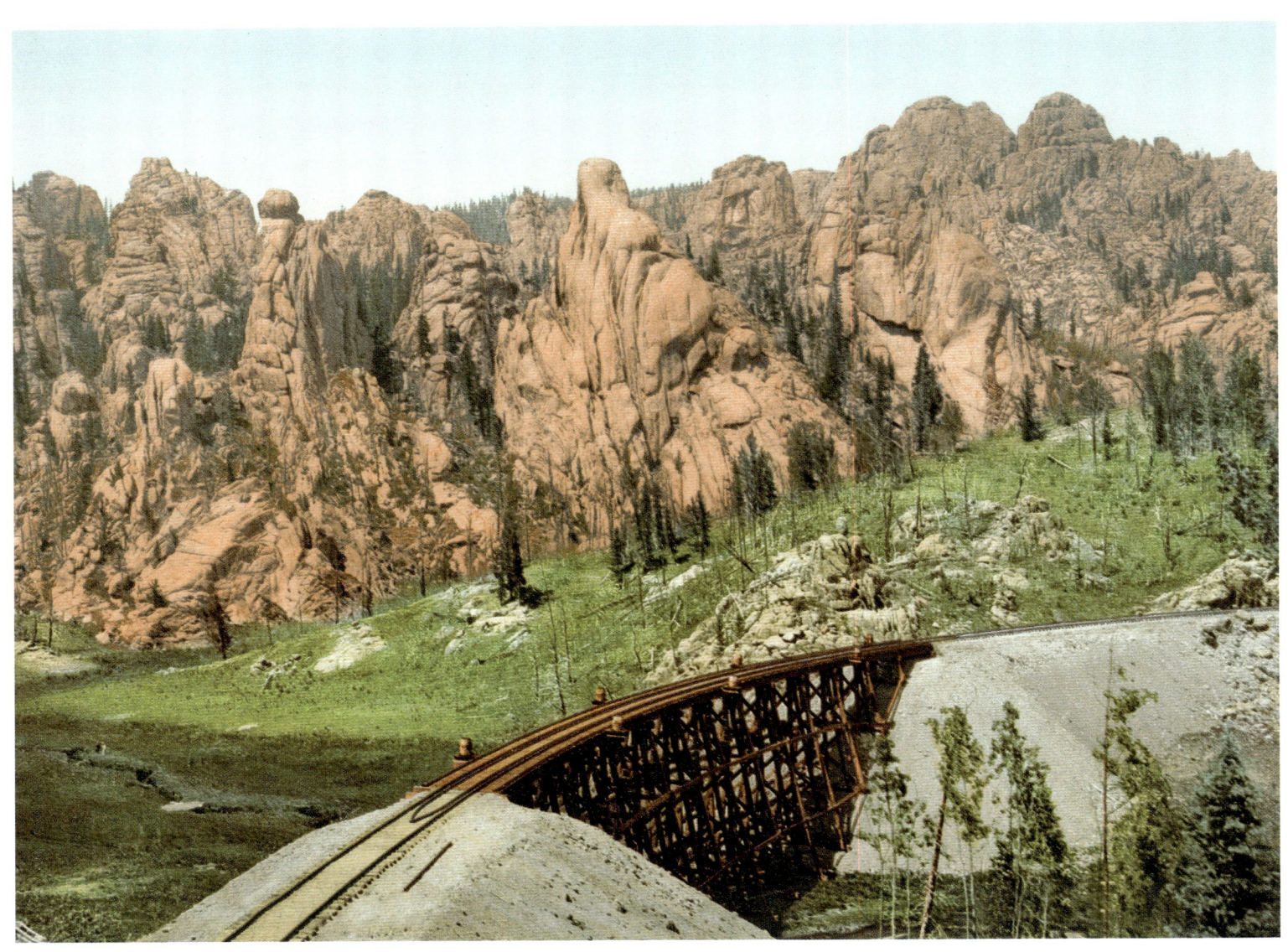

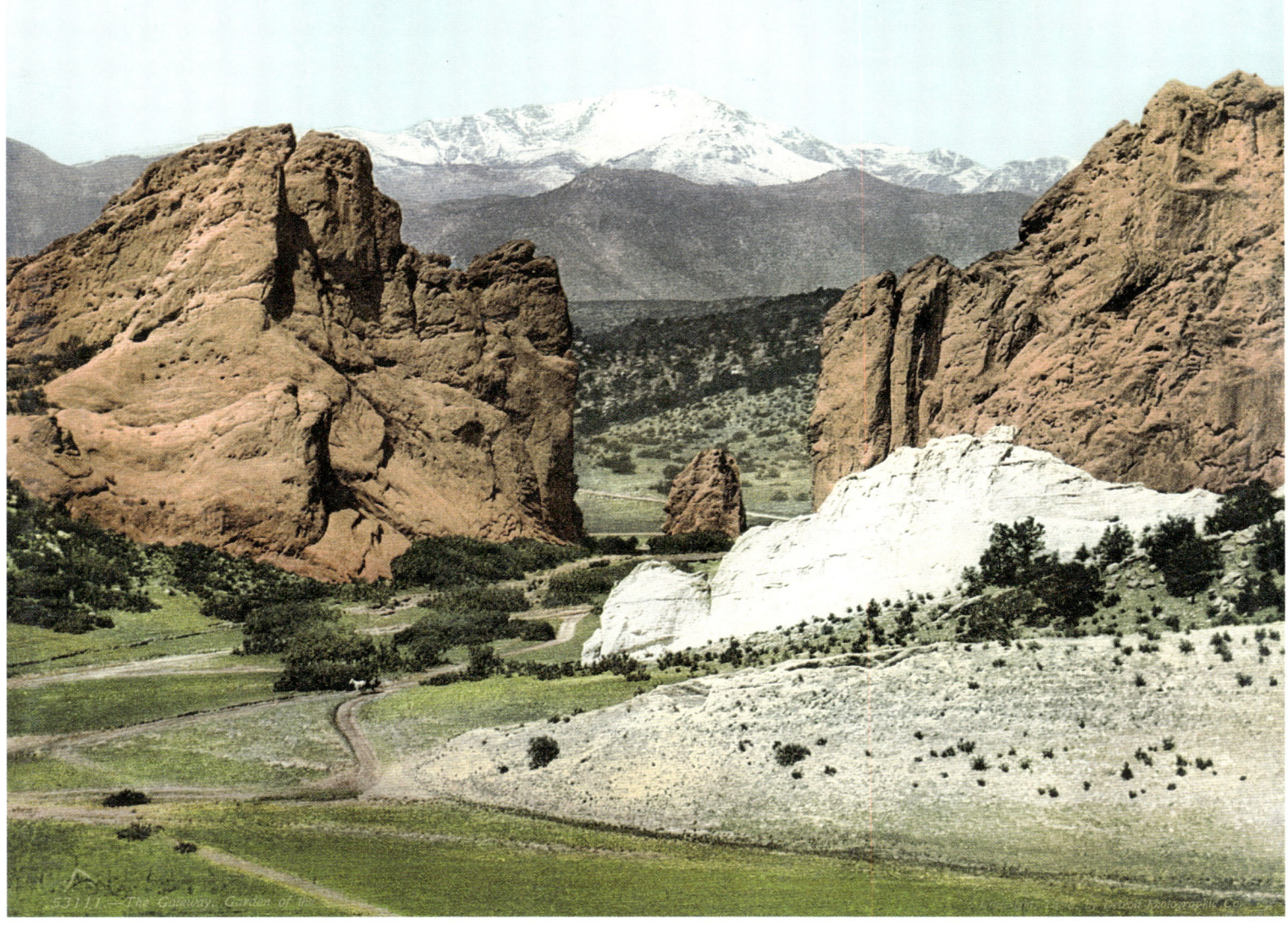

COLORADO | GARDEN OF THE GODS

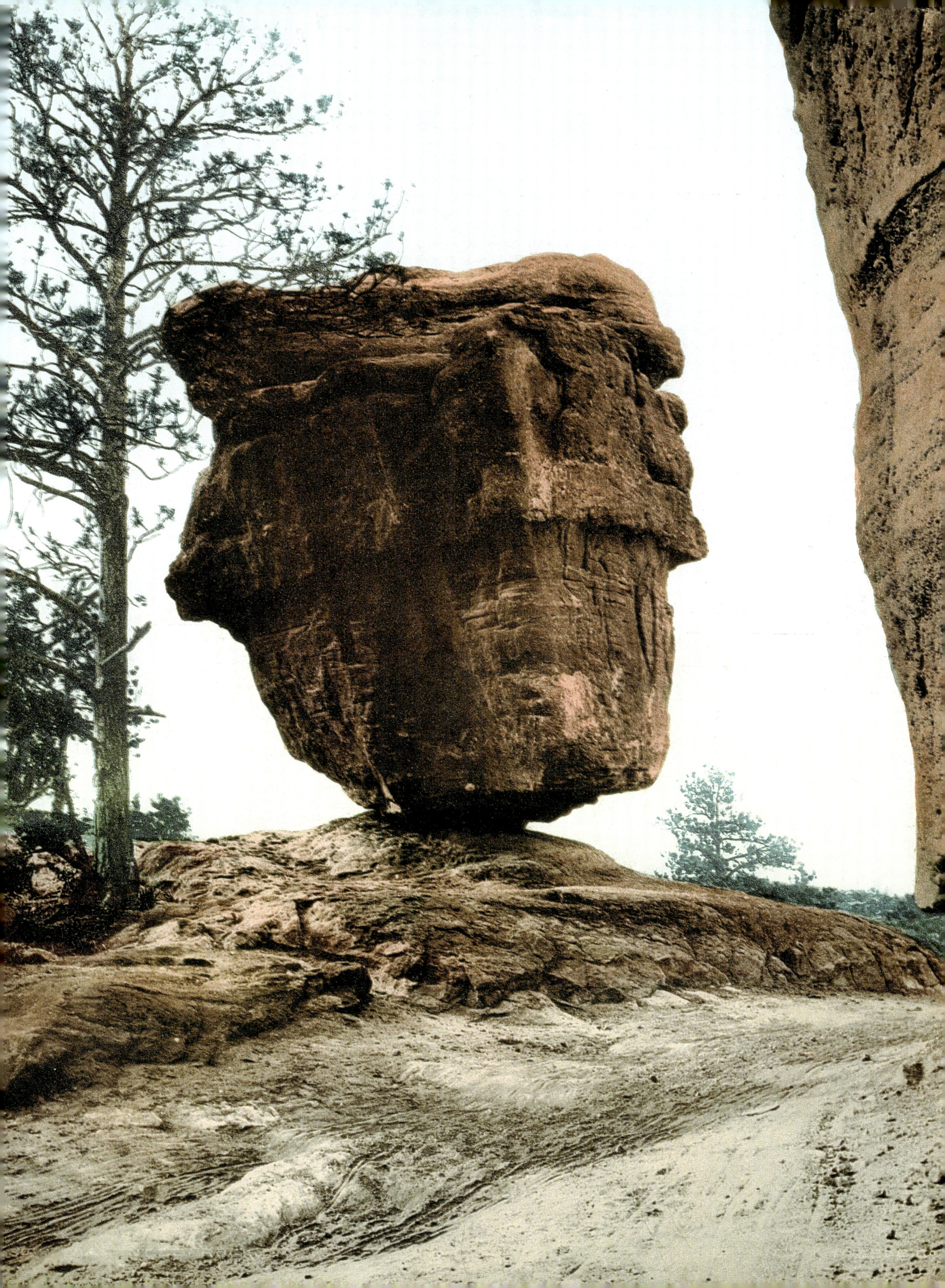

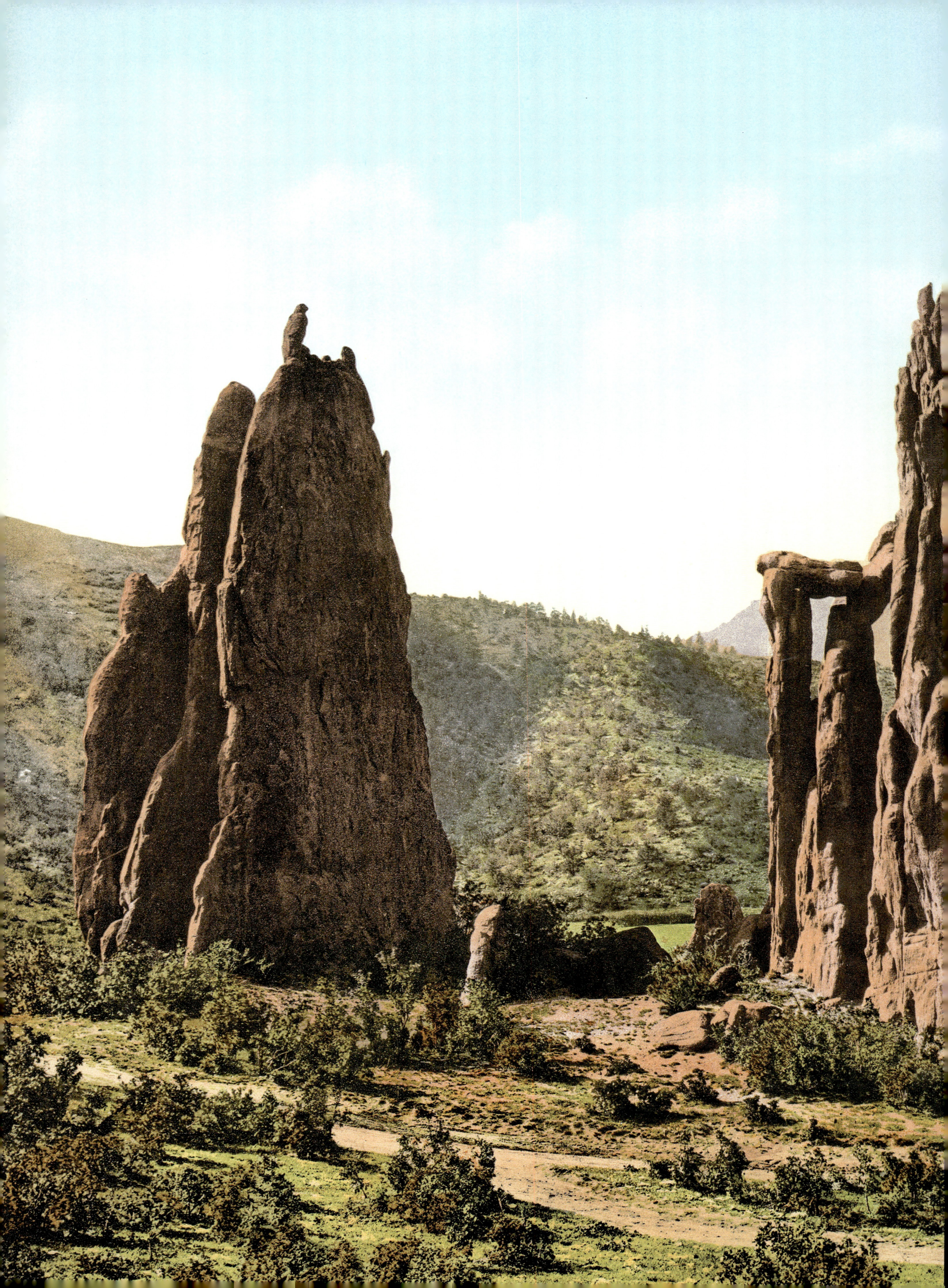

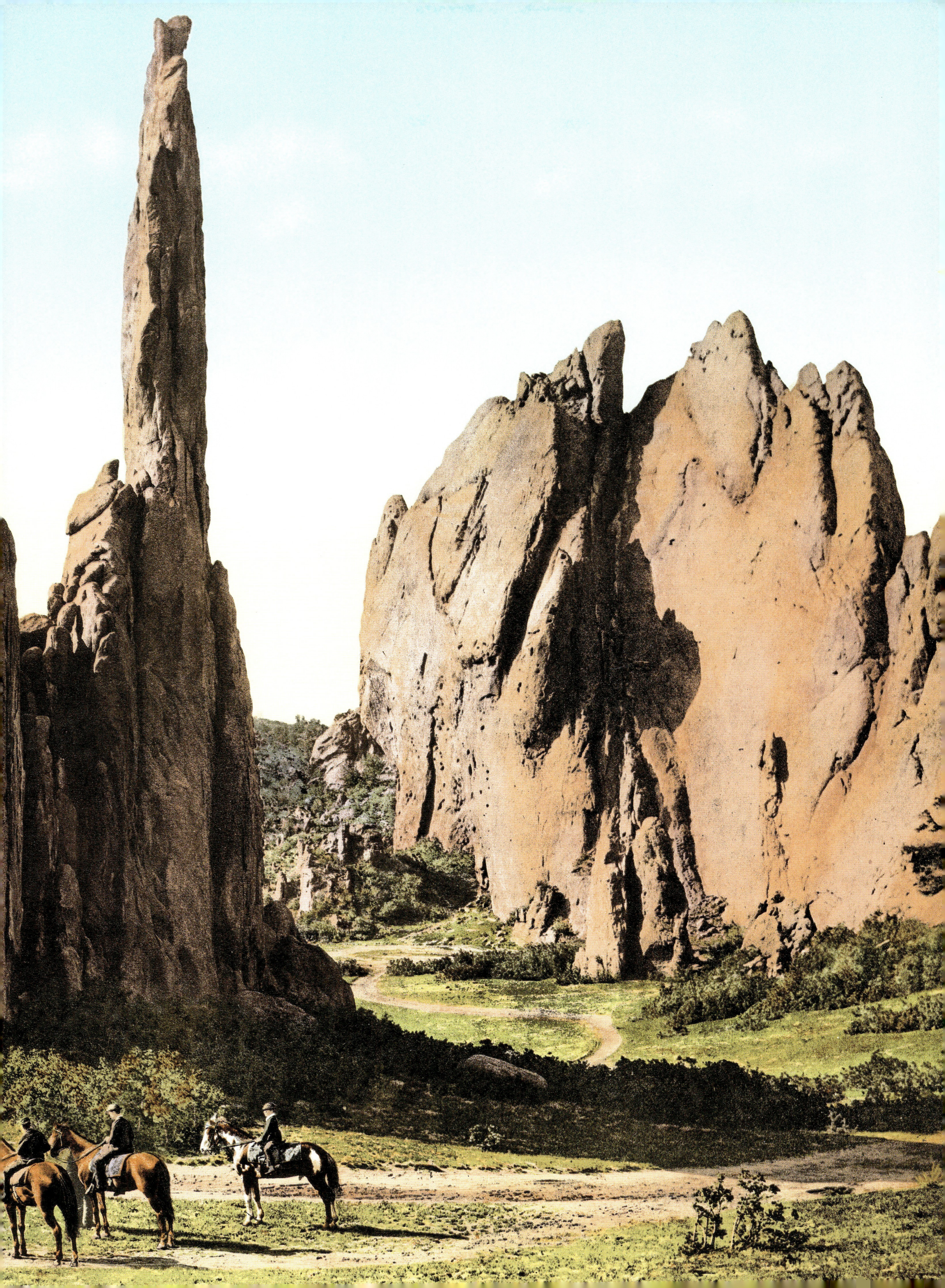

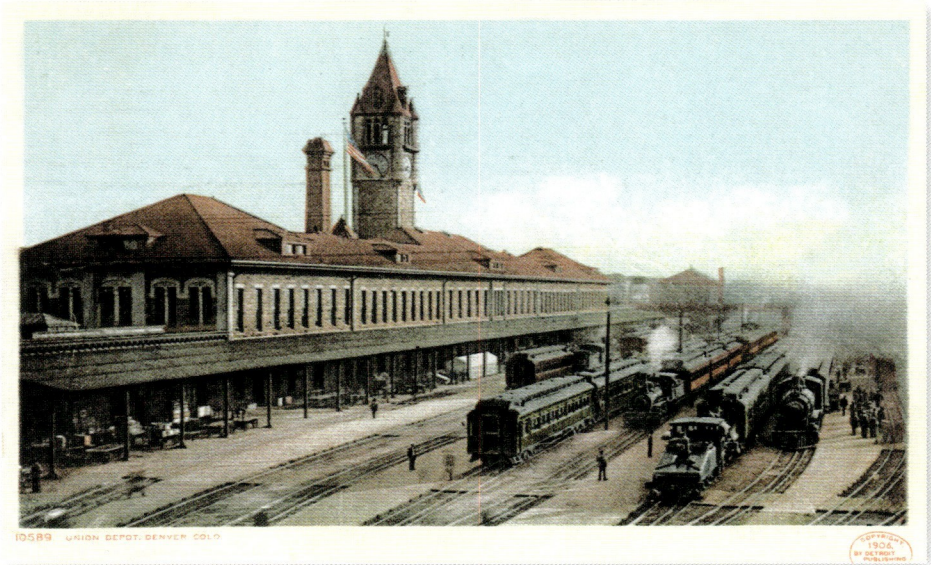
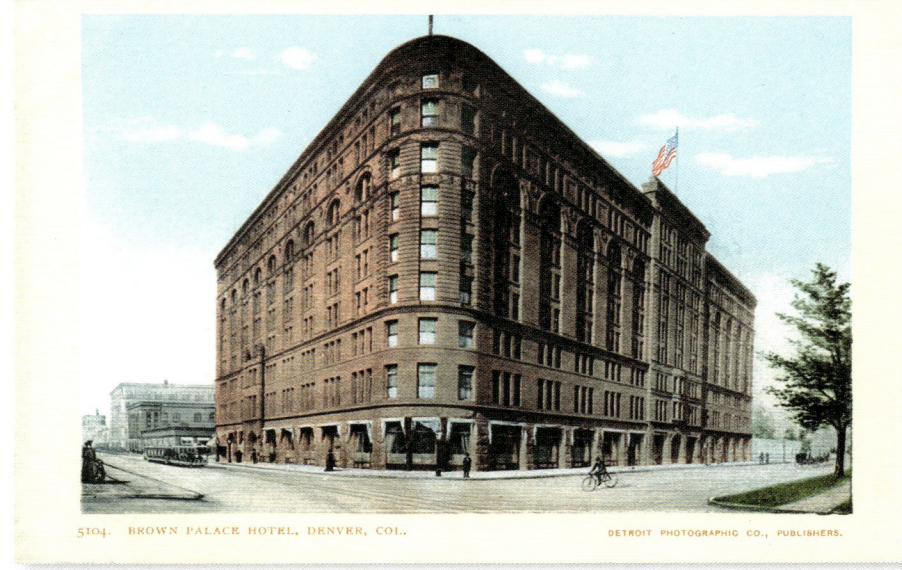

Top left: **Union Depot**
Top right: **Brown Palace Hotel**
Bottom: **View of Denver from the Capitol, photochrom**
Page 465:
Top: **The horse car Cherrelyn with a horse aboard**
Right: **City Park**

Denver lies at 5,250 feet (1,600 m) above sea level and was considered by travelers at the turn of the 19th century as the gate to the Rockies and the West. The town was founded in 1858, at the time of the Pike's Peak Gold Rush. The Brown Palace Hotel, built in red Colorado granite and Arizona sandstone, opened on August 12, 1892. Designed by the architect Frank Edbrooke and dominated by eight stories of balconies, it was the first atrium-style hotel in the United States. Teatime in Brown's atrium is something of an institution.

Oben links: **Der Bahnhof Union Depot**
Oben rechts: **Das Hotel Brown Palace**
Unten: **Blick vom Kapitol auf Denver, Photochrom**
Seite 465:
Oben: **Die Pferdebahn Cherrelyn mit einem Pferd an Bord**
Rechts: **City Park**

Das in 1 600 Metern Höhe gelegene Denver galt unter Reisenden an der Wende zum vergangenen Jahrhundert als Tor zu den Rocky Mountains und zum Westen. Die Stadt wurde 1858 zur Zeit des Goldrausches von Pike's Peak gegründet. Das aus rotem Granit aus Colorado und Sandstein aus Arizona errichtete Hotel Brown Palace wurde am 12. August 1892 eingeweiht. Die von dem Architekten Frank Edbrooke als Atrium – das erste seiner Art in den USA – gestaltete Eingangshalle wird von acht Stockwerken von Balkonen beherrscht. Die Teestunde im Atrium des Hotels Brown ist noch immer eine Institution.

En haut à gauche : **la gare d'Union Depot**
En haut à droite : **l'hôtel Brown Palace**
En bas : **vue de Denver depuis le Capitol, photochrome**
Page 465 :
En haut : **le tramway hippomobile Cherrelyn et son cheval à bord**
À droite : **le parc municipal (City Park)**

À 1 600 mètres d'altitude, Denver était considérée par les voyageurs du tournant du siècle dernier comme la porte des Rocheuses et de l'Ouest. La ville fut fondée en 1858, au moment de la ruée vers l'or de Pike's Peak. L'hôtel Brown Palace, construit en granit rouge du Colorado et en grès d'Arizona, a été inauguré le 12 août 1892. Le hall, aménagé en atrium – le premier du genre aux États-Unis – par l'architecte Frank Edbrooke, est dominé par huit étages de balcons. L'heure du thé dans l'atrium du Brown reste une institution.

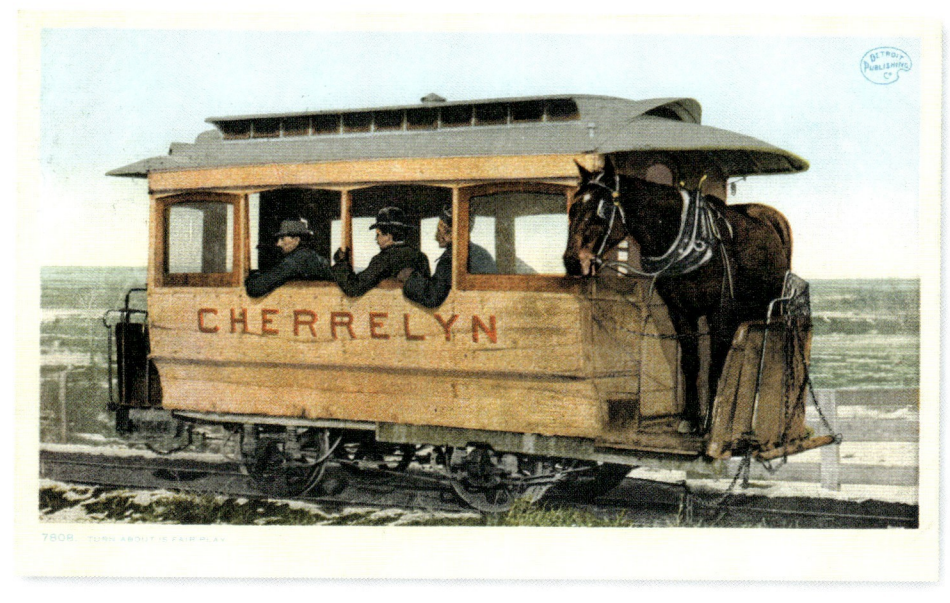

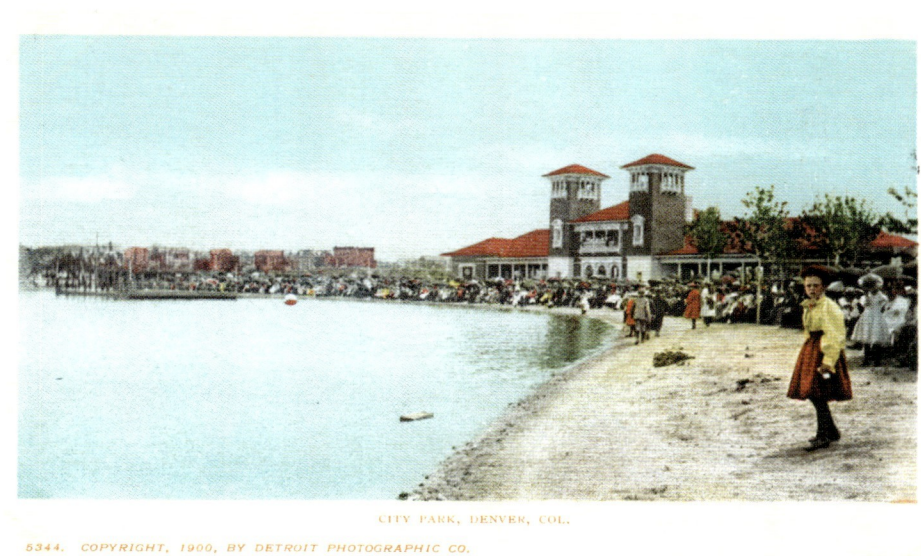

CITY PARK, DENVER, COL.
5344. COPYRIGHT, 1900, BY DETROIT PHOTOGRAPHIC CO.

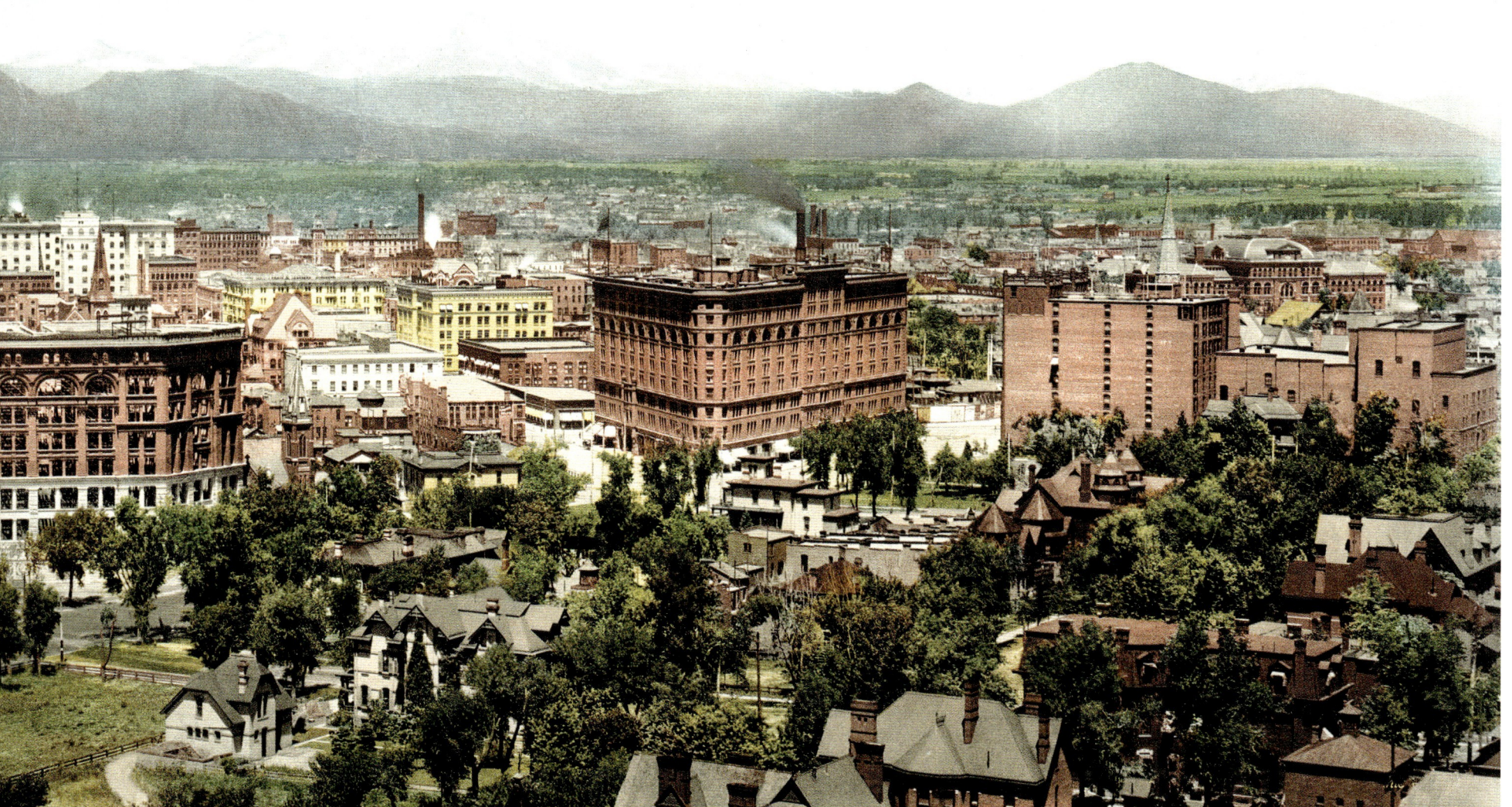

COLORADO | DENVER

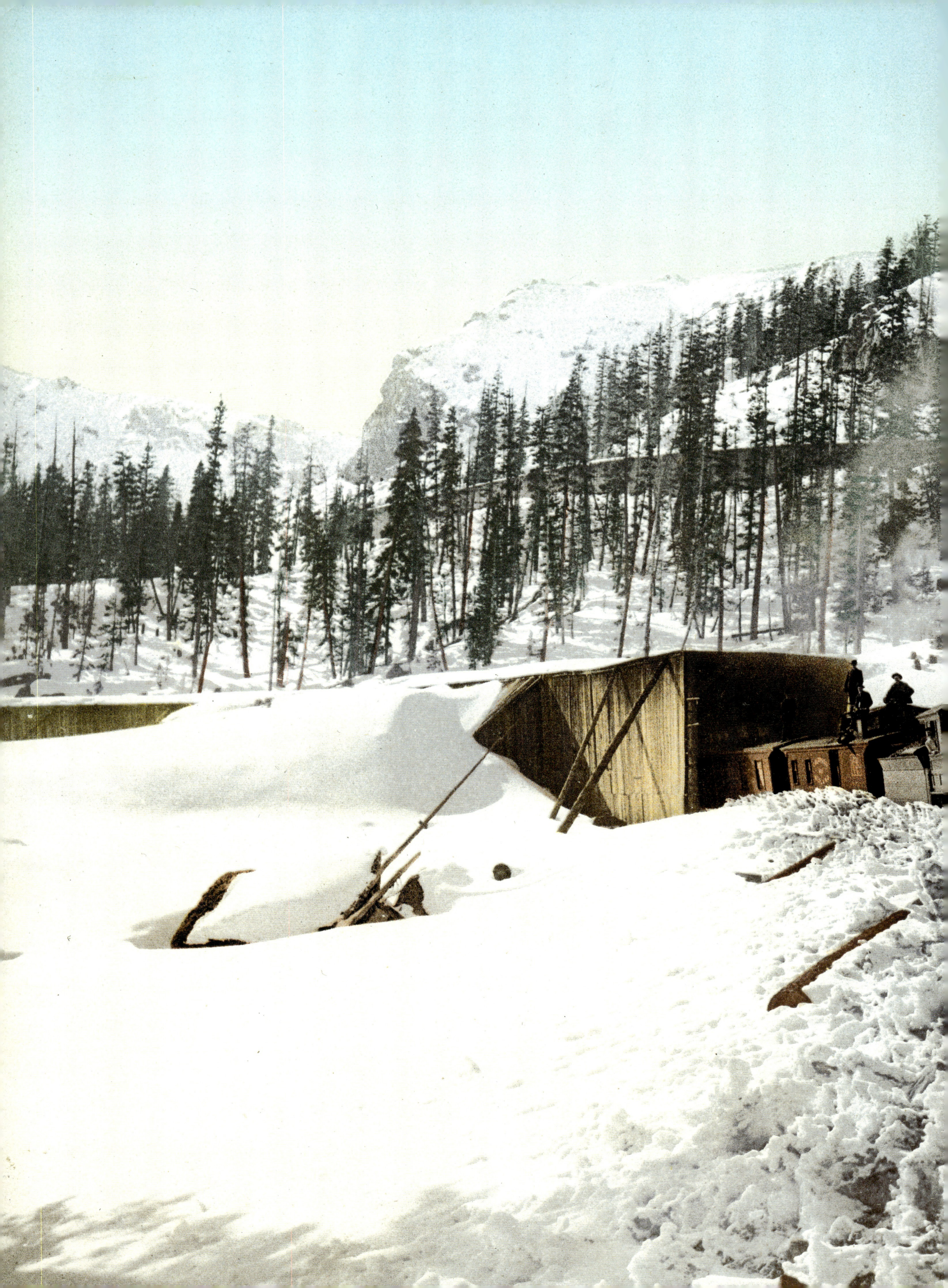

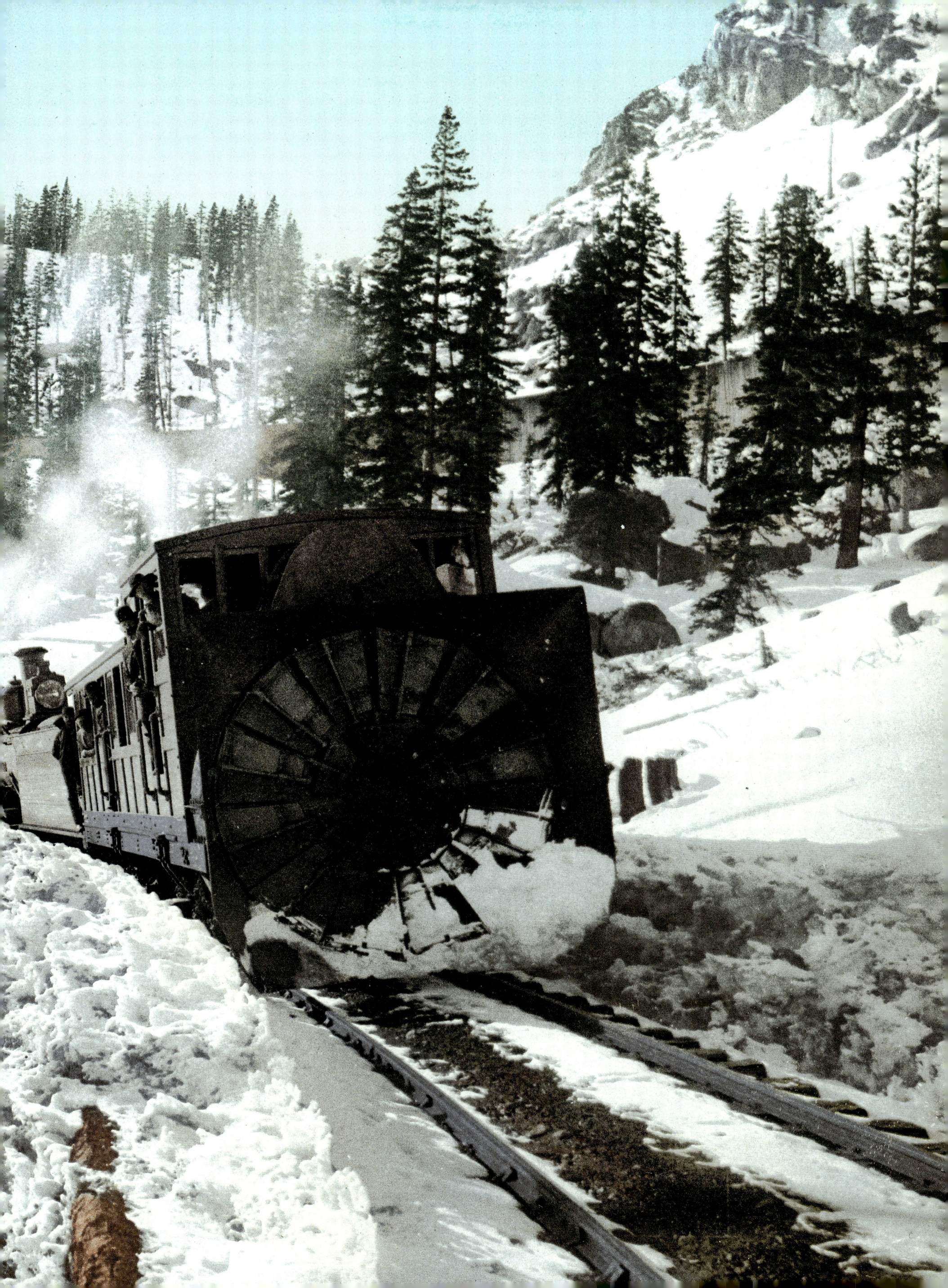

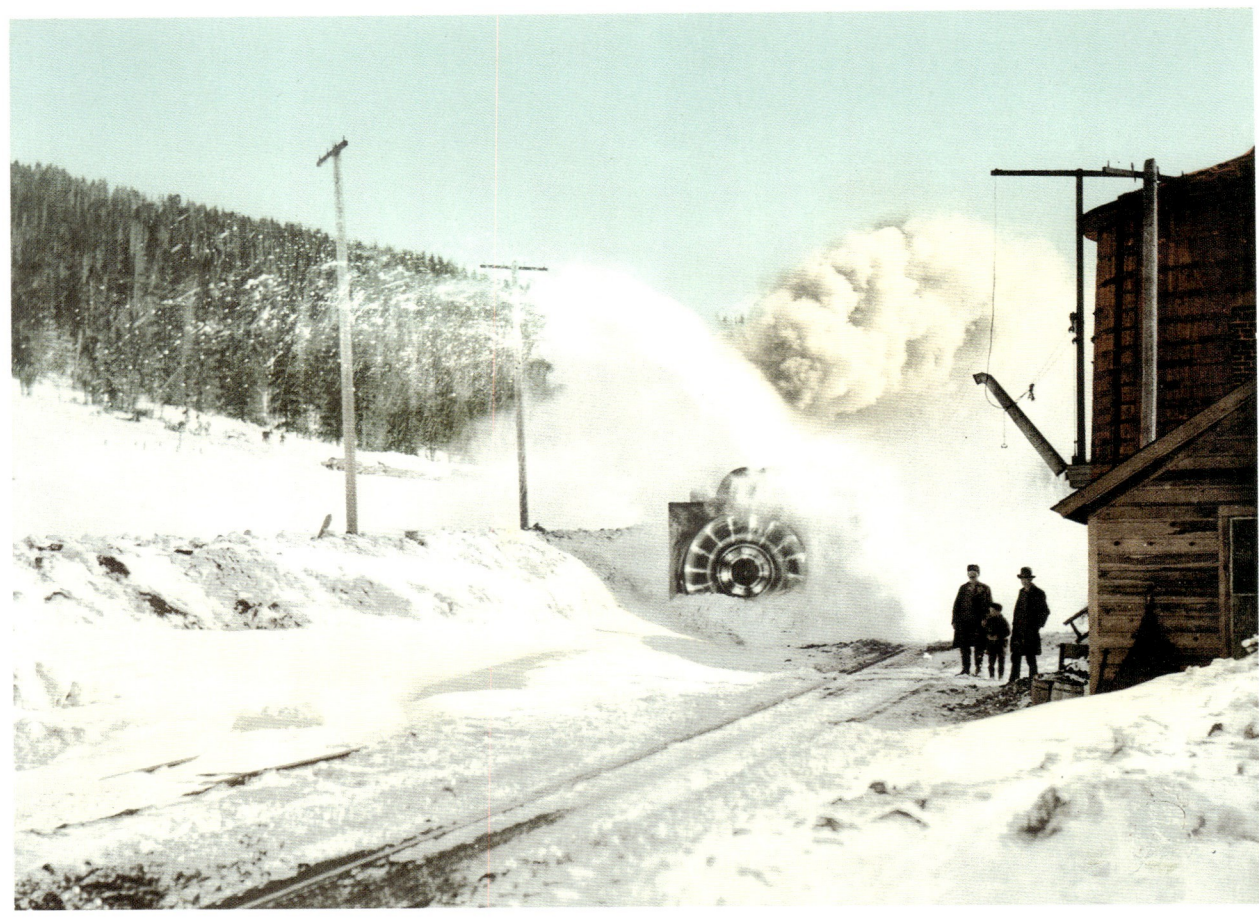

Page 466/467: Snow shed at Hagerman Pass, photochrom
Above: Snow plow on the Midland Railway, Hagerman Pass, photochrom
Below: Hagerman Pass, photochrom
Page 469: Mount Holy Cross fadeout, photochrom

At 11,925 feet (3,625 m) above sea level, Hagerman Pass takes its name from the constructor of the Colorado Midland Railway and linked Colorado Springs to Aspen. It was accessible by a tunnel, opened in 1887; the lines were protected against avalanches by shelters.
This photochrom of Mount of the Holy Cross was made from an original photograph by William Henry Jackson, who took part in the first official ascent of this summit in the Sawatch Range of the Rockies during the survey expedition of F.V. Hayden in 1873.

Seite 466/467: Ein Zug fährt aus einer Schneeschutzhütte am Hagerman-Pass heraus, Photochrom
Oben: Schneepflug auf der Strecke der Midland Railway, Hagerman-Pass, Photochrom
Unten: Hagerman-Pass, Photochrom
Seite 469: Der Berg Holy Cross im Nebel, Photochrom

Der Hagerman-Pass auf 3 625 Metern Höhe – benannt nach dem Erbauer der Colorado Midland Railway – verband Colorado Springs mit Aspen. Er war durch einen 1887 eröffneten Tunnel zu erreichen. Die Gleise waren gegen Lawinen gesichert.
Das Photochrom des Berges Holy Cross wurde nach einem Originalklischee von William Henry Jackson realisiert, der im Rahmen der von F.V. Hayden 1873 geleiteten Expedition an der ersten offiziellen Besteigung dieses Gipfels der Sawatch-Gruppe in den Rocky Mountains teilnahm.

Pages 466/467 : train sortant d'un pare-neige au col de Hagerman, photochrome
En haut : chasse-neige sur la ligne du Midland Railway, col de Hagerman, photochrome
En bas : col de Hagerman, photochrome
Page 469 : le mont Holy Cross dans la brume, photochrome

À 3 625 mètres d'altitude, le col de Hagerman – du nom du constructeur du Colorado Midland Railway – reliait Colorado Springs à Aspen. Il était accessible par un tunnel ouvert en 1887 ; les voies étaient protégées des avalanches par des abris.
Le photochrome du mont Holy Cross a été réalisé d'après un cliché original de William Henry Jackson, qui participa à la première ascension officielle de ce sommet du groupe des Sawatch, dans les Rocheuses, lors de l'expédition de surveillance de F.V. Hayden en 1873.

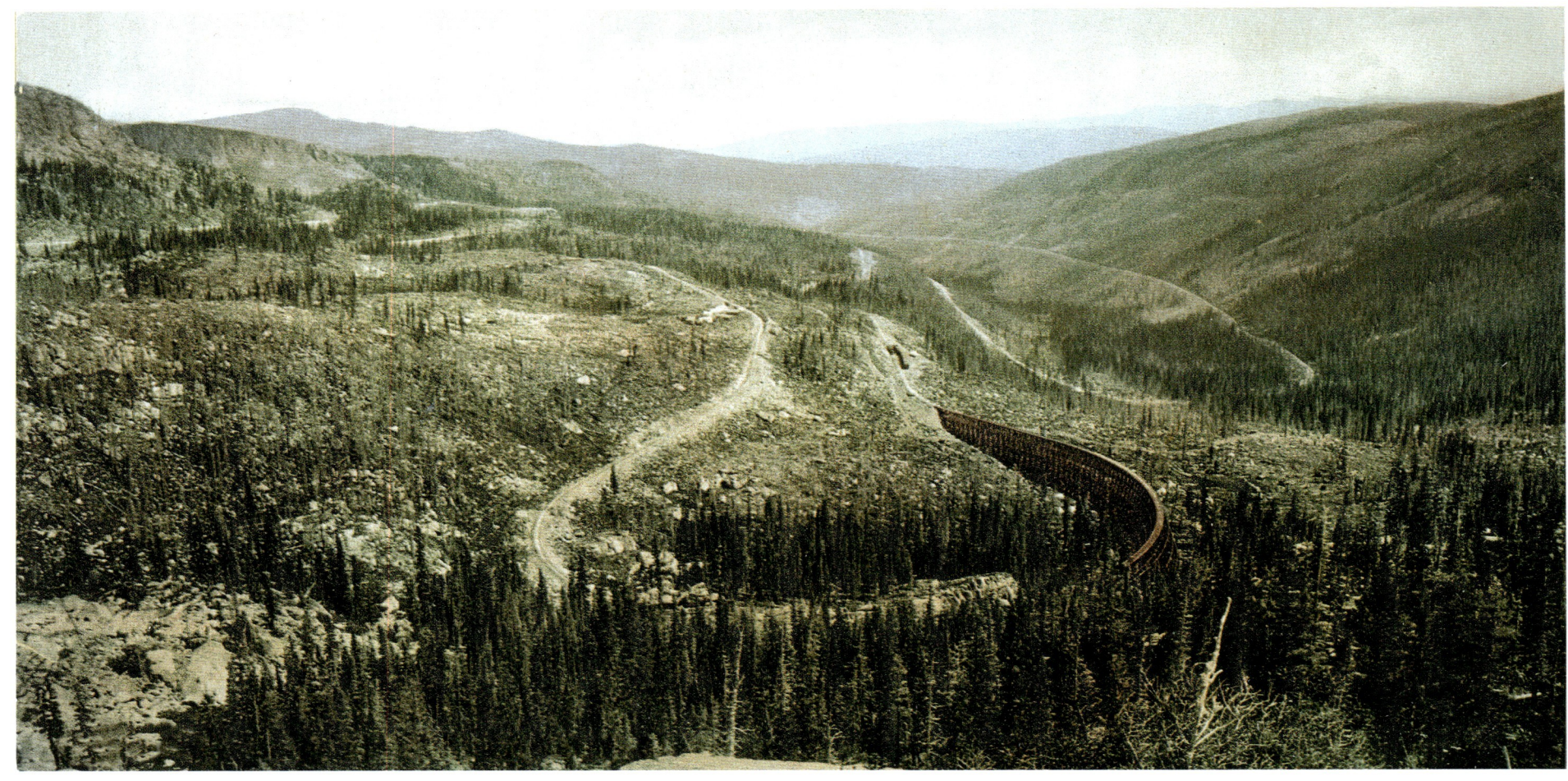

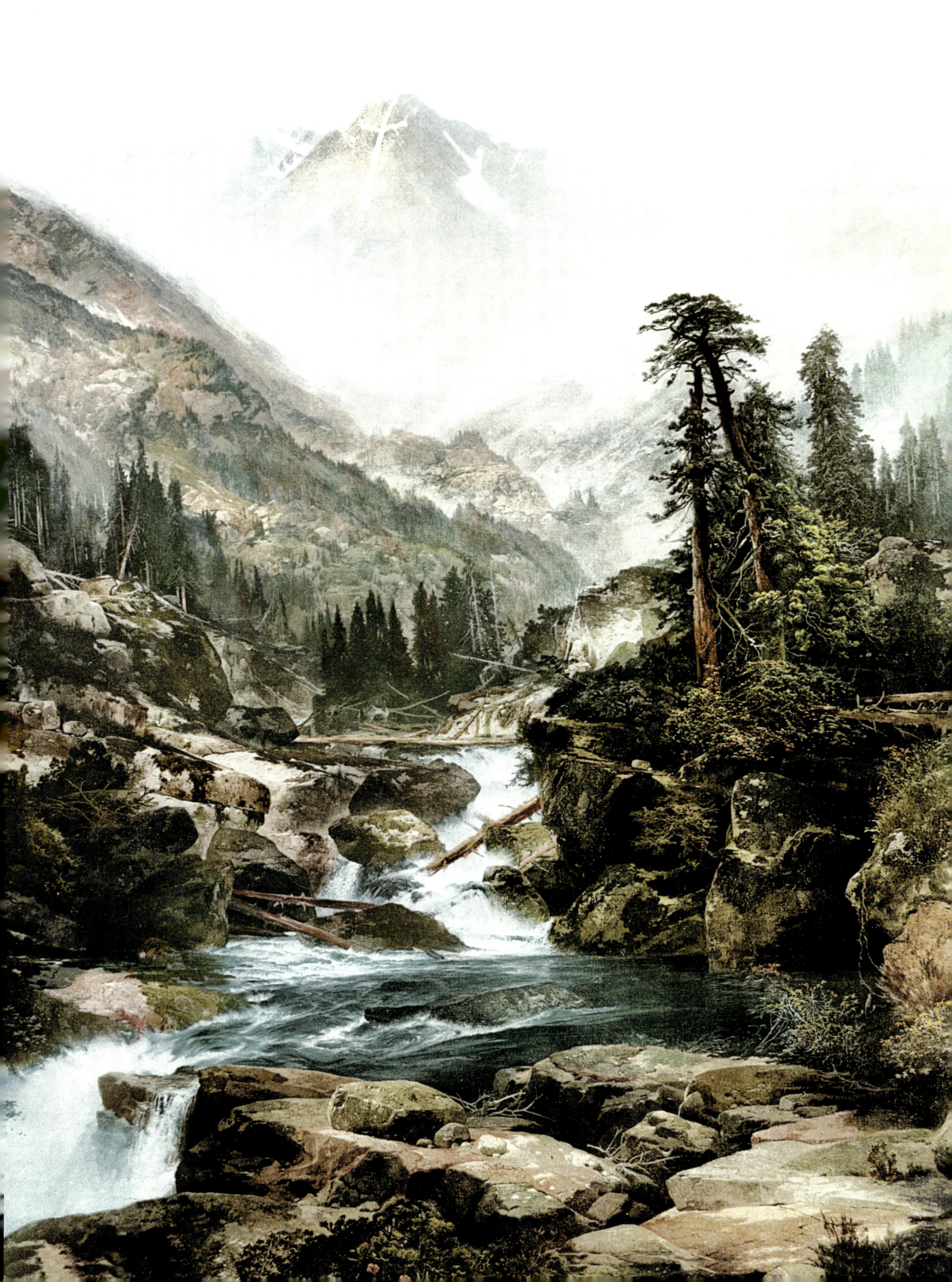

Below: **Eagle River Canyon, mines in the canyon, photochrom**
Page 471, from top to bottom:
**Bathing in the pool, Colorado Hotel, Glenwood Hot Springs
The pool, Colorado Hotel
Colorado Hotel, photochrom**
The Hotel Colorado in Glenwood Hot Springs opened in 1893 and is the work of Edward Lippincott Tilton, who designed it as a replica of the Villa Medici in Rome. The sulphurous hot springs of Glenwood spa were renowned and the luxurious hotel possessed all the amenities of a modern spa: a thermal swimming pool, Turkish baths, and an internal lake in which trout were bred so that guests could catch their own for breakfast. President Theodore Roosevelt was particularly fond of staying at this hotel.

Unten: **Minen im Eagle River Canyon, Photochrom**
Seite 471, von oben nach unten:
**Bad im Swimmingpool des Hotels Colorado, Glenwood Hot Springs
Das Schwimmbad des Hotels Colorado
Das Hotel Colorado, Photochrom**
Das 1893 eröffnete Hotel Colorado in Glenwood Hot Springs ist das Werk von Edward Lippincott Tilton, der es als Replik der Villa Medici in Rom entwarf. Das warme, schwefelhaltige Wasser des Badeortes Glenwood war weithin bekannt, und das äußerst luxuriöse Hotel besaß alle Einrichtungen eines modernen Spas: Thermalbad und Dampfbäder sowie ein Bassin im Inneren, in dem Forellen gehalten wurden, die die Besucher für ihr Frühstück selbst fangen konnten. Präsident Theodore Roosevelt war im Hotel Colorado Stammgast.

En bas : **mines dans le canyon d'Eagle River, photochrome**
Page 471, de haut en bas :
**Baignade dans la piscine de l'hôtel Colorado, Glenwood Hot Springs
La piscine de l'hôtel Colorado
L'hôtel Colorado, photochrome**
L'hôtel Colorado de Glenwood Hot Springs, ouvert en 1893, est l'œuvre d'Edward Lippincott Tilton qui le conçut comme une réplique de la villa Médicis à Rome. Les eaux chaudes sulfureuses de la station de Glenwood étaient réputées et l'hôtel, très luxueux, possédait tous les équipements d'un spa moderne : piscine thermale et bains de vapeur, plus un bassin intérieur où l'on élevait des truites que les clients pouvaient pêcher eux-mêmes pour leur petit déjeuner. Le président Theodore Roosevelt fut un habitué de l'hôtel Colorado.

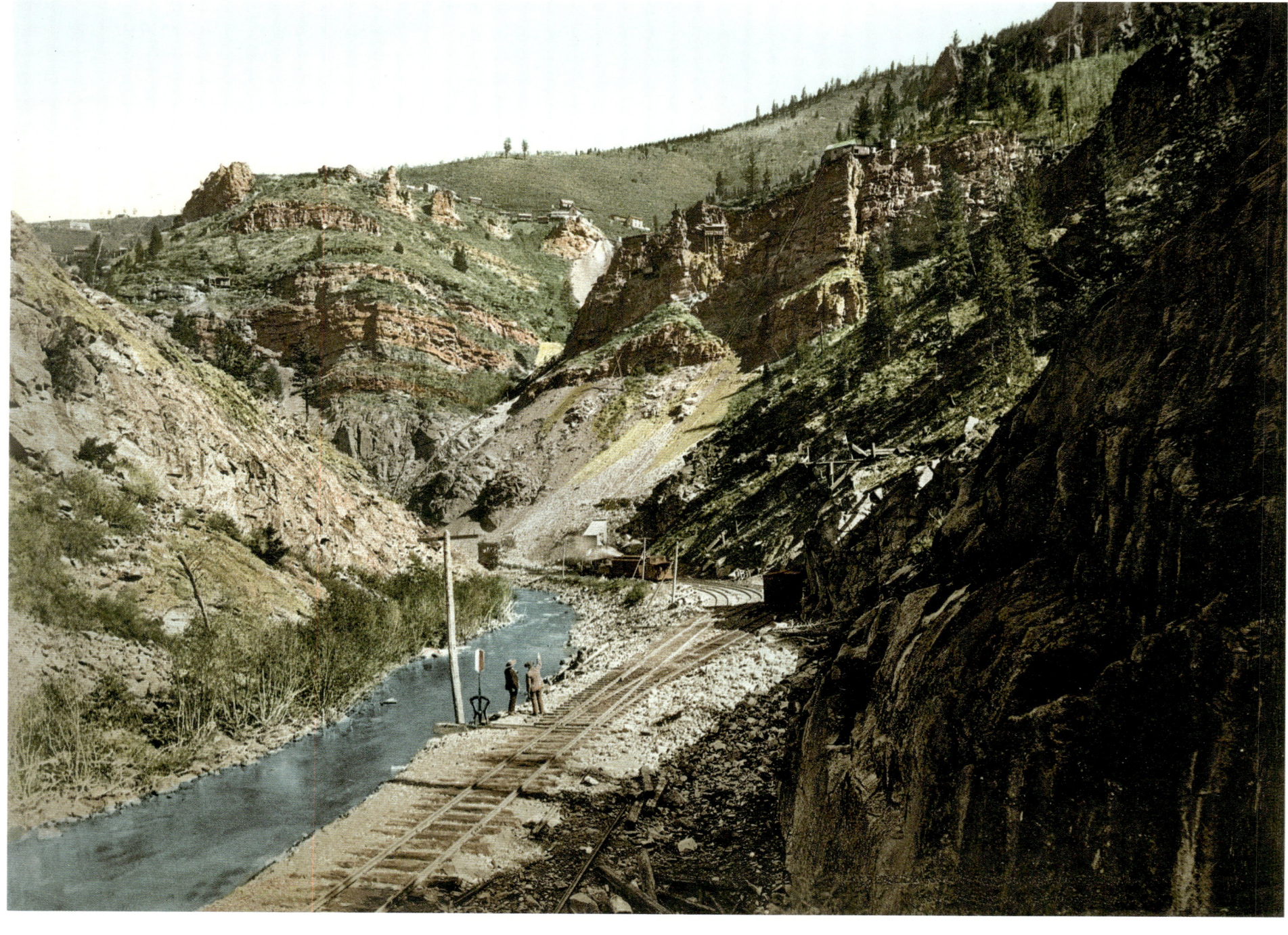

6752. BATHING IN THE POOL, GLENWOOD SPRINGS, COLORADO.

13827 THE POOL, GLENWOOD SPRINGS, COLO

COLORADO | GLENWOOD HOT SPRINGS

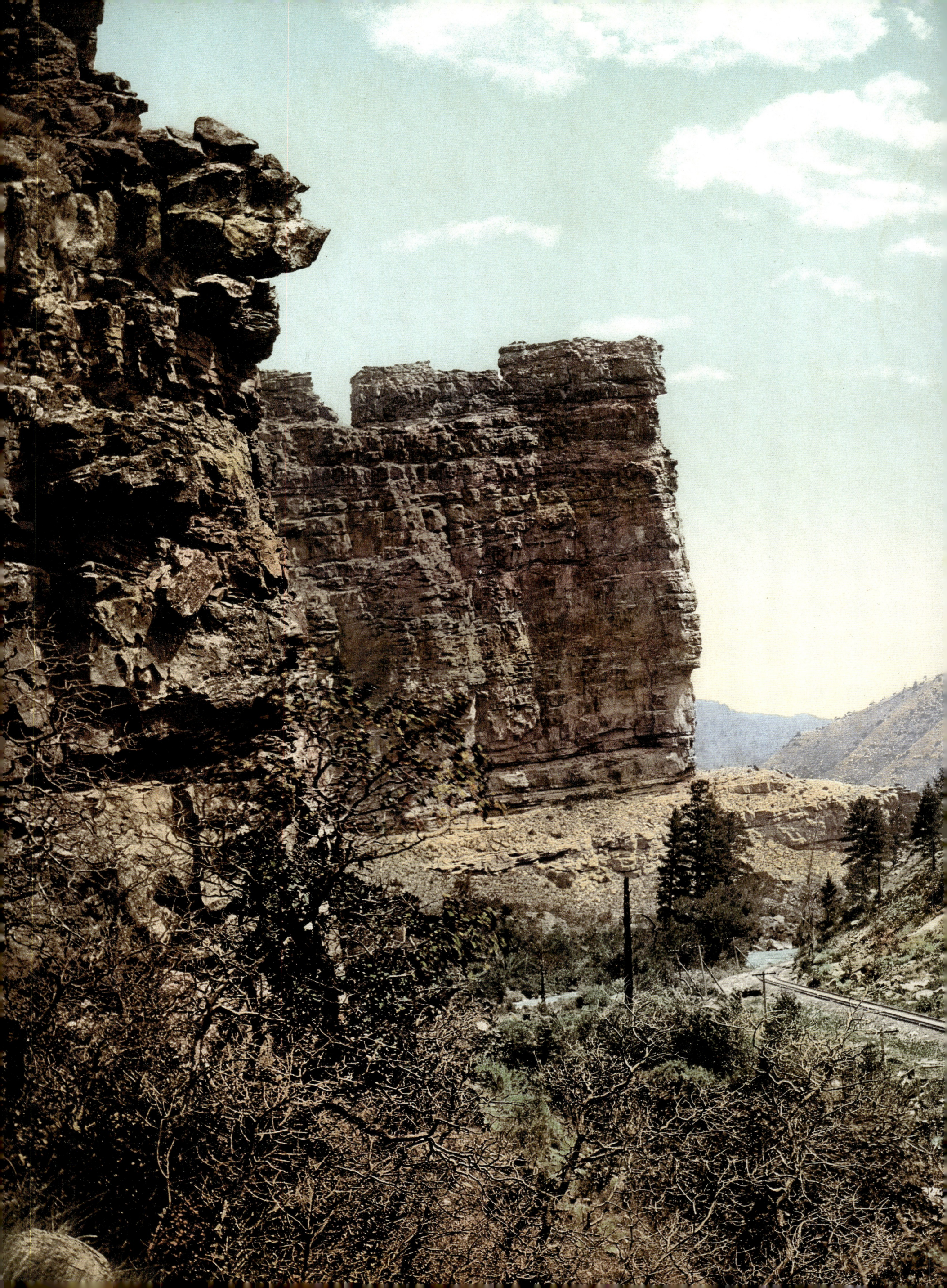

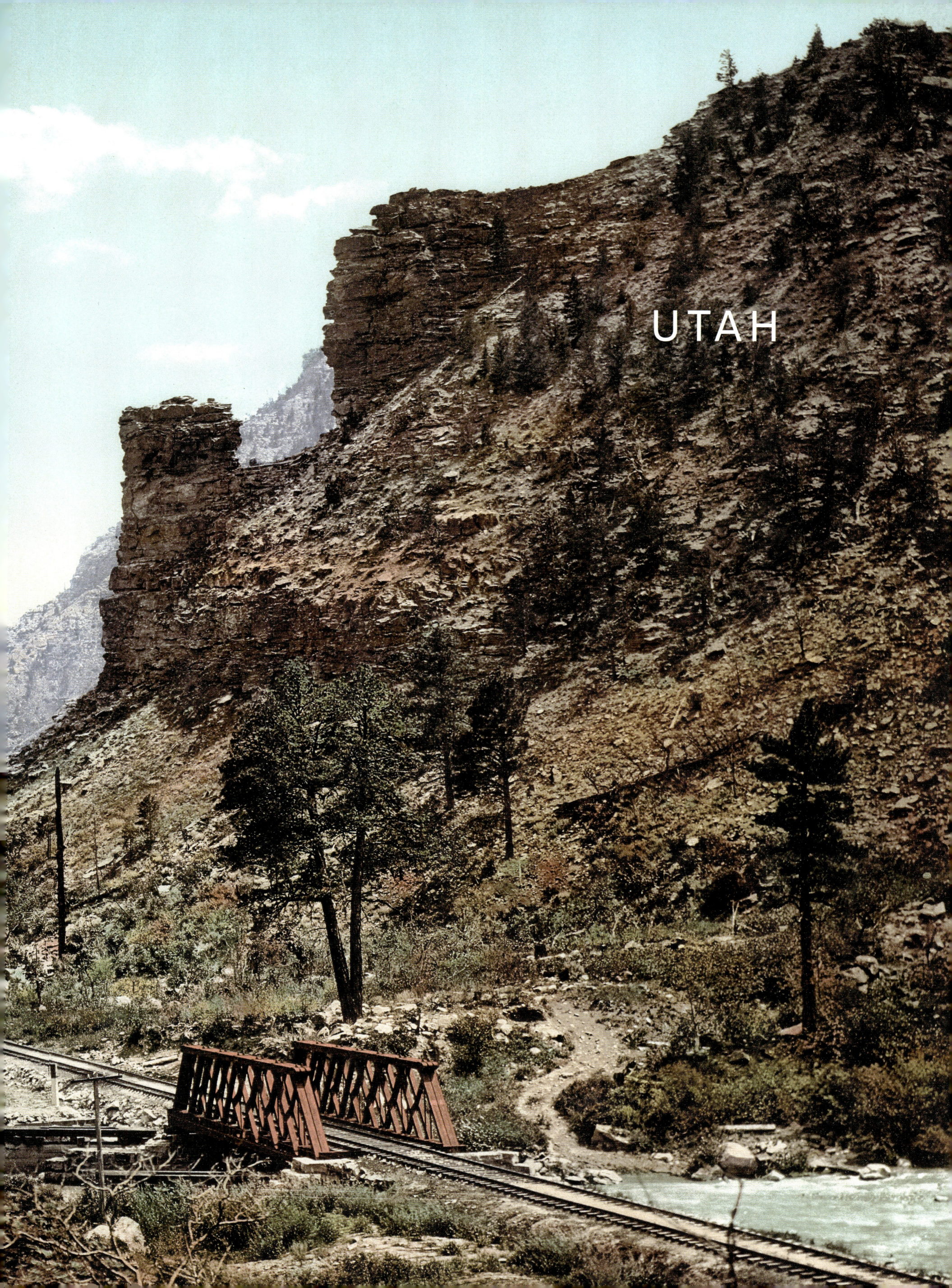
UTAH

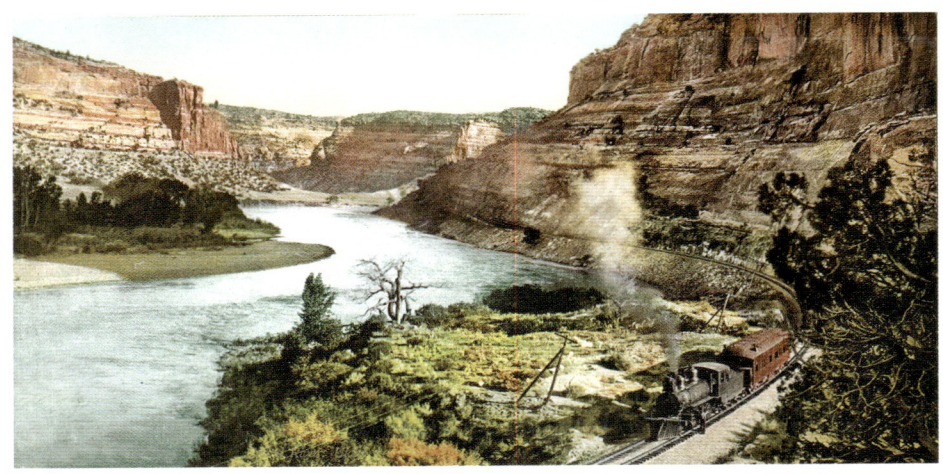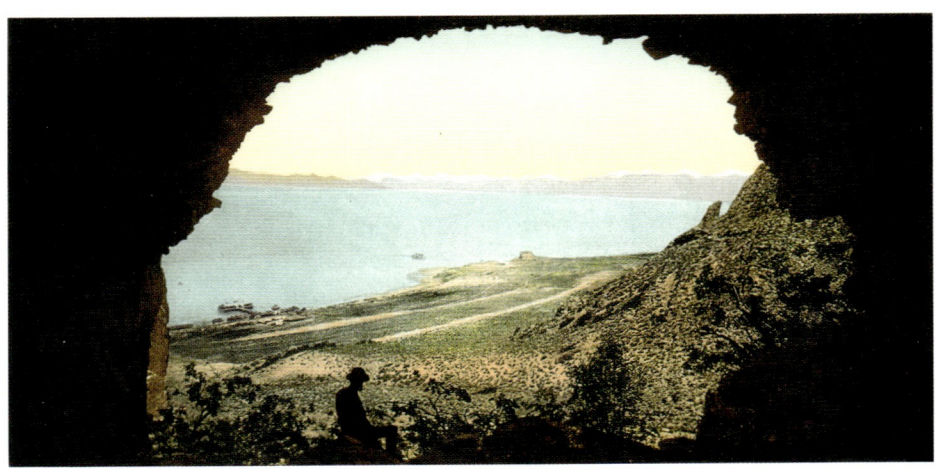

474 UTAH | GRAND RIVER CANYON | GARFIELD | LITTLE COTTONWOOD CANYON

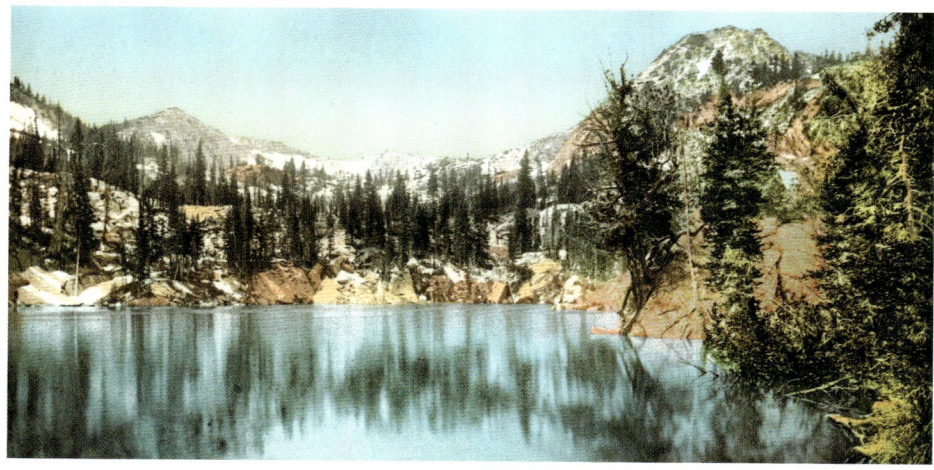

Page 472/473: Price Canyon, Castle Gate, photochrom
Page 474, from left to right and top to bottom:
Grand River Canyon, Ruby Castle, photochrom
Great Salt Lake near Garfield, photochrom
Little Cottonwood Canyon, photochrom
Above left: Big Cottonwood Canyon, Twin Lake, photochrom
Above right: Weber Canyon, Witch Rocks, photochrom
Below: Little Cottonwood Canyon, Temple Quarry, photochrom

Seite 472/473: Price Canyon, Castle Gate, Photochrom
Seite 474, von links nach rechts und von oben nach unten:
Grand River Canyon, Ruby Castle, Photochrom
Great Salt Lake bei Garfield, Photochrom
Little Cottonwood Canyon, Photochrom
Oben links: Big Cottonwood Canyon, Twin Lake, Photochrom
Oben rechts: Weber Canyon, Witch Rocks (Hexenfelsen), Photochrom
Unten: Little Cottonwood Canyon, Temple Quarry, Photochrom

Pages 472/473 : Price Canyon, Castle Gate, photochrome
Page 474, de gauche à droite et de haut en bas :
Grand River Canyon, Ruby Castle, photochrome
Le Grand Lac Salé près de Garfield, photochrome
Little Cottonwood Canyon, photochrome
En haut à gauche : Big Cottonwood Canyon, Twin Lake, photochrome
En haut à droite : Weber Canyon, Witch Rocks (les Rochers de la sorcière), photochrome
En bas : Little Cottonwood Canyon, Temple Quarry, photochrome

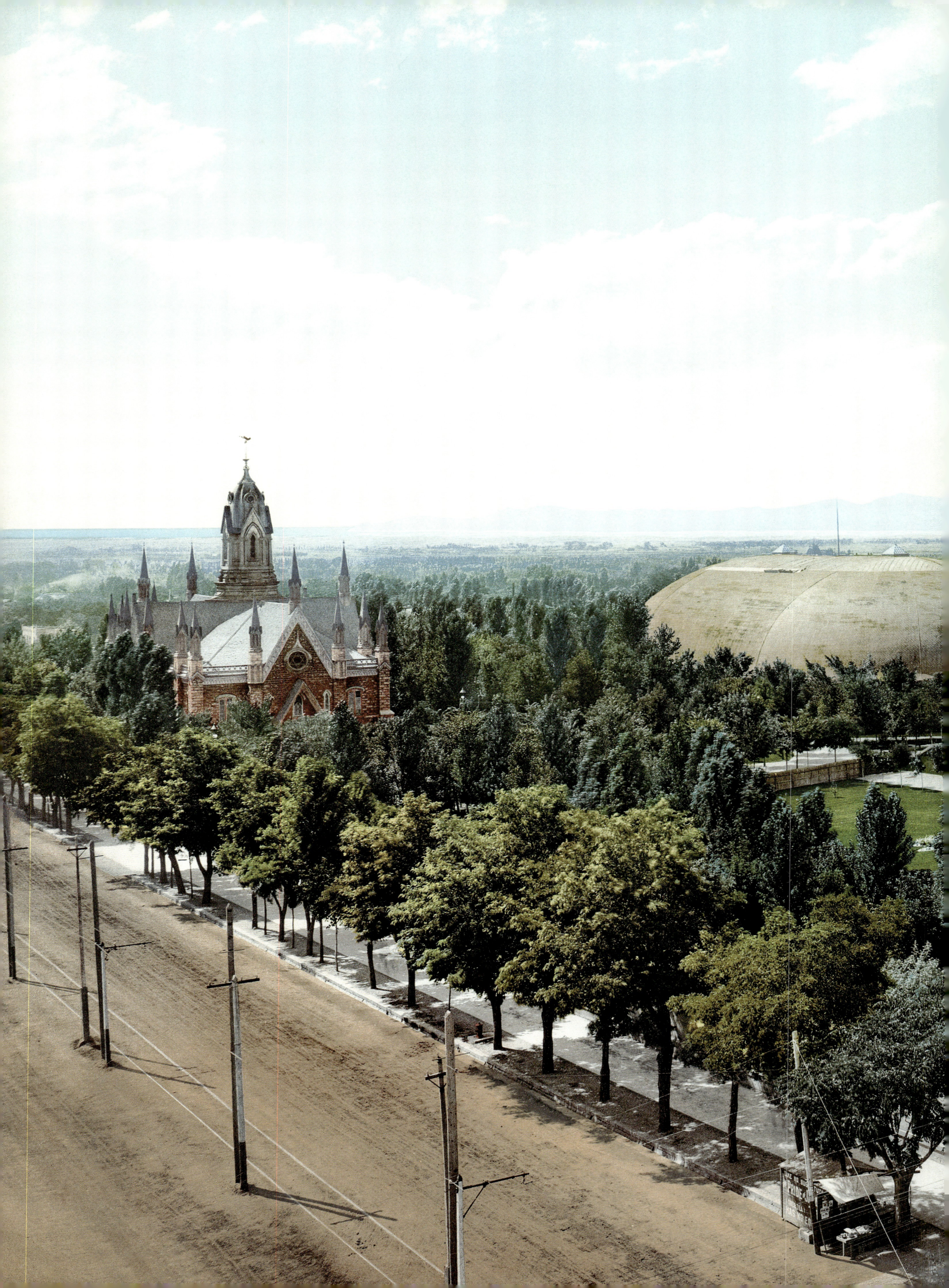

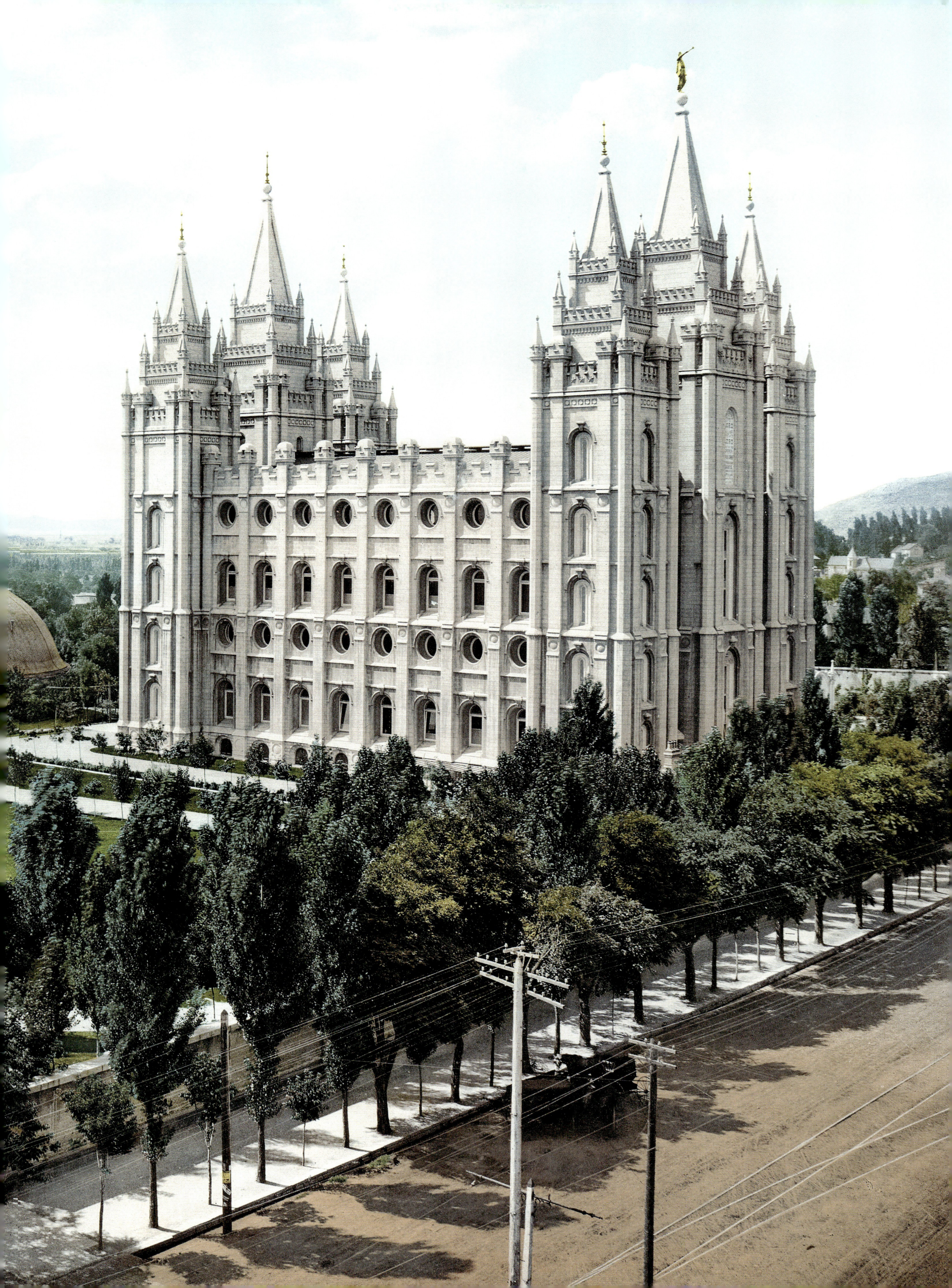

Page 476/477: Salt Lake City, Temple Square, photochrom
Left: Grave of Brigham Young, photochrom
Below: Eagle's Gate, photochrome
Page 479:
Top: The Lion House and Temple, photochrom
Bottom: Old Tithing House, photochrom

Seite 476/477: Salt Lake City Temple Square (Platz), Photochrom
Links: Grabstätte von Brigham Young, Photochrom
Unten: Eagle's Gate (Adlertor), Photochrom
Seite 479:
Oben: Lion House (Löwenhaus) und Tempel, Photochrom
Unten: Old Tithing House (Altes Zehnthaus), Photochrom

Pages 476/477 : Salt Lake City, place du Temple, photochrome
À gauche : tombeau de Brigham Young, photochrome
En bas : Eagle's Gate (la porte de l'Aigle), photochrome
Page 479 :
En haut : Lion House (la maison du Lion) et le temple, photochrome
En bas : Tithing House (la maison de la dîme), photochrome

UTAH | SALT LAKE CITY

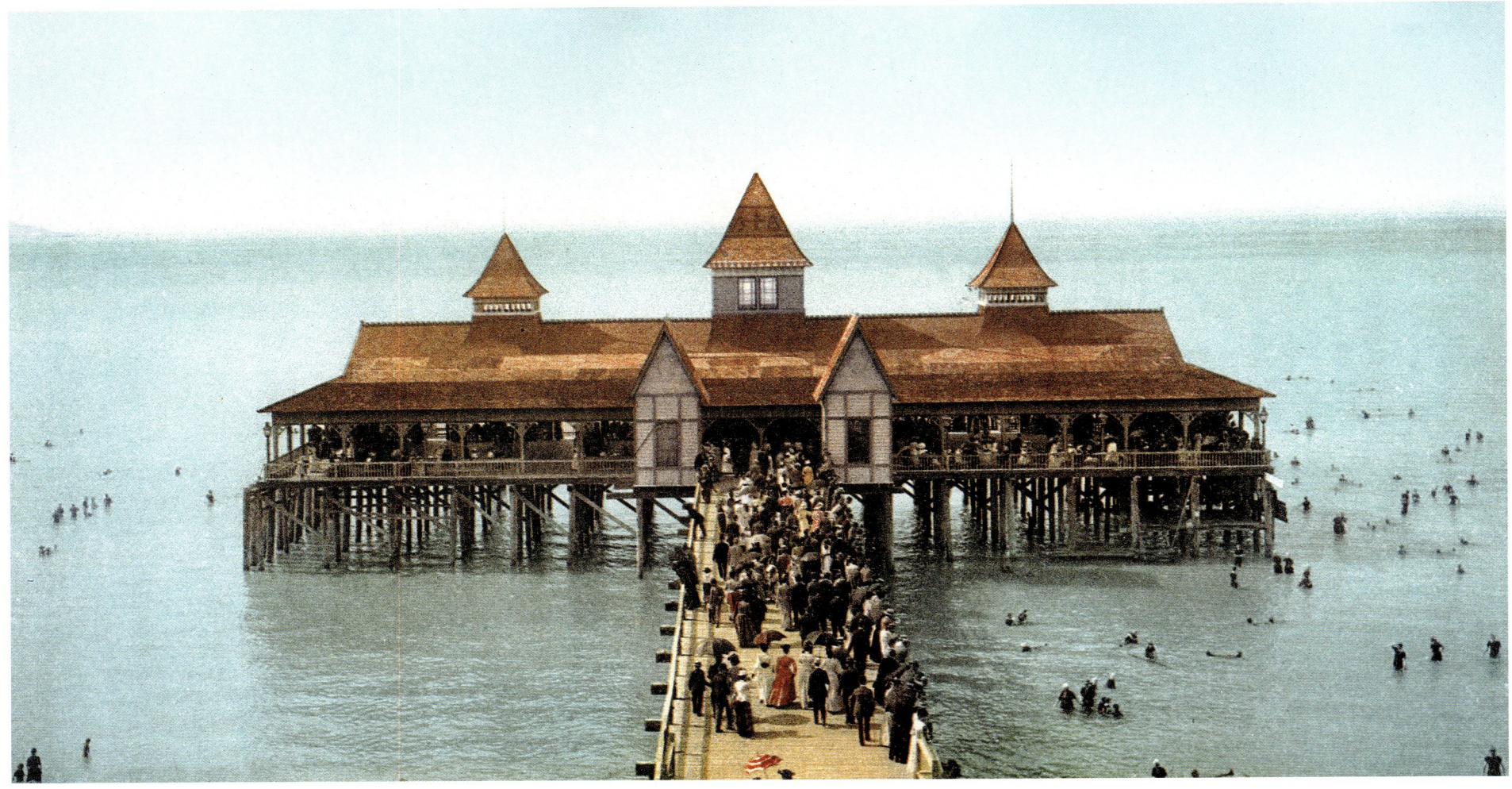

Above: Garfield Bathing Pavilion, Great Salt Lake, photochrom
Left: Bathing at Saltair
Below: Arriving at Saltair Beach, Great Salt Lake
Page 481:
Top: The great salt beds, Salduro
Bottom: Saltair Pavilion, photochrom

The earliest pioneers to settle in Salt Lake Valley were Mormons, led by Brigham Young, president of the Quorum of the Twelve Apostles. The city was founded on July 24, 1847, and the construction of the temple, which began in 1853, lasted 40 years. Until the arrival of the railroad in 1869, the blocks of quartz from Little Cottonwood Canyon, 20 miles (32 km) away, had to be transported one by one on ox carts.

Oben: Badepavillon von Garfield, Great Salt Lake, Photochrom
Links: Baden in Saltair
Unten: Ankunft am Strand von Saltair, Great Salt Lake
Seite 481:
Oben: Die großen Salzfelder, Salduro
Unten: Der Pavillon von Saltair, Photochrom

Die ersten Pioniere, die sich im Salt Lake Valley niederließen, waren Mormonen unter Führung von Brigham Young, dem Präsidenten des Kollegiums der Zwölf Apostel. Die Stadt wurde am 24. Juli 1847 gegründet, und der Bau des Tempels, mit dem man 1853 begann, zog sich über 40 Jahre hin. Bis zum Anschluss an das Eisenbahnnetz im Jahr 1869 mussten die Quarzblöcke aus dem 32 Kilometer entfernten Little Cottonwood Canyon auf Ochsenkarren einzeln herantransportiert werden.

En haut : le pavillon des bains de Garfield, photochrome
À gauche : baignade à Saltair
En bas : arrivée à la plage de Saltair, Grand Lac Salé
Page 481 :
En haut : les grandes salines, Salduro
En bas : le pavillon de Saltair, photochrome

Les premiers pionniers qui s'installèrent dans la vallée de Salt Lake étaient des Mormons, menés par Brigham Young, président du Collège des douze apôtres. La ville fut fondée le 24 juillet 1847 et la construction du temple, commencée en 1853, dura quarante ans. Jusqu'à l'arrivée du chemin de fer (1869), les blocs de quartz provenant du canyon de Little Cottonwood, à 32 kilomètres de là, durent être transportés un par un sur des chariots tirés par des bœufs.

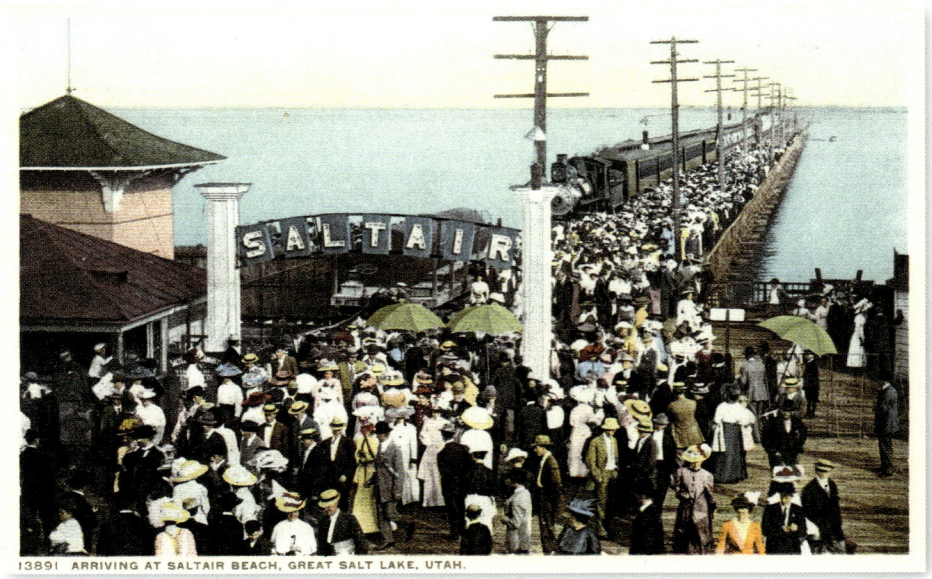

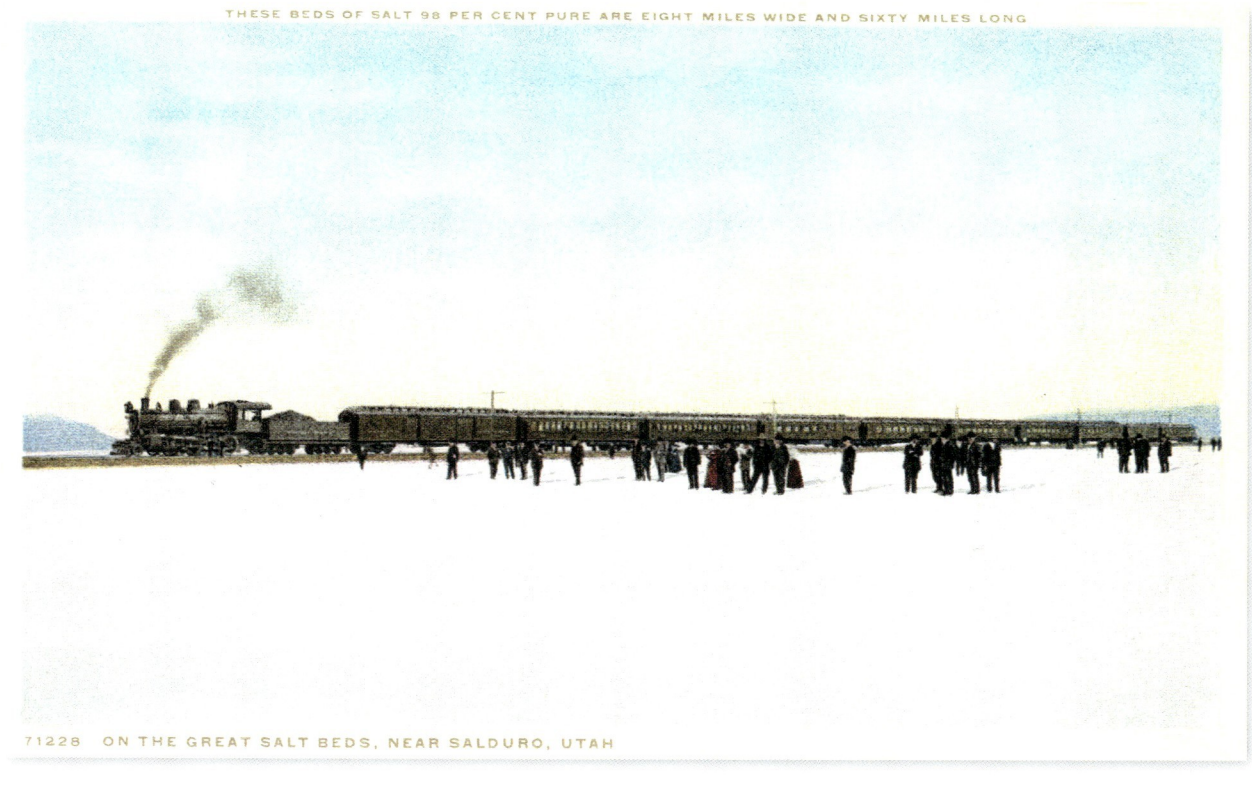

71228 ON THE GREAT SALT BEDS, NEAR SALDURO, UTAH

THESE BEDS OF SALT 98 PER CENT PURE ARE EIGHT MILES WIDE AND SIXTY MILES LONG

UTAH | GREAT SALT LAKE

481

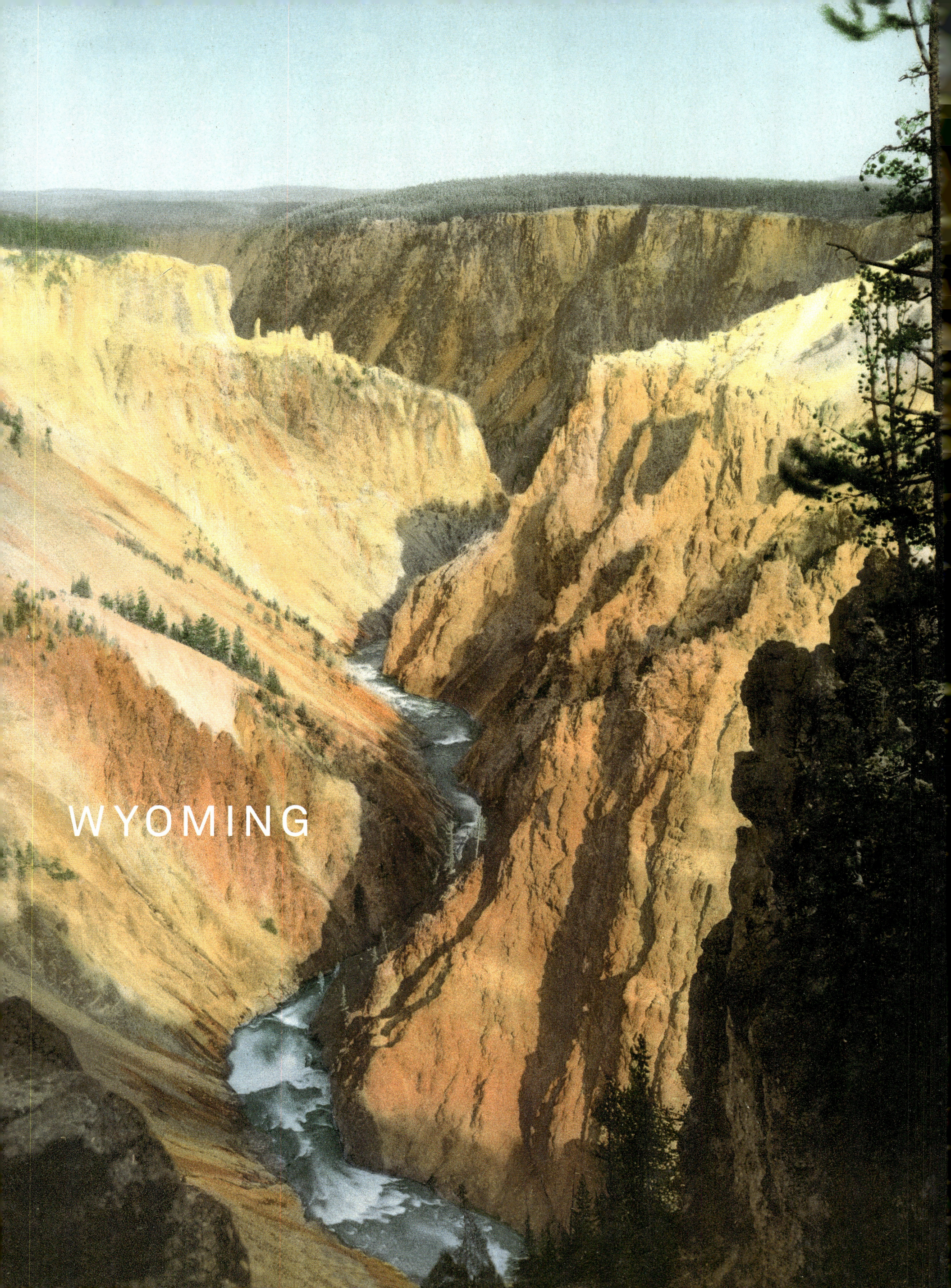

Page 482: Canyon of the Yellowstone, Inspiration Point, photochrom
Right: Yellowstone National Park, Golden Gate, photochrom
Below: Yellowstone National Park, Silver Gate and the Hoodoos, photochrom

Seite 482: Canyon des Yellowstone River, Inspiration Point, Photochrom
Rechts: Yellowstone National Park, Golden Gate, Photochrom
Unten: Yellowstone National Park, Silver Gate und Hoodoos (Felspfeiler), Photochrom

Page 482 : canyon de la rivière Yellowstone, Inspiration Point, photochrome
À droite : parc national de Yellowstone, Golden Gate, photochrome
En bas : parc national de Yellowstone, la Porte d'argent et les *hoodoos*, photochrome

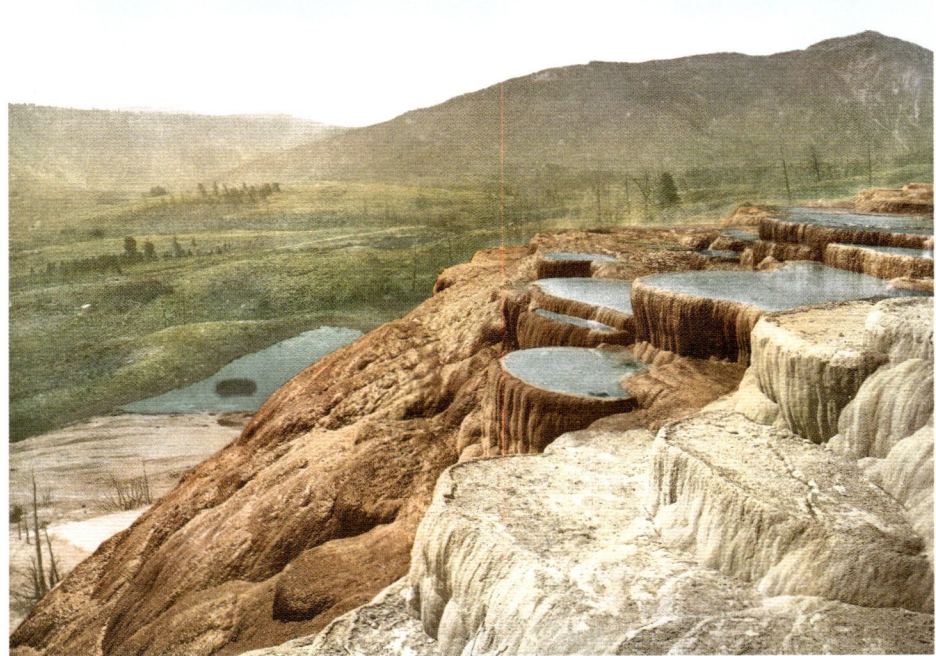

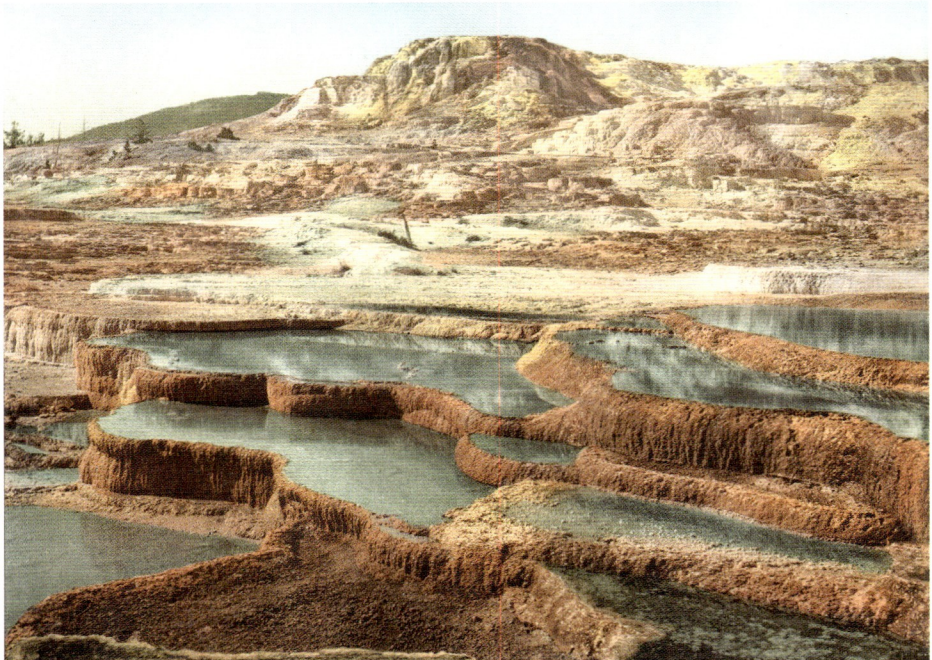

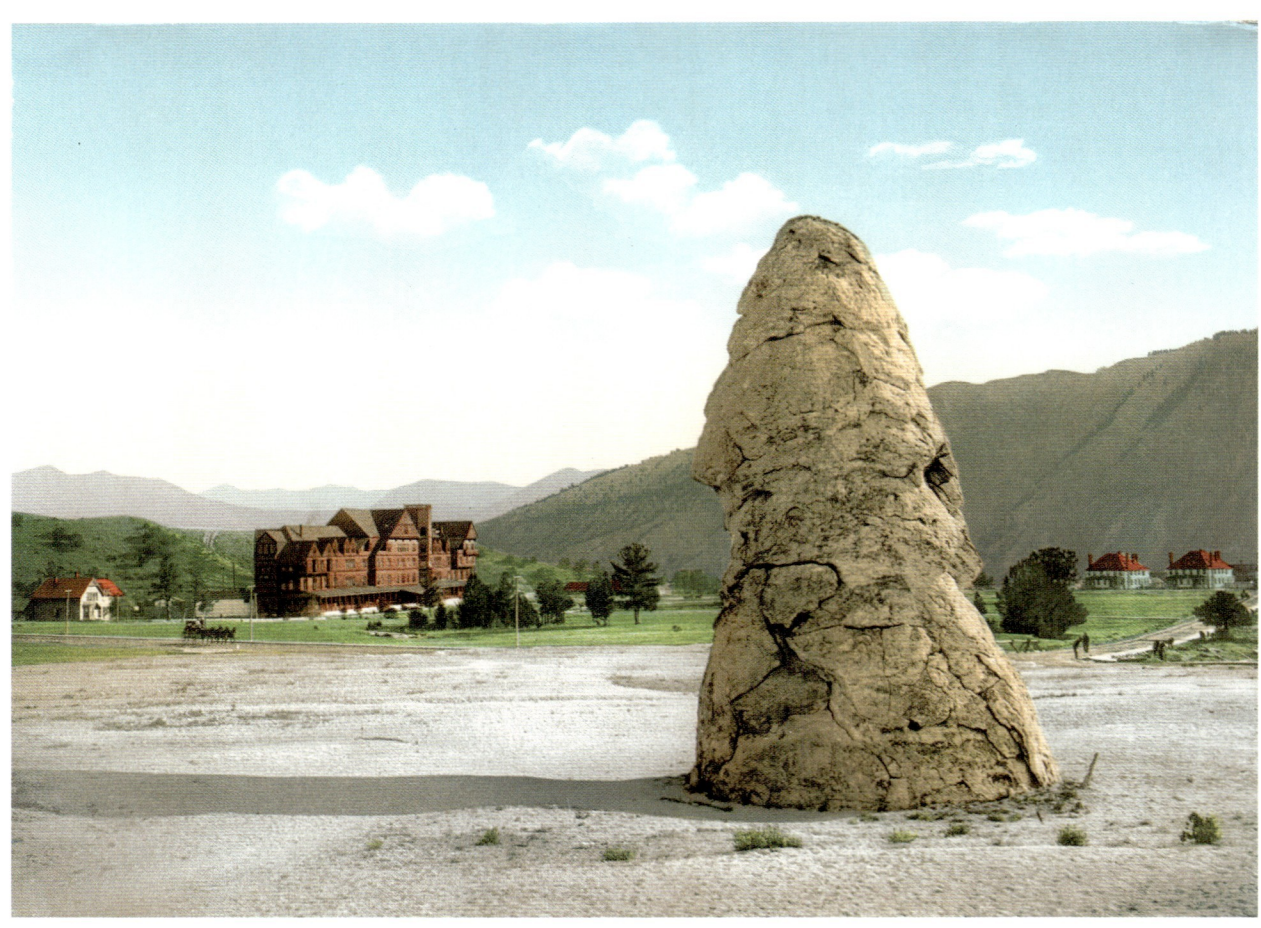

From top to bottom:
Pulpit Terraces, photochrom
Jupiter and Minerva Terrace, photochrom
Yellowstone Mammoth Hot Springs Hotel, photochrom
Page 485: **Mammoth Hot Springs Hotel from Jupiter Terrace, photochrom**

"If only we could photograph this in its true colors": these were the words of William Henry Jackson when he saw Mammoth Hot Springs for the first time in 1872. His wish was fulfilled 20 years later, when he instructed the DPC colorists on how to tint his Yellowstone negatives using the Photochrom process.

Von oben nach unten:
Die Terrassen von Pulpit, Photochrom
Die Jupiter-und-Minerva-Terrasse, Photochrom
Das Hotel Yellowstone Mammoth Hot Springs, Photochrom
Seite 485: **Das Hotel Mammoth Hot Springs von der Jupiter-Terrasse aus, Photochrom**

„Ach, wenn wir das nur in den echten Farben fotografieren könnten", so William Henry Jackson, als er an einem Tag im Jahr 1872 zum ersten Mal die Quellen von Mammoth Hot Springs sah. 20 Jahre später wurde Jacksons Wunsch Wirklichkeit, als er die Retuscheure der DPC bei der Kolorierung seiner Negative von Yellowstone im Photochrom-Verfahren anleitete.

De haut en bas :
Les terrasses de Pulpit, photochrome
La terrasse de Jupiter et Minerve, photochrome
L'hôtel Yellowstone Mammoth Hot Springs, photochrome
Page 485 : **l'hôtel Mammoth Hot Springs depuis la terrasse de Jupiter, photochrome**

« Si seulement nous pouvions photographier cela en couleurs... » : tels sont les mots qui vinrent aux lèvres de William Henry Jackson en voyant pour la première fois les sources de Mammoth Hot Springs, un jour de 1872. Le souhait de Jackson sera exaucé vingt ans plus tard, lorsqu'il guidera les chromistes de la DPC lors de la mise en couleurs de ses négatifs de Yellowstone selon le procédé *Photochrom*.

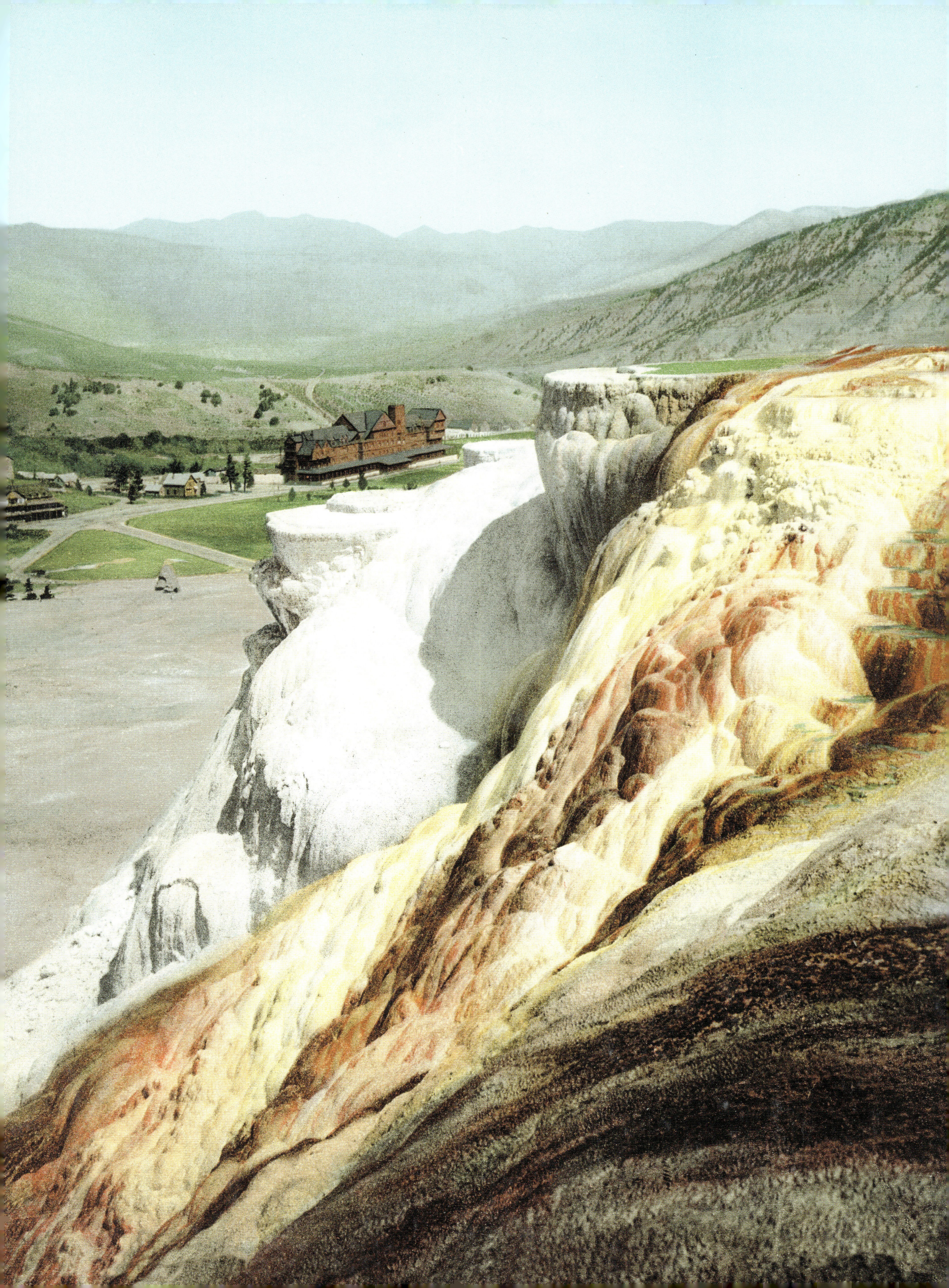

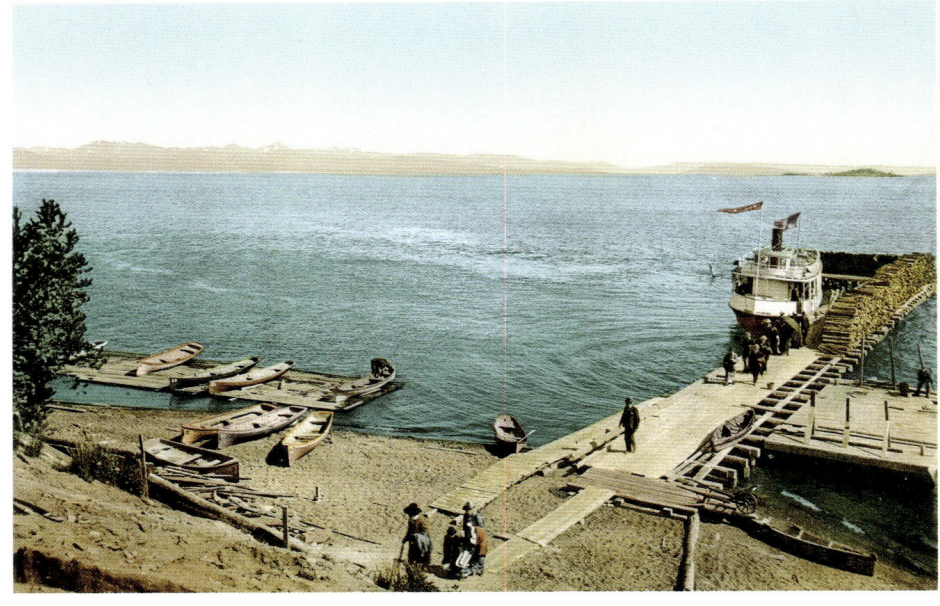
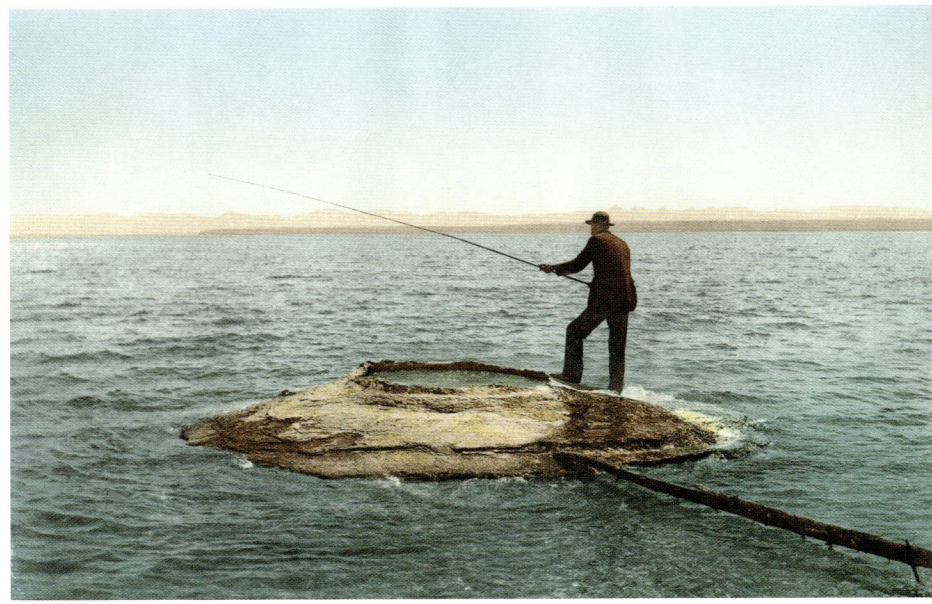
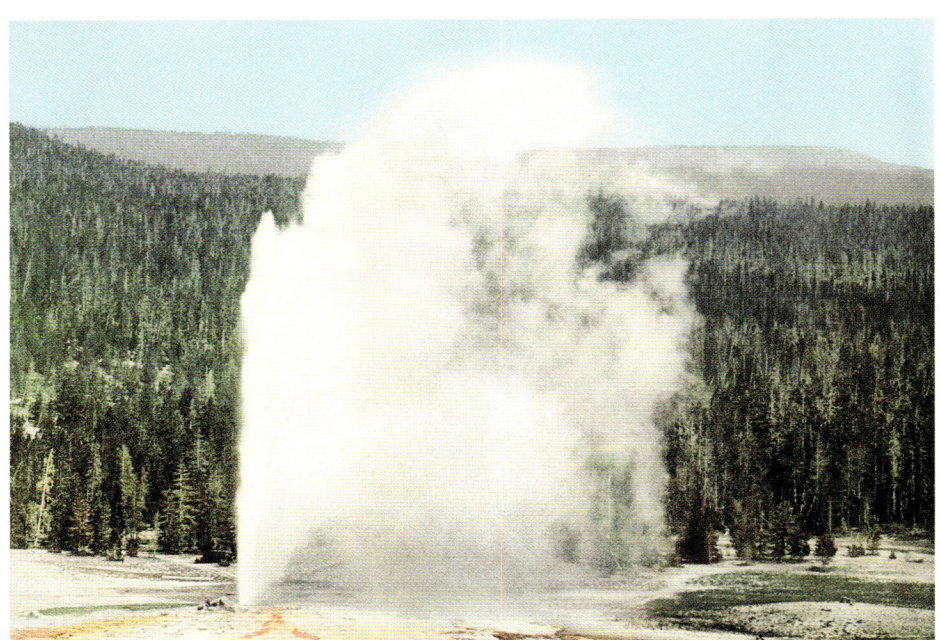
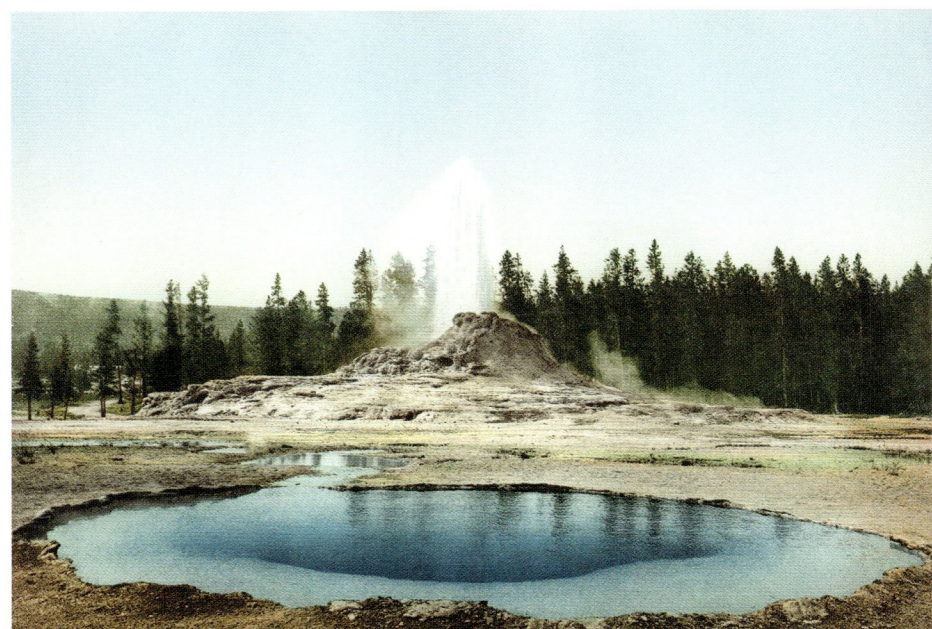
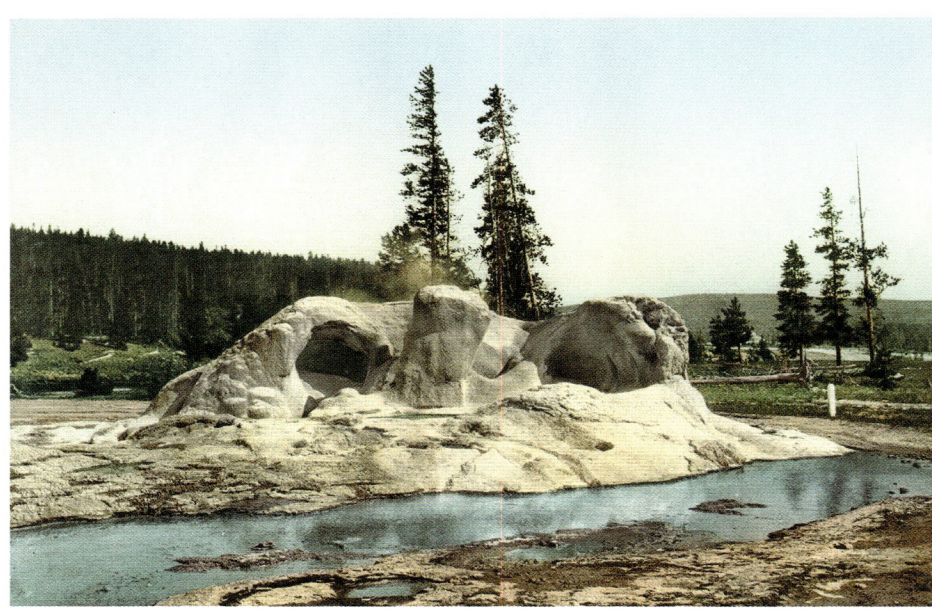
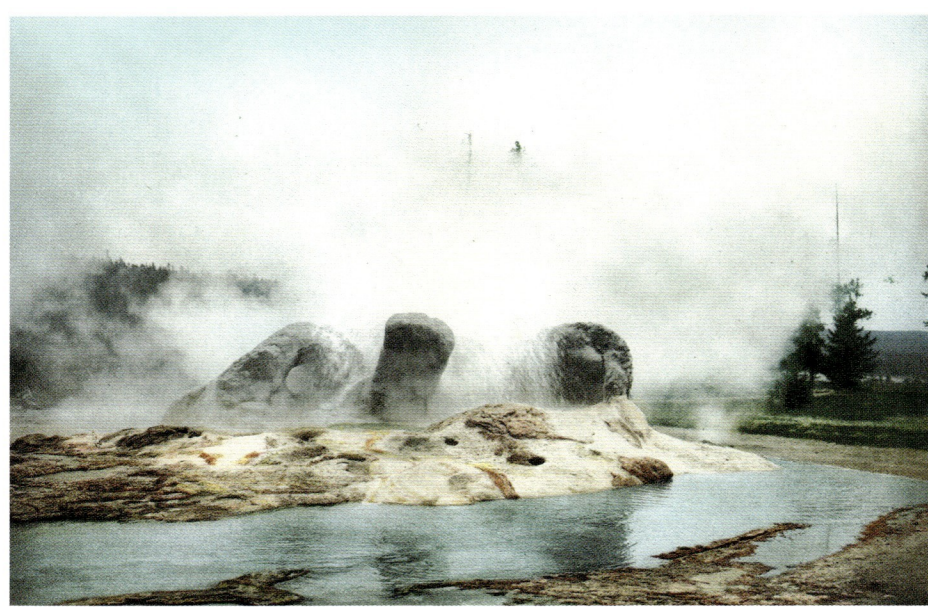
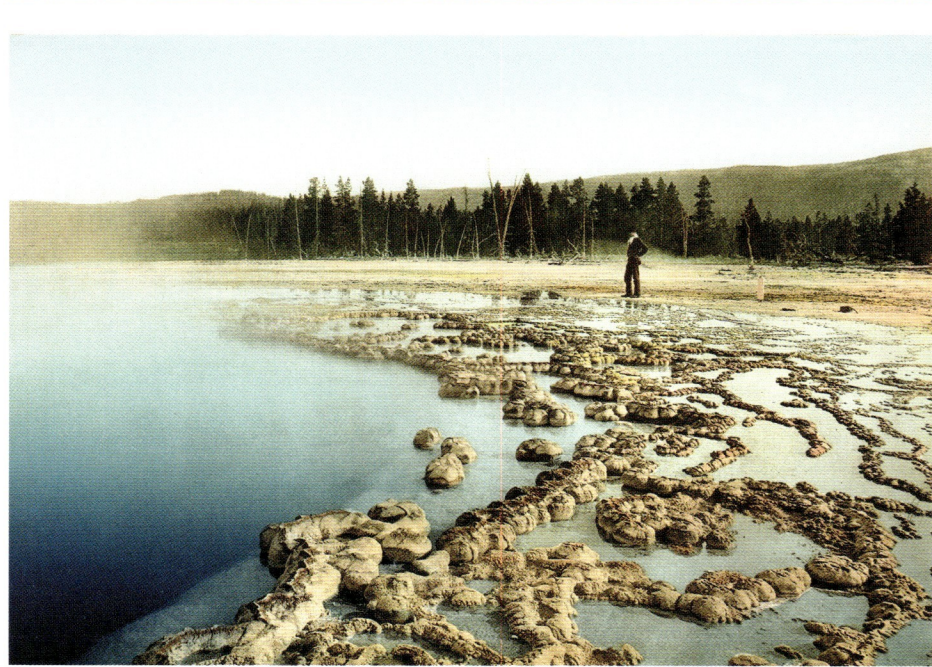
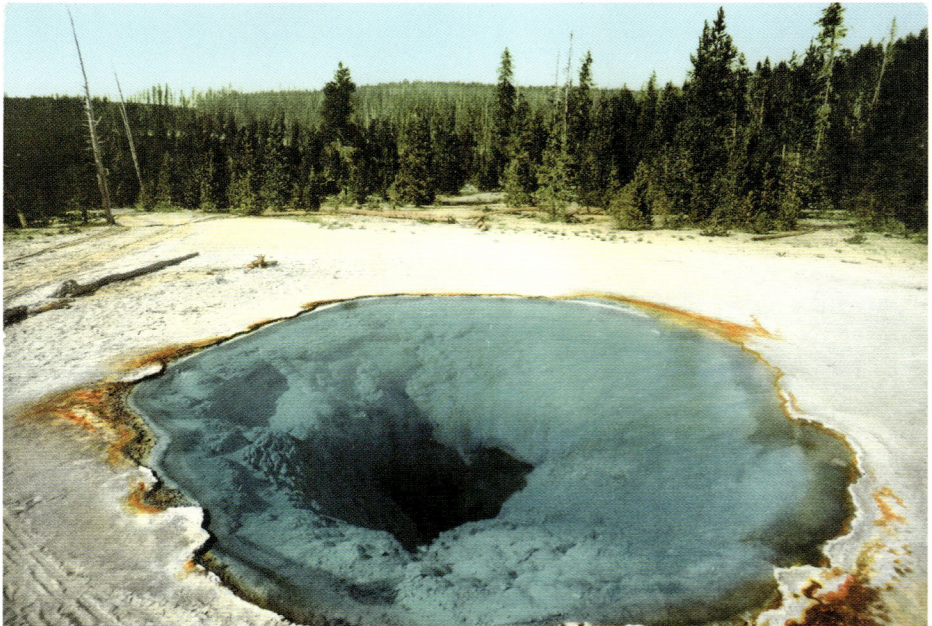

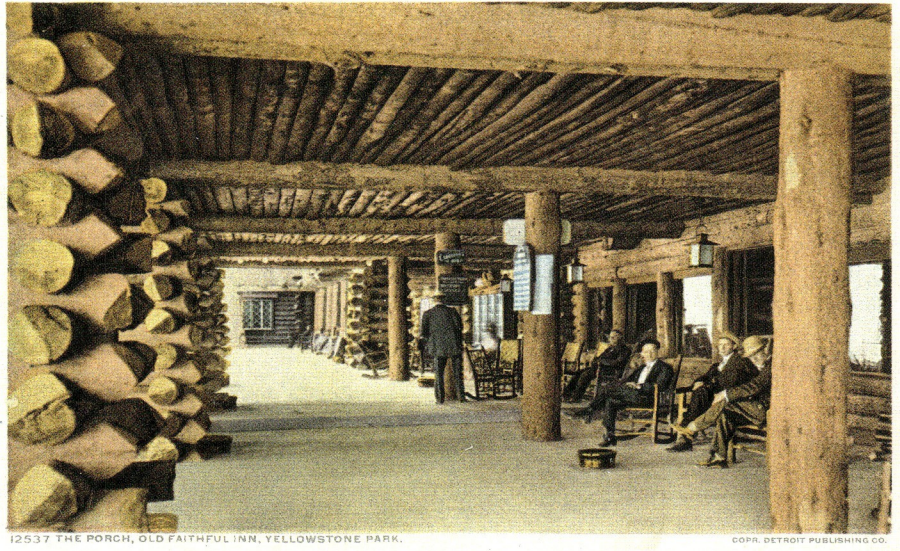
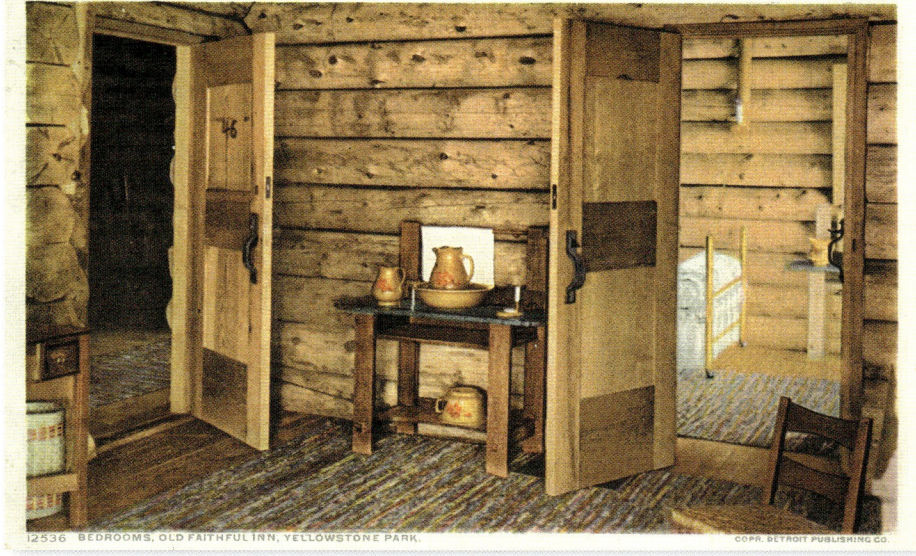
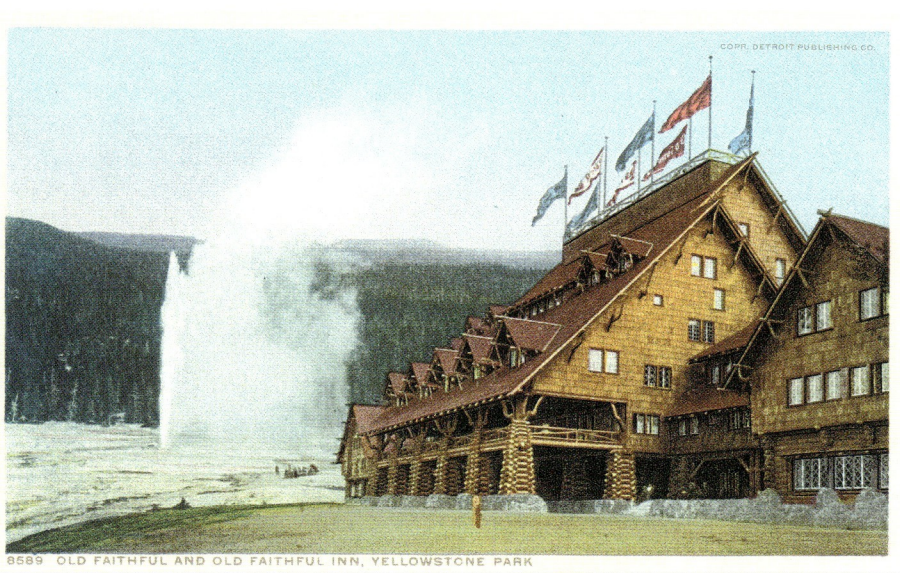

Top left: **The porch of Old Faithful Inn**
Top right: **Bedrooms at Old Faithful Inn**
Left: **Old Faithful and Old Faithful Inn**
Bottom: **The lobby of Old Faithful Inn**

Harry W. Child, one of the administrators of Yellowstone National Park, entrusted the construction of Old Faithful Inn to the young architect Robert Reamer. The goal was to offer the park's clientele first-class accommodations onsite in a building both typical of the region and modern. Electrically lit, designed in the rustic "parkitecture" style and built in lodgepole pine, the building's central support was an enormous dressed-stone chimney in the center of the hall. The hotel opened in the summer of 1904.

Oben links: **Eingangsbereich des Hotels Old Faithful Inn**
Oben rechts: **Hotelzimmer im Old Faithful Inn**
Links: **Der Geysir Old Faithful und das Hotel Old Faithful Inn**
Unten: **Empfangshalle im Old Faithful Inn**

Harry W. Child, einer der Verwalter des Yellowstone-Nationalparks, betraute 1902 den jungen Architekten Robert Reamer mit dem Bau des Hotels Old Faithful Inn. Den Besuchern des Parks sollte damit vor Ort eine erstklassige und gleichermaßen typische wie moderne Unterkunft geboten werden. Das Hotel, das im Sommer 1904 eröffnet wurde, war im rustikalen „Parkitecture"-Stil aus heimischer Drehkiefer erbaut worden und verfügte über einen riesigen steinernen Kamin, der inmitten der Lobby stand, sowie über elektrisches Licht.

En haut à gauche : **le porche de l'hôtel Old Faithful Inn**
En haut à droite : **chambres de l'hôtel Old Faithful Inn**
À gauche : **le geyser et l'hôtel Old Faithful Inn**
En bas : **le hall de l'hôtel Old Faithful Inn**

La réalisation de l'hôtel Old Faithful Inn a été confiée, en 1902, par l'un des administrateurs du parc national de Yellowstone, Harry W. Child, au jeune architecte Robert Reamer. Le but était d'offrir à la clientèle du parc, sur place, un hébergement de première classe à la fois typique et moderne. De style rustique « Parkitecture », bâti en pin tordu local (*lodgepole pine*) et soutenu par une énorme cheminée en pierre dressée au centre du hall, éclairé à l'électricité, l'hôtel ouvrit à l'été 1904.

Page 486, from left to right and top to bottom:
Yellowstone Lake from hotel landing, photochrom
Fishing in Yellowstone Lake, photochrom
Old Faithful geyser, photochrom
The Castle geyser, photochrom
Crater of the Grotto geyser, photochrom
Grotto geyser, photochrom
Upper Geyser Basin, Sapphire Pool, photochrom
Upper Geyser Basin, the Morning Glory, photochrom

Seite 486, von links nach rechts und von oben nach unten:
Der Yellowstone-See und die Hotel-Anlegestelle, Photochrom
Angeln im Yellowstone-See, Photochrom
Der Geysir Old Faithful, Photochrom
Der „Schloss-Geysir", Photochrom
Krater des „Höhlen-Geysirs", Photochrom
„Höhlen-Geysir", Photochrom
Oberes Geysir-Becken, das „saphirblaue Schwimmbad", Photochrom
Oberes Geysir-Becken, die „morgendliche Pracht", Photochrom

Page 486, de gauche à doite et de haut en bas:
Le lac de Yellowstone et le débarcadère, photochrome
Pêcheur sur le lac de Yellowstone, photochrome
Le geyser d'Old Faithful (le Vieux Fidèle), photochrome
Le « geyser forteresse », photochrome
Le cratère du geyser de la Grotte, photochrome
Le geyser de la Grotte, photochrome
Geyser supérieur, la « piscine bleu saphir », photochrome
Geyser supérieur, la « gloire du matin », photochrome

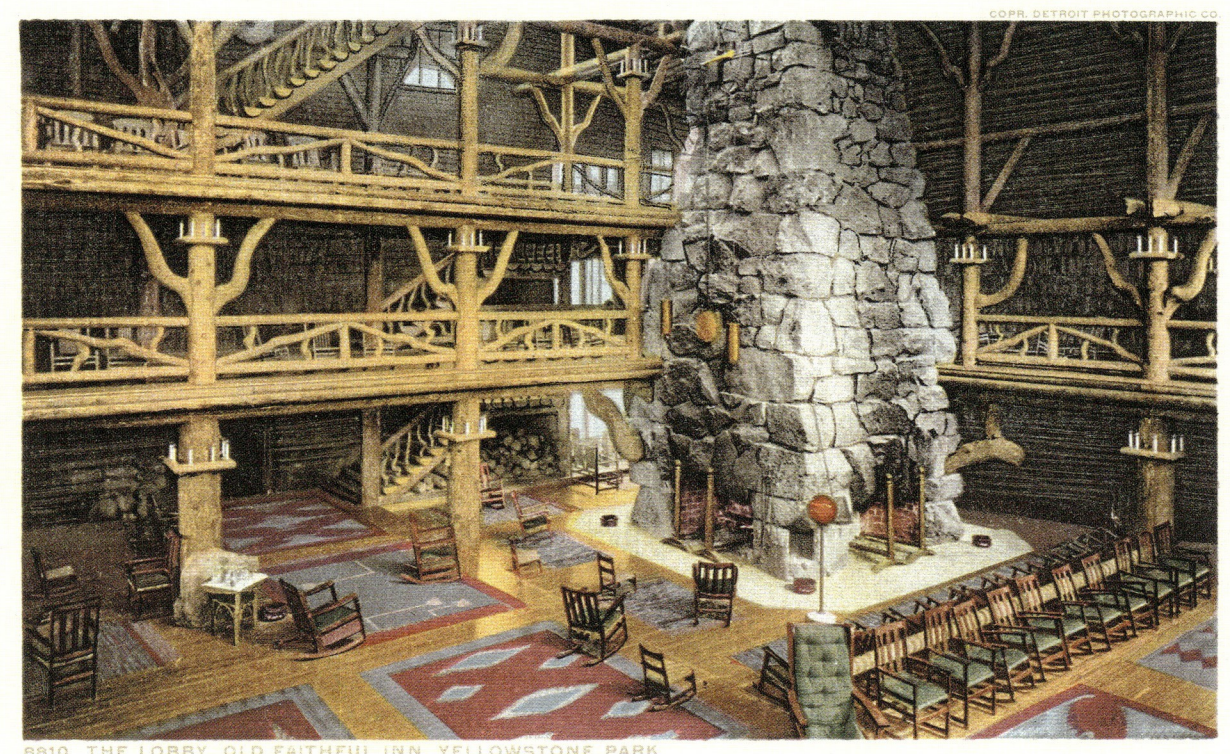

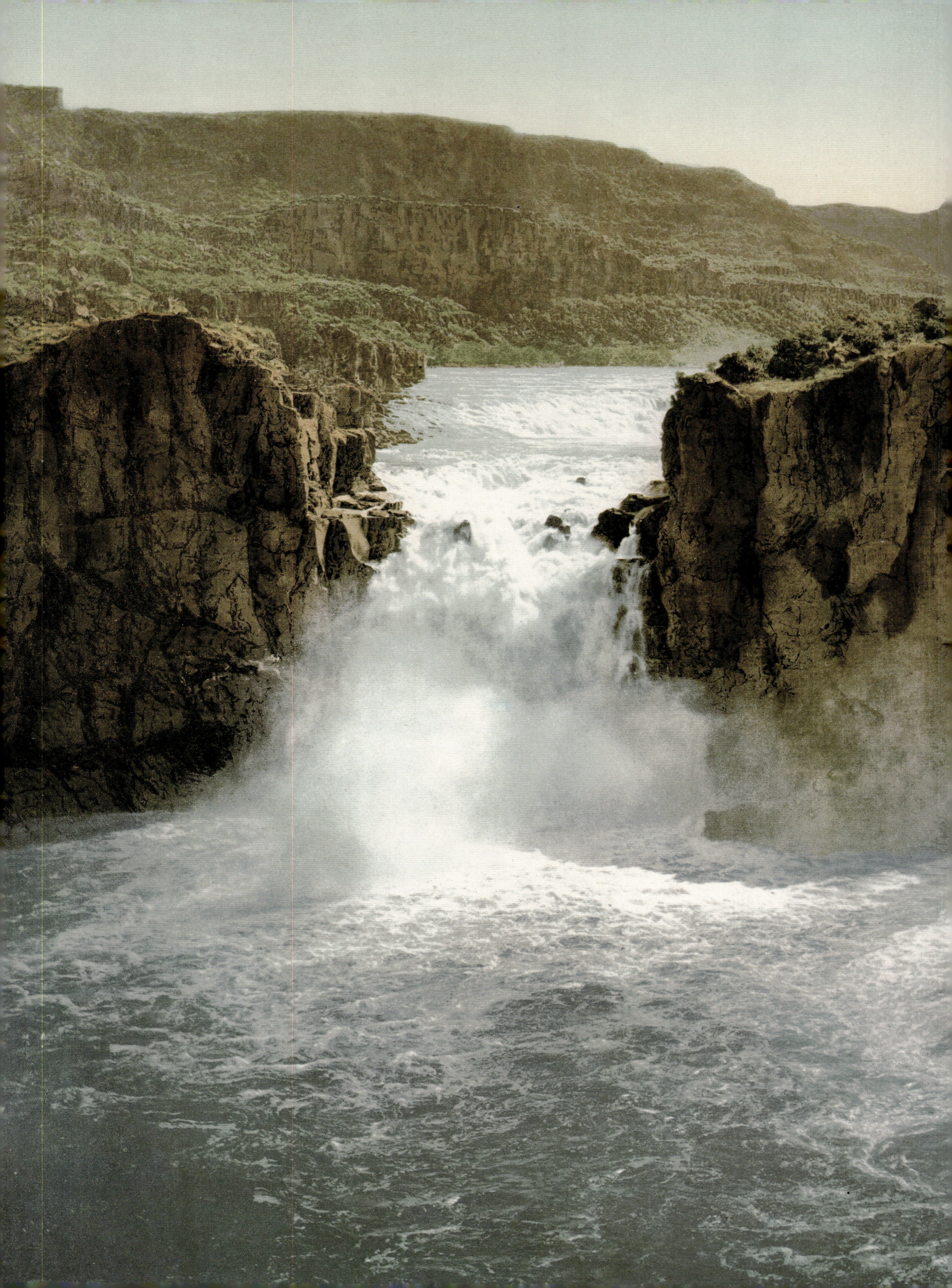

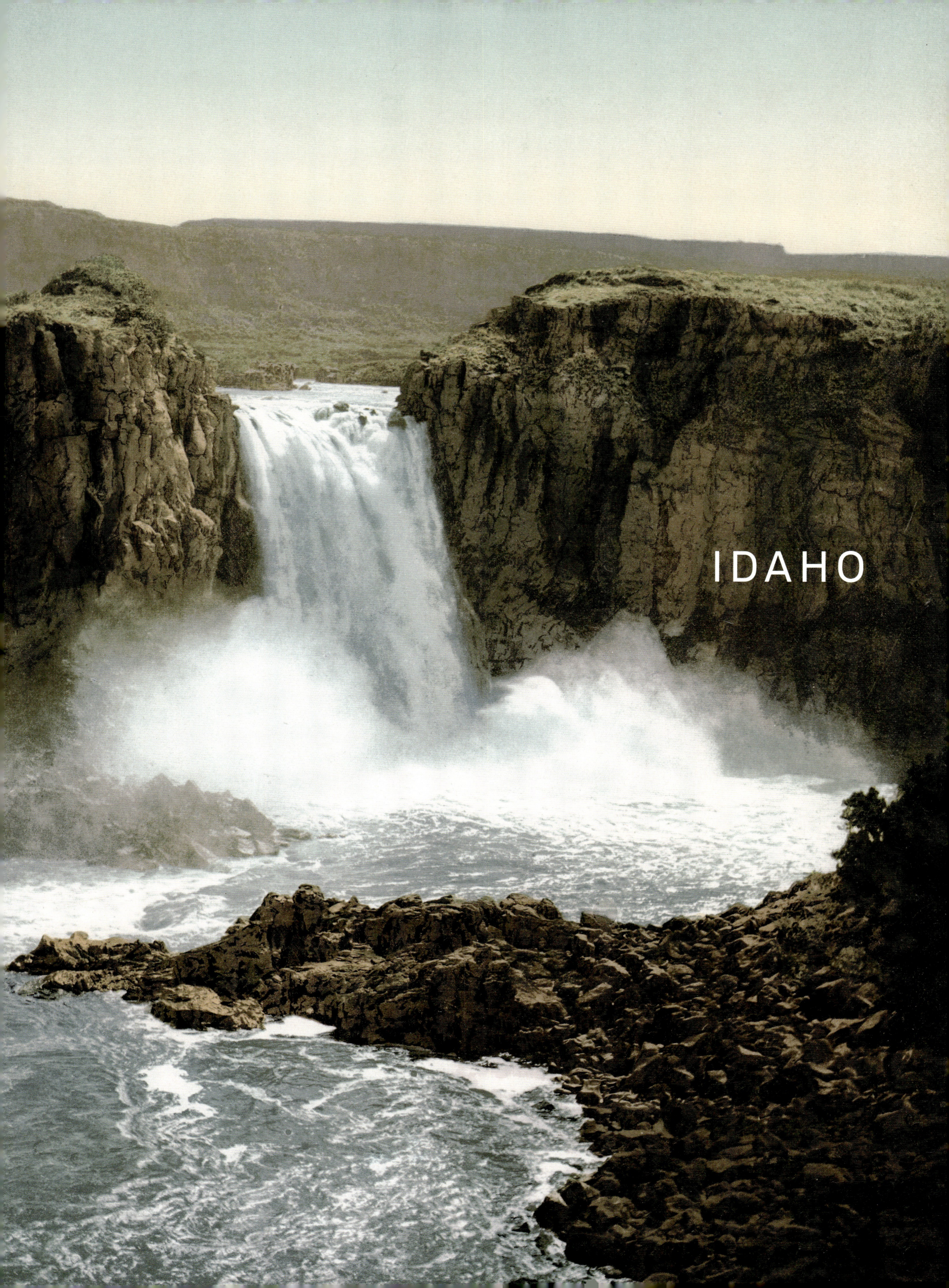

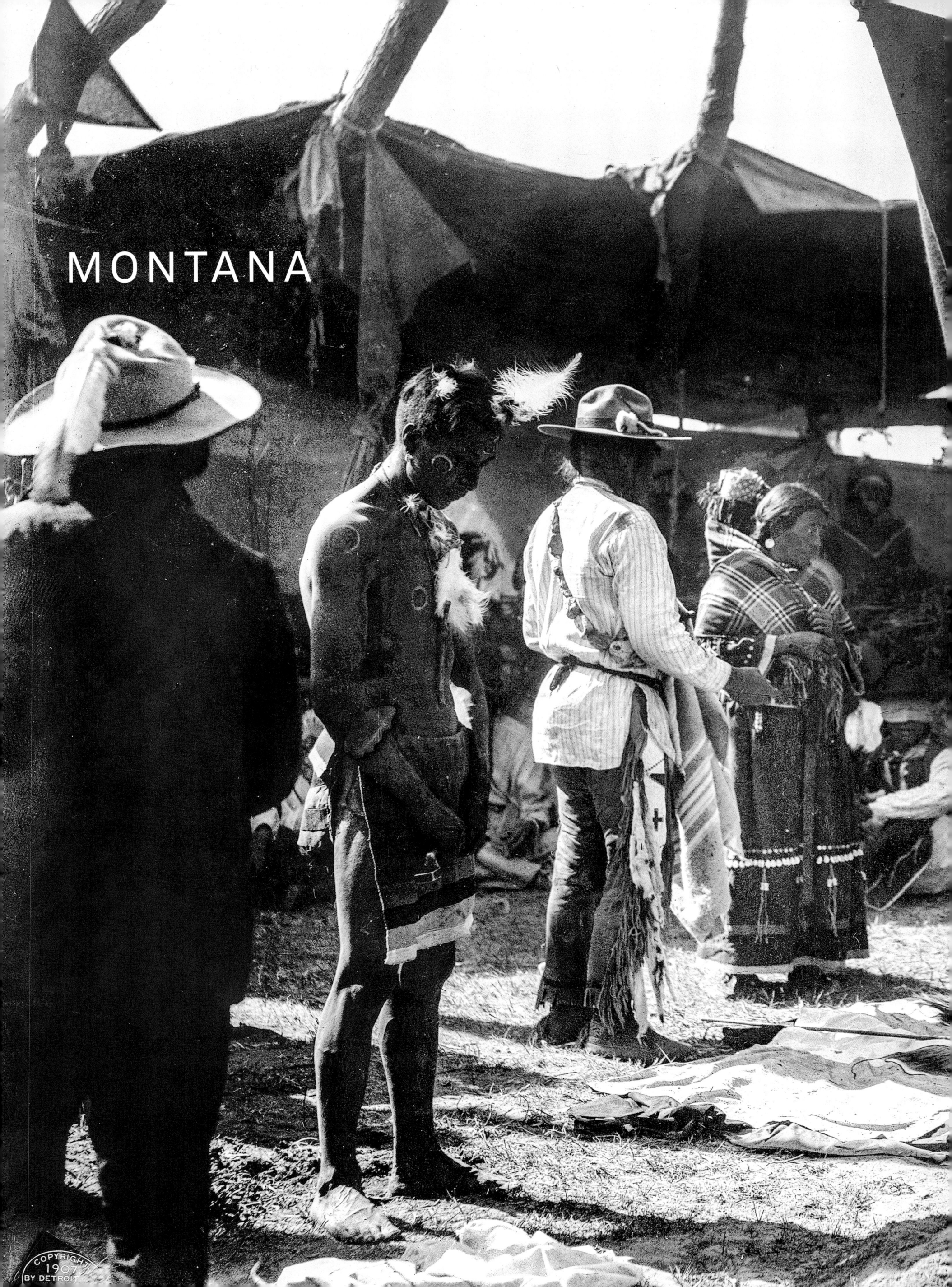

MONTANA

Page 488/489: **Twin Falls, Shoshone River, Idaho, photochrom**
Page 490: **Receiving presents after a three-day fast in the medicine lodge, Fort Belknap, glass negative, 1907**

Fort Belknap became an Indian reservation for the Assiniboine and Gros Ventre by decree of Congress on March 2, 1889.

Seite 488/489: **Twin Falls (Zwillingsfälle) am Shoshone River, Idaho, Photochrom**
Seite 490: **Ritual der Indianermedizin: Opfergaben, die nach dreitägigem Fasten erbracht werden, Fort Belknap, Glasnegativ, 1907**

Die Gegend von Fort Belknap wurde per Dekret durch den Kongress vom 2. März 1889 zum Indianerreservat für die Assiniboine und die Gros Ventre bestimmt.

Pages 488/489 : **Twin Falls, les chutes de la rivière Shoshone, Idaho, photochrome**
Page 490 : **rituel de médecine indienne : offrandes faites après un jeûne de trois jours, Fort Belknap, plaque de verre, 1907**

Le site de Fort Belknap devint une réserve indienne pour les Assiniboine et les Gros Ventre par décret du Congrès le 2 mars 1889.

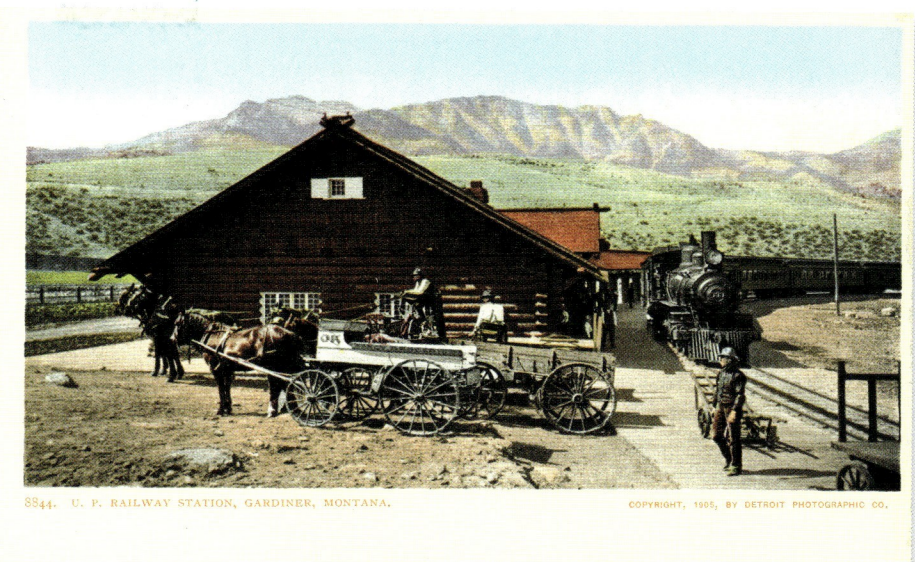

From top to bottom:
Union Pacific Railway station, Gardiner
Cleaning up on a gold dredge
A gold dredge

The high point for gold prospecting in Montana began in 1862 with the discovery of quantities of gold in the rivers of the Bannack region, on the site of Grasshopper Creek in the southwest of the state. The production of the district is estimated at $184 million at current gold prices.

Von oben nach unten:
Bahnhof der Union Pacific Railway in Gardiner
Goldwäsche auf einem Schwimmbagger
Goldbagger

Die Zeit der Goldsucher in Montana begann im Wesentlichen 1862 mit der Entdeckung großer Mengen Gold in den Gewässern der Region um Bannack am Grasshoper Creek im Südwesten des Bundesstaates. Nach dem aktuellen Goldpreis entsprach die geförderte Menge in diesem Gebiet schätzungsweise etwa 184 Millionen Dollar!

De haut en bas :
Gare de l'Union Pacific Railway à Gardiner
Lavage de l'or sur une drague
Dragage d'or

Le temps des chercheurs d'or dans le Montana débute en 1862, avec la découverte de grandes quantités de minerai aurifère dans les cours d'eau de la région de Bannack, sur le site de Grasshoper Creek, au sud-ouest de l'État. On estime la production du district à quelque 184 millions de dollars au prix actuel de l'or !

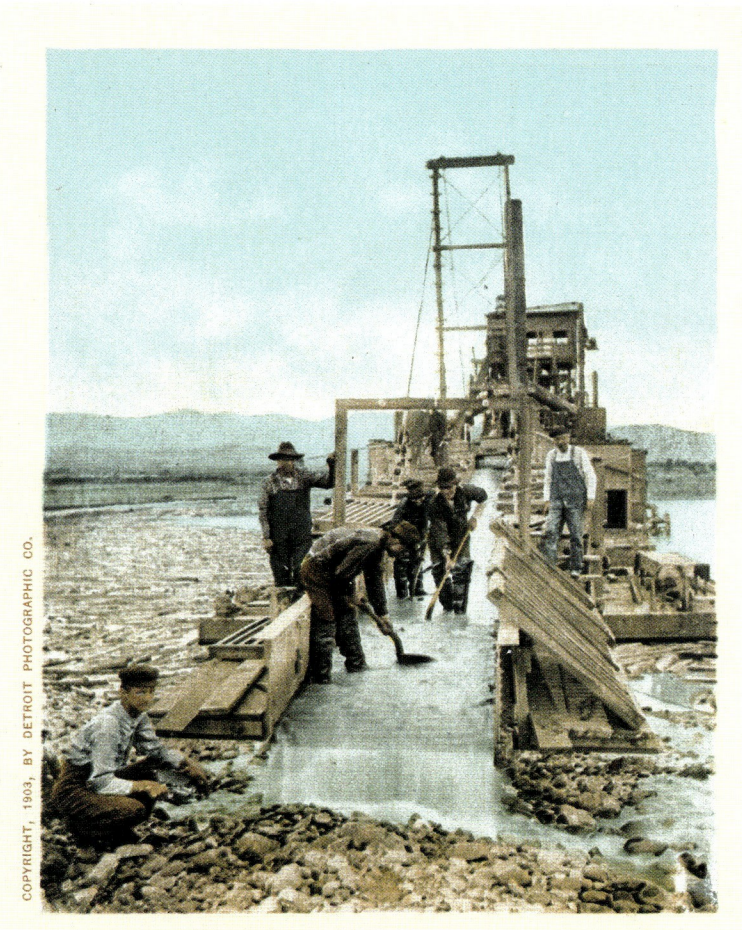

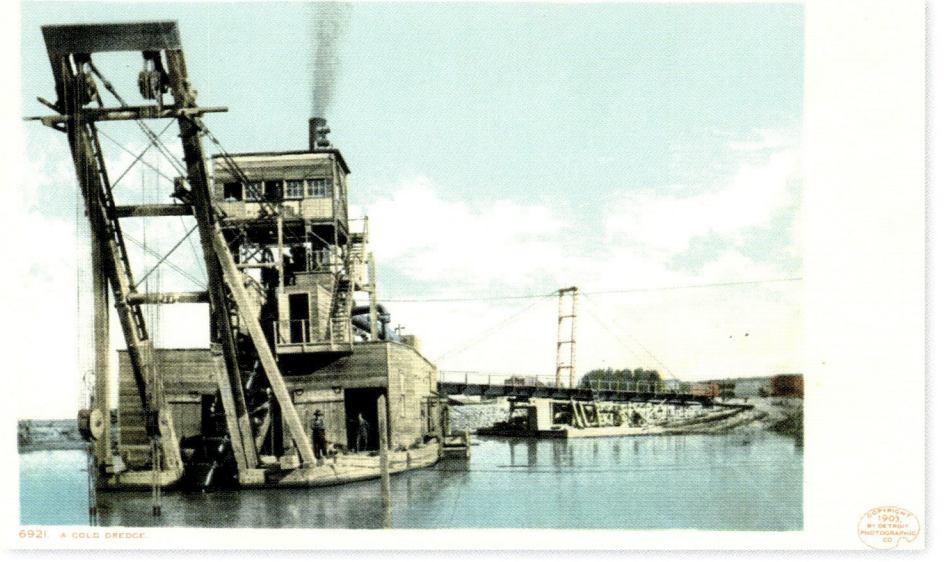

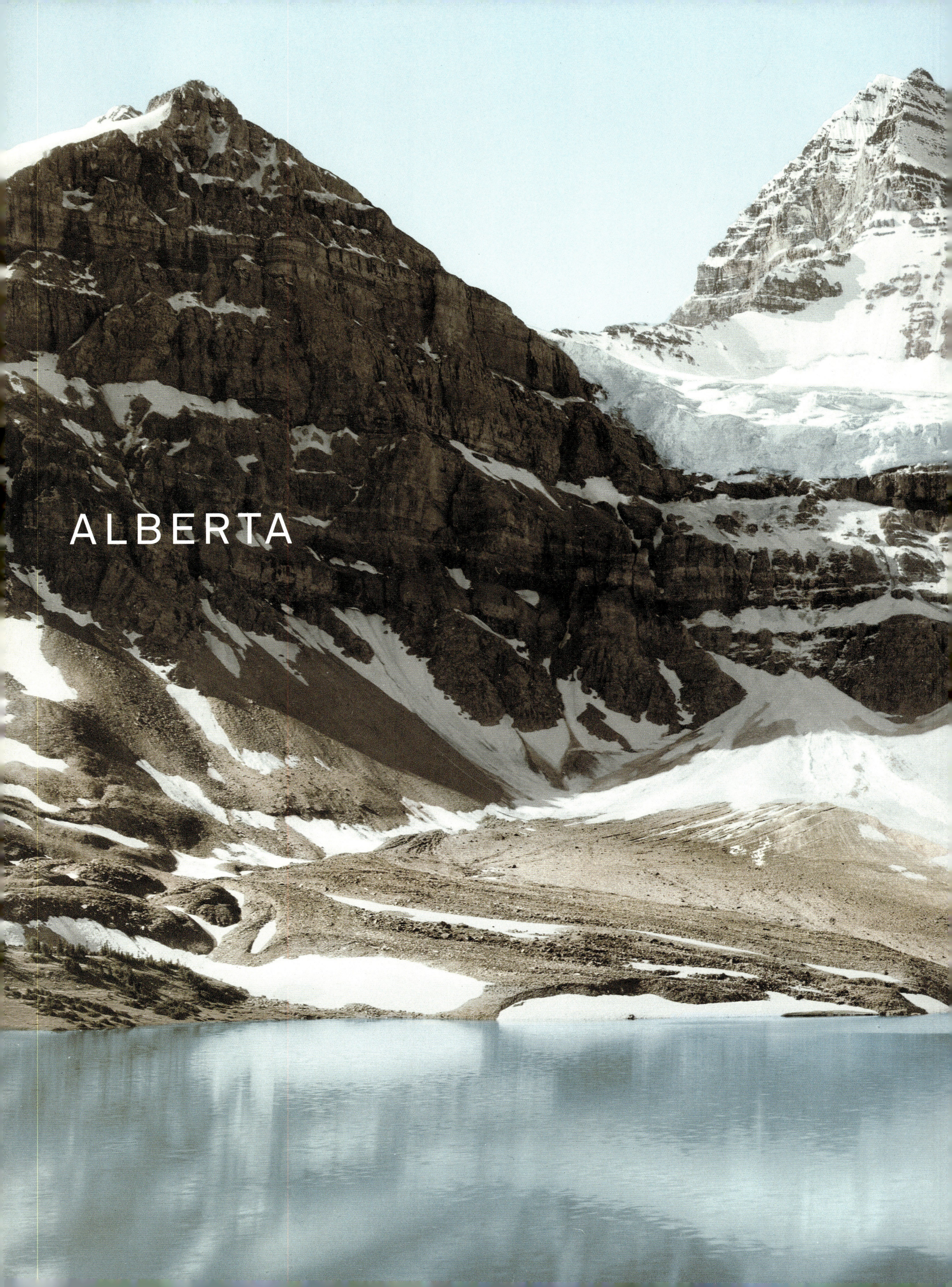
ALBERTA

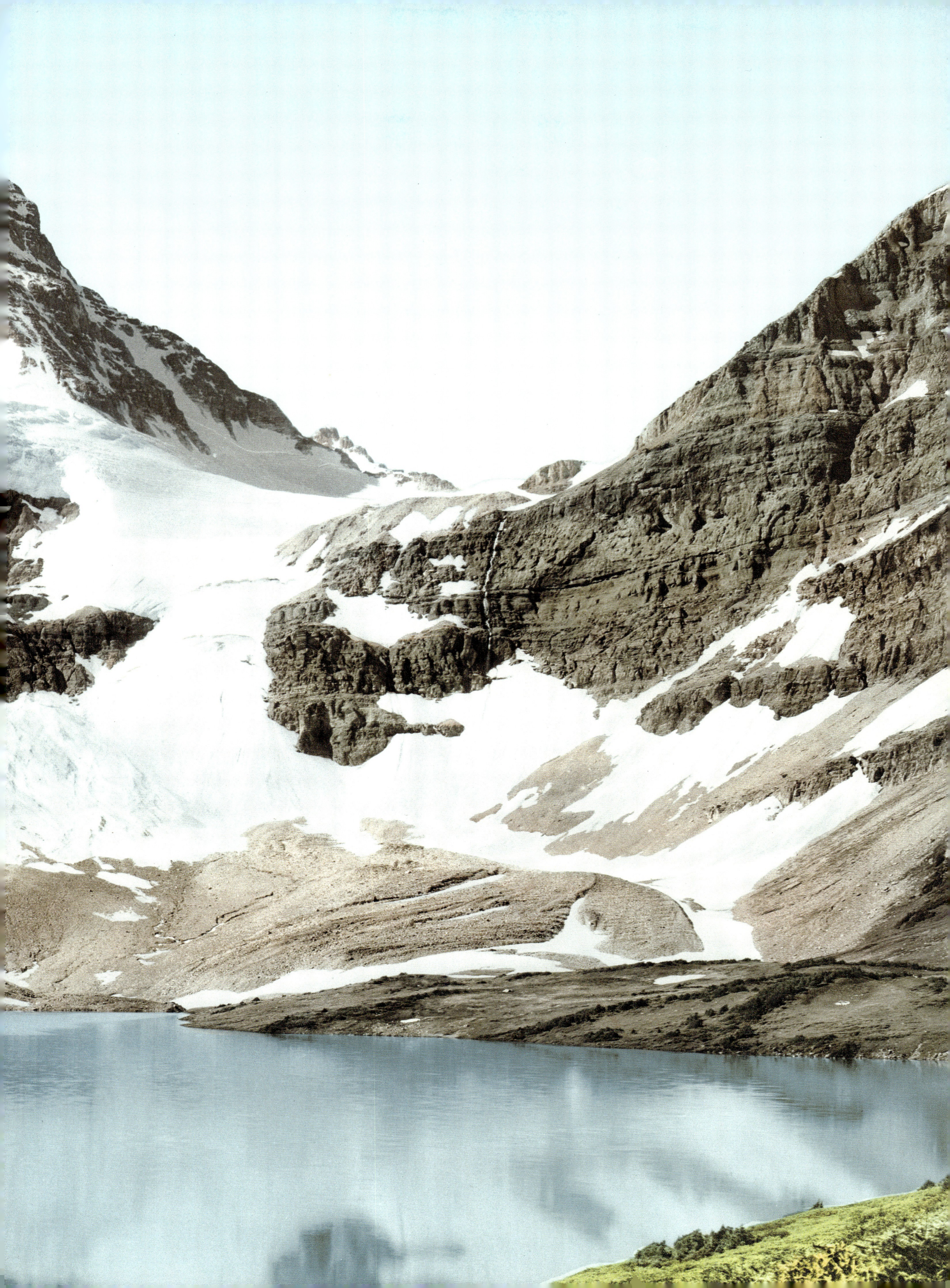

Page 492/493: Mount Assiniboine, photochrom
Above: Lake Louise from Chalet, photochrom
Right: Banff Springs Hotel, photochrom

Seite 492/493: Mount Assiniboine, Photochrom
Oben: Blick auf den Lake Louise vom Hotel Lake Louise aus, Photochrom
Rechts: Das Hotel Banff Springs, Photochrom

Pages 492/493 : le mont Assiniboine, photochrome
En haut : le lac Louise vu depuis l'hôtel Lake Louise, photochrome
À droite : l'hôtel Banff Springs, photochrome

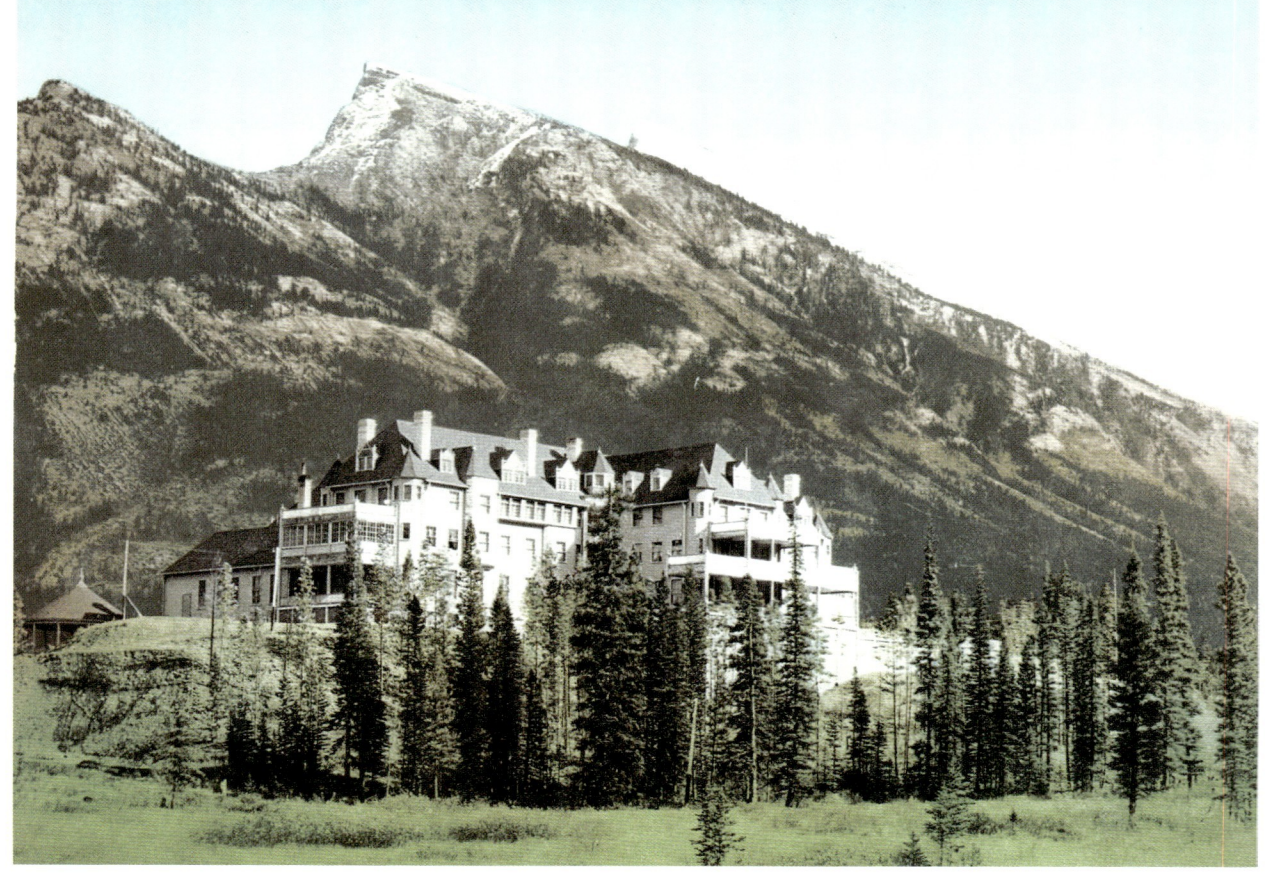

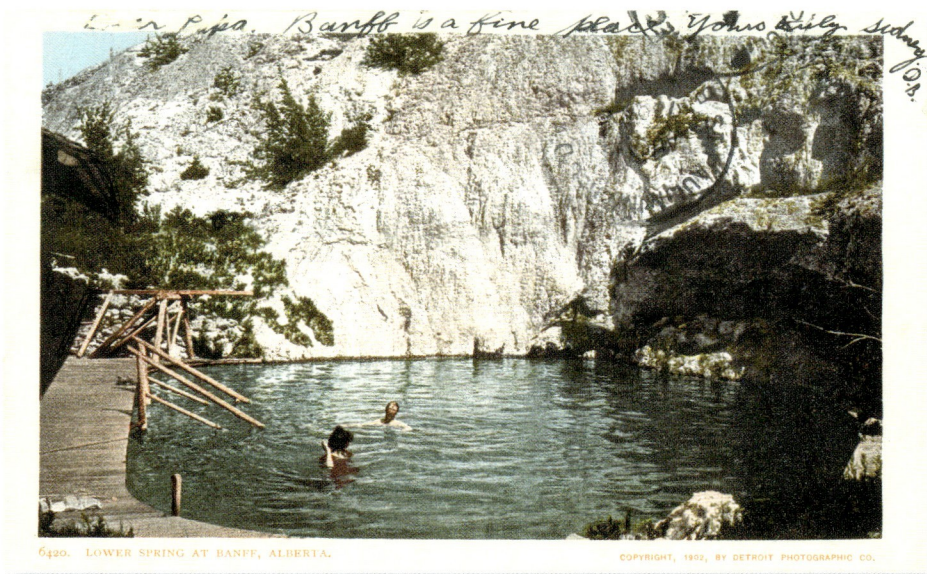

Above: **The landing of Lake Minnewanka, photochrom**
Right: **Lower spring at Banff**

Lake Minnewanka and Lake Louise form part of the Banff National Park in Alberta, Canada. The Chateau Lake Louise Hotel and Banff Springs Hotel were built by the Canadian Pacific Railway Co. respectively in 1888 and 1890.

Oben: **Anlegestelle am Minnewanka-See, Photochrom**
Rechts: **Baden in der unteren Quelle von Banff**

Die Seen Lake Minnewanka und Lake Louise gehören zum Banff-Nationalpark in Alberta. Das Hotel Château Lake Louise sowie das Hotel Banff Springs wurden 1888 bzw. 1890 von der Eisenbahngesellschaft Canadian Pacific Railway erbaut.

En haut : **le débarcadère du lac Minnewanka, photochrome**
À droite : **Banff, baignade dans la source inférieure**

Le lac Minnewanka et le lac Louise font partie du parc national de Banff, dans l'Alberta. L'hôtel Château Lake Louise comme l'hôtel Banff Springs ont été construits par la compagnie du Canadian Pacific Railway, respectivement en 1888 et 1890.

CANADA | ALBERTA | MT. ASSINIBOINE | BANFF | LAKE MINNEWANKA

NATIVE AMERICANS / INDIANER / INDIENS D'AMÉRIQUE

The destiny of the indigenous peoples of North America was not a happy one, "drowned in a tidal wave of immigrants … and destined to disappear beneath the unfurling of a material civilization of irresistible power," writes Claude Fohlen, a French specialist on North American history. The evangelization attempted in California, Texas, and New Mexico by the Spanish and in Canada and the Great Lakes by the French encountered firmly entrenched beliefs and was a complete fiasco. British settlers, with the exception of William Penn and Roger Williams (Rhode Island), did not even attempt to convert these "savages" but simply set about eliminating them. Already decimated by the illnesses brought by the Europeans, the Native Americans were first driven out of Virginia (around 1620) and ever farther west of the Mississippi. Between 1830 and 1835, the five southeastern tribes—Choctaw, Seminole, Chickasaw, Creek, and Cherokee—were deported by forced marches from Mississippi, Alabama, Florida, Georgia, and North Carolina to Oklahoma, which had been designated "Indian territory." Two-thirds of the displaced population died over the course of this abominable exodus, which earned the name "Trail of Tears." There followed the "Long Walk of the Navajos," who were expelled from Arizona to the far bank of the Rio Grande (1864–66), as well as that of the Nez Perce, from Wallowa, Oregon, to Montana and Canada (1877) and that of the Utes from Colorado to Utah (1881). That same year, in 1881, the author Helen Hunt Jackson published *A Century of Dishonor*, a powerful indictment of the Indian policy of the government; it was intended to raise awareness amid the often underinformed American public. This first step led in 1911 to the creation of the Society of American Indians and paved the way for the preservation of Native American culture, whose renaissance began in the 1950s and led to the "astonishing resurrection" (Claude Fohlen) of the Indian nations between 1970 and 1990.

Ein seltsames Schicksal ereilte das Volk der nordamerikanischen Indianer, das „in der Flut von Emigranten ertrank […] und dessen Bestimmung es war, angesichts der Expansion einer materiellen Zivilisation von unwiderstehlicher Macht zu verschwinden", schreibt der Historiker und Nordamerikaspezialist Claude Fohlen in *Les Indiens d'Amérique du Nord*. Der Evangelisierungsversuch der Spanier in Kalifornien, Texas und New Mexico und der Franzosen in Kanada und der Region der Großen Seen stieß auf einen zu stark verwurzelten Glauben und scheiterte. Die britischen Siedler, abgesehen von William Penn und Roger Williams (Rhode Island), versuchten nicht einmal diese „Wilden" zu christianisieren, sondern beseitigten sie kurzerhand. Die Indianer waren bereits durch die von den Europäern eingeschleppten Krankheiten dezimiert, als sie zuerst aus Virginia vertrieben (um 1620) und über Mississippi hinaus immer weiter gen Westen gedrängt wurden. Zwischen 1830 und 1835 wurden die fünf südöstlichen Stämme – die Choctaw, Seminolen, Chickasaw, Creek und Cherokee – von Mississippi, Alabama, Florida, Georgia und North Carolina zu Fuß in das zum „Indianer-Territorium" erklärte Oklahoma deportiert. Zwei Drittel der umgesiedelten Bevölkerung starben bei diesem schrecklichen Exodus, dem man den Namen „Trail of Tears" (Pfad der Tränen) gab. Es folgten der Lange Marsch der Navajo, die aus Arizona ans andere Ufer des Rio Grande verdrängt wurden (1864–1866), der Marsch der Nez Percé von Wallowa (Oregon) nach Montana und Kanada (1877) und der der Ute von Colorado nach Utah (1881). Im selben Jahr 1881 veröffentlichte die Schriftstellerin Helen Hunt Jackson mit *A Century of Dishonor* (Ein Jahrhundert der Schande) ein kämpferisches Pamphlet gegen die Indianer-Politik der Regierung, das auf die Sensibilisierung der allzu oft schlecht informierten Öffentlichkeit abzielte. Dieser erste Schritt, der 1911 zur Gründung der Society of American Indians führte, hat den Weg freigemacht für den Schutz der indianischen Kultur und ihre Renaissance ab den 1950er-Jahren, bis hin zur „erstaunlichen Wiederauferstehung" (Claude Fohlen) der indianischen Völker zwischen 1970 und 1990.

Étrange destin que celui des Indiens d'Amérique du Nord, peuple « noyé dans une marée d'émigrants […], destiné à disparaître face à l'expansion d'une civilisation matérielle à la puissance irrésistible », écrit Claude Fohlen, historien spécialiste de l'Amérique du Nord, dans *Les Indiens d'Amérique du Nord*. L'évangélisation tentée en Californie, au Texas et au Nouveau-Mexique par les Espagnols, au Canada et dans la région des Grands Lacs par les Français, se heurta à des croyances trop enracinées et fut un échec. En dehors de William Penn et Roger Williams (Rhode Island), les colons d'origine britannique n'essayèrent même pas de christianiser des « sauvages » qu'ils ne cherchaient qu'à éliminer. Déjà décimés par les maladies apportées par les Européens, les Indiens furent d'abord chassés de Virginie (vers 1620) et repoussés toujours plus loin à l'ouest du Mississippi. Entre 1830 et 1835, les cinq tribus du sud-est – Choctaws, Séminoles, Chickasaws, Creeks, Cherokees – furent déportées à pied du Mississippi, d'Alabama, de Floride, de Géorgie et de Caroline du Nord, vers l'Oklahoma, baptisé « territoire indien ». Les deux tiers des populations déplacées périrent au cours de cet exode atroce auquel on a donné le nom de « Trail of Tears » (« la Piste des larmes »). Suivirent la « longue marche des Navajos », expulsés d'Arizona vers l'autre rive du Rio Grande (1864-1866), celle des Nez Percés, de Wallowa (Oregon) au Montana et au Canada (1877), celle des Utes, du Colorado à l'Utah (1881). Cette même année 1881, l'écrivain Helen Hunt Jackson publie *A Century of Dishonor* (*Un siècle de déshonneur*), violent réquisitoire contre la politique indienne du Gouvernement, destiné à sensibiliser une opinion publique trop souvent désinformée. Ce premier pas, qui aboutira à la création en 1911 de la Society of American Indians, a ouvert la voie de la préservation de la culture indienne, à sa renaissance à partir des années 1950, jusqu'à l'« étonnante résurrection » (Claude Fohlen) des nations indiennes entre 1970 et 1990.

Left: *The Ojibwa Moccasin game*, postcard
Page 497: *Ojibwa camp, Hiawatha's arrival*, photochrom

Links: *Das Mokassin-Spiel bei den Ojibwa*, Postkarte
Seite 497: *Ojibwa-Lager, die Ankunft Hiawathas*, Photochrom

À gauche : *le jeu du mocassin chez les Ojibwas*, carte postale
Page 497 : *camp Ojibwa, l'arrivée de Hiawatha*, photochrome

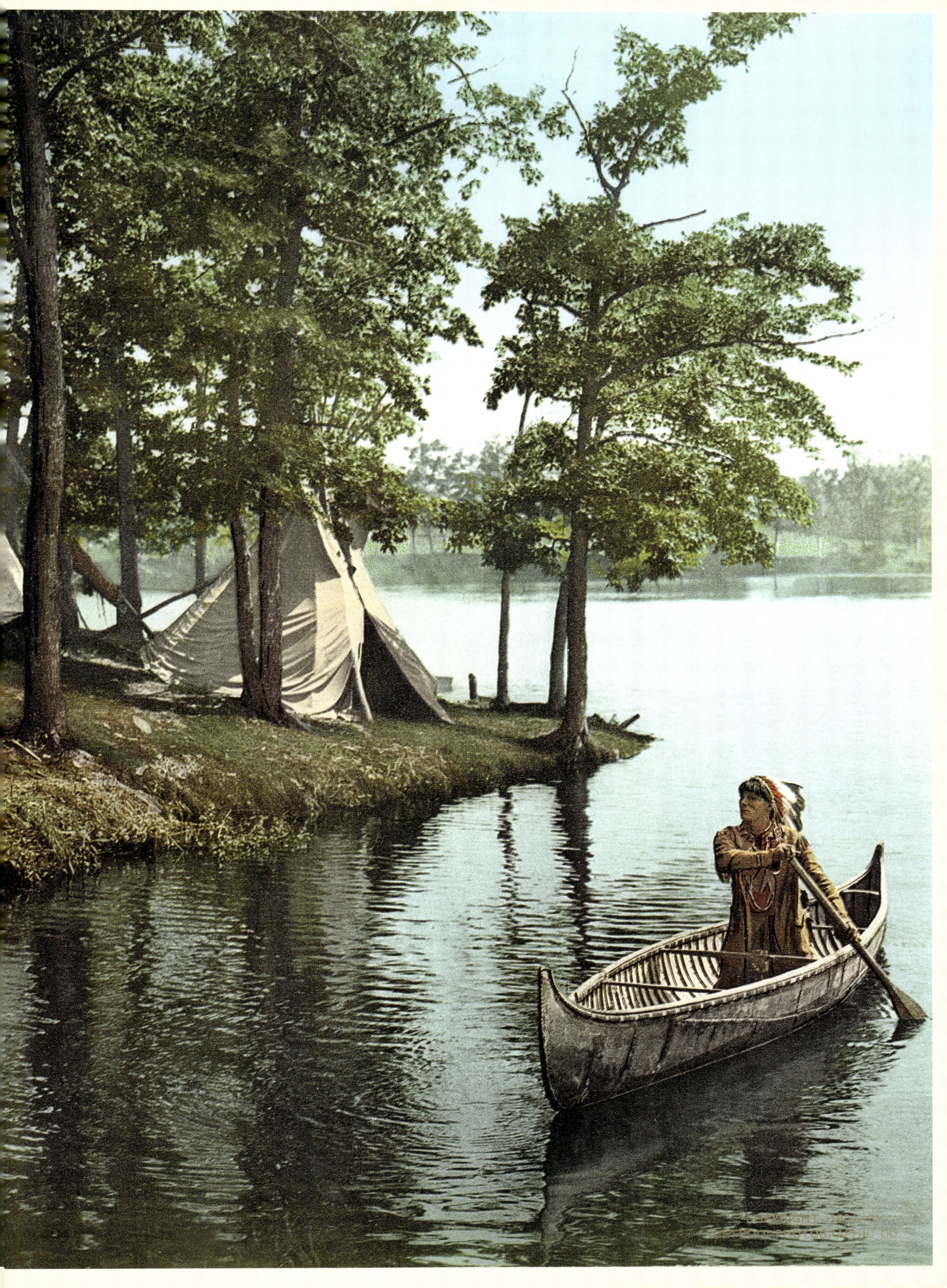

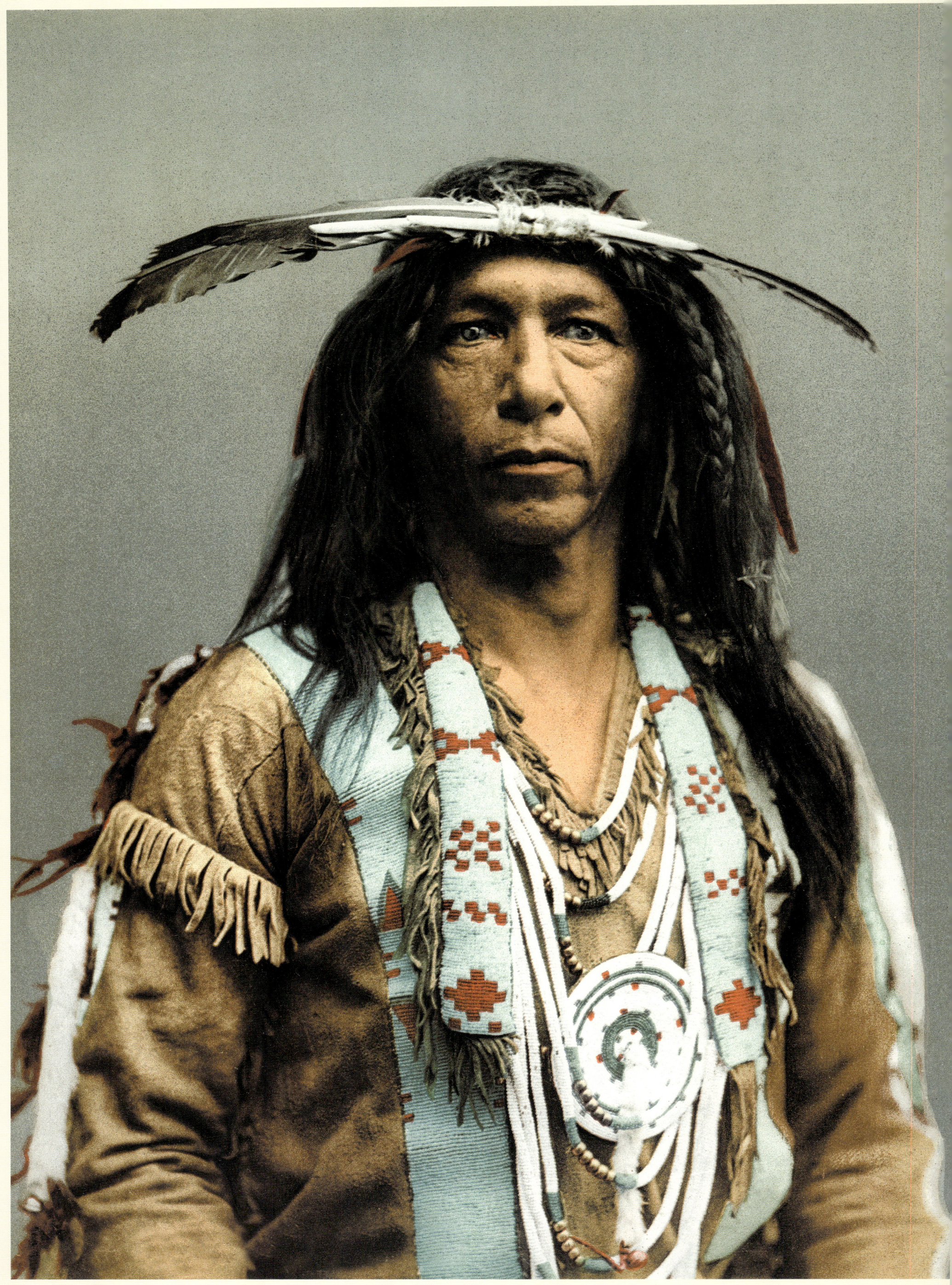

Page 498: Arrowmaker, Ojibwa brave, photochrom
Near right: Wabunosa, Ojibwa brave, photochrom
Far right: Ojibwa mother and child, photochrom
Below, from left to right:
Arrowmaker, Ojibwa brave, postcard
Young Ojibwas braves, postcard
Chief Paupuk Keewis, Iroquois adopted by the Ojibwas, postcard

Seite 498: Arrowmaker, ein tapferer Ojibwa, Photochrom
Rechts: Wabunosa, ein tapferer Ojibwa, Photochrom
Rechts außen: Ojibwa-Frau mit ihrem Kind, Photochrom
Unten, von links nach rechts:
Arrowmaker, ein tapferer Ojibwa, Postkarte
Kleine tapfere Ojibwa, Postkarte
Häuptling Paupuk Keewis, ein von den Ojibwa adoptierter Irokese, Postkarte

Page 498: Arrowmaker, brave Ojibwa, photochrome
Ci-contre: Wabunosa, brave Ojibwa, photochrome
À droite: mère et bébé Ojibwas, photochrome
En bas, de gauche à droite:
Arrowmaker, brave Ojibwa, carte postale
Jeunes braves Ojibwas, carte postale
Le chef Paupuk Keewis, Iroquois adopté par les Ojibwas, carte postale

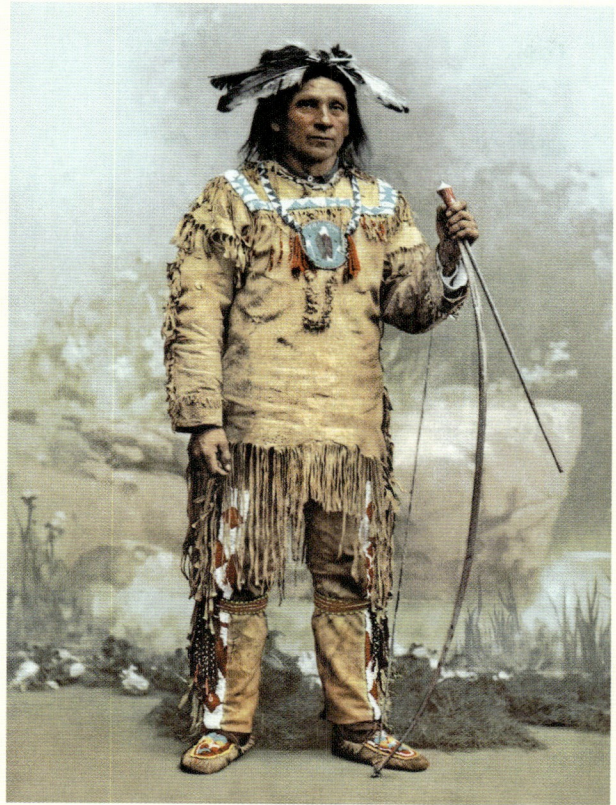 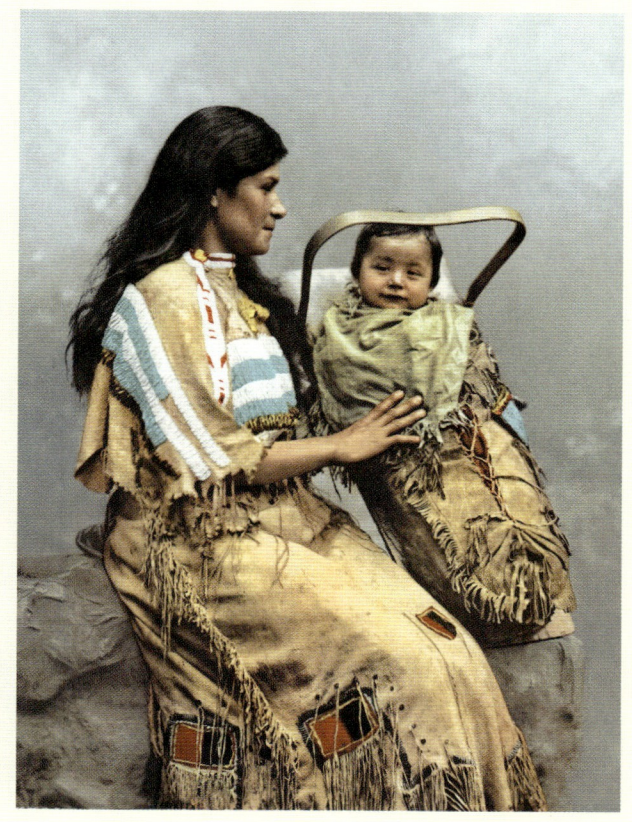

The destiny of the indigenous peoples of North America was not a happy one, "drowned in a tidal wave of immigrants... and destined to disappear beneath the unfurling of a material civilization of irresistible power."

Ein seltsames Schicksal ereilte das Volk der nordamerikanischen Indianer, das „in der Flut von Emigranten ertrank [...] und dessen Bestimmung es war, angesichts der Expansion einer materiellen Zivilisation von unwiderstehlicher Macht zu verschwinden".

Étrange destin que celui des Indiens d'Amérique du Nord, peuple « noyé dans une marée d'émigrants [...], destiné à disparaître face à l'expansion d'une civilisation matérielle à la puissance irrésistible ».

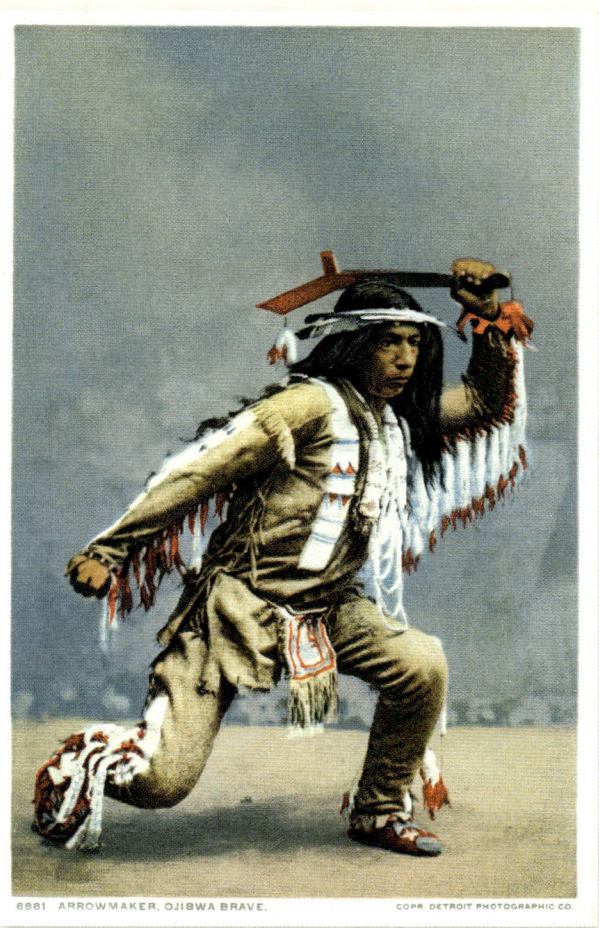 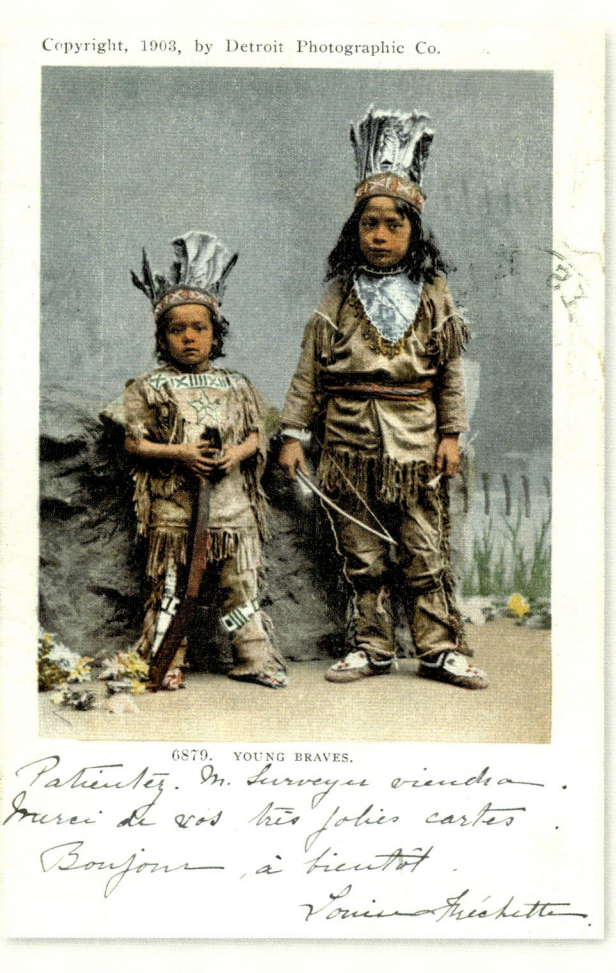 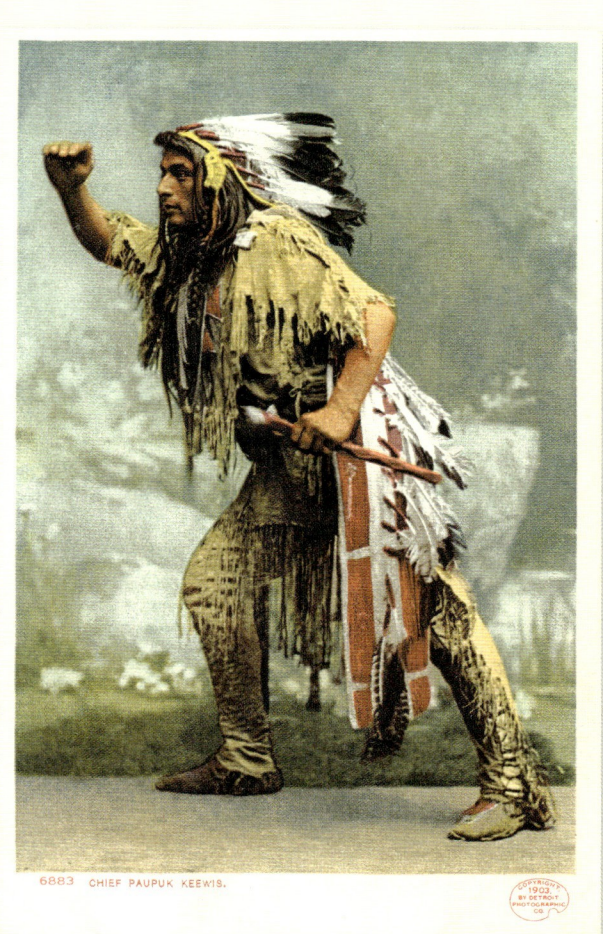

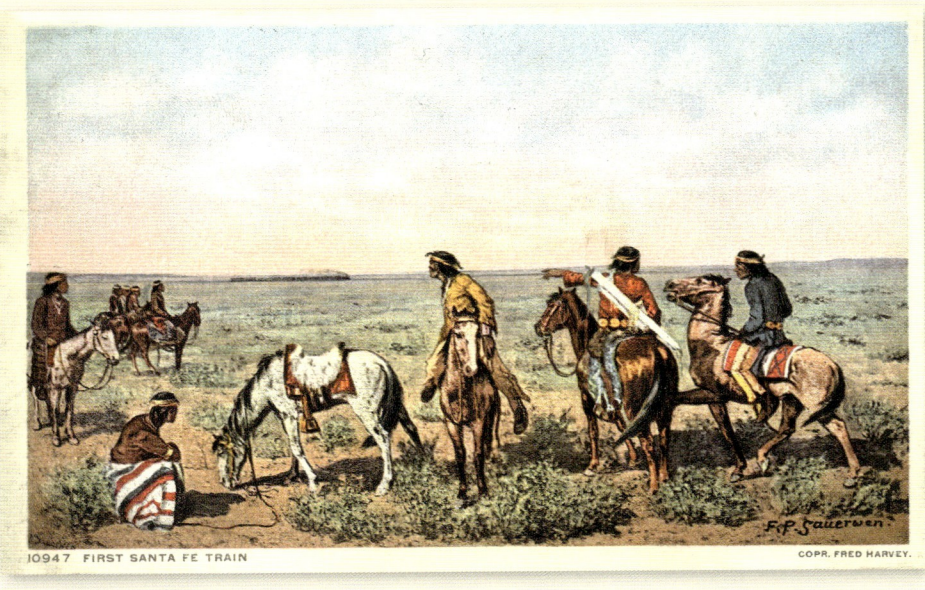
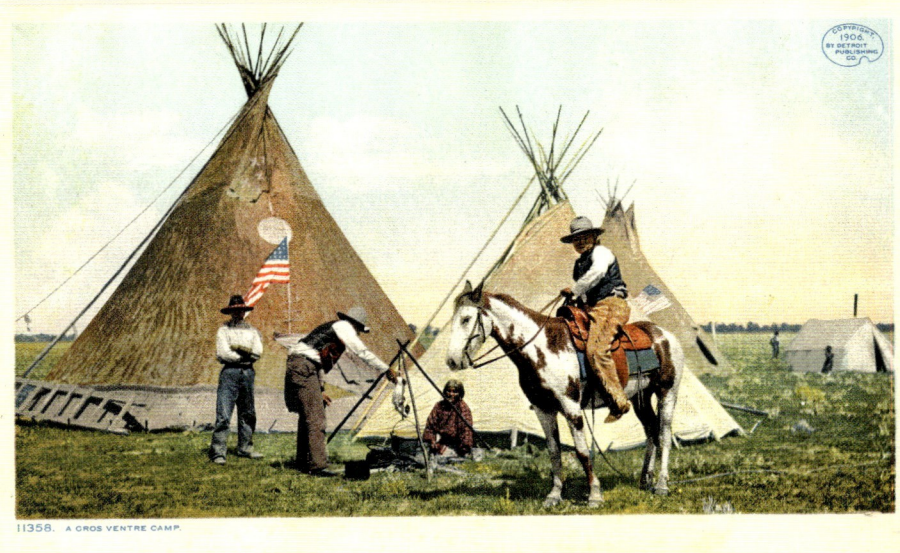
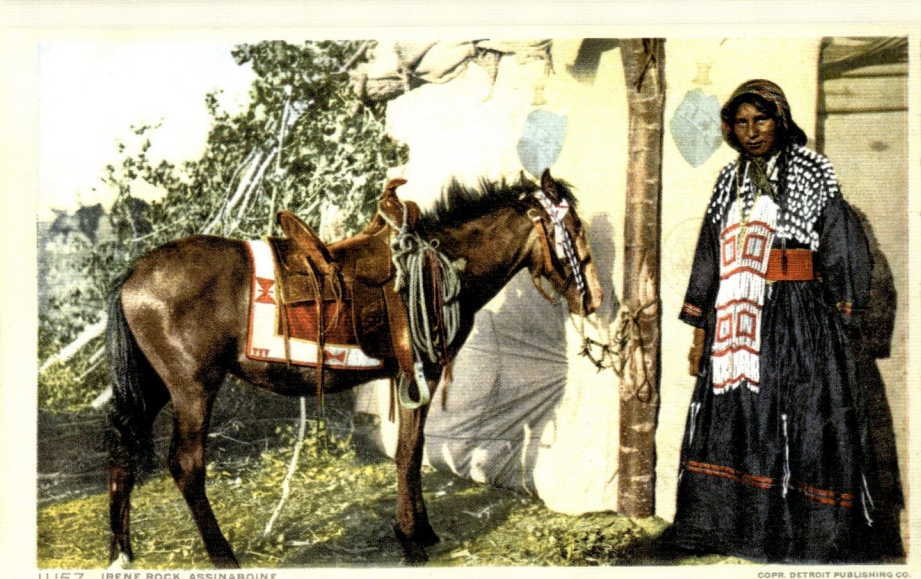

Top left: First Santa Fe train, postcard
Top right: A Gros Ventre camp, postcard
Right: Irene Rock, Assiniboine Indian, Montana, postcard
Bottom left: White and Yellow Cow and his wife Singing Bird, Gros Ventre Indians, postcard
Bottom right: Bull's Head, Gros Ventre Indian, postcard
Page 501: Chief Paupuk Keewis, Iroquois adopted by the Ojibwa, photochrom

Oben links: Der erste Zug nach Santa Fe, Postkarte
Oben rechts: Ein Gros-Ventre-Lager, Postkarte
Mitte: Irene Rock, Assiniboine-Indianerin, Montana, Postkarte
Unten links: White and Yellow Cow und seine Frau Singing Bird, Gros-Ventre-Indianer, Postkarte
Unten rechts: Bull's Head, Gros Ventre, Postkarte
Seite 501: Häuptling Paupuk Keewis, ein von den Ojibwa adoptierter Irokese, Photochrom

En haut à gauche : le premier train de Santa Fe, carte postale
En haut à droite : un camp Gros Ventre, carte postale
Ci-dessus : Irene Rock, Indienne Assiniboine, Montana, carte postale
En bas à gauche : White and Yellow Cow et sa femme, Singing Bird, Indiens Gros Ventre, carte postale
En bas à droite : Bull's Head, Gros Ventre, carte postale
Page 501 : le chef Paupuk Keewis, Iroquois adopté par les Ojibwas, photochrome

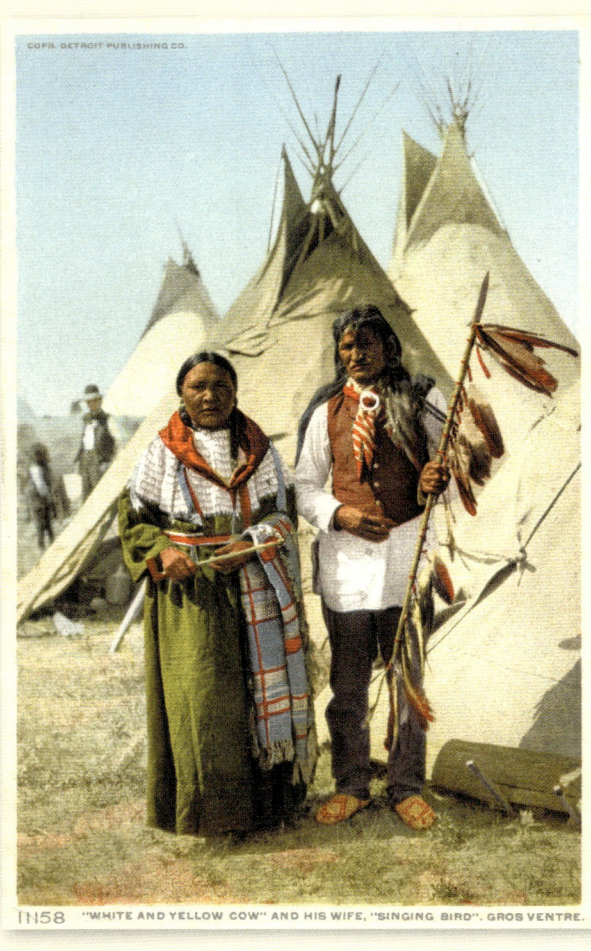
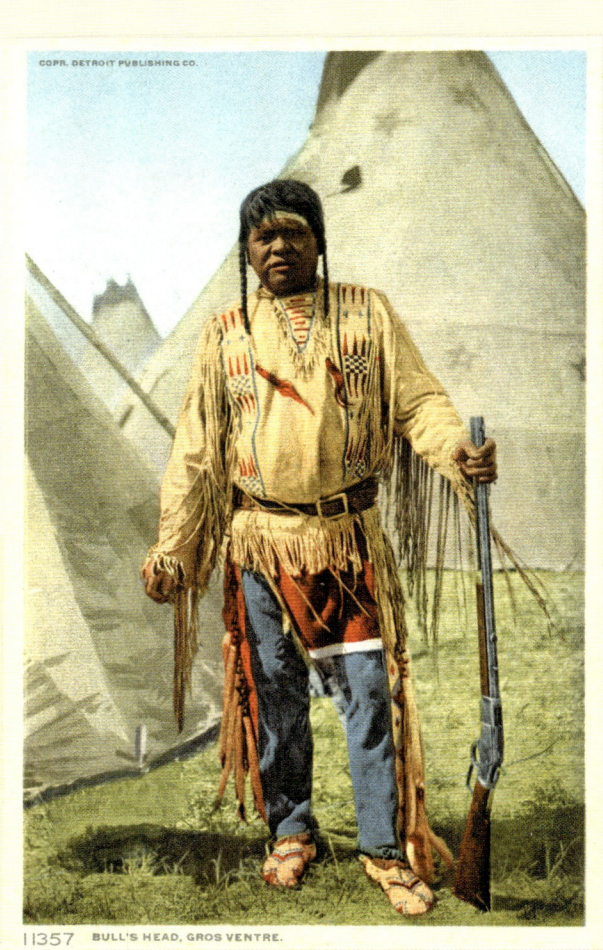

500

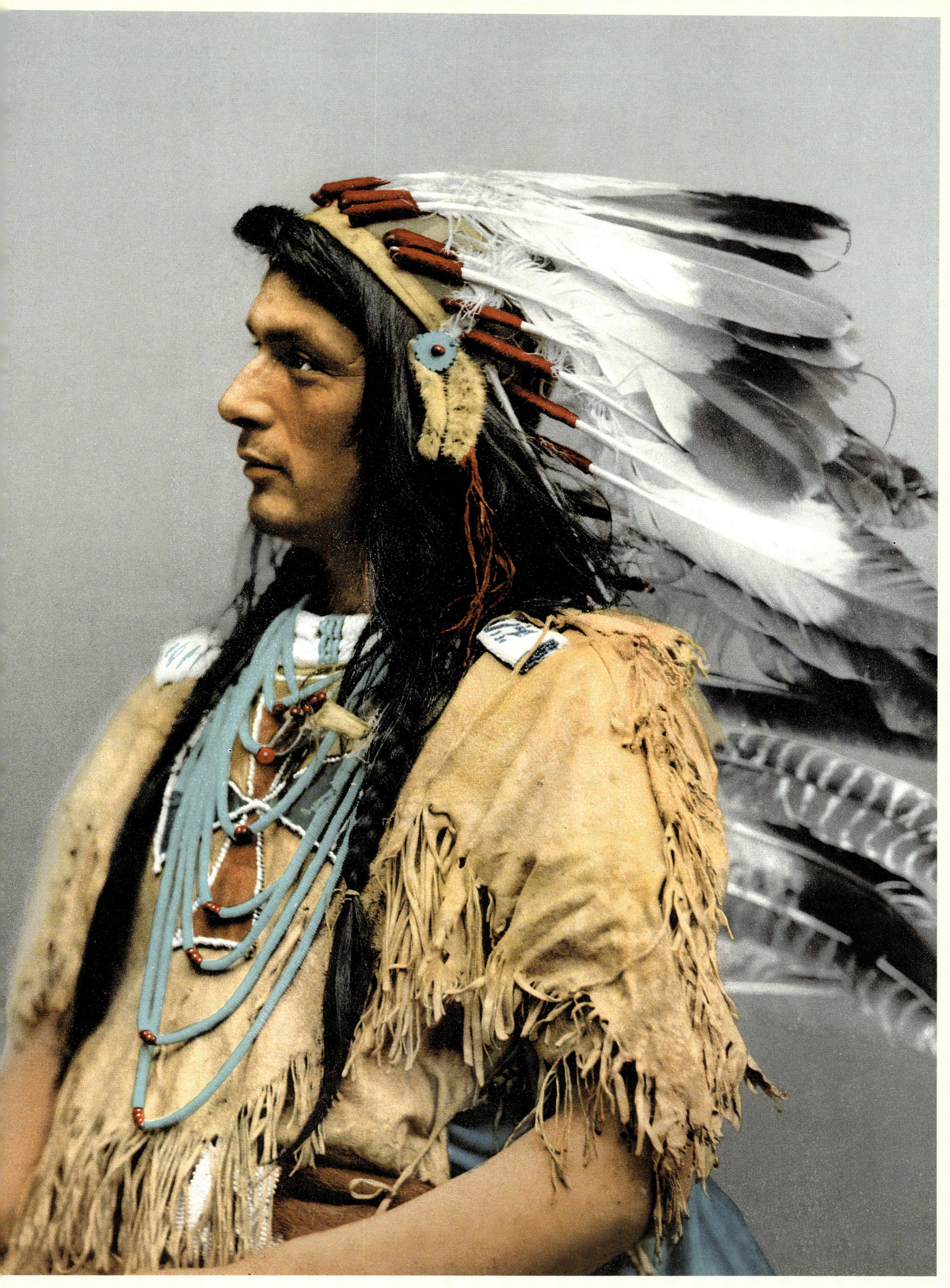

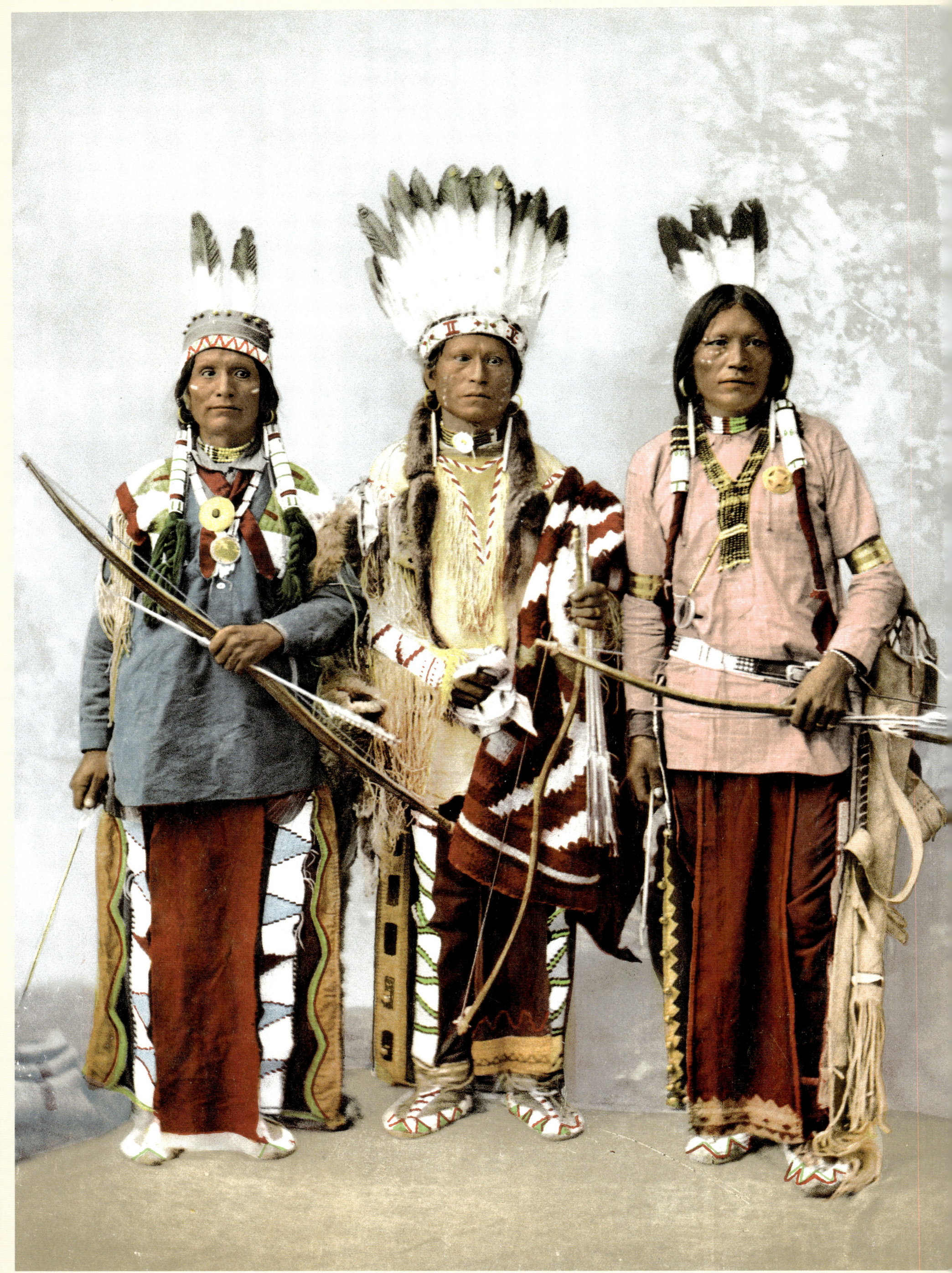

Page 502: Apache warriors, photochrom
Right: Apache warrior at Navajo Rio, Arizona, postcard
Below right: U.S. government scout Indian, Fort Apache, Arizona, postcard
Bottom, from left to right:
Rattlesnake on guard, Assiniboine Indian, postcard
A young Cree Indian, postcard
Lame Chicken, Assiniboine, postcard

Seite 502: Apachen-Krieger, Photochrom
Oben rechts: Apachen-Krieger am Navajo Rio, Postkarte
Mitte rechts: Indianischer Scout der US-Regierung, Fort Apache, Arizona, Postkarte
Unten, von links nach rechts:
Rattlesnake, Assiniboine auf Wache, Postkarte
Junger Cree-Indianer, Postkarte
Lame Chicken, Assiniboine, Postkarte

Page 502 : guerriers apaches, photochrome
À droite en haut : guerrier apache à Navajo Rio, carte postale
À droite en bas : scout indien du Gouvernement, Fort Apache, Arizona, carte postale
En bas, de gauche à droite :
Rattlesnake, Assiniboine montant la garde, carte postale
Un jeune Indien Cree, carte postale
Lame Chicken, Assiniboine, carte postale

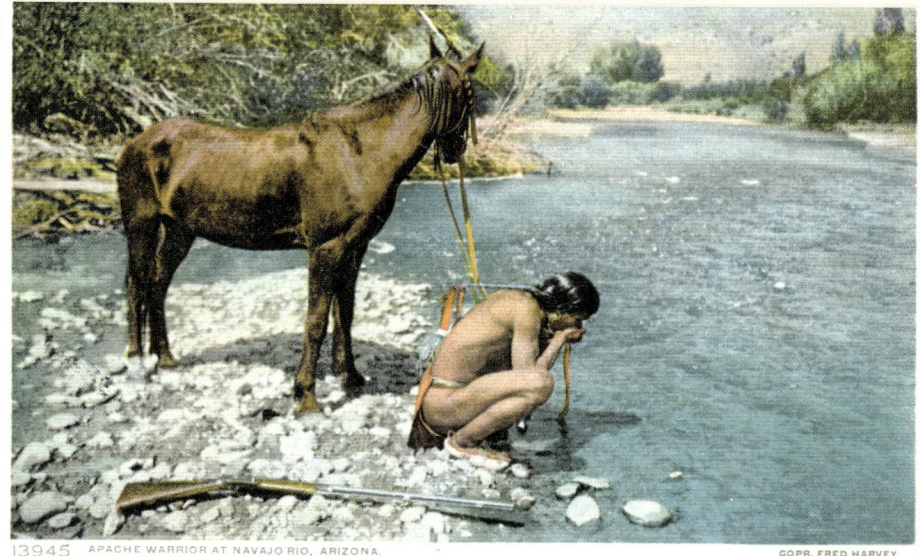
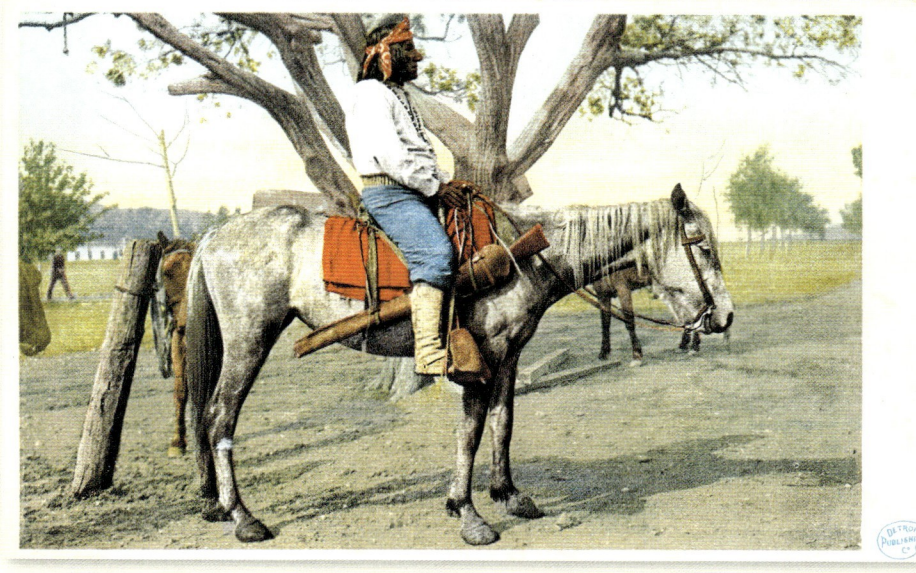
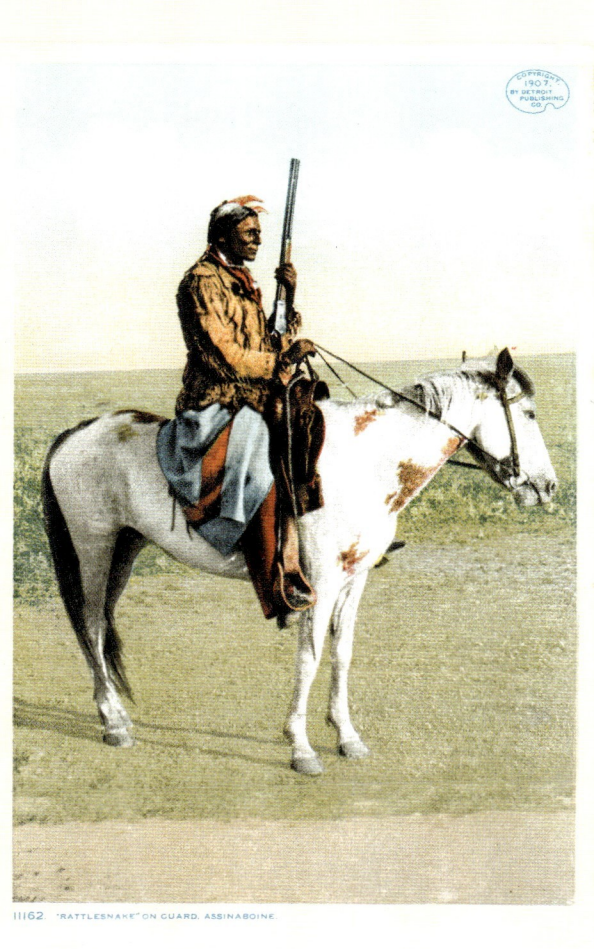
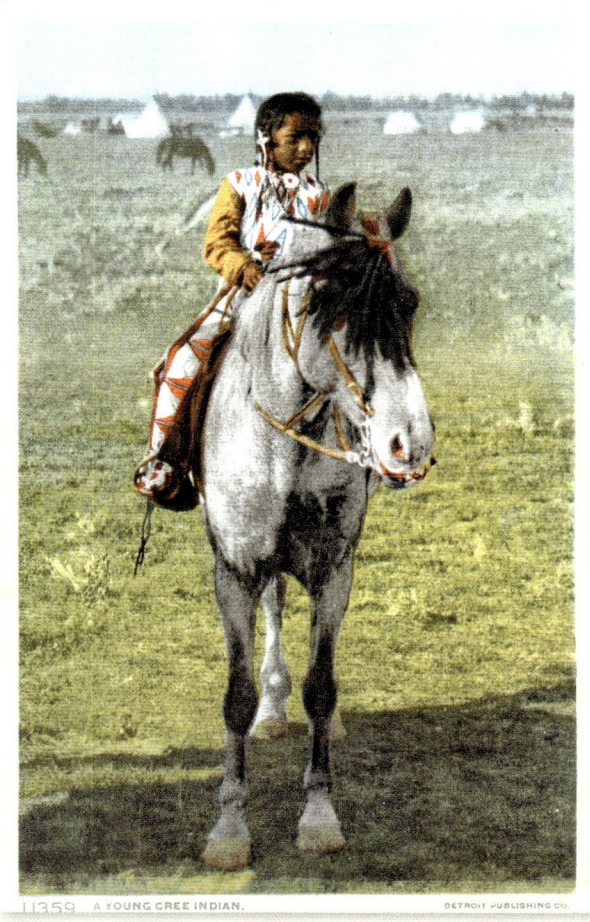
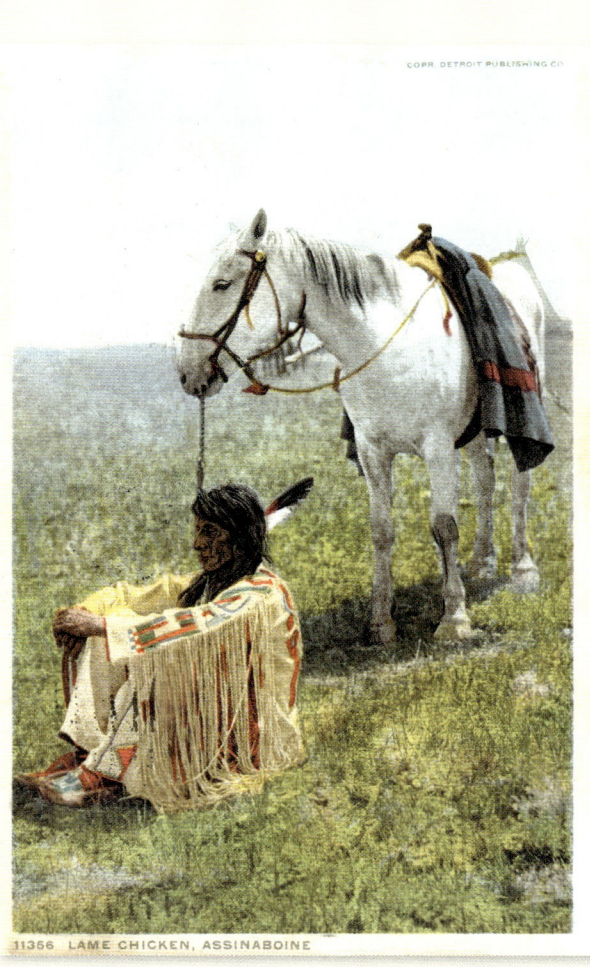

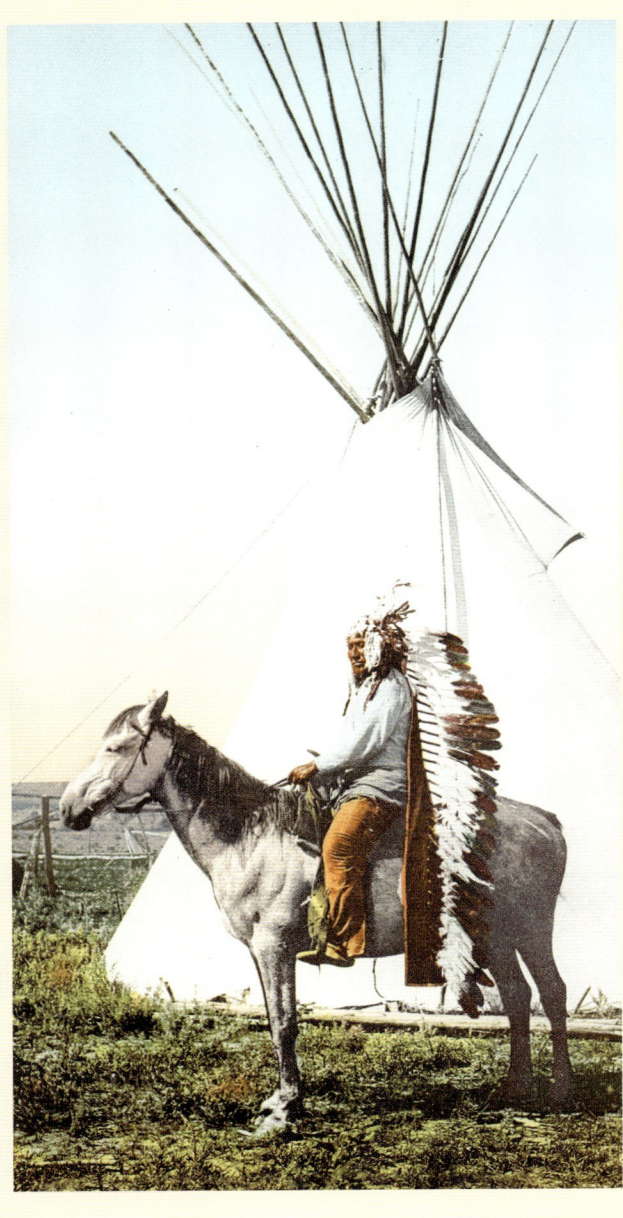
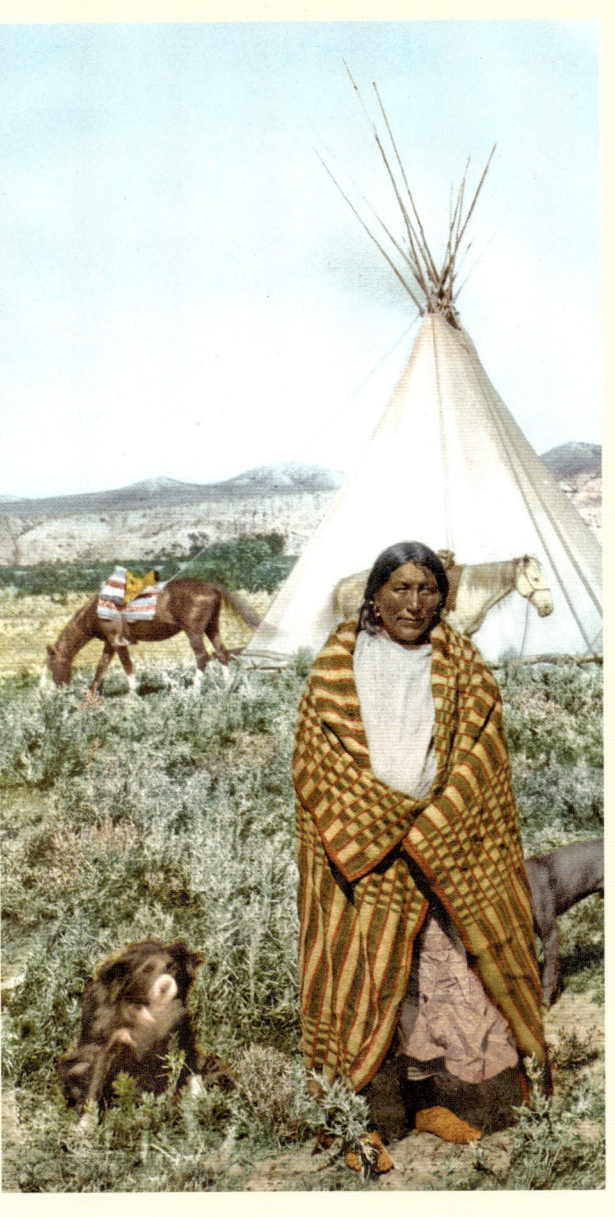

Far left: Pretty Old Man, Crow Indian, photochrom
Near left: A Crow Indian, photochrom
Below, from left to right:
Bo-Ni-To, a White Mountains Apache government scout, postcard
An Apache chief in camp, postcard
Buffalo Calf, Jicarilla Apache, Arizona, postcard
Page 505: Apache Chief James A. Garfield, photochrom
Page 506/507: Chief Sevara and family, Utes, photochrom

Links außen: Pretty Old Man, Crow-Indianer, Photochrom
Links: Crow-Indianer, Photochrom
Unten, von links nach rechts:
Bo-Ni-To, Apache aus den White Mountains, Regierungs-Scout, Postkarte
Häuptling der Apachen vor seinem Tipi, Postkarte
Buffalo Calf, Jicarilla-Apache, Arizona, Postkarte
Seite 505: Apachen-Häuptling James A. Garfield, Photochrom
Seite 506/507: Häuptling Sevara und seine Familie, Ute-Indianer, Photochrom

À gauche: Pretty Old Man, Indien Crow, photochrome
Ci-contre: Indien Crow, photochrome
En bas, de gauche à droite :
Bo-Ni-To, Apache des White Mountains, scout du Gouvernement, carte postale
Chef apache devant son tipi, carte postale
Buffalo Calf, Jicarilla Apache, Arizona, carte postale
Page 505 : le chef apache James A. Garfield, photochrome
Pages 506/507 : le chef Sevara et sa famille, Utes, photochrome

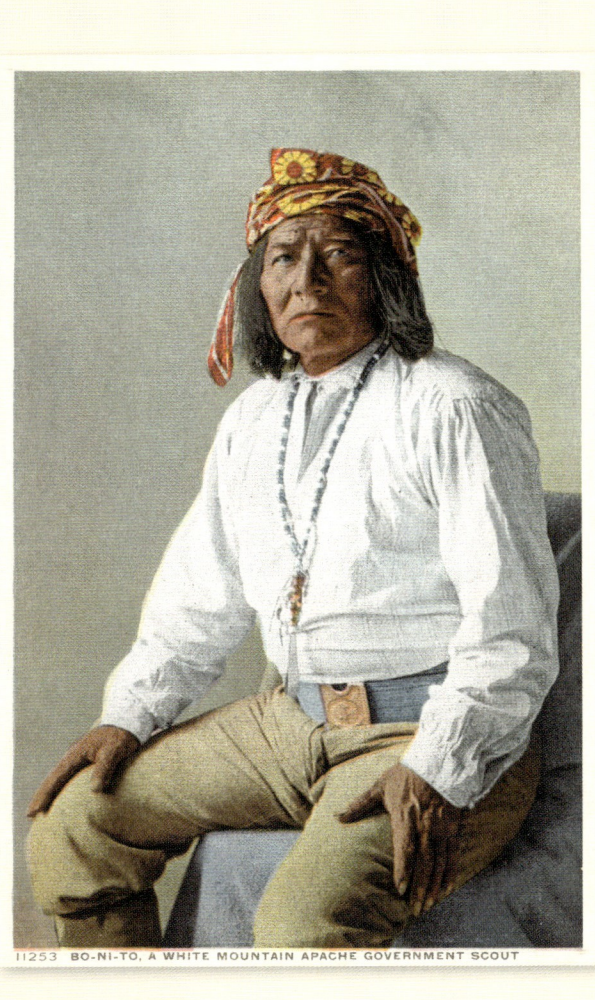
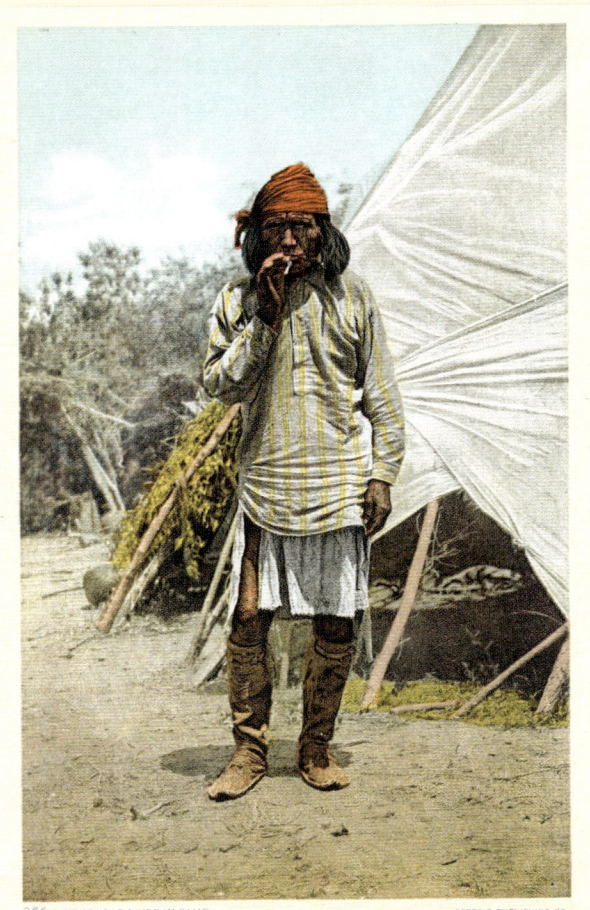
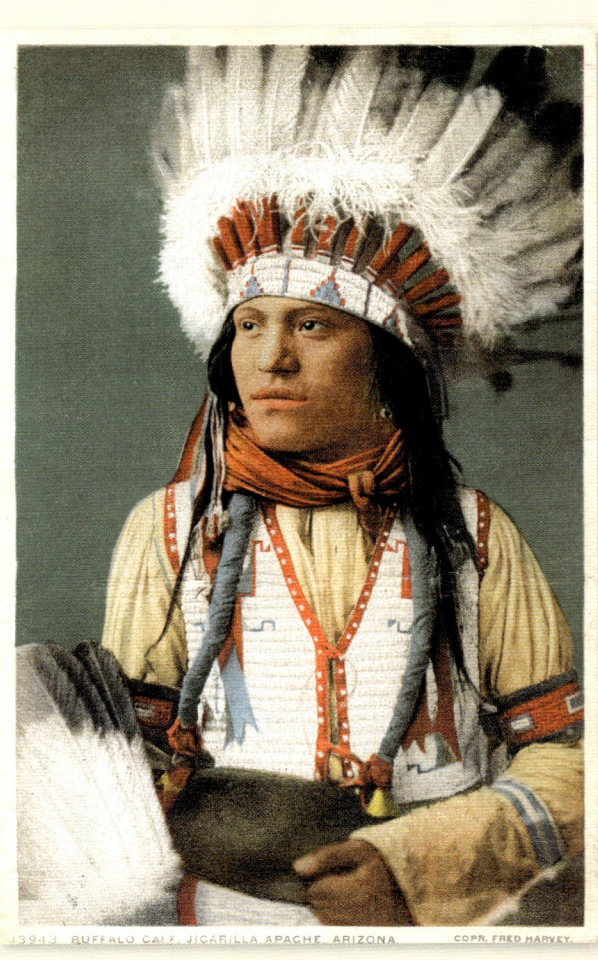

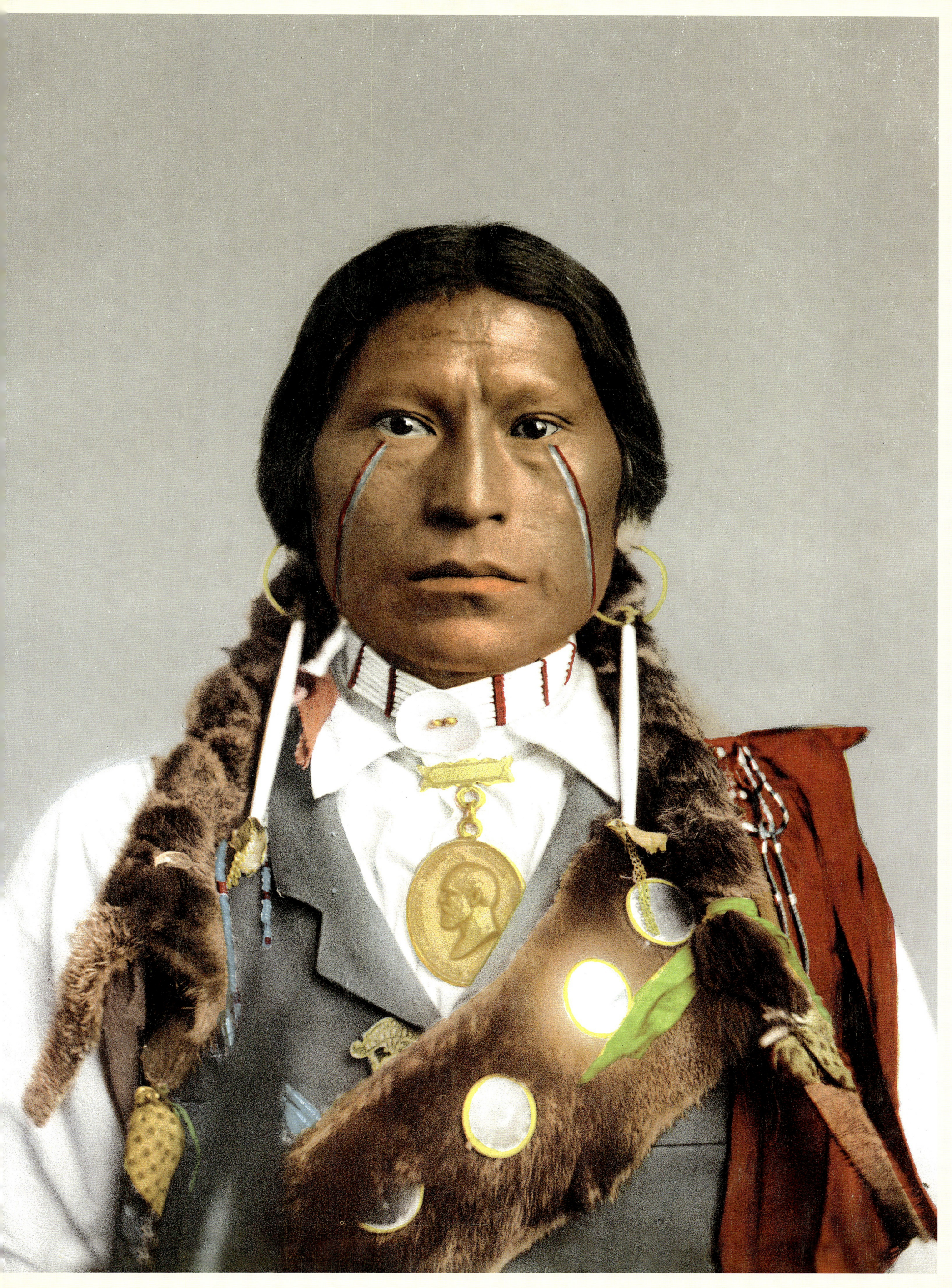

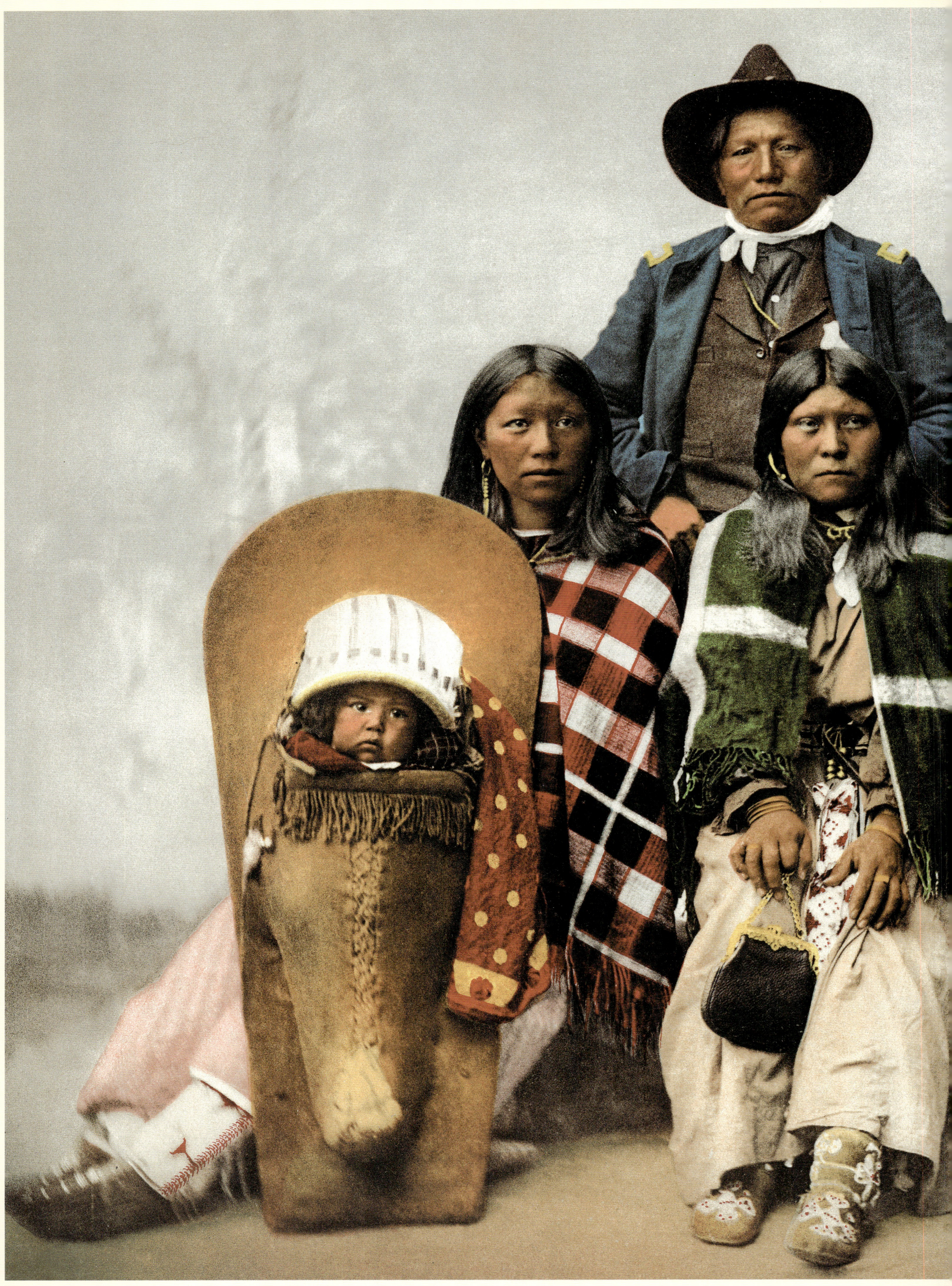

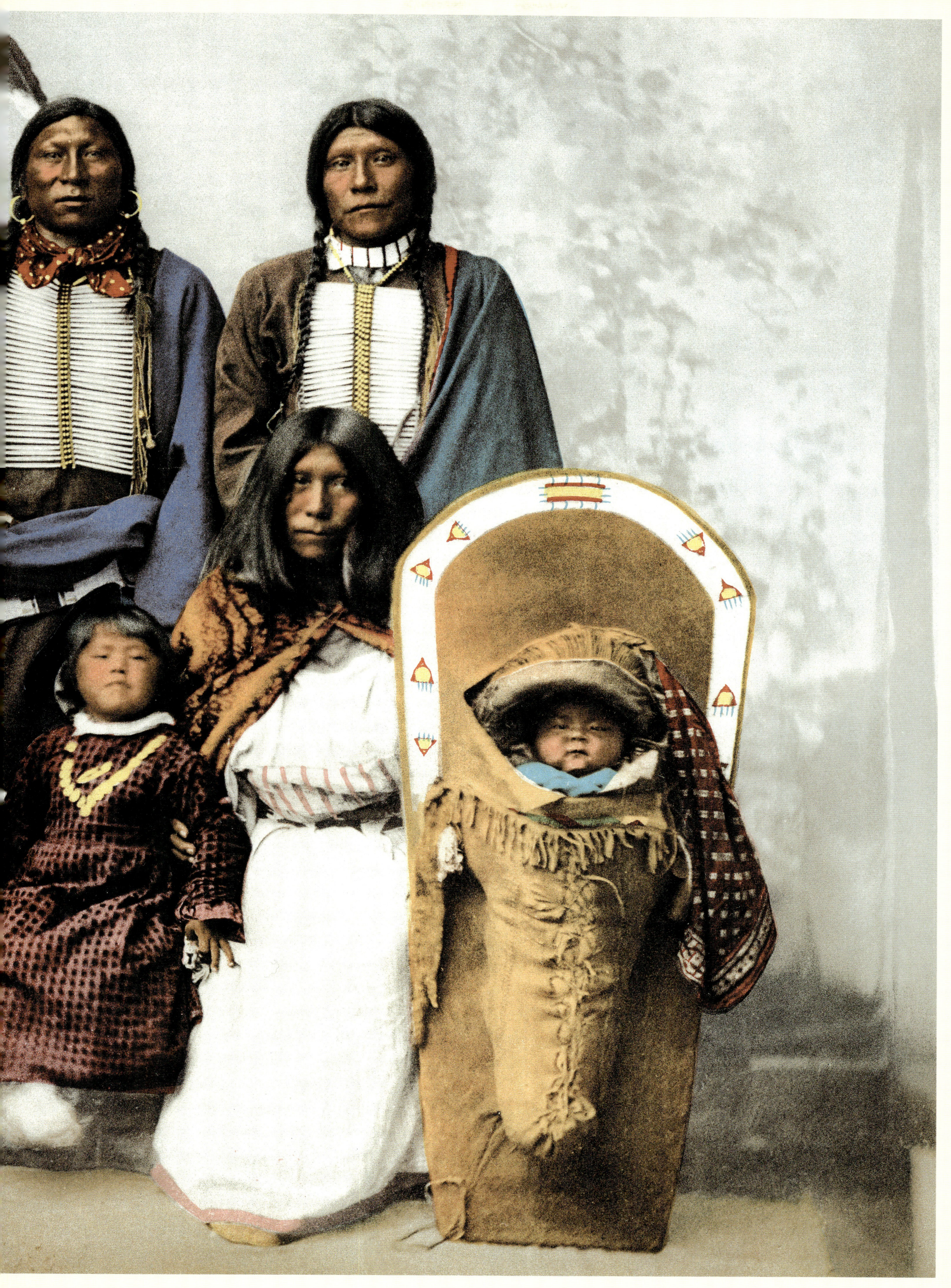

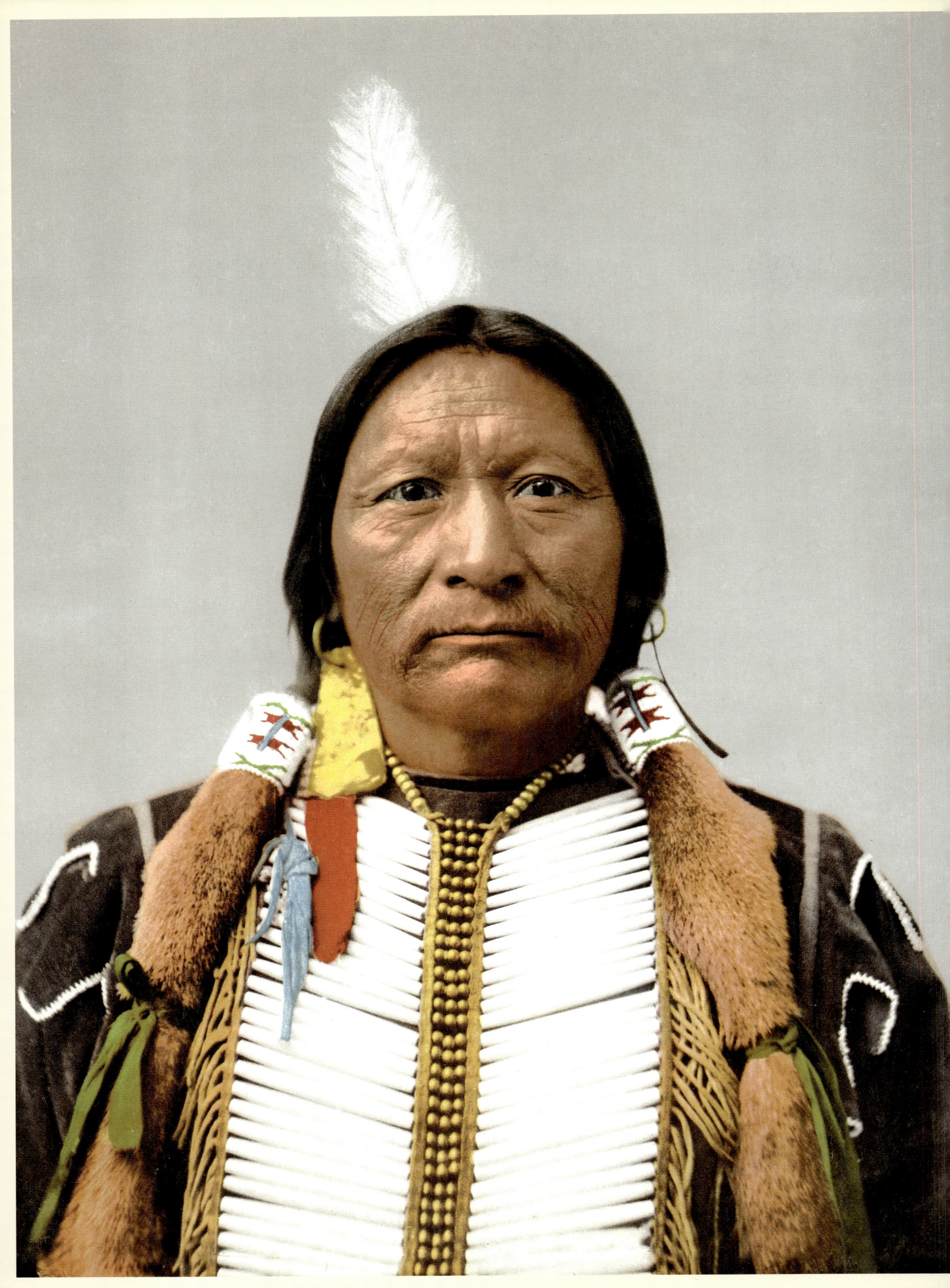

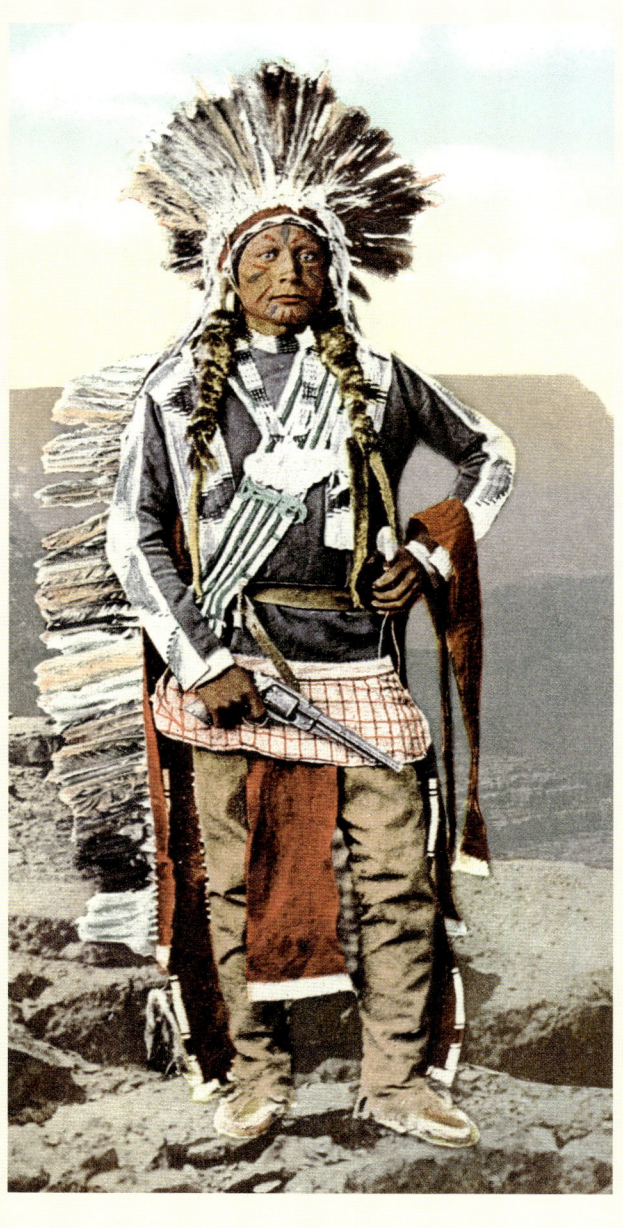
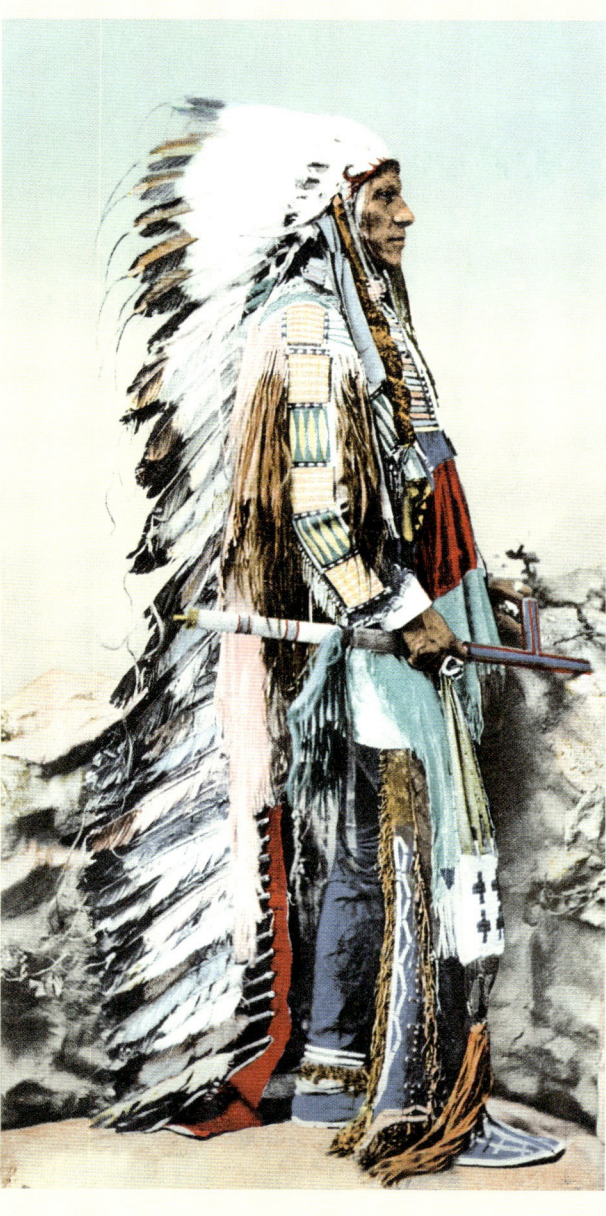

Page 508: Buckskin Charlie, sub chief of the Utes, photochrom
Far left: Ute chief in war bonnet, photochrom
Near left: American Horse, Ogallala chief, Colorado, photochrom
Bottom left: Ignacio High Chief, Ute Indian, photochrom
Bottom right: Pedro, Ute brave, photochrom
Page 510: Jose Romero and family, Ute, photochrom
Page 511: Group of children, Ute, photochrom

Seite 508: Buckskin Charlie, stellvertretender Ute-Häuptling, Photochrom
Links außen: Häuptling der Ute mit Kriegskopfschmuck, Photochrom
Links: American Horse, Ogallala-Häuptling, Colorado, Photochrom
Unten links: Oberhäuptling Ignacio, Ute-Indianer, Photochrom
Unten rechts: Pedro, tapferer Ute, Photochrom
Seite 510: José Romero und seine Familie, Ute-Indianer, Photochrom
Seite 511: Gruppe von Ute-Kindern, Photochrom

Page 508: Buckskin Charlie, sous-chef Ute, photochrome
À gauche: chef Ute en coiffe de guerre, photochrome
À droite: American Horse, chef Ogallala, Colorado, photochrome
En bas à gauche: grand chef Ignacio, Indien Ute, photochrome
En bas à droite: Pedro, brave Ute, photochrome
Page 510: Jose Romero et sa famille, Utes, photochrome
Page 511: groupe d'enfants Utes, photochrome

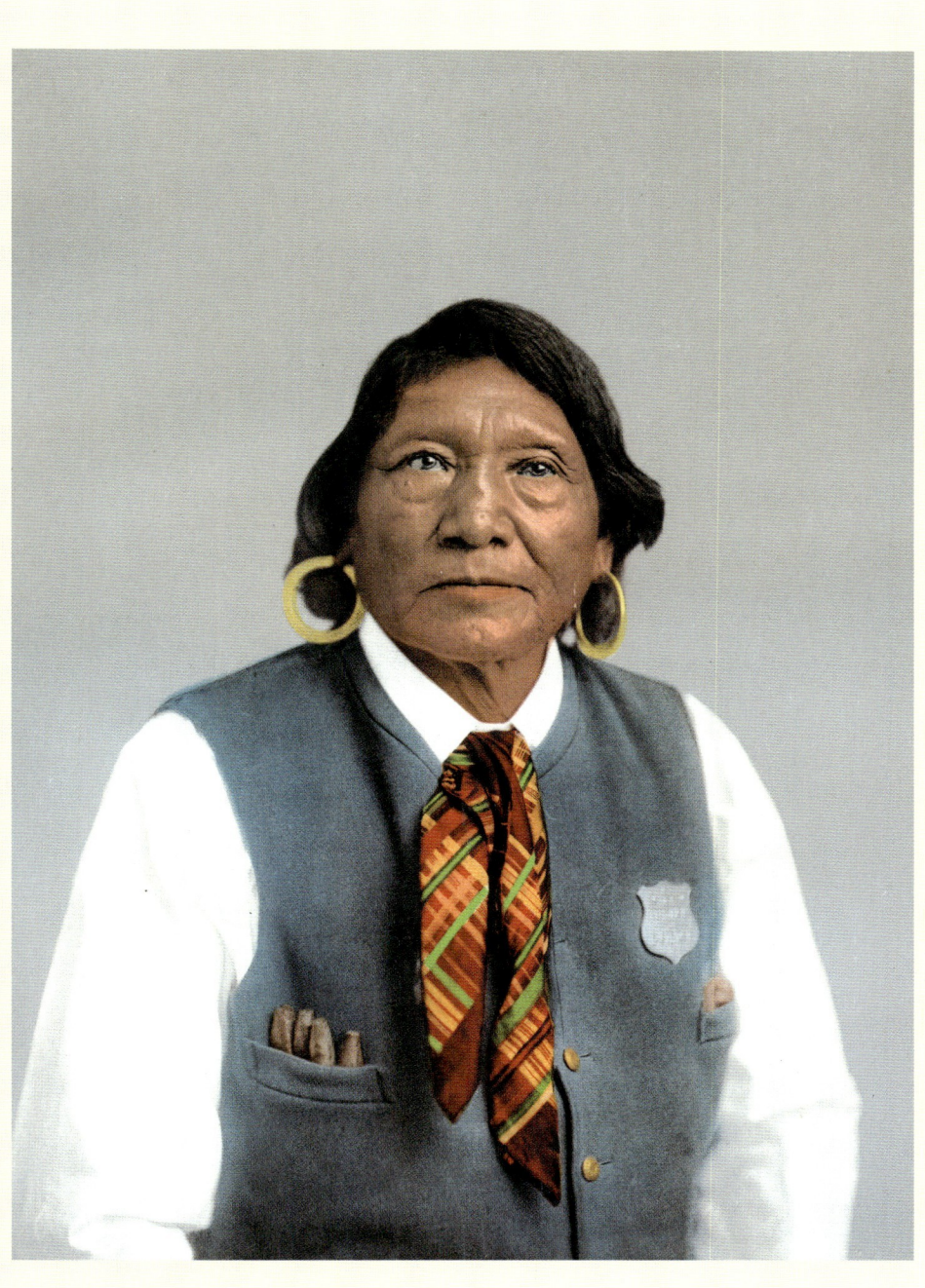
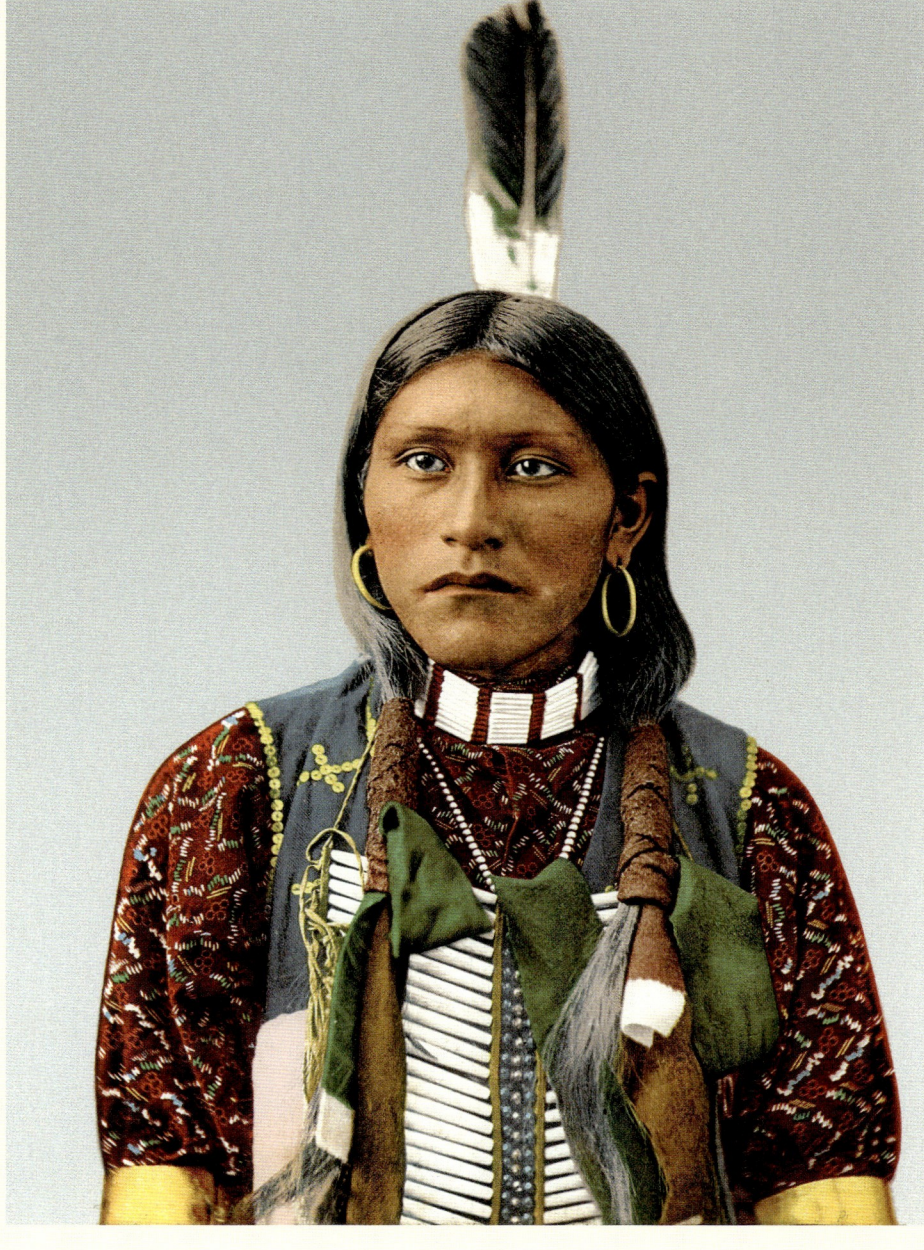

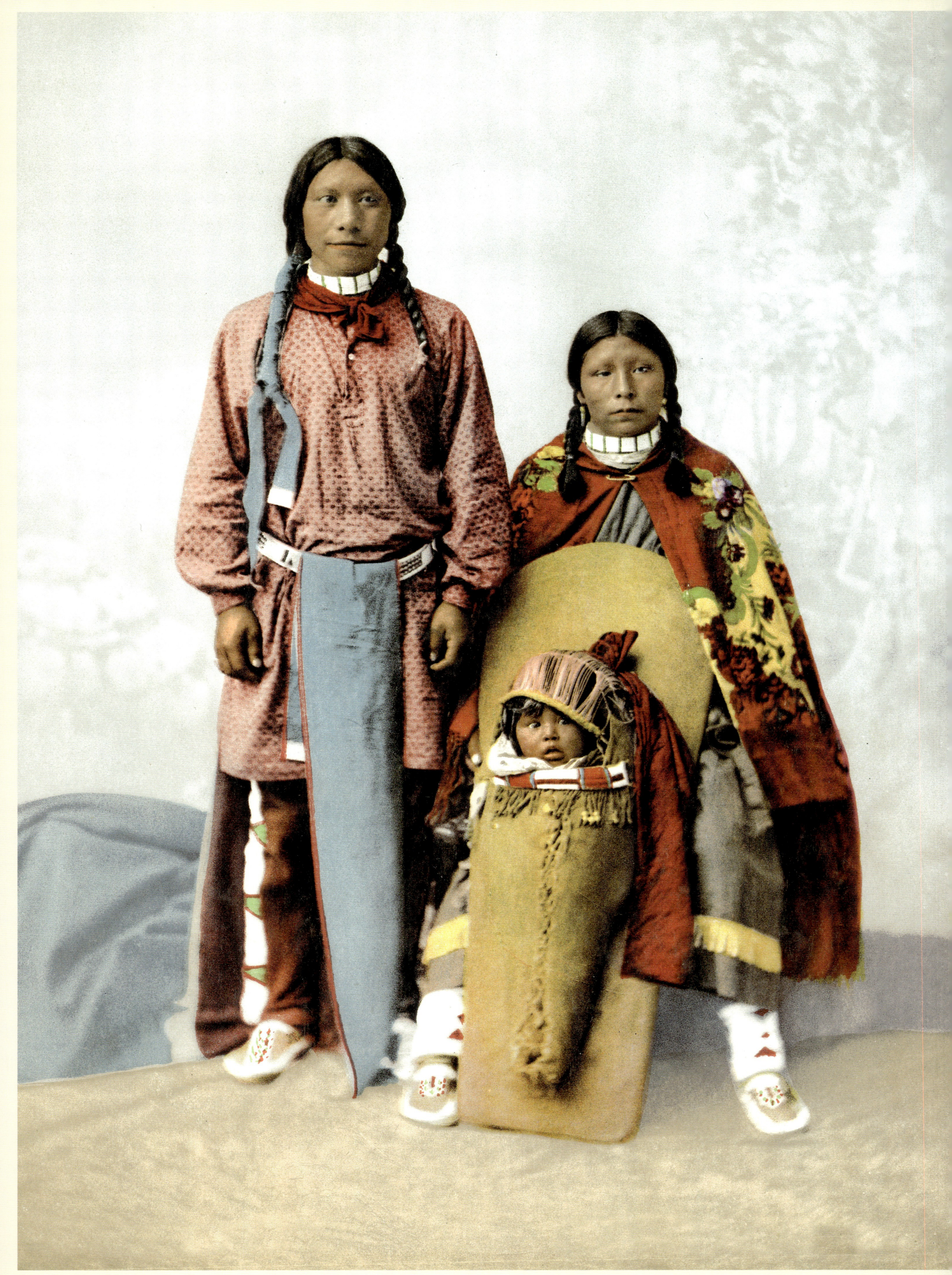

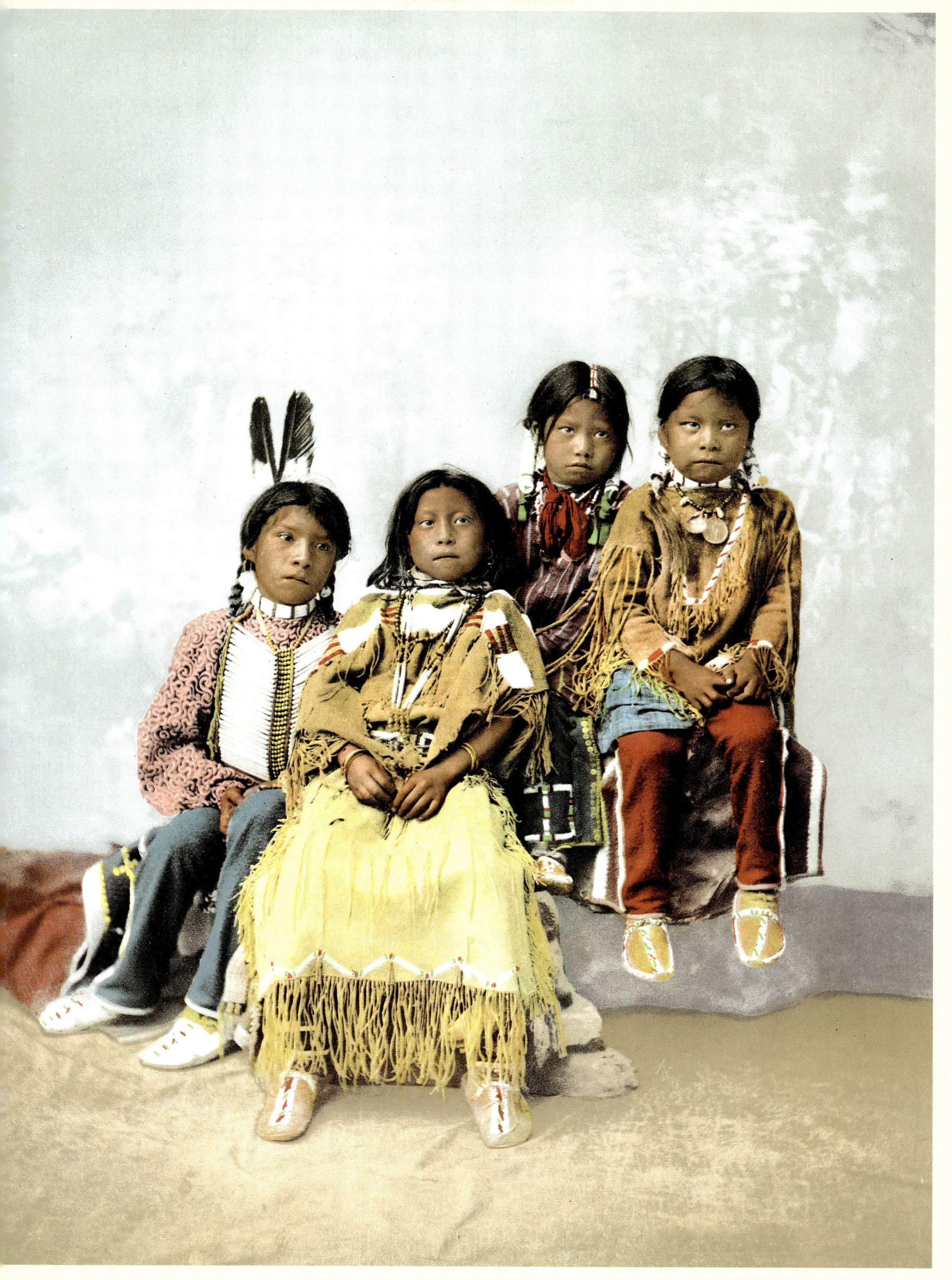

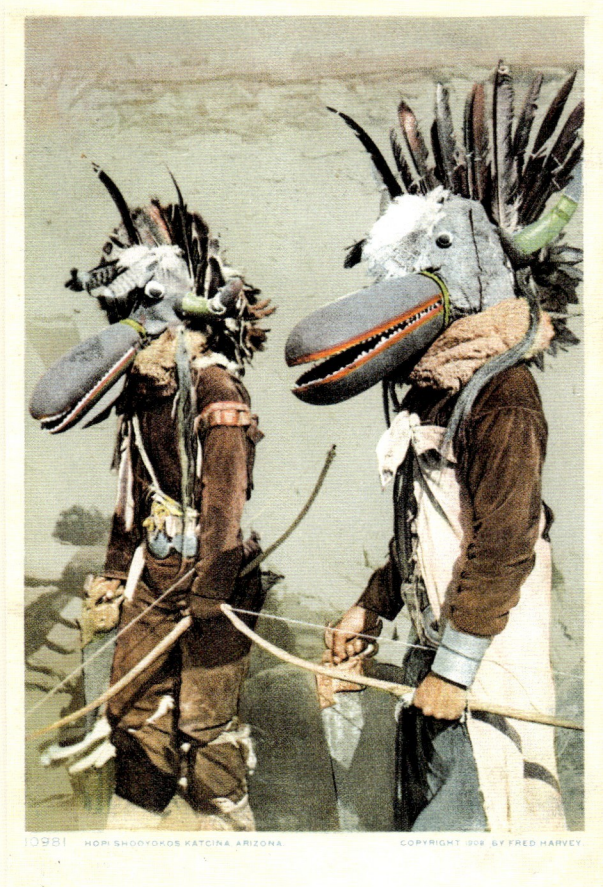 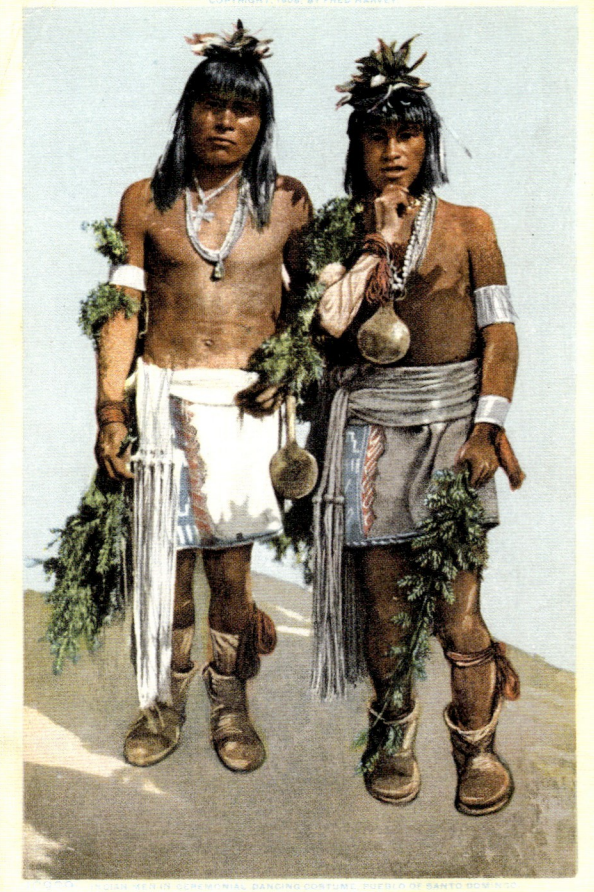 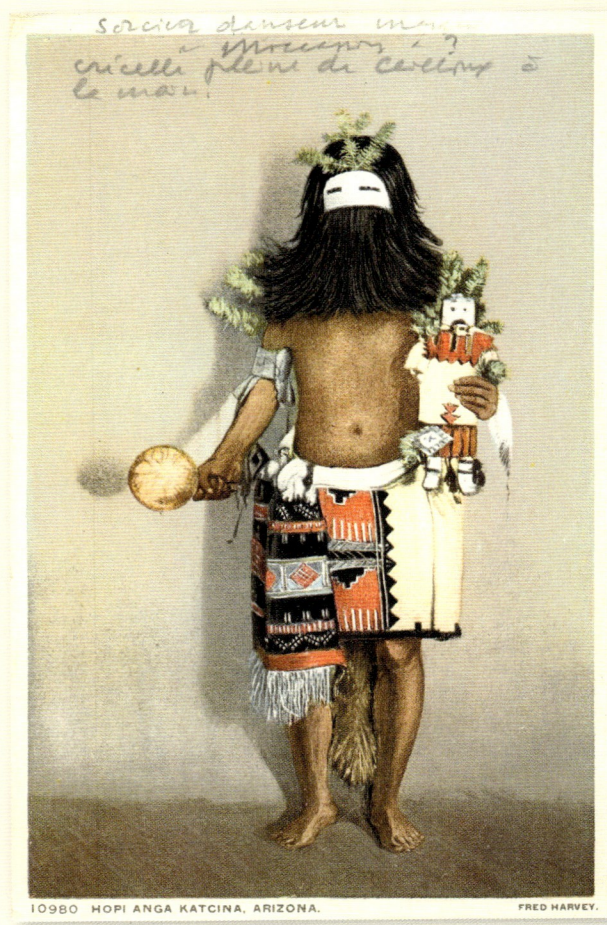

Top, from left to right:
Hopi "Shooyokos" Katcina [Spirit], postcard
Pueblo Indians in ceremonial dancing costume, pueblo of Santo Domingo, New Mexico, postcard
Hopi "Anga" Katcina [Spirit], postcard
Bottom: Hopi Harvest Dance, postcard
Page 513: Taqui, a Hopi (Moki) Snake Priest, photochrom
Page 514: Indian woman of Isleta pueblo, photochrom
Page 515, from left to right and top to bottom:
Hopi (Moki) women cooking, photochrom
A Navajo blanket weaver, photochrom
Hopi (Moki) basket weaver, photochrom

The Indians of the southwest United States (New Mexico, and southern Arizona and Colorado)—the Hopis, Mokis, Taos, Zunis, Tacomas and others—belong to the Pueblo group. They were heirs to a culture imported from the south (the Aztec civilization) based on agriculture and in particular the cultivation of maize: "Indian corn." The Pueblo culture, represented for example at Mesa Verde (Colorado), reached its culminating point in the 13th century. It was already in a decadent phase, "for reasons still unknown" (Claude Fohlen) when the Spanish discovered it in the 16th century. The daily life of the Pueblos was structured by ancestral religious beliefs though these came to be leavened by some Christian practices: The Thanksgiving Dance clearly announces its origins. Their ceremonial life took various forms: prayers, offerings, visions, and dance. The wearing of sacred masks is linked to the cults of the blessed spirits: the *Kachinas* (or *Katcinas*).

Oben, von links nach rechts:
Personifizierung des Hopi-Geistes „Shooyokos", Postkarte
Pueblo-Indianer in ritueller Tanzbekleidung, Pueblo Santo Domingo, New Mexico, Postkarte
Personifizierung des Hopi-Geistes „Anga", Postkarte
Unten: Hopi Harvest Dance (Erntetanz), Postkarte
Seite 513: Taqui, Hopi-(Moki-)Schlangenpriester, Photochrom
Seite 514: Pueblo-Indianerin aus dem Pueblo Isleta, Photochrom
Seite 515, von links nach rechts und von oben nach unten:
Hopi-(Moki-)Frauen beim Kochen, Photochrom
Navajo-Indianerin beim Weben einer Decke, Photochrom
Hopi-(Moki-)Frau beim Korbflechten, Photochrom

Die Hopi, Moki, Tao, Zuni, Tacoma und anderen Indianer aus dem Südosten der Vereinigten Staaten – aus New Mexico sowie dem Süden Arizonas und Colorados – gehören zur Gruppe der Pueblo-Indianer. Sie sind die Erben einer aus dem Süden eingeführten Kultur (der aztekischen Kultur), die auf Ackerbau und Landwirtschaft – insbesondere dem Anbau von Mais – beruht. Die Pueblo-Kultur, die sich beispielsweise in den Höhlenbehausungen von Mesa Verde (Colorado) zeigt, erreichte um das 13. Jahrhundert ihren Höhepunkt. Als die Spanier sie im 16. Jahrhundert entdeckten, erlebten sie bereits „aus noch unbekannten Gründen" ihren Niedergang (Claude Fohlen). Der Alltag der Pueblo-Indianer ist geprägt von althergebrachten religiösen Glaubensformen unter Beimischung christlicher Praktiken: Der Thanksgiving Dance offenbart deutlich seinen Ursprung. Bei den Pueblo-Indianern gibt es unterschiedliche zeremonielle Formen wie Gebete, Opfergaben, Visionen oder Tänze. Die heiligen Masken werden im Zusammenhang mit dem Kult der guten Geister, der *Kachinas*, getragen.

En haut, de gauche à droite :
Personnification de l'esprit Hopi « Shooyokos », carte postale
Indiens Pueblos en costume de danse rituelle, village de Santo Domingo, Nouveau-Mexique, carte postale
Personnification de l'esprit Hopi « Anga », carte postale
En bas : Hopi Harvest Dance (danse de la récolte), carte postale
Page 513 : Taqui, prêtre Hopi (Moki) de la Snake Dance (danse du Serpent), photochrome
Page 514 : Indienne Pueblo du village d'Isleta, photochrome
Page 515, de gauche à droite et de haut en bas :
Femmes Hopis (Moki) cuisinant, photochrome
Indienne Navajo tissant une couverture, photochrome
Femme Hopi (Moki) tressant une corbeille, photochrome

Les Indiens du sud-ouest des États-Unis – Nouveau-Mexique, sud de l'Arizona et du Colorado –, Hopis, Mokis, Taos, Zunis, Tacomas, etc., appartiennent au groupe des Pueblos. Ils sont les héritiers d'une culture importée du Sud (civilisation aztèque), fondée sur le travail de la terre – notamment la culture du maïs (*Indian corn*). La culture Pueblo, représentée par exemple à Mesa Verde (Colorado) dans les habitations troglodytiques, atteignit son apogée vers le XIIIe siècle. Elle était déjà, « pour des raisons encore inconnues », selon l'historien Claude Fohlen, en phase décadente lorsque les Espagnols la découvrirent au XVIe siècle. La vie quotidienne des Pueblos est imprégnée de croyances religieuses ancestrales mâtinées de pratiques chrétiennes : la *Thanksgiving Dance* annonce clairement son origine. Chez les Pueblos, le cérémonial prend des formes diverses : prières, offrandes, visions, danses… Le port de masques sacrés est lié au culte des esprits bienheureux, les *Kachinas*.

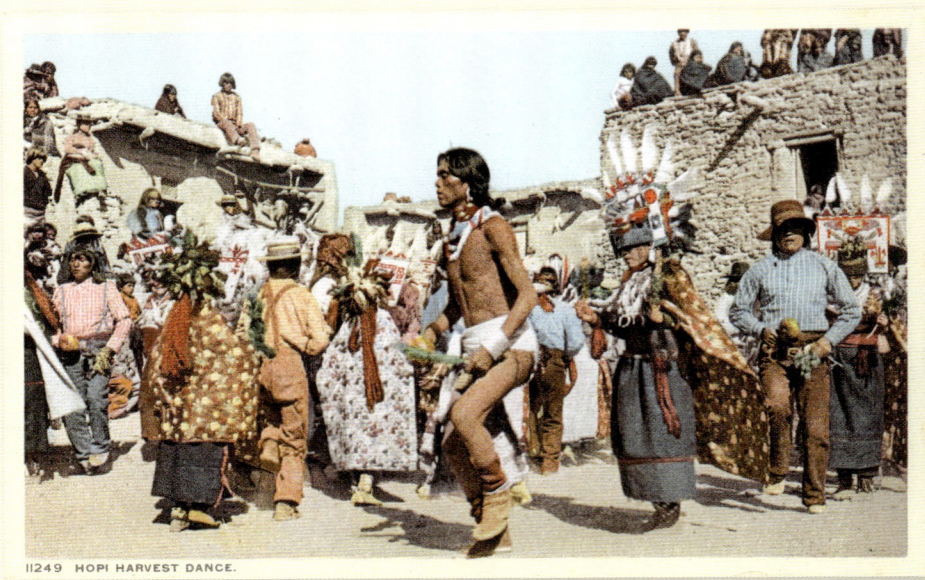

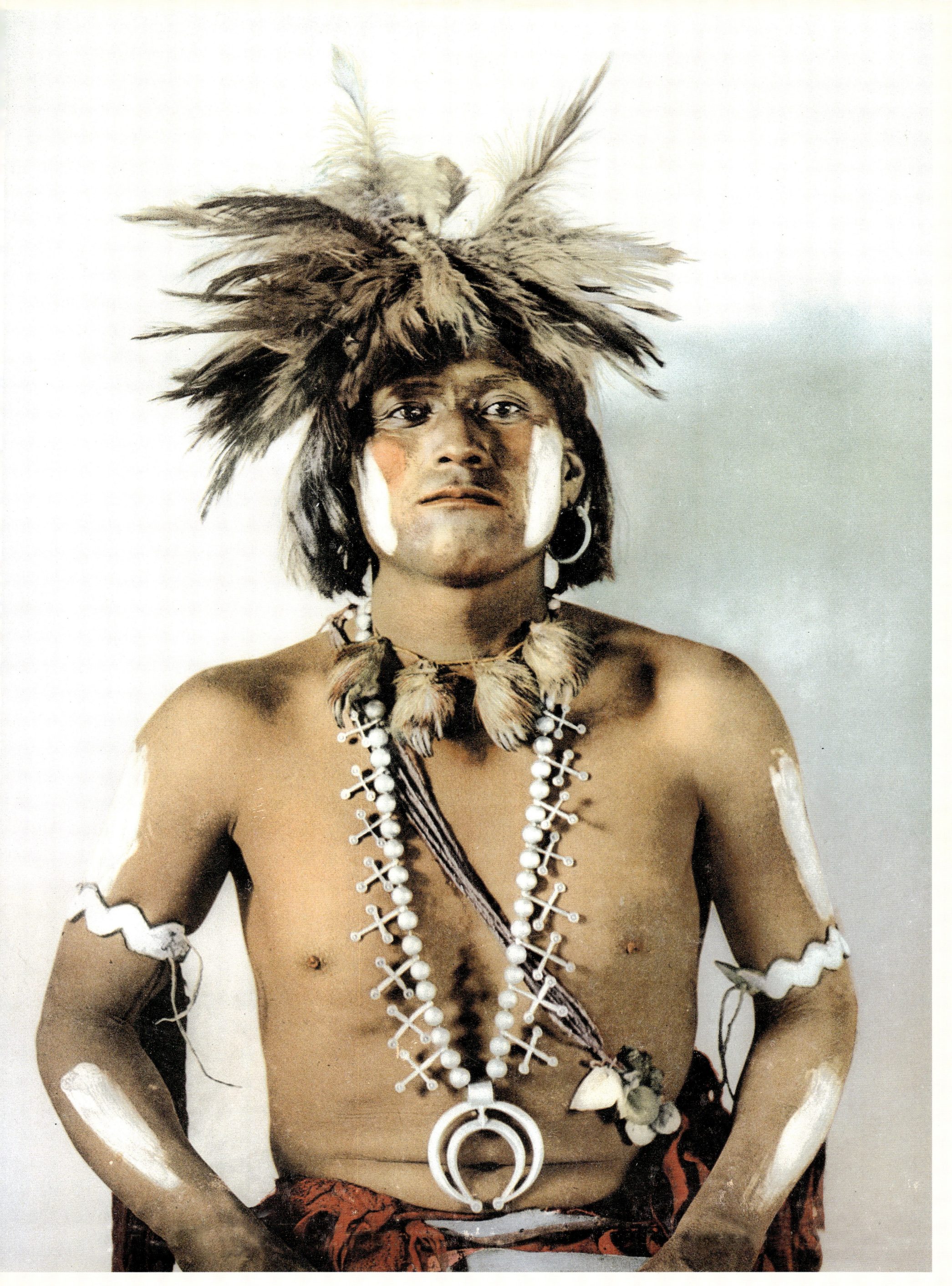

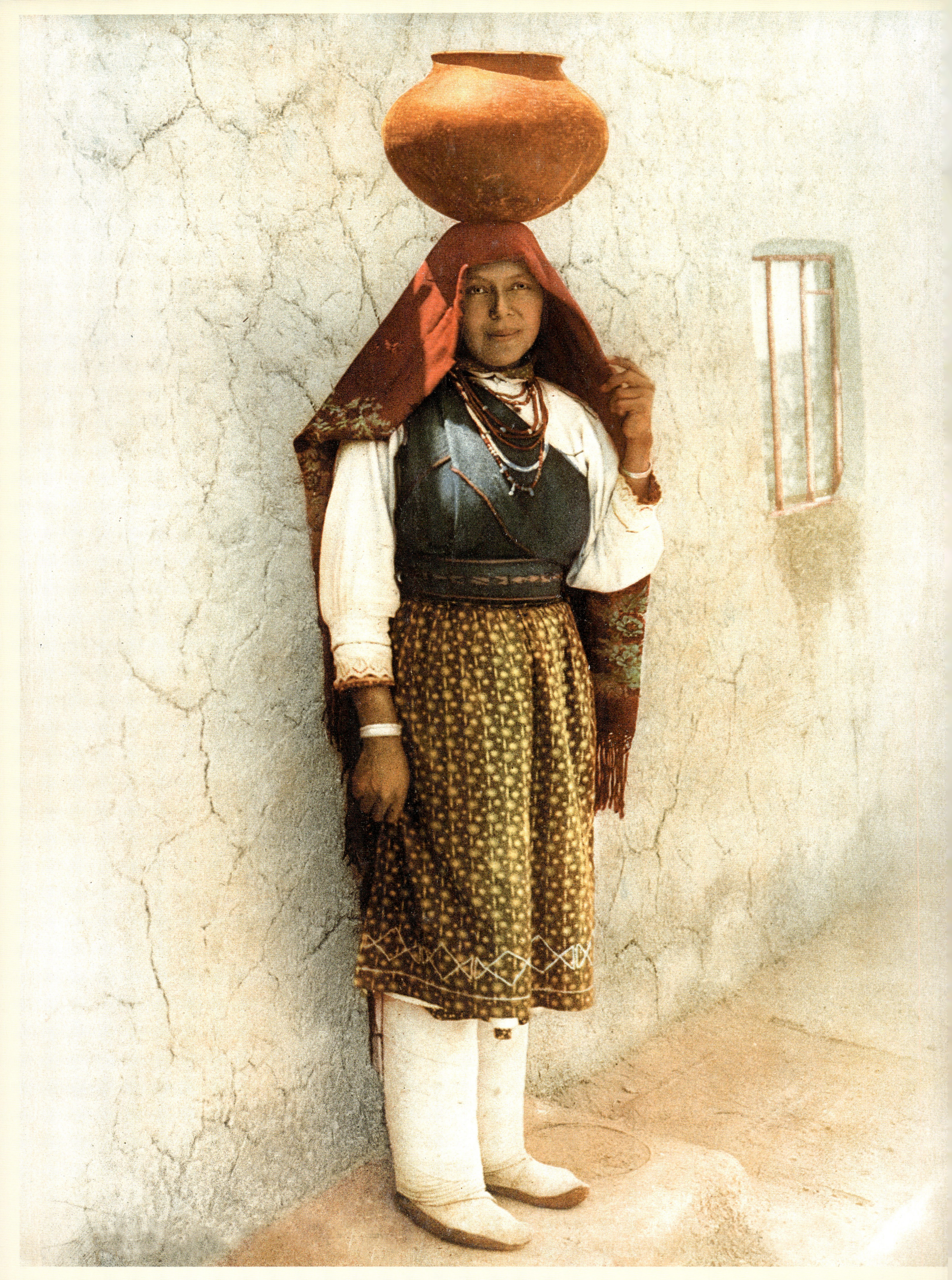

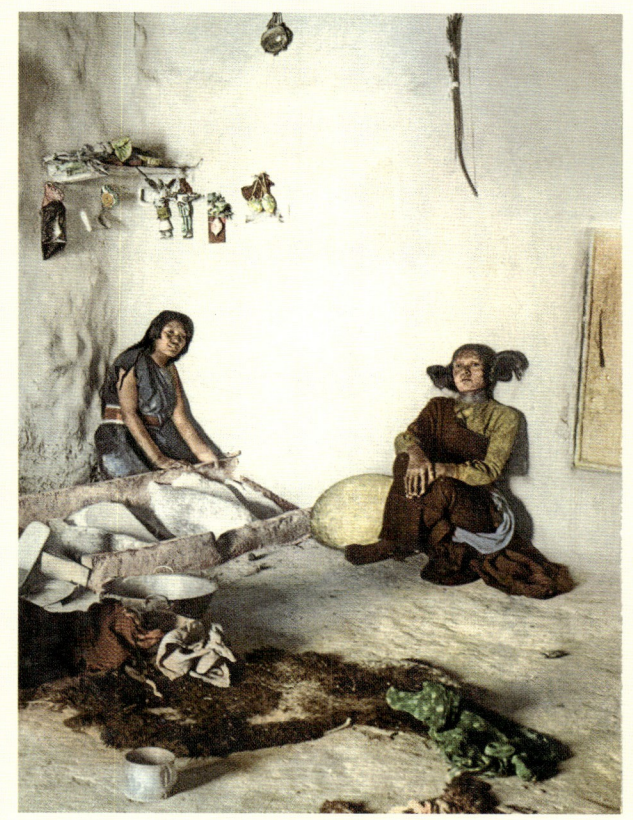
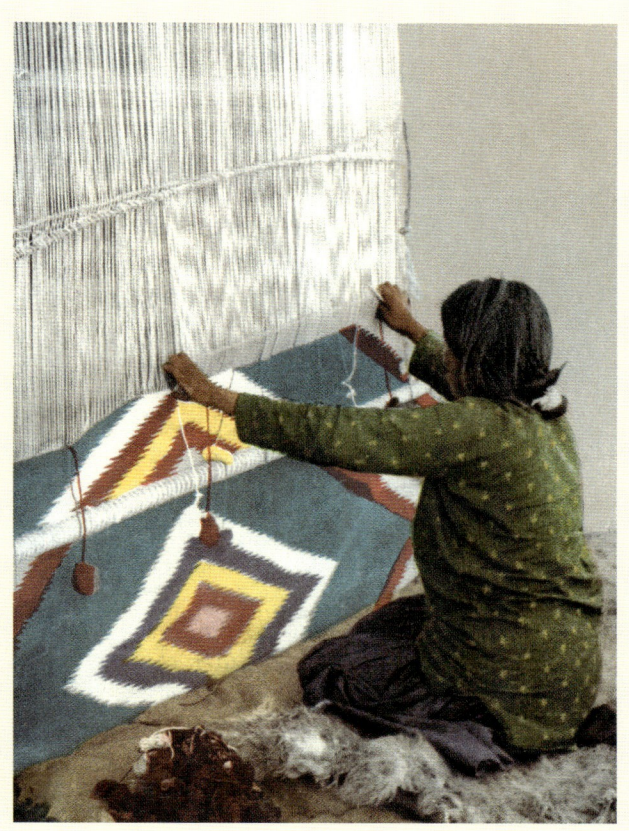

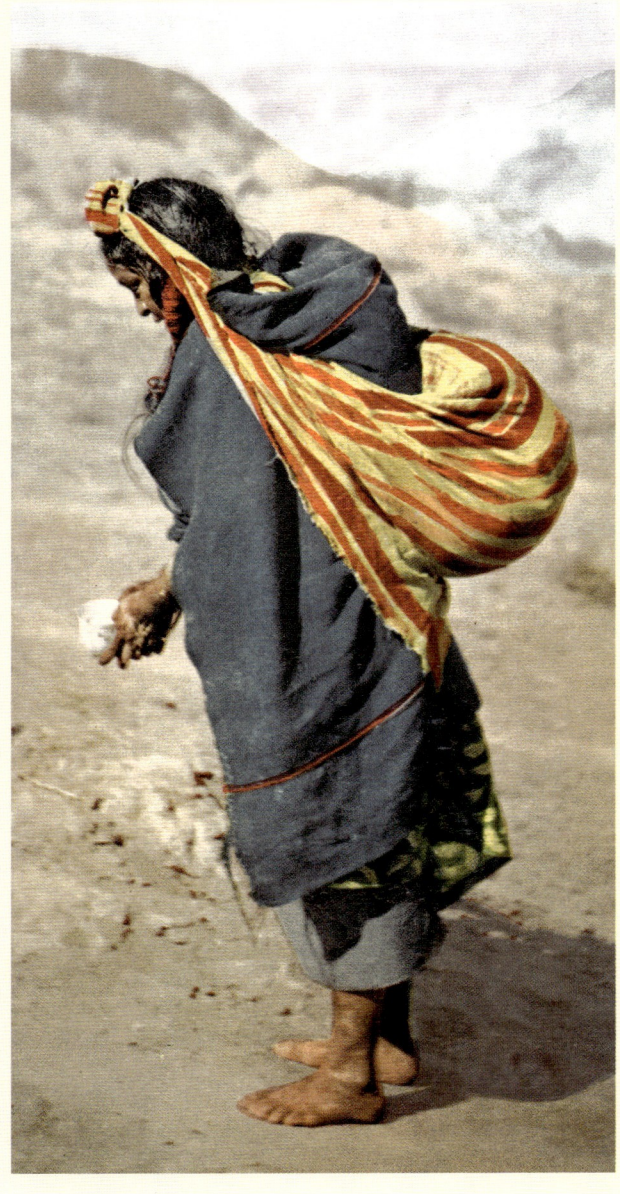 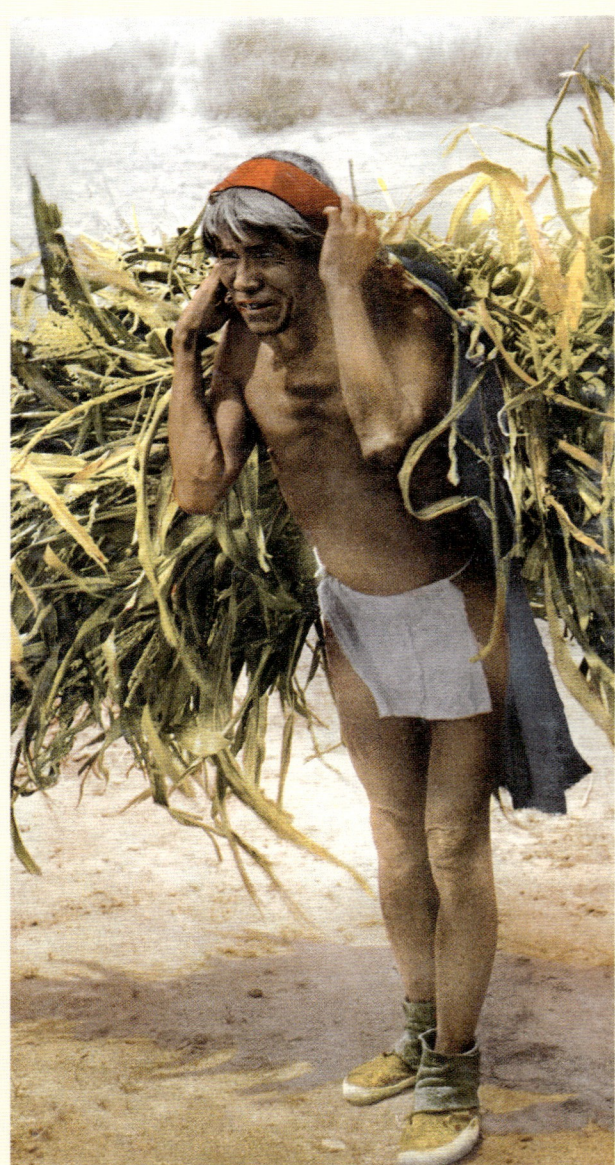 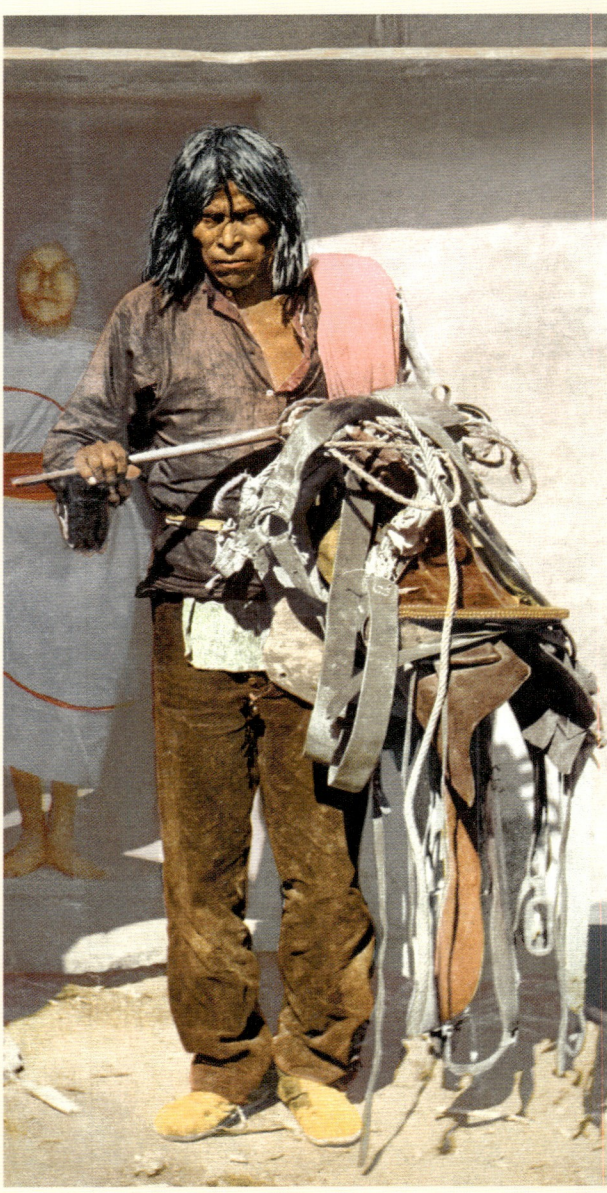

Top, from left to right:
"Patient Toil," Moki Pueblo Indian, photochrom
Bringing in the harvest, Moki Indian, photochrom
A Hopi (Moki) farmer, photochrom
Right: Moki Indian cigarette smoker, postcard
Page 517: Pueblo Indians, Jose Jesus and his wife, photochrom

Oben, von links nach rechts:
„Geduldsspiel", Pueblo-Indianerin vom Stamm der Moki, Photochrom
Ein Hopi-(Moki-)Indianer bringt die Ernte ein, Photochrom
Moki-Bauer, Photochrom
Rechts: Moki-Indianer, eine Zigarette rauchend, Postkarte
Seite 517: Pueblo-Indianer, Jose Jesus und seine Frau, Photochrom

En haut, de gauche à droite :
« Un jeu de patience », Indienne Moki Pueblo, photochrome
Indien Hopi (Moki) portant la récolte, photochrome
Fermier Moki, photochrome
À droite : Indien Moki fumant une cigarette, carte postale
Page 517 : Indiens Pueblos, Jose Jesus et sa femme, photochrome

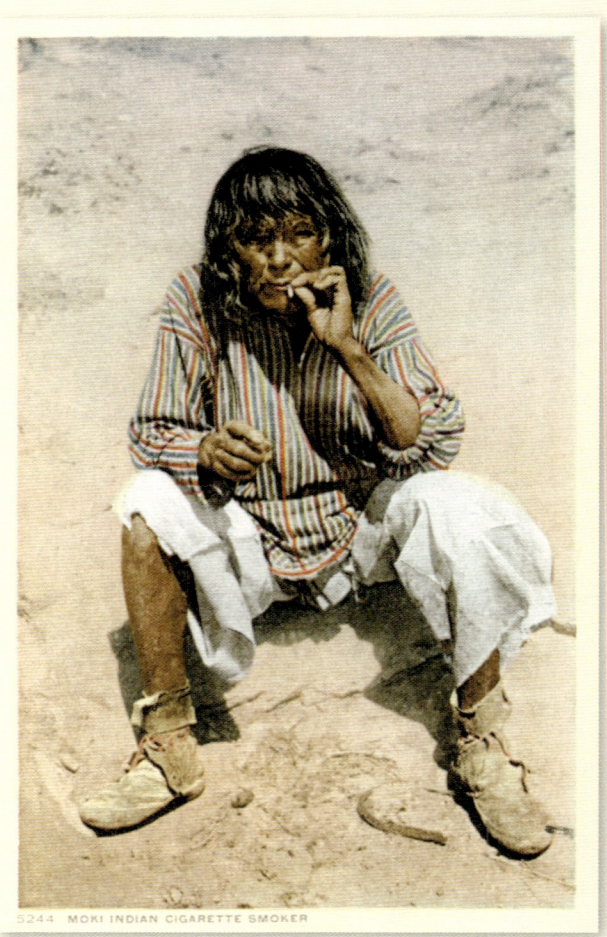

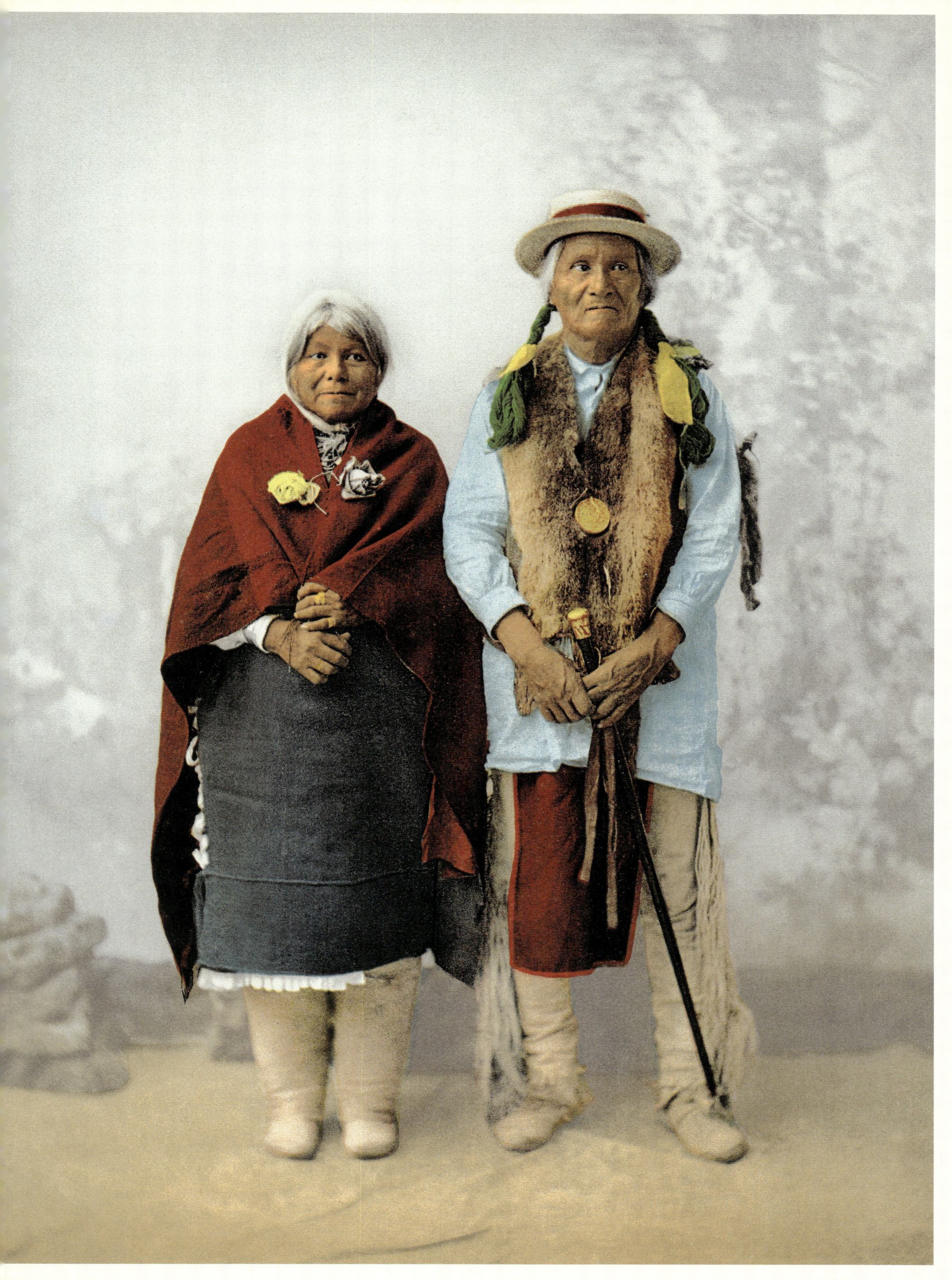

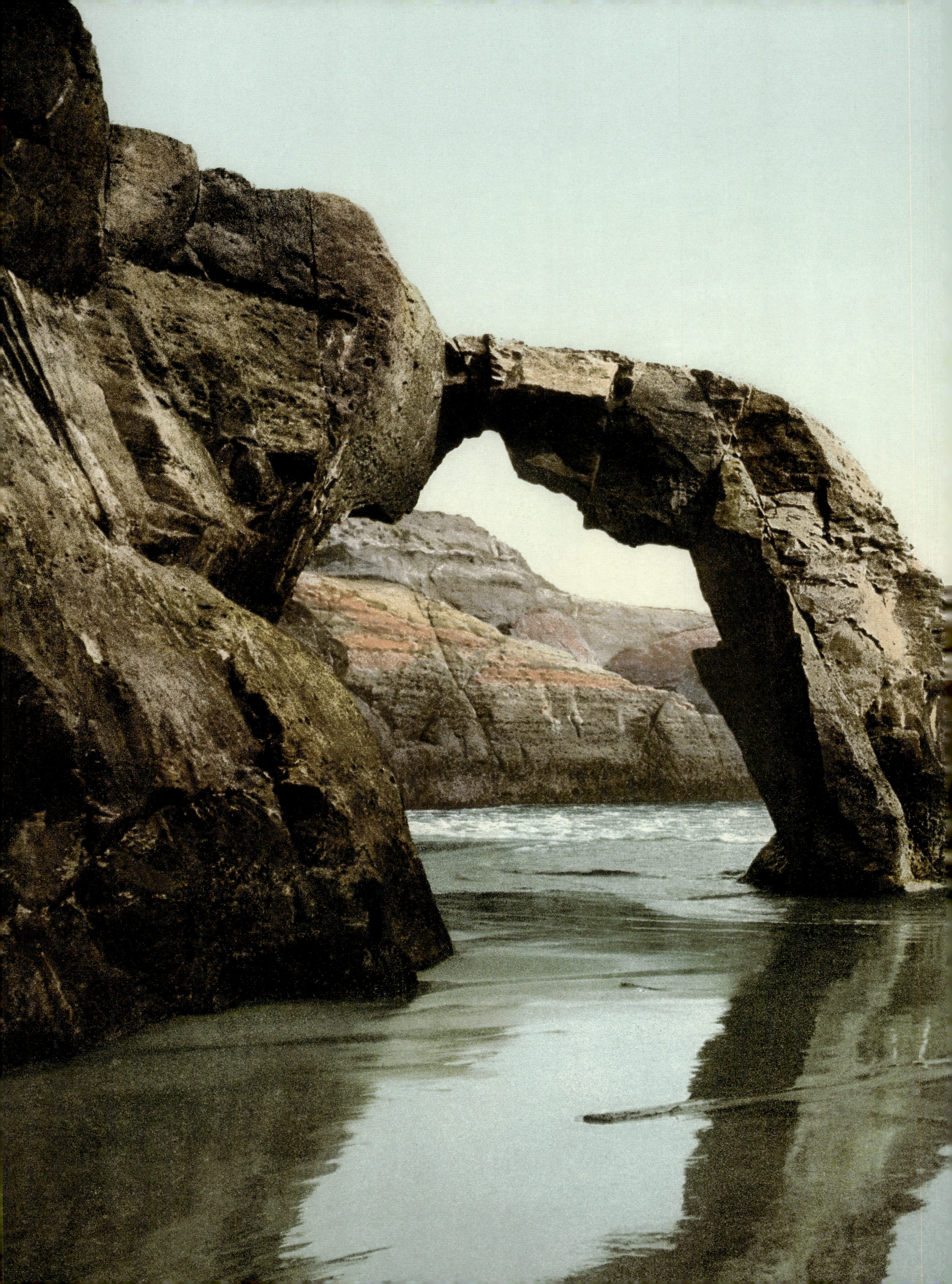

THE PACIFIC COAST

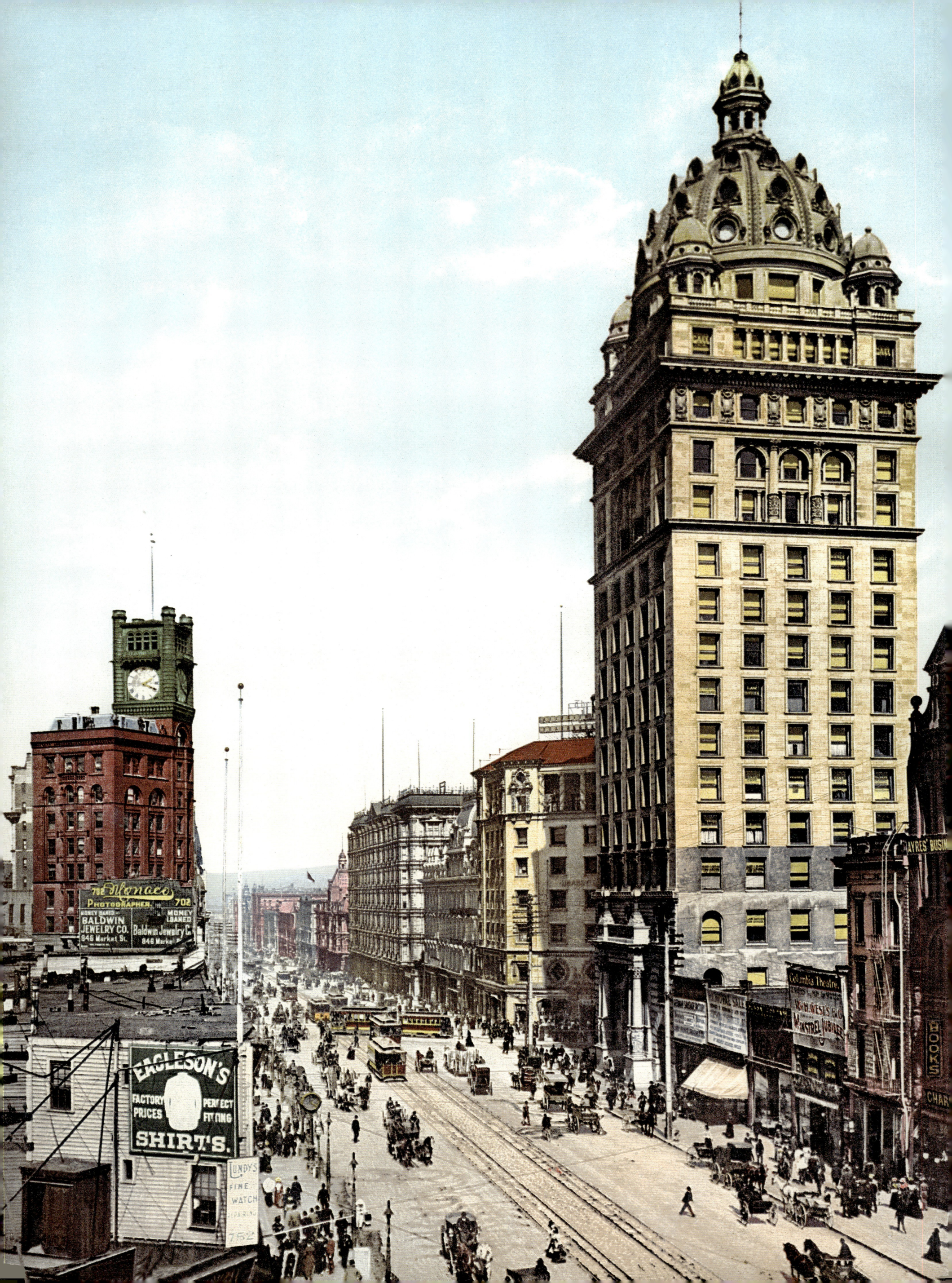

Page 518/519: Santa Cruz Arch Rock, California, photochrom
Page 520: Market Street, San Francisco, California, photochrom
Right: Furnace Creek Wash, entrance to Death Valley, California

Seite 518/519: Santa Cruz Arch Rock, Kalifornien, Photochrom
Seite 520: Market Street, San Francisco, Kalifornien, Photochrom
Rechts: Das vulkanische Relief von Furnace Creek am Eingang zum Death Valley (Tal des Todes), Kalifornien

Pages 518/519: l'Arche (Arch Rock) de Santa Cruz, Californie, photochrome
Page 520: Market Street, San Francisco, Californie, photochrome
À droite: le relief volcanique de Furnace Creek à l'entrée de la vallée de la Mort, Californie

THE PACIFIC COAST

On the night of July 31–August 1, 1890, the reporter Edmond Cotteau arrived in Vancouver only six days after having left Montreal on the Trans-Canadian. He had traveled more than 2,300 miles (3,700 km) by train in considerably greater comfort than was available on the American railroad network. The Canadian Pacific Railway (CPR) had been in service for four years and William Cornelius Van Horne, the company's general manager, had kept his promise made to British Columbia in 1871 when he entered the dominion: to link it to the other states of the confederation by a transcontinental railroad. Now not only had the east–west line been established, but the CPR had obtained from the government grants of land that favored settlement. And settlers arrived in ever greater numbers, by railway—and by sea, since, starting in 1891, the CPR had created its own fleet on the two oceans. If one considers just how isolated the West Coast of America was from the North before 1870, this was bordering on the miraculous. We should remember that the east–west railroad link in the United States had not been completed until 1869.

The history of American colonization is that of the "mirage" of the West, of what lay beyond the "frontier": the spoils of an unending battle against a wild, hostile landscape and climate. What drove settlers to cross the Mississippi and risk their lives in the desert regions of the Southwest was, above all, the lure of gold. The Spanish in the 16th century, and subsequently the French, followed the old Indian trails: the Gila Trail from Mexico into Arizona and Lower California, discovered by Francisco Vásquez de Coronado; El Camino Real ("the royal road") taken by the Franciscan Father Junípero Serra, who founded the first California mission in San Diego and a score of others along the coast as far north as San Francisco; and the Santa Fe Trail, which served as a military route during the war against Mexico.

But the great pioneer trails were those of the first half of the 19th century, the Oregon Trail and the California Trail, which skirted around the north of the Rockies. The Oregon Trail effectively followed the route opened by the Lewis and Clark Expedition (1804–6) from St. Louis on the Missouri to the Columbia River and crossed the Mormon Trail, which extended from Wyoming to Salt Lake City. It is thought that, by 1893, as many as 900 people a day took this trail and continued to do so throughout the California and Colorado gold rushes for some 20 years. The California Trail followed the Humboldt River, which crosses what is now the state of Nevada. The first settlers to venture along it were 32 people led by one John Bidwell. They left in 1841 without a guide; they are said to have lost their way in the Sierra Nevada and to have been forced to abandon their wagons and eat their horses in order to survive. Nevertheless, they arrived in the "promised land": California. The "Golden State," richer in wheat, fruit, and oil (which was discovered in the early 20th century) than it ever had been in gold, is today the richest state of the United States.

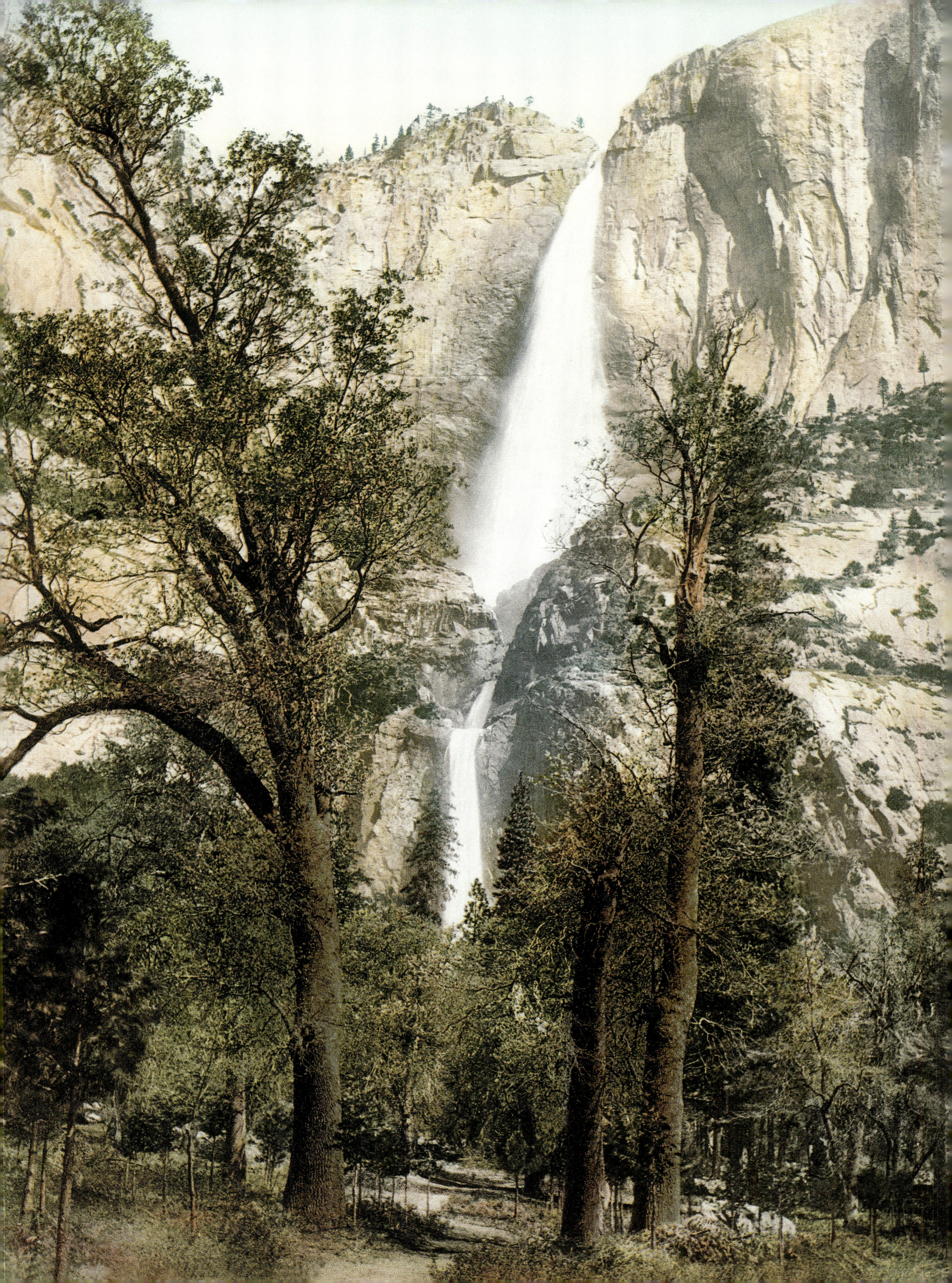

Page 522: Yosemite Falls, Yosemite Valley, California, photochrom
Right: "An oil well in every yard," Los Angeles, California

Seite 522: Die Yosemite-Fälle, Yosemite Valley, Kalifornien, Photochrom
Rechts: „Eine Ölquelle in jedem Hof", Los Angeles, Kalifornien

Page 522 : les chutes de Yosemite, vallée de Yosemite, Californie, photochrome
À droite : « Un puits de pétrole dans chaque cour », Los Angeles, Californie

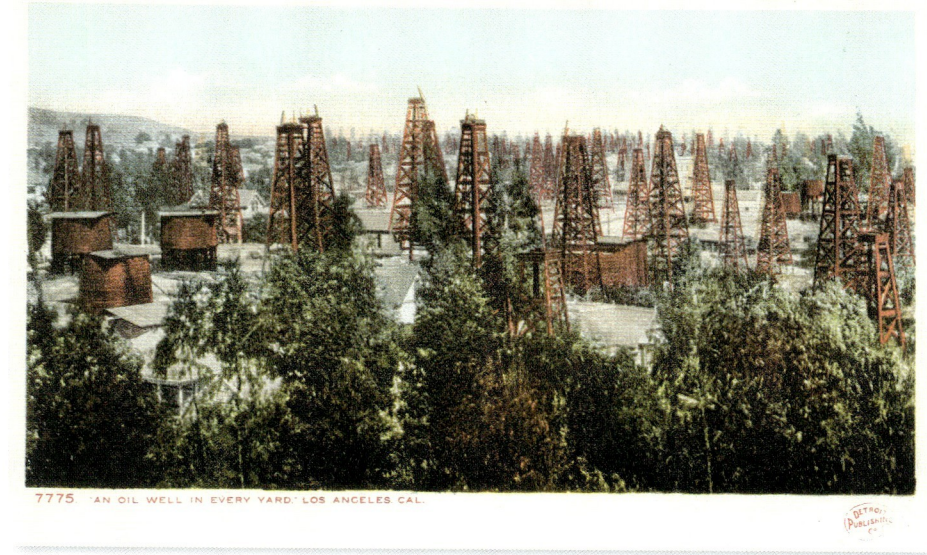

DIE PAZIFIKKÜSTE

In der Nacht vom 31. Juli auf den 1. August 1890 kam der Reporter Edmond Cotteau in Vancouver an, nur sechs Tage, nachdem er Montreal mit dem Trans-Canadian verlassen hatte. Er legte über 3 700 Kilometer mit dem Zug zurück, und zwar mit noch größerem Komfort als auf dem amerikanischen Schienennetz geboten wurde. Die Strecke mit der Canadian Pacific Railway Co. (CPR) war seit vier Jahren in Betrieb, und ihr Generaldirektor William Cornelius Van Horne hatte das Versprechen gehalten, das er 1871, bei seiner Ankunft in der Dominion British Columbia gegeben hatte: nämlich Letztere mit den anderen Staaten der Konföderation durch einen transkontinentalen Schienenverkehr zu verbinden. Und so wurde nicht nur die Ost-West-Verbindung gebaut, sondern die CPR hatte von der Regierung auch Gebiete zugesprochen bekommen, in denen sich Siedler niederlassen konnten. Es kamen immer mehr Siedler, sei es mit der Eisenbahn oder übers Meer, denn ab 1891 setzte die CPR auf beiden Ozeanen eine eigene Schiffsflotte ein. Wenn man bedenkt, wie isoliert die amerikanische Westküste vom Norden vor 1870 war, dann glich das geradezu einem Wunder! Man darf schließlich nicht vergessen, dass die Ost-West-Verbindung der Eisenbahn in den Vereinigten Staaten erst 1869 vollendet worden war.

Die Geschichte der amerikanischen Kolonialisierung war jene Fantasievorstellung vom Westen, das, was sich jenseits der „frontier" befand und zu einem unermüdlichen und schrecklichen Kampf gegen eine feindselige und wilde Natur herausforderte. Es war vor allem der Traum vom Gold, der die Siedler veranlasste, den Mississippi zu überqueren und sich in die öden Gegenden des Südwestens vorzuwagen. Ab dem 16. Jahrhundert waren es die Spanier, dann die Franzosen, die den alten indianischen Pfaden folgten: dem sogenannten Gila Trail von Mexiko nach Arizona und Südkalifornien, den Francisco Vásquez de Coronado entdeckt hatte; dem „Camino Real" (Königsweg), den der Franziskanerpater Junípero Serra eingeschlagen hatte, der in San Diego seine erste Missionsstation und später etwa zwanzig weitere die Küste entlang bis nach San Francisco gründete; und der Santa Fe Trail, der während des Krieges gegen Mexiko als Marschroute für das Militär diente.

Doch die großen Siedlerrouten waren die der ersten Hälfte des 19. Jahrhunderts, der Oregon Trail und der California Trail, die nördlich um die Rocky Mountains herumführten. Der Oregon Trail verlief mehr oder weniger auf der durch die Expedition von Lewis und Clark (1804–1806) zwischen St. Louis am Missouri und dem Columbia River zurückgelegten Strecke. Diese kreuzte den Mormon Trail, der von Wyoming bis nach Salt Lake City verlief. Ab 1843 benutzten täglich schätzungsweise 900 Personen diese Strecke, und dies über zwanzig Jahre hinweg, solange der Goldrausch in Kalifornien und Colorado anhielt. Der California Trail folgte dem Humboldt River, der den heutigen Bundesstaat Nevada durchquert. Die ersten Siedler, die sich 1841 dorthin vorwagten – 32 Personen folgten einem gewissen John Bidwell –, machten sich ohne Führer auf den Weg, und es heißt, sie hätten sich in der Sierra Nevada verirrt und hätten, um zu überleben, ihre Wagen aufgeben und das Fleisch ihrer Pferde essen müssen; doch sie erreichten das „Gelobte Land" und kamen nach Kalifornien. Der „Golden State", der reicher an Weizen, Früchten und – wie man zu Beginn des 20. Jahrhunderts entdeckte – Erdöl ist, als er jemals an Gold war, ist heute der wohlhabendste Bundesstaat der USA.

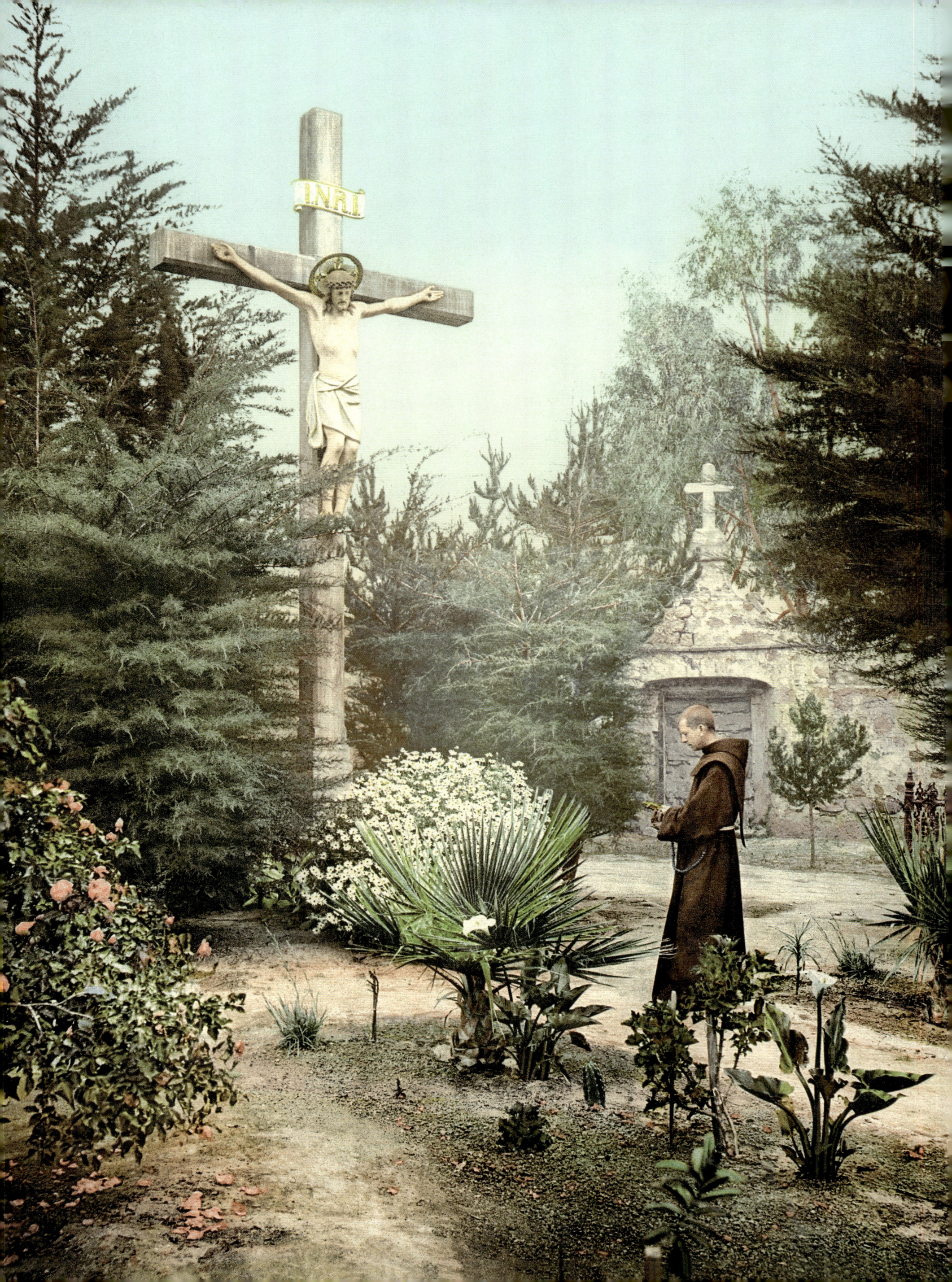

Page 524: The garden crucifix, Santa Barbara Mission,
California, photochrom
Right: Beverly Hills Hotel and bungalows, Beverly Hills,
California

Seite 524: Das Kruzifix im Garten der Mission Santa Barbara,
Kalifornien, Photochrom
Rechts: Hotel Beverly Hills, Beverly Hills, Kalifornien

Page 524 : le crucifix du jardin de la mission Santa Barbara,
Californie, photochrome
À droite : l'hôtel Beverly Hills, Beverly Hills, Californie

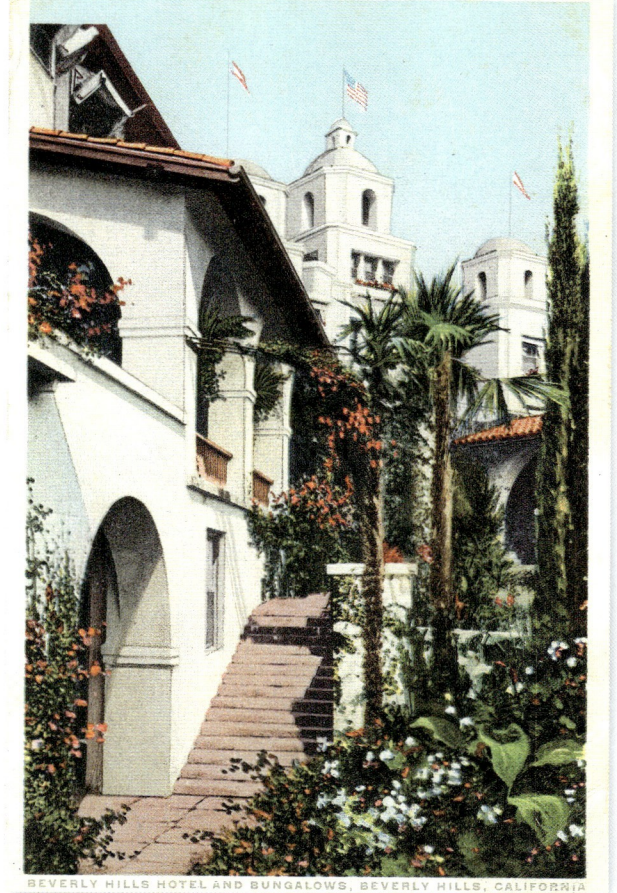

LA CÔTE PACIFIQUE

Dans la nuit du 31 juillet au 1er août 1890, le reporter Edmond Cotteau arrive à Vancouver, six jours seulement après avoir quitté Montréal par le Trans-Canadian. Il a parcouru plus de 3 700 kilomètres en train, dans des conditions de confort encore supérieures à celles que propose le réseau américain. La ligne de la Canadian Pacific Railway Company (CPR) est en service depuis quatre ans et William Cornelius Van Horne, son directeur général, a tenu la promesse faite à la Colombie-Britannique en juillet 1871, lors de son entrée dans le dominion du Canada : la relier aux autres États de la Confédération par un chemin de fer transcontinental. Non seulement la liaison Est-Ouest a été établie, mais la CPR a obtenu du Gouvernement l'octroi de terres pour favoriser l'installation des colons. Des colons qui arrivent de plus en plus nombreux, par le chemin de fer et par la mer : en 1891, la CPR crée sa propre flotte sur les deux océans. Si l'on songe à l'isolement qui était celui de la côte Ouest de l'Amérique du Nord avant 1870, c'est proprement miraculeux ! Souvenons-nous qu'aux États-Unis la jonction ferroviaire Est-Ouest n'a été réalisée qu'en 1869.

L'histoire de la colonisation américaine, c'est ce « mirage » de l'Ouest, cet au-delà de la « Frontière », enjeu d'une inlassable et terrible bataille contre une nature hostile et sauvage. Ce qui poussa les colons à franchir le Mississippi et à s'aventurer dans les régions désertiques du Sud-Ouest, c'est d'abord le mirage de l'or. Les expéditions des Espagnols dès le XVIe siècle, puis des Français, suivirent les anciennes pistes indiennes : la Gila Trail (piste de Gila), du Mexique en Arizona et en basse Californie, que découvrit Francisco Vásquez de Coronado ; le Camino Real (le chemin royal), emprunté par le père franciscain Junípero Serra, qui fonda la première mission à San Diego puis une vingtaine d'autres le long de la côte jusqu'à San Francisco ; ou encore la piste de Santa Fe, qui servit de route militaire pendant la guerre contre le Mexique.

Mais les grandes pistes d'émigration sont celles de la première moitié du XIXe siècle, l'Oregon Trail (piste de l'Oregon) et la California Trail (piste de Californie), qui contournaient les Rocheuses par le nord. L'Oregon Trail suivait plus ou moins la voie ouverte par l'expédition de Lewis et Clark (1804–1806) entre Saint-Louis du Missouri et le fleuve Columbia. Elle croisait la Mormon Trail (piste des Mormons), qui descendait du Wyoming à Salt Lake City. On estime qu'à partir de 1843 900 personnes l'ont empruntée chaque jour tant qu'a duré la fièvre de l'or en Californie et au Colorado, soit une vingtaine d'années. La California Trail suivait le fleuve Humboldt, qui traverse l'actuel État du Nevada. Les premiers colons qui s'y risquèrent en 1841 – 32 personnes menées par un certain John Bidwell – partirent sans guide ; on dit qu'ils s'égarèrent dans la Sierra Nevada et durent abandonner leurs chariots puis manger la chair de leurs chevaux pour survivre. Mais ils arrivèrent à la « terre promise », ils arrivèrent en Californie. Le « Golden State », plus riche en blé et en fruits qu'il ne l'a jamais été en or, riche surtout en pétrole découvert dès le début du XXe siècle, est aujourd'hui l'État le plus prospère des États-Unis.

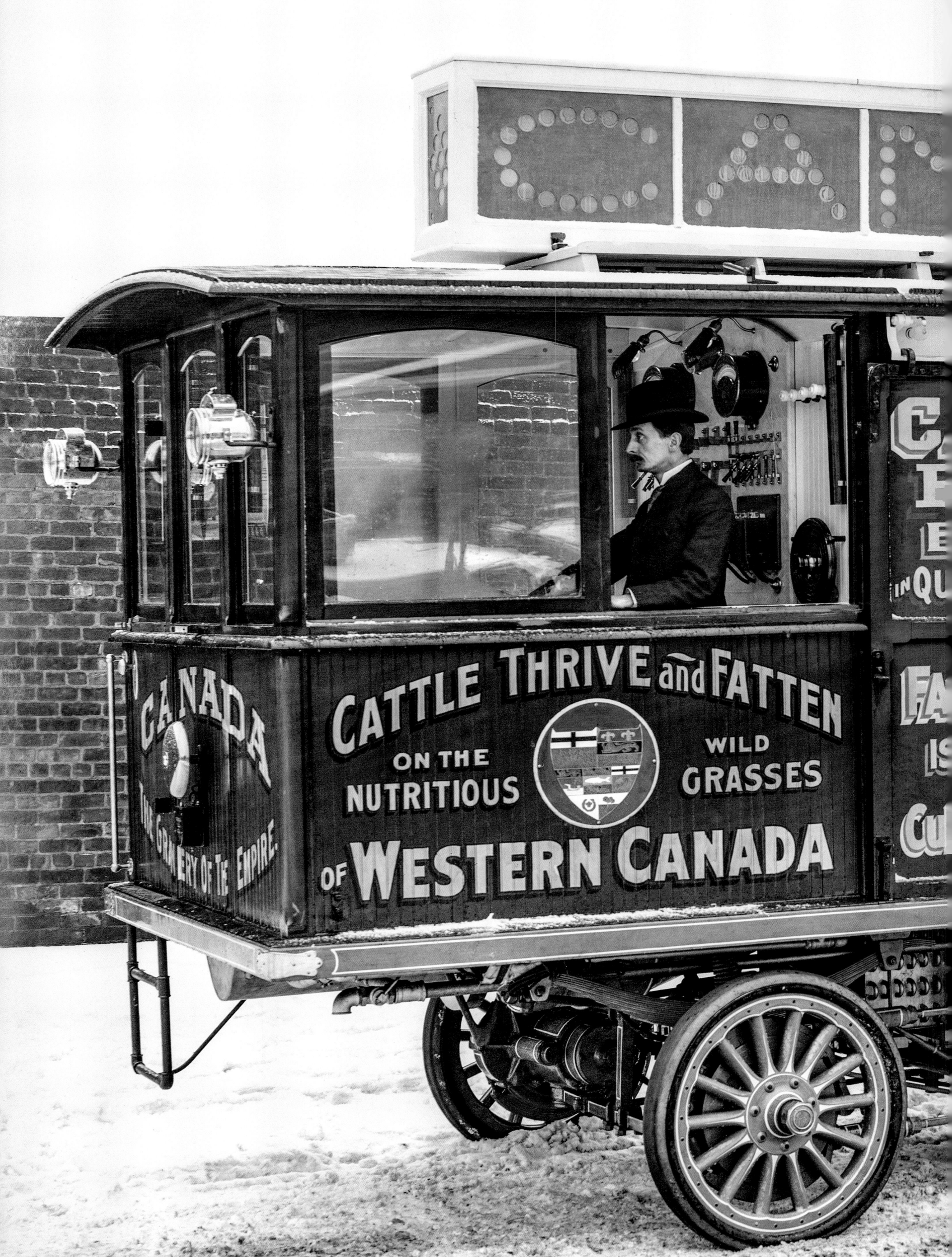

BRITISH COLUMBIA

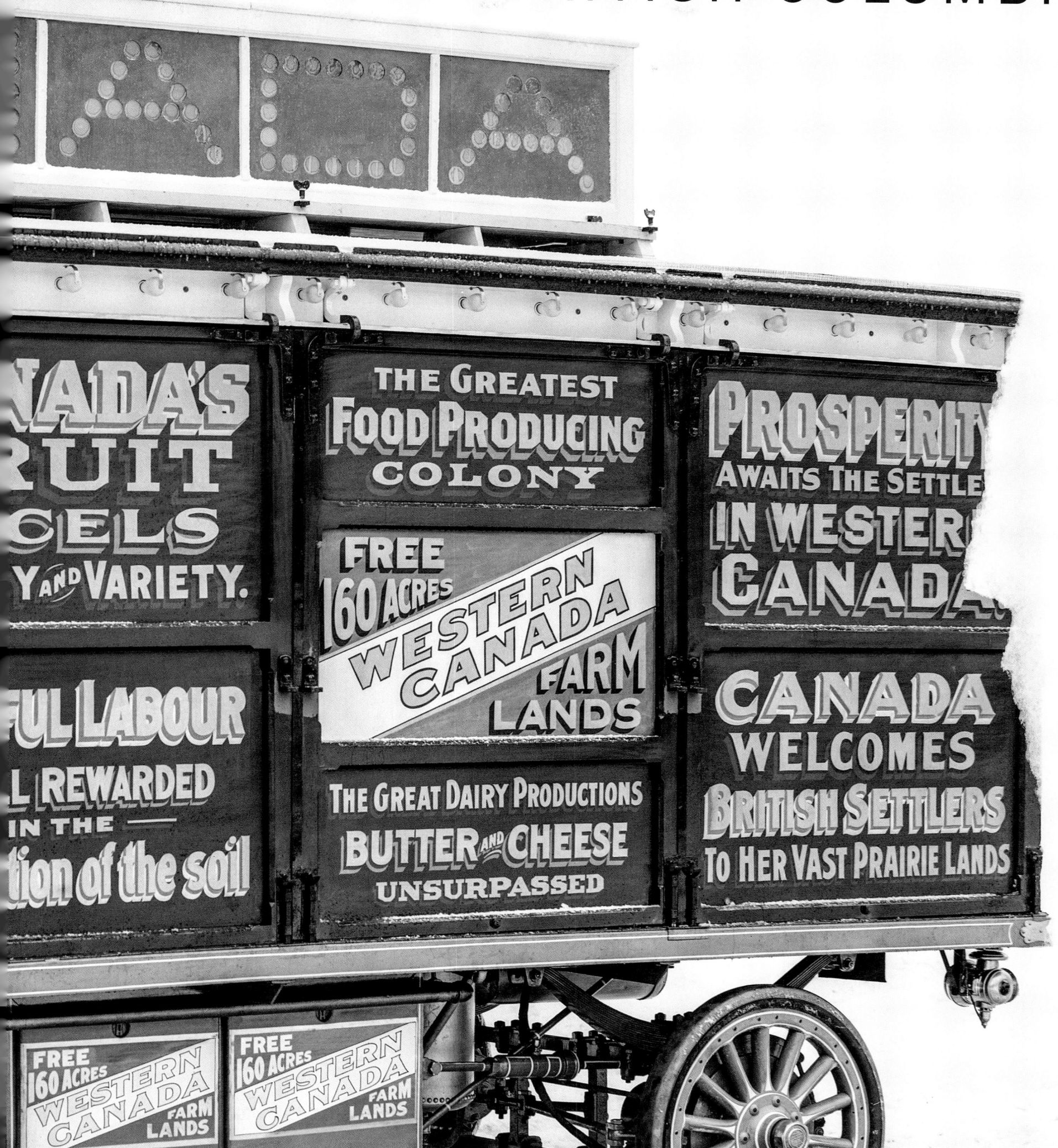

Page 526/527: Motor car, Canadian Government Colonization Co., glass negative, 1900–1905
Top: A panoramic view of Selkirk Mountains, Mt. Fox and Mt. Dawson, photochrom
Above left: Illecillewaet Glacier, photochrom
Above right: Illecillewaet Glacier, crevasse formation, photochrom

Seite 526/527: Reklamewagen der Canadian Government Colonization Co., Glasnegativ, 1900–1905
Oben: Rundblick auf die Selkirk Mountains, Mount Fox und Mount Dawson, Photochrom
Mitte links: Illecillewaet-Gletscher, Photochrom
Mitte rechts: Illecillewaet-Gletscher, Ausformung einer Gletscherspalte, Photochrom

Pages 526/527 : voiture publicitaire de la Canadian Government Colonization Co., plaque de verre, 1900–1905
En haut : panorama des monts Selkirk, les monts Fox et Dawson, photochrome
Au centre à gauche : Le glacier Illecillewaet, photochrome
Au centre à droite : Crevasse en formation sur le glacier Illecillewaet, photochrome

Below left: Mount Stephen and Mount Stephen Hotel, photochrom
Below right: Emerald Lake and Van Horne Range, photochrom
Page 530/531: Illecillewaet Glacier from seracs, glass negative, 1900–1905

The discovery by Major Albert B. Rogers of a viable pass at last allowed the Canadian Pacific Railway to cross the Selkirk Mountains. The ascent began at Donald Station, where a second locomotive joined the train; the railroad then crossed the coniferous forests of Beaver Valley, went over Rogers Pass, through Summit Station, and down again, to Glacier House. The train stopped lower again, before Revelstoke, to allow travelers to admire the sight, described by Edmond Cotteau as "extraordinary: sublime in its horror."

Opened in 1886 as a restaurant chalet and converted into a hotel in 1900, Mount Stephen House was the first mountain hostelry built by the Canadian Pacific.

Unten links: Der Berg Mount Stephen und das Hotel Mount Stephen, Photochrom
Unten rechts: Der Emerald-See und die Bergkette Van Horne Range, Photochrom
Seite 530/531: Illecillewaet-Gletscher von den Séracs aus, Glasnegativ, 1900–1905

Als Major Albert B. Rogers einen befahrbaren Pass entdeckte (1881), konnte die Eisenbahn der Canadian Pacific endlich die Gebirgskette der Selkirk Mountains überqueren. Der Anstieg begann im Bahnhof von Donald, wo man eine zweite Lokomotive ankoppelte, anschließend durchquerte der Zug die Nadelwälder von Beaver Valley, überquerte erst den Rogers-Pass, erreichte dann die Station von Summit und fuhr wieder nach Glacier House hinunter. Er hielt etwas weiter unten, vor Revelstoke, sodass die Fahrgäste die „außergewöhnliche, schauerlich schöne" Landschaft bewundern konnten, wie Edmond Cotteau schrieb.

Das Mount Stephen House, das 1886 zunächst als einfaches Chalet mit Gastwirtschaft eröffnet und 1900 in ein Hotel umgebaut wurde, war das erste von der Gesellschaft Canadian Pacific errichtete Berghotel.

En bas à gauche : le mont Stephen et l'hôtel du Mont Stephen, photochrome
En bas à droite : le lac Emerald et le massif Van Horne, photochrome
Pages 530/531 : le glacier Illecillewaet depuis les séracs, plaque de verre, 1900–1905

La découverte d'un passage par le major Albert B. Rogers (1881) permit au chemin de fer du Canadian Pacific de franchir enfin la chaîne des Selkirks. L'ascension commençait à la gare de Donald, où l'on attelait une seconde locomotive, puis le train traversait les forêts de conifères de la vallée du Beaver, passait le col (de Rogers), la station de Summit et redescendait vers Glacier House. Il s'arrêtait plus bas, avant Revelstoke, pour permettre aux voyageurs d'admirer le site « extraordinaire, sublime dans son horreur », comme l'écrit Edmond Cotteau.

Ouvert en 1886 comme simple chalet de restauration et transformé en hôtel en 1900, l'hôtel du Mont Stephen est le premier établissement de montagne édifié par la compagnie du Canadian Pacific.

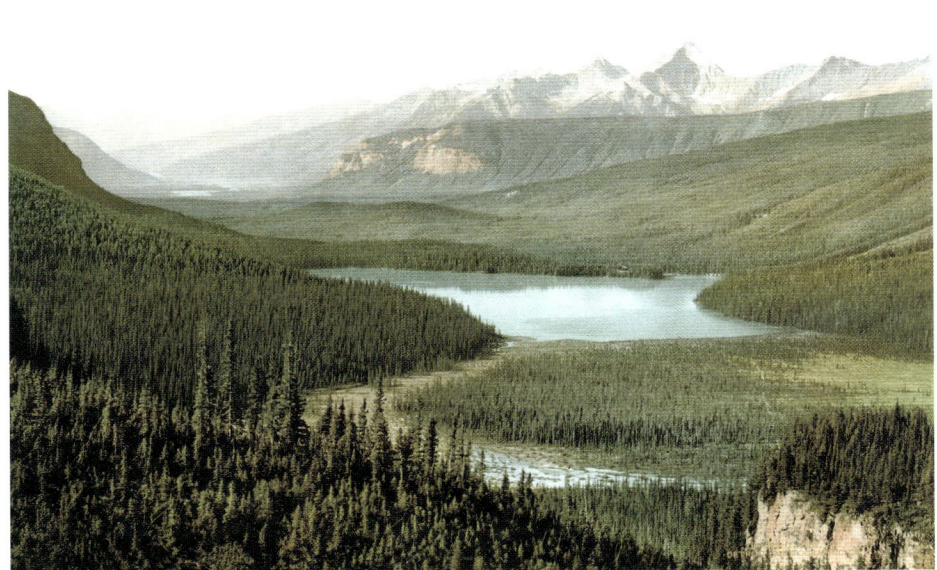

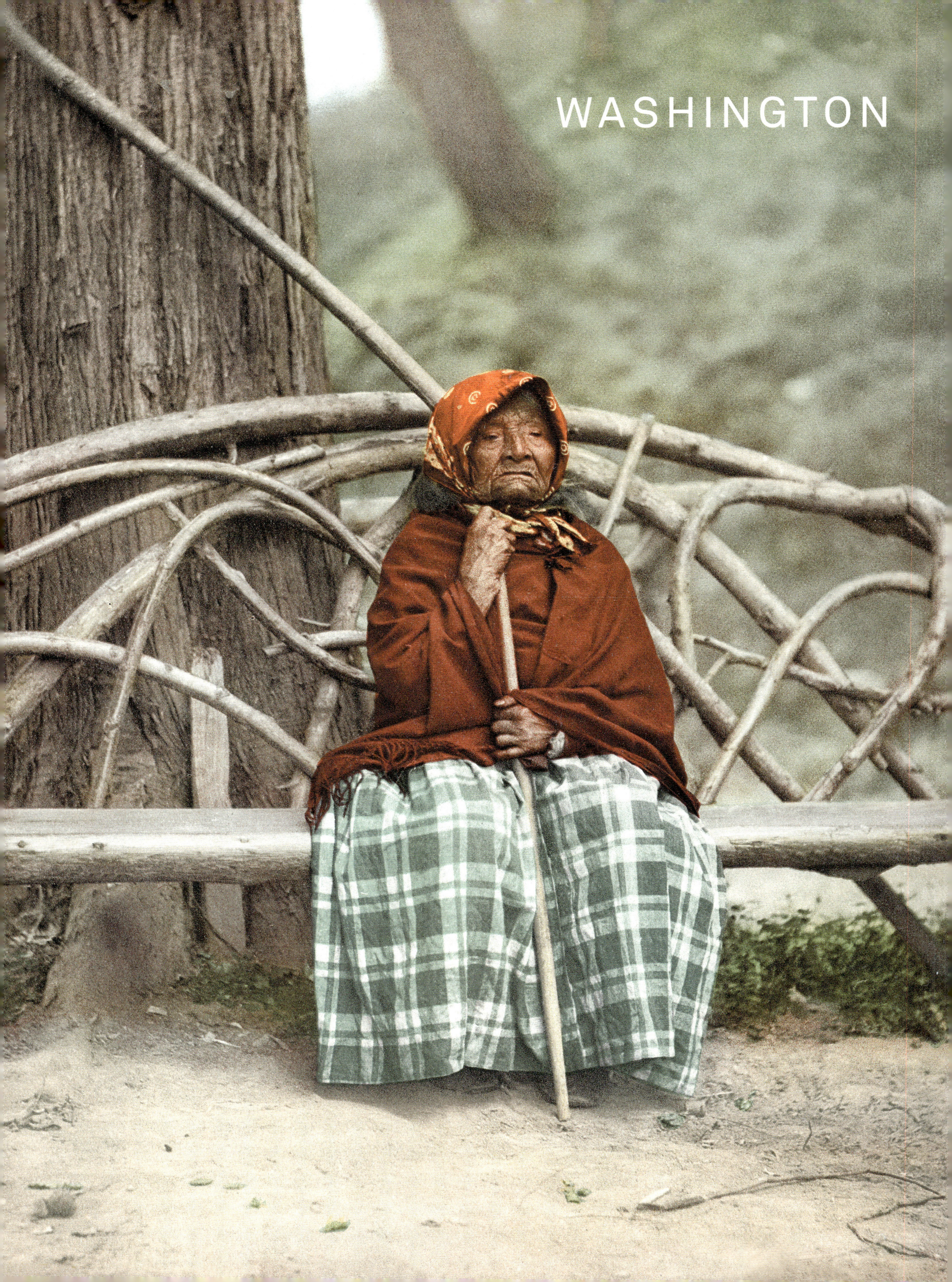

WASHINGTON

Page 532: Angeline, daughter of Chief Seattle, photochrom
From top to bottom:
Gateway to Tacoma
Madison Street Cable Incline, Seattle
Indians on Puget Sound
Totem pole, Pioneer Square, Seattle

The first settlers disembarked at Seattle in 1851. The city was named after Chief Seattle, the peaceful leader of the Duwamish and Suquamish tribes, which ceded their Puget Sound territories to the settlers in 1855 through the Treaty of Point Elliott. Chief Seattle continued to enjoy excellent relations with the settlers. His daughter, Princess Angeline, lived all her life in a waterfront cabin.

Seite 532: Angeline, die Tochter des Indianerhäuptlings Seattle, Photochrom
Von oben nach unten:
Zufahrt zur Stadt Tacoma
Straßenbahn auf der Madison Street, Seattle
Indianer in der Bucht Puget Sound
Totempfahl auf dem Pioneer Square, Seattle

Die ersten Siedler gingen 1851 in Seattle von Bord, das nach Häuptling Seattle, dem friedfertigen Häuptling der Stämme der Duwamish und Suquamish, benannt ist. Diese traten 1855 ihre Gebiete am Puget Sound an die Siedler ab (Vertrag von Point Elliott). Häuptling Seattle unterhielt stets ausgezeichnete Beziehungen zu den Siedlern. Seine Tochter, Prinzessin Angeline, bewohnte bis zu ihrem Tod eine Hütte auf der Meerseite von Seattle.

Page 532 : Angeline, fille du chef indien Seattle, photochrome
De haut en bas :
L'entrée de la ville de Tacoma
Le tramway de Madison Street, Seattle
Indiens dans l'estuaire du Puget Sound
Le totem de Pioneer Square, Seattle

Seattle, où les premiers colons débarquèrent en 1851, a été baptisée d'après Chief Seattle, leader pacifique des tribus Duwamish et Suquamish qui cédèrent leurs terres du Puget Sound aux colons en 1855 (traité de Point Elliott). Chief Seattle entretint toujours d'excellents rapports avec les colons. Sa fille, la « princesse Angeline », habita jusqu'à sa mort dans une cabane sur le front de mer de Seattle.

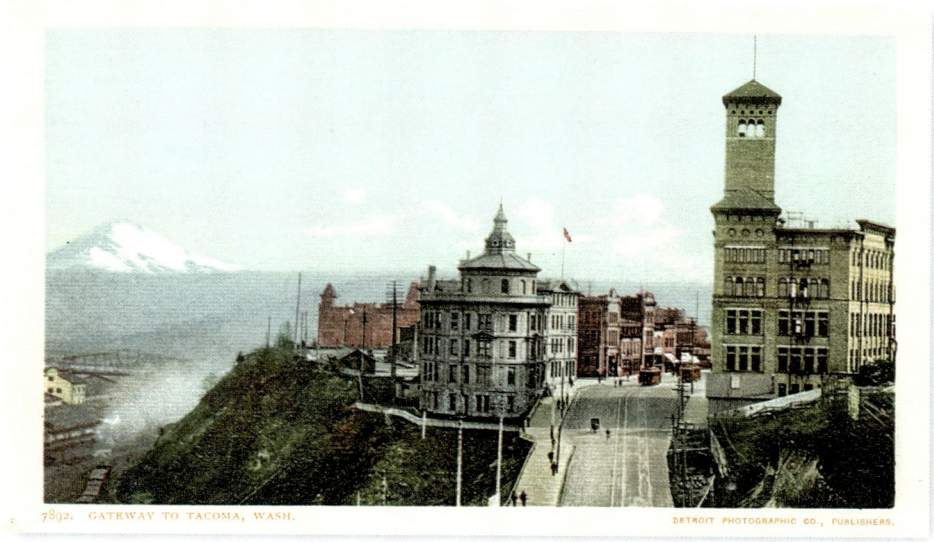
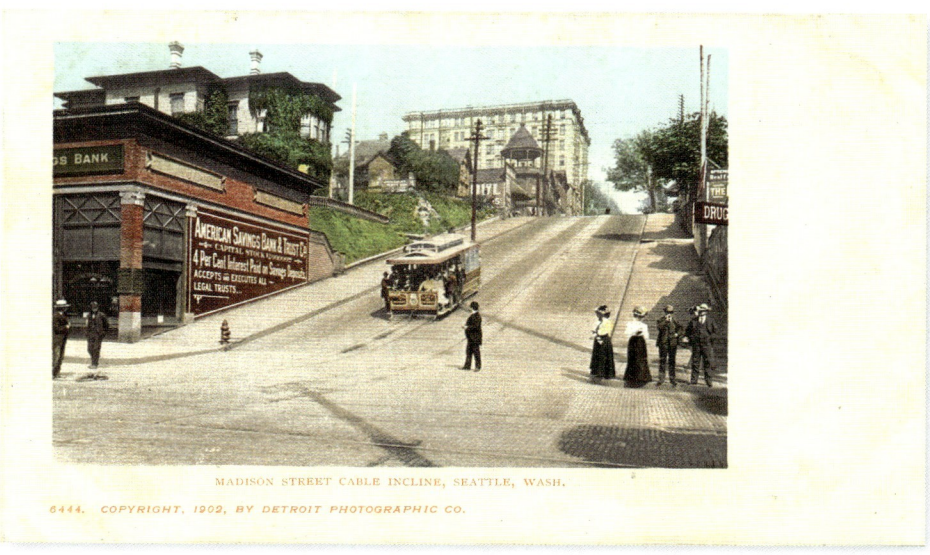
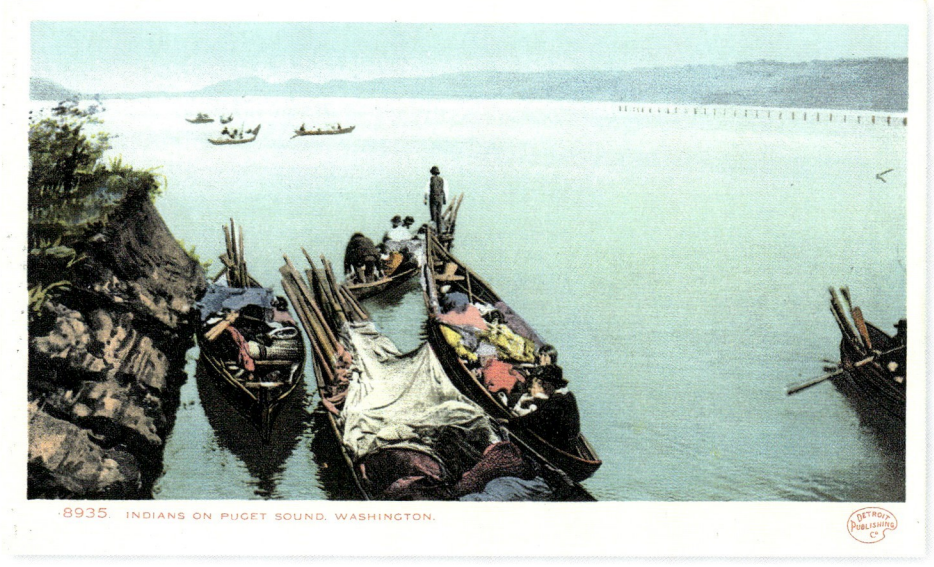
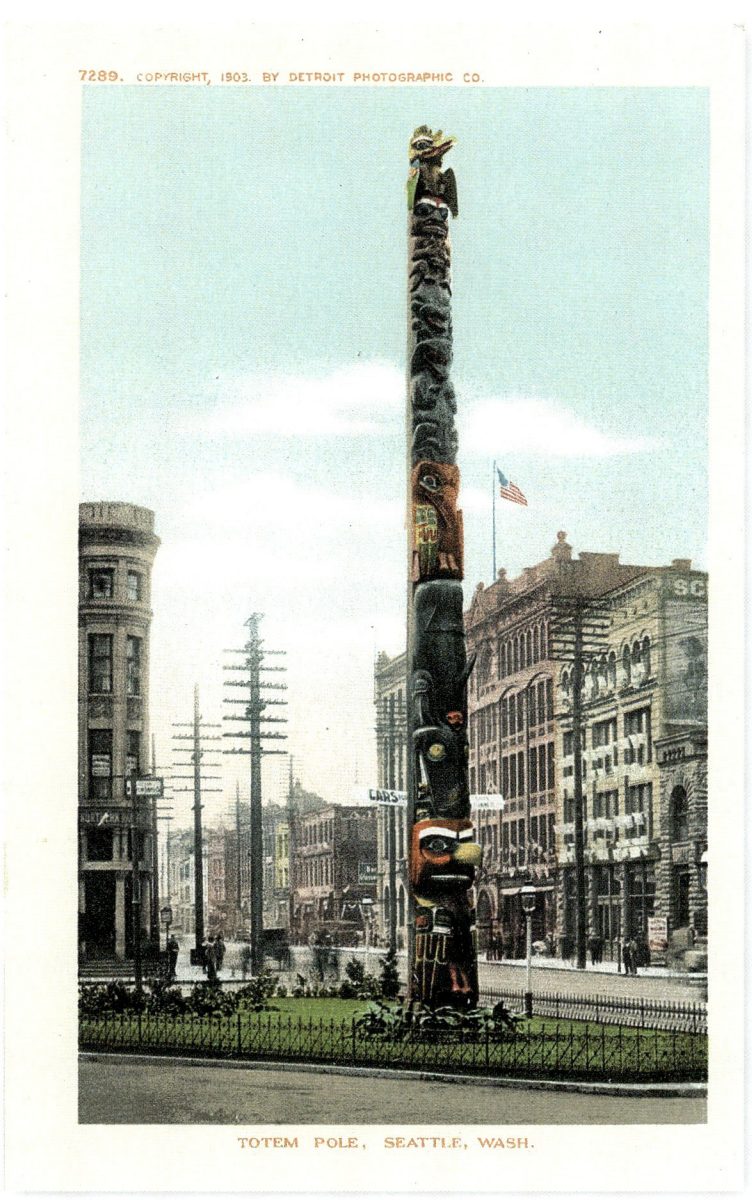

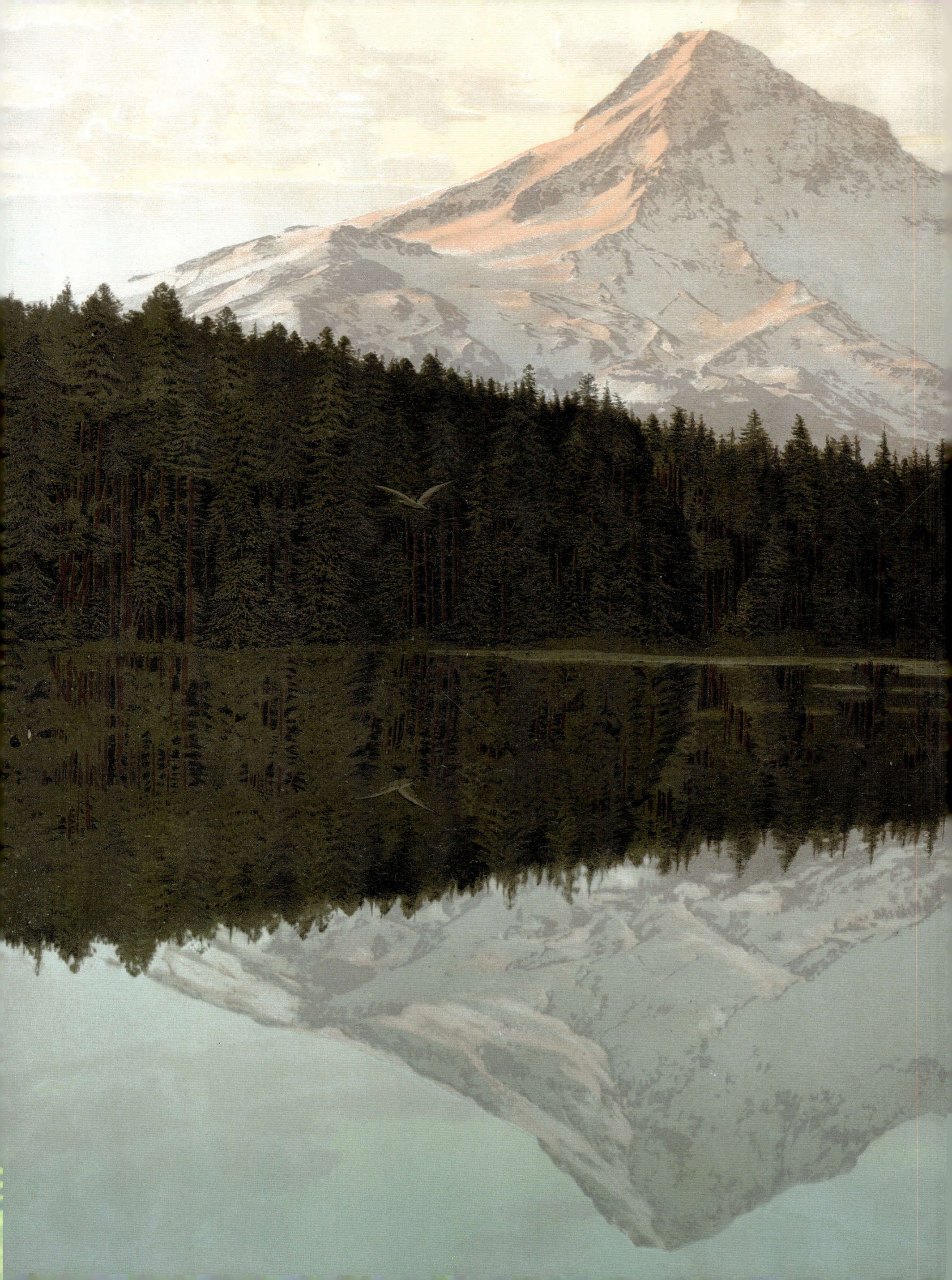

Page 534/535: Mount Hood from Lost Lake, photochrom
Right: Felling a big tree
Bottom: Portland, Willamette River, photochrom

Seite 534/535: Mount Hood vom Lost Lake aus, Photochrom
Rechts: Fällen eines riesigen Baumes
Unten: Portland, Willamette River, Photochrom

Pages 534/535 : le mont Hood vu depuis le lac Lost
(« lac perdu »), photochrome
À droite : abattage d'un arbre géant
En bas : Portland, le fleuve Willamette, photochrome

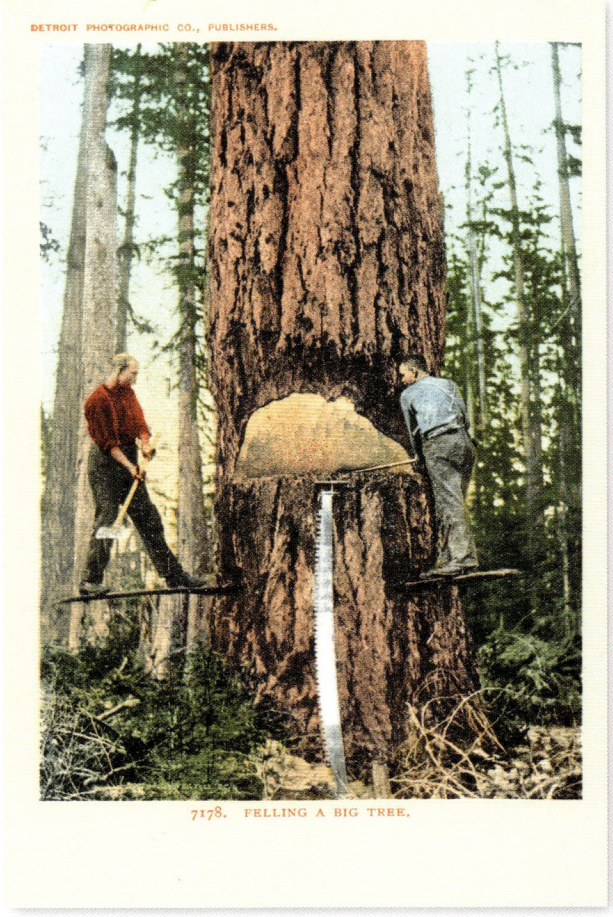

OREGON | PORTLAND

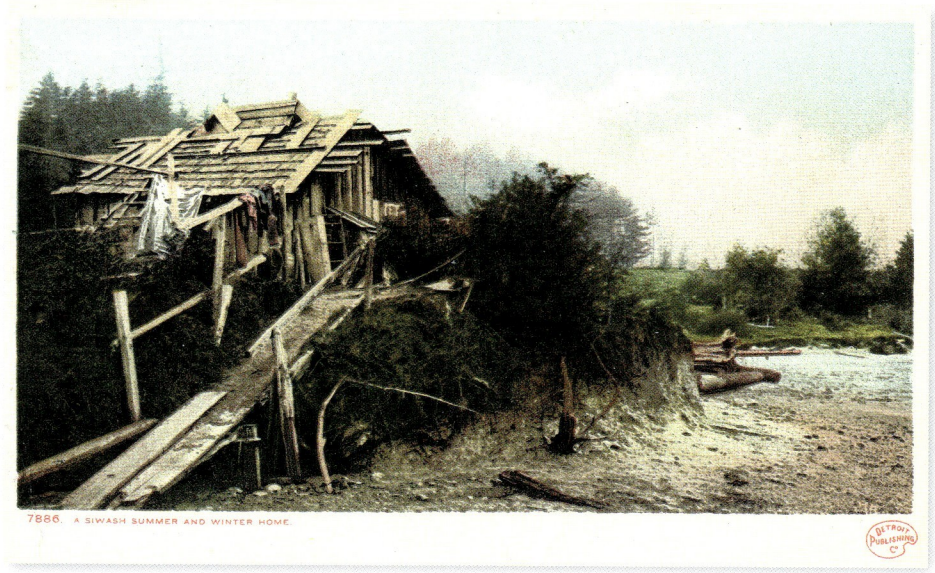
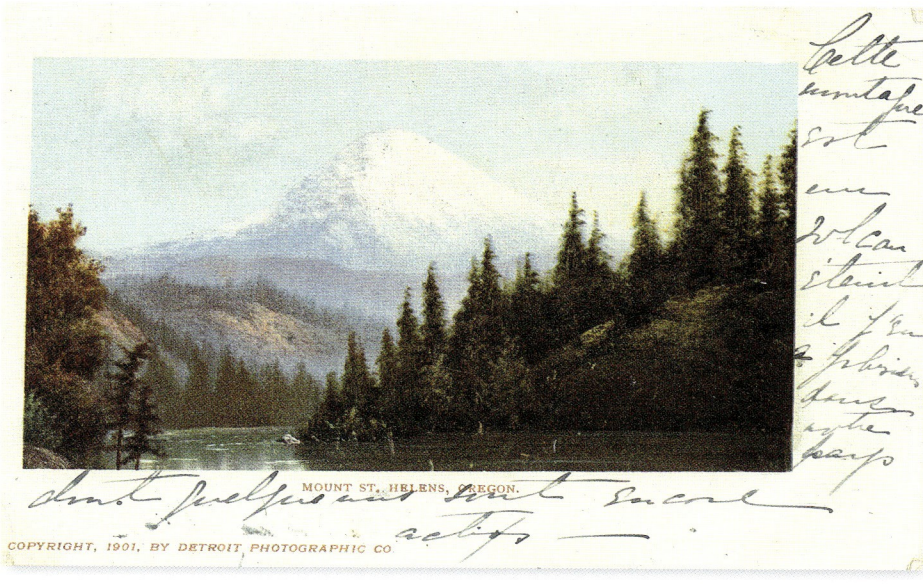

Top left: A "siwash" summer and winter home
Top right: Mount St. Helens
Bottom: Mount Hood, photochrom

The Chinook Indians who inhabited the banks of the Columbia River at the time of the Lewis and Clark Expedition (1804–1806) lived by fishing, hunting, and fur trading. When the first settlers came to Portland, in 1843, the Chinook turned out to be excellent traders. By 1900, most of them had died of illnesses contracted from the whites. Many Chinook words, deformed by Europeans, have passed into general use, some of them with strong racist connotations. Thus the word *siwash*, from the French *sauvage* (meaning "savage" or "wild"), became a pejorative way of referring to anyone of Indian origin.

Oben links: Ein „Siwash", ein indianisches Sommer- und Winterhaus
Oben rechts: Mount St. Helens
Unten: Mount Hood, Photochrom

Die Chinook-Indianer lebten zur Zeit der Expedition von Lewis und Clark (1804–1806) am Ufer des Columbia River, betrieben Fischfang und jagten Pelztiere. Als sich 1843 die ersten Siedler in Portland niederließen, erwiesen sich die Chinook als ausgezeichnete Händler. 1900 war der größte Teil von ihnen durch die im Kontakt mit den Weißen übertragenen Krankheiten gestorben. Zahlreiche, durch die Europäer umgeformte Worte aus dem Chinook haben in die Alltagssprache Eingang gefunden, einige davon mit stark rassistischem Unterton: So bezeichnet etwa das Wort „siwash" – nach dem französischen „sauvage" (wild) jegliche Person indianischen Ursprungs.

En haut à gauche: habitation indienne *siwash*
En haut à droite: le mont St. Helens
En bas: le mont Hood, photochrome

Les Indiens Chinooks qui vivaient sur les bords de la Columbia River au moment de l'expédition de Lewis et Clark (1804–1806) pratiquaient la pêche et chassaient les animaux à fourrure. Lorsque les premiers colons s'établirent à Portland, en 1843, les Chinooks se révélèrent excellents commerçants. En 1900, la plupart d'entre eux avaient été décimés par les maladies contractées au contact des Blancs. De nombreux mots chinooks, déformés par les Européens, sont passés dans le langage usuel, certains fortement connotés de racisme : ainsi le mot *siwash* – du français « sauvage » – désigne-t-il toute personne d'origine indienne.

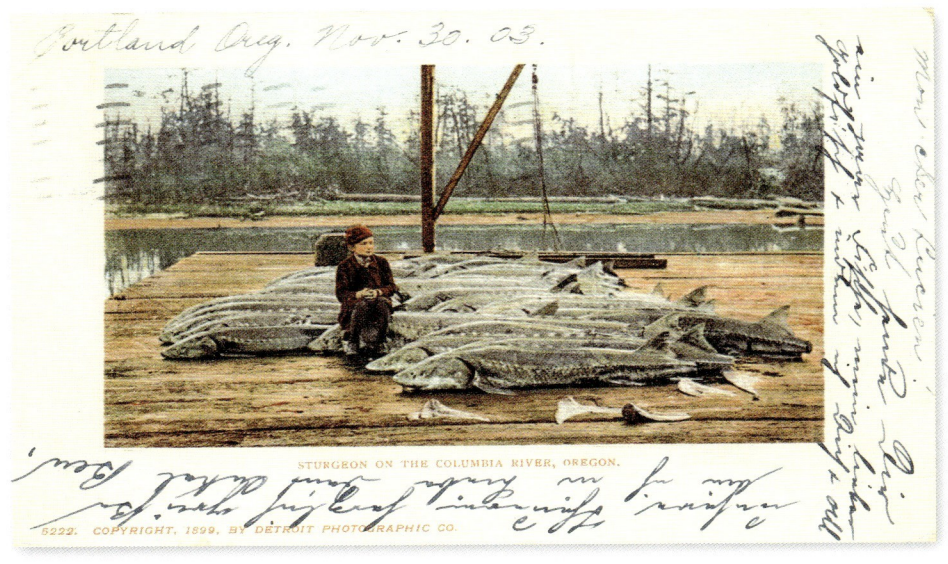
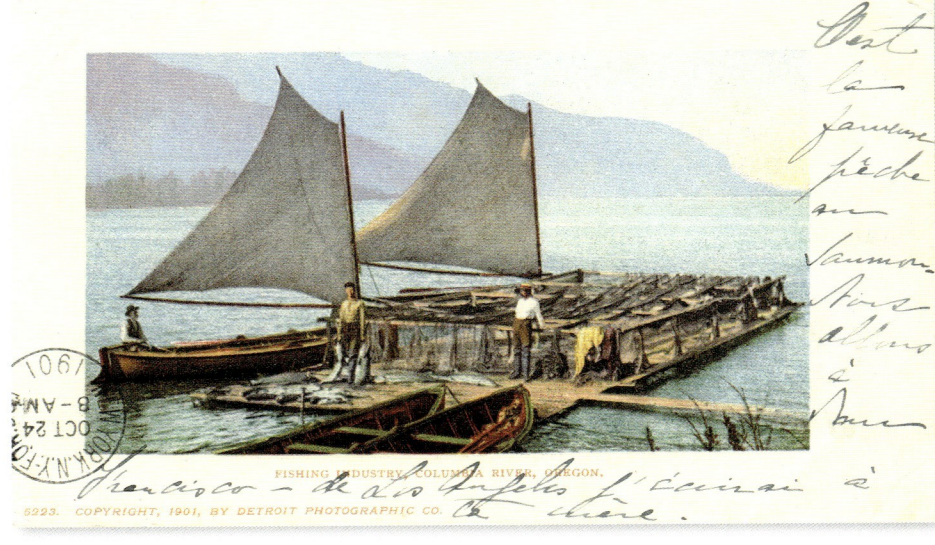

Top left: Sturgeons on the Columbia River
Top right: Fishing industry, Columbia River
Bottom: The Cascades on the Columbia River, photochrom
Page 539: Cape Horn on the Columbia River, photochrom

The rapids of the Columbia River, which the Indians would "shoot" in their canoes, formed an important obstacle to navigation. The Nez Perce guided the explorers Meriwether Lewis and William Clark from the Snake River to the mouth of the Columbia River on the Pacific, where the expedition arrived on November 15, 1805. Locks were built in 1896, allowing steamers like the paddleboat in our photochrom to venture onto the river.

Oben links: Störe auf einem Angelsteg am Columbia River
Oben rechts: Störangler auf einem Bootsanleger, Columbia River
Unten: Die Stromschnellen auf dem Columbia River, Photochrom
Seite 539: Der Felsen von Cape Horn über dem Columbia River, Photochrom

Die Stromschnellen des Columbia River, die die Indianer mit ihren Kanus hinunterfuhren, stellten ein erhebliches Hindernis für die Schifffahrt. Die Nez Perce führten die Entdecker Meriwether Lewis und William Clark vom Snake River bis zur Mündung des Columbia River in den Pazifik, wo die Expedition am 15. November 1805 ankam. 1896 wurden Schleusen gebaut, die es Dampfschiffen wie dem Raddampfer auf diesem Photochrom erlaubten, den Fluss zu befahren.

En haut à gauche : esturgeons sur un ponton de pêche
En haut à droite : pêcheurs d'esturgeons sur un ponton
En bas : les rapides de la Columbia River, photochrome
Page 539 : la falaise du cap Horn dominant la Columbia River, photochrome

Les rapides de la Columbia River, que les Indiens descendaient en canoë, constituaient un obstacle à la navigation. Ce sont des Nez-Percés qui guidèrent les explorateurs Meriwether Lewis et William Clark depuis la Snake River jusqu'à l'embouchure de la Columbia River dans le Pacifique, où l'expédition arriva le 15 novembre 1805. Des écluses furent aménagées en 1896, qui permirent aux vapeurs – tel le steamer à aubes de notre photochrome – de s'aventurer sur le fleuve.

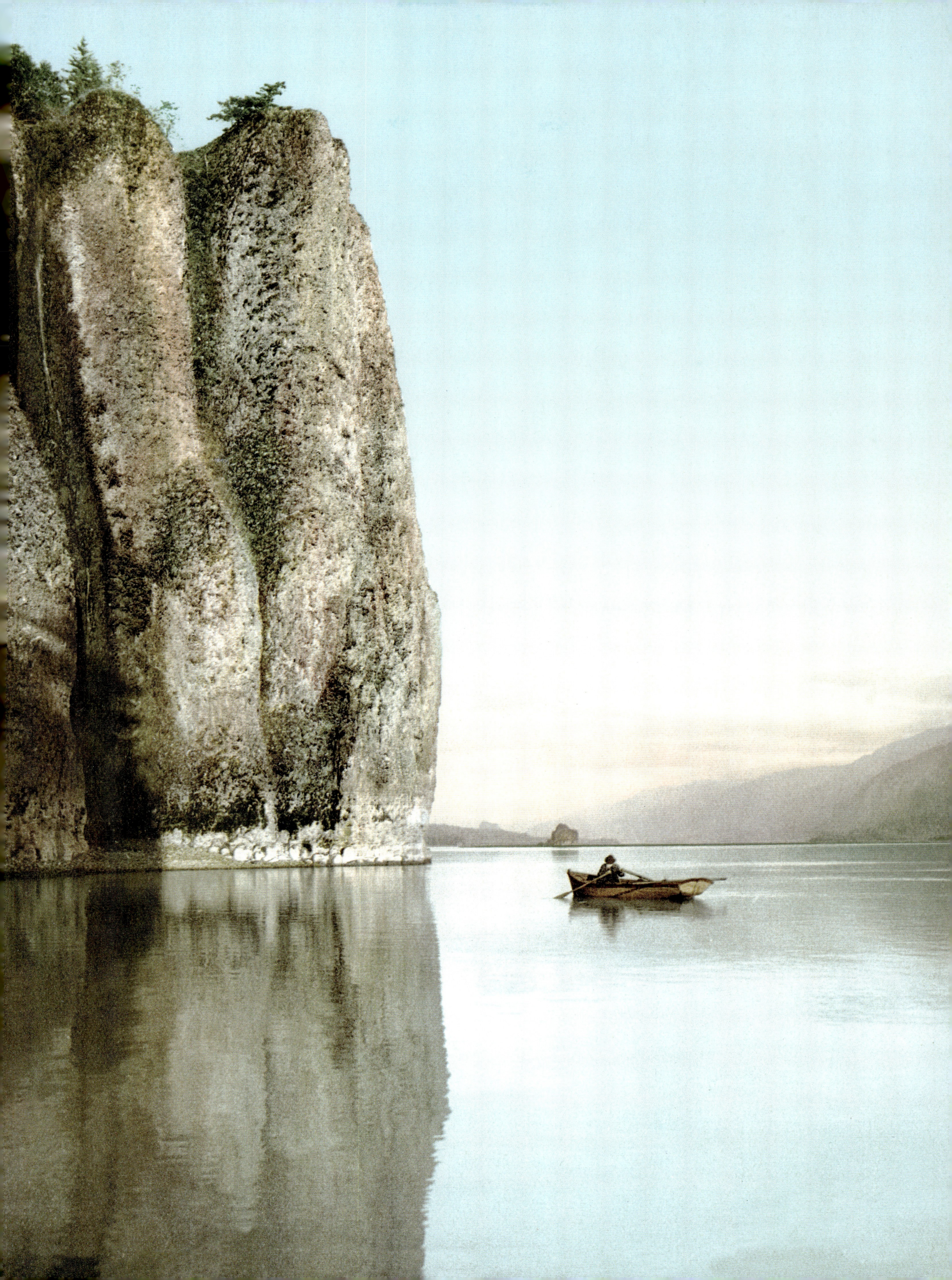

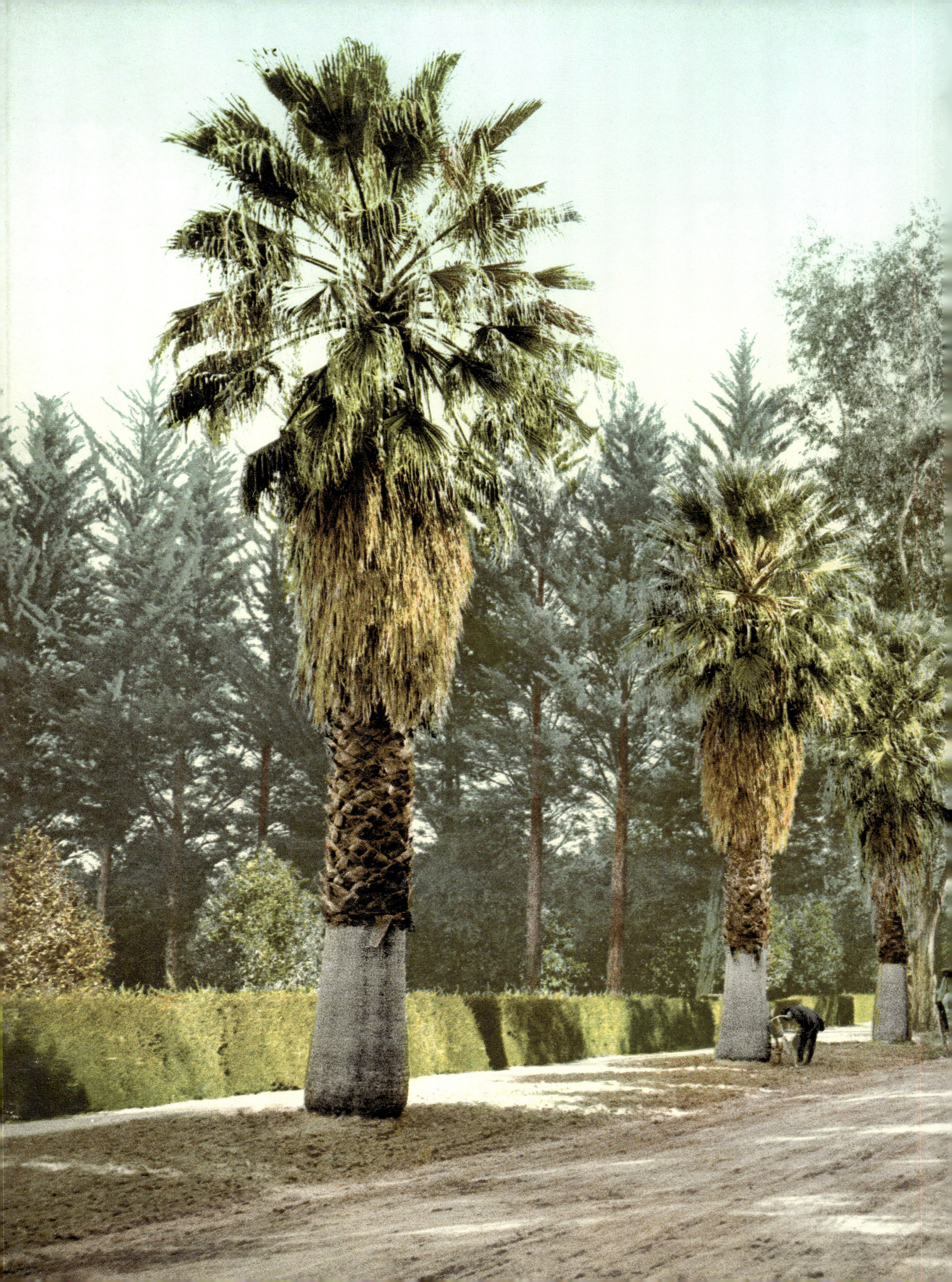

CALIFORNIA

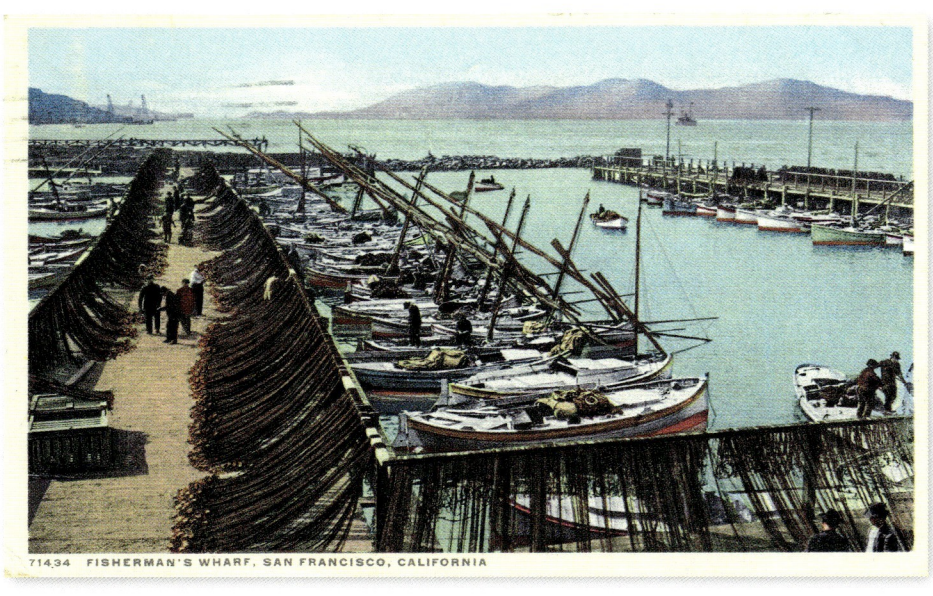

71434 FISHERMAN'S WHARF, SAN FRANCISCO, CALIFORNIA

CALIFORNIA | SAN FRANCISCO

Below: **Surf near Golden Gate in San Francisco, California,** photochrom
Page 540/541: **Riverside, Magnolia Avenue,** photochrom
Page 542:
Top: **Fisherman's wharf, San Francisco**
Bottom: **A view of the harbor,** photochrom

Unten: **Brandung am Golden Gate von San Francisco, Kalifornien,** Photochrom
Seite 540/541: **Riverside, Magnolia Avenue,** Photochrom
Seite 542:
Oben: **Fischereihafen, San Francisco**
Unten: **Ein Teil des Hafens von San Francisco,** Photochrom

Ci-dessous : **vagues près du Golden Gate à San Francisco, Californie,** photochrome
Pages 540/541 : **Riverside, Magnolia Avenue,** photochrome
Page 542 :
En haut : **le port de pêche, San Francisco**
En bas : **une partie du port de San Francisco,** photochrome

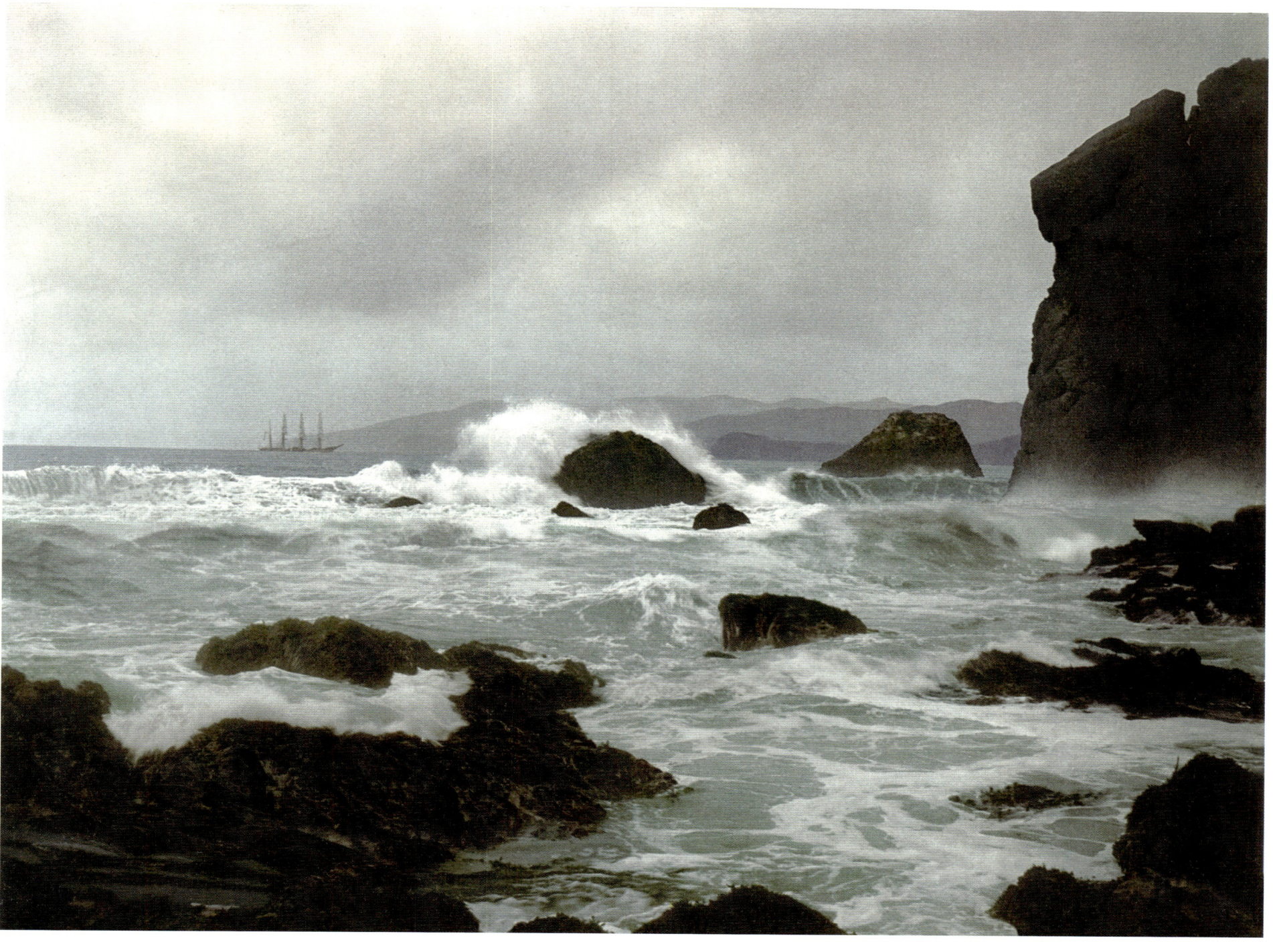

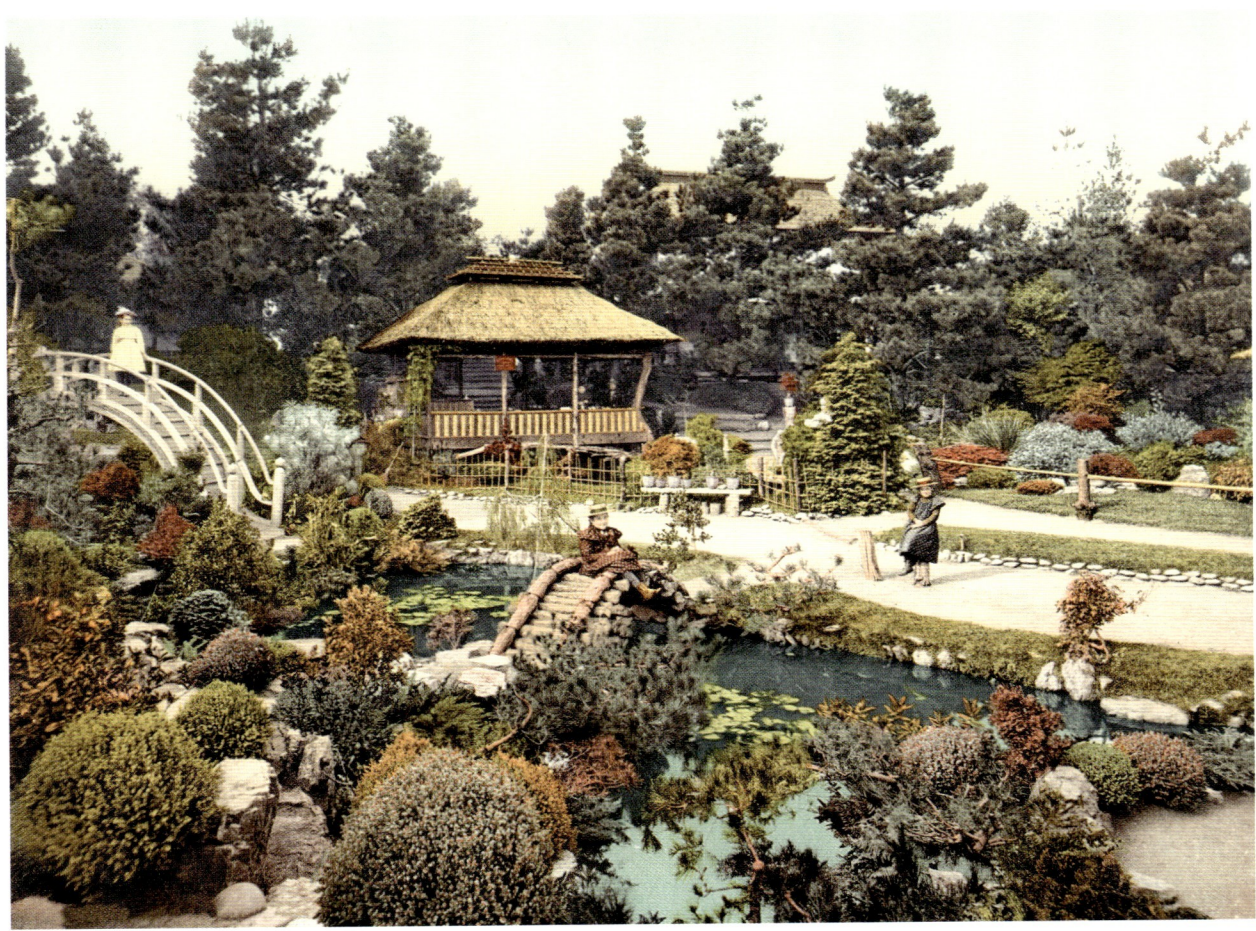

Left: Golden Gate Park, Tea Garden, photochrom
Bottom: San Francisco, Golden Gate and Mount Tamalpais from Chestnut Street, photochrom
Page 545:
Left: Japanese Tea Garden, Golden Gate Park
Right: Reflections, Japanese Tea Garden

Links: Golden Gate Park, Teegarten, Photochrom
Unten: San Francisco, Golden Gate und Mount Tamalpais von der Chestnut Street aus, Photochrom
Seite 545:
Links: Japanischer Teegarten, Golden Gate Park
Rechts: Spiegelungen, Japanischer Teegarten

Ci-contre : parc du Golden Gate, le jardin de thé, photochrome
En bas : San Francisco, le Golden Gate et le mont Tamalpais depuis Chestnut Street, photochrome
Page 545 :
À gauche : le jardin de thé japonais, parc du Golden Gate
À droite : « Reflets », jardin de thé japonais

CALIFORNIA | SAN FRANCISCO

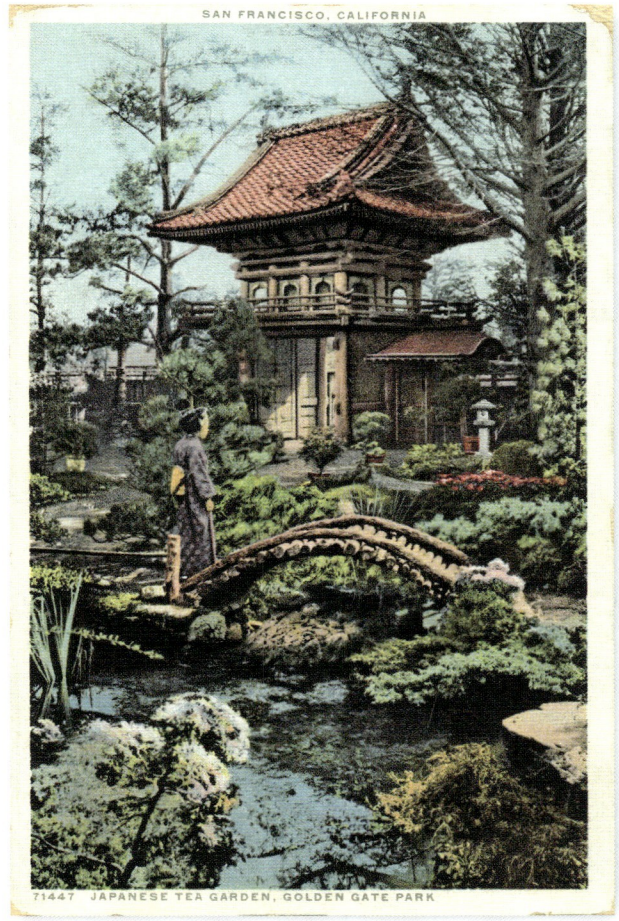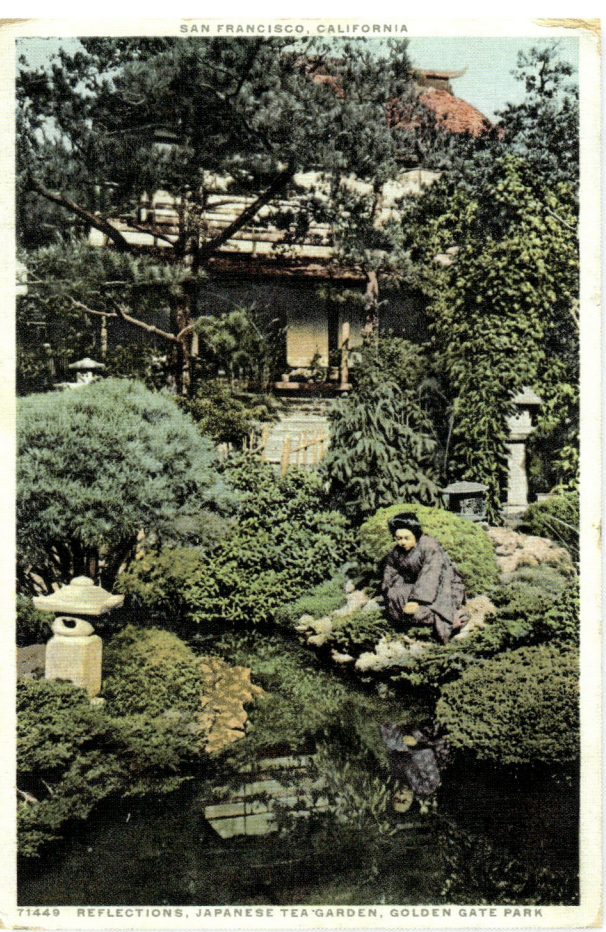

CALIFORNIA | SAN FRANCISCO

545

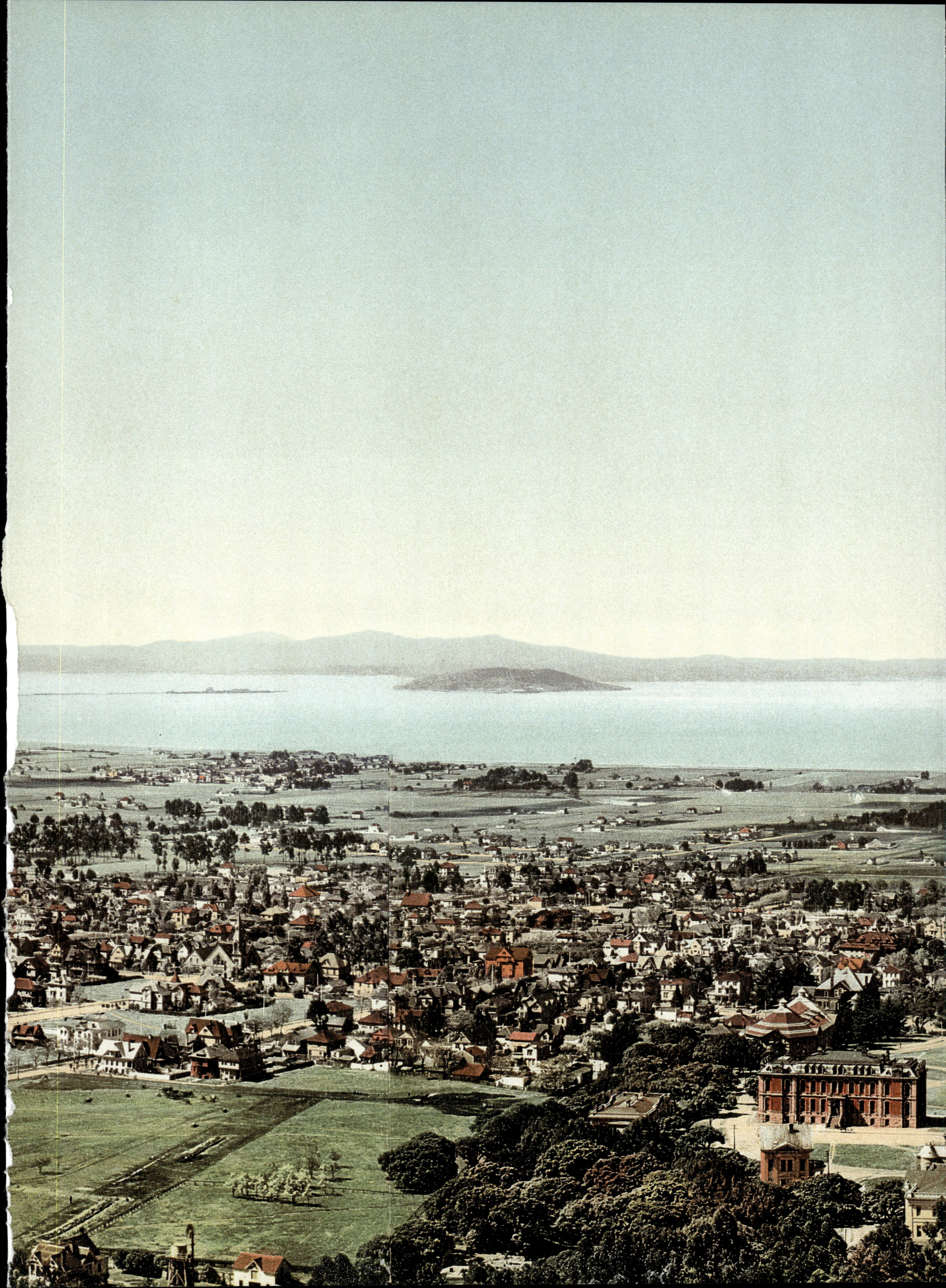

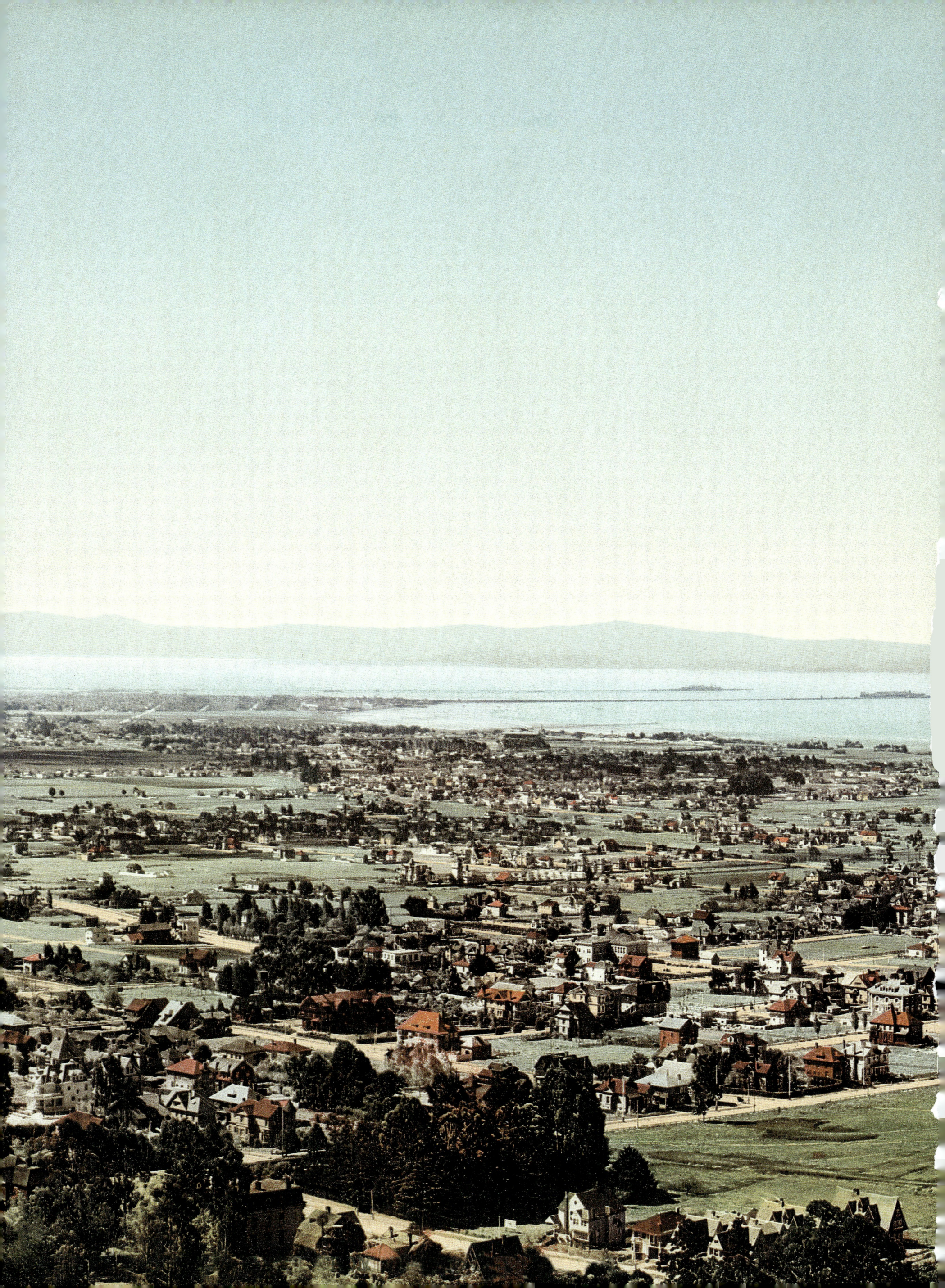

Bottom: San Francisco Seal Rocks, photochrom
Page 547–550:
Berkeley and the Golden Gate, photochrom
Page 551:
Top: Sutro Baths swimming pool, photochrom
Bottom: Sutro Baths and Golden Gate, photochrom
Like Cliff House and the Golden Gate Aquarium, the Sutro Baths was the work of Adolph Sutro. With its seven swimming pools, Sutro Baths was also a place of culture and entertainment, holding natural-history exhibitions and concerts, for example. In the late 19th century, family visits to the complex were quite the thing. Like Cliff House, the ruins of the baths (closed and subsequently burned down in 1966) now form part of the Golden Gate National Recreation Area.

Unten: Die Seal Rocks (Seehundfelsen) von San Francisco, Photochrom
Seite 547–550:
Berkeley und Golden Gate, Photochrom
Seite 551:
Oben: Das Schwimmbad der Badeanstalt Sutro Baths, Photochrom
Unten: Sutro Baths und Golden Gate, Photochrom
Die Sutro Baths gehen ebenso wie Cliff House und das Golden Gate-Aquarium auf Adolph Sutro zurück. Die Sutro-Badeanstalt mit ihren sieben Schwimmbecken war auch ein Ort der Kultur und des Vergnügens, an dem insbesondere naturgeschichtliche Ausstellungen und Konzerte stattfanden. Ende des 19. Jahrhunderts waren die Sutro Baths ein Ausflugsziel für Familien. Die Ruinen der (nach ihrer Schließung 1966 abgebrannten) Badeanstalt gehören heute ebenso wie Cliff House zur Golden Gate National Recreation Area, einem Erholungsgebiet.

En bas: les Seal Rocks (« rochers aux phoques ») de San Francisco, photochrome
Pages 547–550:
Berkeley et le Golden Gate, photochrome
Page 551:
En haut: la piscine des bains Sutro, photochrome
En bas: les bains Sutro et le Golden Gate, photochrome
Les bains Sutro sont, comme Cliff House et l'aquarium du Golden Gate, l'œuvre d'Adolph Sutro. Avec ses sept piscines, la maison de bains était également un lieu de culture et de divertissement où se déroulaient notamment des expositions d'histoire naturelle et des concerts. La visite aux bains Sutro était un but d'excursion familiale à la fin du xix® siècle.
Les ruines des bains Sutro (fermés puis incendiés en 1966) font aujourd'hui partie du parc national de loisirs du Golden Gate.

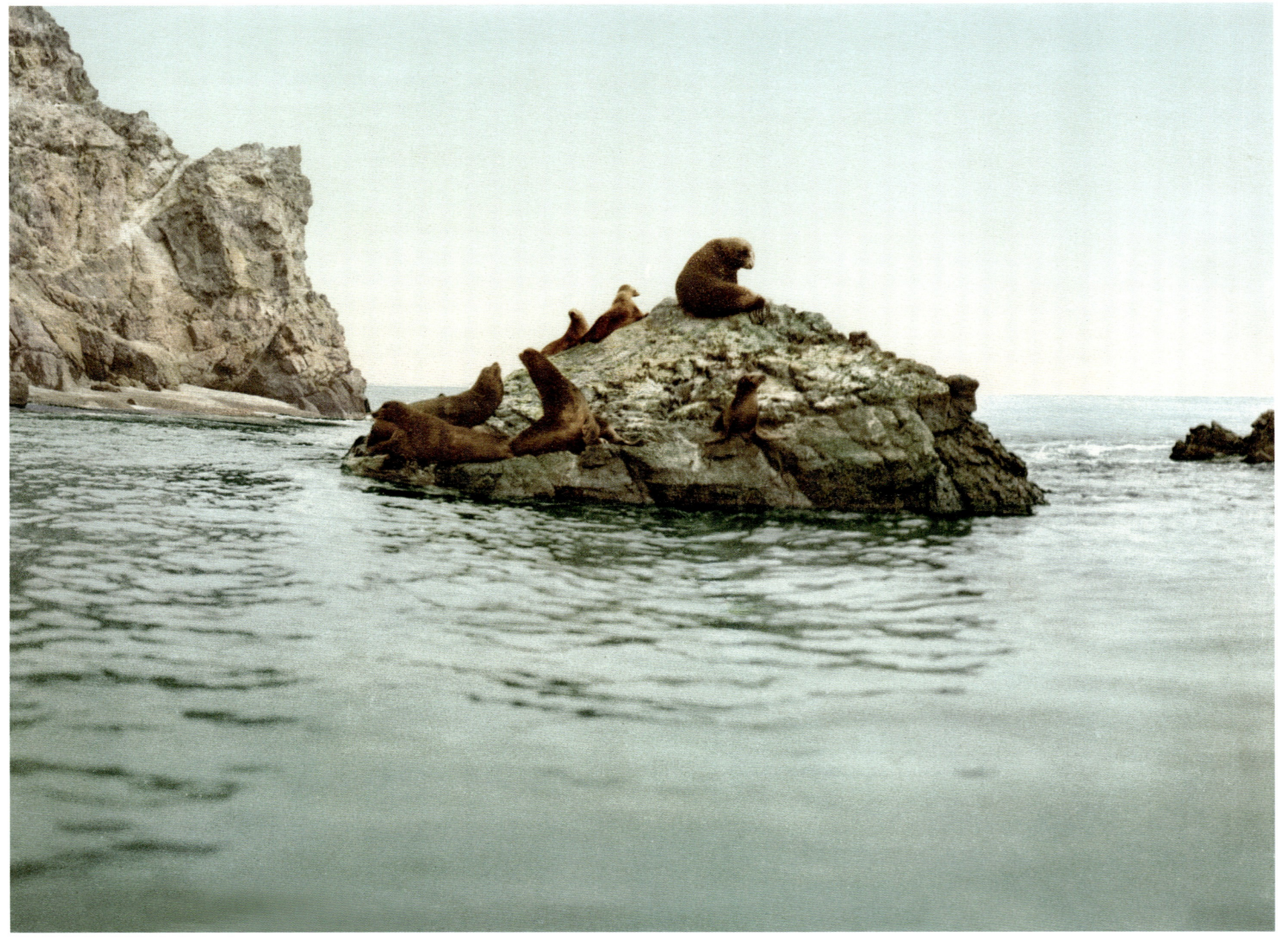

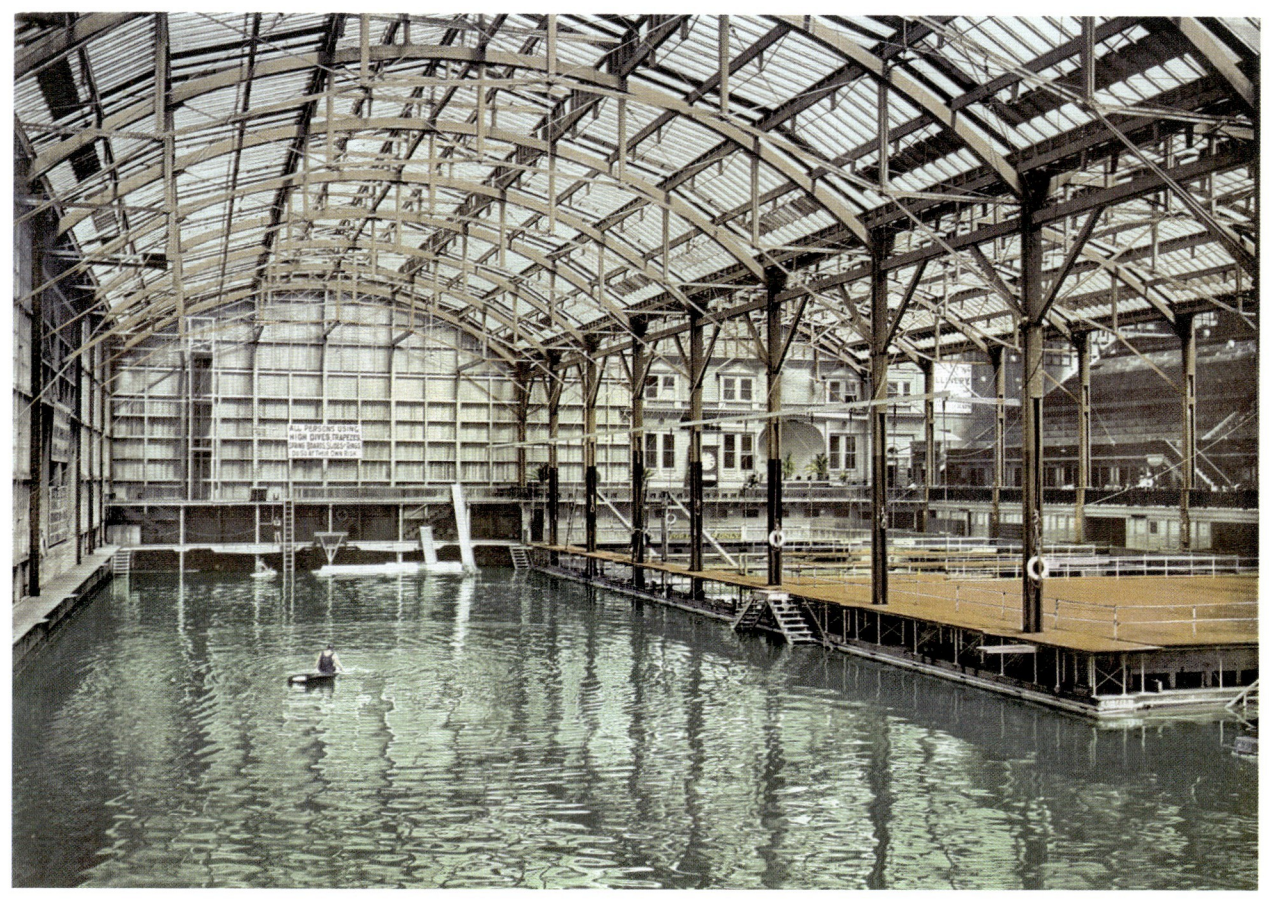

CALIFORNIA | SAN FRANCISCO

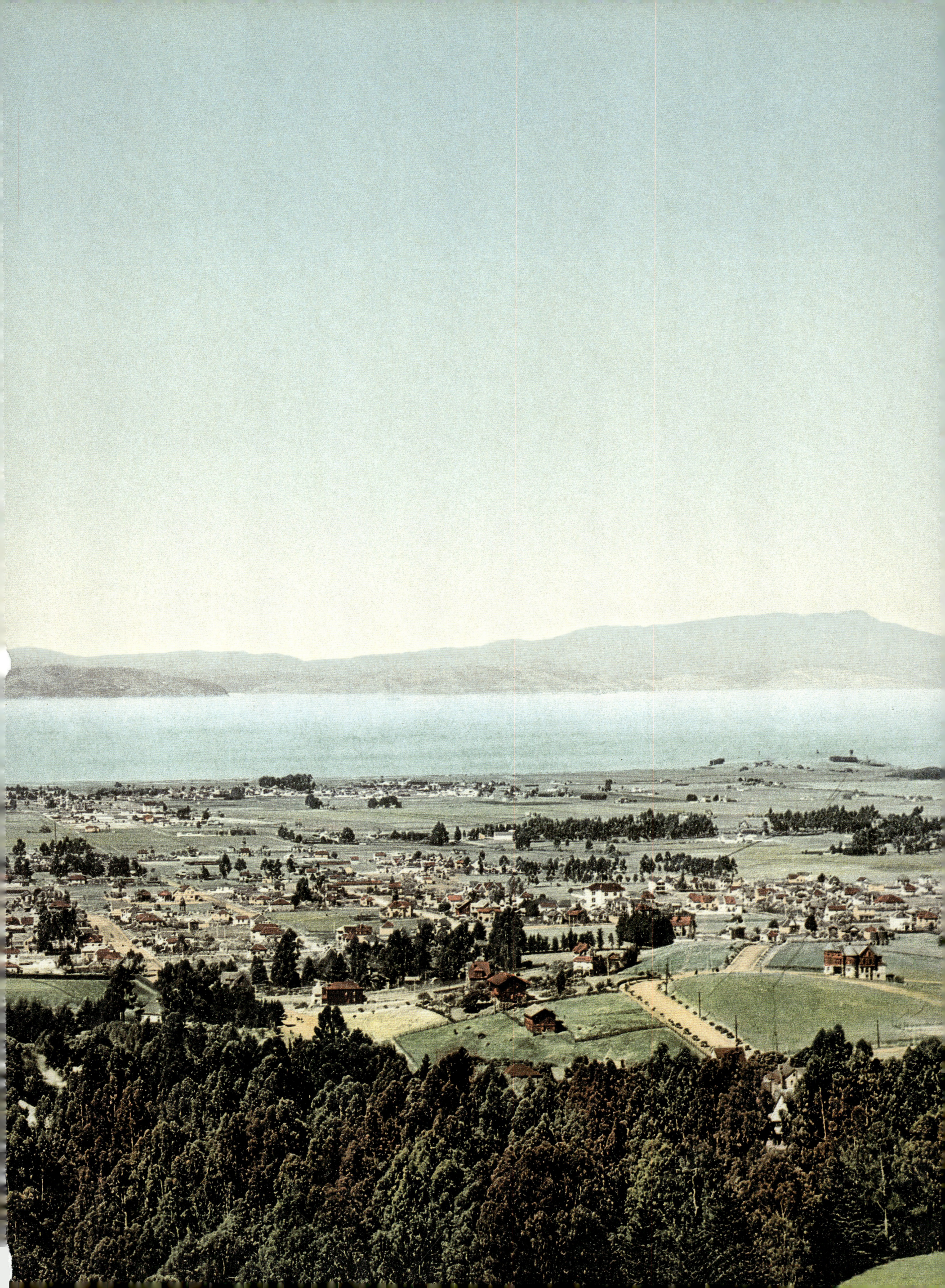

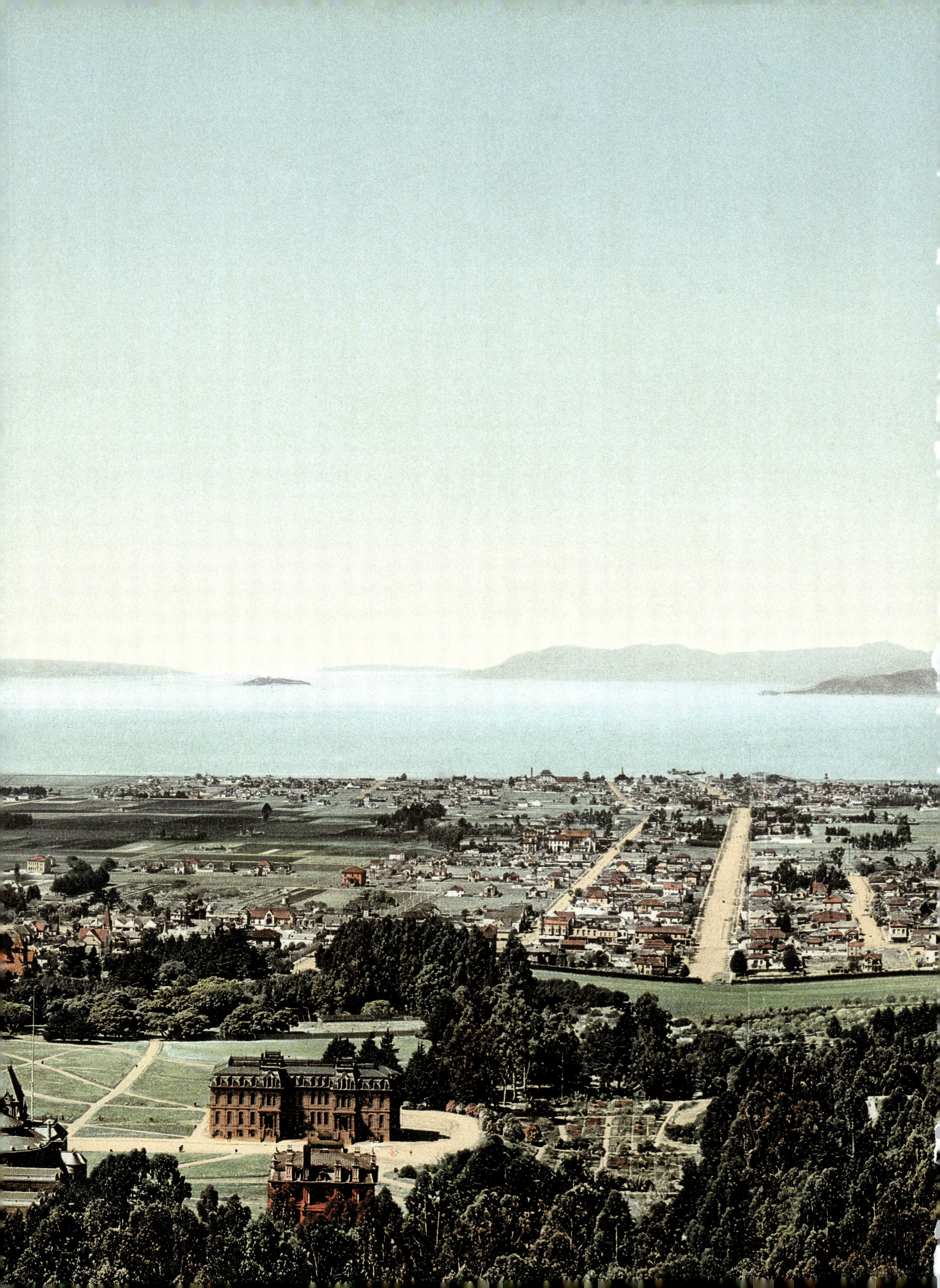

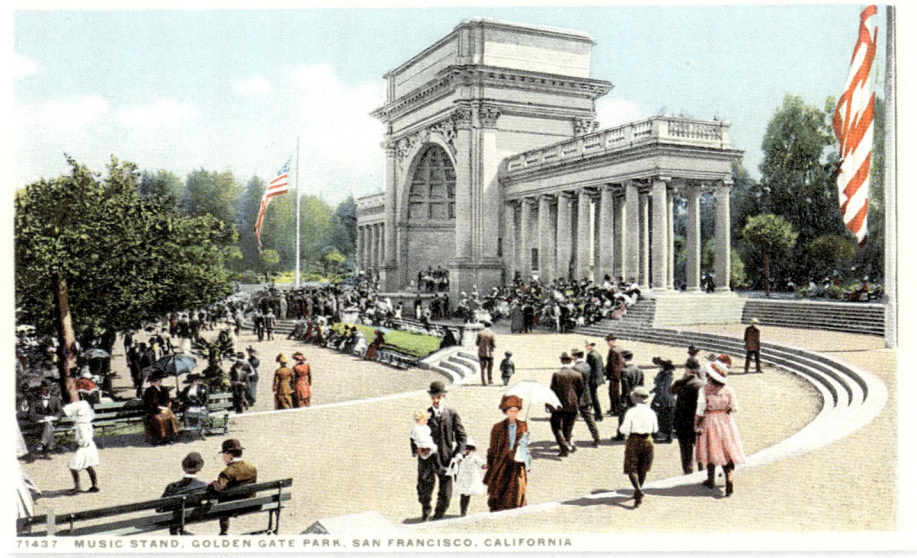

Above: **Music stand, Golden Gate Park**
Below: **Cliff House, photochrom**
Page 553:
Top left: **Cliff House from Sutro Heights**
Top right: **Cliff House (after the fire) and beach**
Bottom: **Moonlight on Cliff House, photochrom**
Cliff House, its dining room offering a panoramic view of the famous Seal Rocks of Golden Gate, was built in the chateau style by the billionaire Adolph Sutro on the site of an earlier building destroyed by fire in 1894. Having survived the 1906 earthquake, Cliff House burned to the ground the following year.

Oben: **Musikpavillon im Golden Gate Park**
Unten: **Cliff House, Photochrom**
Seite 553:
Oben links: **Cliff House von den Sutro Heights aus**
Oben rechts: **Strand und Cliff House nach dem Brand von 1907**
Unten: **Mondschein über Cliff House, Photochrom**
Cliff House (Haus auf dem Felsen), dessen Speisesaal einen herrlichen Rundblick über die berühmten Seehundfelsen von Golden Gate bot, wurde von dem Milliardär Adolph Sutro im Stil eines „französischen Schlosses" am Standort eines früheren Gebäudes errichtet, das 1894 einem Brand zum Opfer fiel. Cliff House überstand das Erdbeben von 1906, wurde allerdings im darauffolgenden Jahr durch einen Brand zerstört.

Ci-dessus : **le pavillon de musique du parc de Golden Gate**
En bas : **Cliff House, photochrome**
Page 553 :
En haut à gauche : **Cliff House depuis les hauteurs de Sutro**
En haut à droite : **la plage et Cliff House après l'incendie de 1907**
En bas : **clair de lune sur Cliff House, photochrome**
Cliff House (la « maison sur la falaise »), dont la salle à manger offrait une vue panoramique sur les célèbres « rochers aux phoques » du Golden Gate, fut édifiée dans le style « château français » par le milliardaire Adolph Sutro sur le site d'un premier bâtiment détruit par le feu en 1894. Cliff House résista au tremblement de terre de 1906 mais disparut l'année suivante dans un incendie.

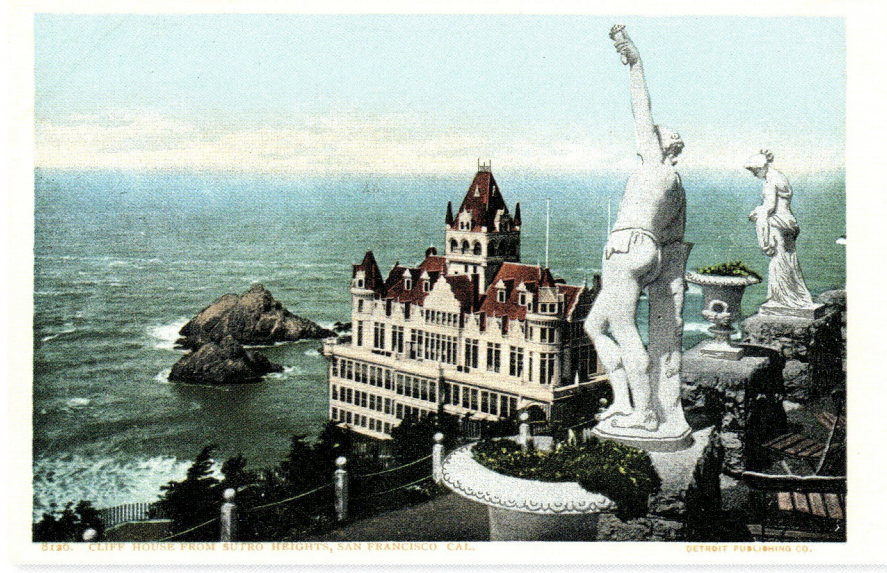
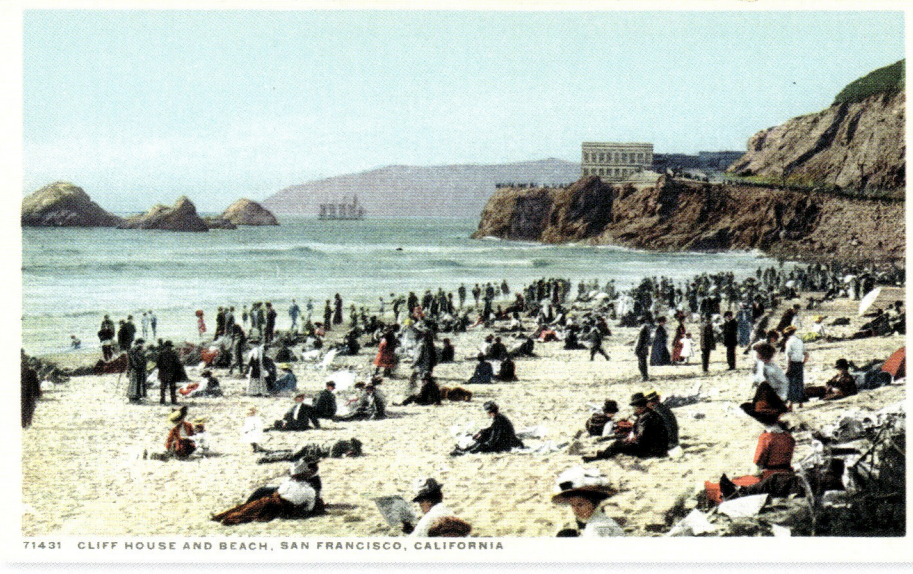

CALIFORNIA | SAN FRANCISCO

553

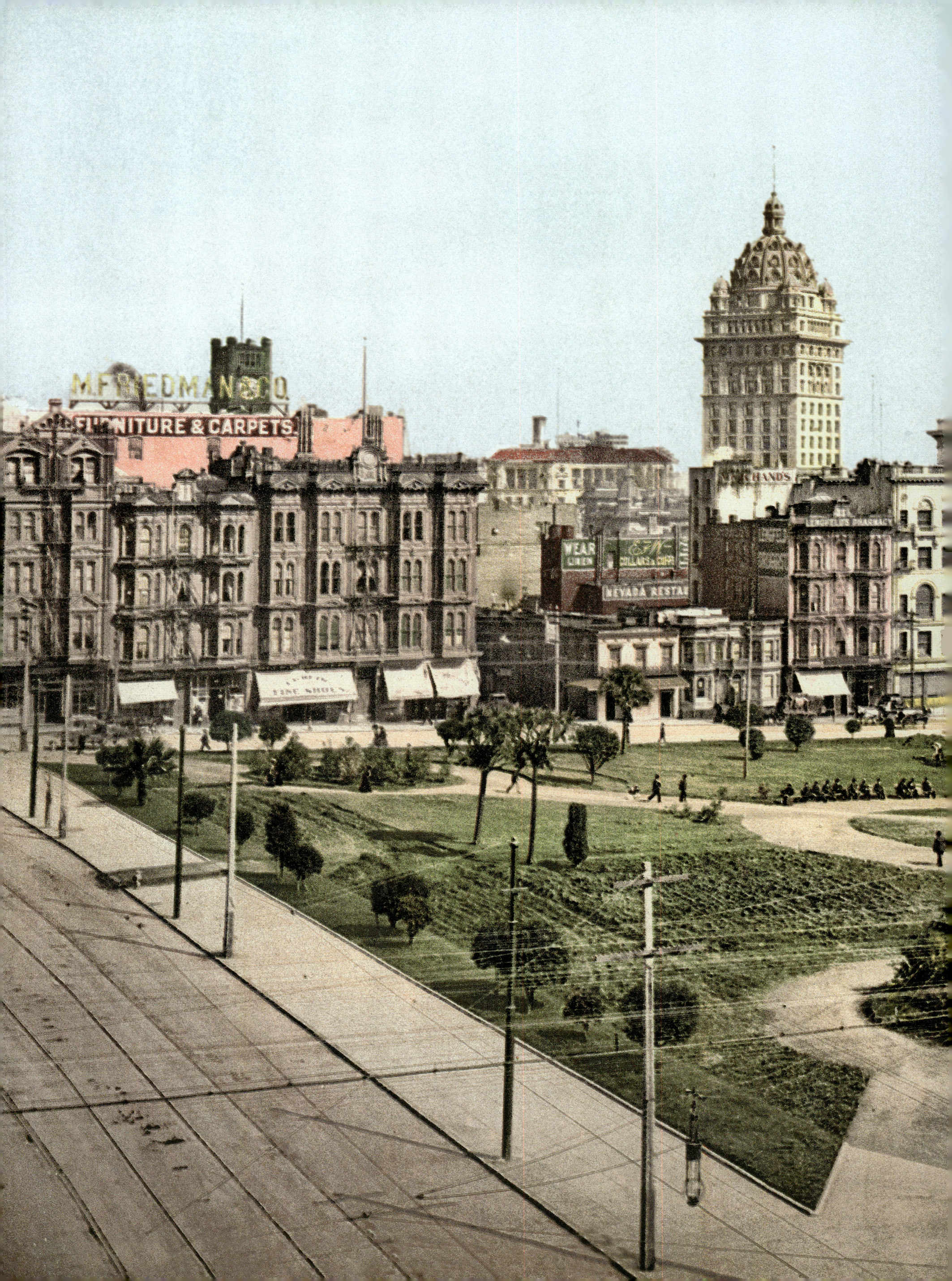

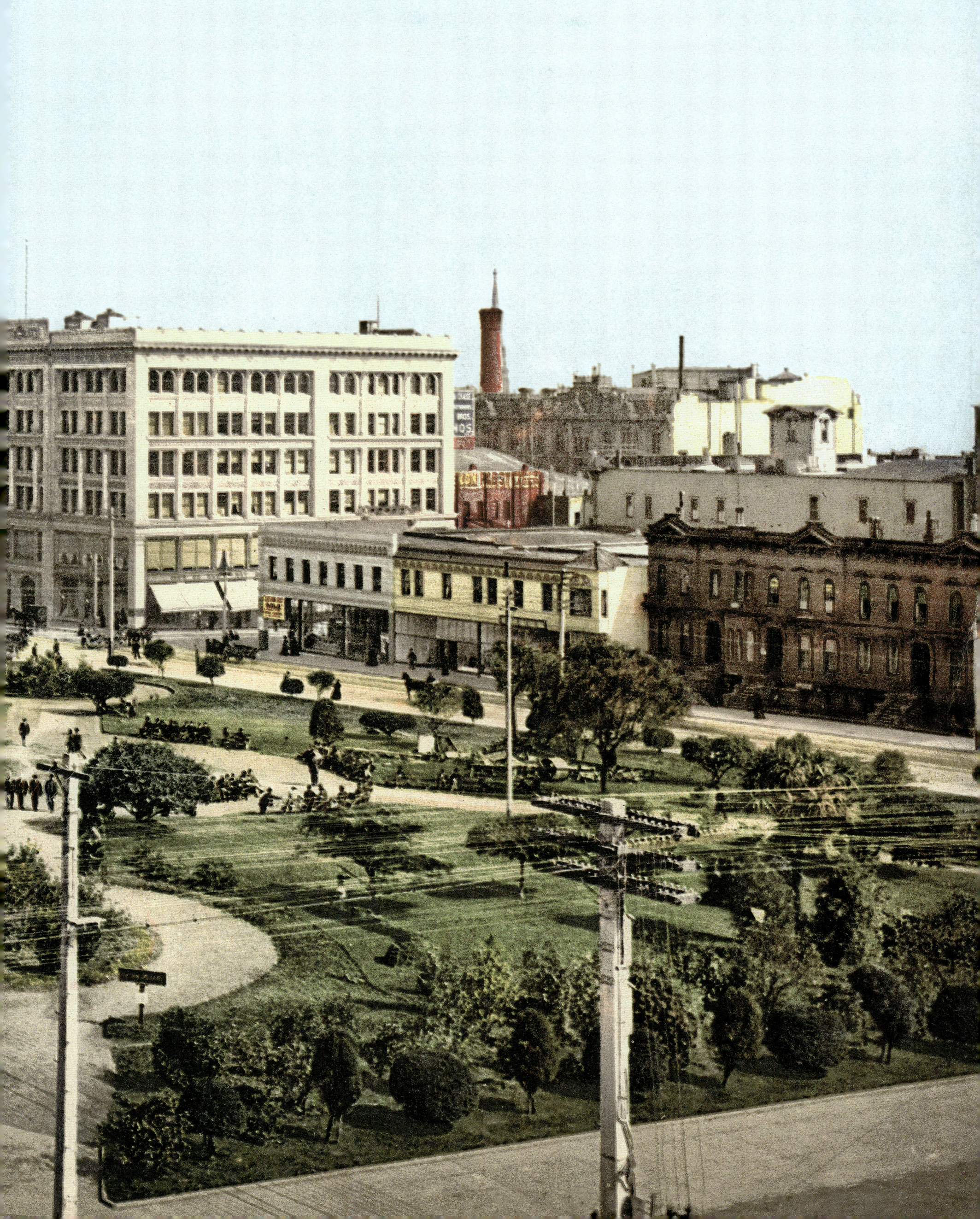

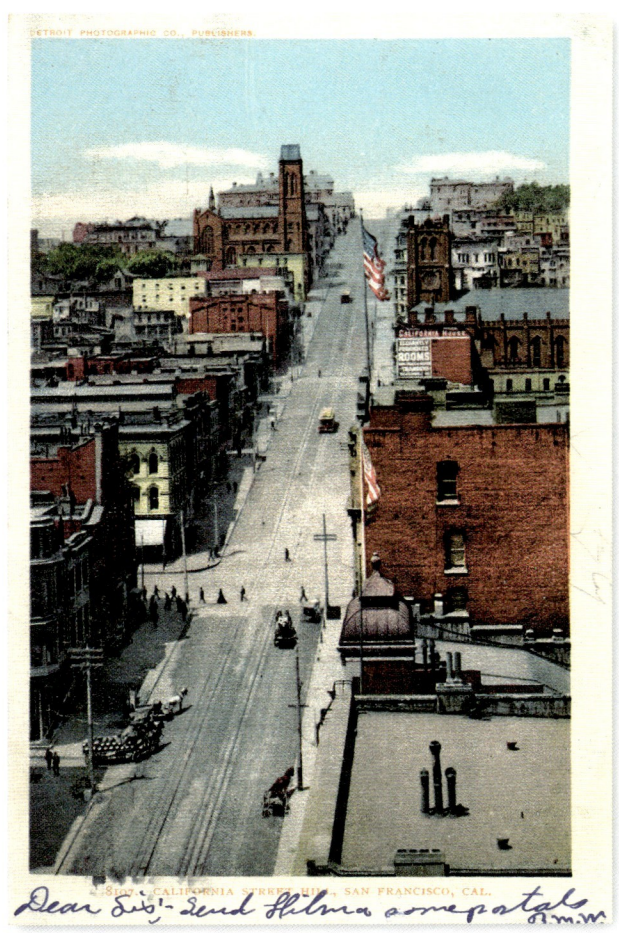
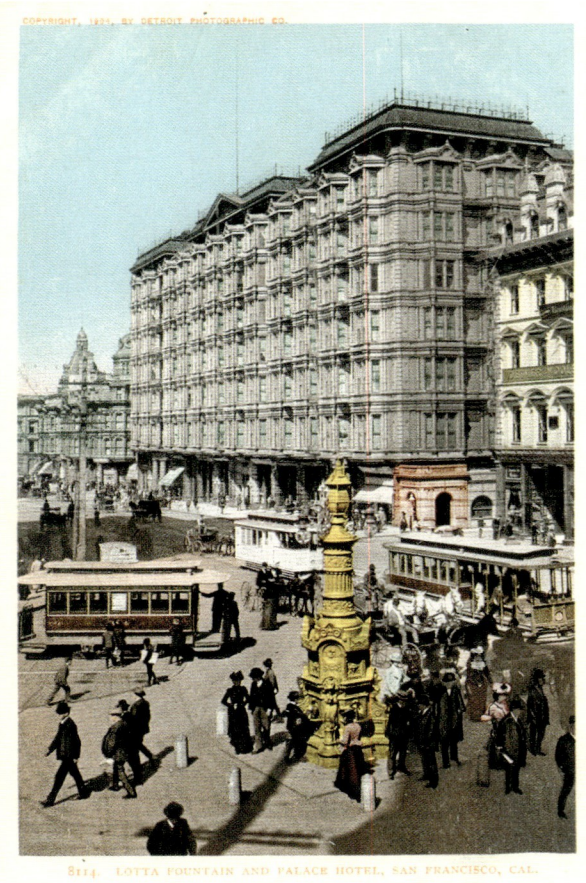
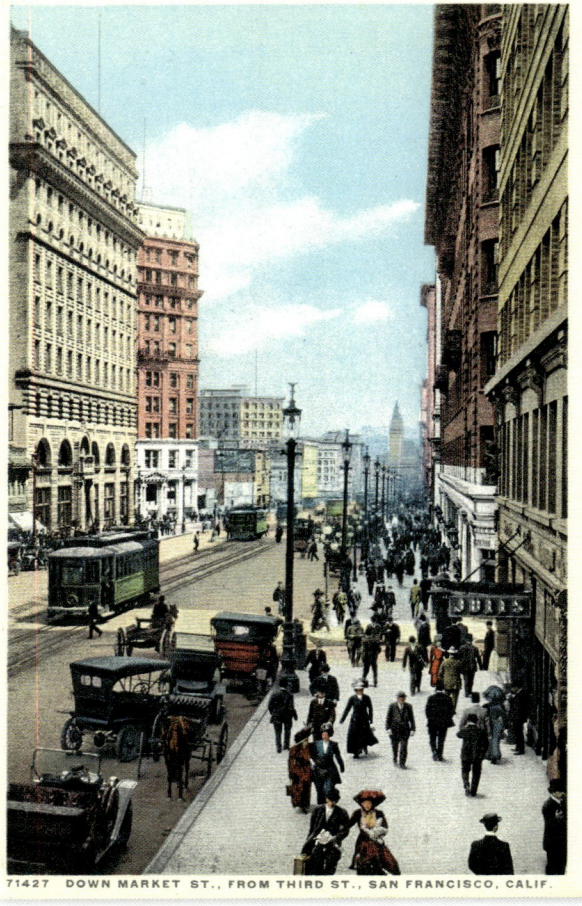

Page 554/555: **Union Square,** photochrom
Above, from left to right:
California Street Hill and Fairmont Hotel
Lotta Fountain and Palace Hotel
Down Market Street from Third Street
Below: **The court, Palace Hotel**

The first palatial hotels in San Francisco, the Palace, Baldwin, and Grand Hotel, arose on the city's main artery, Market Street; the Fairmont Hotel stood higher up on the summit of Nob Hill, at the terminus of the funicular. The Palace and Fairmont, along with some 28,000 other large buildings, were razed to the ground by the fires that followed the terrible San Francisco earthquake of April 18, 1906.

Seite 554/555: **Union Square,** Photochrom
Oben, von links nach rechts:
California Street Hill und Fairmont Hotel
Der Lotta-Brunnen und das Palace Hotel
Market Street von der Third Street kommend
Unten: **Innenhof des Palace Hotels**

An der Market Street, der Hauptverkehrsader von San Francisco, entstanden die ersten Grand Hotels, darunter das Palace, das Baldwin und das Grand; das Fairmont lag oberhalb, auf dem Gipfel des Nob Hill an der Bergstation der Seilbahn. Das Palace Hotel und das Fairmont – sowie weitere rund 28 000 Gebäude – wurden durch die Brände infolge des heftigen Erdbebens, das San Francisco am 18. April 1906 verwüstete, vollständig zerstört.

Pages 554/555 : **Union Square,** photochrome
En haut, de gauche à droite :
La colline de California Street et l'hôtel Fairmont
La fontaine Lotta et le Palace Hotel
En descendant Market Street depuis Third Street
En bas : **le patio du Palace Hotel**

Sur la principale artère de San Francisco, Market Street, s'élevèrent les premiers grands hôtels, le Palace, le Baldwin, le Grand. Le Fairmont, lui, était situé plus haut, au sommet de Nob Hill, à l'arrivée du funiculaire. Le Palace Hotel, le Fairmont et quelque 28 000 autres immeubles furent entièrement détruits par les incendies consécutifs au violent tremblement de terre qui ravagea la ville le 18 avril 1906.

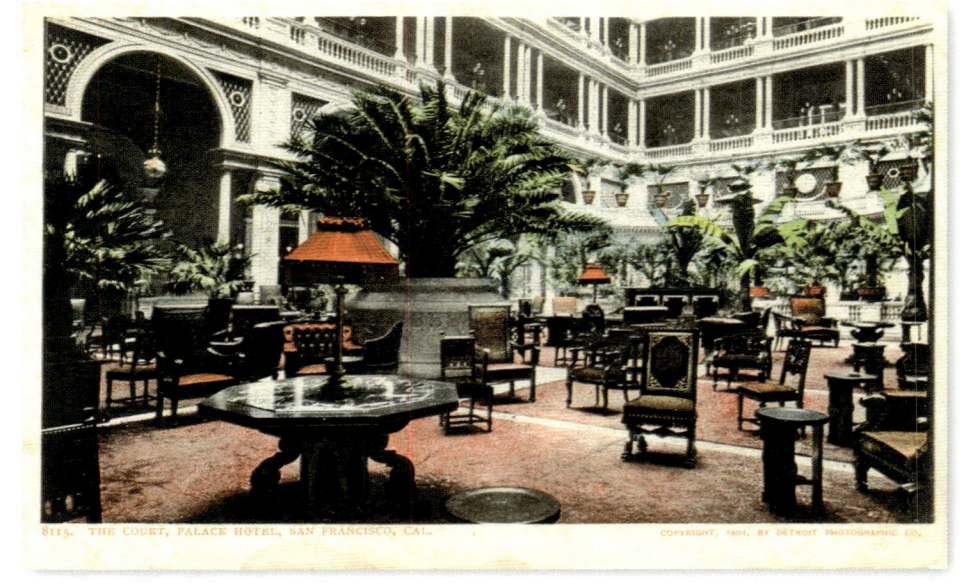

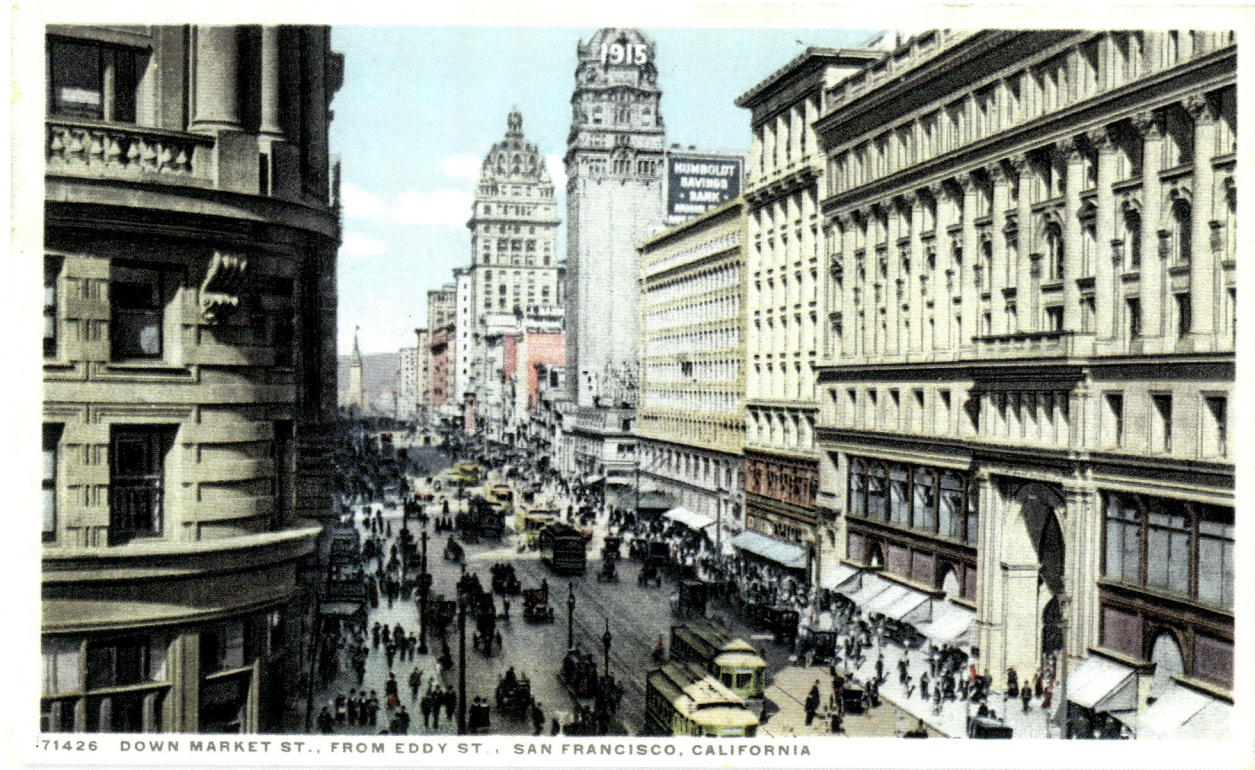

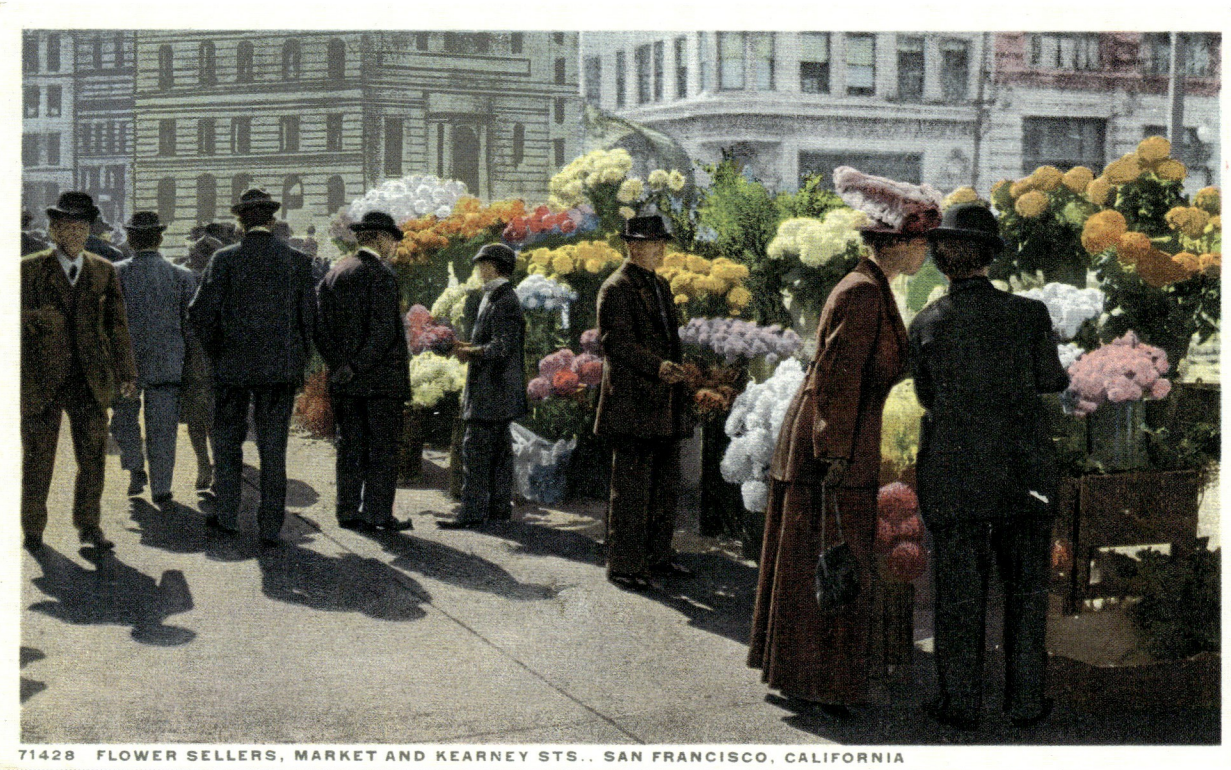

From top to bottom:
Down Market Street from Eddy Street
Market Street
Flower sellers, Market and Kearney Streets
Page 558/559: Market Street toward ferry, San Francisco earthquake, glass negative, 1906

Von oben nach unten:
Die Market Street von der Eddy Street aus
Market Street
Blumenhändler an der Ecke von Market Street und Kearney Street
Seite 558/559: Market Street in Richtung Fähre, Erdbeben von San Francisco, Glasnegativ, 1906

De haut en bas :
En descendant Market Street depuis Eddy Street
Market Street, vue en perspective
Fleuristes au coin de Market Street et de Kearney Street
Pages 558/559 : Market Street dans la direction du ferry, tremblement de terre de San Francisco, plaque de verre, 1906

CALIFORNIA | SAN FRANCISCO

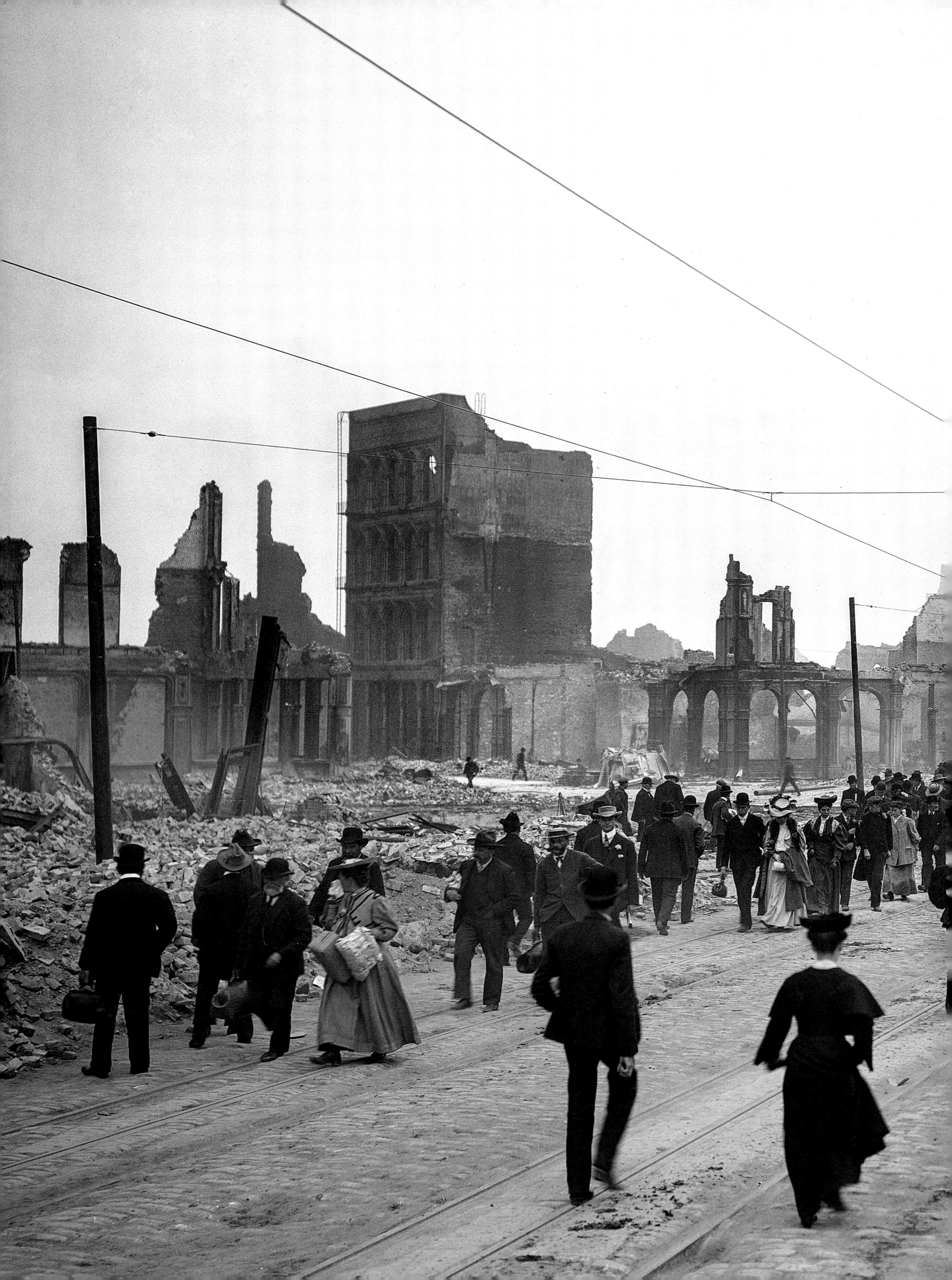

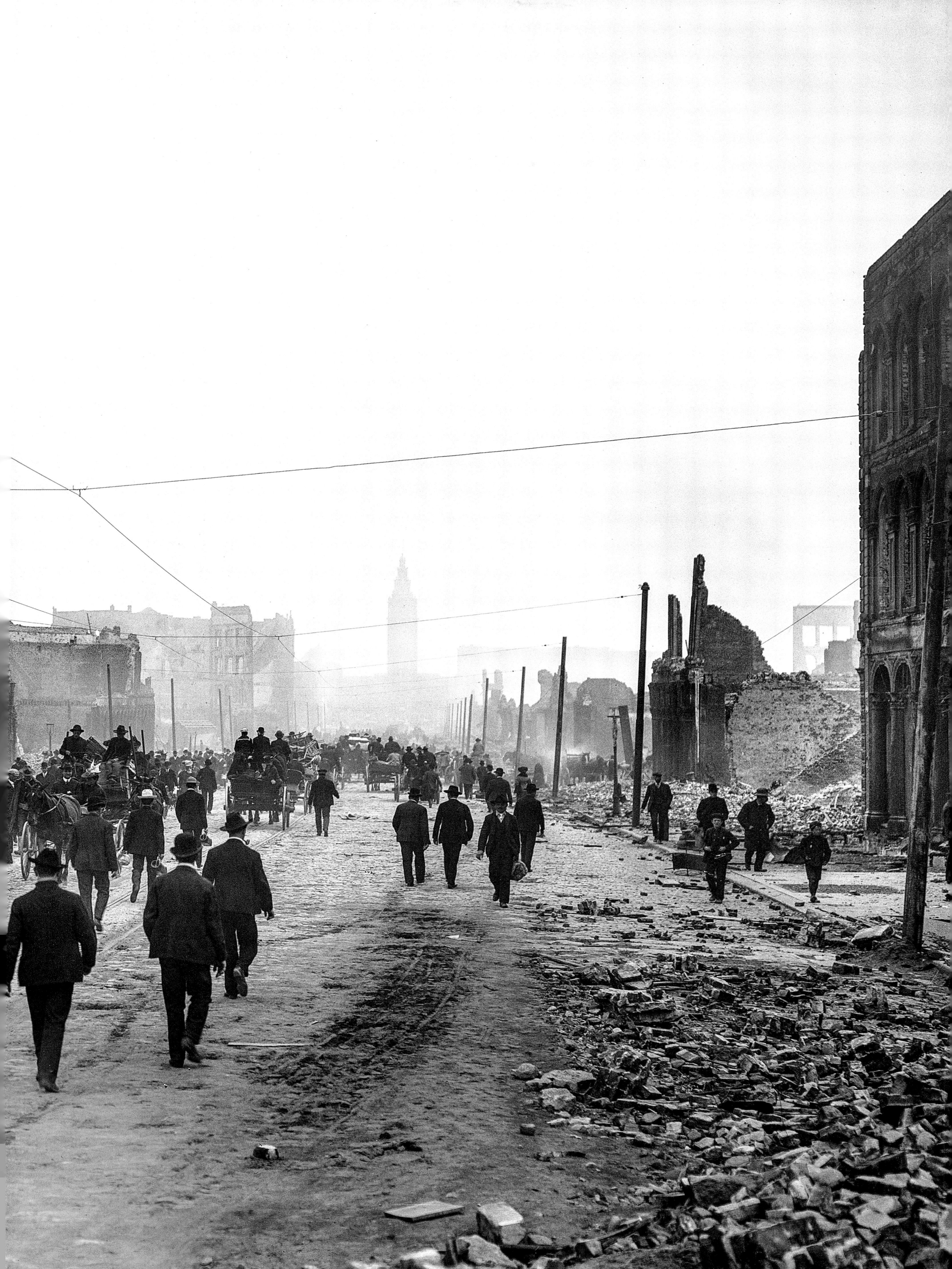

Below, from top to bottom and left to right:
The Tent City, Santa Cruz
Sea Beach Hotel, Santa Cruz
Casino and Sea Beach Hotel, Santa Cruz
Page 561: Carmel Bay, Monterey, photochrom

The first bathing establishment in Santa Cruz was built in 1865 at the mouth of the San Lorenzo River. Tourists came to take seawater cures there. Soon, restaurants, souvenir shops, and photo booths opened up. The first casino was opened in 1904 and burned down two years later. In the late summer of 1906, the architect William H. Weeks designed a boardwalk and a new casino equipped with a ballroom and a swimming pool.

Unten, von oben nach unten und von links nach rechts:
Tent City (Zeltdorf), Santa Cruz
Hotel Sea Beach, Santa Cruz
Das Kasino und das Hotel Sea Beach, Santa Cruz
Seite 561: Carmel-Bucht, Monterey, Photochrom

Die erste Badeanstalt von Santa Cruz entstand 1865 nahe der Mündung des San Lorenzo River. Die Touristen kamen, um sich hier einer Meerwasserkur zu unterziehen. Schon bald eröffneten Restaurants sowie Souvenir- und Fotoläden. Das erste Kasino wurde 1904 eröffnet; zwei Jahre später brannte es ab. Am Ende des Sommers 1906 entwarf der Architekt William H. Weeks eine Promenade sowie ein neues Kasino mit Ballsaal und Schwimmbad.

En bas, de haut en bas et de gauche à droite :
Tent City (le camping) de Santa Cruz
L'hôtel Sea Beach à Santa Cruz
Le casino et l'hôtel Sea Beach à Santa Cruz
Page 561 : la baie de Carmel, Monterey, photochrome

La première maison de bains de Santa Cruz fut créée en 1865 près de l'embouchure du fleuve San Lorenzo. Les touristes venaient y faire des cures d'eau de mer. Bientôt des restaurants, des boutiques de souvenirs et de photographie ouvrirent. Le premier casino fut inauguré en 1904 ; il brûla deux ans plus tard. À la fin de l'été 1906, l'architecte William H. Weeks dessina les plans d'une promenade et d'un nouveau casino, équipé d'une salle de bal et d'une piscine.

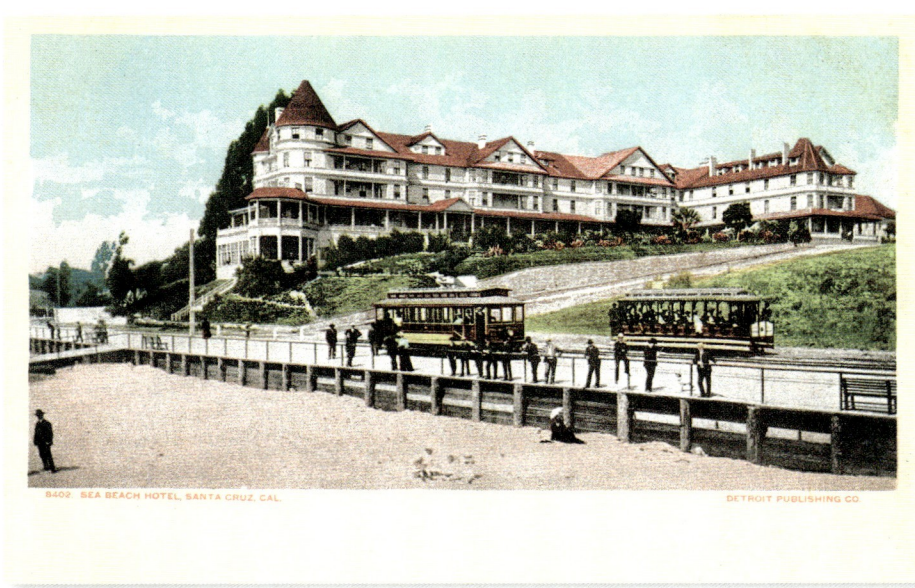

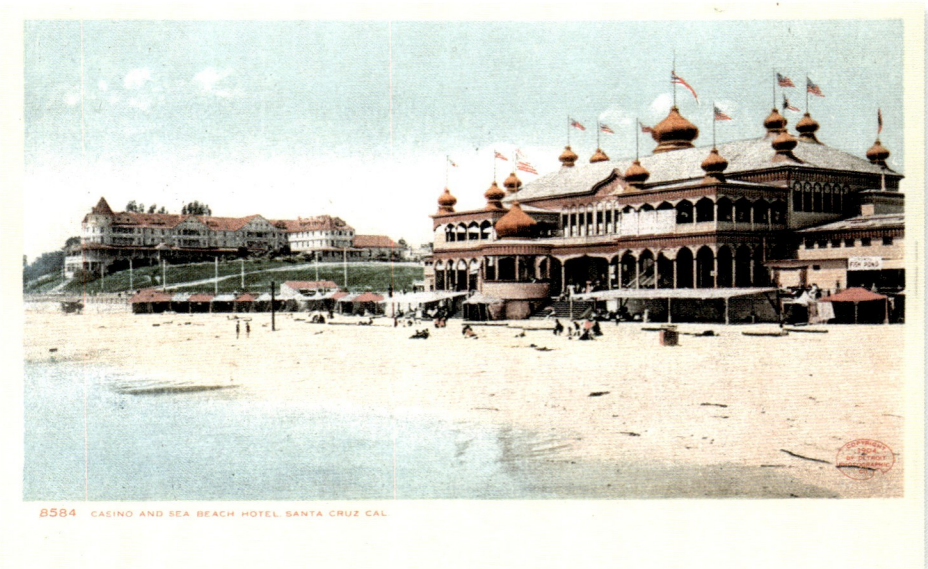

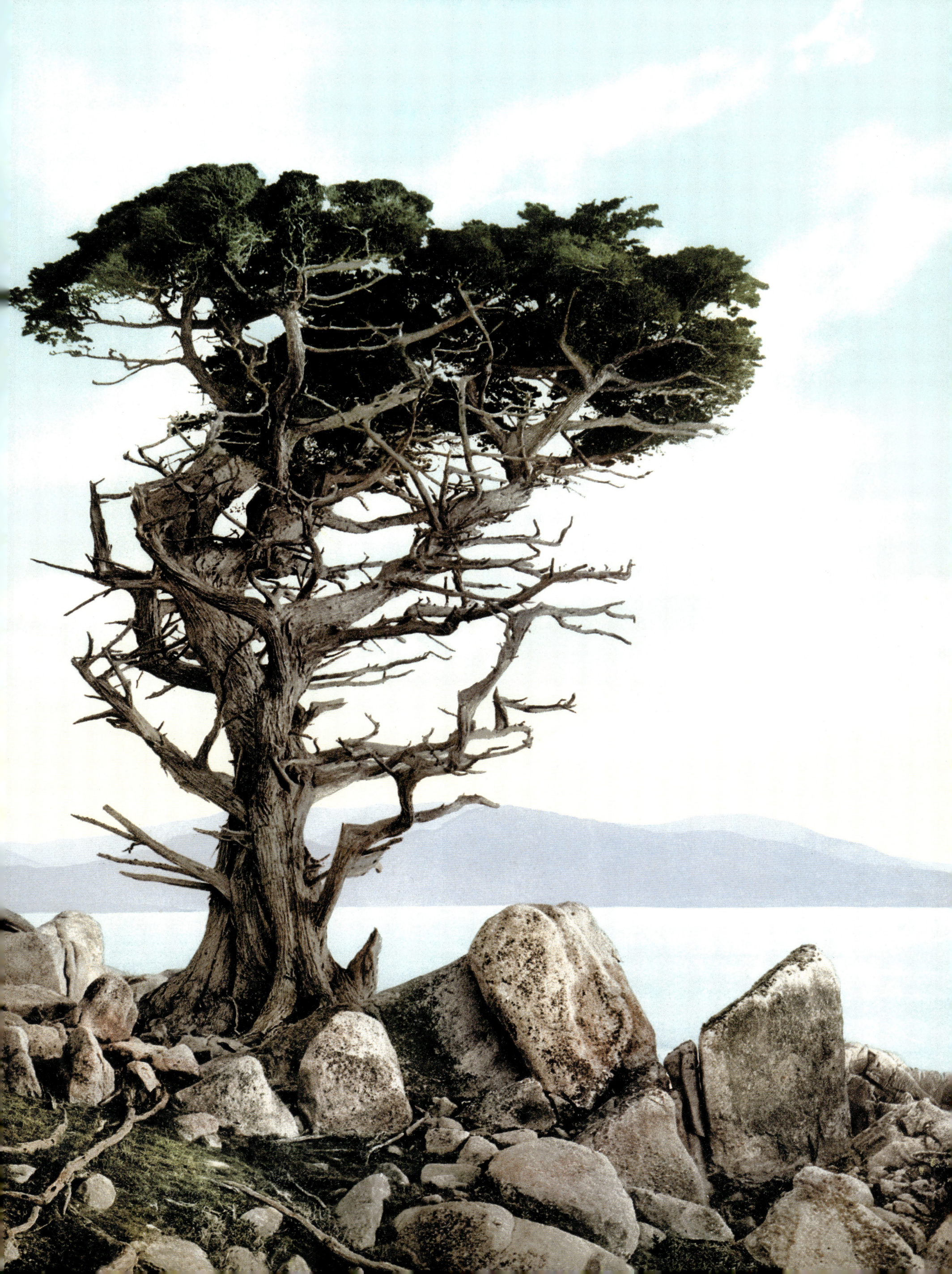

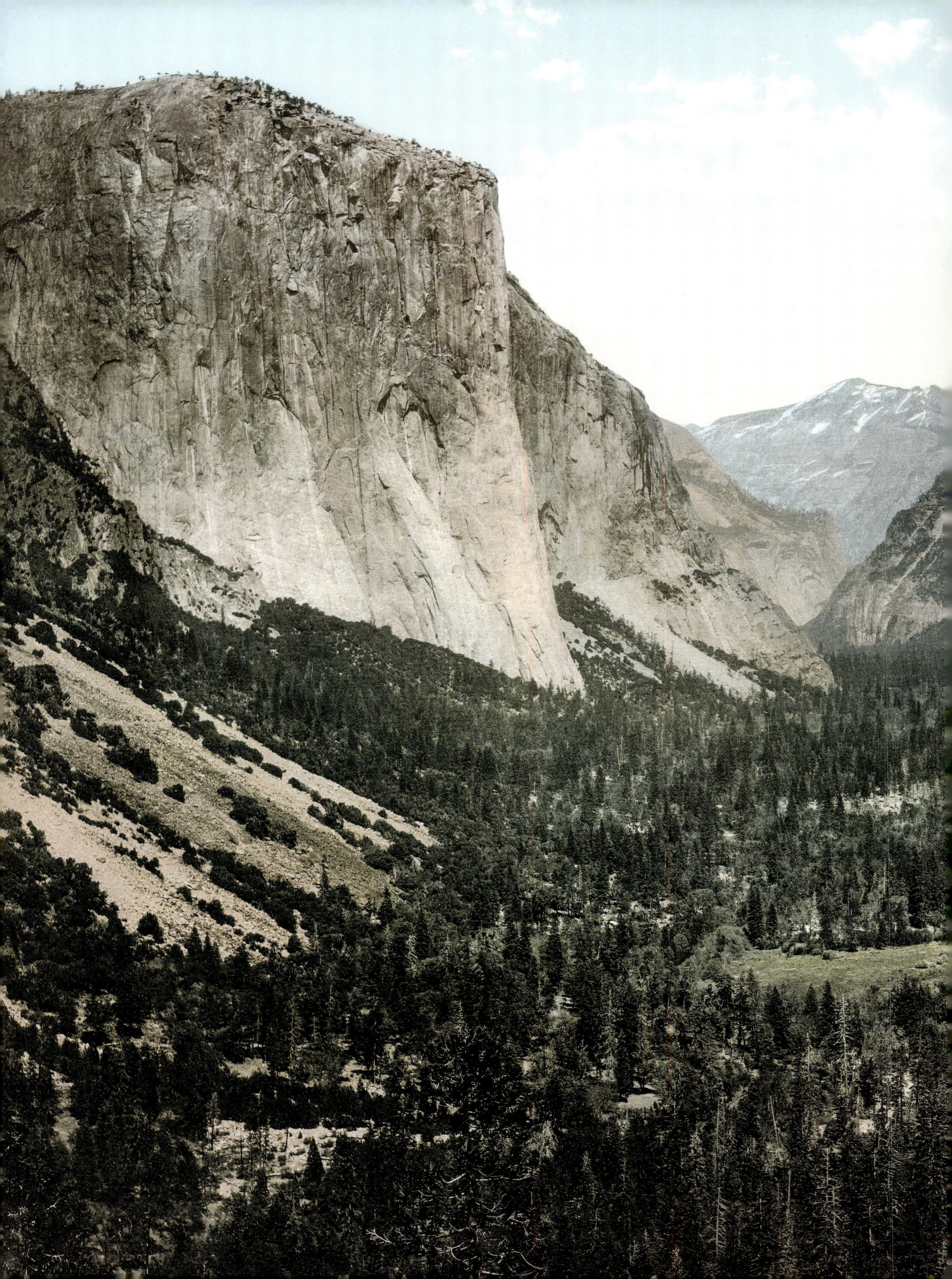

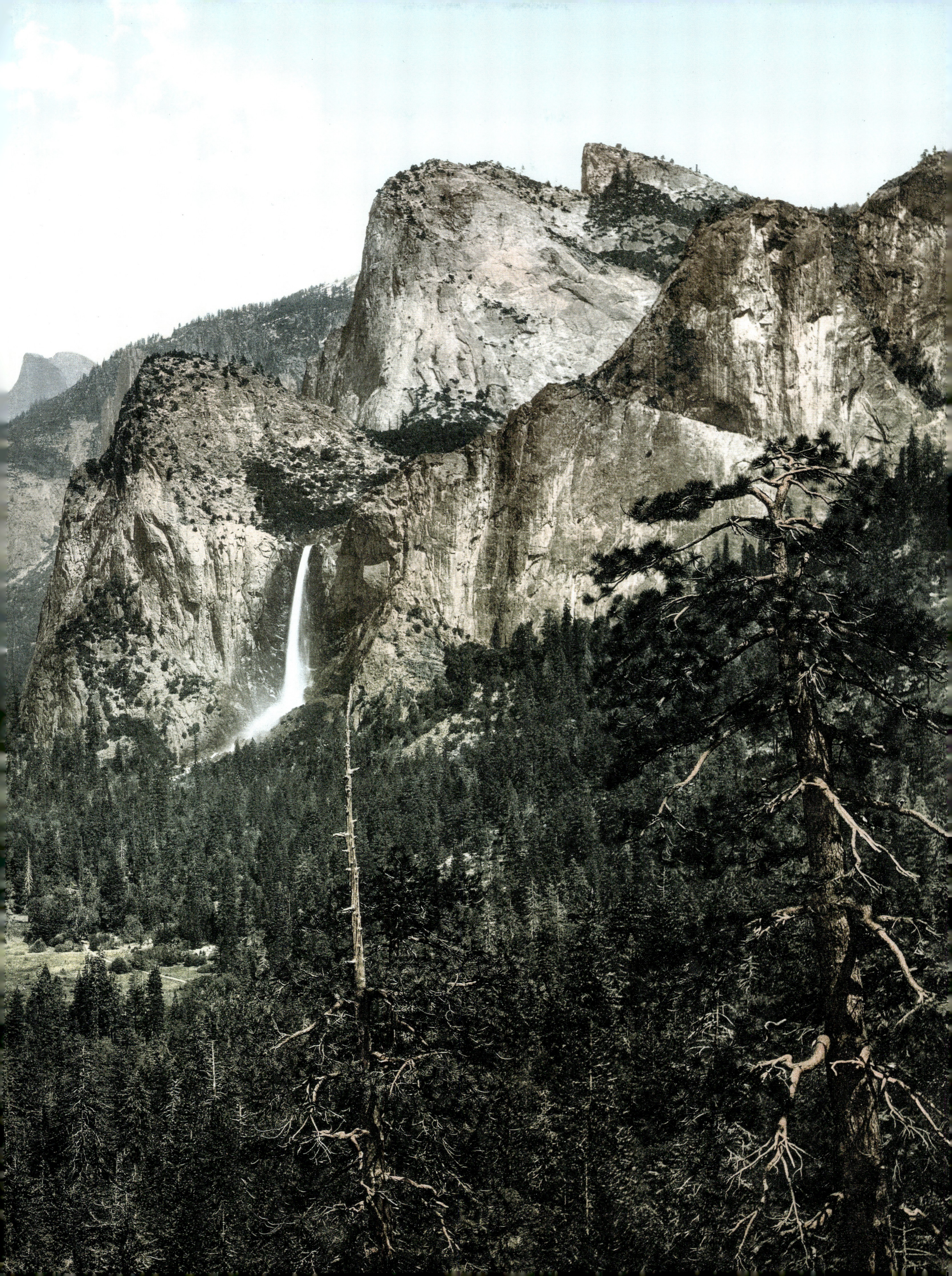

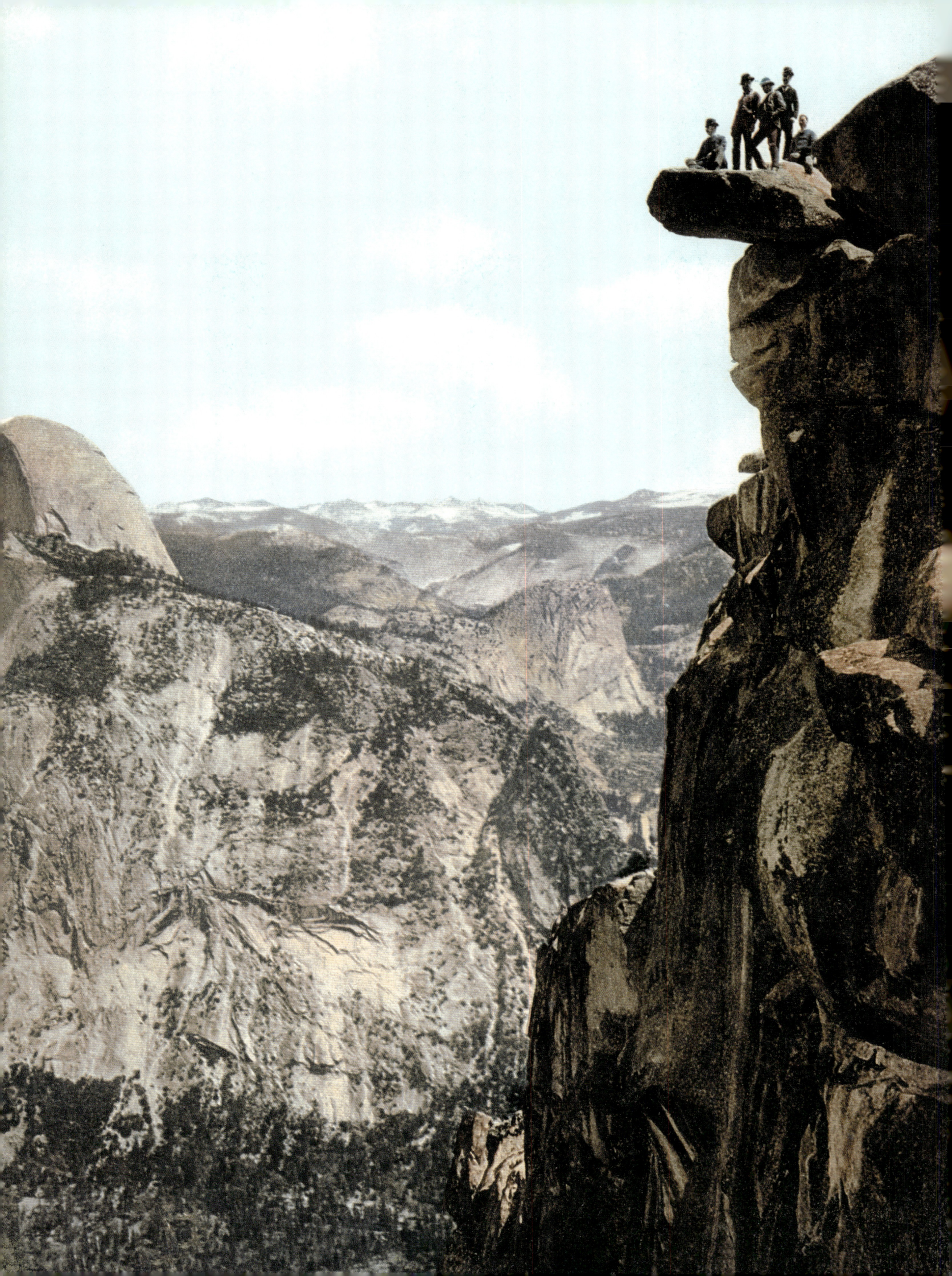

Page 562/563: Yosemite Valley, general view, photochrom
Page 564: Glacier Point and South Dome (Half Dome), photochrom
Right: Stage at Arch Rock

Yosemite's Half Dome was first climbed in 1875, by a Scot, George Anderson, and, shortly afterwards, by the explorer John Muir; it had until then been considered the most inaccessible mountain of the Sierra Nevada because the granite of its curved summit was so smooth. Anderson's extraordinary exploit paved the way for Muir and subsequent climbers.

Seite 562/563: Gesamtansicht des Yosemite-Tals, Photochrom
Seite 564: Blick vom Glacier Point auf den South Dome oder Half Dome, Photochrom
Rechts: Eine Postkutsche fährt unter dem Arch Rock (Felsenbogen) hindurch

Der Half Dome von Yosemite, der wegen des glatten Granits auf der Kuppe seines Gipfels als der unzugänglichste Berg der Sierra Nevada galt, wurde erstmals 1875 erklommen, zuerst von dem Schotten George Anderson und dann von dem Entdecker John Muir. Andersons außerordentliche Leistung ebnete den Weg für Muir und später für Touristen, die sportlich genug waren, es ihm gleichzutun.

Pages 562/563 : vue générale de la vallée de Yosemite, photochrome
Page 564 : vue sur le South Dome ou Half Dome (dôme Sud ou Demi-Dôme) depuis Glacier Point, photochrome
À droite : diligence passant sous le rocher de l'Arche (Arch rock)

Escaladé pour la première fois en 1875, d'abord par un Écossais, George Anderson, puis par l'explorateur John Muir, le dôme Sud de Yosemite était considéré comme le mont le plus inaccessible de la Sierra Nevada tant le granit de la courbe à son sommet était lisse. L'extraordinaire exploit d'Anderson ouvrit la voie à Muir, puis aux touristes assez sportifs pour suivre ses pas.

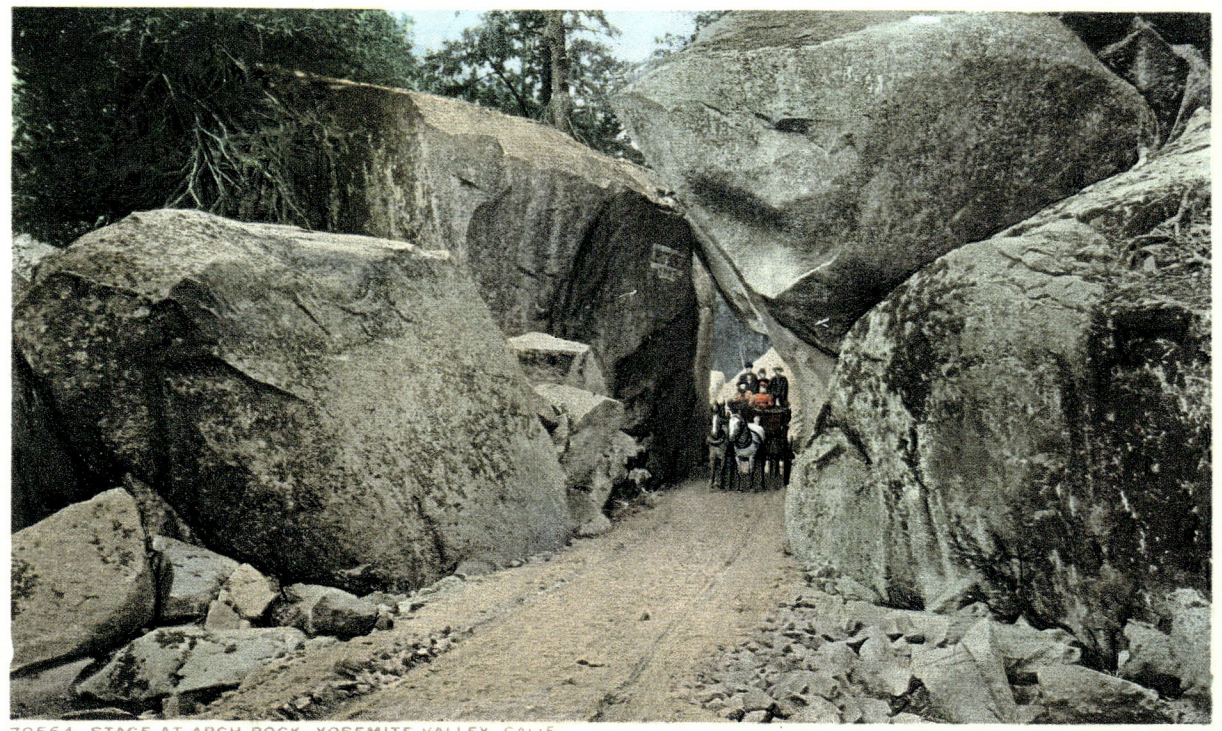

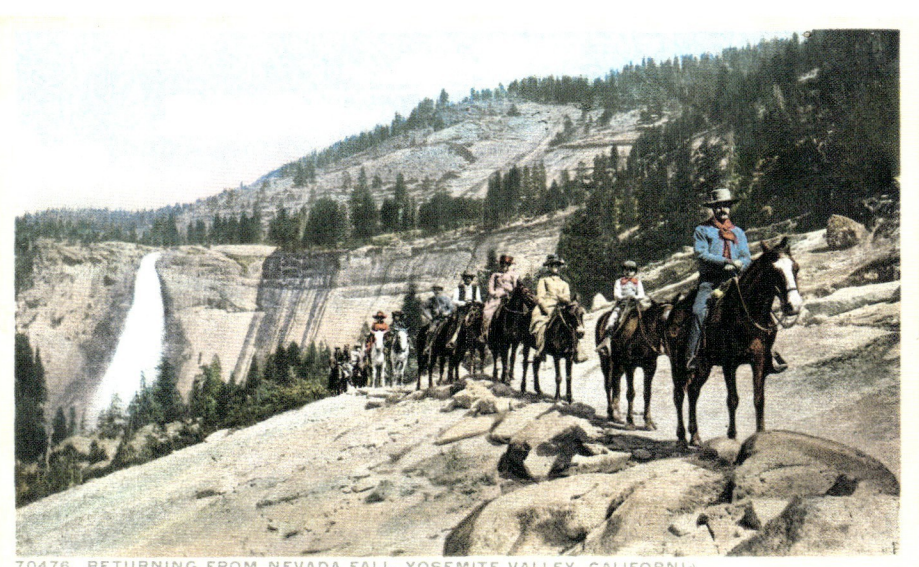

Left: Returning from Nevada Fall
Bottom left: "A bare-faced steal"
Below: The Sentinel Hotel
Page 566/567: Mirror Lake

Links: Auf dem Rückweg vom Nevada-Fall
Unten links: Bär auf Nahrungssuche
Unten rechts: Das Hotel Sentinel
Seite 566/567: Der Mirror Lake (Spiegelsee)

À gauche : en revenant de Nevada Fall (la chute Nevada)
En bas à gauche : ours en quête de nourriture
Ci-dessous : l'hôtel Sentinel
Pages 566/567 : le Mirror Lake (lac Miroir)

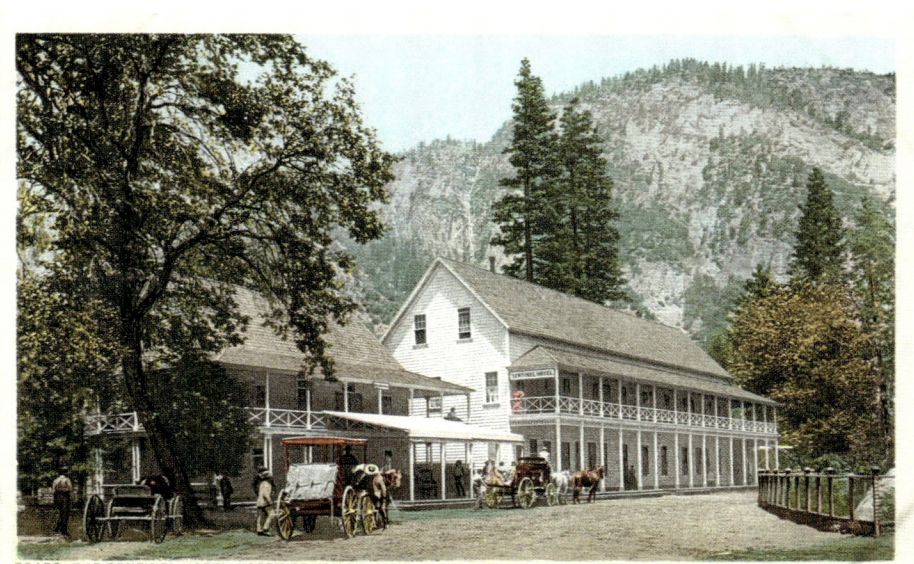

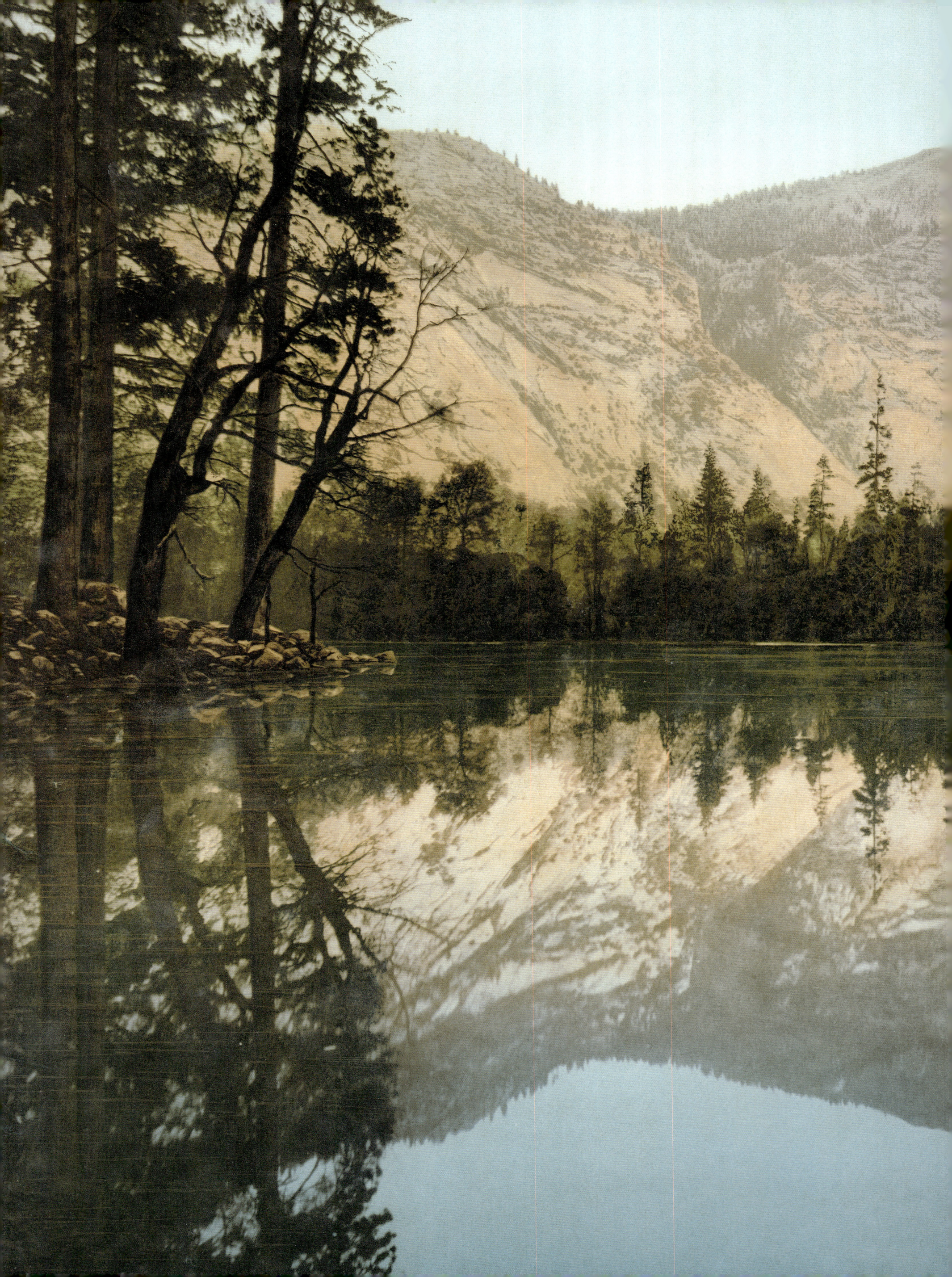

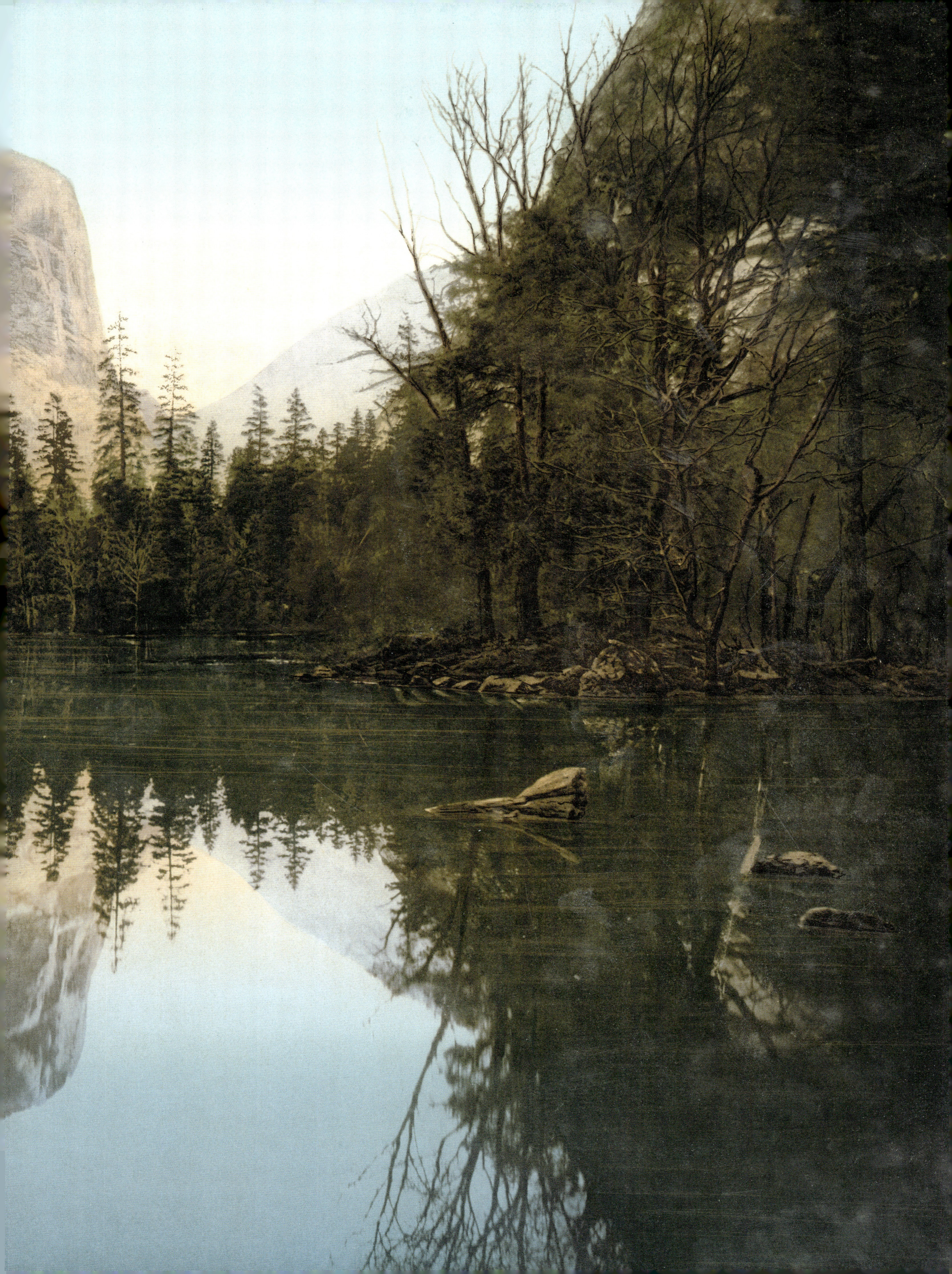

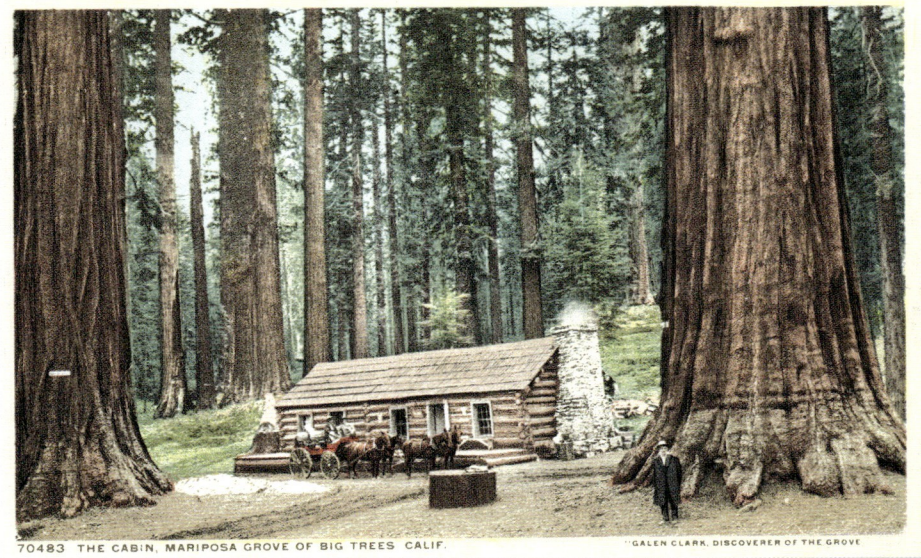
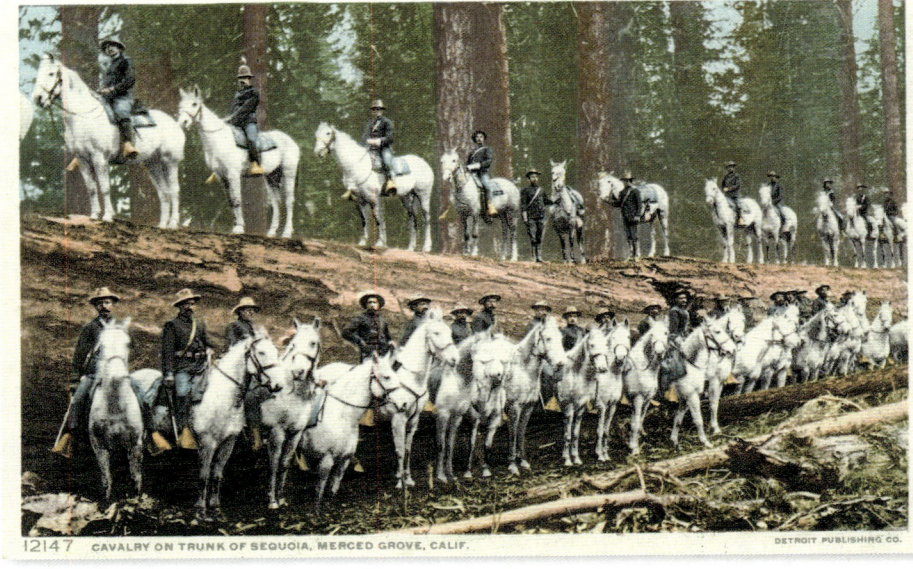
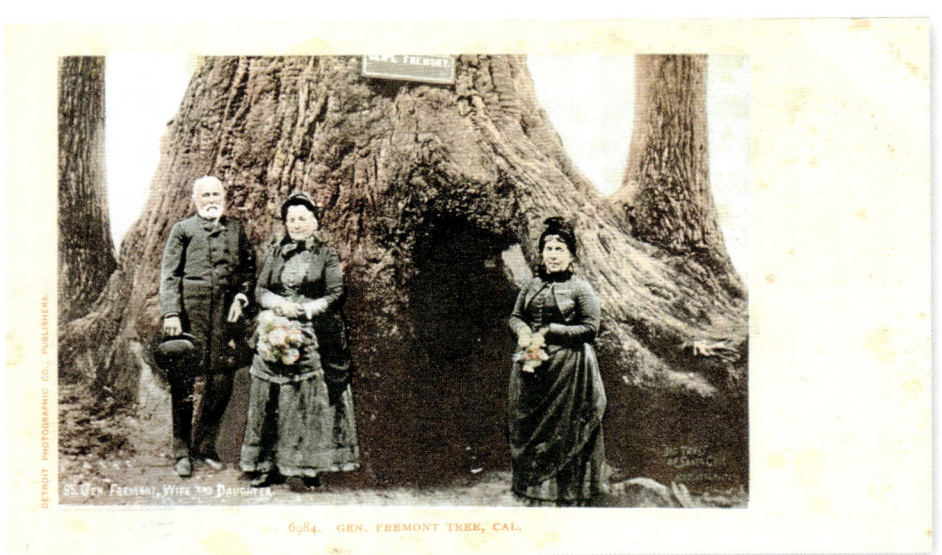
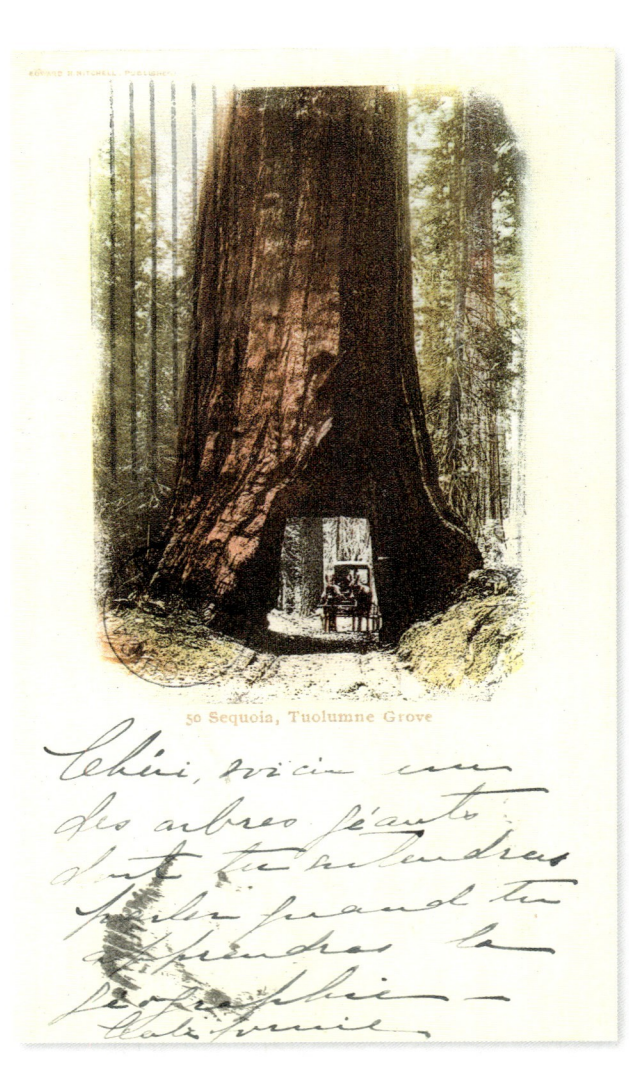

Top left: **The cabin, Mariposa Grove**
Top right: **Cavalry on trunk of sequoia, Merced Grove, Yosemite National Park**
Above: **General Frémont Tree, Big Trees Park, Santa Cruz County**
Right: **Sequoia, Tuolumne Grove**
Page 569: **Mariposa Grove, "Three Graces"**

Certain sequoias in Mariposa Grove in Yosemite National Park and Sequoia National Park, slightly to the south of Yosemite, are between 2,000 and 3,000 years old. Many giant sequoias have been named after famous men who have visited them. For example, the "General Frémont"—260 feet (80 m) tall and 66 feet (20 m) in diameter—was named after the Californian senator and abolitionist John C. Frémont; he and his men are said to have made camp in its shelter. It fell in 2010.

Oben links: **Die Hütte im Mariposa Grove (Mariposa-Wald)**
Oben rechts: **Kavallerieregiment auf dem Stamm eines Mammutbaums, Merced Grove, Yosemite-Nationalpark**
Mitte: **General-Frémont-Baum, Big Trees Park, Santa Cruz County**
Rechts: **Mammutbaum im Tuolumne Grove**
Seite 569: **Die „Drei Grazien" vom Mariposa Grove**

Einige Mammutbäume (Sequoias) des Mariposa Grove im Yosemite-Nationalpark oder im südlicher gelegenen Sequoia-Nationalpark sind zwischen 2 000 und 3 000 Jahre alt. Zahlreiche Riesen-Sequoias sind nach berühmten Männern benannt, die sich in ihrer Nähe aufgehalten haben: so zum Beispiel der „General Frémont" genannte Riesenbaum (80 Meter hoch bei 20 Meter Umfang), unter dem der Senator von Kalifornien und glühende Gegner der Sklaverei, Offizier John C. Frémont, mit seinen Leuten kampiert haben soll. Der Baum ist im Jahr 2010 umgefallen.

En haut à gauche : **la cabane de Mariposa Grove (le bosquet de Mariposa)**
En haut à droite : **régiment de cavalerie sur le tronc d'un séquoia, Merced Grove, parc national de Yosemite**
Ci-dessus à gauche : **l'arbre du général Frémont, Big Trees Park, comté de Santa Cruz**
À droite : **séquoia dans le bosquet de Tuolumne**
Page 569 : **les « Trois Grâces » de Mariposa Grove**

Certains séquoias du bosquet de Mariposa, dans le Parc national de Yosemite, ou du parc national de Sequoia, plus au sud, ont entre 2 000 et 3 000 ans. Nombre de ces arbres doivent leur nom aux hommes célèbres qui les ont approchés : ainsi l'arbre géant dit « du général Frémont » (80 mètres de hauteur et 20 mètres de circonférence), à l'abri duquel l'officier John C. Frémont, sénateur de Californie et fervent anti-esclavagiste, aurait campé avec ses hommes. L'arbre du général Frémont est tombé en 2010.

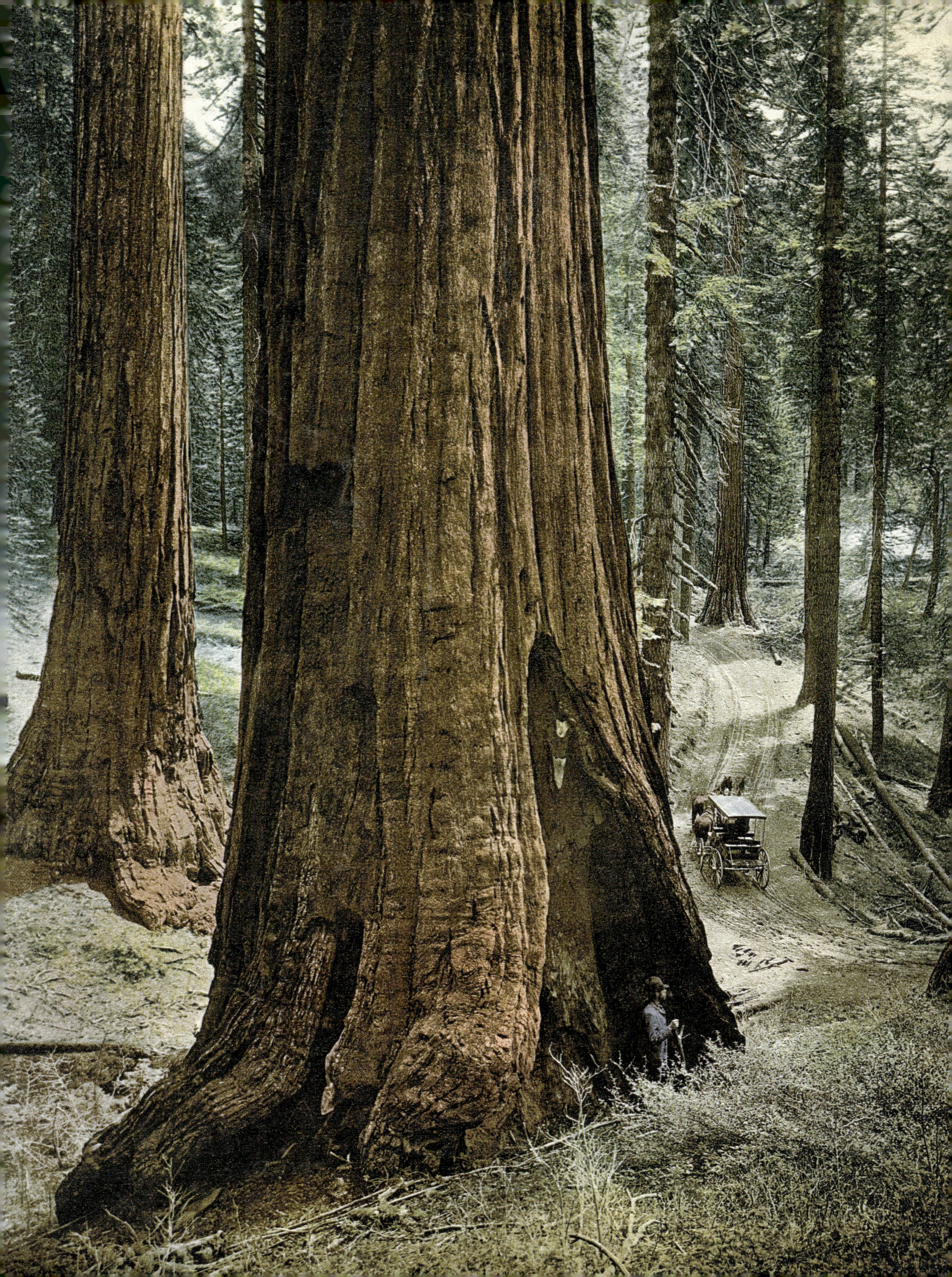

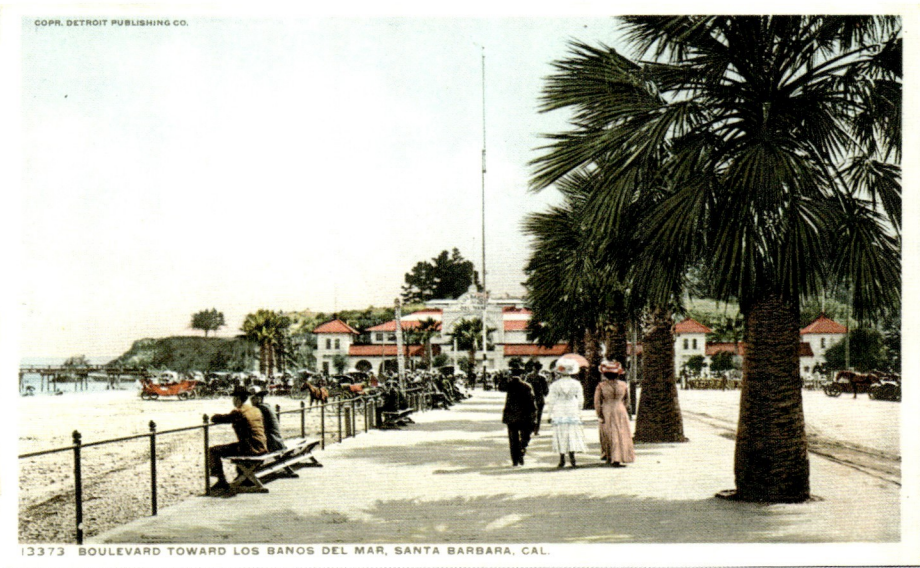

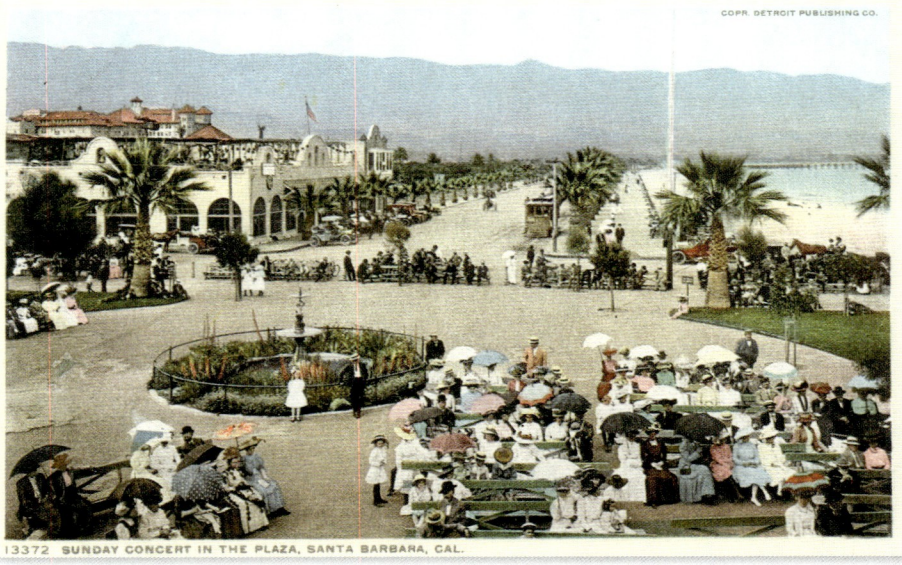

Top left: **Boulevard toward Los Baños del Mar, Santa Barbara**
Top right: **Sunday concert on the Plaza**
Bottom: **The garden of Santa Barbara Mission, photochrom**
Page 571, from top to bottom:
Hotel Potter, veranda and main entrance
Bougainvillea at Hotel Potter
Arlington Hotel, photochrom

Founded by Spanish Franciscans in an attempt to convert the Chumash Indians, the Santa Barbara Mission was consecrated in 1786, on the feast of St. Barbara, December 4. The church shown in this photochrom was built in 1820, an earlier one having been destroyed by the earthquake of 1812. Once Spanish, Santa Barbara became Mexican in 1822 but was captured by Union troops in 1846. California joined the Union in 1850; this and the arrival of the railroad in 1887 were epoch-making events in its history. The luxury Arlington Hotel was built in 1887.

Oben links: **Boulevard nach Los Baños del Mar, Santa Barbara**
Oben rechts: **Sonntagskonzert auf der Plaza**
Unten: **Garten der Mission Santa Barbara, Photochrom**
Seite 571, von oben nach unten:
Veranda und Haupteingang des Hotels Potter
Bougainvillea am Hotel Potter
Das Hotel Arlington, Photochrom

Die am 4. Dezember 1786, dem Fest der heiligen Barbara, geweihte Mission Santa Barbara wurde von spanischen Franziskanern mit dem Ziel gegründet, die Chumash-Indianer zu bekehren. Die Kirche, die auf diesem Photochrom zu sehen ist, wurde 1820 errichtet, nachdem ihre Vorgängerin bei dem Erdbeben von 1812 zerstört worden war. Die ehemals spanische Mission Santa Barbara wurde 1822 mexikanisch, fiel jedoch 1846 an die Truppen der Union. Mit dem Eintritt Kaliforniens in die Union (1850) und dem Anschluss ans Eisenbahnnetz im Jahr 1887 änderte sich ihr Schicksal endgültig. Das Luxushotel Arlington wurde ebenfalls 1887 errichtet.

En haut à gauche : **le boulevard menant à Los Baños del Mar, Santa Barbara**
En haut à droite : **le concert du dimanche sur la Plaza**
En bas : **le jardin de la mission de Santa Barbara, photochrome**
Page 571, de haut en bas :
L'entrée et la véranda de l'hôtel Potter
Bougainvillées à l'hôtel Potter
L'hôtel Arlington, photochrome

Fondée par des franciscains espagnols afin d'évangéliser les Indiens Chumash, la mission de Santa Barbara fut consacrée le 4 décembre 1786, jour de la Sainte-Barbara. L'église que l'on voit sur notre photochrome a été édifiée en 1820, la précédente ayant disparu dans le tremblement de terre de 1812. D'abord espagnole, Santa Barbara devint mexicaine en 1822, mais elle fut conquise par les troupes de l'Union en 1846. L'entrée de la Californie dans l'Union (1850), et enfin l'arrivée du chemin de fer en 1887 changèrent définitivement son destin. L'hôtel de luxe Arlington fut édifié cette année-là.

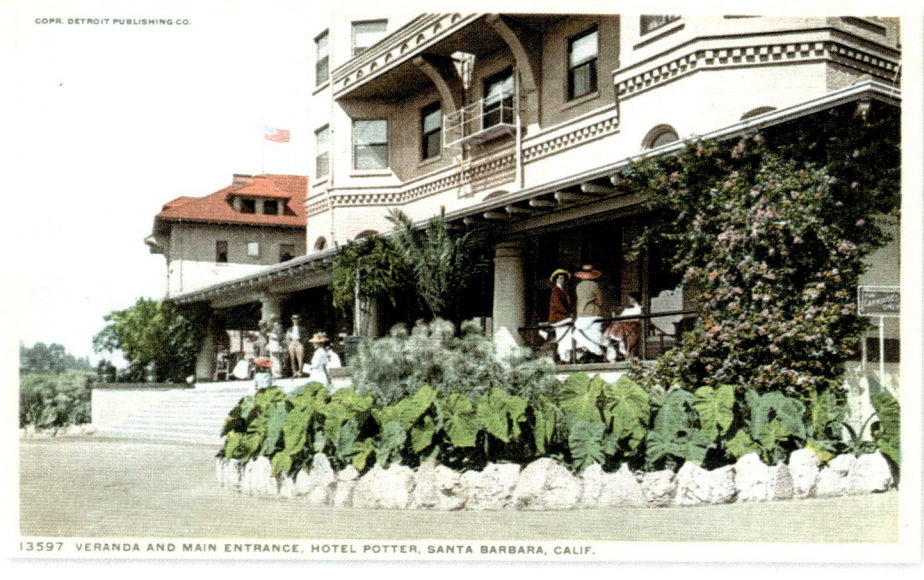

CALIFORNIA | SANTA BARBARA

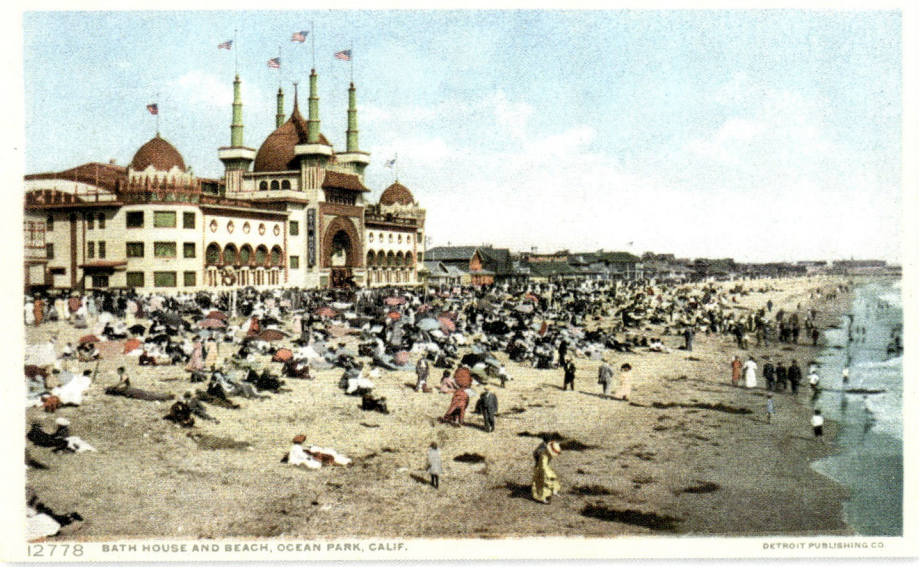
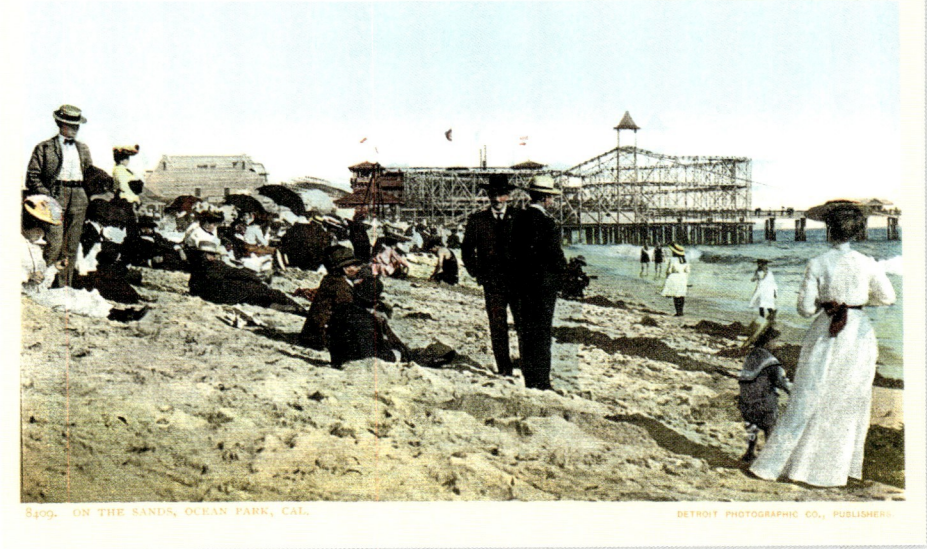
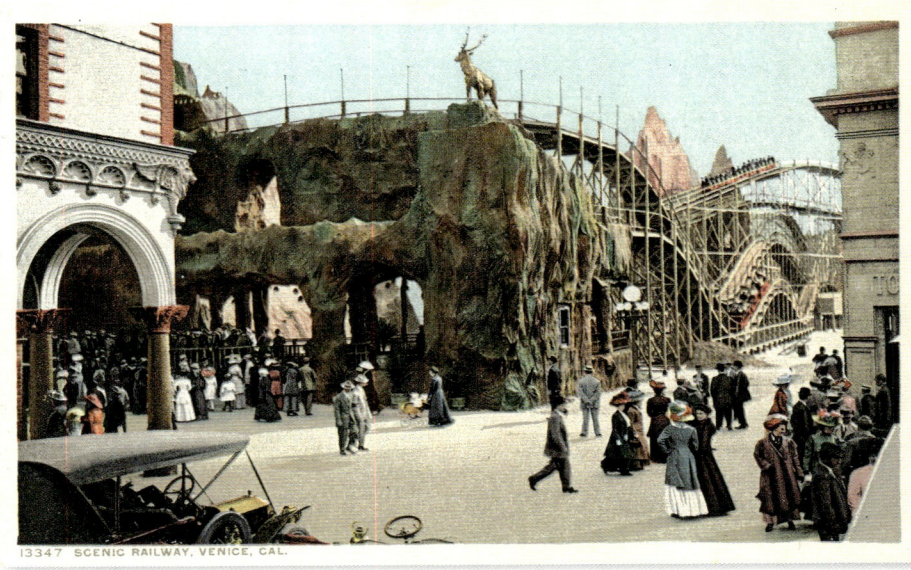
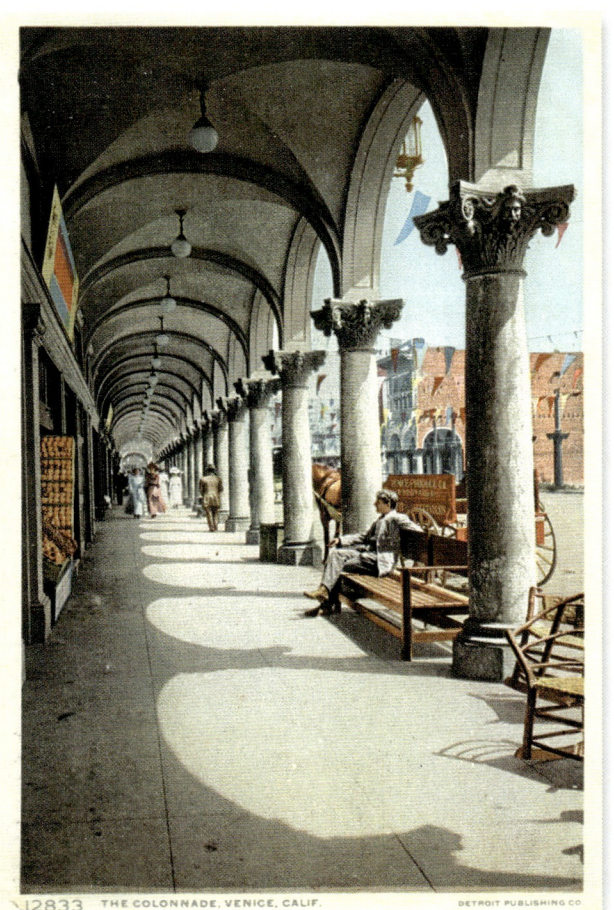

Top left: Bath house and beach, Ocean Park
Top right: On the sands, Ocean Park
Above: Scenic railway, Venice
Left: The Colonnade, Venice
Page 573: Hotel St. Marc and street, Venice, glass negative, ca. 1900
Page 574/575: View of the Abbot Kinney Pier showing the auditorium, Ship Café, and dance hall in Venice, glass negative, 1907

Venice as a tourist resort was the dream of Abbot Kinney, who owned the casino in neighboring Ocean Park. A great traveler, this tobacco magnate decided to create an American Venice on the peninsula south of Ocean Park. He bought land, had a replica of the Grand Canal excavated, and set about the construction of a pier promenade, public buildings, and Venetian Renaissance-style hotels. The storms of March 1905 demolished the pier, and the grand opening, planned for the spring, finally took place on July 4 that year.

Oben links: Badepavillon und Strand von Ocean Park
Oben rechts: Im Sand, Ocean Park
Mitte: Achterbahn, Venice
Links: Kolonnade, Venice
Seite 573: Das Hotel St. Marc, St. Marc Street, Venice, Glasnegativ, um 1900
Seite 574/575: Die Landungsbrücke Abbot Kinney Pier mit Auditorium, Restaurantschiff und Tanzlokal, Venice, Glasnegativ, 1907

Die Touristenattraktion Venice entstand aus einem Traum des Kasinobesitzers im benachbarten Ocean Park, Abbot Kinney. Der Tabakmagnat, der gerne reiste, beschloss, auf der Halbinsel südlich von Ocean Park ein amerikanisches Venedig (englisch „Venice") zu erschaffen. Er kaufte Land, ließ eine Replik des Canal Grande anlegen und veranlasste dann den Bau einer Hafenpromenade sowie von öffentlichen Gebäuden und von Hotels im Stil der venezianischen Renaissance. Die Stürme im März 1905 zerstörten die Mole. Die ursprünglich für das Frühjahr vorgesehene Eröffnung fand am 4. Juli 1905 statt.

En haut à gauche : le pavillon des bains et la plage d'Ocean Park
En haut à droite : sur le sable, Ocean Park
Ci-dessus : les montagnes russes, Venice
À gauche : sous les arcades de la Colonnade, Venice
Page 573 : l'hôtel et la rue St. Marc, Venice, plaque de verre, vers 1900
Pages 574/575 : la jetée Abbot Kinney Pier avec l'auditorium, le bateau-restaurant et le dancing, Venice, plaque de verre, 1907

La vocation touristique de Venice est née du rêve d'Abbott Kinney, propriétaire du casino de la station voisine d'Ocean Park. Grand voyageur, ce magnat du tabac décida de créer une Venise américaine sur la péninsule située au sud d'Ocean Park. Il acheta les terrains, fit creuser une réplique du Grand Canal, et entreprit de faire édifier une jetée-promenade, des bâtiments publics et des hôtels de style « Renaissance vénitienne ». Les tempêtes de mars 1905 jetèrent à bas la jetée et L'inauguration prévue au printemps eut lieu le 4 juillet 1905.

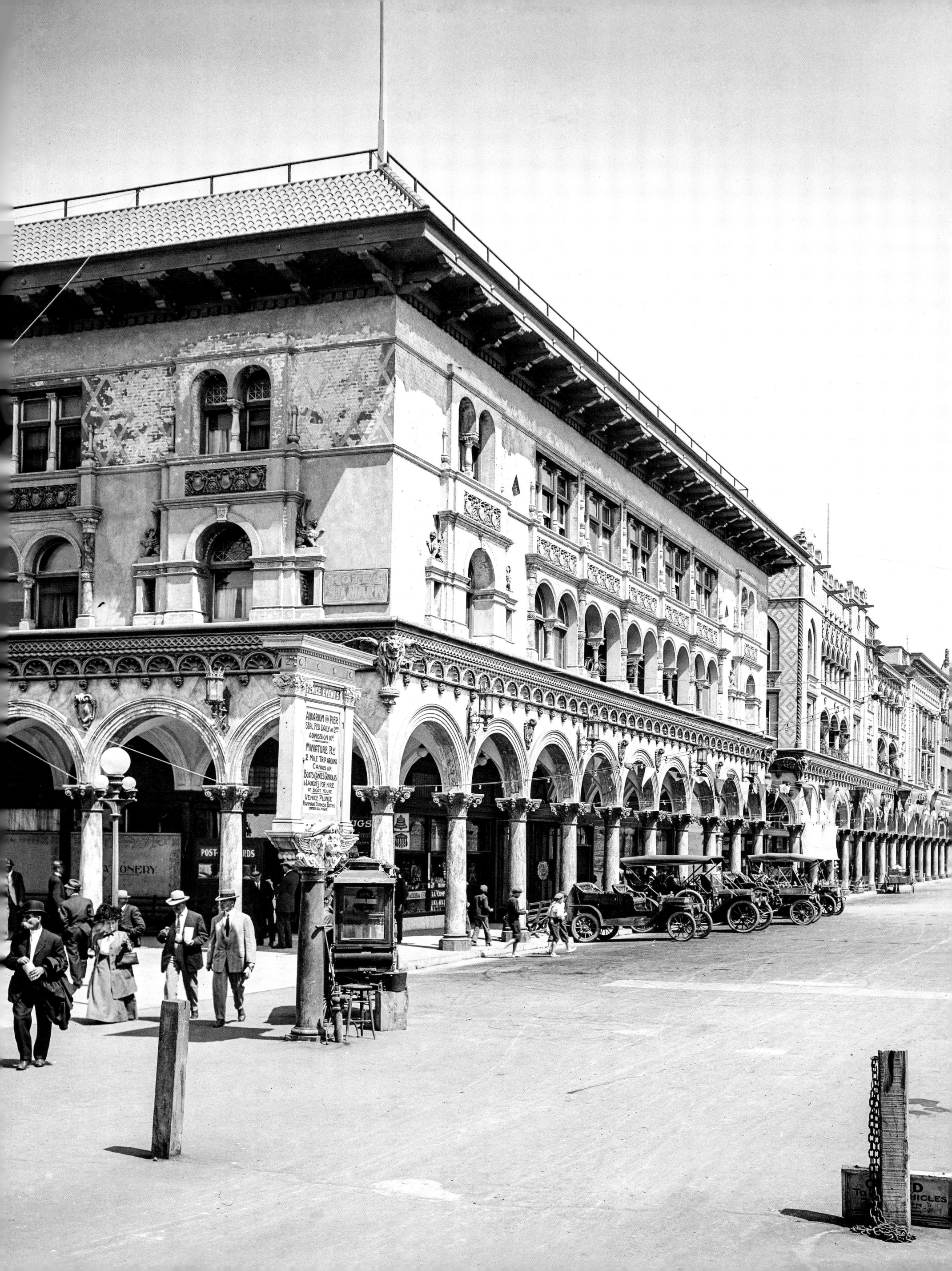

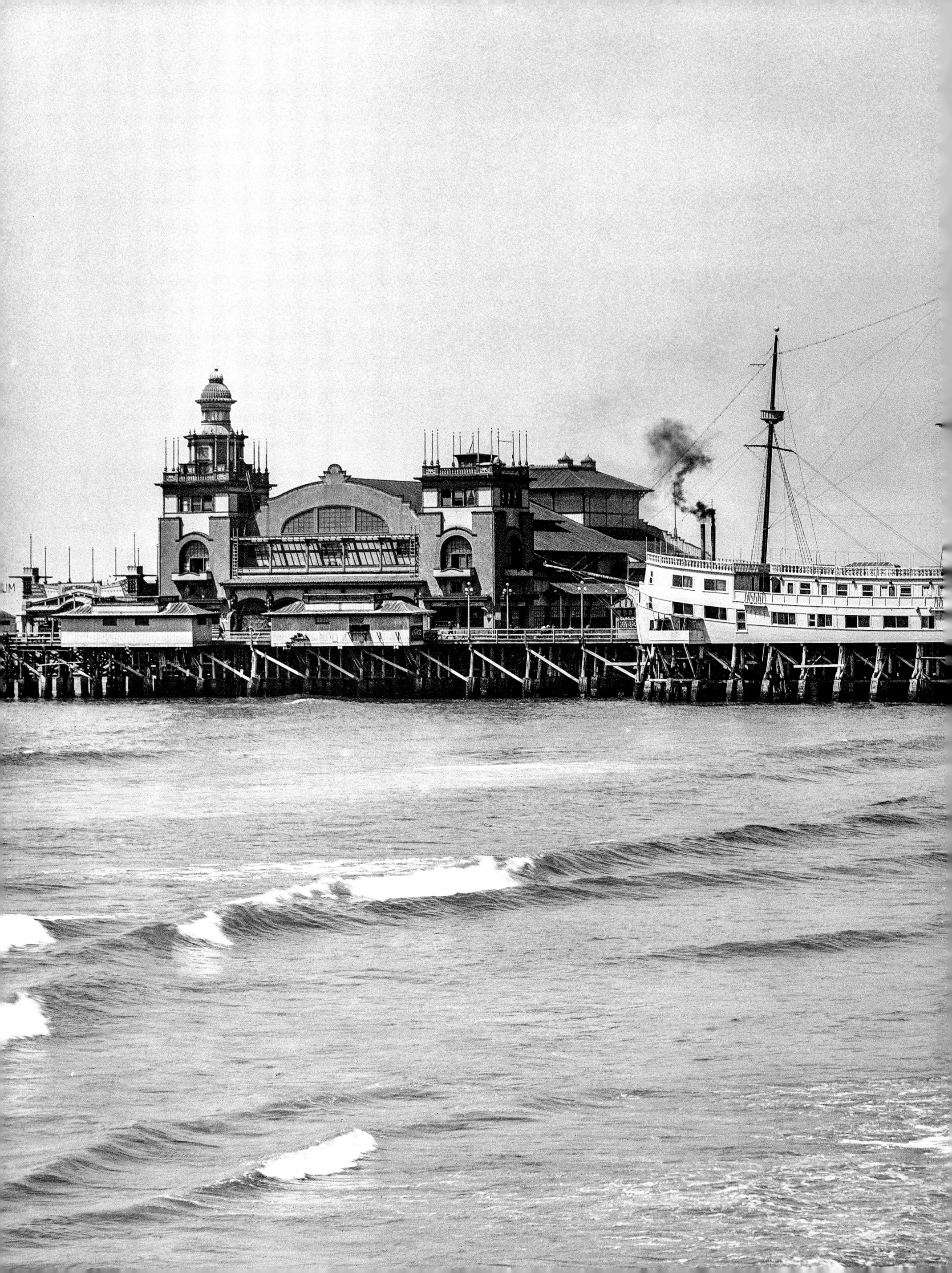

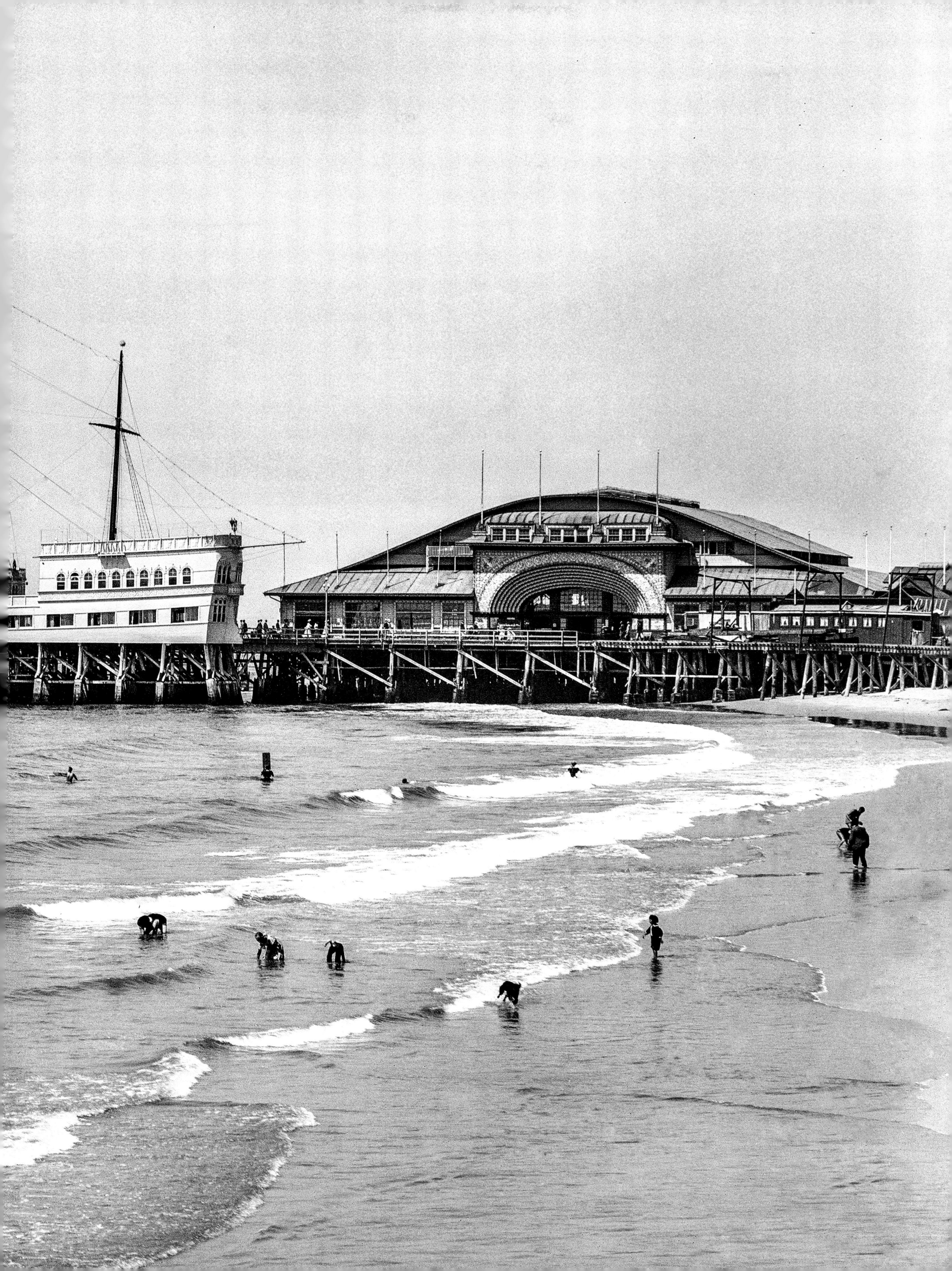

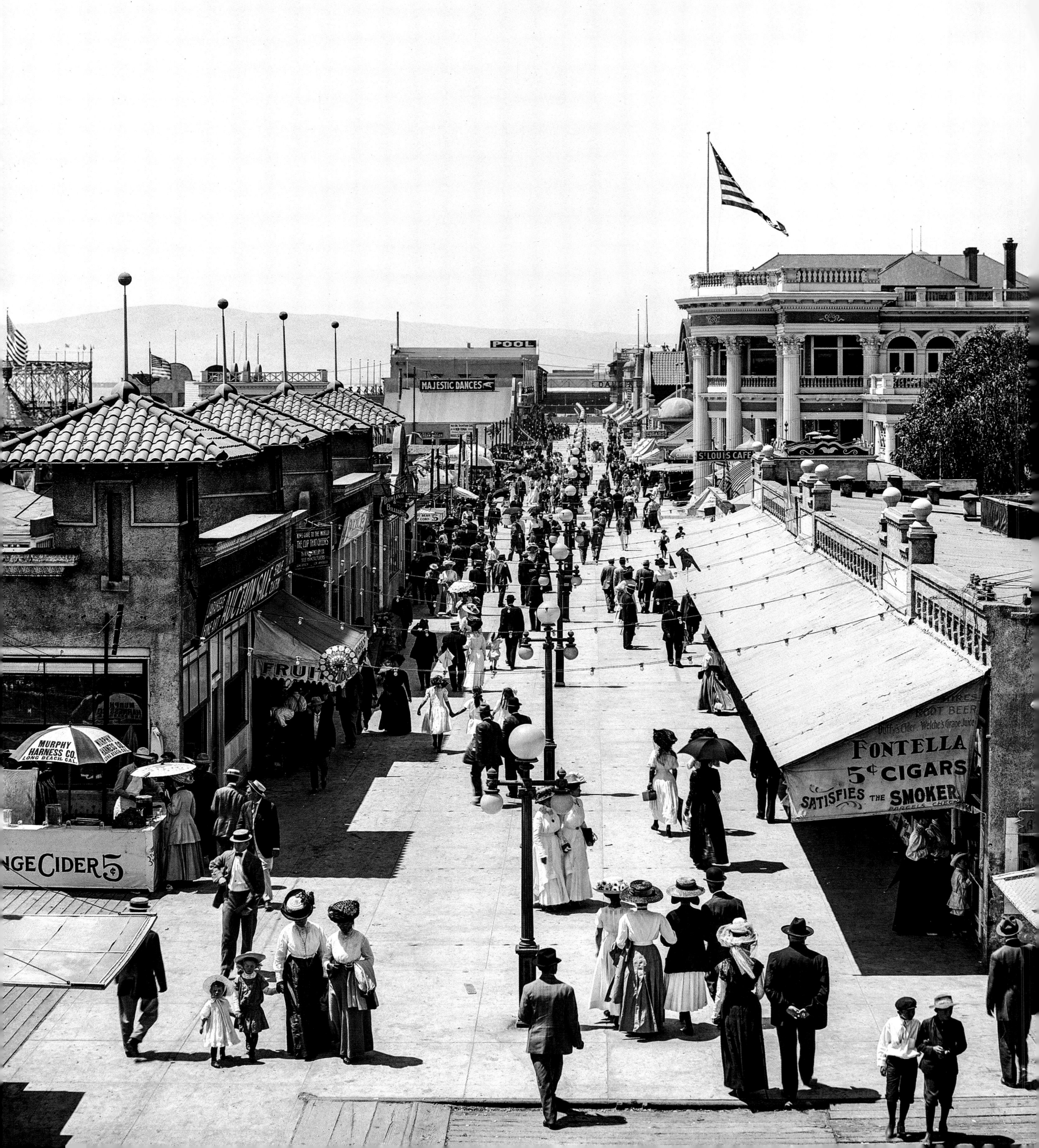

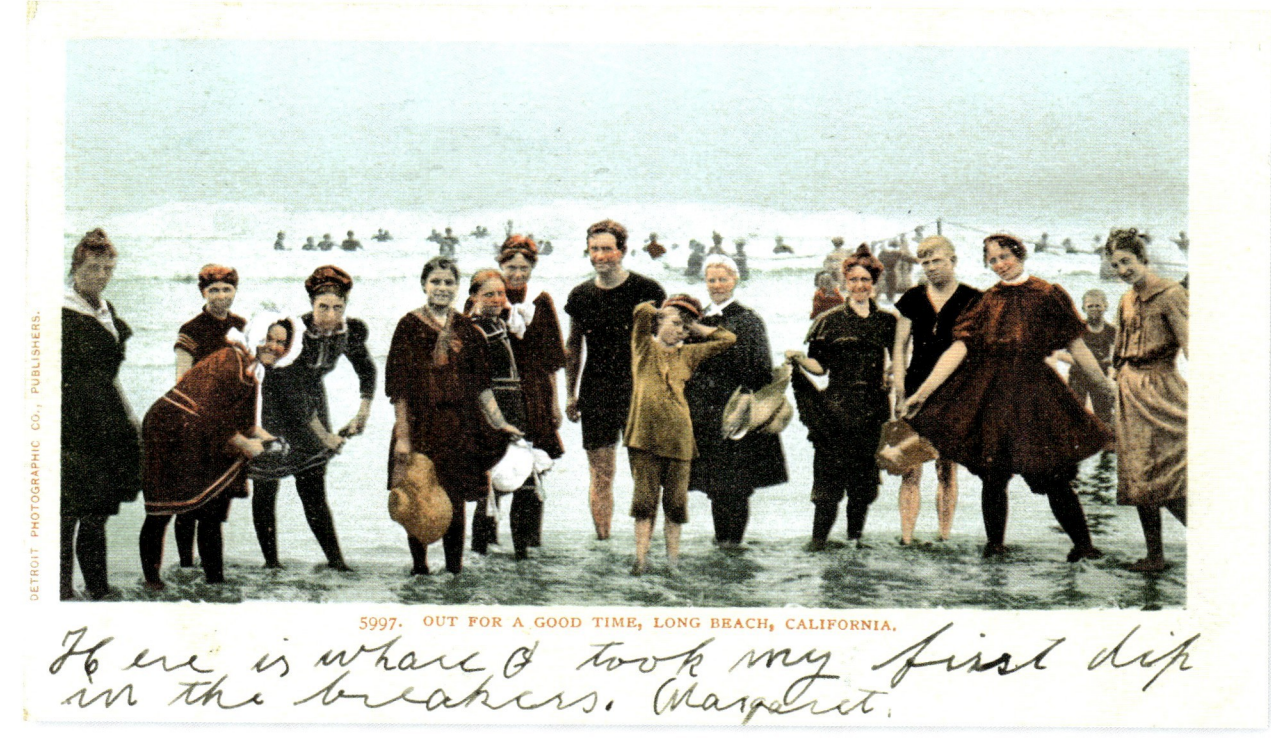

Page 576: A midway, Long Beach, glass negative, 1910–1920
Above: Out for a good time
Below, from left to right and top to bottom:
Looking down the Pike at Long Beach
View of pier and auditorium
Bath house and beach
The beach and pier

The Long Beach "Pike," opened in 1902, was an enormous amusement zone running along the seafront. The circuses, shops, and restaurants of this "Coney Island of the West" attracted visitors in the thousands; they came by the Red Car Line—a Pacific Electric streetcar service—from Los Angeles.

Seite 576: Eine Straße im Stadtzentrum, Long Beach, Glasnegativ, 1910–1920
Oben: Strandvergnügen in Long Beach
Unten, von links nach rechts und von oben nach unten:
Blick auf den Pike, den Vergnügungspark von Long Beach
Ansicht von Landungsbrücke und Auditorium
Badepavillon und Strand
Strand und Landungsbrücke

Der 1902 eröffnete „Pike" von Long Beach war ein riesiger Vergnügungspark an der Strandpromenade. Die Karussells, Läden und Restaurants dieses „Coney Island" des Westens lockten Scharen von Besuchern an, die, aus Los Angeles mit der Red Car Line – der elektrischen Straßenbahn der Pacific Electric – hierherkamen.

Page 576 : une rue du centre-ville, Long Beach, plaque de verre, 1910–1920
En haut : les joies de la plage à Long Beach
En bas, de gauche à droite et de haut en bas :
Vue vers le Pike – le parc d'attractions de Long Beach
Vue de la jetée et de l'auditorium
Le pavillon des bains et la plage
La plage et la jetée

Ouvert en 1902, le « Pike » de Long Beach était un énorme parc d'attractions installé le long du front de mer. Les manèges, les boutiques et les restaurants de ce « Coney Island » de l'Ouest attiraient les visiteurs, qui débarquaient en foule du « Red Car Line », la ligne de tramways électriques de la Pacific Electric en provenance de Los Angeles.

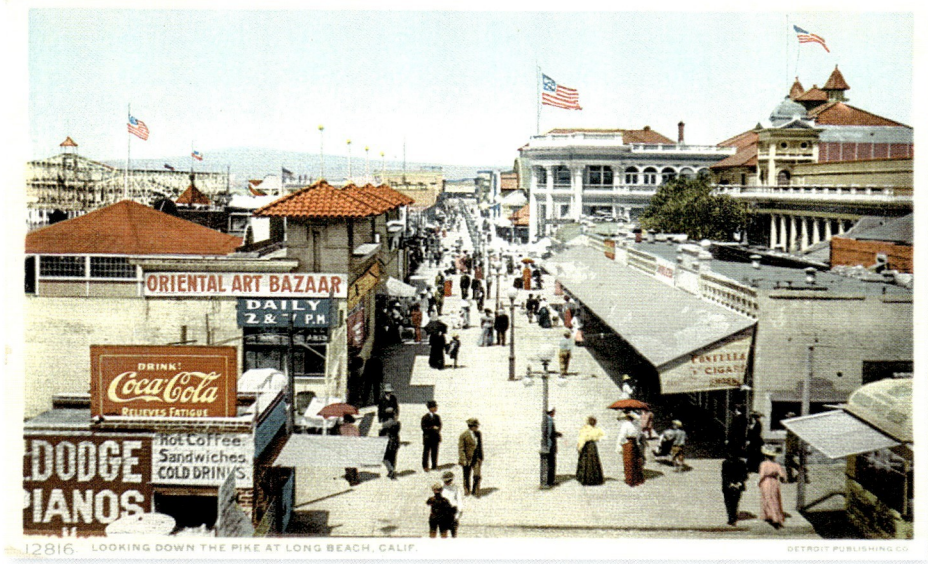

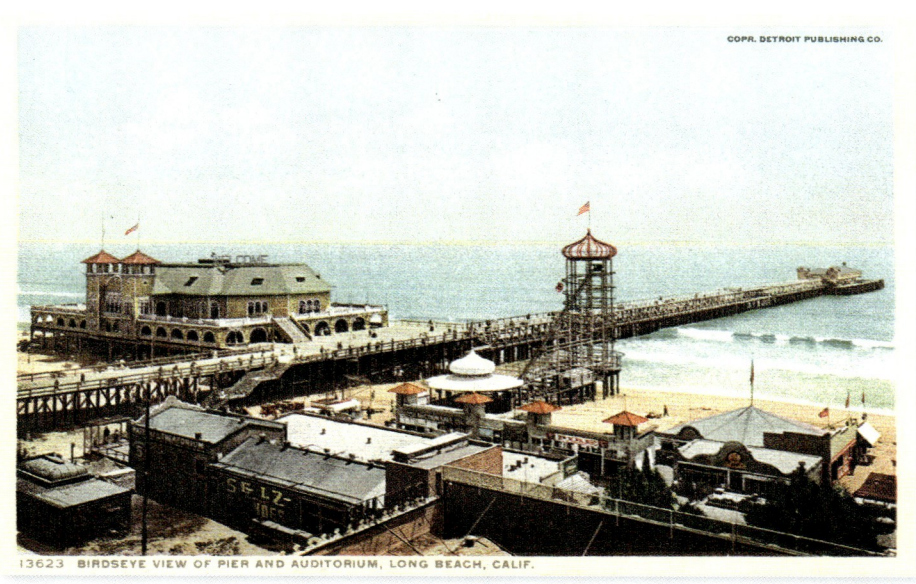

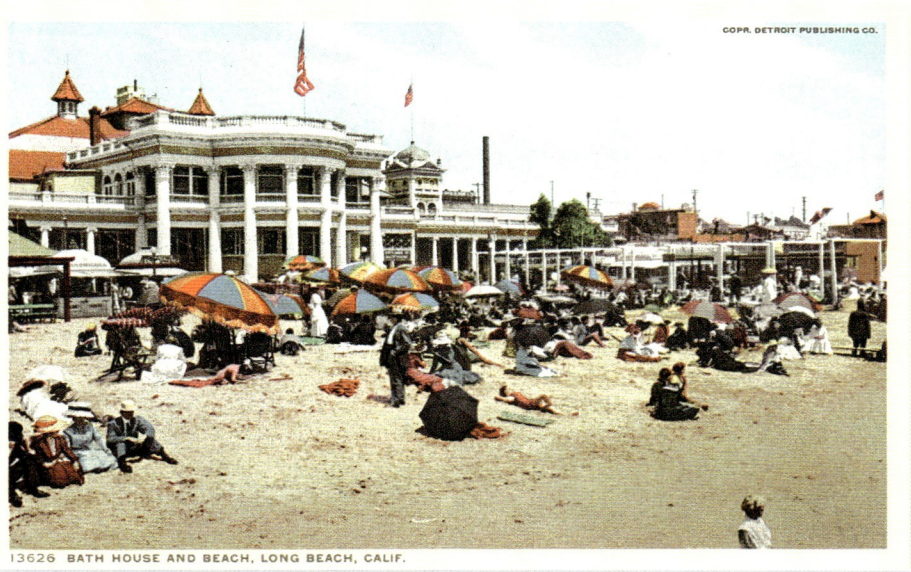

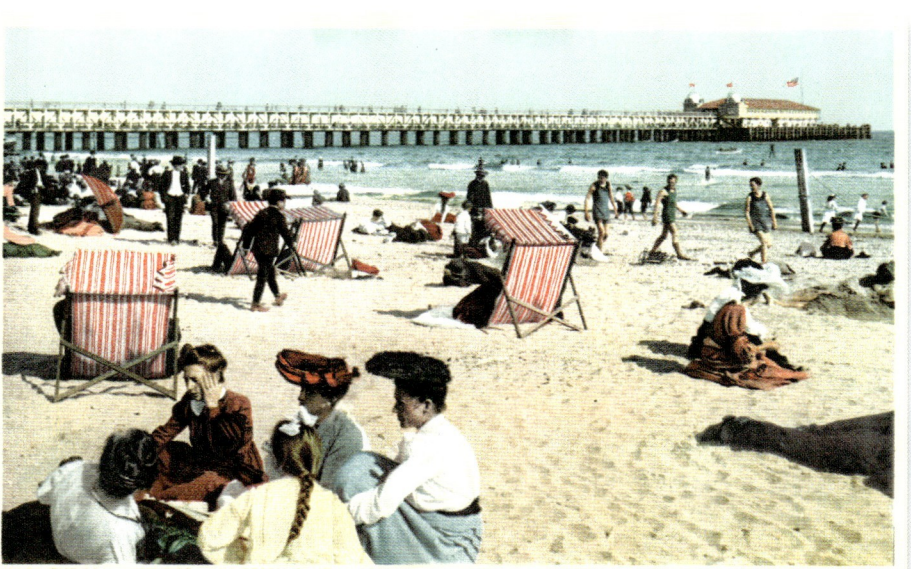

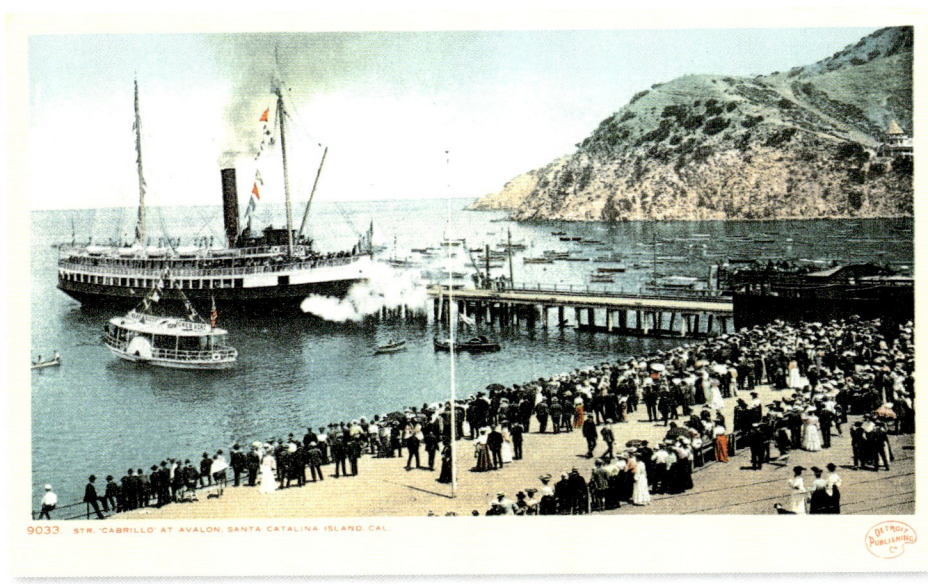
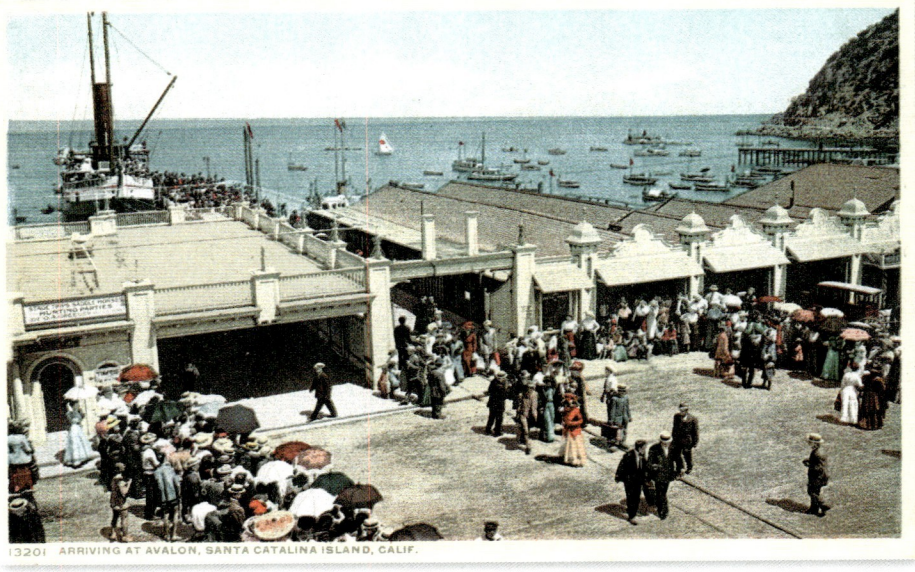

CALIFORNIA | SANTA CATALINA

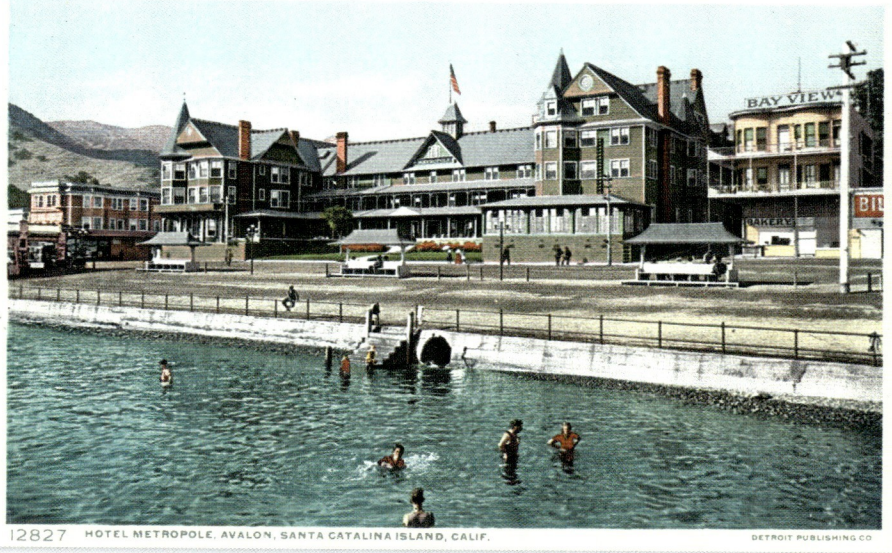
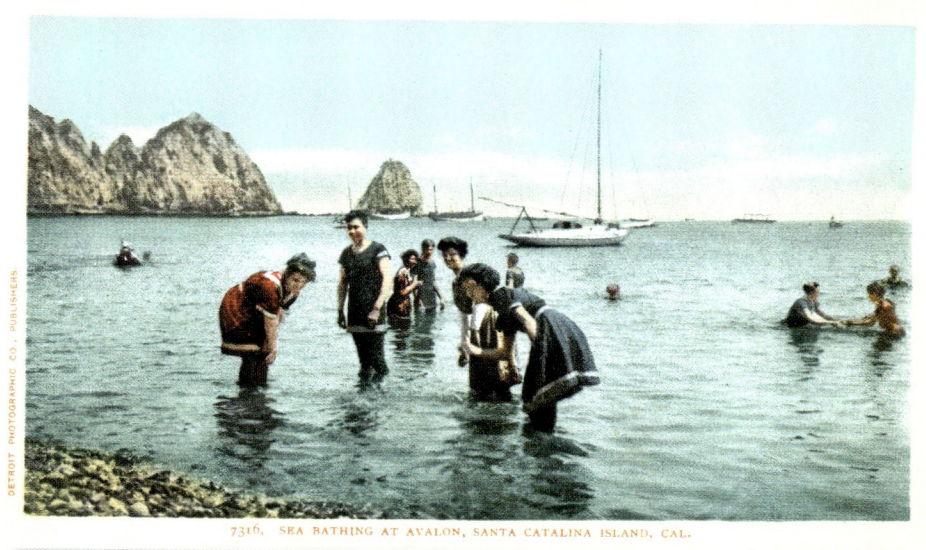

Page 578:
Top left: Steamer *Cabrillo* at Avalon
Top right: Arriving at Avalon
Bottom: View of Avalon, Santa Catalina Island, photochrom

Top left: Hotel Metropole at Avalon
Top right: Sea bathing at Avalon
Bottom: The beach at Avalon, photochrom

The "discoverer" of Santa Catalina Island was George Shatto, a real-estate developer from Michigan, who bought the island in 1887. He founded the city of Avalon and built the first hotel there, the Metropole; he also bought a ferry to ensure a daily connection between the island and the continent. Heavily indebted, he defaulted on his mortgages and had to return Santa Catalina to its former owner, James Lick.

Seite 578:
Oben links: Das Dampfschiff *Cabrillo* in Avalon
Oben rechts: Ankunft in Avalon
Unten: Blick auf Avalon, Santa Catalina Island, Photochrom

Oben links: Hotel Metropole in Avalon
Oben rechts: Badezeit in Avalon
Unten: Der Strand von Avalon, Photochrom

Der „Entdecker" von Santa Catalina Island war George Shatto, Inhaber einer Baufirma aus Michigan, der die Insel 1887 kaufte. Er gründete die Stadt Avalon, ließ dort als erstes Hotel das Metropole errichten und kaufte ein Passagierschiff, um die tägliche Verbindung zwischen der Insel und dem Festland sicherzustellen. Als er zu hoch verschuldet war, um seine Hypotheken abzuzahlen, musste er Santa Catalina an ihren ehemaligen Besitzer, die Gesellschaft James Lick, zurückgeben.

Page 578 :
En haut à gauche : le steamer *Cabrillo* à Avalon
En haut à droite : l'arrivée à Avalon
En bas : vue d'Avalon, île de Santa Catalina, photochrome

En haut à gauche : l'hôtel Metropole à Avalon
En haut à droite : l'heure du bain à Avalon
Ci-dessous : la plage d'Avalon, photochrome

Le « découvreur » de l'île de Santa Catalina est George Shatto, un promoteur immobilier du Michigan, qui acheta l'île en 1887. Il créa la ville d'Avalon, y fit édifier un premier hôtel, le Metropole, et acheta un paquebot pour assurer une liaison quotidienne entre l'île et le continent. Trop endetté, il ne put honorer ses traites et dut céder Santa Catalina à son ancien propriétaire, la compagnie James Lick.

From top to bottom:
Viewing the marine gardens
A glass bottom row boat
Arch Rock, Santa Catalina Island, photochrom

Von oben nach unten:
Beim Betrachten der Meeresgärten
Ruderboot mit Glasboden
Arch Rock (Felsbogen), Santa Catalina Island, Photochrom

De haut en bas :
Contemplation des jardins sous-marins
Une barque à fond en verre
L'« Arche » (Arch Rock), île de Santa Catalina, photochrome

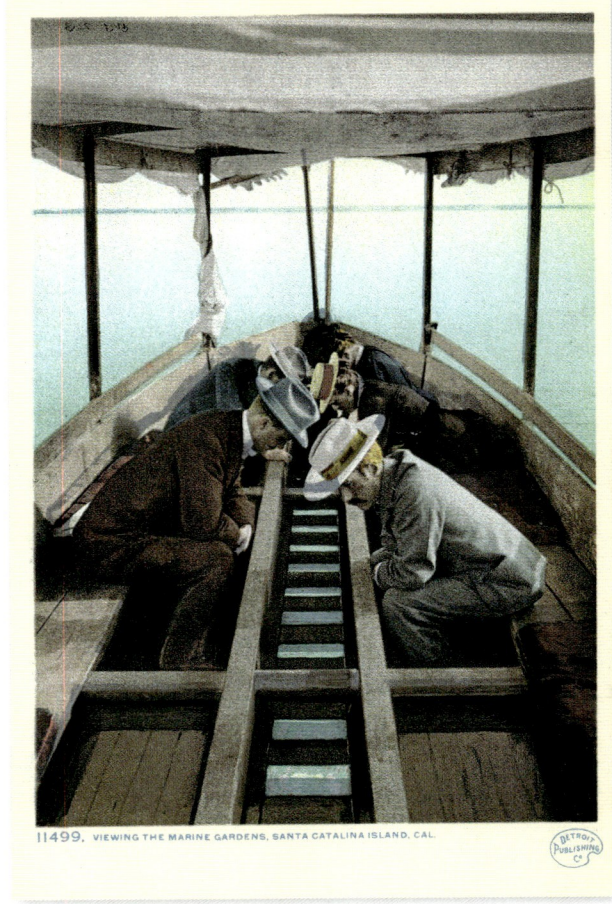

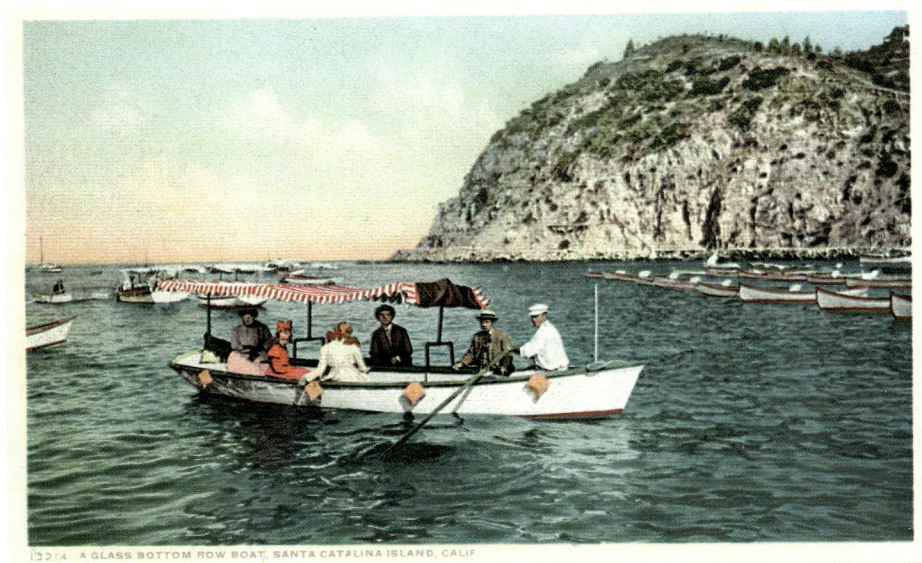

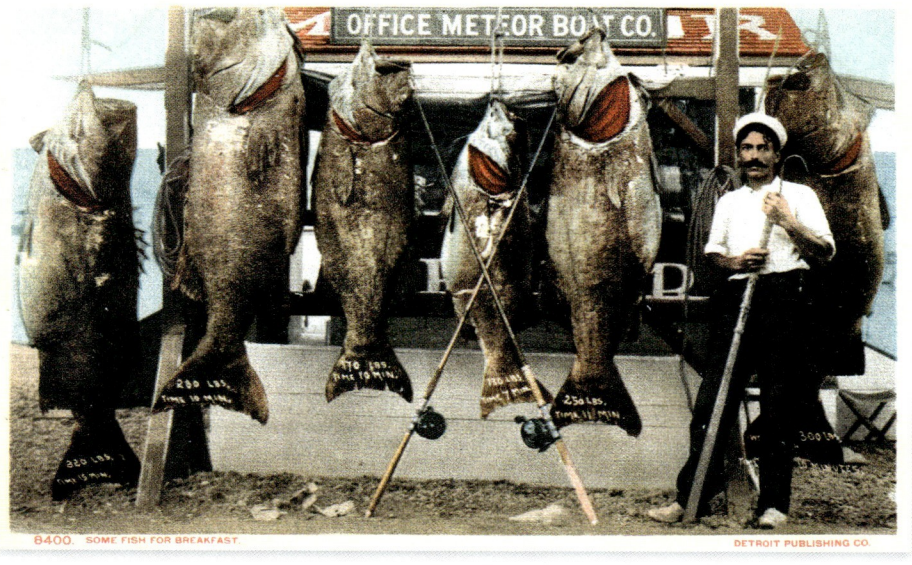
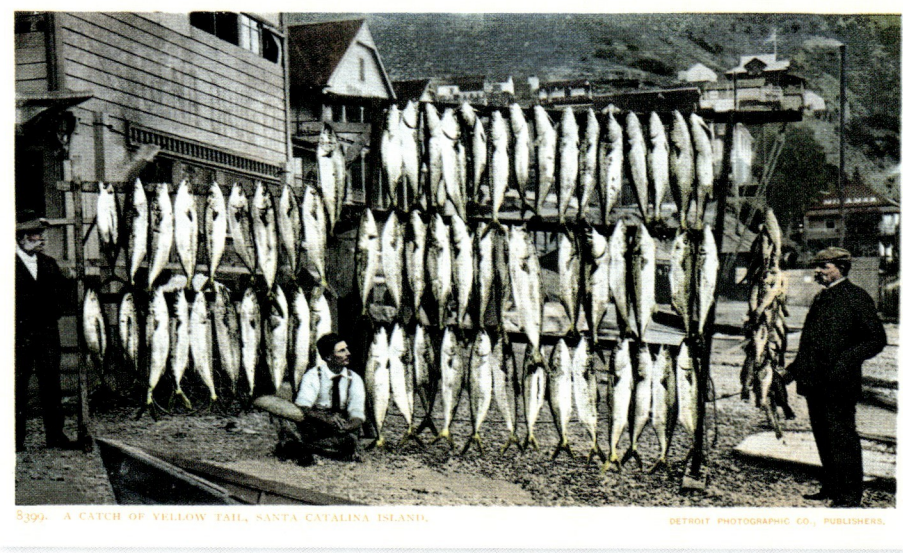
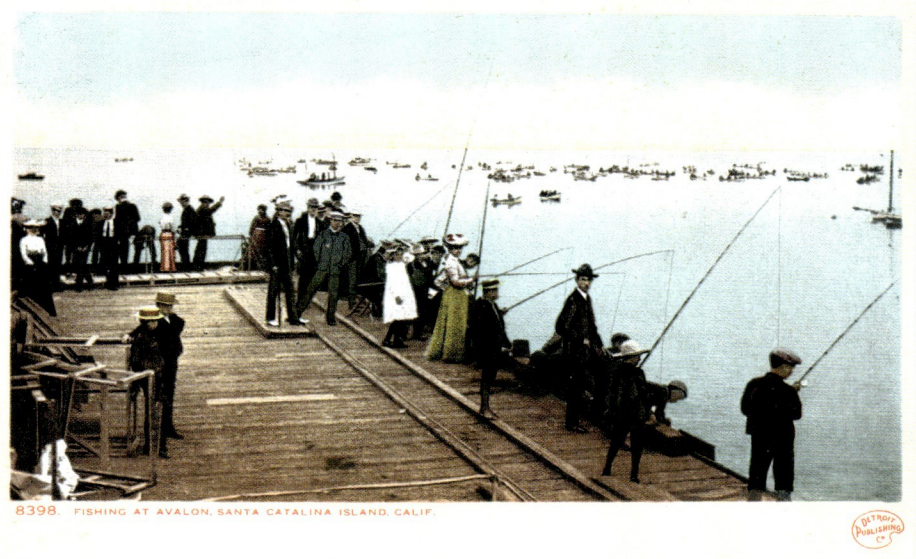

Top left: **Some fish for breakfast…**
Top right: **A catch of yellow tail**
Above: **Fishing at Avalon**
Right: **Black sea bass caught at Santa Catalina Island**

Santa Catalina really took off as a tourist resort in 1891 thanks to the Banning brothers. They put two new steamers into service, the SS *Hermosa* and the SS *Cabrillo*, built a dance pavilion, an aquarium, and a bathhouse, opened a tent city, and organized fishing excursions and competitions. One of the island's principal attractions was the presence in its waters of innumerable species of fish.

Oben links: **Fisch zum Frühstück…**
Oben rechts: **Fang von Fischen mit gelbem Schwanz**
Mitte: **Angeln in Avalon**
Rechts: **Schwarzer Sägebarsch (black sea bass), gefangen auf Santa Catalina Island**

Santa Catalina erlebte seinen eigentlichen touristischen Aufschwung im Jahr 1891 dank der Brüder Bannings. Sie nahmen zwei neue Dampfschiffe, die SS *Hermosa* und die SS *Cabrillo*, in Betrieb, errichteten einen Tanzpavillon, ein Aquarium und ein Badehaus, eröffneten ein Zeltdorf und organisierten Ausflüge und Angelwettbewerbe – denn einer der Vorzüge der Insel war das Vorkommen zahlloser Fischarten in ihren Gewässern.

En haut à gauche : **du poisson pour le petit déjeuner…**
En haut à droite : **une pêche de poissons à queue jaune**
Ci-dessus : **pêche à Avalon**
À droite : **perche noire (***black sea bass***) pêchée à Santa Catalina**

Santa Catalina prit son véritable essor touristique en 1891 grâce aux frères Bannings. Ils mirent en service deux nouveaux steamers, le SS *Hermosa* et le SS *Cabrillo*, édifièrent un pavillon de danse, un aquarium et une maison de bains, ouvrirent un village de tentes (*tent city*) et organisèrent des excursions et des concours de pêche – l'un des atouts de l'île étant la présence dans ses eaux d'innombrables espèces de poissons.

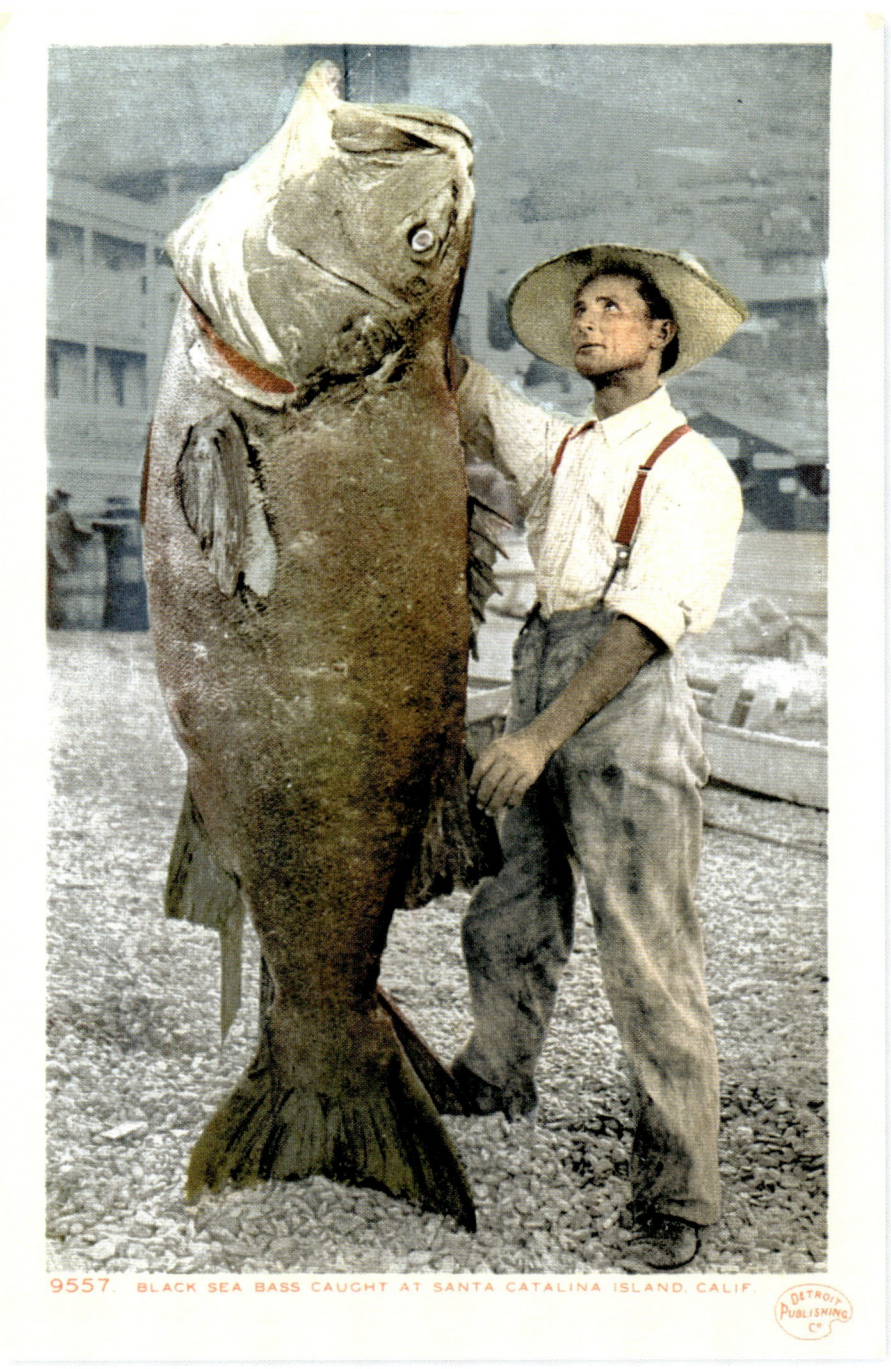

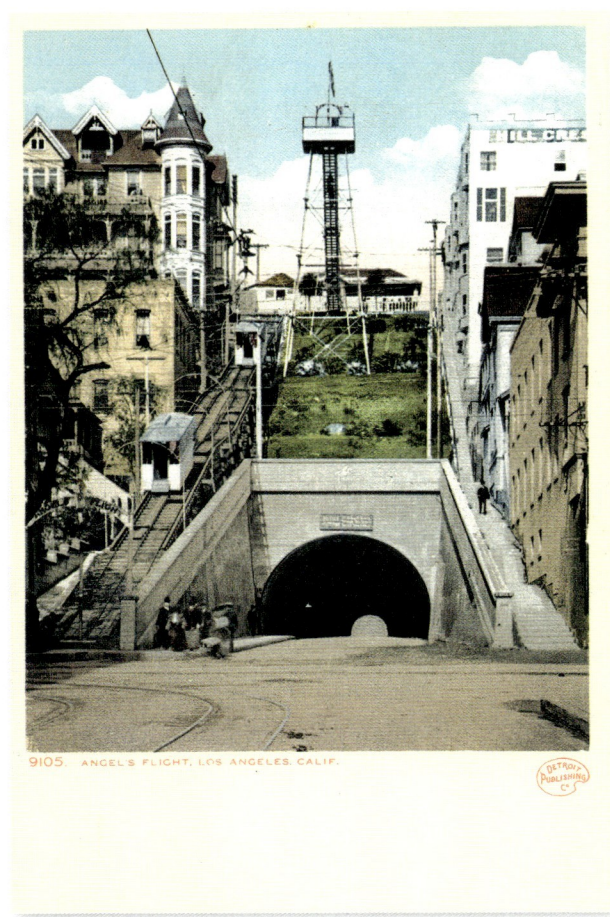
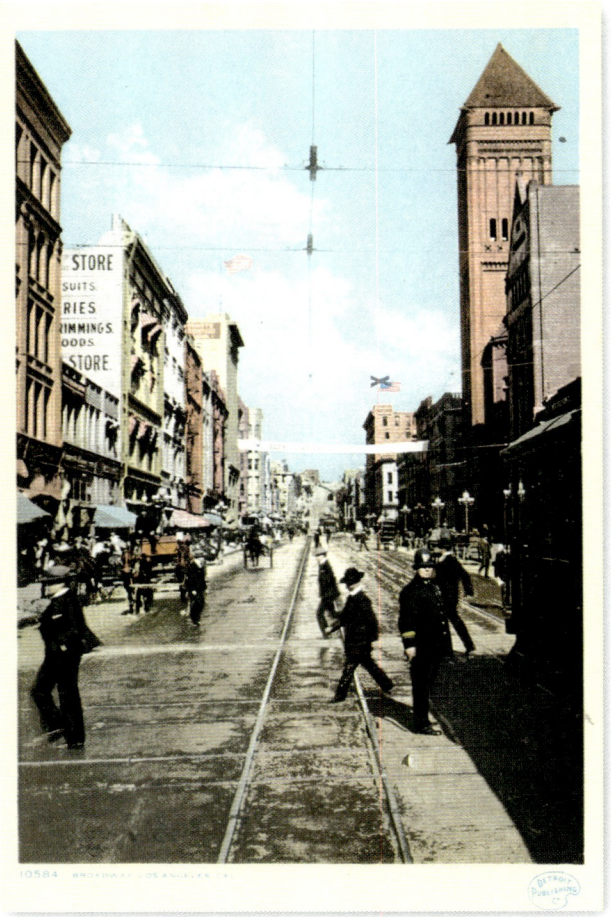
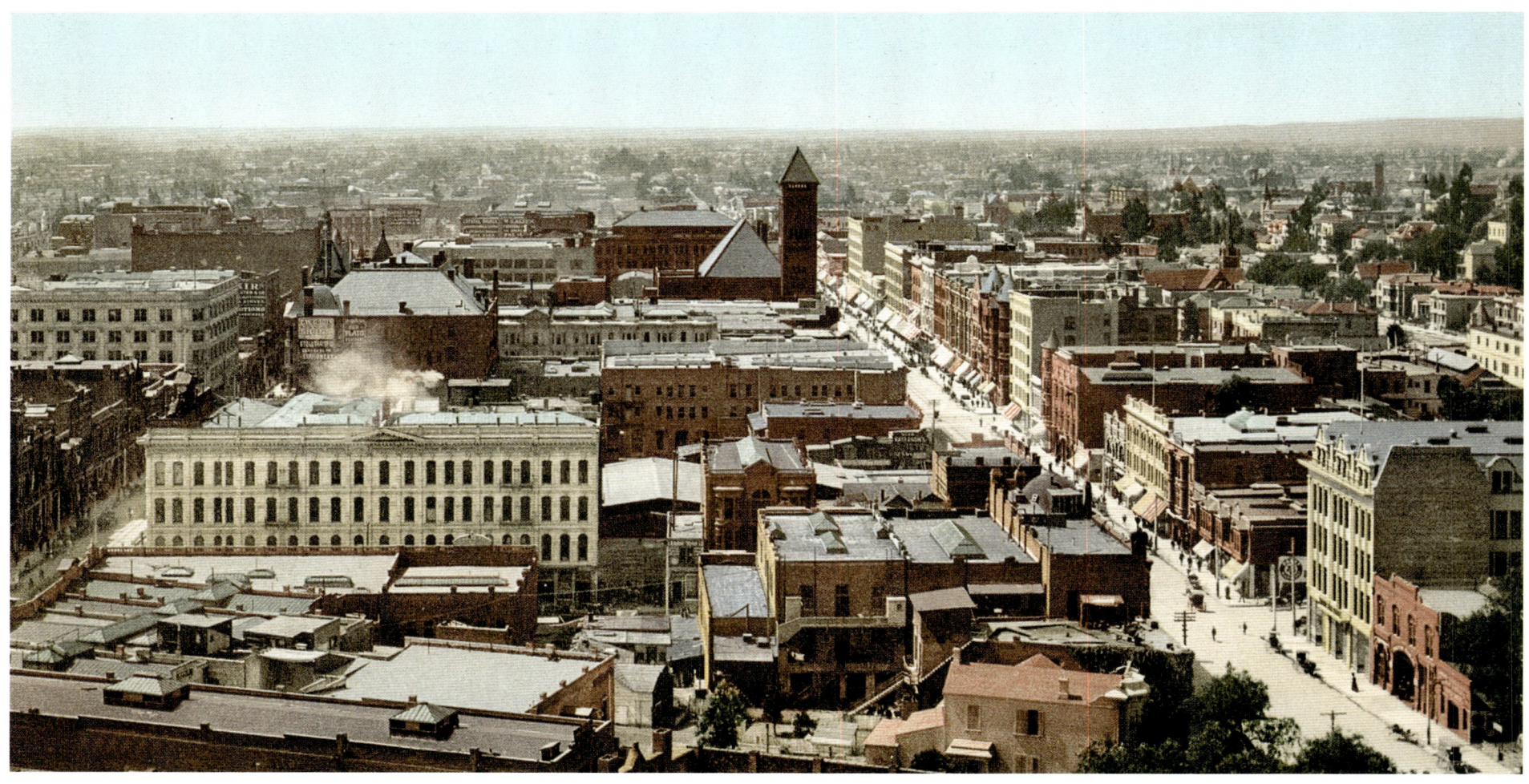

CALIFORNIA | LOS ANGELES

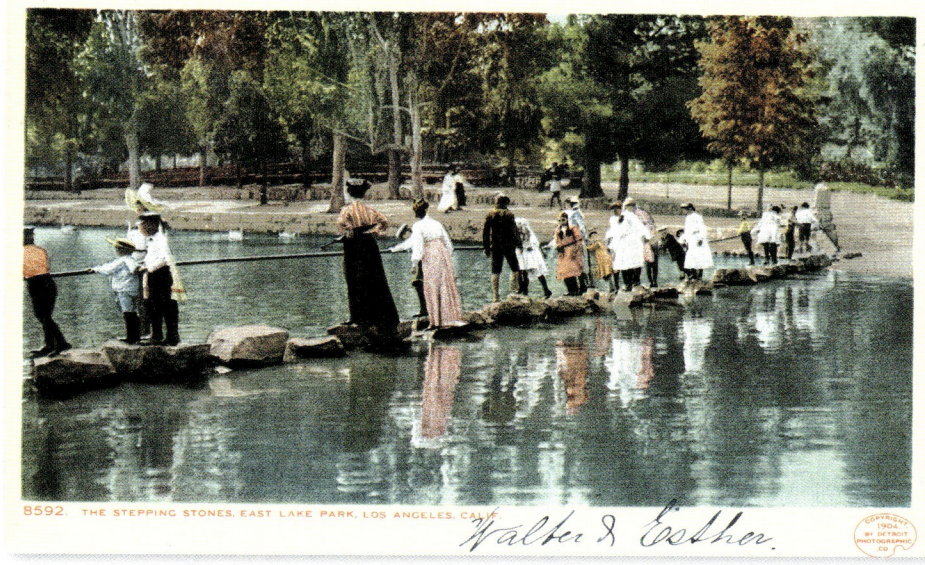 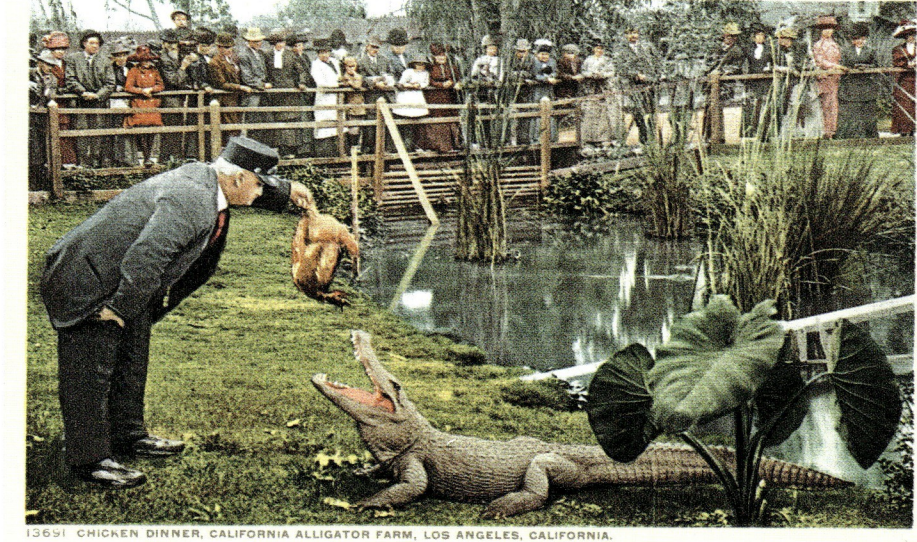

Page 582:
Top left: Angel's Flight
Top right: Broadway
Bottom: Panorama of Los Angeles, photochrom

Top left: East Lake Park, the stepping stones
Top right: California Alligator Farm
Bottom: West Lake Park, photochrom

Parks flowering all year round with luxuriant, semitropical vegetation, a recently reconstructed town with brick-built blocks and elegant timber residences, whose population had grown by a factor of five in ten years: such was the capital of South California, "a region perpetually flowering and fruiting," as the 1893 Baedeker puts it. This was how Los Angeles, the "city of the queen of the angels," was seen at the time of these images.

Seite 582:
Oben links: Die Standseilbahn Angel's Flight (Engelsflug)
Oben rechts: Broadway
Unten: Panoramablick auf Los Angeles, Photochrom

Oben links: Trittsteine im East Lake Park
Oben rechts: Kalifornische Alligatorenfarm
Unten: West Lake Park, Photochrom

Das ganze Jahr über blühende Parks mit üppiger halbtropischer Vegetation, eine unlängst wieder aufgebaute Stadt mit Mehrfamilienhäusern aus Backstein und eleganten Wohnhäusern aus Holz, deren Bevölkerung sich innerhalb von zehn Jahren verfünffacht hatte: Das war die Hauptstadt von Südkalifornien, „eine Region in voller Blüte, die fortwährend Früchte trägt" – wie der Baedeker aus dem Jahr 1893 schrieb: Los Angeles, die „Stadt der Engel", zu jener Zeit, als diese Bildern entstanden.

Page 582:
En haut à gauche: le funiculaire d'Angel's Flight («Vol de l'ange»)
En haut à droite: Broadway
En bas: panorama de Los Angeles, photochrome

En haut à gauche: le gué de pierres du parc d'East Lake
En haut à droite: la ferme californienne d'alligators
Ci-dessous: le parc de West Lake, photochrome

Des parcs fleuris en toute saison d'une végétation semi-tropicale luxuriante, une ville nouvellement reconstruite avec des immeubles en brique et d'élégantes résidences en bois, dont la population a quintuplé en dix ans: telle était la capitale de la Californie du Sud, «une région en floraison et en fructification perpétuelles», précise le guide Baedeker de 1893. Telle était Los Angeles, la «Cité de la Reine des anges», à l'époque où on la voit sur ces images.

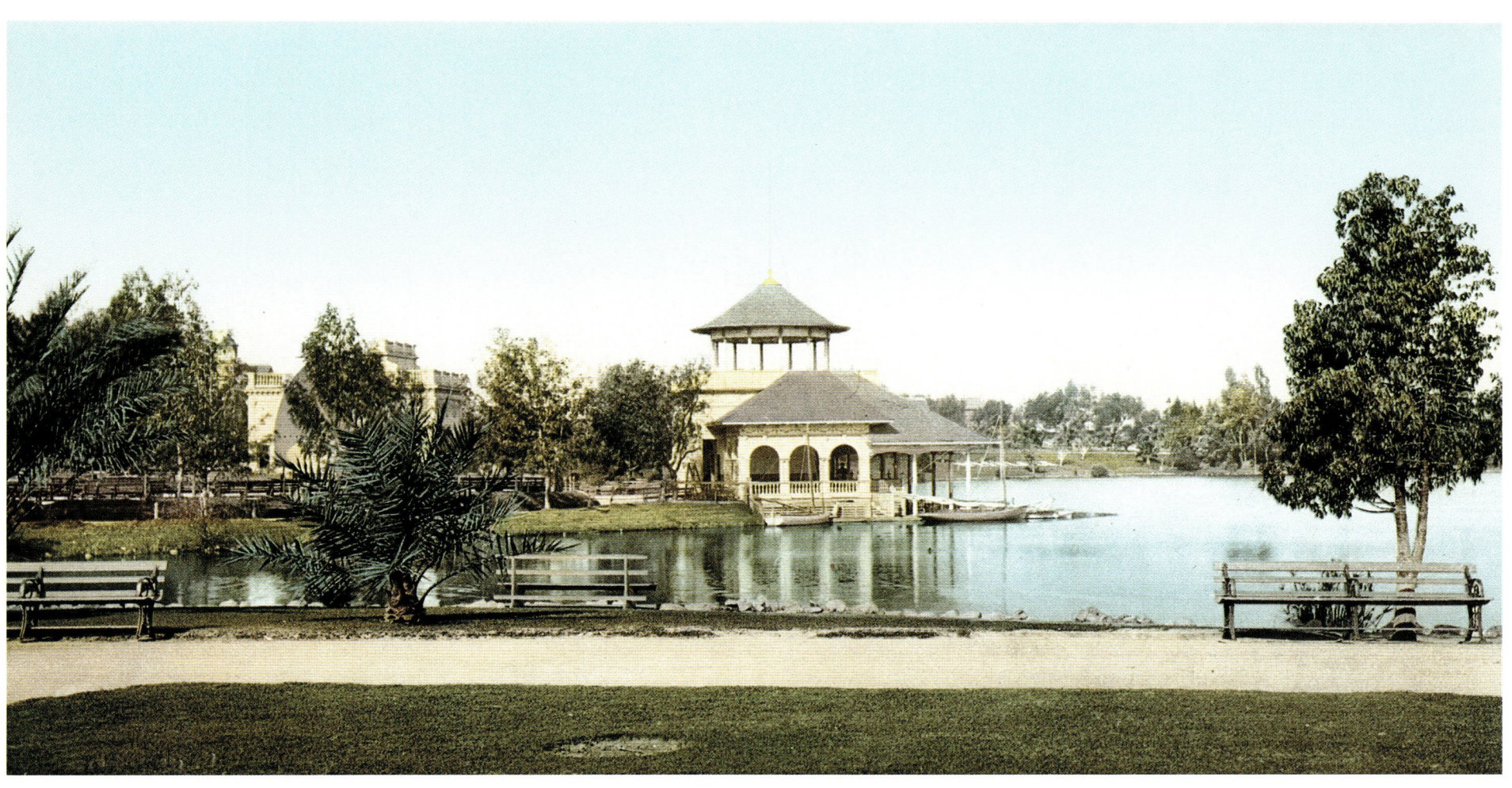

CALIFORNIA | LOS ANGELES

CHINATOWN

Chinese immigrants arrived in California at the height of the Gold Rush, starting in 1848 and disembarking in San Francisco; that city boasts the oldest and largest Chinese community in the United States. Los Angeles, Monterey, San Diego, Sacramento, and Portland, Oregon, also have substantial Chinatowns. The San Francisco Chinatown occupied a dozen blocks right in the city center. It was a veritable warren in which those of Chinese origin worked and lived together, creating their own associations, schools, places of worship, newspapers, shops, restaurants, and clubs. In the late 19th century, the Chinese Six Companies, a very powerful association of rich notables, was empowered to represent the interests of Chinese Americans in the United States. Many tourists came to Chinatown for a "taste of debauchery" and its spicy reputation was carefully maintained by scandal sheets whose editorial policies were dictated by unscrupulous and notoriously xenophobic political parties.

Die chinesischen Immigranten, die ab 1848 während des Goldrausches nach Kalifornien kamen, gingen in San Francisco von Bord. Es ist daher kein Zufall, dass in dieser Stadt die älteste und bedeutendste chinesische Gemeinschaft der USA zu Hause war, auch wenn Los Angeles, Monterey, San Diego, Sacramento und sogar Portland (in Oregon) ebenfalls ein chinesisches Viertel hatten. Die Chinatown von San Francisco umfasste über ein Dutzend Blocks mitten im Stadtzentrum. Sie war ein regelrechter Ameisenhaufen, in dem die chinesischen Staatsangehörigen unter sich blieben und eigene Vereine, Schulen, religiöse Zentren, Zeitungen, Geschäfte, Restaurants und Clubs gegründet hatten. Ende des 19. Jahrhunderts besaß die Chinese Six Companies, eine äußerst einflussreiche Vereinigung reicher Honoratioren, die Vollmacht, die auf dem Territorium der Vereinigten Staaten weilenden amerikanischen Chinesen der Regierung gegenüber zu vertreten. Zahlreiche Touristen kamen, um sich in Chinatown „üblen Sitten hinzugeben". Der schlechte Ruf des Viertels wurde natürlich von der Skandalpresse im Auftrag skrupelloser und offenkundig fremdenfeindlicher politischer Parteien geschürt.

Les immigrants chinois arrivés en Californie au moment de la ruée vers l'or, à partir de 1848, débarquaient à San Francisco, et ce n'est pas un hasard si cette ville abrite la plus ancienne et la plus importante communauté chinoise des États-Unis, même si Los Angeles, Monterey, San Diego, Sacramento ou encore Portland (en Oregon) ont aussi leur quartier chinois. Le « Chinatown » de San Francisco occupait une douzaine de blocs, en plein centre-ville. C'était une ruche où les ressortissants chinois travaillaient et vivaient entre eux, avaient créé leurs associations, écoles, lieux de culte, journaux, boutiques, restaurants et clubs. À la fin du XIXe siècle, la Chinese Six Companies, une association très puissante de riches notables, avait le pouvoir de représenter les Chinois américains présents sur le territoire des États-Unis auprès du Gouvernement. Les touristes venaient nombreux s'« encanailler » à Chinatown, dont la réputation sulfureuse fut bien entretenue par une certaine presse aux ordres de partis politiques peu scrupuleux et notoirement xénophobes.

From left to right and top to bottom:
Children of Chinatown
Chinese restaurant
Chinatown, San Francisco
Children of Chinatown
Page 585: A Chinese pharmacy, photochrom

Von links nach rechts und von oben nach unten:
Kinder in Chinatown
Chinesisches Restaurant
Chinatown, San Francisco
Kinder in Chinatown
Seite 585: Chinesische Apotheke, Photochrom

De gauche à droite et de haut en bas :
Enfants de Chinatown
Restaurant chinois
Chinatown, San Francisco
Enfants de Chinatown
Page 585 : une pharmacie chinoise, photochrome

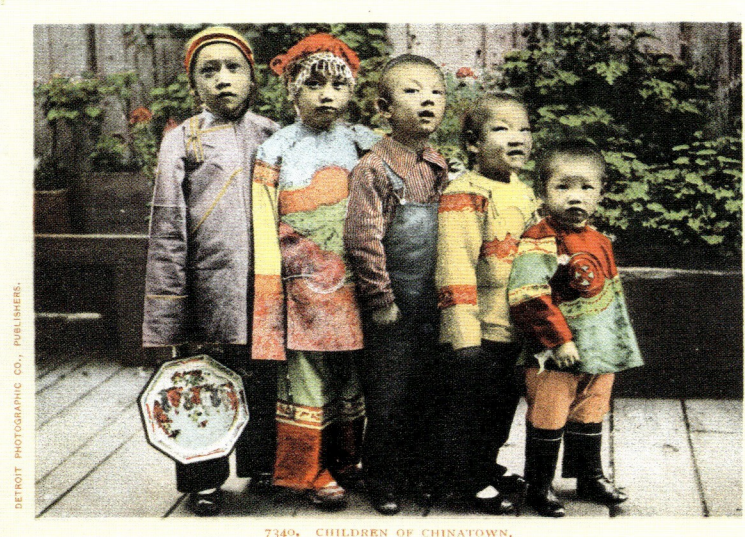

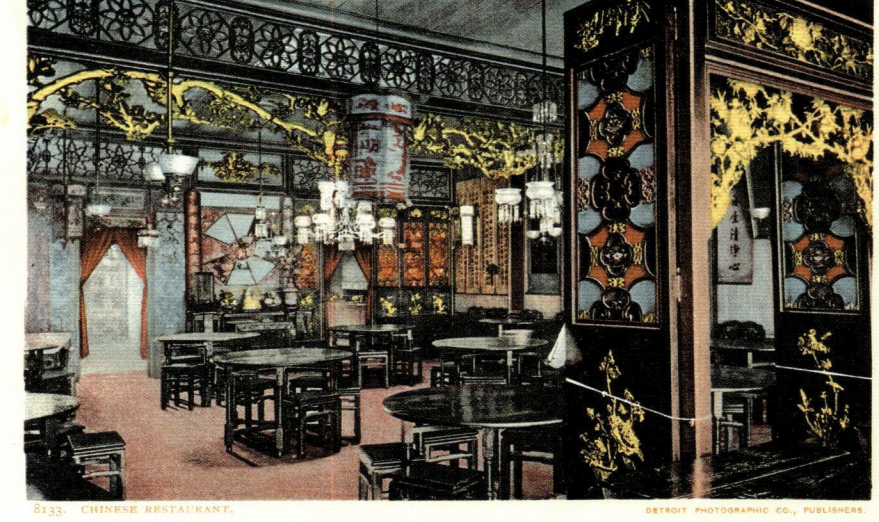

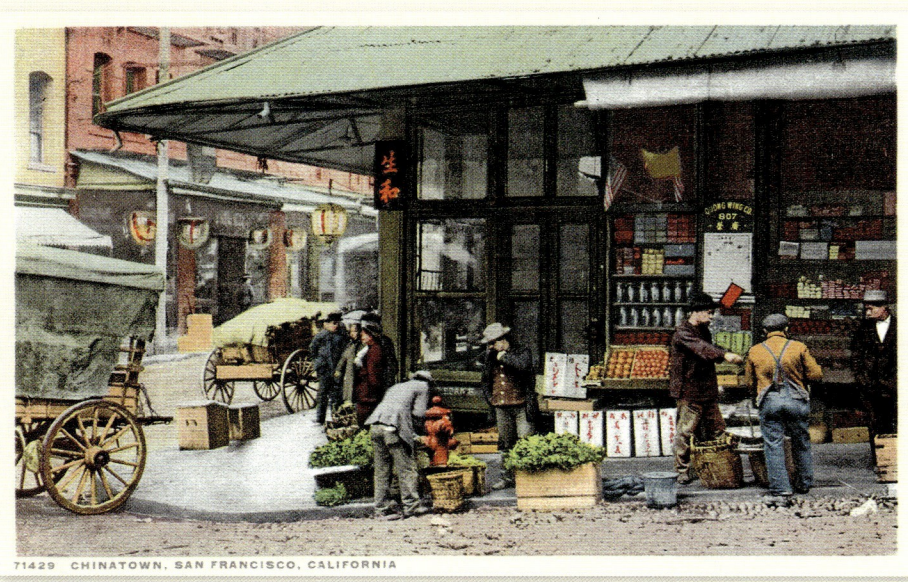

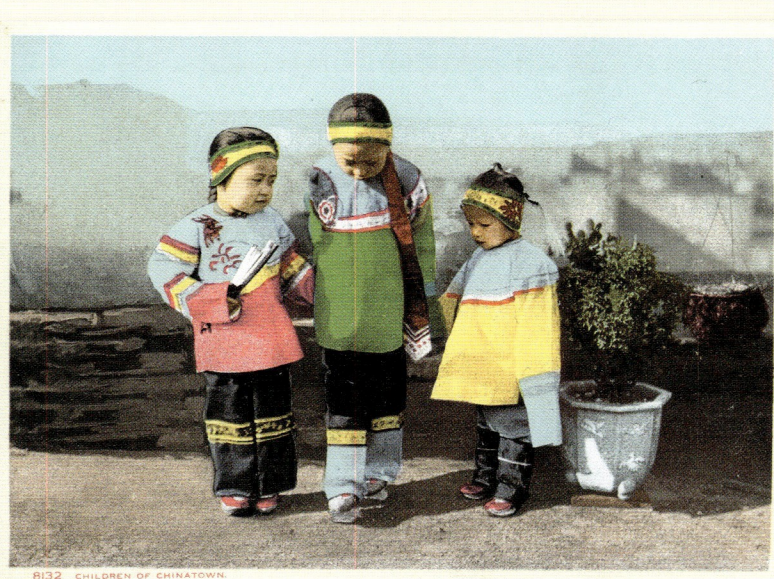

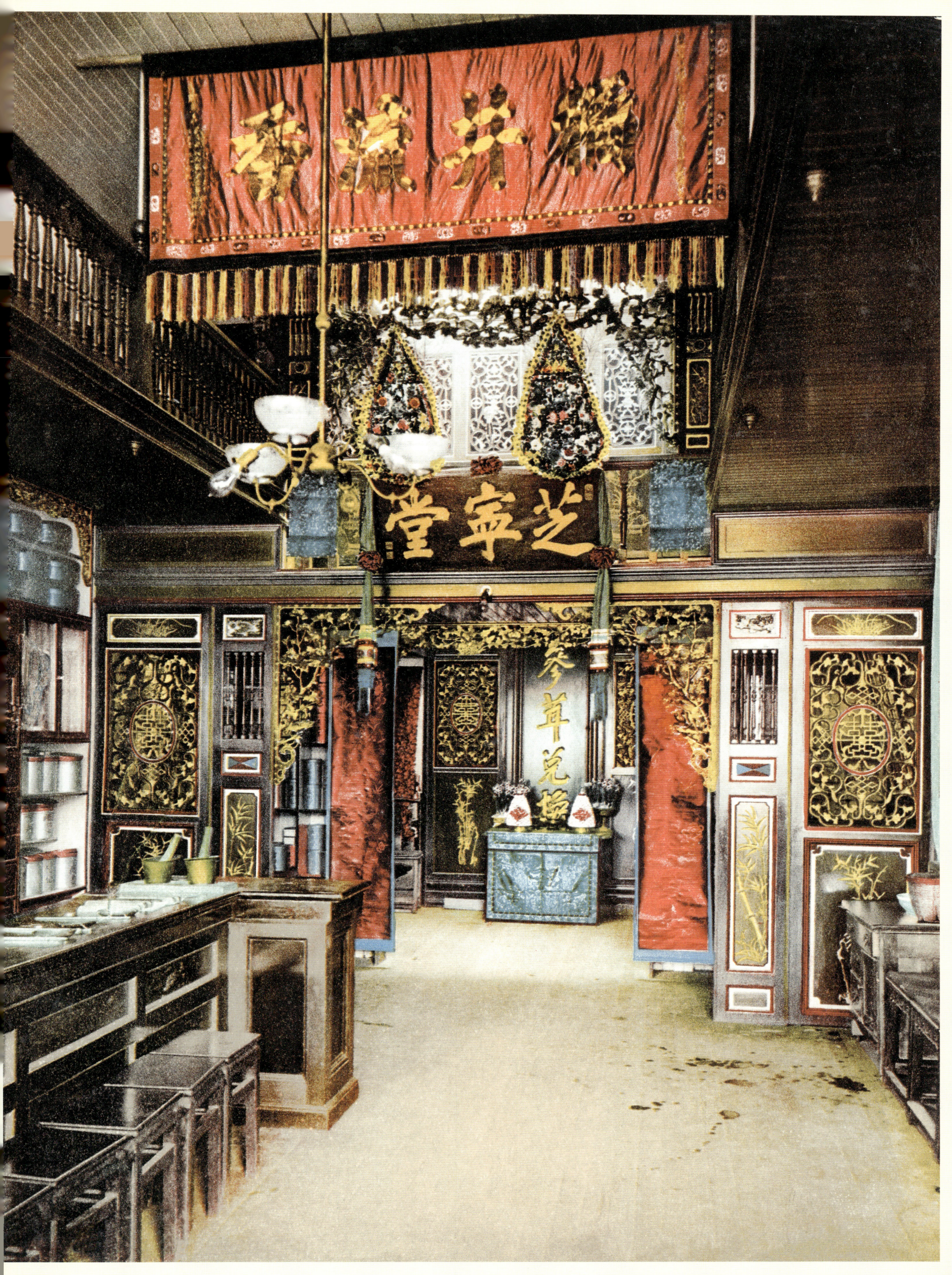

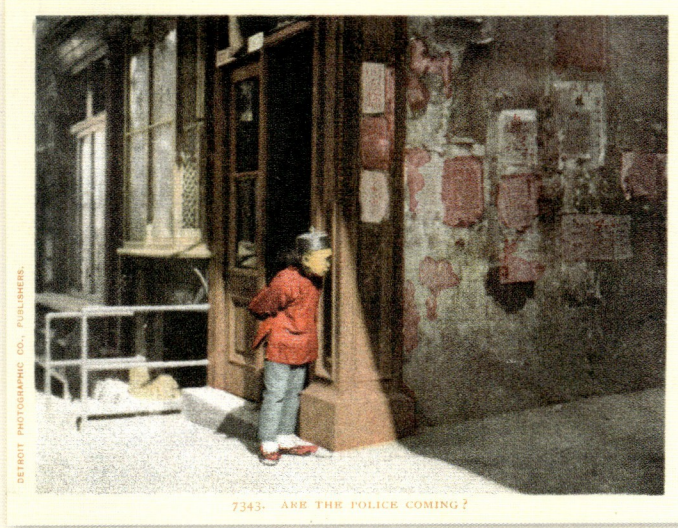
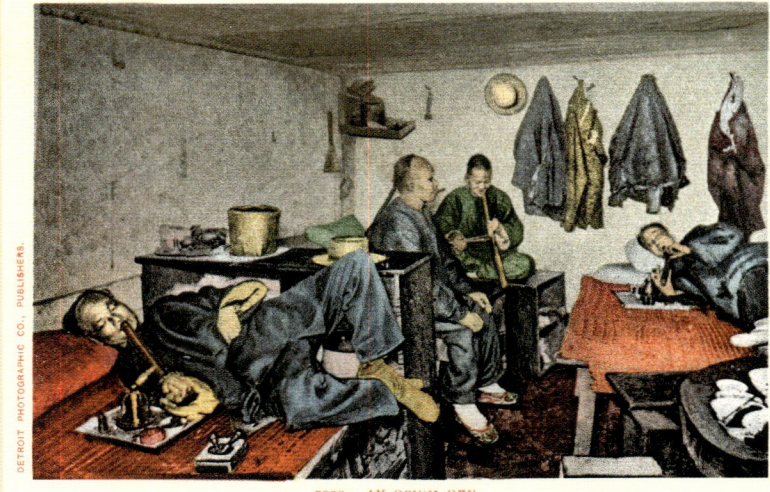

Top left: "Are the police coming?"
Top right: An opium den
Bottom: Children of Chinatown, photochrom
Page 587:
Above: A Chinese family, photochrom
Below left: "Gimme a light"
Below center: In Chinatown
Below right: Children in Chinatown, San Francisco

Oben links: „Kommt die Polizei?"
Oben rechts: Eine Opiumhöhle
Unten: Kinder in Chinatown, Photochrom
Seite 587:
Oben: Chinesische Familie, Photochrom
Unten links: „Gib mir Feuer"
Unten Mitte: In Chinatown
Unten rechts: Kinder in Chinatown, San Francisco

En haut à gauche : jeune guetteur chinois…
En haut à droite : une fumerie d'opium
Ci-dessous : enfants de Chinatown, photochrome
Page 587 :
En haut : une famille chinoise, photochrome
En bas à gauche : « Donne-moi du feu »
En bas au centre : à Chinatown
En bas à droite : enfants de Chinatown, San Francisco

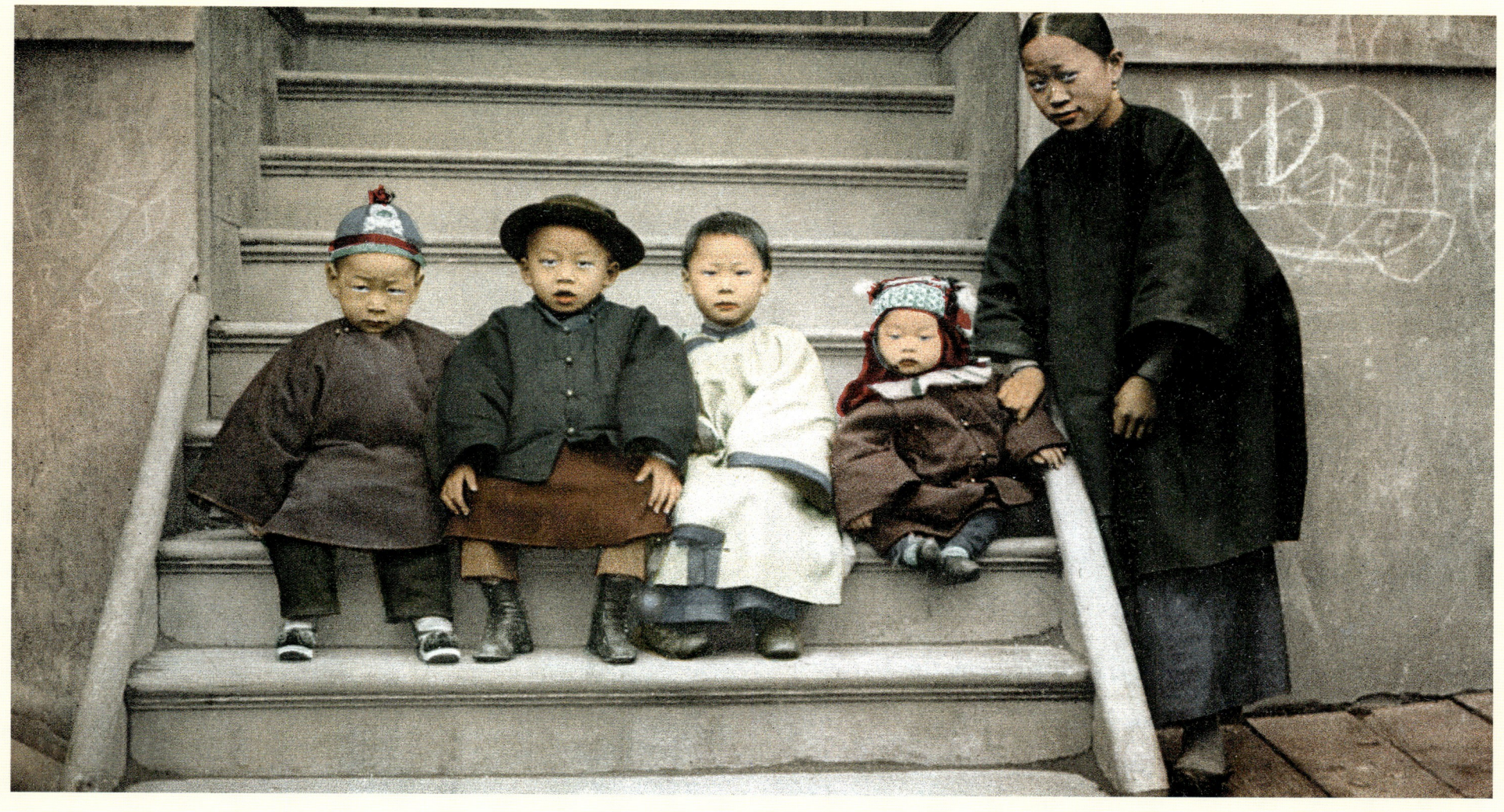

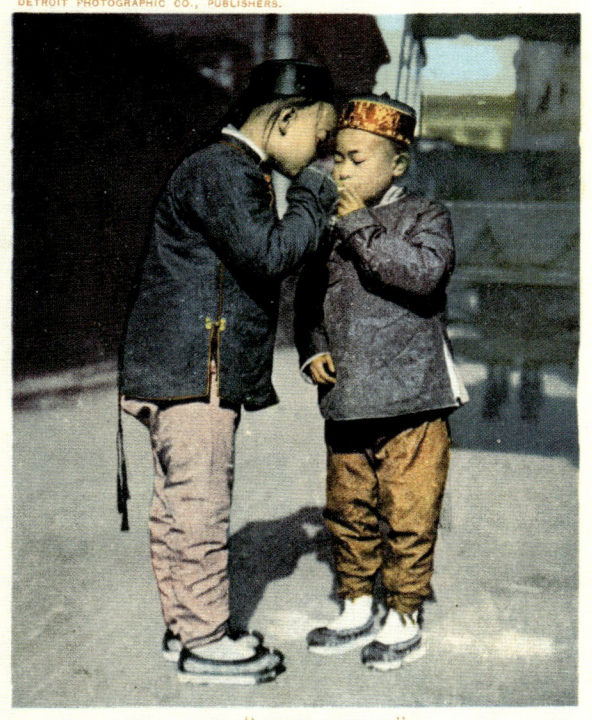

Many tourists came to Chinatown for a "taste of debauchery" and its spicy reputation was carefully maintained by scandal sheets.

Zahlreiche Touristen kamen, um sich in Chinatown „üblen Sitten hinzugeben". Der schlechte Ruf des Viertels wurde natürlich von der Skandalpresse geschürt.

Les touristes venaient nombreux « s'encanailler » à Chinatown, dont la réputation sulfureuse fut bien entretenue par une certaine presse.

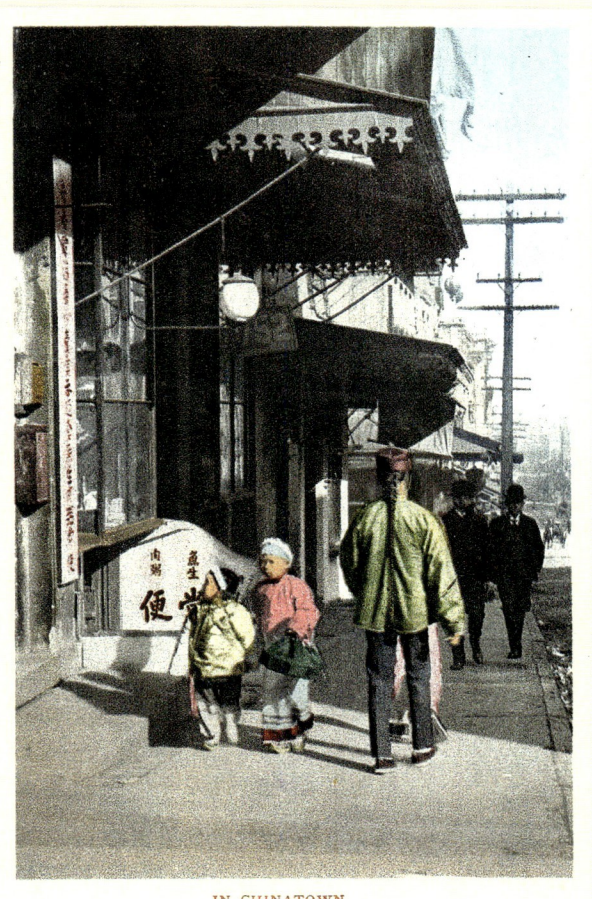

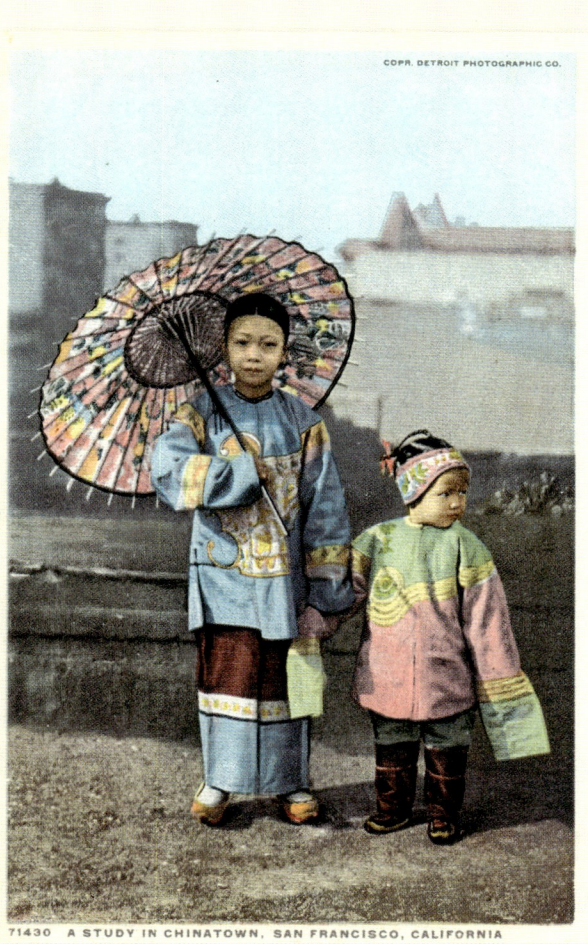

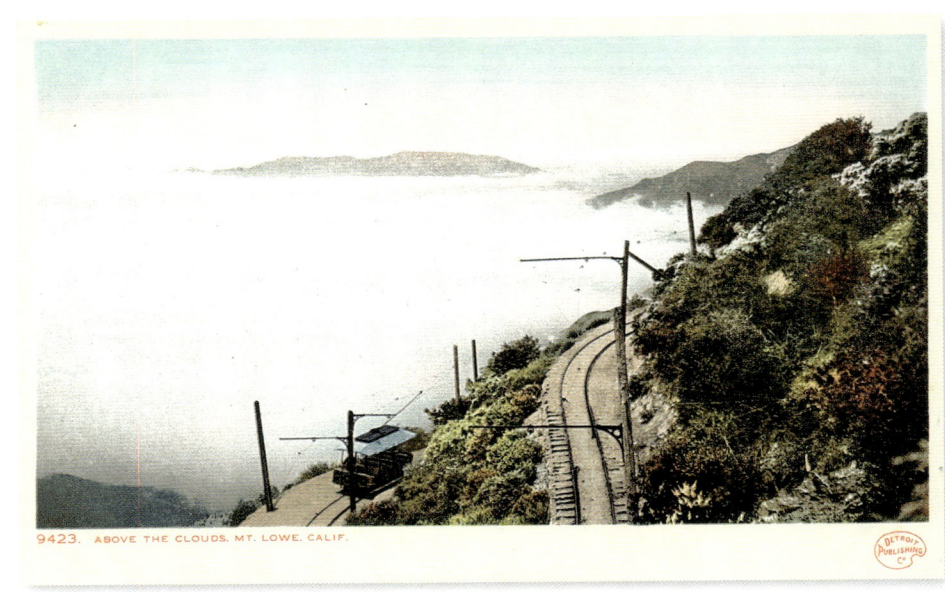

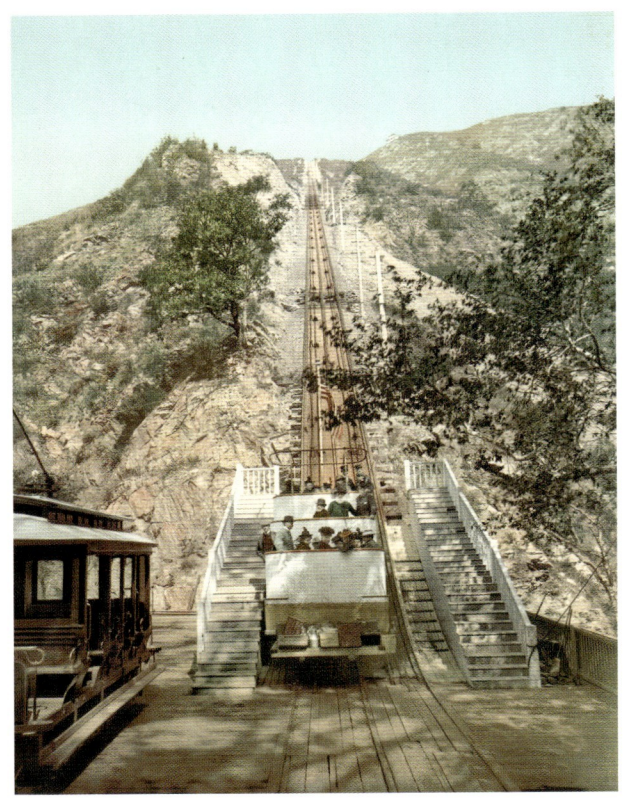

CALIFORNIA | MOUNT LOWE

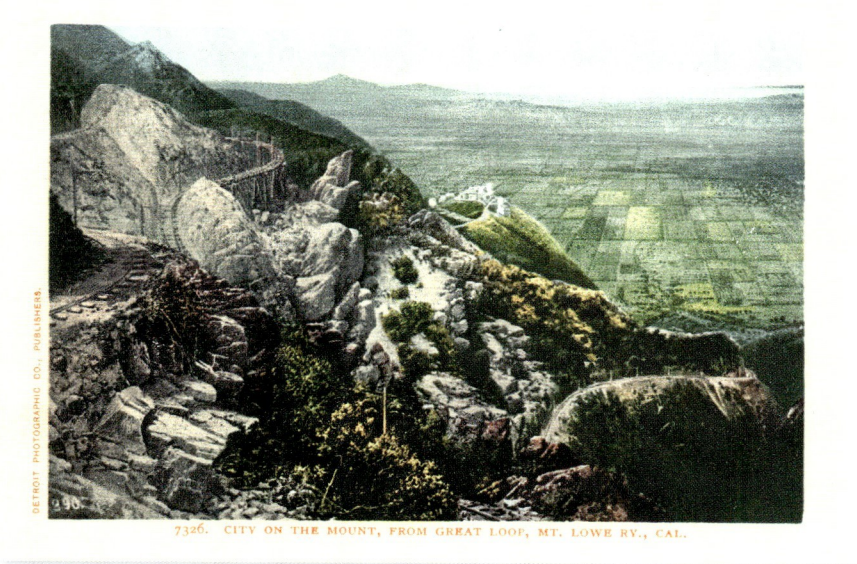

Above: Mt. Lowe from great loop of the funicular railway
Below: Old trail to Mount Wilson, Pasadena, photochrom
Page 588, from top to bottom:
Above the clouds, Mt. Lowe
Mount Lowe Railway cable incline, photochrom
Mount Lowe Railway, on the circular bridge, photochrom

Built in 1891, the "Railway to the Clouds" of engineer Thaddeus Lowe was for some 40 years one of the most popular tourist attractions in California. This electric mountain train connected Altadena to the summit of Echo Mountain, where a casino and an observatory awaited visitors. The alpine section of the line crossed Millard Canyon, ca. 9,800-foot (3,000 m) precipice above which a vertiginous circular bridge was built.

Oben: Ansicht des Mount Lowe von der großen Kehre der Standseilbahn aus
Unten: Der alte Pfad zum Mount Wilson, Pasadena, Photochrom
Seite 588, von oben nach unten:
Über den Wolken, Mount Lowe
Abfahrt der Mount-Lowe-Drahtseilbahn, Photochrom
Mount Lowe Railway auf der großen ringförmigen Brücke, Photochrom

Die 1891 fertiggestellte „Railway to the clouds" (Eisenbahn in die Wolken) des Ingenieurs Thaddeus Lowe war 40 Jahre lang eine der beliebtesten Touristenattraktionen Kaliforniens. Diese elektrische Bergeisenbahn verband Altadena mit dem Gipfel des Echo Mountain, wo den Besucher ein Kasino und ein Observatorium erwarteten. Auf dem gebirgigen Streckenabschnitt überquerte die Bahn den Millard Canyon, einen 3 000 Meter tiefen Abgrund, über den sich eine schwindelerregende ringförmige Brücke spannte.

En haut : aperçu de Mount Lowe depuis le grand virage du funiculaire
En bas : la vieille piste du mont Wilson, Pasadena, photochrome
Page 588, de haut en bas :
Au-dessus des nuages, Mount Lowe
Départ du chemin de fer de Mount Lowe, photochrome
Chemin de fer de Mount Lowe, sur le grand pont circulaire, photochrome

Réalisé en 1891, le « Railway to the clouds » (le « chemin de fer dans les nuages ») de l'ingénieur Thaddeus Lowe fut pendant quarante ans l'une des attractions touristiques les plus populaires de Californie. Ce chemin de fer de montagne électrique, reliait Altadena au sommet du mont Echo, où un casino et un observatoire attendaient les visiteurs. La partie alpine de la ligne traversait le canyon de Millard, au-dessus duquel un vertigineux pont circulaire avait été jeté.

CALIFORNIA | MOUNT LOWE | PASADENA

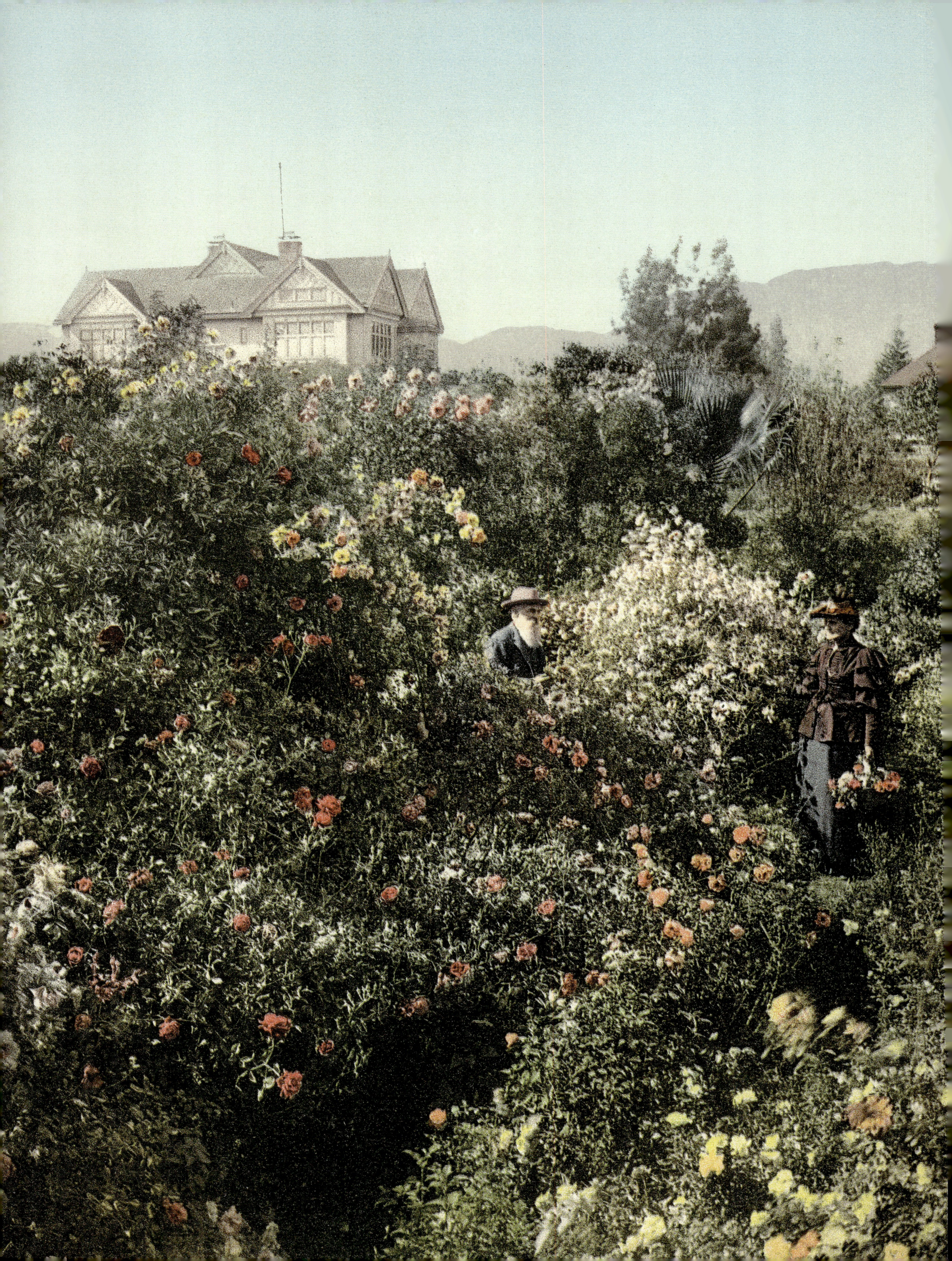

Page 590: A rose garden at Pasadena, photochrom
Right: Cawston Ostrich Farm, riding an ostrich
Below: Hotel Green
Bottom: Colorado Street Bridge over the Arroyo Seco

One of the standard excursions from Pasadena was and is the ascent of Mt. Wilson. In the 1880s, before the construction of the funicular, the journey was made by barouche to the foot of the trail and the ascent itself by mule. People also visited the orange plantations at Stoneman's Ranch, the Cawston Ostrich Farm, and, of course, the San Gabriel Mission.

Page 590 : une roseraie à Pasadena, photochrome
À droite : à dos d'autruche, ferme de Cawston
Ci-dessous : l'hôtel Green
En bas : le pont de Colorado Street sur le fleuve Arroyo Seco

L'une des excursions fétiches de Pasadena était – et reste – l'ascension du mont Wilson. Dans les années 1880, avant la construction du funiculaire, on partait en calèche jusqu'au pied de la piste et l'on terminait le trajet à dos de mulet. On visitait aussi les plantations d'orangers de Stoneman's Ranch, la ferme d'autruches de Cawston et, bien sûr, la mission San Gabriel.

Seite 590: Ein Rosengarten in Pasadena, Photochrom
Rechts: Die Straußenfarm von Cawston, Ritt auf einem Strauß
Mitte: Hotel Green
Unten: Colorado Street Bridge über den Fluss Arroyo Seco

Eine der beliebtesten Exkursionen von Pasadena war – und ist noch immer – ein Ausflug auf den Mount Wilson. In den 1880er-Jahren, bevor die Seilbahn gebaut wurde, fuhr man zuerst mit der Kalesche bis zum Beginn des Reitwegs und bestritt das letzte Stück der Strecke auf dem Rücken eines Maultiers. Man besichtigte auch die Orangenplantagen von Stoneman's Ranch, die Straußenfarm von Cawston und natürlich die Mission San Gabriel.

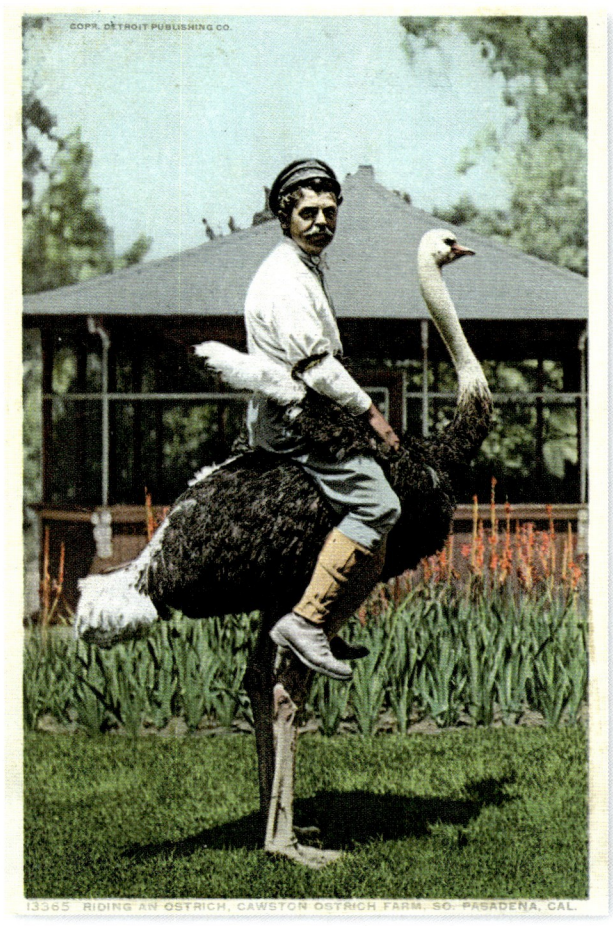

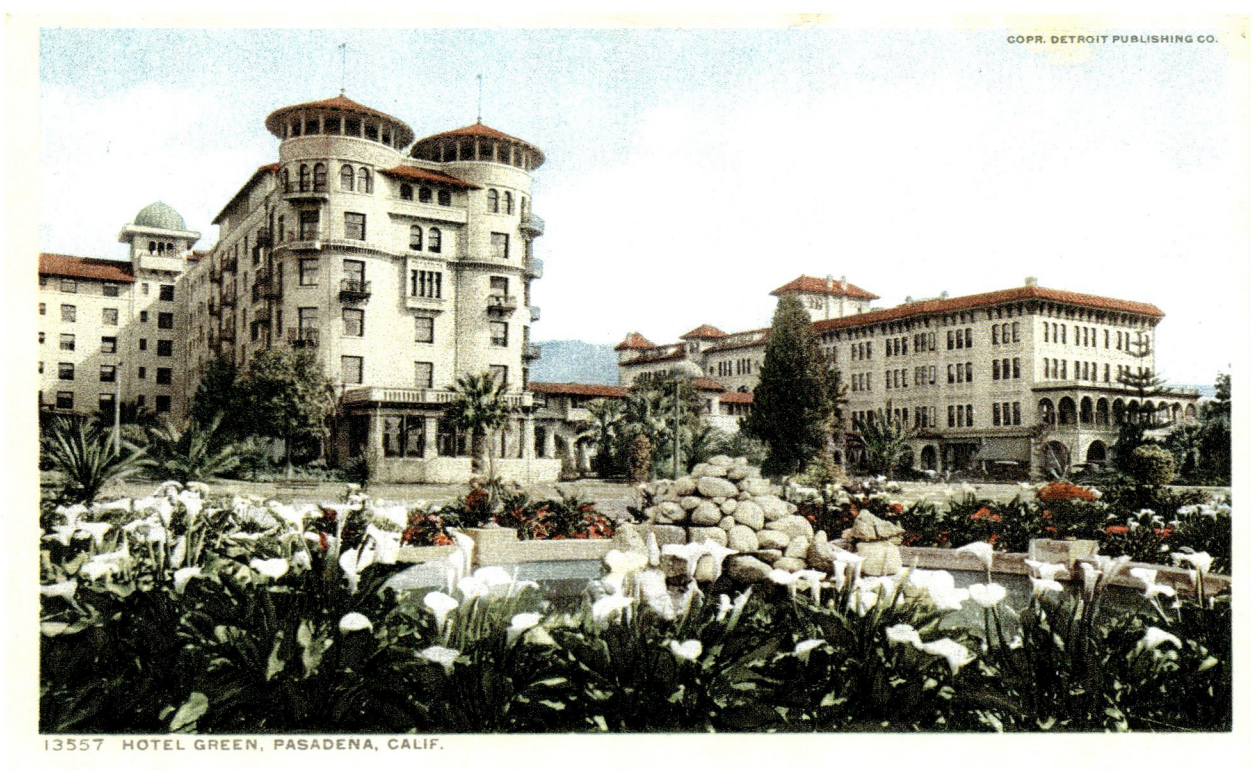

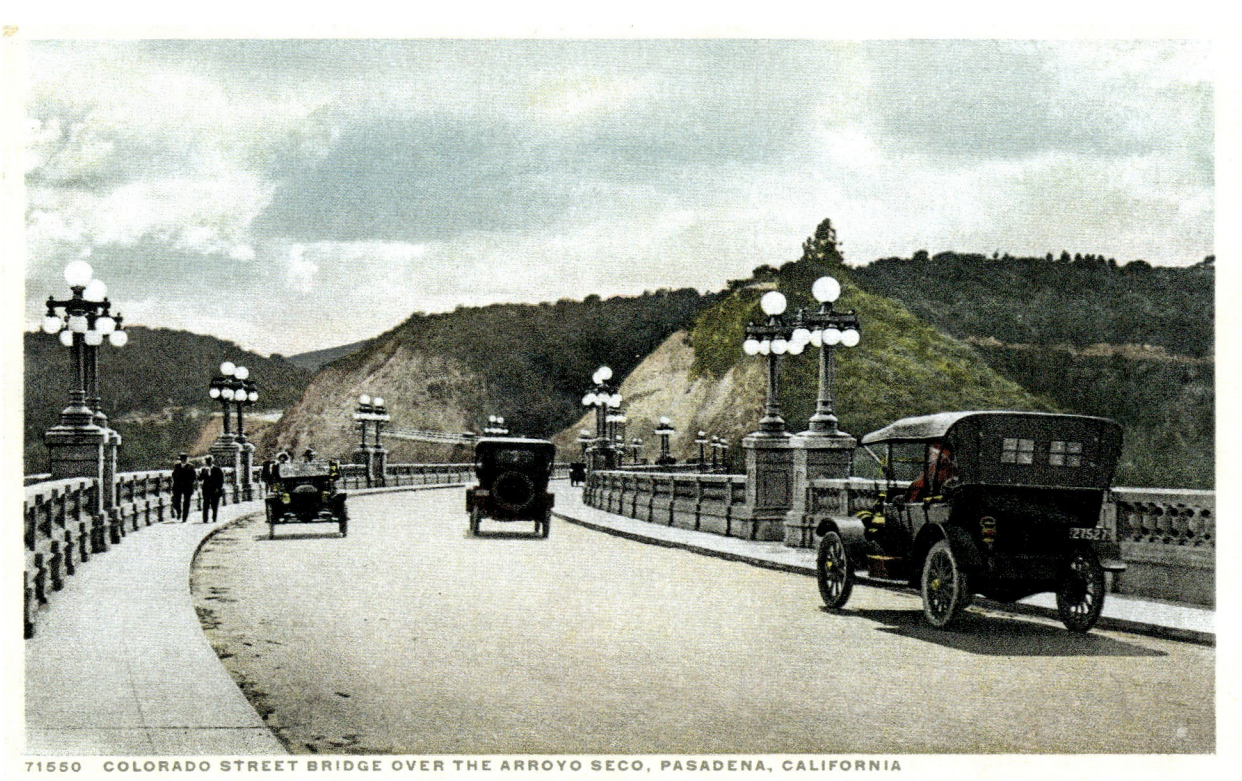

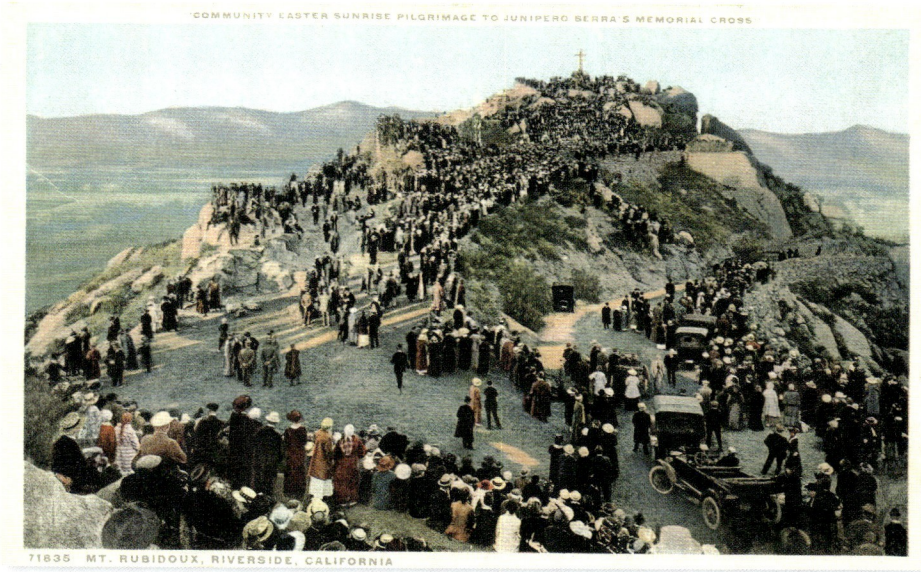

Above: Mount Rubidoux, Riverside
Below: The Glenwood Mission Inn, photochrom
Page 592:
Above: Glenwood Mission Inn, entrance, photochrom
Below: Music Room, Glenwood Mission Inn, photochrom

The Glennwood Mission Hotel in Riverside is both a museum and an art gallery—and a worthy successor to a building in an immemorial style; the simple adobe guesthouse constructed in Californian style by the "Master of the Inn," Frank Augustus Miller, was built in 1870–80 and perfectly suited to its epoch and environment. In 1902, the hotel was completely transformed in the Hispanic style of the moment and took the name Glenwood Mission Inn. The cloister wing with the music room was added after 1910.

Oben: Mount Rubidoux, Riverside
Unten: Das Hotel Glenwood Mission Inn, Photochrom
Seite 592:
Oben: Eingang zum Hotel Glenwood Mission Inn, Photochrom
Unten: Musiksaal des Hotels Glenwood Mission Inn, Photochrom

Das Hotel Glenwood Mission in Riverside, zugleich Museum und Kunstgalerie, ist der würdige Erbe einer säkularen Tradition; der einfache Ziegelbau im kalifornischen Stil, der von seinem „Besitzer" Frank Augustus Miller in den Jahren 1870–1880 errichtet wurde, vermochte es, sich an seine Zeit und seine Umgebung anzupassen. 1902 wurde das Hotel der damaligen hispanisierenden Strömung in der Architektur entsprechend vollständig umgebaut und hieß fortan Glenwood Mission Inn. Der Flügel des Klosters mit dem Musiksaal wurde nach 1910 hinzugefügt.

Ci-dessus : le mont Rubidoux, Riverside
Ci-dessous : l'hôtel Glenwood Mission Inn, photochrome
Page 592 :
En haut : L'entrée de l'hôtel Glenwood Mission Inn, photochrome
En bas : La salle de musique de l'hôtel Glenwood Mission Inn, photochrome

En même temps musée et galerie d'art, l'hôtel Glenwood Mission de Riverside est le digne héritier d'une tradition séculaire ; le simple bâtiment en adobe de style californien édifié par le « maître des lieux », Frank Augustus Miller, dans les années 1870–1880, a su s'adapter à son époque et à son environnement. En 1902, l'hôtel fut totalement transformé selon le courant architectural hispanisant du moment et prit le nom de Glenwood Mission Inn. L'aile du cloître avec la salle de musique fut ajoutée après 1910.

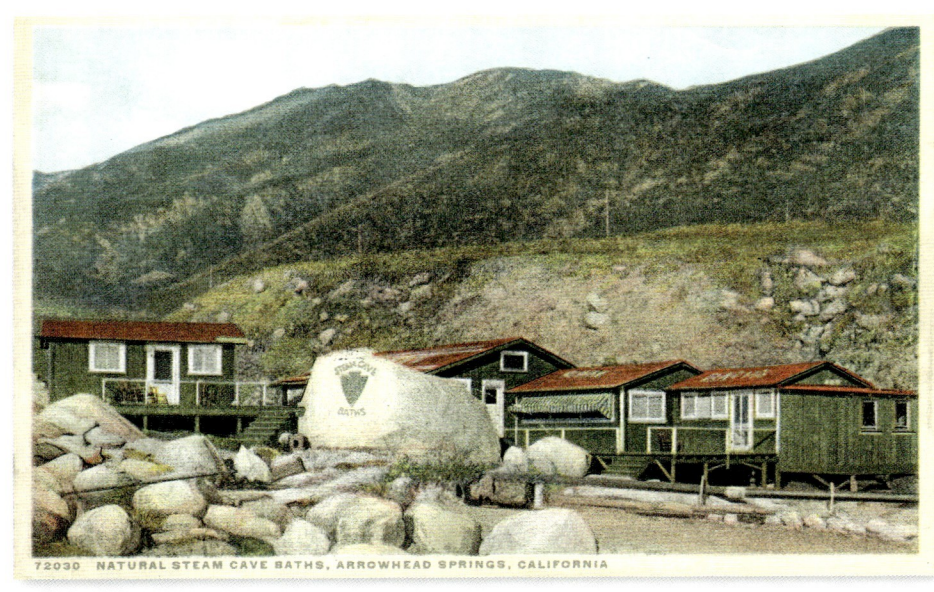
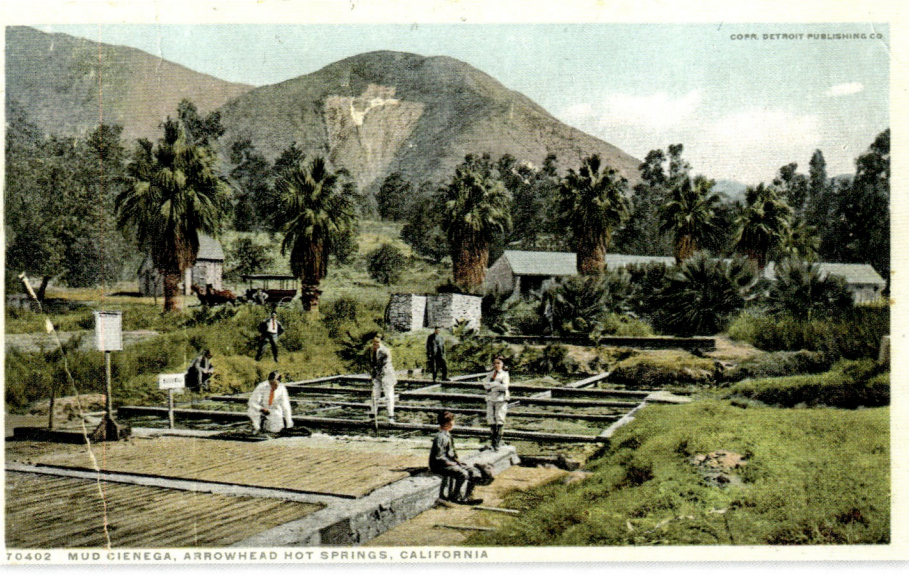

594

CALIFORNIA | RIVERSIDE | ARROWHEAD SPRINGS

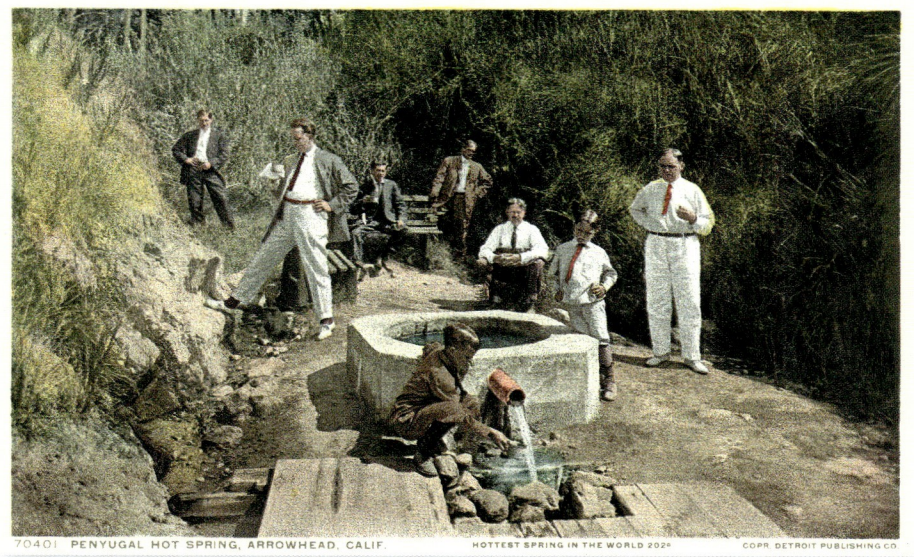

Above: Penyugal Hot Spring, Arrowhead Springs
Below: A cactus garden in California, photochrom
Page 594:
Top left: Natural steam cave baths, Arrowhead Springs
Top right: Mud cienega, Arrowhead Springs
Bottom: Almond trees in blossom, Riverside, photochrom

Oben: Penyugal Hot Spring, Arrowhead Springs
Unten: Kaktusgarten in Kalifornien, Photochrom
Seite 594:
Oben links: Natürliche Dampfbäder, Arrowhead Springs
Oben rechts: Schlammbäder, Arrowhead Springs
Unten: Blühende Mandelbäume, Riverside, Photochrom

En haut : la source chaude de Penyugal, Arrowhead Springs
Ci-dessous : jardin de cactées en Californie, photochrome
Page 594 :
En haut à gauche : Bains de vapeur naturels, Arrowhead Springs
En haut à droite : Bains de boue, Arrowhead Springs
En bas : Amandiers en fleur, Riverside, photochrome

CALIFORNIA | RIVERSIDE | ARROWHEAD SPRINGS

ORANGES / ORANGEN / ORANGES

The California Gold Rush had one unexpected side effect: between 1848 and 1850, the demand for citrus fruit went through the ceiling! The gold prospectors, aware of the antiscorbutic properties of lemons and oranges, emptied the shops of them. The first citrus plantation designed to meet this new demand was created by William Wolfskill at Riverside; he planted hundreds of lemon and orange seeds from the San Gabriel Mission—since the 18th century the Spanish missionaries had been cultivating a variety of citrus that had probably originated in China. The success of Wolfskill's plantation demonstrated the existence of a local market, but large-scale production did not begin until the 1870s with the introduction of the navel orange, a mutation of a Brazilian variety, sweet-flavored, seedless, and a winter fruit. One of the earliest orange groves planted in Riverside, which dates from 1873, was added to the list of Californian heritage sites in 2010.

Die Zeit des kalifornischen Goldrausches hatte einen durchaus unerwarteten „Nebeneffekt": Zwischen 1848 und 1850 explodierte die Nachfrage nach Zitrusfrüchten! Die Goldsucher kannten die Wirksamkeit von Zitronen und Orangen gegen Skorbut und plünderten die Läden. Die erste an dieses neue Bedürfnis angepasste Plantage mit Zitrusfrüchten war die des Pioniers William Wolfskill in Riverside. Er pflanzte Hunderte von Zitronen- und Orangensamen aus der Missionsstation von San Gabriel – die spanischen Missionare bauten nämlich seit dem 18. Jahrhundert eine Zitrusfruchtvarietät an, die vermutlich aus China stammte. Der Erfolg von Wolfskills Plantage bestätigte, dass es durchaus einen regionalen Markt gab, doch die Produktion im großen Maßstab begann erst in den 1870er-Jahren mit der Einführung der Navelorange, einer Mutation der brasilianischen Varietät, die den Vorteil hatte, eine Winterfrucht ohne Kerne und mit feinem Aroma zu sein. Einer der ersten Orangenbäume, die 1873 in Riverside angepflanzt wurden, wurde 2010 zum historischen Erbe Kaliforniens erklärt.

L'époque de la ruée vers l'or en Californie eut un « effet secondaire » assez imprévisible : entre 1848 et 1850, la demande en agrumes explosa ! Les chercheurs d'or, connaissant les vertus antiscorbutiques des citrons et des oranges, dévalisèrent les boutiques. La première plantation d'agrumes adaptée à cette nouvelle demande fut celle du pionnier William Wolfskill, à Riverside. Ce dernier planta des centaines de graines de citron et d'orange provenant de la mission de San Gabriel – les missionnaires espagnols cultivaient depuis le XVIIIe siècle une variété d'agrumes probablement originaire de Chine. Le succès de la plantation de Wolfskill prouva qu'il existait bien un marché local, mais la production à grande échelle ne commença que dans les années 1870 avec l'introduction de l'orange navel, mutation d'une variété brésilienne, qui présentait l'avantage d'être un fruit d'hiver, sans pépin et de saveur douce. L'un des premiers orangers plantés à Riverside en 1873 a été classé en 2010 au patrimoine historique de la Californie.

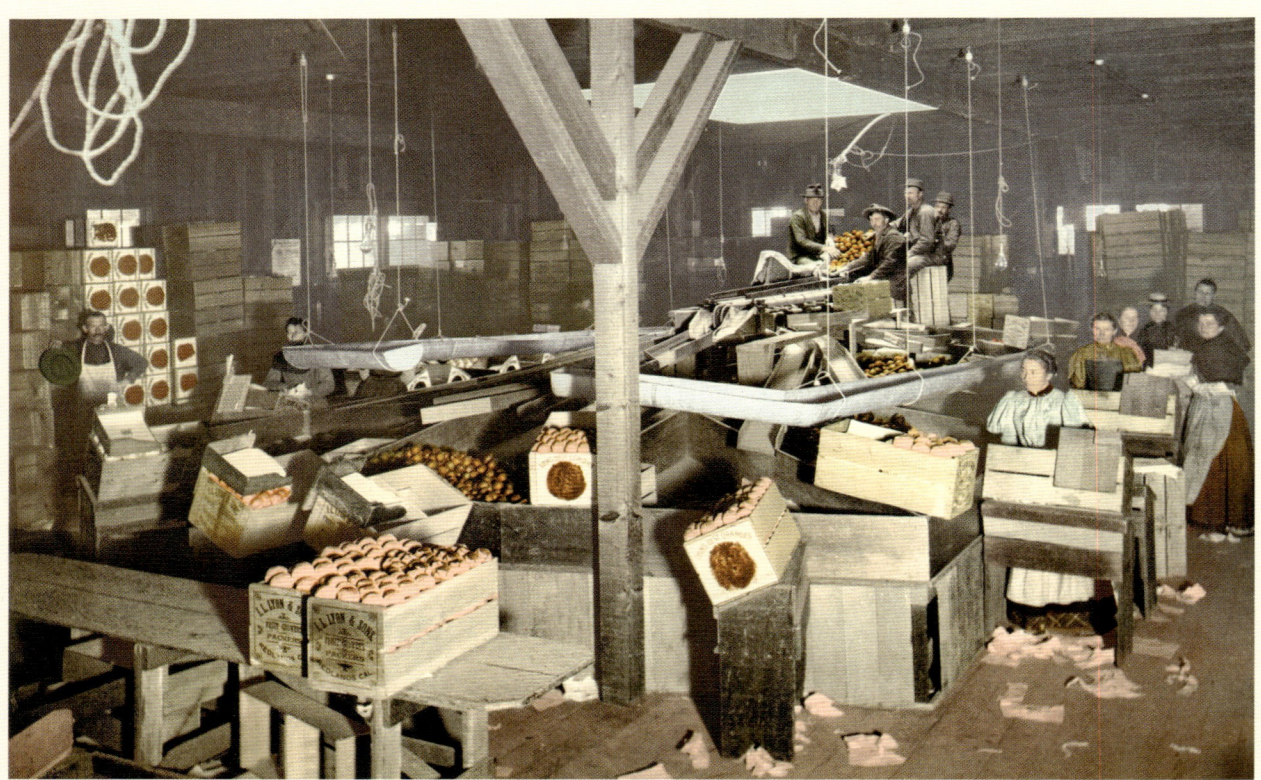

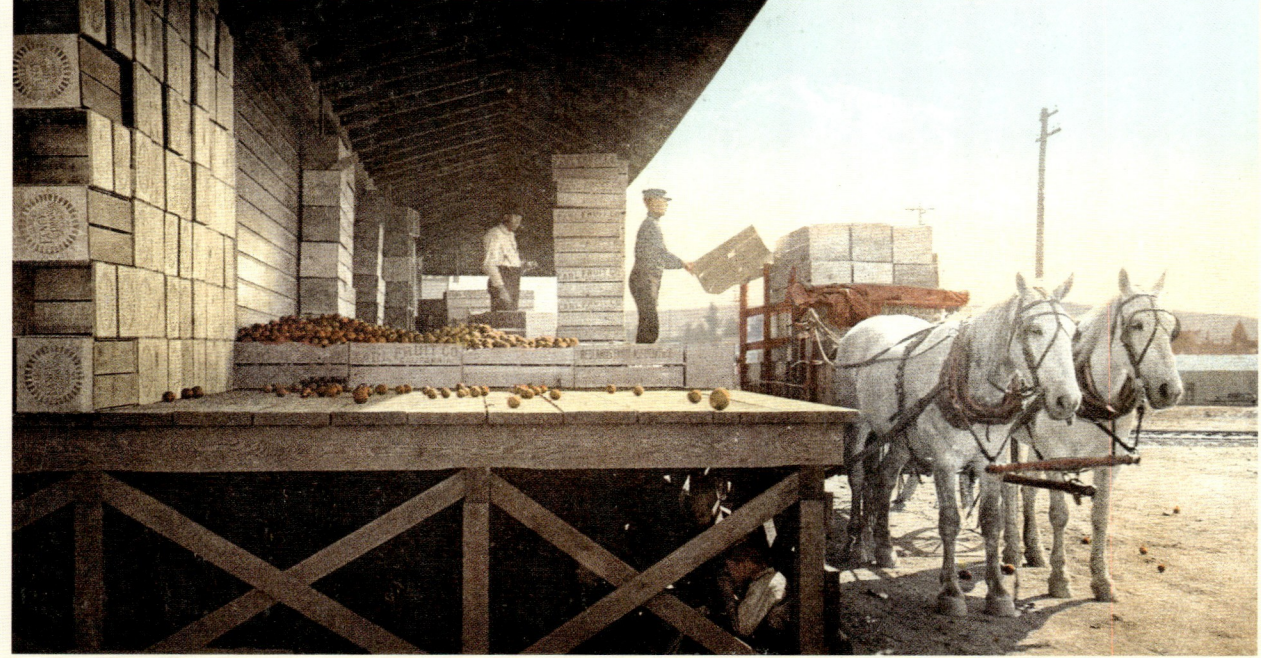

Between 1848 and 1850, the demand for citrus fruit went through the roof!

Zwischen 1848 und 1850 explodierte die Nachfrage nach Zitrusfrüchten!

Entre 1848 et 1850, la demande en agrumes explosa !

Above: Orange packing in Redlands, photochrom
Left: Shipping oranges, Redlands, photochrom
Page 597: Picking oranges, Riverside, photochrom

Oben: Verpacken von Orangen in Redlands, Photochrom
Links: Verladung von Orangen, Redlands, Photochrom
Seite 597: Orangenernte, Riverside, Photochrom

En haut: emballage d'oranges à Redlands, photochrome
Ci-contre : expédition d'oranges, Redlands, photochrome
Page 597 : récolte des oranges à Riverside, photochrome

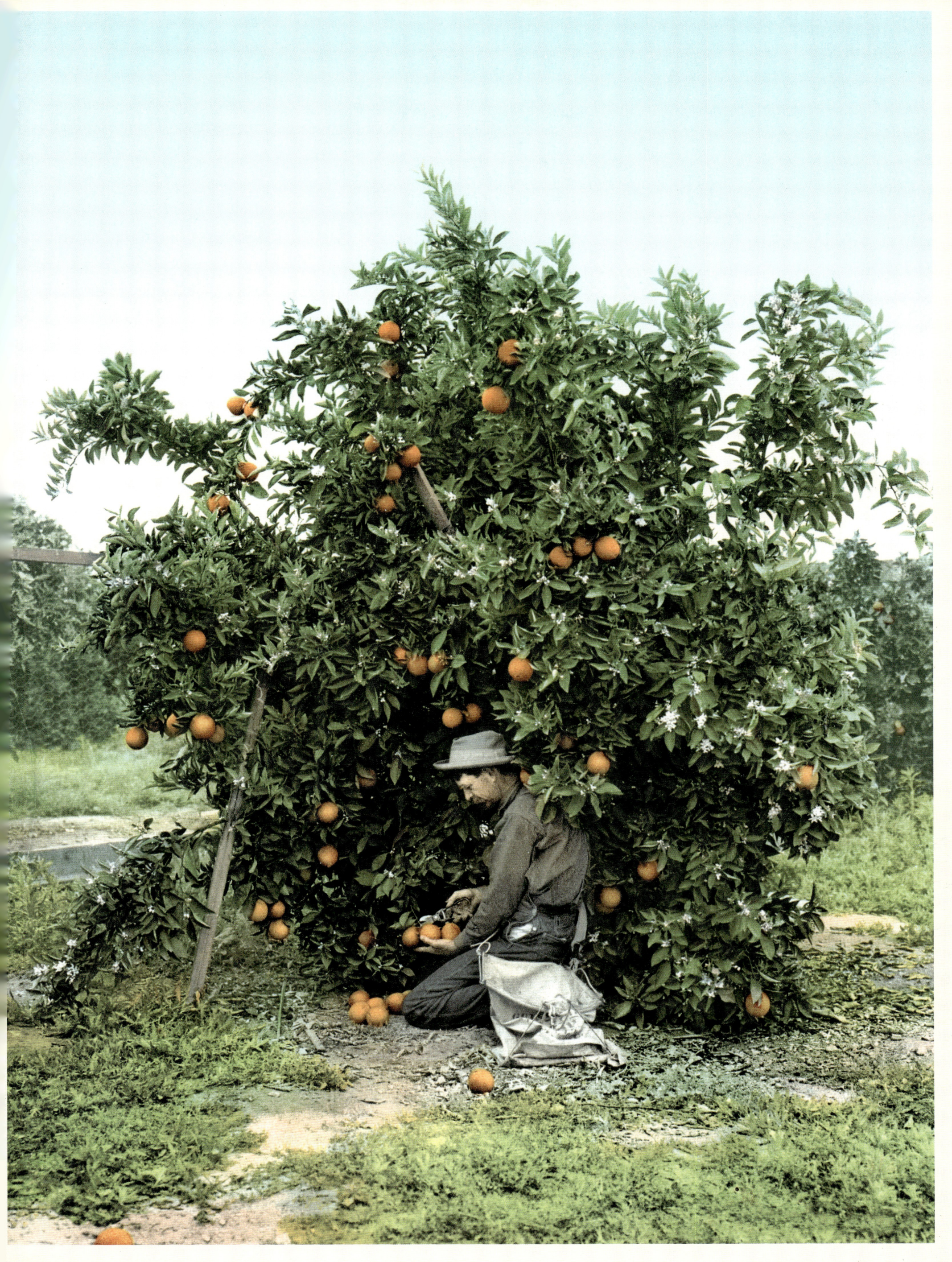

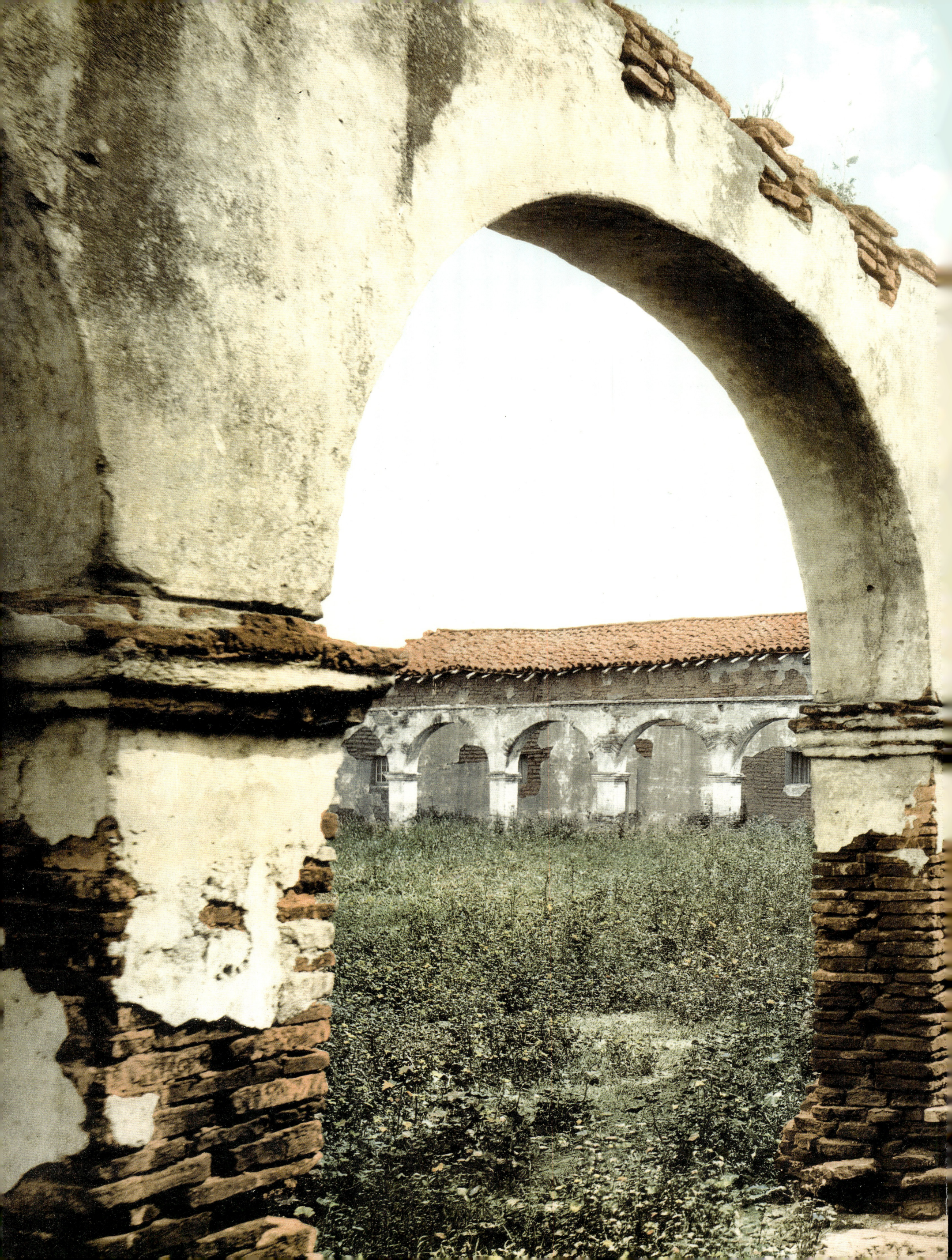

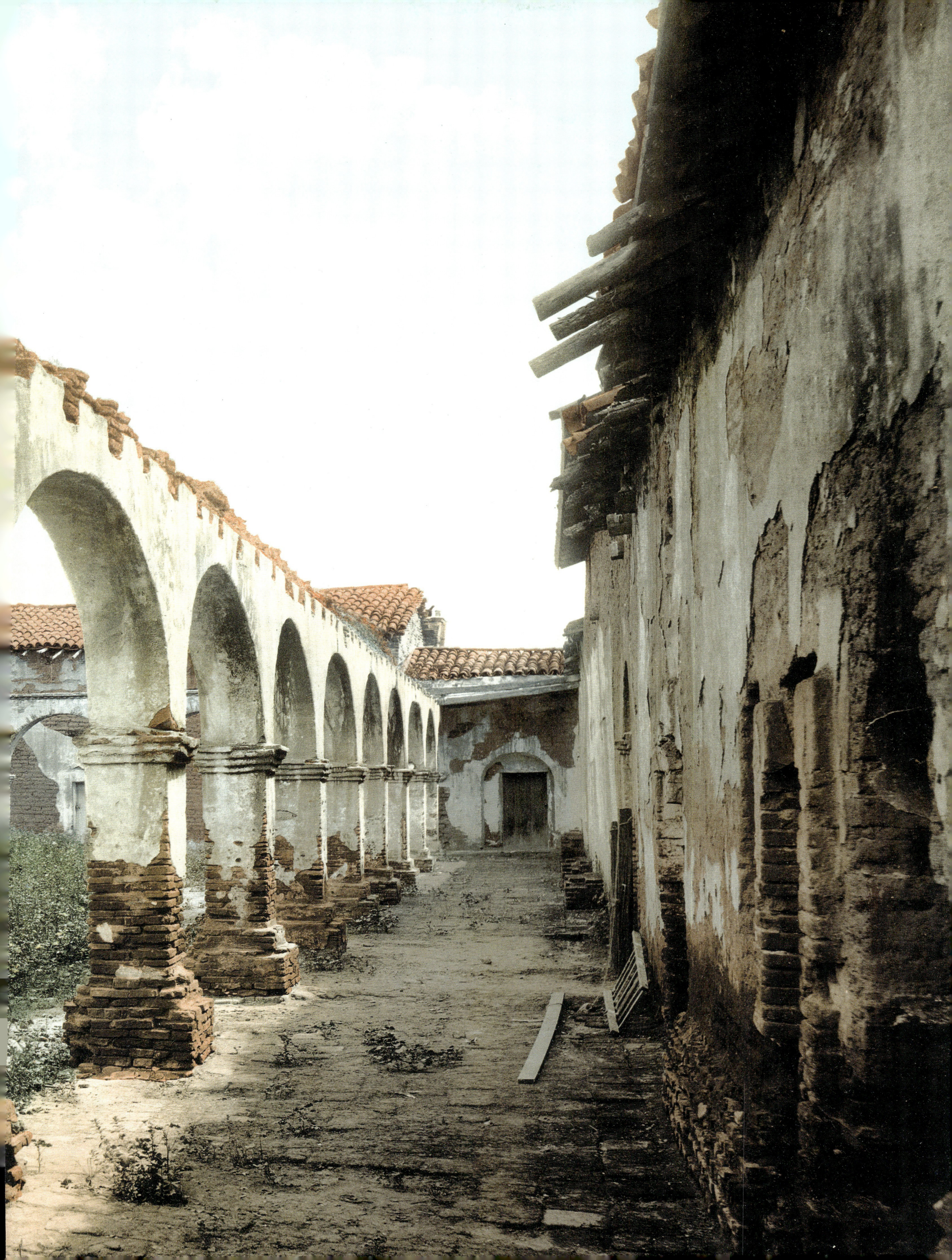

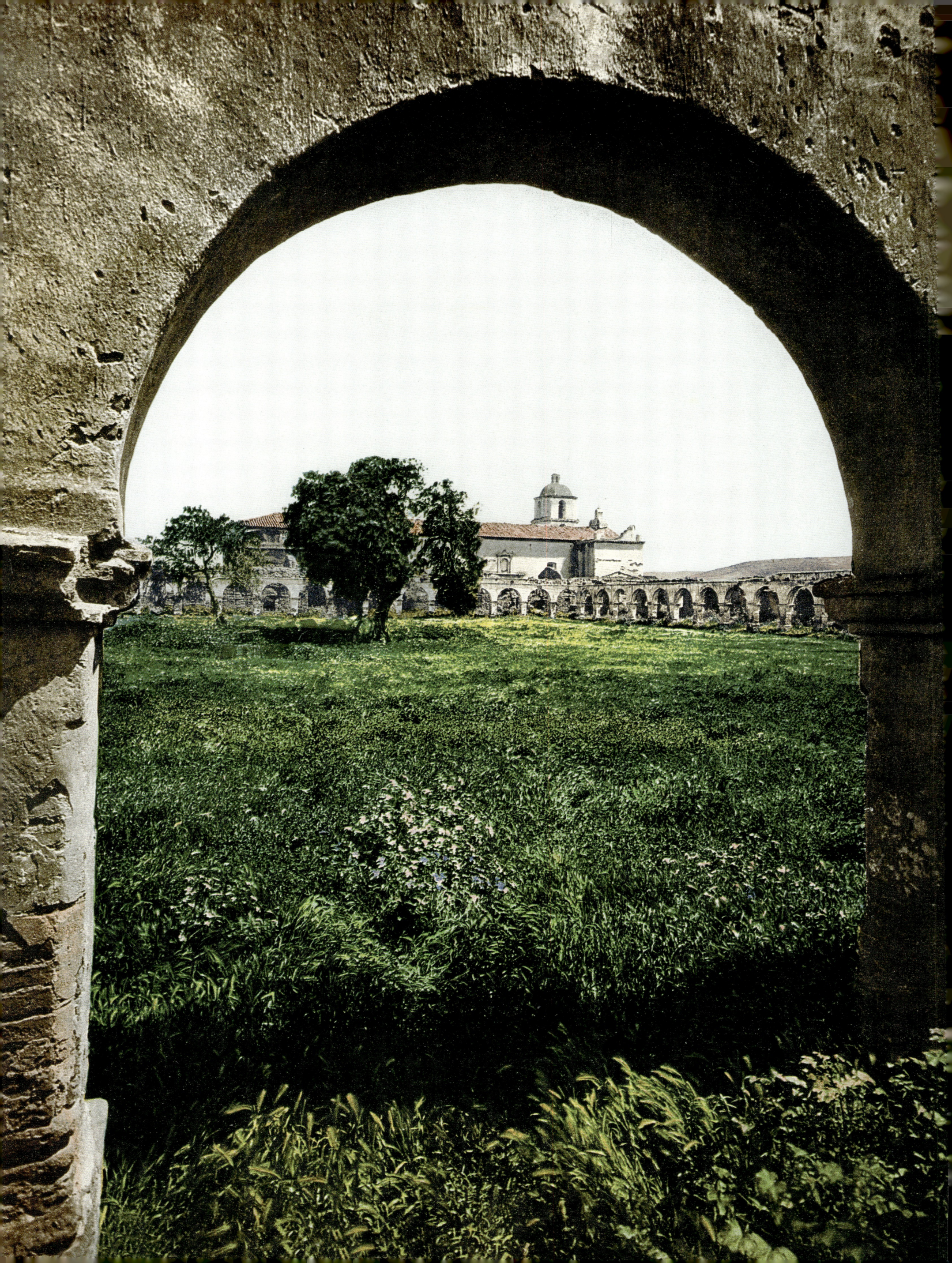

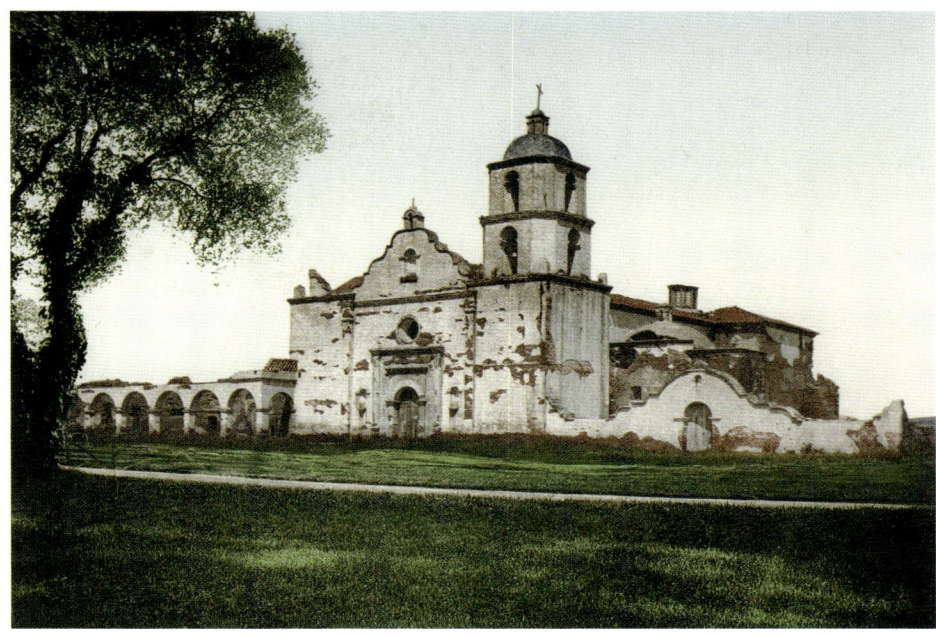

Page 598/599: Mission San Juan Capistrano, arcades, photochrom
Page 600: Mission San Luis Rey, photochrom
Above: Mission San Luis Rey, photochrom
Below: The old caretaker at Mission San Juan Capistrano, photochrom

San Juan Capistrano was built in 1776 and was the seventh mission founded by the Franciscan Father Junipero Serra. The Acjachemen Indians were induced to help with the construction of the adobe buildings. The church was raised and consecrated in 1806, but it survived only six years before its destruction in 1812 by a strong earthquake. The mission was gradually abandoned and left in a ruinous state until the late 1880s, when restoration work began.

Seite 598/599: Mission San Juan Capistrano, die Arkaden, Photochrom
Seite 600: Mission San Luis Rey, Photochrom
Oben: Mission San Luis Rey, Photochrom
Unten: Der alte Wärter der Mission San Juan Capistrano, Photochrom

Die 1776 errichtete Mission San Juan Capistrano war die siebte, die von dem Franziskanerpater Junipero Serra gegründet wurde. Für die Errichtung der Gebäude aus Lehmziegeln zog man die Acjachemen-Indianer heran. Man baute eine Kirche und weihte sie 1806 ein. Sie existierte jedoch nur sechs Jahre und wurde 1812 bei einem starken Erdbeben zerstört. Die Missionsstation wurde nach und nach aufgegeben, und es blieben nur Ruinen zurück, bis man Ende der 1880er-Jahre mit den Restaurierungsarbeiten begann.

Pages 598/599 : les arcades de la mission San Juan Capistrano, photochrome
Page 600 : la mission San Luis Rey, photochrome
Ci-dessus : la mission San Luis Rey, photochrome
Ci-dessous : le gardien de la mission San Juan Capistrano, photochrome

Édifiée en 1776, la mission San Juan Capistrano est la septième fondée par le père franciscain Junipero Serra. Ce sont les Indiens Acjachemen qui furent mis à contribution pour la construction des bâtiments, qui sont en adobe. L'église qui fut élevée, consacrée en 1806, ne survécut que six ans : elle fut détruite en 1812 par un fort tremblement de terre. La mission fut progressivement abandonnée et laissée à l'état de ruine, jusqu'à la fin des années 1880 où des travaux de restauration commencèrent.

Below: Bath house and bathing pool, La Jolla
Bottom: La Jolla caves, San Diego, photochrom
Page 603:
Above: Caves of La Jolla
Below: Cathedral Rock, near San Diego, photochrom

"Cathedral Rock is now but a mass of broken rocks… like the debris… from an explosion in a quarry," read the *San Diego Union* of January 20, 1906. "Between 3 and 4 o'clock yesterday morning, there resounded through the suburb a great roar… a distinct tremor accompanying the sound…Early risers looked over the brow of the bluff and… saw that their beloved Cathedral Rock had collapsed."

Mitte: Badehaus und Schwimmbad, La Jolla
Unten: Die Grotten von La Jolla, San Diego, Photochrom
Seite 603:
Oben: Grotten von La Jolla
Unten: Cathedral Rock (Felsenkathedrale) bei San Diego, Photochrom

„Cathedral Rock ist nur noch ein Haufen zerbrochener Steine, wie nach einer Explosion in einem Steinbruch", konnte man am 20. Januar 1906 in der Tageszeitung *San Diego Union* lesen. „Heute Nacht zwischen 3 und 4 Uhr vernahmen die Bewohner von La Jolla ein dumpfes Grollen, begleitet von einem heftigen Erdbeben, und dann nichts mehr… Erst am nächsten Morgen erkannten sie die Ursache, als die ersten Spaziergänger entdeckten, dass ihre geliebte ‚Felsen-Kathedrale' eingestürzt war."

Ci-dessous : le pavillon des bains et la piscine de La Jolla
En bas : grottes de La Jolla, San Diego, photochrome
Page 603, de haut en bas :
En haut : Grottes de La Jolla
En bas : Cathedral Rock (le « rocher cathédrale »), près de San Diego, photochrome

« Cathedral Rock n'est plus qu'un tas de roches brisées, que l'on dirait issues de l'explosion d'une carrière », pouvait-on lire le 20 janvier 1906 dans le journal *San Diego Union*. « Cette nuit, entre 3 et 4 heures, les résidents de La Jolla entendirent un grondement sourd, accompagné d'un fort tremblement, puis plus rien… Ce n'est qu'au matin qu'ils en comprirent la raison, lorsque les premiers promeneurs découvrirent que leur cher "rocher cathédrale" s'était effondré. »

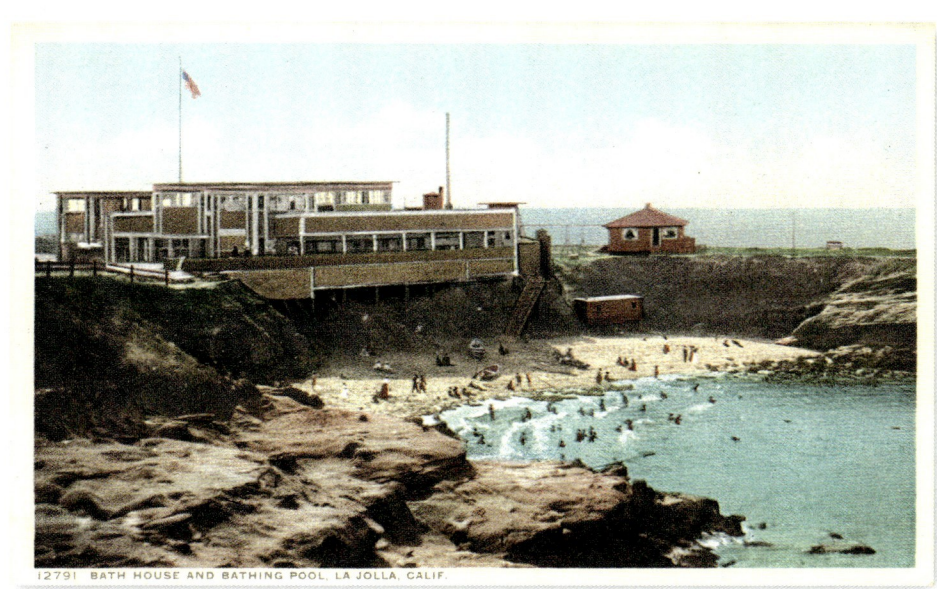

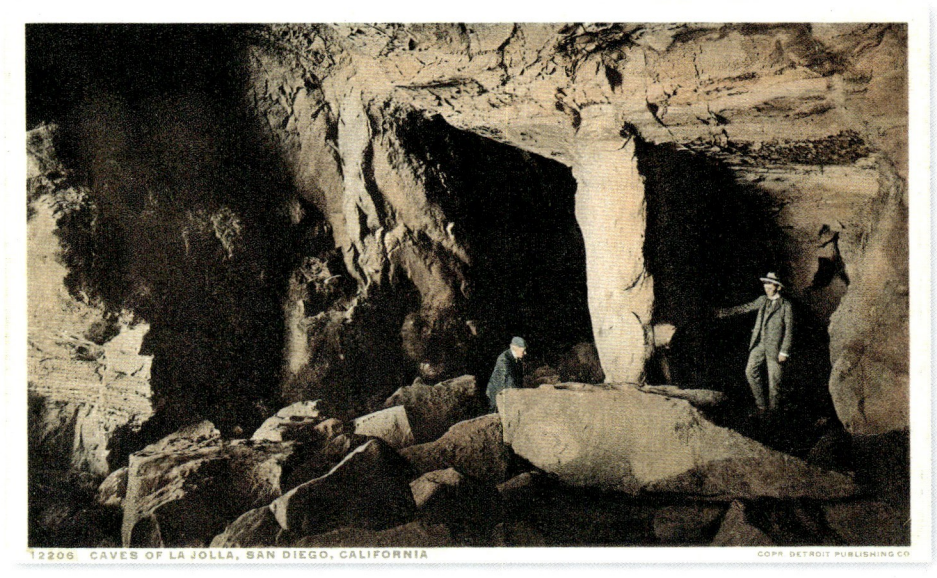

CALIFORNIA | SAN DIEGO

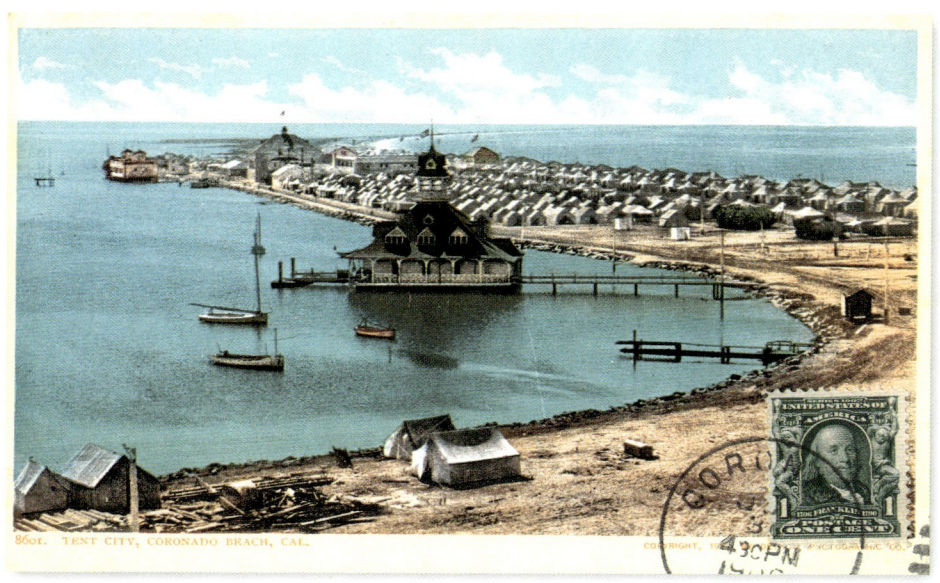

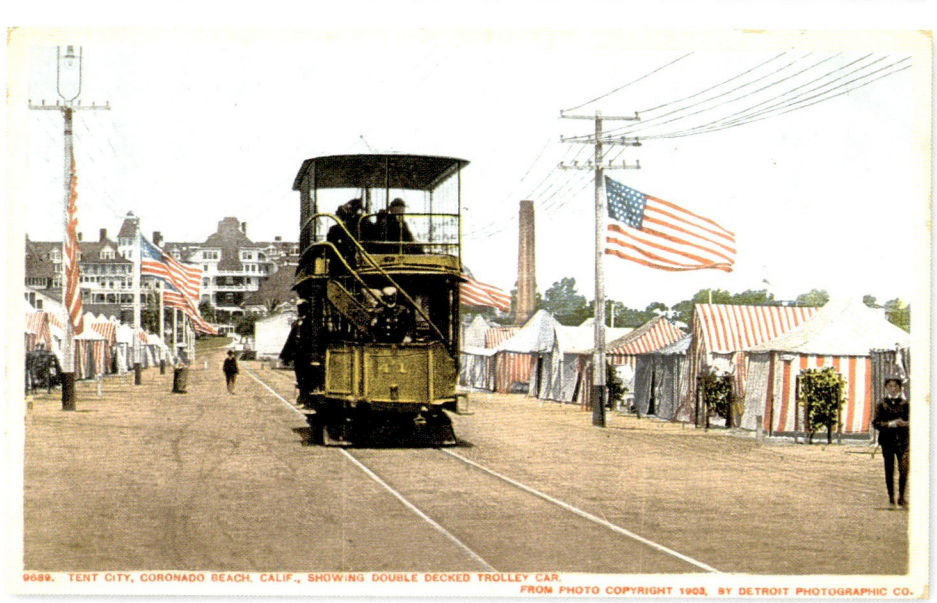

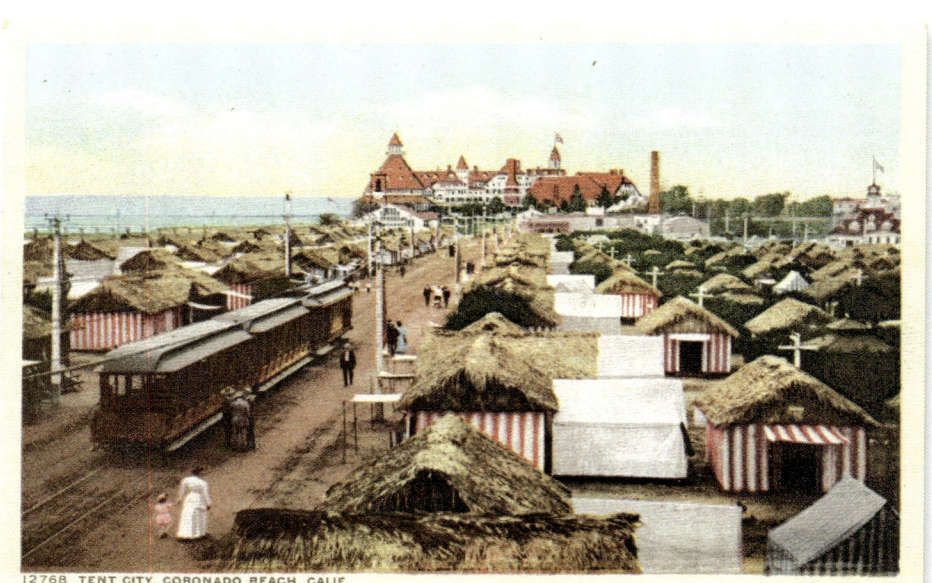

Above: **Hotel del Coronado, Coronado Beach, San Diego, photochrom**
Below: **Bathing pool, Coronado Tent City**
Page 604:
Middle: **View of Tent City, Coronado Beach**
Bottom left: **Double-decked trolley car, Tent City**
Bottom right: **Tent City, Coronado Beach**
Page 606/607: **New York City, West Street, photochrom**

The famous Hotel del Coronado, better known as "the Del" or "Del's," opened in 1888. Four years later, in 1892, the sugar magnate John D. Spreckels bought it and added Tent City, which he equipped with all the bathing and leisure facilities required to attract a more popular summer clientele than that of the hotel.

Oben: **Das Hotel del Coronado, Coronado Beach, San Diego, Photochrom**
Unten: **Schwimmbad, Coronado Tent City**
Seite 604:
Mitte: **Blick auf Tent City (Zeltdorf), Coronado Beach**
Unten links: **Doppeldeckertrolley, Tent City**
Unten rechts: **Tent City, Coronado Beach**
Seite 606/607: **New York City, West Street, Photochrom**

Das berühmte Hotel del Coronado, der Einfachheit halber auch „The Del" oder „Del's" genannt, wurde 1888 eröffnet. Vier Jahre später, im Jahr 1892, ging es in den Besitz des Zuckermagnaten John D. Spreckels über, der ein Zeltdorf anfügte, das mit allen Bade- und Freizeiteinrichtungen ausgestattet war, die man benötigte, um im Sommer ein breiteres Publikum anzulocken, als es das eigentliche Hotel vermochte.

Ci-dessus : **l'hôtel del Coronado, plage de Coronado (Coronado Beach), San Diego, photochrome**
Ci-dessous : **la piscine, Coronado Tent City**
Page 604 :
Au centre : **Vue générale de Tent City (le camping de Coronado Beach)**
En bas à gauche : **Trolley à deux plates-formes, Tent City**
En bas à droite : **Tent City, Coronado Beach**
Pages 606/607 : **New York City, West Street, photochrome**

Le célèbre hôtel del Coronado, plus simplement appelé « The Del », ou « Del's », ouvrit ses portes en 1888. Quatre ans plus tard, en 1892, le magnat du sucre John D. Spreckels en fit l'acquisition et lui ajouta un village de tentes, Tent City, doté de tous les équipements balnéaires et de loisirs susceptibles d'attirer, l'été, une clientèle plus populaire que celle de l'hôtel lui-même.

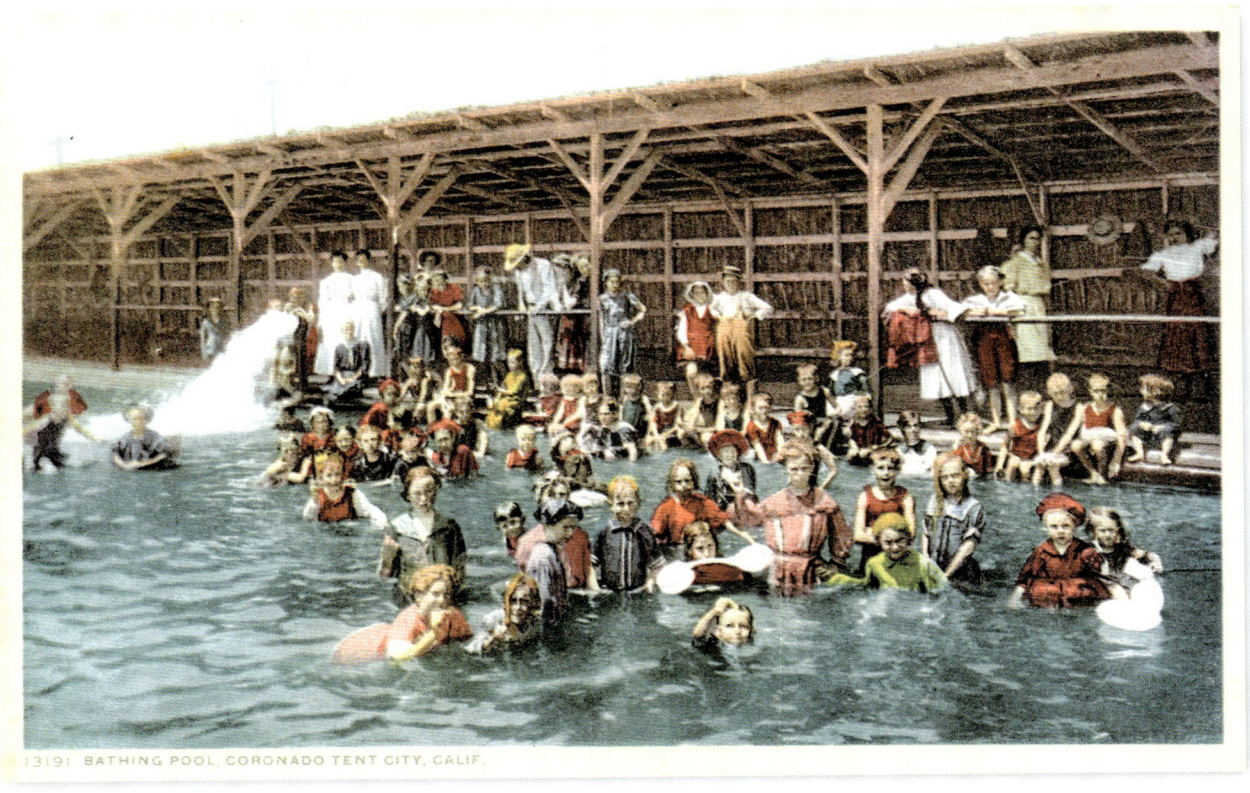

CALIFORNIA | SAN DIEGO

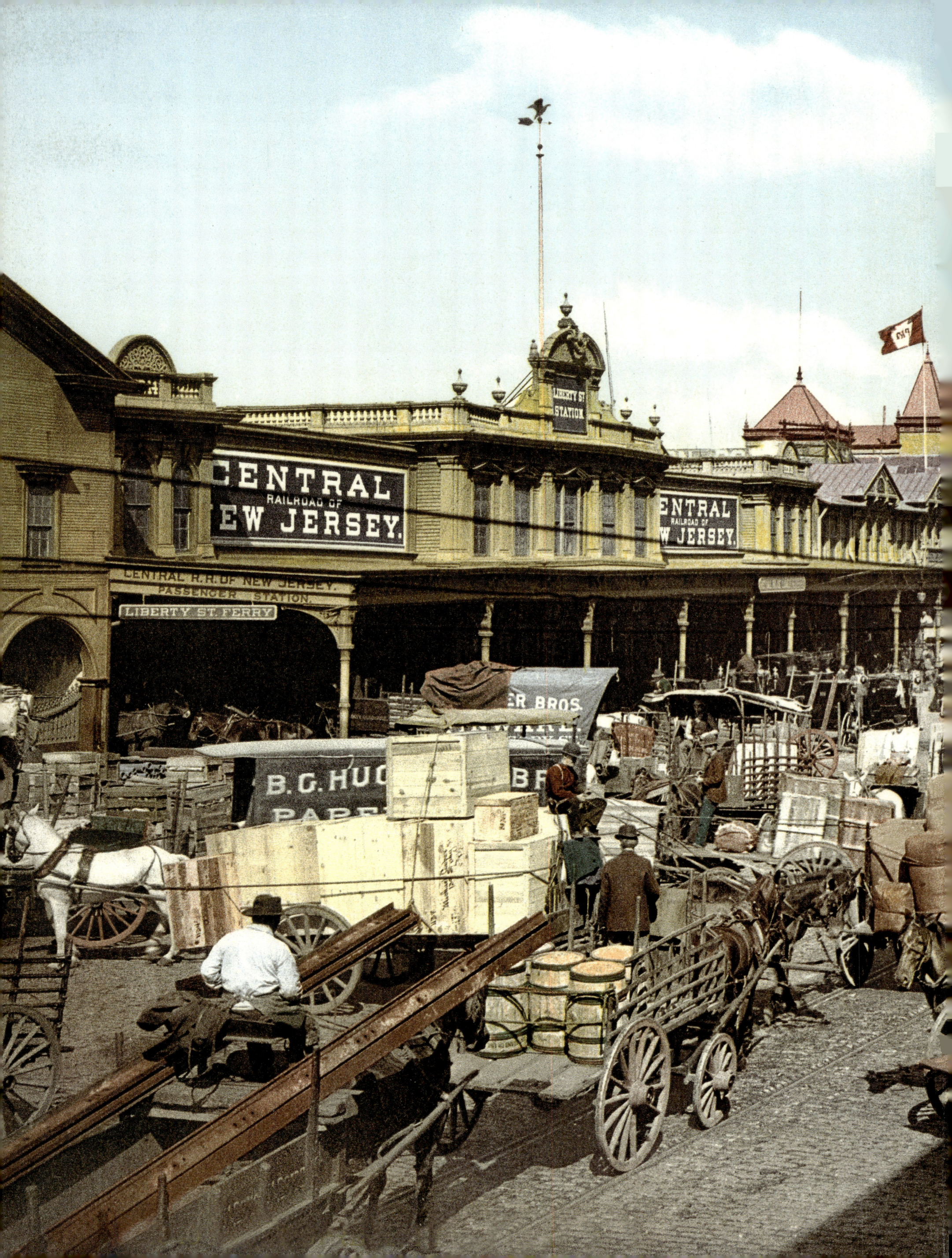

APPENDIX

Index

A

Abilene, Kansas 402
Absecon Island, New Jersey 183
Acadia, Nova Scotia (Canada) 89, 91, 93
Acjachemen (tribe) 601
Acoma, New Mexico 410–412
Acoma Pueblo, New Mexico 411
Acquadocton, New Hampshire 139
Adamana, Arizona 416
Adams, John 165, 186
Adams, Samuel 165
Adirondack Mountains 92–93, 106–109
Agate Bridge, Petrified Forest 416
Alabama 279, 281, 283, 302–305, 368, 496
Alaska 393, 395, 397
Alberta (Canada) 492–495
Albuquerque, New Mexico 408–409
 Indian Building 408–409
 Santa Fe Station 409
Algonquin (tribe) 89, 91, 93
Alligator Joe 321
Altadena, California 589
The Alton Limited (train) 250–251
Alton, Illinois 250
American Horse (Ogallala chief) 509
American Photochrom Archive, Minnesota 12, 20, 28
American Steel & Wire Co. 227
Ampère, Jean-Jacques 166
Anderson, George 565
Anderson, Gilbert M. (Broncho Billy) 393, 395, 397
Animas Canyon, Colorado 24–25, 441
Annisquam Light, Massachusetts 150–152
Apache (tribe) 417, 502–505
Apostle Islands, Wisconsin 261
Appalachian Mountains 89, 91, 93, 393, 395, 397
Appomattox, Virginia 279, 283
Aquidneck Island, Rhode Island 175
Arch Rock, Lake Superior 243
Ariss, John 384
Arizona 393, 395, 397, 414–433, 496, 503–504, 512, 521, 523, 525
Arkansas 279, 281, 283, 306–307, 368
Arrowhead Springs, California 498, 594–595
Arrowmaker (Ojibwa brave) 499
Arroyo Seco River 591
Ashley River 362
Aspen, Colorado 468
Assiniboine (tribe) 491, 500, 503
Astor family 33, 35, 37, 79
Atlantic City, New Jersey 86–87, 89, 91, 93, 178–183
 Steel Pier 180
 Young's Million Dollar Pier 181, 183
Augusta (ship) 211, 213, 215
Ausable Chasm, New York 104–105
Ausable River, New York 105
Avalon, California 578–579, 581

B

Bahamas 11, 19, 27, 336–341
Bald Head Cliff, Maine 88–89
Baltimore, Maryland 9, 17, 25, 89, 91, 93, 192–194
 Fell's Point 194
 Lexington Market 194
Banff, Alberta (Canada) 494–495
Banff National Park 495
Bannack, Montana 491
Banning family 581
Barber Park, Vermont 148
Bartholdi, Frédéric Auguste 38
Bass, Samuel 393, 395, 397
Beaver, Ralph 206
Beaver Valley, British Columbia (Canada) 529
Bellows Falls, Vermont 148–149

Bell, William 9, 17, 25
Belmont family 33, 35, 37
Beman, Solon S. 260
Berkeley, California 546–550
Bethlehem, New Hampshire 144
Beverly Hills, California 5, 525
Bidwell, John 521, 523, 525
Big Cottonwood Canyon 475
Billy the Kid 393, 395, 397
Biloxi, Mississippi 299
Black Hills 270–271, 454
Bluff Point, New York 105
Bo-Ni-To (Apache tribe) 504
Bonney, William (Billy the Kid) 393, 395, 397
Boston and Maine Railroad 156
Boston, Massachusetts 9, 11, 17, 19, 25, 27, 89, 91, 93, 158–165
 Adams Square 160–161
 Beacon Street Mall 165
 Boston Common 160
 Bromfield Street 162
 Charlestown Navy Yard 158–159
 Faneuil Hall 165
 Milk Street 162
 North Station 162
 Old South Church 89, 162–163
 Old State House 164–165
 Quincy Market 160–161
 Tremont Street 160
 West Boston Bridge 162
Boulder Rock 97
Boulouch, Nathalie 12, 20, 28
Bourne, Judge Edward E. and Lizzie 141
Bozeman, Montana 12, 20, 28
Brattleboro, Vermont 149
Bretton Woods, New Hampshire 141
Bright Angel Canyon 424
Bright Angel Trail, Grand Canyon 5, 426, 431–433
British Columbia (Canada) 521, 523, 525–531
Broncho Billy 393, 395, 397
Brown, John 388
Buckskin Charlie (Ute sub chief) 508–509
Buffalo Bill 180, 393, 395, 397
Buffalo Calf (Jicarilla Apache tribe) 504
Buffalo, New York 89, 91, 93, 110–111, 119
Washburn-Crosby Co. flour mills 110–111
Bull's Head (Gros Ventre tribe) 500
Burlington, Vermont 147
Burnham, Daniel 71
Butte, Montana 454

C

SS *Cabrillo* (ship) 578–579, 581
California 10–11, 19, 26–27, 454, 496, 521, 523, 525, 540–605
California Limited (train) 11, 19, 27
California Trail 521, 523, 525
Calumet and Hecla Mining Co. 244
Cambridge, Massachusetts 263
Camden-Atlantic City Railroad 183
Camino Real 521, 523, 525
Canada 89, 91, 93, 103, 120–129, 492–496, 521, 523, 525–531
Canadian Government Colonization Co. 528
Canadian Pacific Railway Co. (CPR) 122, 495, 521, 523, 525, 529
Canon City, Colorado 448
Cape Ann, Massachusetts 152
Cape Cod, Massachusetts 89, 91, 93
Cape Horn, Columbia River 538–539
Cape Neddick, Maine 134
Caribbean 9, 17, 25, 27, 276–277, 279, 281, 283
Carmel Bay, California 560–561
Carnegie family 79
Carolina Coast 66

Cartier, Jacques 126
Carver, Al 180
Carver, William Frank (Doc) 180
Casey, Edward Pearce 191
Castle Gate, Utah 475
Castle Geyser 487
Catskill Mountains 97
Cattle Trail 402
Cavelier, René-Robert, Sieur de La Salle 211, 213, 215
Cayuga Creek 211, 213, 215
Champlain, Samuel de 89, 91, 93
Charleston, South Carolina 276–277, 279, 281, 283, 360–365
 East Battery Parade 364
 Fort Sumter 279, 281, 283
 Magnolia-on-the-Ashley 276–277, 279, 360–363
 St. Michael's Church 364–365
Charles Town, Bahamas 337
Chas. H. Organ (ship) 372
Chattanooga, Tennessee 375
Cherokee (tribe) 375, 496
Cherrelyn (horse car) 464–465
Chesapeake and Ohio Railway (C&O) 380
Chesapeake Bay 381
Cheyenne Canyon, Colorado 448
Chicago & Alton Railroad (C&A) 250
Chicago, Illinois 9–10, 17, 19, 25–26, 211, 213–215, 246–257, 393, 395, 397, 402
 Adams Street 248
 Adams/Wabash station 248
 Dearborn Street 253
 Halstead Street 256
 Illinois Central Station 249
 Illinois Trust and Savings Bank 253
 Jackknife Bridge 256–257
 Lake Shore Drive 248
 LaSalle Street 215
 Lincoln Park 248
 Madison Street 254
 Marshall Field's 254
 Masonic Temple 252–253
 Michigan Avenue 248
 Randolph Street 214–215
 Rush Street Bridge 256–257
 Savings Bank 253
 State Street 254–255
 Wabash Avenue 246–248
Chicago & Mississippi (C&M) 250
Chicago & North Western Railway Co. 249
Chicago River 256
Chickamauga Battlefield 370–372
Chickamauga Creek 375
Chickasaw (tribe) 373, 496
Chinook (tribe) 537
Choctaw (tribe) 496
Chumash (tribe) 570
Cincinnati, Ohio 26, 211, 213, 215, 220–221, 402
 Union Central Life Insurance Building 215
 Vine Street 215
Clark, George Rogers 217
Clark, William 538
Clear Creek Canyon, Rocky Mountains 390–393
Clearwater (ship) 106
Cleveland, Ohio 9, 17, 25, 211–213, 215, 218–220, 222–229
 Arcade Building 222–225
 Lake View Park 218–220
 Locomotive Engineers building 222
 Soldiers and Sailors Monument 212–213
 Superior Street Viaduct 227
 Wheeling Bridge 213
Clinton, DeWitt 111
Cody, William F. (Buffalo Bill) 393, 395, 397
Colorado 9–11, 13, 19, 25, 27, 393, 397, 434, 438–471, 496, 509, 512, 521, 523, 525
Colorado Midland Railway 468

Colorado River 431
Colorado Springs, Colorado 451, 458–463, 468
 Austin Bluffs 451
 Cathedral Park 460
 Garden of the Gods 451, 460–463
 John Hay Cabin 458–459
 Manitou Springs 451
 Pike's Peak Avenue 458–459
Columbia River 521, 523, 525, 537–539
Columbus, Christopher 337
Colvin, Verplanck 106
Coney Island, New York 84–85
 Brighton Beach 84
 Dreamland 84
 Luna Park 84–85
 Manhattan Beach 84
 Rockaway Beach 84
 Steeplechase Park 84
 West Brighton Beach 84
Connecticut 176–177
Connecticut River 177
USS *Constellation* (ship) 194
Constitution (ship) 226–227
Coronado Beach and Tent City, California 604–605
Coronado, Francisco Vásquez de 521, 523, 525
Corwin, Jonathan 156
Cotteau, Edmond 521, 523, 525, 529
Cotton Belt 368
Crackers (Anglo-American pioneers) 333
Crawford Notch 93, 145
Creek (tribe) 323, 496
Cree (tribe) 503
Cripple Creek, Colorado 456–457
Crockett, Davy 393, 395, 397
Crow (tribe) 504
Crush, Texas 275
Crush, William George 275
Cuba 9, 11, 17, 19, 25, 27, 283, 342–353
Cuyahoga River 222

D

Dahomey, Mississippi 367
Dakin, James H. 373
Dakota 402
Dakota (tribe) 263, 265
Daytona Beach, Florida 329
Deadwood, South Dakota 454
Dearborn, Michigan 12, 20, 28
 Edison Institute 12, 20, 28
 Henry Ford Museum and Greenfield Village 12, 20, 28
Death Valley, California 521
Delaware 206
Delaware & Hudson 106
Delaware River 206
Delaware Water Gap 26, 204–206
Demme, Rudolph 10, 18, 26
Denver, Colorado 10, 11, 19, 27, 249, 438, 464–465
 Capitol 464
 City Park 464–465
Denver & Rio Grande Western Railroad 438, 448
Des Moines River 272–273, 275
Detroit, Michigan 9, 17, 19, 25–28, 211, 213, 215, 230–235
 Alexandrine Avenue 18
 Belle Isle 230–232
 Campus Martius 232
 Detroit News Building 232
 Dime Savings Bank 232
 Fort Pontchartrain 234
 Griswold Street 234–235
 Huron Street 234
 Linden Avenue 10, 18, 26
 Photochrom Company building 18–19
 Vermont Avenue 10, 18, 26
 Washington Boulevard 233
 Waterworks Park 233
 Woodward Avenue 10, 18, 26, 234–235
Detroit Photochrom Co. 10–11, 18–19, 26–27
Detroit Photographic Co. 3, 7, 9–21, 23–28, 279, 281, 283

Detroit Publishing Co. 9, 11, 17–20, 27–28
Detroit River 211, 213, 215, 229, 234–237
Drayton, Thomas and Ann 362
Duluth, Minnesota 211, 266, 267
Dupré, Céline 211, 213, 215
Duwamish (tribe) 533

E

Eagle River Canyon 470
Eames, Emma 33, 35, 37
Eau Claire, Wisconsin 261
Echo Cliffs, Grand River Canyon 434–435, 437
Echo Mountain 589
Edbrooke, Frank 464
Edison, Thomas 119
SS *Edmund Fitzgerald* (ship) 211, 213, 215
Eiffel, Gustave 38
Elle of Ganado 409
El Paso, Texas 400–401
 El Paso Street 400
 Lower International Bridge 401
 Mexican church 401
 Pioneer Plaza 401
Emerald Lake 529
Erie Canal 111, 211, 213, 215
Eureka, Colorado 441

F

Fairfax County, Virginia 384
Fennemore, J. J. 9, 17, 25
First Lake 108
Flagler, Henry 316, 329, 333
Florida 11, 19, 27, 278–279, 281, 283, 308–336, 348–349, 368, 496
Flume Gorge 142–144
Fohlen, Claude 496, 512
Forest City, Maine 131
Forrest Park, Memphis 373
Fort Apache, Arizona 503
Fort Belknap, Montana 490–491
Fort Carillon 103
Fortress San Carlos de la Cabaña, Havana 348–349
Fort Ticonderoga 103
Fort William Henry 103
Fort Yellowstone 395
Frank J. Hecker (ship) 234–235
Frémont, John C. 568
Frick family 79
Fulton Chain, Adirondacks 106
Furnace Creek Wash, California 521

G

Gallier, James Jr. 295
Galveston, Texas 400
Gaona, Ignacio 418
Gardiner, Montana 491
Garfield, James A. 504
Garfield, Utah 474–475
George I, King of Great Britain 177
Georgetown Loop Railroad 390–393
Georgia 279, 281, 283, 323, 354–359, 366, 496
Gettysburg, Pennsylvania 10, 18, 26
Gila Trail 521, 523, 525
Gilbert, Bradford 249
Gilliland, William 105
Glacier Point 564–565
Glen Afton Spring, Maryland 195
Glenwood Hot Springs, Colorado 470–471
Gloucester, Massachusetts 152
Glover, Lycurgus Solon 11, 19, 27
Golden Gate, Yellowstone National Park 483
Gosnold, Bartholomew 171
Gould family 33, 35, 37, 79
Grand Canyon 9, 11, 17, 19, 25, 27, 414–416, 424–427, 434
Grand Canyon National Park 393, 395, 397
Grand River Canyon 434–435, 437–438, 474–475
Grand Trunk Railway 89, 91, 93

Grandview Point, Grand Canyon 426
Grandview Trail, Grand Canyon 426
Grant, Ulysses S. 279, 281, 283
Grasshopper Creek 491
Great Lakes 9, 17, 25, 208, 211, 213, 215, 234, 241, 243, 266, 496
Great Plains 9, 17, 25, 265, 393, 395, 397, 402
Great Salt Lake 11, 27, 474–475, 480–481
Garfield Bathing Pavilion 480
Saltair Beach and Pavilion 480
Green Bay, Lake Michigan 211, 213, 215
Green Island 102–103
Green Mountains 147
Gros Ventre (tribe) 491, 500
Grotto Geyser 487
Gwynedd, Pennsylvania 206

H

Hagerman Pass, Rocky Mountains 466–468
Halifax River 329
Hance Trail, Grand Canyon 431
Hancock, John 165
Harlem River 83
Harper's Ferry, West Virginia 386–388
Hartford, Connecticut 176–177
 Memorial Arch 176–177
Harvard, John 166–167
Harvard University, Cambridge, Massachusetts 166–167
Harvey, Fred 9, 11, 20, 27, 408, 425
Hathaway, J. F. 329
Havana, Cuba 282–283, 342–353
 Cathedral of the Virgin Mary of the Immaculate Conception 342–343, 344, 348
 Muelle del Gobierno 348–349
 Muelle San Francisco 282–283
 Paseo del Prado 344, 350
 Tacón Theater 344, 346–347, 350
 Tempietto 348–349
Hawaii 393, 395, 397
Hayden, Ferdinand V. 10, 13, 19, 26, 468
Haynes, Frank Jay 12, 20, 28
Hennepin, Louis 211, 213, 215
Hermit's Rest, Grand Canyon 425
SS *Hermosa* (ship) 581
Hertz, Alfred 33, 35, 37
Hiawatha (Indian leader) 263, 496–497
Hillers, John K. 9, 17, 25
Holyoke, Massachusetts 168
Holyoke Street Railway Co. 168
Homestake Mine, South Dakota 268–271, 454
Hopi 410–423, 512–516
Horseshoe Falls, Niagara Falls 115–117
Hotels
 Alberta and Velvet Hotels, Old Orchard 133
 Alcazar Hotel, St. Augustine 332–333
 Alvarado Hotel, Albuquerque 408–409
 Antlers Hotel, Colorado Springs 458–459
 Arlington Hotel, Santa Barbara 570–571
 Baldwin Hotel, San Francisco 556
 Banff Springs Hotel, Banff National Park 494–495
 Belmont Hotel, New York City 33, 35, 37
 Belmont Hotel, Old Orchard 133
 Beverly Hills Hotel, Beverly Hills 5, 525
 Blackstone Hotel, Chicago 4, 215
 Blue Mountain House, Pen Mar 195

Hotels (continued)
 Book-Cadillac Hotel, Detroit 232
 Breakers Hotel, Palm Beach 316
 Brown Palace Hotel, Denver 464
 Buena Vista Spring, Pen Mar 195
 Hotel Champlain, Bluff Point 105
 Château Frontenac Hotel, Quebec 120–122
 Chateau Lake Louise Hotel, Alberta 494–495
 Hotel Colorado, Glenwood Hot Springs 470–471
 Commodore Hotel, New York City 33, 35, 37
 Hotel del Coronado, Coronado Beach 605
 El Porvenir Hotel, New Mexico 397
 El Tovar Hotel, Grand Canyon 425
 Hotel Essex, Boston 165
 Evans Hotel, Hot Springs, South Dakota 270–271
 Fairmont Hotel, San Francisco 556
 Fort William Henry Hotel, Lake George 103
 Fred Harvey hotel chain 9
 Hotel Gayoso, Memphis 373
 Hotel Glenwood Mission Inn, Riverside 592–593
 Gotham Hotel, New York City 78
 Grand Hotel, San Francisco 556
 Hotel Green, Pasadena 590–591
 Hollenden Hotel, Cleveland 222
 The Homestead, Hot Springs 385
 Hotel Kaaterskill, Catskill Mountains 97
 Kittatinny Hotel, Delaware Water Gap 206
 Mammoth Hot Springs Hotel, Yellowstone National Park 484–485
 Marlborough-Blenheim Hotel, Atlantic City 183
 Hotel Metropole, Avalon 579
 Mohonk House, Lake Mohonk 91
 Montross Hotel, Biloxi 299–301
 Mount Stephen Hotel, Mount Stephen 529
 Mount Washington Hotel, Bretton Woods 141
 Murphy's Hotel, Richmond 379
 New Greenbrier Hotel, White Sulphur Springs 388–389
 New Mackinac Hotel, Mackinac Island 239
 New Murray Hotel, Mackinac Island 239
 Old Orchard Hotel, Maine 133
 Hotel Ormond, Ormond 328–329
 Palace Hotel, San Francisco 556
 Palm Beach Inn, Palm Beach 316
 Palmer House Hotel, Chicago 254
 Parker House Hotel, Boston 89
 Plaza Hotel, New York City 33, 35, 37, 79
 Point Hotel, Chattanooga 375
 Ponce de León Hotel, St. Augustine 332–333
 Hotel Potter, Santa Barbara 570–571
 Ritz-Carlton Hotel, Montreal 126
 Royal Palm Hotel, Miami 315
 Royal Poinciana Hotel, Palm Beach 316–317
 Santa Fe Railroad's hotels 9
 Sea Beach Hotel, Santa Cruz 560

Hotels (continued)
 Seashore Hotel, Old Orchard 133
 Sentinel Hotel, Yosemite Valley 565
 St. Louis Hotel, New Orleans 292
 Hotel St. Marc, Venice 572–573
 St. Regis Hotel, New York City 78–79
 Sylvan Lake Hotel 270–271
 Tampa Bay Hotel, Tampa 310–311
 Tampa Inn, Tampa 311
 United States Hotel, Boston 160–161
 Vanderbilt Hotel, New York City 35
 Victory Hotel, Put-in-Bay 229
 Waldorf Astoria Hotel, New York City 33, 35, 37, 77, 79
 Waumbek Hotel, Mount Washington Valley 145
 Wentworth Hotel, New Castle 138
 Westin Book Cadillac Hotel, Detroit 233
 Hot Springs, Arkansas 307
 Hot Springs, South Dakota 270–271
 Mammoth Site 270–271
 Hot Springs, Virginia 385
 Houghton, Michigan 243
 Houston, Texas 275
 Hudson River 66, 83, 89, 91, 93–96, 111, 211, 213, 215
 Hudson Valley 89, 91, 93–96
 Hughes, Jim 12, 20, 28
 Hughes, John 77
 Humboldt River 521, 523, 525
 Hunt, Richard Morris 79
 Huret, Jules 9, 17, 25, 33, 35, 37
 Huron (tribe) 89, 91, 93
 Husher, Edwin H. 10, 11, 18, 19, 26, 27
 Hutchison (ship) 240

I
 Idaho 454, 488–489, 491
 Ignacio (Ute chief) 509
 Illecillewaet Glacier 528–531
 Illinois 215, 246–257
 Indian Leap 144
 Inspiration Point 482–483
 Invincible (ship) 211, 213, 215
 Iowa 272–273, 275
 Iroquois (tribe) 89, 91, 93, 499–501
 Irving, Washington 97
 Isles of Shoals, New Hampshire 138
 Isleta Pueblo, New Mexico 413, 512

J
 Jackson Brothers, Photographers 9, 10, 19, 26
 Jackson, Helen Hunt 496
 Jacksonville, Florida 334–335
 Jackson, William Henry 9–13, 17–20, 25–28, 108, 127, 400, 441, 454, 468, 484
 Jacob's Ladder, Grand Canyon 431
 Jacob's Ladder, Mount Washington 136–138
 James Lee (ship) 286
 James River 376–379
 Jamestown, Virginia 379
 Jefferson, Joseph 5, 316
 Jefferson, Thomas 191
 Jesus, Jose (Pueblo tribe) 516–517
 Jezierski, John V. 10, 11, 18, 20, 26–27
 Jicarilla Apache (tribe) 504
 Johns Hopkins University, Baltimore 194
 Joliet, Illinois 250
 J. P. Morgan & Co. 55
 Juneau, Solomon 260
 Jungle Trail, Florida 318
 Jupiter Terrace 484

K
 Kahn, Albert 233
 Kansas City, Missouri 211, 213, 215, 250, 274–275, 402
 Delaware Street 275
 Main Street 275
 Stock Exchange Building 275
 Stockyards 274–275
 Kansas City Railway 393, 395, 397
 Kansas River 275
 Kennebunk, Maine 141
 Kentucky 216–217, 221, 368
 Key West, Florida 308–309, 311–313
 Kingston, Pennsylvania 202–203
 Kinney, Abbot 572
 Kino, Eusebio Francisco 418
 Kittery, Maine 89, 91, 93, 135
 Portsmouth Navy Yard 135
 Ku Klux Klan 9, 17, 25

L
 Lachine Rapids, St. Lawrence River 126–129
 Lackawanna & Western Railroad Co. 17, 25
 Lady Elgin (ship) 211, 213, 215
 Laguna Pueblo, New Mexico 413
 La Jolla, California 450
 Lake Champlain 89, 91, 93, 105
 Lake Chautauqua 111–113
 Lake Erie 89, 91, 93, 111, 211, 213, 215, 222, 229, 234
 Lake George 89–91, 93, 102–103
 Lake Gogebic 243
 Lake Huron 211, 213, 215, 234, 239, 241
 Lake Linden 244
 Lake Louise 494–495
 Lake Michigan 211, 213, 215, 239, 248–249
 Lake Minnewanka 93, 494–495
 Lake Mohonk 91
 Lake Ontario 211
 Lake San Cristobal 441–443
 Lake St. Clair 211, 213, 215, 234
 Lake Superior 211, 213, 215, 241–243, 261, 266
 Lake Winnipesaukee 89, 91, 93, 139
 Lake Worth 316–317
 Lame Chicken (Assiniboine tribe) 503
 Lamothe-Cadillac, Antoine de 233–234
 Las Vegas, New Mexico 397
 Leadville, Colorado 448
 Lee, Robert E. 279, 281, 283, 388
 Le Griffon (ship) 211, 213, 215
 Le Moyne, Jean-Baptiste, Sieur de Bienville 287, 298
 Le Moyne, Pierre, Sieur d'Iberville 298
 Lewis and Clark Expedition 521
 Lewis, Meriwether 538
 Lick, James 579
 Lincoln, Abraham 279, 281, 283
 Little Cottonwood Canyon 474–475, 480
 Little Rock, Arkansas 307
 Livingstone family 10, 11, 18–19, 26–27
 Livingstone, Robert B. 18
 Livingstone, William A. 11, 18–19, 27
 Lizzie Bourne monument, Mount Washington 140
 Long Beach, California 576–577
 Longfellow, Henry Wadsworth 131, 263
 Lookout Mountain 374–375
 Los Angeles, California 11, 17, 19, 27, 523, 577, 582–587
 Broadway 582–583
 East Lake Park 583
 West Lake Park 583
 Lost Lake 536
 Louisiana 211, 213, 215, 279, 281, 283–295, 368
 Louisville, Kentucky 216–217
 White City Park 217
 Lower Falls 16–17

Lowe, Thaddeus 589
Lucayan Islands 337
Lucayan (tribe) 337
Lumière brothers 9, 17, 25

M
 Mackinac Island, Michigan 211, 213, 215, 238–239
 Arch Rock 238–239
 Mackinac Straits 239
 Magnolia, Massachusetts 152
 Magnolia-on-the-Ashley 276–277, 279, 360–363
 Mahler, Gustav 33, 35, 37
 Maid of the Mist (ship) 115
 Maine 66, 89, 91, 93, 103, 130–135, 138
 Mallet locomotive 408
 Mandat-Grancey, Baron Edmond de 454
 Manitou & Pike's Peak Cog Railway 451
 Marquette, Michigan 242–243
 Mardi Gras Point 287
 Mariposa Grove, California 568–569
 Maryland 192–195
 Massachusetts 89, 91, 93, 103, 150–171, 263
 Massachusetts Bay 171
 McAlpin, Henry 358
 McClellan, George 74
 McLeod, Norman 307
 Memphis, Tennessee 369, 372–373
 Menéndez de Avilés, Pedro 333
 Merced Grove, California 568
 Merrimac, Wisconsin 261
 Mesabi Range, Minnesota 266
 Mesa Encantada, New Mexico 410–413
 Mesa Verde National Park, Colorado 436–437, 512
 Balcony House 437
 Cliff Palace 436–437
 Mexico 9, 17, 25, 348–349, 521, 523, 525
 Miami, Florida 314–315
 Biscayne Bay 314–315
 Miami River 314–315, 323
 Michigan 11–12, 18–20, 25–28, 213, 230–245, 579
 Michigan Central (ship) 234, 236–237
 Michilimakinac 211, 213, 215
 Millard Canyon 589
 Miller, Frank Augustus 593
 Miller, Henry 9, 17, 25
 Milwaukee, Wisconsin 211, 213, 215, 258–260
 Leif Ericson statue 260
 Pabst Building 260
 Sycamore Street 260
 Minerva Terrace 484
 Minneapolis, Minnesota 211, 213, 215, 264–265
 Minnehaha Falls, Minneapolis 263
 Minnehaha Park, Minneapolis 263
 Minnesota 12, 20, 28, 211, 262–267
 Minnesota Point, Duluth 266
 Mirror Lake 565–567
 Missionary Ridge, Chattanooga 375
 Mission San Juan Capistrano 598–599, 601
 Mission San Luis Rey 600–601
 Mississippi 279, 281, 296–301, 367–368, 496
 Mississippi River 9, 12, 17, 20, 25–28, 211, 213, 215, 250, 264–265, 283, 286, 296–298, 373, 393, 395, 397, 496, 521, 523, 525
 Missouri 10, 12, 19–20, 26, 28, 211, 213, 215, 250, 274–275, 368, 402
 Missouri, Kansas & Texas Railway 275
 Missouri River 10, 211, 213, 215, 275, 521, 523, 525

Mobile, Alabama 287, 302–305
Mohawk (tribe) 33, 35, 37, 101
Moki (tribe) 420–423, 512–516
Montana 12, 20, 28, 402, 454, 490–491, 496, 500
Monterey, California 560–561, 584
Montreal, Quebec (Canada) 89, 91, 93, 126–127, 211, 213, 215, 521, 523, 525
 Château Ramezay 126–127
 Jacques Cartier Square 126
 Mount Royal 126
 Notre-Dame 127
 Sherbrooke Street 126
Moore, Annie 39
Mormon Trail 521, 523, 525
Morning Glory 487
Mound City, Memphis 372
Mount Adams 221
Mount Assiniboine 492–495
Mount Beacon 96
Mount Dawson 528
Mount Fox 528
Mount Hood 534–537
Mount Holy Cross 13, 468–469
Mount Lowe 588–589
Mount Lowe Railway 588–589
Mount Pleasant 144
Mount Rubidoux 593
Mount Sneffels 440–441
Mount Stephen 529
Mount St. Helens 537
Mount Tamalpais 544
Mount Tom 168–169
Mount Tom Railway 168
Mount Vernon 384
Mount Washington 136–141, 144–145
Mount Washington Railway 136–138, 140
Mount Waumbek 144
Mount Wilson 589, 591
Mowry, Frank 10, 18, 26
Mt. Washington (ship) 139
Muir, John 565

N
 Nantasket, Massachusetts 89, 91, 93
 Nantucket, Massachusetts 4, 89, 91, 93, 170–171
 Starbuck House 170
 Narragansett, Rhode Island 175
 Nassau, Bahamas 337–341
 Grant's Town 339
 Queen's Staircase 340–341
 Navajo Rio, Arizona 503
 Navajo (tribe) 417–418, 420, 496, 512, 515
 Nebraska 9, 10, 13, 19, 26
 Needle Mountains 441
 Nelson, Horatio 126
 Nevada 521, 523, 525
 Nevada Fall, Yosemite National Park 565
 New Castle, New Hampshire 138
 New England 133, 139, 147, 149, 152
 New Hampshire 103, 136–145
 New Haven, Connecticut 177
 New Jersey 66, 86–87, 89, 178–183, 206
 New Mexico 393, 395, 397, 400, 402, 406–413, 496, 512
 New Orleans, Louisiana 89, 91, 93, 217, 280–281, 284–295, 369
 Bourbon Street 295
 Camp Street 287
 Canal Street 287–289, 295
 Chartres Street 292
 Cotton Exchange 368–369
 French Market 290–291
 French Opera House 294–295
 French Quarter (Vieux Carré) 292, 295
 Italian Quarter 292
 Madison Street 292
 Old French courtyard 292
 Royal Street 291–293, 295
 St. Louis Cathedral 291, 295
 Newport News, Virginia 376–378, 380

Newport, Rhode Island 89, 91, 93, 172–175
 Ochre Point 175
New Providence, Bahamas 337
USS *New York* (ship) 381
New York City 9–11, 17, 19, 25, 27, 30–85, 89, 91, 93, 111, 211, 393, 395, 397, 605–607
 23rd Street 71–72
 42nd Street 78
 51st Street 78
 65th Street 79
 135th Street 74
 181st Street 83
 Bankers Trust Building 35
 Bank of Manhattan Trust Building 55
 Battery Park 33, 39
 Baxter Street 61
 Beach Pneumatic Transit 74
 Bowery 61, 64–65
 Bowling Green 72
 Broadway 33, 35, 37, 46, 48–49, 66–74
 Bronx 83
 Brooklyn 44, 66, 82
 Brooklyn Bridge 33, 40–41, 44–45, 84
 Canal Street 61
 Central Park 66–67, 72, 80–81
 Chinatown 57, 61
 Chrysler Building 55
 City Hall 55, 74
 City Hall Station 74–75
 City Investing Building 50, 55
 Columbia University 82–83
 Cortlandt Street 33
 Dewey Arch 72–73
 Dey Street 46
 East River 33
 East Side (Manhattan) 60–61
 Elizabeth Street 61
 Ellis Island 38–39
 Empire State Building 55
 Equitable Building 35
 Equitable Life Building 55
 Fifth Avenue 9, 33, 35, 37, 66–67, 71, 76–80
 Flatiron Building 68–69, 71
 Flatiron District 33, 68
 Fulton Street 46
 Gillender Building 33
 Grand Central Station 72–73
 Grant's Tomb 83
 Harbor 38–45
 Harlem 33, 35, 37
 Herald Square 71
 Hippodrome 71
 Hudson Terminal 50, 55
 Knickerbocker Trust Building 77
 Little Italy 60–61
 Lower East Side 33, 35, 37
 Madison Avenue 77
 Madison Square 66–67, 70–73
 Madison Square Garden 70–71
 Manhattan 33, 35, 37, 57, 72, 74, 83
 Manhattan Bridge 44–45
 Metropolitan Insurance Building, 4, 37
 Metropolitan Life Tower 55
 Metropolitan Museum of Art 79
 Metropolitan Opera 33, 35, 37, 79
 Millionaire's Row 79
 Morningside Heights 82–83
 Mott Street 56–57, 61
 Mulberry Street 33, 35, 37, 57–61
 Newspaper Row 55
 Park Avenue 33, 35, 37
 Park Row Building 34–35, 55
 Pennsylvania Station 72, 74
 Prospect Park 82
 Riverside Drive 83
 Riverside Park 83
 Sherman Statue 79
 Singer Building 33, 50, 55
 South Street 40–41, 44
 Statue of Liberty 2, 9, 38
 St. Patrick's Cathedral 77
 St. Paul Building 36–37

New York City (continued)
Subway 74–75
Surf Avenue 84
Theatre District 72
Times Building 37
Times Square 72
Trinity Church 46–47
Upper West Side 83
Wall Street 33, 35, 37, 46, 51–55
Washington Bridge 82
Washington Building 72
Washington Heights 83
West Street 44–45, 605–607
Woolworth Building 55
New York (state) 89, 91, 93–119, 194, 206
Nez Perce (tribe) 496, 538
Niagara Falls 11, 19–21, 27, 89, 91, 93, 114–119
Niagara Power Station 119
Prospect Park 115
Niagara River 89, 91, 93, 115, 211, 213, 215
Norfolk, Virginia 380–381
North Carolina 279, 281, 283, 496
Nova Scotia (Canada) 89, 91, 93
Nubble Island, Maine 134–135

O
Ocala, Florida 322–327
Ocala National Forest, Florida 322–327
Ocean Park, California 572
Ocean Springs, Mississippi 298
Fort Maurepas 298
Old Fort Bayou 298
Ocklawaha River 322–327
Ogallala (tribe) 509
Ohio 26, 213, 217–229
Ohio River 211, 213, 215, 221
Ojibwa (tribe) 241, 261, 496–501
Okeehumkee (ship) 324
Oklahoma 393, 395, 397, 496
Old Faithful Geyser 394–395, 486–487
Old Forge House 108
Old Orchard, Maine 89, 91, 93, 132–133
Old Point Comfort, Virginia 381–383
Fortress Monroe 381–383
Hampton Roads 381
Olmsted, Frederick Law 80, 83
Omaha, Nebraska 9, 10, 13, 19, 26
Omaha (tribe) 10, 19, 26
O'Neill's Point, Grand Canyon 416, 424
Oregon 496, 534–539
Oregon Trail 521, 523, 525
Orell Füssli 9, 18, 21, 25–26
Ormond, Florida 326–329
Osage (tribe) 10, 19, 26
O'Sullivan, Timothy 9, 17, 25
Otis Elevating Railway 97
Otis, James 165
Otoe (tribe) 10, 19, 26
Ottawa River 126
Ouray, Colorado 445–447
Box Cayon 445
Outaouac (tribe) 211, 213, 215
Ozark Mountains 307

P
Pabst Brewery, Milwaukee 260
Pacific Coast 518–605
Pacific Electric Railway 577
Palm Beach, Florida 5, 316–321
Palmer, Potter 254
Palmer, William 459
Panama 9, 17, 25
Papago (tribe) 422–423
Pasadena, California 589–591
Paupuk Keewis (Indian chief) 499–501
Pawnee (tribe) 10, 19, 26
Peabody, Henry Greenwood 11, 19, 27
Peak's Island, Maine 131
Pelz, Paul J. 191
Pemigewasset River 144
Pénicaut, André 298
Pen Mar, Maryland 195

Pennsylvania 10, 18, 26, 194, 196–207
Penn, William 496
Penyugal Hot Spring 595
Pergola Casino 103
Peru 348–349
Petrified Forest, Arizona 416
Philadelphia, Pennsylvania 9, 17, 25, 89, 91, 93, 196–201
Arch Street 198
Betsy Ross House 199–201
Carpenters' Hall 198
Friends meeting house 198
Independence Hall 198–199
Liberty Bell 198
South Broad Street 198
Phips, William 156
Phoenix, Arizona 417
Photochrom Co. Ltd., London 10, 18, 25–26
Photochrom Co., Zurich 9–10, 18, 25–26
Photoglob Co., Zurich 10, 12, 18, 20, 25–26, 28
Pike's Peak 450–454, 460, 464
Pine Bluff, Lake Mohonk 91
Pitney, Jonathan 183
Pittsburgh, Pennsylvania 89, 91, 93, 203
Pocono Mountains 206–207
Point Sublime, Colorado 458–459
Port Huron, Michigan 234
Portland, Maine 89, 91, 93, 131, 133
Cape Cottage 131
Portland Head Light 130–131
Portland, Oregon 249, 536–537, 584
Portsmouth, New Hampshire 138
Poughkeepsie Bridge, Hudson River 94–96
Presque Isle, Lake Superior 261
Pretty Old Man (Crow tribe) 504
Price, Bruce 122, 177
Price Canyon 472–473, 475
Princeton University, New Jersey 166
Pueblo, Colorado 448, 512
Pueblo (tribe) 408, 412, 422–423, 437, 514, 516–517
Puget Sound, Washington 533
Pulitzer, Joseph 38
Pullman, George 250
Pulpit Rock, Utah 396–397
Pulpit Terraces 484
Put-in-Bay, Ohio 228–229
Delaware Avenue 229

Q
Quebec (Canada) 87, 89, 91, 93, 120–129
Quebec City (Canada) 120–125
Champlain Street 124
Dufferin Terrace 120–122
Sous-le-Cap Street 124–125
St. Louis Gate 122–123

R
Raquette Lake 109
Rattlesnake (Assiniboine tribe) 503
Redlands, California 596
Revelstoke, British Columbia (Canada) 529
Revere, Paul 162
Rhode Island 172–175, 496
Rice Creek, Florida 324–325
Richmond, Virginia 378–379
Main Street 378
Sixth Street 378
Rieupeyrout, Jean-Louis 393, 395, 397
Riis, Jacob A. 33, 35, 37, 57, 61
Rio Grande 393, 395, 397, 400, 496
Riverside, California 540–541, 543, 592–596
Rochester, New York 110–111
Upper Genesee Falls 110–111
Rock, Irene (Assiniboine tribe) 500
Rock of Ages, Niagara Falls 114–115

Rocky Mountains 10, 13, 19, 26, 393, 395, 397, 454, 464, 468, 521, 523, 525
Rogers, Albert B. 529
Romero, Jose (Ute tribe) 509–510
Roosevelt, Theodore 33, 35, 37, 437, 470
Ross, Betsy 198–199
Ross, John 199
Royal Gorge, Colorado 8–9, 448–449
Rubin, Ernest 279, 281, 283
Ruby Castle, Utah 474–475
Rutland, Vermont 147

S
Sacandaga Park 108
Sacramento, California 454, 584
Sagamore, New York 103
Saginaw Bay, Michigan 211, 213, 215
Saint-Domingue 366
Saint Paul, Minnesota 211, 213, 215, 264–265
Union Station 265
Wabasha Street 265
Salduro, Great Salt Lake 480–481
Salem, Massachusetts 152, 154–157
Essex Institute 157
Essex Street 156
Old Witch House 156
Riley Plaza 154–156
Seven Gables 157
Saltair Pavilion, Great Salt Lake 480–481
Salt Lake City, Utah 11, 19, 27, 476–479, 521, 523, 525
Eagle's Gate 478
Lion House 478–479
Old Tithing House 478–479
Temple Square 476–478
Salt Lake Valley 480
San Antonio, Texas 275
San Diego, California 521, 523, 525, 584, 602–605
San Francisco, California 454, 520–521, 523, 525, 540–559, 584, 586
California Street Hill 556
Chestnut Street 544
Chinatown 584–585, 587
Cliff House 533, 546, 552–553
Down Market Street 557
Eddy Street 557
Fisherman's wharf 542–543
Golden Gate 543–551
Golden Gate National Recreation Area 546
Golden Gate Park 544–545, 552
Habor 542–543
Japanese Tea Garden 544–545
Kearney Street 557
Lotta Fountain 556
Magnolia Avenue 540–541, 543
Market Street 520–521, 556–559
Nob Hill 556
Sutro Baths 546, 551
Sutro Heights 552
Third Street 556
Union Square 554–556
San Gabriel Mission 591, 596
San Lorenzo River 560
Santa Barbara, California 570–571
Los Baños del Mar 570
Santa Barbara Mission 524–525, 570
Santa Catalina Island, California 578–581
Santa Cruz, California 518–519, 521, 560, 568
Big Trees Park 568
Santa Fe, New Mexico 500, 521, 523, 525
Santa Fe Railroad Co. 9, 11, 19–20, 27, 408, 425, 448
Santa Fe Trail 521, 523, 525
Santa Inez River 402
Santo Domingo, New Mexico 512

San Xavier del Bac Mission, Arizona 418
Sapphire Pool 487
Saratoga Lake 100
Saratoga, New York 100–101
Congress Spring Park 100
High Rock 101
High Rock Spring 100
Sault Ste. Marie, Michigan 211, 213, 215, 240–241
Davis Lock 240
Poe Lock 241
Savannah, Georgia 356, 358–359, 369
Bonaventure Cemetery 358
Hermitage Plantation 358–359
Savannah River 354–356
Sawatch Range, Rocky Mountains 468
Schmid, Hans Jakob 9, 18, 21, 25
Schroeder & Cie 10, 18, 26
Schuler, Albert 21
Scripps, James E. 233
Seabreeze, Florida 329
Searsburg, Vermont 148
Seattle (Duamish/Suquamish chief) 533
Seattle, Washington 279, 281, 283, 533
University of Washington 279, 281, 283
Selkirk Mountains 528–529
Seminole (tribe) 322–323, 496
Sequoia National Park, California 393, 395, 397, 568
Serra, Junípero 521, 523, 525, 601
Sevara (Ute tribe) 504, 506–507
Seven Falls, Cheyenne Canyon 448
Shatto, George 579
Shoshone River 490–491
Sierra Nevada 521, 523, 525, 565
Silver Gate 483
Silverton, Colorado 445
Simmons, Zalmon 451
Singing Bird (Gros Ventre tribe) 500
Sioux (tribe) 393
Sitting Bull (Sioux chief) 393, 395, 397
Sleepy Hollow 97–99
Smithmeyer, John L. 191
Snake River 538
Snodgrass House, Georgia 370–372
Sonoran Desert 418
South Bass Island, Ohio 229
South Carolina 279, 281, 283, 360–365, 368
South Dakota 210–211, 268–271, 454
South Mountain 97
Spearfish Canyon, Black Hills 270–271
Spreckels, John D. 605
Springfield, Illinois 250
St. Anthony Falls, Minneapolis 264–265
St. Augustine, Florida 330–333
St. Clair River 211, 213, 215
St. Hubert's Isle 109
St. Joseph, Missouri 10, 19, 26
St. Lawrence River 122, 126–129
St. Louis Bay, Mississippi 298
St. Louis, Missouri 12, 20, 28, 211, 213, 215, 250, 521, 523, 525
St. Louis River 266
St. Marys River 241
Standard Oil Co. 222, 316
Star Island, Isles of Shoals 138
Stella Cove, Lake Superior 261
Stewart, Jas. K. 26
Sultan's Mountain, Colorado 440–441
Sunset Hill, Virginia 385
Suquamish (tribe) 533
Sutro, Adolph 546, 552
Sutter's Mill, California 454

Sylvan Lake 270–271
Syracuse, New York 111

T
Tacoma (tribe) 512
Tacoma, Washington 533
Tampa, Florida 310–311
Taos, New Mexico 412
Taos Pueblo (tribe) 512
Taqui (Hopi (Moki) Snake Priest) 512–513
Temple Quarry, Utah 475
Tennessee 279, 281, 283, 368, 370–375
Tesla, Nikola 119
Texas 275, 279, 281, 283, 368, 398–405, 496
Texas Bank & Trust Co., Galveston 400
Thomas, George H. 372
Thunder Bay, Lake Superior 211, 213, 215
Tilton, Edward Lippincott 470
Tip Top House, Mount Washington 140
Tohono O'odham (tribe) 418
Toledo, Ohio 211, 213, 215, 229
Toltec Gorge, Colorado 438–439
Tommy Atkins (dog in uniform) 612
Tom of Ganado 409
Tomoka River 318, 324, 326–327, 329
Trans-Canadian (train) 521, 523, 525
Trois Tetons, Rocky Mountains 10–11
Tucson, Arizona 418
Tuolumne Grove, California 568
Turner, Frederick Jason 393, 395, 397
Twain, Mark 393, 395, 397
Twin Falls, Shoshone River 488–491
Twin Lake 475

U
Ulster & Delaware Railroad 97
Umbrella Rock, Chattanooga 375
Uncompahgre River 444–445
Union Pacific Railway 275, 491
Upjohn, Richard 46
Utah 397, 472–481, 496
Ute (tribe) 496, 504, 506–511

V
Vale Minne-ka-ta, South Dakota 210–211
Vancouver, British Columbia (Canada) 521, 523, 525
Vanderbilt, Alva 79
Vanderbilt family 33, 35, 37, 79
Van Horne Range 521
Van Horne, William Cornelius 521, 523, 525
Vaux, Calvert 80
Venice, California 572, 594–575
Abbot Kinney Pier 572
Vermilion Range, Minnesota 266
Vermont 10, 13, 18, 26, 103, 146–149
Vicksburg, Mississippi 296–298
Virginia 279, 281, 283, 368, 376–385, 496

W
Wabunosa (Ojibwa brave) 499
Wagner, Richard 33, 35, 37
Wallowa (Ojibwa brave) 496
Walter, Marc 12, 21, 28, 29
Walter, Thomas U. 188
Wampanoag (tribe) 171
Washington, D.C. 9, 11, 17, 19, 25, 27–28, 91, 184–191
Capitol 184–186, 188, 191
House of Representatives 188
Jackson Monument 188
Library of Congress 5, 12, 20, 28, 188, 190–191
Union Station 91

Washington, D.C. (continued)
Washington Monument 188–189
White House 186, 187, 188
Washington, George 101, 186, 198, 384
Washington, Lawrence 384
Washington, Martha 186, 384
Washington (state) 532–533
Washington's Tomb, Mount Vernon 384
Weber, Bruno 12, 20, 28
Weber Canyon 475
Weeks, William H. 560
Weirs, New Hampshire 139
Western Maryland Railroad Co. 195
Westinghouse Air Brake Co. 203
Westinghouse, George 119
West Virginia 386–389
Whirlpool Rapids, Niagara Falls 115, 119
White and Yellow Cow (Gros Ventre tribe) 500
Whitefish Point, Michigan 211, 213, 215
White Mountains 89, 91, 93, 140–145
White, Richard 211, 213, 215
White, Stanford 71, 79
White Sulphur Spring, Saratoga Lake 100
White Sulphur Springs, West Virginia 388–389
White Tiger 321
Whitman, Walt 44
Whitney, Eli 368
Whitney family 33, 35, 37
Whittlesey, Charles 425
Wild Brothers 10, 18, 26
Wild, Heinrich 10, 18, 26
Wild West 390–397
Willamette River 536
William III, Duke of Orange-Nassau 337
Williams, Roger 496
Wilmington, Vermont 148
Winkle, Rip Van 97
Winnipesaukee (tribe) 139
Winooski Gorge, Vermont 146–147
Wisconsin 258–261
Wisconsin River 261
Witch Rocks, Utah 475
Wolfeborough, New Hampshire 139
Wolfskill, William 596
Woodward Coal Mines, Kingston 202–203
Wyoming 13, 17, 395, 402, 482–487, 521, 523, 525

Y
Yale College, Connecticut 166, 177
Yale, Elihu 177
Yavapai Point, Grand Canyon 424
Yellowstone Lake 486–487
Yellowstone National Park 10–11, 13, 17, 19, 26–27, 392–395, 397, 482–487
Yellowstone River 17, 482–483
York, Maine 89, 91, 93, 134–135
Yosemite Arch Rock, California 565
Yosemite Falls, California 522–523
Yosemite National Park 11, 19, 27, 393, 562–569
Yosemite Valley, California 522–523, 562–563, 565
Young, Brigham 478, 480

Z
Zimmermann, Maurice 89, 91, 93
Zuni Pueblo (tribe) 406–408, 512

Bibliography
Bibliografie
Bibliographie

GENERAL AND MONOGRAPHIC WORKS/ ÜBERBLICKSWERKE UND MONOGRAFIEN/ OUVRAGES GÉNÉRAUX ET THÉMATIQUES

ARQUÉ Sabine, BOULOUCH Nathalie, JEZIERSKI John Vincent and WEBER Bruno, *Voyage en couleur, photochromie (1876–1914)*, Paris bibliothèques/Eyrolles, Paris, 2009.

COTTEAU Edmond, "Le Transcanadien et l'Alaska," in *Le Tour du monde*, a travel journal founded by Édouard Charton, Librairie Hachette et Cie, Paris, London, 1891 gallica.bnf.fr.

DONZEL Catherine, GREGORY Alexis and WALTER Marc, *Grand American Hotels*, Vendôme, New York, Thames and Hudson, London, 1989.

DUPRÉ Céline, *Dictionnaire biographique du Canada/Dictionary of Canadian Biography*, Les Presses de l'université Laval, Québec, 1969.

FOHLEN Claude, *Les Indiens d'Amérique du Nord*, Presses universitaires de France, Paris, 1985.

FORSEE Aylesa, *William Henry Jackson, The Pioneer Photographer of the West*, The Viking Press, New York, 1964.

HUGHES Jim, *The Birth of a Century*, Tauris Parke Books, London and New York, 1994.

LOWE James L. and PAPELL Ben, *Detroit Publishing Company Collector's Guide*, Deltiologists of America, An International Society of Picture Postcard Collectors, Norwood, PA, 1975.

MANDAT-GRANCEY Edmond, *Dans les Montagnes Rocheuses*, Plon, Paris, 1884, gallica.bnf.fr

RICHARDSON, Bruce "Brown Palace, Colorado", in *The Great Tea Rooms of America* [p. 14], Benjamin Press © 2006"

RIEUPEYROUT Jean-Louis, *La Grande Aventure du Far West*, Tchou, Paris, 1989.

RIIS Jacob A., *How the Other Half lives: Studies Among the Tenements of New York City*, first published by Charles Scribner's Sons, New York, 1890.

RUBIN Ernest, *Les Esclaves aux États-Unis de 1790 à 1860*, Institut national d'études démographiques, Paris, 1959.

SHOEMAKER Nancy, *American Indian Population Recovery in the Twentieth Century*, New Mexico, University of New Mexico Press, 2000.

SHUGAAR Anthony, DONZEL Catherine and WALTER Marc, *Voyages en Amérique du Nord*, Éditions du Chêne, Paris, 2008.

SINCLAIR Andrew, *A Concise History of the United States*, Thames and Hudson, London, 1967.

STICKELS STECHSCHULTE Nancy, *The Detroit Company Postcards*, Nancy Stickels Stechschulte, Big Rapids, MI, 1994.

WALTER Marc and ARQUÉ Sabine, *Portrait d'un monde en couleurs*, Éditions Solar, Paris, 2006.

WHITE Richard, *The Middle Ground: Indians, Empires, and Republics in the Great Lakes Region, 1650–1815*, Cambridge University Press, Cambridge, 1991.

DIGITAL REFERENCES/ DIGITALE QUELLEN/ RÉFÉRENCES NUMÉRIQUES

New York City
www.archives.metoperafamily.org
www.pbs.org/godinamerica/people/john-hughes.html
www.saintpatrickscathedral.org/about_history_timeline.php
Walt Whitman, "Crossing Brooklyn Ferry" (1856; 1881) www.blackcatpoems.com
www.ny.com/articles/centralpark.html, article by Sarah Waxman
www.nycsubway.org
www.pbs.org/wgbh/amex/carnegie/gallery

The East Coast and Quebec
www.blog.achotelexperts.com/history-of-the-atlantic-city-boardwalk
www.books.google.fr *Petit manuel d'histoire d'Acadie de 1670 à 1755*, La Librairie acadienne de l'université de Moncton, Jean Daigle, 1976
www.books.google.fr Roger W. Moss, "Historic Houses of Philadelphia," University of Pennsylvania Press, 1998 / Betsy Ross House
www.edwardmaby.com rip van winkle
www.explorepahistory.com King coal mining bituminous
www.niagarafrontier.com
www.statueofliberty.org
www.wikipedia.org/wiki/Breaker_boy
www.wikipedia.org/wiki/William_Frank_Carver
www.acfpl.org/atlantic-city
www.ausablechasm.com/history
www.buildings.yale.edu
www.catskillarchive.com/Mt Tom Railway
www.downtosea.com
 "The History of Gloucester Fishing", published April 7, 1923, "Short Essays of Gloucester, History of the Fisheries of Gloucester"
www.dutotmuseum.com Delaware Water Gap
www.emmitsburg.net/history "Gateway to the Mountains, Pen Mar Park" by George Wireman
www.findagrave.com/Lizzie Bourne
www.foundationsofamerica.com/Yale University
www.golfinthewhitemountainscom
www.history.com/this-day-in-history/erie-canal-opens
www.library.yale.edu
www.loc.gov/about/history
www.lighthouse.cc/capeneddick/history © Jeremy D'Entremont
www.nha.org/library/faq/briefhistory "Brief History of Nantucket" by Elizabeth Oldham, Research Associate NHA Research Library
www.persee.fr Maurice Zimmermann, "La diminution de l'immigration aux États-Unis en 1908", *Annales de Géographie*, année 1909, vol. XVIII, n° 100, 1979, p. 383
www.saratoga-springs.org
www.vtliving.com/maple/history

The Great Lakes and the Midwest
"The Great Lakes Shipwreck" File: Total Losses of Great Lakes Ships, 1679–1999, by Dave Swayze © 1998–2001 David D. Swayze, Lake Isabella, MI All Rights Reserved
en.wikipedia.org/wiki/Crush,_Texas
en.wikipedia.org/wiki/History_of_Louisville,_Kentucky
en.wikipedia.org/wiki/Missouri–Kansas–Texas_Railroad
http://seekingmichigan.org
www.ameriquefrancaise.org
www.hotspringshousing.org/evans.php
www.legendsofamerica.com
www.mammothsite.com
 Hot Springs, South Dakota
www.nps.gov/apis/historyculture/Apostle Islands
www.thecanadianencyclopedia.com

The Old South and the Carribean
www.louisianabicentennial2012.com/Louisiana-Statehood-History
sites.google.com/site/lcrpnola/the-city-of-new-orleans-history
www.ushistory.org
www.answers.com/topic/cotton-belt
www.persee.fr /Ernest Rubin
www.russguerin.com "A Creole in Mississippi, Settlement History of Bay St. Louis" © Russell Guerin
http://biloxihistoricalsociety.org *The Biloxi Herald*, March 17, 1888, p. 8
www.encyclopediaofarkansas.net
www.divingheritage.com "Sponge fishing in Key West" © by Sandra Hendrikse and André Merks
www.semtribe.com © 2013 Seminole Tribe of Florida/Willard Steele
www.library.vcu.edu "Timeline of Emancipation Day Celebrations in Richmond, Virginia, 1863 through Today," Virginia Commonwealth University

The Wild West
cograilway.com/history Manitou & Pike's Peak Cog Railway
en.wikipedia.org/wiki/El_Tovar_Hotel
http://texashistory.unt.edu William W. Mills, "Forty years at El Paso, 1858–1898; recollections of war, politics, adventure, events, narratives, sketches, etc., 1901"; University of North Texas Libraries, The Portal to Texas History
thewest.harpweek.com Harper's Weekly, 1857–1916
wikipedia.org/wiki/Broncho_Billy_Anderson
www.goldhunter.webs.com
www.hotelcolorado.com/history
www.nativevillage.org Helen Hunt Jackson (1830–1885), "An early advocate for Native People", thanks to Terri Jean from The Native Truth
www.nps.gov/grca/index.htm "Day Hike-Bright Angel Trail", Grand Canyon National Park National Park Service, U.S. Department of the Interior
www.pbs.org/wgbh/americanexperience Buffalo Bill's Wild West Show
www.sanxaviermission.org
www.trails.com
www.uapress.arizona.edu/ "A Gift of Angels The Art of Mission San Xavier del Bac" Bernard L. Fontana; Edward McCain © 2010. The Arizona Board of Regents
www.wheelsmuseum.org "The Historic Railroad Buildings of Albuquerque, An Assessment of Significance" by Chris Wilson
www.yellowstone-notebook.com © Frank Marley "History of the Old Faithful Inn"

The Pacific Coast
bancroft.berkeley.edu (Chinatown) The Online Archive of California © 2009 The Regents of the University of California, The Bancroft Library
http://linguistics.uoregon.edu
www.californiacountry.org California Country magazine, March/April 2010; story by Ching Lee, interview by Dick Barker, president and founder of Citrus Roots-Preserving, Citrus Heritage Foundation
www.chiefseattle.com article of the *Seattle Times*, July 13, 2001, by Sara Jean Green © 2009
www.missioninnmuseum.com Text courtesy of Tom Patterson and the Friends of the Mission Inn © The Mission Inn Museum 2004–2006
www.sandiegohistory.org ; quoted by Nan Cuthbert, in "Journal of San Diego History", Spring 1980, from *The San Diego Union*, January 20, 1906
www.sjchistoricalsociety.com
www.sos.wa.gov/history
www.stanford.edu/~galic/history/halfdome/

Acknowledgements
Danksagung
Remerciements

Marc Walter would like to thank Benedikt Taschen for the opportunity to publish this "American Odyssey," which is the realization of a collector's dream.

The authors would like to thank Simone Philippi for her kindly and efficient support in the making of this book. Thanks also to Andy Disl, Frank Goerhardt, Horst Neuzner, and Veronica Weller.

Marc Walter would particularly like to thank Gion Schneller (Photoglob AG, Zurich) and Bruno Tartarin.
Thanks also to Christopher Cardozo (The American Photochrom Archive).
We are very grateful to John Vincent Jezierski and Bruno Weber, whose knowledge of photochroms and the Detroit Photographic Co. helped us to record the history of this company as accurately as possible; to the Library of Congress (Washington, D.C.) whose holdings in glass negatives allowed us to enrich the iconography of this volume and match the photochroms and postcards from the Marc Walter Collection with the original negatives.
Thank you to Daniela Wegmann for kindly reading the section on Detroit Photographic Co., and to Chris Miller and Philippe Rollet for their helpful observations and encouragement.
And thank you to Jean Walter, who has maintained the tradition of the DPC retouchers!

Marc Walter bedankt sich bei Benedikt Taschen, der es ihm ermöglicht hat, diese „American Odyssey" zu veröffentlichen und damit einen seiner Träume als Sammler zu verwirklichen.

Die Autoren danken Simone Philippi für ihre stets freundliche und tatkräftige Unterstützung bei der Realisierung ihres Projekts. Danke auch an Andy Disl, Frank Goerhardt, Horst Neuzner und Veronica Weller.

Marc Walters besonderer Dank gilt Gion Schneller (Photoglob AG, Zürich) und Bruno Tartarin.
Danke ebenfalls an Christopher Cardozo (The American Photochrom Archive).
Wir bedanken uns insbesondere bei John Vincent Jezierski und Bruno Weber, deren Kenntnisse zum Photochromdruck und zur Detroit Photographic Co. uns geholfen haben, die Geschichte dieses Unternehmens so exakt wie möglich zu rekonstruieren, sowie bei der Library of Congress (Washington, D.C.), deren Bestand an Glasnegativen es uns ermöglicht hat, die Ikonografie dieser Publikation zu erweitern und den Photochromen und Postkarten aus der Sammlung Marc Walter die bei ihrer Realisierung verwendeten Original-Glasnegative gegenüberzustellen.
Vielen Dank an Daniela Wegmann, die so freundlich war, den Text über die Detroit Photographic Co. zu lektorieren; danke auch an Chris Miller und Philippe Rollet für ihre klugen Anmerkungen und ihre Ermutigungen.
Und vielen Dank an Jean Walter, der es vermochte, die Tradition der Retuscheure der DPC fortzuführen!

Marc Walter remercie Benedikt Taschen de lui avoir offert l'opportunité de publier cette «Odyssée américaine», qui représente la concrétisation d'un de ses rêves de collectionneur.

Les auteurs remercient Simone Philippi de son amical et efficace soutien tout le temps de la réalisation de leur travail. Merci aussi à Andy Disl, Frank Goerhardt, Horst Neuzner et Veronica Weller.

Marc Walter remercie particulièrement Gion Schneller (Photoglob AG, Zurich) et Bruno Tartarin.
Merci aussi à Christopher Cardozo (The American Photochrom Archive).
Nous sommes très redevables à John Vincent Jezierski et à Bruno Weber, dont les connaissances sur le photochrome et la Detroit Photographic Co. nous ont aidés à résumer aussi exactement que possible l'histoire de cette compagnie ; ainsi qu'à la Bibliothèque du Congrès (Washington, D.C.) dont le fonds de plaques de verre nous a permis d'enrichir l'iconographie de cet ouvrage et de mettre en relation les photochromes et les cartes postales de la collection de Marc Walter avec les clichés originaux qui ont servi à leur réalisation.
Merci à Daniela Wegmann, qui a bien voulu relire le texte sur la Detroit Photographic Co. ; merci aussi à Chris Miller et à Philippe Rollet pour leurs remarques perspicaces et leurs encouragements.
Et merci à Jean Walter qui a su perpétuer la tradition des retoucheurs de la DPC !

Imprint
Impressum
Mentions légales

To stay informed about upcoming TASCHEN titles, please subscribe to our free Magazine at www.taschen.com/magazine, find our Magazine app for iPad on iTunes, follow us on Twitter and Facebook, or e-mail us at contact@taschen.com for any questions about our program. Delve in and enjoy!

© 2014 TASCHEN GmbH
Hohenzollernring 53, 50672 Köln, Germany
www.taschen.com

Editorial coordination
Simone Philippi, Cologne

Design
Marc Walter, Paris
Sense/Net Art Direction, Andy Disl
and Birgit Eichwede, Cologne
www.sense-net.net

English translation
Chris Miller, Oxford

German translation
Katja Naumann, Berlin

Production coordination
Frank Goerhardt, Horst Neuzner, Cologne

Printed in Italy
ISBN 978-3-8365-4210-4

"Tommy Atkins," dog in uniform, glass negative, ca. 1905
„Tommy Atkins", Hund in Uniform, Glasnegativ, um 1905
«Tommy Atkins», chien en uniforme, plaque de verre, vers 1905